D1196097

The

EMILY
CARR

Omnibus

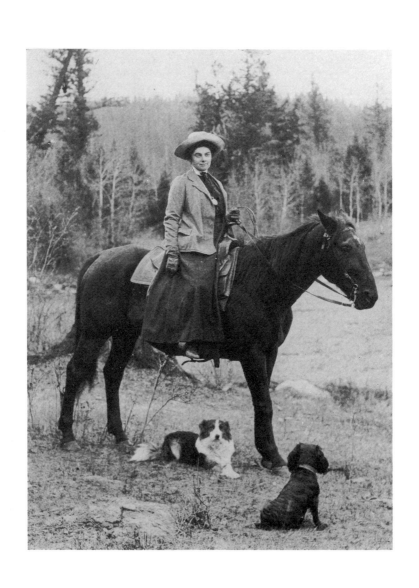

The EMILY CARR *Omnibus*

INTRODUCTION BY

DORIS SHADBOLT

DOUGLAS & McINTYRE

VANCOUVER/TORONTO

UNIVERSITY OF WASHINGTON PRESS

SEATTLE

93 94 95 96 97 5 4 3 2 1

Published by arrangement with Stoddart Publishing Co. Limited.

Published in Canada by
Douglas & McIntyre Ltd.
1615 Venables Street
Vancouver, BC V5L 2H1

CANADIAN CATALOGUING IN PUBLICATION DATA
 Carr, Emily, 1871–1945.
 Emily Carr omnibus

 ISBN 1-55054-031-9

 1. Carr, Emily, 1871–1945. 2. Painters—
 Canada—Biography. I. Title.
 ND249.C3A2 1993 759.11 C93-091628-X

Published simultaneously in the United States of America by
The University of Washington Press, P.O. Box 50096, Seattle, WA 984145-5096.

LIBRARY OF CONGRESS CATALOGUING IN PUBLICATION DATA
Carr, Emily, 1871–1945.
 The Emily Carr omnibus / Introduction by Doris Shadbolt.
 p. cm.
 ISBN 0-295-97306-4
 1. Carr, Emily, 1871–1945—Themes, motives. I. Shadbolt, Doris.
II. Title.
ND249.C3A4 1993
759.11—dc20 93-22994
 CIP

Design by Barbara Hodgson
Printed and bound in Canada by D.W. Friesen & Sons Ltd.
Printed on acid-free paper

FRONTISPIECE: *Emily Carr in British Columbia's Cariboo region, fall 1904.*
 Private collection

CONTENTS

THE EMILY CARR
OMNIBUS

INTRODUCTION

AS EMILY CARR was clearing out the cupboards, drawers and attic of her twenty-three-year-old house in preparation for its sale, an "old green bag," the one she used to carry her dance slippers in, full of "old letters and childish poems," put her in a reminiscent mood. The year was 1936; she had just turned sixty-five. "Poor silly little rhymes that eased me in writing," she said, thinking back over her life. "For writing is a strong easement for perplexity. My whole life is spread out like a map with all the rivers and hills showing" (HT 813).

Carr had the impulse to put her thoughts and feelings into written words early in her life. She wrote poems as a child and as an art student in San Francisco, and later in England she wrote humorous skits about her experiences and illustrated them with drawings. When she was in England between 1899 and 1904 writing was already sufficiently important for her to approach Beatrix Potter's publisher—and to receive what was probably her first rejection. During the discouraged years of the 1920s when she was painting little, she wrote what she referred to as her 'stories', the beginnings of most of the pieces now published, and in the fall of 1926, in pursuit of what clearly had become a rewarding and compulsive form of expression, she enrolled in the Palmer School of Authorship, a correspondence school based in Los Angeles. In 1934 she took a summer course in short story writing in Victoria, having little confidence in the instructress but intent on keeping the practice going and further improving her skills. She was sending stories off to such magazines as *Maclean's*, the *Saturday Evening Post* and *The Countryman* at this time, but none were accepted for publication.

The re-writing and final drafting of the works, often begun many years before, that comprise this volume, was done between 1934 and 1941, that is, when she was between the ages of sixty-three and sixty-seven. During those years at times she wanted to write more than paint. In fact the creative flow alternated so readily between the two channels that in reading her journals, as she discusses her work on any particular day, one has to stop at times to determine whether she is talking about her writing or her painting. "I'm thirsting to be at it (painting) again" she says in 1934, "but the story course has me tied by the arms and legs for another week yet. I've written an Indian story . . ." (HT 756). In 1937 at the age of sixty-six she suffered the first of several heart attacks. During the lengthy convalescence which followed, painting activity was curtailed, giving fresh impetus to the less physically demanding writing. "One

approach is apparently cut off, I'll try the other. I'll word those things which during my painting life have touched me deeply" (GP 460).

Flora Burns, the daughter of a Victoria friend of Emily's mother, whom Emily had persuaded to join her in the correspondence course, became one of an essential group of help-mates—supporters of morale, critics and facilitators without whom her work would not have achieved publication. Her role was to provide writerly companionship, to read Emily's work, encourage, offer her gentle criticism and often to type the stories. There was also Ruth Humphrey, a professor of English at Victoria College, a more sophisticated critic than Flora and also a dedicated reader and supporter despite Carr's frequent irascibility. Garnett Sedgewick, a Shakespearian scholar and Head of the Department of English at the University of British Columbia was drawn into the cause. Humphrey, who was determined to see Carr's work published, showed it to Sedgewick who, along with another enthusiastic friend, sent a manuscript to the Toronto publisher Macmillan in 1937. It was rejected by Macmillan, as it was by Ryerson Press a year or so later.

Finally the most important of the little group of devotees was Ira Dilworth, regional director of the Canadian Broadcasting Corporation. At Dilworth's invitation Sedgewick read several of Carr's stories over the local radio on two occasions in 1940, and Dilworth himself did further readings over the CBC national network. This public exposure of her work marked a critical turn in her writing fortunes, and when in 1940 Dilworth approached William H. Clarke of Oxford University Press, he received an enthusiastic response. Eventually Clarke and his wife Irene, who was part of the firm, accepted both *Klee Wyck* and *The Book of Small* for publication. Today Carr's books have been translated into several languages and can be read in many countries of the world.

Ira Dilworth became, throughout Carr's last years, her literary mentor and the close soul-friend she had always longed for. She depended on him for moral support and the steering of her literary career as she had earlier turned to Lawren Harris for confirmation in her role as painter. He was instrumental in the first publication of all her books, became her editor and eventually the executor and heir of her literary estate.

Klee Wyck, in 1941, was the first of the books of 'stories' to appear. During that stay in hospital in 1937 Carr was drawn back in her memory to the rich experiences she had had years before, visiting native village sites in little-frequented places and coming in contact with various native people. It was these 'native' stories that she now began to re-work, and they offered a logical and fortuitous place for publication to start. *Klee Wyck*, certainly to Carr's surprise, won the Governor General's award for literature that same year. *The Book of Small*, in which she reconstructs herself as the little girl growing up in early Victoria, came in 1942. It appropriately includes the charming collection *A Little Town and a Little Girl*, although this was written as a separate piece. *The House of All Sorts*, also published in 1942, remains most memorable as the recalling of her life as a harassed landlady between 1913 and the mid-1930s. As in almost all her books,

however, there is a great deal about her animals as well, in this case her stories of *Bobtails*. The remaining books came out after her death in Victoria in 1945. *Growing Pains: The Autobiography of Emily Carr*, published in 1946, was written in the early 1940s, replacing an earlier version. It includes brief sketches of her family and childhood and then in selective fashion takes us through her art student days in San Francisco and England, describes her introduction to 'modern art' in France and her return to life on the Canadian west coast. *Pause: An Emily Carr Sketch Book* and *Heart of a Peacock* were both assembled and published in 1953—the former a collection of drawings and written sketches done while a patient in England in 1903–04; the latter a miscellany of sketches and vignettes in which her beloved animals are prominent, including the stories called *Woo's Life. Hundreds and Thousands: The Journals of Emily Carr*, consisting of sporadic entries made between December 1927 and March 1941, the period of her full maturity as a painter, was published in 1966. The entries deal with her thoughts as she had them and the round of her daily life as she lived it. They are not episodes recalled in nostalgic or revisionary retrospect, and in that respect this book is very much apart from the others. Emily gave the journals to Dilworth with a letter, naming the title she had chosen for them and making it clear that she intended their publication—though the directness and spontaneity of many of the entries suggest that intention may have been forgotten from time to time or have been an afterthought. Dilworth took on the task of transcribing her difficult handwriting and preparing the journals for publication; at his death it was carried through to completion by her publishers. Two public lectures she gave in Victoria in 1930 and 1935 were published in 1972 under the title *Fresh Seeing*. They were not written for publication and have not been included in this volume.

The books of Emily Carr found a ready audience. They spoke directly to the ordinary reader 'in the street', the response she always wanted for her painting and never found. They appealed as well to more sophisticated readers to whom they came as the proverbial breath of fresh air. There was the clean unadorned prose, at times almost blunt in its directness; there was the vivid imaging in homey simile or metaphor of the most ordinary or the most momentous episodes in her life; there was the sharp evocation of a particular place in a particular time. Perhaps most of all there was the forthright and sturdy person—Emily herself—that the writing projected. Read today, her writing continues to renew its original fresh appeal, even if our appreciation is overlain with an inescapable layer of regret as the world of relative innocence she evokes fades into a fairly recent and yet already almost unimaginable past.

By the time Carr emerged as a writer, her work as a vital and significant artist was almost finished and her painting, though not as widely known as it would come to be, was already critically recognized. Her dual accomplishment as painter-writer soon assured her a position of prominence in the Canadian cultural scene. She continues to inspire others in their own creative efforts, so that poetry, drama, criticism, dance and film using Carr as their theme exist in

plenty. She has been drawn into the intense critical discussions which are part of our present-day socio-cultural climate. First of all, because of the important role played by native North-West Coast culture in her art and life, she has become pertinent to the broad dialogue centring in native issues. Her story as that of a woman who surmounted the gender prejudices endemic to her time to achieve her goals with such distinction gives her relevance in the context of ongoing feminist discourse. And her deep commitment to nature in all its manifestations speaks to the environmental dilemmas that face us now. As a consequence, the presence of Emily Carr resonates in our midst today with a reverberation different from that of ten or fifteen years ago and perhaps even more strongly than ever before. In the current critical climate of social, political and cultural perception, the art itself—the art of painting and the art of writing—sometimes seems to disappear through the cracks of analysis. But not the woman—not this woman who is both author and subject of her own books. This volume gives us the opportunity to look once again at their 'subject'.

For Carr, writing was another form of expression as vital and at times as compelling as painting. "I have not written in my book (the Journals) for a long time. I have been writing stories and that, I expect, eased me, pouring out that way. It seems as if one must express some way, but why? What good do your sayings or doings do? The pictures go into the picture room, the stories into the drawer" (HT 845). And we know from the many times she spoke of her writing intentions in *Hundreds and Thousands* how assiduously she worked over each piece, striving to get inside and to give it the particular expressive quality of the experience which prompted it, just as she did with each of her paintings. Similarly, she brought to her writing the same sense of appropriate thoughtful workmanship. She does not attempt long or complex literary construction but, for all its simplicity, conscious crafting is clearly manifest in the deliberate un-stylish style of her work. Her very term 'stories' for the short pieces that make up most of the books—really sketches, vignettes or anecdotes, some of them scarcely more than a page in length—implies objectification and shaping. In *The Book of Small*, perhaps the most crafted of the books, she avoids the more intimate "I" by referring to herself in the third person as "Small." It is a crafting device, distancing the author from her subject, though it was not repeated in other books. She would like, she says, to "make little daily incidents ring clean cut and clear as a bell, dress 'em up in gowns simple and yet exquisite like Paris gowns" (HT 755).

She is more than an engaged artist/writer, however, writing for the sake of writing. There is a sense in which, on a deep psychological level, Carr's painting is autobiographical. In her writing, the overlap of subject and author is direct; the books are about herself. Accurate chronological recording has no part in her intentions; nor has she any inclination to intimacy or self-confessional outpourings, the exception being the journals. We might ask what we learn from the books about the person writing them—not just the depicted outer person, but the person underneath her creation.

Taken together they represent a woman well past middle age who had most of her life to look back upon. The time had come to recollect her childhood and other parts of her life by which she chose to present herself. She was responding to a need, well-known to artists and others of strong ego, to confer meaning on their life by giving it written form so that they themselves and others could read it. That compelling if unconscious motivation is evident in the self-mirroring quality that characterizes much of the writing. It is as though, when ostensibly narrating an incident or describing a place, there is frequently present the underlying purpose of creating herself through and by means of the incident. So the books are about herself in a special kind of way. Despite her intention to recall certain happenings and incidents of her life, rather than concern herself with self-revelation or analysis, the person comes through strongly, a woman who has held back much of herself and yet revealed more than she probably knew.

Carr was fortunate enough to possess in good measure the strong ego that artists require. It shows in her writing in the frequency with which she points to her difference from others. The sense of her 'I', the unshakeable certainty of her own being, is there from her birth. She points to her early wilfulness when, refusing to be born according to schedule, she forced her father (who usually got his way in everything) out in the middle of a snowy night to fetch Nurse Randal. It is significant that this early display of spiritedness should be against her father, a symbol of the authoritarian forces in her life against which she would define and toughen herself for her never-ending struggle to become her own full being. She was "contrary from the start" she tells us, "the disturbing element of the family. The others were prim, orthodox, religious" (GP 307). Refusing to act the obedient nice-little-girl part expected of her, she plays in the dirt and gets her clothes soiled, she thinks wicked thoughts; as an adult she is rude to people who get on her nerves, she rides 'cross-saddle' instead of the more lady-like side-saddle, she smokes cigarettes and is generally "not a nice person." There is a note of satisfaction in the writing as she reconstructs the independent person she sees in her retrospective mirror and we, as we read, rarely lose the ring in our ears of her implied "I." Not the neutral first person of a narrative autobiography but either the resilient self-assertive individual or the reverse, the victimized 'me'.

The criticism, impatience and frequent anger Carr directed at many of those she encountered in the world inevitably affirms that cherished sense of herself. Even though she finds fault with herself on occasion, the accumulated shortcomings of the large number of people she found wanting are in implied comparison with her own relative virtues. When she writes of her childhood the criticisms are sometimes on the light and whimsical side, but they are there. Like the stuffy Bishop who thought hymns would be more suitable than her own preferred and joyous "cow-songs"; or the older sister who almost "twisted my nose off" for a failure in manners at a children's birthday party. She cannot, however much she tries, disguise her deep hatred of her father which runs as an

undercurrent through *The Book of Small*. When studying in London, there were the stiff and snooty clergymen (frequent recipients of her scorn) and landladies with their 'make-believe gentility'. The most conspicuous objects of her dislike are, later on, her own "damned" tenants and boarders whose transgressions she describes (and exorcises) in *The House of All Sorts*. They draw her open ire like a lightning rod—understandably, for their very existence represents the circumstances and obstacles that stood in the way of her painting. "Tenants, how I've *hated* the whole business of them—like a galling collar round my neck," she said as she finally put the house up for sale. "Of all that have passed through my flats in twenty years how very, very few I have said good-bye to with regret. Some of the partings have been very ugly indeed, some bitter" (HT 785).

Altogether her list of those found wanting is long, and after a while in our reading they congeal into a lumpen 'them'—the boring, small-minded, unctuously pious, tea-addicted, socially constrained Victorians whose ultimate failure was that they had no comprehension of the real difference that underlay her small eccentricities. 'They' for a long time included her older sisters (who also never understood her art) until finally old age, mutual dependency and a belated measure of success softened her attitude. It is clear that the world of social establishment into which she was born, grew up and carried out her life's work, with its conventions, its self-righteousness and prejudices, made her touchy, impatient and resentful. Her accumulated anger seeps through the books, charging even her recollections of a cherished childhood.

Her self-admitted crusty exterior ensured her of the solitude and concentration required for her art, and yet she longed at times for satisfying sociability. She laments her "repelling of mankind and at the same time rebelling at having no one to shake hands with but myself and the right hand weary of shaking the left" (HT 732–33). And so we have, alongside the resilient and morally tough individual who grits her teeth and forges ahead, the vulnerable victim who finds it necessary on occasion to go off and "weep bitterly." She may be the victim of outside events: "the horrid tenant below, the miserable woman who lost my dog, the creature I met in the street the other night who took me by the shoulders and shook me because I was trying to fend her dog off mine, the insurance company who have swindled me out of cash by misrepresentation of their men—all these and more heaped in a pile and me straddled atop trying to forget them all, but they will stick out teeth and claws and gnaw and pinch and scratch and it's hard to sit steady on the pile . . ." (HT 764). Or she may be the self-pitying victim of her own felt inadequacies: "I don't fit anywhere, so I'm out of everything and I ache and ache. I don't fit in the family and I don't fit in the church and I don't fit in my own house as a landlady. It's dreadful—like a game of Musical Chairs. I'm always out, never get a seat in time; the music always stops first" (HT 764). The victim is simply the reverse side of the ego coin.

Childhood, the symbolic time of innocence, whatever its frustrations, was still a happy time for Emily and she loved thinking back to it. There is the whole of

The Book of Small and most of the pieces in *The Heart of a Peacock*. Some of her most delightful writing comes out of her recollections of those early days, passage after passage capturing an air of wonder and delight that rekindles our own warm memories of childhood. There is a delightful story in *A Little Town and a Little Girl* describing the walk to visit family friends on the other side of the town. It is a journey ingeniously traced by the different kinds of smells through which one passed on the way. There was first the stretch of wild rose bushes growing at the road-sides whose perfume was "delicious. Then we came to the mud flats and our noses hurt with its dreadfulness when the tide was out. We had no sooner got over that than there was Chinatown with stuffy, foreign smells. Then came the gas-works—this smell was said to be healthful but it was not nice. Rock Bay Bridge had more low-tide smells, which were made easier by a sawmill; the new sawdust smelled so nice that you forgot your nose until the other end of the bridge came. There sat a tannery from which came, I thought, the worst smell of them all. There was one still more dreadful—Parker's slaughter-house and piggery . . ." (BS 151–52).

Even when writing about her later life she often appears to yearn for the "little self that is always learning things without knowing that it is doing so" (GP 423). In her last years she wrote to Ira Dilworth, slipping into her persona as "Small" when she wanted to recapture the carefree, imaginative spirit of her childhood. Sometimes she remembers herself as younger and smaller than she was at the time (a "girl of fifteen in pigtails," when on her first visit to the native village of Ucluelet, when in fact she was twenty-seven or twenty-eight)—an inclination to distance herself from the harsh world of adult scrutiny by becoming more childlike.

The spunkily appealing child that Carr projects belongs to a larger image of herself as an innocent and artless person who is simple and direct in all things and attracted to those qualities in others. Simplicity, artlessness, honesty and directness were held as primary personal values by Carr and they determined her grown-up attitude to most things in life. Her aversion to anything that might be interpreted as pretension is reflected in her approach to her writing. Speaking about *Growing Pains* she says "Flora wants my English to be perfect, but in the biography I'm talking as myself, of very average education, my words learned of decent parents rather than from a stabilized school of education . . . better in my own words than in A-1 language that does not belong to me" (HT 878). Her school education had stopped early, a fact which contributed to later feelings of intellectual inadequacy—and she did not learn from her own reading. She eagerly read selected poetry and some art books, but she was not a 'reader' of literature in the usual sense. She knew what she wanted however. "I did not know book rules," she said in *Growing Pains*. "I made two for myself. They were about the same as the principles I used in painting—Get to the point as directly as you can; never use a big word if a little one will do" (GP 460–61). She was never tempted to move beyond telling, direct description into philosophic speculation and her writing is alive with precisely remembered

sensory detail in stories that are often not much longer than a page. "The canoe took the water as a beaver launches himself—with a silent scoot"; "Victoria was like a lying down cow, chewing" and "I slept, cosy as jam in a roly poly" (KW 55, BS 148 and GP 419, respectively) are images typical in their simplicity, homeyness and physicality.

If Carr emulated naturalness as a principle, she was also, literally, a creature of nature, more comfortable with trees and flowers than with most people. And of course, most comfortable with animals. Because she loved them so intensely and spent so much time with them, animals, along with childhood, have elicited some of her most particular observation, and animal similes and metaphors abound. When the family's "great red and white loose-knit cow . . . walked, her great bag swung slowly from side to side. From one end of her large-hipped square body nodded a massive head, surmounted by long pointed horns. From the other dangled her tail with its heavy curl and pendulum-like movement. As her cloven hoofs moved through the mud, they made a slow clinging squelch, all in tune with the bagging, sagging, nodding, leisureliness of the Cow's whole being" (BS 98). The importance of animals in Carr's life (and their prominence in her writing) is often given the tired explanation that it is compensation for the absence of children of her own and her apparent inability to make close friends. It is true that being with animals, even thinking about them, satisfied a deep emotional need and deflected her frustrations with humans. Bored with self-centred old-maids and married women absorbed in their husbands and families, she thanks the Lord for "the dogs and the monkey and the rat" (HT 757); and during a prolonged illness in an English sanatorium she kept her spirit alive by nurturing song-birds. Animals had their practical side, too, and for a number of years she bred bob-tailed sheep dogs to make a living. But animals also relate to her broader predisposition to the natural in all things, and they were an essential part of her larger relation to nature. Animals accompanied her everywhere— on her trips to England, to France, to native villages in locations difficult of access and always on her sketching expeditions. "I have taken birds, a monkey, even a little white rat into the woods with me while studying. The creatures seemed somehow to bridge that gap between vegetable and human. Perhaps it was their mindless comprehension of unthinking life linking humanity and vegetation"(GP 444).

She was also attracted to people whom she could see as simple, artless, unpretentious folk like herself, sometimes those separated by barriers of language from the risk of demanding relationships; and sometimes, it must be admitted, separated by socially inferior status. Those, in short, with whom she could feel comfortable because they presented no challenge to her various points of vulnerability. During her stay in France, painting in the villages and countryside of Brittany, while not speaking the language, she enjoyed a "gesticulating, nodding, laughing acquaintance with every peasant" (GP 433). She prefers the response to her painting of Mayo Tong, "a Chinese cook boy" (HT 758), and "little Lee Nan" (HT 696), an untutored young Chinese painter, to that of art-conscious viewers. We note the patronizing (and diminutizing) implication of

"little." In *Klee Wyck* there was the elderly chieftain at Ucluelet with whom, to her obvious satisfaction, she felt she was able to communicate without the benefit of words in the way that counted with her—intuitively, eye to eye. And of course there is Sophie, a native woman from a reserve in North Vancouver, "always my first and best friend," who claims a chapter in the same book. Many of the dimensions of full friendship were denied in a relationship that precluded an exchange of ideas and a sharing of cultural traditions, but the emotional bonding was real, and together she and Sophie "contentedly sat long whiles upon the wide church steps, talking little" (GP 437).

In her writing, in fact, Carr carries her innocence and simplicity in front of herself like a banner, announcing a quality that had high value for her and that she emulated—but also thereby shading herself from the critical scrutiny of those she was quick to see as intellectually and socially more sophisticated than herself. It is from this perspective that her relationship with native people can be seen. She found in them a naturalness and a literal and ideological closeness to nature she wanted to find and which she exemplified within the limit of her own circumstances. On more than one occasion she spoke of their honesty, dignity and forthrightness in contrast belittling to qualities of white people. In recalling the writing of the *Klee Wyck* stories she says "I tried to be plain, straight, simple, Indian" (HT 864). She confessed that at one time in her youth she wished she had been born 'an Indian'.

The truth is that native people as she saw them were really a metaphor for her own personality (as in some way were animals). She did not know them by other than the limited sides they were at that time able to expose to those belonging to the dominant and dominating segment of society. And as for the natives whom she met and on whom she often depended for help on her trips to native villages, with them there could have been no revealing personal or cultural exchanges. She had read a limited amount of anthropological material in order to know something about the people whose villages and carvings she admired and painted; but from natives themselves she learned little, simply interpreting her contacts according to her own romantic constructs.

Her admiration for native people was based on her limited experience and knowledge, but it was also able to fortify her sense of her individuality and her difference from others around her. Her Victorian contemporaries did not share her admiration. She recalls an incident in which her father, a successful wholesaler, distributed raisins to natives lined up in front of his store. It was a gesture of generosity surprising to Emily until she learned that the raisins were full of maggots—unsaleable but 'good enough for Indians'. In the telling she both reflects the prevalent patronizing attitude of white towards native people, and appears to separate herself from it.

Similarly, and inevitably, she applied her own construct to her reading of native art. So while her feeling for the great native carvings was strong and genuine, she saw them through the artistic lens of her time and her personal perspective. When she first began using native material as her subjects, her intention was documentary. She wished to make records of historic and anthro-

pological interest and so she painted them, first in the realistic style she had inherited from her early training and then for a time in the Post-Impressionist manner she had learned in France. When in the late 1920s her paintings of native subjects completely changed character, their new charge of expressive content was consistent with artistic ideas she had received during and following her trip to eastern Canada. This turn-about in her painting attitude is vividly reported in the opening pages of *Hundreds and Thousands*. Thus, reading her own new goals into the old carvings she could find that native art is "the most modern in spirit of anything in Canada" and that "the artists have searched beneath the surface for the hidden thing which is felt rather than seen, the reality . . . which underlies everything" (Supplement to the *McGill News* (1919), 18,19). And when she speaks (mistakenly) of the native artist's "deep desire for self expression" it is quite clear that it is her own desire which she is reading into *his* attitude. *Klee Wyck* is full of Carr's sense of adventure and excitement as she launches out in pursuit of experience and subject material for her paintings, finding herself in situations which often presented physical difficulties but where she was at ease emotionally. And significantly this book is free of the undertone of anger and defiance, the clamouring 'me' which seeps through in much of her other writing. The aboriginal people she met were still so muted by years of white subjugation as to present no challenge to her constructions of their culture or use of their material. At the same time she could claim her interest and artistic investment in them as a challenge to common prevalent white attitudes, another indication of her 'difference'. Evidently it was only white society—its solid conventional citizens and its institutions who could and did challenge her—who roused the resistant and angry rebel in her.

Hundreds and Thousands adds important dimension to Carr's portrayal of herself. We learn a lot about her everyday life in Victoria during the period covered—about her trips to eastern Canada, the rapture of life in her sketching 'van' where she was separated from nature by only a "canvas shell," her small domestic pleasures, her failing health, her increasing recognition by a larger art world, her sisters' changing fortunes. But in this presentation of herself she writes not only *about* herself, but also *out* of herself. The mirror in which she saw and fashioned herself in the other books has been put away. It is here, too, that the various manifestations of Carr's 'natural', as they surface elsewhere, become *nature* in the simple common understanding of the word in her time. Here the little girl acutely attuned to the flowers and growth of Victoria's abundant gardens and parks becomes the adult who finds in the woods and beaches and open skies answers to her long quest for meaning in existence. Nature and Emily together surge through the pages and by the time we come to the end they have become one: she is totally in nature and nature is totally in her.

Perhaps we could say that here the conspicuous ego of her other writing is replaced by the soul. Here alone does she reveal her spiritual self; and the journals remain most memorable as the intimate telling of her search to probe and clarify her closely related artistic and spiritual drives and to find their full expression in her art. It is a struggle, discouraging much of the time, but broken by

flashes of incandescent exhilaration. It is in these pages that we learn of the excitement with which she first received and then lived out in her mature painting the romantic notion of the artist as an especially endowed and inspired individual. It was a notion that, finding its spiritual roots in the nineteenth century Romantic movement in northern Europe, persisted in certain channels of modernism. It was transmitted to her in its Canadian version—a kind of transcendentalism of nature—chiefly through Lawren Harris with whom she had a critical friend-counsellor relationship, but also through other artists whom she met or read about in the early 1930s just as she was coming into her full painter's authority. Sweeping social and cultural changes since her time have brought about drastically different notions of the artist's role today, but that does not prevent us from recognizing the force of her vision or the totality of her commitment.

The province of British Columbia and the city of Victoria were too close to frontier days when Emily Carr was born there in 1871 to offer an understanding and nurturing climate to a person of her creative spirit. Her comfortable middle-class parents of prideful English background brought her up in the atmosphere of polite social convention and strict protestant religious practice that was characteristic of Victorians of their economic and social class. Neither her family nor the community was equipped to understand art as much more than a graceful ornament to living nor an artist as more than a talented, perhaps sensitive, depicter of approved subjects. That she had the will and the persistence, without artistic models, and in a cultural backwater, to become an artist of striking power and a writer of originality and charm, is remarkable enough. But she did so in a world which was unable to imagine such an achievement *by a woman*. David Milne, a major eastern Canadian artist and contemporary of Carr, could say (in a January 1932 letter in the National Gallery files) without much fear of being contradicted, that "there are no great women artists, no women creators. Too much cleverness and no courage. I am not going to be fooled any more." His further comment that Carr's *"little"* Indian Church, a painting in the Toronto exhibition which he had just seen, was outstanding, does not deny the broader import of his statement. Long after her death many people found it difficult to acknowledge her strength as other than a masculine attribute that had somehow become misplaced.

We might say that Carr's achievement as a painter is the supreme example of the 'otherness' she claimed in her writing; and we see how it rested on the strength of character built and maintained through a lifetime's accumulation of other assertions of individuality, all those that are reflected in her books. While nature was her refuge, she also cultivated her defiant self-image as a necessary carapace within which she could find her creative space, clinging to her difference, dramatizing her anger and protecting herself behind her innocence.

By the time Carr reached her late fifties she had come to terms with her Victorian family and upbringing; she had freed herself from the repressive authoritarian presences in her life; she had broken away from the landlady image into which economic circumstances had trapped her for some thirteen

years. She had quite some time before declined the wife-mother role her society would have assigned to her in order to pursue the life of her own choosing. It was then that the various components of her life came together into fully working harmony, and she achieved her transformation into her own full being. Her acceptance after 1927 by the art establishment of English Canada, centred in Ontario, coincided with the change that had occurred and was partly responsible for it. But we really know it from her painting which took on new power and identity at this time. Apparently it was about that time, too, that the need to look back on her life and see and write its pattern, became urgent.

Doris Shadbolt

KLEE WYCK

Contents

FOREWORD

MY EARLIEST vivid memories of Emily Carr go back to a period considerably more than a quarter of a century ago, to a time when she was living in Victoria, British Columbia, still largely unnoticed as an artist and, by most of those who did know her in that capacity, unappreciated or treated with ridicule and even hostility. In those days she was a familiar figure passing down Simcoe Street in front of our house which was little more than a stone's throw away from her home. With methodical punctuality by which you could almost have set your clock, she passed by each morning on her way to the grocer's or butcher's. She trundled in front of her an old-fashioned baby carriage in which sat her favourite pet, Woo, a small Javanese monkey dressed in a bright costume of black, red and brown which Emily had made for her. Bounding around her as she went would be six or eight of the great shaggy sheep dogs which she raised for sale. Half an hour later you could see her returning, the baby carriage piled high with parcels, Woo skipping along at the end of a leash, darting under the hedge to catch succulent earwigs which she loved to crunch or sometimes creeping right through the hedge into the garden to have her tail pulled by the children hiding there. The great sheep dogs still bounced around the quaint figure whom they recognized as their devoted mistress. I thought of her then, as did the children behind the hedge and as did most of her fellow-citizens who thought of her at all, as an eccentric, middle-aged woman who kept an apartment house on Simcoe Street near Beacon Hill Park, who surrounded herself with numbers of pets—birds, chipmunks, white rats and the favourite Woo— and raised English sheep dogs in kennels in her large garden.

Emily Carr was a great painter, certainly one of the greatest women painters of any time. It has been said that for originality, versatility, driving creative power and strong, individual achievement she has few equals among modern artists. Her talent in drawing revealed itself when she was still a small child and was encouraged by her father. Emily set herself, early, and with singleness of devotion, to master the technique of painting and, despite discouragement and many difficulties, worked with great courage and experimental enthusiasm until the time of her death.

After the turn of the century, with study in San Francisco and England behind her, she became particularly concerned with the problem of devising a

style in painting which would make it possible for her to express adequately not only what she saw but also what she felt in her subject matter—the great totem poles, tribal houses and villages of the West Coast Indians and, later, the tangled, solemn, majestic beauty of the Pacific Coast forest. Nothing ever meant so much to her as the struggle to gain that power; she was never satisfied that she had achieved her aim. In this connection, therefore, it is interesting to have the opinion of Lawren Harris, himself a great original Canadian painter and for years one of Emily Carr's closest and most valued friends. He says in an article, "The Paintings and Drawings of Emily Carr",

> It (British Columbia) is another world from all the land east of the Great Divide. Emily Carr was the first artist to discover this. It involved her in a conscious struggle to achieve a technique that would match the great, new motifs of British Columbia. It was primarily this long and deepening discovery which made her work modern and vital, as it was her love of its moods, mystery and majesty that gave it the quality of indwelling spirit which the Indians knew so well. It was also her life with the Indians and their native culture which led her to share and understand their outlook on nature and life, and gave her paintings of totems, Indian villages and the forest a quality and power which no white person had achieved before.

Emily Carr is now also recognized as a remarkable writer. Her diaries, which first came to light after her death and remain still unpublished, make it clear that her desire to express herself in words began in the late 1920's. As in the case of her painting, she worked very hard to master this medium. She was fascinated by the great range of new possibilities which it opened up but mastery of it did not come easily.

Why did she turn to writing? Sometimes, undoubtedly, merely for comfort in her loneliness, sometimes quite consciously to relive experiences of the past. She once told me that when she was working on the first stages of a painting, trying to put down in pictorial form a subject for which she had made field sketches, she found it of great value to "word" her experience. In this way, she said, the circumstances and all the details of the incident or place would come back to her more vividly and she could reconstruct them more faithfully than was possible with paint and canvas alone. From this developed, I suspect, one of the controlling principles of her method and style in literary composition.

I have seen her "peeling" a sentence, as she called it,—a process which involved stripping away all ambiguous or unnecessary words, replacing a vague word by a sharper, clearer one until the sentence emerged clean and precise in its meaning and strong in its impact on the reader. As a result, there is in her writing the quality of immediacy, the ability, by means of descriptive words chosen with the greatest accuracy, to carry the reader into the very heart of the experience she is describing, whether it be an incident from her own childhood or a sketch of an Indian and his village—and that so swiftly as to give an impression almost of magic, of incantation.

She has spoken many times in her diaries of the difficulties she had to overcome in writing. Late in October, 1936, she made a characteristic, vivid entry:

There's words enough, paint and brushes enough and thoughts enough. The whole difficulty seems to be getting the thoughts clear enough, making them stand still long enough to be fitted with words and paint. They are so elusive—like wild birds singing above your head, twittering close beside you, chortling in front of you, but gone the moment you put out a hand. If ever you do catch hold of a piece of a thought it breaks away leaving the piece in your hand just to aggravate you. If one only could encompass the whole, corral it, enclose it safe—but then maybe it would die, dwindle away because it could not go on growing. I don't think thoughts *could* stand still—the fringes of them would always be tangling into something just a little further on and that would draw it out and out. I guess that is just *why* it is so difficult to catch a complete idea—it's because everything is always on the move, always expanding.

A very closely related characteristic of her writing is its sincerity. I shall let her speak again for herself in her own forceful, inimitable style.

Be careful that you do not write or paint anything that is not your own, that you don't know in your own soul. You will have to experiment and try things out for yourself and you will not be sure of what you are doing. That's all right, you are feeling your way into the thing. But don't take what someone else has made sure of and pretend that it's you yourself that have made sure of it, till it's yours absolutely by conviction. It's stealing to take it and hypocrisy and you'll fall in a hole. . . . If you're going to lick the icing off somebody else's cake you won't be nourished and it won't do you any good,—or you might find the cake had caraway seeds and you hate them. But if you make your own cake and *know the recipe and stir the thing with your own hand* it's *your* own cake. You can ice it or not as you like. Such lots of folks are licking the icing off the other fellow's cake!

Consequently, Emily Carr's style is characterized by a great simplicity and directness—a simplicity, it's true, that is a little deceptive in view of the sustained discipline from which it resulted—but perhaps it is just in that way that the only true simplicity is achieved. Words are used by her with great courage, sometimes taking on new and vivid meanings. They are in her writing the equivalent of the quick, sure brush strokes and dramatic, strong colours which are so characteristic of her canvases.

It has been remarked by many readers—and with justification—that Emily Carr's prose style has much in common with poetry. This is to be seen in her rigid selectivity in the use of diction described above, in her daring use of metaphorical language, in the rhythm, the cadence of her writing and in her consciousness of form. Look, for instance, at this passage from "Century Time":

In the late afternoon a great shadow mountain stepped across the lake and brooded over the cemetery. It had done this at the end of every sunny day for centuries, long, long before that piece of land was a cemetery. Dark came and held the shadow mountain there all night, but when morning broke, it was back again inside its mountain, which pushed its grand purple dome up into the sky and dared the pines swarming around its base to creep higher than half way up its bare rocky sides.

Indians do not hinder the progress of their dead by embalming or tight coffining. When the spirit has gone they give the body back to the earth. Cased only in a box it is laid in a shallow grave. The earth welcomes the body—coaxes new life and beauty from it, hurries over what men shudder at. Lovely tender herbage bursts from the graves—swiftly—exulting over corruption.

and again at this passage from "Bobtails":

The top of Beacon Hill was bare. You could see north, south, east and west. The dogs rested, tongues lolling, while I looked at the new day, at the pine trees, at the sky, at the sea where it lay flat, and at the near broom bushes drooped with early morning wetness. The song of the meadow-lark crumbled away the last remnants of night, three sad lingering notes followed by an exultant double note that gobbled up the still vibrating three.

For one moment the morning took you far out into vague chill; your body snatched you back into its cosiness, back to the waiting dogs on the hill top. They could not follow out there; their world was walled, their noses trailed the earth.

or at this from "Canoe":

The canoe passed shores crammed with trees, trees overhanging stony beaches, trees held back by rocky cliffs, pointed fir trees climbing its dark masses up the mountain sides, moonlight silvering their blackness.

Our going was imperceptible, the woman's steering paddle the only thing that moved, its silent cuts stirring phosphorus like white fire.

Time and texture faded, ceased to exist—day was gone, yet it was not night. Water was not wet or deep, just smoothness spread with light.

Such writing transcends the usual limits of prose and becomes (but without aesthetic offence) lyrical.

The quality of form, not a surprising attribute in view of her distinction as a painter, can be seen over and over again but notably in the exquisite lyric, "White Currants", in the simply shaped but touchingly effective "Sophie" and in "D'Sonoqua" which has the quality of a musical symphony with its dominant themes, its sectional development and its use of suspense and tense emotional crescendo.

As a final point in this discussion of Emily Carr's literary style it should be noted that she was not a great reader. Her style is, therefore, not the result of imitation of literary models. Undoubtedly it is better so, for the originality and simplicity which marked all her work, whether in painting, rug-making, pottery or writing, remained uninhibited by academic literary standards. Of these Miss Carr knew little or nothing. But there is some literary influence. She was a devoted reader of the poems of Walt Whitman, attracted to them by Whitman's deep feeling for nature and by his vigorous style. There is too, I think, a discernible influence at times of the Bible, notably of the Psalms, and of the English Prayerbook.

But above everything else, Emily Carr was a truly great Canadian. Her devotion to her own land marked everything she did. She approached no subject in writing or painting with any condescension or purely artistic self-consciousness. She was driven always by a passion to make her own experience in the place in which life had set her vivid and real for the onlooker or the reader and to do this with dignity and distinction. She found life in her part of Canada often hard and baffling but always rich and full. It was her single purpose to share through the medium of her art and in as memorable a fashion as possible the experiences of her life. She was never happy outside Canada. Indeed, during her sojourns in England and France she was the victim of such overwhelming homesickness that she became physically ill and was ordered by her physician to return to her Canadian home.

She was an amazing woman. May I take the liberty of quoting a note which I set down in 1941? I hold the views as firmly today as then:

> I have heard her talking and watched her devour the conversation of others, of Lawren Harris, of Arthur Benjamin, of Garnett Sedgewick; I have watched her anger tower over some meanness in the work or conduct of an artist and I have seen her become incandescent with generous enthusiasm for another's fine work; I have seen her gentleness to an old woman and to an animal; I have beheld the vision of forest and sky enter and light her eyes as she sat far from them—and I am convinced that Emily Carr is a great genius and that we will do well to add her to that small list of originals who have been produced in this place and have lived and commented in one way or another on this Canada of ours.

Emily Carr was herself more modest. Asked a few years before her death to state what had been the outstanding events of her life, she wrote,

> Outstanding events!—work and more work! The most outstanding seems to me the buying of an old caravan trailer which I had towed to out-of-the-way corners and where I sat self-contained with dogs, monk and work—Walt Whitman and others on the shelf—writing in the long, dark evenings after

painting—loving everything terrifically. In later years my work had some praise and some successes, but the outstanding event to me was the *doing* which I am still at. Don't pickle me away as a "done".

It is impossible to think of that vivid person as a "done". No, she goes on in her work. As surely as Wordsworth marked the English Lake District with his peculiar kind of seeing and feeling, leaving us his experience patterned in poetry, so surely this extraordinary, sensitive, gifted Canadian touched a part of our landscape and life and left her imprint there so clearly that now we, who have seen her canvases or read her books must feel, as we enter the vastness of the western forest or stand before a totem pole or in the lonely ruin of an Indian village, less bewildered and alone because we recognize that another was here before us and humanized all this by setting down in paint or words her reaction to it.

IRA DILWORTH

Robin Hill,
Knowlton, P.Q.,
June, 1951

U C L U E L E T

THE LADY Missionaries expected me. They sent an enormous Irishman in a tiny canoe to meet the steamer. We got to the Ucluelet wharf soon after dawn. Everything was big and cold and strange to me, a fifteen-year-old school girl. I was the only soul on the wharf. The Irishman did not have any trouble deciding which was I.

It was low tide, so there was a long sickening, ladder with slimy rungs to climb down to get to the canoe. The man's big laugh and the tippiness of the canoe were even more frightening than the ladder. The paddle in his great arms rushed the canoe through the waves.

We came to Toxis, which was the Indian name for the Mission House. It stood just above hightide water. The sea was in front of it and the forest behind.

The house was of wood, unpainted. There were no blinds or curtains. It looked, as we paddled up to it, as if it were stuffed with black. When the canoe stuck in the mud, the big Irishman picked me up in his arms and set me down on the doorstep.

The Missionaries were at the door. Smells of cooking fish jumped out past them. People lived on fish at Ucluelet.

Both the Missionaries were dignified, but the Greater Missionary had the most dignity. They had long noses straddled by spectacles, thin lips, mild eyes, and wore straight, dark dresses buttoned to the chin.

There was only two of everything in the kitchen, so I had to sit on a box, drink from a bowl and eat my food out of a tin pie-dish.

After breakfast came a long prayer. Outside the kitchen window, just a few feet away at the edge of the forest, stood a grand balsam pine tree. It was very tall and straight.

The Missionaries' "trespasses" jumped me back from the pine tree to the Lord's Prayer just in time to "Amen". We got up from our knees to find the house full of Indians. They had come to look at me.

I felt so young and empty standing there before the Indians and the two grave Missionaries! The Chief, old Hipi, was held to be a reader of faces. He perched himself on the top of the Missionaries' drug cupboard; his brown fists clutched the edge of it, his elbows taut and shoulders hunched. His crumpled shoes hung loose as if they dangled from strings and had no feet in them. The stare of his eyes searched me right through. Suddenly they were done; he lifted

them above me to the window, uttered several terse sentences in Chinook, jumped off the cupboard and strode back to the village.

I was half afraid to ask the Missionary, "What did he say?"

"Not much. Only that you had no fear, that you were not stuck up, and that you knew how to laugh."

Toxis sat upon a long, slow lick of sand, but the beach of the Indian village was short and bit deep into the shoreline. Rocky points jutted out into the sea at either end of it.

Toxis and the village were a mile apart. The school house was half-way between the two and, like them, was pinched between sea and forest.

The school house called itself "church house" on Sundays. It had a sharp roof, two windows on each side, a door in front, and a woodshed behind.

The school equipment consisted of a map of the world, a blackboard, a stove, crude desks and benches and, on a box behind the door, the pail of drinking-water and a tin dipper.

The Lesser Missionary went to school first and lit the fire. If the tide were high she had to go over the trail at the forest's edge. It was full of holes where high seas had undermined the big tree roots. Huge upturned stumps necessi-tated detours through hard-leafed sallal bushes and skunk cabbage bogs. The Lesser Missionary hated putting her feet on ground which she could not see, because it was so covered with growing green. She was glad when she came out of the dark forest and saw the unpainted school house. The Greater Missionary had no nerves and a long, slow stride. As she came over the trail she blew blasts on a cow's horn. She had an amazing wind, the blasts were stunning, but they failed to call the children to school, because no voice had ever suggested time or obligation to these Indian children. Then the Greater Missionary went to the village and hand-picked her scholars from the huts.

On my first morning in Ucluelet there was a full attendance at school because visitors were rare. After the Lord's Prayer the Missionaries duetted a hymn while the children stared at me.

When the Missionary put *A*, *B*, *C* on the board the children began squirming out of their desks and pattering down to the drinking bucket. The dipper regis-tered each drink with a clank when they threw it back.

The door squeaked open and shut all the time, with a second's pause between opening and closing. Spitting on the floor was forbidden, so the children went out and spat off the porch. They had not yet mastered the use of the pocket handkerchief, so not a second elapsed between sniffs.

Education being well under way, I slipped out to see the village.

When I did not return after the second's time permitted for spitting, the chil-dren began to wriggle from the desks to the drinking bucket, then to the spit-ting step, looking for me. Once outside, their little bare feet never stopped till they had caught me up.

After that I was shut up tight at Toxis until school was well started; then I went to the village, careful to creep low when passing under the school windows.

On the point at either end of the bay crouched a huddle of houses—large,

squat houses made of thick, hand-hewn cedar planks, pegged and slotted together. They had flat, square fronts. The side walls were made of driftwood. Bark and shakes, weighted with stones against the wind, were used for roofs. Every house stood separate from the next. Wind roared through narrow spaces between.

Houses and people were alike. Wind, rain, forest and sea had done the same things to both—both were soaked through and through with sunshine, too.

I was shy of the Indians at first. When I knocked at their doors and received no answer I entered their houses timidly, but I found a grunt of welcome was always waiting inside and that Indians did not knock before entering. Usually some old crone was squatted on the earth floor, weaving cedar fibre or tatters of old cloth into a mat, her claw-like fingers twining in and out, in and out, among the strands that were fastened to a crude frame of sticks. Papooses tumbled around her on the floor for she was papoose-minder as well as mat-maker.

Each of the large houses was the home of several families. The door and the smoke-hole were common to all, but each family had its own fire with its own things round it. That was their own home.

The interiors of the great houses were dim. Smoke teased your eyes and throat. The earth floors were not clean.

It amused the Indians to see me unfold my camp stool, and my sketch sack made them curious. When boats, trees, houses, appeared on the paper, jabbering interest closed me about. I could not understand their talk. One day, by grin and gesture, I got permission to sketch an old mat-maker. She nodded and I set to work. Suddenly a cat jumped in through the smoke-hole and leaped down from a rafter on to a pile of loose boxes. As the clatter of the topple ceased there was a bestial roar, a pile of mats and blankets burst upwards, and a man's head came out of them. He shouted and his black eyes snapped at me and the old woman's smile dried out.

"Klatawa" (Chinook for "Go") she shouted, and I went. Later, the old wife called to me across the bay, but I would not heed her call.

"Why did you not reply when old Mrs. Wynook called you?" the Missionary asked.

"She was angry and drove me away."

"She was calling, 'Klee Wyck, come back, come back.' when I heard her."

"What does 'Klee Wyck' mean?"

"I do not know."

The mission house door creaked open and something looking like a bundle of tired rags tumbled on to the floor and groaned.

"Why, Mrs. Wynook," exclaimed the Missionary, "I thought you could not walk!"

The tired old woman leaned forward and began to stroke my skirt.

"What does Klee Wyck mean, Mrs. Wynook?" asked the Missionary.

Mrs. Wynook put her thumbs into the corners of her mouth and stretched them upwards. She pointed at me; there was a long, guttural jabber in Chinook between her and the Missionary. Finally the Missionary said, "Klee Wyck is the

Indians' name for you. It means 'Laughing One'."

The old woman tried to make the Missionary believe that her husband thought it was I, not the cat, who had toppled the boxes and woke him, but the Missionary, scenting a lie, asked for "straight talk". Then Mrs. Wynook told how the old Indians thought the spirit of a person got caught in a picture of him, trapped there so that, after the person died, it had to stay in the picture.

"Tell her that I will not make any more pictures of the old people," I said. It must have hurt the Indians dreadfully to have the things they had always believed trampled on and torn from their hugging. Down deep we all hug something. The great forest hugs its silence. The sea and the air hug the spilled cries of sea-birds. The forest hugs only silence; its birds and even its beasts are mute.

When night came down upon Ucluelet the Indian people folded themselves into their houses and slept.

At the Mission House candles were lit. After eating fish, and praying aloud, the Missionaries creaked up the bare stair, each carrying her own tin candlestick. I had a cot and scrambled quickly into it. Blindless and carpetless, it was a bleak bedroom even in summer.

The room was deathly still. Outside, the black forest was still, too, but with a vibrant stillness tense with life. From my bed I could look one storey higher into the balsam pine. Because of his closeness to me, the pine towered above his fellows, his top tapering to heaven.

Every day might have been a Sunday in the Indian village. At Toxis only the seventh day was the Sabbath. Then the Missionaries conducted service in the school house which had shifted its job to church as the cow's horn turned itself into a church bell for the day.

The Indian women with handkerchiefs on their heads, plaid shawls round their shoulders and full skirts billowing about their legs, waddled leisurely towards church. It was very hard for them to squeeze their bodies into the children's desks. They took two whole seats each, and even then the squeezing must have hurt.

Women sat on one side of the church. The very few men who came sat on the other. The Missionaries insisted that men come to church wearing trousers, and that their shirt tails must be tucked inside the trousers. So the Indian men stayed away.

"Our trespasses" had been dealt with and the hymn, which was generally pitched too high or too low, had at last hit square, when the door was swung violently back, slopping the drinking bucket. In the outside sunlight stood old Tanook, shirt tails flapping and legs bare. He entered, strode up the middle of the room and took the front seat.

Quick intakes of horror caught the breath of the women; the Greater Missionary held on to her note, the Lesser jumped an octave.

A woman in the back seat took off her shawl. From hand to hand it travelled under the desks to the top of the room, crossed the aisle and passed into the hand of Jimmy John, old Tanook's nephew, sitting with the men. Jimmy John squeezed from his seat and laid the shawl across his uncle's bare knees.

The Missionary's address rolled on in choppy Chinook, undertoned by a gentle voice from the back of the room which told Tanook in pure Indian words what he was to do.

With a defiant shake of his wild hair old Tanook got up; twisting the shawl about his middle he marched down the aisles, paused at the pail to take a loud drink, dashed back the dipper with a clank, and strode out.

The service was over, the people had gone, but a pink print figure sat on in the back seat. Her face was sunk down on her chest. She was waiting till all were away before she slunk home. It is considered more indecent for an Indian woman to go shawl-less than for an Indian man to go bare-legged. The woman's heroic gesture had saved her husband's dignity before the Missionaries but had shamed her before her own people.

The Greater Missionary patted the pink shoulder as she passed.

"Brave woman!" said the Greater Missionary, smiling.

One day I walked upon a strip of land that belonged to nothing.

The sea soaked it often enough to make it unpalatable to the forest. Roots of trees refused to thrive in its saltiness.

In this place belonging neither to sea nor to land I came upon an old man dressed in nothing but a brief shirt. He was sawing the limbs from a fallen tree. The swish of the sea tried to drown the purr of his saw. The purr of the saw tried to sneak back into the forest, but the forest threw it out again into the sea. Sea and forest were always at this game of toss with noises.

The fallen tree lay crosswise in this "nothing's place"; it blocked my way. I sat down beside the sawing Indian and we had dumb talk, pointing to the sun and to the sea, the eagles in the air and the crows on the beach. Nodding and laughing together I sat and he sawed. The old man sawed as if aeons of time were before him, and as if all the years behind him had been leisurely and all the years in front of him would be equally so. There was strength still in his back and limbs but his teeth were all worn to the gums. The shock of hair that fell to his shoulders was grizzled. Life had sweetened the old man. He was luscious with time like the end berries of the strawberry season.

With a final grin, I got up and patted his arm—"Goodbye!" He patted my hand. When he saw me turn to break through the forest so that I could round his great fallen tree, he ran and pulled me back, shaking his head and scolding me.

"Swaawa! Hiyu swaawa!" Swaawa were cougar: the forest was full of these great cats. The Indians forbade their children to go into the forest, not even into its edge. I was to them a child, ignorant about the wild things which they knew so well. In these things the Indian could speak with authority to white people.

T A N O O

JIMMIE had a good boat. He and his wife, Louisa, agreed to take me to the old villages of Tanoo, Skedans and Chumshewa, on the southern island of the Queen Charlotte group. We were to start off at the Indian's usual "eight o'clock" and got off at the usual "near noon". The missionary had asked me to take his pretty daughter along.

We chugged and bobbed over all sorts of water and came to Tanoo in the evening. It looked very solemn as we came nearer. Quite far out from land Jimmie shut off the engine and plopped the anchor into the sea. Then he shoved the canoe overboard, and putting my sheep dog and me into it, nosed it gently through the kelp. The grating of our canoe on the pebbles warned the silence that we were come to break it.

The dog and I jumped out and Jimmie and the canoe went back for the others.

It was so still and solemn on the beach, it would have seemed irreverent to speak aloud; it was if everything were waiting and holding its breath. The dog felt it too; he stood with cocked ears, trembling. When the others came and moved about and spoke this feeling went away.

At one side of the Tanoo beach rose a big bluff, black now that the sun was behind it. It is said that the bluff is haunted. At its foot was the skeleton of a house; all that was left of it was the great beams and the corner posts and two carved poles one at each end of it. Inside, where the people used to live, was stuffed with elderberry bushes, scrub trees and fireweed. In that part of the village no other houses were left, but there were lots of totem poles sticking up. A tall slender one belonged to Louisa's grandmother. It had a story carved on it; Louisa told it to us in a loose sort of way as if she had half forgotten it. On the base of this pole was the figure of a man; he had on a tall, tall hat, which was made up of sections, and was a hat of great honour. On the top of the hat perched a raven. Little figures of men were clinging to every ring of honour all the way up the hat. The story told that the man had adopted a raven as his son. The raven turned out to be a wicked trickster and brought a flood upon his foster parents. When the waters rose the man's nephews and relations climbed up the rings of his hat of honour and were thus saved from being drowned. It was a fine pole, bleached of all colour and then bloomed over again with greeny-yellow mould.

The feelings Jimmie and Louisa had in this old village of their own people must have been quite different from ours. They must have made my curiosity seem small. Often Jimmie and Louisa went off hand in hand by themselves for a little, talking in Indian as they went.

A nose of land ran out into the sea from Tanoo and split the village into two parts; the parts diverged at a slight angle, so that the village of Tanoo had a wall-eyed stare out over the sea.

Beyond the little point there were three fine house fronts. A tall totem pole stood up against each house; in the centre of its front. When Jimmie cut away the growth around the foot of them, the paint on the poles was quite bright. The lowest figure of the centre pole was a great eagle; the other two were beavers with immense teeth—they held sticks in their hands. All three base figures had a hole through the pole so that people could enter and leave the house through the totem.

Our first night in solemn Tanoo was very strange indeed.

When we saw the Indians carrying the little canoe down to the water we said:

"What are you going out to the boat for?"

"We are going to sleep out there."

"You are going to leave us alone in Tanoo?"

"You can call if anything is wrong," they said.

But we knew the boat was too far out beyond the kelp beds for them to hear us.

The canoe glided out and then there was nothing but wide black space. We two girls shivered. I wanted the tent flaps open; it did not seem quite so bad to me if I could feel the trees close.

Very early in the morning I got to work. The boat lay far out with no sign of life on her. The Indians did not come ashore; it got late and we wanted breakfast—we called and called but there was no answer.

"Do you remember what they said about those Indians being asphyxiated by the fumes from their engine while they slept?"

"I was thinking of that too."

We ran out on the point as far as we could so as to get nearer to the boat and we called and called both together. There was a horrible feeling down inside us that neither of us cared to speak about. After a long while a black head popped up in the boat.

"You must not leave us again like that," we told Jimmie and Louisa.

I met them coming over the sand, Louisa hurrying ahead to get supper. Away back I saw Jimmie carrying something dreadful with long arms trailing behind in the sand, its great round body speared by the stick on Jimmie's shoulder.

"We've took the missionary's daughter hunting devilfish," chuckled Louisa, as she passed me.

We ate some of the devilfish for supper, fried in pieces like sausage. It was sweet like chicken, but very tough.

The devilfish were in the puddles around the rocks at low tide. When they saw people come, they threw their tentacles around the rocks and stuck their heads into the rocky creases; the only way to make them let go was to beat their heads in when you got the chance.

It was long past dinnertime. Louisa could not cook because there was no water in camp. That was Jimmie's job. The spring was back in the woods, nobody but Jimmie knew where, and he was far out at sea tinkering on his boat. Louisa called and called; Jimmie heard, because his head popped up, but he would not come. Every time she called the same two Indian words.

"Make it hotter, Louisa; I want to get back to work." She called the same two words again.

"Are those words swears?"

"No, if I swore I would have to use English words."

"Why?"

"There are no swears in Haida."

"What do you say if you are angry or want to insult anybody?"

"You would say, 'Your father or your mother was a slave,' but I could not say that to Jimmie."

"Well, say something hot. I want dinner!"

She called the same two words again but her voice was different this time. Jimmie came.

Pictures of all the poles were in my sketch sack. I strapped it up and said, "That's that."

Then we went away from Tanoo and left the silence to heal itself—left the totem poles staring, staring out over the sea.

Almost immediately we were in rough water. Jimmie spread a sail in the bottom of the boat, and we women all lay flat. Nobody spoke—only groans. When the boat pitched all our bodies rolled one way and then rolled back. Under the sail where I was lying something seemed very slithery.

"Jimmie, what is under me?"

"Only the devilfish we are taking home to Mother—she likes them very much."

"Ugh!" I said. Sea-sickness on top of devilfish seemed too much.

Jimmie said, "They're dead; it won't hurt them when you roll over."

S K E D A N S

JIMMIE, the Indian, knew the jagged reefs of Skedans Bay by heart. He knew where the bobbing kelp nobs grew and that their long, hose-like tubes were waiting to strangle his propeller. Today the face of the bay was buttered over with calm and there was a wide blue sky overhead. Everything looked safe, but Jimmie knew how treacherous the bottom of Skedans Bay was; that's why he lay across the bow of his boat, anxiously peering into the water and motioning to Louisa his wife, who was at the wheel.

The engine stopped far out. There was the plop and gurgle of the anchor striking and settling and then the sigh of the little canoe being pushed over the edge of the boat, the slap as she struck the water. Jimmie got the sheep dog and me over to the beach first, so that I could get to work right away; then he went back for Louisa and the missionary's daughter.

Skedans was more open than Tanoo. The trees stood farther back from it. Behind the bay another point bit deeply into the land, so that light came in across the water from behind the village too.

There was no soil to be seen. Above the beach it was all luxuriant growth; the earth was so full of vitality that every seed which blew across her surface germinated and burst. The growing things jumbled themselves together into a dense thicket; so tensely earnest were things about growing in Skedans that everything linked with everything else, hurrying to grow to the limit of its own capacity; weeds and weaklings alike throve in the rich moistness.

Memories came out of this place to meet the Indians; you saw remembering in their brightening eyes and heard it in the quick hushed words they said to each other in Haida.

Skedans Beach was wide. Sea-drift was scattered over it. Behind the logs the ground sloped up a little to the old village site. It was smothered now under a green tangle, just one grey roof still squatted there among the bushes, and a battered row of totem poles circled the bay; many of them were mortuary poles, high with square fronts on top. The fronts were carved with totem designs of birds and beasts. The tops of the poles behind these carved fronts were hollowed out and the coffins stood, each in its hole on its end, the square front hiding it. Some of the old mortuary poles were broken and you saw skulls peeping out through the cracks.

To the right of Skedans were twin cones of earth and rock. They were covered to the top with trees and scrub. The land ran out beyond these mounds and met the jagged reefs of the bay.

We broke through growth above our heads to reach the house. It was of the old type, but had been repaired a little by halibut fishers who still used it occasionally. The walls were full of cracks and knotholes. There were stones, blackened by fire, lying on the earth floor. Above them was a great smoke-hole in the roof; it had a flap that could be adjusted to the wind. Sleeping benches ran along the wall and there was a rude table made of driftwood by the halibut fishers: Indians use the floor for their tables and seats.

When the fire roared, our blankets were spread on the platforms, and Louisa's stew-pot simmered. The place was grand—we had got close down to real things. In Skedans there were no shams.

When night came we cuddled into our blankets. The night was still. Just the waves splashed slow and even along the beach. If your face was towards the wall, the sea tang seeped in at the cracks and poured over it; if you turned round and faced in, there was the lovely smoky smell of our wood fire on the clay floor.

Early in the morning Jimmie stirred the embers; then he went out and brought us icy water from the spring to wash our faces in. He cut a little path like a green tunnel from the house to the beach, so that we could come and go easily. I went out to sketch the poles.

They were in a long straggling row the entire length of the bay and pointed this way and that; but no matter how drunken their tilt, the Haida poles never lost their dignity. They looked sadder, perhaps, when they bowed forward and more stern when they tipped back. They were bleached to a pinkish silver colour and cracked by the sun, but nothing could make them mean or poor, because the Indians had put strong thought into them and had believed sincerely in what they were trying to express.

The twisted trees and high tossed driftwood hinted that Skedans could be as thoroughly fierce as she was calm. She was downright about everything.

C U M S H E W A

TANOO, Skedans and Cumshewa lie fairly close to each other on the map, yet each is quite unlike the others when you come to it. All have the West Coast wetness but Cumshewa seems always to drip, always to be blurred with mist, its foliage always to hang wet-heavy. Cumshewa rain soaked my paper, Cumshewa rain trickled among my paints.

Only one house was left in the village of Cumshewa, a large, low and desolately forsaken house that had a carefully padlocked door and gaping hole in the wall.

We spent a miserable night in this old house. All our bones were pierced with chill. The rain spat great drops through the smoke-hole into our fire. In comfortless, damp blankets we got through the night.

In the morning Jimmie made so hot a fire that the rain splatters hissed when they dropped into it. I went out to work on the leaky beach and Jimmie rigged up a sort of shelter over my work so that the trickles ran down my neck instead of down my picture, but if I had possessed the arms and legs of a centipede they would not have been enough to hold my things together to defy the elements' meanness towards my canopy, materials and temper.

Through the hole in the side of the house I could hear the fretful mewings of the cat. Indian people and the elements give and take like brothers, accommodating themselves to each others' ways without complaint. My Indians never said to me, "Hurry and get this over so that we may go home and be more comfortable." Indians are comfortable everywhere.

Not far from the house sat a great wooden raven mounted on a rather low pole; his wings were flattened to his sides. A few feet from him stuck up an empty pole. His mate had sat there but she had rotted away long ago, leaving him moss-grown, dilapidated and alone to watch dead Indian bones, for these two great birds had been set, one on either side of the doorway of a big house that had been full of dead Indians who had died during a smallpox epidemic.

Bursting growth had hidden house and bones long ago. Rain turned their dust into mud; these strong young trees were richer perhaps for that Indian dust. They grew up round the dilapidated old raven, sheltering him from the tearing winds now that he was old and rotting because the rain seeped through the moss that grew upon his back and in the hollows of his eye-sockets. The Cumshewa totem poles were dark and colourless, the wood toneless from pouring rain.

When Jimmie, Louisa, the cat and the missionary's daughter saw me squeeze back into the house through the hole and heard me say, "Done", they all jumped up. Curling the cat into her hat, Louisa set about packing; Jimmie went to prepare his boat. The cat was peeved. She preferred Louisa's hat near the fire to the outside rain.

The memory of Cumshewa is of a great lonesomeness smothered in a blur of rain. Our boat headed for the sea. As we rounded the point Cumshewa was suddenly like something that had not quite happened.

S O P H I E

SOPHIE knocked gently on my Vancouver studio door.

"Baskets. I got baskets."

They were beautiful, made by her own people, West Coast Indian baskets. She had big ones in a cloth tied at the four corners and little ones in a floursack.

She had a baby slung on her back in a shawl, a girl child clinging to her skirts, and a heavy-faced boy plodding behind her.

"I have no money for baskets."

"Money no matter," said Sophie. "Old clo', waum skirt—good fo' basket."

I wanted the big round one. Its price was eight dollars.

"Next month I am going to Victoria. I will bring back some clothes and get your basket."

I asked her in to rest a while and gave the youngsters bread and jam. When she tied up her baskets she left the one I coveted on the floor.

"Take it away," I said. "It will be a month before I can go to Victoria. Then I will bring clothes back with me and come to get the basket."

"You keep now. Bymby pay," said Sophie.

"Where do you live?"

"North Vancouver Mission."

"What is your name?"

"Me Sophie Frank. Everybody know me."

Sophie's house was bare but clean. It had three rooms. Later when it got cold Sophie's Frank would cut out all the partition walls. Sophie said, "Thlee loom, thlee stobe. One loom, one stobe." The floor of the house was clean scrubbed. It was chair, table and bed for the family. There was one chair; the coal-oil lamp sat on that. Sophie pushed the babies into corners, spread my old clothes on the floor to appraise them, and was satisfied. So, having tested each other's trade-straightness, we began a long, long friendship—forty years. I have seen Sophie glad, sad, sick and drunk. I have asked her why she did this or that thing— Indian ways that I did not understand—her answer was invariably "Nice ladies always do." That was Sophie's ideal—being nice.

Every year Sophie had a new baby. Almost every year she buried one. Her little graves were dotted all over the cemetery. I never knew more than three of her twenty-one children to be alive at one time. By the time she was in her early

34

fifties every child was dead and Sophie had cried her eyes dry. Then she took to drink.

"I got a new baby. I got a new baby."

Sophie, seated on the floor of her house, saw me coming through the open door and waved the papoose cradle. Two little girls rolled round on the floor; the new baby was near her in a basket-cradle. Sophie took off the cloth tented over the basket and exhibited the baby, a lean poor thing.

Sophie herself was small and square. Her black hair sprang thick and strong on each side of the clean, straight parting and hung in twin braids across her shoulders. Her eyes were sad and heavy-lidded. Between prominent, rounded cheekbones her nose lay rather flat, broadening and snubby at the tip. Her wide upper lip pouted. It was sharp-edged, puckering over a row of poor teeth—the soothing pucker of lips trying to ease an aching tooth or to hush a crying child. She had a soft little body, a back straight as honesty itself, and the small hands and feet of an Indian.

Sophie's English was good enough, but when Frank, her husband, was there she became dumb as a plate.

"Why won't you talk before Frank, Sophie?"

"Frank he learn school English. Me, no. Frank laugh my English words."

When we were alone she chattered to me like a sparrow.

In May, when the village was white with cherry blossom and the blue water of Burrard Inlet crept almost to Sophie's door—just a streak of grey sand and a plank walk between—and when Vancouver city was more beautiful to look at across the water than to be in,—it was then I loved to take the ferry to the North Shore and go to Sophie's.

Behind the village stood mountains topped by the grand old "Lions", twin peaks, very white and blue. The nearer mountains were every shade of young foliage, tender grey-green, getting greener and greener till, when they were close, you saw that the village grass outgreened them all. Hens strutted their broods, papooses and pups and kittens rolled everywhere—it was good indeed to spend a day on the Reserve in spring.

Sophie and I went to see her babies' graves first. Sophie took her best plaid skirt, the one that had three rows of velvet ribbon round the hem, from a nail on the wall, and bound a yellow silk handkerchief round her head. No matter what the weather, she always wore her great shawl, clamping it down with her arms, the fringe trickling over her fingers. Sophie wore her shoes when she walked with me, if she remembered.

Across the water we could see the city. The Indian Reserve was a different world—no hurry, no business.

We walked over the twisty, up-and-down road to the cemetery. Casamin, Tommy, George, Rosie, Maria, Mary, Emily, and all the rest were there under a tangle of vines. We rambled, seeking out Sophie's graves. Some had little wooden crosses, some had stones. Two babies lay outside the cemetery fence:

they had not faced life long enough for baptism.

"See! Me got stone for Rosie now."

"It looks very nice. It must have cost lots of money, Sophie."

"Grave man make cheap for me. He say, 'You got lots, lots stone from me, Sophie. Maybe bymby you get some more died baby, then you want more stone. So I make cheap for you.'"

Sophie's kitchen was crammed with excited women. They had come to see Sophie's brand-new twins. Sophie was on a mattress beside the cook stove. The twin girls were in small basket papoose cradles, woven by Sophie herself. The babies were wrapped in cotton wool which made their dark faces look darker; they were laced into their baskets and stuck up at the edge of Sophie's mattress beside the kitchen stove. Their brown, wrinkled faces were like potatoes baked in their jackets, their hands no bigger than brown spiders.

They were thrilling, those very, very tiny babies. Everybody was excited over them. I sat down on the floor close to Sophie.

"Sophie, if the baby was a girl it was to have my name. There are two babies and I have only one name. What are we going to do about it?"

"The biggest and the best is yours," said Sophie.

My Em'ly lived three months. Sophie's Maria lived three weeks. I bought Em'ly's tombstone. Sophie bought Maria's.

Sophie's "mad" rampaged inside her like a lion roaring in the breast of a dove.

"Look see," she said, holding a red and yellow handkerchief, caught together at the corners and chinking with broken glass and bits of plaster of Paris. "Bad boy bloke my grave flower! Cost five dollar one, and now boy all bloke fo' me. Bad, bad boy! You come talk me fo' p'liceman?"

At the City Hall she spread the handkerchief on the table and held half a plaster of Paris lily and a dove's tail up to the eyes of the law, while I talked.

"My mad fo' boy bloke my plitty glave flower," she said, forgetting, in her fury, to be shy of the "English words".

The big man of the law was kind. He said, "It's too bad, Sophie. What do you want me to do about it?"

"You make boy buy more this plitty kind for my glave."

"The boy has no money but I can make his old grandmother pay a little every week."

Sophie looked long at the broken pieces and shook her head.

"That ole, ole woman got no money." Sophie's anger was dying, soothed by sympathy like a child, the woman in her tender towards old Granny. "My bloke no matter for ole woman," said Sophie, gathering up the pieces. "You scold boy big, Policeman? No make glanny pay."

"I sure will, Sophie."

There was a black skirt spread over the top of the packing case in the centre of Sophie's room. On it stood the small white coffin. A lighted candle was at the

head, another at the foot. The little dead girl in the coffin held a doll in her arms. It had hardly been out of them since I had taken it to her a week before. The glassy eyes of the doll stared out of the coffin, up past the closed eyelids of the child.

Though Sophie had been through this nineteen times before, the twentieth time was no easier. Her two friends, Susan and Sara, were there by the coffin, crying for her.

The outer door opened and a half dozen women came in, their shawls drawn low across their foreheads, their faces grim. They stepped over to the coffin and looked in. Then they sat around it on the floor and began to cry, first with baby whimpers, softly, then louder, louder still—with violence and strong howling: torrents of tears burst from their eyes and rolled down their cheeks. Sophie and Sara and Susan did it too. It sounded horrible—like tortured dogs.

Suddenly they stopped. Sophie went to the bucket and got water in a tin basin. She took a towel in her hand and went to each of the guests in turn holding the basin while they washed their faces and dried them on the towel. Then the women all went out except Sophie, Sara and Susan. This crying had gone on at intervals for three days—ever since the child had died. Sophie was worn out. There had been, too, all the long weeks of Rosie's tubercular dying to go through.

"Sophie, couldn't you lie down and rest?"

She shook her head. "Nobody sleep in Injun house till dead people go to cemet'ry."

The beds had all been taken away.

"When is the funeral?"

"I dunno. Pliest go Vancouver. He not come two more day."

She laid her hand on the corner of the little coffin.

"See! Coffin-man think box fo' Injun baby no matter."

The seams of the cheap little coffin had burst.

As Sophie and I were coming down the village street we met an Indian woman whom I did not know. She nodded to Sophie, looked at me and half paused. Sophie's mouth was set, her bare feet pattered quick, hurrying me past the woman.

"Go church house now?" she asked me.

The Catholic church had twin towers. Wide steps led up to the front door which was always open. Inside it was bright, in a misty way, and still except for the wind and sea-echoes. The windows were gay coloured glass; when you knelt the wooden footstools and pews creaked. Hush lurked in every corner. Always a few candles burned. Everything but those flickers of flame was stone-still.

When we came out of the church we sat on the steps for a little. I said, "Who was that woman we met, Sophie?"

"Mrs. Chief Joe Capilano."

"Oh! I would like to know Mrs. Chief Joe Capilano. Why did you hurry by so quick? She wanted to stop."

"I don' want you know Mrs. Chief Joe."

"Why?"

"You fliend for me, not fliend for her."

"My heart has room for more than one friend, Sophie."

"You fliend for me, I not want Mrs. Chief Joe get you."

"You are always my first and best friend, Sophie." She hung her head, her mouth obstinate. We went to Sara's house.

Sara was Sophie's aunt, a wizened bit of a woman whose eyes, nose, mouth and wrinkles were all twisted to the perpetual expressing of pain. Once she had had a merry heart, but pain had trampled out the merriness. She lay on a bed draped with hangings of clean, white rags dangling from poles. The wall behind her bed, too, was padded heavily with newspaper to keep draughts off her "Lumatiz".

"Hello, Sara. How are you?"

"Em'ly! Sophie's Em'ly!"

The pain wrinkles scuttled off to make way for Sara's smile, but hurried back to twist for her pain.

"I dunno what for I got Lumatiz, Em'ly. I dunno. I dunno."

Everything perplexed poor Sara. Her merry heart and tortured body were always at odds. She drew a humped wrist across her nose and said, "I dunno, I dunno", after each remark.

"Goodbye, Sophie's Em'ly; come some more soon. I like that you come. I dunno why I got pain, lots pain. I dunno—I dunno."

I said to Sophie, "You see! The others know I am your big friend. They call me 'Sophie's Em'ly'."

She was happy.

Susan lived on one side of Sophie's house and Mrs. Johnson, the Indian widow of a white man, on the other. The widow's house was beyond words clean. The cook-stove was a mirror, the floor white as a sheet from scrubbing. Mrs. Johnson's hands were clever and busy. The row of hard kitchen chairs had each its own antimacassar and cushion. The crocheted bedspread and embroidered pillowslips, all the work of Mrs. Johnson's hands, were smoothed taut. Mrs. Johnson's husband had been a sea captain. She had loved him deeply and remained a widow though she had had many offers of marriage after he died. Once the Indian agent came, and said:

"Mrs. Johnson, there is a good man who has a farm and money in the bank. He is shy, so he sent me to ask if you will marry him."

"Tell that good man, 'Thank you', Mr. Agent, but tell him, too, that Mrs. Johnson only got love for her dead Johnson."

Sophie's other neighbour, Susan, produced and buried babies almost as fast as Sophie herself. The two women laughed for each other and cried for each other. With babies on their backs and baskets on their arms they crossed over on the ferry to Vancouver and sold their baskets from door to door. When they came to

my studio they rested and drank tea with me. My parrot, sheep dog, the white rats and the totem pole pictures all interested them. "An' you got Injun flower, too," said Susan.

"Indian flowers?"

She pointed to ferns and wild things I had brought in from the woods.

Sophie's house was shut up. There was a chain and padlock on the gate. I went to Susan.

"Where is Sophie?"

"Sophie in sick house. Got sick eye."

I went to the hospital. The little Indian ward had four beds. I took ice cream and the nurse divided it into four portions.

A homesick little Indian girl cried in the bed in one corner, an old woman grumbled in another. In a third there was a young mother with a baby, and in the fourth bed was Sophie.

There were flowers. The room was bright. It seemed to me that the four brown faces on the four white pillows should be happier and far more comfortable here than lying on mattresses on the hard floors in the village, with all the family muddle going on about them.

"How nice it is here, Sophie."

"Not much good of hospital, Em'ly."

"Oh! What is the matter with it?"

"Bad bed."

"What is wrong with the beds?"

"Move, move, all time shake. 'Spose me move, bed move too."

She rolled herself to show how the springs worked. "Me ole-fashion, Em'ly. Me like kitchen floor fo' sick."

Susan and Sophie were in my kitchen, rocking their sorrows back and forth and alternately wagging their heads and giggling with shut eyes at some small joke.

"You go live Victoria now, Em'ly," wailed Sophie, "and we never see those babies, never!"

Neither woman had a baby on her back these days. But each had a little new grave in the cemetery. I had told them about a friend's twin babies. I went to the telephone.

"Mrs. Dingle, you said I might bring Sophie to see the twins?"

"Surely, any time," came the ready reply.

"Come, Sophie and Susan, we can go and see the babies now."

The mothers of all those little cemetery mounds stood looking and looking at the thriving white babies, kicking and sprawling on their bed. The women said, "Oh my!—Oh my!" over and over.

Susan's hand crept from beneath her shawl to touch a baby's leg. Sophie's hand shot out and slapped Susan's.

The mother of the babies said, "It's all right, Susan; you may touch my baby."

Sophie's eyes burned Susan for daring to do what she so longed to do herself. She folded her hands resolutely under her shawl and whispered to me,

"Nice ladies don' touch, Em'ly."

D'SONOQUA

I WAS sketching in a remote Indian village when I first saw her. The village was one of those that the Indians use only for a few months in each year; the rest of the time it stands empty and desolate. I went there in one of its empty times, in a drizzling dusk.

When the Indian agent dumped me on the beach in front of the village, he said, "There is not a soul here. I will come back for you in two days." Then he went away.

I had a small griffon dog with me, and also a little Indian girl, who, when she saw the boat go away, clung to my sleeve and wailed, "I'm 'fraid."

We went up to the old deserted Mission House. At the sound of the key in the rusty lock, rats scuttled away. The stove was broken, the wood wet. I had forgotten to bring candles. We spread our blankets on the floor, and spent a poor night. Perhaps my lack of sleep played its part in the shock that I got, when I saw her for the first time.

Water was in the air, half mist, half rain. The stinging nettles, higher than my head, left their nervy smart on my ears and forehead, as I beat my way through them, trying all the while to keep my feet on the plank walk which they hid. Big yellow slugs crawled on the walk and slimed it. My feet slipped and I shot headlong to her very base, for she had no feet. The nettles that were above my head reached only to her knee.

It was not the fall alone that jerked the "Oh's" out of me, for the great wooden image towering above me was indeed terrifying.

The nettle bed ended a few yards beyond her, and then a rocky bluff jutted out, with waves battering it below. I scrambled up and went out on the bluff, so that I could see the creature above the nettles. The forest was behind her, the sea in front.

Her head and trunk were carved out of, or rather into, the bole of a great red cedar. She seemed to be part of the tree itself, as if she had grown there at its heart, and the carver had only chipped away the outer wood so that you could see her. Her arms were spliced and socketed to the trunk, and were flung wide in a circling, compelling movement. Her breasts were two eagle-heads, fiercely

carved. That much, and the column of her great neck, and her strong chin, I had seen when I slithered to the ground beneath her. Now I saw her face.

The eyes were two rounds of black, set in wider rounds of white, and placed in deep sockets under wide, black eyebrows. Their fixed stare bored into me as if the very life of the old cedar looked out, and it seemed that the voice of the tree itself might have burst from that great round cavity, with projecting lips, that was her mouth. Her ears were round, and stuck out to catch all sounds. The salt air had not dimmed the heavy red of her trunk and arms and thighs. Her hands were black, with blunt finger-tips painted a dazzling white. I stood looking at her for a long, long time.

The rain stopped, and white mist came up from the sea, gradually paling her back into the forest. It was as if she belonged there, and the mist were carrying her home. Presently the mist took the forest too, and, wrapping them both together, hid them away.

"Who is that image?" I asked the little Indian girl, when I got back to the house.

She knew which one I meant, but to gain time, she said, "What image?"

"The terrible one, out there on the bluff."

"I dunno," she lied.

I never went to that village again, but the fierce wooden image often came to me, both in my waking and in my sleeping.

Several years passed, and I was once more sketching in an Indian village. There were Indians in this village, and in a mild backward way it was "going modern". That is, the Indians had pushed the forest back a little to let the sun touch the new buildings that were replacing the old community houses. Small houses, primitive enough to a white man's thinking, pushed here and there between the old. Where some of the big community houses had been torn down, for the sake of the lumber, the great corner posts and massive roof-beams of the old structure were often left, standing naked against the sky, and the new little house was built inside, on the spot where the old one had been.

It was in one of these empty skeletons that I found her again. She had once been a supporting post for the great centre beam. Her pole-mate, representing the Raven, stood opposite her, but the beam that had rested on their heads was gone. The two poles faced in, and one judged the great size of the house by the distance between them. The corner posts were still in place, and the earth floor, once beaten to the hardness of rock by naked feet, was carpeted now with rich lush grass.

I knew her by the stuck-out ears, shouting mouth, and deep eye-sockets. These sockets had no eye-balls, but were empty holes, filled with stare. The stare, though not so fierce as that of the former image, was more intense. The whole figure expressed power, weight, domination, rather than ferocity. Her feet were planted heavily on the head of the squatting bear, carved beneath them. A man could have sat on either huge shoulder. She was unpainted, weather-worn, sun-cracked and the arms and hands seemed to hang loosely. The fingers were thrust into the carven mouths of two human heads, held crowns down. From

behind, the sun made unfathomable shadows in eye, cheek and mouth. Horror tumbled out of them.

I saw Indian Tom on the beach, and went to him.

"Who is she?"

The Indian's eyes, coming slowly from across the sea, followed my pointing finger. Resentment showed in his face, greeny-brown and wrinkled like a baked apple,—resentment that white folks should pry into matters wholly Indian.

"Who is that big carved woman?" I repeated.

"D'Sonoqua." No white tongue could have fondled the name as he did.

"Who is D'Sonoqua?"

"She is the wild woman of the woods."

"What does she do?"

"She steals children."

"To eat them?"

"No, she carries them to her caves; that," pointing to a purple scar on the mountain across the bay, "is one of her caves. When she cries 'oo-oo-oo-oeo,' Indian mothers are too frightened to move. They stand like trees, and the children go with D'Sonoqua."

"Then she is bad?"

"Sometimes bad . . . sometimes good," Tom replied, glancing furtively at those stuck-out ears. Then he got up and walked away.

I went back, and sitting in front of the image, gave stare for stare. But her stare so over-powered mine, that I could scarcely wrench my eyes away from the clutch of those empty sockets. The power that I felt was not in the thing itself, but in some tremendous force behind it, that the carver had believed in.

A shadow passed across her hands and their gruesome holdings. A little bird, with its beak full of nesting material, flew into the cavity of her mouth, right in the pathway of that terrible oo-oo-oo-oeo. Then my eye caught something that I had missed—a tabby cat asleep between her feet.

This was D'Sonoqua, and she was a supernatural being, who belonged to these Indians.

"Of course," I said to myself, "I do not believe in supernatural beings. Still— who understands the mysteries behind the forest? What would one do if one did meet a supernatural being?" Half of me wished that I could meet her, and half of me hoped I would not.

Chug—chug—the little boat had come into the bay to take me to another village, more lonely and deserted than this. Who knew what I should see there? But soon supernatural beings went clean out of my mind, because I was wholly absorbed in being naturally seasick.

When you have been tossed and wracked and chilled, any wharf looks good, even a rickety one, with its crooked legs stockinged in barnacles. Our boat nosed under its clammy darkness, and I crawled up the straight slimy ladder, wondering which was worse, natural seasickness, or supernatural "creeps". The trees crowded to the very edge of the water, and the outer ones, hanging over it, shad-

owed the shoreline into a velvet smudge. D'Sonoqua might walk in places like this. I sat for a long time on the damp, dusky beach, waiting for the stage. One by one dots of light popped from the scattered cabins, and made the dark seem darker. Finally the stage came.

We drove through the forest over a long straight road, with black pine trees marching on both sides. When we came to the wharf the little gas mail-boat was waiting for us. Smell and blurred light oozed thickly out of the engine room, and except for one lantern on the wharf everything else was dark. Clutching my little dog, I sat on the mail sacks which had been tossed on to the deck.

The ropes were loosed, and we slid out into the oily black water. The moon that had gone with us through the forest was away now. Black pine-covered mountains jagged up on both sides of the inlet like teeth. Every gasp of the engine shook us like a great sob. There was no rail round the deck, and the edge of the boat lay level with the black slithering horror below. It was like being swallowed again and again by some terrible monster, but never going down. As we slid through the water, hour after hour, I found myself listening for the oo-oo-oo-oeo.

Midnight brought us to a knob of land, lapped by the water on three sides, with the forest threatening to gobble it up on the fourth. There was a rude landing, a rooming-house, an eating-place, and a store, all for the convenience of fishermen and loggers. I was given a room, but after I had blown out my candle, the stillness and the darkness would not let me sleep.

In the brilliant sparkle of the morning when everything that was not superlatively blue was superlatively green, I dickered with a man who was taking a party up the inlet that he should drop me off at the village I was headed for.

"But," he protested, "there is nobody there."

To myself I said, "There is D'Sonoqua."

From the shore, as we rowed to it, came a thin feminine cry—the mewing of a cat. The keel of the boat had barely grated in the pebbles, when the cat sprang aboard, passed the man shipping his oars, and crouched for a spring into my lap. Leaning forward, the man seized the creature roughly, and with a cry of "Dirty Indian vermin!" flung her out into the sea.

I jumped ashore, refusing his help, and with a curt "Call for me at sundown," strode up the beach; the cat followed me.

When we had crossed the beach and come to a steep bank, the cat ran ahead. Then I saw that she was no lean, ill-favoured Indian cat, but a sleek aristocratic Persian. My snobbish little griffon dog, who usually refused to let an Indian cat come near me, surprised me by trudging beside her in comradely fashion.

The village was typical of the villages of these Indians. It had only one street, and that had only one side, because all the houses faced the beach. The two community houses were very old, dilapidated and bleached, and the handful of other shanties seemed never to have been young; they had grown so old before they were finished, that it was then not worth while finishing them.

Rusty padlocks carefully protected the gaping walls. There was the usual

broad plank in front of the houses, the general sitting and sunning place for Indians. Little streams ran under it, and weeds poked up through every crack, half hiding the companies of tins, kettles, and rags, which patiently waited for the next gale and their next move.

In front of the Chief's house was a high, carved totem pole, surmounted by a large wooden eagle. Storms had robbed him of both wings, and his head had a resentful twist, as if he blamed somebody. The heavy wooden heads of two squatting bears peered over the nettle-tops. The windows were too high for peeping in or out. "But, save D'Sonoqua, who is there to peep?" I said aloud, just to break the silence. A fierce sun burned down as if it wanted to expose every ugliness and forlornness. It drew the noxious smell out of the skunk cabbages, growing in the rich black ooze of the stream, scummed the water-barrels with green slime, and branded the desolation into my very soul.

The cat kept very close, rubbing and bumping itself and purring ecstatically; and although I had not seen them come, two more cats had joined us. When I sat down they curled into my lap, and then the strangeness of the place did not bite into me so deeply. I got up, determined to look behind the houses.

Nettles grew in the narrow spaces between the houses. I beat them down, and made my way over the bruised dark-smelling mass into a space of low jungle.

Long ago the trees had been felled and left lying. Young forest had burst through the slash, making an impregnable barrier, and sealing up the secrets which lay behind it. An eagle flew out of the forest, circled the village, and flew back again.

Once again I broke silence, calling after him, "Tell D'Sonoqua—" and turning, saw her close, towering above me in the jungle.

Like the D'Sonoqua of the other villages she was carved into the bole of a red cedar tree. Sun and storm had bleached the wood, moss here and there softened the crudeness of the modelling; sincerity underlay every stroke.

She appeared to be neither wooden nor stationary, but a singing spirit, young and fresh, passing through the jungle. No violence coarsened her; no power domineered to wither her. She was graciously feminine. Across her forehead her creator had fashioned the Sistheutl, or mythical two-headed sea-serpent. One of its heads fell to either shoulder, hiding the stuck-out ears, and framing her face from a central parting on her forehead which seemed to increase its womanliness.

She caught your breath, this D'Sonoqua, alive in the dead bole of the cedar. She summed up the depth and charm of the whole forest, driving away its menace.

I sat down to sketch. What was the noise of purring and rubbing going on about my feet? Cats. I rubbed my eyes to make sure I was seeing right, and counted a dozen of them. They jumped into my lap and sprang to my shoulders. They were real—and very feminine.

There we were—D'Sonoqua, the cats and I—the woman who only a few moments ago had forced herself to come behind the houses in trembling fear of the "wild woman of the woods"—wild in the sense that forest-creatures are wild—shy, untouchable.

THE BLOUSE

THE SOUND of waves came in at the open door; the smell of the sea and of the sun-warmed earth came in too. It was expected that very soon death would enter. A row of women sat outside the hut—they were waiting to mourn and howl when death came.

The huddle of bones and withered skin on the mattress inside the hut knew death was coming. Although the woman was childless and had no husband, she knew that the women of her tribe would make sorrow-noise for her when death came.

The eyes of the dying woman were glassy and half closed. I knelt beside her and put my hand over her cold bony one. My blouse touched her and she opened her eyes wide. Turning her hand, she feebly clutched the silk of my sleeve.

"Is there something you want, Mary?"

"Good," she whispered, still clutching the sleeve.

I thought that she was dead, holding my sleeve in a death grip. One of the women came in and tried to free me. Mary's eyes opened and she spoke in Indian.

"Mary wants your blouse," said the stooping woman to me.

"Wants my blouse?"

"Uh huh—wants for grave."

"To be buried in?"

"No, for grave-house."

I understood. Mary had not many things now but she had been important once. They would build a little wooden room with a show window in it over her grave. Here they would display her few poor possessions, the few hoarded trifles of her strong days. My blouse would be an addition.

The dying woman's eyes were on my face.

I scrambled out of the blouse and into my jacket. I laid the blouse across Mary. She died with her hands upon it.

THE STARE

MILLIE'S stare was the biggest thing in the hut. It dimmed for a moment as we stood in its way—but in us it had no interest. The moment we moved from its path it tightened again—this tense, living stare glowing in the sunken eyes of a sick Indian child.

All the life that remained in the emaciated, shrivelled little creature was concentrated in that stare. It burned a path for itself right across the sea to the horizon, burning with longing focused upon the return of her father's whaling-boat.

The missionary bent over the child.

"Millie!"

Millie's eyes lifted grudgingly, then hastened back to their watching.

Turning to the old crone who took the place of a mother who was dead and cared for the little girl, the missionary asked, "How is she, Granny?"

"I t'ink s'pose boat no come quick, Milly die plitty soon now."

"Is there no word of the boats?"

"No, maybe all Injun-man dead. Whale fishin' heap, heap bad for make die."

They brought the child food. She struggled to force down enough to keep the life in her till her father came. Squatted on her mat on the earth floor, her chin resting on the sharp knees encircled by her sticks of arms, she sat from dawn till dark, watching. When light was gone the stare fought its way, helped by Millie's ears, listening, listening out into black night.

It was in the early morning that the whaling-boats came home. When the mist lifted, Millie saw eight specks out on the horizon. Taut, motionless, uttering no word, she watched them grow.

"The boats are coming!" The cry rang through the village. Women left their bannock-baking, their basket-weaving and hurried to the shore. The old crone who tended Millie hobbled to the beach with the rest.

"The boats are coming!" Old men warming their stiff bodies in the sun shaded dull eyes with their hands to look far out to sea, groaning with joy that their sons were safe.

"The boats are coming!" Quick ears of children heard the cry in the school house and squeezing from their desks without leave, pattered down to the shore. The missionary followed. It was the event of the year, this return of the whaling-boats.

46

Millie's father was the first to land. His eyes searched among the people.
"My child?"

His feet followed the women's pointing fingers. Racing up the bank, his bulk filled the doorway of the hut. The stare enveloped him, Millie swayed towards him. Her arms fell down. The heavy plaits of her hair swung forward. Brittle with long watching, the stare had snapped.

GREENVILLE

THE CANNERY boss said, "Try Sam; he has a gas boat and comes from Greenville. That's Sam over there—the Indian in the striped shirt."

I came close to where Sam was forking salmon from the scow on to the cannery chutes.

"Sam, I want to go to Greenville. Could you take me there on Sunday?"

"Uh huh."

"What time Sunday?"

"Eight o'clock."

On Sunday morning I sat on the wharf from eight o'clock till noon. Sam's gas boat was down below. There was a yellow tarpaulin tented across her middle. Four bare feet stuck out at one end and two black heads at the other.

From stir to start it took the Indians four hours. Sam and his son sauntered up and down getting things as if time did not exist. Round noon the gas boat's impudent sputter ticked out across the wide face of the Naas River.

The Indian and his son were silent travellers.

I had a small griffon dog who sat at my feet quivering and alert. I felt like an open piano that any of the elements could strum on.

The great Naas swept grandly along. The nameless little river that Greenville was on emptied into the Naas. When our boat turned from the great into the little river she had no more ambition. Her engine died after a few puffs. Then we drifted a short way and nosed alongside a crude plank landing. This was Greenville.

It was between lights, neither day nor dark.

Five or six shadows came limping down the bank to the landing—Indian dogs—gaunt forsaken creatures. They knew when they heard the engine it meant man. The dogs looked queer.

"What is the matter with the dogs?"

"Porkpine," grunted the Indian.

The creatures' faces were swollen into wrong shapes. Porcupine quills festered in the swellings.

"Why don't the Indians take their dogs with them and not leave them to starve or hunt porcupine?"

"Cannery Boss say no can."

When I went towards the dogs, they backed away growling.

"Him hiyu fierce," warned the Indian.

In the dusk with the bedding and bundles on their shoulders the two Indians looked monstrous moving up the bank ahead of me.

I held my dog tight because of the fierceness of those skulking shadow-dogs following us.

Greenville was a large village, low and flat. Its stagnant swamps and ditches were glory places for the mosquitoes to breed in. Only the hum of the miserable creatures stirred the heavy murk that beaded our foreheads with sweat as we pushed our way through it.

Half-built, unpainted houses, old before ever they were finished, sat hunched irregularly along the grass-grown way. Planks on spindly trestles bridged the scummed sloughs. Emptiness glared from windows and shouted up dead chimneys, weighted emptiness, that crushed the breath back into your lungs and chilled the heart in your sweating body.

Stumbling over stones and hummocks I hurried after the men who were anxious to place me and be gone down the Naas to the cannery again.

I asked the Indian, "Is there no one in this village?"

"One ole man, one woman, and one baby stop. Everybody go cannery."

"Where can I stay?"

"Teacher's house good for you."

"Where is the teacher?"

"Teacher gone too."

We were away from the village street now and making our way through bracken breast high. The school house was among it crouched on the edge of the woods. It was school house and living quarters combined. Trees pressed it close; undergrowth surged up over its windows.

The Indian unlocked the door, pushed us in and slammed the door too violently, as if something terrible were behind us.

"What was it you shut out, Sam?"

"Mosquito."

In here the hum of the mosquitoes had stopped, as every other thing had stopped in the murky grey of this dreadful place, clock, calendar, even the air— the match the Indian struck refused to live.

We felt our way through the long school room to a room behind that was darker still. It had a drawn blind and every crevice was sealed. The air in it felt as solid as the table and the stove. You chewed rather than breathed it. It tasted of coal-oil after we lit the lamp.

I opened a door into the shed. The pungent smell of cut stove-wood that came in was good.

The Indians were leaving me.

"Stop! The old man and the woman, where are they? Show me."

Before I went I opened all the doors. Mosquitoes were better than this strangling deadness, and I never could come back alone and open the door of the big dark room. Then I ran through the bracken and caught up with the Indians.

They led me to the farthest house in the village. It was cut off from the school house by space filled with desperate loneliness.

The old man was on the floor; he looked like a shrivelled old bird there on his mattress, caged about with mosquito netting. He had lumbago. His wife and grandchild were there too.

The womanliness of the old squaw stayed with me when I came back. All night long I was glad of that woman in Greenville.

It was dark when I got back to the school and the air was oozing sluggishly through the room.

I felt like a thief taking possession of another's things without leave. The school teacher had left everything shipshape. Everything told the type of woman she was.

Soon I made smoke roll round inside the stove and a tiny flame wavered. I turned forward the almanac sheets and set the clock ticking. When the kettle sang things had begun to live.

The night was long and black. As dawn came I watched things slowly poke out of the black. Each thing was a surprise.

The nights afterwards in this place were not bad like the first one, because I then had my bearings. All my senses had touched the objects around me. But it was lying in that smothering darkness and not knowing what was near me—what I might touch if I reached out a hand—that made the first night so horrible.

When I opened the school house door in the morning the village dogs were in the bracken watching. They went frantic over the biscuits I threw to them. A black one came crouching. She let me pull the porcupine quills out of her face. When the others saw her fear dry up, they came closer too. It was people they wanted even more than food. Wherever I went about the village they followed me.

In the swampy places and ditches of Greenville skunk cabbages grew—gold and brimming with rank smell—hypocrites of loveliness peeping from the lush green of their great leaves. The smell of them was sickening.

I looked through the blindless windows of the Indian houses. Half-eaten meals littered the tables. Because the tide had been right to go, bedding had been stripped from the springs, food left about, water left unemptied to rust the kettles. Indians slip in and out of their places like animals. Tides and seasons are the things that rule their lives: domestic arrangements are mere incidentals.

The houses looked as if they had been shaken out of a dice box on to the land and stayed just where they lit. The elements dominated them from the start. As soon as a few boards were put together the family moved in, and the house went on building around them until some new interest came along. Then the Indian dropped his tools. If you asked when he was going to finish building his house he said, "Nodder day—me too busy now," and after a long pull on his pipe he would probably lie round in the sun for days doing nothing.

I went often to the last house in the village to gossip with the woman. She was not as old as you thought at first, but very weatherbeaten. She was a friendly soul, but she spoke no English. We conversed like this,—one would point at something, the other clap her hands and laugh, or moan and shake her head as was right. Our eyebrows worked too and our shoulders and heads. A great deal of fun and information passed back and forth between us.

Ginger Pop, my griffon, was a joy to Granny. With a chuckle that wobbled the fat all over her, she would plant her finger on the snub of her own broad nose and wrinkle it back towards her forehead in imitation of the dog's snub, and laugh till the tears poured out of her eyes. All the while the black eyes of her solemn grandchild stared.

Granny also enjoyed my duck "pantalettes" that came below my skirts to the soles of my shoes, my duplicate pairs of gloves, and the cheese-cloth veil with a glass window in front. This was my mosquito armour. Hers consisted of pair upon pair of heavy wool stockings handknitted, and worn layer upon layer till they were deeper than the probes of the mosquitoes, and her legs looked like barrels.

The old man and I had a few Chinook words in common. I went sometimes to the darkened shed where he was building a boat. He kept a smudge and the air was stifling. Tears and sweat ran down our faces. He wiped his face with the bandana floating under his hat brim to protect his neck and blew at the mosquitoes and rubbed his lumbago. Suddenly his eye would catch the comic face of Ginger Pop and he too would throw down his tools and give himself up to mirth at the pup's expense. When he laughed, that was the time to ask him things.

"I am sorry that there are no totem poles in Greenville. I like totem poles," I said.

"Halo totem stick kopa Greenville."

"Old village with totem poles stop up the Naas?"

"Uh huh."

"I would like to see them."

"Uh huh."

"Will you take me in your boat?"

"Uh huh, Halo tillicum kopet."

"I want to see the poles, not people. You take me tomorrow?"

"Uh huh."

So we went to Gittex and Angedar, two old village sites on the Naas River. His old boat crept through the side-wash meanderings of the Naas. Suddenly we

came out on to its turbulent waters and shot across them: and there, tipping drunkenly over the top of dense growth, were the totem poles of Gittex. They looked like mere sticks in the vast sea of green that had swallowed the old village. Once they, too, had been forest trees, till the Indian mutilated and turned them into bare poles. Then he enriched the shorn things with carvings. He wanted some way of showing people things that were in his mind, things about the creatures and about himself and their relation to each other. He cut forms to fit the thoughts that the birds and animals and fish suggested to him, and to these he added something of himself. When they were all linked together they made very strong talk for the people. He grafted this new language on to the great cedar trunks and called them totem poles and stuck them up in the villages with great ceremony. Then the cedar and the creatures and the man all talked together through the totem poles to the people. The carver did even more—he let his imaginings rise above the objects that he saw and pictured supernatural beings too.

The creatures that had flesh and blood like themselves the Indians understood. They accepted them as their ancestors but the supernatural things they feared and tried to propitiate.

Every clan took a creature for its particular crest. Individuals had private crests too, which they earned for themselves often by privation and torture and fasting. These totem creatures were believed to help specially those who were of their crest.

When you looked at a man's pole, his crests told you who he was, whom he might marry and whom he might not marry—for people of the same crest were forbidden to marry each other.

You knew also by the totem what sort of man he was or at least what he should be because men tried to be like the creature of their crest, fierce, or brave, or wise, or strong.

Then the missionaries came and took the Indians away from their old villages and the totem poles and put them into new places where life was easier, where they bought things from a store instead of taking them from nature.

Greenville, which the Indians called "Lakalzap", was one of these new villages. They took no totem poles with them to hamper their progress in new ways; the poles were left standing in the old places. But now there was no one to listen to their talk any more. By and by they would rot and topple to the earth, unless white men came and carried them away to museums. There they would be labelled as exhibits, dumb before the crowds who gaped and laughed and said, "This is the distorted foolishness of an uncivilized people." And the poor poles could not talk back because the white man did not understand their language.

At Gittex there was a wooden bear on top of such a high pole that he was able still to look over the top of the woods. He was a joke of a bear—every bit of him was merry. He had one paw up against his face, he bent forward and his feet clung to the pole. I tried to circle about so that I could see his face but the monstrous tangle was impossible to break through.

I did beat my way to the base of another pole only to find myself drowned under an avalanche of growth sweeping down the valley. The dog and I were alone in it—just nothings in the overwhelming immensity.

My Indian had gone out to mid-river. It seemed an awful thing to shatter that silence with a shout, but I was hungry and I dared not raise my veil till I got far out on the Naas. Mosquitoes would have filled my mouth.

After seven days the Indians came back with their boat and took me down the Naas again.

I left the old man and woman leisurely busy, the woman at her wash-tub and the man in his stifling boat-house. Each gave me a passing grin and a nod when I said goodbye; comings and goings are as ordinary to Indians as breathing.

I let the clock run down. Flapped the leaves of the calendar back, and shut the Greenville school house tight.

The dogs followed to the edge of the water, their stomachs and hearts sore at seeing us go. Perhaps in a way dogs are more domestic and more responsive than Indians.

Two Bits and a Wheel-Barrow

THE SMALLEST coin we had in Canada in early days was a dime, worth ten cents. The Indians called this coin "a Bit". Our next coin, double in buying power and in size, was a twenty-five cent piece and this the Indians called "Two Bits".

Two bits was the top price that old Jenny knew. She asked two bits for everything she had to sell, were it canoe-bailer, eagle's wing, cedar-bark basket or woven mat. She priced each at "two bits" and if I had said, "How much for your husband or your cat?" she would have answered "two bits" just the same.

Her old husband did not look worth two bits. He was blind and very motheaten. All day he lay upon a heap of rags in the corner of their hut. He was quite blind but he had some strength still. Jenny made him lie there except when he was led, because he fell into the fire or into the big iron cook-pot and burned himself if he went alone. There was such a litter over the floor that he could not help tripping on something if he took even a step. So Jenny Two-Bits ordered her old blind Tom to stay in his corner till she was ready. Jenny was getting feeble. She was lame in the hip and walked with a crooked stick that she had pulled from the sea.

Tommy knew that day had come when he felt Jenny Two-Bits' stick jab him. The stick stayed in the jab until Tom took hold. Then still holding the stick Jenny steered him across to where she lay. When he came close she pulled herself up by hanging on-to his clothes. When bits of his old rags tore off in her hands she scolded Tom bitterly for having such poor, weak clothes.

Tom could tell by the cold clammy feel how very new the morning was when Jenny pushed him out of the door and told him to stand by the wall and not move while she went for the wheel-barrow. It screeched down the alley. Jenny backed Tom between the handles and he took hold of them. Then she tied a rope to each of his arms above the elbow. She used the ropes for reins and hobbled along, slapping the barrow with her stick to make Tom go and poking her stick into his back to make him stop. At that early hour the village was empty. They always tried to be the first on the beach so that they could have the pick of what the sea had thrown up.

They went slowly to the far end of the village street where the bank was low and here they left the barrow.

Jenny Two-Bits led Tom along the quiet shore. She peered this way and that to see what the waves had brought in. Sometimes the sea gave them good things, sometimes nothing at all, but there were always bits of firewood and bark to be had if they got there before anyone else.

The old woman's eyes were very sharp and the wheel-barrow hardly ever came back empty. When Jenny found anything worthwhile, first she peered, then she beat it with her stick and took Tom's hand and laid it on the wet cast-up thing. Tom would lift it and carry it to the barrow. Then they came back to their shanty and sat down in the sun outside the door to rest.

Sometimes Jenny and Tom went in a canoe to fish out in the bay. Tom held the lines, Jenny paddled.

When they caught a fish or when Jenny sold something for two bits or when they sat together baking themselves in the sunshine, they were happy enough.

SLEEP

WHEN I was a child I was staying at one of Victoria's beaches.

I was down on the point watching a school of porpoises at play off Trail Island when a canoe came round the headland. She was steering straight for our beach.

The Government allowed the Indians to use the beaches when they were travelling, so they made camp and slept wherever the night happened to fall.

In the canoe were a man and woman, half a dozen children, a dog, a cat and a coop of fowls, besides all the Indians' things. She was a West Coast canoe—

dug out of a great red cedar tree. She was long and slim, with a high prow shaped like a wolf's head. She was painted black with a line of blue running round the top of the inside. Her stern went straight down into the water. The Indian mother sat in the stern and steered the canoe with a paddle.

When the canoe was near the shore, the man and the woman drove their paddles strong and hard, and the canoe shot high up on to the pebbles with a growling sound. The barefoot children swarmed over her side and waded ashore.

The man and the woman got out and dragged the canoe high onto the beach. There was a baby tucked into the woman's shawl; the shawl bound the child close to her body. She waddled slowly across the beach, her bare feet settling in the sand with every step, her fleshy body squared down on to her feet. All the movements of the man and the woman were slow and steady; their springless feet padded flatly; their backs and shoulders were straight. The few words they said to each other were guttural and low-pitched.

The Indian children did not race up and down the beach, astonished at strange new things, as we always were. These children belonged to the beach, and were as much a part of it as the drift-logs and the stones.

The man gathered a handful of sticks and lit a fire. They took a big iron pot and their food out of the canoe, and set them by the fire. The woman sat among the things with her baby—she managed the shawl and the baby so that she had her arms free, and her hands moved among the kettles and food.

The man and a boy, about as big as I was, came up the path on the bank with tin pails. When they saw me, the boy hung back and stared. The man grinned and pointed to our well. He had coarse hair hanging to his shoulders; it was unbrushed and his head was bound with a red band. He had wrinkles everywhere, face, hands and clothing. His coat and pants were in tatters. He was brown and dirty all over, but his face was gentle and kind.

Soon I heard the pad-pad of their naked feet on the clay of the path. The water from the boy's pail slopped in the dust while he stared back at me.

They made tea and ate stuff out of the iron pot; it was fish, I could smell it. The man and the woman sat beside the pot, but the children took pieces and ran up and down eating them.

They had hung a tent from the limb of the old willow tree that lolled over the sand from the bank. The bundles and blankets had been tossed into the tent; the flaps were open and I could see everything lying higgledy-piggledy inside.

Each child ate what he wanted, then he went into the tent and tumbled, dead with sleep, among the bundles. The man, too, stopped eating and went into the tent and lay down. The dog and the cat were curled up among the blankets.

The woman on the beach drew the smouldering logs apart; when she poured a little water on them they hissed. Last of all she too went into the tent with her baby.

The tent full of sleep greyed itself into the shadow under the willow tree. The wolf's head of the canoe stuck up black on the beach a little longer; then it faded back and back into the night. The sea kept on going slap-slap-slap over the beach.

SAILING TO YAN

AT THE appointed time I sat on the beach waiting for the Indian. He did not come and there was no sign of his boat.

An Indian woman came down the bank carrying a heavy not-walking-age child. A slim girl of twelve was with her. She carried a paddle and going to a light canoe that was high on the sand, she began to drag it towards the sea.

The woman put the baby into the canoe and she and the girl grunted and shunted the canoe into the water, then they beckoned to me.

"Go now," said the woman.

"Go where?"

"Yan.—My man tell me come take you go Yan."

"But—the baby—?"

Between Yan and Masset lay ugly waters—I could not—no, I really could not—a tippy little canoe—a woman with her arms full of baby—and a girl child—!

The girl was rigging a ragged flour sack in the canoe for a sail. The pole was already placed, the rag flapped limply around it. The wind and the waves were crisp and sparkling. They were ready, waiting to bulge the sack and toss the canoe.

"How can you manage the canoe and the baby?" I asked the woman and hung back.

Pointing to the bow seat, the woman commanded, "Sit down."

I got in and sat.

The woman waded out holding the canoe and easing it about in the sand until it was afloat. Then she got in and clamped the child between her knees. Her paddle worked without noise among the waves. The wind filled the flour sack beautifully as if it had been a silk sail.

The canoe took the water as a beaver launches himself—with a silent scoot.

The straight young girl with black hair and eyes and the lank print dress that clung to her childish shape, held the sail rope and humoured the whimsical little canoe. The sack now bulged with wind as tight as once it had bulged with flour. The woman's paddle advised the canoe just how to cut each wave.

We streaked across the water and were at Yan before I remembered to be frightened. The canoe grumbled over the pebbly beach and we got out.

We lit a fire on the beach and ate.

The brave old totems stood solemnly round the bay. Behind them were the old houses of Yan, and behind that again was the forest. All around was a blaze of rosy pink fireweed, rioting from the rich black soil and bursting into loose delicate blossoms, each head pointing straight to the sky.

Nobody lived in Yan. Yan's people had moved to the newer village of Masset, where there was a store, an Indian agent and a church.

Sometimes Indians came over to Yan to cultivate a few patches of garden. When they went away again the stare in the empty hollows of the totem eyes followed them across the sea, as the mournful eyes of chained dogs follow their retreating masters.

Just one carved face smiled in the village of Yan. It was on a low mortuary pole and was that of a man wearing a very, very high hat of honour. The grin showed his every tooth. On the pole which stood next sat a great wooden eagle. He looked down his nose with a dour expression as a big sister looks when a little sister laughs in church.

The first point at the end of Yan beach was low and covered with coarse rushes. Over it you could see other headlands—point after point . . . jutting out, on and on . . . beyond the wide sweep of Yan beach to the edge of the world.

There was lots of work for me to do in Yan. I went down the beach far away from the Indians. At first it was hot, but by and by haze came creeping over the farther points, blotting them out one after the other as if it were suddenly aware that you had been allowed to see too much. The mist came nearer and nearer till it caught Yan too in its woolly whiteness. It stole my totem poles; only the closest ones were left and they were just grey streaks in the mist. I saw myself as a wet rag sticking up in a tub of suds. When the woolly mist began to thread and fall down in rain I went to find the woman.

She had opened one of the houses and was sitting on the floor close to a low fire. The baby was asleep in her lap. Under her shawl she and the child were one big heap in the half-dark of the house. The young girl hugged her knees and looked into the fire. I sat in to warm myself and my clothes steamed. The fire hissed and crackled at us.

I said to the woman, "How old is your baby?"

"Ten month. He not my baby. That," pointing to the girl, "not my chile too."

"Whom do they belong to?"

"Me. One woman give to me. All my chiles die—I got lots, lots dead baby. My fliend solly me 'cause I got no more chile so she give this an' this for mine."

"Gave her children away? Didn't she love them?"

"She love plenty lots. She cly, cly—no eat—no sleep—cly, cly—all time cly."

"Then why did she give her children away?"

"I big fliend for that woman—she solly me—she got lots more baby, so she give this and this for me."

She folded the sleeping child in her shawl and laid him down. Then she lifted up some loose boards lying on the earth floor and there was a pit. She knelt, dipped her hand in and pulled out an axe. Then she brought wood from

the beach and chopped as many sticks as we had used for our fire. She laid them near the fire stones, and put the axe in the pit and covered it again. That done, she put the fire out carefully and padlocked the door.

The girl child guiding the little canoe with the flour-sack sail slipped us back through the quiet mist to Masset.

CHA-ATL

WHILE I was staying at the missionary's house, waiting to find someone to take me to Cha-atl, the missionary got a farm girl, with no ankles and no sense of humour, to stay there with me. She was to keep me company, and to avoid scandal, because the missionary's wife and family were away. The girl had a good enough heart stowed away in an ox-like body. Her name was Maria.

Jimmie, a Haida Indian, had a good boat, and he agreed to take me to Cha-atl, so he and his wife Louisa, Maria and I all started off in the boat. I took my sheep dog and Louisa took her cat.

We made a short stop at a little island where there were a few totem poles and a great smell because of all the dogfish thrown up on the beach and putrefying in the sun. Then we went on till we got to the long narrow Skidegate Inlet.

The tips of the fresh young pines made circles of pale green from the wide base of each tree to the top. They looked like multitudes of little ladies in crinolines trooping down the bank.

The day was hot and still. Eagles circled in the sky and porpoises followed us up the Inlet till we came to the shallows; they leaped up and down in the water making a great commotion on both sides of our boat. Their blunt noses came right out of the water and their tails splashed furiously. It was exciting to watch them.

It took Jimmie all his time in the shallows to keep us in the channel. Louisa was at the wheel while he lay face down on the edge of the boat peering into the water and making signals to Louisa with his arms.

In the late afternoon, Jimmie shut off the engine and said, "Listen."

Then we heard a terrific pounding and roaring. It was the surf-beat on the west coast of Queen Charlotte Islands. Every minute it got louder as we came nearer to the mouth of the Inlet. It was as if you were coming into the jaws of something too big and awful even to have a name. It never quite got us, because we turned into Cha-atl, just before we came to the corner, so we did not see the awfulness of the roaring ocean. Seamen say this is one of the worst waters in the world and one of the most wicked coasts.

Cha-atl had been abandoned a great many years. The one house standing was quite uninhabitable. Trees had pushed the roof off and burst the sides. Under the hot sun the lush growth smelt rank.

Jimmie lowered the canoe and put Billy, the dog, and me ashore. He left the gas boat anchored far out. When he had put me on the beach, he went back to get Louisa and Maria and the things. While I stood there that awful boom, boom, seemed to drown out every other thing. It made even the forest seem weak and shivery. Perhaps if you could have seen the breakers and had not had the whole weight of the noise left entirely to your ears it would not have seemed so stunning. When the others came ashore the noise seemed more bearable.

There were many fine totem poles in Cha-atl—Haida poles, tragic and fierce. The wood of them was bleached out, but looked green from the mosses which grew in the chinks, and the tufts of grass on the heads of the figures stuck up like coarse hair. The human faces carved on the totem poles were stern and grim, the animal faces fierce and strong; supernatural things were pictured on the poles too. Everything about Cha-atl was so vast and deep you shrivelled up.

When it was too dark to work I came back to the others. They were gathered round a fire on the beach. We did not talk while we ate; you had to shout to be heard above the surf. The smell of the ocean was very strong.

Jimmie had hung one end of my tent to a totem pole that leaned far over the sand. The great carved beaks of the eagle and the raven nearly touched the canvas.

"Jimmie, don't you think that pole might fall on us in the night?"

"No, it has leaned over like that for many, many years."

Louisa's white cat looked like a ghost with the firelight on her eyes. We began to talk about ghosts and supernatural things—tomtoms that beat themselves, animals that spoke like men, bodies of great chiefs, who had lain in their coffins in the houses of their people till they stank and there were smallpox epidemics—stories that Louisa's grandmother had told her.

When we held the face of the clock to the firelight we saw that it was late. Louisa went to the tent and laughed aloud; she called out, "Come and see."

The walls of the tent and our beds and blankets were crawling with great yellow slugs. With sticks we poked them into a pan. They put in their horns and blunted their noses, puckering the thick lips which ran along their sides and curving their bodies crossly. We tossed them into the bush.

Louisa hung the lantern on to the tent pole and said—

"Jimmie and I will go now."

"Go?"

"Yes, to the gas boat."

" 'Way out there and leave us all alone? Haven't you got a tent?"

Jimmie said he forgot it.

"But . . . Jimmie won't sleep in Cha-atl . . . too many ghosts . . ."

"What about us?"

"There are some bears around, but I don't think they will bother you. . . . Goodnight."

Their lantern bobbed over the water, then it went out, and there was not anything out there but roar. If only one could have seen it pounding!

We lay down upon the bed of rushes that the Indians had made for us and drew the blanket across us. Maria said, "It's awful. I'm scared to death." Then she rolled over and snored tremendously. Our lantern brought in mosquitoes, so I got up and put it out. Then I went from the tent.

Where the sea had been was mud now, a wide grey stretch of it with black rocks and their blacker shadows dotted over it here and there. The moon was rising behind the forest—a bright moon. It threw the shadows of the totems across the sand; an owl cried, and then a sea-bird. To be able to hear these close sounds showed that my ears must be getting used to the breakers. By and by the roar got fainter and fainter and the silence stronger. The shadows of the totem poles across the beach seemed as real as the poles themselves.

Dawn and the sea came in together. The moon and the shadows were gone. The air was crisp and salty. I caught water where it trickled down a rock and washed myself.

The totem poles stood tranquil in the dawn. The West Coast was almost quiet; the silence had swallowed up the roar.

And morning had come to Cha-atl.

WASH MARY

MARY came to wash for Mother every Monday.

The wash-house was across the yard from the kitchen door—a long narrow room. The south side of it was of open lattice—when the steam poured through it looked as if the wash-house was on fire. There was a stove in the wash-house. A big oval copper boiler stood on the top of the stove. There was a sink and a pump, and a long bench on which the wooden tubs sat.

Mary stood on a block of wood while she washed because she was so little. Her arms went up and down, up and down over the wash-board and the suds bobbed in the tub. The smell of washing came out through the lattice with the steam, and the sound of rubbing and swishing came out too.

The strong colours of Mary's print dress, brown face, and black hair were paled by the steam that rolled round her from the tubs. She had splendid braids of hair—the part went clear from her forehead to her spine. At each side of the part the hair sprang strong and thick. The plaits began behind each ear. Down at the ends they were thinner and were tied together with string. They made a loop across her back that looked like a splendid strong handle to lift little Mary

up by. Her big plaid shawl hung on a nail while she washed. Mary's face was dark and wrinkled and kind.

Mother said to me, "Go across the yard and say to Mary, 'Chahko mucka-muck, Mary'."

"What does it mean?"

"Come to dinner."

"Mother, is Mary an Indian?"

"Yes child; run along, Mary will be hungry."

"Chahko muckamuck—Chahko muckamuck—" I said over and over as I ran across the yard.

When I said to Mary, "Chahko muckamuck", the little woman looked up and laughed at me just as one little girl laughs at another little girl.

I used to hang round at noon on Mondays so that I could go and say, "Chahko muckamuck, Mary". I liked to see her stroke the suds from her arms back into the tub and dry her arms on her wide skirt as she crossed to the kitchen. Then too I used to watch her lug out the big basket and tip-toe on her bare feet to hang the wash on the line, her mouth full of clothes pins—the old straight kind that had no spring, but round wooden knobs on the top that made them look like a row of little dolls dancing over the empty flapping clothes.

As long as I could remember Mary had always come on Mondays and then suddenly she did not come any more.

I asked, "Where is Wash Mary?"

Mother said, "You may come with me to see her."

We took things in a basket and went to a funny little house in Fairfield Road where Mary lived. She did not stay on the Reserve where the Songhees Indians lived. Perhaps she belonged to a different tribe—I do not know—but she wanted to live as white people did. She was a Catholic.

Mary's house was poor but very clean. She was in bed; she was very, very thin and coughed all the time. The brown was all bleached out of her skin. Her fingers were like pale yellow claws now, not a bit like the brown hands that had hung the clothes on our line. Just her black hair was the same and her kind, tired eyes.

She was very glad to see Mother and me.

Mother said, "Poor Mary", and stroked her hair.

A tall man in a long black dress came into Mary's house. He wore a string of beads with a cross round his waist. He came to the bed and spoke to Mary and Mother and I came away.

After we were outside again, Mother said quietly—"Poor Mary!"

JUICE

IT WAS unbelievably hot. We three women came out of the store each eating a juicy pear. There was ten cents' express on every pound of freight that came up the Cariboo road. Fruit weighs heavy. Everything came in by mule-train.

The first bite into those Bartletts was intoxicating. The juice met your teeth with a gush.

I was considering the most advantageous spot to set my bite next when I saw Doctor Cabbage's eye over the top of my pear, feasting on the fruit with unquenched longing.

I was on the store step, so I could look right into his eyes. They were dry and filmed. The skin of his hands and face was shrivelled, his clothes nothing but a bunch of tatters hanging on a dry stick. I believe the wind could have tossed him like a dead leaf, and that nothing juicy had ever happened in Doctor Cabbage's life.

"It is a good apple?"

After he had asked, his dry tongue made a slow trip across his lips and went back into his mouth hotter and dryer for thinking of the fruit.

"Would you like it?"

A gleam burst through his filmed eyes. He drew the hot air into his throat with a gasp, held his hand out for the pear and then took a deep greedy bite beside mine.

The juice trickled down his chin—his tongue jumped out and caught it; he sipped the oozing juice from the holes our bites had made. He licked the drops running down the rind, then with his eyes still on the pear, he held it out for me to take back.

"No, it's all yours."

"Me eat him every bit?"

"Yes."

His eyes squinted at the fruit as if he could not quite believe his ears and that all the pear in his hands belonged to him. Then he took bite after bite, rolling each bite slowly round his mouth, catching every drop of juice with loud suckings. He ate the core. He ate the tail, and licked his fingers over and over like a cat.

"Hyas Klosshe (very good)," he said, and trotted up the hill as though his joints had been oiled.

Some days later I had occasion to ride through the Indian village. All the cow

ponies were busy—the only mount available was an old, old mare who resented each step she took, and if you stopped one instant she went fast asleep.

Indian boys were playing football in the street of their village. I drew up to ask direction. The ball bounced exactly under my horse's stomach. The animal had already gone to sleep and did not notice. Out of a cabin shot a whirl of a little man, riddled with anger. It was Doctor Cabbage.

He confiscated the ball and scolded the boys so furiously that the whole team melted away—you'd think there was not a boy left in the world.

Laying his hand on my sleeping steed, Doctor Cabbage smiled up at me.

"You brave good rider," he said, "Skookum tumtum (good heart)!"

I thanked Doctor Cabbage for the compliment and for his gallant rescue.

I woke my horse with great difficulty, and decided that honour for conspicuous bravery was sometimes very easily won.

F R I E N D S

"WE HAVE a good house now. We would like you to stay with us when you come. My third stepfather gave me the house when he was dead. He was a good man."

I wrote back, "I would like to stay with you in your house."

Louisa met me down on the mud flats. She had to walk out half a mile because the tide was low. She wore gum boots and carried another pair in her hand for me. Her two small barefoot sons took my bags on their backs. Louisa's greetings were gracious and suitable to the dignity of her third stepfather's house.

It was a nice house, and had a garden and verandah. There was a large kitchen, a living-room and double parlours. The back parlour was given to me. It had a handsome brass bed with spread and pillow-slips heavily embroidered, and an eiderdown. There was also a fine dresser in the room; on it stood a candle in a beer bottle and a tin pie-plate to hold hairpins. There was lots of light and air in the room because the blind would not draw down and the window would not shut up.

A big chest in the centre of the room held the best clothes of all the family. Everyone was due to dress there for church on Sunday morning.

Between my parlour and the front parlour was an archway hung with skimpy purple curtains of plush. If any visitors came for music in the evenings and stayed too long, Louisa said, "You must go now, my friend wants to go to bed."

The outer parlour ran to music. It had a player-piano—an immense instrument with a volume that rocked the house—an organ, a flute and some har-

monicas. When the cabinet for the player rolls, the bench, a big sofa, a stand-lamp with shade, and some rocking chairs got into the room, there was scarcely any space for people.

In the living-room stood a glass case and in it were Louisa's and Jimmie's wedding presents and all their anniversary presents. They had been married a long time, so the case was quite full.

The kitchen was comfortable, with a fine cook-stove, a sink, and a round table to eat off. Louisa had been cook in a cannery and cooked well. Visitors often came in to watch us eat. They just slipped in and sat in chairs against the wall and we went on eating. Mrs. Green, Louisa's mother, dropped in very often. Louisa's house was the best in the village.

At night Louisa's boys, Jim and Joe, opened a funny little door in the living-room wall and disappeared. Their footsteps sounded up and more up, a creak on each step, then there was silence. By and by Jimmie and Louisa disappeared through the little door too. Only they made louder creaks as they stepped. The house was then quite quiet—just the waves sighing on the shore.

Louisa's mother, Mrs. Green, was a remarkable woman. She clung vigorously to the old Indian ways, which sometimes embarrassed Louisa. In the middle of talking, the old lady would spit on to the wood-pile behind the stove. When Louisa saw she was going to, she ran with a newspaper, but she seldom got there in time. She was a little ashamed, too, of her mother's smoking a pipe; but Louisa was most respectful to her mother—she never scolded her.

One day I was passing the cabin in the village where Mrs. Green lived. I saw the old lady standing barefoot in a trunk which was filled with thick brown kelp leaves dried hard. They were covered with tiny grey eggs. Louisa told me it was fish roe and was much relished by the Japanese. Mrs. Green knew where the fish put their eggs in the beds of kelp, and she went out in her canoe and got them. After she had dried them she sent them to the store in Prince Rupert and the store shipped them to Japan, giving Mrs. Green value in goods.

When Mrs. Green had tramped the kelp flat, Louisa and I sat on the trunk and she roped it and did up the clasps. Then we put the trunk on the boys' little wagon and between us trundled it to the wharf. They came home then to write a letter to the store man at Prince Rupert. Louisa got the pen and ink, and her black head and her mother's grey one bent over the kitchen table. They had the store catalogue: it was worn soft and black. Mrs. Green had been deciding all the year what to get with the money from the fish roe. Louisa's tongue kept lolling out of the corner of her mouth as she worried over the words; she found them harder to write than to say in English. It seemed as if the lolling tongue made it easier to put them on the paper.

"Can I help you?" I asked.

Louisa shoved the paper across the table to me with a glad sigh, crushing up her scrawled sheet. They referred over and over to the catalogue, telling me what to write. "One plaid shawl with fringe, a piece of pink print, a yellow silk handkerchief, groceries" were all written down, but the old woman kept turning

back the catalogue and Louisa kept turning it forward again and saying firmly, "That is all you need, Mother!" Still the old woman's fingers kept stealthily slipping back the pages with longing.

I ended the letter and left room for something else on the list.

"Was there anything more that you wanted, Mrs. Green?"

"Yes, me like *that!*" she said with a defiant glance at Louisa.

It was a patent tobacco pipe with a little tin lid. Louisa looked ashamed.

"What a fine pipe, Mrs. Green, you ought to have that," I said.

"Me like little smoke," said Mrs. Green, looking slyly at Louisa.

That night, old Mother Green sat by the stove puffing happily on her old clay pipe. She leaned forward and poked my knee. "That lid good," she said. "When me small, small girl me mama tell me go fetch pipe often; I put in my mouth to keep the fire; that way me begin like smoke." She had a longish face scribbled all over with wrinkles. When she talked English the big wrinkles round her eyes and mouth were seams deep and tight and little wrinkles, like stitches, crossed them.

The candle in my room gave just enough light to show off the darkness. Morning made clear the picture that was opposite my bed. It was of three very young infants. How they could stick up so straight with no support at that age was surprising. They had embroidered robes three times as long as themselves, and the most amazing expressions on their faces. Their six eyes were shut as tight as licked envelopes—the infants, clearly, had tremendous wills, and had determined never to open their eyes. Their little faces were like those of very old people; their fierce wrinkles seemed to catch and pinch my stare, so that I could not get it away. I stared and stared. Louisa found me staring.

I said, "Whose babies are those?"

"Mother's tripples," she replied grandly.

"You mean they were Mrs. Green's babies?"

"Yes, the only tripples ever born on Queen Charlotte Islands."

"Did they die?"

"One died and the other two never lived. We kept the dead ones till the live one died, then we pictured them all together."

Whenever I saw that remarkable old woman, with her hoe and spade, starting off in her canoe to cultivate the potatoes she grew wherever she could find a pocket of earth on the little islands round about, I thought of the "tripples". If they had lived and had inherited her strength and determination, they could have rocked the Queen Charlotte Islands.

M A R T H A ' S J O E Y

ONE DAY our father and his three little girls were going over James Bay Bridge in Victoria. We met a jolly-faced old Indian woman with a little fair-haired white boy about as old as I was.

Father said, "Hello Joey!", and to the woman he said: "How are you getting on, Martha?"

Father had given each of us a big flat chocolate in silver paper done up like a dollar piece. We were saving them to eat when we got home.

Father said, "Who will give her chocolate to Joey?"

We were all willing. Father took mine because I was the smallest and the greediest of his little girls.

The boy took it from my hand shyly, but Martha beamed so wide all over me that I felt very generous.

After we had passed on I said, "Father, who is Joey?"

"Joey", said my father, "was left when he was a tiny baby at Indian Martha's house. One very dark stormy night a man and woman knocked at her door. They asked if she would take the child in out of the wet, while they went on an errand. They would soon be back, they said, but they never came again, though Martha went on expecting them and caring for the child. She washed the fine clothes he had been dressed in and took them to the priest; but nobody could find out anything about the couple who had forsaken the baby.

"Martha had no children and she got to love the boy very much. She dressed him in Indian clothes and took him for her own. She called him Joey."

I often thought about what Father had told us about Joey.

One day Mother said I could go with her, and we went to a little hut in a green field where somebody's cows grazed. That was where Martha lived.

We knocked at the door but there was no answer. As we stood there we could hear someone inside the house crying and crying. Mother opened the door and we went in.

Martha was sitting on the floor. Her hair was sticking out wildly, and her face was all swollen with crying. Things were thrown about the floor as if she did not care about anything any more. She could only sit swaying back and forth crying out, "Joey—my Joey—my Joey—".

Mother put some nice things on the floor beside her, but she did not look at

65

them. She just went on crying and moaning.

Mother bent over Martha and stroked her shoulder; but it was no good saying anything, she was sobbing too hard to hear. I don't think she even knew we were there. The cat came and cried and begged for food. The house was cold.

Mother was crying a little when we came away.

"Is Joey dead, Mother?"

"No, the priests have taken him from Martha and sent him away to school."

"Why couldn't he stay with Martha and go to school like other Indian boys?"

"Joey is not an Indian; he is a white boy. Martha is not his mother."

"But Joey's mother did not want him; she gave him away to Martha and that made her his boy. He's hers. It's beastly of the priest to steal him from Martha."

Martha cried till she had no more tears and then she died.

SALT WATER

AT FIVE o'clock that July morning the sea, sky, and beach of Skidegate were rosily smoothed into one. There was neither horizon, cloud, nor sound; of that pink, spread silence even I had become part, belonging as much to sky as to earth, as much to sleeping as waking as I went stumbling over the Skidegate sands.

At the edge of the shrunken sea some Indians were waiting for me, a man and his young nephew and niece. They stood beside the little go-between canoe which was to carry us to a phantom gas boat floating far out in the Bay.

We were going to three old forsaken villages of the British Columbia Indians, going that I might sketch. We were to be away five days.

"The morning is good," I said to the Indian.

"Uh huh," he nodded.

The boy and the girl shrank back shyly, grinning, whispering guttural comments upon my Ginger Pop, the little griffon dog who trotted by my side.

In obedience to a grunt and a pointing finger, I took my place in the canoe and was rowed out to the gas boat. She tipped peevishly as I boarded, circling a great round "O" upon the glassy water; I watched the "O" flatten back into smoothness. The man went to fetch the girl and boy, the food and blankets.

I had once before visited these three villages, Skedans, Tanoo and Cumshewa. The bitter-sweet of their overwhelming loneliness created a longing to return to them. The Indian had never thwarted the growth-force springing up so terrifically in them. He had but homed himself there awhile, making use of what he needed, leaving the rest as it always was. Civilization crept nearer and the Indian

went to meet it, abandoning his old haunts. Then the rush of wild growth swooped and gobbled up all that was foreign to it. Rapidly it was obliterating every trace of man. Now only a few hand-hewn cedar planks and roof beams remained, moss-grown and sagging—a few totem poles, greyed and split.

We had been scarcely an hour on the sea when the rosiness turned to lead, grey mist wrapped us about and the sea puckered into sullen, green bulges.

The Indians went into the boat's cabin. I preferred the open. Sitting upon a box, braced against the cabin wall, I felt very ill indeed. There was no deck rail, the waves grew bigger and bigger licking hungrily towards me. I put the dog in his travelling box and sent him below.

Soon we began dipping into green valleys, and tearing up erupting hills. I could scarcely retain my grip on the box. It seemed as if my veins were filled with sea water rather than blood, and that my head was full of emptiness.

After seven hours of this misery our engine shut off outside Skedans Bay. The Indian tossed the anchor overboard. My heart seemed to go with it in its gurgling plop to find bottom, for mist had turned to rain and Skedans skulked dim and uninviting.

"Can the boat not go nearer?"

The Indian shook his head. "No can, water floor welly wicked, make boat bloke." I knew that there were kelp beds and reefs which could rip the bottoms from boats down in Skedans Bay.

"Eat now?" asked the man.

"No, I want to land."

The canoe sighed across our deck. The waves met her with an angry spank. The Indian juggled her through the kelp. Kelpie heads bobbed around us like drowning Aunt Sallies, flat brown streamers growing from their crowns and floating out on the waves like long tresses. The sea battered our canoe roughly. Again and again we experienced nightmare drownings, which worked up and up to a point but never reached there. When we finally beached, the land was scarcely less wet than the sea. The rain water lacked the sting of salt but it soaked deeper.

The Indian lit a great fire for me on the beach; then he went back to his gas boat, and a wall of mist and rain cut me off from all human beings.

Skedans on a stormy day looked menacing. To the right of the Bay immediately behind the reef, rose a pair of uncouth cone-like hills, their heads bonneted in lowering clouds. The clumsy hills were heavily treed save where deep bare scars ran down their sides, as if some monster cruelty had ripped them from crown to base. Behind these two hills the sea bit into the shoreline so deeply as to leave only a narrow neck of land, and the bedlam of waves pounding on the shores back and front of the village site pinched the silence out of forsaken old Skedans.

Wind raced across the breast-high growth around the meagre ruins more poignantly desolate for having once known man.

A row of crazily tipped totem poles straggled along the low bank skirting Skedans Bay. The poles were deep planted to defy storms. In their bleached and

hollow upper ends stood coffin-boxes, boarded endwise into the pole by heavy cedar planks boldly carved with the crest of the little huddle of bones inside the box, bones which had once been a chief of Eagle, Bear or Whale Clan.

Out in the anchored gas boat the Indian girl became seasick, so they brought her ashore. Leaving her by the fire I wandered to the far end of the Bay. Ginger Pop was still on the gas boat and I missed him at my heels for the place was very desolate, awash with rain, and the sea pounding and snatching all it could reach, hurling great waves only to snatch them back to increase the volume of its next blow.

Suddenly above the din rose a human cry. The girl was beckoning to me wildly. "Uncle's boat," she cried. "It is driving for the reef!"

I saw the gas boat scudding towards her doom, saw the Indian in the small canoe battling to make shore with our bedding and food.

"Listen!" screamed the girl, "it is my brother."

Terrified shrieks from the gas boat pierced the tumult, "Uncle, Uncle!"

The man hurled the food and blankets ashore without beaching the canoe, then he stepped into the waves, holding the frantic thing like a dog straining on a leash. He beckoned me as near as the waves would let me go.

"Water heap wicked—maybe no come back—take care my girl," he said, and was gone.

Rushing out to the point above the reef, we watched the conflict between canoe and sea. When the man reached the gas boat, the screams of the boy stopped. With great risk they loaded the canoe till she began to take water. The boy bailed furiously. The long dogged pull of the man's oars challenged death inch by inch, wave by wave. There were spells like eternity, when the fury out there seemed empty when the girl hid her face on my shoulder and screeched. I stared and stared, watching to tell the Indians in the home village what the sea had done to their man and boy. How it had sucked them again and again into awful hollows, walled them about with waves, churned so madly that the boat did not budge in spite of those desperate pulling oars.

Then some sea demon tossed her upon a crest and another plunged her back again. The hugging sea wanted her, but inch by inch she won. Then a great breaker dashed her on the beach with the smashing hurl of a spoiled child returning some coveted toy.

The boy jumped out and made fast. The man struggled a few paces through the foam and fell face down. We dragged him in. His face was purple. "He is dying!"—No, life came back with tearing sobs.

Among our sodden stuff was a can of milk, another of beans; we heated them, they put new life into us. Night was coming. We made what preparation we could, spreading a tent-fly over a great log and drying out our blankets. There was no lack of driftwood for the fire.

The Indian's heart was sore for his boat; it looked as if nothing could save her. She was drifting more slowly now, her propeller fouled in kelp.

Mine was sore for my Ginger Pop in his box on the doomed boat. We each took our trouble to an opposite end of the bay . . . brooding.

Suddenly the mournful little group on the farther point galvanized into life. I heard a chorus of yells, saw the man strip off his oilskin pants, tie them to a pole and beat the air. I hurried across but found the Indians limp and despairing again.

"Boat see we was Indian, no stop," said the man bitterly.

Fish boats were hurrying to shelter, few came our way, sanctuary was not to be found in Skedans Bay. I could not help hoping none would see our distress signal. The thought of going out on that awful sea appalled me.

A Norwegian seine boat did see us however. She stood by and sent two small boats ashore. One went to the rescue of the drifting gas boat and the other beached for us.

"Please, please leave us here on the land," I begged. The Indians began rushing our things into the boat and the big Norwegian sailors with long beards like brigands said, "Hurry! Hurry!" I stood where land and sea wrangled ferociously over the overlap. The tea kettle was in my hand. "Wait!" I roared above the din of the waves, seeing I was about to be seized like a bale of goods and hurled into the boat. "Wait!"—plunging a hand into my pocket I took out a box of "Mothersill's Seasick Remedy", unwrapped a pill, put it on my tongue and took a gulp from the kettle's spout; then I let them put me into the maniac boat. She was wide and flat-bottomed. It was like riding through bedlam on a shovel. "Mothersill" was useless; her failure climaxed as we reached the seiner, which at that particular moment was standing on her nose. When she sat down again they tied the rescued gas boat to her tail and dragged us aboard the seiner. When they set me on the heaving deck, I flopped on top of the fish hatch and lay there sprawling like a star fish.

Rooting among my things the Indian girl got a yellow parasol and a large tin cup; but the parasol flew overboard and the cup was too late—it went clanking down the deck. Being now beyond decency I made no effort to retrieve it. The waves did better than the cup anyway, gurgling and sloshing around the hatch which was a foot higher than the deck. Spray washed over me. The taste of the sea was on my lips.

The Captain ordered "all below"; everyone rushed to obey save me. I lay among the turmoil with everything rattling and smashing around and in my head no more sense than a jelly fish.

Then the Captain strode across the deck, picked me up like a baby and dumped me into the berth in his own cabin. I am sure it must have been right on top of the boiler for I never felt so hot in my life. One by one my senses clicked off as if the cigarette ladies jazzing over every inch of the cabin walls had pressed buttons.

When I awoke it hardly seemed possible that this was the same boat or the same sea or that this was the same me lying flat and still above an engine that purred soft and contented as an old cat. Then I saw that the Indian girl was beside me.

"Where are we?"

"I dunno."

"Where are they taking us?"

"I dunno."

"What time is it?"

"I dunno."

"Is Ginger Pop safe?"

"I dunno."

I turned my attention to the Captain's cabin, lit vaguely from the deck lantern. The cigarette ladies now sat steady and demure. From the window I could see dark shore close to us. Suddenly there was no more light in the room because the Captain stood in the doorway, and said, as casually as if he picked up castaways off beaches most nights, "Wants a few minutes to midnight—then I shall put you off at the scows."

"The scows?"

"Yep, scows tied up in Cumshewa Inlet for the fish boats to dump their catches in."

"What shall I do there?"

"When the scows are full, packers come and tow them to the canneries."

"And must I sit among the fish and wait for a packer?"

"That's the idea."

"How long before one will come?"

"Ask the fish."

"I suppose the Indians will be there too?"

"No, we tow them on farther, their engine's broke."

Solitary, uncounted hours in one of those hideous square-snouted pits of fish smell! Already I could feel the cold brutes slithering around me for aeons and aeons of time before the tow ropes went taut, and we set out for the cannery. There, men with spiked poles would swarm into the scow, hook each fish under the gills. The creatures would hurtle through the air like silver streaks, landing into the cannery chutes with slithery thumps, and pass on to the ripping knives. . . . The Captain's voice roused me from loathsome thoughts.

"Here we are!"

He looked at me—scratched his head—frowned. "We're here," he repeated, "and now what the dickens—? There is a small cabin on the house scow—that's the one anchored here permanently—but the two men who live on it will have been completely out these many hours. Doubt if sirens, blows, nor nothin' could rouse 'em. Well, see what I can do. . . ."

He disappeared as the engine bell rang. The Indian girl, without goodbye, went to join her uncle.

Captain returned jubilant.

"There is a Jap fishboat tied to the scows. Her Captain will go below with his men and let you have his berth till four A.M.; you'll have to clear out then—that's lookin' far into the future tho'. Come on."

I followed his bobbing lantern along a succession of narrow planks mounted on trestles, giddy, vague as walking a tight rope across night. We passed three cavernous squares of black. Fish smell darted at us from their depths. When the

planks ended the Captain said, "Jump!" I obeyed wildly, landing on a floored pit filled with the most terrifying growls.

"Snores," said the captain. ". . . House scow."

We tumbled over strange objects, the door knob of the cabin looked like a pupil-less eye as the lantern light caught its dead stare.

We scrambled up the far side of the scow pit and so on to the Jap boat; three steps higher and we were in the wheel-house. There was a short narrow bench behind the wheel—this was to be my bed. On it was my roll of damp blankets, my sketch sack, and Ginger Pop's box with a mad-for-joy Ginger inside it, who transformed me immediately back from a bale of goods to his own special divinity.

The new day beat itself into my consciousness under the knuckles of the Japanese captain. I thanked my host for the uncomfortable night which, but for his kindness, would have been far worse, and biddably leapt from the boat to the scow. It seemed that now I had no more voice in the disposal of my own person than a salmon. I was goods—I made no arrangements, possessed neither ticket, pass, nor postage stamp—a pick-up that somebody asked someone else to dump somewhere.

At the sound of my landing in the scow bottom, the door of the cabin opened, and yellow lamplight trickled over a miscellany of objects on the deck. Two men peered from the doorway; someone had warned them I was coming. Their beds were made, the cabin was tidied, and there were hot biscuits and coffee on the table.

"Good morning, I am afraid I am a nuisance. . . . I'm sorry."

"Not at all, not at all, quite a—quite er—" he gave up before he came to what I was and said, "Breakfast's ready . . . crockery scant . . . but plenty grub, plenty grub; . . . cute nipper," pointing to Ginger Pop. "Name?"

"Ginger Pop."

"Ha! Ha!" He had a big round laugh. "Some name, some pup, eh?"

The little room was of rough lumber. It contained two of each bare necessity—crockery, chairs, beds, two men, a stove, a table.

"Us'll have first go," said the wider, the more conversational of the two. He waved me into one of the chairs and took the other.

"This here," thumbing back at the dour man by the stove, "is Jones; he's cook, I'm Smith."

I told them who I was but they already knew all about us. News travels quickly over the sea top. Once submerged and it is locked in secrecy. The hot food tasted splendid. At last we yielded the crockery to Jones.

"Now," said Smith, "you've et well; how'd you like a sleep?"

"I should like a sleep very much indeed," I replied, and without more ado, hat, gum boots and all climbed up to Smith's bed. Ginger Pop threw himself across my chest with his nose tucked under my chin. I pulled my hat far over my face. The dog instantly began to snore. Smith thought it was I. "Pore soul's dead beat," he whispered to Jones, and was answered by a "serves-'er-right" grunt.

It was nearly noon when I awoke. I could not place myself underneath the hat. The cabin was bedlam. Jones stretched upon his bed was snoring, Smith on the floor with my sketch sack for a pillow "duetted", Ginger Pop under my chin was doing it too. The walls took the snores and compounded them into a hodge-podge chorus and bounced it from wall to wall.

Slipping off the bed and stepping gingerly over Smith I went out of the cabin into the fullness of a July noon, spread munificently over the Cumshewa Inlet. The near shores were packed with trees, trees soaked in sunshine. For all their crowding, there was room between every tree, every leaf, for limitless mystery. On many of their tops sat a bald-headed eagle, fish glutted, his white cap startling against the deep green of the fir trees. No cloud, no sound, save only the deep thunderous snores coming from the cabin. The sleeping men were far, far away, no more here than the trouble of last night's storm was upon the face of the Inlet.

The door of the cabin creaked. Smith's blinky eye peeped out to see if he had dreamed us. When he saw Ginger and me he beamed, hoped we were rested, hoped we were hungry, hoped Jones' dinner would be ready soon; then the door banged, shutting himself and his hopes into the cabin. He was out again soon, carrying a small tin basin, a grey towel, and a lump of soap. Placing the things on a barrel-end, he was just about to dip when the long neck of Jones twisted around Smith's body and plunged first with loud sputters. Still dripping he rushed back among the smells of his meat and dumplings. Smith refilled the basin and washed himself with amazing thoroughness considering his equipment, engaging me in conversation all the while. After he had hurled the last remaining sud into the sea he filled the basin yet again, solemnly handed me the soap and, polishing his face as if it had been a brass knob, shut Jones and himself up and left me to it.

We dined in the order we had breakfasted.

"Mr. Smith," I said, "how am I going to get out of here?"

"That is," said Smith with an airy wave of his knife, "in the hands of the fish."

"They haven't any," I replied a little sulkily. The restriction of four walls and two teacups was beginning to tell and nobody seemed to be doing anything about releasing me.

"Pardon, Miss, I were speakin' figurative. Meanin' that if them fish critters is reasonable there'll be boats; after boats there'll be packers."

"Easy yourself now," he coaxed, "'Ave another dumpling?"

Ginger and I scrambled over the various scows getting what peeps of the Inlet we could. It was very beautiful.

By and by we saw the scrawny form of Jones hugging the cabin close while he eased his way with clinging feet past the scow house to the far end. Here he leaned from the overhang and like a magician, produced a little boat from nowhere.

He saw us watching and had a happy thought. He could relieve the conges-

tion in the scow house. He actually grinned—"Going to the spring. You and the dog care for a spell ashore?" He helped Ginger across the ledge and the awkward drop into the boat, but left me to do the best I could. I was thicker than Jones and the rim of the boat beyond the cabin was very meagre.

The narrow beach was covered with sea-drift. Silence and heat lay heavy upon it. Few breezes found their way up the Inlet. The dense shore growth was impossible to break into. Jones filled his pails at the spring and returned to the scow, leaving us stranded on the shore. When the shadows were long he returned for us. As we were eating supper, night fell.

We sat around the coal-oil lamp which stood upon the table, telling stories. At the back of each mind was a wonder as to whose lot would be cast on the floor if no packer came before night. Little fish boats began to come. We went out to watch them toss their catch hastily into the scows and rush back like retrieving pups to fetch more.

There was a great bright moon now. The fish looked alive, shooting through the air. In the scows they slithered over one another, skidding, switch-backing across the silver mound till each found a resting-place only to be bounced out by some weightier fellow.

The busy little boats broke the calm and brought a tang of freshness from the outside to remind the Inlet that she too was part of the great salt sea.

So absorbed was I in the fish that I forgot the packer till I heard the enthusiastic ring in Jones' voice as he cried "Packer!" He ran to his cupboard and found a bone for Ginger while Smith parleyed with the packer's Japanese captain. Yes, he was going my way. He would take me.

Smith led me along the narrow walk and gave me into the Captain's care. Besides myself there was another passenger, a bad-tempered Englishman with a cold in his head. As there was nowhere else, we were obliged to sit side by side on the red plush cushion behind the Captain and his wheel. All were silent as we slipped through the flat shiny water bordered on either side by mountainous fir-treed shores. The tree tops looked like interminable picket fences silhouetted against the sky, with water shadows as sharp and precise as themselves.

My fellow passenger coughed, hawked, sneezed and sniffed. Often he leaned forward and whispered into the Captain's ear. Then the Captain would turn and say to me, "You wish to sleep now? My man will show you." I knew it was "sniffer" wanting the entire couch and I clung to the red plush like a limpet. By and by, however, we came to open water and began to toss, and then I was glad to be led away by the most curious little creature. Doubtless he had a middle because there was a shrivelled little voice pickled away somewhere in his vitals, but his sou'wester came so low and his sea-boots so high, the rest of him seemed negligible.

This kind little person navigated me successfully over the deck gear, holding a lantern and giving little inarticulate clucks continuously, but my heart struck bottom when he slid back a small hatch and sank into the pit by jerks till he was all gone but the crown of his sou'wester.

"Come you please, lady," piped the queer little voice. There was barely room for our four feet on the floor between the two pair of short narrow bunks which tapered to a point in the stern of the boat. To get into a berth you must first horizontal yourself, then tip and roll. "Sou'wester-Boots" steadied me and held aside fishermen's gear while I tipped, rolled, and scraped my nose on the underneath of the top bunk.

"I do wish you good sleep, lady."

My escort and the light were gone. The blackness was intense and heavy with the smell of fish and tar.

I was under the sea, could feel it rushing by on the other side of the thin boards, kissing, kissing the boat as it passed. Surely at any moment it would gush into my ears. At the back of the narrow berth some live-seeming thing grizzled up my spine, the engine bell rang and it scuttled back again; then the rudder groaned, and I knew what the thing was. Soon the mechanics of the boat seemed to be part of myself. I waited for the sequence—bell, grizzle, groan—bell, grizzle, groan; they had become part of me.

Several times during the night the hatch slid back, a lantern swung into my den and shadow hands too enormous for this tiny place reached for some article.

"I am afraid I am holding up all the sleeping quarters," I said.

"Please, lady, nobody do sleep when at night we go."

I floated in and out of consciousness, and dream fish swam into my one ear and out of the other.

At three A.M. the rudder cable stopped playing scales on my vertebrae. The boat still breathed but she did not go. Sou'wester opened my lid and called, "Please, lady, the Cannery."

I rolled, righted, climbed, followed. He carried my sketch sack and Ginger's box. We took a few steps and then the pulse of the engine was no longer under our feet. We stood on some grounded thing that had such a tilt it pushed against our walking. We came to the base of an abnormally long perpendicular fish ladder, stretching up, up into shadow so overwhelmingly deep it seemed as if a pit had been inverted over our heads. It was the wharf and the Cannery.

A bulky object mounted the ladder, and was swallowed into the gloom. After a second a spot of dim light dangled high above. Breaths cold and deathly came from the inky velvet under the wharf. I could hear mud sucking sluggishly around the base of piles, the click of mussels and barnacles, the hiss and squirt of clams. From far above came a testy voice . . . "Come on, there." There were four sneezes, the lantern dipping at each sneeze.

"Quick, go!" said Sou'wester, "Man do be mad."

I could not . . . could not mount into that giddy blackness; that weazened little creature, all hat and boots, was such a tower of strength to abandon for a vague black ascent into . . . nothingness.

"Couldn't I . . . couldn't I crawl under the wharf round to the beach?" I begged.

"It is not possible, go!"

"The dog?"

"He . . . you see!" Even as he spoke, Ginger's box swung over my head.

"What's the matter down there? . . . Hurry!"

I grasped the cold slimy rung. My feet slithered and scrunched on stranded things. Next rung . . . the next and next . . . endless horrible rungs, hissing and smells belching from under the wharf. These things at least were half tangible. Empty nothingness, behind, around; hanging in the void, clinging to slipperiness, was horrible—horrible beyond words! . . .

Only one more rung, then the great timber that skirted the wharf would have to be climbed over and with no rung above to cling to. . . .

The impact of my body, flung down upon the wharf, jerked my mind back from nowhere.

"Fool! Why did you let go?" "Sneezer" retrieved the lantern he had flung down, to grip me as I reeled . . . Six sneezes . . . dying footsteps . . . dark.

I groped for the dog's box.

Nothing amazed Ginger Pop. Not even that his mistress should be sitting T-squared against wharf and shed . . . time, three A.M. . . . place, a far north Cannery of British Columbia.

CENTURY TIME

YOU WOULD never guess it was a cemetery. Death had not spoiled it at all.

It was full of trees and bushes except in one corner where the graves were. Even they were fast being covered with greenery.

Bushes almost hid the raw, split-log fence and the gate of cedar strips with a cross above it, which told you that the enclosed space belonged to the dead. The land about the cemetery might change owners, but the ownership of the cemetery would not change. It belonged to the dead for all time.

Persistent growth pushed up through the earth of it—on and on eternally—growth that was the richer for men's bodies helping to build it.

The Indian settlement was small. Not many new graves were required each year. The Indians only cleared a small bit of ground at a time. When that was full they cleared more. Just as soon as the grave boxes were covered with earth, vines and brambles began to creep over the mounds. Nobody cut them away. It was no time at all before life spread a green blanket over the Indian dead.

It was a quiet place this Indian cemetery, lying a little aloof from the village. A big stump field, swampy and green, separated them. Birds called across the field and flew into the quiet tangle of the cemetery bushes and nested there among foliage so newly created that it did not know anything about time.

There was no road into the cemetery to be worn dusty by feet, or stirred into gritty clouds by hearse wheels. The village had no hearse. The dead were carried by friendly hands across the stump field.

The wooded part of the cemetery dropped steeply to a lake. You could not see the water of the lake because of the trees, but you could feel the space between the cemetery and the purple-topped mountain beyond.

In the late afternoon a great shadow-mountain stepped across the lake and brooded over the cemetery. It had done this at the end of every sunny day for centuries, long, long before that piece of land was a cemetery. Dark came and held the shadow-mountain there all night, but when morning broke, it was back again inside its mountain, which pushed its grand purple dome up into the sky and dared the pines swarming around its base to creep higher than half-way up its bare rocky sides.

Indians do not hinder the progress of their dead by embalming or tight coffining. When the spirit has gone they give the body back to the earth. The earth welcomes the body—coaxes new life and beauty from it, hurries over what men shudder at. Lovely tender herbage bursts from the graves, swiftly, exulting over corruption.

Opening the gate I entered and walked among the graves. Pushing aside the wild roses, bramble blossoms and scarlet honeysuckle which hugged the crude wooden crosses, I read the lettering on them—

SACRED OF KATIE—IPOO

SAM BOYAN HE DIDE—IPOO

RIP JULIE YECTON—IPOO

JOSEPH'S ROSIE DI—IPOO

Even these scant words were an innovation—white men's ways; in the old days totem signs would have told you who lay there. The Indian tongue had no written words. In place of the crosses the things belonging to the dead would have been heaped on the grave: all his dear treasures, clothes, pots and pans, bracelets—so that everyone might see what life had given to him in things of his own.

"IPOO" was common to almost every grave. I wrote the four-lettered word on a piece of paper and took it to a woman in the village.

"What does this mean? It is on the graves."

"Mean die time."

"Die time?"

"Uh huh. Tell when he die."

"But all the graves tell the same."

"Uh huh. Four this kind," (she pointed separately to each of the four letters, IPOO) "tell now time."

"But everybody did not die at the same time. Some died long ago and some die now?"

"Uh huh. Maybe some year just one man die—one baby. Maybe influenza

come—he come two time—one time long far, one time close. He make lots, lots Injun die."

"But, if it means the time people died, why do they put 'IPOO' on the old graves as well as on the new?"

Difficult English thoughts furrowed her still forehead. Hard English words came from her slow tongue in abrupt jerks. Her brown finger touched the I and the P. "He know," she said, "he tell it. This one and this one" (pointing to the two O's) "small—he no matter. He change every year. Just this one and this matter" (pointing again to I and P). "He tell it."

Time was marked by centuries in this cemetery. Years—little years—what are they? As insignificant as the fact that reversing the figure nine turns it into the letter P.

KITWANCOOL

WHEN THE Indians told me about the Kitwancool totem poles, I said:

"How can I get to Kitwancool?"

"Dunno," the Indians replied.

White men told me about the Kitwancool poles too, but when I told them I wanted to go there, they advised me—"Keep out." But the thought of those old Kitwancool poles pulled at me. I was at Kitwangak, twenty or so miles from Kitwancool.

Then a halfbreed at Kitwangak said to me, "The young son of the Kitwancool Chief is going in tomorrow with a load of lumber. I asked if he would take you; he will."

"How can I get out again?"

"The boy is coming back to Kitwangak after two days."

The Chief's son Aleck was shy, but he spoke good English. He said I was to be at the Hudson's Bay store at eight the next morning.

I bought enough food and mosquito oil to last me two days; then I sat in front of the Hudson's Bay store from eight to eleven o'clock, waiting. I saw Aleck drive past to load his lumber. The wagon had four wheels and a long pole. He tied the lumber to the pole and a sack of oats to the lumber; I was to sit on the oats. Rigged up in front somehow was a place for the driver—no real seat, just a couple of coal-oil boxes bound to some boards. Three men sat on the two boxes. The road was terrible. When we bumped, the man on the down side of the boxes fell off.

A sturdy old man trudged behind the wagon. Sometimes he rode a bit on the end of the long pole, which tossed him up and down like a see-saw. The old man carried a gun and walked most of the way.

The noon sun burnt fiercely on our heads. The oat-sack gave no support to my back, and my feet dangled. I had to clutch the corner of the oat-sack with one hand to keep from falling off—with the other I held my small griffon dog. Every minute I thought we would be pitched off the pole. You could seldom see the old man because of clouds of yellow dust rolling behind the wagon. The scrub growth at the road-side smelt red hot.

The scraggy ponies dragged their feet heavily; sweat cut rivers through the dust that was caked on their sides.

One of the three men on the front seat of the wagon seemed to be a hero. The other men questioned him all the way, though generally Indians do not talk as they travel. When one of the men fell off the seat he ran round the wagon to the high side and jumped up again and all the while he did not stop asking the hero questions. There were so many holes in the road and the men fell off so often that they were always changing places, like birds on a roost in cold weather.

Suddenly we gave such an enormous bump that we all fell off together, and the horses stopped. When the wheels were not rattling any more we could hear water running. Then the old man came out of the clouds of dust behind us and said there was a stream close by.

We threw ourselves onto our stomachs, put our lips to the water and drank like horses. The Indians took the bits out of their horses' mouths and gave them food. Then the men crawled under the wagon to eat their lunch in its shade; I sat by the shadiest wheel. It was splendid to put my legs straight out and have the earth support them and the wheel support my back. The old man went to sleep.

After he woke and after the horses had pulled the wagon out of the big hole, we rumbled on again.

When the sun began to go down we were in woods, and the clouds of mosquitoes were as thick as the clouds of dust, but more painful. We let them eat us because, after bumping for seven hours, we were too tired to fight.

At last we came to a great dip where the road wound around the edge of a ravine shaped like an oblong bowl. There were trees growing in this earth bowl. It seemed to be bottomless. We were level with the tree-tops as we looked down. The road was narrow—its edges broken.

I was afraid and said, "I want to walk."

Aleck waved his hand across the ravine. "Kitwancool," he said and I saw some grey roofs on the far side of the hollow. After we had circled the ravine and climbed the road on the other side we would be there, unless we were lying dead in that deep bowl.

I said again, "I want to walk."

"Village dogs will kill you and the little dog," said Aleck. But I did walk

around the bend and up the hill, until the village was near. Then I rode into Kitwancool on the oat-sack.

The dogs rushed out in a pack. The village people came out too. They made a fuss over the hero-man, clustering about him and jabbering. They paid no more attention to me than to the oat-sack. All of them went into the nearest house taking Aleck, the hero, the old man and the other man with them, and shut the door.

I wanted to cry, sticking alone up there on top of the oats and lumber, the sagging horses in front and the yapping dogs all round, nobody to ask about anything and very tired. Aleck had told me I could sleep on the verandah of his father's house, because I only had a cot and a tent-fly with me, and bears came into the village often at night. But how did I know which was his father's house? The dogs would tear me if I got down and there was no one to ask, anyway.

Suddenly something at the other end of the village attracted the dogs. The pack tore off and the dust hid me from them.

Aleck came out of the house and said, "We are going to have dinner in this house now." Then he went in again and shut the door.

The wagon was standing in the new part of the village. Below us, on the right, I could see a row of old houses. They were dim, for the light was going, but above them, black and clear against the sky stood the old totem poles of Kitwancool. I jumped down from the wagon and came to them. That part of the village was quite dead. Between the river and the poles was a flat of green grass. Above, stood the houses, grey and broken. They were in a long, wavering row, with wide, windowless fronts. The totem poles stood before them there on the top of a little bank above the green flat. There were a few poles down on the flat too, and some graves that had fences round them and roofs over the tops.

When it was almost dark I went back to the wagon.

The house of Aleck's father was the last one at the other end of the new village. It was one great room like a hall and was built of new logs. It had seven windows and two doors; all the windows were propped open with blue castor-oil bottles.

I was surprised to find that the old man who had trudged behind our wagon was Chief Douse—Aleck's father.

Mrs. Douse was more important than Mr. Douse; she was chieftainess in her own right, and had great dignity. Neither of them spoke to me that night. Aleck showed me where to put my bed on the verandah and I hung the fly over it. I ate a dry scrap of food and turned into my blankets. I had no netting, and the mosquitoes tormented me.

My heart said into the thick dark, "Why did I come?"

And the dark answered, "You know."

In the morning the hero-man came to me and said, "My mother-in-law wishes

to speak with you. She does not know English words so she will talk through my tongue."

I stood before the tall, cold woman. She folded her arms across her body and her eyes searched my face. They were as expressive as if she were saying the words herself instead of using the hero's tongue.

"My mother-in-law wishes to know why you have come to our village."

"I want to make some pictures of the totem poles."

"What do you want our totem poles for?"

"Because they are beautiful. They are getting old now, and your people make very few new ones. The young people do not value the poles as the old ones did. By and by there will be no more poles. I want to make pictures of them, so that your young people as well as the white people will see how fine your totem poles used to be."

Mrs. Douse listened when the young man told her this. Her eyes raked my face to see if I was talking "straight." Then she waved her hand towards the village.

"Go along," she said through the interpeter, "and I shall see." She was neither friendly nor angry. Perhaps I was going to be turned out of this place that had been so difficult to get into.

The air was hot and heavy. I turned towards the old village with the pup Ginger Pop at my heels. Suddenly there was a roar of yelpings, and I saw my little dog putting half a dozen big ones to rout down the village street. Their tails were flat, their tongues lolled and they yelped. The Douses all rushed out of their house to see what the noise was about, and we laughed together so hard that the strain, which before had been between us, broke.

The sun enriched the old poles grandly. They were carved elaborately and with great sincerity. Several times the figure of a woman that held a child was represented. The babies had faces like wise little old men. The mothers expressed all womanhood—the big wooden hands holding the child were so full of tenderness they had to be distorted enormously in order to contain it all. Womanhood was strong in Kitwancool. Perhaps, after all, Mrs. Douse might let me stay.

I sat in front of a totem mother and began to draw—so full of her strange, wild beauty that I did not notice the storm that was coming, till the totem poles went black, flashed vividly white and then went black again. Bang upon bang, came the claps of thunder. The hills on one side tossed it to the hills on the other; sheets of rain washed over me. I was beside a grave down on the green flat; some of the pickets of its fence were gone, so I crawled through on to the grave with Ginger Pop in my arms to shelter under its roof. Stinging nettles grew on top of the grave with mosquitoes hiding under their leaves. While I was beating down the nettles with my easel, it struck the head of a big wooden bear squatted on the grave. He startled me. He was painted red. As I sat down upon him my foot hit something that made a hollow rattling noise. It was a shaman's rattle. This then must be a shaman's, a medicine-man's grave, and this the rattle

he had used to scare away evil spirits. Shamen worked black magic. His body lay here just a few feet below me in the earth. At the thought I made a dash for the broken community house on the bank above. All the Indian horses had got there first and taken for their shelter the only corner of the house that had any roof over it.

I put my stool near the wall and sat upon it. The water ran down the wall in rivers. The dog shivered under my coat—both of us were wet to the skin. My sketch sack was so full of water that when I emptied it on to the ground it made the pool we sat in bigger.

After two hours the rain stopped suddenly. The horses held their bones stiff and quivered their skins. It made the rain fly out of their coats and splash me. One by one they trooped out through a hole in the wall. When their hooves struck the baseboard there was a sodden thud. Ginger Pop shook himself too, but I could only drip. Water poured from the eyes of the totems and from the tips of their carved noses. New little rivers trickled across the green flat. The big river was whipped to froth. A blur like boiling mist hung over it.

When I got back to the new village I found my bed and things in a corner of the Douses' great room. The hero told me, "My mother-in-law says you may live in her house. Here is a rocking-chair for you."

Mrs. Douse acknowledged my gratitude stolidly. I gave Mr. Douse a dollar and asked if I might have a big fire to dry my things and make tea. There were two stoves—the one at their end of the room was alight. Soon, mine too was roaring and it was cosy. When the Indians accepted me as one of themselves, I was very grateful.

The people who lived in that big room of the Douses were two married daughters, their husbands and children, the son Aleck and an orphan girl called Lizzie. The old couple came and went continually, but they ate and slept in a shanty at the back of the new house. This little place had been made round them. The floor was of earth and the walls were of cedar. The fire on the ground sent its smoke through a smoke-hole in the roof. Dried salmon hung on racks. The old people's mattress was on the floor. The place was full of themelves—they had breathed themselves into it as a bird, with its head under its wing, breathes itself into its own cosiness. The Douses were glad for their children to have the big fine house and be modern but this was the right sort of place for themselves.

Life in the big house was most interesting. A baby swung in its cradle from the rafters; everyone tossed the cradle as he passed and the baby cooed and gurgled. There was a crippled child of six—pinched and white under her brown skin; she sat in a chair all day. And there was Orphan Lizzie who would slip out into the wet bushes and come back with a wild strawberry or a flower in her grubby little hand, and kneeling by the sick child's chair, would open her fingers suddenly on the surprise.

There was no rush, no scolding, no roughness in this household. When

anyone was sleepy he slept; when they were hungry they ate; if they were sorry they cried, and if they were glad they sang. They enjoyed Ginger Pop's fiery temper, the tilt of his nose and particularly the way he kept the house free of Indian dogs. It was Ginger who bridged the gap between their language and mine with laughter. Ginger's snore was the only sound in that great room at night. Indians sleep quietly.

Orphan Lizzie was shy as a rabbit but completely unselfconscious. It was she who set the food on the big table and cleared away the dishes. There did not seem to be any particular meal-times. Lizzie always took a long lick at the top of the jam-tin as she passed it.

The first morning I woke at the Douses', I went very early to wash myself in the creek below the house. I was kneeling on the stones brushing my teeth. It was very cold. Suddenly I looked up—Lizzie was close by me watching. When I looked up, she darted away like a fawn, leaving her water pails behind. Later, Mrs. Douse came to my corner of the house, carrying a tin basin; behind her was Lizzie with a tiny glass cream pitcher full of water, and behind Lizzie was the hero.

"My mother-in-law says the river is too cold for you to wash in. Here is water and a basin for you."

Everyone watched my washing next morning. The washing of my ears interested them most.

One day after work I found the Douse family all sitting round on the floor. In the centre of the group was Lizzie. She was beating something in a pail, beating it with her hands; her arms were blobbed with pink froth to the elbows. Everyone stuck his hand into Lizzie's pail and hooked out some of the froth in the crook of his fingers, then took long delicious licks. They invited me to lick too. It was "soperlallie", or soap berry. It grows in the woods; when you beat the berry it froths up and has a queer bitter taste. The Indians love it.

For two days from dawn till dark I worked down in the old part of the village. On the third day Aleck was to take me back to Kitwangak. But that night it started to rain. It rained for three days and three nights without stopping; the road was impossible. I had only provisioned for two days, had been here five and had given all the best bits from my box to the sick child. All the food I had left for the last three days was hard tack and raisins. I drank hot water, and rocked my hunger to the tune of the rain beating on the window. Ginger Pop munched hard tack unconcerned—amusing everybody.

The Indians would have shared the loaf and jam-tin with me, but I did not tell them that I had no food. The thought of Lizzie's tongue licking the jam-tin stopped me.

When it rained, the Indians drowsed like flies, heavy as the day itself.

On the sixth day of my stay in Kitwancool the sun shone again, but we had to wait a bit for the puddles to drain.

I straightened out my obligations and said goodbye to Mr. and Mrs. Douse. The light wagon that was taking me out seemed luxurious after the thing I had come in on. I climbed up beside Aleck. He gathered his reins and "giddapped".

Mrs. Douse, followed by her husband, came out of the house and waved a halt. She spoke to Aleck.

"My mother wants to see your pictures."

"But I showed her every one before they were packed."

At the time I had thought her stolidly indifferent.

"My mother wishes to see the pictures again."

I clambered over the back of the wagon, unpacked the wet canvases and opened the sketchbooks. She went through them all. The two best poles in the village belonged to Mrs. Douse. She argued and discussed with her husband. I told Aleck to ask if his mother would like to have me give her pictures of her poles. If so, I would send them through the Hudson's Bay store at Kitwangak. Mrs. Douse's neck loosened. Her head nodded violently and I saw her smile for the first time.

Repacking, I climbed over the back of the seat to Aleck.

"Giddap!"

The reins flapped: we were off. The dust was laid; everything was keen and fresh; indeed the appetites of the mosquitoes were very keen.

When I got back to Kitwangak the Mounted Police came to see me.

"You have been in to Kitwancool?"

"Yes."

"How did the Indians treat you?"

"Splendidly."

"Learned their lesson, eh?" said the man. "We have had no end of trouble with those people—chased missionaries out and drove surveyors off with axes—simply won't have whites in their village. I would never have advised anyone going in—particularly a woman. No, I would certainly have said, 'Keep out'."

"Then I am glad I did not ask for your advice," I said. "Perhaps it is because I am a woman that they were so good to me."

"One of the men who went in on the wagon with you was straight from jail, a fierce, troublesome customer."

Now I knew who the hero was.

CANOE

THREE RED bulls—sluggish bestial creatures with white faces and morose blood-shot eyes—made me long to get away from the village. But I could not: there was no boat.

I knew the roof and the ricketiness of every Indian woodshed. This was the steepest roof of them all, and I was panting a bit. It is not easy to climb with a little dog in one hand and the hot breath of three bulls close behind you. Those three detestable white faces were clustered round my canvas below. They were giving terrible bellows and hoofing up the sand.

Far across the water there appeared a tiny speck: it grew and grew. By the time the bulls had decided to move on, it was a sizeable canoe heading for the mud-flats beyond the beach. The tide was very far out. When the canoe grounded down there on the mud, an Indian family swarmed over her side, and began plodding heavily across the sucking ooze towards an Indian hut above the beach. I met them where the sand and the mud joined.

"Are you going back to Alliford? Will you take me?"

"Uh huh," they were; "Uh huh," they would.

"How soon?"

"Plitty-big-hully-up-quick."

I ran up the hill to the mission house. Lunch was ready but I did not wait. I packed my things in a hurry and ran down the hill to the Indian hut, and sat myself on a beach log where I could watch the Indians' movements.

The Indians gathered raspberries from a poor little patch at the back of the house. They borrowed a huge preserving kettle from the farthest house in the village. Grandpa fetched it; his locomotion was very slow. The women took pails to the village tap, lit a fire, heated water; washed clothes—hung out—gathered in; set dough, made bread, baked bread; boiled jam, bottled jam; cooked meals and ate meals. Grandpa and the baby took sleeps on the kitchen floor, while I sat and sat on my log with my little dog in my lap, waiting. When the bulls came down our way I ran, clutching the dog. When the bulls had passed, we sat down again. But even when I was running, I watched the canoe. Sometimes I went to the door and asked,

"When do we go?"

"Bymby," or "Plitty soon," they said.

I suggested going up to the mission house to get something to eat, but they

shook their heads violently, made the motion of swift running in the direction of the canoe and said, "Big-hully-up-quick."

I found a ship's biscuit and a wizened apple in my sketch sack. They smelled of turpentine and revolted my appetite. At dusk I ate them greedily.

It did not get dark. The sun and the moon crossed ways before day ended. By and by the bulls nodded up the hill and sat in front of the mission gate to spend the night. In the house the Indians lit a coal-oil lamp. The tide brought the canoe in. She floated there before me.

At nine o'clock everything was ready. The Indians waded back and forth stowing the jam, the hot bread, the wash, and sundry bundles in the canoe. They beckoned to me. As I waded out, the water was icy against my naked feet. I was given the bow seat, a small round stick like a hen roost. I sat down on the floor and rested my back against the roost, holding the small dog in my lap. Behind me in the point of the canoe were two Indian dogs, which kept thrusting mangy muzzles under my arms, sniffing at my griffon dog.

Grandpa took one oar, the small boy of six the other. The mother in the stern held a sleeping child under her shawl and grasped the steering paddle. A young girl beside her settled into a shawl-swathed lump. Children tumbled themselves among the household goods and immediately slept.

Loosed from her mooring, the big canoe glided forward. The man and the boy rowed her into the current. When she met it she swerved like a frightened horse—accepted—gave herself to its guiding, her wolf's head stuck proud and high above the water.

The child-rower tipped forward in sleep and rolled among the bundles. The old man, shipping the child's oar and his own, slumped down among the jam, loaves and washing, resting his bent old back against the thwart.

The canoe passed shores crammed with trees—trees overhanging stony beaches, trees held back by rocky cliffs, pointed fir trees climbing in dark masses up the mountain sides, moonlight silvering their blackness.

Our going was imperceptible, the woman's steering paddle the only thing that moved, its silent cuts stirring phosphorous like white fire.

Time and texture faded . . . ceased to exist . . . day was gone, yet it was not night. Water was not wet nor deep, just smoothness spread with light.

As the canoe glided on, her human cargo was as silent as the cedar-life that once had filled her. She had done with the forest now; when they shoved her into the sea they had dug out her heart. Submissively she accepted the new element, going with the tide. When tide or wind crossed her she became fractious. Some still element of the forest clung yet to the cedar's hollow rind which resented the restless push of waves.

Once only during the whole trip were words exchanged in the canoe. The old man, turning to me, said,

"Where you come from?"

"Victoria."

"Victorlia? Victorlia good place—still. Vancouver, Seattle, lots, lots trouble. Victorlia plenty still."

It was midnight when the wolf-like nose of our canoe nuzzled up to the landing at Alliford. All the village was dark. Our little group was silhouetted on the landing for one moment while silver passed from my hand to the Indian's.

"Good-night."

"Gu-ni'."

One solitary speck and a huddle of specks moved across the beach, crossed the edge of visibility and plunged into immense night.

Slowly the canoe drifted away from the moonlit landing, till, at the end of her rope, she lay an empty thing, floating among the shadows of an inverted forest.

THE BOOK OF SMALL

CONTENTS

SUNDAY

ALL OUR Sundays were exactly alike. They began on Saturday night after Bong the Chinaboy had washed up and gone away, after our toys, dolls and books, all but *The Peep of Day* and Bunyan's *Pilgrim's Progress*, had been stored away in drawers and boxes till Monday, and every Bible and prayer-book in the house was puffing itself out, looking more important every minute.

Then the clothes-horse came galloping into the kitchen and straddled round the stove inviting our clean clothes to mount and be aired. The enormous wooden tub that looked half coffin and half baby-bath was set in the middle of the kitchen floor with a rag mat for dripping on laid close beside it. The great iron soup pot, the copper wash-boiler and several kettles covered the top of the stove, and big sister Dede filled them by working the kitchen pump-handle furiously. It was a sad old pump and always groaned several times before it poured. Dede got the brown windsor soap, heated the towels and put on a thick white apron with a bib. Mother unbuttoned us and by that time the pots and kettles were steaming.

Dede scrubbed hard. If you wriggled, the flat of the long-handled tin dipper came down spankety on your skin.

As soon as each child was bathed Dede took it pick-a-back and rushed it upstairs through the cold house. We were allowed to say our prayers kneeling in bed on Saturday night, steamy, brown-windsory prayers—then we cuddled down and tumbled very comfortably into Sunday.

At seven o'clock Father stood beside our bed and said, "Rise up! Rise up! It's Sunday, children." He need not have told us; we knew Father's Sunday smell—Wright's coal-tar soap and camphor. Father had a splendid chest of camphor-wood which had come from England round the Horn in a sailing-ship with him. His clean clothes lived in it and on Sunday he was very camphory. The chest was high and very heavy. It had brass handles and wooden knobs. The top let down as a writing desk with pigeon-holes; below there were little drawers for handkerchiefs and collars and long drawers for clothes. On top of the chest stood Father's locked desk for papers. The key of it was on his ring with lots of others. This desk had a secret drawer and a brass plate with R. H. CARR engraved on it.

On top of the top desk stood the little Dutchman, a china figure with a head

that took off and a stomach full of little candies like coloured hailstones. If we had been very good all week we got hailstones Sunday morning.

Family prayers were uppish with big words on Sunday—reverend awe-ful words that only God and Father understood.

No work was done in the Carr house on Sunday. Everything had been polished frightfully on Saturday and all Sunday's food cooked too. On Sunday morning Bong milked the cow and went away from breakfast until evening milking-time. Beds were made, the dinner-table set, and then we got into our very starchiest and most uncomfortable clothes for church.

Our family had a big gap in the middle of it where William, John and Thomas had all been born and died in quick succession, which left a wide space between Dede and Tallie and the four younger children.

Lizzie, Alice and I were always dressed exactly alike. Father wanted my two big sisters to dress the same, but they rebelled, and Mother stood behind them. Father thought we looked like orphans if we were clothed differently. The Orphans sat in front of us at church. No two of them had anything alike. People gave them all the things their own children had grown out of—some of them were very strange in shape and colour.

When we were all dressed, we went to Mother's room to be looked over. Mother was very delicate and could not get up early or walk the two miles to church, and neither could Tallie or little Dick.

Father went to Dr. Reid's Presbyterian Church at the corner of Pandora and Blanshard streets. Father was not particularly Presbyterian, but he was a little deaf and he liked Dr. Reid because, if we sat at the top of the church, he could hear his sermons. There was just the Orphans in front of us, and the stove in front of them. The heat of the stove sent them all to sleep. But Dr. Reid was a kind preacher—he did not bang the Bible, nor shout to wake them up. Sometimes I went to sleep too, but I tried not to because of what happened at home after Sunday's dinner.

If the road had not been so crooked it would have been a straight line from the gate of our lily-field to the church door. We did not have to turn a single corner. Lizzie, Alice and I walked in the middle of the road and took hands. Dede was on one end of us and Father on the other. Dede carried a parasol, and Father, a fat yellow stick, not a flourish stick but one to walk with. If we met anything, we dangled in a row behind Father like the tail of a kite.

We were always very early for church and could watch the Orphans march in. The Matron arranged every bad Orphan between two good ones, and put very little ones beside big ones, then she set herself down behind them where she could watch and poke any Orphan that needed it. She was glad when the stove sent them all to sleep and did not poke unless an Orphan had adenoids and snored.

The minute the church bell stopped a little door in front of the Orphans opened, and Dr. Reid came out and somebody behind him shut the door, which was rounded at the top and had a reverend shut.

Dr. Reid had very shiny eyes and very red lips. He wore a black gown with two little white tabs like the tail of a bird sticking out from under his beard. He carried a roll in his hand like Moses, and on it were all the things that he was going to say to us. He walked slowly between the Orphans and the stove and climbed into the pulpit and prayed. The S's sizzled in his mouth as if they were frying. He was a very nice minister and the only parson that Father ever asked to dinner.

The moment Dr. Reid amened, we rushed straight out of the church off home. Father said it was very bad taste for people to stand gabbing at church doors. We came down Church Hill, past the Convent Garden, up Marvin's Hill, through the wild part of Beacon Hill Park into our own gate. The only time we stopped was to gather some catnip to take home to the cats, and the only turn we made was into our own gate.

Our Sunday dinner was cold saddle of mutton. It was roasted on Saturday in a big tin oven on legs, which was pushed up to the open grate fire in the breakfast-room. Father had this fire-place specially built just like the ones in England. The oven fitted right up to it. He thought everything English was much better than anything Canadian. The oven came round the Horn with him, and the big pewter hot-water dishes that he ate his chops and steaks off, and the heavy mahogany furniture and lots of other things that you could not buy in Canada then. The tin oven had a jack which you wound up like a clock and it turned the roast on a spit. It said 'tick, tick, tick' and turned the meat one way, and then 'tock, tock, tock' and turned it the other. The meat sizzled and sputtered. Someone was always opening the little tin door in the back to baste it, using a long iron spoon, with the dripping that was caught in a pan beneath the meat. Father said no roast under twenty pounds was worth eating because the juice had all run out of it, so it was lucky he had a big family.

Red currant jelly was served with the cold mutton, and potato salad and pickled cabbage, afterwards there was deep apple pie with lots of Devonshire cream. In the centre of the dinner-table, just below the cruet stand, stood an enormous loaf of bread. Mr. Harding, the baker, cooked one for Father every Saturday. It was four loaves baked in one so that it did not get as stale as four small loaves would have. It was made cottage-loaf-shape—two storeys high with a dimple in the top.

When dinner was finished, Father folded his napkin very straight, he even slipped his long fingers inside each fold again after it was in the ring, for Father always wanted everything straight and right. Then he looked up one side of the table and down the other. We all tried not to squirm because he always picked the squirmiest. When he had decided who should start, he said, "Tell me what you remember of the sermon."

If Dede was asked first, she "here and there'd" all over the sermon. If it was Lizzie, she plowed steadily through from text to amen. Alice always remembered the text. Sometimes I remembered one of Dr. Reid's jokes, that is if I was asked first—if not I usually said, "The others have told it all, Father," and was dread-

fully uncomfortable when Father said, "Very well; repeat it, then."

When we had done everything we could with Dr. Reid's sermon, Father went into the sitting room to take his Sunday nap, Mother read, and Dede took hold of our religion.

She taught Sunday School in Bishop Cridge's house, to a huge family of Balls and an enormous family of Fawcetts, a smarty boy called Eddy, a few other children who came and went, and us. The Bishop's invalid sister sat in the room all the time. Her cheeks were hollow, she had sharp eyes with red rims, sat by the fire, wore a cap and coughed, not because she had to, but just to remind us that she was watching and listening.

From dinner till it was time to go to the Bishop's, we learned collects, texts and hymns. Dede was shamed because the Balls, the Fawcetts and all the others did better than I who was her own sister.

You got a little text-card when you knew your lessons. When you had six little cards you had earned a big text-card. I hardly ever got a little card and always lost it on the way home, so that I never earned a big one. I could sing much better than Addie Ball, who just talked the hymns out very loud, but Dede only told me not to shout and let Addie groan away without any tune at all.

When Dede marched us home, Father was ready, and Mother had her hat on, to start for the Sunday walk around our place. Dede stayed home to get the tea, but first she played very loud hymns on the piano. They followed us all round the fields. Tallie was not strong enough for the walking so she lay on the horse-hair sofa in the drawing-room looking very pretty, resting up for her evening visitor. Lizzie squeezed out of coming whenever she could because she had rather creep into a corner and learn more texts. She had millions of texts piled up inside her head just waiting for things to happen, then she pushed the right text over onto them. If you got mad any time after noon, the sun was going to set on your wrath. You could feel the great globe getting hotter and hotter and making your mad fiercer because of the way the text stirred it up. If you did not see things just in Lizzie's way, you were dead in your sins.

So the rest of us started for the Sunday walk. We went out the side door into the garden, through ever so many gates and the cow-yard, on into a shrubbery which ran round two sides of the cow pasture, but was railed off to keep the cows from destroying the shrubs. A twisty little path ran through the shrubbery. Father wanted his place to look exactly like England. He planted cowslips and primroses and hawthorn hedges and all the Englishy flowers. He had stiles and meadows and took away all the wild Canadian-ness and made it as meek and English as he could.

We did not take the twisty path but a straight little one of red earth, close up under the hedge. We went singly, Father first, then Mother with little Dick by the hand. Because of William, John and Thomas being dead, Mother's only boy was Dick. He had a lovely little face with blue eyes and yellow curls. He wore a little pant suit with a pleated skirt over the pants which came half-way down over his thin little legs. These suits were very fashionable for small boys—Mr.

Wilson knew that they would sell, because of the jack-knife on a knotted cord brought through the buttonhole and dropping into a pocket on the chest. When boys saw these knife suits they teased and teased till they got one. Alice plodded along behind Dick, her arms hung loose and floppy. Father thought all make-believes were wicked on Sunday, even make-believe babies, so her darling dolls sat staring on the shelf in our bedroom all day. I came last and wished that our Sunday walk was not quite so much fenced. First there was the thorny hedge and then the high pickets.

Mr. Green, my friend Edna's father, took his family to the beach every Sunday. They clattered and chattered past our place having such jokes. I poked my head through the hedge to whisper,

"Hello, Edna!"

"Hello! How dull you do look walking round your own cow-field! Come to the beach with us."

"I don't think I can."

"Ask your mother."

I scraped between Alice and the hedge.

"Can I, Mother?"

"Your Father likes you to walk with him on Sunday."

I stuck my head through the thorns again, and shook it. Once I actually asked Father myself if I could go with the Greens, and he looked as hurt as if I'd hit him.

"Are my nine acres not enough, but you must want to tear over the whole earth? Is the Sabbath a right day to go pleasuring on the beach?" he said.

But one Sunday I did go with the Greens. Father had the gout and did not know. We had fun and I got "show-off" from being too happy. The boys dared me to walk a log over the sea, and I fell in. When I came home dripping, Lizzie had a text about my sin finding me out.

But I was telling about the family taggling along the path under the hedge. Father's stick was on the constant poke, pushing a root down or a branch up, or a stone into place, for he was very particular about everything being just right.

As we neared the top corner of our big field, that one wild place where the trees and bushes were allowed to grow thick and tangled, and where there was a deep ditch with stinging-nettles about it, and a rank, muddy smell. Father began to frown and to walk faster and faster till we were crouched down in the path, running after one another like frightened quail. If there were voices on the other side of the hedge, we raced like mad.

This corner of Father's property always made him very sore. When he came from England he bought ten acres of fine land adjoining Beacon Hill Park, which was owned by the City of Victoria. It took Father a lot of money to clear his land. He left every fine tree he could, because he loved trees, but he cleared away the scrub to make meadows for the cows, and a beautiful garden. Then he

built what was considered in 1863 a big fine house. It was all made of California redwood. The chimneys were of California brick and the mantelpieces of black marble. Every material used in the building of Father's house was the very best, because he never bought anything cheap or shoddy. He had to send far away for most of it, and all the time his family was getting bigger and more expensive, too; so, when a Mrs. Lush came and asked if he would sell her the corner acre next to the Park and farthest away from our house, and as she offered a good price, he sold. But first he said, "Promise me that you will never build a Public House on the land," and Mrs. Lush said, "No, Mr. Carr, I never will." But as soon as the land was hers, Mrs. Lush broke her word, and put up one of the horridest saloons in Victoria right there. Father felt dreadful, but he could not do anything about it, except to put up a high fence and coax that part of the hawthorn hedge to grow as tall and be as prickly as it could.

Mrs. Lush's Public House was called the Park Hotel, but afterwards the name was changed to the Colonist Hotel. It was just a nice drive from Esquimalt, which was then a Naval Station, and hacks filled with tipsy sailors and noisy ladies drove past our house going to the Park Hotel in the daytime and at night. It hurt Father right up till he was seventy years old, when he died.

After we had passed the Park Hotel acre we went slow again so that Father could enjoy his land. We came to the "pickets," a sort of gate without hinges; we lifted the pickets out of notches in the fence and made a hole through which we passed into the lily field.

Nothing, not even fairyland, could have been so lovely as our lily field. The wild lilies blossomed in April or May but they seemed to be always in the field, because, the very first time you saw them, they did something to the back of your eyes which kept themselves there, and something to your nose, so that you smelled them whenever you thought of them. The field was roofed by tall, thin pine trees. The ground underneath was clear and grassed. The lilies were thickly sprinkled everywhere. They were white, with gold in their hearts and brown eyes that stared back into the earth because their necks hooked down. But each lily had five sharp white petals rolling back and pointing to the treetops, like millions and millions of tiny quivering fingers. The smell was fresh and earthy. In all your thinking you could picture nothing more beautiful than our lily field.

We turned back towards our house then, and climbed a stile over a snake fence. On the other side of the fence was a mass of rock, rich and soft with moss, and all round it were mock orange and spirea and oak trees.

Father and Mother sat down upon the rock. You could see the thinking in their eyes. Father's was proud thinking as he looked across the beautiful place that he had made out of wild Canadian land—he thought how splendidly English he had made it look. Mother's eyes followed our whispered Sunday playing.

When Father got up, Mother got up too. We walked round the lower hay field, going back into the garden by the back gate, on the opposite side of the house

from which we had left. Then we admired the vegetables, fruit and flowers until the front door flew open and Dede jangled the big brass dinner bell for us to come in to tea.

When the meal was finished the most sober part of all Sunday came, and that was the Bible reading. Church and Sunday School had partly belonged to Dr. Reid and Dede. The Bible reading was all God's. We all came into the sitting-room with our faces very straight and our Bibles in our hands.

There was always a nice fire in the grate, because, even in summer, Victoria nights are chilly. The curtains were drawn across the windows and the table was in front of the fire. It was a round table with a red cloth, and the brass lamp sitting in the middle threw a fine light on all the Bibles when we drew our chairs in close.

Father's chair was big and stuffed, Mother's low, with a high back. They faced each other where the table began to turn away from the fire. Between their chairs where it was too hot for anyone to sit, the cats lay sprawling on the rug before the fire. We circled between Father and Mother on the other side of the table.

Father opened the big Family Bible at the place marked by the cross-stitch text Lizzie had worked. In the middle of the Bible, between the "old" and the "new," were some blank pages, and all of us were written there. Sometimes Father let us look at ourselves and at William, John and Thomas who were each written there twice, once for being born, and once for dying. That was the only time that John, Thomas and William seemed to be real and take part in the family's doings. We did little sums with their Bible dates, but could never remember if they had lived for days or years. As they were dead before we were born, and we had never known them as Johnny- or Tommy- or Willie-babies, they felt old and grown up to us.

Tallie was more interested in the marriage page. There was only one entry on it, "Richard and Emily Carr," who were Father and Mother.

Tallie said, "Father, Mother was only eighteen when she married you, wasn't she?"

"Yes," said Father, "and had more sense than some girls I could name at twenty." He was always very frowny when the doorbell rang in the middle of Bible reading and Tallie went out and did not come back.

We read right straight through the Bible, begat chapters and all, though even Father stuck at some of the names.

On and on we read till the nine o'clock gun went off at Esquimalt. Father, Mother, and Dede set their watches by the gun and then we went on reading again until we came to the end of the chapter. The three smallest of us had to spell out most of the words and be told how to say them. We got most dreadfully sleepy. No matter how hard you pressed your finger down on the eighth verse from the last one you had read, when the child next to you was finishing and kicked your shin you jumped and the place was lost. Then you got scolded and were furious with your finger. Mother said, "Richard, the children are tired," but Father said, "Attention! Children" and went right on to the end of

the chapter. He thought it was rude to God to stop in a chapter's middle nor must we shut our Bibles up with a glad bang when at last we were through.

No matter how sleepy we had been during Bible reading, when Father got out the *Sunday at Home* we were wide awake to hear the short chapter of the serial story. Father did not believe in fairy stories for children. *At the Back of the North Wind* was as fairy as anything, but, because it was in the *Sunday at Home*, Father thought it was all right.

We kissed Mother good night. While the others were kissing Father I ran behind him (I did so hate kissing beards) and, if Father was leaning back, I could just reach his bald spot and slap the kiss there.

Dede lighted the candle and we followed her, peeping into the drawing room to say good night to Tallie and her beau. We did not like him much because he kissed us and was preachy when we cheeked pretty Tallie, who did not rule over us as Dede did; but he brought candy—chocolates for Tallie and a bag of "broken mixed" for the children, big hunky pieces that sucked you right into sleep.

Dede put Dick to bed. Lizzie had a room of her own. Alice and I shared. We undid each other and brushed our hair to long sweet suckings.

"I wish he'd come in the morning before church."

"What for?"

"Sunday'd be lots nicer if you could have a chunk of candy in your cheek all day."

"Stupid! Could you go to church with candy poking out of your cheek like another nose? Could you slobber candy over your Sunday School Lesson and the Bible reading?"

Alice was two years older than I. She stopped brushing her long red hair, jumped into bed, leaned over the chair that the candle sat on.

Pouf! . . . Out went Sunday and the candle.

THE COW YARD

THE COW YARD was large. Not length and breadth alone determined its dimensions, it had height and depth also. Above it continually hovered the spirit of maternity. Its good earth floor, hardened by many feet, pulsed with rich growth wherever there was any protection from the perpetual movement over its surface.

Across the ample width of the Cow Yard, the old Barn and the New Barn faced each other. Both were old, but one was very old; in it lodged the lesser creatures. The Cow alone occupied the New Barn.

But it was in the Cow Yard that you felt most strongly the warm life-giving existence of the great red-and-white loose-knit Cow. When she walked, her great bag swung slowly from side to side. From one end of her large-hipped square body nodded a massive head, surmounted by long, pointed horns. From the other dangled her tail with its heavy curl and pendulum-like movement. As her cloven hoofs moved through the mud, they made a slow clinging squelch, all in tune with the bagging, sagging, nodding, leisureliness of the Cow's whole being.

Of the three little girls who played in the Cow Yard, Bigger tired of it soonest. Right through she was a pure, clean child, and had an enormous conscience. The garden rather than the Cow Yard suited her crisp frocks and tidy ways best, and she was a little afraid of the Cow.

Middle was a born mother, and had huge doll families. She liked equally the tidy garden and the free Cow Yard.

Small was wholly a Cow Yard child.

When the Cow's nose was deep in her bran mash, and her milk purring into the pail in long, even streams, first sounding tinny in the empty pail and then making a deeper and richer sound as the pail filled, Bong, sitting on his three-legged stool, sang to the Cow—a Chinese song in a falsetto voice. The Cow took her nose out of the mash bucket, threw back her great ears, and listened. She pulled a tuft of sweet hay from her rack, and stood quite still, chewing softly, her ears right about, so that she might not miss one bit of Bong's song.

One of the seven gates of the Cow Yard opened into the Pond Place. The Pond was round and deep, and the primroses and daffodils that grew on its bank leaned so far over to peep at themselves that some of them got drowned. Lilacs and pink and white may filled the air with sweetness in Spring. Birds nested

there. The Cow walked on a wide walk paved with stones when she came to the Pond to drink. Hurdles of iron ran down each side of the walk and into the water, so that she should not go too far, and get mired. The three girls who came to play used to roost on the hurdles and fish for tadpoles with an iron dipper that belonged to the hens' wheat-bin. From the brown surface of the water three upside-down little girls laughed up and mocked them, just as an upside-down Cow looked up from the water and mocked the Cow when she drank. Doubtless the tadpoles laughed, because down under the water where they darted back and forth no upside-down tadpoles mocked.

The overflow from the Pond meandered through the Cow Yard in a wide, rock-bordered ditch. There were two bridges across the ditch; one made of two planks for people to walk over, and the other made of logs, strong and wide enough for the Cow. The hens drank from the running water. Musk grew under the Cow's bridge; its yellow blossoms gleamed like cats' eyes in the cool dark.

Special things happened in the Cow Yard at each season of the year, but the most special things happened in Spring.

First came the bonfire. All winter the heap in the centre of the Cow Yard had mounted higher and higher with orchard prunings, branches that had blown down in the winter winds, old boxes and hens' nests, garbage, and now, on top of all, the spring-cleaning discards.

The three little girls sat on three upturned barrels. Even Bigger, her hands folded in a spotless lap, enjoyed this Cow Yard event. The Cow, safely off in the pasture, could not stamp and sway at her. Middle, hugging a doll, and Small, hugging a kitten, banged their heels on the sides of the hollow barrels, which made splendid noises like drums.

The man came from the barn with paper and matches, and off the bonfire blazed with a tremendous roar. It was so hot that the barrels had to be moved back. The hens ran helter-skelter. The rabbits wiggled their noses furiously as the whiffs of smoke reached their hutches. The ducks waddled off to the Pond to cool themselves. Soon there was nothing left of the bonfire but ashes and red embers. Then the barrels were rolled up close, and the three little girls roasted potatoes in the hot ashes.

Bigger told stories while the potatoes roasted. Her stories were grand and impossible, and when they soared beyond imagining, Small said, "Let's have some real ones now," and turned to Middle, "Will you marry?"

"Of course," came the prompt reply. "And I shall have a hundred children. Will you?"

Small considered. "Well, that depends. If I don't join a circus and ride a white horse through hoops of fire, I may marry a farmer, if he has plenty of creatures. That is, I wouldn't marry just a vegetable man."

"I am going to be a missionary," said Bigger, "and go out to the Heathen."

"Huh! if you're scared of our old cow, what will you be of cannibals?" said Small. "Why not marry a missionary, and send him out first, so they wouldn't be so hungry when you got there?"

"You are a foolish child," said Bigger. "The potatoes are cooked. You fish them out, Small, your hands and pinafore are dirty anyway."

The ashes of the bonfire were scarcely cold before Spring burst through the brown earth, and the ashes and everything. The Cow and the chickens kept the tender green shoots cropped down, but every night more pushed up and would not be kept under. The Cow watched the willow trees that grew beside the Pond. Just before the silky grey pussies burst their buds, she licked up as far as she could reach and ate them, blowing hard, upside-down sniffs—all puff-out and no pull-in—as though the bitter-sweet of the pussy-willows was very agreeable to her. She stood with half-closed eyes, chewing and rolling her jaws from side to side, with delighted slobbering.

About this time, the fussy old hens got fussier. After sticking their feathers on end, and clucking and squawking and being annoyed at everybody, they suddenly sat down on their nests, and refused to get up, staring into space as though their orange eyes saw something away off. Then they were moved into a quiet shed and put into clean boxes of hollowed-out hay, filled with eggs. They sat on top of the eggs for ages and ages. If you put your hand on them, they flattened their feathers to their bodies and their bodies down on their eggs and gave beaky growls. Then, when you had almost forgotten that they ever had legs and could walk, you went to the shed and put food and water before them. Fluffy chickens peeped out of every corner of the hen's feathers, till she looked as fat as seven hens. Then she strutted out into the yard, to brag before the other creatures, with all the chicks bobbing behind her.

One old hen was delighted with her chickens and went off, clucking to keep them close, and scratching up grubs and insects for them by the way, but when they came to the ditch her little ones jumped into the water and swam off. She felt that life had cheated her, and she sat down and sulked.

"How mad she must be, after sitting so long," said Bigger.

"As long as they are alive, I don't see why she should care," said Middle. "They'll come to her to be cuddled when they are tired and cold."

"Oh, girls," cried Small, bursting with a big idea, "if the hen hatched ducks, why couldn't the Cow have a colt? It would be so splendid to have a horse!"

Bigger got up from the stone where she was sitting. "Come on," she said to Middle, "she is such a foolish child. Let's play ladies in the garden, and leave her to mudpuddle in the Cow Yard."

The ducklings crept back to the old hen when they were tired, just as Middle had said they would. The old hen squatted down delightedly, loosening up her feathers, and the little ducks snuggled among them.

"Aren't they beastly wet and cold against your skin?" shouted Small across the ditch to the hen. "Gee, don't mothers love hard!"

She cast a look around the yard. Through the fence she saw the Cow in the pasture, chewing drowsily. Spring sunshine, new grass, daisies and buttercups filled the pasture. The Cow had not a trouble in the world.

Small nodded to the Cow. "All the same, old Cow, I do wish you could do

something about a colt. Oh, dear, I do want to learn to ride!"

Suddenly she sprang up, jumped the ditch, tiptoed to reach the iron hoop that kept the pasture-gate fast, and ran up to the Cow. "Be a sport, old girl," she whispered in the great hairy ear, and taking her by the horn she led the Cow up to the fence.

The Cow stood meek and still. Small climbed to the top rail of the fence, and jumped on the broad expanse of red back, far too wide for her short legs to grip. For one still moment, while the slow mind of the Cow surmounted her astonishment, Small sat in the wide valley between horns and hip-bones. Then it seemed as though the Cow fell apart, and as if every part of her shot in a different direction.

Small hurled through space and bumped hard. "Beast!" she gasped, when she had sorted herself from the mud and the stones. "Bong may call you the Old Lady, but I call you a mean, miserable old cow." And she shook her fist at the still-waving heels and tail at the other end of the pasture.

That night, when Small showed Middle the bruises, and explained how they had come, Middle said, "I expect you had better marry a farmer; maybe you're not exactly suited for a circus rider."

Spring had just about filled up the Cow Yard. The rabbits' secrets were all out now. They had bunged up the doors of their sleeping boxes with hay and stuff, and had pretended that there was nothing there at all. But if you went too close, they stamped their feet and wagged their ears, and made out that they were brave as lions. But now that it had got too stuffy in the boxes, the mother pulled down the barricade and all the fluffy babies scampered out, more than you could count.

One day when the Cow was standing under the loft, the loveliest baby pigeon fell plumb on her back. But there were so many young things around, all more or less foolish, that the Cow was not even surprised.

Then one morning the Father called the little girls into the Cow Yard, to see the pigmy image of the Old Cow herself, spot for spot, except that it had no wisdom. He had a foolish baby face and foolish legs; he seemed to wonder whose legs these were, and never dreamed that they were his own. But he was sure that he owned his tail, and flipped it joyously.

The Cow was terribly proud of him, and licked him and licked him till all his hair crinkled up.

Now, the Cow Yard was not Heaven, so of course bad things and sad things happened there too.

Close by the side of the ditch was a tree covered with ivy. The running water had washed some of the roots bare, and they stuck out. When the little girls sailed boats down the ditch, the roots tipped the boats and tried to drown the dolls.

It was not a very big tree, but the heavy bunch of ivy that hung about it made it look immense. The leaves of the ivy formed a dense dark surface about a foot away from the bole of the tree, for the leaves hung on long stems. The question was—what filled the mysterious space between the leaves and the tree?

Away above the ivy, at the top, the bare branches of the tree waved skinny arms, as if they warned you that something terrible was there.

One day the children heard the Father say to the Mother, "The ivy has killed that tree."

It was strange that the ivy could kill anything. Small thought about it a lot, but she did not like to ask the older ones, who thought her questions silly. She would not have thrust her arm into that space for anything.

The pigeons flew over the tree, from the roof of one barn to the roof of the other, but they never lighted on it. Sometimes the noisy barn sparrows flew into the ivy; they were instantly silent, and you never saw them come out. Sometimes owls hoo-hoo-hooed in there. Once when Small was sitting on the chopping block, one flew out, perfectly silently, as though its business were very secret. Small crept home and up to bed, although it was not quite time, and drew the covers tight up over her head. To herself she called that tree "The Killing Tree".

Then one day she found a dead sparrow under the Killing Tree.

She picked it up. The bird was cold, its head flopped over her hand; the rest of it was stiff and its legs stuck up. Queer grey lids covered its eyes.

Small buried it in a little box filled with violets. A week later she dug it up, to see just what did happen to dead things. The bird's eyes were sunk away back in its head. There were some worms in the box, and it smelled horrid. Small buried the bird in the earth again quickly.

Winter came by and by and, looking out from their bedroom window, Middle said, "The Old Cow Yard tree is down." They dressed quickly and went to look.

The tree had broken the Cow's bridge and lay across the ditch, the forlorn top broken and pitiful. The heavy ivy, looking blacker than ever against the snow, still hid the mystery place.

"Mercy, it's good it did not fall on the Cow and kill her," said Small. "It's a beastly tree and I'm glad it is down!"

"Why should it fall on the Cow; and why was it a beastly tree?" asked Middle.

"Because and because," said Small, and pressed her lips together tight.

"You *are* silly," retorted Middle.

When they came back from school, the top branches were chopped up, and the ivy piled ready for burning. The little tawny roots of the ivy stuck out all over the bole like coarse hair. The Man was sawing the tree in lengths. He rolled one towards the children. "Here's a seat for you," he said. Middle sat down. Small came close to the Man.

"Mr. Jack, when you chopped the ivy off the tree did you find anything in there?"

"Why, I found the tree."

"I mean," said Small in a tense voice, "anything between the tree and the ivy?"

"There wasn't nothing in there that I saw," replied the Man. "Did you lose a ball or something maybe?"

102

"When are you going to burn the ivy?"

"Just waiting till you came home from school," and he struck a match.

Dense, acrid smoke blinded the children. When they could see again, long tongues of flame were licking the leaves, which hissed back like a hundred angry cats, before they parched, crackled, and finally burst into flames.

"Isn't it a splendid bonfire?" asked Middle. "Shall we cook potatoes?"

"No," said Small.

The next spring, when everyone had forgotten that there ever had been a Cow Yard tree, the Father bought a horse. The Cow Yard was filled with excitement; children shouted, hens ran, ducks waddled off quacking, but the Cow did not even look up. She went right on eating some greens from a pile thrown over the fence from the vegetable garden.

"I suppose we shall have to call it the Horse Yard now," said Small. "He's bigger and so much grander than the Cow."

Middle gave the horse an appraising look. "Higher, but not so thick," she said.

The horse saw the pile of greens. He held his head high, and there was confidence in the ring of his iron shoes as he crossed the bridge.

The Cow munched on, flapping the flies off her sides with a lazy tail. When she got a particularly juicy green, her tail forgot to flap, and lay curled across her back.

When the horse came close, the tail jumped off the Cow's back and swished across his nose. He snorted and pulled back, but still kept his eyes on the pile of greens. He left his four feet and the tips of his ears just where they had been, but the roots of his ears, and his neck and lips stretched forward toward the greens till he looked as if he would fall for crookedness. The Cow's head moved ever so little; she gave him a look, and pointed one horn right at his eye. His body shot back to where it should be, square above his legs, and he sighed and turned away, with his ears and tail pressed down tight.

"I guess it will be all right for us to call it the Cow Yard still," said Middle.

THE BISHOP AND THE CANARY

SMALL had earned the canary and loved him. How she did love him!

When they had told her, "You may take your pick," and she leaned over the cage and saw the four fluffy yellow balls, too young to have even sung their first song, her breath and her heart acted so queerly that it seemed as if she must strangle.

She chose the one with the topknot. He was the first live creature she had ever owned.

"Mine! I shall be his God," she whispered.

How could she time her dancing feet to careful stepping? She was glad the cage protected him sufficiently so that she could hug it without hurting him.

Save for the flowers that poked their faces through the fences, and for the sunshine, the long street was empty. She wished that there was someone to show him to—someone to say, "He *is* lovely!"

A gate opened and the Bishop stepped into the street. The Bishop was very holy—everybody said so. His eyes were blue, as if by his perpetual contemplation of Heaven they had taken its colour. His gentle voice, vague and distant, came from up there too. His plump hands were transparent against the clerically black vest.

Though she played ladies with his little girls, Small stood in great awe of the Bishop. She had never voluntarily addressed him. When they were playing in his house, the children tiptoed past his study. God and the Bishop were in there making new hymns and collects.

Her lovely bird! Because there was no one else to show him to she must show him to the Bishop. Birds belonged to the sky. The Bishop would understand. She was not at all afraid now. The bird gave her courage.

She ran across the street.

"Look, Bishop! Look at my bird!"

The Bishop's thoughts were too far away, he did not heed nor even hear the cry of joy.

She stood before him with the cage held high. "Bishop! Oh please Bishop, see!"

Dimly the Bishop became aware of some object obstructing his way. He laid a dimpled hand upon the little girl's head.

"Ah, child, you are a pretty picture," he said, and moved her gently from his path.

The Bishop went his way. The child stood still.

"My beautiful bird!"

The look of hurt fury which she hurled at the Bishop's back might have singed his clerical broadcloth.

THE BLESSING

FATHER'S religion was grim and stern, Mother's gentle. Father's operated through the Presbyterian, Mother's through the Anglican Church. *Our* religion was hybrid: on Sunday morning we were Presbyterian, Sunday evening we were Anglican.

Our little Presbyterian legs ached from the long walk to church on Sunday morning. Our hearts got heavy and our eyes tired before the Presbyterian prayers and the long Presbyterian sermon were over. Even so, we felt a strong "rightness" about Father's church which made it endurable. Through scorch of summer heat, through snow and rain, we all taggled along behind Father. Toothaches, headaches, stomach-aches—nothing was strong enough to dodge or elude morning religion.

Mother's religion was a Sunday evening privilege. The Anglican church was much nearer our house than the Presbyterian, just a little walk down over Marvin's Hill to our own James' Bay mud-flats. The little church sat on the dry rim just above the far side.

Evening service was a treat that depended on whether big sister wanted to be bothered with us. Being out at night was very special too—moon and stars so high, town lights and harbour lights low and twinkly when seen from the top of Marvin's Hill on our side of the mud-flats. A river of meandering sludge loitered its way through the mud—a huge silver snake that twisted among the sea-grass. On the opposite side of the little valley, on a rocky ridge, stood Christ Church Cathedral, black against the night-blue of the sky. Christ Church had chimes and played scales on them to walk her people to church. As we had no chimes, not even a bell on our church, we marched along on the spare noise of the Cathedral chimes.

The mud-flats did not always smell nice although the bushes of sweet-briar on the edge of the high-water rim did their best, and the sea crept in between the calfless wooden legs of James' Bay Bridge, washed the muddied grass and stole out again.

Our Church was mellow. It had a gentle, mild Bishop. He wore a long black

gown with a long white surplice over it. His immense puffed sleeves were caught in at the wrists by black bands and fluted out again in little white frills round his wrists. There was a dimple on each knuckle of his hands. He was a wide man and looked wider in his surplice, especially from our pew, which was close up under the pulpit. He looked very high above us and every time he caught his breath his beard hoisted and waved out.

The Bishop's voice was as gentle as if it came from the moon. Every one of his sentences was separated from the next by a wheezy little gasp. His face was round and circled by a mist of white hair. He kept the lids shut over his blue, blue eyes most of the time, as if he was afraid their blueness would fade. When you stood before him you felt it was the lids of his own eyes he saw, not you.

The Bishop's favourite word was "Ah!", not mournful or vexed "ahs", just slow contemplating "ahs". But it was the Bishop's Blessing! He blessed most splendidly! From the moment you went into church you waited for it. You could nap through most of the Presbyterian sermon, but, although the pews were most comfortable, red cushions, footstool and all, you dared not nap through the Bishop's for fear you'd miss the blessing.

Our Evangelical church was beautiful. There was lots of music. A lady in a little red velvet bonnet, with strings under the chin, played the organ.

There were four splendid chandeliers dangling high under the roof. They had round, wide reflectors made of very shiny, very crinkly tin. Every crinkle caught its own particular bit of light and tossed it round the church—and up there ever so high the gas jets hissed and flickered. Music stole whispering from the organ and crept up among the chandeliers and the polished rafters to make echoes.

Our choir was mixed and sang in every sort of clothes, not in surplices like the Cathedral choir on the hill.

The Bishop climbed into the pulpit. He laid the sheets of his sermon on the open Bible which sat on a red velvet cushion; then he shut his eyes and began to preach. Once in a while he would stop, open his eyes, put on his glasses and read back to be sure he had not skipped.

When the last page was turned the Bishop said a gentle "Amen" and then he lifted his big round sleeves with his hands dangling out of the ends. We all stood up and drooped our heads. The church was full of stillness. The Bishop curved his palms out over us—they looked pink against his white sleeves. He gave the blessing just as if he was taking it straight from God and giving it to us.

Then the Bishop came down the pulpit stairs; the organ played and the choir sang him into the vestry; the verger nipped the side lights off in such a hurry that everyone fell over a footstool.

Big doors rolled back into the wall on either side of the church door to let us out. As soon as we were all in the night the verger rolled shut the doors and blotted out the chandeliers.

We climbed Marvin's Hill, each of us carrying home a bit of the Bishop's blessing.

SINGING

SMALL'S singing was joyful noise more than music; what it lacked in elegance it made up in volume. As fire cannot help giving heat so Small's happiness could not help giving song, in spite of family complaint. They called her singing a "horrible row", and said it shamed them before the neighbours, but Small sang on. She sang in the cow-yard, mostly, not that she went there specially to sing, but she was so happy when she was there among the creatures that the singing did itself. She had but to open her mouth and the noise jumped out.

The moment Small sat down upon the cow-yard woodpile the big rooster would jump into her lap and the cow amble across the yard to plant her squareness, one leg under each corner, right in front of Small and, to shut out completely the view of the old red barn, the hen houses, and the manure-pile.

The straight outline of the cow's back in front of Small was like a range of mountains with low hills and little valleys. The tail end of the cow was as square as a box. Horns were her only curve—back, front, tail, neck and nose in profile, were all straight lines. Even the slobber dripping from her chin fell in slithery streaks.

When Small began to sing the old cow's nose-line shot from straight down to straight out, her chin rose into the air, her jaws rolled. The harder Small sang, the harder the cow chewed and the faster she twiddled her ears around as if stirring the song into the food to be rechewed in cud along with her breakfast.

Small loved her cow-yard audience—hens twisting their silly heads and clawing the earth with mincing feet, their down eye looking for grubs, their up eye peering at Small, ducks trying hard to out-quack the song, pigeons clapping their white wings, rabbits hoisting and sinking their noses—whether in appreciation or derision Small could never tell.

White fluttered through the cow-yard gate, Bigger's apron heralding an agitated Bigger, both hands wrestling with the buttons of her apron behind and her tongue ready sharpened to attack Small's singing.

"It's disgusting! Stop that vulgar row, Small! What must the neighbours think? Stop it, I say!"

Small sang harder, bellowing the words. "The cow likes it and this is her yard."

"I wish to goodness that she would roof her yard then, or that you would sing under an umbrella, Small, and so keep the sound down and not let it boil

over the fences. There's the breakfast bell! Throw that fowl out of your lap and come! Song before breakfast means tears before night."

"Whose tears—mine, the cow's or the rooster's?"

"Oh, oh, oh! That cow-brute has dripped slobber down my clean apron! You're a disgusting pair," shrieked Bigger and rushed from the yard.

Breakfast over, the Elder detained Small.

"Small, this singing of yours is scandalous! Yesterday I was walking up the street with a lady. Half a block from our gate she stopped dead. 'Listen! Someone is in trouble,' she said. How do you think I felt saying, 'Oh, no, it is only my little sister singing'?"

Small reddened but said stubbornly, "The cow likes my singing."

Cows are different from humans; perhaps the hairiness of their ears strains sound.

The Bishop came to pay a sick-visit to Small's mother. He prayed and Small watched and listened. His deliberate chewing of the words, with closed eyes, reminded her of the cow chewing her cud. The Bishop was squarely built, a slow calm man. "They are very alike," thought Small.

Rising from his knees, the Bishop, aware of the little girl's stare, said, "You grow, child!"

"She does," said Small's mother. "So does her voice; her singing is rather a family problem."

"Song is good," replied Bishop. "Is it hymns you sing, child?"

"No, Mr. Bishop, I prefer cow-songs."

The Bishop's "a-a-h!" long drawn and flat lasted all the way down the stairs.

"You should not have said that," said Small's mother. "A Bishop is a Bishop."

"And a cow is a cow. Is it so wicked to sing to a cow?"

"Not wicked at all. I love your happy cow-yard songs coming into my window. We will have your voice trained some day. Then perhaps the others will not scold so much about your singing."

"But will the cow like my voice squeezed little and polite? It won't be half so much fun singing beautifully as boiling over like the jam kettle."

Small's four sisters and her brother went holidaying to a farm in Metchosin. Small was left at home with her mother. Just at first Small, to whom animal life was so dear, felt a pang that she was not of the farm party. But the quiet of the empty house was a new experience and something happened.

Mrs. Gregory, her mother's friend of long standing, came to spend an afternoon.

Both ladies were nearing the age of fifty—straightbacked, neatly made little ladies who sat primly on the horsehair chairs in the drawing-room wearing little lace-trimmed matron's caps and stitching each on a piece of plain sewing as they chatted.

Having exchanged recipes for puddings, discussed the virtue of red flannel as against white, the problem of Chinese help and the sewing-circle where they

made brown holland aprons for orphans, all topics were exhausted.

They sewed in silence, broken after a bit by Mrs. Gregory saying, "There was English mail this morning, Emily. Do you ever get homesick for the Old Country?"

Small's mother looked with empty eyes across the garden. "My home and my family are here," she replied.

The ladies began "remembering". One would say, "Do you remember?" and the other would say, "I call to mind." Soon this remembering carried them right away from that Canadian drawing-room. They were back in Devonshire lanes, girl brides rambling along with their Richard and William, pausing now and then to gather primroses and to listen to the larks and cuckoos.

Small's mother said, "Richard was always one for wanting to see new countries."

"My William's hobby," said Mrs. Gregory, "was growing things. Here or there made no difference to him as long as there was earth to dig and flowers to grow."

Small knew that Richard and William were her Father and Mr. Gregory or she would never have recognized the ladies' two jokey boys of the Devonshire lanes in the grave middle-aged men she knew as her father and Mrs. Gregory's husband.

The ladies laid their sewing upon the table and, dropping their hands into their laps, sat idle, relaxing their shoulders in the hard backs of the chairs. Small felt it extraordinary to see them doing nothing, to see Canada suddenly spill out of their eyes as if a dam had burst and let the pent-up England behind drown Canada, to see them sitting in real chairs and yet not there at all.

The house was quite still. In the yard Bong was chopping kindling and droning a little Chinese song.

Suddenly Mrs. Gregory said, "Emily, let's sing!" and began:

"I cannot sing the old songs now I sang long years ago. . . ."

Small's mother joined, no shyness, no hesitation. The two rusty little voices lifted, found to their amazement that they *could* sing the old songs still, and their voices got stronger and stronger with each song.

Sitting on a stool between them, half hidden by the tablecloth and entirely forgotten by the ladies, Small watched and listened, saw their still fingers, unornamented except for the plain gold band on the third left of each hand, lying in sober-coloured stuff-dress laps, little white caps perched on hair yet brown, lace jabots pinned under their chins by huge brooches. Mrs. Gregory's brooch was composed of tiny flowers woven from human hair grown on the heads of various members of her family. The flowers were glassed over the top and framed in gold, and there were earrings to match dangling from her ears. The brooch Small's mother wore was made of quartz with veins of gold running through it. Richard had dug the quartz himself from the California gold mines and had had it mounted in gold for his wife with earrings of the same.

Each lady had winds and winds of thin gold watch-chain round her neck, chains which tethered gold watches hiding in stitched pockets on the fronts of

their dresses. There the ladies' hearts and their watches could tick duets.

Small sat still as a mouse. The singing was as solemn to her as church. She had always supposed that Mother-ladies stopped singing when there were no more babies in their nurseries to be sung to. Here were two ladies nearly fifty years old, throwing back their heads to sing love songs, nursery songs, hymns, God Save the Queen, Rule Britannia—songs that spilled over the drawing-room as easily as Small's cow songs spilled over the yard, only Small's songs were new, fresh grass snatched as the cow snatched pasture grass. The ladies' songs were rechews—cudded fodder.

Small sneezed!

Two mouths snapped like mousetraps! Four cheeks flushed! Seizing her sewing, Mrs. Gregory said sharply, "Hunt my thimble, child!"

Small's mother said, "I clean forgot the tea," and hurried from the room.

Small never told a soul about that singing but now, when she sat on the cow-yard woodpile she raised her chin and sang clean over the cow's back, over the yard and over the garden, straight into her mother's window . . . let Bigger and the Elder scold!

THE PRAYING CHAIR

THE WICKER chair was new and had a crisp creak. At a quarter to eight every morning Father sat in it to read family prayers. The little book the prayers came out of was sewed into a black calico pinafore because its own cover was a vivid colour and Father did not think that was reverent.

The Elder, a sister much older than the rest of the children, knelt before a hard, straight chair: Mother and little Dick knelt together at a low soft chair. The three little girls, Bigger, Middle, and Small usually knelt in the bay window and buried their faces in its cushioned seat but Small's Father liked her to kneel beside him sometimes. If she did not get her face down quickly he beckoned and Small had to go from the window-seat to under the arm of the wicker chair. It was stuffy under there. Small liked the window-seat best, where she could peep and count how many morning-glories were out, how many new rosebuds climbing to look in through the window at her.

Father's wicker chair helped pray. It creaked and whispered more than the children would ever have dared to. When finally Father leaned across the arm to reach for the cross-work book-mark he had laid on the table during prayers, the chair squawked a perfectly grand Amen.

One morning Father had a bit of gout and Small thought that instead of

Amen Father said "Ouch!" She could not be quite sure because just at the very moment that the chair amened, Tibby, the cat, gave a tremendous "meow" and a splendid idea popped into Small's head.

Small had wanted a dog—she did not remember how long she had wanted it—it must have been from the beginning of the world. The bigger she got the harder she wanted.

As soon as everyone had gone about their day's business Small took Tibby and went back to the praying chair.

"Look, Tibby, let's you and me and the praying chair ask God to give you a puppy for me. Hens get ducks, why couldn't you get a puppy? Father always sits in that chair to pray. It must be a good chair; it amens splendidly. I'll do the words: you and the chair can amen. I don't mind what kind of a puppy it is as long as it's alive."

She tipped the chair and poked Tibby underneath into the cage-like base. Tibby left her tail out.

"So much the better," said Small. "It'll pinch when the time for amen is ready."

Tibby's amen was so effective that Small's Mother came to see what was the trouble.

"Poor cat! Her tail is pinched. Take her out into the garden, Small."

"It's all spoilt now!"

"What is?"

"We were praying for a puppy."

"Your Father won't hear of a puppy in his garden, Small."

Small's birthday was coming.

The Elder said, "I know something that is coming for your birthday!"

"Is it—is it—"

"Wait and see."

"Does it commence with 'd'? Or, if it's just a little one, maybe with 'p'?"

"I think it does."

The day before the great day Small's singing was a greater nuisance than usual. Everyone scolded till she danced off to the woodshed to sing there, selected three boxes of varying sizes and brushed them out.

"Which size will fit him? Middle, when you got your new hair-brush what did you do with the old one?"

"Threw it out."

Small searched the rubbish pile which was waiting for the Spring bonfire and found the brush-back with its few remaining bristles.

"A lot of brushing with a few is as good as a little brushing with a lot . . ."

"Rosie," she said to the wax doll whose face had melted smooth because a mother, careless of dead dolls, had left her sitting in the sun, "Rosie, I shall give your woollie to my new pup. You are all cold anyhow. You melt if you are warmed. Pups are live and shivery . . ."

"He . . . she . . . Oh, Rosie what *shall* I do if it's a she? It took years to think

up a good enough name and it's a boy's name. Oh, well, if it's a girl she'll have thousands of puppies; the Elder says they always do."

She plaited a collar of bright braid, sewing on three hooks and eyes at varying distances.

"Will he be so big—or so big—or so big? I don't care about his size or shape or colour as long as he's alive."

She put the collar into the pocket of tomorrow's clean pinafore.

"Hurry up and go, day, so that tomorrow can come!" And she went off to bed so as to hurry night.

Small's father drew back the front-door bolt; that only half unlocked the new day—the little prayer book in its drab covering did the rest. It seemed a terrible time before the chair arm squeaked Amen. The Elder rose, slow as a snail. Small wanted to shout, "Hurry, hurry! Get the pup for me!"

Everyone kissed Small for her birthday; then all went into the breakfast room. On Small's plate was a flat, flat parcel. Small's eyes filled, drowning the gladness.

"Open it!" shouted everyone.

The Elder cut the string. "I am glad to see," she remarked, noting Small's quivering blue hands, "that you did not shirk your cold bath because it was your birthday."

The present was the picture of a little girl holding a dog in her arms.

"She looks like you," said Middle.

"No, she isn't like me, she has a dog."

Small went to the fire pretending to warm her blue hands. She took something from her apron pocket, dropped it into the flames.

"I'm not hungry—can I go and feed my ducks?" In the cow-yard she could cry.

The birthday dawdled. Small went to bed early that night too.

"Small, you forgot your prayers! cried Bigger.

"I didn't—God's deaf."

"You're dreadfully, dreadfully wicked—maybe you'll die in the night."

"Don't care."

Years passed. Small's father and mother were dead. The Elder was no more reasonable than Small's father had been about dogs. Small never asked now, but the want was still there, grown larger. Bigger, Middle and Small were grown up, but the Elder still regarded them as children, allowed them no rights. Like every girl Small built castles in the air. Her castle was an ark, her man a Noah, she tended the beasts.

Unexpected as Amen in a sermon's middle came Small's dog. She had been away for a long, long time; on her return the Elder was softened. Wanting to keep Small home, she said, "There's a dog in the yard for you."

Dabbing a kiss on the Elder's cheek Small rushed. Kneeling she took the dog's muzzle between her hands. He sniffed, licked, accepted. Maybe he too had

waited for a human peculiarly his. She loosed him. He circled round and round. Was he scenting the dream-pup jealously?

He had been named already. The dream-pup would always keep the name that had been his for his own.

"He'll run away—chain him. Remember he must not come in the house, Small!"

Small roamed beach and woods, the dog with her always. Owning him was better even than she had dreamed.

Small sat on a park bench waiting for a pupil, the dog asleep at her feet. The child-pupil, planning a surprise for Small, stole up behind her and threw her arms round her neck. Small screamed. The dog sprang, caught the child's arm between his teeth, made two tiny bruises and dropped down—shamed.

"That dog is vicious," said the Elder.

"Oh, no, he thought someone was hurting me; he was dreadfully ashamed when he saw that it was a child."

"He must be kept chained."

Chickens for table use were killed close to the dog's kennel. He smelled the blood—heard their squawks. The maid took a long feather and tickled his nose with it. He sprang, caught the girl's hand instead of the feather. The Elder's mouth went hard and grim.

"I teased him beyond endurance," pleaded the maid.

That day Small was hurt in an accident. The dog was not allowed to go to her room. Broken-hearted he lay in his kennel, disgraced, forsaken. Small was sent away to an old friend to recuperate. The day before she was to return, the old lady's son came to Small blurting, "They've killed your dog."

"Cruel, unjust, beastly!" shrieked Small.

"Hush!" commanded the old lady. "The dog was vicious."

"He was not! He was not! Both times he was provoked!"

Small ran and ran across the field till she dropped face down among the standing grain. There was a dark patch on the earth where her tears fell among roots of the grain.

"Only a dog! This is wrong, Small," said the not-understanding old woman.

Small went home and for six weeks spoke no word to the Elder—very few to anybody. She loathed the Elder's hands; they made her sick. Finally the Elder lost patience. "I did not kill the vicious brute," she cried. "The police shot him."

"You made them!"

Small could look at the Elder's hands again.

Small was middle-aged; she built a house. The Elder had offered her another dog. "Never till I have a home of my own," she had said. The Elder shrugged.

Now that Small had her house, the Elder criticized it. "Too far forward," she said. "You could have a nice front garden."

"I wanted a large back yard."

"A glut of dogs, eh Small?"

"A kennel of Bobtail Sheep dogs."

The Elder poked a head, white now, into Small's puppy nursery. "What are you doing, Small?"

"Bottling puppies—too many for the mothers."

"Why not bucket them?"

"There is demand for them—sheep dogs—cattle dogs."

"How many pups just now?"

"Eve's eight, Rhoda's seven, Loo's nine."

"Twenty-four—mercy! and, besides, those absurd bearded old patriarchs—Moses, Adam and the rest."

"Open the door for Adam."

The kennel sire entered, shaggy, noble, majestic. He rested his chin a moment on Small's shoulder where she sat with pup and feeding bottle, ran his eye round the walls where his mates and their families cuddled in boxes. He embraced all in good fellowship, including the Elder, picked the sunniest spot on the nursery floor and sprawled out.

"Oh, Small, I was throwing out Father's old wicker chair. Would you like it in the kennel nursery to sit in while bottling the pups?"

"The praying chair?—Oh, yes."

So the Praying Chair came to Small's kennel. Sitting in it Small remembered Tibby, the picture pup, the want, her first dog. Adam rested his chin on the old chair's arm. Small leaned forward to rest her cheek against his woolly head. All rasp, all crispness gone, "Amen", whispered the Praying Chair.

MRS. CRANE

I HEARD two women talking. One said to the other, "Mrs. Crane has a large heart."

"Yes," replied her companion, "and it is in the right place too."

I thought, "That's queer—hearts are in the middle of people. How can any person know if another person's heart is big or small, or if it is in the right or the wrong place?"

Soon after I heard this conversation about Mrs. Crane's heart, our Mother was seized with a very serious illness. My sister Alice and I—she was two years older—were hushed into the garden with our dolls and there, peeping from behind the currant bushes, we saw a high yellow dogcart stop in front of our

gate. Mrs. Crane descended from it and came stalking up our garden walk.

"Come to enquire, I s'pose," whispered Alice.

"My! Isn't she long and narrow?" I replied.

Silently I fell to trying to make all the different hearts I knew fit into Mrs. Crane's body—the gold locket one that made your neck shiver, beautiful valentine ones with forget-me-nots around them, sugar hearts, with mottoes, a horrible brown thing Mother said was a pig's heart and boiled for the cat—none of these would fit into Mrs. Crane's long narrow body.

She seemed to grow taller and taller as she came nearer. When she tiptoed up the steps, to us, crouched behind the currant bushes, she seemed a giant.

My big sister opened the door to Mrs. Crane. They whispered. Then my sister came to us and said, "Children, kind Mrs. Crane is going to take you home with her until Mother is better."

Alice's big eyes darkened with trouble. Obediently she picked up her doll and turned towards the house. I set my doll down with a spank, planted my feet wide apart and said, "Don't want to go!"

My sister gave me an impatient shake. Mrs. Crane ahemmed.

We were scrubbed hard, and buttoned into our starchiest. Mrs. Crane took one of Alice's hands and one of mine into a firm black kid grip and marched us to the gate. While she opened the gate, she let go of Alice's hand but doubled her grip on mine. Her eyes were like brown chocolate drops, hot and rich in colour when she looked at Alice, but when she looked at me they went cold and stale-looking.

We were hoisted up to the back seat of the dogcart. Father's splendid carpet bag with red roses on its sides and the great brass lock, was put under our feet to keep them from dangling. The bag was full of clean frocks and handkerchiefs and hairbrushes.

Mrs. Crane climbed up in front beside Mr. Crane. His seat was half a storey higher than hers. Mr. Crane cracked his whip and the yellow wheels spun furiously. Our house got smaller and smaller, then the road twisted and it was gone altogether. The world felt enormous.

We crossed two bridges. Mud flats were under one and the gas works were under the other—they both smelt horrid. The horse's hoofs made a deafening clatter on the bridges, and then they pounded steadily on and on over the hard road. When at last we came to the Cranes' house, it seemed as if we must have gone all around the world, and then somehow got there hind-before. You passed the Cranes' back gate first, and then you came to the front gate. The front door was on the back of the house. The house faced the water, which looked like a river, but was really the sea and salt. You went down the hill to the house and up the hill to the stable; everything was backwards to what it was at home and made you feel like Mother's egg-timer turned over.

Mrs. Crane had three little girls. The two younger were the same age as Alice and I.

The three little Cranes ran out of the house when they heard us come. They

kissed Mama politely and, falling on Papa, hugged him like bears.

A man came to lead the horse away. The little Cranes were all busy guessing what was in the parcels that came from under the seat of the dogcart, but the receding clop! clop! of the horse's hoofs, hammered desolation into the souls of Alice and me.

The Cranes' hall was big and warm and dark, except for the glow from a large heater, which pulled out shiny things like the noses of a lot of guns hanging in a rack on the wall and the fire irons and the stair rods. It picked out the brass lock of Father's bag and the poor glassy eyes of stuffed bear and wolves and owls and deer. Helen saw me looking at them as we went upstairs and said, "My Papa shot all those."

"What for?"

Helen stared at me. "What for? Doesn't your Papa go in for sport?"

"What is sport, Helen?"

Helen considered. "Why it's—killing things just for fun, not because you are hungry, chasing things with dogs and shooting them."

"My Father does not do that."

"My Papa is a crack shot," boasted Helen.

Alice and I had a grown-up bedroom. One window looked over the water and had a window seat. The other window looked into a little pine wood. There was a pair of beautiful blue china candlesticks on the mantel-piece.

We children had nursery tea. Mrs. Crane had Grace the biggest girl pour tea and Grace was snobbish. After tea we went into the drawing-room.

Mrs. Crane's drawing-room was a most beautiful room. There was a big three-cornered piano in it, two sofas and a lot of lazy chairs for lolling in. At home only Father and Mother sat in easy chairs: they did not think it was good for little girls to sit on any kind but straight up-and-down chairs of wood or cane. Mrs. Crane's lazy chairs were fat and soft and were dressed up in shiny stuff with rosebuds sprinkled all over it. But bowls of real roses everywhere made the cloth ones look foolish and growing ones poking their pink faces into the open windows were best of all and smelled lovely. A bright little fire burned in the grate and kept the little sea breeze from being too cold and the breeze kept the fire from being too hot. In front of the fire was a big fur rug; a brown-and-white dog was sprawled out upon it.

When we five little girls trooped into the drawing-room, I thought that the dog was the only creature in the room. Then I saw the top of Mr. Crane's head and his slippers sticking out above and below a mound of newspapers in an easy chair on one side of the fire. On the other side the fire lit up Mrs. Crane's hands folded in her lap. Her face was hidden behind a beaded drape hanging from a brass rod which shaded her eyes from the fire-light. One hand lifted and patted a stool at her knee—this Helen went and sat on. Mrs. Crane's lap was deep and should have been splendid to sit in, but her little girls never sat there. Helen said it was because Mama's heart was weak and I said, "But Helen, I thought big things were always strong?"

Helen did not know what I meant, because of course she had not heard those

ladies discussing her Mother's heart and so she did not know what I knew about it.

Mrs. Crane told "Gracie dear", to play one of her "pieces" on the piano. She always added dear to her children's names as if it was a part of them.

Mary Crane and our Alice were shy little girls. They sat on the sofa with their dolls in their laps. Their eyes stared like the dolls' eyes. Mrs. Crane would not allow dolls to be dressed or undressed in the drawing-room; she said it was not nice. I sat on the edge of a chair till it tipped, then I found myself in the very best place in all the room—right down on the fur rug beside the dog. When I put my head down on his side, he thumped his tail and a lovely live quiver ran through his whole body. I had meant to fight off sleep because of that strange bed upstairs, but the fire was warm and the dog comforting . . . I couldn't think whose far-off voice it was saying, "Come to bed, children," or whose hand it was shaking me.

The cold upstairs woke us up. Mrs. Crane looked black and tall standing by the mantel-piece lighting the blue candles. The big room ran away into dark corners. The bed was turned down and our nighties were ready, but we did not seem to know what to do next unless it was to cry. Mrs. Crane did not seem to know what to do either, so she said, "Perhaps you little girls would like to come into my little girls' room while they undress?" So we sat on their ottoman and watched. They brushed themselves a great deal—their hair and nails and teeth. They folded their clothes and said their prayers into Mrs. Crane's front, then stepped into bed very politely. Mrs. Crane told them to lie on their right sides, keep their mouths shut and breathe through their noses, then she threw the windows up wide. The wind rushed in, sputtered the candle and swept between Mrs. Crane's kisses and the children's foreheads. Then she blew the candle gently as if she was trying to teach the wind manners.

Back in our room, Mrs. Crane said something about "undoing buttons". I backed up to Alice very quickly and she told Mrs. Crane that we could undo each other.

"Very well," said Mrs. Crane, "I'll come back and put out the candle presently."

We scurried into bed, pulled the covers up over our heads and lay very still.

She came and stood beside the two white mounds for a second—then two gentle puffs, the up-screech of the window, long soft footsteps receding down the hall.

Two heads popped up from the covers.

"Weren't you scared she'd kiss us?"

"Awfully! Or that she'd want to hear our prayers?"

"The Crane girls are very religious."

"How'd you know?"

"They said two verses of 'Now I lay me'. We only know one."

Alice always slept quickly and beautifully. I tossed every way and did not sleep, till all my troubles were pickled away in tears.

At breakfast while Mrs. Crane was busy with the teacups I got the first chance of staring at her hard. The light was good and she was much lower, sitting. She talked to Mr. Crane as she poured the tea, using big polite words in a deep voice. The words rolled round her wisdom teeth before they came out. Her hair, skin and dress were brown like her eyes. Her heart could not help being in the right place, it was clasped so tight by her corset and her brown stuff dress was stretched so taut above that and buttoned from chin to waist. Her heart certainly could not be a wide one. Her hands were clean and strong, with big knuckles. The longer I looked at Mrs. Crane the less I liked her. But I did like a lot of her things—the vase in the middle of the dining-room table for instance. Helen called it Mama's "epergne". It was a two-storey thing of glass and silver and was always full of choice flowers, pure white geraniums that one longed to stroke and kiss to see if they were real, fat begonias and big heavy-headed fuchsias. Flowers loved Mrs. Crane and grew for her.

Mrs. Crane's garden was not as tidy as Father's but the flowers had a good time and were not so prim. Mrs. Crane was lenient with her flowers. She let the wild ones scramble up and down each side of the clay path that ran down the bank to the sea. They jumbled themselves up like dancers—roses and honeysuckle climbed everywhere. The front drive, which was really behind the house, was circular and enclosed a space filled with fruit trees and raspberry canes. The vegetable garden was in the front and the flowerbeds in the back, because, of course, the front of the house was at the back. There was a little croquet lawn too and the little pine wood that our bedroom looked out on.

In the middle of this wood was a large platform with lots of dog-kennels on it—to these Mr. Crane's hunting dogs were chained.

The dogs did not know anything about women or girls and Mrs. Crane did not like them. Mr. Crane would not let the children handle them; he said it spoilt them for hunting. I wanted to go to them dreadfully but Helen said that I must not. The children were allowed to have the old one who had been in the drawing-room because he was no good for hunting.

Helen said, "Once I had a little black dog. I loved him very much, but Papa said he was a mongrel. So he got his gun and shot him. When the little dog saw the gun pointed at him he sat up and begged. The shot went through his heart, but he still sat up with the beg frozen in his paws."

"Oh Helen, how could your father? Why didn't your mother stop him?"

"It did not make any difference to Mama. It was not her dog."

In our house nobody would have thought of telling Father "not to". Nor would we have thought of meddling with Father's things. In the Cranes' home it was different. When Helen took me into a funny little room built all by itself in the garden and said, "This is Papa's Den," I was frightened and said, "Oh Helen! surely we ought not to."

There was not a single woman's thing in the Den. There were guns and fishing rods and wading boots and there was a desk with papers and lots of big books. There was a bottle of quicksilver. Helen uncorked it and poured it onto the table. It did amazing things, breaking itself to bits and then joining itself

together again, but presently it rolled off the table and we could not find it. Whenever Mr. Crane came home after that, I was in terror for fear he would ask about the quicksilver and I hated him because he had shot the little begging dog.

The little Cranes never took liberties with Mama's things.

It seemed years since we left home, but neither Alice nor I had had a birthday and there had been only one Sunday at Mrs. Crane's. There was one splendid thing though and that was Cricket. He was a pinto pony belonging to the children. Every day he was saddled and we rode him in turns. The older girls rode in a long habit. Helen's legs and mine were too young to be considered improper by Mrs. Crane. So our frillies flapped joyously. Helen switched Cricket to make him go fast, but fast or slow were alike to me. It was a delight to feel his warm sides against my legs. The toss of his mane, the switch of his tail, his long sighs and short snorts, the delicious tickle of his lips when you fed him sugar—everything about him was entrancing, even the horsy smell. Just the thought of Cricket, when you were crying yourself to sleep, helped.

There was no more room for Cricket in Mrs. Crane's heart than there was for the dogs, but Mrs. Crane's heart did take in an old lady called Mrs. Miles. Mrs. Miles was almost deaf and almost blind. She wore a lace cap and a great many shawls and she knitted and blinked, knitted and blinked, all day. She came to stay with Mrs. Crane while we were there. Mrs. Miles liked fresh raspberries for her breakfast and to make up for being nearly blind and nearly deaf, Mrs. Crane gave her everything she could that she was fond of. We children had to get up earlier to pick raspberries and Mrs. Crane did not even mind if our fresh frocks got wetted with dew, because she wanted to comfort Mrs. Miles for being old and deaf and blind.

One Sunday afternoon Mrs. Miles draped her fluffiest shawl over her cap and face and everything and presently big snores came straining through it. Mr. Crane's newspaper was sitting on top of his bald spot and he was snoring too—the paper flapped in and out above his mouth. Mr. Crane's "awk, awk" and Mrs. Miles' "eek, eek" wouldn't keep step and we little girls giggled.

Mrs. Crane said, "It is very rude for little girls to laugh at their elders."

Helen asked, "Even at their snores, Mama?"

"Even at their snores," said Mrs. Crane. She hushed us into the far corner of the drawing-room and read us a very dull story.

Helen on the stool at her mother's knee and the three others on the sofa were all comfortable enough to shut their eyes and forget, but how could anyone on a three-legged stool under the high top of the sofa sleep? Especially if the fringe of an antimacassar lolled over the top and tickled your neck? My fingers reached up to the little tails of wool bunched in colours and began to plait—red, yellow, black, red, yellow, black. A neat little row of pigtails hung there when the story was done and I thought it looked fine.

When we trooped down the stairs next morning, Mrs. Crane was waiting at the foot. Her teeth looked very long, the chocolate of her eyes very stale. From

the upper landing we must have looked like a long caterpillar following her to the drawing-room.

Of course she knew it was me, because she had told me to sit there, but she put me through five separate agonies, her pointing finger getting longer and her voice deeper, with every "Did you do it?" When it came to me, her finger touched the antimacassar and her voice dragged me into a deep pit. When I said my, "Yes, Mrs. Crane," she said that I had desecrated the work of her dear dead mother's hands, that it was Satan that had told my idle fingers to do it, that I was a naughty mischievous child and that after breakfast I must undo all the little pigtails.

Not the boom of the breakfast gong, nor the bellow of Mr. Crane's family prayers, nor the leather cushion that always smelt so real and nice when your nose went into it, could drown those horrid sobs. They couldn't be swallowed nor would they let my breakfast pass them. So Mrs. Crane excused me and I went to the beastly antimacassar and wished her mother had taken it to Heaven with her. Mrs. Miles came and sat near and blinked and clicked, blinked and clicked.

"Please! Please! Mrs. Crane, can't we go home?"

"And make your poor Mama worse?"

I did not even want to ride Cricket that day.

After tea we went to visit a friend of Mrs. Crane's. We went in the boat. Mr. Crane rowed. Night came. Under the bridges the black was thick and the traffic thundered over our heads. Then we got into a boom of loose logs. They bumped our boat and made it shiver and when Mr. Crane stood up and pushed them away with his oar, it tipped. Helen and I were one on each side of Mrs. Crane in the stern. When she pulled one tiller rope her elbow dug into me, when she pulled the other her other elbow dug into Helen.

The ropes rattled in and out and the tiller squeaked. I began to shake and my teeth to chatter.

"Stop it, child!" said Mrs. Crane.

But I could not stop. I stared down into the black water and shook and shook and was deadly cold.

Mrs. Crane said I must have taken a chill. I had not eaten anything all day, so she gave me a large dose of castor oil when we got home. I felt dreadfully bad, especially in bed, when Alice said, "Why can't you behave? You've annoyed Mrs. Crane all day."

"I hate her! I hate her!" I cried. "She's got a pig's heart."

Alice said, "For shame!"—hitched the bedclothes over her shoulder and immediately long breaths came from her.

Next morning was wet, but about noon there was meek sunshine and Helen and I were sent to run up and down the drive.

Everything was so opposite at Mrs. Crane's that sometimes you had to feel your head to be sure you were not standing on it. For instance you could do all sorts of things in the garden, climb trees and swing on gates. It was not even wicked

to step on a flower bed. But it was naughty to play in the stable yard among the creatures, or to tumble in the hay in the loft, or to lift a chicken, or to hold a puppy. Every time we came to the stable end of the drive, I just *had* to stop and talk to Cricket through the bars and peer into his great big eyes and whisper into his ears.

In the yard behind Cricket I saw a hen.

"Oh Helen, just look at that poor hen! How bad she does feel!

"How do you know she feels bad?"

"Well, look at her shut eyes and her head and tail and wings all flopped. She feels as I did yesterday. Maybe oil . . . "

"I'll pour if you'll hold," said Helen.

We took the hen to the nursery. She liked the holding, but was angry at the pouring. When her throat was full she flapped free. I did not know a hen could fly so high. She knocked several things over and gargled the oil in her throat, then her big muddy feet clutched the top of the bookcase and she spat the oil over Mrs. Crane's books so that she could cackle. She had seemed so meek and sick we could not believe it. I was still staring when I heard a little squashed "Mama" come from Helen, as if something had crushed it out of her.

Sometimes I have thought that Mrs. Crane had the power to grow and shrivel at will. She filled the room, her eyes burnt and her voice froze.

"Catch that fowl!"

As I mounted the chair to catch the hen, I saw what her muddy feet and the oil had done to me. Helen's hair was long and she could hide behind it, but mine was short. I stepped carefully over the hateful blue bottle oozing sluggishly over the rug.

Out on the drive I plunged my burning face down into the fowl's soft feathers.

"Oh, old hen, I wish I could shrivel and get under your wing!" I cried. I had to put her down and go back alone.

It seemed almost as if I had shrivelled, I felt so shamed and small when I saw Mrs. Crane on her knees scrubbing the rug.

I went close. "I'm sorry, Mrs. Crane."

No answer. I went closer. "I wanted to help your hen. She's better. Perhaps it was only a little cuddling she wanted."

Oh, why didn't she speak! Why didn't she scold or even smack, not just scrub, scrub, scrub!

I stood looking down at Mrs. Crane. I had never seen the top of her before. I saw the part of her hair, the round of her shoulders, her broad back, her thickness when you saw her from on top. Perhaps after all there was room for quite a wide heart.

Suddenly now while I could reach her, I wanted to put my arms round her and cry.

Mrs. Crane rose so suddenly that she almost trod on me. I stepped back. The wings of her nose trembled. Mrs. Crane was smelling.

She strode to the doll cupboard and doubled down into it. When she backed out, a starfish dangled from the tips of the fingers of each hand. Helen and I had caught some under the boathouse ten days before and dressed them up in doll's clothes. Mrs. Crane's nose and hands were as far as they could get away from each other.

Mrs. Crane looked at me hard. "Such things never enter my Helen's head," she said. "Your mama is better; they are coming for you tonight."

In spite of the bad-smell-nose she wore, and the disgust in her fingertips, Mrs. Crane seemed to me just then a most beautiful woman.

"Oh, Mrs. Crane!"

My hands trembled up in that silly way pieces of us have of doing on their own, but the rest of me pulled them down quickly before Mrs. Crane saw.

WHITE CURRANTS

IT HAPPENED many times, and it always happened just in that corner of the old garden.

When it was going to happen, the dance in your feet took you there without your doing anything about it. You danced through the flower garden and the vegetable garden till you came to the row of currant bushes, and then you danced down it.

First came the black currants with their strong wild smell. Then came the red currants hanging in bright tart clusters. On the very last bush in the row the currants were white. The white currants ripened first. The riper they got, the clearer they grew, till you could almost see right through them. You could see the tiny veins in their skins and the seeds and the juice. Each currant hung there like an almost-told secret.

Oh! you thought, if the currants were just a wee bit clearer, then perhaps you could see them *living*, inside.

The white currant bush was the finish of the garden, and after it was a little spare place before you came to the fence. Nobody ever came there except to dump garden rubbish.

Bursting higgledy-piggledy up through the rubbish everywhere, grew a half-wild mauvy-pink flower. The leaves and the blossoms were not much to look at, because it poured every drop of its glory into its smell. When you went there the colour and the smell took you and wrapped you up in themselves.

The smell called the bees and the butterflies from ever so far. The white but-

terflies liked it best; there were millions of them flickering among the pink flowers, and the hum of the bees never stopped.

The sun dazzled the butterflies' wings and called the smell out of the flowers. Everything trembled. When you went in among the mauvy-pink flowers and the butterflies you began to tremble too; you seemed to become a part of it—and then what do you think happened? Somebody else was there too. He was on a white horse and he had brought another white horse for me.

We flew round and round in and out among the mauvy-pink blossoms, on the white horses. I never saw the boy; he was there and I knew his name, but who gave it to him or where he came from I did not know. He was different from other boys, you did not have to see him, that was why I liked him so. I never saw the horses either, but I knew that they were there and that they were white.

In and out, round and round we went. Some of the pink flowers were above our heads with bits of blue sky peeping through, and below us was a mass of pink. None of the flowers seemed quite joined to the earth—you only saw their tops, not where they went into the earth.

Everything was going so fast—the butterflies' wings, the pink flowers, the hum and the smell, that they stopped being four things and became one most lovely thing, and the little boy and the white horses and I were in the middle of it, like the seeds that you saw dimly inside the white currants. In fact, the beautiful thing *was* like the white currants, like a big splendid secret getting clearer and clearer every moment—just a second more and——.

"Come and gather the white currants," a grown-up voice called from the vegetable garden.

The most beautiful thing fell apart. The bees and the butterflies and the mauvy-pink flowers and the smell, stopped being one and sat down in their own four places. The boy and the horses were gone.

The grown-up was picking beans. I took the glass dish.

"If we left the white currants, wouldn't they ripen a little more? Wouldn't they get—clearer?"

"No, they would shrivel."

"Oh!"

Then I asked, "What is the name of that mauvy-pink flower?"

"Rocket."

"Rocket?"

"Yes—the same as fireworks."

Rockets! Beautiful things that tear up into the air and burst!

THE ORANGE LILY

HENRY MITCHELL'S nursery garden was set with long rows of trees, shrubs and plants. It sat on the edge of the town. In one corner of its acreage was the little grey cottage where Henry and his wife, Anne, lived. They were childless and well on in years, trying honestly to choke down homesickness and to acclimatize themselves as well as their Old Country plants to their step-land.

Small came into the nursery garden taking the gravel path at a gallop, the steps at a jump, tiptoeing to reach the doorbell—then she turned sharp against the temptation of peering through the coloured glass at the door-sides to see sombre Anne Mitchell come down the hall multicoloured—green face, red dress, blue hair. The turn brought Small face to face with the Orange Lily.

The lily grew in the angle made by the front of the house and the side of the porch. Small's knees doubled to the splintery porch floor. She leaned over to look into the lily's trumpet, stuck out a finger to feel the petals. They had not the greasy feel of the wax lilies they resembled, they had not the smooth hard shininess of china. They were cool, slippery and alive.

Lily rolled her petals grandly wide as sentinelled doors roll back for royalty. The entrance to her trumpet was guarded by a group of rust-powdered stamens—her powerful perfume pushed past these. What was in the bottom of Lily's trumpet? What was it that the stamens were so carefully guarding? Small pushed the stamens aside and looked. The trumpet was empty—the emptiness of a church after parson and people have gone, when the music is asleep in the organ and the markers dangle from the Bible on the lectern.

Anne Mitchell opened the cottage door.

"Come see my everlasting flowers, Small—my flowers that never die."

With a backward look Small said, "What a lovely lily!"

"Well enough but strong-smelling, gaudy. Come see the everlastings."

The front room of the cottage was empty; newspapers were spread over the floor and heaped with the crisping everlasting flowers, each colour in a separate pile. The sunlight in the room was dulled by drawn white blinds. The air was heavy—dead, dusty as the air of a hay loft.

The flowers crackled at Anne's touch. "Enough to wreathe the winter's dead," she said with a happy little sigh and, taking a pink bud from the pile, twined it in the lace of her black cap. It dropped against her thin old cheek that was nearly as pink, nearly as dry as the flower.

"Come, Mrs. Gray's wreath!" She took Small to the sitting-room. Half of Mrs. Gray's wreath was on the table, Anne's cat, an invalid guinea hen and Henry huddled round the stove. The fire and the funereal everlastings crackled cheerfully.

Presently Small said, "I had better go now."

"You shall have a posy," said Anne, laying down the wreath.

"Will there be enough for Mrs. Gray and me too?" asked Small.

"We will gather flowers from the garden for you."

The Orange Lily! Oh if Mrs. Mitchell would only give me the Orange Lily! Oh, if only I could hold it in my hand and look and look!

Anne passed the lily. Beyond was the bed of pinks—white, clove, cinnamon.

"Smell like puddings, don't they?" said Small.

"My dear!"

Anne's scissors chawed the wiry stems almost as sapless as the everlastings. Life seemed to have rushed to the heads of the pinks and flopped them face down to the ground. Anne blew off the dust as she bunched the pinks. Small went back to the lily. With pocket-handkerchief she wiped the petals she had rusted by pushing aside the stamens.

"There are four more lilies to come, Mrs. Mitchell!"

Anne lifted the corner of her black silk apron.

"That lily has rusted your nose, Small."

She scrubbed.

Small went home.

"Here's pinks," she said, tossing the bunch upon the table.

In her heart she hugged an Orange Lily. It had burned itself there not with flaming petals, not through the hot, rich smell. Soundless, formless, white—it burned there.

HOW LIZZIE WAS
SHAMED RIGHT THROUGH

NOW THAT I am eight, the same age that Lizzie was when the party happened, and am getting quite near to being grown-up, I can see how shamed poor Lizzie must have been of me then.

Now I know why the Langleys, who were so old, gave a party for us who were so little, but then I was only four so I did not wonder about it at all, nor

notice that the fair, shy boy was their own little brother, hundreds and hundreds of years younger than his big brother and two big sisters. They did not poke his party in the little boy's face, did not say, "Albert, this is your party. You must be kind and polite to the boys and girls." That would have made Albert shyer than he was already. They let him enjoy his own party just as the other children were enjoying it.

The Langleys' party was the first one we had ever been to. Mother made us look very nice. We had frilly white dresses, very starched. Lizzie who was eight, and Alice who was six, had blue sashes and hair ribbons. There was pink ribbon on me and I was only four.

Sister Dede bustled round saying, "Hurry! Hurry!" scrubbing finger nails and polishing shoes. She knotted our ribbons very tightly so that we should not lose them,—they pulled the little hairs under our curls and made us "ooch" and wriggle. Then Dede gave us little smacks and called us boobies. The starch in the trimming about our knees was very scratchy. Dede snapped the white elastics under our chins as she put on our hats and said to Mother, "I wonder how long these youngsters will stay clean." Being fixed up for the party was very painful.

There were three pairs of white cotton gloves waiting on the hall stand, like the mitts of the three little kittens. Mother sorted them and stroked them onto the fingers we held out as stiff as they'd go, and by the time that Mr. Russell's hansom cab, the only one in Victoria, jingled up to the door, we were quite ready.

Mother kissed us. Dede kissed us.

"Have you all got clean pocket handkerchiefs?"

Yes, we had.

"Don't forget to use them."

No, we wouldn't.

"Be sure to thank Miss Langley for the nice time."

"S'pose it isn't nice?"

"Say 'thank you' even more politely."

We sat in a row on the seat; Mr. Russell slammed the apron of the cab down in front of us, jumped up like a monkey to his perch at the back, and we were off—eight, six and four years old going to our first party.

It was such fun sitting there and being taken by the horse, just as if he knew all by himself where to find parties for little girls, for, after Mr. Russell had climbed up behind so that you could not see him, you forgot that there was a driver.

Lizzie looked over my hat and said to Alice, "I do hope this child will behave decently, don't you? There! See, already!" She pointed to the tips of my gloves which were all black from feeling the edge and buttons of the cab's inside.

"Stop it, bad child," she squealed so shrilly that a little door in the roof of the cab opened and Mr. Russell put his head in. When he saw it was only a "mad" squeal he took his head out again and shut up the hole.

We drove a long way before we came to the Langleys'. Their gate did not

know which road it liked best, Moss or Fairfield, so it straddled the corner and gaped wide. We drove up to the door. The two Miss Langleys and Mr. Langley were there, shaking boys and girls by the hands.

The three Langleys had been grown-up a long, long time. They had big shining teeth which their lips hugged tight till smiles pushed them back and then you saw how strong and white the teeth were. They had yellow hair, blue eyes, and had to double down a long way to reach the children's hands.

Mr. Russell flung back the apron of his cab but we still kept on sitting there in a close row like the three monkeys, "See no evil, hear no evil, and speak no evil." He said, "Come now, little leddies. Me 'oss and 'ansom baint inwited." He lifted me out and Mr. Langley had to pull the others from the cab, for now that we were in the middle of the party Lizzie was as scared as any of us. She took Alice by one hand and me by the other and we shook hands with all the Langleys, for no matter how scared Lizzie was she always did, and made us do, what she knew was right.

The house was the wide, sitting sort. Vines and creepers tied it down to the ground.

The garden was big. It had tress, bushes and lawns—there were rocks covered with ivy, too.

The Langleys tried to mix the children by suggesting "hide and seek" among the bushes. Everybody hid but no one would seek. Each child wanted to hold a hand belonging to another of its own family. The boys were very, very shy and the girls' clothes so starchy they rattled if they moved.

By and by Miss Langley counted . . . "Sixteen," she said. "That is all we have invited so we had better start." Something was coming up the drive. Lizzie thought it was our cab and that Miss Langley meant that it was time to be going home, so she took us up to Miss Langley to say what Mother had told us to, but it was not Mr. Russell at all. It was Mr. Winter's big picnic carriage, all shiny and new, the one he had got specially for taking children to parties and picnics. There seemed to be no end to the amount of children he could stuff into this carriage, but there was, because, when they put me in, there was not a crack of space left except the door handle, so I sat on that. The boys were all up in the front seat, swarming over Mr. Winter like sparrows. Behind sat all the little girls—so still—so polite. Suddenly I had a thought and cried, "If this door busted open I'd fall out!"

"Millie, don't say 'busted'. It's horrible! Say 'bursted'." Lizzie's face was red with shame.

We went to Foul Bay and had games on the beach. After we had played a long time Lizzie was just as clean as when we left home, Alice was almost as clean, and I was all mussed up, but they were not having half such a good time as I.

We went back to the Langleys' house for tea. There were all sorts of sandwiches and there was cocoa and two kinds of cake—one just plain currant, the other a most beautiful cake with pink icing and jelly.

Lizzie and Alice sat across the table from me and were being frightfully

polite, taking little nibbling bites like ladies, holding their cups with one hand, and never forgetting "thank you".

My mug was big, it took both my hands. Even then it was heavy and slopped. Miss Langley said, "Oh, your pretty frock!" and tied a bib round me and pulled the little neck hairs so hard that I could not help one or two squeaks . . . they weren't big, but Lizzie scowled and whispered to Alice. I was sure she said, "Bad, dirty little thing." I was just going to make a face at her when Miss Kate Langley came with the splendid pink cake. I had a piece of the currant kind on my plate. I was so afraid Miss Kate would see it and pass me—maybe she would never come back—that I stuffed the currant cake into both cheeks and held my hand up as the girls did at lessons if they wanted something.

"Jelly cake, dear!"

I couldn't speak, but I nodded. Lizzie's forehead crinkled like cream when mother was skimming for butter. She mouthed across at me, "I'm going to tell." My mouth was too busy to do anything with, but I did the worst I could at her with my eyes and nose. She had spoilt everything. Somehow the jelly cake was not half as nice as I thought it was going to be.

The moment tea was over Miss Langley took my bib off and, holding me by the wrists with my hands in the air, said:

"Come, dear. Let me wash you before . . ."

She washed beautifully, and was a lovely lady. I told her about my cat Tibby, and after she had washed my face she kissed it.

I felt very special going back to the others with my hand in that of the biggest and best Miss Langley.

Out on the lawn they were playing "Presents for shies." Mr. Langley stuck up four wobbly poles and put a prize on top of each—bells and tops and whistles. If your shy hit a pole so that a prize fell off, it was yours to keep. I wanted a whistle most dreadfully. When my turn came my shy flew right over the other side of the garden. I had been quite sure that I could knock the whistle off the pole but my shy stick just would not do it. I had three tries and then I ran to Alice who was sitting on a bench and put my head down in her lap and howled. She lifted me by the ribbon and spread her handkerchief under my face so that I should not spoil her dress. Miss Langley heard my crying.

"There, there!" she said and gave me a little muslin bag with six candies in it—but it was not a whistle.

Lizzie told Miss Langley that she was very ashamed of me and that I always did behave dreadfully at parties. That made me stop crying and shout, "I never, never went to one before." Then I did make the very worst face I knew how at Lizzie and gave two sweets to Alice, two to Miss Langley, two to myself, and threw the empty bag at Lizzie as she went off to have her shy. I don't know how I should have felt if she had won a whistle but when she came back without any prize I picked up the bag and put the candy I was not eating in it and gave it to her.

Jingle, jingle, clop, clop—Mr. Russell's cab was coming up the drive. Again Lizzie marched us to Miss Langley.

"Thank you for a very nice party, Miss Langley," she said.

Then she poked at Alice, but Alice only went red as a geranium! She had forgotten what it was she had to say. Poor Lizzie looked down at me and saw the spot of jelly, the cocoa and the front part of me where I'd gone under the bush after my shy stick. She pushed me back and pulled her own clean skirt across me quickly.

When Lizzie wasn't looking at her Alice could remember all right. She said, "Miss Langley, I liked myself, and I'm glad I came."

Miss Langley gave her such a lovely smile that I tore my hand from Lizzie's, ran up and tiptoed, with my face as high as it would go, for Miss Langley to kiss.

We all jumped into the cab then and the apron slammed off everything but our heads and waving hands. The cab whisked round. The party was gone.

"Where're your gloves?"

"L—l—lost."

"Where's your hankie?"

"L—l—lost."

Lizzie took out her own and nearly twisted the nose off my face.

"I'm going to tell Mother about 'busted', about grabbing the jelly cake with your mouth full, about having to wear a bib and be washed. Oh! and there's the two lost things as well. I expect you'll get spanked, you disgusting child. I'm shamed right through about you, and I'm never, never, never going to take you to a party again."

One of my eyes cried for tiredness and the other because I was mad.

Alice got out her hankie, her very best one with Christmas scent on it. "Keep it," she whispered, pushing it into my hand. "Then there'll be only one lost thing instead of two."

BRITISH COLUMBIA
NIGHTINGALE

MY SISTER Alice was two years older than I and knew a lot. Lizzie was two years older than Alice and thought she knew it all. My great big sister *did* know everything. Mother knew all about God. Father knew all about the earth. I knew more than our baby, but I was always wondering and wondering.

Some wonders started inside you just like a stomach-ache. Some started in

outside things when you saw, smelled, heard or felt them. The wonder tickled your thinking—coming from nowhere it got into your head running round and round inside until you asked a grown-up about this particular wonder and then it stopped bothering you.

Lizzie, Alice and I were playing in the garden when our Chinaboy Bong came down the path—that is how I know exactly what time of evening it was that this new noise set me wondering, because Bong was very punctual. The tassel on the end of his pigtail waggled all down the path and, as he turned out of the gate, it gave a special little flip. Then you knew that it was almost bed-time. It was just as the slip-slop of Bong's Chinese shoes faded away that I first noticed that new noise.

First it was just a little bunch of grating snaps following each other very quickly, as if someone were dragging a stick across a picket fence as he ran. The rattles got quicker and quicker, more and more, till it sounded as if millions of sticks were being dragged across millions of fences.

I said, "Listen girls! What is it?"

Alice said she did not hear anything in particular.

Lizzie said, "It's just Spring noises, silly!"

First the sound would seem here, then there, then everywhere—suddenly it would stop dead and then the stillness startled you, but soon the rattles would clatter together again filling the whole world with the most tremendous racket, all except just where you stood.

I was glad when my big sister put her head out of the window and called, "Bed-time, children!" I wanted to pull the covers up over my head and shut out the noise.

We went into the sitting-room to kiss Father and Mother goodnight. The fire and the lamp were lighted. Mother was sewing—Father looked at her over the top of his newspaper and said:

"Listen to British Columbia's nightingale, Mother! Spring has come."

Mother replied, "Yes, he certainly does love Spring in the Beacon Hill skunk-cabbage swamp!"

"Come along, children!" called Big Sister.

Upstairs our bedroom was full of the noise. It came pouring in through the dormer window. When the candle was taken away it seemed louder because of the dark. I called to Big Sister as she went down the stair, "Please may we have the window shut?"

"Certainly not! Stuffy little girl! The night is not cold."

"It isn't the cold, it's the noise."

"Noise? Fiddlesticks! Go to sleep."

I nosed close to Alice, "Do you know what nightingales are Alice?"

"Some sort of creature."

"They must be simply *enormous* to make such a big noise."

Alice's "uh-huh" was sleep talk.

I lay trying to "size" the nightingale by its noise. Our piano even with sister

Edith pounding her hardest could never fill the whole night like that. Our cow was bigger than the piano, but even when they shut her calf away from her and great moos made her sides go in and out, her bellows only rumbled round the yard. This nightingale's voice crackled through the woods, the sky and everywhere. The band that played in the Queen's birthday parade died when you lost sight of it. This sound of something which you could not see at all filled the world. Why, even the cannon that went off at Esquimalt for people to set their watches by every night at nine-thirty and made Victoria's windows rattle, went silent after one great bang, but this monster in Beacon Hill Park adjoining our own property kept on and on with its roar of crackles.

I knew now why we were never allowed to go into Beacon Hill swamp to gather spring flowers: it was not on account of the mud at all, but because of this nightingale monster.

"I shall never, never go into Beacon Hill Park again," I said to myself. "I won't let on I'm scared but when we go for a walk I shall say, 'Let's go to the beach, it's much nicer than the Park.'"

I thought, "Perhaps she comes to the Park like the birds to nest in the Spring. Perhaps the Park might be safe in winter when the Monster went south."

I heard Father shoot the front-door bolt and the grown-ups coming up the stair. As the candles flickered past our door I whispered, "Mother!"

She came to me.

"Why are you not asleep?"

"Mother, how big is a nightingale?"

"Nightingales are small birds, we do not have them in Victoria."

Birds!—None in Victoria!

"But Father said—"

"That was just a joke, calling our little green frogs nightingales. Go to sleep, child."

Dear little hopping frogs!—I slept.

T I M E

FATHER was a stern straight man. Straight legs and shoulders; straight side-trim to his beard, the ends of which were straight-cut across his chest. From under heavy eyebrows his look was direct, though once in a rare while a little twinkle forced its way through. Then something was likely to happen.

Our family had to whiz around Father like a top round its peg.

It was Sunday. Father was carving the saddle of mutton. Everybody was helped. Father's plate had gone up for vegetables. Uncle and Auntie Hays were visiting us from San Francisco.

Father's twinkle ran up the table to Mother and zigzagged back, skipping Auntie, who was fixing her napkin over her large front with a diamond pin.

Father said, "What about a picnic on Saturday, Mother? We will have the omnibus and go to Mill Stream."

The two big sisters, we three little girls and the small brother were glad. Mother beamed on us all. Auntie attended to her mutton. Uncle never did have anything to say. He was like the long cushion in the church pew—made to be sat on.

All week we stared at the clock, but, for all she ticked, her hands stuck; it took ages for her to register even a minute. But Saturday did come at last and with it, sharp at ten, the yellow bus.

Uncle Hays made a nest of cushions in one corner of the bus for Auntie. Pies and cakes, white-wrapped and tucked into baskets like babies, the tea-billy wrapped in a newspaper petticoat—all were loaded in and we took our places and rattled away.

The bus had two horses and carpet seats. Its wheels were iron-bound and made a terrible racket over the stones.

Only the very middle of our town was paved and sprinkled; beyond the town was dust and bumps.

The seats of the bus were high. We three little girls discovered that we bumped less if we did not dangle, so we knelt on the seat and rested our arms on the open window ledges, till Auntie told Uncle he must shut all the windows except one, or the dust would ruin her new dust coat. After that we dangled and bumped.

Auntie grumbled all the way about Victoria's poor little blue water-barrel cart, that could only do the middle of the town, and told us of the splendid water-wagons of San Francisco.

At last we drove through a gate and down a lane and stopped. The driver opened the door and we all spilled out onto the grass beside a beautiful stream.

Uncle built a new rest for Auntie. There were pine boughs as well as pillows to it now, and she looked like a great fat bird sitting there peeping and cooing at Uncle over the edge.

The table-cloth was spread on the grass close to Auntie's nest. As soon as lunch was over Mother said, "Now children, run along. Don't go into the thick woods, keep by the stream."

Father looked at his watch and said, "It's now one o'clock—you have till five."

Downwards the stream broadened into a meadow; upstream it bored a green tunnel through the forest, a tunnel crooked as a bed-spring. It curled round and

round because there were so many boulders and trees and dams in the way. The sides of the tunnel were forest, the top overhanging trees, the floor racing water.

We could not have squeezed into the woods had we tried because they were so thick, and we could not have seen where to put our feet, nor could we have seen over the top, because the undergrowth was so high.

Every twist the stream took it sang a different tune and kept different time. It would rush around the corner of a great boulder and pour bubbling into a still pool, lie there pretending it had come to be still, but all the time it was going round and round as if it was learning to write "O's"; then it would pour itself smoothly over a wedged log and go purling over the pebbles, quiet and dreamy. Suddenly it would rush for another turn, and roar into a rocky basin trickling out of that again into a wide singing place. It had to do all these queer things and use force and roughness to get by some of the obstacles. But sometimes the stream was very gentle, and its round stones were covered with a fine brown moss. When the moss was wet it looked just like babies' hair. You could pretend the stones were babies in their bath and the stream was sponging water over their heads.

Five-finger maidenhair ferns grew all along the banks. Some of them spread their thin black arms over the edge and, dipping their fingers in the water, washed them gently to and fro. Then the wind lifted them and tossed them in the air like thousands of waving hands. All kinds of mosses grew by the stream—tufty, flat, ferny, and curly, green, yellow and a whitish kind that was tipped with scarlet sealing wax.

Yellow eyes of musk blossoms peeped from crannies. They had a thick, soft smell. The smell of the earth was rich. The pines and the cedars smelled spicy. The wind mixed all the smells into a great, grand smell that made you love everything. There were immense sober pines whose tops you could not see, and little pines, fluffed out ready to dance. The drooping boughs of the cedars formed a thatch so thick and tight that creatures could shelter under it no matter how hard it rained. The bushes did not grow tight to the cedars because it was too dry and dark under them. Even their own lower limbs were red-brown and the earth bare underneath.

The wind sauntered up the stream bumping into everything. It was not strong enough to sweep boldly up the tunnel, but quivered along, giving bluffs and boulders playful little whacks before turning the next corner and crumbling the surface of that pool.

There was much to see as we went up the river, and we went slowly because there were so many things to get over and under. Sometimes there were little rims of muddy beach, pocked with the dent of deer hooves. Except for the stream the place was very quiet. It was like the stillness of a bird held in the hand with just its heart throbbing.

Sometimes a kingfisher screamed or a squirrel scolded and made you jump. I heard a plop down at my feet—it was a great golden-brown toad. I took him in my hands.

One sister said, "Ugh!" The other said, "Warts".

I put him in a tin and weighted it with a stone and hid it under a skunk cabbage.

We were very, very far up the stream, though it had not seemed a long way at all, when our big sister came around the bend behind us.

"Come children," she called. "It is time to go home."

We looked at each other. What did she mean? Time to go home? We had only just come.

I faced about.

"It is not," I said rudely, and received a smart box on the ear. But it was not our sister's word we doubted, it was Time.

I lagged behind to pick up the toad, wondering deeply about Time. What *was* Time anyway, that things could play such tricks with it? A stream could squeeze a whole afternoon into one minute. A clock could spread one week out into a whole year.

The baskets were packed. Uncle was building another nest for Auntie. Mother was seated in the bus looking very tired. Dick was asleep on the seat with his head in Mother's lap and his toy watch dangling out of his pocket.

I stared at the watch hard. The hands were at the same place they were when we started in the morning. Play things were always truer than real.

The bus started bumping along and the dust rolled behind. I sat opposite Auntie. I had draped a skunk cabbage leaf over the toad's tin.

"See dear, you will have to throw that leaf out of the window; the smell of it upsets Auntie." She detested me, and always tacked on that hypocritical "dear".

The leaf fluttered out of the window. I put my hand over the top of the tin.

"What have you got in the tin, dear? Let Auntie see."

I shot it under her nose, hoping it would scare her. It did. She gave a regular parrot-screech. The big sister reached across, seized the tin, looked, and flung tin, golden toad and all, out of the window.

Then suddenly those gone hours pulled out and out like taffy. It *was* late. The bus wheels started to roll quietly because we were in town now and under Mr. Redfern's big clock, which gave six slow sad strikes.

Father pulled out his big silver watch. Uncle pulled out a gold one. Auntie fussed with a fancy thing all wound up in lace and gold chains.

They all said "Correct", snapped the cases shut and put them back in their pockets.

I leaned against Father and shut my eyes.

Throb-throb-throb—was that Father's watch eating up minutes or was it hop-hop-hop, my golden toad, making his patient way down the long dusty road, back to the lovely stream where there was no time?

A LITTLE TOWN AND A LITTLE GIRL

BEGINNINGS

VICTORIA, on Vancouver Island, British Columbia, was the little town; I was the little girl.

It is hard to remember just when you first became aware of being alive. It is like looking through rain onto a bald, new lawn; as you watch, the brown is all pricked with pale green. You did not see the points pierce, did not hear the stab—there they are!

My father did not come straight from England to Victoria when, a lad of nineteen, he started out to see something of the world. He went to many countries, looking, thinking, choosing. At last he heard of the California gold rush and went there. He decided that California was a very fine country, but after the rush was over he went back to England, married an English girl and brought his bride out to California in a sailing ship, all round Cape Horn. Intending to settle in California, he went into business but after a while it irked Father to live under any flag other than his own. In a few years, having decided to go back "home" to live, he chartered a vessel and took to England the first shipment of California wheat. But, staunch Englishman though my Father was, the New Land had said something to him and he chafed at the limitations of the Old which, while he was away from it, had appeared perfect. His spirit grew restless and, selling all his effects, he brought his wife and two small daughters out to the new world. Round the Horn they came again, and up, up, up the west coast of America till they came to the most English-tasting bit of all Canada—Victoria on the south end of Vancouver Island, which was then a Crown Colony.

Father stood still, torn by his loyalty to the Old Land and his delight in the New. He saw that nearly all the people in Victoria were English and smiled at how they tried to be more English than the English themselves, just to prove to themselves and the world how loyal they were being to the Old Land.

Father set his family down in British Columbia. He and Mother had accepted Canada long before I, the youngest but one of their nine children, was born. By that time their homesickness was healed. Instead of being English they had broadened out into being British, just as Fort Camosun had swelled herself from being a little Hudson's Bay Fort, inside a stockade with bastions at the corners, into being the little town of Victoria, and the capital of British Columbia.

Father bought ten acres of land—part of what was known as Beckley Farm. It

was over James' Bay and I have heard my mother tell how she cried at the lone-someness of going to live in a forest. Yet Father's land was only one mile out of the town. There was but one other house near—that of Mr. James Bissett of the Hudson's Bay Company. Mr. Bissett had a wife and family. They moved East long before I was born but I was to know, when nearly grown up, what the love of those pioneer women must have been for one another, for when years later I stood at Mrs. Bissett's door in Lachine, seeing her for the first time, and said, "Mrs. Bissett, I am Emily Carr's daughter, Emily," she took me to herself in the most terrific hug.

As far back as I can remember Father's place was all made and in order. The house was large and well-built, of California redwood, the garden prim and carefully tended. Everything about it was extremely English. It was as though Father had buried a tremendous homesickness in this new soil and it had rooted and sprung up English. There were hawthorn hedges, primrose banks, and cow pastures with shrubberies.

We had an orchard and a great tin-lined apple room, wonderful strawberry beds and raspberry and currant bushes, all from imported English stock, and an Isabella grape vine which Father took great pride in. We had chickens and cows and a pig, a grand vegetable garden—almost everything we ate grew on our own place.

Just one of Father's fields was left Canadian. It was a piece of land which he bought later when Canada had made Father and Mother love her, and at the end of fifty years we still called that piece of ground "the new field". The New Field had a snake fence around it, that is, a zigzag fence made of split cedar logs or of young sapling trees laid criss-cross, their own weight holding them in place so that they required no nails. Snake fences were extravagant in land and in wood, but wood and land were cheaper in Canada in early days than were nails and hinges. You made a gate wherever you wanted one by lowering bars to pass through and piling them up again. The only English thing in our new field was a stile built across the snake fence.

The New Field was full of tall fir trees with a few oaks. The underbrush had been cleared away and the ground was carpeted with our wild Canadian lilies, the most delicately lovely of all flowers—white with bent necks and brown eyes looking back into the earth. Their long, slender petals, rolled back from their drooping faces, pointed straight up at the sky, like millions of quivering white fingers. The leaves of the lilies were very shiny—green, mottled with brown, and their perfume like heaven and earth mixed.

JAMES' BAY AND
DALLAS ROAD

JAMES' BAY DISTRICT, where Father's property lay, was to the south of the town. When people said they were going over James' Bay they meant that they were going to cross a wooden bridge that straddled on piles across the James' Bay mud flats. At high tide the sea flooded under the bridge and covered the flats. It receded again as the tide went out with a lot of kissing and squelching at the mud around the bridge supports, and left a fearful smell behind it which annoyed the nose but was said to be healthy.

James' Bay was the part of the town to be first settled after Victoria had ceased to be a fort. Many Hudson's Bay men built fine homes across the Bay— Sir James Douglas, Mr. Alexander Munroe, Mr. James Bissett, Mr. James Lawson, Senator Macdonald, Bishop Cridge and Dr. Helmcken.

The district began at the south corner of the Bridge where Belville Street crossed it. Belville skirted the mud flats until they ended at Blanshard Street. On the other side of the Bridge, Belville ran along the harbour's edge, skipping places where it could not get to the water. When it came to the mouth of the harbour it met Dallas Road and doubled back along the shore of the Straits of Juan de Fuca, making a peninsula of the James' Bay District, the limit of which was Beacon Hill Park, a beautiful piece of wild land given to the people of Victoria by Sir James Douglas.

The Hill itself was grassy, with here and there little thickets of oak scrub and clumps of broom. Beyond the Hill the land was heavily wooded. When you climbed to the top of Beacon Hill and looked around you knew that the school geography was right after all and that the world really was round. Beacon Hill seemed to be the whole top of it and from all sides the land ran away from you and the edges were lost. To the west lay the purple hills of Sooke; to the south were the Straits of Juan de Fuca, rimmed by the snowy Olympic mountains, whose peaks were always playing in and out among the clouds till you could not tell which was peak and which sky. On the east there were more sea and islands. The town was on the north, with purple Cedar Hill and green Mount Tolmie standing behind it. Our winds came from the Olympics in summer and from the icy north in the winter.

There was a good race track measuring exactly one mile, running round the base of Beacon Hill. Here they had horse-racing and foot-racing. They played cricket and football on the flat ground outside the track, and there were sham

battles between sailors and soldiers all over the Hill on the Queen's Birthday. In the woody swamps of the Park millions and millions of frogs croaked all through the Spring nights. They sounded as if all the world was made of stiff paper and was crackling up.

Dallas Road was the first pleasure drive made in Victoria. Everyone drove along it to admire the view. The road ran sometimes close to the edge of the clay cliffs and sometimes there were thickets of willow and wild rose bushes between. The trees and bushes were so waved by the beating of the wind that they grew crooked from always being pushed north when they were really trying to poke south into the sun. There were stretches of fine, soft grass on the cliffs and great patches of camass and buttercups. As the wind swept over these they looked as if they, too, were running away from the sea. How the petals of the wild roses managed to stick to their middles I can't think, but they did and the bushes were more pink than green in June. Their perfume, salted by the sea air, was the most wonderful thing that ever happened to your nose.

Beside one of the willow clumps on the Dallas Road were two white picket fences, each just as long as a man. They were the graves of two sailors who died of smallpox before Victoria had a cemetery. The fences were kept painted but the names on the head-boards were faded right out.

Farther along Dallas Road on the two highest parts of the cliffs were set two cannons, hidden from the Straits by sodded earth mounds. These were really ammunition cellars, one on either side of each cannon; they had heavy-timbered and padlocked doors which we children longed to see inside. These cannons guarded the entrance to Esquimalt Harbour, a British naval base, three miles out from Victoria.

Most of the beaches below Dallas Road were pebbly and had rough, rocky points jutting out into the sea and dividing the long beaches and the little bays one from another. All the beaches were piled with driftwood—great logs bruised and battered out of all resemblance to trees except that some of them still had tremendous, interlocked roots tough as iron, which defied all the pounding of the waves, all the battering against the rocks to break them. The waves could only wash them naked and fling them high up on the beach to show man what he had to wrestle against under the soil of the Canadian West. But the settlers were not stopped. They went straight ahead taming the land. It took more than roots to stop these men.

The waters of the Straits were icy. Occasionally we were allowed to put on white cotton nightgowns and go bathing in the sea. Your body went down, the nightgown stayed up, icy cold bit through your skin. At the first plunge you had no breath left; when it came back it was in screeches that out-screamed the seagulls.

SILENCE AND PIONEERS

THE SILENCE of our Western forests was so profound that our ears could scarcely comprehend it. If you spoke your voice came back to you as your face is thrown back to you in a mirror. It seemed as if the forest were so full of silence that there was no room for sounds. The birds who lived there were birds of prey— eagles, hawks, owls. Had a song bird loosed his throat the others would have pounced. Sober-coloured, silent little birds were the first to follow settlers into the West. Gulls there had always been; they began with the sea and had always cried over it. The vast sky spaces above, hungry for noise, steadily lapped up their cries. The forest was different—she brooded over silence and secrecy.

When we were children Father and Mother occasionally drove out beyond the town to Saanich, Metchosin or the Highland District, to visit some settler or other carving a home for his family in the midst of overwhelming growth— rebellious, untutored land that challenged his every effort. The settler was rais- ing a family who would carry on from generation to generation. As he and his wife toiled at the breaking and the clearing they thought, "We are taming this wilderness for our children. It will be easier for them than for us. They will only have to carry on."

They felled mighty trees with vigour and used blasting powder and sweat to dislodge the monster roots. The harder they worked with the land, the more they loved these rooty little brown patches among the overwhelming green. The pioneer walked round his new field, pointing with hardened, twisted fingers to this and that which he had accomplished while the woman wrestled with the inconveniences of her crude home, planning the smart, modern house her chil- dren would have by and by, but the children would never have that intense joy of creating from nothing which their parents had enjoyed; they would never understand the secret wrapped in virgin land.

Mr. Scaife, a pioneer, had digged a deep ditch round his forest field. The field was new ploughed. He showed Father with pride how few blackened stumps there were now left in the earth of it. I let go of Father's hand to gather wild flowers among the pokes of the snake fence. I fell into the deep, dry ditch. Brambles and tall grasses closed over my head, torn roots in the earthy sides of the ditch scraped me as I went down. It was the secret sort of place where snakes like to wriggle and where black hornets build their nests—nearly dark, only a

little green light filtering through the brambles over my head. I screamed in terror. Willie Scaife, a farm lad, jumped into the ditch and pulled me out. He was my first hero.

The first Victorians could tell splendid stories of when Victoria was a Hudson's Bay Post, was called Fort Camosun and had a strong blockade about it with a bastion at each corner to protect the families of the Hudson's Bay men from Indians and wild beasts.

Though my parents did not come to Victoria till after the days of the Fort and I was not born for many years after that, still there were people in Victoria only middle-aged when I was little, who had lived in the old Fort and could actually tell you about it. Nothing delighted me more than to hear these "still-fresh-yesterday" stories, that were not old "once-upon-a-timers"! You could ask questions of the very story people themselves and they did not have to crinkle their foreheads, trying to remember a long way back.

There was a childless couple with whom I was a favourite—Mrs. Lewis and her husband, the sea captain. Mrs. Lewis had been Miss Mary Langford before her marriage. Her Father was Captain Langford, a naval man. I am not certain whether the Langfords ever actually lived in the Fort or not but they came to Victoria at the very beginning of its being. Captain Langford built a log farmhouse six or seven miles out of town. The district was named for him.

Sometimes when Captain Lewis was away Mrs. Lewis invited me to stay with her for company. They lived on Belville Street, on the same side of James' Bay as we did, in a pretty cottage with flowers and canaries all over it. The windows overlooked the Harbour and Mrs. Lewis could watch the Captain's boat, the old paddle-wheel steamer, *Princess Louise*, go and come through the Harbour's mouth, and could wave to the Captain on his bridge. It was Captain Lewis who took me for my first trip by sea, and later, when the Railway was built to Nanaimo, for my first trip by rail. When you put your hand in his it was like being led about by a geography (he knew everywhere) and Mrs. Lewis was history. Seated at her feet before the fire among the dogs and cats, I listened open-mouthed to tales of early Fort days.

Mrs. Lewis was a good teller. She was pretty to watch. The little bunch of black curls pinned high at the back of her head bobbed as she talked and her eyes sparkled. She told how young Naval officers used to take the pretty Miss Langfords out riding. When they came to Goldstream and Millstream, which were bubbling rivers with steep banks, that crossed the Langford trails, the men would blindfold the girls' horses and lead them across the river, using as a bridge a couple of fallen logs. One night as they were hurrying along a narrow deer trail, trying to get home before dark, they saw a panther stretched out on the limb of a tree under which they must pass in single file. The bushes were too dense for them to turn aside, so each rider whipped his horse and made a dash along the trail under the panther.

Mrs. Lewis told, too, of the coming of their piano from England. It sailed all round Cape Horn and was the first piano to come into the Colony of British

Columbia. It landed at Esquimalt Harbour and was carried on the backs of Indians in relays of twenty at a time through a rough bush trail from Esquimalt to Langford. The tired Indians put the piano down in a field outside the house to rest a minute. The Langford girls rushed out with the key, unlocked and played the piano out there in the field. The Indians were very much astonished. They looked up into the sky and into the woods to see where the noise came from.

The stories jumped sharply out of Mrs. Lewis's mouth almost catching her breath, as she recalled vividly the excitement which these strange happenings had brought to her and to her sister, just out from their sheltered English life.

Sometimes Mrs. Cridge, Mrs. Mouat, Doctor Helmcken, or some of Sir James Douglas's daughters, all of whom had lived in the old Fort, would start chatting about old days and then we younger people would stand open-mouthed thinking it must have been grand to live those exciting experiences.

"It was, my dears," said Mrs. Cridge, "but remember too that there were lots of things to face, lots of things to do without, lots of hardships to go through."

I was a very small girl when the business men of Victoria chartered a steamer and, accompanied by their families, made a tour of Vancouver Island. It took the boat, the *Princess Louise*, ten days to go all round the Island. My Father and two of my sisters went. I was thought to be too small but I was not too small to drink in every word they said when they came back.

Father was overwhelmed by the terrific density of growth on the Island. Once when they were tied up for three hours he and another man took axes and tried to see how far they could penetrate into the woods in the given time. When the ship's whistle blew they were exhausted and dripping with sweat but their attack on the dense undergrowth scarcely showed. Father told of the magnificent trees, of their closeness to each other, of the strangling undergrowth, the great silence, the quantity of bald-headed eagles. "Really bald, Father?" I asked, but he said they were a rusty black all over except for white heads which shone out against the blue sky and the dark forest. Great white owls flew silently among the trees like ghosts, and, too, they had seen bears and whales.

One of my sisters was more interested in the passengers on the boat and made a lot of new friends. The other told me about the Indian villages where the boat had touched. This was all far more interesting to me than the stories people had to tell when they came back from trips to the Old Country, bragging about the great and venerable sights of the Old Land. I did not care much about old things. These wild, western things excited me tremendously. I did not long to go over to the Old World to see history, I wanted to see *now* what was out here in our West. I was glad Father and Mother had come as far as the West went before they stopped and settled down.

SALOONS AND ROADHOUSES

ON ALMOST every street corner in Victoria there was one saloon or more. There were saloons in the middle of every block as well.

I used to think that every saloon belonged to the Navy because sailors, wearing little boys' collars and wide trouser legs that flapped round their feet, rolled in and out of saloon doors at all times. These doors swung to noiselessly. They were only pinafore doors, made of slats and flapped to so quickly when a sailor went in or out that you never got a chance to see what it was they hid, not even if you were right in front when one was pushed open and nearly knocked you over. We were strictly forbidden to look at a saloon in passing. Grown-ups dragged you quickly past and told you to look up the street though there was nothing whatever to see there.

This made me long to know what was inside saloons. What was it that we were not supposed to see? Why was it naughty to twist your neck and look? You heard laughing and singing behind the swing doors. What did they do in there?

There were saloons, too, every few miles along the driving roads. These they called roadhouses. Each had two doors. Over one was written "Parlour", over the other, "Bar". These roadhouses were most attractive; they had verandahs with beautiful flower-boxes at the windows, filled with gay flowers and drooping, five-finger maidenhair fern. Very often they had cages of birds and of wild animals too. The Colonist Hotel in Beacon Hill Park had a panther on its verandah. The Four Mile House had a cage of raccoons. Another roadhouse had a baby bear and another a cage of owls.

Once when Aunt and Uncle were visiting us from San Francisco we took a long drive on a hot day. When we got to the top of the Four Mile Hill Uncle poked Father. Father ignored the poke and we passed the bar and drove to the bottom of the hill. Then Father dug the driver in the back and he pulled up his horses. Father, Uncle and the driver all toiled up the hill again on foot, leaving us sitting in the hack by the roadside. We children were allowed to get out and gather wild roses. I slipped behind the hack and started up the hill to have a look at the coons in the cage. Mother called me back. Auntie said something about "the unwholesome nosiness of little people".

I said, "I just wanted to see the little coons, Auntie."

"Pick some roses for Auntie," she ordered, but when I did she threw them

over the wheel. She said the dust on them made her sneeze.

Goodacre, the butcher, had a slaughter-house out on Cadboro Bay Road. Cattle and sheep were brought from the Mainland by boat and landed at the wharf in front of Father's store. They were then driven straight through the centre of the town, up Fort Street which, after it had gone straight in the town, wiggled and twisted and called itself "Cadboro Bay Road".

The wild range cattle were crazed with fright. They bellowed and plunged all over the sidewalk, hoofing up the yellow dust. Women ran to shut their gates before the cattle rushed in and trampled their gardens. All the way up the street doors banged and gates slammed as everyone hurried to shelter.

I had been to visit my sister who lived on Fort Street. I was to go home by myself as there was no one to fetch me that day. It was the first time I had been through town alone. When I was just opposite the Bee Hive Saloon a drove of these wild cattle came tearing up the street. They were almost on top of me before I knew what all the dust and shouting and bellowing was about. Men with long whips whooped, dogs barked, the street seemed to be waving up and down with the dull red movement of beasts' backs bumping through the dust. Suddenly I was snatched up in a pair of huge black arms, a black face was near mine. It had grinning white teeth. We backed through the swing door and I was inside a saloon at last. The big black man set me down on the bar. The barkeeper and the negro ran to the window to look over the painted green glass at the boiling tumult of cattle outside. I could only hear their bellowing and scuttling.

I looked around the Saloon. Shiny taps were beside me and behind the long counter-bar ran shelves full of bottles and sparkling glasses; behind them again was looking-glass so that there seemed to be twice as many bottles and twice as many glasses as there really were, and two barmen and two negroes and two me's! In the back half of the saloon were barrels and small wooden tables; chairs with round backs stood about the floor with their legs sunk in sawdust; bright brass spitoons were everywhere. The saloon was full of the smell of beer and of sawdust. There was nothing else, nothing that I could see to make anyone sing.

The noise moved on up the street. The two men returned to the bar. The barman poured something yellow into a glass and shoved it towards the negro who threw back his head and gulped it like medicine. Then he lifted me down, held the swing door open and I went out into the still unsettled, choking dust of Fort Street.

My big sister had a kind heart. Nothing pleased her more than to drive old, lame or tired people into the country. There was always some ailing person tucked up in her little phaeton being aired. All about Victoria were lovely drives—Admiral Road, Burnside, Cadboro Bay, Cedar Hill. The country roads were very dusty and dry, so every few miles there was a roadhouse with a bar for men and a watering trough for horses—ladies went thirsty. No lady could possibly be seen going into a bar even if only for a glass of water.

We bought a new horse called Benny. His former master had been accustomed to look in at every roadhouse bar. Benny knew them every one. If my sister were talking to her invalid passenger and not noticing, Benny swerved gently up to the bar door and stopped so dead it unsettled the ladies' bonnets.

When my sister saw where she was she would give Benny a cut with the whip which would send him dashing from the saloon at a guilty gallop, my sister sitting very red and crooked behind him. She was sure just then to meet someone whom she knew and be too upset to bow and then she had double shame.

WAYS OF
GETTING ROUND

BEYOND the few blocks of Victoria upon which the shops stood the roads were of dirt and had sidewalks of one, two or three planks according to the street's importance. A great many people kept cows to supply their own families with milk. When their own pasture field was eaten down they turned the cow into the street to browse on roadside grass along the edges of the open ditches, or to meander out to the grassy land on top of the cliffs off Dallas Road. Victoria cows preferred to walk on the plank sidewalks in winter rather than dirty their hooves in the mud by the roadside. They liked to tune their chews to the tap, tap, tap of their feet on the planks. Ladies challenged the right of way by opening and shutting their umbrellas in the cows' faces and shooing, but the cows only chewed harder and stood still. It was the woman-lady, not the lady-cow who had to take to the mud and get scratched by the wild rose bushes that grew between sidewalk and fence while she excursioned round the cow.

If people did not wish their flowers to be turned into milk it was up to them to fence their gardens. Father's property was very securely fenced and his cows were always kept within their own pastures. We had a painted fence in front of our property, tarred fences on the sides, and our field had a snake fence.

There was no way to get about young Victoria except on legs—either your own or a horse's. Those people who had a field, a barn, and a cow usually kept a horse too. The horses did not roam; they had to be kept handy for hitching. All the vehicles used were very English. Families with young children preferred a chaise, in which two people faced the horse and two the driver. These chaises were low and so heavy that the horse dragged, despondent and slow. The iron

tires made such a rumbling over the rough stony roads that it was difficult to hear conversation while travelling in a chaise especially when to the rumble was added the rattle of wheel spokes that had got over-dry and loosened. What you did then was to drive as deep as you dared into the first stream you knew of and let the chaise wheels soak, all the while encouraging the horse to go forward and back, turning the wheels in the water until they swelled again. You could not go into very deep water for fear of drowning the driver for the chaises were set so low that the driver sat right down among the wheel hubs. If children fell out of these low chaises they did not get hurt, only dusty. The horse stood so much higher than the driver that there was a tall iron rack in the front to hold the reins so that the horse could not swish his tail over them and pin the reins down so tight that he could not be guided.

Men preferred to drive in high, two-wheeled dogcarts in which passengers sat back to back and bumped each other's shoulder blades. The seat of the driver was two cushions higher than that of the other passengers. Men felt frightfully high and fine, perched up there cracking the whip over the horse's back and looking over the tops of their wives' hats. There were American buggies, too, with or without hoods which could be folded back like the top of a baby's pram.

In Victoria nobody was in a particular hurry to get anywhere—driving was done mostly for the pleasure of fresh air and scenery.

In town there were lots of livery stables where you could hire horses or could board your own. The smell of horse manure was so much a part of every street that it sat on your nose as comfortably as a pair of spectacles. Of course there were no livery stables among the drygoods, food, and chemists' shops. Every-where else you saw "Livery Stable" printed above wide, cool entries and heard horses chewing and stamping, and saw long rows of tails swishing out of stalls on either side of a plankway while ugly, square vehicles called hacks stood handy waiting for horses to be hitched to them. These hacks for hire were very stuffy. The town had one imported hansom-cab which thought itself very smart, and there was Mr. Winter's picnic carriage, a huge vehicle that held as many children as the Old Woman's Shoe. When its wide, circular back seat was crammed and more children were heaped on top of Mr. Winter up on his high driver's seat, and they were all yelling, and yellow dust rolling, and wheels rumbling, it looked and sounded like a beehive swarming. For immense affairs like Sunday School picnics and excursions there were yellow buses with long rows of win-dows, long wooden seats, uncushioned except for strips of carpet running from driver to door. They had no springs to speak of, and were so noisy that you could not hear your own groans being bumped out of you.

Victoria's baker and butcher boys delivered meat and bread on horse-back, carrying their loaves and joints in huge wicker baskets rested against their hips. As soon as they had one foot in the stirrup and while their other leg was still fly-ing in the air over the horse as he galloped off, they shouted "Giddap!" It was a wonder the boys did not grow crooked balancing such heavy baskets on their hips, but they did not—they were straight and strong. I used to wish I were a delivery boy to throw my leg across a horse and shout "Giddap!" to feel myself

rush through the air, but I should have preferred bread to meat in my basket.

The first time I knew that Victoria was slower than other towns was when, at the age of twelve, I was recovering from typhoid fever and a lady whom Mother knew, and whose two children had had typhoid in the same epidemic as I, took me along with her little girls for a trip to Puget Sound. It was my first visit to an American city and I felt giddy in the head from its rush. I heard Americans laugh and say "slow as Canadian" and call my town "sleepy old Victoria".

I heard one man say to another, "Went across the line this summer."

"Did eh? What sort of a place is Victoria?"

"Sleepiest ever!" laughed the first. "Every place of business had a notice up, 'Gone to lunch. Back in a couple of hours.'"

That was the first time I knew we were slow.

San Francisco was the biggest, the most important city on the Pacific Coast. It was a terrible trip in the small, bouncy steamer, down the rough coast. Victorians only went for something very, very important like a big operation or a complete change for health, to save their lives. Even then they stuck their noses up and said, "I am going across the line," or "going to the other side", as if the "other side" was an underneath and inferior side of the earth. But, if they had to have such an enormous operation that it was quite beyond Victoria's skill, then, rather than go all round the Horn back to England and either die before they got there or else get well and forget what the operation was for, they allowed San Francisco to "operate" them.

Americans dashed across the line sometimes to look at us Canadians and at British Columbia as if we had been dust-covered antiques. They thought English and Canadian people as slow and stupid as we thought the American people uncomfortable rushers—makers of jerry-built goods that fell to pieces in no time. We preferred to wait ages for our things to come by sailing ship round the Horn from England rather than to buy American goods. This annoyed the American manufacturers.

An aunt of ours in San Francisco sent us American dolls. They were much prettier than English dolls. The first that came were made of wax but they melted when we left them in the sun. Next Christmas she sent us bisque dolls, very lovely but too breakable to hug; we could not even kiss them but they cracked. We went back to our lovable old wood and china dolls that took their time to come to us all round the Horn, and, even if they were plain, they were substantial and could bear all the loving we gave them.

FATHER'S STORE

VICTORIA was like a lying-down cow, chewing. She had made one enormous effort of upheaval. She had hoisted herself from a Hudson's Bay Fort into a little town and there she paused, chewing the cud of imported fodder, afraid to crop the pastures of the new world for fear she might lose the good flavour of the old to which she was so deeply loyal. Her jaws went rolling on and on, long after there was nothing left to chew.

Government Street was the main street of the town. Fort Street crossed it and at the cross, in a little clump, stood most of the shops. On Yates, View and Broad Streets were a few lesser shops, several livery stables and a great many saloons. On Bastion Street stood the Courthouse and the Jail. Down on Wharf Street, facing the Harbour, were the wholesale houses. Fisgard, Cormorant and Johnson Streets were Chinatown. At the tail ends of all these streets were dwelling-houses set in gardens where people grew their own flowers and vegetables.

The rest of Victoria was higgledy-piggledy. It was the cows who laid out the town, at least that portion of it lying beyond the few main streets. Cow hooves hardened the mud into twisty lanes in their meanderings to and fro—people just followed in the cows' footsteps.

When the first settlers cut up their acreage, the resulting lots were all shapes and sizes. Owners made streets and lanes over the property anywhere that seemed convenient at the moment.

My father was a wholesale importer of provisions, wines and cigars. His store was down on Wharf Street among other wholesale places. The part of Wharf Street where Father's store stood had only one side. In front of the store was a great hole where the bank of the shoreline had been dug out to build wharves and sheds. You could look over the top of these to the Songhees Indian Reserve on the opposite side of the Harbour. To one side of the hole stood the Hudson's Bay Company's store—a long, low building of red brick with a verandah. The Indians came across the Harbour in their dugout canoes to trade at the store. They squatted on the verandah, discussing new-bought goods, or their bare feet pattered up and down the board walks of Wharf Street. They were dressed in gay print dresses, plaid shawls and bright head handkerchiefs. Once I saw Father's man take out case after case of beautiful cluster Malaga raisins and pour them into the outspread shawls and handkerchiefs of the jabbering Indians, who

held out their hands and stuffed their mouths, giving grunts of delight.

I asked Father, "Why do you give all these raisins to the Indians?"

He replied, "They are maggoty, the whole lot of them—but Indians love raisins and don't mind maggots at all."

At the opposite side of the Wharf Street hole stood the Customs House, close to the water's edge. Made of red brick, it was three storeys high and quite square. The Customs House steps were very dignified—high and widespread at the bottom. Underneath the steps was the Gregorys' door.

Gregory was an Old Country gardener. His wife was very homesick as well as really ill. The Gregorys were the caretakers of the Customs House. In front of their rooms they had a beautiful little garden, sheltered by a brick wall. Sometimes Mother sent Mrs. Gregory things and Mrs. Gregory gave us beautiful posies of flowers in exchange. On the lower floor of the Customs House, where the Gregorys had their quarters, there was a wide hall which ran straight through the building. The wind roared down this passage from a great doorway opening onto the Harbour. Furious that the Gregorys' door under the steps was not big enough to let it all out at once, it pounded and bellowed at all the doors down the hall as it passed them. The waves came dashing up the slip and rushed through the door and into the hall. I used to think that ships sailed right into the Gregorys' hall-way to do their customs business and I begged to go to see Mrs. Gregory on any excuse whatever, always hoping to meet a ship sailing down the hall-way. I was much disappointed that I never struck a tide high enough to bring a ship in. Once I thought I was going to but when no more than two waves had washed in through the great doors Mr. Gregory rushed out, shut and barred them.

The inside of Father's store was deep and dark. Cases, crates, and barrels stood piled on top of another right up to the ceiling, with just a narrow lane running down the middle and ending in what was called "the yard"—not a yard at all, only a strong, rough board shed filled with "empties" and cats. There were no windows; the cats, crawled in and out of the "empties" hunting for rats, their eyes shining in the black. Slits of daylight cut between the boards of the shed walls, and shadows thrown by a sputtering gas jet made it all spooky and unreal—different from the solid, comfortable feel of the outer store crammed with provisions.

Father had every colour of cat. He took fresh milk in a bottle from home every morning to them; he said a diet of straight rat was not healthy for cats. Only one of them was a comfortable, particular cat and came to sit by the stove in Father's office. The rest were just wholesale cats.

Father's office was beside the open front of his big store and in it Father sat in front of a large, square table covered with green baize; on it in front of him was a cupboard full of drawers and pigeon-holes. He sat in a high-backed wicker armchair. His beard was white and, after he went bald, he wore a black skull cap. A fat round stove, nearly always red hot, was between Father's table and the long, high desk where his men stood or sat on high stools doing their books when they were not trundling boxes on a truck. There was an iron safe in

one corner of the office with a letter press on top and there were two yellow chairs for customers to sit on while Father wrote their orders in his book. Everything was dozened in Father's store: his was not a business that sold things by pinches in paper bags. High along the wall ran four long shelves holding glass jars of sample English sweets—all pure, all wholesome, all English. The labels said so.

NEW NEIGHBOURS

AS I FIRST remember it, James' Bay district had many fields and plenty of wooded land left, but houses began to creep nearer and nearer to ours and the fields were being cut up into town lots. I was very sorry when Bishop Cridge's big, wild field opposite us was sold. The Bishop's house sat back in the little bit of wood with an orchard and two fields. His driveway curved and had laurels and little bushes of yellow roses all the way up. We children used to play "ladies" in the Bishop's wild field with his three little girls. Being the youngest of the six children I could never be a "lady"—I had always to be "bad child", while the play mothers fed me on green gooseberries, wild and very sour.

The Bishop's house was built some time after Father's. The street was very narrow and in that one long block from Toronto to Simcoe Street there was only his house and ours. Father gave a good strip of his land to make the street wider; so the City named it Carr Street after Father. Carr Street would have joined Birdcage Walk if Mrs. McConnell's cow farm had not stood in the way, and Birdcage Walk would have been Government Street if the James' Bay Bridge had not been there to get people over the mud flats. After many years Government Street swallowed them up—James' Bay Bridge, Carr Street and Birdcage Walk—and went straight out to Dallas Road.

One day when we were playing "ladies" in the Bishop's field and I, the "baby", was being hidden in the bushes from the ferocious wild beast which ate children but which was really the Bishop's gentle cow "Colie", some men climbed over the fence. They had instruments on three legs which they sat beside the road and squinted through. They came right into our mock-orange parlour and our gooseberry-bush dining-room. They swept the tin cans which had furnished our kitchen from our own particular log and sat down upon it and wrote in little books. They even tore pickets off the fence. The cow was taken to another enclosure, wagons dumped lumber and bricks all over the field. Soon real houses stood on top of our pretend ones, real ladies smacked real babies and pushed prams right on top of where our fun had been, and Mother

was sending us across to ask if the new neighbour would like pots of tea or anything till her own stove was up.

VISITING MATRONS

VICTORIA matrons did not fritter away their time in the paying of short calls. They had large families. The Chinese help could not be left in charge of the nursery while the mothers went visiting. So when they came to call, they brought their family along and stayed. Besides, unless people had a horse, there was no way of getting about other than on foot. So ladies took their families of young children along, packing the baby into the pram, wedging him in firmly with feeding bottles, infant necessities, a bag of needlework and the mother's little lace cap in a paper bag. After an early lunch they started immediately, prepared to make a day of it. The visit had been planned between the two ladies a long time ahead, weather permitting.

Average ladies had six children. When a family visited us the eldest wheeled the youngest in the pram. They all trooped through our gate. First the baby was exhibited, fed and put to sleep. Then the visitor took off her bonnet and put on her cap. The children dispersed to see dolls, pets and eat enormous quantities of fruit picked right off the trees. Our visitors were always very anxious about their families when they heard of all the plums, apples, cherries and pears they had eaten while the ladies sat sewing in the garden. Mother told them not to worry and none of them ever died of it. Mother knew a certain number of families whom she invited to our garden for one long summer afternoon every year.

My big sister used to visit a friend who had three little girls the same ages as we three. We played with them while the ladies visited in the drawing-room.

Those children had all the things we did not, and we had what they did not. They lived on the waters of the Arm and had a boat. They had a pony and a big kennel of hunting dogs. Their Mama was stern and their Papa easy; *our* Father was stern, our Mother easy. Our garden was prim and theirs rambling.

Those friends were as far from town on the other side as we were from town on our side. There were two bridges to cross and ever so many different kinds of smells to pass through. From our own gate to the James' Bay Bridge wild rose bushes grew at the roadsides nearly all the way and their perfume was delicious. Then we came to the mud flats and our noses hurt with its dreadfulness when the tide was out. We had no sooner got over that than there was Chinatown with stuffy, foreign smells. Then came the gas-works—this smell was said to be healthful but it was not nice. Rock Bay Bridge had more low-tide smells, which

were made easier by a sawmill; the new sawdust smelled so nice that you forgot your nose until the other end of the bridge came. There sat a tannery from which came, I thought, the worst smell of them all. There was one still more dreadful—Parker's slaughter-house and piggery—but that was two miles further on and we did not have to pass it on the way to call on our friends.

Sometimes our friends rowed us down to James' Bay Bridge in their boat and we slipped past all the smells and were home in no time.

In early Victoria there were family evening parties in which the father, mother and all sizes of growing children went together and at which they played charades, dumb crambo, guessing games and forfeits. There was music, too, for nearly everyone could play at least one piece on the piano or sing a song or do a recitation, or they did things together. Nobody minded if it was not quite perfect. Everyone laughed just the same. Everyone helped to entertain the others and you did some trick or told a story if you could not sing. My two big sisters went to Navy balls occasionally, but Father did not approve of the way Victoria mothers scrambled among the Navy to find husbands for their daughters. He was very strict; he had made a nice home for us and thought we should stay in it.

Another form of young Victoria entertainment was the church conversazione. The Bishop opened, shut and blessed the affair but the congregation did the talking. Conversaziones were held in the church schoolroom which the ladies cut into little cubicles with benches—three sitting sides and one open. The benches were just close enough for one lady's lips to reach across confidentially to the opposite lady's ear. There was music for people who were not chatty and when everything had been done and encored tea was served. Young girls carried it to the cubicles. Both sexes and all ages came to conversaziones. You had to pay only two bits, which was twenty-five cents, for all the talking, listening, music, tea and the Bishop's blessing.

Presbyterians had what were called church socials but, as they were held in the church itself, personal conversation was very restricted. Dr. Reid told stories from the pulpit, there was choir singing and no tea.

As Victoria grew bigger, social groups grew smaller, selecting only those people who were congenial to each other. They became too a great deal more particular about the ability of performers and the quality of entertainment. Victoria stood like a gawky girl, waiting, waiting to be a grown-up city.

SERVANTS

WHAT WITH big families and only green little Chinese boys for servants, Victoria matrons were kept busy. The boys came from China at the age of twelve. It took much patience to teach these foreign children our language as well as how to work.

English servants who came out to Canada did so with the firm determination of finding a husband in a hurry and of making homes and raising families who would be not servants but masters. While waiting for the husbands these women accepted positions, grumbling from morning till night at the inconveniences of the West. There were hosts of bachelors trying to make good in this new world—men who were only too willing to marry a helpmate. Love did not much matter if she was competent and these women in their turn were glad enough to go through drudgery and hardship if they were working for themselves and for their own independence. Man and wife each got something from the bargain and pushed forward, keeping step choppily, getting used to each other's gait. While these imported-from-England domestics were creating a class to put themselves into, Victoria ladies made do with raw, neat pigtailed, homesick China boys. Many a muddly housewife, accustomed to good servants in the Old Country, had first herself to learn how to run a house before she could teach her Chinese help.

The Chinese all wore clothes cut from exactly the same pattern—long black pants, loose white shirts worn outside the pants, white socks and aprons, cloth shoes with soles an inch thick and no heels. They scuffed along with a little dragging slip-slop sound.

The Chinese kept themselves entirely to themselves like rain drops rolling down new paint—learning our ways, keeping their own. When their work was done they put on black cloth coats made the same shape as their white shirts, let the pigtail which had been wound round their heads all day drop down their backs, and off they went to Chinatown to be completely Chinese till the next morning. They learned just enough of our Canadian ways to earn Canadian money—no more.

Our Chinaboy, Bong, was not pretty—he was pock-marked; but Bong was a good boy and was part of our childhood. He came to Mother at the age of twelve, green and homesick, without one word of English. When things were more than Bong could bear he sat down and cried. Then Mother patted his

shoulder as if he had been one of her own children and said, "Come on, Bong, be a good boy," and Bong would rub his big sleeve across his eyes, run out to the barn and sing a little Chinese song to the cow. The cow was a great comfort to Bong. She would stop chewing, roll back her ears and listen to the Chinese words as if she understood them. Bong loved her.

Bong stayed with us for many years. We were all as fond of him as one could be of anything holding itself so completely aloof. He seemed really to love my little brother. When Bong went back to China to see his mother, he left a hole in our kitchen and a hole in the cow yard, queer, foreign holes, belonging and not belonging to us, for Bong never had become one bit Canadian in all the years he worked for us in Canada.

There was Wash Mary too, an Indian woman who came to wash for Mother every Monday. She was gentle, had a crinkled-up skin and was so small she had to stand on a block to reach her washtub. The Indian in Mary was more human and understandable than the Chinese in Bong.

The wash-house was across the yard. First Mary lit the stove; then she hung her shawl up on a nail and there was her thin, lumpy little body, buttoned into a pink print dress with a very full skirt reaching right to her bare feet. But her clothes were western, not eastern like Bong's. She took off the black silk handkerchief that bound her head. Her hair, thick and black, stood up from both sides of the parting that began at her forehead and ended at the back of her neck. On each side the hair was roped into a thick plait. The right plait had nothing to do with the left till after it had reached and rested on her shoulder blades; then the plaits were united again, tied together with a bit of string and looped across Mary's shoulders like a strong, splendid handle.

Mary was a wonderful washer. The suds boiled up to her shoulders and the steam about her faded the wrinkles till she looked almost young. Up and down, up and down, she went over her washboard, her brown eyes staring and her mouth tied up in puckers. It was a big mouth that could hold six clothes pins at once. After our lines were full of washing and Mother's clothes white as snow, and after Mary had enjoyed a good dinner in our kitchen, she shut herself into the wash-house and washed and dried all the clothes she wore, drying them quickly over the fire. Then she knotted her dollar into the corner of her new-washed handkerchief and went smiling out of the gate.

Mary was not a Songhees Indian. She lived in a little house in Fairfield.

E AST AND WEST

CHINAMAN and Indian played a very real part in young Victoria.

The Chinaman shuffled along in heelless shoes with his vegetable or fish baskets swinging. He peddled his wares with few words. The Indian's naked feet fell pat-pat upon the earth roads. It was the Chinese man but the Indian woman who shouldered the burden. The Chinaman's wife was back home in China. The Indian rolled leisurely and with empty hands, behind his squaw. A cedar-root burden basket of her own weaving was slung across the woman's back, steadied by a woven pack strap worn across the chest. Women of some tribes wore the strap across their foreheads, pushing their heads forward against the burden's weight.

The Indian squatted upon each doorstep to rest. The Chinaman never rested—he kept up his mechanical jog-trot all day. He lived frugally, sending the earnings of his brown, calloused hands and his sweating toil home to China. The Indian wasted no sweat on labour—he took from nature those things which came easiest. What money he earned he spent in the nearest store immediately, exchanging it for whatever pleased his eye or his stomach. The Indian's money circulated; he had no idea of its value nor of saving it. The satisfying of immediate needs was enough for him. To our sombre landscape his careless picturesqueness was an enrichment. He was the link between the primitive and civilization. Unlike the Chinese vegetable gardener who forced the land to produce so that he might make money from it, money to send back to China, taking the land's goodness, not caring to put anything back, the native Indian sat staring, enjoying leaving Nature to do her own work while he got along with a minimum of exertion and a great deal of happiness.

The white man more or less understood the childlike Indian; he belonged to his own hemisphere. The Oriental eluded him.

A C U P O F T E A

ONE NIGHT an Indian family beached their canoe on the shore below Cook Street. Indians were allowed to pitch a tent and remain the night on any beach during their long canoe journeys up and down the Coast.

This party of Indians was coming to Victoria but there was no hurry, the waves were high and night came down. The canoe contained the family and all they owned. There was a man, a woman, three children, one dog, two cats, a crate of fowls, besides a tent, bedding, cooking utensils, fishing gear, clothes and odd bits of hoarded possessions gleaned from Nature's bounty or from man's discards.

They flung an old tent across a conveniently low willow bough that stuck out of the bank. The unpegged sides of the tent flapped and billowed in the wind, rain drizzled. They tossed the bedding under the tent. The man, dog and cats crept at once into its cosiness.

The woman and children huddled round a low beach fire, tending the black iron cooking-pot and the tall tin for the brewing of tea. A sleeping child was tucked among the shapeless folds of the woman's motherliness, under her shawl. The movement of her arms across his sleeping body did not disturb him when she mended the fire. She was tired with his heaviness and from the sweep of her paddle all day long. She yawned, lolled back against a log and swept the bay with eyes used to judging what wind and waves were up to. Suddenly she called to her man; a lazy hand raised the canvas. The man followed with screwed-up eyes the woman's pointing finger.

Out in the bay a lone Chinaman in a clumsy fish-boat was wrestling with his sail. The unwieldy craft lay over first to one side, then to the other, her sail almost flat to the water. That the man in her did not tip out was a marvel.

The Indian man and woman left their fire and their supper. Waddling across the pebbles, they launched the heavy canoe. The woman laid her baby in the bow, close under the canoe's wolf-head prow, while she did a full share of the shoving and grunting necessary to launch the craft. It was she who stepped into the icy water to give the final freeing push, then she got into the canoe which was already staggering among the waves. She took her steering paddle and directed the canoe how to cut each wave. The man doggedly dipped, dipped, dipped his paddle, giving force, but not guidance.

They helped the Chinaman to ship his sail and clamber into their canoe.

They brought him ashore, towing his boat behind them.

The Chinaman's face was a greenish mask; nervous grins of gratitude were strewn over it. He sat himself uncomfortably on a log near the Indians' fire. They squatted round their fish pot, dog and cats skulked near, hoping. The man dipped, the woman and the children dipped. The Chinaman dipped but, too embarrassed, ate sparingly. No words were spoken. The only sound was that of clams being sucked from their shell and the brittle rap of the empties flung among the stones.

The woman poured tea into a tin cup and passed it to the Chinaman. The sham grin left the man's face, his Oriental mask dropped. Bowing to the woman, he raised the steaming liquid to his lips, made a kissing sound into the tea and sluiced its warmth noisily into every corner of his mouth before the great gulps gurgled down his throat. The woman nodded.

"Uh-huh!" she said, and smiled.

CATHEDRAL

CHRIST CHURCH CATHEDRAL sat on the top of Church Hill. The Hill sloped gently to the town on its north side and sharply down to James' Bay on the south, with shelves and sheer drops where rock had been blasted out for road-making.

A French family by the name of Jourand built Roccabella, a large boarding-house on the south side of Church Hill just below the Cathedral. It had a beautiful garden and was a quietly superior place in which to stay, holding its own even after modern conveniences in other boarding-houses overtook its level, clinging to its little open fireplaces and defying central heating. English guests particularly favoured Roccabella. They liked the sound of the Cathedral bells that came quavering in through their windows. They liked to sit by their own particular fire and to look across James' Bay to the snowy Olympics.

The first Cathedral was burned down. The one I remember was built of wood and had a square tower with a cross on top. As Victoria grew they kept adding wings and more wings to the Cathedral till it looked squat and mother-hennish. Brick and stone churches sprang up in other parts of the city but the national significance of the old wooden Cathedral, sitting on the top of its hill, made it, in comparison with the others, like the star on top of a Christmas tree. The tree's other ornaments seemed mere baubles. Christ Church Cathedral was the emblem of our National Faith. It meant something to every Briton, whether he realized it or not, whether he were Methodist, Presbyterian, Roman Catholic, no matter what he worshipped, even if he professed no religion at all. There was

something particularly British, something secure about it.

Our family did not attend Christ Church Cathedral. Mother went to the Reformed Episcopal Church on Humboldt Street. Church Hill was too steep for her to climb and anyways she liked the evangelical service.

Bishop Cridge of the Reformed Episcopal Church had once been Dean of the Cathedral, but, long before I can remember, he and Bishop Hills had had a bitter clash of conscience—"High" and "Low", that same old controversy that never will be settled while people are people. Spiteful folks spoke of this church split as "the Big Church kicking the Little Church down the hill." The little church smiled up from the mud flats, the Cathedral frowned down, austere and national, and Victorians chose High or Low, whichever comforted them most.

CEMETERY

THE FIRST cemetery that I can remember was on Quadra Street. It was only one-half block big and was already nearly full when we went through it coming from church one Sunday morning. It had a picket fence and was surrounded by tall, pale trees whose leaves had silver backs. Except for what care relatives gave the graves, it was a wild place, grave being tied to grave by a network of brambles and vines. There were one or two handsome headstones among the mat of wild and tame, flowers and weeds—interwoven growth. It was a favourite nesting place for the few shy birds that were native to British Columbia.

On the far side of the cemetery the Chinese had erected a great stone altar on which they placed whole pigs roasted and great piles of white cakes, looking like pure grease, to please the appetites of their dead who lay in rows in front of unpainted headboards with only Chinese characters written on them. The graves were as much alike as the Chinese themselves had been in clothes, pigtails and customs in life. There those foreigners lay, temporarily pitted, like winter vegetables. When there were bones enough they would all be gathered together from the graves and shipped back to China.

When the old Quadra Cemetery was quite full, its gates were closed and it was left to go entirely wild. Only the very tallest monuments could peer above the bushes. They seemed to say, "Hush!" as we children clattered past on our way to school.

Victoria had made a big new cemetery at Ross Bay, much farther out of town. Funerals took far longer then. The horses were not allowed to go faster than a walk as long as the corpse was behind them. They might trot as briskly as

they liked back to town with the empty hearse behind them. Hayward's hearse had six enormous black plumes waving over the top of it. They swayed and writhed and were considered most dignified and in very good taste. Mr. Storey, the rival undertaker, had a hearse with six fuzzy black things on top having waists like the forms dressmakers used for fitting; they had woolly tails hanging down all round, waggling and lashing as the hearse went over the bumpy roads. They looked like six angry monkeys dancing over the coffin. Crêpe streamed from the hats of the undertaker, the driver, the widows' bonnets, the carriage whips and the knobs of the house doors where death waited for the hearse. The horses that dragged the dead were black and wore black plumes nodding on the top of their heads, black nets over their backs with drooping mournful fringes that ended in tassels tumbling over the shafts. Dead children had a little white hearse with white ponies and white nets and plumes. Funerals were made as slow and nodding and mournful as possible.

Every friend of the dead who owned a chaise or buggy and some hired hacks joined in the procession. Nobody thought of crossing the path of a funeral; people stood holding their hats in their hands with heads bowed patiently until the procession had passed. People drew down their front blinds as a funeral passed their houses. In Victoria the dead were buried as leisurely as the living lived.

The first graves in Ross Bay Cemetery looked very lonely and far apart, because Episcopalians could not lie beside Nonconformists, nor could Catholics rest beside Episcopalians. Methodists, Chinese, paupers buried by the City and people who believed in nothing at all, had to lie each in a separate part of the cemetery.

There were wide, gravelled driveways among the graves. Some of the graves were like little, low-walled gardens filled with flowers. This cemetery had a gravekeeper who kept the graves from getting muddled together with weeds and brambles.

But the waves of Ross Bay boomed against the cemetery bank and broke it. They bit into the earth, trying to wash out the coffins. They seemed to say, "I, the sea, can take better care of you, the dead, than the earth can. My gulls will cry over all of you alike. In me all denominations can mingle."

SCHOOLS

IT TOOK a generation and a half for English settlers in Victoria to accept the Canadian public school which they insisted on calling the "free school". They turned their noses up at our public schools as if they had been bad smells, preferring to send their children to old, ultra-genteel-hard-up English Ladies' Academies. Of these there were quite a few in Victoria; in them learning was confined to good manners. Politeness-education ladies had migrated to Canada, often in the hope of picking up bread and butter and possibly a husband, though they pretended all the while that they had come out on a very special mission—to teach the young of English-born gentlemen how not to become Canadian, to believe that all niceness and goodness came from ancestors and could have nothing to do with the wonderful new land, how not to acquire Colonial deportment, which was looked upon as crude, almost wicked. The only teaching qualifications these ladies possessed, and for their services they charged enormously, had been acquired by generations of habit.

So young ladies whose papas had sufficient means learned English manners—how to shut a door, how to bow gracefully, how to address people of their own class and how a servant, how to write a dignified letter in beautiful script, how to hold their heads up, their stomachs in and how to look down their noses at the right moment. For all this the old ladies were very handsomely remunerated and the girls' brains remained quite empty. Canadian public schools taught book learning but no manners to speak of.

My parents sent their two eldest daughters to a Ladies' Deportment Academy. Their next three children died before they were of school age. We four younger children were sent to the Public School. Father said we could "learn manners at home", but we could not get education in those days at the private school out west.

Later, Angela College, a Church School for girls, was built and endowed by Lady Burdett-Coutts. A red brick building, it stood on Church Hill. Education in it was costly. All our friends went to Angela College, but Father was by this time so prejudiced against private schools that he sent us to the Public School and was very much criticized for doing so. Our manners were watched closely and apprehensively by our friends. It hurt Mother but Father was proud that all his children, with the exception of me, were good students by Canadian standards. I hated school with the exception of the first two years when, being too

young for so long a walk, I went to Mrs. Fraser's school for little girls near our own house.

Mrs. Fraser had large white teeth, a great many little dogs and a brother, Lennie, who kept house for her while she taught school. We sneaked potatoes out of Lennie's fry-pan as we trooped through the lean-to kitchen so as not to track dirt into Mrs. Fraser's front hall. The dunce stool was very comfortable—much more so than the wooden forms where the good pupils sat; I had ample opportunity of knowing. You could almost say the dunce's stool was specially mine.

The thing that I loved best at Mrs. Fraser's school was a big book of *Grimm's Fairy Tales* owned by a girl called Lizzie. At lunch time out in the mint bed in the backyard we went fairy and under the school desk when Mrs. Fraser was busy with a sick dog or a pupil's mama we seized other snatches.

By and by other English settlers began to send their children to the Public School and the High School too; then that old ladies' type of private school faded out of existence because education required a certain standard set by our Public School system if people expected to obtain positions in Canada.

Those families who were able to send their sons and daughters to England to be "finished" did so. They came back more exaggeratedly English than the English themselves, "patering" and "matering" their father and mother, saying "Awfully jolly, don't you know!" and "No, not rawlly!" At first it seemed to us Canadians as if that "No" meant "You lie!" By and by, however, we found that it was only an English elegance in vogue just then.

CHRISTMAS

VICTORIA Christmas weather was always nippy—generally there was snow. We sewed presents for weeks before Christmas came—kettle holders, needle books, penwipers and cross-stitch bookmarkers. Just before Christmas we went out into the woods, cut down a fir tree and brought it home so alive still that the warm house fooled it into thinking spring had come, and it breathed delicious live pine smell all over the house. We put fir and holly behind all the pictures and on the mantelpiece and everywhere.

Plum puddings were dangling from under the pantry shelf by the tails of their boiling cloths. A month ago we had all sat round the breakfast-room table, stoning raisins while someone read a story aloud. Everyone had given the pudding a good-luck stir before it went into the bowls and was tied down and boiled for hours in the copper wash boiler while spicy smells ran all over the

house. On Christmas Day the biggest pudding came out for a final boil before being brought to the table with brandy fire leaping up its sides from the dish, and with a sprig of holly scorching and crackling on its top.

Christmas Eve Father took us into town to see the shops lit up. Every lamp post had a fir tree tied to it—not corpsy old trees but fresh cut firs. Victoria streets were dark; this made the shops look all the brighter. Windows were decorated with mock snow made of cotton wool and diamond dust. Drygoods shops did not have much that was Christmassy to display except red flannel and rabbit fur baby coats and muffs and tippets. Chemists had immense globes of red, green and blue medicine hanging from brass chains in their shop windows. I wished some of us could be sick enough for Dr. Helmcken to prescribe one of the splendid globes for us. The chemists also showed coloured soap and fancy perfume in bottles. Castor oil in hideous blue bottles peered from behind nice Christmas things and threw out hints about over-eating and stomach-ache. A horrid woman once told my mother that she let her children eat everything they wanted on Christmas Day and finished them up with a big dose of castor oil. Mr. Hibben, the stationer, was nicer than that woman and the chemist. He hid all the school books behind story books left open at the best pictures. He had "Merry Christmas" in cotton wool on red cardboard in his window.

It was the food shops that Merry Christmassed the hardest. In Mr. Saunders', the grocer's, window was a real Santa Claus grinding coffee. The wheel was bigger than he was. He had a long beard and moved his hands and his head. As the wheel went round the coffee beans went in, got ground, and came out, smell and all. In the window all round Santa were bonbons, cluster raisins, nuts and candied fruit, besides long walking-sticks made of peppermint candy. Next to this splendid window came Goodacre's horrible butcher shop—everything in it dead and naked. Dead geese and turkeys waggled, head down; dead beeves, calves and pigs straddled between immense meat hooks on the walls; naked sheep had bunches of coloured paper where their heads ought to have been and flowers and squiggles carved in the fat of their backs. Creatures that still had their heads on stared out of eyes like poached eggs when the white has run over the yolk. Baby pigs looked worst of all—pink and naked as bathing babies, their cheeks drawn back to make them smile at the red apples which had been forced into their toothless, sucking mouths. The shop floor was strewn deep in sawdust to catch blood drips. You heard no footsteps in the shop, only the sharpening of knives, sawing of bones, and bump, bump of the scale. Everybody was examining meat and saying, "Compliments of the Season" to everyone else, Father saying, "Fine display, Goodacre, very fine indeed!" We children rushed out and went back to Santa while Father chose his meat.

The shop of old George, the poulterer, was nearly as bad as Goodacre's, only the dead things did not look so dead, nor stare so hard, having shut the grey lids over their eyes to die. They were limp in necks and stiff in legs. As most of them had feathers on they looked like birds still, whereas the butcher's creatures had been rushed at once from life to meat.

The food shops ended the town, and after that came Johnson Street and

Chinatown, which was full of black night. Here we turned back towards James' Bay, ready for bed.

There was a high mantelpiece in the breakfast room. And while we were hanging our stockings from it my sister read:

" 'Twas the night before Christmas and all through the house

Not a creature was stirring, not even a mouse."

On the way to bed we could smell our Christmas tree waiting in the dining-room. The room was all dark but we knew that it stood on the floor and touched the ceiling and that it hung heavy with presents, ready for tomorrow. When the lights were lit there would be more of them than any of us children could count. We would all take hands and sing carols round the tree; Bong would come in and look with his mouth open. There was always things on it for him but he would not wait to get his presents. He would run back to his kitchen and we would take them to him there. It seemed as if Bong felt too Chinese to Christmas with us in our Canadian way.

The Presbyterian Church did not have service on Christmas morning so we went to the Reformed Episcopal with my sister; Father stayed home with Mother.

All the week before Christmas we had been in and out of a sort of hole under the Reformed Church, sewing twigs of pine onto long strips of brown paper. These were to be put round the church windows, which were very high. It was cold under the church and badly lighted. We all sneezed and hunted round for old boards to put beneath our feet on the earth floor under the table where we sat pricking ourselves with holly, and getting stuck up with pine gum. The pricking made the ladies' words sharp—that and their sniffy colds and remembering all the work to be done at home. Everything unusual was fun for us children. We felt important helping to decorate the Church.

Present-giving was only done to members in one's immediate family. Others you gave love and a card to, and kissed the people you did not usually kiss.

New Year's Day had excitement too. It was the custom for ladies to stay at home, sitting in their drawing-rooms with decanters of wine and fine cakes handy. Gentlemen called to wish them the "Compliments of the Season". Right after lunch we went up to Mother's room where you could see farthest down the street, to watch for Mother's first caller, and it was always the shy Cameron brothers, coming very early so as to avoid other visitors.

Gentlemen paid their respects at Government House, too, on New Year's Day, and Naval officers made a point of returning the hospitality of those who had entertained them while stationed in Victoria.

REGATTA

THE BEAUTIFUL Gorge waters were smooth as glass once Victoria Harbour had been crossed. The Gorge was an arm of the sea which ran into the land for three miles. Near its head was a narrow rocky pass with a hidden rock in the centre which capsized many a canoe and marooned many a picnic party above the Gorge until long after midnight, for when the tide was running in or out through the pass there was a four-foot fall with foam and great roaring. A bridge ran across from one side of the Gorge to the other, high above the water. The banks on both sides of the Arm were heavily wooded; a few fine homes snuggled among the trees and had gardens running to the water. Most of the other property was public—anyone could picnic on it.

The waters of the Gorge were much warmer than the water of the beaches round Victoria. Jones' Boathouse beside James' Bay Bridge rented out boats and canoes; many people living along the harbour front had boathouses and boats of their own, for regattas and water sports were one of Victoria's chief attractions. Visitors came from Vancouver and from the States on the 24th of May to see them.

The Navy and the Indian tribes up and down the Coast took part in the races, the Navy rowing their heavy ship's boats round from Esquimalt Harbour, manned by blue-jackets, while smart little pinnaces "pip-pipped" along commanded by young midshipmen. The Indians came from long distances in their slender, racing dugout canoes—ten paddles and a steersman to each canoe.

The harbour was gay with flags. Races started from the Gorge Bridge at 1 P.M. Our family went to the Regatta with Mr. and Mrs. Bales. Mr. Bales had a shipyard just below Point Ellice Bridge, at the beginning of the Arm waters. We got into Mr. Bales' boat at the shipyard where unfinished boats stood all round us just above high tide. They looked as we felt when we shivered in our night-gowns on Beacon Hill beaches waiting for the courage to dip into the sea. But rosy-faced Mr. Bales eased his boats gently into the water; he did not seize and duck them as my big sister did us.

When the picnic was all stowed into Mr. Bales' boat we pushed out into the stream and joined the others—sail boats, canoes, rafts and fish boats, all nosing their way up the Gorge along with the naval boats and war canoes. There were bands and mouth-organs, concertinas and flags. The Indian families in their canoes glided very quietly except for an occasional yapping from one of their

dogs when he saw a foe in another canoe.

There was the hollow rumble of traffic over Point Ellice Bridge as we passed under it. Dust sprinkled down between the planks and fell on us. Out-of-town people came to the Regatta in wagons and buggies, driving up the Gorge Road on one side of the Arm or the Craigflower Road on the other side, tying their horses in the bush and carrying their picnic baskets through the woods to the shore. People lit small fires and picnicked near the water's edge where they could see the races pass.

The races started from the Gorge Bridge, came down the Arm, turned round Deadman's Island, an old Indian burial ground, and returned to the bridge.

The Indian canoe races were the most exciting of all the Regatta. Ten paddles dipped as one paddle, ten men bent as one man, while the steersman kept time for them with grunting bows. The men had bright coloured shirts and gay head-bands; some even had painted faces. The Kloochman's was an even grander race than the Indian men's. Solid, earnest women with gay shawls wound round their middles gave every scrap of themselves to the canoe; it came alive and darted through the water like a flash, foam following the paddles. The dips, heaves and grunts of all the women were only one dip, heave and grunt. Watchers from the banks yelled; the Indians watched from their canoes by the shore, with an intent, silent stare.

The Bluejacket Races were fine, too. Each boat was like a stout, brave monster, enduring and reliable—the powerful, measured strokes of the British Navy, sure and unerring as the earth itself, not like the cranky war canoes, flashing through their races like running fire.

At the end of the Regatta came something mean and cruel. An old hulk was towed to midstream; a long pole hung over the water at one end of her, and, suspended from its tip, was a crate crammed full of agonized pig squeals. The pole was greased and men tried to walk out to the end of it and dislodge the crate. The pole was supple, the crate swayed as each man crept out clinging desperately and finally fell off into the sea. The terrified pig in the crate squealed. People roared with laughter and greasers applied fresh grease for the next person's try. When at last a man was successful and with a great splash crate and pig plunged into the sea, sailors hurried to pull it into a boat before the poor pig drowned.

The band blared, "God Save The Queen" and everyone on the banks and in the boats raised their hats and sang with the band. "Queen! Queen!" echoed back from the trees and the rocks.

The wet, shivering pig in his crate did not care whether the Queen were saved or not. "God save *me!*" was his imploring squeal.

CHARACTERS

STRANGE characters came to little Victoria. It seemed as if people who could not fit in anywhere else arrived here sooner or later till Victoria poked, bulged and hollowed over queer shapes of strange people, as a snake, swallowing its food whole, looks lumpy during digestion. Victoria had some hard lumps to digest.

Sometimes they came, hurried by a firm push from behind given by relatives in the Old Country, around whose necks they had hung too heavily for many years, and who said, "Now that travel is so easy, why not, dear? . . . Door to door without a stop! . . . Such an adventure! Victoria is a crown colony, not Canadian—try it, darling!" So the "darlings" whose lives from birth had been humdrum, especially since the rest of the family had married and left the old home to them and nothing for its upkeep, nibbled at the thought, grabbed for the word "adventure", sold up and sailed. Relatives saw them off, calling them "old sports", begging them to write—they, who had never had anything to write about in their whole lives were now launched proudly into adventure.

Sometimes it was a bachelor brother and spinster sister of the glued-together type of family remnants.

After the whistle shrieked every mile of water washed the old land away fainter and fainter and hurried them into the unknown. They began to ache—such vast quantities of water! Such vast quantities of land! The ache grew and grew. By and by they saw the western forests and the little town of Victoria drowned in silent loneliness; there was then no describing how they felt. They rented uncomfortable, mean little cottages or shacks and did with incompetent hands what well-trained Old Country servants had all their lives done for them. Too late! Turning back was impossible; the old home was sold, its price already seeping away too fast. There were many of these sad people in Victoria, shuddering when they saw a Western funeral, thinking of the cosiness of Old Country churchyards.

There were maiden aunts, who had attached themselves to the family circle of a married brother and who undertook the diction and deportment of his children, bitterly regretting the decision of Brother to migrate to Canada, but never for one moment faltering in their duty to Brother's family, standing between his children and colonialism. The Maiden Aunts swallowed their crosses with a difficult gulp. Auntie's job was discounted in the New World;

Canadian-born children soon rebelled at her tyranny. She sank into a wilted homesick derelict, sniffling by the fireside while the mother learned more or less to work with her own hands, so that she could instruct what Auntie called her "heathen help" in kitchen low art. Auntie herself refused to acknowledge base presences such as cook-stoves and wash-tubs.

In our family there were no maiden aunts. Our delicate little Mother had six living children and three dead ones and, with the help of her older daughters and the Chinese boy, Bong, we managed very comfortably without aunts. Many a useless servant-dependent woman from the Old Country was shown by my mother how to use her own hands and her own brain in her Canadian home with no other help than green Chinese boys.

In Toronto Street over James' Bay way there lived a most astonishing family, consisting of two brothers, Fat O'Flahty and Lean O'Flahty and a sister, Miss O'Flahty. All were above middle age. They built a shanty entirely of driftwood which they gathered and hauled from the beach. They might be seen any hour of the day or night trundling logs home on a wheel-barrow, taking long rests on its handle while they smoked a pipe. The brothers never sawed the driftwood but used it any length, just as it came out of the sea—mostly longish, round tree trunks rubbed smooth by rocks and sea on their long swims, where from no one knew.

The O'Flahty's house looked like a bonfire heaped ready for lighting. The only place where the wood of the entire shanty was halfway level was at the ground and even there it was bumpy. The up ends of all the logs higgledy-piggledied into the sky, some logs long, some short. The door was made of derelict planks gathered on the beach, too, and the roof was of anything at all—mostly of tin cans. It had a stovepipe sticking through the top. The fence round the O'Flahty's small piece of ground was built to match the house.

The O'Flahtys had lived in this strange house for some years when Mother heard that Miss O'Flahty was very ill. She sent us post haste down, with some soup. We knocked on the gate which was padlocked. Fat O'Flahty came and let us in. We walked on a plank up to the door which was also padlocked.

"She's bad," he said and led the way into the shanty.

It was nearly dark and very smoky. In the centre of the one room stood a jumble of drift logs standing upright to make a little room. Fat O'Flahty moved two logs aside and, when we were accustomed to the dark, we saw a white patch lying in the corner. It was Miss O'Flahty's face. Her bed was made of logs too. It was built on the floor and had no legs. There was no space for us to step inside Miss O'Flahty's bedroom. There was scarcely room for even our looks to squeeze in.

Fat O'Flahty behind my sister said, "Does she look awful sick?" and Lean O'Flahty peering behind Fat with some of the soup in a tin cup, said also, "Does she seem turrible bad?" Their voices were frightened. Lean O'Flahty held the tin cup of soup towards the sick woman. The dim patch of white face in the corner shook a feeble "No". The brothers groaned.

Miss O'Flahty died. Lean and Fat had her embalmed and put her into a handsome casket. She rode to the Outer Wharf in the same wheel-barrow which had lugged their building wood from the beach. The brothers trundled it. We were down at the Outer Wharf, seeing Auntie away by the San Francisco boat. "Ouch! It's a coffin!" squealed Auntie as her cloak brushed it. Fat and Lean O'Flahty were sitting one on either handle of the barrow, crying. When all were aboard, the brothers, each with a fist in his eye and with loud sniffs, wheeled the coffin down between decks and the O'Flahty family disappeared. Next time we passed down Toronto Street their crazy house was gone too.

Another human derelict was Elizabeth Pickering—she wore a bright red shawl and roamed the streets of Victoria, intoxicated most of the time. Occasionally she sobered briefly and went to the kindly Bishop to ask help. The Bishop handed her over to his maiden sister who specialized in correction. Elizabeth would settle herself comfortably, drawing a chair to the fire to toast her toes and doze till she became thirsty again. Then, with a great yawn, she would reach for the little packages the Bishop's wife had put near her on the table. Regardless of whether Aunt Cridge had finished her lecture on drink or not she would rise with a sympathetic, "Feelin' yer rheumatics today, baint ye, pore soul? Me and you suffers the same—its crool!"

Old Teenie was another familiar figure of our school days. Teenie was half negro—half crazy. Her hut was on Fort Street in the centre of a rough field and lay a little below street level. Boys used to throw stones onto her tin roof and then run away. Out came old Teenie, buzzing mad as a whole nest of wasps. Muttered awfulness came from her great padded bonnet. It shook, her tatters shook, so did wisps of grey hair and old Teenie's pair of tiny black fists.

I don't know who looked after Teenie. She scoured with stick and sack the ditches and empty lots, putting oddments into her sack, shaking her stick at everyone, muttering, always muttering.

Nobody questioned where these derelicts came from. They were taken as much for granted as the skunk cabbages in our swamps.

Victoria's queer people were not all poor, either—there were doddering old gentlemen. I can remember them driving about Victoria in their little buggies—the fatter the man, the smaller the buggy! They had old nursemaid horses who trundled them as faithfully as any mammy does her baby in its pram. Every day, wet or fine, the horses aired their old men on Dallas Road. Knowing that their charges slept through the entire outing, the faithful creatures never moved from the middle of the road nor changed from a slow walk. The public also knew by the lolling heads and slack reins that the old men slept and gave their buggies right of way. Street traffic was not heavy, time no object. Chaises, gentlemen's high dog-carts passed the nursemaid horses briskly. The dog-carts paused at roadhouse bars and again overtook the patient plodding horses who walked their charges to a certain tree on Foul Bay Road, circled it and strolled home again

just as the old men's Chinese cooks put their dinner on the table. The old horses were punctual to the dot.

One of these old men was very fond of children. When he met us, if he happened to be awake, he pulled up with a wheezy "Whoa", meant both for us and for his horse. Taking a screw of paper from his pocket he bent over the wheel and gave us each a lollipop and a smile. He was so ugly that we were afraid, but Mother, who knew who he was told us he loved children and that it was all right. If, however, we saw his buggy coming in time we hid until it was past; he was such a very ugly old man!

A family we knew had one of those "Papa's-sister" Aunts who took it upon herself to be a corrector of manners not only for her own nieces but for young Canadians in general. In fact she aspired to introduce elegance into the Far West. This elegant and energetic lady walked across Beacon Hill at seven-thirty on fine summer mornings, arriving at our house in time for family prayers and breakfast. In site of her erect carriage she could flop to her knees to pray as smart as any of us. That over, she kissed us all round, holding each at arm's length and with popping, piercing eyes, criticized our tooth-brushing, our hair ribbons, our finger nails, recommended that we eat more porridge or less, told Mother to give us no raw fruit at all, always to stew it, no stone fruit at all, no candy, told us never to ask for second helps, but wait to be invited, had us do a little English pronouncing, then, having made us late, said, "Hurry! hurry! Lateness is unpardonable, dears! Ladies are never late."

Then there were Brother Charlie and Sister Tilly, evidently sworn each to see other into the grave. This pair minced up Birdcage Walk like elderly fowls, holding their heads each a little to one side—Charlie so that Tilly's lips could reach his deaf ear, Tilly so that she might direct her shriek straight into Charlie's drum. The harder she shrieked the higher she squeaked. Charlie, on the other hand, was far too gentlemanly to speak in public places above a whisper which he could not hear himself, so he felt it safest always to say "Yes, yes, dear Tilly" or "Exactly so, Tilly dear" when he should often have said, "No, Tilly, certainly not!"

Brother and sister whispered and squeaked up Birdcage Walk where they lived. They hopped up the two steps to the inset door of their cottage and cooed themselves in.

"Yes, yes, dear Tilly, yes!"

LOYALTY

MEDINA'S GROVE was a gentle place; its moist mildness softened even the starch in Father and begged the twinkle that sat behind his stern grey eyes to come out. The Grove had not the sombre weight that belongs to the forest, nor had it the bare coldness of a windswept clearing. It was beautifully half real, like the place you fall into after the candle is blown out, and sleep is just taking hold of you.

Victoria had to be specially loyal because she was named after the Queen. To her the most important day, after Christmas Day of course, was the Queen's Birthday, on the twenty-fourth of May. We made more fuss over the Queen's Birthday than did any other town in Canada.

May is just about our most lovely month. The lilacs, the hawthorn, the laburnums and the broom are all in blossom, just begging the keen Spring winds to let their petals hang on till after the twenty-fourth so that Victoria can look most splendid for the Queen's Birthday. On the twenty-third, one often had to stand on the chopping block and, hanging onto the verandah post with rain spittering in your face, sing right up into the sky—

> "Rain, rain go away.
> Come again another day
> When I cook and when I bake
> I'll send you up a patty-cake."

Sometimes the rain listened, sometimes it did not. But most of our twenty-fourths were fine which was lucky because on the Queen's Birthday we wore our Summer frocks for the first time.

Mother prepared a splendid picnic. Father left his business frown and his home sternness behind him. Rugs, food and the black billy for making tea, were packed into the old baby buggy and we trundled it straight down Simcoe Street. Simcoe Street passed the side of our place and ended in Medina's Grove. In May, what with the new green on the bushes, the Medina's calves skipping about, and Medina Grove birds nesting, it was like fairy land. Sea air blew in from the beach, just one field away! Seagulls swooped down to look for picnic bits. The ground was all bumpy from being crowded with more new grass than the cows could eat. There were some big trees in the Grove, but not thick enough to keep the sun out. Every kind of delicious spring smell was there. It was not like being

in a garden to play; the Grove was gently wild but had not the awe of the forest. Bushes grew here in little groups like families. Each picnic could have its own place quite private; just the laughs tumbled through the bushes and mixed. There were no gates to remember to shut, no flower beds you must not scoot across. You might pick anything you liked and eat as much picnic as you could. These Medina Grove picnics were our first Queen's Birthdays. By and by we grew older and steady enough to sit still in boats; then we went to regattas, up the Arm, on the twenty-fourth. The Queen's Birthday changed then. It was not so much our own day. A shadowy little old lady owned it.

This Queen, after whom Victoria was named, did not mean any more to me than a name. The older ones knew all about her and so I suppose they thought I did. It was Mrs. Mitchell who made the Royal Family stop being fairy and turned Royalty into real live people for me. Mrs. Mitchell was a little, frail, old woman. Henry, her husband, was an English nurseryman. They came from England and started a nursery garden not far from our house, at the time when farm land was being cut into small personal pieces. Mother went to see any new people who came to live near us, if she saw that they were lonely and homesick. Mrs. Mitchell was very homesick and very lonely. She said she loved me from the first time my Mother took me to see her, because I was fat and rosy just like an English child. But I was not an English child and I didn't love her because she was English. I loved Mrs. Mitchell because she loved creatures, and I loved her garden, too, with its long rows of nursery stock, and its beds of pinks and mignonette. Mrs. Mitchell was gentle, small and frail. She had a little weak voice, which squeaked higher and higher the more she loved. Her guinea fowl and I cracked it altogether. She had four speckled guinea fowl—she and Henry loved them as if they had been real children. They opened the door of their cottage and called, "Coom, coom, coom, pretty little dears"—and the guineas came mincing through the kitchen into the sitting-room, and jumped into their laps.

The Mitchells' nursery garden was next to a farm rented by Jim Phillips. Jim got angry because the guinea fowl flew over the fence into his grain field and he shot three of them. The old couple cried and cried. They took it to law and got the price of the guineas but the price of the birds' flesh meant nothing to them. It was the life gone from their birds that they cried for. Never having any children the guineas had been next best. This last bird of their four they never let out of their sight. Jim Phillips was furious that he had to pay for the bodies of the other three especially as he knew it was only for love, not value, that they cried.

Mrs. Mitchell cuddled the last bird in her little black silk apron and bowing her head on his speckled back cried into his feathers mournfully rocking him and herself. She took the little pink bow out of her black lace cap and its long black ties dropped over her shoulders as she bent crying. There was always a little bunch of everlasting flowers sewn into her cap over one ear, brittle, dried up little things like chrisalises; she let these be. She had a whole floor of everlasting flowers spread to dry in her front room. They smelled like hay and were just as

much alive after they had been dead for a whole year. She made wreaths of them for funerals. Everlasting flowers reminded people there was no death, she said.

I went very often to Mrs. Mitchell to try to cheer her over the guinea fowl, but it seemed I could not cheer her at all. The remaining guinea's wings were all drooped with loneliness and she held him in her lap nearly all day. I looked around the sitting-room to find something happy to say. The walls were covered with pictures of gentlemen and ladies cut out of the *London News* and the *Daily Graphic*. Grand ladies with frizzled hair and lots of necklaces, men with medals on and sashes across their chests.

"Q-u-e-e-n V-i-c-t-o-r-i-a", I spelled out.

"Is that the lady who has the twenty-fourth of May birthday?"

"Yes, my dear," Mrs. Mitchell sniffled into the guinea's feathers. "Yes, our most gracious Queen Victoria."

"Who is the man beside her?"

"The late Prince Consort, my dear, and this is the Princess Royal, and here is the Prince of Wales and Princess Beatrice."

"Who *are* these people?" I asked. "I thought Princes and Princesses just belonged to fairy tales. What have they to do with Queen Victoria?"

Mrs. Mitchell was very much shocked indeed. She stopped crying and, using the guinea fowl as a pointer, she went from picture to picture telling the bird and me who all the Royalties were, how old, whom they had married and so on. At last we came to a lady in a black frame with a bow of crêpe over the top of it and a bunch of everlasting flowers underneath. "Princess Alice", said Mrs. Mitchell with a long, long sniffle, "now a blessed saint," and she began to cry all over again.

I thought these picture people must be relatives of Mrs. Mitchell's, she seemed to know them so well and cried so hard about Alice. The Queen's picture was everywhere. I knew she was someone tremendous, though to me she had been vague and far off like Job or St. Paul. I had never known she was real and had a family, only that she owned Victoria, Canada, and the twenty-fourth of May, the Church of England and all the soldiers and sailors in the world. Now suddenly she became real—a woman like Mother with a large family.

Mrs. Mitchell took a great deal of pains to get the Royal family straight in my head and it was lucky she did, because who should come out to Canada, to Victoria, that very year and pay a long visit to Government House, but the Princess Louise and the Marquis of Lorne! This excited Mrs. Mitchell so that she stopped crying. She, who never went out, found a bonnet that I had never seen before, put a dolman over her best silk dress, locked the guinea fowl safe in her kitchen and got into a hack with Henry, her smelling-bottle and her cap, in which was a new bunch of everlasting flowers. The cap was in a paper bag on Henry's knee. They drove to the house of Dr. Ashe on Fort Street where the procession was to pass and sat in a bow window and waved at the Princess. When she saw the Princess smiling and dressed in gay colours, she realized that her beloved Princess Alice had been dead longer than she thought and that Court

mourning was finished. She went home and took the crêpe off Alice but she left the everlasting flowers.

Mrs. Mitchell watched the papers for every crumb of news of her Princess while the visitors were in Victoria—how she had gone sketching in the Park, how she used to go into the shops and chat with people; how once she went into a bake-shop to buy some cakes and stepped behind the counter to point out the kind to the baker who ordered her back, saying gruffly, "Nobody ain't allowed behind my counter, mum," and then when she gave the address, the baker nearly died of shame and so did Mrs. Mitchell as she read it.

Seeing Royalty waked again all Mrs. Mitchell's homesickness for England. They sold everything and she and Henry went back to the Old Country to die. She gave me a doctor's book on diseases and an empty box with a lock and key. I did not like the disease book and could never find anything important enough to lock up in the box; so I put it away on a high shelf. Mrs. Mitchell cried dreadfully when she left Victoria but kept saying "I'm going home, my dear, going home."

The journey nearly killed her, and England did quite. All her people were dead except distant cousins. England was different from what she had remembered. She sent me Gray's *Elegy in a Country Churchyard* and Henry wrote saying she was crying for me and for Victoria now as she had cried for England and Princess Alice and the guinea fowl. Then came a silver and black card "In Memoriam to Anne Mitchell"—then I had something to lock away in the little box, with a little bunch of everlasting flowers, the last that Mrs. Mitchell gave me.

DOCTOR AND DENTIST

WHEN VICTORIA WAS young specialists had not been invented—the Family Doctor did you all over. You did not have a special doctor for each part. Dr. Helmcken attended to all our ailments—Father's gout, our stomach-aches; he even told us what to do once when the cat had fits. If he was wanted in a hurry he got there in no time and did not wait for you to become sicker so that he could make a bigger cure. You began to get better the moment you heard Dr. Helmcken coming up the stairs. He did have the most horrible medicines—castor oil, Gregory's powder, blue pills, black draughts, sulphur and treacle.

Jokey people called him Dr. Heal-my-skin. He had been Doctor in the old Fort and knew everybody in Victoria. He was very thin, very active, very cheery. He had an old brown mare called Julia. When the Doctor came to see Mother

we fed Julia at the gate with clover. The Doctor loved old Julia. One stormy night he was sent for because Mother was very ill. He came very quickly and Mother said, "I am sorry to bring you and Julia out on such a night, Doctor."

"Julia is in her stable. What was the good of two of us getting wet?" he replied.

My little brother fell across a picket fence once and tore his leg. The Doctor put him on our dining-room sofa and sewed it up. The Chinaboy came rushing in to say, "House all burn up!" Dr. Helmcken put in the last stitch, wiped his needle on his coat sleeve and put it into his case, then, stripping off his coat, rushed to the kitchen pump and pumped till the fire was put out.

Once I knelt on a needle which broke into my knee. While I was telling Mother about it who should come up the steps but the Doctor! He had just looked in to see the baby who had not been very well. They put me on the kitchen table. The Doctor cut slits in my knee and wiggled his fingers round inside it for three hours hunting for the pieces of needle. They did not know the way of drawing bits out with a magnet then, nor did they give chloroform for little things like that.

The Doctor said, "Yell, lassie, yell! It will let the pain out." I did yell, but the pain stayed in.

I remember the Doctor's glad voice as he said, "Thank God, I have got all of it now, or the lassie would have been lame for life with that under her knee cap!" Then he washed his hands under the kitchen tap and gave me a peppermint.

Dr. Helmcken knew each part of every one of us. He could have taken us to pieces and put us together again without mixing up any of our legs or noses or anything.

Dr. Helmcken's office was a tiny two-room cottage on the lower end of Fort Street near Wharf Street. It sat in a hummocky field; you walked along two planks and came to three steps and the door. The outer room had a big table in the centre filled with bottles of all sizes and shapes. All were empty and all dusty. Round the walls of the room were shelves with more bottles, all full, and lots of musty old books. The inner office had a stove and was very higgledy-piggledy. He would allow no one to go in and tidy it up.

The Doctor sat in a round-backed wooden chair before a table; there were three kitchen chairs against the wall for invalids. He took you over to a very dirty, uncurtained window, jerked up the blind and said, "Tongue!" Then he poked you round the middle so hard that things fell out of your pockets. He put a wooden trumpet bang down on your chest and stuck his ear to the other end. After listening and grunting he went into the bottle room, took a bottle, blew the dust off it and emptied out the dead flies. Then he went to the shelves and filled it from several other bottles, corked it, gave it to Mother and sent you home to get well on it. He stood on the step and lit a new cigar after every patient as if he was burning up your symptoms to make room for the next sick person.

Victoria's dentist was a different sort of person. He shammed. "Toothache, eh?" he said in a "pretend" sorry voice with his nose twisted against one cheek or the other as if he felt the pain most awfully himself. He sat you in a green plush chair and wound you up to his eye. Then he took your head in his wide red hand that smelled of fancy soap and pushed back your cheek, saying, "Let me just see—I am not going to do anything." All the time he was taking something from a tray behind you and, before you knew where you were, he had nearly pulled the head off your neck.

I shouted, "You lied!" and got slapped as well as extracted, while the blood ran down my chin.

My Father never had a toothache till he was sixty years of age, nor did he lose a tooth. When the dentist said four of my second teeth needed to be filled, Father said, "Nonsense! Pull them out." The dentist said it was a shame to pull the teeth and his shamming nose twisted; but all the time he was looking over my head at my pretty sister who had taken me. He grabbed my head; I clenched my teeth. They bribed me with ten cent pieces and apples till I opened and then I was sorry and bit down on his fingers.

I knew a girl who liked the dentist, but she had only had her teeth filled, never pulled, and he gave her candy. One day she said to me, "I wonder what the dentist's name is? His initials are R.B."

"I know. It is Royal Beast," I said.

Beast was a word we were never allowed to use. I always called the dentist "Royal Beast" after that. It made me feel much better.

CHAIN GANG

THE TWO sisters a lot older than I taught the two sisters a little older about many things, but when I was old enough to puzzle over these same things and to ask questions I was told, "Don't pester! Don't ask questions just for the sake of asking." But two years and four years make a lot of difference in the sense and understanding of a small girl. At six I was not able to grasp what eight and ten could, so there were gaps in my knowing and a great many things that I only half understood such as Saloons, and the Royal Family, and the Chain Gang.

One day we were going to town with my big sister and passed a lot of men working at the roadside by the Parliament Buildings. They wore unusual clothes and had little round caps on top of heads shaved so close they looked like peeled apples stuck on top of their bodies. They sat on big rocks and crushed smaller rocks into little bits with sharp pointed hammers—Crack, tap! Crack,

tap! Two men stood behind the workers watching their every move. Each held a gun and never took his eyes off them for one moment, staring as hard as the men stared at the stones. Nobody's stare shifted and nobody spoke. There was only the unhappy tap, tap of the little hammers and the slow roll of each piece of rock rolling down the little stone piles, falling at the feet of the men like enormous stone tears.

I looked up at my sister to ask but she gave me a "hush-frown" and dragged me quickly past. We had just got on to James' Bay Bridge when there was a clank, clank and a tramp, tramp, tramp behind us. The queer men were being marched into town and the two men with the guns were marching one in front and one behind them, watching as hard as ever. One leg of each man had a dragging limp. Then I saw that every man had a bar of iron fastened to one leg at the knee and again at the ankle. It took a long time for them to catch up to us and pass. We walked on the other side of the foot rail of the bridge. My sister was very put out at having to march beside the men; you could not help keeping time to the jangling tramp. We crossed Bastion Street on the way to Father's store and came to an immense, close board fence with spikes on the top, which I had never noticed before. The fence broke suddenly into a gate which swallowed the marching men, shutting with a snap that cut off the limping clank before I could get even a peep of what was inside it. There was a red brick building with barred windows beside the fence. Again I looked up at my sister. "Jail," she said—"Chain Gang."

When Victoria was so nearly a city that there were many roads to be built, the town bought a noisy monster called "Lizzie". Lizzie snorted up to a rock pile and they fed her chunks of rock in iron buckets which ran round on a chain. She chewed and spat, chewed and spat until the rocks were ready for road making. So now the Chain Gang did not have to sit by the roadside and smack rocks any longer. Lizzie chewed instead and the Gang now worked on the grounds of Government House and the Parliament Buildings.

"Lizzie" fed for a very long time on Marvin's Hill on the James' Bay side of the mud flats. It had an immense quantity of rock. Horses hated the steepness of Marvin's Hill: the heavy chaises slipped back. The smart old horses zig-zagged them up sideways, pretending that they were not trying to climb a hill at all but just having fun making snake fence patterns in the deep dust.

Marvin's Hill and Church Hill frowned hard at each other; the mud flats, all soft and smelly, smiled between them. Blanshard Street dipped down Marvin's Hill and up Church Hill again. The deepest part of its dip was from Humboldt Street on the north to the top of Marvin's Hill. The town built a high sidewalk on stilts which made the climb for walking people easier. We went over the high sidewalk every Sunday on the way to church. It was the most exciting part of the two-mile walk. From the high sidewalk you looked out across the flats to James' Bay Bridge. There was a row of cabins on Humboldt Street. It was called Kanaka Row: the cabins rested their chins on the street and their hind legs stuck high out of the mud behind. Working men with Indian wives lived in Kanaka

Row and Sunday was the day for the women to wash the men's clothes. The men lazed in bed while their shirts and pants flapped on clothes lines high over the mud.

On the corner of Humboldt and Blanshard stood the Reformed Episcopal Church; criss-cross from it was the White Horse Saloon. A great brick drain ran under Blanshard Street, gushing into the slough which rambled over the mud flats and out to the sea. Above the flats on the Belville Street side were Governor Douglas's and Doctor Helmcken's houses. There was always plenty to be seen from the high sidewalk. The Reformed Episcopal Sunday School was beside the church. It was sure to be either going in or coming out as we passed. There were splendid slides on either side of its steps which must have spoiled heaps of boys' Sunday pants. Below the schoolhouse was a jungle of sweet-briar rose bushes and then came the mud, covered round the edges with coarse marsh grass.

There were nearly always Indians camped on the Flats. They drew their canoes up the slough. Some camped right in their canoes with a canvas tent across the top, some pitched tents on the higher ground. The smoke of their camp fires curled up. Indians loved camping here because for many, many years the mud flats were used as the town's rubbish dump. Square blue carts backed to the edge of Blanshard Street and spattered their loads overboard—old clothes, old stoves, broken baby buggies, broken crockery and beds. The Indians picked it all over, chose what they could use, stowed it away in their canoes to take to their houses. When the tide came up and flooded the slough and flats the canoes slipped away, the Indians calling to their dogs who lingered for a last pick among the rubbish. Then they waded through the mud and caught up with the canoes just before they reached the sea. You got excited watching to see if they'd make it.

The last and very meanest pick of all the rubbish was left to the screeching seagulls that swooped for the dregs of refuse, rising triumphant as kings with new crowns.

From the high sidewalk you could see all this besides looking down into the Convent garden lying on the other side of the raised walk. Here the Convent Sisters marched two and two along the garden paths with a long snake of boarders wiggling in front of them, in and out among flower beds. The nuns' veils billowed and flapped behind the snaky line of girls as if the sisters were shooing the serpent from the Garden of Eden.

At the top of Marvin's Hill, gaunt and quiet, stood the rock-chewing monster, "Lizzie". She did not chew on Sundays. Father measured how much she had done since last Sunday. He was stern about Lizzie. She was an American notion. She had cost the town a lot of money—Father was a tax-payer and a good citizen.

COOK STREET

COOK STREET crossed Fort Street just before the point at which a better class of houses mounted the Fort Street Hill and made it residential.

A few semi-nice houses did trickle round the corner of Fort into Cook but they got smaller, poorer and scarcer as Cook Street went south. At Fairfield Road Cook stopped being a street at all except on the town map in the City Hall. In reality, from Fairfield Road to the sea, it was nothing but a streak of skunk-cabbage bog running between King's and Smith's dairy farms. Cows peered through the farm fence bars at the luscious greenery in the "street" where bushes were so snarled and tangled together that down there in the greasy bog among the skunk cabbages they could not tell which root was theirs.

In summertime the swamp dried out somewhat, enough at least for the stout shoes of school children to tramp a crooked little path through its centre. Skirting puddles and nobbledy roots, among which lurked dank smells of cat-flower and skunk cabbages, this path was a short cut to school.

In winter, if there was much rain, this so-called "Street" and the low-lying fields on either side lay all drowned together under a stretch of water which was called King's Pond. After several good frosts people went there to skate.

When James' Bay mud flats had become too "towny" to be a rubbish heap any more, the little two-wheeled, one-horse dump-carts trundled their loads of garbage to the unmade end of Cook Street and spilled it among the boggy ooze. Each load of rubbish built foothold as it went. The horse clung with his hooves to the last load while he spilt the next. The little blue carts tipped and splattered, tipped and splattered their contents over the edge. Every load helped to build a foundation for Cook Street, rubbish pounded to solidity by horses' hooves and children's boots. The street formed slowly, working from its middle and firming gradually to the fence on either side. Occasionally clay discarded from some building excavation was thrown on top to solidify wash boilers and stoves, old kettles and beds. It took all our school years for rusty iron to flake into dust. Soft things rotted and grew fungi or dissolved to a kind of jelly which by and by hardened and powdered to dust.

It took years to steady the underneath of Cook Street between Fairfield and Dallas Road. Here the map said that Cook Street stopped and the sea bounced and bellowed along the pebbly beach under the cliffs.

When I exercised the pony, old Johnny, after school hours I loved to ride

through the Cook Street chaos of garbage. High and safe on the horse's back I could look down into it and see wild rose bushes forcing their blooms up through lidless cook stoves and skunk cabbage peeping out of bottomless perambulators, beds tipped at any angle, their years of restfulness all finished and done with.

The harder the town grew, the more back-door rubbish there was. The clay-coloured, padded bonnet of half-crazy, half-negro old Teenie bobbed among the garbage while her stick poked and her claw-like hands clutched, ramming gleanings into her sack with derelict mutterings scarcely more audible than the click of disintegration amongst the decay in which she rooted. Teenie herself belonged to this sisterhood of discards. Back in her cabin she poured what she had rescued from her sack onto the floor, muttering and gibbering to the castoffs as if they were her friends.

At last the emptiness was flattened out of every discard, the chinks between were filled up with clay and Cook Street was hard and level; the Town drained and paved it and it became a finished highway running from the town to the sea. New houses set their faces to it, houses with flower gardens in front. All its old cow farms moved out into the country.

Our town now had a mature garbage system which towed our horribles out to sea in barges. It seemed, though, that the old kettles and much of the rubbish got homesick; back they danced patiently riding wave after wave to the beach below Cook Street to lie there, hideous in broken nakedness, no soft spread of greenery to hide their ugliness.

As Cook Street progressed from cow farm to residential district she had a spell of being Chinese vegetable gardens. In the fields on either side patient, blue-jean figures worked from dawn till dark, bending over the soil, planting, weeding, watering by hand from wells. The water was carried in five-gallon coal oil cans, one on either end of a bamboo pole slung over the Chinaman's shoulder. He stood the load among his vegetable rows and dipped a little to each plant.

When his vegetables were ready to market, the Chinaman put them into great bamboo baskets slung on each end of his pole. As he had carried water to his plants, so he carried vegetables to townspeople, going from door to door joggety-trot with baskets swaying.

WATERWORKS

THOSE Victorians who did not have a well on their own place bought water by the bucket from the great barrel water-cart which peddled it. Water brought in wooden pipes from Spring Ridge on the northern outskirts of the town was our next modernness. Three wonderful springs watered Victoria, one on Spring Ridge, one in Fairfield and one at Beacon Hill. People carried this sparkling deliciousness in pails from whichever spring was nearest their home.

My father was so afraid of fire that he dug many wells on his land and had also two great cisterns for soft water. Everyone had a rain barrel or two at the corners of his house. The well under our kitchen was deep and had a spring at the bottom. Two pumps stood side by side in our kitchen. One was for well water and one was a cistern pump—water from the former was hard and clear, from the cistern it was brownish and soft.

When Beaver Lake water was piped into Victoria, everyone had taps put in their kitchen and it was a great event. House walls burst into lean-to additions with vent pipes piercing their roofs. These were new bathrooms. With the coming of the water system came sewerage. The wretched little "privies" in every backyard folded their evil wings and flapped away—Victoria had at last outgrown them and was going stylish and modern.

Father built a beautiful bathroom. Two sides of it were of glass. It was built over the verandah and he trained his grape-vine round the windows. The perfume of the vine in spring poured through the open windows deliciously. Father had tried to build several bathrooms before Beaver Lake came to town, but none of them had been any good. First he used a small north room and had a cistern put in the attic to fill the bathtub. But hot water had to be lugged upstairs in a bucket and anyway the cistern froze every winter; so that bathroom was a failure. He had made us an enormous, movable wooden tub like a baby's bath big enough for a grown-up to lie in flat. It was very heavy and lived on the back verandah. Bong brought it into the kitchen on Saturday nights before he left for town. It had to be filled and emptied over and over by the ladies of the household with a long-handled dipper until all the family had had their baths. Besides this Saturday night monster there were wooden wash tubs painted white which lived under our beds. We pulled these out at night and filled them with cold water. Into this we were supposed to plunge every morning. This was believed to harden us; if your nose were not blue enough at the breakfast table

to guarantee that you had plunged, there was trouble.

Father later tried a bathroom off the wash-house across the yard. A long tin pipe hung under the chin of the wash-house pump and carried cold water, but hot water had to be dipped out of the wash boiler on the stove. This hot bath arrangement was bad; we got cold crossing the yard afterwards. So the wooden tub was invited into the kitchen again each Saturday night until we became "plumbed".

It was glorious having Beaver Lake pour out of taps in your kitchen and we gloated at being plumbed. Mothers were relieved to see wells filled in, to be rid of the constant anxiety of their children falling in and being well-drowned. Everyone was proud and happy about this plumbing until the first hard frost.

Victoria used to have very cold winters. There was always some skating and some sleighing and spells of three or four days at a time when the wind from the north would pierce everything. Mother's milk pans in the dairy froze solid. We chopped ice-cream off the top to eat with our morning porridge. Meat froze, bread froze, everything in the house froze although the big hall stove was red hot and there were three or four roaring grate fires as well. Windows were frosted in beautiful patterns all day and our breath smoked.

It was then discovered that plumbers, over-driven by the rush of modern arrangements, had neglected to protect the pipes from frost. Most of the bath-rooms were built on the north side of the houses and everything froze except our deep kitchen well. Neighbours rushed to the Carr pump, spilling new snow over Mother's kitchen floor till our house was one great puddle and the kitchen was filled with the icy north wind. Everyone suddenly grumbled at modern plumbing. When the thaw came and all the pipes burst everyone wished Beaver Lake could be piped right back to where it came from.

Once Victoria had started modern off she flew with all sorts of newfangled notions. Cows were no longer allowed to roam the streets nor browse beside open ditches. The ditches were replaced by covered drains and, if your cow wandered into the street, she was impounded and you had to pay to get her out. Dogs were taxed but were still allowed to walk in the streets. A pig you might not keep within so many yards of your neighbour's nose. Jim Phillips had to give up his James' Bay farm and remove his piggery to the country. Small farms like his were wanted for cutting into city lots. You never knew when new lumber might be dumped on any piece of land and presently the lumber was a house and someone was moving in.

Jim Phillips' big turnip field across from us was made into the Caledonian Park, a place for the playing of public ball and lacrosse games. It was fenced high and close and admission was charged. The gate of Caledonian Park was on the corner of Simcoe and Carr Streets, just opposite us. There was a long, unpainted building inside, which was the players' dressing room. Bob Foster lived there. He was the boys' trainer and one of those ousted-out-of-England ne'er-do-wells. There was some good in old Bob but drinking spoiled it. He trained, rubbed down and doctored the boys for sprains and hurts on the field.

He took good care of the boys and the boys took care of Bob. He owned a little white dog whom he also trained to scour the neighbourhood for somebody else's hen and bring her home for Bob's dinner parties. The noise of these parties flew over our hedge, filled our garden all night and made our dreams bad.

Caledonian Park existed for many years but finally the lease expired and then the land was cut into building lots.

Just before the high board fence came down a Barnum and Bailey Circus (three rings and a menagerie) came to town. It came at night, so silently that we slept through its arrival. Before it was fully light little boys had their eyes glued to knot holes in the board fence. Tops of great tents poked tantalizingly into the sky.

The Circus gave free passes to boys who lugged water for the animals. When every beast was full, even the elephants and the seven stomachs of the camel, a little boy came; he was too late to get any job. He was feeling very sad when a tall, lean man popped out of a tent.

"Say, son, I gotta have a dress shirt in an hour. Hand over one of your pa's and you git a pass."

As the little boy started to run home, the man shouted,

"Yer pa's fat? Then bring along safety pins!"

The boy and his mother argued a bit about Pa's shirt, but the boy not only got into the big tent free, he could boast of having pinned a real live clown into his father's shirt—more exciting even than watering an elephant.

FROM CARR STREET

TO JAMES' BAY

WHEN FATHER started for town in the morning I went with him down the drive to the gate, holding his hand. The gate stood between two high, high Lombardy poplars. Their tops were right up in the sky. If you could have got to their tippy tops you could have spoken right into God's ear.

Father planted our poplars when they were little. The two by the gate were the tallest.

The bigger I grew the farther I was allowed to go with Father. When I was seven I went as far as the Lindsays'.

We got up early in our house. I came downstairs perfectly clean but when it was time for Father to go to town I was dirty because of being such great friends with the hens and ducks. And then I always sat by Carlow for a little because he

was chained to his kennel. His feet and chain made lots of dust on me and the leaks from the can when I watered my own particular garden made it into mud.

As soon as Father began to go he went quickly, so Mother made me a "jump-on-top" of sprigged muslin. It went over my head so that there were no buttons to burst off. There were frills all round it and a tape tieback underneath. The front sat plain but the back bunched up into a bustle like a lady's. I had a pair of cloth-top, button boots and a sun-bonnet. I looked quite nice when I took Father's hand and we started.

Father walked fast and held my hand tight. The plank walk was just wide enough for us both but, if you did not watch, your foot slipped off into the mud. We did not talk much because Father was thinking of all the things he had to do at his big wholesale business where boxes and barrels and cases stood on top and on top and on top, till they touched the ceiling. When he thought hard a ditch came between Father's eyebrows; then I did not dare to chatter. I just looked at things as we went along. It was on the way home that I got to know "the ladies".

Our street was called Carr Street after my Father. We had a very nice house and a lovely garden.

Opposite our gate was Bishop Cridge's "wild field". It was full of trees and bushes and fallen logs and was a grand place to play ladies with little girls. The Bishop's house and garden were beyond the field. The drive was curved and had laurels and roses down it so you could not see his house. Then came his big field with the barn in the corner where his horse and cow lived. The field was so big it took up all the rest of Carr Street. There was a well in it where the Cridges got their water to wash and drink. Every morning we saw the China-man carrying two square coal oil cans of water across the field, they dangled one on each end of a pole and slopped a little over the stubble.

On the other side of Carr Street where our poplars ended the Fawcetts' place began. They had hundreds of heavy, wide children with curls. Their clothes were always too big. Their mother told our mother that she made them that way because she knew her children would grow. Mrs. Fawcett was wide too and had very crimpy hair and a crooked neck; "Pa" Fawcett was tremendously lean and tall and had a long, thin beard.

Then came the Bishop's field—not Bishop Cridge's but Bishop Hill's. He did not live in his field; there were cows there. One corner had a thicket with wild lilies growing in it. The two Bishops did not like each other much and it was a good thing there were two fences between their cows. There were picket fences all the way down Carr Street. The fences stopped suddenly because Mrs. McConnell's farm sat right in the way and had a rail fence of its own.

Carr Street was a very fine street. The dirt road waved up and down and in and out. The horses made it that way, zigzagging the carts and carriages through it. The rest of the street was green grass and wild roses. There was a grand, wide open ditch with high grass by the sides. The cows licked in great mouthfuls to chew as they walked up and down to the pasture land at the end of Carr Street

down by the beach. In front of our place Father had made a gravel walk but after our trees stopped there were just two planks to walk on.

At Mrs. McConnell's farm Father and I turned into Toronto Street. It was not half so fine; there was only a one-plank walk so we had to go one in front of the other. The ditch was little and mean, too. When we came to "Marifield Cottage" we turned into Princess Avenue. It was smaller still and had no ditch and no sidewalk. It was just a green strip pinched in between two fences. If two carts came in at both its ends at the same time one of them had to back out.

Uncle Jack's garden was on one side of Princess Avenue. He was not uncle to everybody but everybody called him that. He was a kind man who did jobs. When he worked for Father he took us for rides in his cart. It had no seat—just a loose plank laid across the cart. If the plank slid, Uncle Jack held on to you. There was such a high fence round his place that nothing could look over except the lilacs and the may trees. Their smell tumbled right over the fence on to you.

Opposite Uncle Jack's was Mrs. Swannick's house. She had no nose, only a wrinkle and two holes. She had a sick son, too. Before he died Father sent him a bottle of brandy because he was so very sick. Mrs. Swannick was so glad she cried. Her hands went up and she said, "O Lor! It's 'three star', too!"

Mrs. Robinson's house came next. She was a stout lady. She had a great friend named Mrs. Johnson who lived up past our house. Mrs. Robinson went every day to see Mrs. Johnson and Mrs. Johnson walked home with Mrs. Robinson; then Mrs. Robinson walked back with Mrs. Johnson. They went up and down, up and down; at last they stopped at our gate which was just about half way and then each ran home alone. These ladies were very fond of each other.

The last house on Princess Avenue was Mrs. Lipsett's. She was skinny and red, her nose and chin and elbows were sharp. She was always brushing or shaking something but no dirt ever came out. Her skinny arms hugged the great mattresses and plumped them onto her window ledges, as far as they could go without falling out, so that they could be sunned. It made Mrs. Jack very angry to see Mrs. Lipsett's beds hanging out of the windows. That is why "Uncle" put up such a high fence. It went all round the corner onto Michigan Street and shut out everything else as well as the beds and made it dark for poor Mrs. Jack—like living behind the world. Mrs. McConnell's front came right next to Uncle Jack's fence.

Mrs. McConnell was a splendid lady; I liked her very much indeed. She had such a large voice you could hear it on Toronto Street, Princess Avenue and Michigan Street all at once. She was so busy with all her children and cows and pigs and geese and hens that she had no time to be running after things, so she stood in the middle of her place and shouted and everything came running—Joseph, Tommy, Lizzie, Martha-Anne, Spot, Brownie and Daisie, and when she yelled "Chuck, Chuck, Chuckie" the whole farm was wild with wings. Some-

thing was always running to Mrs. McConnell. She sort of spread herself over the top of everything about the place and took care of it.

Mrs. McConnell worked very hard. She sold milk and eggs and butter and pork. She let people go through her place instead of round by Princess Avenue if they wanted to. Father did not, but I often used to come home that way because I liked Mrs. McConnell and her things. She called me "Lovey" and showed me her calves and little pigs. She said I was a "faithful lamb" taking my "Pa" to town every morning, but really it was Father who took *me*. She was Irish, with shiny eyes and high red cheeks, black hair and long teeth with wide gaps where there were not any; when she laughed you saw the gaps. The windows of Mrs. McConnell's and Mrs. Cameron's houses peered down Birdcage Walk like a pair of spectacles.

I don't remember what was on the corner of Birdcage Walk opposite Mrs. Cameron's "spectacle". Mrs. Cameron had a lot of cows, too, and a big barn with a little windmill on the top. All the wind running down Birdcage Walk caught it and turned the wheel. Mrs. Cameron had quite white hair, bundled into a brown net. She had a pink face with a hole of a mouth that had no teeth in it, only a pink tongue which rolled round when she talked, and a fluffy chin. She was a dear old lady and had two daughters. Jessie was the oldest and had a turned-up nose; her mouth turned up too when she laughed, and when she met her friends she began to bow by jerking her head away back on her neck and then she bounced it forward like a sneeze. Agnes was very clever: she taught school and quarrelled with the trustees. She wrote things that were printed too.

Mrs. McConnell's "spectacles" looked right across at Mrs. Plummer who was on the corner of Michigan and Birdcage Walk. Mrs. Plummer lived in a field—that is, her house sat in the middle of a very big field. Her cottage was made of corrugated iron and had a verandah all round it. The most splendid thing about it was that every window was a door made of glass and coming to the floor, so that Mrs. Plummer could rush straight out of any room into her garden—like a swallow darting out of a bank—she did not have to go through passages first. I expect that is why she built her house just like that, with so many doors. Her garden had a little fence round it to keep the cows in the big field from eating her flowers. Because of there being two fences round Mrs. Plummer I did not get to know her, but I saw her sometimes. She had a reddish face and a purple dress and was thick round the middle. In my own mind I called her "Mrs. Plum". When a cow looked over her fence she burst out of one of the "door windows" shouting "Shoo-shoo-shoo!" and beat one of her mats to show the cow what she meant. I always hoped Mrs. Plummer would come rushing out as we passed.

Birdcage Walk was almost a very grand street because the Parliament Buildings were nearly on it. Just a little row of houses was between. Besides, if it had not

been for James' Bay Bridge breaking in, Birdcage Walk would have been Government Street which was the most important street in Victoria. Birdcage Walk was wide and had a plank walk on both sides—wide enough to pass other people as you walked on it and it had a covered-in drain, too.

The Wilsons lived in the big house on the corner after Mrs. Plummer. They had a large family and a beautiful pine tree that was not a pine at all . . . it came from another country. The lawn where the children played was down three steps from the flower garden. Mr. Wilson was square and looked pressed hard as if he had grown up under something heavy. Mrs. Wilson was like a bird, with a sharp little nose. She wore her hair cut in a tiny fringe where the parting ended.

Then came the birdcagy part of Birdcage Walk—some funny little square houses with a chimney right in the middle of the top of each like a handle to hang it up by. In the first of these little houses Miss Wylie lived. She was squeaky and quite old. Her brother Charlie lived with her. He was very, very deaf. Miss Wylie had to squeak very high indeed for Charlie to hear her at all. Generally he said "Yes—yes—ah, yes—Tillie," but did not hear a word. Miss Wylie was a very timid lady. When she was coming to see Mother she sent word first so that Mother could send me down to fetch her, because she was so afraid of meeting a cow. I did feel brave walking up Carr Street on the ditch side of Miss Wylie, sucking one of her peppermints, particularly if there was a cow down in the ditch and I could look over the top of her back and horns.

Mrs. Green in the "birdcage" opposite the Wylies' was very kind to the Wylies because they were old. The Greens were important people: Mr. Green was a banker. They had a lot of children so they had to build more and more pieces on to their house till it did not look like a birdcage any more. The Greens had everything—a rocking-horse, real hair on their dolls, and doll buggies, a summerhouse and a croquet set. They gave a Christmas-tree party every year and everyone got a present. The Mason's fence was at the end of the Greens' lawn; it was covered with ivy which was a bother for the Greens' croquet balls. The Masons had a grey house and a boy, Harry, who was rough and cruel to our dolls.

And now we had come to the Lindsays' and James' Bay Bridge was just in front. Then Father doubled down and kissed me goodbye. Across the Bridge there was a saloon on every corner, so I was not allowed to go any farther. I waved to Father on the Bridge and then I was free.

I peeped between the stalky parts of the Lindsays' lilacs. Their gate had an arbour and you went down two steps into the garden. Next to Mrs. Plummer's I liked the Lindsays' place the best. There was a round flowerbed in the middle of their garden with a little path round it. All the rest of the garden was bushes and shrubs. Everything sweet grew in the Lindsays' garden. Perhaps they did it because sometimes the mud flats under James' Bay Bridge smelt awful. There was mignonette and cabbage roses and little yellow roses and red ones and moss ones. You could hardly see the house for vines, honeysuckle and clematis—then there were the lilacs, much purpler and sweeter than anyone else's.

As I went on home everyone nodded to me, but Miss Jessie Cameron gave me a whole bow as if I were a grown-up lady.

I often took the short cut through Mrs. McConnell's farm. She never stopped flying round but she always said, "Well, Lovey, is it yourself sure?" I always shut her gates most carefully.

One morning Mother gave me a beautiful bunch of flowers. She said I was only to go with Father as far as Mrs. McConnell's front gate and then I was to take the flowers to Mrs. McConnell and say they were for the baby.

I tapped at the door . . . everything was quite still. Instead of shouting, "Come right in", Mrs. McConnell came and opened the door quietly. Her eyes were red.

"Mother sent some flowers for your baby, Mrs. McConnell."

"Come and give them to him, Lovey."

She took my hand and led me in. I looked round, expecting to see the baby sitting in his pram. I was going to bounce the flowers at him and hear him giggle. The pram was not there. There was a little table in the middle of the room with a white box on it. Mrs. McConnell put her hands under my arms and lifted me so that I could look into the box. The baby was there—asleep, but his eyes were not quite shut.

Mrs. McConnell said, "Kiss him, Lovey". I kissed the baby's cheek. It was hard and cold. I dropped the flowers on his feet. Mrs. Cameron came in then, so I slipped out and ran home.

"Mother, why was Mrs. McConnell's baby so cold and funny?"

"Did you see the baby?"

"I kissed him. Mrs. McConnell told me to."

Mother looked vexed. She told me about death but I only half understood. I did not take the short cut for a long time after that but went round by Mrs. Lipsett's and Mrs. Swannick's.

The worst thing about Carr Street was that the houses were set far back in the gardens. There was nothing to see except what was in the street. Often the Bishop's chaise was going in or out and I ran to open the gate for Mrs. Cridge. It was a very big, low, wide chaise. There was a high hook for the reins to hang over so that they could not be swished under old Charlie's tail. He was a very lazy old horse and never ran. You could get in and out of the chaise while Charlie was going. They never stopped him because it was so hard to start him again. When Mrs. Cridge got very impatient to get anywhere she stood up and flapped the reins on Charlie's back. Then Charlie lashed his tail across the reins and pinned them down so tight that Mrs. Cridge could not drive at all and had to hang over the front and work at them. Her face went red and her bonnet crooked but all she ever said was "Ahem!" and "Oh, Charlie! Charlie!" The Bishop sat beside her smiling, with his eyes shut. Charlie held the reins down tight and pretended Mrs. Cridge was stopping him. Then by and by, when she had fished his tail up off the reins with the whip handle, he went on.

Every morning I met the Johnson girl on Carr Street. The Johnsons had a vegetable garden round the corner and their girl carried the vegetables to people in a basket. I don't know what her name was. We never spoke. She was taller than I and had a flat body and a meek face . . . which made me angry. After she had passed I always turned round and made a face at her. She knew I was going to so she looked back. One morning she had a big basket of potatoes on her arm and I made a dreadful face. She looked so hard and long that she tripped and sprawled in the mud, all her potatoes flying into the ditch. I laughed right out loud and stood watching while she fished them out. Her apron was all mud. She took it off and wiped each potato and put it back onto the basket. She did not look at me or say one word. When the potatoes were wiped and back in the basket she wiped first one of her eyes and then the other on the muddy apron, picked up her basket and went on down the street.

I went home too. I felt the meanest, meanest meanest thing I had ever heard of. Why didn't the Johnson girl hit me? Or throw mud, or say something? Why didn't she?

Father and Mother were talking about it . . . I was old enough but I cried every time I thought about going to school. My sisters tramped two miles night and morning. If I went with them I would not be able to see Mrs. Lipsett's bed or Mrs. Swannick's nose or Mrs. Plummer fly out or Miss Jessie's bow. We'd go on a straight, horrible road that had no friends on it . . . but, I did not have to.

Mrs. Fraser, the lady who had come to live in "Marifield Cottage" started a little school, so I went there. I could still go as far as the gate of the school every morning with Father, and on Saturdays I could go right to the Lindsays' and see all my friends.

When Saturday came I wanted to tell Father something, only it wouldn't come out. I looked up a lot of times but the ditch between his eyes was very deep—I was half afraid. We had passed the Greens' . . . we were at the Masons' steps . . . the Lindsays' lilacs were just coming.

"Father—Father—don't you think—now that I go to school I am too big to be kissed in the street?"

"Who said so?"

"The girls at school."

"As long as I have to stoop you won't be too big," Father said, and he kissed me twice.

G R O W N U P

VICTORIA'S top grandness was the Driard Hotel; all important visitors stayed at the Driard. To sit in crimson plush armchairs in enormous front windows and gaze rigid and blank at the dull walls of the opposite side of View Street so close to the Driard Hotel that they squinted the gazer's eyes, to be stared at by Victoria's inhabitants as they squeezed up and down narrow View Street which had no view at all, was surely worth a visit to the capital city.

The Driard was a brick building with big doors that swung and squeaked. It was red inside and out. It had soft red carpets, sofas and chairs upholstered in red plush and rep curtains, red also. All its red softness sopped up and hugged noises and smells. Its whole inside was a jumble of stuffiness which pushed itself into your face as you opened the outer door, licking the outside freshness off you greedily, making a dash for the open. But the Driard door squawked and slammed to before the stuffiness could escape and hit back smotheringly onto you. When you came out of the hotel you were so soaked with its heaviness you might have been a Driard sofa. Even the hotel bus had the Driard odor, although it did not actually live inside the hotel. It was a long, jolty two-horse bus with "Driard" painted on both its sides and a man shouting "Driard" from the back step. Stow-away Driard smells hid in the cushions of the bus and drove to the wharf ready to pounce on visitors.

The Driard visitors came mostly from San Francisco; Vancouver and Sound cities were too busy growing to waste time on visiting.

Victoria and Vancouver were always rivals and made jealous faces at one another. Vancouver had a finer harbour and grew faster; she was the easier to reach, being the end of the rail. Victoria had the Queen's name, was the capital of British Columbia and had the Esquimalt Naval Station.

When the East and West were linked by the Canadian Pacific Railway, Vancouver said, "Ha! I am the end of the rail; nobody will now bother about that little Victoria town on her island. Settlers and visitors will get off the train and stay here with me."

So she built factories, lumber mills, wharves and swelled herself furiously; but no matter how she swelled she could not help Victoria's being the capital of British Columbia or having the Naval Station. The navy men's wives came from England direct to Victoria to live while their husbands' ships were stationed at Esquimalt a mile or so out of the city.

Victoria kept in closer touch with England. She got more and more "Old Country"; Vancouver got more and more new-world. Vancouver coveted Victoria's gentility; Victoria coveted Vancouver's business.

These two cities made Canada's West, her far Pacific edge which lured pioneers on and on till they came to the rim of the ocean, earth bent to the world's roundness—land and water circling the West back to the East again.

Pioneers slid across Canada's vastness on the C.P.R. trains and were so comfortable in doing it that they did not get off till they had to. Often the first Canadian land their feet touched was British Columbia. The stark West snarled a little when they touched her first but she was really nearer to England in her ways and feelings than the East was, although the West was some four thousand miles farther away in space. By and by the English forgave the West her uncouth vastness and the West forgave them their narrow littleness.

The C.P.R. watched the West grow. She saw Victoria's squatty little old red brick Parliament Buildings give place to magnificent stone structures—domes, copper roofs—everything befitting a Capital City. Facing the Parliament Buildings across James' Bay arose a sedate stone and cement Post Office. Little old knock-kneed wooden James' Bay bridge still straddled the mud flats between the two. The C.P.R. pillowed their heads upon the mud flats and dreamed a dream. First they tore down the old wooden bridge and built in its place a wide concrete causeway, damming the Bay waters back from the flats. The sea was furious and dashed, but the concrete wall hurled it back. Smells got frantic and stank to high Heaven until engineers came and drained the seepage slough.

Pendray's soap works and Kanaka Row could not endure life without smells,—so they just faded out of existence. The soap-fat refuse from the soap works stopped playing glorious iridescent colours across the mud when the sun shone. No tide came in to sweep away Kanaka Row's refuse: their back doors were heaped round with it and were disgusting. The yellow clay of the mud flats parched and cracked. The mash grass, through which the Indian canoes had slithered so caressingly, turned harsh and brittle.

The City bartered with the Songhees Indians giving them money and a new reserve at Esquimalt in exchange for their fine harbour properties, which the City wanted for industrial purposes. All around Victoria's little harbour there was change. Even our dumpy little concept of Queen Victoria, drawn from the *Illustrated London News* changed when a swarthy stone amazon rose on a pedestal in front of the Parliament Buildings. Except for the crown and sceptre we would never have recognized this as our civic godmother.

While these changes were wrecking Victoria's calm, the C.P.R. were still dreaming their mud-flat dream and architects were making blue prints of it. To be private and undisturbed during their dreaming they built a huge hoarding the entire length of the causeway shutting the dream into the mud. A citizen's eye was applied to every knot-hole in the hoarding but they could make neither head nor tail of what was going on. The pile-driver gawked over the top of the hoarding. Thud, thud, thud! Her fearful weight obeyed the squeaky little whistle of

her engine, driving mighty logs, each one a complete tree-bole, end down into the mud. There they stood shoulder to shoulder, a headless wooden army tramping the old mud-smells clean through to China. When the flats were a solid wooden pack the harbour bottom was dredged and the liquid mud pumped in between the standing logs. Thousands of men wheeled millions of barrowloads of earth and rocks for hundreds of weeks—dumping, loading till solid ground was made on which the c.p.r. could found their dream.

The dream took shape in reality. The hoarding came down at last and there stood the beautiful Empress Hotel. It never looked crude and new because, while the back was building, the finished front was already given over to creepers and shrubs, and gardens were set the moment workmen's feet had stopped trampling. Beautiful conservatories sat right on top of where the city garbage dump had once been. Under their glass roofs bloomed rare flowers from all parts of the world, but none were more sweet, more lovely than the little wild briar roses that had so graciously soothed our noses over the old mud-flat smells.

The Driard Hotel could not blush herself any redder than she already was when confronted by her rival so she withered entirely away. No visitors wanted to sit enthroned on red plush, to stare at brick two feet from their noses when they could sit behind plate glass and look out over Victoria's lovely little harbour. Beautiful steamers snuggled up to the wharf, almost to the very door of the Hotel. From London dock to Empress Hotel door was one uninterrupted slither of easy travel.

Victoria ceased to be an English naval station: Canada navied herself. Esquimalt Harbour now had a huge dry-dock and a cannery. A few Indian dugout canoes stole in and out to the new reservation but most of the Indians now came and went in their new gas fishing-boats.

Victoria knew a little boom—a little bustle—but it was not her nature to boom and bustle; she slumped, settling to slow easy development—reticent, calm, deliberate.

These enormous happenings—the building of the Parliament Buildings, Empress Hotel and Causeway, the establishing of a first class boat service between the Island and the mainland stirred the heart of Victoria and sent lesser happenings quivering through her outskirts.

The narrow, three-mile strip of warm, inland sea opening out of the harbour and called the Gorge because of a narrow pass half-way up its course, one of Victoria's beauty spots where her people had bathed, and where regattas had been held on the Queen's birthday, became infested with booms of logs and saw-mills. Bathers protested. They did not like sawdust skins after bathing in the Gorge waters so went to the swimming tanks in the y.m.c.a. and in the Crystal Pool of the new Empress Hotel. The Gorge that had once been so fine a residential district went unfashionable. The beautiful homes on its banks sold for a mere song. Canoes and row-boats ceased carrying pleasure parties up its

protected waters to picnic. The fleet of sailing schooners still stuck to their winter quarters just below the Point Ellice bridge, where the harbour ended and the Gorge began, coming back to its safeness every winter like homing birds. A hideous railway bridge now spanned the Harbour and carried trains from "up-island" into the city. Spanning the upper harbour this bridge hoisted a section of itself for the sealers to pass under and then shut them safe in shelter.

Cedar Hill lying to the north of the town went "snooty"; elevating her name to Mount Douglas, she became a Public Park, smug with tameness. Little Saanich Mountain hatted her crown with an observatory the white dome of which looked for all the world like an inverted white pudding basin.

Because there was no more English Navy stationed at Esquimalt there were no more navy balls and no sham battles between the soldiers and sailors on Beacon Hill. There were no more road-house saloons with lovely flower boxes and cages of wild animals and horses' drinking troughs—there were no more driving horses. Automobiles purred over oiled and paved highways and there was no dust to make people and horses thirsty.

From the top of Church Hill the Cathedral stepped one block back. Instead of dominating the city she now dominated the old Quadra Street cemetery long since replaced by the new Ross Bay burying ground. Brambles no longer overran the dead Pioneers. Victoria's early settlers slept tidily under well mown lawns. The old head-stones and name-boards had been huddled into a corner, glowering morosely from their pale names, resenting the nakedness of being without the clinging vines and the riot of undergrowth that had protected their dead and themselves. On benches the public sat on top of the dead. Children scampered over them—jangle of the new cathedral bells quivered the dead's stillness.

James' Bay is James' Bay still. The smart forsook her long ago. First they moved to Upper Fort Street, then to Rockland Avenue, then on to Oak Bay, finally to the Uplands where they could not keep a cow or hang out a wash or have too many children. The entire shore line of greater Victoria is now spread with beautiful homes.

Victoria's inner land being higher than her shore, every aspect is lovely, North, South, East and West—blue sea, purple hills, snow-capped Olympic mountains bounding her southern horizon, little bays and beaches heaped with storm-tossed drift, pine trees everywhere, oak and maple in plenty.

So stands tranquil Victoria in her Island setting—Western as West can be before earth's gentle rounding pulls West east again.

THE HOUSE OF
ALL SORTS

CONTENTS

BOBTAILS

F O U N D A T I O N

THE HOUSE OF ALL SORTS could not have been quite itself in any other spot in the world than just where it stood, here, in Victoria, across James' Bay and right next to Beacon Hill Park. The house was built on part of the original property my father had chosen when he came to the new world and settled down to raise his family. This lot was my share of the old cow pasture. Father's acreage had long ago been cut into city lots. Three houses had been built in the cow yard, more in the garden and others in the lily field. The old house in which I was born was half a block away; one of my sisters still lived in it, and another in her little schoolhouse built in what had once been the family vegetable garden.

Bothers cannot be escaped by property owners and builders of houses. I got my share from the very digging of the hole for the foundation of the House of All Sorts. But the foundations of my house were not entirely of brick and cement. Underneath lay something too deep to be uprooted when they dug for the basement. The builders did not even know it was there, did not see it when they spread the cement floor. It was in my memory as much as it was in the soil. No house *could* sit it down, no house blind what my memory saw—a cow, an old white horse, three little girls in pinafores, their arms full of dolls and Canton-flannel rabbits made and stuffed with bran by an aunt, three little girls running across the pasture to play "ladies" in the shrubberies that were screened from Simcoe Street by Father's hawthorn hedge, a hedge now grown into tall trees, flowering in the month of May.

I remembered how I had poked through the then young bushes to hang over those old rotted pickets, now removed to permit the dumping of the lumber for my house. I remembered how I had said to Bigger and Middle, "Listen, girls, see if you can tell what sort of person is coming up the street by the kind of tune I blow," and I put the harmonica to my lips and puffed my cheeks. But a gentle little old lady passed, so I played very softly. She stopped and smiled over the fence at the three of us, and at the dolls and foolish, lop-eared, button-eyed rabbits.

"Eh, dearies, but how you are happy playing ladies in this sweetie wee grove!"

And now my house was built in the "sweetie wee grove," and I was not playing "lady," but was an actual landlady with tenants, not dollies, to discipline. And tenants' pianos and gramaphones were torturing my ears, as my harmonica

had tortured the ears of Bigger and Middle. The little old lady had made the long pause—she would not come that way again.

Ah! little old lady, you, like cow, horse, dolls and rabbits, contributed a foundation memory to the House of All Sorts.

FRICTION

FRICTION quickly scraped the glamour of newness from my house—even from the start of its building. My Architect was a querulous, dictatorial man who antagonized his every workman. He had been recommended to me by an in-law; like a fool I trusted and did not investigate for myself, making enquiry of the two Victoria families he had built for since coming out from England. Always impatient, as soon as I decided to build I wanted the house immediately.

I drew up a plan and took it to the Architect asking what roughly such a building would cost. He took my plan, said it was "concise and practical"—if I would leave it with him a day or two he'd look it over and return it to me with some idea of the cost so that I could decide whether I wanted to build or not.

"A very good little plan," the man said. "But naturally I could make a suggestion or two."

In a few days he returned my drawing so violently elaborated that I did not recognize it. I said, "But this is not the house I want." He replied tartly that I would have to pay him two hundred dollars whether I accepted his plan or not because of the time he had spent mutilating it unasked! I made enquiry from the other people he had built for, finding out he had been most unsatisfactory. I was too inexperienced to fight. I knew nothing about house building; besides, I was at the time living and teaching in Vancouver. I could not afford to pay another architect as well as this one for his wretched plan. It seemed there was nothing to do but go on.

The man hated Canada and all her living. *He* was going to show her how to build houses the English way. He would not comply with Canadian by-laws; I had endless trouble, endless expense through his ignorance and obstinacy. I made frequent trips up and down between Vancouver and Victoria. Then the man effected measles and stayed off the job for six weeks, babying himself at home, though he lived just round the corner from my half-built house.

I had hundreds of extra dollars to pay because of the man's refusal to comply with the city by-laws and the building inspectors' ripping the work out. It was a disheartening start for the House of All Sorts, but, when once I was quit of the

builders and saw my way to climbing out of the hole of debt they had landed me in, I was as thrilled as a woman is over her first baby even if it is a cripple.

The big boom in Victoria property tumbled into a slump, an anxious shuddery time for every land-owner. There had been no hint of such a reverse when I began building. Houses were then badly needed. Now the houses were half of them staring blankly at each other.

Tenants were high-nosed in their choosing of apartments. The House of All Sorts was new and characterless. It had not yet found itself—and an apartment house takes longer to find itself than do individual private houses.

I had expected to occupy the Studio flat and paint there, but now the House of All Sorts could not afford a janitor. I had to be everything. Rents had lowered, taxes risen. I was barely able to scrape out a living. Whereas I had been led to believe when I started to build there would be a comfortable living, all the rentals together barely scraped out a subsistence.

The House of All Sorts was at least honest even if it was not smart. People called it quaint rather than that. It was an average house, built for average tenants. It was moderately made and moderately priced. It had some things that ultra-modern apartments do not have these days—clear views from every window, large rooms and open fire-places as well as furnace heat. Tenants could make *homes* there. Lower East and Lower West were practically semi-detached cottages.

It takes more than sweet temper to prevent a successful Landlady from earning the title of "Old Crank."

Over-awareness of people's peculiarities is an unfortunate trait for a Landlady to possess. I had it. As I approached my house from the street its grim outline seemed to slap me in the face. It was mine. Yet by paying rent others were entitled to share it and to make certain demands upon me and upon my things. I went up a long, steep stair to my door. The door opened and gulped me. I was in the stomach of the house, digesting badly in combination with the others the House of All Sorts had swallowed, mulling round in one great, heavy ache. Then along would come Christmas or the signing of the armistice, or a big freeze-up with burst pipes, an earthquake, a heat wave—some universal calamity or universal joy which jumped us all out of ourselves and cleared the atmosphere of the house like a big and bitter pill.

SOUNDS AND SILENCES

SOMETIMES I rented suites furnished, sometimes unfurnished, according to the demand. Two things every tenant provided for himself—sound and silence. His own personality manufactured these, just as he stamped his imprint on every inch of his environment, placing his furniture just so, hoisting and lowering his window blinds straight or crooked. Even the boards of the floor creaked differently to each tenant's tread, walls echoed his noises individually, each one's hush was a different quiet.

Furniture is comical. It responds to humans. For some it looks its drabbest, for others it sparkles and looks, if not handsome, at any rate comfortable. And heavens! how tormenting furniture is to a guilty conscience—squeaking, squealing, scrooping! Let someone try to elude rent day or contemplate a fly-by-night. That man the furniture torments.

OLD ATTIC

THE ATTIC was no older than the rest of the house. Yet, from the first to me it was very old, old in the sense of dearness, old as the baby you hug and call "dear old thing" is not old in years, but just in the way he has tangled himself round your heart, has become part of you so that he seems always to have existed, as far back as memory goes. That was the way with my attic. Immediately I came into the house the attic took me, just as if it had always "homed" me, became my special corner—the one place really my own. The whole house, my flat, even my own studio, was more or less public. People could track me down in any part of the house or even in the garden. Nobody ever thought of tracking me up to my attic.

I had a fine bedroom off the studio, but I kept that as a guest room, preferring to sleep in my attic. A narrow, crooked little stair in one corner of the

studio climbed to a balcony, no more than a lower lip outside the attic door. If people could not find me about house or garden, they stood in the studio and shouted. Out I popped on the tiny balcony, high up on the studio wall, like a cuckoo popping out of a clock.

In the attic I could wallow in tears or in giggles,—nobody saw.

There was an outer hall and front door shared by the doll's flat and my own. If the doorbell rang while I was in my attic, I stuck my head out of the window in the gable without being seen, and called, "Who? Down in a second!"

That second gave me a chance to change my face. Those experienced in land-ladying told me, "Develop the 'landlady face,' my dear—not soft, not glad, not sorry, just blank."

ATTIC EAGLES

THE SLOPE of my attic roof rose in a broad benevolent peak, poking bluntly into the sky, sinking to a four-foot wall. At one end of the gable were two long, narrow windows which allowed a good view to come into the room, a view of sea, roof tops and purple hills. Directly below the windows spread a great western maple tree, very green. Things about my place were more spready than high, myself, my house, the sheep-dogs, and Dolf, the Persian cat, whose silver fleece parted down the centre of his back and fluffed wide. Even my apple trees and lilacs grew spready.

In the wall, opposite the windows of my attic, was the room door with a tiny landing before it. Off this landing and over the studio was a dark cobwebby place, tangled with wiring, plumbing, ventilation and mystery. The plaster had oozed up through the lathing on the wrong side of the ceiling and set in bumpy furrows. I had a grim dislike of this place but the high studio ventilated through it, so the little square door had to be left ajar. I painted an Indian bear totem on this white-washed door.

On the generous slope of the attic roof I painted two Indian eagles. They were painted right on the under side of the roof shingles. Their great spread wings covered the entire ceiling of the attic. The heads of the eagles tilted upwards in bold, unafraid enquiry. I loved to lie close under these strong Indian symbols. They were only a few feet above my face as I slept in this attic bed-room. They made "strong talk" for me, as my Indian friends would say.

When, after twenty years, people bought my house and turned it into a fine

modern block, they did not require the attic, so they took away the little stair leading from the studio, they removed the door and windows, but they could not remove my eagles without tearing the roof off the house. The eagles belonged to the house for all time.

Old eagles, do you feel my memories come creeping back to you in your entombed, cobwebby darkness?

BROODING AND HOMING

HOUSE, I have gone to bed in your attic crying with smart and hurt as though I had been a hen under whose wing hornets had built their nest and stung me every time I quivered a feather. House, I have slept too in your attic, serene as a brooding dove.

The Indian eagles painted on the underside of the roof's shingles brooded over my head, as I brooded over the House of All Sorts. Three separate sets of souls beside my own it housed, souls for whose material comfort I was responsible. Every hen loosens up her feathers to brood over what she has hatched. Often the domestic hen is badly fooled, finds herself mothering goslings, ducks or guinea-fowl instead of good, ordinary chickens. Only the hen who "steals her nest away" can be sure whose eggs she is sitting on.

The House of All Sorts seemed to get more goslings and guinea-fowl than plain chickens. I tried to be a square old hen, but the mincing guineas and the gawky goslings tried me. The guineas peeped complainingly, the goslings waddled into all the puddles and came back to chill my skin. In no time too they outgrew my brooding squat, hoisting me clear off my feet.

You taught me, old House, that every bird wants some of her own feathers in the lining of her nest.

At first I tried to make my suites into complete homes—arranged everything as I would like it myself—but people changed it all round, discarded, substituted. It is best in a House of All Sorts to provide the necessary only and leave each woman to do her own homing.

S P A C E

ROOF, WALLS, floor can pinch to hurting while they are homing you, or they can hug and enfold. Hurt enclosed is hurting doubled; to spread misery thins it. That is why pain is easier to endure out in the open. Space draws it from you. Enclosure squeezes it close.

I know I hurt my tenants sometimes—I wanted to; they hurt me! It took a long time to grind me into the texture of a landlady, to level my temperament, to make it neither all up nor all down.

The tenant always had this advantage—he could pick up and go. I could not. Fate had nailed me down hard. I appeared for the present to have no hammer-claw strong enough to pry myself loose. No, I was not nailed. I was *screwed* into the House of All Sorts, twist by twist. Every circumstance, financial, public, personal, artistic, had taken a hand in that cruel twirling of the driver. My screws were down to their heads. Each twist had demanded—"Forget you ever wanted to be an artist. Nobody wanted your art. Buckle down to being a landlady."

If only I could have landladied out in space it would not have seemed so hard. The weight of the house crushed me.

F I R S T T E N A N T

SHE WAS A BRIDE just returned from honeymooning, this first tenant of mine. Already she was obviously bored with a very disagreeable husband. In her heart she knew he was not proud of her. He kept his marriage to this Canadian girl secret from his English mother.

The bride was a shocking housekeeper and dragged round all day in boudoir cap, frowsy negligée and mules—slip, slop, slip, slop. In my basement I could hear her overhead. Occasionally she hung out a grey wash, left it flapping on the line for a week, unless, for very shame, I took it in to her. "Awfully kind," she

would say, "I've been meaning to bring it in these six days. Housekeeping is such a bore!" As far as I could see she did not do any. Even trees and bushes flutter the dust off, manage to do some renewing. Slip, slop—slip, slop—her aimless feet traipsed from room to room. She did not trouble to raise the lid of the garbage can, but tossed her discards out of the back door. Occasionally she dressed herself bravely and, hanging over the front gate, peered and peered. As people passed, going to Beacon Hill Park, she would stop them, saying, "Was there a thin man in grey behind you when you turned into this street?"

Astonished they asked, "Who would it be?"

"My husband—I suppose he has forgotten me again—a bachelor for so long he forgets that he has a wife. He promised to take me to the Races to-day—Oh, dear!"

Going into her flat she slammed the door and melted into negligée again.

He was a horrid man, but I too would have tried to forget a wife like that. Negligée, bad cooking, dirty house!

They had leased my flat for six months. Three days before the fourth month was up, the man said to me casually,

"We leave here on the first."

"Your lease?" I replied.

"Lease!" He laughed in my face. "Leases are not worth their ink. Prevent a landlady from turning you out, that's all."

I consulted the lawyer who admitted that leases were all in favour of the tenant. He asked, "Who have you got there?" I told him.

"I know that outfit. Get 'em out. Make 'em go in the three days' notice they gave you. Tell them if they don't vacate on the dot they must pay another full month. Not one day over the three, mind you, or a full month's rental!"

When I told the couple what the lawyer had said they were very angry, declaring that they could not move in three days' time, but that they would not pay for overtime.

"All right," I said. "Then the lawyer . . ."

They knew the lawyer personally and started to pack violently.

The bride and groom had furnished their own flat—garish newness, heavily varnished, no nearer to being their own than one down payment, less near, in fact, as the instalments were overdue. Store vans came and took the furniture back. The woman left in a cab with a couple of suitcases. The forwarding address she left was that of her mother's home. The man left a separate forwarding address. His was a hotel.

To describe the cleaning of that flat would be impossible. As a parting niceness the woman hurled a pot of soup—meat, vegetables and grease—down the kitchen sink. She said, "You hurried our moving," and shrugged.

The soup required a plumber.

The first tenant nearly discouraged me with landladying. I consulted an experienced person. She said, "In time you will learn to make yourself hard, hard!"

DEW AND ALARM CLOCKS

POETICAL EXTRAVAGANCE over "pearly dew and daybreak" does not ring true when that most infernal of inventions, the alarm clock, wrenches you from sleep, rips a startled heart from your middle and tosses it on to an angry tongue, to make ugly splutterings not complimentary to the new morning; down upon you spills cold shiveriness—a new day's responsibilities have come.

To part from pillow and blanket is like bidding goodbye to all your relatives suddenly smitten with plague.

The attic window gaped into empty black. No moon, no sun, no street lamps. Trees, houses, telephone poles muddled together and out in that muddle of blank perhaps one or two half-hearted kitchen lights morosely blinking. Sun had not begun.

The long outside stair, from flat to basement, never creaked so loudly as just before dawn. No matter how I tiptoed, every tread snapped, "Ik!"

Punk, the house dog, walked beside me step by step, too sleepy to bounce.

Flashlights had not been invented. My arms threshed the black of the basement passage for the light bulb. Cold and grim sat that malevolent brute the furnace, greedy, bottomless—its grate bars clenched over clinkers which no shaker could dislodge. I was obliged to thrust head and shoulders through the furnace door. I loathed its black, the smell of soot. I was sure one day I should stick. I pictured the humiliation of being hauled out by the shoes. Could I ever again be a firm dignified landlady after being pulled like that from a furnace mouth!

I could hear tenants still sleeping—the house must be warm for them to wake to. . . .

"Woo, Woo!" A tiny black hand drew the monkey's box curtain back. "Woo, Woo!" A little black face enveloped in yawn peeped out. One leg stretched, then the other. "Woo." She crept from her box to feel if her special pipe was warm, patted approvingly, flattened her tummy to the heat. The cat came, shaking sleep out of her fur. Crackle, crackle!—the fire was burning. Basement windows were now squares of blue-grey dawn.

Carrying a bucket of ashes in each hand I went into the garden, feeling like an anchor dropped overboard. Everything was so coldly wet, I so heavy. Dawn was warming the eastern sky just a little. The Bobbies were champing for liberty.

They had heard my step. The warmth of their loving did for the garden what the furnace was doing for the house.

Circled by a whirl of dogs I began to live the day.

We raced for Beacon Hill, pausing when we reached its top. From here I could see my house chimney—mine. There *is* possessive joy, and anyway the alarm clock would not rouse me from sleep for another twenty-three hours—might as well be happy!

Up came the sun, and drank the dew.

MONEY

FROM THE MOMENT key and rent exchanged hands a subtle change took place in the attitude of renter towards owner.

The tenant was obviously anxious to get you out, once the flat was hers. She might have known, silly thing, that you wanted to be out—before she began to re-arrange things.

Bump, bump, bump! It would never do to let a landlady think her taste and arrangement were yours. Particularly women with husbands made it their business to have the man exchange every piece of furniture with every other. When they left you had to get some one to move them all back into place. When once they had paid and called it "*my* flat" they were always asking for this or that additional furniture or privilege.

There was the tenant who came singing up my long stair and handed in the rent with a pleasant smile. It was folded in a clean envelope so that the raw money was not handled between you. You felt him satisfied with his money's worth. Perhaps he did change his furniture about, just a little, but only enough to make it home him. Every hen likes to scrape the straw around her nest, making it different from every other hen's. There was the pompous person who came holding a roll of bills patronizingly as if he were handing you a tip. There was the stingy one, parting hardly with his cash, fishing the hot tarnished silver and dirty bills from the depths of a trouser pocket and counting them lingeringly, grudgingly, into your palm. There was the rent dodger who always forgot rent date. There was every kind of payer. But most renters seemed to regard rent as an unfairness—was not the earth the Lord's? Just so, but who pays the taxes?

DIRECT ACTION

OUR DISTRICT was much too genteel to settle disagreements by a black eye or vituperation. Troubles were rushed upstairs to the landlady. I wished my tenants would emulate my gas stove. In proud metallic lettering she proclaimed herself "Direct action" and lived up to it.

How bothersome it was having Mrs. Lemoyne mince up my stair to inform on Mrs. FitzJohn; having to run down the long stair, round the house and carry the complaint to Mrs. FitzJohn, take the retort back to Mrs. Lemoyne and return the ultimatum—upping and downing until I was tired! Then, often, to find that there was no trouble between the two ladies at all. The whole affair was a fix-up, to convey some veiled complaint against my house or against me, to have the complainer send a sweet message to the complained-of: "Don't give the matter another thought, my dear. It is really of no consequence at all," and from my window see the ladies smiling, whispering, nodding in the direction of my flat. I would have liked better an honest pig-sow who projected her great grunt from the depths of her pen right into one's face.

My sisters, who lived round the corner from the House of All Sorts, watched my landladying with disapproval, always siding with the tenant and considering my "grunt" similes most unrefined. But they did not have to be landladies.

COLD SWEAT

HIS HAND TREMBLED—so did his voice.

"You will leave the door of your flat unlocked tonight? So that I could reach the 'phone?"

"Certainly."

He went to the door, stood there, clinging to the knob as if he must hold on to something.

"Beautiful night," he said and all the while he was turning up his coat collar because of the storming rain outside. He went into the night. I closed the door; the knob was wet with the sweat of his hand.

Bump, bump, bump, and a curse. I ran out and looked over the rail. He was rubbing his shins.

"That pesky cat—I trod on her—" he cursed again. He loved that cat. I heard him for half an hour calling among the wet bushes. "Puss, Puss, poor Puss." Maybe that mother cat knew his mind needed to be kept busy and was hiding.

I was just turning in when he came again.

"She's all right."

"You have had word? I am so glad—"

"The cat, I mean," he said, glowering at me. "She was not hurt when I trod on her—shan't sleep tonight—not one wink, but if I should not hear your 'phone—would you call me?—leave your window open so I shall hear the ring?"

"All right, I'll call you; I am sure to hear if you don't."

"Thanks, awfully."

The telephone did not ring. In the morning he looked worse.

He came up and sat by the 'phone, scowling at the instrument as if it were to blame. At last he found courage to ring the hospital. After a terse sentence or two he slammed the receiver down and sat staring.

"That your porridge burning?"

"Yes!" He rushed down the stair, and returned immediately with the black, smoking pot in his hand.

"If it were not Sunday I'd go to the office—hang! I'll go anyhow."

"Better stay near the 'phone. Why not a hot bath?"

"Splendid idea. But—the 'phone?"

"I'll be here."

No sooner was he in the tub than the message came.

"You are wanted on the 'phone." I shouted through two doors.

"Take it." He sounded as if he were drowning.

I was down again in a moment. "A boy—both doing well." Dead stillness.

By and by I went down. He was skimming the cream off the milk jug into the cat's dish. The hair stuck damp on his forehead, his cheeks were wet.

"Thank God I was in the tub! I could not have stood it—I should never have thought of asking how she—*they*—were." Realization of the plural clicked a switch that lit up his whole being.

A Tyrant and a Wedding

SHE CAME FROM the prairie, a vast woman with a rolling gait, too much fat, too little wind, only one eye.

She stood at the bottom of the long stair and bribed a child to tell me she was there. Her husband sat on the verandah rail leaning forward on his stick, her great shapeless hand steadying him. This lean, peevish man had no more substance than a suit on a hanger. A clerical collar cut the mean face from the empty clothes.

The old lady's free hand rolled towards the man. "This," she said, "is the Reverend Daniel Pendergast. I am Mrs. Pendergast. We came about the flat."

The usual rigmarole—rental—comfortable beds—hot water . . . They moved in immediately.

I despised the Reverend Pendergast more every day. His heart was mean as well as sick. He drove the old lady without mercy by night and by day. She did his bidding with patient, adoring gasps. He flung his stick angrily at every living thing, be it wife, beast or bird—everything angered him. Then he screamed for his wife to pick up his stick—retrieve it for him like a dog. She must share his insomnia too by reading to him most of the night; that made the tears pour out of the seeing and the unseeing eyes all the next day. Her cheeks were always wet with eye-drips.

I was sorry for the old lady. I liked her and did all I could to help her in every way except in petting the parson. She piled all the comforts, all the tidbits, on him. When I took her flowers and fruit from my garden, it was he that always got them, though I said, most pointedly, "For *you, Mrs.* Pendergast," and hissed the "s's" as loud as I could.

She would beg me, "Do come in and talk to 'Parson'; he loves to see a fresh face."

Sometimes, to please her, I sat just a few minutes by the sour creature.

One morning when I came down my stair she moaned through the crack of the door, "Come to me."

"What is the matter?" I said. She looked dreadful.

"I fell into the coal-bin last night. I could not get up. My foot was wedged between the wall and the step."

"Why did you not call to me?"

"I was afraid it would disturb the Parson. I got up after a while but the pain

of getting up and down in the night to do for my husband was *dreadful* torture."

"And he let you do it?"

"I did not tell him I was hurt. His milk must be heated—he must be read to when he does not sleep."

"He is a selfish beast," I said. She was too deaf, besides hurting too much, to hear me.

When I had helped to fix her broken knees and back, I stalked into the living-room where the Reverend Pendergast lay on a couch.

"Mrs. Pendergast has had a very bad fall. She can scarcely move for pain."

"Clumsy woman! She is always falling down," he said indifferently.

I can't think why I did not hit him. I came out and banged the door after me loudly, hoping his heart would jump right out of his body. I knew he hated slams.

There was an outbreak of caterwaulings. The neighbourhood was much disturbed. The cats were strays—miserable wild kittens born when their owners went camping and never belonging to anyone.

The tenants put missiles on all window ledges to hurl during the night. In the morning I took a basket and gathered them up and took them to the tenants' doors so that each could pick out his own shoes, hairbrushes, pokers and scent bottles. Parson Pendergast threw everything portable at the cats. The old lady was very much upset at his being so disturbed. At last with care and great patience, I enticed the cats into my basement, caught them and had them mercifully destroyed.

When I told the Pendergasts, the Parson gave a cruel, horrible laugh. "I crushed a cat with a plank once—beat the life out of her, just for meowing in our kitchen—threw her into the bush for dead; a week later she crawled home—regular jelly of a cat." He sniggered.

"You—a parson—you did that? You cruel beast! To do such a filthy thing!"

Mrs. Pendergast gasped. I bounced away.

I could not go near the monster after that. I used to help the old lady just the same, but I would not go near the Reverend Pendergast.

One day, I found her crying.

"What is it?"

"Our daughter—is going to be married."

"Why should she not?"

"He is not the kind of man the Parson wishes his daughter to marry. Besides they are going to be married by a J.P. They will not wait for father. There is not another parson in the vicinity."

The old lady was very distressed indeed.

"Tell your daughter to come here to be married. I will put her up and help you out with things."

The old lady was delighted. The tears stopped trickling out of her good eye and her bad eye too.

We got a wire off to the girl and then we began to bake and get the flat in order.

The Parson insisted it should be a church wedding—everything in the best ecclesiastical style, with the bishop officiating. The girl would be two days with her parents before the ceremony. She was to have my spare room. However, the young man came too, so she had the couch in her mother's sitting room. They sent him upstairs without so much as asking if they might.

I was helping Mrs. Pendergast finish the washing-up when the young couple arrived. Mrs. Pendergast went to the door. She did not bring them out where I was, but keeping her daughter in the other room, she called out some orders to me as if I had been her servant. I finished and went away; I began to see that the old lady was a snob. She did not think me the equal of her daughter because I was a landlady.

It was very late when the mother and daughter brought the young man upstairs to my flat to show him his room. They had to pass through my studio. From my bedroom up in the attic I could look right down into the studio. My door was ajar. There was enough light from the hall to show them the way, but the girl climbed on a chair and turned all the studio lights up full. The three then stood looking around at everything, ridiculed me, made fun of my pictures. They whispered, grimaced and pointed. They jeered, mimicked, playacted me. I saw my own silly self bouncing round my own studio in the person of the old lady I had tried to help. When they had giggled enough, they showed the young man his room and the women went away.

I was working in my garden next morning when the woman and the girl came down the path. I did not look up or stop digging.

"This is my daughter. . . . You have not met, I think."

I looked straight at them, and said, "I saw you when you were in my studio last night."

The mother and daughter turned red and foolish looking; they began to talk hard.

The wedding was in the Cathedral; the old man gave his daughter away with great pomp. The other witness was a stupid man. I was paired with him. We went for a drive after the ceremony.

I had to go to the wedding breakfast because I had promised to help the old lady; I hated eating their food. The bride ordered me around and put on a great many airs.

The couple left for the boat. Mrs. Pendergast and I cleared up. We did not talk much as we worked. We were tired.

Soon the doctor said the Reverend Daniel Pendergast could go home to the prairies again because his heart was healed. I was glad when the cab rolled down the street carrying the cruel, emaciated Reverend and the one-eyed ingrate away from my house—I was glad I did not have to be their landlady any more.

A V i s i t o r

DEATH HAD BEEN snooping round for a week. Everyone in the house knew how close he was. The one he wanted lay in my spare room but she was neither here nor there. She was beyond our reach, deaf to our voices.

The sun and spring air came into her room—a soft-coloured, contented room. The new green of spring was close outside the windows. The smell of wall-flower and sweet alyssum rose from the garden, and the inexpressible freshness of the daffodils.

The one tossing on the bed had been a visitor in my house for but a short time. Death made his appointment with her there. The meeting was not hateful—it was beautiful and welcome to her.

People in the house moved quietly. Human voices were tuned so low that the voices in inanimate things—shutting of doors, clicks of light switches, crackling of fires—swelled to importance. Clocks ticked off the solemn moments as loudly as their works would let them.

Death came while she slept. He touched her, she sighed and let go.

We picked the wall-flowers and the daffodils, and brought them to her, close. There was the same still radiance about them as about her. Every bit of her was happy. The smile soaked over her forehead, eyelids and lips—more than a smile—a glad, silent expression.

Lots of people had loved her; they came to put flowers near and to say goodbye. They came out of her room with quiet, uncrying eyes, stood a moment by the fire in the studio, looking deep into it, and then they went away. We could not be sad for her.

The coffin was taken into the studio. One end rested on the big table which was heaped with flowers. The keen air came in through the east windows. Outside there was a row of tall poplars, gold with young spring.

Her smile—the flowers—quiet—possessed the whole house.

A faint subtle change came over her face. She was asking to be hidden away.

A parson came in his mournful black. He had a low, sad voice—while he was talking we cried.

They took her down the long stairs. The undertakers grumbled about the corners. They put her in the waiting hearse and took her away.

The house went back to normal, but now it was a mature place. It had known birth, marriage and death, yet it had been built for but one short year.

THE DOLL'S HOUSE
COUPLE

IT WAS MADE FOR THEM, as surely as they were made for each other. I knew it as soon as I saw the young pair standing at my door. They knew it too the moment I opened the door of the Doll's House. His eyes said things into hers, and her eyes said things into his. First their tongues said nothing, and then simultaneously, "It's ours!" The key hopped into the man's pocket and the rent hopped into mine.

One outer door was common to their flat and to mine. Every time I came in and out passing their door I could hear them chatting and laughing. Their happiness bubbled through. Sometimes she was singing and he was whistling. They must do something, they were so happy.

At five o'clock each evening his high spirits tossed his body right up the stair—there she was peeping over the rail, or hiding behind the door waiting to pounce on the tragedy written all over him because he had not found her smiling face hanging over the verandah rail. She pulled him into the Doll's House, told him all about her day—heard all about his.

She tidied the flat all day and he untidied it all night. He was such a big "baby-man," she a mother-girl who had to take care of him; she had always mothered a big family of brothers. They had taught her the strangeness of men, but she made more allowance for the shortcomings of her man than she had done for the shortcomings of her brothers.

I was making my garden when they came to live in my house. They would come rushing down the stair, he to seize my spade, she to play the hose so that I could sit and rest a little. They shared their jokes and giggles with me.

When at dusk, aching, tired, I climbed to my flat, on my table was a napkined plate with a little surprise whose odor was twin to that of the supper in the Doll's House.

Sometimes, when my inexperience was harried by Lower East or Lower West, when things were bothersome, difficult, so that I was just hating being a landlady, she would pop a merry joke or run an arm round me, or he would say, "Shall I fix that leak?—put up that shelf?"

Oh, they were like sunshine pouring upon things, still immature and hard by reason of their greenness. Other tenants came and went leaving no print of themselves behind—that happy couple left the memory of their joyousness in every corner. When, after they were gone, I went into the Doll's House emptiness, I felt their laughing warmth still there.

References

EXPERIENCE TAUGHT ME to beware of people who were glib with references. I never asked a reference. I found that only villains offered them.

There was a certain Mrs. Panquist. The woman had a position in a very reputable office. Her husband was employed in another. Her relatives were people of position, respected citizens. She gave me this voluntary information when she came to look at the flat.

"It suits me," she said. "I will bring my husband to see it before deciding."

Later she rang up to say he was not coming to see it. They had decided to take the flat and would move in early the next morning. She would bring her things before business hours. Furthermore she asked that I prepare an extra room I had below for her maid. To do this I had to buy some new furniture.

She did not come or send her things next morning; all day there was no word of her. I had the new furniture bought and everything ready.

Late in the evening she arrived very tired and sour.

She snatched the key out of my hand.

"It is usual to exchange the rent for the key," I said knowing this was wartime and that there was some very shady fly-by-nights going from one apartment house to another.

"I am too tired to bother about rent tonight!" she snapped. "I will come up with it in the morning before I go to work."

Again she failed to keep her promise. I asked her for the rent several times but she always put me off. Finally she said rudely, "I am not going to pay; my husband can."

I went to the man, who was most insolent, saying, "My wife took the flat; let her pay."

"Come," I said. "Time is going on, one or the other of you must pay." I pointed to the notice on my kitchen door "RENTS IN ADVANCE." He laughed in my face. "Bosh!" he said. "We don't pay till we are ready."

I began to make enquiries about the couple, not from those people whose names they had given as reference, but from their former landlady. Their record was shocking. They had rented from a war widow, destroyed her place, and gone off owing her a lot of money.

Both of the Panquists had jobs; they could pay and I was not going to get caught as the war widow had been.

I consulted the law—was turned over to the Sheriff.

"Any furniture of their own?"

"Only a couple of suitcases."

"Not enough value to cover the rental they owe?"

"No."

"This is what you are to do. Watch—when you see them go out take a pass key, go in and fasten up the flat so that they cannot get in until the rental is paid."

"Oh, I'm scared; the man is such a big powerful bully!"

"You asked me for advice. Take it. If there is any trouble call the police."

I carried out the Sheriff's orders, trembling.

The Panquists had a baby and a most objectionable nursemaid. She was the first to come home, bringing the child.

I was in my garden. She screamed, "The door is locked. I can't get in!"

"Take the child to the room I prepared for you." (The woman had decided she did not want it after I had bought furniture and prepared the room.) I took down milk and biscuits for the child. "When your mistress has paid the rent the door will be opened," I said. The maid bounced off and shortly returned with the woman, who stood over me in a furious passion.

"Open that door! You hear—open that door!"

"When the rent is paid. You refuse, your husband refuses. The flat is not yours till you pay. I am acting under police orders."

"I'll teach you," she said, livid with fury, and turned, rushing headlong; she had seen her husband coming.

He was a huge man and had a cruel face. His mouth was square and aggressive; out of it came foul oaths. He looked a fiend glowering at me and clenching his fists.

"You—(he called me a vile name)! Open or I will break the door in!" He braced his shoulder against it and raised his great fists. I was just another woman to be bullied, got the better of, frightened.

I ran to the 'phone. The police came. The man stood back, his hands dropping to his sides.

"What do you want me to do?" said the officer.

"Get them out. I won't house such people. They got away with it in their last place, not here."

I was brave now though I shook.

"The town is full of such," said the officer. "House owners are having a bad time. Scum of the earth squeezing into the shoes of honest men gone overseas. How much do they owe?"

I told him.

He went to the man and the woman who were snarling angrily at one another.

"Pay what you owe and get out."

"No money on me," said the man, "my wife took the flat."

"One of you must," said the officer.

"Shell out," the man told the woman brutally.

She gave him a look black with hatred, took money from her purse and flung it at me. My faith in proffered references was dead.

DOGS AND CATS

AT FIRST, anxious to make people feel at home, happy in my house, I permitted the keeping of a dog or a cat, and I endured babies.

My Old English Bobtail Sheep-dogs lived in kennels beyond the foot of my garden. They had play fields. The tenants never came in contact with the dogs other than seeing them as we passed up the paved way in and out for our run in Beacon Hill Park. One old sheep-dog was always in the house with me, always at my heels. He was never permitted to go into any flat but mine. There was, too, my great silver Persian cat, Adolphus. He also was very exclusive. People admired him enormously but the cat ignored them all.

I enjoyed my own animals so thoroughly that when a tenant asked, "May I keep a dog or a cat?" I replied, "Yes, if you look after it. There are vacant lots all round and there is Beacon Hill Park to run the animal in."

But no, people were too lazy to be bothered. They simply opened their own door and shoved the creature into the narrow strip of front garden, let him bury his bones and make the lawn impossible. Always it was the landlady who had to do the tidying up. I got tired of it. Anyone should be willing to tend his creature if he has any affection for it. They managed cats even worse, these so-called "animal lovers." Stealthily at night a basement window would open, a tenant's cat be pushed through. The coal pile became impossible. I was obliged to ban all animals other than a canary bird, although I would far rather have banned humans and catered to creatures.

MATRIMONY

I HAD NEVER before had the opportunity of observing the close-up of married life. My parents died when I was young. We four spinster sisters lived on in the old house. My girlhood friends who married went to live in other cities. I did not know what "till-death-do-us-part" did to them.

Every couple took it differently of course, but I discovered I could place "Marrieds" in three general groupings—the happy, the indifferent, and the scrappy.

My flat being at the back of the house I overlooked no tenant nor did I see their comings and goings. The walls were as soundproof as those of most apartments, only voice murmurs came through them, not words. No secrets were let out. I neither saw nor heard, but I *could* feel in wordless sounds and in silences; through the floor when I went into my basement to tend the furnace I heard the crackle of the man's newspaper turning and turning—the creak of the woman's rocker.

There are qualities of sound and qualities of silence. When the sounds were made only by inanimate things, you knew that couple were the indifferent type. When you heard terse jagged little huddles of words, those were the snappers! If there was a continuous rumbling of conversation, contented as the singing of a tea kettle or the purring of a cat, you knew that couple had married happily. There was the way they came to pay the rent too, or ask a small favour, or project a little grumble. The happily married ones spared each other; the wife asked or grumbled for the husband, the husband for the wife.

Snappy couples tore up my stairs, so eager to "snap their snaps" that they often found themselves abreast of each other anxious to be first!

It was immaterial whether the man or the woman of the indifferent pair came. They handed in the rent grudgingly and went away without comment. I liked them the least.

L I F E L O V E S L I V I N G

THERE WERE FOUR western maple trees growing in the lot upon which I built my house. Two were in the strip of front lawn, clear of foundations, but when the builders came to overhead wiring they found one of the trees interfered. The line-men cut it down. The other front-lawn maple was a strong, handsome tree. I circled her roots with rock and filled in new earth. The tree throve and branched so heavily that the windows of Lower West and the Doll's Flat were darkened. Experts with saws and ladders came and lopped off the lower branches. This sent the tree's growth rushing violently to her head in a lush overhanging which umbrellaed the House of All Sorts. She was lovely in spring and summer, but when fall came her leaves moulted into the gutters and heaped in piles on the roof, rotting the cedar shingles. It put me to endless expense of having roof-men, gutter-men and tree-trimmers. At last I gave the grim order, "Cut her down."

It is horrible to see live beauty that has taken years to mature and at last has reached its prime hacked down, uprooted.

The other two maple trees had stood right on the spot where my house was to be built. The builders had been obliged to saw them to within three or four feet of the ground. Both trees' roots were in that part underneath the house which was not to be cemented; it would always be an earthy, dark place. The maple stumps were left in the ground. One died soon. The other clung furiously to life, her sap refused to dry up; grimly she determined to go on living.

The cement basement was full of light and air, but light and air were walled away from that other part, which was low. I could not stand there upright; there was but one small square of window in the far corner. The old maple stump shot sickly pink switches from her roots, new switches every year. They crept yearningly toward the little square of window. Robbed of moisture, light and air, the maple still remembered spring and pushed watery sap along her pale sprouts, which came limper and limper each year until they were hardly able to support the weight of a ghastly droop of leaves having little more substance than cobwebs.

But the old maple stump would not give up. It seemed no living thing in the House of All Sorts had less to live for than that old western maple, yet she clung to life's last shred—she loved living.

BRIDES

LOWER EAST and Lower West were both rented to brides.

The brides sat in their living-rooms with only a wall dividing; they looked out at the same view. They did not know each other.

In the East flat, the young husband was trying to accommodate himself to a difficult and neurotic wife.

In the West flat a middle-aged groom was trying to slow a bright young girl down to his dullness. The girl drooped, was home-sick, in spite of all the pretty things he gave her and the smart hats she made for herself (she had been a milliner in New York before she married the middle-aged man). It was freedom she thought she was marrying—freedom from the drudgery of bread-and-but-ter-earning. When he dangled a "home of her own" before her eyes, she married him and was numbed; now came the pins and needles of awaking.

I had known the other bride since she was a child. When I welcomed her into my house, she chilled as if to remind me that she was a popular young bride—I a landlady; I took the hint. I had put the best I had into her flat, but she scornfully tossed my things into her woodshed, replacing them with things of her own. The rain came, and spoiled my things. When I asked her to hand back what she did not want, so that I might store them safely, she was very insulting, as if my things were beyond contempt or hurting.

The little New York bride was very, very lonely, with her dull, heavy husband. She came up to my flat on any excuse whatever. One day she cried and told me about it. She said that she knew no one. "The girl next door is a bride too; she's smart; she has lots of friends. I see them come and go. Oh, I do wish I knew her." Then she said, "You know her; couldn't you introduce me? Please!"

"I have known her since she was a child, but I could not introduce you to each other."

"Why?"

"It is not my place to introduce tenants. People make opportunities of speaking to each other if they are neighbours, but they would resent being compelled by their landlady to know each other."

"But you have known this girl since she was little—couldn't you? I have no friends at all. Please, please."

"Listen, it would not make you happy. She is a snob."

I would not subject this unhappy, ill-bred, little bride, with her ultra clothes

218

worn wrong, her overdone make-up and her slangy talk, to the snubs of the stuck-up bride next door.

"You'll come and see me, won't you? Come often—he is out so much."

"I will come when I can."

She went slowly down to her empty flat, this lonely little bride who had sold her pretty face for laziness and a home.

Next day she ran up, all excitement.

"My opportunity came! The postman asked me to deliver a registered letter, because my neighbour was out; you are all wrong, she is lovely. I expect we shall see a lot of each other now. I am so happy."

She flew down-stairs, hugging her joy.

I missed her for some days. I went to see if she were ill, found her crumpled into a little heap on the sofa. She had red eyes.

"Hello! Something wrong?"

She gulped hard. "It is as you said—she is a snob. We met in the street. They saw me coming. When I was close they looked the other way and talked hard. Her husband did not even raise his hat!"

"Perhaps they did not see it was you."

"They could not help seeing—not if they'd been as blind as new kittens. I spoke before I saw how they felt," she sobbed.

"Pouf! Would I care? She is not worth a cry! What pretty hats you make!"

She had been working on one—it lay on the table half finished.

"You like them? I make them all myself. I was a milliner in New York—head of all the girls. They gave me a big pay because I had knack in designing—big fine store it was too!"

"Here you are crying because a snob who couldn't make one 'frump's bow' did not speak to you! Come, let's go into the garden and play with the pups."

She was soon tumbling with them on the lawn, kind whole-hearted clumsy pups, much more her type than the next-door bride.

ALWAYS SOMETHING

SHE WAS SO YOUNG, so pretty, so charming! But when it came to a matter of shrewd bargaining, you couldn't beat her. Her squeezing of the other fellow's price was clever—she could have wrung juice from a raw quince. Her big husband was entirely dominated by his tall, slender wife; he admired her methods enormously. Sometimes he found it embarrassing to look into the face of the "squeezed." While she was crumbling down my rent, he turned his back,

looking out of the window, but I saw that his big ears were red and that they twitched.

It was the Doll's Flat she bargained for, which seemed ridiculous seeing that he was so large, she so tall, and the Doll's Flat so little.

"Won't it be rather squeezy?" I suggested.

"My husband is used to ship cabins. For myself I like economy."

She was an extremely neat, orderly person, kept the Doll's Flat like a Doll's Flat—no bottles, no laundry, no garbage troubles, as one had with so many tenants. She made the place attractive.

She entertained a bit and told me all the nice things people said about her flat.

"If only I had 'such and such a rug' or 'such and such a curtain' it would be perfect!" and she wheedled till I got it for her. But these added charms to make her flat *perfect* always came out of my pocket, never out of hers.

I had a white cat with three snowball kittens who had eyes like forget-me-nots. When the tall, slim wife was entertaining, she borrowed my "cat family," tied blue ribbons round their necks. Cuddled on a cushion in a basket they amused and delighted her guests—inexpensive entertainment. Flowers were always to be had out of my garden for the picking.

"If only toasted buns grew on the trees!" She liked toasted buns for her tea parties—the day-before's were half-price and toasted better. . . . I heard her on my 'phone.

"Not deliver five cents' worth! Why should I buy more when I don't require them?" Down slammed the receiver and she turned to me.

"They do not deserve one's custom! I shall have to walk to town: it is not worth paying a twelve-cent carfare to fetch five cents' worth of stale buns!"

I swore at the beginning of each month I would buy nothing new for her, but before the month was out I always had, and wanted to kick myself for a weak fool. I liked her in spite of her meanness.

She was proud of her husband's looks; he wore his navy lieutenant's clothes smartly.

"Ralph, you need a new uniform."—He ordered it. "How much is the tailor charging? . . . Ridiculous!"

"He is the best tailor in town, my dear."

"Leave him to me."

The next day she came home from town. "I've cut that tailor's price in half!"

"What a clever wife!" But the lieutenant went red. He took advantage of her bargaining but he shivered at her boasting in front of me about it.

She did hate to pay a doctor. She had been a nurse before she married; she knew most of the doctors in town. It was wonderful how she could nurse along an ailment till someone in the house fell sick, then she just "happened to be coming in the gate" as the doctor went out. He would stop for a word with the pretty thing.

"How are you?"

Out came tongue and all her saved-up ailments. She ran down to the druggist's to fill the prescription, to shop a little. Butcher, grocer always added a bit of suet, or a bone, or maybe she spotted a cracked egg, had it thrown in with her dozen. They *loved* doing it for her, everybody fell before her wheedle.

"I am going to stay with you forever," she had said as an inducement to make me lower the rent and buy this or that for her flat. Then, "The very smartest apartment block in town—Ralph always fancied it, but it was too expensive for us. But—only one room, a bachelor suite—the man is sub-letting at *half* its usual price, furniture thrown in. He will be away one year. Wonderful for us! Such a bargain, isn't it my dear?"

"One room!"

"But, the block is so smart: such a bargain!"

They went to their bargain room. A professor and his wife moved into my Doll's Flat. They were as lavishly open-handed as the others had been stingy. The professor was writing a book. He had a talkative wife whom he adored, but though he loved her tremendously, he could not get on with his book because of her chattering. He just picked her up, opened my door, popped her in.

"There! chatter, dear, all you like." He turned the key on his peace—what about mine? I pulled the dust-sheet over my canvas. Landlady's sighs are heavy—is it not enough to give shelter, warmth, furniture? Must a landlady give herself too?

MEAN BABY

THE BABY had straight honey-coloured hair, pale eyes, puckered brow, pouting mouth, and a yell, a sheer, bad-tempered, angry yell which she used for no other reason than to make herself thoroughly unpleasant. Bodily she was a healthy child.

Her family brought her to my house suddenly because the whole lot of them had come down with measles while staying in a boarding-house nearby. The other boarders got panicky and asked them to go! Early in the morning the mother came to me, very fussed. Lower West was empty and measles being a temporary complaint, I let the woman have the flat.

When the taxi load of spotty children drove up to my door I was hustling to warm up the beds and make up extras. Some of the children sat limp and mute waiting, while others whimpered fretfully. The infant, a lumpy child of

unwalking, un-talking age, was the only one who had not got measles. The mother set the child on the floor while she went to fetch the sick, spotty miseries from the cab. The infant's head, as it were, split in two—eyes, cheeks, brow retired, all became mouth, and out of the mouth poured a roar the equal of Niagara Falls.

The lady in the Doll's Flat above stuck her head out of the window and looked down. "Measles," I warned, and she drew her own and her small son's head back, closed her windows and locked her door.

The measles took their course under a doctor and a trained nurse. I ran up and down the stairs with jellies and gruel. Night and day the baby cried. The House of All Sorts supposed she was sickening for measles and endured it as best they could. The baby did not get measles. After fumigation and quarantine were over and nothing ailed the child we had the Doctor's word as assurance that it was only a cranky, mean temper that was keeping us awake all night. The tenants began coming to me with complaints, and I had to go down and talk to the mother.

I said, "No one in the house can sleep for the child's crying, something will have to be done. I cannot blame my tenants for threatening to go and I cannot afford to lose them." The woman was all syrupy enthusing over the soups and jellies I had sent the measles; but she suddenly realized that I was in earnest and that my patience for my household's rest was at an end.

If only I could have gone down to the mother in the middle of the night when we were all peevish for sleep, it would have been different, but, with the child sitting for the moment angel-like in her mother's lap, it was not easy to proceed. I looked out the window. Near the front gate I saw the child's pram drawn up dishevelled from her morning nap. What my tenants resented most was not that the child kept the whole household awake at night but that the mother put her baby to sleep most of the day in the garden, close by the gate through which people came and went to the house. After listening to her yelling all night every one was incensed to be told in the daytime, "Hush, hush! my baby is asleep: don't wake her." The mother pounced upon the little boy upstairs, upon baker, postman, milkman, visitors; every one was now afraid to come near our house; people began to shun us. I looked at the disordered pram and took courage.

"Would you please let the baby take her day naps on the back verandah; she would be quiet there and not interfere with our coming and going."

"My baby on the back porch! Certainly not!"

"Why does the child cry so at night? My tenants are all complaining; something will have to be done."

"People are most unreasonable."

She was as furious as a cow whose calf has been ill-treated.

"Who is it that suffers most, I'd like to know? Myself and my husband! It is most ill-natured of tenants to complain."

Standing the baby on her knee and kissing her violently, "Oose never been werry seepsy at night has Oo, Puss Ducksey?"

The child smacked the mother's face with extraordinary vigour, leaving a red streak across the cheek. The mother kissed the cruel little fist.

"Something will have to be done, otherwise I shall have an empty house," I repeated determinedly for the third time.

"What, for instance?"

"A few spankings."

The woman's face boiled red.

"Spank Puss! Never!"

My hand itched to spank both child and mother.

"Why don't you train the child? It is not fair to her, only makes people dislike her."

"As if any one could dislike Puss, our darling!" She looked hate at me.

During our conversation Puss had been staring at me with all her pale eyes, her brow wrinkled. Now she scrambled from her mother's lap to the floor and by some strange, crablike movement contrived not only to reach me but to drag herself up by my skirt and stand at my knee staring up into my face.

"Look! Look! Puss has taken her first steps alone and to you, you, who hate her," said the angry mother.

"I don't hate the youngster. Only I cannot have a spoiled child rob me of my livelihood and you must either train her or go elsewhere."

She clutched the honey-haired creature to her.

"The people upstairs have left because of your baby's crying at night. They gave no notice. How could I expect it: the man has to go to business whether your child has yelled all night or not. Another tenant is going too. I wish I could leave myself!"

I saw that my notice was being ignored. I had sent it in when I served her last rent. Go she must! It was in her hand when she came up to pay.

"Of course you don't mean this?" She held out the notice.

"I do."

"But have you not observed an improvement? She only cried four times last night."

"Yes, but each time it lasted for a quarter of the night."

"Sweet Pussy!" she said, and smothered the scowling face with kisses. "They don't want us, Puss!"

"That notice stands," I said, looking away from Puss. "I got no notices from the tenants Puss drove away."

The angry mother rushed for the door. I went to open it for her and a little pink finger reached across her mother's shoulder and gave me a little, pink poke and a friendly gurgling chuckle.

"What I cannot understand," the woman blazed at me as she turned the

corner, "is *why* Puss, my shy baby who won't allow any one to speak to her, appears actually to *like* you, you who hate her."

But did I hate the little girl with honey-coloured hair? She had cost me two tenants and no end of sleep, had heated my temper to boiling, yet, somehow I could not hate that baby. The meanest thing about her was the way she could make you feel yourself. One has to make a living and one must sleep. It is one of the crookednesses of life when a little yellow-haired baby can cause you so much trouble and yet won't even let you hate her.

Puss sailed off to her new home in a pram propelled by an angry parent.

"Ta ta," she waved as they turned the corner—and I? I kissed my hand to Puss when her mother was not looking.

BACHELORS

WHEN A FLAT housed a solitary bachelor, there was a curious desolation about it. The bachelor's front door banged in the morning and again at night. All day long there was deadly stillness in that flat, that secret silence of "Occupied" emptiness, quite a different silence from "To Let" emptiness.

Pedlars passed the flat without calling. The blinds dipped or were hoisted at irregular levels. Sometimes they remained down all day. Sometimes they were up all night. There were no callers and there was no garbage. Men ate out.

Bachelors that rent flats or houses do so because they are home-loving; otherwise they would live in a boarding-house and be "done" for. They are tired of being tidied by landladies; they like to hang coats over chair backs and find them there when they come home. It is much handier to toss soiled shirts behind the dresser than to stuff them into a laundry bag; men do love to prowl round a kitchen. A gas stove, even if it is all dusty over the top from unuse, is home-like, so is the sink with its taps, the saucepan, the dishes. The men do not want to cook, but it is nice to know they could do so if they wished. In the evening, when I tended the furnace, I heard the bachelor tramp, tramp, tramping from room to room as if searching for something. This would have fidgeted a wife, but, if the bachelor had had a wife he would probably not have tramped.

During the twenty-odd years that I rented apartments I housed quite a few bachelors. Generally they stayed a long while and their tenancy ended in marriage and in buying themselves a home.

A bachelor occupied Lower West for several years. Big, pink and amiable, he gave no trouble. Occasionally his sister would come from another town to visit

him. He boarded her with me up in my flat. I enjoyed these visits, so did her brother. I saw then how domestic and home-loving the man was. He loved his sister and was very good to my Bobtail dogs. Once the sister hinted—there *was* "somebody," but, she did not know for certain; brother thought he was too old to marry—all fiddlesticks! She hoped he would. Therefore, I was not surprised when the bachelor came into my garden, and, ducking down among the dogs to hide how red he was, said, "I am going to be married. Am I an old fool?"

"Wise, I think."

"Thank you," he said, grinning all over—"I have been happy here."

He gave formal notice, saying, "I have bought a house."

"I hope you will be very happy."

"Thanks. I think we shall."

He went to the garden gate, turned, such a sparkle in his eye it fairly lit the garden.

"She's fine," he said. "Not too young—sensible."

Then he bolted. I heard the door of his flat slam as if it wanted to shut him away from the temptation of babbling to the world how happy he was.

The wedding was a month distant. During that month, when I tended the furnace there was no tramp, tramp, tramp overhead. I heard instead the contented scrunch, scrunch of his rocking chair.

The morning of the wedding he bounded up my stair, most tremendously shaved and brushed, stood upon my doormat bashfully hesitant. I did not give him the chance to get any pinker before I said, "You *do* look nice."

"Do I really?" He turned himself slowly for inspection. "Hair, tie, everything O.K.?"

"Splendid." But I took the clothes brush from the hall stand and flicked it across his absolutely speckless shoulders. It made him feel more fixed.

His groomsman shouted from the bottom of the stair, "Hi there!" He hurried down and the two men got into a waiting cab.

BANGS AND SNORES

A YOUNG LAWYER and his mother lived in Lower West. They were big, heavy-footed people. Every night between twelve and two the lawyer son came home to the flat. First he slammed the gate, then took the steps at a noisy run, opened and shut the heavy front door with such a bang that the noise reverberated through the whole still house. Every soul in it was startled from his sleep. People

complained. I went to the young man's mother and asked that she beg the young man to come in quietly. She replied, "My son is my son! We pay rent! Good-day."

He kept on banging the house awake at two A.M.

One morning at three A.M. my telephone rang furiously. In alarm I jumped from the bed and ran to it. A great yawn was on the other end of the wire. When the yawn was spent, the voice of the lawyer's mother drawled, "My son informs me your housedog is snoring; kindly wake the dog, it disturbs my son."

The dog slept on the storey above in a basket, his nose snuggled in a heavy fur rug. I cannot think that the noise could have been very disturbing to anyone on the floor below.

The next morning I went down and had words with the woman regarding her selfish, noisy son as against my dog's snore.

Petty unreasonableness nagged calm more than all the hard work of the house. I wanted to loose the Bobtails, follow them—run, and run, and run into forever—beyond sound of every tenant in the world—tenants tore me to shreds.

ZIG-ZAG . . . KI-HI

SIMULTANEOUSLY, two young couples occupied, one Lower East, one Lower West. The couples were friends. One pair consisted of a selfish wife and an unselfish husband. The other suite housed a selfish husband and an unselfish wife.

Zig-zag, zig-zag. There was always pulling and pushing, selfishness against unselfishness.

I used to think, "What a pity the two selfish ones had not married, and the two unselfish." Then I saw that if this had been the case nobody would have got anywhere. The unselfish would have collided, rushing to do for each other. The selfish would have glowered from opposite ends of their flat, refusing to budge. . . .

Best as it was, otherwise there would have been pain—stagnation.

The unselfish wife was a chirping, cheerful creature. I loved to hear her call "Ki-hi, Ki-hi! Taste my jam tarts." And over the rail of my balcony would climb a handful of little pies, jam with criss-cross crust over the top! Or I would cry over the balcony rail, "Ki-hi, Ki-hi! Try a cake of my newest batch of home-made soap."

We were real neighbours, always Ki-hi-ing, little exchanges that sweetened the sour of landladying. This girl-wife had more love than the heart of her

stupid husband could accommodate. The overflow she gave to me and to my Bobtails. She did want a baby so, but did not have one. The selfish wife shook with anxiety that a child might be born to her.

Zig-zag, zig-zag. Clocks do not say "tick, tick, tick," eternally—they say "tick, tock, tick, tock." We, looking at the clock's face, only learn the time. Most of us know nothing of a clock's internal mechanism, do not know why it says "tick, tock," instead of "tick, tick, tick."

Lady Loo, my favourite Bobtail mother, was heavy in whelp. Slowly the dog paddled after my every footstep. I had prepared her a comfortable box in which to cradle her young. She was satisfied with the box, but restless. She wanted to be within sight of me, or where she heard the sound of my voice. It gave the dog comfort.

Always at noon on Sundays I dined with my sisters in our old home round the corner. I shut Lady Loo in her pen in the basement; I would hurry back. When I re-entered the basement, "Ki-hi"—a head popped in the window of Loo's pen. On the pavement outside sat little "Ki-hi."

"Loo whimpered a little, was lonely when she heard you go. I brought my camp stool and book to keep her company. Ki-hi, Lady Loo! Good luck!" She was away!

I think that little kindness to my mother Bobtail touched me deeper than anything any tenant ever did for me.

B L I N D

MOTHER AND DAUGHTER came looking for a flat, not in the ordinary way—asking about this and that, looking out of the windows to see what view they would have. They did not note the colour of the walls, but poked and felt everything, smoothed their fingers over surfaces, spaced the distance of one thing from another. I sensed they sought something particular; they kept exchanging glances and nods, asked questions regarding noises. They went away and I forgot about them. Towards evening they came back; they were on their way to the Seattle boat, had decided to take my flat, and wanted to explain something to me. The cab waited while we sat on my garden bench.

"There will be three people in the flat," said the woman. "My mother, my daughter and my daughter's fiancé."

"It is necessary to get the young man away from his present environment; he has been very, very ill."

She told me that while he was making some experiments recently something

had burst in his face, blowing his eyes out. The shock had racked the young man's nerves to pieces. His fiancée was the only person who could do anything with him. She was devoted. The grandmother would keep house for them. They asked me to buy and prepare a meal so that they could come straight from the boat next day and not have to go to a restaurant.

The meal was all ready on the table when the girl led the crouching huddle that was her sweetheart into the flat. Old grandmother paddled behind—a regular emporium of curiosities. She looked like the bag stall in a bazaar; she was carrying all kinds—paper, leather, string and cloth. They dangled from her hands by cords and loops, or she could never have managed them all. She hung one bag or two over each door-knob as she passed through the flat, and then began taking off various articles of her clothing. As she took each garment off, she cackled, "Dear me, now I must remember where I put that!" Her hat was on the drainboard, her shoes on the gas stove, her cloak on the writing desk, her dress hung over the top of the cooler door. Her gloves and purse were on the dinner-table, and her spectacles sat on top of the loaf. She looked pathetic, plucked. After complete unbuilding came reconstruction. She attacked the bags, pulling out a dressing sacque, a scarf, an apron and something she put on her head. She seemed conscious of her upper half only, perhaps she used only a handmirror. Her leg half was pathetic and ignored. The scant petticoat came only to her knees, there was a little fence of crocheted lace around each knee. Black stockings hung in lengthwise folds around the splinters of legs that were stuck into her body and broke at right angles to make feet. Her face-skin was yellow and crinkled as the shell of an almond—the chin as pointed as an almond's tip.

The girl led the boy from room to room. She held one of his hands, with the other he was feeling, feeling everything that he could reach. So were his feet—shuffling over the carpet, over the polished floor. Grannie and I kept up a conversation, turning from him when we spoke so that he could hear our voices coming from behind our heads and not feel as if we were watching him.

Grannie "clucked" them in to dinner; I came away.

It was natural enough that the blind man should be fussy over sounds. Grannie flew up to my flat and down like a whiz cash-box. The wind caught her as she turned the corner of my stairs, exposing a pink flannelette Grannie one week and a blue flannelette Grannie the next. She was very spry, never having to pause for breath before saying, "Tell those folks above us to wear slippers—tell them to let go their taps gently—have a carpenter fix that squeaky floor board."

Then she whizzed downstairs and the door gave back that jerky smack that says, "Back again with change!"

On Sunday morning the house was usually quiet. Settling in families was always more or less trying. I determined to have a long late lie, Grannie and family being well established. At seven A.M. my bell pealed violently. I stuck my head

out into the drizzling rain and called, "What is wanted?"

Grannie's voice squeaked—"You!"

"Anything special? I am not up."

"Right away! Important!"

I hurried. Anything might have happened with that boy in the state he was.

When I opened the door, Grannie poked an empty vase at me, "The flowers you put in our flat are dead. More!"

The girl and the boy sat in my garden at the back of the house. It was quiet and sheltered there, away from the stares the boy could not bear. The monkey was perched in her cherry-tree, coy as Eve, gibbering if some one pulled in the clothes-line which made her tree shiver and the cherries bob, stretching out her little hands for one of the pegs she had coveted all the while that the pyjamas, the dresses and aprons had been drying. The girl told him about it all, trying to lighten his awful dark by making word-pictures for him—the cat on the fence, the garden, flowers, me weeding, the monkey in her cherry-tree.

"Is that monkey staring at me?"

"No, she is searching the dry grass round the base of the cherry-tree for earwigs now. Hear her crunch that one! Now she is peeping through the lilac bush, intensely interested in something. Oh, it's the Bobtails!"

I had opened the gates from dog-field and puppy-pen. Bobtails streamed into the garden. People sitting with idle hands suggested fondling, which dogs love. They ringed themselves around the boy and girl. The mother dog led her pups to them—the pups tugged at his shoelaces, the mother dog licked his hand. He was glad to have them come of themselves. He could stoop and pick them up without someone having to put them into his arms. He buried his blackness in the soft black of their live fur. A pup licked his face, its sharp new teeth pricked his fingers, he felt its soft clinging tongue, smelled the puppy breath. The old dog sat with her head resting on his knee. He could feel her eyes on him; he did not mind those eyes. The sun streamed over everything. His taut nerves relaxed. He threw back his head and laughed!

The girl gathered a red rose, dawdled it across his cheek and forehead. She did not have to tell him the colour of the rose; it had that exultant rich red smell. He put his nose among the petals and drew great breaths.

Suddenly the back door of their flat flew open—PLOSH!—Out among the flowers flew Grannie's dishwater. Grannie was raised in drought. She could not bear to waste water down a drain.

Old Grannie over-fussed the young folks. She was kind, but she had some trying ways. Afternoon house-cleaning was one of them.

The new bride in Lower East was having her post-nuptial "at home" and Grannie must decide that very afternoon to house-clean her front room. She heaved the rugs and chairs out onto the front lawn; all the bric-a-brac followed. She tied the curtains in knots and, a cloth about her head, poised herself on a

table right in front of the window. Everyone could see the crochet edging dangling over the flutes of black stocking. She hung out—she took in; her arms worked like pistons. The bride's first guest met a cloud of Bon Ami as Gran shook her duster. The waves from Gran's scrub bucket lapped to the very feet of the next guest—dirty waves that had already washed the steps. The bride came up the next day to see me about it.

Why—oh, why—oh, why—could one not secure tenants in packets of "named varieties"—true to type like asters and sweet peas? The House of All Sorts got nothing but "mixed."

S N O W

TALL—LOOSEKNIT—dark-skinned—big brown eyes that could cry grandly without making her face ugly—sad eyes that it took nothing at all to fire and make sparkle.

That funny joker, life, had mated her to a scrunched-up whipper-snapper of a man, with feet that took girls' boots and with narrow, white hands. They had a fiery-haired boy of six. His mother spoiled him. It was so easy for her to fold her loose-knit figure down to his stature. They had great fun. The father scorned stooping. Neither his body nor his mind was bendable.

I heard mother and son joking and sweeping snow from their steps. Sweeping, snowballing—sweeping, laughing. That was on Monday. By Wednesday more snow had fallen, and she was out again sweeping furiously—but she was alone.

"Where is your helper?"

"Sick."

"Anything serious?"

"I have sent for the doctor. I am clearing the snow so that he can get in." She had finished now and went in to her flat and banged the door angrily—evident anger, but not at me.

The doctor came and went; I ran down to her.

"What does the doctor say?"

"Nothing to be alarmed over."

She was out in the snow again. Little red-head was at the window; both were laughing as if they shared some very good joke. Then I saw what she was doing. She was filling snow back into the path she had cleared in the morning, piling the snow deeper than it was before, spanking it down with the shovel to keep it

from blowing away. She carried snow from across the lawn, careful not to leave any clear path to her door.

"Why are you doing that?"

Her eyes sparkled; she gave the happiest giggle and a nod to her boy.

"My husband would not get up and shovel a path for the doctor. Do you think he is going to find a clear path when he comes home to lunch? Not if I know it, he isn't."

"If it were not already finished, I would be delighted to help," I said and we both ran chuckling into our own flats.

ARABELLA JONES'S HOME

ARABELLA JONES ran out of the back door, around the house and into the front door of her flat. Over and over she did it. Each time she rang her own door bell and opened her own front door and walked in with a laugh as if such a delightful thing had never happened to her before.

"It is half like having a house of my own," she said, and rushed into the garden to gather nasturtiums. She put them into a bowl and dug her nose down among the blossoms. "Bought flowers don't smell like that, and oh, oh, the kitchen range! and a pulley clothes-line across the garden! my own bath! Nothing shared—no gas plate hidden behind a curtain—no public entrance and no public hall! Oh, it is only the beginning too; presently we shall own a whole house and furniture and our own garden, not rented but our very own!"

It was not Silas Jones but "a home" that had lured Arabella into marriage. When dull, middle-aged Silas said, "I am tired of knocking round, I want a home and a wife inside that home—what about it, Arabella?" she lifted her face to his like a "kiss-for-a-candy" little girl. And they were married.

That was in Eastern Canada—they began to move West. It was fun living in hotels for a bit, but soon Arabella asked, "When are we going to get the home?"

"We have to find out first where we want to be."

The place did not matter to Arabella. She wanted a home. They travelled right across Canada, on, on, till they came to Vancouver and the end of the rail.

"Now there is no further to go, can we get our home?"

"There is still Vancouver Island," he said.

They took the boat to Victoria. Here they were in "Lower West," while Silas Jones looked around. He was in no hurry to buy. The independence of a self-contained flat would satisfy his young wife for the time being.

Arabella Jones kept begging me, "Do come down to our flat of an evening and talk before my husband about the happiness of owning your own home."

Mortgage, taxes, tenants, did not make home-owning look too nice to me just then—I found it difficult to enthuse.

Silas had travelled. He was a good talker, but I began to notice a queerness about him, a "far-offness"—when his eyes glazed, his jaw dropped and he forgot. Arabella said, "Silas is sleeping badly, has to take stuff." She said too, "He is always going to Chinatown," and showed me vases and curios he bought in Chinatown for her.

One night Silas told me he had been looking round, and expected to buy soon, so I could consider my flat free for the first of the next month should I have an applicant.

The following day I was going down my garden when he called to me from his woodshed. I looked up—drew back. His face was livid—eyes wild; foam came from his lips.

"Hi, there, you!" he shouted. "Don't you dare come into my flat, or I'll kill you—kill you, do you hear? None of your showing off of my flat!"

He was waving an axe round his head, looking murderous. I hurried past, did not speak to him. I went to the flat at the other side of the house; this tenant knew the Joneses.

I said, "Silas Jones has gone crazy or he is drunk."

"You know what is the matter with that man, don't you?"

"No, what?"

"He"—a tap at the door stopped her. Silas Jones's young wife was there.

"Somebody wants to see over our flat," she said.

"Would you be kind enough to show it to them?"

"It would be better for you to do it yourself," she said shortly. I saw she was angry about something.

"I can't—your husband—"

"My husband says you insulted him—turned your back on him when he spoke to you. He is very angry."

"I do not care to talk to drunken men."

"Drunken? My—husband—does—not—drink. . . ." She spoke slowly as if there were a wonder between every word; her eyes had opened wide and her face gone white. "I will show the flat," she said.

I stood on the porch waiting while the women went over the Joneses' flat. Suddenly, Silas was there—gripping my shoulder, his terrible lips close to my ear.

"You told. . . !"

His wife was coming—he let go of me. I went back to my other tenant.

"What was it you were going to tell me about Silas Jones?"

"Dope."

"Dope!" I have never seen any one who took dope."

"You have now—you have let the cat out of the bag, too. Did you see the girl's face when you accused her husband of being drunk? She was putting two and two together—his medicine for insomnia—his violent tempers—Chinatown. . . . Poor child. . . ."

I kept well out of the man's way. He was busy with agents. His wife was alternately excited about the home and very sad.

I knew it was her step racing up the stairs. "My husband has bought a house, furniture and all. It is a beauty. It has a garden. Now I shall have a home of my very own!"

She started to caper about . . . stopped short . . . her hands fell to her sides, her face went dead. She stood before the window looking, not seeing.

"I came to ask if you know of a woman I could get, one who would live in. My husband wants to get a Chinaman to do the work, but I . . . I *must* have a woman."

Her lips trembled, great fear was in her eyes.

She came back to me a few days after they had moved, full of the loveliness of the new home.

"You must come and see it—you will come, won't you?"

"I had better not."

"Because of Silas?"

"Yes."

"If I 'phone some day when he is going to be out, please, will you come?"

"Yes."

She never telephoned. They had been in their new home less than a month when this notice caught my eyes in the newspaper:

"For sale by public auction, house, furniture and lot."

The name of the street and the number of the house were those of Arabella Jones's new home.

A W F U L P A R T I C ' L A R

"PRICE OF FLAT?"

"Twenty-five a month."

"Take twenty?"

"No."

"Twenty-two?"

"No."

"Quiet house? No children? No musical instruments? No mice? My folks is partic'lar, awful partic'lar—awful *clean!* . . . They's out huntin' too—maybe they's found somethin' at twenty. Consider twenty-three?"

"No. Twenty-five is my price, take it or leave it."

He went back to pinch the mattress again, threw himself into an easy chair and moulded his back into the cushions. . . . "Comfortable chair! Well, guess I better go and see what's doin' with the folks. Twenty-three fifty? Great to get partic'lar tenants, you know."

I waved him to the door.

Soon he was back with his wife, dry and brittle as melba toast, and a daughter, dull and sagging. Both women flopped into easy chairs and lay back, putting their feet up on another chair; they began to press their shoulder-blades into the upholstery, hunting lumps or loose springs. Meanwhile their noses wriggled like rabbits, inflated nostrils spread to catch possible smells, eyes rolling from object to object critically. After resting, they went from one thing to another, tapping, punching; blankets got smelled, rugs turned over, cupboards inspected, bureau drawers and mirrors tested.

"Any one ever die in the apartment?"

"No."

"Any one ever sick here?" The woman spat her questions.

"Any caterwauling at nights?"

"We do not keep cats."

"Then you have mice—bound to."

"Please go. I don't want you for tenants!"

"Hoity, toity! Give my folks time to look around. They's partic'lar. I telled you so."

The woman and the girl were in the kitchen insulting my pots and pans. The woman stuck a long thin nose into the garbage pail. The girl opened the cupboards.

"Ants? Cockroaches?"

I flung the outer door wide. "Go! I won't have you as tenants!"

Melba toast scrunched. Pa roared. "You can't do that! You can't do that! The card says 'Vacant.' We've took it."

His hand went reluctantly into his pocket, pulled out a roll of bills, laid two tens upon the table; impertinently leering an enquiring "o.k.?", he held out his hand for the key. I stuck it back into my pocket—did not deign an answer. Slowly he fumbled with the bill-roll, laid five ones on the table beside the two tens. Between each laying down he paused and looked at me. When my full price was on the table I put my hand in my pocket, handed him the key.

At six o'clock the next morning the "partic'lar woman" jangled my doorbell as if the house was on fire.

"There's a rust spot on the bottom of the kettle—Old Dutch."

I gave her a can of Old Dutch. She was scarcely gone before she was back.

"Scoured a hole clean through. Give me another kettle."

Hardly was she inside her door before the old man came running. "She says which is hot and which cold?"

"Tell her to find out!"

No other tenant in that or any other flat in my house left the place in such filth and disorder as those *partic'lar* people.

GRAN'S BATTLE

THE FAMILY in Lower West consisted of a man, a woman and a child. A week after they moved in, the woman's sister came to stay with her. She was straight from hospital and brought a new-born infant with her—a puny, frail thing, that the doctor shook his head over.

Immediately the baby's grandma was sent for, being, they declared, the only person who could possibly pull the baby through. Grandma could not leave her young son and a little adopted girl, so she brought them along.

The flat having but one bedroom, a kitchen and living-room, the adults slept by shifts. The children slept on sofas, or on the floor, or in a bureau drawer. Gran neither sat nor lay—she never even thought of sleep; she was there to save the baby. The man of the family developed intense devotion to his office, and spent most of his time there after Gran moved in.

We were having one of our bitterest cold snaps. Wind due north, shrieking over stiff land; two feet of snow, all substances glibbed with ice and granite-hard. I, as landlady, had just two jobs—shovelling snow—shovelling coal. Gran's job was shooing off death—blowing up the spark of life flickering in the baby.

No one seemed to think the baby was alive enough to hear sounds. Maybe Gran thought noise would help to scare death. The cramming of eight souls into a three-room flat produced more than noise—it was bedlam!

The baby was swaddled in cotton-wool saturated with the very loudest-smelling brand of cod-liver oil. The odour of oil permeated the entire house. The child was tucked into his mother's darning-basket which was placed on the dining table.

The infant's cry was too small to be heard beyond the edge of the table. We in the rest of the house might have thought him dead had not Gran kept us informed of her wrestling, by trundling the heavy table up and down the polished floor day and night. The castor on each of the table-legs had a different screech, all four together a terrible quartette with the slap, slap of Gran's carpet

slippers marking time. Possibly Gran thought perpetual motion would help to elude death's grip on the oiled child.

Periodically the aunt of the infant came upstairs to my flat to telephone the doctor. She sat hunched on the stool in front of the 'phone, tears rolled out of her eyes, sploshed upon her chest.

"Doctor, the baby is dying—his mother cries all the time—when he dies she will die too. . . . Oh, yes, Gran is here, she never leaves him for a minute; night and day she watches and wheels him on the table."

The whole house was holding its breath, waiting on the scrap of humanity in the darning basket. Let anybody doze off, Grandma was sure to drop a milk bottle, scrunch a tap, tread on a child! The house has to be kept tropical. Gran was neither clothed nor entirely bare. She took off and took off, her garments hung on the backs of all the chairs. She peeled to the limit of the law, and snatched food standing. Three whole weeks she waged this savage one-man battle to defeat death—she won—the infant's family were uproarious with joy.

Gran toppled into bed for a long, long sleep. Mother and aunt sat beside the darning basket planning the baby's life from birth to death at a tremendous age.

Gran woke refreshed—vigorous, clashed the pots and pans, banged doors, trundled the table harder than ever, and sang lullabies in a thin high voice, which stabbed our ears like neuralgia.

The House of All Sorts was glad the child was to live. They had seen the crisis through without a murmur. Now, however, they came in rebellion and demanded peace. The doctor had said the child could go home with safety—my tenants said he must go! I marched past twelve dirty milk-bottles on the ledges of the front windows. Gran opened, and led me to the basket to see the infant, red now instead of grey.

I said, "Fine, fine! All the tenants are very glad, and now, when is he going home?"

"Doctor says he could any day. We have decided to keep him here another month."

"No! A three-room flat cannot with decency house eight souls. I rented my flat to a family of three. This noise and congestion must cease."

Grandmother, mother, aunt all screeched reproaches. I was a monster, turning a new-born infant out in the snow. They'd have the law.

"The snow is gone. His mother has a home. His grandmother has a home. I rented to a family of three. The other tenants have been kindly and patient. The child has had his chance. Now we want quiet."

My tenant, the aunt of the baby, said, "I shall go too!"

"Quite agreeable to me."

A "vacancy" card took the place of the twelve dirty milk bottles in the front window of Lower East.

PEACH SCANTIES

COMING UP Simcoe Street I stopped short and nearly strangled! There, stretched right across the front windows of the Doll's Flat, the street side of my respectable apartment house, dangled from the very rods where my fresh curtains had been when I went out—one huge suit of men's natural wool underwear, one pair of men's socks, one pair of women's emaciated silk stockings, a vest, and two pairs of peach scanties.

Who, I wondered, had gone up the street during the two hours of my absence? Who had seen my house shamed?

I could not get up the stairs fast enough, galloping all the way! There was enough breath left for: "Please, *please* take them down."

I pointed to the wash.

Of course she was transient—here today, gone tomorrow—not caring a whoop about the looks of the place.

"I like our underwear sunned," she said with hauteur.

"There are lines out in the back."

"I do not care for our clothes to mix with everybody's—and there are the stairs."

"I will gladly take them down and hang them for you."

"Thanks, I prefer them where they are. It is *our* flat. We have the right—"

"But the appearance! The other tenants!"

"My wash is clean. It is darned. Let them mind their own business, and you yours."

"It *is* my business—this house is my livelihood."

The woman shrugged.

Merciful night came down and hid the scanties and the rest.

Next wash-day the same thing happened. The heavy woolies dripped and trickled over the tenant's clean washed windows below; of course she rushed up—furious as was I!

Again I went to the Doll's Flat. I refused to go away until the washing was taken down and the curtains hung up. "If you live in this house you must comply with the ways of it," I said.

On the third week she hung her wash in the windows the same as before. I gave her written notice.

"I shall not go."

"You will, unless you take that wash down and never hang it on my curtain rods again!"

Sullenly, she dragged the big woollen combination off the rod, threw it on the table; its arms and legs kicked and waved over the table's edge, then dangled dead. Down came the lank stockings, the undervest—last of all the peach scanties. Both pairs were fastened up by the same peg. She snapped it off viciously. A puff of wind from the open door caught and ballooned the scanties; off they sailed, out the window billowing into freedom. As they passed the hawthorn tree its spikes caught them. There they hung over my front gate, flapping, flapping—"Oh dear! Oh dear! Oh dear!"

SHAM

AS THE world war progressed rentals went down till it became impossible to meet living expenses without throwing in my every resource. I had no time to paint so had to rent the studio flat and make do myself with a basement room and a tent in my back garden. Everything together only brought in what a flat and a half had before the war.

A woman came to look at the Studio flat and expressed herself delighted with it.

"Leave your pretty things, won't you?" she begged with a half sob. "I have nothing pretty now and am a widow, a Belgian refugee with a son in the army."

She spoke broken English. We were all feeling very tender towards the Belgians just then.

"Come and see me; I am very lonely," she said and settled into the big studio I had built for myself. I granted her request for a substantial cut off the rental because of her widowhood, her country and her soldier son. Poor, lisping-broken-English stranger! I asked her several questions about Belgium. She evaded them. When she did not remember she talked perfect English, but when she stopped to think, the words were all mixed and broken. When she met any one new her sputterings were almost incoherent. I asked her, "How long since you left Belgium?" She hesitated, afraid of giving away her age, which I took to be fifty-five or thereabouts.

"I was born in Belgium of English parents. We left Belgium when I was four years old."

"You have never been back since?"

"No."

She saw me thinking.

"How the first language one hears sticks to the tongue!" she remarked. "It's queer, isn't it?"

"Very!"

As far as I was concerned, I let her remain the brave little Belgian widow with a son fighting on our side, but the son came back to his mother, returned without thanks from training camp, a schoolboy who had lied about his age and broken down under training. Now the widow added to her pose, "Belgian refugee widow with a war-broken son."

Tonics and nourishing dishes to build Herb up were now her chief topic of conversation with her tenant neighbours. Daily, at a quarter to twelve, one or the other of us could expect a tap on our door and . . . would we lend the mother of Herb a cup of rice, or macaroni, or tapioca, an egg for his "nog" or half a loaf. The baker was always missing her, or the milkman forgot. We got sick of her borrowings and bobbed below the windows when she passed up the stair, but she was a patient knocker and kept on till something on the gas stove began to burn and the hider was obliged to come from hiding. She never dreamed of returning her borrowings. The husbands declared they had had enough. They were not going to support her. She appeared very comfortably off, took in all the shows, dressed well, though too youthfully. Having no husband to protest I became the victim of all her borrowings, and the inroad on my rice and tapioca and macaroni became so heavy my pantry gave up keeping them.

When the "flu" epidemic came along, Herb sneezed twice. His mother knew he had it, shut him in his bedroom, poking cups of gruel in at the door and going quickly away. She told every one Herb had "flu" and she knew she was getting it from nursing him, but Herb had not got "flu" and, after a day or two, was out again. Then the widow told every one she had contracted "flu" from Herb. She hauled the bed from her room out into the middle of the Studio before the open fire and lay there in state, done up in fancy bed-jackets, smoking innumerable cigarettes and entertaining anybody whom she could persuade to visit. For six weeks she lay there for she said it was dangerous to get out of bed for six weeks if you had had "flu." The wretched Herbert came to me wailing for help.

"Get mother up," he pleaded. "Make her take her bed out of the studio; make her open the windows."

"How can I, Herbert? She has rented the flat."

"Do something," he besought. "Burn the house down—only get mother out of bed."

But she stayed her full six weeks in bed. When she saw that people recognized her sham and did not visit her any more she got up—well.

It was a year of weddings. The widow took a tremendous interest in them, sending Herb to borrow one or another of my tenants' newspapers before they were up in the morning to find out who was marrying. She attended all the church weddings, squeezing in as a guest.

"You never know who it will be next," she giggled, sparkling her eyes coyly, and running from flat to flat telling the details of the weddings.

One day she hung her head and said, "Guess." Several of us happened to be together.

"Guess what?"

"Who the next bride is to be?"

"You!" joked an old lady.

The widow drooped her head and simpered, "How *did* you guess?"

He was a friend of Herbert's and "coming home very soon," so she told us.

The house got a second shock when from somewhere the widow produced the most terrible old woman whom she introduced as "My mother, Mrs. Dingham—come to stay with me till after the wedding."

Mrs. Dingham went around the house in the most disgusting, ragged and dirty garments. Her upper part was clothed in a black sateen dressing sacque with which she wore a purple quilted petticoat. Her false teeth and hair "additions" lay upon the studio table except in the afternoons when she went out to assist the widow to buy her trousseau. Then she was elegant. Herb's expression was exasperated when he looked across the table and saw the teeth, the tin crimpers that caught her scant hair to her pink scalp. The House of All Sorts was shamed at having such a repulsive old witch scuttling up and down the stairs and her hooked nose poking over the verandah rail whenever there was a footstep on the stair. It was a relief when she put all her "additions" on and went off to shop.

I wanted my Studio back; I was homesick for it, besides I knew if I did not rescue it soon it would be beyond cleaning. Two years of the widow's occupancy had about ruined everything in it. When I heard that Herb and the old mother were to keep house there during the honeymoon, while the bridegroom was taking some six weeks' course in Seattle, I made up my mind.

The groom came—he was only a year or two older than Herb. The boys had been chums at school. He was good-looking with a gentle, sad, sad face, like a creature trapped. She delighted to show him off and you could see that when she did so they bit him to the bone, those steel teeth that had caught him. On one point he was firm, if there was to be a wedding at all it was to be a very quiet one. In everything Herb was with his friend, not his mother.

They were married. After the ceremony the old woman and daughter rushed upstairs to the studio. Herb and the groom came slowly after. The bride's silly young fixings fluttered back over their heads, and the old woman's cackle filled the garden as they swept up the stair. They had a feast in the studio to which I was not invited. I had raised the rent and they were going—violently indignant with me.

MRS. PILLCREST'S POEMS

SOMETIMES A WORD or two in Pillcrest's poems jingled. More occasionally a couple of words made sense. They flowed from her lips in a sing-song gurgle, spinning like pennies, and slapping down dead.

Mrs. Pillcrest was a small, spare woman with opaque blue eyes. While the poems were tinkling out of one corner of her mouth a cigarette was burning in the other. The poems were about the stars, maternity, love, living, and the innocence of childhood. (Her daughter of ten and her son aged seven cursed like troopers. The first time I saw the children they were busy giving each other black eyes at my front gate while their mother was making arrangements about the flat and poeming for me.)

I said, "I do not take children."

"Canadian children . . . I can *quite* understand . . . *my* children are *English!*"

"I prefer them Canadian."

"Really!" Her eye-brows took a scoot right up under her hat. She said, "Pardon," lit a cigarette from the stump of the last, sank into the nearest chair and burst into jingles!

I do not know why I accepted the Pillcrests, but there I was, putting in extra cots for the children—settling them in before I knew it.

The girl was impossible. They sent her away to friends.

On taking possession of the flat, Mrs. Pillcrest went immediately to bed leaving the boy of seven to do the cooking, washing, and housework. The complete depletion of hot water and perpetual smell of burning sent me down to investigate.

Mrs. Pillcrest lay in a daze of poetry and tobacco smoke. The sheets (mine) were punctured lavishly with little brown-edged holes. It seemed necessary for her to gesticulate with lighted cigarette as she "poemed."

She said, "It is lovely of you to come," and immediately made a poem about it. In the middle there was a loud stumping up the steps, and I saw Mr. Pillcrest for the first time.

He was a soldier. Twice a week the Canadian army went to pot while Dombey Pillcrest came home to visit his family. He was an ugly, beefy creature dressed in ill-fitting khaki, his neck stuck up like a hydrant out of a brown boulevard.

Poems would not "make" on Mr. Pillcrest, so Mrs. Pillcrest made them out of other things and basted him with them. He slumped into the biggest chair in

the flat, and allowed the gravy of trickling poems to soothe his training-camp and domestic friction—as stroking soothes a cat.

Mrs. Pillcrest told me about their love-making. She said, "My people owned one of those magnificent English estates—hunting—green-houses—crested plate—Spode—everything! I came to visit cousins in Canada, have a gay time, bringing along trunks of ball dresses and pretty things. I met Dombey Pillcrest. . . ."

She took the cigarette from her lips, threw it away. Her hands always trembled—her voice had a pebbly rattle like sea running out over a stony beach.

"Dombey told me about his prairie farm; the poetry of its endless rolling appealed, sunsets, waving wheat! We were married. Some of the family plate, the Spode and linen came out from home for my house.

"We went to Dombey's farm . . . I did not know it would be like that . . . too big . . . poems would not come . . . space drowned everything!

"The man who did the outside, the woman who did the inside work kept the place going for a while . . . babies came . . . I began to write poems again—our help left—I had my babies and Dombey!"

She poemed to the babies. All her poems were no more than baby talk—now she had an audience. . . . The blue-eyed creatures lying in their cradle watched her lips, and cooed back.

As the children grew older they got bored by Mother's poems and by hunger. They ran away when she poemed. It hurt her that the children would not listen.

She had another bitter disappointment on that farm. "I did so want to 'lift' the Harvesters! When they came to thresh was my chance. I was determined they should have something different, something refined. For *once* they should see the *real thing*, eat off Limoges, use crested plate! I put flowers on the table, fine linen; I wrote a little poem for each place. The great brown, hungry men burst into the room—staggered back—most touching! . . . none of the bestial gorging you see among the lower classes. They stared; they ate little. Not one of them looked at a poem. If you believe it, they asked the gang foreman to request 'food, not frills' next day. Ruffians! Canadians, my dear!"

"I am Canadian," I said.

"My *deear!* I supposed you were English!"

"One day Dombey said, 'Our money is finished. We cannot hire help; we must leave the farm. You cannot work, darling!' "

They scraped up the broken implements and lean cows and had a sale. Mrs. Pillcrest sat on a broken harrow in the field and made a poem during the sale. Mr. Pillcrest wandered about, dazed. The undernourished, over-accented children got in everybody's way. When it was over, the Pillcrests came out west and hunted round to find the most English-accented spot so that their children should not be contaminated by Canada. That was Duncan, B.C., of course. War came; Dombey joined up. Here they were in my flat.

"I had *so* hoped that you were English, my dear!"

"Well, I'm *not*." Mrs. Pillcrest moaned at my tone.

Potato-paring seemed to be specially inspiring for Mrs. Pillcrest. She liked to do it at the back door of her flat, looking across my garden, poeming as she pared. She always wore a purple chiffon scarf about her throat; it had long floating tails that wound round the knife and got stabbed into holes. The thick parings went slap, slap on the boards of the verandah. The peeled flesh of the potatoes was purpled by the scarf while poems rolled out over my garden.

"Have you ever published your poems, Mrs. Pillcrest?"

"I do not write my poems. They spring direct from some hidden source, never yet located, a joyous—joyous source!"

"Curse you, Mother! Come get dinner, instead of blabbing that stuff!"

"Son—my beloved son!" Mrs. Pillcrest said, and kissed the boy's scowling face.

The Pillcrests were not with me very long because Mr. Pillcrest's training camp was moved.

Just as their time was up—the flat already re-let—Mrs. Pillcrest and son disappeared. Time went on, the new tenant was fussing for possession. After five days elapsed without sign or sound, I climbed a ladder and looked through the windows. Everything was in the greatest confusion.

I rang the barracks. "Mr. Pillcrest? Mrs. Pillcrest's tenancy expired five days ago."

"Yes? Oh, ah—Mrs. Pillcrest is visiting; she will doubtless be returning soon."

"But the flat—the new tenant is waiting . . ." I found myself talking over a dead wire.

She tripped home sparkling with poems.

"Your rent was up five days ago, Mrs. Pillcrest."

"Really! Well, well! Shall I pay five days extra?" (With some rhyme about "honey," "money" and "funny.") My patience was done—"Nothing funny about it! It is not business!"

Taut with fury Mrs. Pillcrest's poem strangled. "Business! Kindly remember, Landlady, Mr. Pillcrest and I do *not belong to that class.*"

"That is evident, but at six tonight I have promised the key to the waiting tenant! *That* is business."

UNMARRIED

PERHAPS THE MOST awkward situation for the inexperienced young landlady was how to deal with "unweds." Every apartment house gets them. They are often undiscernible, even to the experienced. One learns in time to catch on to little indications. . . .

The supposed husband makes all arrangements, the supposed wife approving of everything. A woman who does not nose into the domestic arrangements of the place she is going to occupy gives the first hint, for a woman indifferent to the heating, furnishing, plumbing, cooking utensils of her home is not wifely.

My first experience of this sort was with a very prepossessing couple. Their tenancy was secured by an excessively moral old lady living in Lower West. I was out when the couple came seeking. The old lady next door showed them over. She was delighted at having made so good a "let" for me. Within a week it was put to me by the renters of the other suites, "Them or us?" The couple left.

My second experience of the same kind posed as brother and widowed sister, just out from the Old Country. They offered Old Country references which would have taken six weeks to verify, yet they wanted immediate possession. Things looked all right—I was unsuspicious. You can't ask to see people's marriage certificates. They had my studio flat. It had the required number of rooms and they were delighted with the studio. I had removed myself to a tent in the garden and a gas-ring in the basement for the summer months, ends being difficult to make meet.

The couple had not been in a week before Mrs. "Below" and Mrs. "Next Door" rushed simultaneously to the garden to "tell" and bumped nose to nose.

The House of All Sorts was in ferment. If I was going to cater to that class—!

I went to the hotel the couple had stayed at before taking my flat. Here they had registered as man and wife. I took my perplexity to an experienced apartment-house landlady.

"Mm. . . . We all get them."

"How are they got rid of? Must I wait until their month is up to serve the customary notice?"

"Mm. . . ! If you can prove they are 'that kind' you need give no notice at all, but be sure—libel suits are ugly. Send your janitor into their suite on some pretext or other."

"I am my own janitor."

"Mm!"

I told her I had been to the hotel and how the couple had registered. Again the experienced one said, "Mm." I went home. I could "Mm" there just as well myself.

Mrs. Doubtful was chatty, always running down to my garden to ask advice about cookery. Brother John was fond of this or that, and how was it made? She asked me queer questions too. Was it possible to get lost in British Columbia? To take a cabin in the far woods and disappear? It would be so amusing to vanish!

Between the Doll's Flat and my studio was a locked door, a sofa backed up to the door. The Doubtfuls liked to sit on this sofa and converse. It appeared that Mrs. Doll's Flat's favourite chair was just the other side of the door. Sitting here her ear was level with the keyhole. The man said to the woman:

"Go to the garden, darling. Chat casually with our landlady. Watch her face, her manner."

The woman returned.

"Well?"

"She suspects."

The man came to me.

"How long notice is required?"

"None."

The man bowed. No one saw them go. They left no forwarding address.

STUDIO

IT WOULD NOT BE FAIR to the House of All Sorts were I to omit describing its chief room—the Studio—around which the house had been built. The purpose of its building had been to provide a place in which I could paint and an income for me to live on. Neither objective was ever fully realized in the House of All Sorts.

From the front of the house you got no hint that it contained the finest studio in the town. The tell-tale great north light was at the back of the house and overlooked my own garden, dominating its every corner. There were open fields surrounding my garden—fields that were the playgrounds of my Bobtail Sheep-dogs, kenneled behind the lilacs and apple-trees at the foot of the garden. It was not a very large garden, centred by a lawn which again was centred by a great olivet cherry tree. In the crotch of the tree a shelter box was fixed for the comfort of my monkey, Woo, during the summer months.

The garden was fenced and gated. It belonged exclusively to the animals and myself. No one intruded there. Visitors or tenants who came to pay or to grumble mounted the long outside stair, that met the paved walk on the west side of the house, and took their complaints to me in the studio. The garden seemed more exclusively mine than the studio. People came to the studio to see me on business; if I wanted to see myself I went to the garden. If I was angry I seized a spade and dug my anger into the soil. When I was sad the garden earth swallowed my tears, when I was merry the garden lawn danced with bouncing dogs, monkey, the Persian cat, Adolphus, and me. We did have good times in that old garden. It was in fact but a projection of my studio into the open at ground level. The square ugliness of the apartment house cut us off from the publicity of tenants and the street. High board fences determined the garden's depth and width.

The studio was a high room; its east end was alcoved and had five casement windows in a row, out of them you looked across two vacant lots to Beacon Hill Park. Every bit of the Park was stuffed with delicious memories—not its present sophistication with cultivated lawns, formal lakes, flowerbeds, peacocks and swans. Wild wind-tossed trees, Creator-planted, and very old, tangled bushes were what my memory saw. It saw also skunk cabbage swamps, where frogs croaked in chorus all the summer nights, and owls hooted. I saw too the wicked old "Park Hotel" roaring its tipsy trade. Now where it had stood the land had gone back to respectable brambles that choked everything.

The studio had to be an "everything-for-everybody" place. Its walls were cut by five doors and five windows in addition to a great north light. It was not a good room for showing pictures but fine to paint in. The walls were buff, very high and very crowded: I had no other place to store pictures than on the walls.

The centre space of the room was high emptiness. To ease congestion I suspended my extra chairs from the ceiling. There they dangled, out of the way till wanted, when they were lowered to the floor. Each worked on a pulley of its own.

In one corner of the room was an immense black-topped table, rimmed and legged with massive polished maple wood.

It was an historical table but I forget exactly why. It used to be in the Parliament Buildings and important things had been signed at it.

On top of the table was heaped every kind of article that you could think of, including Susie the white rat, whose headquarters were there. There were also huge lumps of potter's clay and unfinished potteries draped in wet rags to keep them moist during construction.

I had the great brick fire-place with the open grate blocked up. It looked very nice but used enormous quantities of fuel and heated heaven only, so I substituted an open-fronted stove which kept the studio very cosy. It was a lovable room.

In the centre of the studio floor was a long narrow black box not unlike a coffin except that it did not taper. I kept sketches in this box and on its top stood a forest of paint brushes and turpentine bottles. Between this glass-and-

bristle forest and the great north light the space was particularly my own. People never walked there for fear of their shoes squeezing paint tubes or crushing charcoal. Canvases stood on two homemade bench-easels.

I never painted if any one was around and always kept my canvases carefully shrouded in dust sheets. I never did paint much in that fine studio that I had built: what with the furnace, tenants, cleaning and the garden there was no time.

The pictures on my walls reproached me. All the twenty-two years I lived in that house the Art part of me ached. It was not a bit the sort of studio I had intended to build. My architect had been as far from understanding the needs of an artist as it would be possible to believe. The people of Victoria strongly disapproved of my painting because I had gone from the old conventional way. I had experimented. Now I paused. I wished my pictures did not have to face the insulting eyes of my tenants. It made me squirm. The pictures themselves squirmed me in their own right too. They were always whispering, "Quit, quit this; come back to your own job!" But I couldn't quit; I had this house and I had no money. A living must be squeezed from somewhere.

There were two couches in my studio, one in my own special part, the other near the fireplace for visitors. The only chance I got to rest was when a visitor came. I could not leave the visitor upright while I relaxed on a sofa. When I flung myself down, what you might have taken for a fur rug in front of the fire broke into half a dozen pieces, ran to my couch and, springing, heaped themselves on top of me—cat, dogs, monkey and rat. Life in this studio was pleasant. Its high, soft north light was good, yet it was not the sort of studio I wanted.

In Toronto I had seen the ideal artist's studio—a big room about the size of mine. There was not a picture in the room, the walls were calm restful grey. The canvases were stowed in racks in an ante-room. The furnishings were of the simplest. They consisted of a table, a large working easel, a davenport, a quiet-coloured floor covering. The building contained several studios and was set in the quiet corner of a Park. Here the artist came and shut himself in with his work; there he and his work became one. But then he did not have to run a House of All Sorts.

After twenty-two years I sold the House of All Sorts.

ART AND THE HOUSE

IT WAS STRANGE that the first and only specially built, specially lighted studio I ever owned should have been a torment for me to work in. Through the studio only could you enter my four-room flat. A tap at the door—I was caught there at my easel; I felt exposed and embarrassed as if I had been discovered in my bathtub! It was a curious agony.

Possibly it was the ridicule my work had been subject to in Victoria which made me foolishly supersensitive. Even at Art School I had preferred to work in a corner, back to the wall, so that people could not look over my shoulder. In this house, if a tenant found me at my easel, I felt as though I had been cornered committing a crime.

Even while landladying, Art would keep poking me from unexpected places. Art being so much greater than ourselves, it will not give up once it has taken hold.

Victoria had been very stern about my art. Being conservative in her tastes, she hated my particular kind, she believed in having well-beaten tracks and in sticking to them.

The house was fuelling. A huge Negro came to me protesting, "Dat monk in de basement slam de winder ev'time de sacks come fo' to empty. What us do?"

I went below, moved the monkey, left Negro and monkey making friends.

By and by the man came up for me to sign his book. He stood at the studio door.

"Gee! I's envy yous."

"Because I have a monkey?"

"Because you's kin paint. Seem dat what I want all de life of me."

Later that week I was suddenly aware of two men's faces peering through my studio window. Screening hands framed their stare.

In a fury I bounced out the door on to the little balcony where the men stood.

"How dare you stare into my window? Don't you know a person's home is private? Go away."

The men fell back. Then I saw that one was my baker. The other man was a stranger.

"Pardon, Miss. We didn't mean to be rude—this 'ere feller," thumbing towards the stranger, "loves pictures. Come along, I sez, I'll show you!"

I was shamed. Humble people, here in my own town, *wanted* to see and know about Art. They might not like my special kind? What matter? They were interested in pictures.

In Victoria I had only come up against my own class. The art society, called "Island Arts and Crafts," were the exponents of Art on Vancouver Island, an extremely exclusive set. They liked what they liked—would tolerate no innovations. My change in thought and expression had angered them into fierce denouncement. To expose a thing deeper than its skin surface was to them an indecency. They ridiculed my striving for bigness, depth. The Club held exhibitions, affairs of tinkling teacups, tinkling conversation and little tinkling landscapes weakly executed in water colours. None except their own class went to these exhibitions. A baker, a coal-carrier! Good gracious! Ordinary people would never dream of straying into an "Arts and Crafts" exhibition, would have been made to feel awkward had they done so.

An idea popped into my head. I would give an exhibition for ordinary people, invite the general public, but *not* invite the Arts and Crafts. I would invite the people who walked in Beacon Hill on Saturday afternoon and on Sunday. My house was practically *in* Beacon Hill Park. Lower East had just fallen vacant. Lower West was going to be empty next week. I had a carpenter cut me a connecting door. This gave me six large, well-lighted rooms. I invited three other artists to show with me, one a portrait painter, one a lady just returned from England where she had been painting English cottage scenes, the third a flower painter. In one room I would hang my Indian canvases. Examples of my new and disliked work I would hang in the kitchens.

At the last moment the flower painter, finding that the show was not to be sponsored by the Arts and Crafts, did not show. As I read her curt, last-minute withdrawal, a young Chinese came to my door carrying a roll of paintings. He had heard about the exhibition, had come to show his work to me—beautiful water colours done in Oriental style. He was very anxious to carry his work further. He had asked admittance to the Arts and Crafts Sketching Class, and had been curtly refused because of his nationality. I invited him to show in place of the flower painter and he hung a beautiful exhibit.

The exhibition was a varied show and so successful that a few of us got together, working on the idea of starting a People's Art Gallery in these six rooms of mine. It was winter time, there were no Band Concerts in the Park. People walked until they were tired, then went home chilled. To drop in, sit by an open fire, warm, rest themselves and look at pictures, might appeal to the public. It was also suggested that there might be study classes. Young people came to see me saying how ardently they hoped the idea would be carried out.

We elected temporary officers and called a meeting of important people who

could help if they would—the Lieutenant Governor, Mayor, Superintendent of Parks, a number of wealthy people with influence. We called the meeting while the exhibition was still on the walls. The rooms were thronged; there was interest; the plan was discussed. I offered Lower East and Lower West to the City at the lowest possible rental, offering also to shoulder a large proportion of the work connected with the hanging of new shows from time to time.

My friend Eric Brown, of the Canadian National Gallery at Ottawa, was enthusiastic over my plan and promised to send exhibitions out from Ottawa. But influential Victorians were uninterested, apathetic. Why, they asked, was it not sponsored by the Arts and Crafts Society? Vancouver had just built herself a fine Art Gallery. It was endowed. Unless Victoria could do something bigger and more flamboyant than Vancouver she would do nothing at all.

The Lieutenant Governor said that if the City would acquire a property and erect a fireproof building, he would be willing to lend two small etchings, very fine etchings—but he would not lend to be shown in any ordinary building.

Victoria's smart set said Beacon Hill was out of the way.

We replied, "It is handy for those who walk in the Park. You others have your cars."

The Mayor said, "The City has provided artificial lakes, a very fine pair of swans, innumerable ducks, a peacock and a Polar bear. What more could the public desire!"

The people's gallery did not materialize. The everyday public were disappointed. The wealthy closed their lips and their purses. The Arts and Crafts Society smiled a high-nosed superior smile. Lee Nam, the Chinese artist, many boys and girls and young artists were keenly disappointed.

I closed the connecting door between the suites and again rented Lower East and Lower West as dwellings.

The wise, painted eagles on my attic ceiling brooded—sorry for my disappointment. The Indians would say, "They made strong talk for me." Anyway they sent me down to the studio to forget my disappointment and to paint earnestly.

Eric Brown wrote, "I am sorry the people's gallery did not go through." He spoke kindly about my own work. I was now an invited contributor to art shows in the East. Sympathetic criticisms were unnumbing me; I desired to paint again. "After all," wrote Mr. Brown, "the people's gallery might have further crippled your own work. Victoria just is not art minded. Go ahead, paint, don't give way to discouragement. Paint, paint!"

MEN CALLED HER JANE

NICE-LOOKING COUPLE. He had a courtesy that was slightly foreign. She blushed readily and was gentle, had dainty smartness from shoes to the chic little hat that looked to have flown to the top of her head and perched there at just the right angle.

In my garden she bent and sniffed, "May I have a flower?"

"The madame likes flowers. You could spare her a little corner of your earth? This bit by our door, perhaps?"

"I will plant sweet peas to climb the fence," she said happily.

Their blinds never went up till noon was well past. He claimed that work brought him home late at night—very late.

Everybody said they were an attractive-looking couple. The name he gave was "Petrie."

One day I had occasion to take "madame" some things. Her door stood open. I kept to one side while I knocked. There was no answer. I stepped forward, meaning to lay the things inside the door and go away. I saw that "madame" was in the room, arms folded across the back of a chair, head bowed, crying bitterly. I put the things down, came away.

My flat was just above the Petries'. Sometimes I thought I heard crying. Again, there would be long monotonous sounds as of someone pleading unanswered; sometimes for days everything would be deadly still.

One morning, between two and three o'clock, all the house wrapped in sleep, shriek after shriek came from the Petries' flat. Crockery smashed. There were screams and bangs, dull murderous thuds. I jumped out of bed, ran to the room above their flat, leaned out the window.

There were three voices, two men's and a woman's. Desperate fury was in them all—low, bestial, fighting hatred.

I trembled violently, not knowing what to do. The rest of the flats were rented to women—women who expected to live here quietly, decently. It was a quiet, respectable district! How was I going to face them tomorrow, burning with shame for my house?

The door below was torn open. Bump, bump, bump! A man was ejected, thudding on each step, finally lying in a huddle on the cement walk. The door

slammed. The man and the woman inside resumed their screaming and snarling.

Was he dead? I could not take my eyes off that still huddle on the pavement. By-and-by a groan—he crawled on hands and knees to the door—beat upon it with his fists.

"Jane! Jane! Listen, Jane! Let me in. Oh, Jane! Jane!" They were making such a noise they did not hear. He leant against the door, mopping his face. I could see dark stains spreading on his white handkerchief. After a long, long while he stumbled down the street.

The fighting stopped—terrible quiet—I could hear my clock ticking, or perhaps it was my heart. I went to bed hating tenants.

Next morning Petrie swaggered up to my flat, asked to use my telephone. I trembled, wondering what I was going to say to him. He 'phoned a rush order to a dry-cleaner, also for an express to take a trunk to the boat.

"You going away?" I asked.

"The madame is—we've quarrelled in fact."

"It was shameful . . . my tenants. . . ." The man shrugged.

"You wish to serve me notice?"

"Law does not require that such tenants be given notice."

The express came and took away a trunk. At dusk the woman limped down the street sagging under the weight of a heavy suitcase.

There was no sound from Lower East. All day blinds remained close drawn. The gas man came, asking that I let him into that silence to read the meter.

"That flat is still occupied, far as I know."

"Your tenant ordered his final reading this morning."

I took a pass key and went down. The place was in wild disorder. There were dozens of liquor bottles. In an attempt to be funny they had been arranged ridiculously as ornaments. Things were soiled with spilled liquor. The place smelled disgusting. The bedding was stripped from the bed. The laundry man returned it later and told me it had been soaked with blood. My carving knife belonging to that flat was missing.

Holding out a handful of carefully selected pants' buttons that he took from the meter, the gas man said, "That is what the Gas Company got. How about you, got your rent?"

"Yes, advance."

"Good," he said kindly . . . "job enough getting the liquor stains cleaned up."

I saw an envelope at my feet. In the dusk I could see the name was not Petrie, but a short name like my own. I tore it open, supposing it mine.

"Rose, my baby, my dear, why don't you write? If you did not get the job, come home, we will manage somehow. No work for Pa yet, he is sick—so am I—anxiety mostly—Rosie, come home—Mother."

I gave the letter back to the Postman.

"I opened it in the dusk by mistake; there was no forwarding address."

"I suspected," said the Postman. "Her name wasn't his name—nice-looking

couple they was too . . . well . . . New to this rentin' bizness, eh? You'll larn— tough yerself to it."

His look was kind.

FURNITURE

ONCE I TURNED a zinc pail down over the head of a widow tenant.

She was on the top step of my back stair; I was on the landing above. She would neither pay nor go. The law had told me I must retain certain of her possessions until she did one thing or the other. She had given me notice; another tenant was waiting for the flat, but go the widow would not. When I did as the law directed and seized a basket full of her household goods from the back porch, she followed me upstairs screeching. It was only pots and pans, not worth the screech. "Take it then—this too," I said and popped a pail of hers, none too clean, over her head. As the pail swallowed her tatty, frizzled head she seized the basket from my arms and, blinded by the pail, sank, step by step, down, down,—bucket and widow together. She could not see where to put her feet; they pushed like flat irons into the corner of each step. It was a narrow stair. She could cling by her elbows and the basket. At the foot of the stair, a twinkle in his eyes, stood the policeman who had ordered the restraint on her goods. She raised her zinc helmet to find herself circled by his arms.

She said—"Aoow!"

Law and I laughed. Law said, "Pay, or give up the keys."

She paid and went.

A gentleman had married her. Perhaps it would be more correct to say—a gentleman married her purse full of savings. First he spent her money, then he died, leaving her with a pile of debts, a yellow-haired son and twelve rooms of furniture.

She was angry at having a child to support, ignored the debts and adored the furniture—cheap tawdry stuff, highly varnished. She talked a great deal about "my beautiful period furniture." It was shoddy, mock, not "period," always "after," executed in imitation woods.

She moved the twelve roomfuls of furniture, piano and all, into my three-roomed Lower West Flat. Its entire floor space was packed solid to the ceiling. The yellow-haired boy crawled among the legs of furniture and bumped on bric-a-brac.

The dining-table, uncollapsible and highly varnished, the piano, the chesterfield, stuffed chairs and a few sofas made a foundation on which to heap lesser articles. On top, and on top, and on top, the heaped furniture rose to the ceiling. A narrow alleyway ran through the middle enabling her to pass through the flat—but she had to squeeze. In front of the window stood the piano. The woman could be seen and heard singing to it.

The kitchen had standing room only in front of the cook stove and at the sink. In the bedroom, she climbed over high-boys and bureaus to hurl the child into the bed beyond with a screeching of bed springs which delighted him.

She called me in to see how things were, saying "You will simply *have* to give me more storage space!"

"You have much more than your share of the basement now. You saw what space there was before you took the flat. How could you expect three rooms to accommodate the furniture of twelve? Sell what you don't need."

"Sell my furniture! My beautiful furniture! Never!"

"You don't want all of it. It only makes you uncomfortable."

"I want every bit of it—to sell would be to lose money. I shall keep every bit; I expect to entertain members of the Choral Society I belong to."

So she went on living in great discomfort. The verandah and woodshed were crammed to bursting. The stuff was all wrapped in paper and rags to keep it from chafing and spoiling. The back of the House looked fearful because of her.

The child was a stupid pathetic creature whom she perpetually slapped and snapped at. Through the walls we heard the smacks on his wet skin when she bathed him, each smack followed by a wail.

His pants (mother-made) had no slack; his yellow hair hung dank and life-less; the stare in his stupid eyes alone told which way he faced. She put him out to be minded, and took a job. Every morning the no-seat little pants went slowly down the street with stilted steps. The shapeless creature stumbled and bumped into every thing, ambling half a block behind the widow who sulkily approached her job. Every step said, "I hate my job, I hate it! I married to be free! He spent my money, died, left me with *that!*"

"Come on there!"—a backward step and a crack on the yellow head.

The widow acknowledged frankly that she was not averse to a second mar-riage; only next time she'd see to it he had money and she would spend it.

She invited members of the Choral Society (one at a time) to come back with her "for a little music" after the Choral Practice. The child had been locked in, barricaded with furniture. She had been compelled to part with some to allow even two adults to sit by the fire comfortably. There was more than enough left. Scrambling over furniture and lowering herself to the arm of a stuffed chair, she performed, head thrown back. The window blinds were always up to the top so we could see her open mouth, stiffened back, hands beating, black eyes rolling and long horsey teeth munching the words of sentimental songs which echoed at a gallop among the jardinieres and rattled the corpulent glass front of the china cabinet.

She began at the antique shops, next she tried high-class-used, then second-hand—finally a van came and took some of the furniture to the auction rooms. It was like drawing teeth to part with it.

Now as she sang she sighed over the remaining furniture and caressed its shiny surfaces. Every visitor said he had enjoyed himself immensely, but he had so many engagements it was impossible for him to make another date.

She almost wished she had not sold the furniture. She began blaming my house, said it was not a sociable district. She fell behind in the rent, suggested I accept my rental in kind—the kind being a worn-out worthless gas range. I refused—she became abusive. I had to consult the law—that was when I popped the pail over her head and finally got her out of the House of All Sorts.

Making Musicians

I HATE PIANOS, tenants' pianos. They can make a landlady suffer so hideously. Lumbering tanks awaiting the touch (often unskilled) that will make them spill horrible noise, spitting it through their black and white teeth.

First the dreadful bump, bump of arrival, cruel gasps of men with backs bent—bruised and nicked woodwork—screech of rollered push-boards. Radios were a new invention then but it seemed every transient lugged around an old tin kettle of a piano.

Prospective tenants said, "You have no objection to a piano, *of course*."

"Oh, no," one lied, because one was dependent on tenants to pay mortgages and taxes.

So the piano was installed and we waited edgily till the performer operated. We did not mind child practice as much as adult jazz.

There was a sweet young girl who aspired to be a professional musician, very much in earnest, trying to unlearn previous faulty tuition. Scales rolled up and scales rolled down, noises leaped or dived or shivered out of her piano all day long. She began at 7 A.M. and laboured at it till 10 P.M. The performance took place just under my studio. Each note might have been pounded on my vertebrae. This was to go on for ever and ever—at least till the girl was made into a musician. Alas! She was very young.

Lower Westers and Doll's Flatters came to me.

"Are they permanent?"

"I am afraid so."

"The instrument is against my wall."

"It is underneath me."

There were heavy supposings "that we shall get used to it in time."

Get used to it we could not. Every day our nerves got more jangled no matter how we thundered vacuums and carpet sweepers, pots and pans. The scales boomed through every household noise.

The little girl was most persistent. When a bit of her noise went wrong she patiently repeated and repeated over and over till she won out. We were distracted.

After a fortnight we began to resign, as a nose settles down to the smell of frosted cabbage in winter. The bright spot of our day was when the little musician took her daily airing, three to four P.M.

One day we were settling to enjoy this respite when squealing wails pierced walls and floor. What torture equals a violin under the untutored hand! We realized what our peace had been when only the piano had agonized us.

The little girl did not neglect the old for the new either. For the sake of the violin she gave up her daily airing but not her piano practice.

My tenants came again. They sat down, one on either side of me.

"Yi . . . Yi . . . eee . . . ee," wailed the violin underneath us.

The tenants were as nice as possible, but it was not possible to be entirely nice. We were all agreed that the musician's family were lovely people—but—under the circumstances . . . well, something *must* be done about the circumstances. I said, "I will talk with them," but I shirked.

Days went by. I dodged past the windows of the other tenants quickly. They watched, but I just couldn't.

High note, low note, run and quiver! I drew the dust sheet over my canvas and rushed for the garden.

I went. Mother opened the door. The girl was seated at the piano. Her pale little hands on the keyboard did not look strong, wicked or big enough to torture a whole household.

I began to talk of everything in the world except musical instruments. After a pleasant visit I sneaked back upstairs without a glance towards my tenants' windows. I sat at my easel and began to paint. Wail, wail, wail! Every wail wound me tighter. I was an eight-day clock, overwound, taut—the key would not give another turn!

I flew down the stairs.

Mother looked surprised at another visit from me so soon. Father was there and the little girl looking sweeter than ever against the curve of the rich brown violin. I turned my back so that I should not see her. Father understood. Before I got a word out he said, "I know," and nodded towards the instruments.

Sneakily I stammered, "Other tenants . . . object. . . ."

"Exactly."

Papa and Mama exchanged nods.

"Perhaps the violin practice could be arranged for where she learns."

"Impossible," said Mama.

"At the home of one of her aunts, then?"

"Both live in apartments where musical instruments are not tolerated!"

"The Park band-stand," groaned Papa with a nervous glance towards Mama. "I suggest the Park band-stand."

The little girl rushed from the room crying.

"I fear we must look for a house," said Mama.

"An isolated house," groaned Papa.

Through the open door I heard little, hurt, gasping sobs.

JOHN'S PUDDING

JOHN WAS a young bachelor who for several years occupied my Doll's Flat. One Christmas his mother sent him a plum pudding from England. It travelled in a white stone-ware basin, a perfect monster of a pudding.

"Look at the thing!" John twirled it by its stained tie-down cloth. "Cost her six shillings for postage! Me out of work, *needing* underwear, socks! And *wanting* books, books, lots of books. Take the thing—three months *solid* eating."

He handed me the pudding. I shook my head. With a final twirl of the cloth he landed the pudding on the drain-board. The boy had told me of the book hints he had given Mother—of his hopes of what Christmas might bring.

"Orphanage, Salvation Army, both eat, I s'pose," he said. "I'll give 'em the dough. Want the crock? Do to feed the dogs in.

"It would not be quite fair to your mother, John. Let's give a party—feed the party pudding."

"How stomach-achey—nothing else? Who'd come?"

"Widows, spinsters, orphans. I'll get a turkey."

Lower East housed a new widow, Lower West an old widow, also her widowed daughter with a young son. My religious sister and my scholastic sister were invited, John asked his girl. All accepted. The house bubbled with activity and good smells.

We joined three tables which left just enough space for the guests to squeeze into their places. John and I sat near the kitchen door to be handy for toting dishes. There were red candles on the table, holly and apples from the garden. My monkey, dressed in her best scarlet apron, sat warming her toes before the studio fire, all "pepped up," aware that something was going to happen. As the guests poured through the door the monkey squealed at the widows and the widows at the monkey.

The turkey had blushed his nakedness to a rosy brown and was set cross-legged

and blasé in the oven doorway, a boat of gravy beside him.

When the heart of the haughty English pudding in the solid masonry of her basin had been warmed and softened by the wooing of Canadian steam, when every last thing was ready, the widows in black silk rustled into the dining-room, also my two spinster sisters with an orphan or two from the school, and John's girl.

Because of the newness of her widowhood, the East flat widow had brought for the feast a few tears as well as a dish of "foamy rolls"—"My late husband's favourites" . . . sniff! She rushed the rolls into my hands so that she could use her hankie. The seasoned widow brought loganberry wine of her own brew. The young widow brought her young son who ate too much and got sick. My religious sister brought walnuts from her own tree, and the schoolmarm a home-made loaf and her three orphan boarders with all diet restrictions removed for the day. John's girl was shy and talked to everybody except John. My little dogs sat on their tails—their snub noses wiggled in anticipation.

When all had trooped into the dining-room, leaving the monkey alone, she raged and jabbered. The guests poured like liquid along the narrow path into their seats, talking vivaciously about nothing, pretending they were not thinking of gone Christmases.

The turkey cut like a dream, juice trickled out as the sharp knife sliced the white breast—pink ham, turkey stuffing, green peas, potatoes mashed smooth as cream, cranberry sauce not a mite too tart. The widow's rolls melted in our mouths.

When the queenly pudding came in, attended by brandy sauce and mounted on a blue platter, she looked like the dome of the Parliament Buildings riding the sky. Her richness oozed deliciously, spicy, fragrant, ample. The steam of her rose in superb coils as if desirous of reaching the nostrils of the widows' dead husbands. Each plated slice slid down the table, followed by a dish of brandy-sugar sauce. Everyone praised the pudding. John thought with deep affection of his mother.

When appetites were satisfied, John uncorked the widow's wine and solemnly filled all glasses, except that of my "teetotal" sister who shook her head and took her glass to the kitchen tap. We all stood up, raised our glasses to the light, admired the beauty of the wine, its clearness, its colour. We complimented the maker, yet no one drank. All seemed waiting for somebody to say something, but nobody did. Each blinked at his wine, each was thinking—the widows of their "had-beens," we spinsters of our "never materialized." John and his girl smiled their hopes into each other's eyes. We others were relics—a party of scraps and left-overs, nobody intensely related. The people of one suite shared no memories in common with those in any other.

Somebody ventured "The King." We all sipped. My "teetotal" sister choked on one of her own walnuts. The widows darted forward with kindly intended thumps.

"Water!" she spluttered, and everyone put down his wine-glass to rush a water tumbler up to the choke.

"My Mother!" John raised his glass and everyone drank.

"The pudding!" I said solemnly; everyone drank again.

The monkey's patience was entirely at an end. Clank, clank, clank—the iron poke being beaten against the side of the stove. Shriek upon shriek of monkey rage!

We drank what was left of the wine quickly, put the small remnant of pudding on a tin plate, took it in to the waiting monkey and watched her eat, plum by plum, the last of John's pudding.

How Long!

HE WAS CRUDE, enormous, coarse; his fleshy hands had fingers like bananas. You could feel their weight in the way they swung at the end of his arms.

Ridiculous that he should choose the Doll's Flat for a home while he was grinding out the life of his little third wife. She was slowly disintegrating under the grim, cruel bullying.

The Doll's Flat suited his purpose because he could keep his eye on all its rooms at once, cow her every movement crawling to do his bidding. His stare weighted her eyelids and her feet. She felt rather than heard him creeping behind with the stealth of a lerry tom cat stalking a bird, never allowing it beyond the range of his seeing lest it creep aside and die before his teeth got a chance to bite into its warmth, his hand to feel the agony racing through its heart.

The great bulk of him grazed the door posts as he pushed his way from room to room. He mounted the dining table on four blocks of wood so that his huge stomach could find room beneath. I do not know whether his wife was allowed to eat standing beside him, or did she eat at the kitchen sink? His was silent cruelty. I seldom heard voices—the quiet was sinister.

The man wore glasses with thick lenses; it magnified his stare—because he was deaf, his staring was more intense.

When they went out it was he who locked the door behind them. She waited, holding his thick brutal stick. She preceded him down the stair, down the street. It must have been awful to have that heavy crunching step behind and his eyes watching, always watching. She was a meek, noiseless thing.

Bitter cold came. I stuffed the furnace to its limit, hung rugs over north windows. The hot air wouldn't face north wind, it sneaked off through south pipes.

Up and down, up and down the long outside stair I ploughed through snow

which fell faster than I could sweep. During the night, snow had made the stair into one smooth glare—no treads. I shovelled a path as I descended, but the wind threw the snow back just as quickly.

The house, with the exception of the Doll's Flat, were considerate and kindly, realizing my difficulties. Every house-owner knows the agony and the anxiety regarding freeze-up and pipe bursts. Victoria's cold snaps are treacherously irregular. Hot-air pipes are cranky. My tenants were not entirely dependent on the whims of the furnace, each suite had also an open fire and could be cosy in any weather. Nothing froze except one tap in a north bathroom, the bath of the brutal man—one hand-basin tap.

He had hot and cold in his kitchen and bath, but he roared, "This house is unfit to live in. Get a plumber *immediately.*"

I said, "That is not possible. People everywhere are without drinking-water, plumbers are racing round as fast as they can. We must manage without one hand-basin for a day or two."

The man followed me into my basement. I did not hear his footfalls in the snow. As I stooped to shovel coal his heavy fist struck across my cheek. I fell among the coal. I stumbled from basement to garden.

"House! House! how long?"

From the frozen garden I looked at it, hulking against the heavy sky.

BOBTAILS

To My Sister Alice

I think I could turn and live with animals,

they're so placid and self-contain'd,

I stand and look at them long and long.

From WALT WHITMAN'S

Song of Myself

KENNEL

THE IDEA OF a Bobtail kennel did not rush into my mind with a sudden burst. It matured slowly, growing from a sincere love of and admiration for the breed, awaked by my dog, Billie, a half-bred Old English Bobtail Sheep-dog. Billie's Bobtail half was crammed with the loyalty, lovableness, wisdom, courage and kindness of the breed. His something-else half was negligible, though it debarred him from the show bench. Heart, instincts, intelligence—all were pure Bobtail.

When Billie was offered as a gift to me, I refused him, not because of his being cross-bred but because of circumstances. Billie magnificently ignored my refusal and gave himself to me in the wholesome, wholehearted way a Bobtail's devotion works. It was not the easily transferable love of a puppy, for Billie was then three years old. He had the reputation of being wicked and had several bites to his discredit.

First I bathed Billie, then I beat him for killing a chicken—this only glued this self-given allegiance to me the tighter.

He was mine for thirteen years. When he died at the age of sixteen he left such a blank that the Bobtail kennel idea, which had been rooting in me those many years, blossomed. The question was where to obtain stock. There were only a few Bobtails in Canada, brought out as "settlers' effects" from the Old Country. Their owners would as soon have thought of selling their children as their Bobtails. Some of these dogs were excellent specimens, but they were unregistered because the settlers had not bothered to enter them in the Canadian live-stock records at Ottawa, and after a generation or so had elapsed the puppies of these dogs were not eligible for registration.

After long searching I located a litter of Bobtails on a prairie farm and sent for a female puppy. I named her Loo.

Loo was a sturdy puppy of good type and the beautiful Bobtail-blue. The next step was to locate a sire. Friends of mine on a farm up-island had a Bobtail for stock work—a good dog. They mated him to a Bobtail bitch on a neighbouring farm. I never saw the so-called Bobtail mother, but the puppies from the mating were impossible. My friends gave me one.

Intelligence the pup had and a Bobtail benevolent lovableness had won him the name of "Mr. Boffin." But he had besides every point that a Bobby should not have—long nose, short, straight hair, long, impossible tail, black-and-white

colour. I bred Loo to a butcher's dog, a Bobtail imported from England—well-bred, powerful, of rather coarse type but intelligent.

The butcher came to select a puppy from Loo's litter. Dangling his choice by the scruff, he said, "Work waitin', young fella. Your dad was killed last week."

The man sighed—set the pup down gently.

"Shouldn't put a pup to cattle much under a year," he said, and, looking down, saw Boffin standing beside me. Boffin had eased the dog-field gate open and come to me unbidden.

"Go back, Boffin!" I pointed to the gate. The dog immediately trotted back to his field.

"What breed is that dog?"

"Supposedly a Bobtail."

"Bobtail nothin'—I want that dog," said the butcher.

"Not for sale."

"You can't sire a Bobtail kennel by him; 'twouldn't be fair to the breed."

"Don't intend to. That dog is my watch and companion."

"Companion fiddlesticks! That dog wants to work. I want that dog."

"So do I. . . . Hen, Boffin!" I called.

From the field Boffin came and with steady gentleness persuaded the hen from the garden back into her yard.

"I want that dog," the butcher repeated and, taking Boffin's head between his hands, looked into the dog's face. "I want him for immediate work."

"He is untrained."

"He knows obedience. Instinct will do the rest. That dog is just crazy to work. Be fair to him—think it over."

I did think—but I wanted Boffin.

At dusk that night a boy came with a rope in his hand. "Come for the dog."

"What dog?"

"The one my father saw this morning—this fella I guess."

Boffin, smelling cow-barn on the boy's clothes, was leaping over him excitedly.

"We drive cattle up-island tomorrow at dawn," said the boy and threw an arm about the dog.

My Boffin, happy till then in rounding up one hen! My Boffin behind a drove of cattle! How mad—joyful he'd be! I slipped the rope through Boffin's collar, handed it to the boy. He persuaded gently. Boffin looked back at me.

"Go, Boffin!"

The smell of cow was strong, exciting his herding instincts. Boffin obeyed.

Splendid reports came of Boffin's work. I did not go to see him till six months were past, then I went. His welcome of me was overwhelming. The dog was loved and was in good shape. He stuck to my side glue-tight. We stood in the barnyard on the top of the hill. Suddenly I felt the dog's body electrify, saw his ears square. Sheep-bells sounded far off; Boffin left my side and went to that of his new master.

"Away then, Boffin!"

The man waved an arm. The dog's lean, powerful body dashed down the hill. When the dust of his violence cleared, a sea of dirty white backs was wobbling up the hill, a black-and-white quickness darting now here, now there, straightening the line, hurrying a nibbler, urging a straggler. Soberly Boffin turned his flock into their corral, went to his master for approval, then rushed to me for praise.

I was many blocks past the butcher's when I sensed following.

"Boffin!"

I had seen them shut Boffin behind a six-foot fence when I left the butcher's. The wife had said, "Father, shut Boffin in. He intends to follow."

It hurt me to return him, but I knew the job that was his birthright must prevail. . . .

P U N K

LOO'S STRONG, beautiful pups found a ready market. A soldier in Victoria owned a fine Old English Bobtail Sheep-dog. When he went to the war his Bobtail was desolate. I heard of the dog and went to the soldier's house, saw the shaggy huddle of misery watching the street corner around which his master had disappeared. I knocked on the house-door; the dog paid no heed, as if there was nothing now in that house that was worth guarding. A woman answered my knock.

"Yes, that is my husband's dog, 'Punk,' sulking for his master—won't eat—won't budge from watching that street corner."

A child pushed out of the door past the woman, straddled the dog's back, dug her knees into his sides and shouted, "Get up, Punk."

The dog sat back on his haunches, gently sliding the child to the ground—she lay there kicking and screaming.

"Will you sell the dog?" I asked.

"I cannot; my husband is ridiculously attached to the creature."

I told the woman about wanting to start a Bobtail kennel and my difficulty in locating a sire.

"Take Punk till my husband returns. I'd gladly be rid of the brute!"

I went to the dog. After tipping the child off he lay listless.

"Punk!"

Slowly the tired eyes turned from watching the street corner and looked at me without interest.

"He will follow no one but his master," said the woman.

The dog suffered my hand on his collar; he rose and shambled disheartenedly at my side, carrying the only luggage he possessed—his name and a broken heart.

"Punk!" Not much of a name to head a kennel! But it was the only link the dog had with his old master; he should be "Punk" still.

Loo cheered the desolation from him slowly. Me he accepted as weariness accepts rest. I was afraid to overlove Punk, for fear the woman, when she saw him washed, brushed, and handsome, might want him back. But when I took him to see her, neither dog nor woman was pleased. He followed me back to my house gladly.

Punk and Loo made a grand pair, Loo all bounce, Punk gravely dignified. They were staunchly devoted mates.

My Bobtail kennel throve; the demand for puppies was good. The government was settling returned soldiers on the land. Land must be cleared before there was much stock-work for sheep and cattle dogs. But Bobtails were comradely; they guarded the men from the desperate loneliness in those isolated places.

Punk had been with me a year. He loved Loo and he loved me; we both loved Punk. I came down the outside stair of my house one morning and found a soldier leaning over my lower landing, hands stretched out to the dogs in their field. Punk was dashing madly at the fence, leaping, backing to dash again, as breakers dash at a sea-wall. The woman who had lent me Punk and the child who had tormented him were beside the man.

"You have come for him?"—my heart sank.

The man's head shook.

"I shall be moving about. Keep him—I am glad to see him happy."

He pushed the hair back from the dog's eyes and looked into them.

"You were comfortable to think about over there, Punk." The man went quickly away.

Parting from his master did not crush Punk this time; he had Loo and he had me.

B E A C O N H I L L

IN THE EARLY MORNING the dogs burst from their sleeping quarters to bunch by the garden gate, panting for a race across Beacon Hill Park. Springs that had wound themselves tighter and tighter in their bodies all night would loose with a whirr on the opening of the garden gate. Ravenous for liberty, the dogs tore across the ball grounds at the base of Beacon Hill, slackened their speed to tag each other, wheeled back, waiting to climb the hill with me.

The top of Beacon Hill was bare. You could see north, south, east and west. The dogs rested, tongues lolling, while I looked at the new day, at the pine trees, at the sky, at the sea where it lay flat, and at the broom bushes drooped with early morning wetness. The song of the meadow-lark crumbled away the last remnants of night—three sad lingering notes followed by an exultant double chuckle that gobbled up the still-vibrating three. For one moment the morning took you far out into vague chill, but your body snatched you back into its cosiness, back to the waiting dogs on the hill top. They could not follow out there, their world was walled, their noses trailed the earth. What a dog cannot hear or smell he distrusts; unless objects are close or move he does not observe them. His nature is to confirm what he sees by his sense of sound or of smell.

"Shut that door! Shut that door!" staccato and dictatorial shouted the voice of the quail as they scuttled in single file from side to side of the path, feet twinkling and slick bodies low-crouched. The open-mouthed squawks of gulls spilled over the sea. From behind the Hill came the long resentful cry of the park peacock, resentful because, having attained supreme loveliness, he could push his magnificence no further.

Pell-mell we scampered down the hillside. A flat of green land paused before letting its steepness rush headlong down clay cliffs. The sea and a drift-piled beach were below. Clay paths meandered down the bank. They were slippery; to keep from falling you must lodge your feet among the grass hummocks at the path-side. The dogs hurled their steady four-footed shapes down the steepness, and awaited me on the pebbly beach. Sea-water wet their feet, wind tossed their hair, excitement quivered in every fibre of their aliveness.

On our return the house was waking. The dogs filed soberly under yet blinded windows, mounted three steps to the landing, sank three steps to the

garden, passed into their play-field, earnest guardians of our house. I went to my daily tasks.

Whenever the Bobbies heard my step on the long outside stair, every body electrified. Tongues drew in, ears squared, noses lifted. The peer from all the eyes under all the bangs of crimpy hair concentrated into one enormous "looking," riveted upon the turning of the stair where I would first show. When I came they trembled, they danced and leapt with joy, scarcely allowing me to squeeze through the gate, crowding me so that I had to bury my face in the crook of an arm to protect it from their ardent lickings, their adoring Bobtail devotion.

THE GARDEN

THE GARDEN was just ordinary—common flowers, everyday shrubs, apple-trees. Like a turbulent river the Bobtails raced among gay flowers and comfortable shrubs on their way from sleeping-pen to play-field, a surge of grey movement weaving beautiful patterns among poppy, rose, delphinium, whose flowers showed more brilliantly colourful for the grey intertwistings of shaggy-coated dogs among them.

In the centre of the lawn grew a great cherry-tree better at blossoming than at fruiting. To look into the heart of the cherry-tree when it was blossoming was a marvel almost greater than one could bear. Millions and millions of tiny white bells trembling, swaying, too full of white holiness to ring. Beneath the cherry-tree the Bobbies danced—bounding, rebounding on solid earth, or lying flat in magnificent relaxation.

East, west, north the garden was bounded by empty lots; its southern limit was the straight square shadow of my apartment house.

The depth and narrowness of my lot made the height above it seem higher, a height in which you could pile dreams up, up until the clouds hid them.

SUNDAY

RELIGIOUS PEOPLE did not know more precisely which day was Sunday than did my Bobtails. On Sunday the field gate stood open. Into the garden trooped a stream of grey vitality, stirring commotion among the calm of the flowers. The garden's Sunday quiet fastened almost immediately upon the dogs. In complete abandon their bodies stretched upon the grass, flat as fur rugs. You could scarcely tell which end of a dog was head and which tail, both were so heavily draped in shagginess. At the sound of my voice one end lifted, the other wobbled. Neither could you tell under the mop over his eyes whether the dog slept or woke—in sleep he was alert; awake, he was dignified, intent.

When Sunday afternoon's quiet was broken by five far-off strokes of the town clock, we all sprang for the basement. In the entrance hall was a gas-ring; on it stood a great stew-pot. There was also a tap and a shelf piled with dinner pans. The dogs ranged themselves along the basement wall, tongues drawn in, ears alert. I took the big iron spoon and served from the stew-pot into the dinner pans. As I served I sang—foolish jingles into which I wove each dog's name, resonant, rounded, full-sounding. Each owner at the sound of his own name bounced and wobbled—waiting, taut, hoping it would come again.

The human voice is the strongest thing a dog knows—it can coax, terrify, crush. Words are not meaning to a dog. He observes the lilt, the tone, the music—anger and rebuke have meaning too and can crush him. I once had a stone-deaf dog and once I had one that was stone-blind. The deaf dog had nothing to respond to but the pat of pity. She could only "watch"; at night her world was quite blank. The blind dog's blackness was pictured with sounds and with smells. He knew night-scents and night-sounds from day-scents and day-sounds; he heard the good-natured scuffle of dog-play, barkings, rejoicings; he heard also the voice of the human being he loved. The blind dog's *listening* life was happy. The deaf dog's only happiness was to be held close and warm—to feel.

PUPPY ROOM

THE PUPPY ROOM in the basement brimmed with youngness, with suckings, cuddlings, lickings, squirmings—puppies whose eyes were sealed against seeing, puppies whose ears were sealed against hearing for the first ten days of life, puppies rolling around in their mother's box like sausages, heaving in the middle and with four legs foolishly sticking out sideways, rowing aimlessly and quite unable to support the weight of their bodies.

Some Bobtails are born entirely tailless, some have tails which are docked at the age of three days, some have stumps, some twists.

Loo was never happy with a new family until she had brought Punk in to inspect it. Punk lumbered behind his mate, nosed into her box, sniffed and ambled out again, rather bored. It satisfied Loo. The other Bobtail mothers never brought Punk to see their families, but Loo was Punk's favourite mate.

Bobbies have large families—nine is an ordinary litter. Once Flirt had fourteen pups at one birth. I never allowed a mother to raise more than six pups unaided. If the demand was good I kept more, but I went round the family three times a day with a feeding bottle so that all the pups were satisfied and my mothers not overtaxed. One spring thirty pups were born in the kennel nursery within one week. It took me three hours a day for three weeks "bottling" pups, but they throve amazingly. Sometimes a pup was stubborn and would not take the bottle; then I tickled him under the chin; this made him yawn and I popped the bottle into his yawn and held it there till he sucked. The mothers watched me with great interest; my yawn method was a joke between us. They were most grateful for my help, those patient, loving dog mothers.

P O I S O N

THE BUTCHER lifted half a pig's head to his nose, sent it flying with a disgusted hurl into the bundle of scrap that Bobtail Meg was waiting to carry home in her saddle-bags for the kennel. Meg loved to lug the butcher-scraps home for me. When her saddle-bags were filled Meg rose, shook butcher-floor sawdust from her coat and waddled the bones away with pompous pride. Meg never was so happy as when she was busy.

There was something sinister in that pig's one eye when I stuck his half-head into the dog-pot. It made the soup into a rich, thick jelly and smelled good.

Flirt, Loo's daughter, had a litter two weeks old. Flirt was ravenous and gobbled a generous portion of soup and meat. The next day a pup was sick, others were ailing. The veterinary ran a stubby finger around the sick pup's gums. "Teething," he said, and, taking a pocket knife, slashed the pup's gums, wiped the knife on his pants and rammed it into his pocket along with my two dollars. That night the pup died. I was furious—puppies never bothered over teething! I called another veterinary. "Poison," said the old man, and I remembered the butcher's nose and the pig's eye. This vet shook his head and killed the sickest pup to prove his diagnosis by post mortem. He said, "This is a matter for nursing not doctoring. I think all of them will die."

Every pup was bespoken. I did not want them to die and the pups wanted to live—they put up a good fight and won.

I took them away from Flirt. They were too listless to suck a bottle. I spooned brandy and milk down their throats, and to the amazement of the veterinary reared the entire litter. The runt was the grittiest pup of all; for days he writhed out of one convulsion into the next—calmed from one only to go through it all over again. One morning before dawn I found him stiff, tongue lolling, eyes glazed. I had for several days *almost* decided to put an end to his misery. From force of habit I trickled brandy over the lolling tongue—no response. A grave to dig in the morning! Dazed with tiredness I put the pup into his basket and went back to the garden room where I was sleeping during the poison trouble so that I might watch over the puppies. Sticking basket and feeding-bottle into a far corner of the room I tumbled into bed.

The sun and a queer noise woke me. I peeped overboard to see the runt seated on the floor in a patch of sunshine, the feeding-bottle braced between his paws, sucking with feeble fury.

I cried, "You gritty little beast!", warmed his milk and a hot-water bottle, tucked him into his basket and named him "Grits."

Grits turned into a fine and most intelligent dog. He was sold and sent as a love-gift to a man's sweetheart in Bermuda. Another of that poisoned litter went to France, pet of a wealthy man's children; another to Hollywood, where he saved two children from drowning while sea bathing. He was filmed. But mostly my Bobbies homed themselves in Canada. They won in the local dog shows. I did not show them further afield. To raise prize-winners was not the objective of my kennel. I aimed at producing healthy, intelligent working stock and selling puppies at a price the man of moderate means could afford, yet keeping the price high enough to insure the buyer feeling that his *money's worth* must be given due care and consideration.

NAMING

EVERY CREATURE accepting domesticity is entitled to a name.

It enraged me to find, perhaps a year later, that a pup I had sold was adult and unnamed, or was just called "Pup," "Tyke," or some general name. Were humans so blind that a creature's peculiarities suggested no name special to him?—nothing but a *class* tag? In selling a young pup, the naming was always left to the buyer. If I raised or half-raised a dog, I named him. For my kennel I liked the patriarchs—Noah, Moses, David, Adam. They seemed to suit the grey-bearded, rugged dignity of the Bobbies whose nature was earnest, faithful, dutiful.

At dog shows kennel-men smiled at the names on my entries. They said, "Why not 'Prince,' 'Duke,' 'King'?—more aristocratic!" But I clung to my patriarchs. The Old English Bobtail Sheep-dog is more patriarch than aristocrat.

MEG THE WORKER

BOBTAIL MEG was registered. I bought her by mail; I sent the money but no dog came. After writing a number of letters which were not answered, I applied to a lawyer. He wrote—Meg came. Her seller claimed that the dog had been run over on the way to be shipped. She was a poor lank creature with a great half-healed wound in her side. I was minded to return her. Then I saw the look in Meg's eyes, the half-healed, neglected wound, and I could not send her back to the kind of home she had obviously come from. I saw too how ravenously she ate, how afraid she was to accept kindness, how distrustful of coaxing.

Her coat was a tangled mass, barbed with last year's burs, matted disgustingly with cow dung. Before I let her go among my own dogs, she had to be cleaned. I got a tub and a pair of shears. When the filth was cleared away Meg shook herself; her white undercoat fluffed patchily, she looked chewed but felt clean and was eased by the dressing of her wound. She felt light-hearted, too, and self-respecting. Before the shears had finished their job Meg have given me her heart.

The kennel accepted Meg; Meg had no ears or eyes for any living thing, beast or human, but me. All day she sat in the dog-field, her eyes glued to my windows or the stair, waiting, trembling to hear my step, to see my shadow pass.

When her coat grew Meg did not look too bad. She was very intelligent and had been taught to work. Idleness irked Meg; her whole being twitched to obey; her eyes pleaded, "Work!" On Beacon Hill she bustled in and out among the broom hunting imaginary sheep and would slink shamely to my heel when she failed to find any.

I invented work for Meg. I was clearing the smaller stones off the far field, Meg following my every trip to a far corner where I emptied my basket. I stitched a pair of saddle-bags and bound them on to Meg. The dog stood patiently while I filled them with small stones and then trotted them to the dumping place proudly. I took her and her saddle-bags to the butcher's for the daily kennel rations. Meg lugged them home, nose high when she passed the dog-field where the others sniffed enviously. The bone that was her reward did not please Meg much, she let the others take it from her. Had any of them taken her job, Meg's heart would have been broken.

A kind-voiced man rushed into the kennel one day.

"I want a trained, cattle-dog to take with me to the Cariboo immediately!"

He fancied Meg; I liked the way he handled her. I let Meg go to the big spaces and the job that was hers by right.

BASEMENT

CREEPING AROUND a basement in the small dark hours is not cheerful. A house's underneathness is crushing—weight of sleep pressing from the flats above, little lumps of coal releasing miniature avalanches which rattle down the black pile, furnace grimly dead, asbestos-covered arms prying into every corner.

Just inside the basement door was a yawn of black. This portion of basement was uncemented, low-ceiled, earthy, unsunned. Often in daytime I must creep here among the cobwebs to feel hot-air-pipes and see that each tenant got his just amount of heat. Ghastly white pipes twisted and meandered through the dimness. A maple stump was still rooted here. Every year it sprouted feebler, paler shoots, anaemic, ghastly! Punk kept bones under the hollow of this old root. At night when we went down to tend puppies or sick dogs I scuttled quickly past the black. Cobwebby darkness did not worry Punk; he dashed in and dug up a bone to gnaw while I tended puppies.

NIGHT

MANY A WINTER NIGHT Punk, who slept upstairs in my flat, and I crept down the long outside stair to the basement, sometimes crunching snow on every step, sometimes slipping through rain. Old moon saw us when she was full. When new, her chin curled towards her forehead and she did not look at us. The corners of the stairway were black. Sometimes we met puffs of wind, sometimes wreaths of white mist. It was comfortable to rest a hand on Punk, envying his indifference to dark, cold, fear. I envied Punk his calm acceptance of everything.

THE DOG-THIEF

I LOVED SLEEPING in the garden room, my garden room where flowers and creatures were so close.

It was nearly time for the moon to turn in and for me to turn out. Punk, lying on the mat beside my bed, got up, crept to the open door—stood, a blurred mass of listening shadow.

The blind man in my downstairs flat had twice before told me of rustlings in the dog-field at night. His super-sensitiveness had detected fingers feeling along the outer wall of his flat.

"I think," he had suggested, "that someone is after a pup."

I threw on a gown and stood beside Punk. The shadow by the pup-house door looked, I thought, unusually bulky. Punk and I went down the cinder path. Punk growled, the shadow darted behind the lilac bush, uttering a high sing-song squeal. There was light enough to show Chinese cut of clothes—I heard the slip-slop of Chinese shoes.

"What do you want?"

"Me loosed," he whined.

"You are not lost. You came in by my gate. Put him out, Punk!"

Whites of slant, terrified eyes rolled as the dog allowed him to pass but kept at his heels until he was out in the street. Whoever bribed that Chinaman to steal a pup had not reckoned on Punk's being loose, nor had he counted on my sleeping in my garden.

S E L L I N G

A STRANGER STOOD at the garden gate. Young dogs leapt, old dogs stiffened and growled, enquiring noses smelled through the bars of the gate at the head of the garden steps. Fore-paws rested a step higher than hind-paws, making dogs' slanted bodies, massed upon the steps, look like a grey thatch. Strong snuffing breaths were drawn in silently, expelled loudly.

I came into the middle of the dog pack and asked of the stranger, "You wanted something?"

The man bracketed dogs and me in one disdainful look.

"I want a dog."

The coarse hand that swept insolently over the dogs' heads enraged them. They made such bedlam that an upper and a lower tenant's head protruded from the side of the house, each at the level of his own flat.

"What price the big brute?"—indicating Punk.

"Not for sale."

"The blue bitch?"—pointing to Loo.

"Not for sale."

"Anything for sale?" he sneered.

"Puppies."

"More bother'n they're worth! . . . G'ar on!"

He struck Punk's nose for sniffing at his sleeve.

"D'you want to sell or d'you not?"

"Not."

The man shrugged—went away.

Money in exchange for Bobbies was dirty from hands like those.

K I P L I N G

THE DOGS AND I were Sundaying on the garden lawn. Suddenly every dog made a good-natured rush at the garden gate. A man and a woman of middle age were leaning over it. The dogs bunched on the steps below the gate. The woman stretched a kindly hand to them. The man only stared—stared and smiled.

"Were you looking for somebody?" I asked.

"Not exactly—he," the woman waved a hand towards the man, "has always had a notion for Bobtails."

I invited them into my garden.

"Would you like to see the pups?" I said, and led the way to the puppy pen. The woman leant across, but the man jumped over the low fence and knelt on the earth among the puppies.

"Your 'Sunday,' Father!" reminded the woman.

He gave a flip to his dusty knees, but continued kneeling among scraping, pawing pups. Picking up a sturdy chap, he held it close.

"Kip, Kip," he kept saying.

"Kipling and Bobtails is his only queerness," the woman apologized.

"I suppose they are very expensive?" the man said, putting the puppy down on the ground. To the pup he said, "You are not a necessity, little fellow!" and turned away.

"There's times *wants* is *necessities*, Father," said the woman. "You go ahead and pick. Who's ate them millions and millions of loaves you've baked these thirty years? Not you. Jest time it is that you took some pleasure to yourself. Pick the best, too!"

With shaking hand the baker lifted the pup he had held before, the one he had already named Kip. He hurried the puppy's price out of his pocket (Ah! He had known he was going to buy!), crooked one arm to prevent the pup from slipping from beneath his coat, crooked the other arm for his wife to take hold. Neither of them noticed the dust on his "Sundays" as they smiled off down the street.

Sales like this were delicious—satisfactory to buyer, seller, dog.

LORENZO WAS REGISTERED

ONLY ONCE did I come upon a Bobbie who was a near-fool; he was a dog I bought because of his registration, for I went on coveting registration for my dogs. Lorenzo was advertised: "A magnificent specimen of the noble breed—registered name—'Lorenzo.'" He was impressive enough on paper; in the flesh he was a scraggy, muddle-coloured, sparse-coated creature, with none of the massive, lumbering shagginess of the true Bobbie. His papers apparently were all right. His owner described the dog as "an ornament to any *gentleman's* heel." I wanted dignity of registration for my kennels, not ornament for my heels.

Lorenzo had acquired an elegant high-stepping gait in place of the Bobtail shamble, also a pernickety appetite. He scorned my wholesome kennel fare, toothing out dainties and leaving the grosser portions to be finished by the other dogs.

Lorenzo was mine for only a short time. I had a letter asking for a dog of his type from a man very much the type of Lorenzo's former owner. The letter said, "I have a fancy for adding an Old Country note to my Canadian farm in the shape of an Old English Bobtail Sheep-dog. I have no stock to work, but the dog must be a good heeler—registration *absolutely necessary.*"

High-stepping Lorenzo was in tune with spats and a monocle, was registered and a good heeler. I told the man I had better-type dogs unregistered, but a check came by return emphatically stating that Lorenzo was the dog for him.

Lorenzo's buyer declared himself completely satisfied with foolish, high-stepping, bad-typed Lorenzo—Lorenzo was registered.

SISSY'S JOB

THE EARTH was fairly peppered with David Harbin's cousins. No matter what part of the world was mentioned David said, "I have a cousin out there." David was a London lawyer. During law vacation he visited cousins all over the world. He always came to see me when visiting Canadian cousins.

David and I were sitting on my garden bench talking. David said, "My last visit (to a Canadian cousin) has left me very sad. Cousin Allan and I were brought up together; his parents died and my Mother took Allan. He was a deaf-mute. His dumbness did not seem to matter when we were boys. We used dumb language and were jolly. When Allan had to face life, to take his dumbness out into the world, that was different—he bought a ranch in Canada, a far-off, isolated ranch. Now he is doubly solitary, surrounded by empty space as well as dead silence."

While David talked a Mother Bobtail came and laid her chin on his knee. His hand strayed to her head but he did not look at her. His seeing was not in the garden; it was back on the lonely ranch with dumb Allan. The dog sensed trouble in David's voice, in his touch she felt sadness. She leapt, licked his face! David started.

"Down, Sissy," I called.

But David shouted, "Dog, *you're* the solution. Is she for sale?"

"Sissy," I said, "was intended for a kennel matron. But she was temperamental over her first litter, did not mother them well. She will do better next time perhaps, unless. . . ."

I caught David's eye. . . .

"Unless I send her over to mother dumb Allan!"

David fairly danced from my garden, he was so happy in his solution for Allan's loneliness.

From England he wrote, "Allan's letters have completely changed, despondency gone from them. Bless Bobtails!—Sissy did it."

MIN THE NURSE

IN THE PUBLIC MARKET the butcher's scale banged down with a clank. The butcher grinned first at the pointer, then at me. The meat on the scale was worth far more than I was paying.

"Bobtails," murmured the butcher caressingly—"Bobtails is good dogs! . . . 'Member the little 'un I bought from your kennel a year back?"

"I do. Hope she turned out well—good worker?"

"Good worker! You bet. More sick nurse than cattle driver. Our Min's fine! Y'see, Missus be bed-fast. Market days she'd lay there, sun-up to sun-down, alone. I got Min; then she wan't alone no more; Min took hold. Market days Min minds wife, Min minds farm, Min keeps pigs out of potatoes, Min guards sheep from cougars, Min shoos coon from hen-house—Min, Min, Min. Min runs the whole works, Min do!"

He leaned a heavy arm across the scale, enraging its spring. He wagged an impressive forefinger and said, "Females understands females." Nod, nod, another nod. "Times there's no easin' the frets of Missus. Them times I off's to barn. 'Min,' I sez, 'You stay,' an' Min stays. Dogs be powerful understandin'."

He handed me the heavy parcel and gave yet another nod.

"Fido's chop, butcher!"

The voice was overbearing and tart; then it crooned down to the yapping, blanketed, wriggling, "Pom" under her arm, "Oo's chopsie is coming, ducksie!"

The butcher slammed a meagre chop on the scale, gathered up the corners of the paper, snapped the string, flung the package over the counter, tossed the coin into his cash box—then fell to sharpening knives furiously.

BABIES

THE DOGS AND I were absorbing sultry calm under the big maple tree in their play-field. They sprawled on the parched grass, not awake enough to seek trouble, not asleep enough to be unaware of the slightest happening.

A most extraordinary noise was happening, a metallic gurgle that rasped in even-spaced screeches. The noise stopped at our gate; every dog made a dash. Punk and Loo, who had been sitting on top of the low kennel against which I rested, leaped over my head to join the pack. The fence of their field angled the front gate. A weary woman shoved the gate open with the front wheels of the pram she pushed. A squeal or two and the noise stopped.

The woman drove the baby-carriage into the shade of the hawthorn tree and herself slumped on to the bench just inside my gate. Her head bobbed forward; she was so asleep that even the dogs' barking in her ear and pushing her hat over one eye, pawing and sniffing over the fence against which the bench backed, did not wake her. For a few seconds her hand went on jogging the pram, then dropped to her side like a weighted bag. I called the dogs back and every soul of us drowsed out into the summer hum. Only the sun was really awake. He rounded the thorn-tree and settled his scorch on to the baby's nose.

The child squirmed. He was most unattractive, a speckle-faced, slobbery, scowling infant. A yellow turkish-towelling bib under his chin did not add to his beauty. In the afternoon glare he looked like a sunset. He rammed a doubled-up fist into his mouth and began to gnaw and grumble. The woman stirred in her unlovely sleep, and her hand started automatically to jog the pram handle. I had come from the dog field and was sitting beside her on the bench. Eyes peering from partly stuck-together lids like those of a nine-day-old kitten, she saw me.

"Teethin'," she yawned, and nodded in the direction of the pram; then her head flopped and she resumed loose-lipped, snorting slumber.

"Wa-a-a-a!"

The dogs came inquisitively to the fence.

" 'Ush, 'Ush!"

She saw the dogs, felt their cool noses against her cheek.

"Where be I?—Mercy! I come for a pup! *That's* where I be! 'Usband says when we was changin' shifts walkin' son last night. 'Try a pup, Mother,' 'e sez—'We've tried rattles an' balls an' toys. Try a live pup to soothe 'is frettiness.' So I

come. 'Usband sez, 'Git a pup same age as son'—Sooner 'ave one 'ouse-broke me'self—wot yer got?"

"I have pups three months old."

"Ezzact same age as son! Bring 'em along."

She inspected the puppy, running an experienced finger around his gums.

"Toothed a'ready! 'E'll do."

She tucked the pup into the pram beside the baby who immediately seized the dog's ear and began to chew. The pup as immediately applied himself greedily to the baby's bottle and began to suck.

"Well, I never did!" said the mother. "Let 'im finish—'ere's a comfort for son."

She dived into a deep cloth bag.

"That pup was brought up on a bottle," I explained.

"That so? Tote!" she commanded. I operated the pram's screech till the comfort was in the baby's mouth and the pup paid for.

Loo and I, watching, heard the pram-full of baby whine down the street. Loo, when satisfied that the noise was purely mechanical, not puppy-made, shook herself and trotted contentedly back to the field—finished with that lot of puppies. Nature would now rest Loo, prepare her for the next lot of puppies. Life, persistent life! Always pushing, always going on.

DISTEMPER

DISTEMPER SWOOPED upon the kennel. Dance went from strong, straight legs leaving trembling weakness. Noses parched, cracked with fever, eyes crusted, ears lay limp; there were no tailless, all-over wobbles of joy, anticipation, curiosity; dinners went untouched.

One veterinary advocated open air and cold, the other sweating in a steam-box. I tried every distemper remedy then known. Death swept the kennel. A bucket of water stood always ready beside the garden tap for the little ones. When convulsions set in, I put an end to the pup's suffering. After convulsions started the case was hopeless.

These drowning horrors usually had to be done between midnight and dawn. The puppies yelped in delirium. (Tenants must not be disturbed by dog agony.) In the night-black garden I shook with the horror of taking life—when it must be done, the veterinary destroyed adult dogs that could not recover.

That bout of distemper took the lives of fifteen of my Bobtails, and took two months to do it in. Creena, a beautiful young mother dog I had just bought,

was the last adult to die. The vet took her body away; there was room for no more graves in my garden. Two half-grown dead pups in dripping sacks lay in the shed waiting for dark—of Loo's eight puppies (the ones the Prince of Wales had admired and fondled in the Victoria show a few weeks earlier) only two were left; they were ramping around their box in delirium. I could endure no more. It might be several days yet before they died. I took them to the garden bucket.

Now the kennel was empty except for Loo, Punk and Flirt. We must start all over again. That night when dark came I heaped four dripping sacks into the old pram, in which I brought bones from the butcher's, and trundled my sad load through black, wild storm to the cliffs off Beacon Hill. Greedy white breakers licked the weighted sacks from my hands, carried them out, out.

Punk waited at home. The tragedy in the kennel he did not comprehend— trouble of the human being he loved distressed the dog sorely. Whimpering, he came close—licked my hands, my face for sorrow.

G E R T I E

THE MAN SAID, "The garden belongs to my cousins, I board with them."

I could see he minded being only a "boarder," minded having no ground-rights.

The resentful voice continued, "Gertie has outgrown her pen and her welcome."

Pulling a stalk of wild grass, he chewed on it furiously. This action, together with the name of the dog, made me remember the man. A year ago he had come to my kennel. I had been impressed with the hideousness of the name "Gertie" for a dog. He had looked long at Loo's pups, suddenly had swooped to gather a small female that was almost all white into his arms. "This one!" he exclaimed, "daintiest pup of them all!" and, putting his cheek against the puppy, he murmured, "Gertie your name is, Gertie, *Gertie!*" Then he tucked her inside his coat and went sailing down the street, happy.

Now Gertie was up for sale and I was buying her back.

With a squeezing burst Gertie shot through her small door to fling herself upon her master. We stood beside the outgrown pen.

"I made it as big as the space they allowed would permit," giving a scornful glance at the small quarters of the big dog. "All right when she was little. Now it is cruel to keep a creature of her size in it."

Gertie was circling us joyously. Her glad free yelps brought the cousins rushing from their house, one lady furnished with a broom, the other with a duster. One dashed to the pansy-bed waving the duster protectively. The other broomed, militant, at the end of the delphinium row.

"Leash her!" squealed Pansy.

"Leash her!" echoed Delphinium.

The man took a lead from his pocket and secured Gertie. The women saw me take the lead in my hand, saw me put Gertie's price into his. He dashed the money into his pocket without a look, as if it burned his hand to hold it, turned abruptly, went into the house. The duster and the broom limped. The women smiled.

"Destructive and clumsy as a cow!" said Pansy, and scowled as Gertie passed them on her way to the gate, led by me.

"Creatures that size should be banned from city property!" agreed Delphinium with a scowl the twin of Pansy's.

Gertie, her head turned back over her shoulder, came with me submissively to the gate; here she sat down, would not budge. I pushed her out on to the pavement and shut the gate behind her—neither coaxing nor shoving would get Gertie further.

Suddenly there was a quick step on the garden walk—Gertie sprang, waiting for the gate to open, waiting to fling herself upon her adored master, pleading. I let go the lead, busied myself examining blight on the hedge. I was positive the sun had glittered on some unnatural shininess on the man's cheek. He handed me Gertie's lead. "I shall not come to see her. Will you give her the comfort of retaining the sound of her old name? Gertie," he whispered, "Gertie!" and the dog waggled with joy.

Gertie! Ugh, I *loathed* the name—Gertie among my patriarchs!

I said, "Yes, I'll keep the sound."

He commanded, "Go, Gertie."

The dog obeyed, rising to amble unenthusiastically in the direction of his pointing finger and my heels.

Honestly, I "Gertied" Gertie all the way home. Then, taking her head between my hands and bending close said, "Flirtie, Flirtie, Flirtie," distinctly into the dog's ear. She was intelligent and responded just as well to "Flirtie" as to "Gertie." After all, I told myself, it was the *sound* I promised that Gertie should keep.

The "ie" I gradually lopped off too. Maybe her master had abbreviated to "Gert" sometimes. Flirt became one of the pillars of my kennel.

She was frightened to death of her first puppies. She dug holes in the earth and buried them as soon as they were born. I dug the pups up, restored them to life, but Flirt refused to have anything to do with them. In despair I brought old Loo into the next pen and gave the pups to her. She bathed and cuddled them all day. More she could not do as she had no puppies of her own at that time. At evening when the pups squealed with hunger and Loo was just a little bored, I

sat an hour in Flirt's pen reasoning with her. Little by little the terrified, trembling mother allowed her puppies to creep close, closer, finally to touch her.

Her realization of motherhood came with a rush. She gave herself with Bobtail wholeheartedness to her pups, and ever after was a genuine mother.

THE COUSINS' BOBTAILS

TWO MEN, cousins, came to buy Bobtails. One cousin was rich and had a beautiful estate; the other was poor and was overseer and cowman for his cousin.

The rich cousin bought the handsomest and highest-priced pup in the kennel. After careful consideration the poor man chose the runt of the litter.

"This pup has brains," he said.

A chauffeur carried the rich man's pup to his car. The poor man, cuddling his puppy in his arm, walked away smiling.

A year later the rich cousin came to see me. He said, "I am entering my Bobtail in the show. I would like you to look him over." He sent his car and I went to his beautiful estate. His dog, Bob, was Loo's pup, well-mannered, handsome. I asked how the dog was for work.

"Well, our sheep are all show-stock, safely corralled. There *is* no work for Bob except to be ornamental. The women folks are crazy about him, never allow him 'round the barns. My cousin's dog does our cattle work."

We went to the cattle-barns, Bob walking behind us with dignity. The cow-cousin and a burly Bobtail were bringing in the dairy herd. They gave a nod and a "woof" in our direction and continued about their business. When the cows were stalled the man said "Right, Lass!" and man and dog came to where we stood. Wisps of straw stuck in the work-dog's coat, mud was on her feet, she reeked of cow. She stood soberly beside her master paying no heed either to Bob or to us.

"She handles the cows well," I said to the cow-cousin.

"Wouldn't trade Lass for a kingdom!" He directed a scornful eye and a pointing finger towards Bob, muttering, "Soft as mush!"

"Are you entering Lass in the show?"

"Show Lass! Lass has no time to sit on show-benches—on her job from dawn till dark—cows, pigs, hens. Leghorn fowls are pretty flighty you know, but Lass can walk into the midst of a flock—no fuss, just picks out the hen of my pointing, pins the bird to the ground by placing her paw squarely but gently on its back, holds on till I come. She can separate hens from pullets, cajoling each into their right pens—off then to the bushes for those tiresome youngsters

that *will* roost in the trees. No peace for bird or beast 'round this farm unless it obeys Lass!"

Bob went to the show. He won "the blue," delighting in the fuss and admiration. Lass at home commanded her pigs, drove hens, plodded after cows, but no fluttering ribbon of blue on Lass's collar could have exalted her Bobtail pride as did "Good girl, Lass!"—her master's voice, her master's praise.

BLUE OR RED

HER SKIN was like rag ill-washed and rough-dried. Both skin and clothing of the woman were the texture of hydrangea blossoms—thin, sapless. On exaggeratedly high heels here papery structure tottered.

"I want a dog."

"Work dog or companion?"

"One-o-them whatcher-callum—the kind you got."

"Bobtail Sheep-dogs."

"I ain't got no sheep, jest a husband. Lots younger'n me. I tried to keep my years down to his—can't be done,"—she shrugged.

The shrug nearly sent her thin shoulder blades ripping through the flimsy stuff of her blouse. She gripped a puppy by the scruff, raised him to eye-level, giggled, shook the soft, dangling lump lovingly, then lowered him to her flat chest. She dug her nose into his wool as if he had been a powder puff, hugging till he whimpered. She put him on the ground, rummaged in a deep woollen bag.

The money was all in small coin, pinches here and pinches there hoarded from little economies in dress and housekeeping. When the twenty-five and fifty-cent pieces, the nickels and the dimes were in neat piles on the garden bench, she counted them three times over, picked up her pup and went away. The silly heels tap-tapped down the garden path. She gave backward nods at the little piles of coin on the bench, each coin might have been a separate lonesomeness that she was saying goodbye to, grateful that they had brought her this wriggling happy thing to love.

A year later I was working in my garden and the little hydrangea person came again. Beside her lumbered a massive Bobtail. When he saw his brethren in the field his excitement rose to a fury of prances and barkings.

"Down, Jerry, down!"

No authority was in the voice. The dog continued to prance and to bark.

"Must a dog on the show bench be chained?"

"Most certainly he must be chained."

"That settles it! Jerry, Jerry, I *did* so want you to win the blue!"

"He is fine," I said.

"Couldn't be beaten, but Jerry will neither chain nor leash!"

"He could easily be taught."

"I dare not; Jerry is powerful. I'd be afraid."

I took a piece of string from my pocket, put it through Jerry's collar, engaged his attention, led him down the garden and back. He led like a lamb.

"See." I gave the string into her hand. The dog pulled back, breaking the string the moment her thin uncertain grasp took hold.

"Leave Jerry with me for half an hour."

She looked dubious.

"You won't beat him?"

"That would not teach him."

Reluctantly she went away. Jerry was so occupied in watching the dogs in the field he did not notice that she was gone. I got a stout lead, tied Jerry to the fence, then I took Flirt and Loo to the far field and ran them up and down. Jerry wanted to join in the fun. When he wanted hard enough I coupled him to Flirt. We all raced. Jerry was mad with the fun of it. Then I led him alone. By the time the woman came back Jerry understood what a lead was. He was reluctant to stop racing and go with his mistress. I saw them head for home, tapping heels and fluttering drapes, hardly able to keep up with the vigorous Jerry.

Jerry took his place on the show-bench and chained all right, but, in the show ring, his mistress had no control over him. He and his litter brother were competing, having outclassed all entries. Bob, Jerry's competitor, was obedient, mannerly. The Judge turned to take the red and the blue ribbons from the table, the frown of indecision not quite gone. Blue ribbon in right hand, red in left, he advanced. Jerry was flying for the far end of the ring, leash swinging. His mistress was dusting herself after a roll in the sawdust. The Judge handed the blue ribbon to Bob's master, to the hydrangea lady he gave the red. Bob's master fixed the blue to Bob's collar, the red ribbon dangled in the limp hand of Jerry's mistress. She did not care whether its redness fell among the sawdust and was lost or not—her Jerry was beaten!

DECISION

PUNK IN HIS PRIME was siring magnificent puppies, but I had to think forward. Punk and Loo, the founders of my kennel, would one day have to be replaced by young stock. Bobbies are a long-lived breed. Kennel sires and matrons, however, must not be over old if the aim of the kennel is to produce vigorous working stock. It was time I thought about rearing a young pair to carry on.

I had a beautiful puppy, a son of Punk's, named David. I had also a fine upstanding puppy of about the same age that I had imported from the prairies and named Adam. In points there was little to choose between the youngsters, both were excellent specimens and promised well. I watched their development with interest. The pups were entirely different in disposition; they were great chums. David was gentle, calm—Adam bold, rollicking. David's doggy brain worked slow and steady. Adam was spontaneous—all fire. He had long legs and could jump a five-foot fence with great ease. If Adam did not know my exact whereabouts he leapt and came to find me; David lay by the gate patiently waiting, eyes and ears alert for the least hint.

From early puppyhood Adam dominated David; not that David was in any way a weakling, but he adored Adam and obeyed him. Their pens were adjacent. At feeding time Adam bolted his dinner and then came to the dividing partition. David, a slower eater, was only half through his meal, but when Adam came and stood looking through the bars, David pushed his own food dish, nosing it close to Adam's pen. Adam shoved a paw under the boards and clawed the dish through to finish the food that was David's. This happened day after day; there was deliberate uncanny understanding between the two dogs—David always giving, Adam always taking.

One day I was housecleaning and could not have too many dogs under my feet. I shut them all into the play-field, all except David who lay on the lawn quietly watching my coming and going. Young Adam leapt the fence in search of me. Taking him to the far field I chained him and chained Eve at his side for company.

When it began to rain I was too busy to notice, and by the time I went into the garden to shake some rugs everything was soaking wet.

"Oh, poor Adam and Eve!" I exclaimed. "Chained in the open without shelter!"

I went to put them into the shed. To my amazement I found Adam and Eve each cuddled down on to a comfortable warm rug. It was queer for I knew these rugs had been hanging on a line in the basement. While I wondered I heard a chuckle from the porch of a downstair flat.

"David did it," laughed my tenant. "I watched him. The chained dogs got restive in the wet. David went up to Adam. I saw him regard the chained pup. He then went to Eve, snuffed at her wet coat and turned back into the basement. Next thing I saw was David dragging the rug to Adam who lay down upon it. Then he went back and fetched the other rug for Eve. That David is uncanny!

Yet for all David's wisdom Adam was the dominant character of the two. Both dogs possessed admirable traits for a kennel sire. I could not decide which to keep. At last the day came—the thing had to be faced.

I built a crate and furnished it with food and water. I took the buyer's letter from my pocket; my hand trembled as I printed the man's name on the crate. I did not know which dog was going, which one would stay. I read the letter again; either pup would meet the man's requirements—"Young, healthy, well-bred."

I leant over the gate watching the dogs at play in the field. David saw me, came, snuffed at my trouble through the bars, thrust a loving tongue out to lick joy back into me.

"David, I cannot let you go!"

"Adam," I called, "Adam!" But my voice was low, uncertain.

Adam was romping with Eve and did not heed.

Common sense came hanging over the gate beside me and, looking through my eyes, said, "David is of Punk's siring. Adam's new blood would be best for the kennel." My face sank, buried itself in David's wool.

"Dog ready?" The Express Company's van was at the gate. The man waited to lift the crate. The two loose boards, the hammer, the nails were ready, everything was ready, everything but my decision.

"Hurry! We have that boat to make!"

I opened the field gate. David rushed through, jumped into the crate. I nailed the loose boards over David. Adam still romped in the field with Eve.

"David! David!"

L O O

LOO REACHED ME FIRST, her motherliness, always on the alert to comfort any-
thing, pup or human, that needed protection.

I had watched someone die that night. It was the month of February and a bit-
ter freeze-up—ground white and hard, trees brittle. The sick woman had fin-
ished with seeing, hearing and knowing; she had breathed laboriously. In the
middle of the night she had died, stopped living as a blown-out candle stops
flaming. With professional calm the nurse had closed her eyes and mouth as if
they had been the doors of an empty cupboard.

When it was nearly dawn I went through bitter cold and half-light back to
my apartment-house. It was too early to let the Bobbies out, but I wanted the
comfort of them so I freed them into the garden, accepting their loving.
Warmth and cosiness sprang from the pens when I opened the doors, then I
went to tend my furnace. As I stooped to shovel coal, a man's heavy hand struck
me across the face. A tenant living in one of my flats bellowed over me, "I'll
teach you to let my pipes freeze!"

The shovel clanked from my hand—I reeled, fell on the coal pile. I had not
seen the man follow me into the basement. Before I righted myself the man was
gone, leaving the basement door open. Icy wind poured in. I sprang to slam the
door, bolt the brute out. He was on the step, his hand lifted to strike me again.
Quick as lightning I turned on the tap with hose attached at the basement door
and directed the icy water full into his face; it washed the spectacles from his
nose. Too choked, too furious, too wet even to roar, he turned and raced to his
flat upstairs. I waited for his door to shut, then I ran into the garden, ran to the
Bobbies.

The eagerness of Loo's rush to help me knocked me down. I did not get up, but
lay on the hard snow path, my smarting cheek against its cold. Loo stood over
me wanting to lick my hurt. I struck at her for a clumsy brute—told her to go
away. The amazed dog shrank back. Punk and the rest crowded round; Loo,
shamed and pitiful, crept behind the lilac bush. When I saw her crestfallen, bro-
ken-hearted, peeping from behind the bush, great shame filled me. A bully had
struck his landlady. I had struck Loo whom I loved; Loo, symbolizing motherli-
ness, most nearly divine of all loves, who had rushed to comfort me.

"Loo! Loo!"

She came, her forgiving as wholehearted as her loving. I buried my face in her shaggy warmth, feeling unworthy, utterly unworthy.

"Work is breaking me, Loo!"

The dog licked my hands and face.

But the apartment-house must be run; it was my living. The kennel? . . . I had supplied the Bobtail market. For the present the kennel was but expense. Dusting the snow off myself I went up to the studio taking Punk and Loo with me. On the table lay an open letter. A kindly woman on a farm wanted a dog— "Mother Bobtail already bred," she wrote. Giving myself no time to think I quoted Loo. Loo's chin rested on my knee as I wrote. I dared not look below my pen. Soon Loo would have another family.

"The joy of Loo in her puppies will ease her strangeness," I told myself, but—"Loo, Loo, I love you."

Remorseful, bitter—I loathed the money when it came, hated the approving nods, the words "wise," "sensible," which people stuffed into my ears when they knew of my decision. I loathed myself, cursed the grind that broke me and took my dogs from me. Punk searched every corner for Loo. Most he searched my face.

LAST OF THE BOBTAILS

LOO HAD BEEN GONE two days when a dowdy little woman came and held out a handful of small change.

"A guardian and companion for my daughter—delicate, city-bred, marrying a rancher on a lonely island. She dreads the loneliness while her husband is out clearing his land. I thought a sheep-dog . . ."

The price was not that of half a pup. She saw how young my puppies were and began to snivel. "It will be so long before they are protective!"

I took her small money in exchange for Punk, took it to buy value for him in her eyes. Those meagre savings meant as much to her as a big price meant to a rich person. A dog given free is not a dog valued, so I accepted her pittance.

Loo gone, Punk gone—emptying the kennel was numbness. I let every dog go—all except Adam. I would keep just one. Their going gave me more leisure, but it did not heal me. I took young Adam and went to the Okanagan to try high air. I struck a "flu" epidemic and lay six weeks very ill in Kelowna.

They were good to Adam. He was allowed to lie beside my bed. At last we took the lake boat going to Penticton to catch the Vancouver train. The train came roaring into the station and the platform shook. Adam, unused to trains, bolted, In a jiffy he was but a speck heading for the benches above Penticton.

The station master took Adam's chain and ticket.

"Hi, Bill!" he called to a taxi-driver, "Scoot like hell! Overtake that dog. Put him aboard at the water tank two miles down the line. You can make it easy!"

At the tank no Adam was put aboard. I was forced to go on alone. I wired, wrote, advertised. All answers were the same. Adam was seen here and there, but allowed no one to come near him. A shaggy form growing gaunter ever gaunter slunk through the empty streets of Penticton at night, haunting wharf and station. Everyone knew his story, people put out food. Everyone was afraid to try catching him. At great distances a lost terrified dog with tossing coat was seen tearing across country. It was hopeless for me to go up. No one could tell me in what direction to search. Then for months no one saw him. I hoped that he was dead. Two winters and one summer passed—I got a letter from a woman. She said, "We moved into a house some miles out of Penticton. It had been empty for a long while. We were startled to see a large shaggy animal dart from under the house. 'Adam!' I cried, 'Adam!' for I knew about the dog. He halted and looked back one second, then on, on, a mad terrified rush to get away from humans. There was a great hole under our house hollowed to fit his body," said the woman.

At night she put out food. She heard the dog snuff at the door crack. She did not alarm him by opening the door or by calling out. Adam was known the country over as "the wild dog."

One day the woman worked in her garden; something touched her. Adam was there, holding his great paw up. She wrote me, "Come and get him." But before I could start, a wire came saying, "Adam shipped."

I went into the Victoria freight shed. The tired dog was stretched in sleep.
"Adam!"

He quivered but he did not open his eyes.
"Adam!"

His nose stretched to my shoe, to my skirt—sniffing.
"Adam!"

One bound! Forepaws planted one on each of my shoulders, his tongue reaching for my face.

Everyone said, "Adam will be wild, impossible after nineteen months of freedom."

He had forgotten nothing, had acquired no evil habit. Only one torment possessed Adam—fear of ever letting me out of his sight again—Adam, the last of my Bobtails.

GROWING PAINS

AN AUTOBIOGRAPHY

CONTENTS

PART III

FOREWORD

Dear Emily:

You have asked me to write a foreword to your autobiography—this summing up of a number of things that have mattered in your life. It is a hard task but one for which I thank you.

What can I say? Certainly nothing that can possibly matter much. I know how courageous your life has been, how dauntless your purpose, how unshaken and unshakeable your faith that this is not all, that we go on. I know too how intensely you have felt the influence of nature—its loveliness, its deep solemnity, its mystic, overwhelming power to strike awe and sometimes terror in our hearts. You have told us of your reactions to those forces in your painting and your writing. Canadians will remember as they open this book and will be grateful.

You will understand when I say that I should like a poem to stand as preface to your book, a poem which we have both admired so much, Thomas Hardy's *Afterwards*. I know and you know that Hardy did not think it a sad poem—just a comment and a summing up. So, Emily, I shirk my task and set as foreword to your autobiography these lines:

When the present has latched its postern behind my tremulous
　　　stay
　And the May month flaps its glad green leaves like wings,
Delicate-filmed as new-spun silk, will the neighbours say,
　"He was a man who used to notice such things"?

If it be in the dusk when, like an eyelid's soundless blink,
　The dew-fall hawk comes crossing the shades to alight
Upon the wind-warped upland thorn, a gazer may think,
　"To him this must have been a familiar sight."

If I pass during some nocturnal blackness, mothy and warm,
　When the hedgehog travels furtively over the lawn,

One may say, "He strove that such innocent creatures should
 come to no harm,
 But he could do little for them; and now he is gone."

If, when hearing that I have been stilled at last, they stand at
 the door,
 Watching the full-starred heavens that winter sees,
Will this thought rise on those who will meet my face no more,
 "He was one who had an eye for such mysteries"?

And will any say when my bell of quittance is heard in the
 gloom,
 And a crossing breeze cuts a pause in its outrollings,
Till they rise again, as they were a new bell's boom,
 "He hears it not now, but used to notice such things"?

There is a change somewhere in the east. In my western garden this evening grosbeaks are paying their annual visit, a brief pause in our elm trees during their migration; and high in the Canadian sky wild geese, great flocks of them, are shouting their mysterious cry. They are all going on as you and I must, Emily. Life will not stand still.

So, fare forward, dear soul.

IRA DILWORTH

PART ONE

BAPTISM

MY BAPTISM is an unpleasant memory. I was a little over four years of age. My brother was an infant. We were done together, and in our own home. Dr. Reid, a Presbyterian parson, baptized us. He was dining at our house.

We were playing in the sitting room. Brother Dick was in his cradle. Mother came into the room with water in her best china bowl. While she lighted the lamp my big sister caught me, dragged me to the kitchen pump and scrubbed my face to smarting. I was then given to Dr. Reid who presented me kicking furiously to God.

I would have been quite content to sit on Dr. Reid's knee, but his tipping me flat like a baby infuriated me. I tried to bolt. Dr. Reid hung on to a curl and a button long enough to splash water on my hair ribbon and tell God I was Emily; then the button burst off and I wrenched the curl from his hand and ran to Mother. Dr. Reid and Mother exchanged button for baby. Dick gurgled sweetly when the water splashed him.

Father sat at the table with the fat family Bible open at the page on which the names of his seven other children were written. He added ours, Richard and Emily, which as well as being ours were his own name and Mother's. The covers of the Bible banged, shutting us all in. The Bible says that I was born on the thirteenth day of December, 1871.

MOTHER

TO SHOW Mother I must picture Father, because Mother was Father's reflection—smooth, liquid reflecting of definite, steel-cold reality.

Our childhood was ruled by Father's unbendable iron will, the obeying of which would have been intolerable but for Mother's patient polishing of its dull metal so that it shone and reflected the beauty of orderliness that was in all Father's ways, a beauty you had to admire, for, in spite of Father's severity and his overbearing omnipotence, you had to admit the justice even in his dictatorial bluster. But somehow Mother's reflecting was stronger than Father's reality, for, after her death, it lived on in our memories and strengthened, while Father's tyrannical reality shrivelled up and was submerged under our own development.

Father looked taller than he really was because he was so straight. Mother was small-made and frail. Our oldest sister was like Father; she helped Mother raise us and finished our upbringing when Mother died.

I was twelve when Mother died—the raw, green Victoria age, twelve years old.

The routine of our childhood home ran with mechanical precision. Father was ultra-English, a straight, stern autocrat. No one ever dreamt of crossing his will. Mother loved him and obeyed because it was her loyal pleasure to do so. We children *had* to obey from both fear and reverence.

Nurse Randal has told me of my first birthday. I was born during a mid-December snow storm; the north wind howled and bit. Contrary from the start, I kept the family in suspense all day. A row of sparrows, puffed with cold, sat on the rail of the balcony outside Mother's window, bracing themselves against the danger of being blown into the drifted snow piled against the window. Icicles hung, wind moaned, I dallied. At three in the morning I sent Father plowing on foot through knee-deep snow to fetch Nurse Randal.

I never did feel that it was necessary to apologize to my father for being late. It made variety for him, seeing that he always got his way in everything—when Father commanded everybody ran.

Every evening at a quarter to six Mother would say, "Children, is every gate properly shut and fastened? Are no toys littering the garden, no dolls sitting on humans' chairs? Wash your faces, then, and put on clean pinafores; your father will soon be home."

If visiting children happened to be playing with us in our garden, or a neighbour calling on Mother, they scurried for the gate as fast as they could. Father would not have said anything if he had found them in his house—that was just it, he would not have said anything to them at all. He would have stalked in our front door, rushed through the house and out of the side door frowning terribly, hurrying to tend Isabella, the great, purple-fruited grapevine that crawled half over our house and entirely over Father's heart. Her grapes were most beautifully fogged with dusky bloom, behind which she pretended her fruit was luscious; but they were really tough-skinned, sour old grapes.

Father was burstingly proud of miserable old Isabella. He glassed her top so that her upstairs grapes ripened a whole month earlier than her downstairs ones. He tacked Isabella up, he pinched her back, petted, trained her, gave her everything a vine could possibly want, endured far more waywardness from her than all of us together would dare to show.

After Father had fussed over Isabella and eaten a good dinner, he went upstairs to see Mother who was far more often in bed ill than up. He was good to Mother in his own way, gave her every possible comfort, good help, good doctoring, best food, but I resented that he went to Isabella first and Mother after. He was grumpy too when he did go. He sat beside her bed for half an hour in almost complete silence, then he went downstairs to read his paper till bedtime.

I heard a lady say to Mother, "Isn't it difficult, Mrs. Carr, to discipline our babies when their fathers spoil them so?"

Mother replied, "My husband takes no notice of mine till they are old enough to run round after him. He then recognizes them as human beings and as his children, accepts their adoration. You know how little tots worship big, strong men!"

The other mother nodded and my mother continued, "Each of my children in turn my husband makes his special favourite when they come to this man-adoring age. When this child shows signs of having a will of its own he returns it to the nursery and raises the next youngest to favour. This one," she put her hand on me, "has overdrawn her share of favouritism because there was no little sister to step into her shoes. Our small son is much younger and very delicate. His father accuses me of coddling him, but he is the only boy I have left—I lost three."

Father kept sturdy me as his pet for a long time.

"Ah," he would say, "this one should have been the boy."

The very frailness of her little son made Mother love him harder. She did not mind the anxiety and trouble if only he lived.

Father insisted that I be at his heels every moment that he was at home. I helped him in the garden, popping the bulbs into holes that he dug, holding the strips of cloth and the tacks while he trained Isabella. I walked nearly all the way to town with him every morning. He let me snuggle under his arm and sleep during the long Presbyterian sermons. I held his hand during the walk to and from church. This all seemed to me fine until I began to think for myself—then I saw that I was being used as a soother for Father's tantrums; like a bone to a dog. I was being flung to quiet Father's temper. When he was extra cranky I was taken into town by my big sister and left at Father's wholesale warehouse to walk home with him because my chatter soothed him. I resented this and began to question why Father should act as if he was God. Why should people dance after him and let him think he was? I decided disciplining would be good for Father and I made up my mind to cross his will sometimes. At first he laughed, trying to coax the waywardness out of me, but when he saw I was serious his fury rose against me. He turned and was harder on me than on any of the others. His soul was so bitter that he was even sometimes cruel to me.

"Mother," I begged, "need I be sent to town any more to walk home with Father?"

Mother looked at me hard. "Child," she cried, "what ails you? You have always loved to be with your father. He adores you. What is the matter?"

"He is cross, he thinks he is as important as God."

Mother was supremely shocked; she had brought her family up under the English tradition that the men of a woman's family were created to be worshipped. My insurrection pained her. She was as troubled as a hen that has hatched a duck. She wanted to question me but her loyalty to Father forbade.

She said to me, "Shall you and I have a picnic?"—She knew that above all things I loved a picnic.

"All to ourselves?" I asked.

"Just you and I."

It was the most wonderful thing she could have suggested. I was so proud. Mother, who always shared herself equally among us, was giving to me a whole afternoon of herself!

It was wild lily time. We went through our garden, our cow-yard and pasture, and came to our wild lily field. Here we stood a little, quietly looking. Millions upon millions of white lilies were sprangled over the green field. Every lily's brown eye looked down into the earth but her petals rolled back over her head and pointed at the pine-tree tops and the sky. No one could make words to tell how fresh and sweet they smelled. The perfume was delicate yet had such power its memory clung through the rest of your life and could carry you back any time to the old lily field, even after the field had become city and there were no more lilies in it—just houses and houses. Yes, even then your nose could ride on the smell and come galloping back to the lily field.

Between our lily field and Beacon Hill Park there was nothing but a black, tarred fence. From the bag that carried Mother's sewing and our picnic, she took a big key and fitted it into the padlock. The binding-chain fell away from the pickets. I stepped with Mother beyond the confines of our very fenced childhood. Pickets and snake fences had always separated us from the tremendous world. Beacon Hill Park was just as it had always been from the beginning of time, not cleared, not trimmed. Mother and I squeezed through a crack in its greenery; bushes whacked against our push. Soon we came to a tiny, grassy opening, filled with sunshine and we sat down under a mock-orange bush, white with blossom and deliciously sweet.

I made a daisy chain and Mother sewed. All round the opening crowded spiraea bushes loaded with droops of creamy blossom having a hot, fluffy smell. In these, bees droned and butterflies fluttered, but our mock-orange bush was whiter and smelled stronger and sweeter. We talked very little as we sat there.

Mother was always a quiet woman—a little shy of her own children. I am glad she was not chatty, glad she did not perpetually "dear" us as so many English mothers that we knew did with their children. If she had been noisier or quieter, more demonstrative or less loving, she would not have been just right. She was a small, grey-eyed, dark-haired woman, had pink cheeks and struggled breathing. I do not remember to have ever heard her laugh out loud, yet she was always happy and contented. I was surprised once to hear her tell the Bishop, "My heart is always singing." How did hearts sing? I had never heard Mother's, I had just heard her difficult, gasping little breaths. Mother's moving was slow

and weak, yet I always think of her as having Jenny-Wren-bird's quickness. I felt instinctively that was her nature. I became aware of this along with many other things about my mother, things that unfolded to me in my own development.

Our picnic that day was perfect. I was for once Mother's oldest, youngest, her companion-child. While her small, neat hands hurried the little stitches down the long, white seams of her sewing, and my daisy chains grew and grew, while the flowers of the bushes smelled and smelled and sunshine and silence were spread all round, it almost seemed rude to crunch the sweet biscuit which was our picnic—ordinary munching of biscuits did not seem right for such a splendid time.

When I had three daisy chains round my neck, when all Mother's seams were stitched, and when the glint of sunshine had gone quiet, then we went again through our gate, locked the world out, and went back to the others.

It was only a short while after our picnic that Mother died. Her death broke Father; we saw then how he had loved her, how alone he was without her—none of us could make up to him for her loss. He retired from business. His office desk and chair were brought home and put into the room below Mother's bedroom. Here Father sat, staring over his garden. His stare was as empty as a pulpit without a preacher and with no congregation in front of it. We saw him there when we came from school and went stupidly wandering over the house from room to room instead of rushing straight up to Mother's bedroom. By-and-by, when we couldn't bear it any longer, we'd creep up the stairs, turn the door handle, go into emptiness, get caught there and scolded for having red eyes and no bravery.

I was often troublesome in those miserable days after Mother died. I provoked my big sister and, when her patience was at an end, she would say, trying to shame me, "Poor Mother worried about leaving you. She was happy about her other children, knowing she could trust them to behave—good reasonable children—you are different!"

This cut me to the quick. For years I had spells of crying about it. Then by-and-by I had a sweetheart. He wanted me to love him and I couldn't, but one day I almost did—he found me crying and coaxed.

"Tell me."

I told him what my big sister had said. He came close and whispered in my ear, "Don't cry, little girl. If you were the naughtiest, you can bet your mother loved you a tiny bit the best—that's the way mothers are."

D R A W I N G A N D
I N S U B O R D I N A T I O N

I WANTED to draw a dog. I sat beside Carlow's kennel and stared at him a long time. Then I took a charred stick from the grate, split open a large brown-paper sack and drew a dog on the sack.

My married sister who had taken drawing lessons looked at my dog and said, "Not bad." Father spread the drawing on top of his newspaper, put on his spectacles, looked, said, "Um!" Mother said, "You are blacked with charred wood, wash!" The paper sack was found years later among Father's papers. He had written on it, "By Emily, aged eight."

I was allowed to take drawing lessons at the little private school which I attended. Miss Emily Woods came every Monday with a portfolio of copies under her arm. I got the prize for copying a boy with a rabbit. Bessie Nuthall nearly won because her drawing was neat and clean, but my rabbit and boy were better drawn.

Father pruned the cherry tree under our bedroom window. The cherry sticks were twisty but I took three of the straightest, tied them at one end and straddled them at the other and put two big nails in the wood to hold a drawing-board. With this easel under the dormer window of our bedroom I felt completely an artist. My sister Alice who shared the room complained when she swept round the legs of the easel.

When I went to the big public school with my sisters we were allowed on Fridays after school to go to Miss Withrow's house for drawing lessons. I got sick for fear I'd be kept in and miss any of the lesson, so Mother wrote a note to the teacher asking that I be let out on time. My sisters Lizzie and Alice painted flowers, I drew heads.

Miss Withrow sewed small photographs into little squares with white cotton thread, then she ruled a big sheet of paper with big squares and I drew as much in a big square as there was in a little one. In this way I swelled Father and Mother and my sister's baby. Father put Mother and himself in gilt frames and gave me five gold dollars. My sister thought my drawn baby was not good

enough to be her child.

The Victoria tombstone-maker got some plaster casts of noses, hands, lips and eyes, to help him model angels for his tombstones. I heard that to draw from casts was the way they learned at Art schools, so I saved my pocket money and bought some of these over-size human features and drew them over and over.

My mother died when I was twelve years old and my father died two years later. When Father died I was still at school getting into a great deal of trouble for drawing faces on my fingernails and pinafores and textbooks. My sisters and brother were good students. When I moved up a grade the new teacher said, "Ah, another good Carr!" but was disappointed.

After Father and Mother died my big sister ruled; she was stern like Father. She was twenty years older than the youngest of us. Our family had a wide gap near the top where three brothers had died, so there was Mother's big family of two grown-up girls and her little family of three small girls and a boy. The second of the big sisters married. The biggest sister owned everything and us too when Father died.

Lizzie and Alice were easy children and good. Lizzie was very religious. Alice was patient and took the way of least resistance always. Dick too was good enough, but I was rebellious. Little Dick and I got the riding whip every day. It was a swishy whip and cut and curled around our black stockinged legs very hurtfully.

The most particular sin for which we were whipped was called insubordination. Most always it arose from the same cause—remittance men, or remittance men's wives. Canada was infested at that time by Old Country younger sons and ne'er-do-wells, people who had been shipped to Canada on a one-way ticket. These people lived on small remittances received from home. They were too lazy and too incompetent to work, stuck up, indolent, considering it beneath their dignity to earn but not beneath their dignity to take all a Canadian was willing to hand out.

My two elder sisters were born in England. The one who ruled us felt very much "first born" in the English way, feeling herself better than the rest of us because she was oldest. She was proud of being top. She listened to all the hard-luck stories of the remittance people and said, "I too was born in England." She sympathized with their homesickness and filled our home with these people.

Dick and I hated the intruders. Lizzie and Alice resented them too, but quietly. My sister tried to compel my brother and me by means of the riding whip.

A couple called Piddington sat on us for six months. The wife was a hypochondriac and exploited ill-health. The man was an idle loafer and a cruel bully. Anger at his impertinence and sponging kept the riding whip actively busy on our young legs. Things came to a climax when we rented a sea-side cottage in the holidays. The man took a party of boys and girls out in the boat. The sea was rough. I asked to be put ashore. Seeing my green face the man shipped his oars and cried delightedly, "We'll make the kid seasick." He rocked the boat back and forth till he succeeded. I was shamed before all the boys and girls. He

knew, too, how it infuriated me to be called "kid" by him.

"You are not a gentleman anyway!" I cried. "You are a sponger and a bully!"

Purple with rage the man pulled ashore and rushed to his wife saying, "The kid has insulted me!"

For insulting a guest in her house my sister thrashed me till I fainted; but I refused to apologize, and the bully and I went round glowering at each other. I said to my sister, "I am almost sixteen now and the next time you thrash me I shall strike back." That was my last whipping.

Dick went East to school. The whip dangled idle on the hall peg, except after school and on Saturdays when I took it out as an ornament and went galloping over the country on old Johnny.

Johnny had been a circus pony. He knew a lot. When he had galloped me beyond the town and over the highway till all houses and fences were passed, he would saunter, stopping now and then to sniff the roadside bushes as if considering. Suddenly he would nose into the greenery finding a trail no one else could see, pressing forward so hard that the bushes parted, caressing him and me as we passed, and closing behind us shutting us from every "towny" thing. Johnny pressed and pressed till we were hidden from seeing, noise and people. When we came to some mossy little clearing where soft shade-growing grass grew Johnny stopped with a satisfied sigh. I let down his bridle and we nibbled, he on the grass, I at the deep sacred beauty of Canada's still woods. Maybe after all I owe a "thank you" to the remittance ones and to the riding whip for driving me out into the woods. Certainly I do to old Johnny for finding the deep lovely places that were the very foundation on which my work as a painter was to be built.

G R A D U A T I O N

THOUGH I had graduated from whippings life at home was neither easy nor peaceful. Outsiders saw our life all smoothed on top by a good deal of mid-Victorian kissing and a palaver of family devotion; the hypocrisy galled me. I was the disturbing element of the family. The others were prim, orthodox, religious. My sister's rule was dictatorial, hard. Though her whip beat me no more her head shook harder and her tongue lashed. Not content with fighting my own battles, I must decide to battle for the family rights of all us younger children. I would not sham, pretending that we were a nest of doves, knowing well that in our home bitterness and resentment writhed. We younger ones had no rights in the home at all. Our house had been left by my father as a home for us all but

everything was in big sister's name. We younger ones did not exist.

I marched to the dignified, musty office of the old Scotch gentleman whom my father had appointed as our guardian. He knew nothing of our inner home life. His kind, surprised eyes looked at me over the top of his glasses. No other ward of his—he had others beside us—had ever sought him personally in his den.

"What can I do for you, Emily?"

"Please, I want to go away from home. There is an Art School in San Francisco—may I go there?"

My guardian frowned. He said, "San Francisco is a big and wicked city for a little girl to be alone in."

"I am sixteen, almost."

"You do not look it."

"Nobody is allowed to grow up in our house."

My guardian grew stern.

"Your sister," he said, "is an excellent woman and has been a mother to you younger children. Is this Art idea just naughtiness, a passing whim?"

"No, it is very real—it has been growing for a long time."

He looked at me steadily.

"It can be arranged."

When he smiled at me I was glad I had come.

My sister, when she heard what I had done without her advice, blackened. The breaking storm was checked by her chuckle, "So you want to run away from authority? All right, I shall place you under the supervision of the Piddingtons!"

I had forgotten that the hated Piddingtons were now living in San Francisco. I was so glad for them to have moved that I had not cared where they went; but neither the Piddingtons nor the wickedness of San Francisco could crack my joy. Without my sister watching I could defy the Piddingtons. I'd be busy studying Art. I had always been fond of drawing and of beautiful places, particularly woods, which stirred me deeper than anything. Now I would learn how to put the two together. The wickedness of San Francisco caused me no anxiety. Big naughtiness like immorality, drunkenness, vice I knew nothing of. Lies, destructiveness, impertinence were the worst forms of evil of which I was aware.

The wickedness of San Francisco did not show in the least when our boat pushed through sea-fog and entered the Golden Gate. Telegraph Hill sticking up on our right was very naughty the Captain said but it looked beautiful to me perched on the bluff as I stood on the bridge beside the Captain. The sordid shabbiness of Telegraph Hill was wreathed in mist. Our ship eased slowly up to a dirty wharf. Here, smart and trim, stood Mrs. Piddington, an eye full of "ogle" ready for the Captain to whose care I had been entrusted. I was feeling like a tissue-wrapped valuable when he handed me over, but as Mrs. Piddington took me I changed into a common brown paper bundle. She scowled at my luggage—a straw suitcase and a battered birdcage containing a canary in full moult. I felt like a stray pup following elegant Mrs. Piddington from the wharf.

The Piddingtons lived in a large private hotel on Geary Street. They occupied a corner suite on the first floor. A little room was found for me at the top of the house. Until I looked out of its window I had not known there were so many chimney-pots in the world. I hung old Dick in the window and he began to sing at once, and then the strangeness of everything faded and my eyes were full of curiosity.

The San Francisco people swallowed Mrs. Piddington. She tasted nice to them because her tongue made glib use of titles and her voice was extra English. Americans did not notice the missing "aitches"; they liked the cut of her clothes. She was not at all proud of me and was careful to explain that I was no relation, just a Canadian girl put under her care come to San Francisco to study Art.

She hustled me down to the school as soon as possible. The San Francisco School of Art was up over the old Pine Street Public Market, a squalid district, mostly wholesale. From the dismal street you climbed a dirty stair. In a dark, stuffy office at the top sat a lean, long-bearded Curator tugging and tugging at his whiskers as if they operated his brain and he had to think a great deal. Mrs. Piddington did not consider him worth ogling. She told him I was Canadian, but as Canada had no Art Schools and England was too far there was nothing to be done but send me here. She intimated that personally she thought very little of America. However, being handy to Canada,—could I enroll?

The Curator pulled his beard and asked, "What d'you know, girl?"

"Nothing," I replied.

"Oh," said Mrs. Piddington, "she draws very prettily!"

I could have killed her when I saw her hold out a little roll of my drawings that she had got from my sister.

The Curator pushed them aside and said to me, not Mrs. Piddington, "You come along." There was nothing for her to do but go and for me to do but follow.

We passed through a big room hung with oriental rugs and dust. It was not part of the Art School. The Art School lay beyond, but this was the only way in. The School had been a great hall once. The centre was lit by a big skylight, there were high windows all down the north side. Under those windows the hall was cut into long alcoves by grey screens. One corner was boarded closed,—on the door was printed "Life Class, Keep Out". The whole place smelt of rats. Decaying vegetables lay on tables—still-life studies.

Long rows of students sat with lap-boards which had straddled hind legs that rested on the floor. Other students stood at easels drawing. In the centre of the room under a skylight were great plaster images on pedestals. More students were drawing from these images. I was given a lap-board in the first alcove, and a chunk of bread. A very dirty janitor was hacking up a huge crusty loaf; all the students were scrambling for pieces. The floor was littered with old charcoal-blackened crusts. Charcoal scrapings were everywhere. There were men students as well as women. All wore smocks or very dirty painting pinafores. I went back to the office with the Curator to buy charcoal and paper, then I took my place in the long row. On one side of me was a fair, sharp-featured, sweet-faced girl

with long, square-toed shoes like a pair of glove boxes. She wore a black dress and a small black apron of silk with a pocket from which she kept pulling a little lace-bordered handkerchief to flip the crumbs and charcoal from her lap. On the other side of me sat a dirty old man with a tobacco-stained beard. Art School was not exactly what I had expected but this was a beginning and I was eager to attack the big plaster foot they set before me to draw.

"My name is Adda," said the little girl in black with the flipping handkerchief. "What is yours?"

"Emily."

"I was new last week. I come from Los Angeles. Where is your home?"

"Canada!"

"Oh how terrible for you! I mean coming from a foreign country so far away! How long were you on the sea coming?"

"Three days."

"It took me less than one whole day. I'd die if I was farther than one day away from Momma and Poppa. I have a little sister too and a brother. I am dreadfully homesick. The School is very dirty, isn't it? Just wait till you see the next alcove and smell it, dead birds and fish, and rotting vegetables, still life you know. Shoo, shoo!" Her voice rose to a shrill squeal and the lace bordered handkerchief flipped furiously. A rat was boldly marching a crust to his hole under the pedestal of a near image. "Momma said I must be prepared to face things when I went out into the world, but Momma never dreamt there would be rats!"

Adda seemed much older than I but, after a while, I discovered that she was younger. She knew more about the world. Her mother had prepared her to meet any emergency, had told her how to elude evil and, if she could not dodge, then how to face it. Adda said, "Momma says San Francisco is very, very wicked!"

"That is what my guardian said too. It doesn't look bad to me, does it to you?"

"Momma would never say it was bad if it wasn't. She came all the way up from Los Angeles to find a safe home for me to live in. How did your mother manage to see you were safe fixed? You live so far away."

"My mother is dead."

"Oh!" Adda said no more but from that moment she took care of me, sharing with me Momma's warnings, advice, extracts from Momma's letters.

REASONS

BEYOND the last alcove in the great hall was a little dressing room which contained a cracked mirror, a leaky wash-basin, a row of coat pegs, and a twisty little stair leading to an attic. I was searching for still-life material. Being quite new to the school I did not know its queer corners. One of the High Society students, Miss Hatter, was powdering her nose, trying to make the crack in the looking glass divide her face exactly so that she could balance the rouge and powder on both cheeks. She spat out a mouthful of swansdown puff to say, "Lots of junk for studies up there," and pointed to the attic.

That was the way in this old San Francisco School of Art, even a top-swell student was ready to help little new nobodies.

I climbed the stair and squeezed gingerly through a small door which the wind caught and banged behind me. The attic was low-roofed and dim. My sleeve brushed something that vibrated—a dry crackly rattle, some shadowy thing that moved. I put out my hand to feel for the door knob—the attic was nearly dark. I found myself clutching the rib of a skeleton whose eyesockets poured ghastly stares over me, vacant, dumbing stares. The dreadful thing grinned and dangled its arms and legs. The skeleton hung rotating from a hook on the low roof. It was angry with my sleeve for disturbing the stillness. I saw the white knob of the door-handle and, wrenching the door open, tumbled down the stairs screeching!

"Heavens, child, look what you've done to me!" Miss Hatter was dimmed by a blizzard of powder. "One would think you had seen a ghost up there!"

"Oh, worse—more dead—horrible!"

"Why, that's only old Bonesy. He lives up there! One of these days you will be drawing him, learning what is underneath human skin and fat."

"I couldn't sit up in that spooky attic being stared at by a skeleton!"

"Of course not, Bonesy will come down to you. He loves little holidays and if he can make people's teeth chatter so much the better. It is the only way he can converse with fellow bones. People are too cluttered with flesh for Bonesy to feel companionable with."

I saw that we were not alone in the dressing room. A pair of sad, listening eyes was peeping from behind the row of jackets on the rack. The eyes belonged to Nellie McCormick, a student. She came out when Miss Hatter left the room.

"Say, d'you believe in spooks? Up in the attic there is a table that raps. Let's Therese, Lal, you and me go up at lunch-time—ask the spooks things. Lal has only one arm, so it makes seven hands for the table. Spooks like the number seven."

"Couldn't a two-handed person put just one hand on the table?"

"Wouldn't be the same—got to be wholehearted with spooks or they won't work."

Bolting our lunches we hurried to the attic.

The rapping-table was close beside Bonesy. His stare enveloped us. Finger to finger, thumb to thumb, our hands spread themselves upon the table. We trembled a little in the tense silence—rats scuttled—an enormous spider lowered himself from the roof, swayed above the circle of hands, deciding which, dropped on Lal's one hand. Lal screamed. Nellie scowled, rats squeaked, the table tipped a little, tipped harder, rapped, moved sideways, moved forward, became violent! We moved with it, scuffling our feet over the uneven floor, pushing Bonesy crooked. All his joints rattled, his legs kicked, his hands slapped, his head was fast to the hook on the rafter but his body circled, circled. A city clock struck one. We waited until the cackle of voices in the dressing-room subsided. Then four nerve-flushed girls crept down the attic stairs.

Nellie McCormick's strangeness drew me as apparently I drew her. She had few friends; you found her crouched beside the pedestal of this or that great image, the Venus de Milo, the Dancing Faun, the Greek Slave. Nellie was always thinking—her eyes were such a clear blue there seemed only the merest film between her thoughts and you. Had she thought in words you could have read them.

We talked little when we were together, Nellie and I. One day turning to me sharply she asked, "Is your mother decent?"

"My mother is dead."

"Lucky for you. My mother is a beast!"

There were many different nationalities represented in the Art School. Every type of American; there were Jews, Chinese, Japs, poor and wealthy students, old and young students, society women, cripples, deformed, hunchbacked, squint-eyed. There was a deaf-mute girl with one arm, and there was a halfwit. Most of them had come to study seriously, a few came for refuge from some home misery. There was one English girl (Stevie), fresh from the Old Country, homesick. I was not English but I was nearer English than any of the others. I had English ways, English speech, from my English parents though I was born and bred Canadian.

Stevie took comfort in me. Every morning she brought a tiny posy of mignonette and white sweetpeas and laid it on my easel-board. I smelled it the moment I rounded the screen. Its white sweetness seemed rather "in memoriam" to me. I felt as though I ought to be dead; but it was just Stevie's way of paying

tribute to England's memory. She felt me British or, at least, I was not American.

Students never thought of having their overall work-aprons washed. We were a grubby looking lot. A few of the swell girls wore embroidered smocks. The very swellest wore no protection for their fine clothes, intimating that paint spots were of no moment, they had plenty more clothes at home.

A shy girl with a very red pigtail and a very strong squint came to the School. She was strange. Everyone said, "Someone ought to do something to make her feel better." Her shyness made us bashful. It was agreed that the first one who could catch her eye should speak but the shy girl's eyes were so busy looking at each other behind her nose that nobody could catch one. There was more hope of capturing one of her looks under the red pigtail than there was of catching one in her face.

A big circus parade came to San Francisco. We all climbed out of the attic window onto the flat roof to watch the procession. Poor "Squinty" slipped on a skylight and her leg, knitted into a red worsted stocking, plunged through the skylight to the market below, plunged right to the knee. Everyone held their breath while "Squinty" pulled her leg out with both hands. When we were sure the red worsted stocking was not blood, when we saw that "Squinty" herself laughed, everyone roared, thinking how funny it must have looked below in the market to see a scarlet leg dangling from the roof. Laughing broke "Squinty's" shyness; she brought her little parcel of lunch and joined us round the school stove after that. We always gathered about the Art School stove to eat our lunches.

Anne said, "Confound Jimmy Swinnerton!" and screwed her lunch paper hard and flung it into the stove. It flared and jammy trickles hissed out.

"Jimmy's frightfully clever, isn't he?" asked "Squinty".

"Clever? Baa! Look at our morning's work!" The floor of the big room was strewn with easels sprawled on their backs; smudged, smeared, paled, charcoal studies, face down or face up.

To roam in and out among the easels, a ball of twine unrolling as he went, was one of Jimmy's little "jokes"; its point was to go behind the screen and pull the string. With a clatter every easel fell. Every study was ruined, every student infuriated.

Mrs. Major, a stout, motherly student known as "The Drum" sighed, "Poor orphan, he's being ruined by the scandalous prices the newspapers pay for his cartoons, enough to send any lad to the devil, poor motherless lamb!"

"Mothers are just as likely to drive one to the devil as to pull them back," said Nellie McCormick, bitterly adding, "I come to Art School to get away from mine."

Adda's lips tightened to pale threads.

"I suppose half of us don't really come here to study Art," said Sophie Nye.

"What do they come for then?" snapped Adda.

"To have fun and escape housework."

"If my parents like to think they have produced a genius and stick me in Art

School let 'em—passes the time between school and marriage."

The speaker was so unattractive one wondered how long the interval between school and marriage might be for her.

"In my family there is a tradition," said a colourless girl who produced studies as anaemic and flavourless as herself, "that once in every generation a painter is born into our tribe. Aunt Fan, our last genius, painted a picture and when it was hung in an exhibition she was so astonished she died! Someone had to carry on—rest of clan busy—I was thrown to art." She shrugged.

The little hunchback was crouched by the pedestal of the Venus de Milo. She rose to her full mean height, wound long spidery arms about the feet of Venus. "I adore beauty," she cried, "beauty means more to me than anything else in the world. I'm going to be a great artist!"

We all drew long sorry breaths. Poor little hunchback, never had she won any other "crit" from the drawing master than, "Turn, make a fresh start." Her work was hopeless.

Suddenly a crash of irrelevant chatter, kind, hiding chatter. A few had kept out of the discussed reasons for "our Art". There was a general move to pick up the Jimmy-spoiled studies, set easels on their legs. Adda and I alone were left sitting beside the stove.

"Adda, were you pushed into Art or did you come because you wanted to?"

"I wanted to, and you, Dummy?"

I nodded. I was always "Dummy" in the San Francisco Art School. I don't know who gave me the name or why, but "Dummy" I was from the day I joined to the day I left.

THE OUTDOOR
SKETCH CLASS

OF ALL the classes and all the masters the outdoor sketching class and Mr. Latimer were my favourites.

Every Wednesday morning those students who wished met the master at the ferry boat. There were students who preferred to remain in the Art School and work rather than be exposed to insects, staring eyes, and sun freckles. We sketchers crossed the Bay to some quiet spot and I must say people *did* stare. Thirty or forty men and women of all ages and descriptions done up in smocks, pinafores and sunbonnets, sitting on campstools before easels down in cow pastures or in vacant lots drawing chicken houses, or trees, or a bit of fence and a bush, the little Professor hopping from student to student advising and encouraging.

Outdoor study was as different from studio study as eating is from drinking. Indoors we munched and chewed our subjects. Fingertips roamed objects, feeling for bumps and depressions. We tested textures, observed contours. Sketching outdoors was a fluid process, half looking, half dreaming, awaiting invitation from the spirit of the subject to "come, meet me half way". Outdoor sketching was as much longing as labour. Atmosphere, space cannot be touched, bullied like the vegetables of still life or like the plaster casts. These space things asked to be felt not with fingertips but with one's whole self.

NELLIE AND THE LILY FIELD

ONE SULTRY Public Holiday the Art School was empty but not shut. Having nothing particular to do I followed my heels and they took me the daily way. I climbed the dirty Art School stair and found the big, drab room solemn with emptiness. Even the rats were not squeaking and scuttling; there were no breadcrusts to be scrimmaged for. Half-drawn, half-erased studies on the drawing-boards looked particularly like nothing. Everything had stopped in the middle of going-to-be. The parched stare of a big red tommy-cod and a half dozen dried-to-a-curve, smelly smelts sprawled on one of the still-life tables. On another table was a vase of chrysanthemums prematurely dead, limp petals folded over their starved hearts. Even the doings of the plaster images seemed to have halted before completing their objectives. The Dancing Faun had stopped in the middle of his dance. The Greek Slave's serving was suspended, Venus was arrested at the peak of her beauty.

A moment's quiver of homesickness for Canada strangled the Art longing in me. To ease it I began to hum, humming turned into singing, singing into that special favourite of mine, *Consider the Lilies*. Whenever I let that song sing itself in me, it jumped me back to our wild lily field at home. I could see the lilies, smell, touch, love them. I could see the old meandering snake fence round the field's edge, the pine trees overtop, the red substantial cow, knee-deep and chewing among the lilies.

Still singing, I looked up—there over the top of my drawing-board were Nellie McCormick's clear blue eyes staring straight into mine. I knew that Nellie was seeing our lily field too. I knew the clearness of her eyes was visioning the reflection from my own. Perhaps she did not see the actual lilies—I do not know, but she was feeling their loveliness, their glow, their stillness.

I finished the song. Except for the scrape of my charcoal against the paper

there was silence in the room.

"Sing it again."

Again I sang the lily song. Then a long quiet brooded over the big, empty room—only the charcoal's scrape and a sigh that was half sob from Nellie. "You rest me," she said, and was gone.

It was not me, it was the lilies that rested Nellie. I knew our wild lilies. They rested me too, often.

When no one was about Nellie would say to me, "Sing it," and Nellie and I together went into the lovely home lily field.

DIFFERENCE BETWEEN NUDE AND NAKED

ADDA WAS of Puritan stock. I was Early Victorian. We were a couple of prim prudes by education. Neither her family nor mine had ever produced an artist or even known one—tales of artists' life in Paris were not among the type of literature that was read by our people. If they had ever heard of studying Art from the nude, I am sure they only connected it with loose life in wicked Paris, not with Art. The modesty of our families was so great it almost amounted to wearing a bathing suit when you took a bath in a dark room. Their idea of beauty was the clothes that draped you, not the live body underneath. So because of our upbringing Adda and I supposed our art should be draped. Neither of our families nor we ourselves dreamed that Art Schools in new clean countries like Canada and the United States would have any other kind. It was a shock to us to see that close walled corner in the school with the notice "Life Class—Keep Out". Mrs. Piddington nosed curiously and asked me questions; balked by the "keep out" notice on the Life Class door, satisfied that my ignorance and indifference were not put on, she gave up bothering.

One morning a student of the Life Class, a woman of mature years and of great ability, offered to give me a criticism. Everyone acknowledged that "a crit" from a life-class student was worthwhile. They did not know how to draw. The woman gave my work keen attention.

"You should now go into the Life Class, your work is ready," she said.

"I will never draw from the nude."

"Oh? Then you will never be a true artist, never acquire the subtlety in your work which only drawing from the nude teaches both hand and eye, tenderness of flowing line, spiritual quality, life gleaming through living flesh."

"Why should Art show best through live bareness? Aren't statues naked enough?"

"Child, you've got things wrong, surface vision is not Art. Beauty lies deep, deep; it has power to draw, to absorb, make you part of itself. It is so lovely it actually makes you ache all the time that it is raising you right up out of your-self, to make you part of itself." Her eyes strayed across the room to the Venus, beautiful but cold standing there on her pedestal. "One misses warmth of blood, flutter or breath in that."

A girl model slipped through the outer door and darted behind the curtain that hung before the entrance to the Life Class. Priggishly stubborn, I persisted, "I shall go on studying from the cast. Look how the creature scuttles behind the curtain hiding herself while she turns the door knob."

The woman's voice softened. "Poor little shrinking thing ashamed of her lovely body, never trained to have a model's pride."

"Is there anything to learn in being a model? Could a model be proud of being a model?"

"Indeed, there is much to learn and professional models are very proud of their job; most of them too are deeply interested in Art. San Francisco is too new yet, there are not enough professional artists for nude models to earn a livelihood at posing. The school picks up any unfortunate who, at his wit's end to make an honest living, takes what he can get."

"Modelling an honest living!"

"Assuredly, that little girl supports her aged parents, hiding from everyone how she does it, burning with shame, in constant agony that someone will find out. A trained model would exult in her profession, be proud of her lovely body, of the poses she has taught it to hold by long hours of patient practice, proud that artists should rejoice in her beauty and reproduce it on their canvas, proud of the delight and tenderness that flow through the artist's hand as he directs the paint or the charcoal, proud that it was her lovely life that provoked his inspira-tion, made her come alive on the canvas, will keep her there even after her flesh-self has gone. Child, don't let false ideas cramp your Art. Statues are beautiful but they do not throb with life."

Her talk showed me the difference between the words nude and naked. So convinced was I of the rightness of nude and the wrongness of naked in Art that I said nothing to Adda. Momma was always hovering in Adda's background. Momma's eye was a microscope under which her every action was placed. Had it not been for Momma I could have made Adda understand. Momma never would. I did not discuss naked and nude with Adda.

B E A N Y

MISS BEANER the little hunchback did not feel herself insignificant. She did not come up to any of our shoulders as she stood at her easel.

She always picked the biggest images to draw from, preferably Venus. There she stood, her square little chin thrust out, her large feet firmly planted, claw-fingers clutching her charcoal, long arms swinging, and such pitifully poor results! She stood so close under the great images she drew that they were violently foreshortened and became twice as difficult to draw. With her pathetic eyes rolled upwards devouringly and her misshapen body Beany looked fore-shortened herself as if a heavy weight had crushed her head down into her hips forcing what was between into a cruel humped ridge.

Beany's art efforts were entirely ineffectual. The drawing-master obviously disliked going near the deformed creature. Noted always for his terse criticism, all Beany ever got from him was, "Turn over and begin again." Beany turned and turned, her eyes filled with tears. She never got beyond beginnings.

As soon as the master left the room one or another student would go to Beany and say, "He gave everyone a rotten lesson today." That made Beany feel better. Then the student would find something encouraging to say about the poor lines and smudges on her paper and Beany's long spidery arms would flurry around the helper's neck, her head burrow into their waist-line. Beany hugged with a horrible tightness when grateful.

Coming from school one day I found a kitten trapped behind the heavy street door at the foot of the outer stair. It was ravenous for food and for petting. It begged so hard to be hugged that I thought of Beany. Maybe the kitten would satisfy her hug-longing. I took it home that night and offered it to Beany next day. She was delighted. As it was a half-holiday, I said I would take it to her house that afternoon.

Beany lived in one of the older and shabbier parts of San Francisco. The front door of the house opened right into the parlour, a drab room full of vases filled with artificial flowers. There was, too, a stuffed canary under glass and

some sea shells. The room was a sepulchre. The mantelpiece was draped with the stars and stripes. On the stone hearth (fireless because it was summer) sat a plate of fish cleaned and ready to cook. The kitten made a dart towards the fish. Beany raised them to the mantelpiece, remarking as she fanned her hot face with a small brass fire shovel, "Our parlour hearth is the coolest place in the house." She was delighted with her kitten and hugged and hugged, first the kitten, then me. Poor Beany, she had so little and could have done with so much. I felt furious all over again with the drawing master's cruel "crits", his not bothering to hide how he loathed her person and despised her work.

The Frenchman who taught us painting was different from the drawing-master. His "crits" were severe, but his heart was soft—too soft almost. He championed any poor, weak thing. One day he found the little halfwit Jew-boy with his head down on a table of still-life stuff crying into the heap of carrots, onions and beets.

"What is it, Benny?" The master's hand on the boy's head covered it like a hat.

Benny lifted a wet, swollen cheek.

"Dis' mornin' I woked an' de' look-glass tell, 'You got de' toot'-ache, Benny.' Boys dey say, 'Why you so fat one side, Benny?' I say, 'De look-glass say I got toot'-ache.' Boys make tease of me!"

A group of grinning students were peeping from behind the screen.

"Make off there! None of that!" roared the professor.

After that he always kept an eye on Benny. That was the spirit of the old Art School. It seemed that here there was always a champion for the Beanys and the Bennys.

EVIL

I WAS TOO busy at the Art School to pay much heed to Lyndhurst and Piddington affairs. Mrs. Piddington was watching me closely. Because she was English she called me "my dear" which did not in the least mean that I was dear to her nor she to me. I kept out of Frank's way. Mrs. Piddington had a good many friends (those people in the Lyndhurst hotel whom she thought worthwhile). Among them was a widow with two daughters about my own age. I had nothing in common with these girls.

Mrs. Piddington said, "Marie is having a birthday party. She is not asking you because she says she knows no friends of hers who would get on with you."

"Thank goodness she is not asking me. I hate her stuck-up companions."

"It is a pity you are not more friendly. You are very much alone."

"I have lots of friends, thank you, and I have my work."

"That Art School outfit!" sniffed Mrs. Piddington.

One day Mrs. Piddington said, "How did you get through the square today? I went out just after you and found it impossible because of the dense throng attending that large funeral in the Anglican church."

"I managed. I found a quiet, lovely little street, so quaint, not one soul in it. The house doors opened so quaintly right onto the pavement. All the windows had close green shutters, nearly every shutter had a lady peeping through. There was a red lantern hanging over each door. It was all romantic, like old songs and old books! I wonder if the ladies flutter little lace handkerchiefs and throw red roses to gentlemen playing mandolins under their windows at night?"

"Stop it! Little donkey!" shouted Mrs. Piddington. "Don't tell me you went through Grant Street?"

"Yes, that was the name."

"You went into Grant Street? Haven't you seen the headlines in the newspaper for the last week? Grant Street a scandal in the heart of San Francisco's shopping area!"

"I have not time to read the paper. Why is Grant Street a scandal?"

"It is a red light district."

"What is a red light district?"

"A place of prostitutes."

"What are prostitutes?"

Mrs. Piddington gave an impatient tongue click.

"If I ever hear of your going into Grant or any other such place again, home I send you packing! Straight to school, straight home again! Main thoroughfares, no short cuts, d'you hear?"

Frank came into the room. There was an evil grin on his face. He had heard her snapping tones, saw our red faces.

"In hot water, eh kid?"

I hurried from the room.

We had just come up from dinner. Mrs. Piddington was commenting on the family who sat opposite to us at table.

"The man seems very decent to that child."

"Why shouldn't he be decent to his own son?" I asked.

"The child is not his."

"Was the woman married twice? The child calls him father."

"No, she was not married twice, the boy is not the man's son."

"He *must* be!"

She noted my frown of puzzle.

Frank was out. "Sit there, little fool, your sister has no right to send you out into the world as green as a cabbage!" She drew a chair close to mine, facing me. "Now, it is time you learned that it takes more than a wedding ring to produce children. Listen!"

Half an hour later I crept up to my own room at the top of the house afraid

of every shadowed corner, afraid of my own tread smugged into the carpet's soft pile. Horrors hid in corners, terrors were behind doors. I had thought the Lyndhurst provided safety as well as board and lodging. Boarding houses I had supposed were temporary homes in which one was all right. No matter if San Francisco was wicked, I thought the great heavy door of the Lyndhurst and my board money could shut it all out. Mrs. Piddington told me that evil lurked everywhere. She said even under the sidewalks in certain districts of San Francisco were dens that had trap doors that dropped girls into terrible places when they were just walking along the street. The girls were never heard of again. They were taken into what was called "white slavery", hidden away in those dreadful underground dens, never found, never heard of.

Mrs. Piddington spared me nothing. Opium dens in Chinatown, drug addicts, kidnappings, murder, prostitution she poured into my burning, frightened ears, determined to terrify the greenness out of me.

I was glad when the carpet of the hallways and stairs came to an end, glad when I heard my own heels tap, tap on the bare top-stair treads and landing. I looked around my room fearfully before I closed and locked my door. Then I went over to the window. I wanted to see if San Francisco looked any different now that I knew what she was really like. No, she did not! My hand was on old Dick's cage as I looked over the chimneys and roofs. Old Dick nibbled at my finger. It gave me such a curious feeling of protection and reality.

"Dick, I don't believe it, not all. If it was as wicked as she said the black would come up the chimneys and smudge the sky; wicked ones can shut their doors and windows but not their chimneys. There is direct communication always between the inside of the houses and the sky. There is no smudge on the sky above the chimneys. San Francisco's sky is clear and high and blue. She even said, Dick, that she was not sure of that dirty old Art School of mine—it was in a squalid district and that I was never, never to go off the main thoroughfares. I was never to speak to anyone and I was never to answer if anyone spoke to me. All right, Dick, I'll do that but all the rest I am going to forget!"

The most close-up ugliness I saw during my stay in San Francisco was right in the Lyndhurst, in Mrs. Piddington's own private sitting room.

It was Christmas Eve. The Piddingtons had gone to the theatre and left me sitting there by their fire writing letters home. There was a big cake on the table beside me just come from home along with parcels that were not to be opened till Christmas morning.

A tap on the door. A friend of Frank Piddington's was there with a great bunch of roses to Christmas Mrs. Piddington.

"She is not in," I said.

" 'Sno matter, I'll wait."

"They will be very late."

"Thas-all-right."

He pushed past me into the sitting room, steadying himself by laying his hands one on either of my shoulders. He was very unsteady. I thought he was going to fall.

"Don' feel s'good," he said, and flung himself into an arm chair and the roses onto the table.

I went to get water for the flowers and when I came back he was already heavily asleep. His flushed face had rolled over and was pillowed on my home cake.

I stood looking in dismay. He must be very ill. He had seemed hardly able to walk at all. He had gone to sleep with a lighted cigar between his fingers, its live end was almost touching the upholstery of the chair. I dare not take it from his hand, I dare not go to my room and leave it burning. The evening was early. I sat and watched and watched. The cigar smouldered to its very end. The ash did not fall but kept its shape. Would the cigar burn him when it reached his skin and wake him? No, just before it reached the end it went out.

Creak, slam! creak, slam! went the heavy old door of the Lyndhurst, surely it must have swallowed all its inmates by now; but the Piddingtons did not come. I could not go now because Mrs. Piddington enjoyed fainting at shocks. If she came in after midnight and saw a man asleep in her sitting-room she was sure to faint. Half after midnight I heard her hand on the door-knob and sprang!

"Don't be frightened, he's asleep and very ill!"

"Who's asleep? Who's ill?"

"Mr. Piddington's friend."

Mrs. Piddington circled the sleeping man sniffing.

"Frank, take that drunk home!"

Frank burst into guffaws of coarse laughter.

"Our innocent!—entertaining drunks after midnight on Christmas Eve! Ha, ha!"

THE ROARATS

MRS. PIDDINGTON twiddled the envelope. Her eyes upon my face warned me. "Don't forget I am your boss!"

"You are to call on the Roarats at once," she said, and shook my sister's letter in my face.

"I don't intend to call upon the Roarats, I hate them."

"Your hating is neither here nor there. They were old friends of your parents in the days of the California gold rush. Your sister insists."

"And if I won't go?"

"In place of your monthly check you will receive a boat ticket for home. You have the Roarats' address? Very well, next Saturday afternoon, then."

Mrs. Piddington approved the Roarats' address.

"Um, moneyed district."

"They are disgustingly rich, miserably horrible!"

The following perfectly good Saturday afternoon I wasted on the Roarats. The household consisted of Mr., Mrs., Aunt Rodgers, a slatternly Irish servant and an ill-tempered parrot called Laura.

Mr. Roarat was an evil old man with a hateful leer, a bad temper, and cancer of the tongue. Mrs. Roarat was diminutive in every way but she had thickened up and coarsened from long association with Mr. Roarat. She loathed him but stuck to him with a syrupy stick because of his money. Aunt Rodgers had the shapeless up-and-downness of a sere cob of corn, old and still in its sheath of wrinkled yellow, parched right through and extremely disagreeable. Ellen the Irish maid had a violent temper and a fearful tongue. No other family than one specializing in bad temper would have put up with her. The parrot was spiteful and bit to the bone. Her eyes contracted and dilated as she reeled off great oaths taught her by Mr. Roarat. Then with a slithering movement she sidled along her perch, calling, "Honey, honey" in the hypocritical softness of Mrs. Roarat's voice.

The Roarats said they were glad to see me. It was not me they welcomed, anything was a diversion. When I left I was disgusted to discover that I had committed myself to further visits and had, besides, accepted an invitation to eat Thanksgiving dinner at their house.

The turkey was overcooked for Mr. Roarat's taste, the cranberry too tart for Mrs. Roarat's. Aunt Rodgers found everything wrong. Ellen's temper and that of the parrot were at their worst.

Laura, the parrot, had a special dinner-table perch. She sat beside Mr. Roarat and ate disgustingly. If the parrot's plate was not changed with the others she flapped, screamed and hurled it on the floor. Throughout the meal everyone snarled disagreeable comments. Aunt Rodgers' acidity furred one's teeth. The old man swore, and Mrs. Roarat syruped and called us all "Honey".

"Pop goes the weasel!" yelled Laura, squawking, flapping and sending her plate spinning across the floor.

"There, there, Laura, honey!" soothed Mrs. Roarat and rang for Ellen who came in heavy-footed and scowling with brush and dustpan. When she stooped to gather up the food and broken plate Laura bit her ear. Ellen smacked back, there was a few moments' pandemonium, Mr. R., Aunt R., Ellen and Laura all cursing in quartette. Then Mrs. Roarat lifted Laura, perch and all, and we followed into the parlour. For my entertainment a great basket of snapshots was produced. The snaps were all of Mrs. Roarat's relatives.

"Why do they always pose doing silly things?" I asked.

"You see, Honey, this household being what it is, my folks naturally want to cheer me."

Aunt Rodgers gave a snort, Mr. Roarat a malevolent belch. The parrot in a sweet, tender voice (Mrs. Roarat's syrupiest) sang, "Glory be to God on high!"

"Yes, Laura, honey," quavered Mrs. Roarat, and to her husband, "Time you and Laura were in bed."

Mr. Roarat would not budge, he sat glowering and belching. Aunt Rodgers put the parrot in her cage and covered it with a cloth but Laura snatched the cloth off and shrieked fearfully. Aunt Rodgers beat the cage with a volume of poems by Frances Ridley Havergal. It broke a wire of the cage and the book did not silence the bird who screamed and tore till her cover was in shreds.

Mrs. Roarat came back to her relatives in the snapshot basket for comfort.

"Here is a really funny one," she said, selecting a snap of a bearded man in a baby's bonnet kissing a doll.

Mr. Roarat was now sagging with sleep and permitted his wife and Aunt Rodgers to boost one on either side till they got him upstairs. It took a long time. During one of their halts Ellen came from the back in a terrible feathered hat.

"Goin' out," she announced and flung the front door wide. In rushed a great slice of thick fog. Mrs. Roarat looked back and called to me, "It's dense out, Honey, you will have to stay the night." I drew back the window curtain; fog thick as cotton wool pressed against the window.

The Roarats had a spare room. Mr. and Mrs. Piddington would get home very late and would suppose I was up in my bed. Mrs. Roarat's "honey" and Aunt Rodgers' vinegar had so neutralized me that I did not care what I did if I could only get away from that basket of snapshots.

The door of the spare room yawned black. We passed it and out rushed new paint smells. "Redecorating," said Mrs. Roarat. "You will sleep with Aunt Rodgers!"

"Oh!"

"It's all right, Honey, Aunt Rodgers won't mind much."

Aunt Rodgers' room had no air space, it was all furniture. She rushed ahead to turn on the light.

"Look out!" she just saved me a plunge into a large bath tub of water set in the middle of the floor.

"Fleas—San Francisco's sand this time of year! Each night I shake everything over water, especially if I have been out on the street."

Immediately she began to take off and to flutter every garment over the tub. When she was down to her "next-the-skins", I hurried a gasping, "Please, what do I sleep in?"

Too late, the "skin-nexts" had dropped!

Aunt Rodgers said, "Of course child!" and quite unembarrassed but holding a stocking in front of her she crossed the room and took the hottest gown I ever slept in out of a drawer. I jumped it over my head intending to stay under it till Aunt Rodgers was all shaken and reclothed. I stewed like a teapot under its cosy. At last I *had* to poke my head out of the neck to breathe; then I dived my face down into the counterpane to say my prayers.

After a long time the bed creaked so I got up. On Aunt Rodgers' pillow was a pink shininess, on the bed post hung a cluster of brown frizz, there was a lipless grin drowning in a glass of water. Without spectacles Aunt Rodgers' eyes looked like half-cooked gooseberries. Her two cheeks sank down into her throat like a

couple of heavy muffins. A Laura's claw reached for the light pull. I kept as far to my own side of the bed as possible.

Dark—Aunt Rodgers' sleeping out loud! It had never occurred to me that I *could* ever be homesick for my tiny room on top of the old Lyndhurst but I was.

G L A D N E S S

IN GEARY STREET Square, close to the Lyndhurst, was a Church of England with so high a ritual that our Evangelical Bishop would have called it Popish.

On Easter morning I went into the Geary Street Square. The church-bell was calling and I entered the church and sat down in a middle pew. The congregation poured in. Soon the body of the church was a solid pack of new Easter hats. From the roof the congregation must have looked like an enormous bouquet spread upon the floor of the church. But the decoration of the ladies' heads was nothing compared to the decoration of the church, for her flowers were real, banks of Arum and St. Joseph's lilies, flowers of every colour, smell and texture. Every corner of the church was piled with blossoms, such as we would have had to coax in greenhouses in Canada; but here, in California, there was no cold to frighten flowers, nothing had to be persuaded to grow. Stained-glass windows dyed some of the white flowers vivid. White flowers in shadowy corners glowed whiter because of the shine of lighted candles. Incense and flower-perfume mixed and strayed up to the roof. Hush melted and tendered everything. The hush and holiness were so strong that they made you terribly happy. You wanted to cry or sing or something.

Suddenly high up under the roof, where incense and the fragrance of flowers had met, sounded a loveliness that caught your breath. For a moment you thought a bird had stolen into the church, then you found there were words as well as sound.

"Jesus Christ is risen today, Hallelujah!"

Quickly following the words, a violin exquisitely wailed the same thought, and, bursting hurriedly as if they could hardly wait for the voice and the violin to finish, the booming organ and the choir shouted, "Hallelujah! Hallelujah!"

It was a tremendous gladness to be shut up in a building; it was the gladness of all outdoors.

Either the church or I was trembling. The person on either side of me quiv-

ered too, even the artificial hat-flowers shook.

A clergyman climbed up into the pulpit and lifted arms puffy in Bishop's sleeves.

The church hushed to even greater stillness, a stillness like that of the live flowers which, like us, seemed to be waiting for the Bishop's words.

COLOUR-SENSE

I HAD ADVANCED from the drawing of casts and was now painting "still life" under the ogling eye of the French Professor. I was afraid of him, not of his harsh criticisms but of his ogle-eyes, jet black pupils rolling in huge whites, like shoe buttons touring round soup-plates.

He said to me, "You have good colour-sense. Let me see your eyes, their colour."

The way he ogled down into my eyes made me squirm; nor did it seem to me necessary that he should require to look so often into my "colour-sense".

He was powerful and enormous, one dare not refuse. His criticism most often was, "Scrape, re-paint".

Three times that morning he had stood behind my easel and roared, "Scrape!" When he came the fourth time and said it again, my face went red.

"I have, and I have, and I have!" I shouted.

"Then scrape again!"

I dashed my palette knife down the canvas and wiped the grey ooze on my paint rag.

In great gobbing paint splashes I hurled the study of tawny ragged chrysanthemums onto the canvas again. Why must he stand at my elbow watching—grinning?

The moment he was gone I slammed shut my paint-box, gathered up my dirty brushes, rushed from the room.

"Finished?" asked my neighbour.

"Finished with scraping for that old beast." She saw my angry tears.

The Professor came back and found my place empty.

"Where is the little Canadian?"

"Gone home mad!"

"Poor youngster, too bad, too bad! But look there!" He pointed to my study—"Capital! Spirit! Colour! It has to be tormented out of the girl, though. Make her mad, and she can paint."

The hard-faced woman student, the one who ordered birds for her still-life studies to be smothered so that blood should not soil their plumage, the student we called "Wooden-heart", spoke from her easel in the corner.

"Professor, you are very hard on that young Canadian girl!"

"Hard?" The Professor shrugged, spread his palms. "Art—the girl has 'makings'. It takes red-hot fury to dig 'em up. If I'm harsh it's for her own good. More often than not worthwhile things hurt. Art's worthwhile."

Again he shrugged.

SISTERS COMING — SISTERS GOING

HAVING ONCE GONE to my guardian for advice, I continued to do so. The ice was broken—I wrote him acknowledging my check each month and telling him my little news, dull nothings, but he troubled to comment on them. He was a busy man to be bothered writing the formal little interested notes in answer to my letters. I respected my guardian very much and had a suspicion that my going to him direct for advice had pleased him. He was Scotch, wise, handled our money with great care but had no comprehension of Art whatsoever. The camera satisfied him. He sent my board and school fees. I don't suppose it ever occurred to him I needed clothes and painting material. I had to scrape along as best I could in these matters.

My guardian thought very highly of my big sister. I have no doubt that his consenting to let me go to San Francisco was as much for her peace as for my art education. I was not given to good works and religious exercises like the rest of my family. I was not biddable or orthodox. I did not stick to old ways because the family had always done this or that. My guardian thought it was good for me to go away, be tamed and taught to appreciate my home. Art was as good an excuse as any.

Undoubtedly things did run smoother at home without me but, after I had been away one year, the family decided to follow me. My sister rented the old home and the three of them came to San Francisco for a year. My big sister still had a deep infatuation for Mrs. Piddington. It was really Mrs. Piddington that

she wanted to see, not me.

Mrs. Piddington took a flat and we boarded with her but domestic arrangements did not run too smoothly. My sister liked bossing better than boarding, and, in a final clash, dashed off home leaving my other two sisters to follow. Almost simultaneously Frank Piddington got a better job in another city and they too left San Francisco. Then I was all alone among San Francisco's wickedness. Mrs. Piddington handed me over to a friend of a friend of a friend, without investigating the suitability or comfort of my new quarters. The woman I was donated to was an artist. She lived in Oakland. I had to commute. I plunged wholeheartedly into my studies.

The year that my family spent in San Francisco my work had practically been at a standstill. I did attend the Art School but joined in all the family doings, excursions, picnics, explorings. No one took my work seriously. I began to get careless about myself.

Mrs. Tuckett, the friend of the friend was a widow with two children, no income and a fancy for art. She resented that she could not give her whole time to it, was envious that I should be able to. The living arrangements of her cottage were most uncomfortable. Still, I enjoyed my independence and worked very hard. Perhaps after all the "ogle-eyed" French professor and my big sister were right, maybe I needed the whip, needed goading and discomfort to get the best out of me. Easy, soft living might have induced laziness. The harder I worked the happier I was, and I made progress.

We were a happy bunch of students. I do not remember that we discussed Art much; as yet we had not accumulated knowledge enough to discuss. We just worked steadily, earnestly, laying our foundations. San Francisco did not have much to offer in the way of art study other than the school itself, no galleries, no picture exhibitions. Art was just beginning out west. The school was new. Students came here to make a start. Their goal was always to press further afield. San Francisco did not see the finish, only the beginning of their art.

LAST CHANCE

DURING MY SISTERS' VISIT I said to Alice, "Can it be possible that the entire wicked awfulness of the world is stuffed into San Francisco?"

"Why do you think that?"

"Mrs. Piddington said. . . ." But I did not tell Alice what Mrs. Piddington said. She was a contented person, did not nose round into odd corners. This and that did not interest Alice, only the things right in the beaten path. The things she had always been accustomed to—those she clung to.

Before leaving Victoria various friends had asked of her, "Look up my cousin,

look up my aunt." Alice good naturedly always said, "Certainly," and accepted a long list of miscellaneous look-ups. People could just as well have sent a letter to ask how their friends did, or if they liked the New World. They all seemed to have come from the Old. When I said so, Alice replied that I was selfish and that people liked hearing from the mouth of an eye-witness how their relatives are. Alice was rather shy and made me go along though I was not amiable about these visits.

First we went to see the cousin of a friend. She was eighty and had an epileptic son of sixty. He had stopped development at the age of seven or eight; mind and body were dwarfed. He had an immense head, a nondescript body, foolish little-boy legs that dangled from the chair edge as he sat in the parlour opposite to us, nursing his straw hat as if he were the visitor.

His mother said, "Shake hands with the ladies, Jumble." (Jumble was the name he had given himself and it was very appropriate.)

Jumble leapt from his chair as if he were leaping from a house-top, skipped to the far side of the room and laid his hat down on the floor. He came running back and held out two wide short-fingered paws. We each took one and he gave us each a separate little hop which was supposed to be a bow.

"The ladies come from Canada, Jumble."

He clapped his hands. "I like Canada. She sends pretty stamps on her letter; Jumble has a stamp book! Jumble likes stamps, he likes plum cake too! Jumble wants his tea, quick! quick!" He pattered in to the adjoining room where tea was laid, climbed into his chair and began to beat on his plate with a spoon.

"He is all I have," sighed the woman and motioned us to follow, whispering, "I hope, my dears, you are not nervous? Jumble may have a fit during tea."

We had never seen anything but a cat in a fit but we lied and said we were not nervous.

Jumble consumed vast wedges of plum cake but he did not have a fit.

After tea they saw us to our tram—eight-year hobble and trot, trot of a halfwit, escorting us. Once aboard, I groaned, "Who next?"

Alice produced her list.

"Mable's Aunt; now don't be mean, Millie. People naturally want to hear from an eye-witness."

"Pleasanter for them than seeing for themselves."

Mable's Aunt was gaunt. She lived in a drab district. She kissed us before ever we got the chance to say why we had come, but, when we said we came from Mable she fell on us again and kissed and kissed. She had never seen Mable but she had known Mable's mother years before Mable was born. Every time we mentioned Mable's name she jumped up and kissed us again. Needless to say she was English. In time we learned to avoid mention of Mable. That restricted conversation to the weather and Mable's Aunt's cat, a fine tabby. While we were grappling for fresh talk material, the Aunt said:

"Oh my dears, such a drive! Such lovely, lovely flowers!"

"Where? When?" We were eager at the turn the conversation had taken,— flowers seemed a safe pleasant topic.

"My son took me this morning. It is a long way. There were marvellous carpets of flowers, every colour, every kind. Oh my dears, such flowers!"

"My son is a doctor, visiting doctor for the 'Last Chance'. He takes me with him for the drive. Flowers all the way! I don't mind waiting while he is inside. I look at the flowers."

"What is the 'Last Chance'?" I asked.

"Terrible, terrible, oh my dears! Thank God that you are normal, usual." She sprang to kiss us again because we were complete, ordinary girls.

Again I asked, "What is the 'Last Chance'?"

"A place behind bars where they put monstrosities, abnormalities while doctors decide if anything can be done for them." She began describing cases. "Of course I've only seen a little through the bars."

The little she had seen was enough to send Alice and me greenish white. We tried to lead her back to the flowers. It was no use, we took our leave.

We walked along in silence for some time. "Let's forget it," I said. "All the people on your list seem to have some queerness, be the same type. Suppose we lose the list!"

Alice said, "For shame, Millie. People at home want to hear about their relatives. It is selfish of you to grouse over their peculiarities!"

"Relatives' peculiarities would do just as well in letters and only cost three cents. I'd willingly pay the stamp. They are not even relatives of our own friends. For them we might endure but for these nearly strangers why should we?"

Again Alice's, "For shame, selfish girl!"

It happened that Mrs. Piddington had arranged a flower-picking picnic for the very next Saturday. Someone had told her of a marvellous place. You walked through Golden Gate Park and then on and on. There were fields and fields of flowers, all wild and to be had for the picking.

At last we got there only to be confronted by a great strong gate on which hung a notice "Keep Out"! The flowers were beautiful all right. Just outside the gate was a powerhouse and a reservoir. We asked permission at the office and were told we might go through the gate and gather.

"What is the big building just inside the enclosure?" asked Mrs. Piddington but just then the man was summoned back into the office.

"Last Chance," he called over his shoulder. Alice and I looked at each other. We felt sick. "Know-it-all" old Piddington explained. "Windows all barred! Um, doubtless it is a reformatory of some sort."

We scuttled under the barred windows, Alice and I trying to draw our party over toward a little hill away from the building. The hill was lightly wooded and a sunny little path ran through the wood. Flowers were everywhere—also snakes! They lay in the path sunning themselves and slowly wriggled out of our way quivering the grass at the path side. You had to watch your feet for fear of treading on one. Alice and I could not help throwing scared glances behind at the brick, bar-windowed building. Shadowy forms moved on the other side of the bars. We clothed them in Mable's Aunt's describings.

There were not many big trees in the wood. It was all low scrub bush. You

could see over the top of it. I was leading on the path. I had been giving one of my backward, fearful glances at "Last Chance" and turned front suddenly. I was at the brink of a great hole several yards around. My foot hung over the hole. With a fearful scream I backed onto the rest of the party. They scolded and were furious with me.

"Look for yourselves, then!"

They did and screamed as hard as I.

The hole was several feet deep. It was filled with a slithering moil of snakes, coiling and uncoiling. Had my lifted foot taken one more step, I should have plunged headlong among the snakes and I should have gone mad! Mrs. Piddington was too horrified even to faint. She yelled out, "I've been told there are 'rattlers' this side of the park too!" Turning aside, we broke into mad running, helter skelter through the thicket heading for the open. Snakes writhed over and under the scrub to get out of our way. The flowers of our gathering were thrown far and wide. Horrible, horrible! Our nerves prickled and we sobbed with hurrying. We passed the "Last Chance" with scarcely one glance and rushed through the gate, coming back empty-handed. We did not even see the flowers along the way, our minds were too full of snakes.

"Girls," I cried, "I want to go back to Canada. California can have her flowers, her sunshine and her snakes. I don't like San Francisco. I want to go home."

But when my sisters did go back to Victoria I was not with them. I was stuck to the Art School.

M R S . T U C K E T

THE WOMAN who was supposed to have assumed Mrs. Piddington's custody of me bodily and morally ignored everything connected with me except the board money I paid. I was her income. I had to be made to stretch over herself, her two children and myself. The capacity of my check was so severely taxed by all our wants that towards the end of the month it wore gossamer and ceased altogether. Then we lived for the last few days of each month on scraps fried on my spirit lamp to economize kitchen fuel.

The woman's children (a girl of six and a boy of four) any Mother might have been proud of, but she referred to them as "my encumbrances" because they prevented her from devoting her entire time to Art. Mrs. Tucket was jealous of my youngness, jealous of my freedom. An Art dealer had once praised a sketch done by her and from that time she knew no peace from the longing which possessed her to give her life, all of it, to Art.

The boy Kirkby, aged four, and I were great chums. He was at my heels every moment I was in the house—a loving little fellow who had two deep terrors— blood and music. The sight of blood would turn the child dead white, one note of music would send him running outdoors away anywhere from the sound, his hands to his ears. He angrily resented my guitar; pushing it out of my lap he would climb in himself and, reaching his hand to my forehead, would say, "I feel a story in there, tell it." It was a surprise to his Mother and to me, after a few months, instead of pushing away the guitar he would sidle up, pat the instrument, and say, "I like her a little now, sing!"

Mrs. Tucket had health notions, all based on economy. Uninterrupted passage of air through the cottage was one. She said it nourished as much as food. All the inner doors of the house were removed, there was no privacy whatever. No hangings were at the windows, no cushions on chairs or couch. The beds were hard and had coverings inadequate for such cyclonic surges of wind as swept in and out of the rooms. No comfort was in that cottage.

Mrs. Tucket had, too, absolute faith in a greasy pack of fortune-telling cards. She foretold every event (after it had happened). *After* Kirkby had cut his head open she knew he was going to be cut. *After* Anna got the measles she knew the child had been exposed. When I missed the ferry-boat she said the cards had foretold it (but so had the clock). After the dealer had praised her sketch she vowed that she had been prepared because the cards indicated someone would. She was angry because I laughed and would not have my cards read. I got so sick of being haunted by the ace of spades and the queen of hearts that I suggested we read a book aloud after the children were in bed at night. Mrs. Tucket read well but chose depressing books, delighting in deathbed scenes and broken love affairs. She would lay the book down on the table and sob into her handkerchief. It embarrassed me so much that I said, "S'pose we find a good merry funeral story to cheer us up!" Then she was offended and said I was without romance or sentiment.

One day as I came in from school Mrs. Tucket beckoned to me from the doorway of her bedroom. The wind was busy in there, tearing the covers off the bed, whirling the pincushion and clanking the window blind.

"Listen!" In the middle of the turmoil a cruel, tearing breathing.

"Kirkby's!"

I bent over the bed. The child did not know me.

"Get a doctor quick!"

"But doctors are so expensive," she complained.

"Quick." I stamped my foot.

She got a homeopathist, not that she believed in homeopathy but this doctor-woman was a friend of hers and would not charge. We moved a cot into the unfurnished front of the cottage and took turn and turn about sitting on an apple box beside it watching.

Little Kirkby battled with death in this grim setting. The crisis came one night just as I had turned in for my four hours of rest.

"Come!"

The cottage was full of moonlight. She had switched out all the lights so that Kirkby should not see the blood. There was hemorrhage. We worked in and out between shadows and moonlight, doing what we could. The exhausted child dropped back on the pillow like a wilted snowdrop. The woman yawned.

"I'll take forty winks now, your bed I think, handier should you need me."

As she passed through the living room she switched on a light and stood, wrapped in admiration of the sketch the dealer had praised. It was framed and hung on the wall. I heard a deep, deep sigh, then blackness, the sounds of sleep. Moonlight flooded the bare room. The life of the child flickered. Kirkby in the bed was scarcely more tangible than the moonlight. I sat the night out on the apple box. "Art I hate you, I hate you! You steal from babies!" I cried and would not go to school next morning. I did not go back for a whole week. I told stories and sang to Kirkby feeling very tender towards the child and bitter towards Art and the woman.

Summer vacation came. I did not like summer vacation. I was compelled to spend it at Auntie's in San Jose. Auntie undertook to discipline me for two years each vacation, the year that was past and the year to come. Between Aunt and me there was no love.

Mrs. Tucket was giving up the cottage. She was joining a friend in Chicago. They were to run a boarding house. She was full of plans. Kirkby and I watched her packing, Kirkby, a mere shadow child, clinging to his chair to keep the wind from blowing him away. Mrs. Tucket held up his little patched pants. The wind filled them; their empty legs were vigorous with kickings. Kirkby laughed.

"My pants are fatter than me."

The woman pressed the wind out of the pants and tumbled them into the trunk.

"I am not going to Chicago!"

She banged down the trunk lid.

"What has happened?" I asked. "All your arrangements are made."

"The cards say I shall not go!"

When I returned from San Jose the cottage was for rent. I never heard of Mrs. Tucket, her Art or little Kirkby again.

TELEGRAPH HILL

EXIT MRS. PIDDINGTON, and vice and terror faded from my consciousness. Free, unfearful I roamed San Francisco interested in everything, most particularly interested in my art studies. Suddenly I was brought face to face with Piddington horrors again.

I was taking guitar lessons from an old German professor. The frets on my guitar needed resetting, the professor said.

"Take to de' musics-man he sharge you big moneys. My fren' dat make fiddle he do sheep for you!"

He wrote an address on a card and off I started, my guitar in a green cloth bag. I called in at Adda's on the way. It was Saturday afternoon. We often spent the half holiday together.

"Where are you going?"

"To get my guitar fixed."

"I'll come for the walk."

"Hurry then, Adda, it dusks early."

On and on we tramped. It seemed a very long way but we asked direction now and again from people we met. Yes, we were going in the right direction but—they looked at us queerly as if they wondered.

By and by the smells of the sea and tarry wharf smells met our noses. Ah, here was the name on our card. We turned into a wide, quiet street. It had an abandoned, strange look. In front of us was a great building with a sign, "Telegraph Hill Foundry and Storage". Telegraph Hill! "Why, Adda, this is the awful, wicked place Captain pointed out as we came through the Golden Gate, the place I was never to go near."

"It does look very queer," said Adda. "Shall we turn back?"

"No, this is number 213. Ours will be two blocks further on. It is best to show our business but it is almost too dark to see the numbers over the doors."

We walked the two blocks in silence except that I said, "Adda, let's walk in the middle of the street."

Suddenly a burst of light from street lamps and simultaneously over every door came a little red twinkling light. There were big shop windows dazzlingly bright on either side of the way. In them were displayed, not goods but women, scantily clad women, swaying in rocking chairs and showing a great deal of leg. Some toyed with fancy work, some simpered, some stared with blank, unseeing eyes, all rocked restlessly.

"Momma, Momma!" gasped Adda again. "Shall we turn back?" she asked of me.

My head shook. I shook all over because of Mrs. Piddington's horrible tales.

"Here's the great mock fiddle. I'll go in and show why I came. Oh, Adda!"

I was quaking. "Hold the door wide, Adda, don't let them shut me in! Don't, don't!"

Adda braced, spread her members like a starfish, clinging octopus-wise to the floor and to all sides of the door's frame.

The little shop was full of men and smoke. There was only one dim light in the place. An old man pushed forward to take the green bag from my arms. He took the guitar out, touched her strings lovingly.

"She is sweet-toned," he smiled down at me, "but these frets, ach, they tear the little fingers! She is ready Monday."

He laid the instrument upon his work shelf.

Adda released the door posts and grabbed me as if I had just come back from the dead. Momma herself could not have been more protecting towards me, more belligerent towards my danger than was dear, staunch Adda.

We hurried into the middle of the street with firm stepping, determined not to break into a tell-tale run. We nearly burst ourselves for wanting to draw deep breaths and not daring to do so for hurry and worry. We turned the corner and met a policeman. I never knew a policeman could look so beautiful, so safe.

"Momma, Momma, if you knew!" whispered Adda, to me, "Of course you won't go back for the guitar, Dummy?"

"I must, Adda. It belongs to my big sister. You see if I went home without it I would have to explain—and then . . . !"

"I'll go with you, but I won't tell Momma till afterwards. Of course I couldn't deceive Momma. I must tell sometime, but after will be best."

THE MANSION

ONE MORNING I climbed the old grubby stair of the Art School to find everything in excitement and confusion. Clumps of students congested the Oriental Rug Room, groups of students were in the hall, the office was full. The old Curator was tugging at his beard harder than ever, shaking his head, nodding answers or ignoring questions as excitement permitted.

Supposing it to be some American anniversary, I strode through the hubbub into the work hall. Here I found professors, model and janitor in close confabulation around the stove. Obviously some common interest had levelled rank and profession. The only unmoved person I could see was the wooden-faced, stone-hearted painter of still life, the woman who ordered her birds smothered so that their plumage should not be soiled by blood for her studies, the woman who painted tables full of fish with eyes that ogled even when dead and whose stiffened bodies curled and smelled in spite of the fact that she kept trying to revive one last glitter by slopping water over them periodically. On a still-life table stood a forsaken vase of red roses, sagging, prematurely dead, no water. Stevie dashed in to stick her daily posy of mignonette and sweet peas on my easel board—dashed out again. What! Stevie too? Then this was no American do, this excitement. Stevie would not be so unpatriotic as to recognize an American occasion! In bustled Adda tying the strings of her little black silk apron.

"Aren't you excited, Dummy?"

"Excited? What about?"

"The move, of course!"

"What move?"

"Dummy, you *are* dumb! The School move, of course."

"Is the School moving?"

"This very day. Look!" She pointed out the window, where men were tearing down our chimneys, ripping at our roof.

"Time this dilapidated dreadfulness disappeared," scorned Adda. "A mansion! A perfectly clean mansion fallen from the sky! Oh, won't Momma be pleased!"

"Adda, do tell me what it is all about!"

"Well, our lease was up and the market and Art School building is condemned. Haven't you seen how the poor old Curator has torn at his beard the last week? I wonder he did not pull it out! No place for his School to go! Then this mansion falls straight from heaven! Mrs. Hopkins could not take it with her, could she? So she dropped it from heaven's gate. Down it tumbled stuffed with her best wishes for Science and Art!"

Adda's sharp little teeth bit on her lip.

"Oh, Momma, I'm so sorry, you would not, I know, like me to mix heaven and Art. But Dummy, no more smells, no more rats! Lovely, lovely!"

I frowned.

"I'm sorry. I love this old place and don't want to move."

"Oh, Dummy, imagine anybody loving this old School."

Adda's lace-bordered hanky swished, a rat scuttled.

I said, "It is the underneath of it that I love."

"Underneath! that disgusting market!"

"Not exactly, though the market with its honest old roots and chickens and cheese is all right, it is comfortable, commonsense. But I was not thinking of the market, Adda. It is the space and freedom we have here in this old School. We can splash and experiment all we like. Nobody grumbles at us. Our work is not hampered by bullying. 'Don't, don't.' We sharpen charcoal, toss bread crusts. Nobody calls us pigs even if they think we are. Art students are a little like pigs, aren't they, Adda? They'd far rather root in earth and mud than eat the daintiest chef-made swill out of china bowls."

Adda shuddered.

"Dummy, you are . . . ! What would Momma say? Momma never eats pork, not even bacon, and she can't bear the mention of a pig!"

The mantels, banisters and newel posts of the mansion were all elaborately carved. There were all sorts of cunningly devised secret places in the mansion, places in which to hide money or jewels. (Mrs. Hopkins could not have had much faith in banks.) In the dining room you pressed a certain wooden grape in a carved bunch over the mantel and out sprang a little drawer. In the library you squeezed the eye of a carved lion and out shot a cabinet. A towel rack in the bathroom pulled right out and behind it was an iron safe. There were panels that slid and disclosed little rooms between walls. We delighted in going round squeezing and poking to see what would happen next. All the treasure

places were empty. Mrs. Hopkins had cleared them all out before she willed the mansion.

The public roamed from room to room and stared; of course they did not know about all the strange corners that we knew. Occasionally "a public" would stray up our stairs and gaze at us as if we had been part of their fifty cents' worth. They need not have thought us so extraordinary for in the mansion we were quite ordinary, quite normal. If it had been the old school, well . . . but no sightseers had ever thought of climbing those dirty stairs. Art students were just part of the squalor that surrounded the market. Nobody was interested in them! But now that we were stupid and elegant and an institution people wanted to see how we looked.

BACK TO CANADA

SAN FRANCISCO boarding houses were always changing hands. Sometimes I stayed by the change, sometimes I moved.

All boarding houses seemed to specialize in derelict grandmothers and child-less widows, nosey old ladies with nothing to do but sleep, eat, dress up, go out, come back to eat again. Being lonely and bored they swooped upon anything that they thought ought to be mothered. They concentrated on me. I was soon very overmothered. They had only been out in the New World a generation or two. My English upbringing reminded them of their own childhood. They liked my soap-shiny, unpowdered nose, liked my using the names Father and Mother instead of Momma and Poppa. Not for one moment would they exchange their smart, quick-in-the-uptake granddaughters for me but they did take grim satisfaction out of my dowdy, old-fashioned clothes and my shyness. Their young people were so sophisticated, so independent. They tried lending me little bits of finery, a bow or a bit of jewellery to smarten me, should I be invited out, which was not often. One old lady of sixty wanted me to wear a "pansy flat" (her best hat) when someone took me to see *Robin Hood*. It hurt them that I refused their finery, preferring to wear my own clothes which I felt were more suitable to age and comfort even though they were not smart. I had a birthday coming and three of them got together and made me a new dress. The result disheartened them—they had to admit that somehow I looked best, and was most me, in my own things.

The landlady's daughter and I were friends. We decided we would teach our-

selves to sew and make our own clothes. We bought Butterick's patterns, spread them on the floor of the top landing where our little rooms were, and in which there was not much more than space to turn round.

One day I was cutting out on the hall floor. The landlady's daughter was basting. Spitting out six pins she said, "Seen Mother's new boarder?" and pointed to the door of a suite up on our floor.

I replied, "No, what flavour is she?"

"Loud! The old house tabbies are furious at Ma for taking her but we have to live, there is so much competition now."

"The house is big. Those who wish to be exclusive can keep out of each other's way."

"The new girl has her own sitting room—double suite if you please! I don't think I like her much and you won't but she's going to your Art School so you will see her quite a bit."

"If she is such a swell she won't bother about me."

Next morning I slammed the front door and ran down the steps. I had no sooner reached the pavement than the door re-opened and Ishbel Dane, the new boarder, came out.

"Can I come along? I rather hate beginning."

She had large bold eyes, a strong mouth. You would not have suspected her of being shy, but she was. She was very smartly dressed, fur coat, jewellery, fancy shoes. I took her into the school office and left her signing up. I went on up to the studios.

"Who?" I was asked and nudged by students.

"New boarder at my place."

Adda frowned, she had never approved of my boarding house—too big, too mixed. Adda was an only boarder and only sure about places that were "Momma-approved". Suddenly she had a thought. Diving into her pocket she brought out a letter.

"Momma is coming!" she said. "Brother is taking a course at Berkeley University; Momma and sister are coming along; I will join them. We shall rent a house in Berkeley. I've given notice. Why not take my room? Shall I ask them to save it for you?"

"No, thanks, I am very well where I am."

Adda said no more. She watched Ishbel but refused to meet her.

In the evenings I practised on my guitar. There was a tap on my door and there was almost pleading in Ishbel Dane's voice as she said, "Come to my sitting room and have a cup of tea with me?"

I went wondering. We had not got to know each other very well. We were in different studios at School. My "grandmother guardians" in the boarding house advised of Ishbel Dane, "Not your sort my dear." Having found they could not direct my clothes they were extra dictatorial over my morals. I resented it a little, though I knew they meant well. They were very cool to Ishbel, confined conversation to the weather. All they had against the girl was her elegant clothes—she overdressed for their taste.

Ishbel had made her sitting room very attractive—flowers, books, cushions, a quaint silver tea service which she told me had been her mother's. She saw my eyes stray to a beautiful banjo lying on the sofa.

"Yes, I play. I belong to a banjo, mandolin and guitar club. Wouldn't you like to join? It helps one. I have learnt ever so much since I practised with others."

I said slowly, "I'll think." I knew the old grandmothers, the landlady's daughter and Adda would disapprove. When I left, Ishbel took my hand.

"Come again," she said. "It's lonely. My mother died when I was only a baby; Father brought me up. Father's friends are all men, old and dull. A few of them have looked me up for Father's sake. Father is in the South."

I joined the practice club. My friendship with Ishbel warmed while the old ladies' affection chilled towards me. Adda was actively distressed. She moved to Berkeley. Her last shot as she started for her new home was, "My old room is still vacant."

Trouble was in her eyes, anxiety for me, but I liked Ishbel and I knew Ishbel and I knew my friendship meant a lot to her.

I had to go to the music studio for some music. The Club leader was giving a lesson. He shut his pupil into the studio with her tinkling mandolin, followed me out onto the landing. As I took the roll of music from him he caught me round the wrists.

"Little girl," he said, "be good to Ishbel, you are her only woman friend and she loves you. God bless you!" His door banged.

I a woman's friend! Suddenly I felt grown up. Mysteriously Ishbel—a woman—had been put into my care. Ishbel was my trust. I went down stairs slowly, each tread seemed to stretch me, as if my head had remained on the landing while my feet and legs elongated me. On reaching the pavement I was grown up, a woman with a trust. I did not quite know how or why Ishbel needed me. I only knew she did and was proud.

While I was out a letter had come. I opened it. My guardian thought I had "played at Art" long enough. I was to come home and start Life in earnest.

Ishbel clung to me. "Funny little mother-girl," she said, kissing me. "I am going to miss you!"

A man's head was just appearing over the banister rail. She poked something under my arm, pushed me gently towards my own room. A great lump was in my throat. Ishbel was the only one of them all who hadn't wanted to change some part of me—the only one who had. Under my arm she had pushed a portrait of herself.

I came home one week before Christmas. The house was decorated, there was some snow, fires crackled in every grate of every room, their warmth drew spicy delight from the boughs of pine and cedar decorating everywhere. There were bunches of scarlet berries and holly. The pantry bulged with good things already cooked. In the yard was something for me, something I had wanted all my life, a dog!

They were glad to have me home. We were very merry. All day the postman

was bringing cards and letters; flitter, flitter, they dropped through the slit near the front door and we all darted crying, "Whose? whose?"

I got my full share but there were two disappointments—no letter from Nellie McCormick, none from Ishbel Dane. New Year passed before I heard of either.

Adda wrote, "Nellie McCormick could endure home tyranny no longer, she shot herself."

From the boarding house one of the grandmothers absolutely sniffed in writing, "Ishbel Dane died in the 'Good Samaritan' hospital on Christmas Eve. Under the circumstances, my dear, perhaps it was best."

Nellie my friend! Ishbel my trust!

I carried my crying into the snowy woods. The weather was bitter, my tears were too.

PART II

HOME AGAIN

THE TYPE of work which I brought home from San Francisco was humdrum and unemotional—objects honestly portrayed, nothing more. As yet I had not considered what was underneath surfaces, nor had I considered the inside of myself. I was like a child printing alphabet letters. I had not begun to make words with the letters.

No one was teaching drawing in Victoria: mothers asked me to start a children's class. I did not want to teach. I was afraid of pupils, but I did teach and soon I got fond of the children and liked the work. I taught my class in our dining room. The light was bad; the room got messed up; there was trouble after every class.

We had two large barns: one housed our cow, the other our horse. Clambering over the cow, I explored her loft. Low roof, only one tiny window, no door other than a small trap-door over the cow's head and a great double door that opened into space and had a gibbet over the top for the hauling up of bales of hay. The boards of the floor and walls were knotholed, the wood buckled, the roof leaked. But it was a large loft, high in the middle, low at the side walls.

My eldest sister was tyrannical, an autocrat like Father. She claimed every inch of the old home, though really it belonged to us all. Independence had taught me courage.

"Can I have the loft of the old cow barn for a studio?"

"Certainly not. It's the cow's."

"Couldn't the cow share with the horse?"

"Have you come home to unsettle the family and worry the cow?"

My sister knew the cow's barn was very much out of repair. When I offered to mend it she reluctantly consented to my using the loft. I called in a carpenter.

"It's the floor," I said.

"No, the roof," my sister corrected.

"It's the walls!" declared the carpenter with a determined tongue-click and a head-shake.

I said, "As long as everything relates in being bad, let's patch all over and let it go at that. But, carpenter, there *must* be an outside stair up to the big door and another window for light."

So the carpenter let in a wide dormer, hung a little stair onto the outer wall, patched leaks, straightened boards and we were snug. But it was still too dark for

work and all my money was spent. The old garden Chinaman and I mounted the roof with saws and cut a great hole. This we fitted with two old window sashes, making a skylight. Now we had lots of light and lots of leak too. I put a tin gutter all round the skylight and drained the leaks into a flower box, shoved a stovepipe into the wash-house chimney which ran through the loft, blocked up pigeon holes, burlapped walls. There we were cosy as anything, with little more than an eggshell's thickness of wood full of splits, knotholes and cracks and perched right out in the middle of the elements—rain drumming, wind whistling, sun warming, and everybody happy—pupils, me, even the cow and chickens below.

Under my loft the barn contained a wash-house, an apple-storing room, a tool shed, three cow stalls, a chicken house and an immense wood-shed, big enough to accommodate twelve cords of wood (half oak, half fir, for the household's winter burning).

"Please, the cow smells like a cow, may she move to the other barn?" I asked my sister.

"She may not."

I did not really mind sharing with the cow—I was really not keen on her smell but she cosied things.

When I worked at night under a big coal-oil lamp suspended from the rafter under an immense reflector, made by myself out of split coal-oil cans, it was nice to hear the cow's contented chew, chew, chew below. I loved to stick my head through the trap-door above her stall into the warm dark and say, "Hello, old cow." She answered with great hay-fragrant sniff-puffs that filled the barn. Any sudden noise sent the hens on their roosts below hiccoughing in their sleep. On moonlight nights the rooster crowed. Rats and mice saw no reason to change their way of living because we had come—after I brought home a half-drowned kitten from the beach it was different. A peacock came down from Beacon Hill Park and made his daytime quarters on the studio roof, strutting before the doubled-back dormer, using it as a mirror. Most splendid of all was my very own big dog. No studio has ever been so dear to me as that old loft, smelling of hay and apples, new sawed wood. Monday washings, earthy garden tools.—The cow's great sighs! Such delicious content!

In dusk's half-light the dog and I left the studio and raced over Beacon Hill and the beach. Specially permitted friends held trysts in the studio with their sweethearts, sitting on the model throne looking down into the pure delight of a blossoming cherry tree below, or toasting their toes, along with the cat, in front of the open-fronted stove.

I was rebellious about religion. In our home it was forced upon you in large, furious helps. The miserableness of continually sprawling across doubled-over ladies, with their noses on the seats of our chairs, and their praying knees down on our carpets, annoyed me. You never knew in which room nor at what hour.

The Y.W.C.A. was just beginning in Victoria; my sisters were among its founders, and enthusiastic over the concern. As the society had, as yet, no head-quarters, they used to come to our house to pray. I was always bursting in on

them. The knocked-over-ones glowered, and, over their horizontal backs, my sister's eyes shot fire at me. She hung on to her prayer voice till afterwards—and then—!

Then too there was the missionary blight. My second sister wanted to be a Missionary and filled our house with long-faced samples. Missionaries roosted on us during migration, others hopped in to meals while waiting for boats. Missionary steamers had no particular dates or hours of sailing, because they went to outlandish places and waited for cargoes. There was the Sunday School blight too. That was very bad. All there was left of home on Sunday afternoon was the wood pile or you could go off to the lily field. Every room in the house accommodated a Sunday School class. My sister wanted me to conduct one for small boys in the kitchen and called me stubborn and ungodly because I refused.

Artists from the Old World said our West was crude, unpaintable. Its bigness angered, its vastness and wild spaces terrified them. Browsing cows, hooves well sunk in the grass (hooves were hard to draw!), placid streams with an artistic wriggle meandering through pastoral landscape—that was the Old World idea of a picture. Should they feel violent, the artists made blood-red sunsets, disciplined by a smear of haze. They would as soon have thought of making pictures of their own insides as of the depths of our forests.

I was tremendously awed when a real French artist with an English artist-wife came to Victoria. I expected to see something wonderful, but they painted a few faraway mountains floating in something hazy that was not Canadian air, a Chinaman's shack on which they put a curved roof like an Eastern temple, then they banged down the lids of their paintboxes, packed up, went back to the Old World. Canada had no scenery, they said. They said also that the only places you could learn to paint in were London or Paris. I was disappointed at hearing that, but immediately began to save. I slung an old pair of shoes across the studio rafters. When pupils paid me I shoved the money away in my shoes.

"I am going abroad to study!" I told my astonished family.

A Missionary took a liking to me. She had a very long face but a good heart. She was negotiating for my sister to accompany her back to her lonely mission up the West Coast of Vancouver Island, so that she might try out the loneliness and Indians. When the Missionary saw how interested I was in her description of these wild places, she said to me, "Wouldn't you like to come to Ucluelet to sketch in the summer holidays?"

"I would like to frightfully," I replied.

The Willapa was a small coast steamer. I was the only woman on board, indeed the only passenger. We nosed into dark little coves to dump goods at canneries. We stood off rocky bluffs, hooting until a tiny speck would separate itself from the dark of the shoreline. It grew and presently sprouted legs that crawled it across the water. The black nob in its middle was a man. We threw him a rope and he held on, his eyes chewing the parcel in the purser's hands, his face alight.

"Money?" shouted the purser. The man's face unlit. He made a pretence of searching through his ragged clothes and shook his head. The purser threw the

parcel back on our deck and tossed a letter into the man's boat. The man ripped the envelope, tore out his remittance and waved it, the parcel thudded into the boat! We tooted and were away. The tiny boat got smaller and smaller, a mere speck on the grey spread of water. Then it was gone. Vastness had swallowed boat and man.

Life in the Mission House was stark, almost awesome, but you could not awe our Missionary, she had no nerves. She was of cement hardened into a mould. She was not inhuman, there was earth underneath. It was just her crust that was hard and smooth. The slow, heavy Indians had not decided whether or not to accept religion. They accepted missionary "magic" in the shape of castor oil and Epsom salts. But religion? They were pondering. The Missionaries were obliged to restrain their physic-giving. If you gave an Indian a bottle of medicine he drank it all down at once and died or not according to his constitution. He had to be given only one dose at a time. But the Missionaries expected to give the Indians the whole of religion at one go. The Indians held back. If physic was given in prolonged doses, why not religion?

"Toxis", as the Indians called the Mission House, squatted back to forest face to sea just above the frill of foam that said, "No further," to the sea and, "So far," to the land. The Indian village was a mile distant on one side of the Mission House, the cannery store a mile on the other. At high tide we went to them by canoe, at low tide we walked in and out among the drift logs lying stranded on the beach.

No part of living was normal. We lived on fish and fresh air. We sat on things not meant for sitting on, ate out of vessels not meant to hold food, slept on hardness that bruised us; but the lovely, wild vastness did something to it all. I loved every bit of it—no boundaries, no beginning, no end, one continual shove of growing—edge of land meeting edge of water, with just a ribbon of sand between. Sometimes the ribbon was smooth, sometimes fussed with foam. Trouble was only on the edges; both sea and forests in their depths were calm and still. Virgin soil, clean sea, pure air, vastness by day, still deeper vastness in dark when beginnings and endings joined.

Our recreation in the Mission House was the pasting together of broken prayer- and hymn-books. It seemed the churches sent all their cripples to missions.

After the Missionaries blew out their candles and the ceiling blackened down to our noses, the square of window which the candle had made black against outside dark cleared to luminous greys, folding away mystery upon mystery. Out there tree boles pillared the forest's roof, and streaked the unfathomable forest like gigantic rain streaks pouring; the surge of growth from the forest's floor boiled up to meet it. I peered at it through the uncurtained window while the Missionaries prayed.

To attempt to paint the Western forests did not occur to me. Hadn't those Paris artists said it was unpaintable? No artist that I knew, no Art School had taught Art this size. I would have to go to London or to Paris to learn to paint. Still those French painters who had been taught there said, "Western Canada is

unpaintable!" How bothersome! I nibbled at silhouetted edges. I drew boats and houses, things made out of tangible stuff. Unknowingly I was storing, storing, all unconscious, my working ideas against the time when I should be ready to use this material.

LOVE AND POETRY

IMMEDIATELY upon my return from the West Coast Mission, I tasted two experiences for the first time—love, and poetry. Poetry was pure joy, love more than half pain. I gave my love where it was not wanted; almost simultaneously an immense love was offered to me which I could neither accept nor return. Between hurting and being hurt life went crooked. I worked and taught for all I was worth. When my teaching for the day was over, with a book of poetry under my arm and with my dog, I went to the Beach or roamed the broom bushes on Beacon Hill. From the underscored passages in my poets, poetry did not touch love as deeply as it touched nature and beauty for me. Marked passages are all earth and nature.

Up to this time my painting had followed the ordinary Art School curriculum—drawing from the antique, still-life painting, portraiture, design and landscape. Now it took a definite list toward pure landscape.

When, dangling from the studio rafters, the old pair of hoarding shoes were crammed with money from my teaching, I announced, "I am going to London."

"You have friends or relatives there?" asked an old lady friend.

"I have neither, but for my work I must go."

"London is big, much noise, many people; you will miss your pine trees and your beaches, child."

"London will be beastly; all the same, I'm going."

"My sister, Amelia Green, accepts a few paying guests."

"What are paying guests—boarders?"

"My dear! Ladies of good family in England do not take boarders. If circumstances compel them to accept remunerative visitors, they call them paying guests," said the shocked old lady.

"PG's? Then all right, I'll become of your sister's PG's."

It was arranged that Aunt Amelia, wearing something green in her buttonhole, should meet me at Euston Station.

Nearly everyone in Victoria gave me a life-size portrait photograph of himself or sometimes of the entire family grouped. I was supposed to cart them along as a preventative for homesickness. I locked them into my stow-away cupboard at

home. But more friends brought more photographs to the boat-side. On entering my stateroom I was greeted by cardboard stares, male and female, propped against the tooth mug, the waterbottle, the camp stool; a family group rested on my pillow. The nicest family of all slid out the porthole. Undulating on a great green wave it smiled back at me. I gathered the rest into my cabin trunk, I could not be comfortably seasick with them looking on. I was provided also with a bale of introductory letters asking people to be kind. If England could not be kind for my own sake I did not want charity niceness from my friends' friends!

Canada's vastness took my breath. The up-and-downness of the Rockies, their tops dangled in clouds, thrilled and were part of natural me, though I had to steel myself as we glided over trestle-bridges of great height spanning gorges and ravines with rivers like white ribbons boiling far below, and lofty trees looking crouched and squat down there in the bottom of the canyon while we slid over their tops. We squeezed through rocky passes, hid in tunnels, raced roaring rivers, slunk through endless levels of dead, still forest, black-green and mysterious, layer upon layer of marching trees, climbing trees, trees burned, trees fallen, myriad millions of trees and loneliness intertwisted. Our engine gulped endless miles, each rail-length one bite. On, on, till the mountains ended and the train slithered over level land munching space rhythmically as a chewing cow. Was there never to be an end? Did our engine spin track as she advanced like a monster spider? Would we finally topple over the brink into that great bonfire of a sunset when we came to the finish of this tremendous vastness?—No rocks, no trees, no bumps, just once in a great, great way a tiny house, a big barn, cattle in that great space sizing no bigger than flies—prairie houses, cows, barns, drowned in loneliness.

When at last we came to Canada's eastern frontier, just before she touched the Atlantic ocean, she burst into a spread of great cities, clean, new cities. The greedy, gobbling train turned back to regobble Canada's space, while we launched into sea-bounce that grieved the stomach, wearied the eye.—Nothingness, nothingness, till your seeing longed and longed—whale, bird, anything rather than nothing piled on top of nothing!

THE VOYAGE AND
AUNT AMELIA

THE WOMAN in the deck chair next to mine stroked a strand of red hair from her forehead with a freckled hand.

"Oh, my head!"

"Have my smelling bottle."

She took three long sniffs and then pointed the bottle across the deck.

"Awful woman!" indicating a loud, lounging woman in noisy conversation with the Captain.

"Discussing whisky! Irish against Scotch! Glad she prefers Irish, I should feel her preference to Scotch a desecration of my country."

Captain crossed the deck. He looked enquiringly from one to the other of us.

"Miss Carr?"

"Yes, Captain."

"This lady wants to meet you, her maiden name was Carr."

The Captain indicated the loud woman with whom he had been discussing whisky. The Captain's lady flopped noisily into the chair the smelling bottle and the Scotch lady had hastily vacated.

"Any London relatives?" she asked sharply.

"None."

"What are you by birth?"

"Canadian."

She beckoned the Captain back to her side. Irish versus Scotch was again discussed—they forgot me.

Suddenly I felt awful. The former Miss Carr made a swift move. I felt the cold scratchy hardness of an immense sunburst which Mrs. Downey (the former Miss Carr) wore upon her breast, then I was in my berth, and my cabin was full of people but most full of Mrs. Downey. Sometimes I was there, sometimes not; finally I sailed out into blankness entirely.

In those times C.P.R. boats took ten days to cross the Atlantic. We were almost across before I woke. First I thought it was me crying, then I opened my eyes and saw it was Stewardess.

"Are you hurt?" She patted me and mopped herself. "How could your mother send you this great way alone?"

"Mother's dead. I am older than I look."

The Captain, doctor, Stewardess and Mrs. Downey had been in conference.

A girl belonging to no one and for the moment not even to herself had to be landed. It was a problem. Stewardess had volunteered to take me home with her for the week that she was in port and nurse me, but now I had waked up.

They carried me to the upper deck for air. We were lying in the Mersey, not landing our passengers till morning. The air revived me. Doctor said I might take the special boat train in the morning providing there was anyone going my way who would keep an eye on me. There was not, until Mrs. Downey made it her business and changed her route. She sent stewards scuttling with wires. Miss Green was to meet me at Euston. Just because a girl had her maiden name, Mrs. Downey made it her business to see I was delivered safe and sound into competent hands.

The ship's little Irish Doctor saw us comfortably tucked into our train. I heard Mrs. Downey say, "Then come on up, I'll give you a time."

The Doctor waved his cap.

I could not lie back resting, as Mrs. Downey wanted me to. We were skimming across the Old World—a new world to me—entirely different, pretty, small. Every time I looked at Mrs. Downey she was looking at me. Suddenly she said, "You're not a-goin' to that Amelia person. You're a-comin' to me."

"I'm promised to Miss Green, Mrs. Downey."

"She's no relative—bust the promise; I'll fix 'er! 'Twon't cost you nothin' livin' with me. You c'n go to your school, but nights and Sundays you'll companion my little daughter."

"Have you a daughter?"

"Same age as you—'flicted, but we'll 'ave good times, you an' me and my girl. That doctor chap is stuck on you. 'E tole me so. I was lookin' for company for my Jenny. . . . Only jest 'appened . . . 'er 'fliction. . . ." She choked . . . snuffled.

As we pulled into Euston's sordid outskirts of grime and factories the station's canopied congestion threw a shadow of horror over me.

"That white-pinched little woman has green in her button hole, Mrs. Downey."

"She's no gittin' you."

Her fingers gripped my arm as in a vice.

"Miss Green?"

The two women stared at each other belligerently.

"She's comin' to me—been sick—not fit to be among strangers, she isn't. I'm 'er friend."

"I'm promised, Mrs. Downey. My people expect it."

The wiry claw of the lesser woman wrenched me away so that I almost fell. I was clutched fiercely back to the scratchy sunburst, then released with a loud, smacking kiss.

"Any 'ow, come an' see my little girl . . . she needs . . . ," the woman choked and handing me a card turned away.

"Frightful person! The entire platform must have heard that vulgar kiss," gasped Miss Green.

"I was very ill on board; she was kind to me, Miss Green."

"You must never see her again, one cannot be too careful in London."

She glanced at the address on the card in my hand. "Brixton! Impossible!"

"I shall have to go just once to thank her, and to return her umbrella. She gave it to me to carry while she took my heavier things."

"You can post the umbrella. I *forbid* you to associate with vulgar people while living in my house."

"*I am going once.*"

Our eyes met. It was well to start as I meant to continue. I was only Miss Green's PG. My way, my life were my own: it was well she should understand from the start.

AUNT AMELIA'S
PG HOUSE

LONDON was unbearable. August was exceptionally hot. Aunt Amelia lived in West Kensington—one of those houses in a straight row all alike and smeared with smug gentility. I felt the shackles of propriety pinch me before the door was shut.

The six PG's without one direct look amongst them disdainfully "took me in" at lunch. "Colonial!" I felt was their chilly, sniffy verdict. I hated them right away. Their hard, smooth voices cut like ice skates, "dearing" each other while they did not really like each other one bit. The moneyed snob who had the big front room swayed the establishment; next came the opulent Miss Oopsey, a portrait photographer who only "portrayed" titles. The PG's dwindled in importance till at the tail came Miss Green's niece, a nobody who was the snootiest of the lot and earned her keep by doing unnecessary things that were good form around the PG house.

London stewed, incorporating the hot murk into her bricks all day and spitting it out at you at night. The streets were unbearable. Everyone who could get out of London had got and were not missed. I used to wonder where any more population could have squeezed. Certainly if there were many more people in London they would have to ration air for the sake of fairness.

"Miss Green, is there any place one can go to breathe?"

"There are London's lovely parks."

"Just as crammed—just as hot as everywhere else!"

Miss Green clicked, "Dear me! You Canadians demand a world apiece. I have

offered to take you to Hyde Park, show you our titled people riding and driving, but no, you Canadians have no veneration for titles—jealously, I presume."

"I'll admit I do prefer cool air to hot celebrities, Miss Green. Now, about a breathing place?"

"Kew—if it is roots and bushes you want, go to Kew Gardens."

To Kew I went.

The great gates of Kew Gardens were plastered with many notices— "Nobody is allowed in these gardens unless respectably attired."—"No person may carry a bag, parcel, or basket into the gardens; all such impedimenta to be checked at the porter's lodge."—"No one may carry food into the gardens; tea may be procured in the tea-houses."—"You must not walk upon the grass, or run or sing or shout."

Striding past the lodge, clutching my bag, I walked down the main way and, turning into a woodsey path, began to sing. First hint of Autumn was in the air, there were little piles of dead leaves and fallen twigs burning, shreds of blue smoke wandered among the trees deliciously.

Kew was a bouquet culled from the entire world. I found South America, and Asia, Africa, China, Australia—then I found Canada (even to a grove of pines and cedars from my own Province). I rubbed their greenery between my hands—it smelled homey. I stabbed my nose on our prickly blue-pine. I sat down on the grass beneath a great red cedar tree. From close by came the long-drawn cry of a peacock. Suddenly I was back in the old barn studio! I threw up my chin and gave the answering screech which my peacock had taught me—my beauty on the old barn roof. I waited for an ejecting keeper, but my teacher had taught well, no keeper came. I went back to stuffy West Kensington refreshed, happy.

Again Miss Green in company with that swell who snobbed it over her PG's offered to conduct me to see the Hyde Park Parade. The "swell" boarders, Miss Green told me, always sat on penny chairs.—"Much more refined than to sit on a free bench, my dear," drawled Miss Green.

"I'd rather go to the Zoo," I replied and went.

Resignation if not content was in the eye of the captive creatures. Having once acquired a taste for the admiration and companionship of man animals like it. Here and there you saw a rebellious or morose newcomer furiously pacing, but most of the creatures were merry and all were well tended. All here looked more satisfied with life than the weary "great" looked in Hyde Park. I loved Kew.

S T . P A U L ' S

WESTMINSTER School of Art did not open until September. When I was a little rested, a little steadier, I climbed the curving little iron stairways at the backs of omnibuses and, seated above the people, rode and rode, watching the writhe of humanity below me. I had never seen human beings massed like this, bumping, jostling, yet as indifferent to each other as trees in a forest.

I puzzled, wondering. What *was* the sameness with a difference between a crowd and a forest? Density, immensity, intensity, that was it—overwhelming vastness. One was roaring, the other still, but each made you feel that you were nothing, just plain nothing at all.

History always had bored me. *Little Arthur's History of England* in its smug red cover—ugh, the memory of it! And now here before me was the smugness of it ossified, monumented, spotted with dates thick as an attack of measles. The English had heads twisted round onto their backs like drowsy ducks afloat, their eyes on what they had passed, not on what they were coming to.

Dickens had taught me far more about England than had *Little Arthur*. Dickens' people still walked the streets, lived in the houses of old London. Little Arthur's Great were shut up in dull books, battered monuments.

Deep in the City I happened one day upon Paternoster Row, a dark narrow little way lined with book shops. All the Bibles, prayer-books, hymnals in the world began life here. I saw them sprawled open at the fly-page. All the religious books that I remembered had had Paternoster Row printed inside them.

I did not, as Miss Green's other PG's did, attend some fashionable church in the West End. Sunday was the day on which I crept into London's empty heart. Everyone had gone from it, all business houses were closed. The lonely old churches were open but empty; all the light was pinched out of them by the grim huddle of business establishments. The old churches still had their bells, still rang them. Empty London threw back their clamour in echo. Often an entire congregation consisted of me, sitting under a very indifferent preacher, ushered in and out by a very pompous verger in a black robe almost as cleric as the clergy. My coin looked pitiful in the pompous collection-plate. Echo made the squeaky old parson's whisper hit back at you from every corner of the bare church.

London's national religion was conducted either in St. Paul's Cathedral, the heart of London's heart, or in Westminster Abbey in the West End. All immense

events were solemnized in one or the other of these churches.

The business houses and shops of St. Paul's Churchyard fell back from the cathedral allowing it breathing space and sunshine. The steps up to her great doors were very, very wide. Beginning from each side of the steps was a circle of space encompassing the cathedral. It was lightly railed but the gates were flung wide, flowers and shrubs and benches were about and always there were people, sitting on the benches, eating things out of paper bags, feeding the pigeons and resting.

St. Paul's is the kernel of London as London is the kernel of England.

Westminster Abbey is beautiful too but rather historical and it was made a little cheap by sightseers who whispered and creaked. It had not the unity of St. Paul's; there were chapels here and chapels there—all sorts of pokes and juts, tablets, monuments and statues, "great ones" bouncing from niches and banners flapping. St. Paul's was domed under one immense central round. High, pale light flooded down; roll of organ, voice of chorister, prayer trembled upward.

Always there were people in St. Paul's standing, sitting, praying, or doing nothing, not even thinking, wanting only to be let alone.

At five o'clock each afternoon the great organ played, flooding the cathedral with music. The prayer-soaked walls came alive. Great, small, rich and shabby Londoners crept into St. Paul's to find sanctuary.

Sightseers climbed hundreds of steps to look down from a high gallery running round the inside of the dome. It was considered a thing to do, one of London's sights. I did not want to "sight-see" St. Paul's. The people moving up there in the high gallery were black spots in the mystery. I remained among the solid, silent company on the paved floor of the cathedral.

LETTERS OF INTRODUCTION

TURMOIL, crowding, too many people, too little air, was hateful to me. I ached with homesickness for my West though I shook myself, called myself fool. Hadn't I strained every nerve to get here? Why whimper?

Aunt Amelia's mock-genteel PG's galled me at every turn—high-bridged noses, hard, loud, clear voices, veneering the cold, selfish indifference they felt for each other with that mawkish, excessive "dearing". My turbulent nature was restive to be at work; it made me irritable and intolerant. Miss Green suggested the British Museum as a sedative.

To the British Museum I went and loathed it—the world mummified. . . .
No matter which turn I took I arrived back in the mummy-room, disgusting
human dust swaddled in rags, dust that should have been allowed centuries back
to build itself renewingly into the earth. The great mummy halls stank of disin-
fectants. Visitors whispered and crept. . . . Place of over-preservation, all the
solemnity choked out of death, making curiosity out of it, prying, exposing,
indecent.

Miss Green said, "The British Museum is marvellous, is it not, my dear?"

"It's disgusting!—Good decent corpses for me, Miss Green, worms wriggling
in and out, hurrying the disagreeables back to dust, renewing good mother
earth."

Aunt Amelia screeched, "My dear, you are revolting!"

Recoiling from mummies I turned to parsons. Our clergyman at home had
given me two introductory letters to brother clergy—his own particular brand—
in London's suburbs. One had a fancy name, the other was Rev. John Brown
who lived at and parished in Balham. Balham was two hours out of London by
train. In the same suburb I had been commissioned by a Victoria widow to call
on her well-to-do sister-in-law. The widow's husband had just suicided and left
his family in difficult financial circumstances. I was to furnish the well-to-do
"in-law" with the distressing particulars and hint at the straitened circumstances
facing the widow.

The sister-in-law received me in a hideous drawing-room. She rustled with
silk from the skin out, and served tea, very strong, together with plum cake as
black and rich as bog-earth. She said, "To suicide was very poor taste, especially
if you had not first made comfortable provision for your family."

Then at my request she directed me to the residence of the Rev. John Brown.

I meandered through paved suburban streets that called themselves "groves",
and along "terraces" sunk below ground level, and "crescents" that were as
straight as knitting needles.

A slatternly maid, very frilly as to cap and apron, said, "Wite 'ere," and took
my letter into a room where tea cups clattered. After a pause the Reverend came
out holding my opened letter. He snapped his reading glasses into their case and
adjusted a dangling pince-nez to his nose and looked over from hat to shoes.

"What is it you want me to do for you, young woman?"

I felt myself go scarlet.

"Nothing! Nothing at all, sir! I *had* to come because our home parson would
have been mad if I hadn't! They'd have fussed if I had not promised—my people
I mean."

I rushed towards the door.

"Stop!"

His roar was as if he were thundering "amen" over a huge congregation.
Again he changed glasses, scrutinized me and re-read my letter.

"You'd better have a cup of tea and meet my wife."

He said it ponderingly as if wondering if I would pour my tea into the saucer
and blow it.

"I have had tea, thank you."

"But you have not met my wife."

He gestured me into the drawing room with furious authority. A voice, submerged in the vagueness that comes of deafness, called, "John, dear, your tea is getting cold. I've sugared it."

"My dear," he waited for her to adjust the tin ear-trumpet and close her eyes against the impact of his bellow . . . "Canadian, my dear!"

His shout must have filled the trumpet to make her realize that I was standing in front of her. He took her hand and held it out, at the same time tapping the side of the trumpet sharply.

Mrs. Reverend Brown winced, her mild, kind eyes smiled into mine, while she prepared for me a cup of tea, lavishly sugared. The Reverend then began to fire statistic questions at me, roaring them in duplicate into the trumpet.

I did not know the population of Ontario, nor how many cases of salmon British Columbia shipped in export each year. He began to look suspicious, then bellowed his final test watching my face narrowly.

"You have heard my brother, the Reverend Samuel Brown, preach in Chicago?"

"I have never been in Chicago."

"What! So few cities of importance in America and not know Chicago! Every American should be familiar with such cities as they have."

"But I do not live in America. I am Canadian."

"Same thing, same continent!"

Now he *knew* I was an impostor.

"You have finished your tea?"

He rose, took my cup, glanced towards the door.

I rushed back to London, burned the balance of my letters of introduction.

WESTMINSTER ABBEY— ARCHITECTURAL MUSEUM

I WENT to Westminster to hunt up my Art School.

I was to become very familiar with Westminster Abbey because the Art School lay just behind it, being housed in the Architectural Museum in Tufton Street. There stood the richly magnificent Abbey stuffed with monumental history, then a flanking of dim, cold cloisters, after that the treed, grassed dignity of Dean's yard and then you passed through an archway in a brick wall and were

in Tufton Street. Here was the Architectural Museum, a last shred of respectability before Westminster plunged into terrible slum. In the Architectural Museum was housed the Westminster School of Art.

I climbed the Museum's grimy steps, pushed my shoulder against the heavy swing-door, entered a dark, lofty hall smelling of ossification—cold, deadly, deadly cold.

"Wat'cher wantin'?"

"I am looking for the Westminster School of Art."

" 'Ere, but 'olidayin'."

The old janitor thumbed to a door up two steps, muttered, "Orfice" and lighted a gas jet over the door. Down the entire length of the hall was lying a double row of stone couches, on each of which was stretched a stone figure.

"Who are these?"

"Them is Great Uns, Miss."

The janitor's grim, dirty face went proud.

In the office I found Mr. Ford, the Curator, a white-bearded, tall old man, gentle, clean, too lovely for this grim setting. He smiled kindly, pen poised over his figuring.

"Yes?"

"Please, may I join the Art School?"

He reached for his enrolment book, wrote, "Emily Carr, Victoria, B.C. . . . English?"

"No, Canadian."

"Ah! Canadian, eh?"

His smile enveloped Canada from East to West, warming me. So few over here accepted Canada. These people called us Colonials, forgot we were British. English colonists had gone out to America with a certain amount of flourish, years and years ago. They had faded into the New World. Later, undesirable not-wanteds had been shipped out to Canada. It was hoped that America would fade them out too—all the west side of the earth was vaguely "America" to England. This courteous old gentleman recognized Canada as herself—as a real, separate place.

"How soon can I start work?"

"As soon as the class rooms open next Monday, Miss Hurry."

The Museum was lighted when I came out of the Office. A dreary young man in rusty black was drawing in a little black book propped against a stone dove on a shelf, bits of cornices, stone lilies, and saints with their noses worn off. Why must these people go on, and on, copying, copying fragments of old relics from extinct churches, and old tombs as though those were the best that *could ever* be, and it would be a sacrilege to beat them? Why didn't they *want* to outdo the best instead of copying, always copying what had been done?

I walked down the centre of the hall between the rows of stone sofas. I could not see the faces of the "Great Uns". The crowns of their recumbent heads were towards me. Some had stone hair, some hoods of stone, the heads of some were bald. It chilled one to see their bareness against stone pillows—hands crossed

over stone bosoms, feet exactly paired, chipped old noses sticking up from stone faces, uncosy stone robes draping figure and sofa. Except for the Curator, the Westminster Architectural Museum was grim.

Something smelly was very close. The janitor was "shooing" the dreary young man out. He held wide the heavy door, beckoned me and cupped his filthy paw for a tip. . . .

"Closing time!"

Fog was in dirty Tufton Street. I did not put a tip into the dirtier hand. He banged the door after me. Newton expected a tip for every nothing he did or did not do. That janitor was loathsome—my first experience of that type of cockney.

L I F E C L A S S

WHEN SCHOOL OPENED Monday morning at nine sharp I was at the Westminster School of Art. I went first to the Office, enquiring how I was to act. Mr. Ford took me up the broad stairway leading to the balcony off which our class rooms opened. There were two "life" rooms for women. Mr. Ford introduced me to the head student, a woman dour and middle-aged.

"Ever worked from life?" she snapped.

"Only portrait."

"It is usual for new students to work first in the Antique Class."

"I have had three years study in antique and still life at the San Francisco School of Art."

The head student gave a mighty snort, grunted, "Colonial" with great disfavour. She had not the right to place me. Mr. Ford had put me into the Life Class.

"Stars in the West bump pretty hard when they compete with civilized countries!" she said acidly. "Well, Professor will put you where you belong when he returns."

She proceeded to put numbers on a lot of pieces of paper. The students were about to draw for a place in class. I, being the new student, had the last number and therefore no choice.

Around the model throne were three rows of easels—low, higher and high.

"Pose!"

The curtains of a little recess parted, out stepped the model and took her place on the throne.

I had dreaded this moment and busied myself preparing my material, then I

looked up. Her live beauty swallowed every bit of my shyness. I had never been taught to think of our naked bodies as something beautiful, only as something indecent, something to be hidden. Here was nothing but loveliness . . . only loveliness—a glad, life-lit body, a woman proud of her profession, proud of her shapely self, regal, illuminated, vital, highpoised above our clothed insignificance.

The confusion of re-assembly after the holidays stilled. Every eye was upon her as she mounted the throne, fell into pose. Every student was tallying her with perfection, summing up balance, poise, spacing, movement, weight, mood. Charcoal began to scrape on paper and canvas . . . swishing lines, jagged lines, subtle curve, soft smudge. Tremblingly my own hand lifted the charcoal—I was away, lost in the subtlety, the play of line merging into line, curve balancing curve.

"Rest!"

I could not believe the first forty-five minutes had gone. The model broke pose, draped a kimono round herself and sat on the edge of the platform to rest for fifteen minutes. Students too relaxed, moving from easel to easel looking— saying little. No one looked at my work nor spoke to me. I was glad; neverthe- less I was chilled by these cold students. In California there was comradeship from the first day and kindliness towards the new student. I was glad to hear "Pose!", to see that serene creature, with trembling life in every inch of her, snap back into model queen of the room. Everything was for her. The notice on the outside of the door, "Life Class, Keep Out" was for her. Heat, light, hush—all were for her. Unprotected flesh made us tender, protective, chivalrous. Her beauty delighted the artist in us. The illuminated glow of her flesh made sacred the busy hush as we worked.

At four o'clock the model stepped down from her throne, rubbed tired mus- cles a little, disappeared behind the curtain, emerged ordinary, a woman clothed shabbily, all the beauty she had lent us hidden.

The professor did not return to his class for two weeks. I had but one fear during that time—would I be turned back into the Antique Class? His criti- cisms were gruff, uninspiring; however, he let me stay in the Life Class.

MRS. RADCLIFFE

MRS. RADCLIFFE was the aunt of friends of ours at home. They did not give me a letter of introduction but wrote direct to her. They said to me, "Go and see Aunt Marion," and their faces sparkled at her mention. So, while waiting for school to open, I went.

"I've heard all about you from my nieces," she said and accepted me as you accept a letter from the postman. It may contain good. It may contain bad. There I was. She received me kindly but without demonstration.

Mrs. Radcliffe was a widow with one son who was almost middle-aged, a London lawyer. She was Scotch by birth and raising, had spent her married life in Canada, but by inclination she was pure London through and through. Almost her first question to me was, "And how do you like London?"

"I hate it."

Her brown, starey eyes popped, grew angry, were hurt as if I had hit her pet pup. She said, "Dear me, dear me!" four times. "London is the most wonderful city in the world, child!"

"It is stuffy, hard and cruel—Canada . . . is . . . "

"Canada!" biting the word off sharp. "Canada is crude!"

She spread her hands as if she would drip all memories of Canada from her fingertips.

"London will soon polish Canada off you, smooth you, as your English parents were smooth. You are entitled to that. Make the most of your opportunities in London, child."

"I am Canadian, I am not English. I do not want Canada polished out of me."

"Dear me! Dear me!" said Mrs. Radcliffe, shifting the conversation to her Canadian cousins and nieces. "Come to me whenever you want to, child; I am always home on Sunday at tea time."

We parted, feeling neither warm nor cold towards each other.

I went to Mrs. Radcliffe's most Sundays. It got to be a habit. She liked me to come and I liked going. Usually I stayed and went with Mrs. Radcliffe and her son, Fred, to Evening Service in Westminster Abbey, then back with them to supper. Son Fred saw me safely home. Fred was nearly twice my age. He was kindly—teased me about Canada. In his mother's presence he pretended to be all English. She had educated him so—English schools, Cambridge University,

taking him back to England as a small boy at the death of her husband. Down deep Fred loved to remember his early boyhood in Canada. If he saw that I was dreary or homesick he would chatter to me about the woods and the Indians.

One night Fred said, "Tell me about the comic old Indian who threw a tombstone overboard at the spot in the sea where his brother was drowned."

I had been feeling morose at England, homesick for Canada that week. We all started to laugh at the Indian story. Suddenly Fred, looking at me, said, "Now I see why the Indians called you 'Klee Wyck'—means laughing one, doesn't it?" After that the Radcliffes always called me "Klee Wyck".

Mrs. Radcliffe's Sunday tea parties were always masculine for friends of Fred's. Mrs. Radcliffe never asked girls; occasionally she had an old lady, a contemporary of her own. She gave out plainly that she intended to share her son's affections with no woman during her lifetime. She never thought of me as a woman; besides, Fred liked girls stylish and very English. She was not afraid of his liking me.

Mrs. Radcliffe was my English backbone. Her kind, practical strength of character was as a pole to a vine. In all my difficulties I went to her.

Mrs. Radcliffe had a dainty, little old lady friend called Mrs. Denny, who also was a widow with a son a good deal younger than Fred. The two men were warm friends.

Mrs. Denny had three little white curls dangling in front of each ear and wore widow bonnets with long crêpe weepers dangling behind. She was fragile, pink and white, and lowest low Evangelical in religion. Mrs. Radcliffe leaned towards the High Church. The ladies never discussed degrees of ritual, but confined conversation to their sons and to London. Mrs. Denny was as rabid a Londoner as Mrs. Radcliffe. She was as anxious to see "son Ed" happily married before she died, as Mrs. Radcliffe was determined that her son Fred should remain a bachelor. The ladies put their heads together and decided that, with some taming down and brushing up, I would be all right as a wife for Ed Denny. The first thing to be done was so to fill me with London that I would be quite weaned from the crudities of Canada.

Mrs. Denny said to me, "My dear, you stick far too close to that Art School; confinement is telling on your health. Now I tell you what we will do. Every Thursday my daughter Loo and I will call at your school at noon, take you out to lunch; then we will spend the afternoon exploring London. You will come back to dinner with us and Ed will see you home."

"But my work, Mrs. Denny!"

"One afternoon a week will make no difference. There is more to be learned in life than Art."

"Art is what I came over to London for."

"Who knows, you may love here, may never want to go back to Canada—"

"Oh, I hope not! I would not want that."

She kissed me, very fondly pinching my cheek. Then her fingers took hold of a little cornelian cross that I wore.

"Don't wear this as an ornament, child, it savours of R.C."

She never said "Roman Catholics" out loud, only whispered, "R.C." Once I saw her take a half-crown from her purse to tip a "Beef-Eater" who had conducted us round the Tower of London. Her hand was half out when the sun glinted on a little cross dangling from his watch chain. She slipped the half-crown back into her purse, substituted a shilling for it.

Under Mrs. Denny's guidance I saw a lot of London. She always carted a little red *Baedeker* under her arm with the "sight" we were "doing" marked by a slip of paper. We stood before the sight and read *Baedeker* and tried to memorize the date. The wretched part of these excursions was Ed's meeting us for tea. When we came out of the tea shops Loo and her Mother always took a quick, wrong turn on purpose, and left me alone with him for the rest of the time.

I would say, "Oh dear!" in dismay and start hunting them but Ed only laughed and said, "Don't worry, Mother knows her way about London as well as the nose on her face. They will be waiting at home." But it provoked me.

English women were horrid about this marrying business. They seemed to think the aim of every girl was to find a husband. Girl students "adored" their stuck-up, autocratic art masters, or their clergy or their employers. Men and women students did not work together in the Westminster Art School. I was glad. English husband-seeking girls shamed me.

Miss Green's PG's were all women—all silly. Shortly after I came to Miss Green's two men came up to London to see me. One was an Englishman from Liverpool whom I had met out in Canada. The other was the ship's doctor, an Irishman. The Englishman was a brother of Frank Piddington whom I had so detested as a child at home. Clifton had visited Frank in Canada. He did not ask me to marry him there, but came home to think it over and wasted a postage stamp on it. I could not have been more emphatic in saying, "No", but, as soon as he found I was in London, he came from his home in Liverpool to see how I looked in English setting. He sat very uncomfortably on the edge of a chair in Miss Green's drawing room. The PG's were all in a twitter.

When Clifton had got as red as he could get, he said, "Shall we go out and see some sights?"

Anything was better than that horrible drawing room, so I said, "That would be nice . . . what shall we see?"

"I have always had a hanker to see Madame Tussaud's wax works," said Clifton.

Off we went. We punched the real policeman, asked the wax policeman the way, tried to buy a catalogue from the wax dummy, watched the chest of the Sleeping Beauty hoist and flop. Then we came to the head of a dark little stair and a man asked us for an extra sixpence. Over the drop into a cellar was the notice, "Chamber of Horrors. Expectant mothers and nervous persons warned."

"Need we, Clifton?"

"Of course."

Sinking into that dim underworld was horrid. Red glistened and dripped from a severed head in the guillotine, King Somebody was lying in a bath of red ink, having cut his veins in suicide, Indians were scalping, murderers murdering,

villains being villainous. Once outside again, even the dirty London air seemed pure.

"What next, Clifton?"

"Well, I thought—Euston Station?"

"Must you be going so soon?" I said politely.

"Not for several hours yet . . . want to see the engines—very newest models, you know."

I said, "Oh!"

Clifton was an engineer; engines were meat and drink to him. He ran from platform to platform patting the snorting brutes as they slithered panting into their places, calling them "beauties", explaining their internals to me.

"You sit here. There is the four-thirty special. I must see her—the very, very newest."

I sat down on a luggage truck while he ran and dodged and ducked. Then I saw him engage the engineer in conversation. They investigated every bolt and screw of the miserable thing. He came back exhilarated. "Going to let me ride home in the cab with him! Starts in an hour, time for tea first."

We went to an A.B.C. and ate crumpets.

"Good-bye!" His hand was clammy with excitement, he gasped, "Very latest model!"

He grabbed my hand.

"It's been splendid! . . . the Chamber of Horrors, the engines—you."

I was relieved. It was so delightfully plain that this was to be our final meeting.

The Irish doctor's ship was in port. The doctor came to London and to the Art School.

"Impatient young man downstairs in the Museum waiting to see our young Canadian." Mr. Ford smiled at me and gave my arm an affectionate little pat. "Young man unable to wait till the janitor was free. Ordered my old bones to run upstairs and fetch you at once."

He rubbed a rheumatic knee. Dear old man! Descending the stair we saw that the janitor's amble was unusually brisk. He came lashing his feather duster and glowering down the aisle between the architectural tombs. There sat the little Irish ship's doctor on the stomach of a "Great One", impatiently kicking his heels against its stone sofa.

"Oh, doctor, their stomachs are sacred, please don't!"

He jumped down.

"Shall we go into St. James's Park and sit on a bench? It is quite close."

It was a wide bench. The doctor sat down on one end and I on the other. Soon he was so close to my end of the bench that I fell off. I walked round the bench and sat down on its other end,—he did not look nearly so nice or nearly so well-bred in plain clothes. He was ill-at-ease too, trying to make conversation.

I said, "Don't they squabble?" meaning the sparrows who, down in the dust, were having a battle over a crust. A dove swooped down and took the crust.

"Gentlest of all birds!—a dove—" sighed the doctor. He was slithering up the bench again.

"Doves squabble like the dickens," I replied.

The doctor said, "Your tongue is losing its Canadian twist; you have changed in these few months."

"I should hope so! Wasn't I flabby and ghastly? Let's walk."

I jumped up just as his hand touched my arm. We strode silent three times round the duckpond.

"What time is it?"—Being late for dinner is one of the unpardonable sins in England.

"Good-bye."

I held out my hand. He hurried South, I North, neither looked back. Was it his uniform, not he, that had been a little attractive? Perhaps doctors, too, prefer girls meek and sick.

But for that hint, I was grateful to the doctor. I was trying to speak more like the English, ashamed a little of what they ridiculed as my colonialisms. Bless you, doctor, for the warning! Unconsciously I'd tried to be less different from the other students,—I who had seen many Canadian-born girls go to England to be educated and come back more English than the English. I had despised them for it. I was grateful for the doctor's visit and I swore to myself I would go home to Canada as Canadian as I left her.

MRS. SIMPSON'S

ACROSS FROM the dim archway of the Architectural Museum was a tiny grocer shop owned and run by Widow Simpson, a woman mild-voiced and spare. The little·shop was darkly over-shadowed in the narrow street by the Architectural Museum. Pinched in between the grey of the street and the black of the interior, goods mounted to the top of the shop's misty window, pyramids of boxes and cans which Mrs. Simpson sold across a brown counter under a flickering gas jet, sold to ragged children and draggled women who flung their money upon the counter with a coppery clank. Mrs. Simpson's trade was "penny." She handed goods to children unwrapped but for the "lydies" she wrapped in old newspapers. At the back of the little shop was a door with a pane of glass inset. This door led into Mrs. Simpson's "Tea-room for Students." Here students, who wanted an entire light meal or to supplement their carried lunches, hurried at noon across Tufton Street, hatless, hungry and in paint-spotted pinafores.

The small Tea-room was centred by a round table on which stood a loaf,

potted meat, jam, apples, biscuits, cheese and butter cut into ha'penny portions. In the middle of the table stood a handleless delft cup. Business was run on the honour system. You ate a penny's worth, hurled a penny into the delft cup, ate another pennyworth and hurled in another penny. Anyone mean enough to cheat Mrs. Simpson was very low.

Mrs. Simpson trusted us about the food but not with her "cats and her kettles." On either side of the bars of the grate fire were black hobs and on them sat copper kettles. On the floor before the fire was a spread of cats, black, tortoise-shell and tabby, so close packed that they resembled an immense, heaving fur rug. No footgear but Mrs. Simpson's old felts could judge its placing among tails and paws. So Mrs. Simpson herself filled the great brown teapot over and over from the kettles. No one else was allowed to for fear they might scald a cat. When a kettle was empty Mrs. Simpson picked her way among students and cats to a tiny door in the corner and climbed two steps. On the first step she "shoo'd," on the second she "hist" and was answered by a concerted meowing. In her bedroom Mrs. Simpson kept special cats, along with the great jugs of fresh water drawn from some public tap in the district. The jugs were ready to refill the tea kettles and the cats to dart to alley freedom.

The Tea-room boasted two chairs and a stool. Mrs. Simpson usually lunched some dozen or more students. The first three got the chairs and stool, the next six sat on the floor, the remainder squirmed a foothold among the sitters and stood. It took planning to reach the food and to make sure it found its way into your mouth before somebody's elbow jogged and upset it.

The Tea-room window was never open. It looked into a small yard, piled with "empties." This place was the cats' opera-house and sports-field. It was very grimy, a vista of dim congestion, that filtered to us through a lace curtain, grey with the grime of London.

Mrs. Simpson's was a cosy, affectionate institution, very close to the Art School's heart. From Mr. Ford down to the last student every one spoke gently of the little, busy woman, faded, work-worn cockney. There was a pink ridge prominent above her eye-hollows. It was bare of eyebrows. Above the ridge was a sad-lined forehead. The general drag of her features edged towards a hard little walnut of grizzled hair, nobbed at the rounding of her skull.

Even in that slum setting there was something strong, good and kindly about Mrs. Simpson that earned our respect, our love. The men-students helped her "stock-take" and shamble through some crude form of bookkeeping. When the chattering, paint-daubed mob of us pressed through the shop into the little back-room Mrs. Simpson's smile embraced us—her young ladies and gentlemen—as sober and as enduring as the Abbey's shadow. We were the last shred of respectability before Westminster slummed. The Abbey had flung us over the Dean's Yard wall into Tufton Street. Too poor for the Abbey, too respectable for the slum, the Architectural Museum and the art students hovered between dignity and muddle.

L E A V I N G

M I S S G R E E N ' S —

V I N C E N T S Q U A R E

THE MAKE-BELIEVE gentility of Miss Green's Paying-Guest-House became intolerable to me. An injury received to my foot out in Canada was causing me great pain. Transportation from Miss Green's to the Westminster School was difficult and indirect. I made this my excuse to change my living quarters. Miss Green was terribly offended at my leaving her house. She made scenes and shed tears.

I took a room in a house in Vincent Square where two other Art School students lodged. One of these girls, Alice Watkin, was the girl in the school I liked above any other. The other student was the disagreeable head of the Life room. We three shared an evening meal in their sitting room. The disagreeable student made it very plain that I was in no way entitled to use the sitting room, except to eat the miserable dinner with them, sharing its cost. The room was dismal. It was furnished with a table, three plain kitchen chairs of wood, a coal-scuttle and a sugar basin. The sugar basin was kept on the mantelpiece. It was the property of "Wattie" and me who kept it full to help to work our puddings down. Because the disagreeable student was on diet and did the catering our meals were sugarless and hideous. Our grate fire always sulked. Old Disagreeable would often pour some of *our* sugar on the black coals to force a blaze.

Vincent Square was grimly respectable though it bordered on the Westminster slums. The Square lay just behind Greater Victoria Street. You could reach the Architectural Museum in an entirely respectable way by cutting through a little street into "Greater Victoria" which was wide, important and mostly offices. When you came to the Abbey you doubled back through Dean's Yard into Tufton Street and so to the Architectural Museum but this way was circuitous. The others always took it, but I cut through the slums because every saved foot-step spared me pain. The slum was horrible—narrow streets cluttered with barrows, heaped with discards from high-class districts, fruit having decay-spots, wilted greens, cast-off clothing. Women brushed their hair in the street beside their barrows while waiting for trade. Withered, unwashed babies slept among shriveled apples on the barrows.

I tried not to see too much slum while passing through. It revolted my spirit. Wattie said, "Don't go that way, Carlight"—that was always her name for me. When I came to the School motor-cars were just coming into use; they were fractious, noisy, smelly things. It was not a compliment to be called "Motor." Wattie had invented her own name for me. She never called me

"Motor" like the others, always "Carlight"!

"Carlight," Wattie pleaded, "don't go through the slum! How can you!"

"Oh, Wattie, my foot hurts so!"

I continued to limp through the murk, odours, grime, depravity; revolting ooze, eddying in waves of disgustingness, propelled by the brooms of dreadful creatures into the gutters, to be scooped into waiting Corporation wagons dripping in the street.

One raw, foggy morning, as I hobbled along, a half-drunk street-sweeper brought his broom whack across my knees. They bent the wrong way, my bad foot agonized! Street filth poured down my skirt.

" 'Ere you! Obstructin' a gent's hoccipation."

"Yer mucked the swell good, 'Enery," chuckled a woman.

"Let 'er look out, what 'er 'ere for, any'ow? Me, I'm a doin' of me dooty."

I boiled but dared not speak, dared not look at the creature. I could have fought. I think I could have killed just then. Doubling over, the nearest I could to a run, I managed to get to the school cloak-room.

Wattie found me crying over the wash-basin swishing my skirt about in the water, crying, crying!

"Carlight!"

"I got muddied, Wattie."

She groaned, "That wretched foot!" She thought I had tripped. She finished washing the skirt, took it off to the fire to dry, draped a cover-all apron over my petticoat, took me into her arms and rocked. That was Wattie's way. When one was in great tribulation she faced you, crooned, wound her arms round and rocked from side to side. She was such a pretty girl and gentle; had it not been for that clear-cut hardness of English voice, I could have forgotten her nationality.

Wattie would never have cried from being muddied. She would have squared her chin, stuck her high-bridged nose in the air but she would have kept out of slums and not have got herself muddied to begin with. English girls were frightfully brave in their great cities, but when I even talked of our big forests at home they shivered just as I shivered at their big, dreadful London.

While I lived in Vincent Square I breakfasted in my own room. The view from my window was far from nice. I looked directly across a narrow yard into a hospital. Nurses worked with gas full on and the blinds up. I saw most unpleasant things. I could not draw my own blind or I was in complete black—my landlady cut the gas off at dawn. She went by the calendar, not the weather, and daylight was slow piercing through the fogs of Westminster.

The landlady got a notion.

" 'Ere's wot," she said. "You eat in my 'sittin' ' downstairs; save me luggin' up, cosy fer yous."

I breakfasted there once only. Her "sittin' " window looked into a walled pit under the street which was grated over the top. The table was before it. Last night's supper remnants had been pushed back to make room for my cup and plate. A huge pair of black corsets ornamented the back of my chair. There was

an unmade bed in the room. The air was foul. The "sittin' " was reached by a dreadful windowless passage in which was the unmade bed of the little slatternly maid-of-all-work. I rushed back up the stair, calling to the woman, "I prefer to breakfast in my own room."

The woman was angry; she got abusive. I did not know how to tackle the situation, so, as was now my habit, I went to Mrs. Radcliffe, who immediately set out and found nice rooms near to her own. Wattie and I moved into them. Old Disagreeable remained in Vincent Square.

I could scarcely bear to put my foot to the ground. I had to stay at home, penned in dreariness, eating my heart out to be back at work. Wattie was away all day. London landladies are just impossible! Lodgers are their last resort. This woman had taken to drink. She resented my being home all day; there was no kindness in her. I had to have a mid-day meal. She was most unpleasant about it. She got drunk. With difficulty I hobbled to Mrs. Radcliffe. She was seated under an avalanche of newspapers when I burst in. The Boer War was at its height. Mrs. Radcliffe followed its every up and down, read newspapers all day.

Flopping onto the piano stool I burst into tears. "I can't bear it!"

Mrs. Radcliffe looked up vexed.

"What now, Klee Wyck! Dear me, dear me, what a cry-baby! Pull yourself together. A brisk walk is what you need. Exercise—exercise—That stuffy Art School!"

"My foot is bad. I *can't* walk."

"Corns? Nonsense, every one has *them*."

"It is not corns. Where is there a doctor? My foot will have to be cut off or something—I *must* get back to school."

"Doctor, fiddlesticks! You homesick baby! Stop that hullabaloo! Crying over a corn or two!"

The portière parted—there stood Fred. He had heard. I nearly died of shame. He was never home at this hour. I had not dreamed he would be in the dining room.

"Mother, you are cruel!"

I felt Mrs. Radcliffe go thin, cold, hard. Hiding my shamed, teary face in the crook of my arm I slithered off the piano stool. Fred held the door for me, patted my shoulder as I passed out.

"Cheer up, little Klee Wyck."

I did not cheer. Afraid to face the drunk landlady I crawled to a bus, scrambled to its top somehow, got close to the burly, silent driver, rode and rode. The horses were a fine pair of bays. I watched their muscles work. At the end of the route I put fresh pennies in the box and rode back to the start. Back and forth, back and forth, all afternoon I rode. The jogging horses soothed me. At dusk I went home.

"Mrs. Radcliffe has been twice," Wattie said. "She seemed worried about you—left these."

She held up a beautiful bunch of the red roses with the deep smell Mrs. Radcliffe knew I loved so well.

"I don't want her old roses. I hate her, I am never going near her again. She is a cruel old woman!"

"She loves you, Carlight, or else she would not bother to scold. She thinks it is good for you."

Wattie rocked, dabbing the red roses against my cheek as she rocked. Something scratched my cheek. It was the corner of a little note nestling among the blooms.

"Come to dinner tonight, Klee Wyck."

"Wattie, d'you know what hell would be like?"

"Father does not like us to joke about hell, Carlight; he is a clergyman, you know."

"This is not a hell joke, Wattie, at least it is only London hell! London would be hell without you and without Mrs. Radcliffe. But I must hurry or I shall be late for Mrs. Radcliffe's dinner, and she'll scold all over again."

"Good old Carlight. I am glad you are going."

All the houses in Mrs. Radcliffe's street looked exactly alike. I hobbled up the steps I thought were Mrs. Radcliffe's. A young man came out of the door. He stepped aside—I entered. The door closed, then I saw I was in the wrong house. I could not open the door so I went to the head of the stair and rang a bell. A woman came hurrying.

"I got in by mistake, please let me out."

"That's your yarn is it, Miss Sneak-thief; tell it to the police."

She took a police whistle from the hook and put it to her lips; her hand was on the door knob.

"Wait, really, honestly! A man came out and I thought he was the lodger above Mrs. Radcliffe, next house. I ran in before he shut the door. I am going to dine with Mrs. Radcliffe. Please let me out quick. She hates one to be late."

"A likely story!"

"It's true."

She opened the door but stood in front so there was no escape. Taking a leap in the dark, I said, "You know Mrs. Radcliffe; she often sends you roomers. Please ask Mrs. Radcliffe before you whistle the police."

The woman paused, she did not wish to lose custom. My chance leap had been lucky. I had not really known which side Mrs. Radcliffe lodged her visitors. I knew only that it was next door. The woman let me out, but she watched, whistle to lips, till I was admitted to Mrs. Radcliffe's.

Dinner had just been brought up. Fred laughed when I told my story. Mrs. Radcliffe frowned.

"You always manage to jump into situations, Klee Wyck! My nieces don't have these experiences when they come to London."

"They are not Canadian, perhaps."

"Some are."

"But Eastern Canadians. I come from far, far West."

Mrs. Radcliffe smiled, gentler than I had ever seen her smile.

"I have made an appointment with my surgeon-cousin. He is going to have a look at that foot of yours tomorrow," she said.

PAIN AND

MRS. RADCLIFFE—

THE VICARAGE

THE DOCTOR found my foot had a dislocated toe, a split bone—results of an old injury. His treatment made no improvement.

"We will have to amputate that toe," he said. "I do not care to do it, though, without the consent of your home people; your general condition is bad."

"To write home and wait an answer will take so long, do it this afternoon. I want to get back to school. Please do it quick."

"Not so fast. The fact is I do not care to take the responsibility."

"It's my foot. I have no parents."

"Tell cousin Marion to come and see me," said the surgeon. Mrs. Radcliffe went.

"I will accept responsibility," she told her cousin. "If that toe must come off, do it." To me she said, prefacing her words as usual with "dear me!"—"My cousin is a good surgeon. If he says amputation is best, it is. You don't mind, I suppose, don't feel sentimental over a toe?"

"Goodness, no! I only want to get back to work."

"Of course a toe is not like your hand or head. I've told Cory to go ahead," said Mrs. Radcliffe.

The foot went wrong. I suffered cruelly. Every day Mrs. Radcliffe tramped clear across London in fierce heat to sit by my bed. She kept a vase full of red roses, velvety red ones with the glorious smell, always fresh by my bedside. She sat close, rocking in a rocker. The toe of her shoe struck the bed with every rock, each vibration was agony, but I would not cry out. I bit my lips and my cheeks were scarlet.

She said to the nurse, "Klee Wyck looks fine! Such bright colour! That foot must be doing splendidly!"

"She is suffering," said the nurse.

"Oh, well! The restless creature—doubtless she bangs that foot about all night."

I longed to yell, "Turn the cruel old thing out!" and yet, when Mrs. Radcliffe had gone, I turned my face into the pillow crying, counting the hours until she would come again. She was my strength; without her I was jelly.

Mr. Ford sent his daughter with flowers. Aunt Amelia Green came, wagging her pinched little head, saying, "I told you. . . . You should never have left my house. My Canadian nieces were the same—wayward."

Wattie had won her diploma. She was down in Cambridgeshire, at her Father's vicarage. She wrote, "Come to us, Carlight, the moment they will let you leave the nursing home. You will love the vicarage garden, the wonderful old church. I will take such care of you."

When Wattie left London I had moved to Mrs. Dodds' big boarding house for students.

The vicarage garden was a tangled wilderness, the church and vicarage tumbling down. The Vicar had passed his eightieth year and was doddery. He was, however, still possessed of a beautiful intoning voice, so the Church retained his services. Wattie from her seat in the choir, her sister from the organ bench, agonizingly watched their father. After the Vicar had filled the solemn old church with his voice, reading lessons and intoning the service, his strength was spent. Tottering up the pulpit stair, gasping out the text of his sermon, his eye roved vaguely over the congregation. A halting sentence or two, a feeble lifting of his arms to bless, the congregation was dismissed to its dinner.

But for the old man's prattle Sunday dinner in the vicarage would often have been very sad. One after the other his three daughters taking me aside said, "Father ought to be retired," but, in the next breath, "Isn't his intoning voice rich and mellow?" They were proud of him, but the Church was not being fair to the congregation.

The vicarage garden was high-walled with red brick circled by venerable elm trees in which was a rookery. Daws and starlings chattered around the disused stable. The Vicar could not afford to keep a horse. He had an old gardener, an old cook, and an old nurse to maintain as well as himself and three daughters. The daughters helped to eke out the living expenses by teaching drawing and music and by running his house. The cook was too old to cook, the gardener too old to dig, the nurse too old to be bothered with children; besides, the vicarage nursery had been empty for the last fifteen years.

Wattie, scouring the unpruned rose bushes for a house posy, said to me, "Our gardener is beyond work, besides which he is lazy and drunken."

"Why don't you sack him?"

"Carlight! Sack an old servant! In England servants remain with us until they die."

"What do they do?"

"Cook can still peel potatoes. The gardener sweeps up the paths, when he is

not too drunk to hold the broom. Nurse dusts the nursery and makes our underwear all by hand."

"Can't she run a sewing machine?"

"Our family wearing machine-made body linen! Oh, Carlight!"

"Dozening hand stitches when you could million better, stronger ones by machine! Life's too short! Come to Canada, Wattie."

"Canada! Why, Carlight? England is the only place in the whole world to live."

"Your brothers have all gone abroad, haven't they?"

"Men are different, more adventurous. The world needs educated Englishmen. All my seven brothers went to college. It meant pinching a bit at home. They have all done so well for themselves in the Civil Service—India, China . . ."

"Why don't they do a bit for you girls now, make up for your pinch? Why should everything be for the boys and men in England?"

"Mother brought us up that way—the boys first always. The boys have wives now."

"I'm glad I'm Canadian! I don't like your English ways, Wattie!"

"Being English is my greatest pride, Carlight."

A narrow, walled way led from the side door of the vicarage to the church vestry, a sombre interlude in which to bottle secular thoughts and uncork sacred. Through a squeaky, hinged gate you could pass from vicarage garden to churchyard, from overgrown, shady green to sunny, close-clipped graves. Some of these had gay posies snuggled to the tombstones. Some stones staggered and tipped, almost as if they were dancing on the emerald turf. Everything was so sombre about the vicarage and church it made the graves seem almost hilarious. Gaiety accompanied you through the churchyard, but, at the threshold of the church the merry spirit fell back into the sunlight, sky, air of the graveyard. The church was too dead, too dreary for that bright spirit. It belonged to life, to perpetual living.

"Rebellious Carlight!" Wattie would say, with a shake of her head, and a few swaying rocks to my shoulders. "Rebellious little Carlight!"

There had been moments when I nearly envied Wattie's uneventful calm at Art School. We worked easel-to-easel. Wattie's work was stable, evenly good. Sometimes my work was better than hers, sometimes worse. She neither lifted nor sank. She had enough South Kensington certificates to paper the Vicarage. I had none. She new Art History from the Creation to now. She knew the Elgin Marbles and the National Gallery, the South Kensington Museum, all the art treasures of London. She knew the anatomical structure of the human body, bone for bone. She stepped with reverent tip-toeing among the stone couches of the "Great Ones" in the Architectural Museum, but neither our Art nor our hearts had anything in common other than that we loved one another deeply. Each went her own way unfalteringly, staunch to her own ideals. When our ideals clashed, each jumped back into silence, because we wanted to keep both our friendship and our own opinion.

KICKING THE REGENT STREET SHOE-MAN

MRS. RADCLIFFE'S surgeon cousin advised a surgical support in my shoe.

"I will take her to my own shoe-man in Regent Street," said Mrs. Radcliffe and off we went.

My foot was very sore, very painful to the touch, for a long time after the operation.

I said to the fitter, "Do not handle the shoe when it is on my foot, I will put it on and off myself."

It was a very swell shop. The clerks were obsequious, oily tongues, oily hair, oily dignity and long-tail black coats like parsons. Our salesman was officious, he would persist in poking, prodding, pressing the shoe to my foot in spite of my repeated protests.

At last angry with pain, I shouted, "You stop that!"

Mrs. Radcliffe explained to him that I had recently had an operation on my foot which had left it tender. The man still persisted in pinching; after he had forced about seven squeals out of me, I struck with the well foot giving the princely creature such a kick square amidships that he sprawled flat and backwards, hitting his head against a pile of shoe boxes which came clattering down on him spreading him like a starfish. Every customer, every clerk in the store paused in consternation while the enraged shoe-man picked himself up.

"Klee Wyck!" gasped Mrs. Radcliffe.

"Well, he would persist when I told him not to," I cried. "Serves him right!"

I dragged on my old shoe by myself and we left the shop, Mrs. Radcliffe marching in stony, grim quiet while I limped beside her, silent also.

We waited for our bus, standing among all the Oxford Circus flower women on the island. The flowers were gay in their baskets, the women poked them under our noses, "Tuppence-a'penny a bunch, lydy! Only tuppence!"

"Um, they do smell nice, don't they, Mrs. Radcliffe?"

Mrs. Radcliffe's thoughts were back in the Regent Street shoe shop.

"Thirty years," she moaned, "I have dealt there! Dear me, dear me! I shall never be able to face those clerks again."

Our bus jangled up to the curb. We got in. I knew I was not a nice person. I knew I did not belong to London. I was honestly ashamed of myself, but London was . . . Oh, I wanted my West! I wasn't a London lady.

ARE YOU SAVED?

I TOOK MY LETTER from the rack and read it while waiting for Mrs. Dodds, my landlady, to finish totting up a long row of figures. I liked going down to pay my weekly board. Mrs. Dodds' office was cosy, she was kindly. She knew London like a book and could tell every one of her fifty lady-student boarders all they wanted to know about everything and every place in the world.

"I won't!" I exclaimed, reading down the page. Mrs. Dodds looked up from her figuring.

"Won't what?"

"Pay a snot-visit in Upper Norwood over the week-end. I don't know the people."

"The Handel Festival is being held this week; it is in the Crystal Palace which is at Upper Norwood. Probably that is why your friends are inviting you down. Don't miss a treat like that, child."

"They are not my friends, I've never seen them. My sister did the woman a kindness when she was ill out in Canada. The woman thinks she ought to pay back."

"Well, let her.—Why not?"

"She does not owe me anything. They have money. I refused to bring over a letter of introduction to her. I won't have anybody feel they have got to be good to me because my sister was good to them. They don't owe me a thing!"

"Take all the fun that comes your way, don't be stupid. That foot operation has taken it out of you. Go, have a good time."

"I'd like to hear that festival all right!"

On reconsidering, I wrote, "I've had an operation on my foot. I still limp. If you will excuse a limp and a soft shoe, I would be pleased, etc. . . ."

I loathed the snoopy little woman with boiled-gooseberry eyes from the moment I saw her peering down the platform looking for something resembling my sisters. She knew all about my foot and that I was just out of nursing home—my sister had written her. They had corresponded ever since they met in Victoria.

"I suppose you can walk? It is only one mile."

"No, I am afraid I cannot."

"Then shall I call you a cab?"

She made it plain that it was *my* cab. When we got to her gate she turned her back till I had paid the cabby.

"You do not look the least like any of your sisters."

"So I believe."

They were people of very considerable means. On the way from the station she told me that her son had been in the Boer War. He got enteric. The whole family—father, mother, three sisters and the son's fiancée—had gone out to South Africa to bring him home. They were just back.

"It was such a nice little pleasure jaunt!"

That was the scale on which these people could afford to do things. Six passages to Africa cost a great deal of money!

All the way in the cab she had stared at me.

"No," she said, "I see no resemblance whatever. Three fine women—if ever there are fine women outside . . ." She stopped to consider and added, "Three Godfearing, fine women."

She led me into a tasteless, chapel-like, little drawing room, its walls plastered with framed texts and goody-goody mottos.

"Put your foot up!" indicating a hard shiny sofa in an alcove. As soon as I was settled, she drew a chair to the side of the sofa, also arranged a small table on which stood an aspidistra plant, that beastly foliage thing so beloved of English matrons, because it requires no care, will thrive in any dingy room. English boarding houses always have aspidistras. I think it is the only growing plant that I loathe; it is dull, dry, ugly. When the woman had securely barricaded me into the alcove by her disagreeable self and the hateful plant she turned full upon me her gooseberry-green stare, scummed over the green with suspicion, mistrust and disappointment.

Again she stabbed, "You differ from your family." Then in a voice, harsh, hateful, cruel, "Are you saved?"

Quite taken aback I faltered, "I . . . I . . . don't know . . ."

"That settles the matter, *you are not!* I know that I am saved. I know that my entire family—myself, my husband, our three daughters, my son, my son's fiancée—all are saved, thank God!"

She rolled her eyes over the aspidistra, as if she pitied the poor thing for not being included in family salvation.

The door opened, in marched her three daughters, two stumpy, one lank. Behind them came a maid carrying the tea tray. All the girls had strong, horsey, protruding teeth like their mother. Introductions followed. I was so shaken by my sudden shove into damnation that, not being yet fully recovered from my illness, tears came. I had to wink and sniff during the introductions to the daughters. For five minutes nobody spoke; strong, white teeth chewed insufficiently buttered muffins, hard lips sipped tepid tea. I did the same. The silence got unwelcome. I wanted to reinstate myself after my lack of self control. Mama was obviously upset that my salvation had been interrupted by tea. She drank three cups silently and straight off in long earnest gulps. Looking out of window, I cried, "Oh, is that the roof of the Crystal Palace glittering over there?"

"Yes."

"That is where the Handel Festival is being held, is it not?"

"Yes."

"Have you seen Beerbohm Tree in *Henry the Eighth?* I was taken last night, it was simply splendid!"

Silence.

"I heard the *Elijah* in Albert Hall last week. The vast enclosed empty space made me feel quite queer when we first went into the hall. Does it make you feel that way?" I turned to the lean daughter as being most human.

"No."

The girl was fingering the harmonium in the centre of the drawing room.

"Are you fond of music?" I ventured, and from Mama, in a tornado burst, came, "*Our music* is hymns at home. Of that, yes! Of concerts, theatres, NO! We are Christians."

"But . . . the *Elijah*, the *Messiah*, are sacred." I faltered.

"Sacred! The worst music of all! What do those professionals think of as they sing? Their own voices, their own glory, not the glory of God. We are Christians. We would not attend such performances."

A hymn book fell off the harmonium. Did I see the lean daughter's foot steal towards it as if she would kick it under the instrument? Mama stooped and replaced the book on the harmonium.

"I am very tired," I pleaded. "May I go to my room and rest a little?"

The lean daughter showed me the way, but she did not speak.

Next morning a letter was passed round at breakfast. The lean daughter tossed it across the table to Father when she had read it.

The eldest daughter remarked, "What luck, dear Mama!"

"Providence, not luck, my child!"

The lean daughter scowled and Mama announced, "Brother Simon and Sisters Maria and Therese will be with us for luncheon." Turning to her son, "It is my wish that you be here for lunch, my son. Brother Simon and the Sisters will wish to see you and ask about Africa."

In an aside the lean daughter whispered in my ear, "Relatives by faith, not by blood!"

"Certainly I will be present, dear Mama," said the son of the house.

Faint and chill the door bell tinkled under the hand of Brother Simon at noon. It was as if the pull were frozen by Brother's touch, but the maid heard and admitted. Mama left the drawing room; there were whisperings in the hall, whisperings that chilled me but made my ears burn. I was introduced. Six eyes tore me as a fox tears a rabbit.

"Let us pray," said Brother Simon, lifting fat red hands—the finger nails were very dirty. We all flopped where we were and ducked our noses into the seats of the chairs. My chair was in the bay window close to the street. I felt as if I were "praying on a housetop." I was sure passers-by could hear Brother's roar.

At every footstep I peeped to see how pedestrians were taking it. Suddenly I heard my own name bellowed by Simon. He was explaining me to God as "the stranger within our gates." He told God mean things about me, such personal things as made me feel almost as if I were eavesdropping. He told God that I came of religious stock but that I was rebellious. I felt my face was crimson when I got up from my knees.

The maid was in the doorway waiting to announce lunch. She looked very sorry about something, either a beastly lunch or my sins.

The lunch was certainly dreadful. The three visitors bragged how they had defied nurses and doctors to crawl to the bedsides of dying men in Africa for a last remonstrance with them about their sins. They discussed fallen soldiers with the son of the house.

"Was he saved?"

"No, no! I said a few words but I fear. . . ." Not one of those dead soldiers did Brother Simon credit with being saved or deserving to be.

At last lunch was over. The three trailed drearily away; they were booked for a religious meeting. All embraced Mama and the girls effusively. I'd have done them a damage had any of their kisses attacked my cheek. Brother took my hand in a clammy grip. One of his hands below mine, the other on top, was like being folded between raw kippers. "I shall," he said, "continue to pray for you, my child!"

"Thank you, dear Brother," murmured Mama. The kippers fell apart, releasing me.

The lean daughter's hand slipped through my arm, her whisper was directed straight into my ear. "Brother and Sisters by faith, *not* by blood, thank God!"

QUEEN VICTORIA

ONE DAY when Wattie and I were crossing Leadenhall Street we were halted by a Bobby to let a carriage pass. The wheels grazed our impatient haste. We looked up petulantly into the carriage and our eyes met those of Queen Victoria, smiling down on us.

Chatter ceased, our breath held when Her Majesty smiled right into our surprised faces. She gave us a private, most gracious bow, not a majestic sweeping one to be shared by the crowd. The personal smile of a mother-lady who, having raised a family, loves all boys and girls. The carriage rolled on. Wattie and I stared, first after the carriage, then at one another.

"Carlight—the Queen!"

How motherly! was my impression. The garish, regal chromos on Mrs. Mitchell's walls had been Queens only. This kindly old lady in a black bonnet was woman as well as Queen.

Wattie had never before seen the Queen close. She had been only one of a bellowing multitude watching her pass. She was tremendously excited.

Having just won her final South Kensington teaching certificate she was tip-toey anyhow and she was going out to a married brother in India for a year. I had moved to Mrs. Dodds' big boarding house for students in Bulstrode Street. Wattie had run up to London to bid me goodbye.

Mrs. Radcliffe, surrounded by the daily newspapers, was as near tears as I could imagine her being. Mrs. Denny opposite was openly crying, curls bobbing, handkerchief mopping, the delicate little face all puckered. In the students' boarding house all was silent, the usual clatter stilled. London had hushed, England was waiting and Queen Victoria lay dying. Bulletins were posted every hour on the gates of Buckingham Palace. We stole out in twos and threes all through the day to read them. The ones at home looked up on our return, saw there was no change, looked down again. Every one was restless. Fräulein Zei-gler, the German, at present cubicled in our room in Bulstrode Street, was retrimming her winter hat. From his moth-ball wrappings she took a small green parrot with red beak and glassy eyes. Smoothing his lack-lustre plumage she said, "So, or so, girls?" twisting the mangy bird's stare fore, then aft. Advising heads poked out between cubicle curtains. Nobody's interest in the German woman's hat was keen.

"Extry! Extry! 'Er Majesty gorn!" shrilled the newsboys. Everyone took a penny and went out to buy a black-bordered "Extry." Then they read the bulletin posted on the gate which said,

"Osborne, January 23, 1901.
My beloved Mother has just passed away, surrounded by her children and grandchildren.

Signed 'Albert Edward'."

The following morning, passing through St. James's Park on my way to school, I was halted for a passing carriage. In it sat the new, uncrowned King—Edward VII. He looked sad and old. When they had said to him, "The Queen is dead. Long live the King!" he had replied, "It has come too late!"

I remarked to Wattie, "Queen Victoria might have sat back and let Edward reign a little before he got so old."

"Carlight! It is poor taste to criticize England's Queen, particularly after she is dead."

"She was our Queen too, Wattie. All the same, I do not think it was fair to Edward."

London completely blacked herself. It was ordered so. Shops displayed nothing but black, lamp posts and buildings draped themselves in black rag which

fog soon draggled. Bus-horses wore crêpe rosettes on their bridles. Black bands
were round the drivers' arms, cab and bus whips floated black streamers. Crêpe
was supremely fashionable. The flower women couldn't black the flowers so they
favoured white and purple varieties, ignoring the gay ones. Dye-shops did a
roaring trade; so many gay garments visited them and returned sobered. The
English wallowed in gloom, glutted themselves with mourning.

On the first black Sunday Marie Hall, a young violinist in our house, asked
to come to service in the Abbey with me. Young Marie, sure of herself since
Kubelik had kissed her and told her she was the prodigy of the day, had just
bought a new hat—bright cherry. "I don't care. It's my only hat; I shan't black
it."

Instead of sitting in her usual seat beside me, Mrs. Radcliffe crossed to the far
side of the Abbey. After service she whispered coldly in my ear. "How could you,
Klee Wyck! The whole loyal Abbey blacked—that screaming hat!"

"Can I help it, Mrs. Radcliffe, if an English girl won't kill her hat in honour
of her dead Queen?"

In the boarding-house Fräulein angrily removed the green parrot. "I don't see
why I should," she grumbled, rolling "Polly" back in his moth-ball wrappings,
slapping a black bow in his place and sulking under it.

The funeral preparations were colossal. Every Royalty in Europe must be rep-
resented. Mouse-like queens no one had ever heard of came creeping to the
show—and Kaiser William with his furious moustachios! Hundreds of bands
throbbed dead marches, the notes dragging so slow one behind another the tune
was totally lost. London's population groaned and wept.

I did not want to go to the Queen's funeral procession—Little Kindle, my
cubicle neighbour in the new boarding house, begged, "Come on, you may
never see such another."

We rose at five; at six we took position in the Piccadilly end of St. James
Street, front row. The procession was not due till eleven. In one hour we had
been forced back to the sixth row by soldiers, police and officials who planted
themselves in front of us. In defiance of the law, I carried a little camp-stool, but
by the time I was sitting-tired the crowd was too tight to permit my doubling to
sit. You could not even raise an arm. St. James Street had a gentle rise, the upper
crowd weighted down on those below. Air could only enter your mouth, you
were too squashed to inflate. Each soul was a wedge driven into a mass as a
tightener is forced into an axe handle.

Those with seats reserved in upper windows along the route came much later
than the crowd. Police tore a way for them through the people. The seat-holders
hanging on to the Bobby, the crowd surged into the gap to better their position.
They fought tooth and nail.

"Kindle!"

She half-turned, looked, groaned, pounded a Bobby on the vertebrae, said,
"My friend, get her out quick, Bobby."

"Way there! Lydy faintin'!" shouted the policeman.

A great roaring was in my ears—then nothing. I recovered, draped over an

area railing in a side street. I was very sore, very bruised.

"My camp-stool, Kindle?"

"Back among the legs—rejoicing in the scoop it took out of my shin. I told you not to bring the thing!"

She bound a handkerchief round her bloody stocking.

"Come on," she growled.

"Home?"

"Not after we have waited this long! The Mall, it's wide; hurry up!"

I dragged. I know exactly how a pressed fig feels.

I saw a corner of the bier, Kindle saw the Kaiser William's moustachios. Oh, the dismal hearing of those dead-march bands, which linked the interminable procession into one great sag of woe, dragging a little, old woman, who had fulfilled her years, over miles of route-march that her people might glut themselves with woe and souse themselves in tears on seeing the flag that draped the box that held the bones of the lady who had ruled their land.

E N G L I S H S P R I N G

THE WESTMINSTER Art School closed for a short Easter recess, when I had been nine months in London, nine months of hating the bustle, the crowd, the noise, the smell.

I said, "Mrs. Radcliffe, is there a little village that you know of where I could go and be in real country?"

"There is the village of Goudhurst in Kent. It has a comfortable Inn; I have stayed there myself."

There was another student in the school who came from Victoria. She decided to come to Goudhurst for the holiday, too.

The village was a tiny sprawl of cottages on the top of a little hill. We were met and wavered up the Goudhurst Hill by the Inn's ancient host and his more ancient horse and chaise. The village was all of a twitter because tomorrow the Butcher's daughter was to marry the Baker's son. Everyone was talking of the coming event.

The Inn parlour was low-ceiled, and beamed. There was a bright fire on the open hearth and its glow pinked the table cloth, the teacups, and the cheeks of our host and hostess, who were garrulous about the wedding.

My bedroom was bitterly cold, the bed felt clammy with damp. I woke to a sharp spring rain next morning, but the sky did not want to wet the wedding, clouds scuttled away and soon the sun shone out. Villagers swallowed hasty

breakfasts and hurried with flowers to decorate the church which was just across from the Inn.

I too hurried across the churchyard but not to the wedding. I saw a wood just beyond the graves. There was a stile across the graveyard fence. Thrushes, blackbirds, every kind of song bird was shouting welcome. From the centre of the graveyard two larks rose up, up—wings and song twinkling. The notes scattered down to earth clear as rain drops. I sat one moment on top of the stile. The church bells began to peal such a merry jangle. They must have seen the bride coming down the village street and were reporting to the people. Dog carts, pony carts, chaises from all over the neighbourhood nosed up to the churchyard fence, dogs barked, a donkey brayed—long, derisive, melancholy brays. I climbed over the stile. The gravestones were blackening with sitters waiting the bride.

I heard enough churchbells, saw enough people in London. I pressed hurriedly into the wood, getting drenched by the dripping greenery. Deeper, deeper I penetrated among foliage illuminated by the pale, tender juices of Spring. There were patches of primroses pale as moonlight, patches of bluebells sky colour, beds of softest moss under my feet. Soon my feet were chilled and wet.

"Cuckoo, cuckoo!" Live throats uttered the call I had heard voiced only by little wooden painted birds connected with a mechanical apparatus, unmannerly birds who shrieked "cuckoo!", burst open a door in the front of the clock and slammed it shut again. Violent little birds!

"Oh, London! Oh, all you great English cities! *Why* did you do this to England? Why did you spoil this sublime song-filled land with money-grabbing and grime?"

Baby daffodils hooked the scruffs of their necks up through the moss under my feet; those whose heads were released from the moss were not yet bold enough to nod. Spring was very young. I was so happy I think I could have died right then. Dear Mrs. Radcliffe, I loved her for directing me to Goudhurst. I would gather a big boxful of bluebells, primroses and daffodils, post them for her Easter in London. Oh, the spring smells! The lambs bleating in the field beyond the graveyard! The shimmer of the greenery that was little more than tinted light! How exquisite it all was! How I hated to go back to London!

I burst in on Mrs. Radcliffe, reading the war news as usual.

"Mrs. Radcliffe! Oh, oh, oh!"

"You like our English Spring, Klee Wyck?"

Mrs. Radcliffe was not a kissy person. I was shy of her, but I could not help what I did. I attacked from behind her chair. Her cheek was not soft, nor used to being kissed—my hug knocked her hat crooked.

"Dear me, dear me!" she gasped. "What a—what a 'Klee Wyck' you are, child!"

My Sister's Visit

I HAD BEEN a year in England when my favourite sister came from Canada to visit me.

Wild with excitement I engaged rooms in the centre of the sightseeing London. Houses and landladies had to be approached through a rigorous reference system of Mrs. Radcliffe's. I pinned my best studies on the wall of the rooms, thinking my sister would want to see them.

She came in the evening. We talked all through that night. At five A.M. my senses shut off from sheer tiredness. My last thought was, "She will want a pause between travel and sightseeing."

At seven the next morning she shook me.

"Wake! What sight do we see today?"

"Won't you want to rest a little after travel?"

"The trip was all rest. I am a good traveller."

We started off. She entered the sights in her diary every night—date, locality, description.

At the end of a week I remarked, "Not interested in my work, are you?"

"Of course, but I have not seen any."

"I suppose you thought these were wallpaper?" pointing to my studies on the wall. My voice was nasty. I felt bitter. My sister was peeved. She neither looked at nor asked about my work during the whole two months of her visit. It was then that I made myself into an envelope into which I could thrust my work deep, lick the flap, seal it from everybody.

MARTYN

MARTYN came all the way from Canada to London just to see me and with him he lugged that great love he had offered to me out in Canada and which I could not return. He warned of his coming in a letter, carefully timed to be just too late for me to stop him even by wire. For I would have pleaded, "Dear Martyn, please don't come."

I had been spending the long summer holiday with friends in Scotland. I got his letter there. I had been on the point of returning to London, but, on receipt of that letter, I dallied. It made me unhappy. I wanted time to think.

Martyn got to London first. He was on the platform at Euston waiting for me, had been in London for three days rampaging round, nearly driving my landlady distracted by his frequent—"Have you heard anything of her yet?"

But Martyn on the platform at Euston Station was like a bit of British Columbia, big, strong, handsome. I had to stiff myself not to seem too glad, not to throw my arms round him, deceiving him into thinking other than I meant. He gave me all sorts of messages from everybody at home. Then he searched my face keenly.

"How tired you look!"

"I am, Martyn; please take me straight home."

In the cab we were silent. On my doorstep he said, "What time tomorrow?"

"I am meeting Mrs. Radcliffe at the Abbey door at five to eleven—join us there."

He frowned. "Must she be along? Must anyone but you and me?"

"Mrs. Radcliffe and I always sit together in church. She is fine—you will like her."

Mrs. Radcliffe and Martyn impressed each other at once. Martyn was Canadian born but his parents had raised him ultra-English. After service Mrs. Radcliffe, with a coy smile and one or two "dear me's", left us, taking her way home by a route entirely different to the one that was her habit.

"Goodbye, children!" I don't know how many "dear me's" her eyes twinkled as she said it.

"Bring your friend in to tea with me this afternoon, Klee Wyck." In one of her piercing, tactless whispers she spilled into my ear, "Poor Eddie!"

Martyn and I were alone, Mrs. Radcliffe's back fading down Great Victoria Street.

Martyn asked, "Who is Eddie?"

"The friend of Mrs. Radcliffe's son, Fred."

Martyn frowned. We walked along quiet and stupid.

After lunch Martyn called for me and we went to Kensington Gardens and got things over, sitting uncomfortably on a bench near the lake side. Everywhere was black with children and their nurses. The children sailed boats on the lake and shrieked. The roar and rumble of London backgrounded all sounds. I was glad of London's noise that day and of her crowds.

Martyn had three months' leave. I undertook to show him London. Mrs. Denny and Eddie, Mrs. Radcliffe and Fred, as well as my many solitary pokings round the great city, had made me an efficient guide. Every day at four o'clock I found Martyn ambling among the tombs of the "Great Ones" down below our workrooms at the Architectural Museum, his eyes always directed to the doors leading off the upper balcony of the great hall, closed doors behind which we studied. From his office old Mr. Ford gave us a kind smile as we passed, politely amused smiles but never objectionable nor coy like the ones English ladies and the students lipped at you when they saw you with a man.

I showed Martyn every sight I thought would interest him. We went to the theatres. Martyn liked Shakespearian plays best, but it did not matter much what the play was, whenever I took my eyes off the stage I met Martyn's staring at *me*.

"What's the good of buying tickets!" I said crossly—"you can see my face for nothing any day." He asked me on an average of five times every week to marry him, at my every "No" he got more woebegone and I got crosser. He went to Mrs. Radcliffe for comfort and advice. She was provoked with me about Martyn, she kept his time, while I was at school, divided between intercession services and sentimentality. I wished she would tell him how horrid, how perverse I really was, but she advised patience and perseverance, said, "Klee Wyck will come round in time."

We used to go to tea at the Radcliffes' every Sunday afternoon, stay on and go with her to the Abbey for evening service. One night Mrs. Radcliffe and I were putting on our hats in her bedroom. She returned unexpectedly to the sitting room for her scarf and surprised Martyn on his knees before the fire warming my cloak. He was patting the fur collar as if the thing were a live kitten. Mrs. Radcliffe was delighted.

"Dear me! So romantic, Klee Wyck! Don't be a fool, child!"

"He's a silly goat!" I snapped.

Ever after that night, when Mrs. Radcliffe spoke to me of Martyn, she called him the Knight of the Cloak.

Martyn and I had one perfect day during his stay in London—the day we went to Epping Forest. For a long, long day Martyn promised me that he would not *ask* that day. You could depend on Martyn to keep his promises.

First we pretended that Epping Forest was our Canadian woods, but it was no good, there was not one bit of similarity. We gave up and sipped England's

sweetness happily. Here were trees venerable, huge and grand but tamed. All England's things were tame, self-satisfied, smug and meek—even the deer that came right up to us in the forest, smelled our clothes. There was no turmoil of undergrowth swirling round the boles of the trees. The forest was almost like a garden—no brambles, no thorns, nothing to stumble over, no rotten stumps, no fallen branches, all mellow to look at, melodious to hear, every kind of bird, all singing, no awed hush, no vast echoes, just beautiful, smiling woods, not solemn, solemn, solemn like our forests. This exquisite, enchanting gentleness was perfect for one day, but not for always—we were Canadians.

We hired a pony and cart and drove through the straight *made* roads of the forest, easy, too easy. Soon we returned the pony and went on foot into the forest's lesser ways. Here greenery swished against us, rubbed shoulders with old tree boles. It was good to get our feet on the grass-grown paths and against the cool earth. When we came into the wider ways again, we took hands and ran. Martyn gathered some sprigs of holly for me in the forest.

The woman who hired us the pony said, "Keepers would jail ye shure, ef they sawed you with that there 'olly."

It had never occurred to us we could not gather a twig. At home we might take anything we wanted from the woods.

Epping Forest was honey sweet—rich as cream. That was a perfect day, but too many days like that would have cloyed. We ate our picnic lunch among the trees, enjoying it thoroughly, but all the while there was a gnaw in us for wild, untrimmed places. This entranced, the other satisfied; this was bounded, the other free.

Martyn and I made a great many mistakes in England not realizing that we were doing wrong according to English standards.

One evening we took a bus ride and at the terminus got off to walk in the cool. Tiring, we stepped inside a wide open gateway and sat down on a bench to rest. The place appeared to be a park, no house was in sight. Very soon a man came and walked round our bench several times, staring at us. He went away and brought another man. They both stood staring at us. Simultaneously they shouted, "How dare you!"

Seeing they meant us, Martyn asked, "How dare we what?"

"Trespass."

"We are only resting a few moments, the gate was open."

"Do you think select tennis clubs are for the resting of vagabonds?"

They drove us out and locked the gate. I had difficulty keeping Martyn cool.

"Hateful snob-country! Emily, come home," he begged.

After Art School one late autumn day we went to walk in Kensington Gardens. It was one of Martyn's *asking days*; they always depressed us.

"Come," I said, "it must be near closing time."

Martyn looked at his watch—"Half an hour yet." We sauntered to the great gates; to our horror we found them shut, locked. Nobody could possibly scale

that mile-high iron fence. There we stood between the dusking empty gardens and the light and roar of Piccadilly.

I said, "There is a keeper's lodge close to the Albert Memorial, Martyn. He has a tiny gate. I've noticed it."

We tapped at the door of the lodge and explained that, being strangers, we did not know about winter hours—this it seemed was the first day of the winter change; the time had been hurried on by half an hour. The man said vile things, was grossly insulting. Martyn boiled at the things the man said, the language he used before me. It was all I could do to hold him back.

"Don't," I whispered, "let us get out first."

The man led to the little gate, stood before it with outstretched palm. We must tip before he would open.

"Lend me sixpence," whispered Martyn. "I have only big coin in my pocket. I will not give the brute more than sixpence!"

In my flurry I took half a sovereign from my purse, thinking it was sixpence. The lodge keeper became polite and servile at once when he saw gold. I never dared tell Martyn about my mistake.

We were always doing things that were right for Canada but found they were wrong in England.

"Martyn, I hate, hate, hate London!"

"Come home, Emily; marry me; you don't belong here."

"I can't marry you, Martyn. It would be wicked and cruel, because I don't love that way. Besides—my work."

"Hang work; I can support you. Love will grow."

"It is not support; it is not money or love; it's the work itself. And, Martyn, while you are here, I am not doing my best. Go away, Martyn; please go away!"

"Always that detestable work!"

Dear Martyn, because he loved me he went away.

"Martyn's gone back to Canada."

Mrs. Radcliffe's eyes bulged.

"When are you marrying him, Klee Wyck?"

"Never."

Mrs. Radcliffe jumped to her feet. "Little silly! What more do you want? Is it a prince you wait for?"

"I wait for no one; I came to London to study."

THE RADCLIFFES' ART
AND DISTRICT VISITING

THE WESTMINSTER Art School students did not discuss Art in general very much. They soberly drudged at the foundations, grounding themselves, working like ditch-diggers, straightening, widening, deepening the channel through which something was to flow—none were quite sure what as yet.

I never wrote home about my work nor did my people ask me about it. A student said to me once, "Are any of your people Artists?"

"No."

"Take my advice, then—don't send any of your nude studies home."

"Goodness gracious, I would never dream of doing so! Why, they'd have me prayed for in church. My family are very conservative, they suppose I only draw clothes. If my drawings intimated that there was flesh and blood under the clothes they'd think I'd gone bad!"

The other girl said, "My people wrote begging me, 'Send us home some of your studies to see.' I did. They wrote again, 'Oh, please do not send us any more; we wanted to be able to show your work to our friends—well, the only place we could hang them was in the bathroom.'"

Mrs. Radcliffe and Fred were Art-lovers but they only liked or tolerated old masters or later work of the most conservative type. They knew every continental gallery by heart, had volumes of photos of the masterpieces of the world. The modern school of painting was as indecent to them as my nude studies would have been to the home folks. The Radcliffes had arty cousins, studying in Paris and in Rome. They talked about the Art exploits of these cousins till I was sick of them. Perhaps a little of my disgust came from jealously, for I was beginning to feel that Paris and Rome were probably greater centres for Art than London. The Art trend in London was mainly very conservative. I sort of wished I had chosen to study in Paris rather than in London. What had decided me was the difficulty my tongue had always experienced in crawling round foreign words; even the difference in English and Scotch words from those we used in Canada was perplexing at times. The students ridiculed what they called my colonialism.

Fred asked, "Klee Wyck, do you go often to the National Gallery?"

"I did at first, but not now. It is a dreary place. Besides, one wet day, when the rooms were dark and empty, I was alone in a big gallery. One of the guards came into the room and said something horrid to me. I have never been back to the National Gallery since."

"The man should have been reported," said Fred angrily. "Come with Mother and me next Saturday."

I went. Mrs. Radcliffe and I stood, one on either side of Fred. Fred told us what pictures to look at, the date of each picture's painting. Fred knew every date of every happening in the world. He knew why the artist painted the picture and how. The older they were and the more cracked and faded, the better he loved them. He loved the Old Masters like blood brothers. If he had eaten and shaken hands with them he could not have seemed more intimate with the artists.

Every year the Radcliffes swallowed the Royal Academy show, a week of steady gulping, as if it were a great pill. They went on opening day, bought their catalogues and ticked off just how many pictures they had to do a day. They knew to a minute just when they would *finish* the Academy and were scrupulously conscientious, giving even the more modern canvases (though there were very few with even a modern taint in the Academy show) an honest stare before passing on. They liked sentiment, something that told a story. The more harrowing the story the better. "The Doctor" by Luke Fields was a great favourite of theirs. They wracked themselves over the dying child, the agonized mother, the breaking dawn and the tired doctor. They liked "The Hopeless Dawn" too. I forget whom that was by. It showed the waiting wives and mothers in a fisherman's cottage on the night after a terrific storm. And the Radcliffes liked Arnesby Brown's cow pictures very much—billows of breath bursting from the cows' nostrils like steam from tea kettles. The dark spots in the dewy grass where the milkmaid's feet had smudged the wet, making the grass a deeper green, nearly brought tears to Mrs. Radcliffe's eyes, though, of course, she would have said, "Dear me, dear me! No, I am not the least sentimental."

I found on the whole that it was better not to discuss Art with the Radcliffes. We did not agree about London. We conversed a good deal about churches—not as to their degree of highness or lowness as much as about their mellow old beauty. Even the jump from high to low ritual was not so violent as that between ancient and modern Art. Mrs. Radcliffe leaned towards the high but all churches were more or less acceptable to her. She and I both attended morning service at an unfashionable old church behind Westminster Abbey. It was called St. John's and Canon Wilberforce preached grand sermons there. In the evening we went to Westminster Abbey and Fred came with us.

It provoked Mrs. Radcliffe that I would not cut morning school by an hour every day to attend intercession services for the troops in the Boer War.

Canon Wilberforce called for district visitors in the parish. Mrs. Radcliffe volunteered and said to me, "Klee Wyck, I think you should offer to take a district too."

"Oh, I couldn't, Mrs. Radcliffe. I think it is beastly to go poking into the

houses of the poor, shoving tracts at them and patting the heads of their dirty babies, pretending you are benevolent."

"That is not the idea. A district visitor simply calls in a friendly spirit and reports any cases of sickness or distress to the visiting curate, asks if they would care to have him visit them. Don't let Art be a selfish obsession, Klee Wyck. Art is all very well, but be of some real, practical use in the world, too."

"All right, I'll try to swallow a lump of Westminster slum, but I don't like it and I know the slummers will hate me."

I was to visit two long stacks of three-storey tenements in a dirty court—deadly places. Each family's quarters opened onto a long landing or balcony. Door, window—door, window, down the whole row, monotonous as "knit, purl, knit, purl". All the doors had the most aggressive bangs, all the windows had dirty curtains.

When I knocked, the curtain waggled and a stare peered out. If they *did* open the door it was only so that they might bang it harder against my nose, as they shouted through the keyhole, "Don't want no visitors pokin' round 'ere."

"Mrs. Radcliffe, I tremendously loathe slumming!"

"Dear me! you have only just started, Klee Wyck. You will get fond of the unfortunate creatures by and by."

So I sneaked out of school one afternoon every week, telling no one where I was going. I'd have died of shame if the students had known I was district-visiting in the Westminster slums. At last, after a week or two, a girl twice my own age in what she knew about life, and half my span of years, opened a door after I had passed it and called, " 'Ere you! Ma says, 'Come,' she's took bad."

I went into the tiny stifling room. An enormous, roaring coal fire burned in the grate. Besides that in the tiny room there was a great bed, a chair and a half eaten pie on a tin plate. The pie sat on the bed beside the woman; it was black with flies. The girl flipped the pie onto the floor. The swarm of flies rose and buzzed angrily up to the tight-closed dirty windows as if they were all going to be sick and wanted to get out immediately. I felt that way myself, especially when the morose, aggressive woman in the bed discoursed on her symptoms. She had dropsy and rolled her great body round in the bed so that I might hear her dropsy swish.

"Tell that there Curate feller 'e can come see me ef 'e wants ter."

I came away and the filthy court seemed as a pure lily after that fetid room.

I rushed round to the door of St. John's church and got the address of the visiting curate from the notice board.

"Reverend be 'ome," said the slattern who opened the door to me, adding, "foller!"

We went upstairs, the slattern flung the door back. The Curate was having tea at a littered, messy table, reading as he ate, his book propped against the sugar basin. There was no fire in the room. Late afternoon had dimmed London; it was cold, drab and full of fog, yellow fog that crowded up to the window panes.

A flickering gas jet was over the Curate's head—it "haloed" him. He was ugly

and so lean you saw the shape of his teeth through his cheeks. The Curate's bed was draped with brown cotton hangings. Table, bed, chair, were loaded with books. He stopped chewing to stare at me, first over, then under, finally through his spectacles.

"Mrs. Crotch in Catfoot Court says you can go and see her if you want to. Here's my district card; I can't district-visit any more. It is beastly, how can you!"

The Curate's face twisted into a sighing little smile. He stretched a bloodless hand and took my card. He said, "You are young," and looked as if it were a long time since he had felt young.

"Mrs. Radcliffe, I'm through with slumming!"

"Oh, Klee Wyck!" She looked disgustedly at me.

"Yes, I have abandoned good works; they never were in my line. Ugh, those revolting creatures, rude, horrible! I am much sorrier for the Curate in his wretched lodging than for those slum people with their roaring fires, their dropsies, their half-eaten pies swarming with flies."

"What do you know about the Curate's lodging?"

"Went there, to hand in my district visitor's card."

"You went to the Curate's room!"

"Had to give my card in, didn't I?"

"You should have taken it to the Church House."

"Church House! What's that? I never heard of one, and goodness, my sisters were churchy enough, too."

"All parish work is conducted through the Church House in London parishes. Workers never go direct to the clergy."

"Well, I did and he was the miserablest human I ever saw."

Mrs. Radcliffe assumed a sly simper. "I wonder what he thought of you?" She looked so coy, so hinting, I wanted to hit her. Mrs. Radcliffe twitted me so about that wretched visit to the Curate that I stopped going to St. John's.

To Mrs. Denny I was frankly a disappointment. She had taught me London, pointed out the wrongness of Roman Catholicism, had even intimated that she was willing to share with me the love of her very precious son. And London's history bored me! I continued to wear Mother's little cornelian cross, to go to the Brompton Oratory on occasion to hear magnificent music. Most astounding of all I did not want Ed's love! No wonder she was disappointed. At least I had the decency to be honest with Ed, to show him and his mother, too, that I had no intention of marrying him, that I did not want his love! I spared Ed the humiliation of a "No" by not allowing him to ask me.

The heads of Mrs. Denny and Mrs. Radcliffe nodded a duet of amazement and sorrow. Next to Martyn as a husband for me, Mrs. Radcliffe favoured Eddie. The two old ladies had tried to remodel me. I was so difficult to mould. After a couple of years they gave up, concluding that after all I had really come to London seeking Art, not a husband. By this time they had got to love me a little for myself, had accepted me as an assorted bundle of good and bad.

Everyone was much more comfortable when at last they realized that love won't be pushed into contrary channels.

Good Ed did not marry; he cared devotedly for his old mother till she died. Fred wrote out to Canada at the time of the World War, "Ed is over-age for active service but he drives himself beyond human limit on the home front to release younger men."

LONDON TASTED

NOW THAT my sister's visit was over, now that Martyn had come and gone, foot troubles were straightened out, London explored, and now that I was comfortably settled in Mrs. Dodds' boarding house for students in Bulstrode Street, it seemed that things were shaped for steady, hard work.

Besides all-day Life Class at the Westminster School of Art, I joined night classes—design, anatomy, clay modelling. Against London I was not quite so rebellious, though I did not like life in a great city.

I made a few friends in the school and some in the boarding house. Wattie was out in India. I plunged into work, not noticing that my face had become pasty; but, because I was always tired, I pushed and goaded myself harder. It was a long way I had come to get what London had to give. I must make the best of it, learn all I could.

I knew London well—not the formal sights only, but I knew her queer corners too. Mrs. Denny and Mrs. Radcliffe had shown me national astonishments, great sights. picture-galleries, Bank of England, British Museum, Mint, Guildhall, Tower of London, Buckingham Palace, and Windsor. I had canoed with Fred and his mother up the Thames and down. London had instructed, amazed, inspired, disgusted me. The little corners that I had poked into by myself interested me most. My sight-showers would have gasped had they known the variety and quality of my solitary wanderings. It would have puzzled them that I should want to see such queerness.

The orthodox sights I found wearing. The Zoo I never tired of, nor of Kew Gardens, St. Paul's, the Abbey cloisters. I took endless rides on bus-tops, above the crowd yet watching intently the throngs of humanity. I went into the slums of Whitechapel, Poplar, and Westminster and roamed the squalid crookedness of Seven Dials, which is London's bird-shop district, entering the dark stuffiness of the little shops to chirp with bird prisoners, their throats, glory-filled and unquenchable, swelled with song even in these foul captive dens. There was

Paternoster Row too—the street of books, Lincoln's Inn Fields—the world of Dickens, haunted by Dickens' houses, Dickens' characters, as St. Bartholomew's, Smithfield was haunted by smell of fire and the burning flesh of martyrs. From the "gods" of the great theatres I saw Shakespeare's plays, cried over Martin Harvey in *The Only Way*, roared over *Charlie's Aunt*, saw Julia Nielson in *Nell Gwyn*. That play I saw first from the "gods"; afterwards I saw it from stalls with swell friends from home. I liked it best from the "gods," distance dimmed the make-up, the sham. In the "gods" it was vision and carried me away.

So I looked at London from different sides, mostly hating it; cities did not sit on me comfortably. There were a few little tag ends I loved, insignificant things that most Londoners scorned, but the oldness and history of it made little appeal to me.

There were fifty-two women and girls in Mrs. Dodds' boarding house, every kind of student and all nationalities. Once I counted fourteen countries dining at one table of sixteen souls. Sometimes nationalities clashed but not often. Many foreigners were here to learn English. They learnt squabble English and slang as well as the pure language in our boarding house.

We had two large sitting rooms; one was talkative and had a piano, the other was silent for writing and study. Occasionally I went into the silent room and always got into trouble for drawing caricatures and rhyming, not for talking. Another student would look over my shoulder, see some of our queer ones—giggles were forbidden in the silent room. I would be ejected. But, being out at classes most nights, the sitting room students were not bothered by me much.

The few private rooms at Mrs. Dodds' were small and very dismal. The other rooms were very large and were divided into cubicles by red and yellow curtains.

The girl in the cubicle next mine was a North Country farm girl, jolly and wholesome. We drew back the dividing curtains, so making our cubicles one, and had fun. We kept a big box of goodies and had feasts, making cocoa on a spirit lamp after night-school. My cubicle had a private window—windowed cubicles cost a shilling a week extra. There was a curtained alley down the middle of the big room; a window was at one end of the through alley, the door with a ventilator over it at the other.

There were five cubicles in our room. Three of us were permanent, the other two cubicles were let to transients. It was amusing to wonder who would come next into the transients' cubicles. We had a Welsh singer, a German governess, a French mademoiselle, some little Swedish girls. Often we had two Scotch sisters in the spare cubicles. They quarrelled over the shutting and opening of the public ventilator in the aisle and sneaked on each other when one thought the other asleep. Each had to stand on her bed to reach the hook of the ventilator using her umbrella handle. Stealthily, stealthily they sneaked, but the other always heard—clash! whack! whack! whack! went umbrellas over the curtain tops!

"Ye hurrt me," Little Scot would whimper.

"A' meant ta," Big Scot would reply.

Bed springs squeaked impatiently, the three permanents were disturbed. Three "shut-ups!" came from their cubicles.

The food at Mrs. Dodds' had no more variety than a calendar. You knew exactly what the kitchen saucepans were doing without the help even of your nose. Sunday's supper was the peak of misery. The maids were out; we helped ourselves to the everlasting monotony—same old cold ham, same salad, same cake, same sliced pineapple. Why couldn't the salad have been other than beet-root and lettuce? Why must the cake always be raspberry slab? Why not another canned fruit than pineapple? Everyone who could wangle an invite to sup out on Sunday wangled.

When it came to bed time, one cubicle would brag, "I had roast beef and Yorkshire."

Groans!

"I had duck and green peas," from another cubicle.

More groans.

"Must you gloat over your greed!" from a cubicle who had supuped at home. Bedclothes dragged over heads, there was savage, "goody-hungry" quiet.

THE OTHER SIDE
OF LIFE

WHEN Westminster School closed for the long summer vacation I, with other students, joined a sketching class at Boxford down in Berkshire. The quaintness of thatched cottages in the village delighted me. The sketching master was a better teacher than painter, I learned a lot from him. It was the first time I had sketched out-doors in England. Even across one field there was soft hazy distance, distance gradations were easier here to get than in our clear Canadian atmosphere and great spaces; everything was faded, gentle here. Colour did not throb so violently. English landscape painting was indolent seeing, ready-made compositions, needing only to be copied. I was very happy in my work, sorry when the summer ended.

The other students went home. I lingered, hating to leave woods and fields for chimney-pots and clatter. The weather grew sharp and a little wet. The master and his wife lived in another village. The man was drinking. He forgot his lesson dates, smelled beery. I stopped taking lessons from him and worked on alone.

I had given the landlady my week's notice. She came to me in distress.

"A lady from Westminster Art School wants accommodation immediate. 'Er

wants comin' afore weather's broke. I got no 'sittin'' till you goes!—Plenty bed-rooms, no 'sittin's'."

"Who is the lady?"

"Miss Compton."

"I know her; she may share my sitting room, if it is any convenience for you and her."

"Thanks, miss."

Mildred Compton came. At school I knew her only slightly; she was older than I, wealthy, stand-offish, prim.

"We will have little in common, but any way I shall only be in Boxford one week," I thought.

Mildred Compton was a society girl. I decidedly was not. We ate together, sat together, worked together—amiable, not intimate.

"I'm going back to London tomorrow," I said one night.

Mildred looked as if I had loosed an evil upon her.

"Oh! I did want to get two whole weeks sketching here, in Boxford."

"Does my going make any difference?"

"Of course, I could not *possibly* stay in a strange village all alone. Nothing but villagers!"

"They are quite tame."

"Queer things happen in out-of-the-way places!"

Mildred had been born condensed. Space alarmed her. She was like a hot loaf that had been put immediately into too small a bread-box and got mis-shapen by cramping. She was unaware of being cramped, because she was unconscious of any humans except those of her own class. The outer crowd propped her, but she was unaware of them. Away from crowds Mildred flopped.

I said, "I am in no hurry; I can stay another week if you like."

"Would you? How very kind!"

She was glad to have me. I was glad to elude London a little longer. Gladness drew us into companionship in spite of our different upbringings.

Cows and cobwebby barns terrified Mildred as history and crowds terrified me. The weather broke, there was nothing but cowbarns and sheds to shelter in against wind and rain while we worked. Smartly-dressed, lily-fair Mildred crouched on a campstool, set on a not too clean stable floor, hens scratching in the straw about her feet, a sow and litter penned in the corner, did seem unnat-ural, topsy-turvy, I'll confess.

Mildred, hurrying her things into her sketch-sack, asking breathlessly, "Doesn't the cow come home about this time, Motor?" Mildred saying, "I had no idea hens had such a vocabulary. The speckled thing has made six entirely different squawks in as many minutes. She makes me nervous, Motor!"

"Not as nervous as you make her."

"Ouch! there's a mouse!—behind that barrel—ouch, ouch!" She pinched her skirt in close.

"Mice much prefer the bran barrels to you!" I laughed.

She gathered up her things.—"Let's go."

"Motor, will you visit us for a week when we go back to London?"

"Me! Why, your life would scare me worse than the barn and hen scare you, Mildred. Besides . . . I couldn't."

"Why not?"

"Clothes!"

"*You* would be inside the clothes, Motor. We don't love our friends for their clothes. I want you to know my mother; I want my mother to know you. She is an old lady, a little lonely, a very lonely old lady sometimes!"

"Thank you, Mildred, I'd be a sparrow in a peacock house,—still—if a washed-to-bits muslin dress won't shame your dinner-table, I'll come. I would love to meet your mother."

I dreaded the ordeal, but I'd see London from another side. Yes, I'd go to Mildred's.

The Comptons lived in a dignified mansion in Belgrave Square. Every house in that square was important, wealthy, opulent. A little park was in the centre of the Square; none but residents were permitted a key to the gate in its high iron fence. Belgravians seldom walked. Very few of the Belgrave Square people were aware of having legs, all owned horses. You could not drive in the little park; there were no roads, only trees, shrubs, grass, seats, and gravel paths.

The Compton family consisted of Mrs. Compton, her companion, an elderly lady named Miss Bole, who was a family institution—began as governess, continued as secretary till Mr. Compton died and was now companion to Mrs. Compton. Mildred divided her time between being a society girl and an Art student of Westminster. A staff of twelve servants attended to the creature comforts of the three women.

The Compton mansion was enormous and not half as cosy as one of our Western homes—thousands of stairs, no elevator, no telephone, no central heating. There were roaring grate-fires in every room but the halls and passages were like ice.

There was a marble swimming bath, a glass-topped billiard room, a conservatory and a walled garden through which I longed to run, unlock an arched doorway in the wall and pass into the mews where the Compton carriages lived. I hinted to Mildred about wanting to visit the horses, but Mildred hinted back that it was not done by London ladies, and I did not want to shame Mildred before her family.

The servants ran the house like clockwork, but they upset me dreadfully. The maids were so superior, and I wanted to push the footmen out of the way to save tumbling over them, rushing to do things for me I had rather do for myself. They made me feel as stupid as a doll.

Mildred's mother was beautiful. She was plump, with a tiny waist and great dignity, white hair, blue eyes, pink cheeks. I loved her the moment she took my hand and said, "So this is our little Motor." I was always "our" little Motor to her.

Miss Bole was plump too, with bright brown eyes like a robin's, black hair smoothed back. She always dressed in plain, rich black.

Belgrave food was marvellous, each help faded into your appetite without

effort, like a tiny dream, not like the boarding-house stuff. This was food which, somehow, you never connected with a kitchen or a cook. The butler juggled it off the sideboard like a magician. A footman slid the silver dishes noiselessly to your elbow. Sometimes I remembered the heavy plates of heaped monotony slapped down in front of us by a frowsy maid at Mrs. Dodds' student home and laughed to myself.

Besides three table-meals a day we ate snacks in other rooms—wine and biscuits in the library at eleven in the morning, afternoon tea in the drawing-room, a little something in the library before going to bed, the early morning tea in bed that destroyed your loveliest sleep and from which I begged to be excused.

When I asked, "Must I have that early tea, Mildred?" she exclaimed, "No early morning tea, Motor! Oh, you'd better."

So a prettiness in a frilly cap and apron stole into my room very early. She pulled back the heavy silk curtains, lit a fire in the grate, laid a downy pink rug before it; on that she set a white bath, half pudding-basin and half arm-chair. On either side of the tub she stood a great covered can of hot water, draped over the top with a snowy bath towel. Then she fetched a dainty tea tray, put it on a little table at the bedside, and, bending close, whispered, "Tea, Miss," and was gone. At Bulstrode Street yawns and groans would that minute be filtering through the cubicle curtains. The dressing bell—we called it the distressing bell—would clang, there would be pandemonium. And yet this wealth of luxury weighted me, not being born to it.

I had not dreamt that social obligations could be so arduous. After breakfast we marched soberly into the library to write notes, notes of inviting or of accepting. Every dinner, tea, house-party, call, must be punctiliously returned. I was rather sorry for these rich, they could so seldom be themselves; even their smiles were set, wound up to so many degrees of grin for so much intimacy. Their pleasures seemed kept in glass cases just out of reach. They saw but could not quite handle or feel their fun, it was so overhung with convention.

When later I told Mrs. Radcliffe where I had been staying, her eyes popped. She said "dear me!" six times, then she exclaimed, "Fred, Klee Wyck in Belgravia!" and again, "dear me!" After that she had nothing more to say.

While the ladies attended to the answering of the morning notes, Miss Bole took me and the key and went into the Park in the centre of the Square. This was the time I felt I really had got ahead of London. In the middle of the little park, among the trees and bushes, you were quite hidden from London and London was quite hidden from you. There was no traffic in Belgrave Square, only the purring roll of carriages and the smart step of dainty horses outside the railing of the little park. Even London's roar was quite cut off by great, high mansions all round. Every house-front was gay with flower-boxes. There was no grime, scarcely any sparrows—only a few very elegant pigeons who strutted in the park cooing. Miss Bole and I watched them, we did not talk much but we liked each other.

Mildred had a married sister who despised me for one of Mildred's "low-

down student friends." When she came to the house I was unhappy. She talked over my head and made me feel so awfully naked, as if I had no clothes on at all. I felt ugly, shy, shabby and nervous the moment she came into the house, and feeling that way made me so.

One night Mrs. Compton gave a dinner party. The married daughter came. I slunk from my bedroom in the old white muslin, to find Mildred waiting for me on the stairs. She looked lovely, dressed in a gown all colours yet no colour at all, just shimmer. She held her hand to me. "Come, my poppet!"

"Oh, Mildred, I am so shabby in this wretched old muslin!"

"Motor, you are *Spring.*"

She caught me up and kissed me. Suddenly I did not care about the old muslin any more. Mildred had sent Spring bubbling up into my heart, I knew she loved me for me, not for my clothes.

We "Noah-arked" into the dining-room. The men's coat tails swished so elegantly, the silks of the women rustled and billowed. Then came Miss Bole in her rich black, very quiet and clinging to her arm was me, just a little cotton rattle. Mrs. Compton placed me close to her. I watched, shy and very quiet till Mrs. Compton said, "Tell that little Indian story you told us at lunch, Motor." My face burned—I thought I should have died, but to please her I tried. It went all right till a beastly footman slithered a dish of peas close to my elbow and made me jump—the peas upset. The married daughter began to talk and laugh very loud. I wanted to hurl the peas, along with a frightful face, at her. I wish now that I had.

"Look at my face, Mildred."

"It is rather greeny white, isn't it? It's those stuffy rooms in the Westminster Art School, Motor."

"Is there any part of England where one can work outdoors all the year round?"

"At St. Ives there is an Art Colony who work outdoors nearly all the year."

"I'm going there."

Mrs. Compton ordered a great hamper to be packed for me. In it were four bottles of wine, a great plum cake, biscuits, nuts and fruit—the kind she knew I liked. I was to stay at the Temperance Hotel in St. Ives until I found rooms.

I went to say goodbye to Mrs. Radcliffe and to Mrs. Denny. Mrs. Radcliffe was a little glad; I think she resented the Comptons having me. Perhaps she thought Mrs. Compton would make me soft with too much petting. I did love Mrs. Compton, but I could not have got along without Mrs. Radcliffe's bullying and strength.

Mrs. Denny shook her head. "My dear," she said, "the R.C.'s are strong in Cornwall, beware!" She frowned at the little cornelian cross I still wore in spite of her protests. The next day Ed staggered to Belgrave Square carrying two huge books, one under each arm—*Roman Catholicism Exposed, Volumes I and II!*

"Mother wants you to take these with you to read in your spare time."

"I shan't have any spare time, I am going to St. Ives to work like blazes, Ed. I

have more luggage now—work things and food—than I can manage."

Kind Ed tucked the volumes under his arms again saying, "I understand." I liked Ed better that moment than I ever had before, loyal to his mother—understanding both to his mother and to me.

S T . I V E S

AS OUR TRAIN slithered through the small prettiness of Devonshire I was angered. My parents had so lavishly praised its beauty to us when we were children. I wondered if after many years in Canada it would have seemed as small and pinched to them as it did to me seeing it for the first time—something one could fold up and put in his pocket, tiny patches of grass field hemmed about with little green hedges.

When we came to Cornwall, the land grew sterner and more jagged—stony fields, separated by low stone walls, stunted, wind-blown trees, wild but not with the volume of Canada's wildness. Cornwall's land had been punished into tameness, but her sea would always be boisterous, stormy. From Devonshire to Cornwall the land changed; Devon was, as it were, pernickety check, while Cornwall loosened to broader plaid.

My luggage looked sneaky and self-conscious wheeled into the Temperance Hotel. I knew Mrs. Compton's red wine blushed in its middle. I tried to forget its presence as I entered the Hotel, a sour-faced structure down in the old town. Never having stayed alone in a hotel before, I entered timidly.

The old town of St. Ives lay low, its rocky edges worn by the violence of the sea. On the hillside above was a smarter, newer St. Ives, composed of tourist hotels, modern houses and fine studios of Artists who had inherited wealth or made names—few students could afford the heights. Most students other than snobs and the ultra-smarts lived down among the fisherfolk in the old town. Fisherfolk packed themselves like sardines in order to enlarge their incomes by renting rooms to student lodgers. Many of the old sail lofts were converted into studios.

A few students lived at the Temperance Hotel and from them I made enquiry about studios.—Did I want *work* or studio tea-parties?—Work? Then go to Julius Olsen's Studio; he worked you to the last gasp!

To Julius Olsen I presented myself.

Julius Olsen's studio had been an immense sail loft overlooking the sea. The massive, blue-eyed Swede carelessly shoved my fee into the sagging pocket of his old tweed jacket, waved a hand towards the beach and left me stranded like a

jelly fish at low tide, he striding off to criticize canvases which some boy students were turning from the walls.

"I'll show you," said an Irish voice at my elbow.

Hilda was the only girl student in the room.

"You will want to outfit?" she asked.

"I have my kit."

She looked at it with disapproval.

"Too light—'Jo' insists on weight,"—she exhibited her own equipment.

"Gracious! That easel is as heavy as a cannon and that enormous brass-bound paintbox! I can't, I *won't* lug such heaviness."

"Jo bellows if you cross his will," warned Hilda.

"Let him roar!"

She led me to the open front of the studio. Great doors folded back, creating an opening which was wide enough to admit three or four fishing boats abreast. A bar was fixed across the opening, we leaned on it looking at the busy fisher life buzzing on the beach below. Morning fish market was in progress. Buyers raced down from London on swift express trains, bartered for the night's catch, raced it back to London's markets.

Not Cornwall ate St. Ives' fish, but London. In St. Ives you could not buy so much as one herring.

Shrill-voiced fish-wives bargained, children yelled, cats yowled. Every house-roof, every street, every boat, swarmed with cats.

Each wife had seven sacks,
Each sack had seven cats,
Each cat had seven kits!

This was obviously the *cat* St. Ives of our nursery rhyme book.

The tide was far out. Looking down on it all, I was suddenly back in Mrs. Compton's drawing room standing before Moffatt Linder's picture, "St. Ives' Beach." Sky, sea, mudflats were shown but he had left out the bustle and the smell.

"Now," said Hilda, "to the sands and work!"

"Not work on those sands amid that turmoil!"

"Jo insists—white boats in sunlight—sunlight full on the canvas, too."

"Jo will find me in a shady street-end sitting with my back to the wall so that rubbernoses can't overlook."

Hilda's head nodded forebodings beyond working. "I'd advise that you don't let him see you work sitting," was her parting headshake. Leaving me to my fate she went off, lugging her heavy kit.

Stump, stump, I heard Jo's heavy footfalls on the cobbles and trembled, not scared of Jo, the man, but of Jo's artist eye, a splendid eye for colour, space, light. Nervous as a cat, I waited.

"Sitting to work!"

"Bad foot, sir."

"Huh! I said the sands, didn't I? Sunshine on sea and white boats. With the first puff that thing will blow out to sea," pointing to my easel. "Get the weighty 'Standard'."

"Too heavy to lug, sir. Mine is weighted. See!"

I showed him a great rock suspended in a paint rag and hung from my easel top.

"If you please, sir, the glare of sea and white sand blind me with headache."

Jo snorted, strode away—adoring English students never argued with their masters. He came back by-and-by, gave a grunt, made no comment and was away again! That was my first day of study under Julius Olsen. We remained antagonistic always. I believe each admired the other's grim determination but neither would give in.

The St. Ives students were a kindly lot—ready to give, ready to take, criticism. We numbered ten or more in the studio. Three Australian boys, a Frenchman, an ultra-Englishman, and an ultra-Englishwoman, (swells rooming up on the hill), a cockney boy, the Irish girl, myself, and the nondescript old women who are found in most studios just killing time.

We met in the big studio at eight each morning to receive "crits" on the work done the afternoon before. Olsen gave us criticisms three times a week, his partner, Talmage, the other three days. What one taught the other untaught; it was baffling but broadening. After "crit" we dispersed. The master came wherever we were working to examine our work on the spot. From eight in the morning till dusk we worked outdoors, in all weathers except during hurricanes. The great studio doors were shut then and we huddled under the studio skylight and worked from a model. But St. Ives was primarily a school for land- and seascape painting.

I found living quarters next to the churchyard. My host was a maker of antiques; he specialized in battering up and defacing old ship's figure-heads and grandfather clocks. Six grandfathers higgledy-piggledyed their ticks in my sitting room. When they all struck high-count hours simultaneously your hands flew to your ears, and your head flew out the window.

My window opened directly onto the cobblestoned street with no mediating sidewalk. Heavy shoes striking cobblestones clattered, clattered day and night.

Student heads, wrapped in student grins, thrust themselves through my window announcing, "We are about to call!" Then I rushed like a flurried hen to protect "the complete beach." This object was an enormous mahogany and glass cabinet in which was displayed everything nautical except a mermaid—shells, coral, seaweed, fish bones, starfish, crabs—all old and brittle as eggshell. My foot and that of every student who called on me itched to thrust through the prominent glass corporation of this rounded glass monster, to crush, to crackle. My hosts, the Curnows, valued the thing highly. When a student warned through the window, I pushed the six straight-backed leather chairs whose leather laps were usually under the big mahogany dining-table (as if the chair feet had corns and were afraid of having them tramped on) and circled the chairs, round "the complete beach." The room was not any too large. What

with this massive furniture, a fireplace, the cat and me in it, it was over-full.

My bedroom was marvellous! You reached it through an ascending streak of black between two walls. The treads were so narrow that they taught your toes the accuracy of fingertips on a keyboard. But glory dawned when I opened my bedroom door. Two large windows overlooked the sea. In the centre of the room stood an enormous bed—mahogany, carved with dolphins galloping on their tails. Mrs. Curnow told me this treasure-antique was built in the room by Pa Curnow himself. It would have sold many times over, only it had been built in the room, and could never be moved because no door, no window, certainly not our stair, would have permitted the passage of its bulk! There were four posts to the bed and a canopy of pink cotton. I was solemnly warned not to lay so much as a pocket handkerchief across the foot-board for fear of scratching or otherwise defacing a dolphin. Even on the side-boards dolphins galloped. I had to taut myself, run and vault in order to avoid touching one, when at night I retired to rest on the hard unbouncy mattress. Beside the bed there was little else in the room—a meagre washstand, a chair, a clothes closet set in the wall. The closet contained all the family's "best." This is a Cornish way; rental of a room does not include its cupboards.

My Curnow family were reputed the cleanest folk in St. Ives because for years they had threatened to install a bath in their house. No other family had gone that far. I bargained for a hot wash once a week. The three women, mother and two girls who would never see forty again, gravely consulted. It could be managed, they said mournfully, but Saturday was always an anxious and disturbed day for the Curnow family.

Ma tiptoed into my room after supper and, carefully shutting the door, whispered, "The cauldron, Miss, it is heated to wash your feet."

She would not have allowed "the girls" to hear mention of such a thing as a bath. No one suspected of such indecency as taking an "all-over"! The tin foot-bath was set as far as possible from the dolphins, who were draped in pink calico for the event. Greatest secrecy was exercised in getting the bath down the dark stair and through the kitchen without old Curnow or a visitor seeing. The girls frankly admitted they preferred men lodgers. If they must bathe they did it in the sea.

When storms came the whole St. Ives Bay attacked my room with fury and with power. The house was built partly on the sea-wall, and waves beat in thuds that trembled it. The windows, of heavy bottle-glass stoutly braced, were dimmed with mazed green lights. I was under the sea. Sea poured over my roof, my windows were translucent, pouring green, which thinned, drew back receding in a boil of foam, leaving me amazed that the house could still be grounded. Water raced up the alley between the graveyard wall and our house, curled over the cobble-street to meet the flood pouring over the low roof-top of the house on the other side of ours. We were surrounded by water. Privies, perched on the sea wall, jaunted gaily off into the bay. Miles inland bundles of white fluff, dry as wool, clung to the trees; it was beaten foam, carried inland by tearing wind. These storms were, of course, exceptional but there was usually breeze in St.

Ives, though she had many, many bright, glistening days—sea sparkling, air clear, mudflats glowing.

Tides ruled the life of the town and of the fishermen. All night lanterns bobbed, men shouted, boats clattered over cobbles, cats prowled the moonlight, their eyes gleaming.

The Irish girl Hilda and I were warm friends. Outdoors we did not work together—she was for sea, I for land. But we hired fisher children to pose for us in the evenings, working by a coal-oil lamp in my sitting-room. The boy students jeered at our "life class" but they dropped in to work with us off and on.

The atmosphere of Julius Olsen's studio was stimulating. He inspired us to work. He was specially nice to his boy students, inviting them up to his own fine studio on the hill, showing them his great seascapes in the making, discussing an artist's problems with them, treating them as fellow workers.

Mrs. Olsen was a billowy creature who only called on those of her husband's students who were worth while; she did not call on me.

I never liked Jo much, but I respected his teaching and the industry which he insisted that his students practise and which he practised himself.

Christmas came, everyone went home except me. The Olsens went to Sweden on their yacht. Noel, a nice English student, came to bid me goodbye.

"I say, it's going to be beastly lonely for you with everybody gone—studio shut. What shall you do with yourself?"

"Explore. Albert will still be here, he will pilot me, he knows Cornwall."

"Albert! That wretched little cockney!" said the autocrat, Noel, with a lift of his nose.

"I *could* visit, too, if I wanted." I tossed a letter across for Noel to read.

"Whew—horses to ride and all and you turned this down!" he exclaimed.

"Don't like the outfit, connections by marriage, snobs, titled too!"

"What matter? Put likes and dislikes in your pocket, silly; take all the good times you can get."

"Take and hate the giver?"

Noel shrugged, "I *was* going to ask Mother to invite you to visit us in the summer holidays. How about it, Miss Snifty?"

"Try."

"Tell me, what are you doing at this present moment?" asked Noel. "Hat, felt slipper, snipping, sewing—it's beyond my figuring entirely!"

"Felt from under hat ribbon provides patch for toe of slipper. See, Mr. Dull-Head?" I fitted the patch.

Noel's roaring laugh—"Canadian thrift!" He vaulted through the window shouting, "I'll ask Mother about the summer visit."

Cornish people love a wrench of misery with every joy. The Curnows wept all through Christmas. I came upon Pa, Ma, and both girls, stirring the plum pudding, eight eyes sploshing tears down into the mixing bowl.

"Anything wrong?"

"Always something wrong for we," wailed Ma.

It seemed some relative preferred to Christmas elsewhere than with the Curnows. Their grief seemed so disproportionate to the cause that I laughed. Eight mournful looks turned upon me.

"You be awfu' merry, Miss. Thousands of miles betwixt you and yours, yet you larf!" There was reproach in the voice.

Under the guidance of Albert I saw Polperro, Mouse-hole, St. Earch, St. Michael's Mount and more places. Little cockney Albert enjoyed having company. He was not quite one of us—no one bothered about him.

For one week Albert and I holidayed, then I fell on work with doubled fury. I knew I was a fool, grinding, grinding, but I had so much to learn, so little time.

They all came trooping back to the studio. Olsen outstayed himself by a matter of six weeks. Talmage took charge. High on the hill I had discovered Tregenna Wood—haunting, ivy-draped, solemn Tregenna. Talmage saw what I had been doing up there during the holidays, away from the glare and racket of St. Ives. He was a calm, gentle man, one who understood.

"Trot up to your woods; that's where you love to be. I will come there and give you your lesson."

I gave a delighted squeal. "Oh, but, Mr. Talmage, wouldn't it be too far for you to come for my lesson alone. None of the other students work there."

"Trot along; one works best where one is happy."

Tregenna Wood was solemn, if not vast. A shallow ravine scooped through its centre. Ivy crept up the tree-trunks to hang down in curtains. No students worked here, few people passed this way. A huge white sow frequented Tregenna, a porky ghost, rustling through the bushes. She aimed always to pass at lunch hour so that she might share my lunch. If I had any form of pigmeat (Mrs. Curnow often gave me fat pork sandwiches), then, out of delicacy, I did not offer anything but the breadcrust.

The students teased me about my "lady friend in Tregenna" but I loved my sow. I wrote a poem and made a skit about the students and her. It was more complimentary to the sow than to the students.

I said to Talmage, "I don't care if Jo never comes back; I learn much more from you than from him."

"Jo is the better artist," replied Talmage. "Jo is a genius. What I have got has been got through grind. Probably that helps me to understand my students' problems better."

He praised my woods studies highly, so did the students.

Jo came home.

"Jo's home! 'Crits' in the studio at eight tomorrow!" A student's head thrust the news through my window.

I had a vast accumulation to show Jo. I knew the work was good—happy, honest stuff. I swung into the studio with confidence. Jo was pacing the floor. The Frenchman sat crying before his easel. Jo gave me a curt nod, "Fetch your stuff."

I turned my canvases face out, waited—silence, except for Jo's snorts through a dead pipe.

"Maudlin! Rubbish!" he bellowed, pointing his dead pipe at my canvases. "Whiten down those low-toned daubs, obliterate 'em. Go out *there*," (he pointed to the glaring sands) "out to bright sunlight—PAINT!"

Kicking the unlucky canvases into a corner, I bolted. No one was going to see me as I had seen Frenchie.

On a desolate road far beyond the town I came to my unhappy self. On either side the way were fields of frosted cabbages. I crept among them to sit down on a boulder, rocking myself back and forth, crying, crying till I was very hideous and very hungry.

I got up. I'd see how the others came out. I dragged myself back to town.

Burgess, one of the Australians, studied under Jo, but he had a studio of his own. Burgess and I had a pact. He had chased away a fisherman who had religious mania and tormented any student he could find working in a quiet corner, as to their views on purgatory. In return I went to Burgess' studio when the Frenchman had declared his intention of giving him a "crit," because, unless Burgess had company, the Frenchman *would* kiss him, not only on one but on both cheeks.

It took three knocks to rouse a dreary, "Come in." When I pushed open the door Burgess was seated on a three-legged stool before a dead grate, his red hair wild, his hands shaky. He kicked forward another stool.

"Poor Mother, she will be so disappointed. Do you suppose Grant's will take back that gold leaf frame?"

"The one for your Academy picture?"

"Academy! I'm returning to Australia right away. You may have the pile of canvas stretchers."

"Thanks, but I'm thinking of leaving for Canada myself immediately."

Shamed grins spread over our faces.

"Let's call on the rest, see what Jo did to them."

We met Ashton; he was whistling.

"Get a good 'crit', Ashton?"

"You bet."

"Liar," muttered Burgess. "Hello! There's Maude, . . . morning, Miss Horne, Taken your 'crit'?"

"Criticism first morning after Jo's vacation! Not I. Jo always returns in a rage. This time it is two rages—his usual and a toothache. You pair of young fools!" she grinned at our grief-wracked faces. "Poor children, I s'pose you knew no better." Maude put on airs.

"I'm hungry as a hunter, Burgess. I'll run home for a bit, then the sun will be just right for painting those cottages in the Diji. Oh, about those canvas stretchers?"

"Needing them myself!"

We exchanged grins. Burgess had forgotten Australia. I had forgotten Canada. With noses and hopes high we were off again to work.

When long vacation came I went back to London.

A sneezing creature sitting next to me in the train gave me 'flu. When that was through with me, I crawled to Westminster. 'Flu had sapped the energy I

had forced so long. Mildred found me huddled on a bench in the Architectural Museum, among the tombs—idle.

"Why, Motor!"

"After 'flu, Mildred."

"If we were not just starting for Switzerland I'd take you home right now."

Mrs. Radcliffe groaned, "You'd best take a strong tonic, Klee Wyck. Why you should fall to pieces the moment you come to London I can't imagine. London suits *me* all right."

Always kind, Fred said, "Try Bushey, Herts, Klee Wyck—Herkomer's Art School, a big art colony. Bushey is an easy run up to London for exhibitions and galleries. You just don't thrive as Mother does in London."

To Bushey I went.

B U S H E Y

THE STATION Master's direction was accurate. "Bushey? Turn by that 'ere pub and keep a-goin'."

The road was a long squirm without any actual turnings.

Herkomer had built a theatre in connection with his Bushey art school; more time was now devoted to drama, they said, than to Art. For earnest Art I was advised to go to John Whiteley, Number 9, Meadows Studios.

The Meadows Studios stretched in a long row. Of unplaned lumber, linked together like stitches in a chain of crochet, they ran across a hummocky field, spattered with kingcups. Each frame building was one room and a thin corridor wide. Each had a door into the emaciated passage and a large north window.

The land around Bushey dipped and rose pastorally and was dotted with sheep, cows and spreads of bluebells. Everything was yellow-green and pearly with young spring. Larks hurried up to Heaven as if late for choir practice. The woods in the hollows cuckooed all day with cuckoos; the air melted ecstatically into the liquid of nightingale music all night.

John Whiteley was a quiet man and shy, his teaching was as honest as himself. There were sixteen students in his class, men and women. We worked from costumed models, often posed outdoors among live greenery. The students were of the Westminster type—cold, stand-offish. They lodged in the village. Being mid-term, all rooms were full, so I had to climb the hill to a row of working men's houses to find accommodation. Many in the row were glad to let rooms. The man and wife in my house kept the kitchen and the front bedroom for their own use, renting the front room downstairs, into which the house door opened, and the back, upstairs bedroom. The back door was their entrance.

They were expecting their first baby—and were singing happy about it, so happy that they just had to do something for somebody. They showed me many kindnesses. When there was nothing else she could think of the woman would run into their tiny patch of back garden and pull half a dozen rosy, tender-skinned radishes for my tea. The man, returning from labouring as a farm hand, would ask of me, "Can 'er go through you, Miss; it be a long round from back. 'Er's not spry jest now. Us likes listenin' to nightingales down to valley"— and, passing hand in hand through my room, they drifted into the dimness of the dusky fields.

Mr. Whiteley's was a silent studio. No one talked during pose; few spoke during rests. To English girls Canadians were foreigners. A snobby trio in the studio were particularly disagreeable to me. They rented a whole cottage and were very exclusive. The bossiest of the three was "Mack," an angular Scotch woman. The other two were blood sisters and English. They had yellow hair and black eyes and were known as "The Canaries." After an ignored week, I came into the passage one morning to find a scrawny youth trying to make up his mind to knock on Mr. Whiteley's door.

"This Mr. Whiteley's studio?"

"Yes."

"Can I see him?"

"He does not come for 'crit' before ten."

The youth fidgeted.

"What'll I do? I'm a new student."

"Come on, I'll show you.

He threw a terrified look round the room when I opened the door, saw the work on the easels and calmed. I think he had expected a nude model. I got him an easel and board, set him in a far corner where he could not be over-looked, showed him where to get charcoal and paper. He was very grateful, like a chicken from a strange brood that an old hen has consented to mother. He stuck to me. The Canaries and Mack froze, throwing high noses and cold glances over our heads.

That night there was a tap at my door. A tall, loose-knit boy stood there. He said, "I'm from St. Ives. The students said to be sure to look you up. My name is Milford and do you mind if I bring Mother to see you? I'm going to White-ley's too. Mother's come to settle me in—she's two doors off."

Milford had a stepfather who considered both stepsons and art unnecessary nonsense. The mother doted on Milford. "That dear boy won't chew, such poor digestion. Keep an eye on his eating," she pleaded, "insist that he chew and, if you would take charge of his money. He spends it all the first day, afterwards he starves!"

I said I would do my best over Milford's chewing and cash. I felt very mater-nal with two boys under my wing.

Milford lived down the street; his table was pushed close to the window. I passed at mealtimes whenever possible and yelled up, "Chew, Milford, chew!" He kept his weekly allowance in a box on my mantelpiece.

"Can I run up to London this week-end?"

We would get the box down and count. Sometimes I would say, "Yes," and sometimes, "No, Milford, you can't."

Milford and I sketched around the Bushey woods. Little Canary followed us. Presently we would find her easel set close to ours. Milford and I humanized those Canaries. (We never tackled Mack.) Little Canary soon ate out of my hand; she was always fluttering around me, and I gave her a hard flutter too. I made her smoke, damn, crawl through thorny hedges, wade streams. I brought her home in such tatters as made Big Canary and Mack gasp. They were provoked at Little Canary for accepting my lead. I behaved outrageously when Mack and Big Canary were around; I wanted to shock them! I was really ashamed of myself. The boys grinned; perhaps they were ashamed of me too— they were English. Mack would say, "Where *were* you brought up?" and I would retort, "In a different land from you, thank Heaven!"

One Saturday morning I came to Studio late. The door banged on me and I "damned". I felt shudders and tension in the room, then I saw two strangers—a doll-pretty girl, and an angular sourness, who knitted beside the doll while she drew.

Kicking Little Canary's shin, I mouthed, "Who?"

"Wait till rest," Little Canary mouthed back.

It seemed that the silk-smocked, crimp-haired girl was titled and a tremendous swell, an old pupil of Mr. Whiteley's. The other was her chaperon. They had been abroad. This was their first appearance since I had been at Mr. Whiteley's studio. The girl only "arted" on Saturday mornings and was always chaperoned. The chaperon had been heard to allude to Mr. Whiteley's Studio as "that wild place!" Her lips had glued to a thread-thin line when I "damned." She stopped knitting, took a shawl from their various luggages, draped it over the doll's shoulder that was nearest to the wind which had rushed in with my entry. She took the doll's spectacles off her nose, polished them and straddled them back again, sharpened six sticks of charcoal neatly into her pocket-handkerchief, then shook the dust and sharpenings over the other students and resumed knitting. After class they were escorted to their waiting carriage by a foot-man bearing the girl's work gear. The Canaries and Mack bowed as they passed.

I laughed all the way home, then I drew and rhymed a skit in which we all decided that we must bring chaperons to this "wild place." Even the Master had to "bring his loving wife and she their children three."

> *The model said, "I will not sit*
> *In solitude alone,*
> *My good old woman too must come*
> *And share the model throne!"*

I took my skit to class on Monday. The Canaries were very much shocked,— a student caricaturing a master!

"Suppose he saw!" they gasped.

"It would not kill him," I grinned.

At rest I was sitting on the fence, giggling over my skit with the boys when Mr. Whiteley came by.

"Can I share the joke?"

The boy holding the sketch wriggled, "It does not belong to me, sir, it is Miss Carr's."

Mr. Whiteley looked enquiringly at me.

"Just some nonsense, but certainly if you wish to, Mr. Whiteley."

He took the skit in his hand, called "Pose"; it was the last pose of the morning. Dead silence in the studio, Canaries very nervous. Noon struck, model and students filed out, Mr. Whiteley settled himself to read, to look. The Canaries hovered; they were going to be rather sorry to see me evicted from the class—in spite of my being colonial and bad form it had been livelier since I came, they said.

Chuckle, chuckle, laugh, roar! Great knee-slap roars! No one ever dreamed Mr. Whiteley could be so merry. The hovering Canaries stood open-mouthed.

"May I take this home to show my wife?"

"Certainly, Mr. Whiteley."

"This chaperon business has always amused her."

He did not bring my skit back next morning, instead he took from the wrapping a beautiful sketch of his own.

"Will you trade?" he held out the sketch—"My wife simply refuses to give your skit up!"

"She is most welcome to it, Mr. Whiteley, but it is not worth this."

"We think so and, anyway, I should like you to have a sketch of mine to take back to Canada."

There was wild jealousy. Mack happened to be home ill. Little Canary asked, "May I take Mr. Whiteley's picture to show Mack?"

Mack said, "Huh! I doubt *that Canadian* is capable of appreciating either the honour or the picture!"

In the little wood behind the Meadows Studio, where the cuckoos called all day, I learned a lot. Like Mr. Talmage, Mr. Whiteley said, "Trot along to your woods; I will give you your 'crit' there, where you are happy and do your best work."

That was a luscious wood, lovely in seeing, smelling and hearing. Perpetual spring seemed to be there.

I remember with affection and gratitude something special that every Master taught me. Mr. Whiteley's pet phrase was, "The coming and going of foliage is more than just flat pattern." Mr. Talmage had said, "Remember, there is sunshine too in the shadows," when my colour was going black. Sombreness of Tregenna! Sunshine of Bushey! Both woods gave me so much, so much, each in its own splendid way, and each was interpreted to me by a good, sound teacher.

B I R D S

I WORKED in Bushey till late Autumn, then decided to winter again in St. Ives. But first I must return to my London boarding house and get my winter clothing from a trunk stored at Mrs. Dodds'. (We were allowed to store trunks in her basement at tuppence a week, a great convenience for students like me who were moving around.)

Always, when approaching London, a surge of sinking awfulness swept over me as we came to its outskirts, and the train began slithering through suburban manufacturing districts. Open country turned to human congestion, brick and mortar pressed close both sides of our way—ache of overcrowded space, murk, dullness stared from behind the glazed fronts and backs of brick houses. No matter how hard I tried, I could not take interest in manufacturing districts— they wilted me. Love of everything, that swamped me in the country, was congealed here, stuffed away like rotten lettuce. Nothing within me responded to the hum of machinery.

A crawling slither and the train oozed into the allotted slot, opened her doors and poured us into Euston's glare and hurry. Worry about luggage came first. To me the wonder is that any ever *was* found—no checking system, identification established solely by means of a pointing finger. The hot, hard pavements of London burned my foot soles.

"Why must you fuss so immediately upon coming to town?" I enquired angrily of my aching feet, and took a huge china water-pitcher from my cubicle to the floor below for hot water. The stair was straight and very long, the jug of water heavy. Only one step more, but one too many! I reeled; every step registered a black bump on me. There I lay in a steaming pool, among pieces of broken pitcher. I might have been an aquatic plant in a fancy garden.

The steaming water seeped beneath the doors of rooms. I hurt terribly, but the water must be mopped up. My groans brought students to doors which they slammed too quick and grumpily to keep the water out of their rooms.

I was unable to rise next morning. I sent a wire to Mildred, "Tumbled downstairs, can't come." Mildred sent the carriage and insisted. So I went. I managed to keep going till bedtime. That night is a blur of awfulness. When Mildred came into my room next morning she sent quickly for the doctor. Two nurses came, straw was laid on the pavement to dull the rumble even of those elegant, smooth-rolling carriages. For six weeks I lay scarcely caring which way things went.

"Send me to a nursing home," I begged. But Mrs. Compton's cool hand was over mine, "Go to sleep, little Motor, we're here." She always wore three rings— a hoop of rubies, a hoop of sapphires, and a hoop of diamonds. Even in the darkened room the gems glowed—they are the only gems I have ever loved. They were alive and were on a loved hand.

The doctor came and came. One day after a long, long look at me, he said, "You Canadians, I notice, don't take kindly to crowded cities. Try the sea-side for her, Mrs. Compton."

"There will be trees and air," I thought, and was glad.

There were no trees. The small, private convalescent home was kept by a fool. Because she had nursed in the German Royal Family she fancied herself. Every day she took their Royal Highnesses' photographs from the mantelpiece and kissed their ugly faces before us all. It made us sick. She was the worst kind of a snob ever made.

The sea was all dazzle and the sands white. My room was white, even the blinds. I asked for dark—the glare hurt my head. If I sat in dark corners Nurse said I was morbid! From my window I saw a scrub willow-tree. I took a rug and lay in the little back lane under the willow. Looking up into its leaves rested my eyes. Nurse rushed out, furious.

She shrieked, "Morbid nonsense! Get out onto that beach, let sunshine burn the germs out of you!"

I was wretched but I shammed robust health to get away from her house. I fooled the nurse so that she let me travel to Noel's mother. She had come several times to Belgrave Square and said, "Come to us as soon as they will let you travel. Don't wait to be well, come and get well in our garden—my four boys to wait on you!"

The journey relapsed me. I was so desperately ill that they wired to Canada. I did not know that until my sister Lizzie marched into the room. They sent her because she was on the edge of a nervous breakdown and they thought the trip would do her good. It was bad for both of us. This sister and I had never got on smoothly. We nearly sent each other crazy. She quarrelled with my doctor and my nurse, got very homesick, wanted to take me home immediately. The doctor would not let me travel. She called him a fool, said he knew nothing. She scolded me. I went to a London specialist. He was as determined about the travel as my own doctor.

"Complete rest, freedom from worry and exertion for at least one year."

He recommended an open-air Sanatorium, and, above all, that my sister go home, leave me.

Lizzie was very, very angry. She refused to go because of what people would say. By luck my guardian and his wife came tripping to the Old Country. When my guardian saw me all to bits, tears ran down his cheeks.

"Anything to get you well, Millie," he said, and prevailed on my sister to return home leaving me in a Sanatorium—no work for me for at least one year!

East Anglia Sanatorium was primarily for tuberculosis. They also took patients like myself, who required rest, good feeding and open air. The Sana-

torium was situated in a beautiful part of England. I was there for eighteen months, surrounded by slow-dyings, and coughing! . . . But for birds I doubt I could have stood it.

The countryside was alive with song-birds. It was gentle, rolling country, open fields, little woods, such as birds love. There were wild rabbit warrens too, so undermined with rabbit-holes that few humans walked there. The birds had it all to themselves and let me share.

I could not walk as the lung patients were made to under doctors' orders, slow, carefully timed walks. I was kept in bed a good deal. When up, I was allowed to ramble where I would, my only restriction was, "Do not overtire." I would lie in the near woods for hours, watching the birds.

Everyone was very good to me. The Sanatorium was run entirely by women—women doctors, women gardeners. The head doctor came down from London twice a week. Often she talked with me about Canada—she had a desire to go there.

"England beats Canada in just one thing," I said.

"What is that?"

"Song-birds."

"Why don't they import some?"

"They did, but in such a foolish way they all died—poor trapped, adult birds, terrified to death."

"Could it be successfully done?"

"I know how I'd go about it. First, I would hand-rear nestlings, take them to Canada, keep them in semi-captivity in a large, outdoor aviary. I would never liberate those old birds, but let them breed till there was a strong band of young ones to free."

"Sounds reasonable, go ahead," said the doctor.

"You mean I could raise my little birds here?"

"Why not, open air, birds in plenty!"

My life began again. I sent to London for books on how to hand-raise English song-birds. I decided to concentrate on thrushes and blackbirds. One month now and they would start nesting. Buds on hedge-rows were no more than reddish bulges when blackbirds and thrushes began hurrying twigs and straws into the larger crotches and firming sticks for foundations, lining the nests with mud. Mother thrush and I were friends long before the eggs hatched; she did not suspect me of being a sneak-thief.

I took young birds, nest and all, just before consciousness chased the blank from the fledglings' eyes. Once they saw, it was too late, for they cowered down in the nest and would not feed. My hand must be the first idea in their brains connected with food. Had they seen their feathered mother before me, they would have preferred her. Mother thrush was delighted to be relieved of her responsibility. She was already planning her next nest. If you went out after a steal early next morning, she was busy building again, quite happy. Had I taken but half of her family, left the rest for her in the old nest, she would have let them die.

My nurse was co-operative. Anything that relieved the flat monotony of San life was welcomed by the patients. They were all twittery over the birds for Canada. Suddenly they became interested in ant hills and grubs. Offerings were left for my birdlings on my window ledges when patients came from walks. Soon I had all the nestlings I could care for.

The nests stood on a table by my bedside; I fed the birds every two hours between dawn and dusk, poking the food into their gaping mouths with a tiny pair of pincers I made out of wood. My nestlings grew with such furious intensity you almost saw the feathers unfold. The biggest surprise was when inspiration first touched the wings and, wriggling to be free from the crowding of brothers, the fledgling rose to his feet, flopped one wing over the side of the nest. Then suddenly he knew the ecstasy of flight. Once having spread his wings, never again could he endure the crowded nest. Oh, I knew how it felt! Hadn't I been thrilled when first I felt freedom? Now London had winged me, but I had once known what it was to be free! When they had mastered flying and feeding, the birds were put into a big cage built for them in the yard.

All the San loved my birds. Old Mr. Oakley, broken by the Boer War, wracked by coughing, crawled, by the aid of a nurse and a stick, to the cage every morning to watch my birds take their bath. Therese, the dying child in the room next mine, tapped in our special code, "How are the birds?" I would scrabble little taps all over the wall to describe their liveliness. Gardeners left tins of grubs and worms on my window sill, cook sent things from the kitchen. Patients took long-handled iron spoons on their walks and plunged them into ant-hills to rob the ants of their eggs for my thrushes. Kitchen maids donated rhubarb and cabbage leaves to lay on the grass. These, watered, drew little snails to their underneath cool—bird delicacies.

When the thrushes and blackbirds were out of hand, I took two nests of bullfinches to rear. These were the San darlings. If a patient was feeling sad, a nurse would say, "Lend the soldiers;" and off would go the cage with a row of little pink-breasted bullies sitting, singing and dancing with the bullfinch comic shuffle to cheer somebody's gasping despondency. Oh, the merry birds did help!

The big Scotch house-doctor christened me "Birdmammy" because one day she paid her rest-hour visit to find five baby bullfinches cuddled under my chin. Their wings had just become inspired. This was their first flight and made to me, the only mother they had ever known.

What birds meant to the East Anglia San only those who have lain helpless among slow-dying know. The larks, hoisting their rippling songs to Heaven, sinking with fluttering pause back into an open field! The liquid outpourings from thrush and blackbird throats! A great white owl, floating noiselessly past our open rooms, turned her head this way and that, the lights of our rooms shining her gleaming eyes. A sudden swoop—another field-mouse's career finished! Birds of East Anglia! You almost compensated for torn lungs and overwork breakdowns.

On her weekly visits to the Sanatorium the London specialist scuttled past the door of my room, ashamed to face me. For months she had promised to

write home to my people. (It took six weeks for an answer to a letter in those days.) Every week the little house-doctor pleaded with the big specialist.

"Don't forget to write to Canada about Mammy's condition." I was getting nowhere, nothing was being tried to help me.

Each week the "Big One" would say, "Dear me, I have been too busy to think of it. I will do it this week."

Then she would neglect writing again. Little house-doctor was bitter about it—I was disheartened. Had my check to the San not come regularly the "Big One" would have stirred herself to look into matters at once. Had I been a celebrity or possessed of a title she would have remembered. I was only a student who had overworked. The East Anglia Sanatorium was a company. The London doctor was its head. She snivelled over me, pretending devotion. My faith in this country was broken. I had no faith or confidence in the big, bragging doctor. She was a tuberculosis specialist. I saw patients contract all sorts of other troubles in that San. As long as their lungs healed and added glory to her reputation! Nothing else mattered.

BITTER GOODBYE

WHEN THEY were about nine months old, my birds began to get very quarrelsome, damaging each other by fighting. From my bed I heard trouble in the cage but I could not go to them. I had now been in the Sanatorium for over a year. I was losing, not gaining. At last, to my dismay, I found that all my contemporaries were either dead or had gone home to continue the outdoor treatment there. A few, a very few, were cured.

The big Scotch house-doctor who was at the San when I came had been succeeded by a little English woman doctor of whom I was very fond. Most of the old nurses, too, were gone, new ones had come.

One day the London doctor introduced me to a visiting physician she had brought down with her for the week-end.

She said of me, "This is the San's old-timer." Shame swept me as she said, "Sixteen months, isn't it, Mammy?" She turned to the visitor, explaining, "She's Mammy to every bird in the neighbourhood, raising nestlings to take back to Canada where they have few songsters."

Canada! Why, I was no nearer the voyage than I had been sixteen months back. I knew by everyone's gentleness to me, by the loving, evasive letters I received from old patients, it was not expected I would ever get back to Canada.

I was troubled about my birds. The old friends, who had always been willing

to lend a hand with them when I was laid up, were gone—newcomers were indifferent. They did not know the birds, did not know me. The birds themselves were increasingly quarrelsome. The whole situation bothered, worried me. I pondered, unhappy.

At last the doctor had written to my people in Canada. It was decided to try a severe, more or less experimental, course of treatment. A special nurse was brought down from London, a masseuse, callous, inhuman, whom I hated. The treatment consisted of a great deal of massage, a great deal of electricity and very heavy feeding. This nurse delighted in telling horrible stories, stories of deformities and of operations while she worked over me. Her favourite story was of a nephew of hers, born without a nose. One hole in the middle of his face served as both nose and mouth; it sickened me. I appealed to the doctor who forbade nurse talking to me during the long hours of massage. This angered the woman; she turned mean to me.

The day before treatment started I said to the little house-doctor whom I was fond of, "What about my birds?"

The treatment was to last from six to eight weeks. Doctor was silent. I went silent too.

I asked, "May I get up for half an hour today?"

"You are too weak, Mammy."

"There is something I must attend to before treatment starts."

"Your nurse will do anything."

"This thing only I can do."

She gave a humouring consent. I knew she thought it made little difference. Her eyes filled; she was a dear woman.

In the quiet of the rest hour, when nobody was about, I slipped from my room, out through a side door in the corridor, into the yard where my birdcage stood. The birds heard my stick, my voice—they shrieked delightedly. I caught them every one, put them into a box which I took back into my bedroom.

Panting heavily I rang my bell, "Send doctor!"

Doctor came hurrying.

"Chloroform my birds."

"Oh, Mammy! Why not free them?"

"I love them too much! Village boys would trap the tame things—slow starvation on a diet of soaked bread and earth worms! Please, doctor! I've thought it all out."

She did what I asked.

The next day I was moved into a quiet, spacious room—treatment under the new nurse began. She would allow no one to come into the room but the doctor. I was starved on skim milk, till they had brought me as low as they dared. Gradually they changed starvation to stuffing, beating the food into my system with massage, massage, electricity—four hours of it each day. The nurse was bony-fingered, there was no sympathy in her touch; every rub of her hand antagonized me. The electricity sent me nearly mad. I was not allowed to read, to talk, to think. By degrees I gained a little strength but my nerves and spirit

were in a jangle. By and by I got so that I did not want to do anything, to see anybody, and I hated the nurse. I had two months of this dreadful treatment—eighteen months in the East Anglia Sanatorium all told! Then the doctor said, "Now we will try letting you go back to work."

Work! I had lost all desire to work now. When first ill I used to ask, "When can I get back to work, when can I get back to work?" continually, and they had answered, "When you have ceased wanting to." I suppose they had got me in that place now—thought they had killed eagerness and ambition out of me.

Nurse took me up to London. I spent a wretched day or two in the house of the "Big One." At the time she was in a burst of exhilaration because she had been summoned to attend the wife of the Dean of St. Paul's. If it was not Lady this or Lord that, it was the Very Reverend Dean. Stretching after Big Pots, yearning to hang on to the skirts of titled, of "worthwhile" people—English worship of aristocracy! Oh, I loathed it! I left the doctor's house and went down to Bushey, forbidden ever to attempt working in London again.

The Bushey Studios were closed; classes would not re-open for two weeks. I took rooms in the village, disheartened, miserable, broken, crying, always crying, couldn't stop.

The San's little house-doctor took a long, round-about, cross-country journey from the San to Bushey specially to see me. I cried through her entire visit. She was deeply distressed at my condition, and I was shamed.

Through my tears and a pouring rain, I watched her wash down Bushey High Street. Yet doctor's parting words had done me vast good. This is what they were,—"I realize how hard it is after eighteen months of absolute inertness to find yourself again adrift, nobody, nothing, weak as a cat! I am proud of the fight you are putting up." After she had gone she ran back up the steps again to take me in her arms, hold me a moment tight, tight, say again, "I am proud of you!"

Oh how could she be proud of such a bitter-hearted, sloppy old coward? In my room she saw evidence of trying to pick up life's threads again. She guessed the struggle. I wished I had not cried all the time she was there! I'd make her laugh yet. "I'll make Little Doctor and all of them laugh!" I vowed and, running to my trunk, dug up a sketch book and fell to work.

Two weeks I laboured incessantly over a satire on the San, and on the special treatment. I wrote long doggerel verses and illustrated them by some thirty sketches in colour, steadily crying the while. The paper was all blotched with tears. I just ignored the stupid tears. The skit was funny—*really funny*; I bound the pages together, posted them off to Little Doctor—waited—.

Promptly her answer came.

"Bravo! How the staff roared!—all the staff but matron and me, we knew its price."

The world was upside down! The ones I had aimed to make laugh cried. I loved doctor's and matron's tears all the same and, believe it or not, their tears dried mine.

I went back to Mr. Whiteley's studio and slowly got into work again. It was not easy. I was weak in body, bitter in spirit. In about three months I was to be allowed to travel.

Five years and a half in London! What had I to show for it but struggle, just struggle which doesn't show, or does it, in the long run?

Mrs. Radcliffe, Mrs. Denny, Mildred had all been down to the San, from time to time, to visit me. Just now I could not bear Mrs. Radcliffe's bracing, Mrs. Denny's religion, Mrs. Compton's and Mildred's love. No, my pride could not face them, not just now. Without good-byes, I slipped through London, straight to Liverpool. Good-bye to my high hopes for work, to my beautiful birds, to my youngness! Good-bye, good-bye, good-bye—surely enough good-byes. Yet my ungracious creeping past those in London who were so kind to me has always left deep down in me a sore feeling of shame and cowardice.

I did not know the land which haze was swallowing was Ireland. I only knew I was glad to be leaving the Old World.

"Sure, it's Ireland is your home, too?" an Irish voice said at my side. I looked into the blue eyes of an Irish boy, homesick already.

"Canada is my home," I replied.

He faded into the crowd. I never saw but I thought often again of that kind boy who took for granted that my sadness was homesickness, same as his. Sad I was about my failures, but deep down my heart sang: I was returning to Canada.

PART III

C A R I B O O G O L D

JUST BEFORE I left England a letter came from Cariboo, out in British Columbia. It said, "Visit us at our Cariboo Ranch on your way west." The inviters were intimate friends of my girlhood. They had married while I was in England. Much of their love-making had been done in my old barn studio. The husband seconded his wife's invitation, saying in a P.S., "Make it a long visit. Leave the C.P.R. train at Ashcroft. You will then travel by horse-coach to the One Hundred and Fifty Mile House up the Cariboo Road, a pretty bumpy road too. . . . I will make arrangements.

I had always wanted to see the Cariboo country. It is different from the coast, less heavily wooded, a grain and cattle-raising country. Coming as the invitation did, a break between the beating London had given me and the humiliation of going home to face the people of my own town, a failure, the Cariboo visit would be a flash of joy between two sombres. I got happier and happier every mile as we pushed west.

I loved Cariboo from the moment the C.P.R. train spat me out of its bouncy coach. It was all fresh and new and yet it contained the breath and westernness that was born in me, the thing I could not find in the Old World.

I will admit that I did suffer two days of violence at the mercy of the six-horse stage-coach which bumped me over the Cariboo Road and finally deposited me at the door of One Hundred and Fifty Mile House where my friend lived, her husband being manager of the Cariboo Trading Company there. It had been a strange, rough journey yet full of interest. No possible springs could endure such pitch and toss as the bumps and holes in the old Cariboo road-bed played. The coach was slung on tremendous leather straps and, for all that it was so ponderous, it swayed and bounced like a swing.

A lady school-teacher, very unenthusiastic at being assigned a rural school in the Cariboo, shared the front top seat with the driver and me. She did not speak, only sighed. The three of us were buckled into our seats by a great leather apron. It caught driver round the middle and teacher and me under our chins. We might have been infant triplets strapped abreast into the seat of a mammoth pram. If we had not been strapped we would have flown off the top of the stage. At the extra-worst bumps the heads of the inside passengers hit the roof of the coach. We heard them.

We changed horses every ten miles and wished we could change ourselves,

holding onto yourself mile after mile got so tiresome. The horses saved all their prance for final show-off dashings as they neared the changing barns; here they galloped full pelt. Driver shouted and the whip cracked in the clear air. Fresh horses pranced out to change places with tired ones, lively and gay, full of show-off. When blinkers were adjusted on the fresh horses so as not to tell tales, the weary ones sagged into the barn, their show-off done. The whole change only took a minute, scarcely halting our journey. Sometimes the driver let us climb a short hill on foot to ease the load and to uncramp us.

It was beautiful country we passed through—open and rolling—vast cattle ranges, zig-zag snake-fences and beast-dotted pasturage with little groves of cotton-poplars spread here and there. There were great wide tracts of wild grazing too.

The cotton-poplars and the grain-fields were turning every shade of yellow. The foliage of the trees were threaded with the cotton-wood's silver-white sterns. Long, level sweeps of rippling gold grain were made richer and more luscious by contrast with the dun, already harvested stubble fields. Men had called this land "Golden Cariboo" because of the metal they took from her soil and her creeks, but Cariboo's crust was of far more exquisite gold than the ore underneath—liquid, ethereal, living gold. Everything in Cariboo was touched with gold, even the chipmunks had golden stripes running down their brown coats. They were tiny creatures, only mouse-big. They scampered, beyond belief quick, in single-file processions of twinkling hurry over the top rail of the snake-fences, racing our stage-coach.

At dark we stopped at a road-house to eat and sleep. Cariboo provides lavishly. We ate a huge meal and were then hustled off to bed only to be torn from sleep again at two A.M. and re-mealed—a terrible spread, neither breakfast, dinner, nor supper, but a "three-in-one" meal starting with porridge, bacon and eggs, and coffee, continuing with beef-steak, roast potatoes, and boiled cabbage, culminating in pudding, pie, and strong tea. The meal climaxed finally on its centre-piece, an immense, frosted jelly-cake mounted on a pedestal platter. Its gleaming frosting shimmered under a coal-oil lamp, suspended over the table's centre. At first I thought it was a wedding-cake but as every meal in every road-house in Cariboo had just such a cake I concluded it was just Cariboo. The teacher's stomach and mine were taken aback at such a meal at such an hour. We shrank, but our hostess and the driver urged, "Eat, eat; it's a long, hard ride and no stop till noon." The bumps would digest us. We did what we could.

At three A.M. we trembled out into the cold stillness of starry not-yet-day. A slow, long hill was before us. The altitude made my head woozey. It wobbled over the edge of the leather apron buckled under our chins. Between teacher and driver I slept, cosy as jam in a "roly-poly."

The One Hundred and Fifty Mile trading post consisted of a store, a road-house where travellers could stop or could pause between stages to get a meal, and a huge cattle barn. These wooden structures stood on a little rise and, tucked below, very primitive and beyond our seeing and hearing (because the tiny village lay under the bluff on which sat the Cariboo Trading Company)

were a few little houses. These homes housed employees of the Company. On all sides, beyond the village, lay a rolling sea of land, vast cattle ranges, snake-fenced grain-fields—space, space. Wild creatures, big and little, were more astonished than frightened at us; all they knew was space.

My friend met the coach.

"Same old Millie!" she laughed. Following her point and her grin, I saw at my feet a small black cat rubbing ecstatically round my shoes.

"Did you bring her all the way uncrated?"

"I did not bring her at all; does she not belong here?"

"Not a cat in the village."

Wherever she belonged, the cat claimed me. It was as if she had expected me all her life and was beyond glad to find me. She followed my every step. We combed the district later trying to discover her owner. No one had seen the creature before. At the end of my two months' visit in the Cariboo I gave her to a kind man in the store, very eager to have her. Man and cat watched the stage lumber away. The man stooped to pick up his cat, she was gone—no one ever saw her again.

I can never love Cariboo enough for all she gave to me. Mounted on a cow-pony I roamed the land, not knowing where I went—to be alive, going, that was enough. I absorbed the trackless, rolling space, its cattle, its wild life, its shy creatures who wondered why their solitudes should be plagued by men and guns.

Up to this time I had always decorously used a side-saddle and had ridden in a stiff hat and the long, flapping habit proper for the date. There was only one old, old horse, bony and with a rough, hard gait that would take side-saddle in the Cariboo barns. My friend always rode this ancient beast and used an ortho-dox riding-habit. I took my cue from a half-breed girl in the district, jumped into a Mexican cow-boy saddle and rode astride, loping over the whole country, riding, riding to nowhere. Oh goodness! how happy I was. Though far from strong yet, in this freedom and fine air I was gaining every week. When tired, I threw the reins over the pommel and sat back in the saddle leaving direction to the pony, trusting him to take me home unguided. He never failed.

I tamed squirrels and chipmunks, taking them back to Victoria with me later. I helped my host round up cattle, I trailed breaks in fences when our cattle strayed. A young coyote and I met face to face in a field once. He had not seen nor winded me. We nearly collided. We sat down a few feet apart to consider each other. He was pretty, this strong young prairie-wolf.

The most thrilling sight I saw in the Cariboo was a great company of wild geese feeding in a field. Wild geese are very wary. An old gander is always posted to warn the flock of the slightest hint of danger. The flock were feeding at sun-down. The field looked like an immense animated page of "pothooks" as the looped necks of the feeding birds rose and fell, rose and fell. The sentinel honked! With a whirr of wings, a straightening of necks and a tucking back of legs, the flock rose instantly—they fell into formation, a wedge cutting clean, high air, the irregular monotony of their honking tumbling back to earth, falling

in a flurry through the air, helter-skelter, falling incessant as the flakes in a snow storm. Long after the sky had taken the geese into its hiding their honks came back to earth and us.

Bands of coyotes came to the creek below our windows and made night hideous by agonized howlings. No one had warned me and the first night I thought some fearfulness had overtaken the world. Their cries expressed woe, cruelty, anger, utter despair! Torn from sleep I sat up in my bed shaking, my room reeking with horror! Old miners say the coyote is a ventriloquist, that from a far ridge he can throw his voice right beside you, while from close he can make himself sound very far. I certainly thought that night my room was stuffed with coyotes.

In Cariboo I did not paint. I pushed paint away from me together with the failure and disappointment of the last five years.

There was an Indian settlement a mile or two away. I used to ride there to barter my clothing for the Indians' beautiful baskets. At last I had nothing left but the clothes I stood in but I owned some nice baskets.

My friend was puzzled and disappointed. We had known each other since early childhood. She had anticipated my companionship with pleasure—but here I was!

"Millie!" she said disgustedly, "you are as immature and unsophisticated as when you left home. You must have gone through London with your eyes shut!" and, taking her gun, she went out.

She seldom rode, preferring to walk with gun and dog. She came home in exasperated pets of disgust.

"Never saw a living creature—did you?"

"All kinds; the critters know the difference between a sketching easel and a gun," I laughed.

We never agreed on the subject of shooting. She practiced on any living thing. It provoked her that creatures would not sit still to be shot.

"London has not sophisticated you at all," she complained. "I have quite outgrown you since I married."

Perhaps, but maybe London had had less to do with retarding my development than disappointment had. She was bored by this country as I had been bored by London. Quite right, we were now far apart as the poles—no one's fault. Surfacely we were very good friends, down deep we were not friends at all, not even acquaintances.

Winter began to nip Cariboo. The coast called and Vancouver Island, that one step more Western than the West. I went to her, longing yet dreading. Never had her forests looked so solemn, never her mountains so high, never her drift-laden beaches so vast. Oh, the gladness of my West again! Immense Canada! Oh, her Pacific edge, her Western limit! I blessed my luck in being born Western as I climbed the stair of my old barn studio.

During my absence my sister had lent the studio to a parson to use for a study. He had papered the walls with the *Daily Colonist*, sealed the windows. There were no cobwebs, perhaps he had concocted them into sermons. As I ran

across the floor to fling the window wide everything preached at me.

Creak of rusty hinge, the clean air rushed in! The cherry tree was gone, only the memory of its glory left. Was everything gone or dead or broken? No! Hurrying to me came Peacock, my Peacock! Who had told him I was come? He had not been up on the studio roof this last five years. Glorious, exultant, he spread himself.

Victoria had driven the woods back. My sister owned a beautiful mare which she permitted me to ride. On the mare, astride as I had ridden in Cariboo, my sheep-dog following, I went into the woods. No woman had ridden cross-saddle before in Victoria! Victoria was shocked! My family sighed. Carrs had always conformed; they believed in what always has been continuing always to be. Cross-saddle! Why, everyone disapproved! Too bad, instead of England gentling me into an English Miss with nice ways I was more *me* than ever, just pure me.

One thing England had taught me which my friends and relatives would not tolerate—smoking! Canadians thought smoking women fast, bad. There was a scene in which my eldest sister gave her ultimatum. "If smoke you must, go to the barn and smoke with the cow. Smoke in my house you shall not."

So I smoked with the cow. Neither she nor I were heavy smokers but we enjoyed each other's company.

And so I came back to British Columbia not with "know-it-all" fanfare, not a successful student prepared to carry on art in the New World, just a broken-in-health girl that had taken rather a hard whipping, and was disgruntled with the world.

Of my three intimate school friends two were married and living in other places, the third was nursing in San Francisco. I made no new friends; one does not after school-days, unless there are others who are going your way or who have interests in common. Nobody was going my way, and their way did not interest me. I took my sheep-dog and rode out to the woods. There I sat, dumb as a plate, staring, absorbing tremendously, though I did not realize it at the time. Again I was struck by that vague similarity between London crowds and Canadian forests; each having its own sense of terrific power, density and intensity, but similarity ceased there. The clamorous racing of hot human blood confused, perhaps revolted me a little sometimes. The woods standing, standing, holding the cool sap of vegetation were healing, restful after seeing the boil of humanity.

It did me no harm to sit idle, still pondering in the vastness of the West where every spilled sound came tumbling back to me in echo. After the mellow sweetness of England with its perpetual undertone of humanity it was good to stand in space.

VANCOUVER

EVERYTHING was five and a half years older than when I left home but then so was I—five of the most impressionable years of life past. I was glad some things had changed, sorry others had. I was sorry to say good-bye to my little self—I mean the little self that is always learning things without knowing that it is doing so.

It was nice now to go to church by choice and not be pushed there. It was nice even to miss occasionally without feeling "helly". The Y.W.C.A. were now firmly established in a fine new building of their own and did not have to pray all over our floors. My sisters belonged to many religious and charitable societies. The choice was left to me—Ladies' Aid, Y.W.C.A., King's Daughters, a dozen others. I joined none.

There were no artists in Victoria. I do not remember if the Island Arts and Crafts Club had begun its addled existence. When it did, it was a very select band of elderly persons, very prehistoric in their ideas on Art.

It was nice to be home, but I was not there for long because the Ladies' Art Club of Vancouver asked me to accept the post of Art teacher to their Club. So I went to live in Vancouver. The Vancouver Art Club was a cluster of society women who intermittently packed themselves and their admirers into a small rented studio to drink tea and jabber art jargon.

Once a week I was to pose a model for them and criticize their work. I had been recommended by one of their members who was an old Victorian and who had known me all my life. She was abroad when I accepted the post.

The Art Club, knowing I was just back from several years of study in London, expected I would be smart and swagger a bit. When they saw an unimportant, rather shy girl they were angry and snubbed me viciously, humiliating me in every possible way. Their President was a wealthy society woman. Floating into the studio an hour or more late for class, she would swagger across the room, ignoring me entirely and change the model's pose. Then she would paint the background of her study an entirely different colour to the one I had arranged. If I said anything, she replied, "I prefer it so!"

Other members of the class, following her lead, and tossing their heads, would say with mock graciousness, "You may look at my work if you would like to, but I wish no criticism from you." At the end of my first month they dismissed me. Perhaps I did look horribly young for the post.

On her return to Vancouver my sponsor sent for me.

"I hear the Ladies' Club have dismissed you, my dear."

"Yes. I am glad!"

"All were unanimous in their complaint."

"What was it?"

"Millie, Millie!" she smiled, "You tried to make them take their work seriously! Society ladies serious! My dear, how could you?" she laughed.

"They are vulgar, lazy old beasts," I spluttered. "I am glad they dismissed me and I am proud of the reason. I hate their kind. I'd rather starve."

"What shall you do now?"

"I have taken a studio in Granville Street. The only woman in the Art Club who was decent to me (an American) has sent her little daughter to me for lessons. The child has interested her schoolmates. Already I have a class of nice little girls.

"Good, with them you will be more successful. The Club's former teacher was 'society'. She understood the Club ladies, complimented and erased simultaneously, substituting some prettiness of her own in the place of their daubs, something which they could exhibit. They liked that. She was older, too."

The snubbing by the Vancouver Ladies' Art Club starched me. My pride stiffened, my energy crisped. I fetched my sheep-dog and cage of bullfinches from Victoria, added a bunch of white rats, a bowl of goldfish, a cockatoo and a parrot to my studio equipment and fell into vigorous, hard, happy work, finding that I had learned more during those frustrated years in England than I had supposed—narrow, conservative, dull-seeing, perhaps rather mechanical, but nevertheless honest.

Because I did not teach in the way I had been taught, parents were sceptical, but my young pupils were eager, enthusiastic. Every stroke was done from objects or direct from life-casts, live-models, still life, animals.

Young Vancouver had before been taught only from flat copy. I took my classes into the woods and along Vancouver's waterfront to sketch. A merry group we were, shepherded by a big dog, each pupil carrying a campstool and an easel, someone carrying a basket from which the cockatoo, Sally, screeched, "Sally is a Sally." That was Sally's entire vocabulary. If she was left in the studio when the class went sketching she raised such a turmoil that the neighbours objected. Out with the class, joining in the fun, Sally was too happy even to shout that Sally was a Sally.

We sat on beaches over which great docks and stations are now built, we clambered up and down wooded banks solid now with Vancouver's commercial buildings.

Stanley Park at that time was just seven miles of virgin forest, three quarters surrounded by sea. Alone, I went there to sketch, loving its still solitudes—no living creature but dog Billie and me, submerged beneath a drown of undergrowth. Above us were gigantic spreads of pines and cedar boughs, no bothersome public, no rubbernoses. Occasional narrow trails wound through bracken and tough salal tangle. Underfoot, rotting logs lay, upholstered deep in moss,

bracken, forest wastage. Your feet never knew how deep they would sink.

I loved too the Indian reserve at Kitsilano and to the North Vancouver Indian Mission Billie and I went for long days, our needs tucked into my sketch-sack and great content in our hearts.

Vancouver was then only a little town, but it was growing hard. Almost every day you saw more of her forest being pushed back, half-cleared, waiting to be drained and built upon—mile upon mile of charred stumps and boggy skunk-cabbage swamp, root-holes filled with brown stagnant water, reflecting blue sky by day, rasping with frog croaks by night, fireweed, rank of growth, springing from the dour soil to burst into loose-hung, lush pink blossoms, dangling from red stalks, their clusters of loveliness trying to hide the hideous transition from wild to tamed land.

The foundationless Ladies' Art Club of social Vancouver was crumbling; their President came to me, asking that I give up my studio and share theirs thereby lessening their rental. I refused. Then she said, "Shall we give up ours and come to share yours? Our teas of course—but," smirked the lady, "prestige of the Vancouver Ladies' Art Club behind your classes!"

"No, no, no! I don't want your prestige—I won't have the Ladies' Art Club in my studio!"

The President tore down my stairs. I had not imagined Presidents could rush with such violence.

The first year that I lived and taught in Vancouver my sister Alice and I took a pleasure trip up to Alaska.

The Klondyke rush had been over just a few years. We travelled on a Canadian boat as far as Skagway, end of sea travel for Klondyke. Prospectors had left steamers here and gone the rest of the way on foot over a very rough trail. Those who could afford to, took pack-beasts; those who could not, packed their things on their own backs.

The mushroom town of Skagway had sprung up almost overnight. It consisted of haphazard shanties, spilled over half-cleared land. The settlement lay in a valley so narrow it was little more than a ravine heading the shallow, muddy inlet. Three tipsy plank walks on crooked piles hobbled across the mud to meet water deep enough to dock steamboats. Each runway ended in a blob of wharf.

Jumping gaps where planks had broken away, I went out on to the end of one wharf to look back at Skagway. Bits of my clothing and sketching equipment blew off into the sea.

Wind always moaned and cried down the little valley, smacking this, overturning that shanty. The little town was strewn with collapsed buildings. Crying, crying, the valley was always crying. There was always rain or mist or moaning wind. It had seen such sadness, this valley—high hopes levelled like the jerry-built shanties, broken, crazed men, drinking away their disappointments.

A curious little two-coach train ran up the valley twice a week. Its destination was White Horse. It followed the old Klondyke trail. We took it up as far as the summit. Here, side by side, where their land met, fluttered two flags,

British and American. The train jogged and bumped a good deal. We passed through valleys full of silence, mocking our noisy little train with echoes because our black smoke dirtied the wreaths of white mist which we met in the valleys.

A stark, brooding, surly land was this, gripping deep its secrets. Huddles of bones bleached by the wayside—bullock bones, goat and horse bones, beasts for whom the lure of gold did not exist but who, broken under burdens of man's greed, had fallen by the way, while man, spurred on by the gold glitter, shouldered the burdens of the dead beasts and pushed further. In the valley, drowned under lush growth, we stumbled upon little desolate log shanties, half built. The finger of the wild now claimed the cabins, saying, "Mine, mine!", mossing them, growing trees through the mud floors and broken roofs.

"How do these come to be here?" I asked.

"Failures—men who lacked the courage to go home beaten. Most drank themselves to death. For many, a gun was their last, perhaps their best, friend."

No wonder the valley cried so! Of those who stayed in Skagway it was seldom said, "He made good. He struck it lucky!" The lucky ones went down to the cities, scarred by their Klondyke experience, seldom happier for their added gold.

We stayed one week in Skagway; then, taking an American steamer, crossed to Sitka on Baronoff Island.

Sitka had an American army barracks, a large Indian village, and an ancient Russian church. It also had many, many very large, black ravens, sedate birds but comical. They scavenged the village, calling to one another back in the woods. The male and the female made different squawks; the cry of one was a throaty "Qua", the other answered, "Ping!", sharp and strident as a twanged string. At the top of its flagpole the barracks had a gilt ball which had great attraction for the ravens. There were always three or four of them earnestly trying to get firm foothold on the rounded surface. It was amusing to watch them.

As we walked through the little town of Sitka I saw on a door, "Picture Exhibition—Walk In". We did so.

The studio was that of an American artist who summered in Sitka and wintered in New York where he sold his summer's sketches, drab little scenes which might have been painted in any place in the world. He did occasionally stick in a totem pole but only ornamentally as a cook sticks a cherry on the top of a cake.

The Indian totem pole is not easy to draw. Some of them are very high, they are elaborately carved, deep symbolical carving, as much or more attention paid to the attributes of the creature as to its form.

The Indian used distortion, sometimes to fill spaces but mostly for more powerful expressing than would have been possible had he depicted actualities—gaining strength, weight, power by accentuation.

The totem figures represented supernatural as well as natural beings, mythological monsters, the human and animal figures making "strong talk", bragging of their real or imagined exploits. Totems were less valued for their workmanship than for their "talk".

The Indian's language was unwritten: his family's history was handed down by means of carvings and totemic emblems painted on his things. Some totems were personal, some belonged to the whole clan.

The American artist found me sketching in the Indian village at Sitka. He looked over my shoulder; I squirmed with embarrassment. He was twice my age and had had vastly more experience.

He said, "I wish I had painted that. It has the true Indian flavour."

The American's praise astounded me, set me thinking.

We passed many Indian villages on our way down the coast. The Indian people and their Art touched me deeply. Perhaps that was what had given my sketch the "Indian flavour." By the time I reached home my mind was made up. I was going to picture totem poles in their own village settings, as complete a collection of them as I could.

With this objective I again went up north next summer and each successive summer during the time I taught in Vancouver. The best material lay off the beaten track. To reach the villages was difficult and accommodation a serious problem. I slept in tents, in roadmakers' toolsheds, in missions, and in Indian houses. I travelled in anything that floated in water or crawled over land. I was always accompanied by my big sheep-dog.

Indian Art broadened my seeing, loosened the formal tightness I had learned in England's schools. Its bigness and stark reality baffled my white man's understanding. I was as Canadian-born as the Indian but behind me were Old World heredity and ancestry as well as Canadian environment. The new West called me, but my Old World heredity, the flavour of my upbringing, pulled me back. I had been schooled to see outsides only, not struggle to pierce.

The Indian caught first at the inner intensity of his subject, worked outward to the surfaces. His spiritual conception he buried deep in the wood he was about to carve. Then—chip! chip! his crude tools released the symbols that were to clothe his thought—no sham, no mannerism. The lean, neat Indian hands carved what the Indian mind comprehended.

Indian Art taught me directness and quick, precise decisions. When paying ten dollars a day for hire of boat and guide, one cannot afford to dawdle and haver this vantage point against that.

I learned a lot from the Indians, but who except Canada herself could help me comprehend her great woods and spaces? San Francisco had not, London had not. What about this New Art Paris talked of? It claimed bigger, broader seeing.

My Vancouver classes were doing well. I wrote home, "Saving up to go to Paris."

Everybody frowned—hadn't London been a strong enough lesson but I must try another great city?

But I always took enough from my teaching earnings to go north and paint in the Indian villages, even while saving for Paris.

One summer, on returning from a northern trip, I went first to Victoria to visit my sisters. There I received a curt peremptory command: "Hurry to the

Empress hotel. A lady from England wishes to see you on business connected with your Indian sketches."

The woman was screwed up and frumpy, so stuffed with her own importance that she bulged and her stretched skin shone.

"I wish to see those Indian sketches of yours."

"For the moment that is not possible; they are stored in my Vancouver studio and it is rented," I replied.

"Then you must accompany me to Vancouver tonight and get them out."

"Do you wish to buy my sketches?"

"Certainly not. I only want to borrow them for the purpose of illustrating my lectures entitled 'Indians and Artists of Canada's West Coast'."

"Where do I come in?"

"You?—Publicity—I shall mention your work. Oxford! Cambridge!"

Her eyes rolled, her high-bridged nose stuck in the air. I might have been a lump of sugar, she the pup. Oxford and Cambridge signalled. Pup snapped, Oxford and Cambridge gulped—me.

"I shall see you at the midnight boat, then? You may share my stateroom," magnanimously.

"Thanks, but I'm not going to Vancouver."

"What! You cannot be so poor spirited! My work is patriotic. I am philanthropic. I advance civilization—I educate."

"You make nothing for yourself exploiting our Indians?"

"After expenses, perhaps just a trifle. . . . You will not help the poor Indian by lending the Alert Bay sketches? My theme centres around Alert Bay."

My interest woke.

"You have been there? Are you familiar with it?"

"Oh, yes, yes! Our boat stopped there for twenty minutes. I walked through the village, saw houses, poles, people."

"And you dare talk and write about our Coast Indians having only that much data! The tourist folders do better than that! Good-bye!"

"Stop!"

She clutched my sleeve as I went out the hotel door—followed me down the steps hatless, bellowed at me all the way home, spluttering like the kick-up waves behind a boat. She stalked into our drawing room, sat herself down.

I said, "Excuse me, I am going out."

She handed me a card.

"My London Club. It will always find me. Your better self will triumph!"

She smiled at, patted me.

I said, "Listen! England is not interested in our West. I was in London a few years ago, hard up. A well known author wrote a personal letter for me to a big London publisher.

'Take this to him with a dozen of your Indian sketches,' she said, 'and what a grand calendar they will make! England is interested in Canada just now.'

A small boy took my letter and returned, his nasty little nose held high, his aitchless words insolent.

'Leave yer stuff, Boss'll look it over *if* 'e 'as toime.'

I started down the stair.

' 'Ere, where's yer stuff? Yer ha'n't left any?'

'It is going home with me.'

At the bottom of the third flight the boy caught up with me.

'Boss says 'e'll see you now.'

The elegant creature spread my sketches over his desk.

'America, eh? Well, take 'em there. Our British public want this.' He opened a drawer crammed with pink-coated hunting scenes. 'Indians belong to America; take 'em there.'

'Canada happens to be British,' I said, 'and these are Canadian Indians.'

I put the sketches back in their wrappings.

Teach your English people geography, Madam! Then maybe they will be interested in British things. Half the people over here don't know that all the other side of the Atlantic does not belong entirely to the Americans."

F R A N C E

"TWO PARROTS out in Canada waiting your return! Is it absolutely necessary that you buy another, Millie?"

"Those at home are green parrots; this is an African-grey. I have always wanted an African-grey frightfully. Here we are in Liverpool, actually at Cross's, world-wide animal distributors—it is the opportunity of a lifetime."

Perhaps pity of my green, sea-sick face softened my sister's heart and opened her purse. Half the price of the "African-grey" stole into my hand.

We called the bird Rebecca and she was a most disagreeable parrot. However, nothing hoisted my spirits like a new pet, the delight of winning its confidence!

Hurrying through London, we crossed the Channel, slid through lovely French country—came to Paris.

My sister knew French but would not talk. I did not know French and would not learn. I had neither ear nor patience. I wanted every moment of Paris for Art.

My sister studied the history of Paris, kept notes and diaries. I did not care a hoot about Paris history. I wanted *now* to find out what this "New Art" was about. I heard it ridiculed, praised, liked, hated. Something in it stirred me, but I could not at first make head or tail of what it was all about. I saw at once that it made recent conservative painting look flavourless, little, unconvincing.

I had brought with me a letter of introduction to a very modern artist named Harry Gibb. When we had found a small flat in the Latin Quarter, Rue Campagne Premier, off Montparnasse Avenue, I presented my letter.

Harry Gibb was dour, his wife pretty. They lived in a studio overlooking a beautiful garden, cultivated by nuns. I stood by the side of Harry Gibb, staring in amazement up at his walls. Some of his pictures rejoiced, some shocked me. There was rich, delicious juiciness in his colour, interplay between warm and cool tones. He intensified vividness by the use of complementary colour. His mouth had a crooked, tight-lipped twist. He was fighting bitterly for recognition of the "New Art." I felt him watching me, quick to take hurt at even such raw criticism as mine. Mrs. Gibb and my sister sat upon a sofa. After one look, my sister dropped her eyes to the floor. Modern Art appalled her.

Mr. Gibb's landscapes and still life delighted me—brilliant, luscious, clean. Against the distortion of his nudes I felt revolt. Indians distorted both human and animal forms—but they distorted with meaning, for emphasis, and with great sincerity. Here I felt distortion was often used for design or in an effort to shock rather than convince. Our Indians get down to stark reality.

I could not face that tight-lipped, mirthless grin of Mr. Gibb's with too many questions. There were many perplexities to sort out.

Strange to say, it was Mrs. Gibb who threw light on many things about the "New Art" for me. She was not a painter but she followed the modern movement closely. I was braver at approaching her than her husband with questions.

I asked Mr. Gibb's advice as to where I should study.

"Colorossi," he replied. "At Colorossi's men and women students work together. At Julien's the classes are separate. It is of distinct advantage for women students to see the stronger work of men."—Mr. Gibb had not a high opinion of the work of woman artists.

The first month at Colorossi's was hard. There was no other woman in the class; there was not one word of my own language spoken. The French professor gabbled and gesticulated before my easel—passed on. I did not know whether he had praised or condemned. I missed women; there was not even a woman model. I begged my sister to go to the office and enquire if I were in the wrong place. They said, "No, Mademoiselle is quite right where she is. Other ladies will come by and by."

I plodded mutely on, till one day I heard a splendid, strong English "damn" behind me. Turning, I saw a big man ripping the lining pocket from his jacket with a knife. I saw, too, from his dirty brushes how badly he needed a paint rag.

I went to the damner and said, "Mr., if you will translate my lessons I will bring you a clean paint-rag every morning."

Paint-rags were always scarce in Paris. He agreed, but he was often absent.

The Professor said I was doing very well, I had good colour sense.

That miserable, chalky, lifelessness that had seized me in London overtook me again. The life-class rooms were hot and airless. Mr. Gibb told me of a large studio run by a young couple who employed the best critics in Paris. Mr. Gibb himself criticized there. Students said he was dour and very severe, but that he

was an exceedingly good teacher. I would also have the advantage of getting criticism in my own language.

I studied in this studio only a few weeks and, before Mr. Gibb's month of criticism came, I was flat in hospital where I lay for three hellish months and came out a wreck. The Paris doctor said, as had the London one, I must keep out of big cities or die. My sister and I decided to go to Sweden.

While gathering strength to travel, I sat brooding in an old cemetery at the foot of our street. Why did cities hate, thwart, damage me so? Home people were wearying of my breakdowns. They wrote, "Give Art up, come home—stay home."

I showed some of my Indian sketches to Mr. Gibb. He was as convinced as I that the "New Art" was going to help my work out west, show me a bigger way of approach.

We enjoyed Sweden. She was very like Canada. I took hot salt-baths. In spring we returned to France, but I never worked in the studios of Paris again. I joined a class in landscape-painting that Mr. Gibb had just formed in a place two hours run from Paris. The little town was called Cressy-en-Brie. Mrs. Gibb found me rooms close to their own. My sister remained in Paris.

Cressy was quaint. It was surrounded by a canal. Many fine houses backed on the canal; they had great gardens going to the edge of the water and had little wash-booths on the canal—some were private, some public. The women did their laundry here and were very merry about it. Shrill voices, boisterous laughter, twisted in and out between the stone walls of the canal. Lovely trees drooped over the walls to dabble their branches. Women knelt in wooden trays, spread washing on flat stones before the washing-booths, soaped, folded, beat with paddles, rinsed. Slap, slap, went the paddles smacking in the soap, and out the dirt, while the women laughed and chatted, and the water gave back soapy reflections of their rosy faces and white coifs.

The streets of Cressy were narrow, and paved with cobblestones. Iron-rimmed cartwheels clattered noisily, so did wooden shoes. Pedlars shouted, everybody shouted so as to be heard above the racket.

Opposite my bedroom window was a wine-shop. They were obliged to close at midnight. To evade the law the wine vendors carried tables into the middle of the street and continued carousing far into the night. I have watched a wedding-feast keep it up till four in the morning, periodically leaving the feast to procession round the town, carrying lanterns and shouting. Sleep was impossible. I took what fun I could out of watching from my window.

Distant from Cressy by a mile or by a half-mile, were tiny villages in all directions. Each village consisted of one street of stone cottages, whitewashed. A delicate trail of grape-vine was trained above every cottage door, its main stem twisted, brown and thick as a man's arm, its greenery well tended and delicately lovely.

They grow things beautifully, these Frenchmen—trees, vines, flowers—you felt the living things giving back all the love and care the growers bestowed on them. A Scotch nurseryman of wide repute told me arboriculturists went to

France to study; nowhere else could they learn better the art of growing, caring for, pruning trees.

I tramped the country-side, sketch sack on shoulder. The fields were lovely, lying like a spread of gay patchwork against red-gold wheat, cool, pale oats, red-purple of new-turned soil, green, green grass, and orderly, well-trimmed trees.

The life of the peasants was hard, but it did not harden their hearts nor their laughter. They worked all day in the fields, the cottages stood empty.

At night I met weary men and women coming home, bent with toil but happy-hearted, pausing to nod at me and have a word with Josephine, a green parrot I had bought in Paris and used to take out sketching with me. She wore an anklet and chain and rode on the rung of my camp-stool. The peasants loved Josephine; Rebecca was a disappointment. She was sour, malevolent. Josephine knew more French words than I. I did flatter myself, however, that my grin had more meaning for the peasants than Josephine's French chatter.

Mr. Gibb took keen interest in my work, despite my being a woman student. His criticisms were terse—to the point. I never came in contact with his other students. They took tea with Mrs. Gibb often. Mr. Gibb showed them his work. He never showed it to me. Peeved, I asked, "Why do you never allow me to see your own work now, Mr. Gibb?"

The mirthless, twisted grin came, "Don't have to. Those others don't know what they are after, you do. Your work must not be influenced by mine. You will be one of the painters,—women painters," he modified, "of your day." That was high praise from Mr. Gibb! But he could never let me forget I was only a woman. He would never allow a woman could compete with men.

One day I ruined a study through trying an experiment. I expected a scolding. Instead, Mr. Gibb, grinning, said, "That's why I like teaching you! You'll risk ruining your best in order to find something better."

He had one complaint against me, however. He said, "You work too hard. Always at it. Easy! Easy! Why such pell-mell haste?"

"Mr. Gibb, I dare not loiter; my time over here is so short! Soon I must go back to Canada."

"You can work out in Canada—all life before you."

I replied, "You do not understand. Our far West has complete art isolation . . . no exhibitions, no artists, no art talk. . . ."

"So much the better! Chatter, chatter, chatter—where does it lead?" said Mr. Gibb. "Your silent Indian will teach you more than all the art jargon."

I had two canvases accepted and well hung in the Salon d'Automne (the rebel Paris show of the year). Mr. Gibb was pleased.

My sister returned to Canada. The Gibbs moved into Britanny—I with them.

St. Efflamme was a small watering place. For six weeks each year it woke to a flutter of life. People came from cities to bathe and to eat—the little hotel was famed for its good food. The holiday guests came and went punctually to the minute, then St. Efflamme went to sleep again for another year.

The Gibbs' rooms were half a mile away from the hotel. I had no one to

translate for me. Except for talk with my parrots I lived dumb. Madame Pishoudo owned the hotel, her son cooked for us, her niece was maid. All of them were very kind to the parrots and me.

I was at work in the fields or woods at eight o'clock each morning. At noon I returned to the hotel for dinner, rested until three. Mr. Gibb, having criticized my study of the morning out where I worked, now came to the hotel and criticized the afternoon work done the day before. My supper in a basket, I went out again, did a late afternoon sketch, ate my supper, then lay flat on the ground, my eyes on the trees above me or shut against the earth, according as I backed or fronted my rest. Then up again and at it till dark.

I had a gesticulating, nodding, laughing acquaintance with every peasant. Most of them were very poor. Canadian cows would have scorned some of the stone huts in which French peasants lived. Our Indian huts were luxurious compared with them. Earth floor, one black cook-pot for all purposes—when performing its rightful function it sat outside the door mounted on a few stones, a few twigs burning underneath—cabbage soup and black bread appeared to be the staple diet. The huts had no furniture. On the clay floor a portion framed in with planks and piled with straw was bed for the whole family. There was no window, no hearth, what light and air entered the hut did so through the open door. Yet these French peasants were always gay, always singing, chattering.

I watched two little girls playing "Mother" outside a hut one day. For babies one dangled a stick, the other a stone. They sang and lullabied, wrapping their "children" in the skirt of the one poor garment clinging round their own meagre little figures. Whatever they lacked of life's necessities, nature had abundantly bestowed upon them maternal instinct.

I stuffed paint rags with grass, nobbed one end for a head, straw sticking out of its top for hair. I painted faces on the rag, swathed the creatures in drawing paper, and gave each little girl the first dolly she had ever owned. She kissed, she hugged. Never were grand dolls so fondly cherished.

On a rounded hill-top among gorse bushes a little cow-herd *promenaded* her *vache*. I loved this dignified phrase in connection with the small, agile little Breton cows. The child's thin legs were scratched by the furze bushes as she rustled among them, rounding up her little cows. She had but one thin, tattered garment—through its holes you saw bare skin. She knitted as she herded. Shyly she crept nearer and nearer. I spoke to her in English. She shook her head. Beyond *promener la vache* I could not understand her. She came closer and closer till she knelt by my side, one grimy little hand on my knee. All the time she watched my mouth intently. If I laughed, her face poked forward, looking, looking. Did the child want to see my laugh being made? I was puzzled. There was great amazement in her big, dark eyes. Presently she fingered her own white teeth and pointed to mine.

"D'or, d'or," she murmured. I understood then that it was my gold-crowned tooth which had so astonished her.

There was an aloof ridge of land behind the village of St. Efflamme. I

climbed it often. On the top stood three cottages in a row and one stable. Two of the cottages were tight shut, their owners working in the fields. In the third cottage lived a bricklayer and his family. The woman was always at home with her four small children. They ran after her like a brood of chicks. The children sat round me as I worked; always little Annette, aged four, was closest, a winsome, pretty thing, very shy. I made the woman understand that I came from Canada and would soon be returning. She told the children. Annette came very close, took a corner of my skirt, tugged it and looked up beseeching.

The mother said, "Annette wants go you Canada."

I put my arm round her. With wild crying the child suddenly broke away, clinging to her mother and to France.

This woman was proud of her comfortable house; she beckoned me to *come see*. The floor was of bare, grey earth, swept clean. Beds were concealed in the walls behind sliding panels. There was a great open hearth with a swinging crane and a huge black pot. There were two rush-bottom chairs and four little wooden stools, a table, a broom and a cat. On the shelf were six Breton bowls for the cabbage soup smelling ungraciously this very moment as it cooked. A big loaf of black bread was on the shelf too.

They were a dear, kind, happy family. I made a beautiful rag doll for Annette. It had scarlet worsted hair. Annette was speechless—she clutched the creature tight, kissing its rag nose as reverently as if it had been the Pope's toe. She held her darling at arm's length to look. Her kiss had left the rag nose black. Laying the doll in her mother's arms she ran off sobbing. . . . We saw her take a little bucket to the well in the garden. When Annette came back to us there was a circle round her mouth several shades lighter than the rest of her face. The front of her dress was wet and soapy. She seized her doll—hugged and hugged again.

There was a farm down in the valley—house, stables and hayricks formed a square. The court sheltered me from the wind. I often worked there. A Breton matron in her black dress and white cap came out of the house.

"Burrr! pouf! pouf!" she laughed, mocking the wind. Then, pointing to my blue hands, beckoned me to follow. She was proud of her cosy home. It was well-to-do, even sumptuous for a peasant. Fine brasses were on the mantel-shelf, a side of bacon, strings of onions, hanks of flax for spinning hung from the rafters. There was a heavy, black table, solid and rich with age, a bench on either side of the table, a hanging lamp above. There was a great open hearth and, spread on flat stones, cakes were baking before the open fire—a mountain of already baked cakes stood beside the hearth. The woman saw my wonder at so many cakes and nodded. Laying three pieces of stick on the table, she pointed to the middle one—"Now", she said; to the stick on the left she pointed saying, "Before"; to the right-hand stick, "After." She went through the process of sham chewing, pointing to the great pile of cakes, saying "threshers." I nodded comprehension. The threshers were expected at her place tomorrow. The cakes were her preparation. She signified that I might sketch here where it was warm instead of facing the bitter wind. Again she sat herself by the hearth to watch the cakes and took up her knitting.

The outer door burst open! Without invitation, a Church-of-England clergyman and two high-nosed English women entered. Using English words and an occasional Breton one, the man said the English ladies wished to see a Breton home. The woman's graciousness congealed at the unmannerly entry of the three visitors. She was cold, stiff.

The visitors handled her things, asking, "How much? how much?"

"Non! Non!"

She clutched her treasures, replaced her brasses on the mantel-shelf, her irons on the hearth.

They saw the pile of cakes. The clergyman made long jumbled demands that they be allowed to taste.

"The English ladies want to try Breton cakes."

"Non, non, non!"

The woman took her cakes and put them away in a cupboard.

At last the visitors went. The woman's graciousness came back. Going to the cupboard, she heaped a plate with cakes and, pouring syrup over them, brought and set them on the table before me.

"Pour mademoiselle!"

Such a smile! Such a nod! I must eat at once! Shaking her fist at the door, the woman went outside, shutting the door behind her—burst it open—clattered in.

"Ahh!" she scolded. "Ahh!"

Again going out she knocked politely, waited. She was delighted with her play-acting, we laughed together.

Some five miles from St. Efflamme was a quaint village in which I wanted to sketch. I was told a butcher went that way every morning early, coming back at dusk. I dickered with the butcher and drove forth perched up in the cart in front of the meat, hating the smell of it. I sketched the old church standing knee deep in graves. I sketched the village and a roadside calvary. Dusk came but not the butcher. Dark fell, still no butcher. There was nothing for it but I must walk the five miles back. The road was twisty and very dark. I decided it would be best to follow along the sea-shore where there was more light. My sketch-pack weighed about fifty pounds. The sand was soft and sinky. I was always stopping to empty it out of my shoes. I dragged into the hotel at long last, tired and very cross. Madame Pishoudo beckoned me from her little wine shop in the corner, beyond the parlour.

"That butcher! Ah! Yes, he drunk ver' often! His forget was bad; but Madame she does not forget her little one, her Mademoiselle starving in a strange village."

Madame had remembered—she had kept a little "piece" in the cupboard. Its littleness was so enormous a serving of dessert that it disgusted my tiredness. Madame Pishoudo forgot that she had supplied "her starved Mademoiselle" with a basket containing six hard-boiled eggs, a loaf split in half and furnished with great chunks of cold veal, called by Madame a sandwich, half a lobster, cheese, a bottle of wine, and sundry cookies and cakes. If one did not eat off a

table, under Madame's personal supervision, one starved!

One day I shared a carriage with two ladies from Paris and we went sightseeing. I have half-forgotten what we saw of historical interest but I well remember the merry time we had. The ladies had no English, I no French words. We drank "cidre" in wayside booths, out of gay cups of Breton ware that had no saucers. I persuaded the woman to sell me two cups. I knew they sold in the market for four pennies. I offered her eight pennies apiece. She accepted and with a shrug handed them over saying the equivalent of "Mademoiselle is most peculiar!" We went into a very old church and my companions bowed to a great many saints. They dabbled in a trough of holy-water, crossing themselves and murmuring, "Merci, St. Pierre, merci." One of the ladies took my hand, dipped it into the trough, crossed my forehead and breast with it, murmuring, Merci, St. Pierre, merci!" It would be good for me, she said.

"Mr. Gibb, I have gone stale!"
The admission shamed me.
Mr. Gibb replied, "I am not surprised. Did I not warn you?—rest!"
"I dare not rest; in a month, two at most, I must return to Canada."
I heard there was a fine water colourist (Australian) teaching at Concarneau, a place much frequented by artists. I went to Concarneau—studied under her. Change of medium, change of teacher, change of environment, refreshed me. I put in six weeks' good work under her.

Concarneau was a coast fishing town. I sketched the people, their houses, boats, wine shops, sail makers in their lofts. Then I went up to Paris, crossed the English Channel, and from Liverpool set sail for Canada.

REJECTED

I CAME HOME from France stronger in body, in thinking, and in work than I had returned from England. My seeing had broadened. I was better equipped both for teaching and study because of my year and a half in France, but still mystified, baffled as to how to tackle our big West.

I visited in Victoria, saw that it was an impossible field for work; then I went to Vancouver and opened a studio, first giving an exhibition of the work I had done in France.

People came, lifted their eyes to the walls—laughed!

"You always were one for joking—this is small children's work! Where is your own?" they said.

"This is my own work—the new way."

Perplexed, angry, they turned away, missing the old detail by which they had been able to find their way in painting. They couldn't see the forest for looking at the trees.

"The good old camera cannot lie. That's what we like, it shows everything," said the critics. This bigger, freer seeing now seemed so ordinary and sensible to me, so entirely sane! It could not have hurt me more had they thrown stones. My painting was not outlandish. It was not even ultra.

The Vancouver schools in which I had taught refused to employ me again. A few of my old pupils came to my classes out of pity,—their money burnt me. Friends I had thought sincere floated into my studio for idle chatter; they did not mention painting, kept their eyes averted from the walls, while talking to me.

In spite of all the insult and scorn shown to my new work I was not ashamed of it. It was neither monstrous, disgusting nor indecent; it had brighter, cleaner colour, simpler form, more intensity. What would Westerners have said of some of the things exhibited in Paris—nudes, monstrosities, a striving after the extraordinary, the bizarre, tò arrest attention. Why should simplification to express depth, breadth and volume appear to the West as indecent, as nakedness? People did not want to see beneath surfaces. The West was ultraconservative. They had transported their ideas at the time of their migration, a generation or two back. They forgot that England, even conservative England, had crept forward since then; but these Western settlers had firmly adhered to their old, old, outworn methods and, seeing beloved England as it had been, they held to their old ideals.

That rootless organization, the Vancouver Ladies' Art Club, withered, died. It was succeeded by The Fine Arts Society, an organization holding yearly exhibitions in which I was invited to show.

My pictures were hung either on the ceiling or on the floor and were jeered at, insulted; members of the "Fine Arts" joked at my work, laughing with reporters. Press notices were humiliating. Nevertheless, I was glad I had been to France. More than ever was I convinced that the old way of seeing was inadequate to express this big country of ours, her depth, her height, her unbounded wideness, silences too strong to be broken—nor could ten million cameras, through their mechanical boxes, ever show real Canada. It had to be sensed, passed through live minds, sensed and loved.

I went to the Indian Village on the North Shore of Burrard Inlet often. Here was dawdling calm; no totem poles were in this village. The people were basket-weavers, beautiful, simple-shaped baskets, woven from split cedar roots, very strong, Indian designs veneered over the cedar-root base in brown and black cherry bark.

Indian Sophie was my friend. We sat long whiles upon the wide church steps, talking little, watching the ferry ply between the city and the North Shore, Indian canoes fishing the waters of the Inlet, papooses playing on the beach.

The Village was centred by the Catholic Church—its doors were always wide. Wind entered to whisper among the rafters. The wooden footstools creaked beneath our knees. A giant clam-shell held holy water in the vestibule. The bell-rope dangled idly. When Sophie and I entered the church she bowed and crossed herself with holy water; so did I because it grieved Sophie so that I was not Catholic. She talked to the priest about it. The good man told her not to worry, I was the same and it was all right. Sophie and I were glad for this.

Behind the Indian Village, way up in the clouds stood "The Lions." twin mountain peaks, their crowns gleaming white against blue distance, supporting the sky on their heads.

In Spring the Village shimmered with millions of exquisite, tongueless bells of cherry-blossom (every Indian had his cherry-tree). Springtime flooded the village with new life, human, animal, vegetable. The dirt streets swarmed with papooses, puppies and kittens; old hens strutted broods, and squawked warnings against hawks and rats. Indian mothers had new papoose-cradles strapped on their backs or resting close beside them as they squatted on the floors of their houses, weaving baskets. Indian babies were temporary creatures: behaviour half-white, half-Indian, was perplexing to them. Their dull, brown eyes grew vague, vaguer—gave up—a cradle was empty—there was one more shaggy little grave in the cemetery.

When I visited Sophie her entertainment for me was the showing off of her graves. She had a huge family of tiny tombstones. She had woven, woven baskets in exchange for each tombstone.

We took the twisty dirt road to the point of land on which the cemetery lay. Passing under a big wood cross spanning the gateway, we were in a rough, grassed field bristling with tipping crosses, stone, iron, wood crosses. In the centre stood a big, straight, steady cross raised on a platform, a calm, reassuring cross. Here Sophie knelt one moment before parting brambles to search for her own twenty-one crosses—babies dated barely one year apart.

"Mine, mine," Sophie stooped to pat a cold little stone, "this my Rosie, this Martine, this Jacob, this Em'ly." Twenty-one she counted, saying of each, "Mine, all me—all my baby."

The blue waters of the Inlet separated the hurry and hurt of striving Vancouver from all this peace—stagnant heathenism, the city called it.

Having so few pupils, I had much time for study. When I got out my Northern sketches and worked on them I found that I had grown. Many of these old Indian sketches I made into large canvases. Nobody bought my pictures; I had no pupils; therefore I could not afford to keep on the studio. I decided to give it up and to go back to Victoria. My sisters disliked my new work intensely. One was noisy in her condemnation, one sulkily silent, one indifferent to every kind of Art.

The noisy sister said, "It is crazy to persist in this way,—no pupils, no sales, you'll starve! Go back to the old painting."

"I'd rather starve! I could not paint in the old way—it is dead—meaning-less—empty."

One sister painted china. Beyond mention of that, Art was taboo in the family. My kind was considered a family disgrace.

Victoria had boomed, now she slumped. We had not sold during the boom, now we were compelled to because of increased taxation. My father's acreage was divided into city lots and sold at a loss—each sister kept one lot for herself. Borrowing money, I built a four-suite apartment on mine. One suite had a fine studio. Here I intended to paint, subsisting on the rentals of the other three suites. No sooner was the house finished than the First World War came. Rental sank, living rose. I could not afford help.

I must be owner, agent, landlady and janitor. I loathed landladying. Ne'er-do-wells swarmed into cities to grab jobs vacated by those gone to war. They took advantage of "green" landladies. No matter how I pinched, the rentals would not stretch over mortgage, taxes and living.

I tried in every way to augment my income. Small fruit, hens, rabbits, dogs—pottery. With the help of a chimney sweep I built a brick kiln in my back yard, firing my own pots. The kiln was a crude thing, no drafts, no dampers, no thermometer—one door for all purposes. Stacking, stoking, watching, testing, I made hundreds and hundreds of stupid objects, the kind that tourists pick up—I could bake as many as five hundred small pieces at one firing.

Firing my kiln was an ordeal. I stoked overnight, lighting my fire well before day-break so that nosy neighbours would not rush an alarm to the fire department when the black smoke of the first heavy fire belched from the chimney. The fire had to be built up gradually. The flames ran direct among the pots, sudden heat cracked the clay. First I put in a mere handful of light sticks, the clay blackened with smoke. As the heat became stronger the flames licked the black off. Slowly, slowly the clay reddened passing from red hot to white of an awful transparency, clear as liquid. The objects stood up holding their shapes with terrifying, illuminated ferocity. A firing took from twelve to fourteen hours; every moment of it was agony, suspense, sweat. The small kiln room grew stifling, my bones shook, anticipating a visit from police, fire chief, or insurance man. The roof caught fire. The floor caught fire. I kept the hose attached to the garden tap and the roof of the kiln-shed soaked. The kiln had to cool for twenty-four hours before I could handle the new-fired clay.

I ornamented my pottery with Indian designs—that was why the tourists bought it. I hated myself for prostituting Indian Art; our Indians did not "pot", their designs were not intended to ornament clay—but I did keep the Indian design pure.

Because my stuff sold, other potters followed my lead and, knowing nothing of Indian Art, falsified it. This made me very angry. I loved handling the smooth cool clay. I loved the beautiful Indian designs, but I was not happy about using Indian design on material for which it was not intended and I hated seeing them distorted, cheapened by those who did not understand or care as long as their pots sold.

I never painted now—had neither time nor wanting. For about fifteen years I did not paint.

Before I struck bottom it seemed there was one lower sink into which I must plunge. Taking over the entire upper storey of my house I turned it into a Ladies' Boarding House. Womanhood at its worst is the idle woman of small means, too lazy to housekeep, demanding the maximum, paying the minimum, quarrelling with other guests and demanding entertainment as well as keep and all for the smallest possible price.

Under the calm north light of the big studio window ten women satisfied their greed for all the things of which they had been deprived during the war. Limitation was over, but price still high. They were greedy over those foods which had been scarce. It was hard to satisfy them. I hated sitting at the head of my table forcing a smile—these creatures were my bread-and-butter, so I had to.

They jeered at my pictures on the wall, jeered before my very nose. (Could not the creatures see a burning red ear stuck onto either side of my head?)

Mrs. Smith would say to Mrs. Jones, "I am changing my place at table. Those totems turn the food on my stomach!"

"Mine too! I am positively afraid to come into this room after dark. The stare of those grotesque monsters! Do you suppose the things will ever have money value, Mrs. Smith?"

"Value? Possibly historical, not artistic," Mrs. Smith suggested.

"Daubs, bah! An honest camera—that is what records history."

There was no place other than the walls to store my pictures. I had to head my table and endure.

The ladies liked my food. When I started the boarding house people had said, "Artist cookery! Artist housekeeping!" and rolled their eyes. I proved that an artist could cook and could housekeep; but that an artist could paint honestly and keep boarders simultaneously I did not prove.

Clay and Bobtails saved me. I established a kennel of Old English Bobtail Sheep-dogs in the yards behind my garden. My property was bounded on three sides by vacant lots, treed and grassed. Here my "Bobbies" played; here I rushed to them for solace when the boarders got beyond bearing.

There was good demand for working dogs in those days. The war done, soldiers were settling on the land, raw land in lonely districts. There was not much sheep or cattle work for dogs but there were men to be guarded from themselves, from solitude after army life. No dog is more companionable than a Bobby.

I raised some three hundred and fifty Bobtail puppies. A large percentage of the pups went to soldiers. Clay and Bobtails paid my taxes—clay and Bobtails freed me from the torture of landladying.

"Eric Brown, Canadian National Gallery, speaking . . . I should like to call upon Miss Emily Carr to see her Indian pictures."

I had never heard of Eric Brown nor of the Canadian National Gallery. To be reminded that I had once been an Artist hurt. I replied tartly through the phone, "My pictures, with the exception of a very few on my walls, are stored away."

"May I see those few on the walls?"

I gave grudging consent.

Mr. and Mrs. Brown came; looking, talking together while I stood indifferently apart, my eyes on a lump of clay upon the table, losing its malleability.

"Marius Barbeau, Government Anthropologist, told me of your work," said Mr. Brown. "He heard about it from the Coast Indians. We are having an exhibition of West Coast Indian Art in the Gallery this autumn. Will you lend us fifty canvases? We pay all expenses of transportation. Come over for the show. I can get you a pass on the railway."

"Fifty of my pictures! Me go East! Who did you say you were?" I frowned at Mr. Brown, dazed.

Mr. Brown laughed—A Canadian artist who did not even know that Canada *had* a National Gallery!

"Artists this side of the Rockies don't keep up with art movements, do they? Where did you study?"

"London, Paris, but I am not an Artist any more." A boarder passed through the room. I turned sullen.

"Obviously you have done some study along the line of the modern way. There is a book just out. *A Canadian Art Movement*—read it—all about the Group of Seven and their work—by F. B. Housser."

"Who are the Group of Seven?"

"Seven men who have revolutionized painting in Eastern Canada. Come East, I will see that you meet the Group."

"Oh, but I could not! I could not get away."

Mr. Brown said, "Think that over."

He had seen interest wake in me when he mentioned "New Art." No sooner was he out of the house than I ran to town and bought a copy of *A Canadian Art Movement*, and read it from cover to cover, and was crazy to start that very moment. To my great astonishment when I told my sisters about it they said, "Why not?" and offered to tend the house during my absence.

"I can come," I wrote Mr. Brown, then shipped my pictures east, and off I went, breaking my journey at Toronto. All the Group of Seven men lived there.

The Exhibition of West Coast Art was at Ottawa but I was not going East to see the Exhibition. I wanted to meet the Group of Seven and see their work. I did not know how it was going to be arranged, but I stopped off at Toronto, hoping something might happen, or possibly I should see some of their work around the city.

I had been only a few hours in Toronto when I received a telephone message through the Women's Art Association, inviting me to go to the various studios of the Group members. The women of the Art Association were to conduct me. My eagerness turned suddenly to quakes. These men were workers, I a quitter.

On the steps of the Association I was introduced to Mrs. Housser.

"Wife of the book!" I exclaimed, thrilled.

"Come to tea with us tomorrow and meet 'Mr. Book'."

Mrs. Housser was an artist too. I marvelled how they all accepted me.

First my escorts took me to the studio of A. Y. Jackson. Then we went to Mr. Lismer's, then to J. E. H. MacDonald's. Varley was away, Carmichael and

Casson lived further out of town. They were more recent members of the Group. I met them later. Last of all we went to the studio of Lawren Harris.

"This is an honour," my conductress said. "Mr. Harris is a serious worker, he does not open his studio to every passerby."

I am glad Mr. Harris's studio came last. I could not so fully have enjoyed the others after having seen his work.

I had been deeply impressed by his two pictures reproduced in Mr. Housser's book. The originals impressed me yet more deeply. As Mr. Harris showed us canvas after canvas I got dumber and dumber. My escort was talkative. Mr. Harris left me alone to look and look and look. When it was time to go a million questions rushed to my mind. I wanted to talk then, but it was too late. As he shook hands Mr. Harris said, "Come again." Eager questions must have been boiling out of my eyes and he saw.

I went to Ottawa but all the while I was there I was saying to myself, "I must see those pictures of Mr. Harris's again before I go West." They had torn me.

The Ottawa show was a success. All the familiar things of my West—totem poles, canoes, baskets, pictures (a large percentage of the pictures were mine). It embarrassed me to see so much of myself exhibited. The only big show I had been in before was the Salon d'Automne in Paris. Out West I found it very painful and unpleasant to hang in an exhibition. They hated my things so! Here everyone was so kind that I wanted to run away and hide, yet I did want, too, to hear what they said of my work. I had not heard anything nice about it since I was in France.

In Ottawa all the time I was longing to be back in Toronto to see again Mr. Harris's pictures. I was saying to myself, "I must see those pictures again before I go West." They had torn me; they had waked something in me that I had thought quite killed, the passionate desire to express some attribute of Canada.

I arranged to spend two days in Toronto on may way home. I went straight to the telephone, then scarcely had the courage to ring. I had wasted one whole afternoon of Mr. Harris's work time, had I the right to ask for another? Urgency made me bold.

"I go West the day after tomorrow, Mr. Harris. West is a long way. May I see your pictures again before I go?"

"Sure! Tomorrow. Stay—come and have supper with us tonight; there are pictures at home, too. I will pick you up."

Oh, what an evening! Music, pictures, talk—at last "goodnight" and Mr. Harris said, "What time at the studio tomorrow?"

"You mean *this* is not instead of *that*, I gasped.

"Sure, we have not half talked yet."

So I went to Mr. Harris's big, quiet studio again.

"What was it you particularly wanted to see?"

"Everything!"

Starvation made me greedy—he understood and showed and showed while I asked and asked. No one could be afraid of Mr. Harris. He was so generous, so patient when talking to green students.

"I understand you have not painted for some time?"

"No."

"Are you going to now?"

"Yes."

"Here is a list of books that may help. You are isolated out there. Keep in touch with us. The West Coast Show is coming on to our Gallery after Ottawa. I shall write you when I have seen it."

"Please criticize my things hard, Mr. Harris."

"I sure will."

Three days after my return from the East I was at my painting. Mr. Harris wrote, "The exhibition of West Coast Art is at the Gallery. As interesting a show as we have had in the Gallery. Your work is impressive, more so than Lismer had led me to believe, though he was genuinely moved by it in Ottawa. I really have, nor can have, nothing to say by way of criticism. . . . I feel you have found a way of your own wonderfully suited to the Indian spirit, Indian feeling for life and nature. The pictures are works of art in their own right . . . have creative life in them . . . they breathe."

This generous praise made my world whizz. Not ordinary technical criticism, such as others had given my work. Mr. Harris linked it with the Indian and with Canada.

Sketch-sack on shoulder, dog at heel, I went into the woods singing. Not far and only for short whiles (there was still that pesky living to be earned), but household tasks shrivelled as the importance of my painting swelled.

By violent manœuvring I contrived to go North that summer, visiting my old sketching grounds, the Indian villages, going to some, too, that I had not visited before. Everywhere I saw miserable change creeping, creeping over villages, over people. The Indians had sold most of their best poles. Museums were gobbling them. The recent carvings were superficial, meaningless; the Indian had lost faith in his totem. Now he was carving to please the tourist and to make money for himself, not to express the glory of his tribe.

I sent two canvases east that year, thrilled that "The Group" included me among their list of invited contributors. Eastern Artists expressed amazement at the improvement, the greater freedom of my work. A. Y. Jackson wrote, "I am astonished." Like Mr. Gibb, Jackson patronized feminine painting. "Too bad, that West of yours is so overgrown, lush—unpaintable," he said, "too bad!"

I always felt that A.Y.J. resented our West. He had spent a summer out at the coast sketching. He did not feel the West as he felt the East.

Mr. Harris's letters were a constant source of inspiration to me. He scolded, praised, expounded, clarified. He too had tasted our West, having sketched in the Rocky Mountains. He understood many of my despairs and perplexities. Sometimes my letters were bubbling with hope, sometimes they dripped woe. I wrote him of the change taking place in the Indian villages—in Indian workmanship. His advice was, "For a while at least, give up Indian motifs. Perhaps you have become too dependent on them; create forms for yourself, direct from nature."

I went no more then to the far villages, but to the deep, quiet woods near home where I sat staring, staring, staring—half lost, learning a new language or rather the same language in a different dialect. So still were the big woods where I sat, sound might not yet have been born. Slowly, slowly I began to put feeble scratchings and smudges of paint onto my paper, returning home disheartened, wondering, waiting for the woods to say something to me personally. Until they did, what could I say?

"Wondering?" wrote Mr. Harris, "Why I can almost see your next step. In wondering we dedicate ourselves to find a new approach, fresh vision. . . . Wondering is a process of questioning. Why has the thing I am trying to express not a deep fulness of life? Why is it not clearly and exactly what I am trying to convey? . . . Deeper problem than most of us realize . . . has to do with the highest in us. . . . A talent or aptitude should be developed," he wrote. "Should be worked hard, if we are so placed that we can work (as far as I know you are so placed). Your peculiar contribution is unique. . . . In some ways if a body is removed from the fuss as you are, and, providing the creative urge is strong to keep him working, he is fortunate. . . . Good zest to your work, you can contribute something new and different in the Art of this country. The more joy in the work the better. No one feels what you feel. It will surely develop far reaching results."

These letters cheered and stimulated me. Of course I got into great snarls of despondency. Bitterly in my letters I would cry out, "When I hear of you Eastern Artists going off in bunches, working, sharing each others' enthusiasms and perplexities, I am jealous, furiously jealous!"

"Solitude is swell!" replied Mr. Harris. "Altogether too much chatter goes on."

I knew he was right—stupid me—hadn't I always chosen solitude, squeezing into tight corners in class, always trying to arrange that no one could stand behind and watch me work?

"You old silly!" I said to myself, and took myself in hand.

Two things I found of great help. First, there was the companionship of creatures while working (particularly that of a dog). I have taken birds, a monkey, even a little white rat into the woods with me while studying. The creatures seemed somehow to bridge that gap between vegetable and human. Perhaps it was their mindless comprehension of unthinking life linking humanity and vegetation. The other help was a little note book I carried in my sketch-sack and wrote in while intent upon my subject. I tried to word in the little book what it was I wanted to say. This gave double approach for thoughts regarding what you were after.

I stopped grieving about the isolation of the West. I believe now I was glad we were cut off. What I had learned in other countries now began to filter back to me transposed through British Columbia seeing. Ways suitable to express other countries, countries tamed for generations, could not expect to fit big new Canada.

At long last I learned, too, to surmount the housekeeping humdrum which I had allowed to drift between me and the painting which I now saw was the real worth of my existence.

An American Artist came to visit at my house.

"Come, let us go to Beacon Hill or the sea, while morning is still young," he said.

"The beds! the dishes! the meals!" I moaned.

"Will wait—young morning on Beacon Hill won't. Don't tether yourself to a dishpan, woman! Beds, vegetables! They are not the essentials!"

Suddenly I realized brag and stubbornness had goaded me into proving to my family that an artist could cook, could housekeep. Silly, rebellious me! Hadn't I for fifteen years bruised body and soul, nearly killed my Art by allowing these to take first place in my life?

I corresponded with several Artists in the East and I made three trips to Eastern Canada during Exhibitions of the original Group of Seven, shows to which I was an invited contributor. These visits were a great refreshment and stimulus. The first time I came back a little disgruntled that I must always work alone, while they worked in companies and groups; after awhile I came West again from these visits happy. It was good to go when opportunity opened, good to see what others were doing, but the lonely West was my place. On one of my Eastern trips I slipped across the line. This is how it came about that I saw New York.

N E W Y O R K

"WHY NOT?" Mr. Harris said and closed the book of New York's splendours he had been showing me, photographs of the gigantic wonders, her skyscrapers, bridges, stations, elevated railways.

"Why not see New York now, while you are on this side of the continent? It is only a step across the line. New York is well worth the effort."

I protested, "I hate enormous cities cram-jam with humanity. I hate them!"

Mr. Harris said no more about New York. I had been much interested in his telling of his reactions to New York. He was just back from there, had gone to see a big picture exhibition. In spite of myself my curiosity had been aroused. Instead of sleeping that night as I ought to have done, I lay awake thinking, planning a trip to New York. Next day I acted; curiosity had won over fright. As I bought my ticket my heart sank to somewhere around my knees, which shook

with its weight; but common sense came along, took a hand, whispering, "Hasn't it been your policy all through life to see whenever seeing was good?"

"I'm going," I said to Mr. Harris. "Can you give me a list of New York's Art Galleries, the most modern ones?"

"Good," he said and also gave me introduction to a very modern artist, the President to the "Société Anonyme" (New York's Modern Art Society).

This lady, Miss Katherine Dreier, was a painter, a lecturer and a writer. Her theme throughout was Modern Art. She had just published *Western Art and the New Era*, quite a big volume.

A couple of warm friends of mine who used to farm out west had written me when they knew I was coming to Toronto inviting, "Cross the line and visit us." They now lived on Long Island where the husband had been for some years manager of a millionaire's estate. I wired my friend asking, "Could you meet me at the station in New York? I'm scared stiff of New York!"

Arrangements made, myself committed, I sat down to quake. I do not know why I dreaded New York. I had faced London and Paris unafraid. Perhaps *this* fear was because of what they had done to me and the warnings I had been given to "keep away from great cities". I said to myself, "This is only just a little visit, seeing things, not settling in to hard work."

Before ever the train started I had an argument with the porter. He insisted that my berth be made up so that I rode head first. I insisted that I would ride facing the engine, in other words feet first.

"If there is a axiden yous sho a dead woman ridin' dat-a-way."

"Well, perhaps there won't be an accident. If I ride head first, I shall be a sea-sick woman sure, certain, accident or not!"

He grumbled so much I let him have his way, then remade my bed while he was at the other end of the coach.

I had no sooner fallen asleep than a flashlight, playing across my face, woke me. It was the quota and immigration official. "We are about to cross the line." He proceeded to ask all sorts of impertinent questions about me and my antecedents. I heard other angry passengers in other berths being put through the same foolish indignity. The dark coach hushed to quiet again except for the steady grind of the train-wheels a few feet below the passengers' prone bodies and ragged-out tempers. That was not the end. I was just conscious again when a tobacco-smelling coat sleeve dragged across my face and turned my berth light on. Bump, bump! the porter and the customs were under my berth grappling for my bags. First they rummaged, then they poured everything, shoes, letters, brushes, tooth paste, hairnets, over me.

"Anything to declare?"

"Only that you are a disgusting nuisance!" I snapped, collecting my things back into their bags.

"If folks will cross the line!" he shrugged.

"Drat your old line!" I shouted. "It is as snarly as long hair that has not been brushed for a year!"

No good to try and sleep again! I knew by the feel inside me that we were nearing a great city. The approach to them is always the same.

"New York! New York!" The porter and his ladder bumped into the people, uncomfortably dressing in their berths.

I raised my blind—tall, belching factory chimneys, rows and rows of workmen's brick houses, square, ugly factories, with millions of windows. Day was only half there, and it was raining.

Noises changed, we were slithering into a great covered station. There on the platform, having paddled through rain at that hour, was my friend, Nell. I nearly broke the window rapping on it. She waved her umbrella and both hands.

The station was about to wake and have its face washed. Sleepy boys were coming with pails and brooms. The breathless hither and thither rush common to all stations had not started as yet. Nell skirted the cleaners amiably. I never remember to have seen her ruffled or provoked. Once out west I went with her to feed the sow. Nell lodged her pail of swill in the crotch of the snake fence while she climbed over. Evangeline the sow stood up and snouted the entire pailful over Nell. There Nell stood, potato peeling in her hair, dripping with swill and all she said was, "Oh, Evangeline!"

Well, I suppose if one's disposition could take that it could take New York.

The distance from station to station seemed no way at all, we were talking so hard. Suddenly, I remembered and said, "Why, Nell, is this New York?" Soon our train began skimming over beautiful green fields. The very up-to-datest farm buildings and fences were here and there, and such beautiful horses were in the pastures.

"Nell, where are we?"

"On Long Island. This is where the millionaires and the multi-millionaires come to recuperate when Society ructions have worn them threadbare. These sumptuous estates are what the millionaires are pleased to call their 'country cottages'."

My friends lived on the home farm of their own particular millionaire's estate, in a large, comfortable farm house.

During my week's stay on Long Island I never saw or heard a millionaire but I saw the extravagances on which they poured their millions and it amazed me. They had tennis courts glassed over the top so that they could play in all weathers. They had private golf courses, private lakes for fishing, they had stables full of magnificent race horses and every style and shape of motor cars. They had gardens and conservatories and, of course, they had armies of servants to keep the places in order and have them in readiness any moment the owners took the whim—"I'm sick of Society, it is such hard work. We will run down to our cottage on Long Island." Then a string of motor cars as long as a funeral would tear over the Island roads, endangering dogs and every one else's life, motors stuffed with the fancy equipment millionaires consider indispensable.

It was nothing, my friends told me, for a New York florist to send in a bill of

seventy-five dollars just for providing cut flowers to decorate the house for a single week-end, and there were the rest of us mortals thinking twice before spending one dollar on a plant! The extravagance fairly popped my eyes.

The week of my stay on Long Island happened to be Easter. Our millionaires were giving a week-end party. They kept the manager hopping. My friend's husband was the very finest type of Englishman. Life had given him some pretty hard knocks and left him strong, fine, honourable. The same applied to his wife. The millionaires thought the world of the pair and gave them complete trust, respect and love.

The beginning of Easter week the manager was bidden to search the Island nursery-gardens catering to the wealthy, till he could locate half a dozen blossoming trees. They must be in full bloom. It seemed that there were to be fishing parties on their private lake. Their stables were close to the lake side. The trees must be as high as the stables and hide the buildings from the fisher's eyes. But trees would not hurry growth for any old millionaire. They clamped their buds tight as a good parson's lips clamp on an occasion when only one well-rounded word could express his feelings.

At the last nursery we found six forsythia trees in full bloom. They were as gold as butter and as high as the stables. It took a separate lorry to move each tree. About an acre of dirt had to accompany each tree's roots. It took a battalion of men to do the job. They did it well. The forsythias did not wilt and the reflection in the lake was lovely. The millionaires were pleased. I have no idea what the performance must have cost!

The manager was also instructed to see that the tennis court was in good shape for play. An expert was called in to inspect.

"Carn't do nothin' by Easter," he said. "Court needs makin' over from foundation. Best I can do is to patch her so she'll play 'em over the week-end. Patch'll cost three hundred dollars."

The owners said, "Certainly, go ahead." But the expensive patch was never used once during the Easter holiday.

Our millionaires were childless. Besides this place they had a mansion in New York. Also the wife, who was a millionaire in her own right, had a magnificent estate in Belgium. It was their favourite of the three estates. They frequently visited there.

I heard that the Martha Washington Hotel in New York was a nice place for a lady alone so I went there. It was not as tall or as high priced as many of the newer hotels but it was very comfortable and conveniently situated for everything.

I quaked up to Martha's desk and asked the clerk, "Have you such a thing as a ground-floor room or at least one on second or third floor that can be reached by the stairway?"

The clerk's look was scornful and plainly commented "hayseed". He said, "We have such rooms, Madam; there is little demand for them. Higher the floor, better the light and air."

"I dislike elevators."

The clerk led the way to a room half a storey higher than Martha's lounge. He turned on the light. It was never more than twilight in that room, but I liked it in spite of its dimness. It had a private bath and I thought the price most moderate. My window opened into a well and I was at the very bottom; about a thousand other windows, tier upon tier, opened into my well.

Martha homed many girlish grandmothers, derelicts who had buried their husbands, or divorced them, married off their children and did not quite know what to do with life. They were be-curled, be-powdered and tremendously interested in their food. Martha had glass doors leading from the lounge to the restaurant. These grandmother-girls were always the first to be at the glass doors when the maids unlocked them at meal times. Martha's food was excellent. There was a door leading direct from the street into the dining room. Men were permitted to lunch at Martha's and a tremendous lot of business men came there for lunch. Martha's food was good and very reasonable.

My Long Island friend came up and took sightseeing tours with me. We went in big buses with bigger megaphones which deafened us when they told us about all the marvels we were passing. First we did the "High-Town" and then we did the "Low-Town" and by that time we were supposed to know New York by heart.

My dread of going around New York alone had completely vanished. I have often wondered what caused that fear, almost terror, of New York before I saw her. I had been raised on this continent and was much more in sympathy with the New than with the Old World. New York was clean, the traffic wonderfully managed and the people courteous.

I hunted up the Art Galleries. Alas, I found them mostly located on top storeys. My heart sank to a corresponding depth under the earth. I kept putting off the visiting of Art Galleries. I did do one on the fifteenth floor (with the exception of Roerich Gallery this was about the lowest). Shooting up was fearful but the thought of sinking down again appalled me. It spoiled the pleasure of the pictures.

On the fifteenth floor I stood aside, waiting for the other passengers to enter the elevator. Half in and half out, I paused. The operator got restive. Suddenly I backed out of the cage.

"Where's the stairs?" I started to run in the direction of his pointing thumb. His scorn followed me.

"Yer won't get to the bottom within a week!"

I knew I ought to be ashamed, and I was. I was sure the cable would break, or that the sink would stop my heart-beat entirely.

The Roerich Museum was on the banks of the river. The building was only half a dozen storeys high. The picture galleries occupied the three lower floors. Everything in the building was Mr. Roerich. . . . His pictures covered the walls of all the galleries. There was one room stacked to the ceiling with parchment rolls, whether by or about him I do not remember. He was for sale in book form and by photograph at the desk on the ground floor. The attendant lowered her voice to whispering every time she uttered his name. I am afraid I do

not yet know just who Roerich was; his museum did not greatly interest me. He seemed to have a large following and everybody knew all about him.

I was not alone while I visited the Roerich Gallery. As I went in the door I met Arthur Lismer of the Toronto Group of Seven and a lady Art Teacher of Toronto. They turned and went back with me. They were up in New York to study the method of Art Teaching in the schools there and also to see the spring Exhibitions. The Art Teaching Lady immediately became a devotee of Roerich. She was voluble as we went through the galleries, Mr. Lismer rather silent. Presently the lady left us to run back to the desk below and secure a few more books and photographs.

I said to Mr. Lismer, "These pictures don't make me 'quake', do they you? They are spectacular enough but . . ."

Mr. Lismer nodded, laid his finger across his lips and rolled his eyes in the direction of the lady from Toronto.

"Don't spoil her delight: she is such an ardent adorer!" He pulled his watch out. "Time!" he shouted over the stair rail to the lady, and to me he said, "Old Toronto student of mine meeting us here to conduct us to the new spring shows, come along."

"I'd love to, only . . ." He laughed, knowing my pet horror.

"Elevators? I'll fix that with the operators, come on."

Each time we were about to drop like a pail filled with rocks Mr. Lismer whispered in the elevator man's ear and we slid down slowly and gently. I have always felt gratitude towards Arthur Lismer for that.

Those modern exhibitions were a wonderment beyond my comprehension, but they were certainly not beyond my interest. In some of them I found great beauty which stirred me, others left me completely cold; in fact some seemed silly, as though someone was trying to force himself to do something out of the ordinary.

We saw Kandinsky, Bracque, Ducamp, Dove, Archipenko, Picasso and many others. Some had gripping power. The large canvas, *Nude Descending a Staircase*, hung in one gallery. I had seen reproductions of this painting before. Mr. Lismer stood looking at it intently. His student, the lady from Toronto and I were arranged beside him looking too, but with less understanding. The four of us were dumb, till Lismer said, "One thing certain, the thing is very, very feminine."

Not until my last day in New York did I meet Mr. Harris's artist friend, the President of the "Société Anonyme." I had tried to communicate with her by 'phone from Martha but without success—she lived in such swell Mansions. Ordinary people were not permitted to communicate with the mansion-dwellers except by some special telephonic gymnastics far too occult for me to grasp, so I wrote her a note. She immediately called at my hotel, which was most gracious of her. I happened to be out, so she left a message at the desk. Martha neglected to deliver it till within two hours of the departure of my train for Toronto. I was annoyed with Martha. I wanted to meet Miss Dreier. Martha atoned the best she could by sticking me into a cab and heading me for the Mansions. They

faced on a beautiful park and were of over-powering magnificence. There were as many guards, door-attendants, bellboys, elevatresses and enquiry clerks as if it had been a legation (spies expected). All of them looked down their noses. I was such a very ordinary person to be asking for one of their tenants! Half a dozen attendants consulted. It was decided that one of the elevatresses, who, by the way, was costumed in black velvet, should take a bellboy and ascend. The boy would take my message and see if it was Miss Dreier's wish to receive me.

It *was* Miss Dreier's wish to receive me, but, the black-velveted lady informed me, "She is about to go out, so the visit must be brief!"

Such rigmarole! I began to wish I had not come, but, as soon as I saw Miss Dreier I was glad I had. She was friendly and kind. I explained about Martha's negligence in delivering her message. She asked about Mr. Harris and his work and a little about me and my work out West. I got up to go saying, "I believe, Miss Dreier, you were just about to go out."

"Only to my bank," she replied. "That can wait till another day. I do not meet artists from Canada every day."

She bade me sit down again. Her house was sumptuous. On the walls were fine paintings, all were canvases by Moderns, all "abstract." Then she brought out many canvases of her own painting. She talked about abstraction and abstractionists. She was particularly proud of a Franz Marc which had just come into her possession.

Among her own canvases was one called *Portrait of a Man*. I would never have suspected it. From the midst of squirming lines and half circles was something which rather resembled the outer shape of a human eye, but through its centre was thrust a reddish form that was really a very healthy carrot.

I looked a long time. I had to say something so I asked, "Please, Miss Dreier, why is that carrot stuck through the eye?"

"Carrot!" Miss Dreier gasped. "Carrot! I did think I had so plainly shown the man's benevolence! He was the most benevolent person I ever knew!"

I felt dreadfully wilted, dreadfully ignorant. To put me at ease Miss Dreier told me about her new book just published, *Western Art and the New Era.*

"I shall get it," I said. "Maybe it will teach me something about abstract art."

We discussed Georgia O'Keefe's work. I told of how I had met her in the gallery of Mr. Steiglitz.

I said, "Some of her things I think beautiful, but she herself does not seem happy when she speaks of her work."

Miss Dreier made an impatient gesture.

"Georgia O'Keefe wants to be the greatest painter. Everyone can't be that, but all can contribute. Does the bird in the woods care if he is the best singer? He sings because he is happy. It is the altogether-happiness which makes one grand, great chorus."

I have often thought of that statement of Miss Dreier's, also of how extremely nice she was to me.

"Thank Mr. Harris for sending you. I am so glad I had not already left for my bank," were her good-bye words.

L A W R E N H A R R I S

MY FIRST IMPRESSION of Lawren Harris, his work, his studio has never changed, never faltered. His work and example did more to influence my outlook upon Art than any school or any master. They had given me mechanical foundation. Lawren Harris looked higher, dug deeper. He did not seek to persuade others to climb his ladder. He steadied their own, while they got foot-hold.

The day that I picked my way over that Toronto slush pile outside the Studio Building, under a bleak, wintry sky, against which the trees of Rosedale Park stood bare and stark . . . the day I entered the dreary building, climbed the cold stair, was met by Mr. Harris and led into his tranquil studio,—that day my idea of Art wholly changed. I was done with the boil and ferment of restless, resentful artists, cudgelling their brains as to how to make Art pay, how to "please the public." Mr. Harris did not paint to please the public, he did not have to, but he would not have done so anyway.

Just once was I angry with him; that was over a canvas, painted by myself, entitled *The Indian Church*.

I had felt the subject deeply, painting it from a close-to-shore lighthouse at Friendly Cove Indian Village out West. Immediately on completion I sent the canvas to an Eastern Exhibition. I had a red-hot hustle to get it to the show in time. *The Indian Church* had three would-be purchasers. To my unqualified joy and pride it was bought by Mr. Harris.

A few months later I went East for a "Group" Show. After the preview, Mr. Harris entertained the Artists at his home.

Taking me by the arm, "Come and look!" he said.

Above the supper-table, beautifully framed and lighted, hung my *Indian Church*.

Surely Mr. Harris's house must have bewitched the thing! It was better than I had thought. I had hurried it into its crate, having hardly given a second glance at it.

I had scarcely the courage to look now. There were people all round the picture saying kind things about it. I was embarrassed, being unused to criticism of that sort. Out West, why, only a week before, I had attended an exhibition of the Island Arts and Crafts Society. My sisters invited me to take tea with them at

the social function connected with the affair. I draggled behind them hating it. We had tea and gossip with friends. No one mentioned my two canvases, so I hoped that perhaps they had been rejected, for I shrank from facing them with my sisters present and with people I knew standing about, people who, I was aware, hated my work.

They were hanging in the last room, right in front of the door. With an angry snort my most antagonistic sister saw and turned sharply back.

"We will go again to the flower paintings. I like them," she said pointedly and we wheeled. My other sister gave one backward glance.

"Millie," she said, "I do like—" My breath stopped! She had never expressed liking of anything of mine.—"your frames," she finished.

Many times Mr. Harris wrote me enthusiastically of *The Indian Church*. He sent it to an exhibition in the United States and wrote, "I went to the U.S. Show. Your Church was the best thing there, a swell canvas. I do not think you will do anything better."

At that I flew into a rage. Mr. Harris thought I had reached the limit of my capabilities, did he! Well, my limit was not going to congeal round that Indian Church! I sent other work east. He compared it unfavourably with the Indian Church—I had thought this work just as good, perhaps better. Mr. Harris did not. He still praised the Indian Church.

"You limit me! I am sick of that old Church. I do not want to hear any more about it!" I wrote angrily.

His answer was, "Good! Still, that Indian Church is a grand thing, whatever and despite what you think of it."

We dropped the subject, but he went on writing helpful, encouraging letters. A lesser man might have huffed at my petulance, even stopped writing. If he had I would have broken.

I had now become independent of Indian material. It was Lawren Harris who first suggested I make this change.

I had become more deeply interested in woods than in villages. In them I was finding something that was peculiarly my own. While working on the Indian stuff I felt a little that I was but copying the Indian idiom instead of expressing my own findings.

To gain freedom I saw I must use broad surfaces, not stint material nor space. Material in the West was expensive, space cheap enough. I bought cheap paper by the quire. Carrying a light, folding cedar-wood drawing board, a bottle of gasoline, large bristle brushes and oil paints, I spent all the time I could in the woods. Once or twice each summer I rented some tumble-down shack in too lonesome a part to be wanted by summer campers. Here, with three or four dogs and my monkey, all my troubles left at home, I was very happy and felt my work gain power.

I sent a bundle of these paper sketches East. Mrs. Housser showed them to a group of artists in her house and wrote their comments to me. The criticism did

not help much. However, they did all seem to feel that I was after something and this cheered me.

Lawren Harris wrote, "I saw the sketches. They are vigorous, alive, creative. . . . Personally I do not feel that your sketches are subject to criticism, they represent vital intentions. One can only say, 'I like this one or I do not like that.' They are unusually individual and soaked with what you are after, more than you realize, perhaps. . . . Don't let anything put you off . . . even if you come through with but one out of three or four endeavours, hitting the mark, the thing woven into vital song . . . keep at it."

"When, in my last letter," wrote Mr. Harris, "I said there is no evolution in Art . . . that I think is true, but not with each individual artist. Each artist does unfold, come to his or her particular fulness. But in Art as a whole, there is not evolution; there is change of idiom, approach and expression—development of means, media, and paraphernalia. . . . The old Masters have not been surpassed. Modern artists do different things in terms of their day, place and attitude. Great works of Art are the same yesterday, today and forever. We but endeavour to be ourselves, deeply ourselves; then we approach the precincts of Great Art—timeless—the Soul throughout eternity in essence."

Lawren Harris did not separate Art from life. You could chatter to him freely about what to most people seemed trivialities; observations on woodsey things and about animals as well as about work, honest observations interested him. I wrote him of my friendship with Sophie, the Indian woman.

"It goes to prove," he replied, "that race, colour, class and caste mean nothing in reality; quality of soul alone counts. Deep love transcends even quality of soul. . . . It is unusual, so deep a relationship between folks of different races."

Sometimes my letters were all bubble-loveliness of the woods and creatures—again, they dripped with despairs and perplexities. Then he would try to set my crookedness straight. He would write, "In despair again? Now that is too bad. Let us be as philosophical as we can about it. Despair is part and parcel of every creative individual. Some succumb to it and are swamped for this life. It can't be conquered, one rises out of it. Creative rhythm plunges us into it, then lifts us till we are driven to extricate. None of it is bad. We cannot stop the rhythm but we can detach ourselves from it—we need not be completely immersed . . . we have to learn not to be! How? By not resisting. Resistance is only an aggravation!—one I think that we should escape from if we learned that all things must be faced, then they lose their potency. It is no good to tell you that your work does not warrant despair. Every creative individual despairs, always has since the beginning of time. No matter how fine the things are, there are always finer things to be done and still finer *ad infinitum*. . . . We have to be intense about what we are doing but think what intensity does, what it draws into itself—then, do you wonder that, if things do not go as well as we anticipate, the reaction from intensity is despair? Keep on working, change your approach, perhaps, but don't change your attitude."

Arthur Lismer, the lecturing member of the Group of Seven, came west. He visited my studio, went through my canvases. Lismer's comments were so mixed with joke either at his own or at your expense that you never quite knew where you stood. His criticism left me in a blur. On the lecture platform Lismer draped himself over the piano and worked modern Art enthusiastically, amusing as well as impressive.

Lawren Harris wrote, "Lismer is back from the West, full of his trip. He had great things to say of your present work, could see it emerging into fruition. . . . If I could convey to you his look when he talked about your work, discouragement would never enter your mind again. . . . I suppose we are only content when all our sails are up and full of the winds of heaven—certainly the doldrums are trying. . . . I hope all your sails are up and full of the winds of heaven under high great skies."

Mr. Harris wrote me of making a selection of pictures for an All Canadian Show in the United States, "The choice was left to Jackson and me. Yours were all damned good things. I feel there is nothing being done like them in Canada . . . their spirit, feeling, design, handling, is different and tremendously expressive of the British Columbia Coast—its spirit—perhaps far more than you realize. We who are close to certain things hardly realize the intensity and authenticity of what we do to others who are less close. Your work is a joy to us here, a real vital contribution."

Thus he cheered, gave me heart.

In answer to a perplexed letter of mine he wrote, "The lady you speak of who was moved by your work was right; you may not think so, but, perhaps you are not seeing what you do entirely clearly. You get immersed in problems, the reaction from creative activity, dissatisfaction from the feeling that you have not realized what you desired. We all are in such matters, and it is all as it should be, there is no finality, no absolute standard, no infallible judge. . . . Life is creative and Art, creative Art is Life."

Every letter he wrote stimulated me to search deeper. Lawren Harris made things worthwhile for their own sake.

Again he wrote, "Everything you say describes the true Artist . . . there is no realization, only momentum towards realization. The *becoming of all*, satisfying, completion, fulfilment, something indeed that we cannot attain individually, separately, only as the complete spiritual solidarity, mankind. . . . Strive we must. . . ."

Again, "Your canvases hang in the O.S.A. show. The consensus of opinion, best opinion, is that they are a very great advance on your previous work. It is as if your ideas, vision, feelings, were coming to precise expression; yet nowhere is the work mechanical, laboured or obvious. For goodness sake, don't let temporary depression, isolation, or any other feeling interfere with your work. . . . Keep on . . . do what you feel like doing most. Remember, when discouraged, that there is a rhythm of elation and dejection; and that we stimulate it by creative endeavour. . . . Gracious, what we stir up when we really come to

live! When we enter the stream of creative life, then we are on our own and have to find self-reliance, active conviction, learn to see logic behind the inner struggle. Do, please, keep on and know, if it will help you, that your work has tremendously improved; know, too, that the greater it becomes the less you will be aware of it, perhaps be almost incapable of being convinced; what does that matter? There is only one way—keep on.—How can greatness be true greatness unless it transcend any personal estimate? How can it live in great searchings, in the true spirit, in the informing unity behind the phenomena, if it knows itself as great? . . . Creative imagination is only creative when it transcends the personal. . . . Personality is merely the locale of the endless struggle, the scene of the wax and wane of forces far greater than itself."

So Lawren Harris urged, encouraged, explained. I was often grumbly and not nice. On one occasion when I was cross I wrote a mean old letter to a fellow artist in the East who had annoyed me in some trivial matter. Lawren saw the letter. He scolded me and I felt very much shamed. He wrote me, "Tell you what to do, when you have need of 'ripping things up a bit' get it off your chest by writing to me. The party you tore up was a sensitive soul. Write me when you are rebellious, angry—Bless you and your work."

Once when I was in perplexity he wrote, "I don't suppose you do know precisely what you are after. I don't think in the creative process anyone quite knows. They have a vague idea—a beckoning, an inkling of some truth—it is only in the process that it comes to any clarity. Sometimes, indeed often, we work on a theme with an unformed idea and, when it has passed through the process, its final result is something we could never have predicted when we commenced. . . . Of course there must be the urge, the indefinable longing to get something through into terms of plastic presentation, but results are nearly always unpredictable."

"Sold my apartment house! Moved into a cottage in a dowdy district, old fashioned high windows—think I can paint here," I wrote to Lawren Harris.

He replied, "Sounds good to me. Occasionally uprooting is good for work, stirs up a new outlook, or refreshes the old one."

When later I reported, "Bought a hideous but darling old caravan trailer, am now independent of cabins for sketching trips," "Swell!" was Lawren Harris's hearty comment. "Swell!"

"Yes, I too have been working. My present approach is by way of abstraction. I have done quite a number and with each one learn a little more, or increase that particular way of perceiving. Feeling can be as deep, as human, spiritual and resonant in abstract as in representational work: but, because one has less to rely on by way of association, it requires a greater precision. . . . A struggle all right. . . . There is no doubt in my mind that abstraction enlarges the scope of painting enormously. It replaces nothing, it adds to the realm of painting, makes possible an incalculable range of ideas that representational painting is closed to, increases the field of experience—enlarges it—that is surely all to the good, but abstraction definitely cannot displace or replace representational painting. . . . If

one has not zest, conviction and feeling, one is no better off in abstract, indeed less so.

"Our limitations may make abstraction seem remote, but then once we extend those limitations, which is the purpose of Art, the remoteness disappears. . . . Abstraction can have all the virtue of representational painting plus a more crystallized conviction. I feel that it will become more and more the language of painting in the future and no man can say what it may yet disclose. Some day I may return to representational painting—I do not know. At present I am engrossed in the abstract way.—Ideas flow, it looks as though it would take the rest of my life to catch up with them. . . . When, in your letter, you refer to 'movement in space', that is abstract, try it. . . . Take an idea, abstract its essence. Rather, get the essence from Nature herself, give it new form and intensity. You have the 'innards' of the experience of nature to go by and have done things which are so close to abstraction that you should move into the adventure much more easily than you perhaps think."

I was not ready for abstraction. I clung to earth and her dear shapes, her density, her herbage, her juice. I wanted her volume, and I wanted to hear her throb. I was tremendously interested in Lawren Harris's abstraction ideas, but I was not yet willing to accept them for myself. They seemed the right and natural development for his work. Now that I have seen his beautiful abstractions I think I would be sorry to see him return to representational painting. I do not pretend to understand, to be able entirely to follow the principle of abstract truth, but I do feel unwordable depths in it that move me very much. In Lawren Harris's abstractions I am as aware of truth as I was aware of the calm deep sincerity which uplifted the onlooker in his earlier representational work and in them too I am aware of great beauty and power. I cannot explain why Lawren Harris's abstracts move me so, I feel power there whereas in some abstractions I feel emptiness.

G R E E N

WOODS you are very sly, picking those moments when you are quiet and off guard to reveal yourselves to us, folding us into your calm, accepting us to the sway, the rhythm of your spaces, space interwoven with the calm that rests forever in you.

For all that you stand so firmly rooted, so still, you quiver, there is movement in every leaf.

Woods you are not only a group of trees. Rather you are low space intertwined with growth.

Bless John Whiteley! Bless Algernon Talmage! the two painting masters who first pointed out to me (raw young pupil that I was) that there was coming and going among trees, that there was sunlight in shadows.

In the roof-peak of the apartment house I built was a little attic room, my favourite of all the rooms in that house.

A crooked stair led to it. The stair was in the corner of the studio. I chose this room with its wide view for my bedroom. It had low-drooped walls but the centre of the room was high. Its end walls were peaked. The naked ridge pole and studding showed, because the room was unlined. Rain pattered on the cedar shingles only a few feet above my face.

In its west-end wall the room had two large windows which appeared to be narrow because they were so high, beginning at the floor and ending right in the point of the gable. These windows let in an extensive view, a view of housetops, trees, sea, purple mountains and sky. The view seemed to come companionably into the room rather than to draw me out; and it had an additional glory, but for this glory you must look *out*, look *down*. Then you saw right into the heart of a great Western maple tree. Its huge bole culminated in wide-spread, stout branches. There was room for immense life in this bole.

The maple tree was always beautiful, always gracious. In spring it had a sun-lit, pale-yellow glory, in summer it was deep, restful green, in autumn it was gold and bronze, in winter it was a gnarled network of branches. It was in winter you saw best the tree's reality, its build-up and strength.

On the whitewashed underside of the roof shingles of my attic room I painted two immense totemic Indian Eagles. Their outstretched wings covered the entire ceiling. They were brave birds, powerful of beak and talon. Their plumage was indicated in the Indian way—a few carefully studied feathers painted on wing, breast, and tail gave the impression that the bird was fully plumed.

Sleeping beneath these two strong birds, the stout Western maple tree beneath my window, is it wonder that I should have strong dreams, dreams that folded me very close!

One night I had a dream of greenery. I never attacked the painting of growing foliage quite the same after that dream I think; growing green had become something different to me.

In my dream I saw a wooded hillside, an ordinary slope such as one might see along any Western roadside, tree-covered, normal, no particular pattern or design to catch an artist's eye were he seeking subject-matter. But, in my dream that hillside suddenly lived—weighted with sap, burning green in every leaf, every scrap of it vital!

Woods, that had always meant so much to me, from that moment meant just so much more.

ALTERNATIVE

"LADIES approaching seventy must not expect to work like girls of seventeen—it is unreasonable."

The doctor's voice was reproving but kindly.

"Overdoing has enraged your heart. To begin with we will see what a good long rest in hospital will do."

"How long?"

The doctor resorted to a professional shrug and the spreading of his palms.

"Another thing . . ." he paused. . . . His eyes roved round my studio, finally resting contemplatively on a small monkey and a mother dog and her four pups on the hearth rug. "I notice you have an aviary of birds on the veranda," he mused. "Livestock entails work. You must limit yourself now to a minimum of exertion, throw everything not imperatively necessary overboard. Goodness, you have done a lot of work!"

His eyes roved from my menagerie to my full canvas racks.

My breath caught, "Not half what I want to, Doctor. You don't mean—you are not telling me my painting days are done! Oh, lovely, all-alone caravan-days in the quiet, woodsey camps with my creatures! Seventy isn't so frightfully old!"

"We will talk of that after we see what rest does for that heart; meantime, take things very, very easy. I will engage a room in the hospital for you. One thing certain! Trips alone must be given up."

"Ugh, my stupid heart needs a chaperon! No thank you, I will stay at home. I never could work with danglers hanging round."

The weeks in hospital sauntered slowly by till Eric Newton, noted Art Critic for the *Manchester Guardian*, paid a visit to the West. Eric Brown, Director of the Ottawa National Gallery, had asked Mr. Newton while out west to select some fifteen pictures of mine and ship east. He had prospective buyers. Mr. Newton wired me from Vancouver. Finding I was in hospital he came there to see me.

He said, "As I drove over the Island Highway I saw *Emily Carr pictures* in the woods no matter in which direction I looked. You have caught the Western spirit." Folding his hand over my two sick ones he added, "Get better, these hands are too clever to lie idle."

I turned my face away. What good getting better if I was never to roam the woods again, paint-sack on shoulder, dog at heel?

"Wa! Wa! Wa!"

The maternity ward was across the court from my room. New-borns were taking the unknown life before them hard. Ah! The price of being was this adjusting ourselves to life at different angles.

I blinked hard a time or two and turned back to Mr. Newton.

"All right, I'll try to get well."

When Lawren Harris advised me, "Put aside the Indian motifs, strike out for yourself, Emily, inventing, creating, clothing ideas born of this West, ideas that you feel deep rooted in your heart," I sat before the woods and stared, lost, frustrated. I had let myself be bound. It was not handling of paint but handling of thoughts which overwhelmed me. Trying to get around this problem, I took always in my sketch-sack a little note book. When I had discovered my subject, I sat before it for some while before I touched a brush, feeling my way into it, asking myself these questions, "What attracted you to this particular subject? Why do you want to paint it? What is its core, the thing you are trying to express?"

Clearly, and in as few words as possible, I had answered these questions from myself to myself, wording them in my little note book, presenting essentials only, discarding everything of minor importance. I had found this method very helpful. This saying in words as well as in colour and form gave me double approach. I knew nothing about the rules of writing.

The only author I had ever met was Fred Housser, who wrote *A Canadian Art Movement.* When I stayed with the Houssers in the East, Fred had let me read two of his manuscripts. He talked with me about them afterwards. When I went home I wrote an Indian story and sent it to Fred, asking criticism. He liked my story and wrote me a wonderful letter, finding much fault in my construction, taking infinite pains to explain a story's build-up.

"You do not want 'eye-wash'," he wrote and struck hard. The letter made a great impression on me.

When I grinned back at Mr. Newton and said, "I'll try to get better," I had this idea in the back of my mind—"One approach is apparently cut off, I'll try the other. I'll 'word' those things which during my painting life have touched me deeply."

"Doctor, may I write?"

"Write? Write what?"

"Describe places I've seen on my sketching trips, woods, Indians and things—nice Canadian things of the West, things that will heal, not rile my heart."

"You can try, but don't get excited, don't overtire."

The nurse was told to watch. She kept bouncing in and grabbing my wrist—she did not approve of the doctor's permission, but had to admit that, instead of doing me harm, it soothed and calmed me.

I did not know book rules. I made two for myself. They were about the same

as the principles I used in painting—Get to the point as directly as you can; never use a big word if a little one will do.

So I wrote the stories that were later to be known as *Klee Wyck*, reliving those beautiful, calm places among the dear Indians. Their quiet strength healed my heart. Of course it could not heal old age, but it healed me enough that I could go home and take up that easy, easy life the doctor prescribed. No more was I to go off in my old van alone—that was too strenuous. About that he was firm.

While I was still in hospital, Eric Brown wrote me. For a good many years he had taken interest in and been most helpful about my work. He said my isolation out West was making me think for myself and it showed in my canvases. (I was sending each year to Eastern Exhibitions.) He now wrote, "Will you collaborate with a biographer? We want the 'struggle story' of your work out West written. Better still, will you write it yourself?"

"I don't know how to write," I answered Mr. Brown. "My Indian stories (I had told him about writing them) are just fun and they're medicine. I go back so vividly on those sketching trips, that I forget being sick."

I was fond of Eric Brown; he had dug me out of that dreadful slough of despair at the time when I was too disheartened to paint. I wanted to please him.

I said, "Nobody could write my hodge-podge life but me. Biographers can only write up big, important people who have done great deeds to which the public can attach dates. I could not be bothered with collaborators, nor would they be bothered with the drab little nothings that have made up my life. However, to please you, Mr. Brown, I will have a try."

I had only a few chapters written, and was still in hospital, when I got word that Eric Brown was dead. Following close on the news of his death came the death of my Indian friend Sophie around whom many of my Indian stories were written. Writing as well as painting paused a little inside of me, but soon the "easy" life began to bore me and I continued the biography.

I had two faithful women friends who were very patient in listening to my script—Ruth Humphrey and Flora Burns. It is a tremendous help to hear words with the ears as well as to see them with the eyes; so I read aloud to these friends and received helpful criticism from them.

When I had about three chapters of the biography written I read them to my only surviving relative—a sister. She was very, very angry. She accused me of being disloyal to my family and altogether abominable.

It had been absolutely necessary for truth's sake to include a short few pages on our home life which for me had not been happy after the death of our parents. I had to show what drove me to the woods and to the creatures for comfort, what caused the real starting point of my turn to Art. My family had never been in sympathy with my painting, nor entered into my life as an artist. My home life was always a thing entirely apart from my art life.

My Indian sketches lay in my bureau drawer. My two friends thought I should endeavour to seek a publisher for them. They suggested I send them to a publishing firm in Toronto. I did so. For months I received no word, good or

bad. At last I wrote the publishers and was coolly informed that they had been unable to use the stories but unfortunately they had lost them. They regretted the fact, but there it was—they were lost!

I was furious at their indifference and their carelessness. I wrote and wrote, giving them no peace. I wrote to the head, and the tail, and all the other members of the firm that I could attach a name to. I said, "I have no other copy of the manuscript. It is up to you—it must be found."

The manuscript remained lost for one whole year. Then it was returned to me. They claimed it had slipped off a desk and fallen among a box of books being packed for Queen's College. If that was the case, why had not Queen's College returned it to the publishers when they unpacked their books, not held it for a year? I am convinced it never would have turned up but for the unpleasant nagging I gave the entire lot of them. They told me they never were so glad to return anything to anybody. I had tormented them so.

I too was weary of the nuisance by then. I did not try another publisher. I stuck the manuscript way in a drawer and forgot it.

One of the faithful "listening ladies" who had sat patiently while I read my stories aloud borrowed them, took them to Vancouver and showed them to Ira Dilworth, one-time principal of Victoria High School, later Professor of English at the University of British Columbia and now attached to the CBC at Vancouver.

He was interested and said he would like to have some of the stories read over the radio. He came to see me about it.

The first series of six readings was done by Dr. G. G. Sedgewick of the University of British Columbia, who had seen some of my work earlier. The second series was read by Mr. Dilworth himself. They pleased the air audience. Shortly after reading the second series, Mr. Dilworth went East, taking with him the manuscript which he showed to his friends, Mr. and Mrs. Clarke. On his return from the East he came to see me. He said, "Mr. Clarke wants to publish two volumes of your writings,—one of the Indian stories, the other stories of your childhood."

"Is it possible!" I gasped.

My one publishing try had been so disastrous. I supposed my stories not up to much as they were so indifferent when they were lost.

"What about my punctuation and spelling, Mr. Dilworth? They are awful, you know."

"We can get around that. If it is all right with you, I shall act as your honorary editor."

I can well imagine the relieved "Oh!" I gave then. Spelling and punctuation always were such a horrible trial to me, and now here was a genuine professor offering to stand behind me, ready to be appealed to! His kindness lifted a tremendous load from me, just as if he had kicked all the commas, full stops, quotes and capitals right to another planet.

Mr. and Mrs. Clarke came West that autumn. Mr. Dilworth brought them to see me. We were to proceed with the work at once. They conferred as to which

book should be published first. At first it seemed in order that it should be the childhood stories. On the other hand, my Indian pictures had been exhibited quite a bit in the East. That would, to some extent, lay a foundation for the Indian stories. It was, therefore, decided that these should have first place.

I cannot describe the terror-shakings that overtook me as the stories and I awaited our Editor. I felt so shamed, so terrifically ignorant. I wished I had been a better student, that I had not scuttled off to San Francisco Art School, skipping my last year of "High". I had heard of Mr. Dilworth as a scholar and a very fine teacher. I should die of shame.

We sat down at a table in my studio and alternately read to each other from the script. In two seconds I was not afraid any more.

"Two 'l's' there, one 's' only," he corrected as we read, or, "New sentence here, new paragraph there," but he made me feel such things were subservient and of secondary importance to the spirit of the text. At once I knew he loved Indians and the West just as I did. My Editor never altered my wording arbitrarily. Occasionally he suggested re-phrasing a sentence, always explaining why. He never added or omitted anything without consulting me. Sometimes he made suggestions, but he made me re-word the thought myself. He was a million times younger, a million times cleverer than I but he never made me feel an old fool, or finished, or stupid, or ignorant. Long before the work on the manuscript was finished he was just plain "Eye" to me.

I shall never forget the editing of *Klee Wyck*—the joy of those hours—nor all it taught me. I was almost sorry to see her finished and shipped off to the publisher. After a while she came back—a book!

SEVENTIETH BIRTHDAY
AND A KISS FOR CANADA

Klee Wyck made her first appearance a few days before I was seventy. Victoria was astonished at her. Victoria had never approved of my style in painting. When my painting was accepted in the East a few Westerners tolerated it, a smaller number found they actually liked it. *Klee Wyck* and, a year later, *The Book of Small* Victorians took straight to their hearts and loved even before the favourable Eastern reviews appeared.

Klee Wyck got wonderful press reviews right across Canada. Letters, phone calls came from everywhere. People were not only warm but enthusiastic. I was staggered. My Editor wrote a foreword for *Klee Wyck*. He was also asked by *Saturday Night* of Toronto to write two articles, one on my work, one on me. Following the publication of *Klee Wyck* these appeared in two consecutive issues. Eye showed the script of them to me before sending it east. I wriggled with embarrassment. Those things could not be about me and my work! It was so strange a hearing for my ears. Out west they had slanged, ridiculed my painting.

I had just finished reading the two articles when Lawren Harris came to see me. He too had written a beautiful review of *Klee Wyck* for *The Canadian Forum*. I showed him Ira Dilworth's articles and told him how I felt about the whole matter. This was his answer—"Keep your nose from where it does not belong. We painters and writers have our own work to do—good, let us do it. The critic has his work to do. That is his business, not ours."

I put the critics and their reviews clean out of my head. When reviews came, praise after praise from all over Canada (some from England too; the Oxford University Press have their head office there), I was just very pleased, read them to my sister who wanted to hear, put them away and thought no more about them. I had letters from such different kinds of people, from University professors, very kind about the way I used English in my writing, from lumbermen and fishermen who said, "It is our West Coast, dense, rugged and lavishly watered with mist and rain", from children who said, "We just love *Klee Wyck*!" Even two Missionaries who had worked among the Indians on the West Coast wrote liking the book. She was accepted by libraries and reading clubs, and was the subject of book reviews over the radio.

The Victoria Branch of the University Women's Club did me the honour of inviting me to be an honorary member of their branch. I was so astonished I did not quite know how to act. I had always maintained that unearned honours

were stupid shams. Look how hard real members worked to earn their membership—why should I, never having even squeaked through High School, be honoured by a University Club membership? Half of me said, "I can't!" The other half said, "But, I would be very proud." So I took, thanked and am.

A few days before my seventieth birthday, a member of the University Women's Club telephoned me congratulations on *Klee Wyck*. She said, "Our Club would like to honour you and *Klee Wyck* by having a little tea-party for you. Are you well enough? We know how ill you have been—and, by the way, have you not a birthday coming pretty soon?"

I replied that I had not been out since my illness, but that I thought I could manage it, that it was very kind of them and that the following Saturday was my seventieth birthday.

"Then that is the day we will set for the party," she said, "I am lending my home for it. Some of the Club ladies will call for you."

I imagined it would be a gathering of perhaps six or at most a dozen of the Club members.

On Saturday I was dressed and waiting when in walked Eye.

"Ready?" he asked. "I've come to take you to the party."

"The University Women's tea-party? I am expecting them to pick me up, they promised, so I can't go with you, but how did you know there was to be a party?"

"I am invited. Furthermore, I am going to read out of *Klee Wyck*. It's a big affair, men as well as women coming to honour you and *Klee Wyck*."

"Oh," I said, "I thought it was only half a dozen ladies and a cup of tea."

"It's going to be mammoth—your townspeople, as many as the house will hold—don't get scared."

"Will there be speeches?"

"I should say so!"

"Will I have to reply?"

"I do not think it will be expected of you. They know you have been ill."

"It would be very ungracious to say nothing at all. They have been so kind to me and to the book; I'll scribble a few words and if, as so often happens, my voice goes, will you read them for me, Eye? Oh, I am so glad you are going to be there, I'm frightened."

"Don't worry, you'll be all right."

I scratched a few words on an envelope and clapped it in my spectacle case; then the ladies came for my sister and me.

Our hostess, Mrs. Young, had a big house, large rooms. When I saw them packed with people I dropped into the first chair inside the front door and wilted. Mrs. Young came and stood beside me protectingly so that people would not know I had come. After a few moments I got up and took her arm.

"I'm ready."

She led me into the drawing room and sat me on a pink sofa under a stand lamp. It had commenced to blow and snow outside. Inside all was cosy. My sister was on another sofa across the room and Mrs. Young saw that she had people about her that she knew because my sister is shy and nearly blind; she looked happy and I made up my mind I was going to enjoy my party to the full.

"The Reverend T. Laundy," Mrs. Young said, "will open the occasion with a short invocation."

The Reverend offered a short prayer. I was glad Mrs. Young had invited God to my party.

Then the master of ceremonies came forward, a sheaf of open letters in his hand—letters of congratulation from Victoria's citizens and from the various organizations in the city, good wishes for my birthday and for *Klee Wyck*. A mail box had been placed beside my sofa and I had wondered why. Now I saw that many of the guests carried envelopes. The first letter read was from the Lieutenant-Governor regretting he was not able to be present but sending best wishes; then came letters from the Mayor and Aldermen, the University Women's Club, the Canadian Club, the Native Daughters. There was one from the head of Indian Affairs on behalf of himself and the Coast Indians. After the master of ceremonies had read that many aloud, men and women representatives from many other organizations in Victoria stepped up to my mail box, dropped in their societies' letters and shook hands with me.

Eye stood close beside my sofa. If I did not quite know how to act or what to say, he told me. He was strength and comfort as he had been over editing *Klee Wyck*. Dear Eye! He knew the right way and it made me feel safe.

There were flowers, such beautiful flowers! Bouquets, boxes, corsages heaped round my sofa—someone was always coming up with more. It was like having a beautiful funeral only being very much alive to enjoy it. Such an easy, comfortable party! I found myself having a very good time.

After my right hand had nearly been shaken off there were speeches. Lovely things were said about *Klee Wyck*. When everybody had said everything there was to say, came a tiny pause. I whispered to Eye, "Is it my turn now?" I was shaking with fright. He nodded but, when I went to rise, he put his hand on my shoulder and kept me sat.

"Sure you can make it?"

"Yes," I replied.

My voice rang out strong as a bull's and I was not scared. This is what I said—the envelope is still in my spectacle case—"Thank you everybody for giving me such a splendid, happy birthday party and for being so kind to *Klee Wyck*. I would rather have the good-will and kind wishes of my home town, the people I have lived among all my life, than the praise of the whole world; but I did not write *Klee Wyck*, as the reviewers said, long ago when I went to the West Coast Villages painting. I was too busy then painting from dawn till dark. I wrote *Klee Wyck* one year ago in hospital. They said I would not be able to go about painting here and there any more, lugging and tramping. I was sore about it, so, as I lay there, I relived the villages of *Klee Wyck*. It was easy for my mind

to go back to the lovely places. After fifty years they were as fresh in my mind as they were then because while I painted I had lived them deep. I could sail out of hospital and forget about everything. It was *Klee Wyck* gave my sick heart courage enough to get better and go home to the easy life the doctor had told me I had to expect now."

"Bravo! You'll be a public speaker yet!" whispered Eye in my ear. Then he took *Klee Wyck* in his hands and stood in a central spot to read. When the chairs and sofas were full, people sat round on the floor.

Eye is a beautiful reader. He read *Canoe* and *Juice*. Then he talked about several of the longer stories. He commented on *Klee Wyck*'s place in Canadian literature and how privileged I had been to see the Indian people in their own homes and villages. He said by writing *Klee Wyck* and by painting our woods I had made a contribution to Canada's art and literature.

Eye stopped speaking and the room was very still, so still I was scared—"Perhaps everyone does not like Indians!"

Then everybody began to chatter at once. Praise, praise, praise for *Klee Wyck*. I ducked my face into a box of beautiful chrysanthemums and red carnations that the Canadian Press had sent me.

I did not see or hear Eye cross the room, but suddenly I was aware of a great kindness there before me and the kindness stooped and kissed my cheek!

It was the proudest moment of *Klee Wyck*'s success when, before them all, Eye stooped and gave me that kiss for Canada, prouder far than when *Klee Wyck* won the Governor-General's medal for best non-fiction for Canada in 1941. The medal looked to me to be made of the same metal as our old cowbell. "It is the honour," everyone said, "and remember it is war time!" But the kiss for Canada was made of the pure, real stuff, unadulterable.

We had refreshments and a huge lighted birthday cake and grapefruit punch for healths and "God Save the King." Again I went to stand, again Eye's hand kept me down. "You are tired enough," he said. "Come," and took my sister and me home to begin my seventy-first year.

THE BOOK OF SMALL

ONE YEAR after the publication of *Klee Wyck, The Book of Small* appeared. I had wintered in a Nursing Home. Domestic help and fuel problems were difficult owing to war. I was quite eligible for a Nursing Home because I was really ill.

There I lay waiting and waiting for Small to come from the publisher. The publishing houses were under a heavy war strain—men, presses, material; but at last the book came in a smart green jacket with a medallion of the little old Small in the centre.

The Book of Small was entirely different from *Klee Wyck*. She was bigger. Some people liked her more, some less. The first half of Small was a collection of childhood (our childhood) stories, the life we lived in the far West where Father and Mother pioneered and raised their large family.

The other half of Small was called *A Little Town and a Little Girl*. It told of little old Victoria before she was even a town. Nearly all the people who lived there were English and they had a good many difficulties to cope with. They had only small Chinaboys as helps, no plumbing, only pumps and wells, no electric light and no telephone. Indians went round the streets selling their beautiful cedar-bark baskets or trading them for old clothes, or peddling clams or pitch wood tied in bundles for the lighting of fires. *The Book of Small* told of the slow, conservative development of Canada's most Western city.

My Editor was up north on a business trip. He had waited impatiently for the appearance of Small. She came the day he left. He wrote me, "I suppose you are being swamped with fan mail."

No, Small lay shut in a drawer. I could not bear to look at her. She lay there for three or more weeks. No reviews, no letters came about *The Book of Small*. They had followed the appearance of *Klee Wyck* immediately or within a few days. In bitterness and disappointment I turned to the wall. My Editor came back from the North and, coming to Victoria, dashed into my room.

"The reviews? The letters?"

"There aren't any. Oh, Ira, she's flopped. Small has flopped dead. I'm so shamed!" and I cried till I nearly drowned him. He looked perplexed.

"I can't understand it. Clarke and I both thought she was the equal, if not better than *Klee Wyck*. She can't have flopped!"

I hid my shamed face in the pillow.

"I don't care so much about Small and me, but I've disappointed you and Bill Clarke."

I howled quarts of tears that had been strangled back for three weeks.

"The Press too, Small will be a dead loss to them. I wrote Bill last night and told him how dreadful I felt."

"Cheer up, remember it's war time and everything is higgledy-piggledy. There has been a hold-up somewhere. It's a marvel to get a book published at all these days! All dates are uncertain. Reviewers can't review till they have got the stuff, nor the booksellers sell till they have the books."

He left me cheered, but not convinced. I could only wail, "She's flopped, she's flopped! Small's flopped!"

"Silly!" said my Editor, "you'll see. Small's all right. Look at the reception *Klee Wyck* got; Small will too—give her time."

Letters came from both Mr. and Mrs. Clarke. Kind letters they were, very upset that I should have thought Small had flopped. There had been delays, just as Eye had said, owing to war conditions. The date of publication had had to be postponed several times, the reviews could not come out till the critics got the books and read them. Shipments of books had been late going to the bookstores and libraries. The reviews were just as good, just as complimentary, as those of *Klee Wyck.*

Eye wrote from Vancouver, "What did I tell you? All who read Small (and everyone is reading her now) love her. Bookstores are sold out of copies!"

Mr. Clarke made his autumn trip to the West—dear Bill and his kind little wife felt so sorry about all the doldrums I had been through because of Small. Bill's first question was, "Is the next book ready? I plan to publish one each year." The script was ready, but we were deeper than ever in war. Hitler is a nuisance from every possible angle!

WILD GEESE

SPRING WAS YOUNG, I over seventy. With Spring all about me I sat sketching in the clearing that was now given over to second growth—baby pines, spruce, hemlock, cedar and creeping vines, fireweed, bracken.

The clearing was off the Happy Valley Road at Metchosen, not far from Victoria. Seventy years had maimed me, loggers had maimed the clearing. I could no longer scramble over great logs nor break my way through networks of brambles, creep under bushes and drown myself crown-high in lush, young

growth. I had to be taken out, set down and called for, which was a nuisance, but I got immense delight in just being there, in the quiet wood, nobody for company but Spring.

Though everything was so still, you were aware of tremendous forces of growth pounding through the clearing, aware of sap gushing in every leaf, of push, push, push, the bursting of buds, the creeping of vines. Everything expanding every minute but doing it so subtly you did not actually see anything happen.

In spite of the doctor I went into the woods to paint a few times more. The longing was too terrific to subdue and I felt better. I did not go in my old van (it was deteriorating with unuse so I had sold it). I rented a cabin and took a maid along to cook and carry for me.

The maid was too busy attending to her own work to bother about me; she carried my things out into the woods and came back for them and me later. I was very happy but the last expedition I over-did and came smash.

For a year painting lay dormant but I did some writing. One day a friend took my sister driving. On the way they planted me in a thick lonely place just off the high road while they took a long ride. It was here that I painted *The Clearing* and here the wild geese flew over.

Hark! Hark! High up in the blue, above the clearing, wild geese migrating. Honk, honk, ya honk! A triangle of noisy black dots.

Every Canadian thrills at the sound—the downpour of cackling honks broken, irregular, scattering with the sharp monotony of hailstones while the geese sail smooth and high, untroubled by fear of men, for migrating geese fly far, far above man's highest shooting.

On the ground the wild goose is a shy, quiet fellow. In the sky he is noisy and bold.

I lifted my face to watch the honking triangle pass across the sky. The day was clear, not dazzle-bright. I could look into the face of the sky without blinking. There was just one cloud. The geese caught up with the cloud. The leader dove into it, his flock followed. For a few seconds the cloud nestled the geese to her breast, emptying the sky, muffling the honkings, but the company pierced through the cloud. The leader and those few birds that fly in close formation behind him appeared, then the two long wavering side lines of singly-spaced birds emerged, to continue their way sailing, sailing into the north, one glad rush of going, one flock unswervingly following one leader. At that height each bird appeared no bigger than a small black bead, evenly strung one goose behind the other, a live necklace flung across the throat of heaven.

The racket passed over the clearing, the sky was again still, my eyes came back to the greying stumps amongst which I sat. Young growth had already hidden some. Even the echoes had forgotten how they had shrieked sympathy when the axes bit into the great original forest giants, forgotten the awful crash, the groan, the tremble of the ground as each tree fell.

Today the clearing was not sun-dazzled, rather it was illumined with Spring, every leaf was as yet only half unfurled and held light and spilled some.

Today at seventy I marvelled more at the migration of the geese than I had at the age of seven when, standing in our cow-pasture holding Father's hand and looking up into the sky, I heard Father tell the story of bird-migration and only half believed. Today a new wondering came to me as I watched the flight. What of the old or maimed goose who could not rise and go with the flock? Of course there *was* the old, the maimed goose. What of him when the flock, young and vigorous, rose leaving him grounded? Did despair tear his heart? No, old goose would fill the bitter moment, pouring out proud, exultant honks that would weave among the clatter of the migrating flock. When the flock were away, animal-wise he would nibble here and nibble there, quietly accepting.

Old age has me grounded too. Am I accepting? God give me the brave unquestioning trust of the wild goose! No, being humans, we need more trust, our hopes are stronger than creatures' hopes. Walt Whitman's words come ringing,—*We but level this lift to pass and continue beyond.*

THE HEART OF A PEACOCK

Edited by Ira Dilworth

CONTENTS

PREFACE

THE SKETCHES in this volume are now published for the first time. They were left to me by Emily Carr as part of the contents of a large book or trunk. The trunk contained a great many letters, a number of sketch books, several single sketches in oil and water colour, account books, Emily's journals, a number of manuscripts, and a great many miscellaneous personal items. In a letter, Emily directed me to dispose of the contents of the trunk in any way that seemed right to me, saying that little in it had any value, and reminding me that fire takes care of accumulated possessions "cleanly and decently". Her estimate of the contents was, of course, too modest—there was much in the box which has great interest and value. Everything has been carefully preserved.

These sketches deal with a great variety of subjects reflecting Emily Carr's various interests in life. There are two stories of West Coast Indian life; there are sketches, amusing and sometimes pathetic, of birds and animals that Emily had known, and that had taken an intimate part in her existence. There is an unusual story (unusual for Emily) dealing with a simple human situation. There are a number of sketches dealing with Emily's childhood as seen through the eyes of "Small".

I knew of the existence of most of these sketches before Emily's death—indeed we had worked over most of them during the years after the publication of *Klee Wyck*. The two Indian stories I had never seen before, but "The Life of Woo", the sketches of birds and animals, I was very familiar with.

Some of these sketches, notably "In the Shadow of the Eagle", "The Hully-up Paper", and "Woo's Life", exist in more than one version. In preparing them for publication I have selected what seemed to me the superior version. In a very few cases I have grafted a passage from one version into the other where I felt the passage added something really striking. Otherwise I have done only ordinary editorial work (punctuation, paragraphing, etc.). For instance, in the "Shadow of the Eagle" there is an apparent discrepancy which makes Martha stumble over the base of the eagle which had already fallen. I have not tampered with this. Emily herself told me that Wragge had intended, as part of his honouring of old Susan, to put the eagle back in its place in the cemetery. This, I believe, was in Emily's mind as she wrote—she thought of the eagle as back in its place.

That Emily Carr should in her later life have become known as a writer of

distinction has seemed strange to many people. The story of the development of this talent has never been completely or accurately told. Indeed some of the facts concerning it may never be known. Undoubtedly she had a great initial gift in the use of words. Some critics have gone so far as to say that her talent in writing even outran her talent in painting.

It was not until late in 1938 that I came to know that Emily Carr had for a long time been preoccupied with writing. The information came to me from her friend, Miss Ruth Humphrey. In conversation with me at that time, Emily gave me the impression that she had taken up writing quite recently, indeed after her serious illness only a few years before. This is partially true, but it is not the whole truth. Her interest in writing most certainly increased, and her work on her writing was intensified after her illness, which made it impossible for her to go on long trips sketching in the woods. But there is now ample evidence that her preoccupation with the use of words went back almost as far as her preoccupation with drawing and painting.

As a young girl she had great facility in rhyming, as is illustrated by a number of amusing jingles and limericks which survive. In an article in *The Week* (Victoria, 18 February 1905) Arnold Watson described Emily Carr's studio where she was teaching painting. He says there were many sketches on the walls: ". . . some of these are serial and nicely bound together. Supplemented by verses (which she calls jingles) they illustrate amusingly some of her experiences in English student life."

In 1927, an important year for Emily Carr the painter, she was encouraged by Lawren Harris and the late Eric Brown, Curator of the National Art Gallery, to write about her life and the interesting experiences that had befallen her as an artist, and she began the first of her journals, which have survived. In this year, too, she was taking a correspondence course with an American school of journalism. This fact, which Emily never mentioned to me, is proved by the existence of a letter from one of the readers of the school's staff. He was returning a manuscript which Emily had submitted, with comments and criticisms. The manuscript was "The Nineteenth Tombstone". This must have been an earlier version of the sketch published now in this volume as "In the Shadow of the Eagle". The manuscript of "The Nineteenth Tombstone" I have not been able to find.

In the years between 1927 and 1938 Emily's journals make many references to her writing, although she has nothing to say about formal training until we come to the year 1934. In that year she took a course in short story writing at the Victoria Summer School. There is an interesting item in one of the Victoria papers of that year describing the closing exercises of the summer session: "Real literary style was shown in Miss Emily Carr's 'Hully-up Letter', the prize-winning story produced by N. De Bertrand Lugrin Shaw's short story writing class. Read by the author, this human interest story recounted an incident in B.C. Indian life, and held the rapt attention of the audience". Emily described this ordeal herself in her journal, as she described most amusingly some of her other experiences in the short story class.

During these years, when Emily was working hard at both her painting and writing, she had the habit of reading her stories to her family and friends, asking for criticism, hoping for encouragement. She worked very hard at her writing. Her sister Alice once said to me, "Emily always worked hard at anything she undertook." During this period she received considerable encouragement and help from her friends, notably from Lawren Harris, Flora Burns, Ruth Humphrey, then on the staff of Victoria College in Victoria, B.C., and from the late Fred Housser.

Following the year 1938 we did a great deal of work together on manuscripts which already existed. Some of them were prepared for broadcast, and were read on the air by the late Dr Garnett Sedgewick. The first collection of sketches, *Klee Wyck*, was published by the Oxford University Press in the late autumn of 1941. It was immediately acclaimed by critics and book reviewers, and Emily Carr emerged as a writer of importance in Canada.

A great part of Emily Carr's writing has been autobiographical. It recalls all sorts of people and incidents from her own life, particularly from her childhood. These memories of her early years are brought back through the eyes of Small. Who was Small? She was the embodiment of Emily's childhood—but I had better let Emily describe her herself, as she did in a letter to me dated 9 August 1943, and left in the trunk where I found it after her death. She said in part: "Do not be too sad when you and Small unpack the box, let her giggle a bit . . . she has been a joy to us, hasn't she? . . . and if there should be an et cetera [Emily's designation of my hypothetical wife] who questions 'Who is Small?' say 'Oh, she's just a phantom child, made up of memories and love'. Small's adult outgrew her (as every adult *must* or remain an imbecile) but the child Small learnt the trick of coming back to cheer what used to be her. . . ." Small was full of gaiety and laughter, reacting to joy and sorrow, quick-tempered, tender, devoted, and loyal. Emily often called her a scallywag. Her memory was, perhaps, not always absolutely accurate, particularly in situations where emotion was a prominent factor. For instance, it is quite unlikely that Emily's eldest sister ever punished her with a riding whip, as Small tells us again and again. There was punishment certainly, and deep hurt and sorrow on the part of the child, as is evident in the vivid memory which comes out in such sketches as "One Crow".

I have kept you too long from what I think will be a pleasure—the reading of the sketches that follow. My excuse can only be my hope that the facts given above may help to increase your pleasure as you read.

IRA DILWORTH

FIVE BIRDS

THE HEART OF A
PEACOCK

BLUE HEAVEN, green earth; betwixt the two the big old cherry tree in full blossom, with the sunshine drawing the sweet, heavy scent of honey from the blooms till the air was almost sickly and even the bees were glutted. Suddenly into the honeyed sweetness burst the passionate cry of a peacock with its long-drawn tang of bitterness.

He belonged to the public park but, wearying of its confines, he had flown the fence, wandering through the little pine grove and thence into our old garden.

From head to tail he was magnificent and knew it, arrogantly flaunting his beauty as he came. Beneath the cherry tree he paused and cried again.

I, looking from the window of the old studio in the barn, close above the tree, wondered how the cherry tree felt about this rival loveliness, but the peacock seemed to draw yet more glory out of the tree, using it as a setting for himself, as he spread his tail and strutted back and forth. Presently he flew to the low roof of the barn. The grey shingles still further enhanced the beauty of his colouring as he mounted the slope with mincing steps. Then he spied the mirror formed by the folding back of the dormer window. He ran to it with evident delight and began to peer and prance and preen before it, bending his small, lovely head this way and that, dancing and spreading his tail in a shower of glory. Then he saw me. The indifferent way in which he looked me over made me feel like the poor shabby little girl at the party. Just a careless glance, then he returned to his mirror where he remained all day as though he could not bear to part with himself.

Towards evening his appetite overcame his pride and he returned to the park.

Next day, before the dew was gone, he was back at his mirror. I heard him call in the pines and then he was up on the roof. I offered some wheat but he had breakfasted and only desired to feed his vanity.

From the sunshine he absorbed the glint and glisten, from the quiet grey roof the contrast which multiplied and offset his brilliance; from me he tried to draw admiration and flattery. His beauty pleased me but I resented his arrogance.

"Vain creature!" I said. "Pretty you'd look if they turned you inside out and showed your selfish, shabby heart." I turned to my work, disgusted at his conceit.

He continued to come every day and I grew to like him there behind me as I

worked. Sometimes I pandered to his conceit and applauded his showing off. Then he was pleased and would come and sit on the window-shelf in the far corner, gradually moving closer and closer until his head, surmounted by that glorious coronet of sparkling feathers, rested on my shoulder, and my hand *had* to steal out and caress it. Subtly the bird was drawing from me, as he had drawn from everything else. I knew it, but I knew also that now he was returning what he drew, tenfold. Suddenly I sensed the loneliness of this creature, hatched from an egg, brooded over by a common domestic hen. No kith, no kin: his looking-glass self the only mate he had ever known.

I learned his call. He answered from the pine wood and came hurrying. Often his call woke me in the morning.

Spring passed: the blossoms were cherries now, the bees had moved to the clover patch. The long summer days passed and the crisp autumn ones, and every day the peacock and I screeched our greeting and spent long companionable hours. Then one day I kissed his crest, put him out, and closed the window. That night I went abroad.

In my absence a parson occupied the studio and wrote sermons there. He closed the wall-cracks with newspaper to keep out the singing wind, and caught the mice in traps.

"What of my peacock?" I wrote home.

"He came once, the morning after you left. Since then he has not come at all," was the reply. "We see him strutting in the park, delighted with admiration. He has doubtless forgotten you," they added.

I was absent for over five years. When a young thing stays out of her own world as long as that, and comes back grown, it is hard to fit in. Some things have grown ahead of you, and you have grown ahead of others.

I ran up the rickety barn stairs to the studio. Phew! How musty and "sermony" it smelt! Even as I crossed to the window I was peeling off strips of the parson's newspaper. I threw the dormer wide. The garden was full of November fog. "Come in, old fog, and souse out the sermons," I cried. Everything was drab: the cherry tree, old, past bearing, had been cut down. I thought of the peacock. "Gone where good peacocks go," I sighed, and wondered where that was.

Next morning I was busy on the floor with a pail of suds.

Hark! In my rush the suds were knocked over and trickled through the floor onto the back of the patient cow below. I leaned from the window and screeched that unwritable screech. It was answered instantly. The peacock was hurrying through the garden, unmindful of his tail, which swept the leaves and dirt. Hurrying, hurrying, not to the mirror—he could have had that all these years—but to me.

"Oh, peacock! Now I know that if they did turn you inside out your loyal heart would be lovelier than your feathers!"

How was he aware, that morning, that I had come? I do not know. That is one of the mysteries, and his secret. The park was out of earshot, and I had not been there.

What a pity this happiness could not have continued for years and years, for I hear that peacocks live to a great age. But the park belonged to the people, and the people missed the peacock.

A rumble of little grumbles arose.

What right had an individual to monopolize public property?

They complained to the keepers, who complained to the City fathers, whose fatherly instructions were "Pen the peacock".

Locked up among the sentimental doves and the stupid owls, the peacock beat his breast against the wires in vain. His feathers and his pride were broken.

The glow and sparkle of his plumage dulled, went out. His head sagged forward, wings drooped. He remembered no more the way of brag and display, nor how to spread his tail; it dragged heavily in the dirt.

I tried to cheer him in the padlocked pen. I begged in vain for his release. He belonged to the taxpayers: the City demanded its taxes; the taxpayers demanded their pound of flesh. It gave them satisfaction to see their property securely penned before their eyes. They tried to "shoo" the peacock into strutting for them, and when they did not succeed they said, "Stupid brute! He sulks," and turned away.

When next they came the pen was empty.

"Where is the peacock?" they asked the keeper.

"Dead."

"So? I suppose you saved his feathers? Will you give us some?"

"They wasn't worth the saving," the man replied. "All the glint went off 'em when his heart broke."

ONE CROW

THE TOPS OF the pine trees shut out the sky. Down through their branches tumbled screeches and the flapping noise of many wings. Above the tumult rose an agitated treble screech. "Small! Small! Where are you?"

Small's reply was almost drowned by the screaming of crows, the crackle of dead branches and the swish of green ones. The young girl jumped to the ground so close to the querulous elderly voice that its owner "ouched"!

"Mercy, child! What ever were you doing up there?"

"Getting *him.*"

At sight of the naked, scrawny-necked bird the girl held out, the woman screeched again; disgust swept over her face. "What are you going to do with the revolting creature?"

"Tame him, teach him, love him."

"You have a yard cram full of domestic fur and feathers at home. Why must you desire to add a carrion crow to your collection?"

Small's gasps were quick and exultant, the sobbing breath of a competitor who has won his trophy hard. The hardest part had been the persuading of this relative to drive her out to the wood where she knew crows nested. The excuse she gave was flower gathering. The crow's naked flesh throbbing against her hand thrilled her and was more than compensation for her ripped flesh and clothing. "I do call it luck," she gasped, wrenching apart two portions of garment stuck to each other with pine tree pitch, "great luck to find anything so easy; crows usually build in out-of-the-way places."

"I should call that out of reach," said the woman with an upward glance at the trees and a downward glance at the tattered, gummy girl. "Tidy up, Small, while I untie the horse." One foot on the step of the buggy, she called, "One crow is bad luck!"

"Had I best climb for another?"

"Mercy, no! Come home and get your deserts. One-crow luck will fall on you when the Elder sees your bird, see if it doesn't."

Small placed the crow tenderly in the front of her jacket. At the last turn, with the crow's fate and the Elder just around the corner, she said, "Thank you for taking me. I did so want a crow. Just to touch wild things sends me crazy happy."

"I am glad my children are not like you, Small," said the woman. "Out quick! I'd rather be gone before the Elder sees that bird. Don't let her know I had a hand in his getting. I trust one-crow luck won't spill over me too."

Sniff, cluck, slap—the old horse started. Small went in to face the Elder.

There was one thing you could be absolutely sure of—that the Elder would do what you did not expect. There was a twinkle in her usually stern eyes as she regarded her little sister and the crow. A use for the bird came immediately to her mind.

"Small," she said, "Mr. and Mrs. Smith have come to pay us a long visit." Small grimaced. She detested the Smiths, a pretentious couple who preferred visiting to housekeeping. Small took no pains to hide her dislikes. The Elder figured on using the crow to curb Small's tongue. Each wag of her long forefinger a warning, she said, "Courtesy to my guests, Small, or out goes your crow."

Putting the crow into a small basket, Small was on her way upstairs. "No, Small! The beast lives on the veranda."

The evening meal seemed endless. Mr. Smith told bragging stories which Mrs. Smith laughed at. Neither the Elder nor Small's two other sisters *could* laugh at the type of story told by Mr. Smith. Small chafed, longing to go to her crow.

"Why so sober, kid?" A great tweed elbow dug into her ribs.

Small felt the resentment a girl in her teens knows when called "kid" by an enemy. She starched herself, caught the Elder's eye, sagged. A general move from the supper-table saved her. She rushed out to the veranda and the crow.

At her touch, up was thrust a red hole of a mouth feebly supported on a wobbling neck. A yet unconscious eye was on either side of his head. Above and below the mouth the crow had an ineffectual scrap of soft beak. Out of the mouth poured urgent pleading squawks (not made in the throat but coming direct from the stomach), life's roaring for fuel.

With a little pair of wooden pincers Small stooped to fill the gaping mouth. Smith, who had followed her onto the veranda, leaned across and blew a great puff of tobacco smoke into the crow's mouth. The bird cowered and gagged.

"Despicable bully!" blazed Small, and raised her eyes to see that the Elder had followed them onto the veranda and was watching. There was interest in the crow in her eyes, warning for Small, and contempt for the Bully.

The crow grew with amazing rapidity. Soon his neck stopped wobbling and his legs could support his body. He stood upright in the nest and squawked when Small came to feed him. She stuffed the food down his throat and he gobbled greedily.

Soon the little grey casing in which each feather was sheathed burst and the released feather fluffed to cover his nakedness. They tickled and this induced him to peck and preen. Development rushed upon him, he discovered something new about himself each day. The last and most wonderful thing he learned was the use of his wings. At first they only flapped but had no power to rise. The heavy stomach in which his strength was generating required still the warmth and support of the earth. As yet the air had not called him, so he was content to hop or sit until his wings equalled in strength the rest of his body.

When the desire to rise came he hopped up and up from object to object until he reached great heights—then, afraid to trust his wings to float him down, sat screaming for Small to fetch him.

Small said, "Your bird-mother could help you now so much more than I." But she got a ladder and scrambled up to the roof and fetched him off the chimney, or the ridge pole, while the Bully sat below jeering and calling the bird a fool.

It was at this stage in the bird's life that the Bully found unlimited opportunity of tormenting Small, through her crow. Long ago he had sensed that the Elder used the crow to keep Small's tongue in cheek. He saw Small bite back the angry retort by burying her face down on the back of the crow, holding him tight. The man said to his wife, "Ha! It is fun kicking up pepper in that kid, to watch her hang on to that bally old crow and nearly bust with fury."

"Look out," warned the wife. "For the present this is a convenient habitation. Would you drive me back to drudgery? Are you so anxious yourself to seek a job?"

The man scowled. He compelled Small to fetch and carry for them. If the Elder were present she sullenly complied. If the Elder were not present she refused, and then the couple told on her.

Silently Small noted that the Elder said no more about getting rid of the crow, but punished her instead by whipping, scolding or shutting her in her

room. The man's pleasure in tormenting the girl lost value when he could not use the crow as a medium.

Before the bird had use of his wings, Smith took him one day and set him on the clothes-line. Then he whipped the line up and down furiously. The fledgeling clung to the line as long as the strength in his feet hung out, then he flopped heavily to the stones and squalled for Small. Out of the door she flew. Behind her came the Elder who, looking straight at the man said, "Mr. Smith, I dislike cruelty."

"Only a carrion crow," replied the man with an insolent shrug.

When Crocker, as Small called her crow, had mastered the air, his movements and entire nature quickened. He seemed possessed with the desire to tease and trick humans.

"Crow, you are getting to be a nuisance," said Bigger, flapping her duster at Crocker who, a small china dog held in his beak, impudently contemplated her from the window sill with guttural croaks and a cocked head.

Bigger hurled a pail of suds—soap, scrub-brush and all—over him. He shook the drops from his glossy back, drank from the puddle with relish, speared the soap with his powerful beak, and flew across the garden to the wail "My soap!" from Bigger.

"Mustn't it be grand to make folks scalding mad, to fly off higher than their threats and farther from their hurls," sighed Small. "But it would be best of all to be a waterfowl and able to use the water as well as earth and air."

Bigger stamped an impatient foot. "Look here, Small! Don't you go bringing any waterfowl home!"

Small never caught up with Crocker's damages: first the family came with complaints and then the crow for comfort. One either side of her, up and down, up and down, she was like the pivot across which their troubles seesawed.

The Bully built a boat in the Elder's back yard. The crow watched from the maple tree. When the Bully was not about, the crow stole his small tools and the galvanized nails. Though the Bully never actually saw, he guessed and he complained to the Elder.

"It would be better to put your tools away when you leave work," said the Elder.

Crocker relished a bit of fresh meat. The Elder, frying chops, saw two piercing grey eyes set in shiny blackness peering over the door sill. "No you don't, crow," she said, and shut the door upon him.

To a bird a window is as good as a door. He watched the Elder safely into the pantry and flew into the kitchen. He hovered over the sizzling fry-pan, making careful selection. The Elder's wooden mixing spoon came down on his back. The chop of his selection fell upon the hot stove. But the crow had tasted. With dogged determination he defied the Elder's whacks and hopped across the hot surface, burning his feet but retrieving the chop. Making a good getaway he retired to a coal bin where he morosely nursed first one foot and then the other. Small came to him with butter for his burns and comfort to his heart. With a

twinkle in her eye the Elder related the episode at lunch. Everyone laughed and followed up with some mischief story about the crow.

The Bully alone did not laugh; he looked grim. His wife said, "I can't think why anyone could be bothered with a nuisance like that crow." The Bully looked approval at his wife. He said, "His mischief is not going to last so much longer nor will the kid grin so hard when I wring that vermin's neck. I intend doing so when I catch him stealing my tools."

"You daren't! You bully! You sponger! The crow belongs here, you don't," cried Small, beside herself.

"Small, leave the room." The Elder's voice was cold and hard. The Elder's face was granite.

On her way upstairs Small met the woman who had driven her out to get the crow.

"Crow troubles Small?"

Small nodded. "It's that beastly bully."

"One black crow, child!" The relative wagged a finger, her head, and her reticule at Small.

Small crossed to the bedroom window. She saw the crow on the edge of the barn water-barrel. As she looked, some bright object dropped from his beak into the barrel.

"Crock!" she called. "Caw" came the instant response. The bird flew to her.

When according to their lights the whip and the Elder had thrashed manners into Small, she went, sore and angry, to the water-barrel. In the clear shadowed water at the bottom she saw a number of small tools glistening and a pile of galvanized nails.

Bigger whispered to the Elder, "The 'call of the wild' may be the solution of our crow problems!" The Elder frowned and turned her back. Middle was staring. The Bully and his wife stood grinning. Small, watching intently, was twisting the corner of her apron into a rope. The group stood on the lawn of the cottage they had rented for the holidays. It was near the sea and close to the little wood where Crocker was hatched. To the crow was to be left the choice of returning to the tribe of his blood-brothers, or continuing in captivity with his humans. The crow mob were assembled in a nearby willow tree, clamorously inviting. The wicker cage stood on the lawn with the door open. Six cats crawled out, shortening their legs and elongating their bodies, slinking across the lawn to the nearest shelter available. Administering a smart pinch to the tail of the last cat so that she yowled and hurried, the crow strutted out. He paused to preen the taint of cat from his ruffled feathers. He was keenly aware of the other crows, but gave no answering caw. He shook himself, crouched, spread his wings and took his place among the flock, a perfect crow, black as they; but inside he was different, knowing as he did the feel of human protection, of human love, sensing, by the tone of the human voice, anger and coaxing. Dumbly he understood the difference between human laughter and human crying; here in the willow, among his feathered brothers, he felt the tense watching in the eyes of the humans he loved.

He swooped to Small's shoulder.

The wild flock flew away. The knot of humans dispersed. Small and her crow were alone.

He tried the patience of his humans to the limit that summer—ripping the pillows open for the pleasure of scattering the feathers, hurling every match out the window, picking the eyes out of a visiting child's doll, and the flowers and feathers from the ladies' hats, raiding the larder, pinching the cats' tails, agonizing the canary, ripping, stealing. Everything was at his mercy, as there was little cupboard room and doors and windows always stood open.

The Bully's razor and his wife's curling tongs disappeared.

"That confounded crow!" muttered the Bully. Everyone said, "Nonsense, they are too heavy for a crow's beak." For a week everyone hunted.

His seven-days' beard turned the Bully into a pirate. His wife's hair streamed from her head straight as bulrushes. Their tempers were seven times worse than usual.

After a week: the crow chortling in a tree top—Small climbing to investigate, handing the rusty implements to the Bully with a mock bow as she descended.

The Bully's revenge on the crow was to molest a hornet's nest close to where the bird was roosting. Hornets swarmed around the bird's eyes, imbedding their venomous stings. The bird, mad with torment, flew to Small. As she beat off the hornets she heard a snigger in the bushes. The Bully was there, his hand filled with stones, one of which was poised to hurl.

"Coward! Mean-natured little nobody! Prating of your ancestors! Why, you are not even a common gentleman!" screamed Small.

The Bully rushed to tell his wife that the kid had insulted him. His wife rushed to the Elder. The Elder rushed for the whip.

Bully Smith sat beneath the open window. Each sing of the whip was salve to his gentlemanly wounds.

When it was over, Small, tearing from the house, tripped over his sprawled legs.

"Scuse me, kid!" His leer of delight was unendurable.

Small flew to the woods across the field. Fluttering close behind her came the crow. In the deep moss under the trees, her face down among ants and beetles, Small cried into the earth. Crocker strode up and down her spine, chortling, tweaking the loose hair around Small's ears, fluttering his wings, twisting his head this way and that. He hopped down from her prostrate person and tried to poke his beak down through the moss that he might peer into her face. Soft and throaty were the noises he made as he pecked at her fingers. Tender croonings, as of a mother crow urging her little ones to face the world and fly. For the moment the adult crow had changed places with the child who had mothered him.

Rolling over, Small laughed up at the crow "Aren't we eye-swollen frights! If I was you, Crock, I'd go back to the crows."

The crow pushed his head under her hand, a baby crow again, begging to be caressed, begging mothering from a human child.

The Bully resumed his boat-building and the crow his stealing. The man caught him in the very act of teasing the caulking out of the seams of his boat. In a fury he went to the Elder and demanded that the bird be destroyed. Again the Elder said, "I recommend, Mr. Smith, that you keep your tools in their box when not in use." The Elder resented the overbearing attitude of the man. Coolness sprang up between hostess and guests.

Crocker's opportunity was the hour of family worship, when the Elder, sober-faced, read each morning from a little black book. Small knelt in the window seat and encouraged the bird to come to her there that she might divide her attention between the Elder's prayer and the bird's mischief. Hopping through the open window he would creep under Small's hands, his shiny feathers still hot with sunshine.

Bigger saw. "It is profane to share your prayers with a crow!"

Small retorted. "If you had been praying instead of peeping you would not have seen."

"Hush!" The Elder strode across the room, smacked the crow with the prayerbook, drove him away, and slammed the window. Watching the indignant hop of the bird down the path, Small mumbled, "He'll pay back."

He did. The agitated tap, tap of Bigger's heels down the hall said he had before she burst open the breakfast room door and screamed, "It can't be borne! Come and see!"

All left the breakfast table, all followed to the drawing-room and stood aghast.

Bigger's knick-knacks had been swept from the mantlepiece. Everything was in a smashed heap upon the stone hearth.

"Oh, girls! Look at Auntie! I'm evened on her at last!" giggled Small. The sunlight blazed through two pecked holes in Auntie's photoed eyes. She was torn from her frame. The twisted cardboard forced a crooked smile from Auntie. Another peck had provided her with a dimple foreign to Auntie's flesh and blood.

Middle gently turned Auntie face down.

"Don't do it!" cried Small. "She'd far sooner spit fire at us through holes than snub her nose in a pile of rubbish!"

"Small! For shame!"

But even the Elder's thunder was out-thundered by a bolt from the hall.

"Lady, if that black devil ain't shet up I quits me 'angin'! 'Im tweakin' out pegs! Wash floppin'!"

The distracted Elder went to appease the washerwoman. As she passed Small she said, "He's got to go, Small! Manage it how you wish but go he must!"

"Delighted to officiate," said a voice at Small's elbow. With a disgusting throaty gurgle the Bully drew a coarse finger across his own neck. The Elder gave the Bully a look of utter disgust. Small ducked her head into the crook of her elbow and rushed from the room.

"I've done it," she said to the Elder that night in a squeaky, pitiful voice.

"How?"

"Sent word to that boy on board the ship that he may have Crocker."

"The boy who asked you to get him a crow? He will be good to him."

"They," she pointed towards the guest-room, "are going." She wanted to cheer Small.

Small stood before the Elder one week later. "The boat had sailed. My message was too late!"

The Elder pretended her thoughts were elsewhere. "I am having screens put to all the windows and, Small, it would be better to cage Crocker at night. Crows wake so early."

The Elder crossed the yard. In her apron she carried something tenderly folded.

"What?" asked Bigger.

"The crow."

"How?"

"Shot. This shooting by boys must stop! Their shots always find the wrong mark. The entire band flew away—just one, Crocker, silhouetted against the sky. Of course, he got it."

"Oh, bad luck it should be he," said Bigger.

Middle came and looked into the apron, broke her usual indifferent silence by saying, "I'm sorry."

Small, kneeling by the yard chopping-block, had her head buried among the chips. Her tears were pouring into the sawdust.

Bigger blurted very loud so that Small might hear, "I didn't really mind his mischief."

"My watch didn't break when he threw it out the window." added Middle.

The Elder untied the apron strings from about her waist. She folded the apron round him, making a neat little parcel of the crow, took the spade, and started for the garden. The spade dragging along the gravel roused Small, who lifted a chip-tangled head with red swollen eyes.

"Never mind, Small! I'll do it," said the Elder. Small saw a bright red spot ooze through the white apron. She buried her face again.

"Crow luck again, Small?"

Small jumped and faced the elderly relative.

"You were wrong," she cried. "My one crow was never bad luck. He brought laughs to everybody. He rid us of the Bully."

UNCLE TOM

TOM AND I met in no-man's-land. What of each other we did not understand we were content to leave unexplained.

Uncle Tom was a vulture, a common turkey-buzzard. I acquired him in the Indian village of Sechelt. Indians had stolen him from the nest of his vulture mother on the Island of Texada, tired of him after a few days, and abandoned him to starve. I was walking through the village of Sechelt and the bird came entreating at my heels, mouth open, starving. I dug clams and fed him; then I paid the Indians fifty cents and put Tom into a sack and took him with me.

I was on my way to visit at the summer camp of a friend, a friend who had invited me to bring my old English sheep dog and my Australian cockatoo. She was surprised when she saw that I brought too a vulture in a sack. But her heart was big; it opened to the helpless baby vulture. She gave us a tent to ourselves and we were very happy.

I called my vulture Uncle Tom because of his resemblance to the picture in *Uncle Tom's Cabin*. His face was bare and black and was sunk into a body of white baby fluff. When I got him he would be only a week or ten days old. He grew rapidly and soon shed the white down, replacing it with feathers of rusty black. His face always remained bare. When grown, Tom had tremendous wing spread, keen sight, and an extremely keen sense of smell.

No meat was procurable in camp other than an occasional fowl. Tom gorged on its entrails. I raised him on clams and mussels which I pushed down his gaping throat. He followed my every footstep. I was the only mother he had ever known—he loved me.

Tom grew into a great bird, hunch-shouldered because his wings were so huge there was no room for them to lie against the sides of his body. When furled they rose high on his shoulders.

The cockatoo on my shoulder, the dog and vulture at my heels, I went into the woods and we were very happy. At night we were cosy, folded in our tent. Summer went and playtime was gone. Before returning to my studio in Vancouver I took my creatures and went to visit my people in Victoria. A vulture they could not accept into the family circle. They lent me a calf-pen for his accommodation.

It was when I returned to Vancouver that I discovered how keen was Tom's sense of smell. Leaving him in the travelling box at the far end of my big studio, I went out and bought him some fresh liver. As I came up the stair, while yet the

liver was in its wrappings and there was still a long hall and the length of the studio to go, Tom smelled the meat and began to shout and go crazy. His habit was to gorge, then go to sleep for hours to digest his food.

Now came the problem: What should I do with Tom? I could not keep him in a city studio. I loved the bird. I offered him liberty: Tom refused. He must have known the power in his great wings, yet he never rose on them; he had become thoroughly domesticated, clinging to the earth and to me. He knew nothing of carrion nor of high-sky hoverings, "vulture-waiting" for cow or sheep to die, that he may swoop and gorge. Tom accepted humans, but humans would not accept Tom. He had a queer, wild beast smell.

In perplexity I approached Stanley Park. I said, "I have a tame, hand-reared vulture. He will not accept freedom."

"A curiosity!" they replied. "Bring him to us."

So I gave Uncle Tom to the Vancouver Park. They housed him in a large cage and treated him well. I called often to visit with him.

"Hello, Uncle Tom!"

The bird would press against the bars of his cage and rejoice over me . . . dear Tom!

SALLY AND JANE

SALLY WAS an Australian lemon-crested cockatoo; Jane was a green double-yellow-faced Panama parrot. They hated each other. Parrots, all parrots, are bitterly jealous. Sally was a sweet-tempered, meek bird; Jane was vicious—her orange eyes would dilate and contract their pupils in spasms of rage. Sally's eye, round and black as a shoe button, had amazing expression but lent itself more to sentimentality than to anger. In the studio was an old wooden-backed chair, which was the parrots' own. I perched them on its back when they were out of their cages. First they gave each other a glare of malevolent hate, then drew close; each put out a foot, the foot nearest to her enemy; claw locked claw with a ferocious grip. There they sat, hour after hour, holding hands, each balanced on one leg. It seemed that to hold each other's hand was to safeguard against attack. The slightest move on the part of the attacker gave the attacked warning. The birds never talked when they were foot-locked but gave each other vicious, snarling, beaky growls from time to time.

Living in a flat, as I did at that time, I dared not allow my parrots to screech, or we would have been evicted. Jane was an excellent talker; Sally spoke little but clearly; both could screech magnificently. They knew screeching was

punishable either by a crack over the foot with a paintbrush, or, what they hated worse, being extinguished under a black cover and shoved into the dark closet. When I left them alone in the studio, going down the hall to my kitchen to prepare meals, both birds would set up a chorus of screams. The moment they heard my hurried returning footsteps Jane would say, "Sally! Oh, you bad Sally, stop it!" Sally glowered silently and I administered whacks impartially, knowing both equally to blame. Jane's rebuke to Sally was in exact imitation of my own voice.

Sally was not much of a talker; all she could say was "Hello!" and "Sally is a Sally!" This brilliant statement she taught herself. I tried to make her say "Sally is a fool", but with distinctness she corrected the statement, saying "Sally is a Sally," then made the sound of kissing. Jane sang three songs, words and music complete. Her favourite was "We won't go home till morning". She finished the hurrahs off with a magnificent roll; she loved the letter "r". She was really a clever talker, but if anyone approached the cage to look at her she stopped short, cocked her head, and, looking her admirer full in the eye, said "Oh, you old fool!" and burst into mocking laughter.

Sally adored men, from the sprucest gentleman caller to the very soiled old Chinese janitor. Sally was all for men. Let a man come into the studio and she would turn her back on me, scramble from her perch, climb up his chair and, mounting to the man's shoulder, would lay her crested head sideways against his cheek, roll her beady black eye into his and say, in a most cuddling voice, "Sally is a Sally." Every man fell for Sally; she pleased their vanity. They all wanted to buy her. People laughed at Jane's chatter but they kept out of her reach. Nobody asked for Jane's kisses; Sally kissed everyone.

Jane could assume a sweet, wheedling voice. Once a plumber annoyed me to ferocity with some bad work. He rushed pell-mell down the long stairs, my tirade of righteous indignation following. Jane's cage was round the bend where he could not see the bird. When he got to the bottom of the stair Jane called, mocking the sugariest tones my voice possessed: "Good-bye, dear." I could have wrung her neck! I ran to a curtained window to see how the plumber was taking it. He stood at the stair foot, mouth open, amazed.

They seemed to delight in humbling me, those birds. A new tenant came into the flat below ours. She went to a neighbour and asked, "Who is that extraordinary old woman in the flat above?"

"She is not old," said my neighbour.

"Seventy-five if she's a day," replied the newcomer. "Loyal old soul, always singing 'God Save the King' at the top of her cracked old voice!"

"Oh, that is the parrot," said my neighbour.

The way that Jane learned "God Save the King" was funny. I tried patiently to teach her the National Anthem, working for weeks. Apparently Jane paid no heed; not a syllable of it would she say.

I fell sick. The doctor, suspecting diphtheria, isolated me in my flat, forbidding anyone to leave or to enter. I was in bed. The birds screamed and shrieked at being alone, so I shut them into the dark closet to quiet them. A nurse was

sent in. She was told to enter without knocking, that I was all alone in the flat and in bed. The woman opened the door. A dog barked; two voices said, "Hello! Hello!"

"How are you?" replied the nurse politely, and was greeted by rude laughter. "You old fool! Ha, ha, ha!"

No one was in sight; the nurse was incensed. She came on down the hall.

Up sprang a great sheep-dog and refused her admittance to my bedroom. I quieted the dog. The nurse came in a little stiffly and began to treat my throat. Presently from the cupboard came a soft voice: "God save! God save!" I was too sick to bother. Nurse said, "I understood that you were alone in your flat?"

"I am."

"I heard a voice very close," said the nurse, gingerly stepping over the sheep-dog who resented her tending me.

"Parrots."

"Oh!"

"God save! God save!" came from the dark cupboard. Jane worked back into her memory all day. By night she had reconstructed the whole first verse of the National Anthem. The nurse was highly amused.

"Too late, too late, Jane," she said, for just the day before King Edward had died.

I tried to teach Jane to end the verse "God save King George", but the wayward bird would make her own version: "God save George!" she sang. To the end of my owning her, that was Jane's ending to the National Anthem: "God save George!"

She heard my pupils call me "Miss Carr". She knew it meant me. Well, if George was not "King", could I expect to be Miss? "Carr!" she would yell when she missed me. "Carr, where are you?"

I do not for one moment think a parrot knows the meaning of the words she says. It is just connections of persons and happenings that she puts together. If anyone rose to go out of the room, Jane invariably shouted "Well, good-bye!" For those sticky visitors who stand on one foot lingering, without the courage to make a start, this was sometimes very good. Jane would get more and more insistent, shouting "Good-bye, good-bye" till they really *had* to go.

Jane always got my toast crusts at breakfast. "More toast?" I would ask. Therefore all food to Jane was "toast". When she saw anyone eat she always begged, "More toast!"

One day I locked myself into my flat, got into my bathing suit, and scrubbed my studio floor. In shoving round the furniture I shut my hand into the hinge of a folding bed. The cot-bed was piled with furniture; there was nothing to do but remove it with my left hand, drag the bed to the telephone and call to someone in the building for help.

"Line busy!" Then I remembered the locked door. No one *could* come to me. I would likely lose my hand. I dragged the bed down the hall. The last thing I had to haul it over was Jane's cage, put out there to clear the room while I was scrubbing. I must have been groaning heavily as I turned the key and shouted

"Help!" For a while then I remember nothing. Then I heard groans. "Oh dear, oh dear, oh dear!" Jane's mocking voice! For years I was to be tormented by my own groans. As long as I owned Jane, "Oh, dear!" she would moan, "Oh dear, oh dear!", till I could have wrung her neck. It is obvious that intensity and earnestness of tone make an impression on a bird's ear. I might have tried for months to teach her that groan. Were it only a mock groan it would not have registered.

While living in Vancouver I used often to spend a weekend in Victoria with my people. I took my creatures along, the big sheep-dog, the two parrots.

The gentle Sally was loved. Jane? Well, her singing and chatter *were* amusing; no one came too near her, though. Each bird had her own travelling basket. I tried to look fat and greedy as I sailed past the stewards, who shouted, "Check all hand baggage!" I wanted them to think I was carrying along snacks of lunch to consume on the trip. I could not trust the birds checked. I went to the observation room and selected as remote a chair as was available, snuggling a parrot basket on the floor close on each side of my chair. For the first hour the birds were silent. They were peeping curiously through the basket-work. By and by they got bored; then I would hear chewing and tearing of wicker; a sly kick and the chew would stop for a minute only to begin again. The ladies near me would fidget. Men, half asleep under newspapers, stirred, recrossed their dangled leg so that it hung far from the basket. Suddenly a voice. "Hello! Sally is a Sally! or "You old fool!" and ribald laughter. Out would pop either a green head or a yellow-crested white one from my baskets. Ladies screamed, gentlemen shoved their chairs a little further away. I took my "lunch baskets" and retired to the outer deck. The stewards thought I had gone there to eat. They were pleased that I was not going to muss crumbs in the observation room.

The birds were only half welcomed at home. They scattered seeds and screeched.

Travelling with a parrot is not always easy. Once I was travelling across Britanny and carried an African grey parrot in a box. I put the box with my other light luggage up on the rack over my head. No one was in my compartment except two merry old priests who were saying their prayers hard, clattering rosaries and looking out of the window.

Presently Rebecca, my parrot, began to meow like a cat. The priests looked about and into every corner of the carriage. I could not talk French but I laughed and pointed to my box. "Peroquet," I said, and the priests, bowing, resumed their devotions. We stopped at a station. An old woman got into our compartment with a huge basket of vegetables and a plucked fowl lying over the top, its head dangling. The ticket man came. Rebecca started meowing furiously. There followed an excited argument between the ticket collector and the old woman with the basket. He seized the fowl and made her empty every carrot, onion, and potato onto the floor of the compartment. He shook the basket and then his head. The indignant old woman repacked. Next he attacked a woman with a young baby who had also got into the train at the same stop. He

lifted the child and looked behind it and behind the woman. He gesticulated and raved. He now attacked me. I pointed to my tongue and shook my head. The man said "Bah!" and began to meow.

Then the old priests laid down their rosaries and roared till tears ran down their cheeks. They pointed first at me and then to Rebecca's box up on the rack. The ticket collector peeped into the box and laughed too. He went away. It seems you may travel with a bird but you may not travel with a cat or dog in France.

One night I was making the trip from Victoria back to Vancouver. I had been late in securing my berth; all that was available was a top in a three-berth room. Sally was with me but not Jane. It was a very rough night. The boat pitched and tossed. It took several tries before I landed safely in my berth. I took Sally's basket up with me: I could not leave her rolling around on the floor. I strapped her basket to the wooden open-work of the ventilator. On one side of our room a man coughed all night, on the other a woman, a violent case, was being taken up to the Insane Asylum by two keepers. She swore, cursed, and screamed. Wind shrieked; our empty shoes clattered around the floor, hats too, and tooth brushes. In the middle of the hubbub came a small, sweet voice: "Sally is a Sally!" I gave the basket a sly kick. "Sally is a Sally! Sally is a Sally!" The voice got louder and more insistent. The woman in the bottom berth scragged her neck up to the woman in the middle. "As if," she whispered loud above the turmoil, "that top-berth woman must add to the row by talking in her sleep!"

"Hush, Sally!" Suddenly it occurred to me that the bird was cold. I took her basket under the covers and she stilled.

Sally, after a number of years, got a chill and died. The robust Jane lived on and on; every year of the fifteen she was in my possession her temper got worse. One day, in a fit of violent jealousy because I was tending a sick puppy, she flashed across the room and nearly tore my eye out. Another time she ripped the tip off my finger. Her rages came in a flash. The orange eyes would dilate and contract in fury and then she would strike.

"Enough, Jane!" I put her up for sale.

A woman came in answer to my advertisement. Jane looked her up and down, "Oh, you old fool!" Jane exclaimed, and began to laugh in cackling peals.

"I'll buy that bird," said the woman, much impressed. "Clever!"

"She is wicked," I said. "That is why I am selling her. A wicked bird."

"All parrots is wicked," replied the woman fingering an ear. "See that?" she pointed to a hole in one ear. "A parrot bit that out!" Jane changed hands.

A few years later I happened to see the woman on a street car.

"Have you still got Jane?"

"Nope! Sold her to a poultryman. Jane adored my son. After he went to sea she was morose and evil. I was obliged to get rid of her."

I went to the poultryman, anxious to know the end of Jane.

"Have you a green parrot called Jane?"

"That malignant varmint? No. Sold her to a party out of town." His one

hand crept to the other smoothing an ugly scar. "'Ot one that. Ef that bird got 'otter with years, she's burnt herself long back. They do say as parrots lives long," he shrugged.

"I owned Jane for fifteen years," I said.

"Did, eh? No lady's bird! God save George!" He slapped his knee and chuckled. "Some bird that!"

"Looks pretty old and scraggy to me," said a sharp voice.

The poulterer and I turned. A customer was fingering a fowl upon the counter. It was the woman to whom I had sold Jane.

"I wa'n't mentioning that particular fowl, mum." He recognized the woman.

"God save George! he chuckled.

"You old fool!" the woman giggled back.

The three of us doubled over laughing.

I never heard of Jane again.

SOME ANIMALS

B A L A N C E

THE RACOON'S CAGE was set in a narrow draughty passageway between two Indian houses of Alert Bay village. The imprisoned baby racoon was very young and desperately unhappy. A white girl sketching about the village wanted tremendously to own the baby racoon. The desperation of his animal eyes hurt her. She asked Coon's Indian owner, "Will you sell the baby coon?"

"No, me catch for my child's play, no sell."

Every day the white girl said to the Indian, "Today will you sell the coon?"

Every day the Indian replied, "No sell."

The white girl took another path when going through the village. If she could not help the coon's misery she did not want to see the tortured baby. No dark hiding corner such as coons love, no shelter from the piercing wind or the poking fingers and kicking toes of children.

In spite of his wretchedness, Coon grew. So did his temper, so did his teeth. He bit the Indian children in self-defence. The Indian owner sought the white girl. "Sell now—coon come wicked, bite my child."

"How much for Coon?"

"White man pay thlee dollar for coonskin. S'pose lady buy inside and skin too, thlee dollar just same."

The girl bought the whole thing, skin, insides, and heart of Coon. The village wheelbarrow squeaked up the hill carrying Coon and his coop to the white girl's cabin. She placed the coop in a dark corner. Coon spat and hissed when she came near. She did not worry him with attention; she gave him a deep sack of hay into which Coon burrowed violently, hid himself, cuddled in deep, deep sleep. He slept so long she thought him dead. At last hunger roused him. Vaulting from the sack, he lapped bread and milk greedily and grabbed for an unlucky little crab, spitting at the white girl's hand when she offered it.

The girl looked at her three dollars' worth of spiteful suspicion. He was all contradictions—low-set, heavy body on trim, slender legs, petulant sharp nose wrinkling with hate, and a blunt, merry tail circled with black rings like laughing O's. From nose-tip to high up on Coon's forehead ran a rich brown streak. This marking was paralleled by two similar streaks of brown; one crossed the brow over each eye. These three vertical lines across his forehead gave Coon a great frown, but bristles of stiff white whisker, slanting upward across each

cheek, gave him an acute, cunning smile. Between frown and smile lay Coon's tormented eyes.

Owning such a morose, resentful beast gave the white girl no pleasure. "Go free!" she cried, and flung the door of his cage wide; but, before he darted, she had changed her mind.

"No, you shall not go to the wild, carrying with you such anger and bitterness against humans." She snapped the door shut. "Woods-creatures think badly enough of us as it is! When fear and anger have gone from you, when your eyes side with the smile, not the frown, then you may go if you want to." She left Coon in his quiet corner—ignored him.

Coon ate, slept, watched the girl and her sheep-dog play. Coons are as playful as kittens; he longed to join in the fun—he was lonely. Holding the bars of his cage with small, handlike black paws, he thrust his sharp nose through the bars, begging notice. The girl ignored. Instead of clawing and spitting at her hand when she fed him, he now smelled, then licked it. Still the girl ignored the comradeship Coon offered. There was suspicion still in his eyes and bearing. "Trust me all," she said, and then did a thing to him so monstrous that it drove away what little trust he had. While he fed from her left hand, with her right she fastened a collar about his neck and attached it to a chain. Coon saw the door of his cage open—made a dash—discovered the grip about his neck—went mad—threw himself upon the ground, clawed, spat, and rolled, rasping his teeth against the steel chain. No bars now between him and the woods—yet this other detaining thing sent him worse crazy, this pulling fetter which dragged him back from freedom. The girl fastened the chain to the veranda post of her cabin. She sat down on the step near and read a book.

Coon fought long and bitterly till exhaustion killed his madness—back sprawled on earth, paws upturned, listless, limp as death. The girl read on.

Dusk came, the time that old coons hunt and young coons play. Coon turned right side up and shook himself. Finding that the chain still held, he crept closer to the reading girl. She made no sign, was moveless as a tree. Coon raised his forepaws till they rested on her knee. He stared and stared and stared into her face. She did not embarrass the wild in him by staring back, she lent him her face to explore.

A spring! Coon had decided! A tumbling of softness into the waiting lap, a curling kittenwise to sleep in the lap's cosy warmth. Coon liked her fingers fondling his little rounded ears, her hands buried in his dense harsh coat. Coon's eyes opened. Torture was gone from them. Instead, with perfect pivoting, frown and smile, frown and smile balanced across the contrary features of little Coon.

E V E N A R A T . . .

THE RATPILE in the pet-shop squirmed continually with new life; it never had
time really to cool from the hot, naked bodies of one litter of ratlets before some
other rat mother had filled it again. One nest was common to all the mothers in
the rat-cage; neither mothers nor ratlets knew who belonged to whom. The vital
little rats tore on into maturity, exchanging pink nakedness for white fur, cut
teeth, chewed food, were kicked from the nest to look out for themselves. The
flapper-rats dug themselves into the big ratpile mounded in the centre of the
cage. Rats of all sizes squeaked and squirmed, cosying pink noses into the centre
of the pile to find warmth. Some rat was always rooting for something some
other rat had. The rat-mound was always in a moil. Periodically the cage was
cleaned out. Then confusion was terrible, even the ratty smell got mislaid, every-
thing had to be reconstructed.

Humans were a nuisance with their tidying! How could young rats practise
thrift and hoarding with surfeit of fresh food provided every day? Even a rat
loses dignity and self-respect when glutted.

"Male or female?"
"Female—young—"
A selective hand stirred the ratpile. The smell of that hand was known to the
rats. Its pick was half-grown and snow-white. The little rat was put into a paper
bag. The cash-register jangled, purchaser and purchased joggled away on the
street-car. During the joggling a human eye looked into the bag's mouth.

"Hallo, rat! Your name is Susie." There was glad ownership in the voice as
well as sober assuming of the responsibility for a bit of life, life which has been
pushed from its natural course and, by domesticity, robbed of its initiative. Giv-
ing to the little rat a name of her own hoisted her immediately from rat-hoard to
individual. Named, even a rat becomes "special".

Arrived at their destination, Susie was introduced to the family circle of her
purchaser—her special human. The family drew back with squeals and shud-
ders. They called Susie "vermin". A door banged, another opened, and Susie
came home.

The room that was to home her for life was a big studio in which her partic-
ular human lived. The woman had prepared a wired box for Susie. The box
stood on a large table. The table was a conglomeration. On it, besides Susie's

box, were paint-boxes, nail-boxes, match-boxes, flower-basket, work-baskets, clothes-baskets, carpenter's tools, gardening tools, bundles of rag, balls of string, a great lump of modelling clay, brown shoes and black shoes, a bag of oranges, and a hat. It seemed that every lost thing in the world could be found on that table. Susie was allowed to roam the table and acquaint herself with the smell of all the things. She liked one thing best of all, a big leather-bound Bible that stood on the corner of the table. This was Susie's lookout; mounted there, large flat feet clamped down on the leather cover and haunches squared, the rat pondered and pondered, smelling the world, eyes blank and blinkless, wiggling nose thrust into the air, whisker twitching, tiny pink forefeet waving, beating the air like the paws of a begging dog. The Bible and the soft warmness under her mistress's chin were the high spots in Susie's world—under her "particular" human's chin the rat experienced a throbbing warmth similar to that of the pet-shop rat-pile.

Everything in the studio had absorbed through touch the smell of Susie's own human, even the silence was full of her. Susie homed herself happily, accepting, responding, giving herself wholeheartedly, invisibly chained to this being beyond the smell of whom she never strayed.

Spring found Susie adult and sleek. The mate of the griffon dog had a cosy basket full of puppies. Spring and instinct gave Susie notions; she chewed rag and paper and made nests of quiet, out-of-the-way corners, nests that fitted her body; but she tired of their emptiness and went back to the leather Bible, begged with her paws and wiggled her nose.

Down through the studio ventilator came a faint, faint whiff. Susie's nose became still more active. The attic above the studio was a difficult, perilous journey for Susie—jumps, crawlings, squeezings; but at last it had been accomplished.

"Susie, Susie!" Susie's human heard terrified rat screams and rushed up to the attic. When she opened the door it was not Susie who rushed to her for protection, but an ugly brown rat, scared out of his life by Susie's chasing. The door slammed in the face of the wild rat—he scuttled noisily down between walls, too scared even to be quiet. Susie did not follow; she came, a dusty, cobwebby rat, glad to be taken back to her studio. She never went to the attic again.

Under the soft warmth of a feather pillow in the studio was found a morsel of life badly smashed. The creature looked like a rat but was not ratty quite and he was very nearly dead. Warmed and fed, he revived. Susie was sleeping in a rag-bag hanging on the wall. Her box was requisitioned for the stranger, and a naturalist consulted as to the creature's kind.

He asked, "When did you last coal?"

"Yesterday."

"Ah, you got more than coal in your sacks. This is a black wharf rat, the kind that come in ships. Maybe he carries bubonic plague, looks pretty battered. Being shovelled into, and poured out of, a ton of coal is not exactly tender

handling: better finish him." It seemed "cattish" to pull from death only to push back to death again.

The ragbag quivered, a pink nose stuck out of the top. Susie came to investigate. "Um, check ratlets!" mused the naturalist.

When the black rat saw the white rat he went frantic, tore up and down his box and squealed with fear. For three days he was in the box and screeched whenever Susie set foot on the table. He was disposed of—Susie's human went to the pet-shop and bought a sleek, gentlemanly white rat. Susie turned on him and beat him up so unmercifully, paying back with interest the scorn of the brown and the black rat, that he had to be returned to the pet-shop.

Susie lived and died an old maid.

Susie travelled. She not only made a number of camping trips with her mistress in a caravan, along with some dogs and a monkey, but she went by boat and train and stayed in hotels too.

Susie's human said, "I go travelling. Who will care for Susie during my absence?" There was dead silence—Susie's mistress would not plead. She popped Susie into her handbag along with a purse, travelling clock, knitting needles, and reading matter. When the steward came into the stateroom Susie hid. On the train an over-stout lady sat on the handbag. Susie's human screamed, "Oh, my glasses!" The fat woman said, "I sat lightly," and got up huffed.

Susie's human slipped her hand into the bag to make sure Susie was entire. And then the train stopped. Susie's agitated mistress left the bag on the train! The porter came running down the platform waving the bag. He swung himself again onto the moving train with a tip gripped tight; its size surprised him, and all he could gasp was, "Such a shabby ole bag too!"

In the hotel, Susie slept in the griffon dog's box all day, while the dog and human were off in the woods painting. At night, the dog, the woman, and the rat had romps. The dog was very gentle with the rat. They had been in the hotel a week when the hostess asked Susie's human into her sitting room one hot evening to drink a cup of tea. This hotel proprietress was fond of creatures, and Susie's human went upstairs and came back with Susie. "Oh!" screamed the woman, "I hate rats' tails!"

"Rats steer by their tails and whiskers," said Susie's human. "Did you not see Susie when you did up my room?"

The proprietress thought it *very* strange to travel with a rat. "That explains certain crusts and lumps of sugar," she mused. Susie's human remembered that they had fallen out of her pocket-handkerchief on the stair once or twice.

The normal life of a white rat is two years. Susie, who was robust, added another six months, then she became lean and bony and her teeth got dark brown. She moved wearily and slept a great deal.

It had for two years been the rat's custom to come up the little stair leading direct from the studio to her human's bedroom in early morning. It took weeks of patient practice for the rat to manage the jump from tread to tread. Each bare

shiny step was just beyond the reach of Susie's spring; she fell back over and over to the step below.

The night Susie conquered the stair her human was startled from sound sleep by a patter of feet scuttling over her chest. "Wild rat from the attic!" was her horror-thought on waking. She flung out an arm and struck some small soft thing weighted with life, knocked it onto the floor and switched on the light. On the mat beside the bed sat Susie, half stunned, wholly indignant at the frustration of all those patient tryings. From that time Susie came upstairs at two o'clock every morning, scrambled up the counterpane overhang, pushed a pink nose under the fingers of her dear human, lay quite still. Presently the hand she loved put Susie to the floor.

"Go down, Susie."

The rat ran back to the studio satisfied.

Old Susie's time was up. Any day now she might sleep and forget to wake.

"Susie, we must shut you in your box at night now." Lidded in her box, the old rat went frantic, rattling the door, chewing the wire, squealing for liberation. She got it, and continued to mount the stair nightly. Then one night Susie did not come. In the early dawn her human crept to the stairhead. Susie was on the bottom step, dead.

Loyalty to the very last jump—loyalty even in a rat.

B R A V O , M A R Y A N N E !

FOR PUSH OF NOSE, for perseverance, there is nothing to beat a cat. The kitten, Mary Anne, was born with amazing push and perseverance. It was but natural that she should be born so, for both her parents were "stickers". Mamma was a most persistent ratter. Papa, an itinerant vocalist, held his note on the back fences till every shoe and tin can in the neighbourhood lay at his feet.

Cats sum up life by feels; all the feels of Mary Anne's kittenhood were hard. At a very tender age she fell out of the basement coal-scuttle which had been her bassinet. She did not, like her brothers and sisters, emerge from her cradle creepingly, but, scrambling boldly up the coal-scuttle's spout, launched herself squarely from its mouth, landing on her four paws. Immediately, she began to look for something higher to climb, wiggling her pink nose in the air. In the air she was always smelling for something a little higher than herself.

The kitchen steps lured, liver-and-bacon was frying, whiffs tantalized her inquisitive nose. Up the steps ran the pink nose to poke around the open door. It was met by a cruel leather shoe and a stern "Shoo-cat" uttered in a harsh voice. Mary Anne then learned the feel of kick and spank, and how hard the pavement could hit back when you struck it. The kitten righted herself and, sitting down, lashed the world with her tail—most expressive organ that a cat has. Next she mounted an apple tree that grew so close to the house-of-frying-liver that she was able to spring from it into one of the upstairs windows, landing on so soft a bed that it woke a queer crackling sensation in her throat, a rumbling creak that returned all through life whenever Mary Anne was happy. This time the happy crackle was cruelly cut short, and Mary Anne was introduced to her own scruff by a hard gripping hand. Again Mary Anne hurtled through space—again earth hit back when her pliant little body struck, again Mary Anne's tail lashed in angry protest, but undaunted she rounded the house and came to its front door.

The house-of-fried-liver was the home of several bachelors. The hard hand and cruel shoe belonged to their housekeeper—she fried the liver.

At the very moment that Mary Anne rounded the corner of the house the youngest bachelor was returning at the unusual hour of mid-morning, stricken with an attack of measles. He felt too awful to heed a kitten leaping over his foot, darting in the door and up the stairs ahead of him. A door opened below

and the voice of the dreadful one who kicked and hurled called out, "What's up, Mister—'oliday-in'?"

"I got measles."

"Lor' to goodness! I 'in't 'ad 'em." The door shut with violent haste.

Mary Anne hid under the bed until she heard it creak under Mr. Measles' weight. Then she jumped boldly onto the measled stomach.

"Drat you, cat!" A spotty hand lunged. The cat dodged. "Then catch 'em." That was the worst Mr. Measles could wish for anyone for the moment.

"'Ere's grool." The bedroom door opened three inches' worth of squeak. A steaming basin slid over the polished floor. The door shut with a snap. Measles did not stir, but Mary Anne did. Gruel was good eating. Measles was grateful to the cat for disposing of the gruel. Measles was a bad enough disease without being gruelled by housekeepers.

Quarantined convalescence is duller than ordinary recovery. He was glad of the company of the cat. He called her "Mary Anne", tickled her under the chin and rubbed her ears to make her purr—it sounded companionable.

"I tell you, Mary Anne, this measle disease is humiliating for a business man. Why didn't Mother give it to me when I was a baby?"

He returned to the office lank and peevish; the boys chaffed. "Look," they said, "if he hasn't brought his kitty to the office!"

There was Mary Anne, sure enough: extra humiliation for him—rubbing, purring, notifying everyone that she was particularly *his* cat. He gave her hurried exit, but Mary Anne was not disheartened. Every time a customer came in she rushed in too and leaped onto Measles with purring joy. She overturned waste-baskets, chased papers, jumped on ledgers; when finally she upset an inkwell the boss said, "Leave that cat of yours at home, boy."

How could he? His home was a trunk. Every inch of the house-of-liver was ruled over by the housekeeper, and she hated cats. Sticks and stones directed at Mary Anne flew behind him from house to office; she slunk just out of range, but followed steady as a shadow. He took detours through by-ways, but suddenly out of a doorway ahead she would pounce, delighted at doubling back to meet him. He gave her to a newsboy, saw the bulge of her body under the boy's coat for three blocks, but back she came. He lidded her into boxes and left her meowing in back lanes. She always pushed the lids off and would arrive at the office amid the tittering boys and hail him with delight. There was only one sure way to peace. The thought of it made the boy sick.

The night was black, rain poured. He dared not hug the sack against himself, feel the warm throbbing love of her body. He dangled the meowing sack from his fingertips and ran. When he came to the bluff above the sea the sack hurtled through space and blackness. He put his fingers in his ears and tore away fearful of hearing the splash. After all, the poor little beast, she had only loved him too hard. All the wet on the "business man's" cheeks was not rain—he despised himself.

Shock and wet but invigorated Mary Anne's persistency. Measles' shaky hand had made a poor tie. Mary Ann's push undid it. She swam out of the sack, spat water, battled among the drift, slithered through slime and kelp, beached, crawled up the bank—*yowled!*

If there is one wet that is wetter than salt water it is rain. Salt bites, rain soaks. The shivering cat shook the brine from her coat. The rain chilled her bones. Her yowl was weak; but galoshes splashing through puddles stopped to listen for the feeble wail of cat-distress.

"Kit, Kit!"

The cat crawled towards the galoshes and the voice—was gathered beneath an old grey cape—hugged against warmth.

"Cat, what *will* the Elder say?" The girl's hand was on the kitchen door-knob. (The "Elder" was Grey Cape's big sister.) The Elder said plenty when the dripping pair stood before her.

"Out with her! There is the Persian and the barn cat—enough to mouse our family. Throw her out!"

"She'll finish drowning in the rain."

"So much the better."

Mary Anne knew again the sensation of flying and of wet, but the small-waisted egg-timer on the kitchen shelf could not have half poured her sand into the other end before Mary Ann was again under the grey cape and being hurried up a rickety stair hanging on the outside of a barn. "Studio" was painted on the door. Grey Cape raked the embers in a stove and was soon drying and comforting the half-drowned cat.

Mary Anne found life in the old studio completely satisfactory. Love, mice, a skirted lap, instead of Measles' bony knees.

"I must find you a name, Kit." But that very evening Grey Cape heard the kitten already had a name, for Measles came to call. The kitten stole and rolled spools of thread from Grey Cape's work-basket across the floor. Fast as the girl took one away, the cat got another.

"Pesky, persistent beast!" scolded the girl.

"Persistent, I'll say!" Suddenly the boy sat up and looked earnestly at the cat. "It's Mary Anne! By Jove, it *is* Mary Anne, the cat I drowned a week ago—one toe missing on left forepaw!"

"Isn't it rather beastly to do things by halves?"

"Mary Anne doesn't—Mary Anne, that is the name I gave her; see, she remembers. Mary Anne! Mary Anne!"

The cat turned at the call of her name but would not come to Measles' proffered hand.

"Perhaps she remembers too much," said Grey Cape. "Why did you want to drown her?"

"A business man can't be tagged by a cat!" The business man blushed. He was very young.

Spring sprouted all ways at once. It sprouted mouse-nests in the studio wall and sparrow-nests under the studio eaves. Domestic fowls clucked their broods across the yard. Persistent searching found Mary Anne a mate. Soon she too was hunting cuddly corners. The Elder kept her eyes open and all doors and windows shut. Mary Anne got ahead of her every time. Grey Cape provided a cosy box in the studio; Mary Anne, the coal-scuttle kitten, scorned a barn cradle for her firstborn. She broke the studio window, jumped from the barn roof, climbed the house roof, found Grey Cape's window open—the door of the cupboard in which hung the old grey cape ajar. The cat stole in, sprang onto a flimsy hat-box just to reach her cheek to the cape and rub. The box-top gave, spilling Mary Anne onto a bed of soft felt and velvet violets. Grey Cape found her there in the ecstatic state which newly kittened cats affect. "How could you, Mary Anne? My very best hat!"

"Mary Anne! Mary Anne! Where is that cat? Somebody bring me Mary Anne quick. There is a nest of mice in my drawer—that Persian fool is not even interested. Takes these common tabbies—who's seen Mary Anne?"

"Mary Anne is in my cupboard. She has five kittens on top of my best hat."

"Fetch her!" The Elder's tongue did not even click annoyance at the kittens on the hat. "Fetch Mary Anne quick!" she repeated.

No wonder Mary Anne's purr was so proud, no wonder she held her tail up so straight, a tail with tabby rings running round it like the rings of honour on an Indian chief's high hat—a ring for every exploit.

Mary Anne, common tabby, had brought tears to the eyes and blushes to the cheeks of a "business man", she had overthrown the Elder's antipathy to stray cats. Climb by climb, persistence had hoisted this coal-scuttle kitten till she had achieved the producing of a family upon the very headpiece of that particular human divinity on whom she had heaped the affectionate devotion of her whole being. There, pinnacled in ecstasy, we leave her. . . . Bravo, Mary Anne!

M O R E B I R D S

HEIGHT

VESTOVIUS IS A HIGH MOUNTAIN in Alaska; it is not far from Sitka. A man invited my sister and me to climb Vestovius with him. From Sitka we went to the base of the mountain in a launch, then we climbed, at first through dense, snarled woods and tall trees which got scrubbier as the mountain rose. At the top, Mount Vestovius was only bare, bleak rock.

When we got above the heavy timber the sun was scorching hot and we were very tired. At last we came to a wide mossy ledge and threw ourselves down to rest, sprawling luxuriously in soft deep moss.

I was flat on my back, spread like a starfish, aching all over. At that moment I wished the earth was as flat as a table and that there were no such things as prodigious lumps on its surface to be climbed. Views were all very well—myriads of islands floating in blue sea. People who had climbed Vestovius came back and talked all sorts of poetic stuff about "jewels set in a bed of sapphire" and "inverted skies with islands for stars", but they rubbed their knees and shin bones as they talked, and now, being myself half up Vestovius, I knew why they had rubbed. I was staring straight up into the sky. We were quiet, resting even our voices and groans. High, high, two eagles were soaring in great circles, swooping, diving, floating, exhibiting great power and marvellous control. Maybe they were an old pair, maybe two youngsters glorying in their first high flight, or perhaps they were playmates. I watched them for a long, long time. You could not associate tiredness with those wide-flung wings. They expressed power—power, freedom, endurance!

"I wish I were an eagle."

The man turned.

"Why?" he asked fiercely, as if he too had entertained the same wish. "Why?"

"Power, freedom."

"Girl," he said, "you *are* as free. Aim high. Trust your wings."

We finished climbing. On the way down we lost our way and came again to the shore at a place entirely different from what we had planned and expected. We "cooeyed" and screamed. Finally the launch heard and came round for us.

"You *are* free. Aim high and trust your wings." How many times in moments of depression I have thought of that man's words! How many times too have I lost my way, come down from my mountains on the wrong side, had to "cooey" to be picked up! Often I remember the Vestovius eagles.

EAGLES OF
SKEENA RIVER

POISED EACH ON HIS OWN still pine-tree top, majestically silent in the peaceful overhang of Skeena's turbulent waters, sat Skeena's royal eagles.

Looking up, looking down the river's noble sweep, my eye counted thirty of the kingly birds, each independently throned on his pine tree, each wearing a snowy crown of gleaming white, strong against the green of our sombre northern forest—a square-shouldered, square-tailed bird, except for his white crown, all black, rusty black. I can't think why they call him "Baldhead". He has bountiful head plumage, silvery white, which droops in long points graciously onto his rusty shoulders.

A mighty roaring river is Skeena, treacherous—rapids, shallows, ledges, boulders—a violent river, tearing around curves, echoes shouting back her racket.

Skeena used to be navigated by a fussy little sternwheeler, whose noisy going splashed and churned a moil of whiter whiteness than the river's own, foamier even than Skeena's foaminess of hurried anger.

Twice a week this little steamboat staggered up-river, adding her commotion to all the rest. Twenty Indian lads stood ready on the sternwheeler's deck, listening for their half-breed Captain's signal to leap overboard, stand in the shallows and lay their forty palms against the boat's side, pushing her away from danger: Captain bellowing orders from his glass wheel-house, splash and shout of leaping boys, churn of foam-tossing wheel, echoes doubling the uproar, Skeena's clatter, turning, twisting with the river, but keeping always down between its banks, densely forested banks, which do not allow sounds to escape. Skeena's commotion does not rise more than a few yards above the river but surges up and down. The arch of silence that overhangs all our western forests keeps Skeena's turmoil to the river-bed where it belongs: in the tree tops along the Skeena's banks all is still.

When the Indian lads had persuaded the boat back into the channel and she was safe to hug shore in deep water, they again leapt, this time from deck to shore. Here they attacked neat piles of cordwood prepared for the fuelling of the steamboat.

It took no time at all for the twenty Indian lads to fling the pile, stick by stick (thud, clatter! thud, clatter!) onto the deck of the boat. The boys then leapt aboard, and the little sternwheeler resumed her fussing way up-river.

When she came to the end of steam navigation at Skeena Crossing she was met by huge Indian dug-out canoes. Indians took the passengers the rest of the way. The finish of navigation was at Hazelton, which sat where the Skeena and Bulkley rivers meet, boiling into each other's faces like warring tom-cats.

Hazelton was a tough little mining town. It had three hotels, rough and turbulent as the rivers.

By and by the Grand Trunk Pacific built a railroad a few miles back from the Skeena River. Meek trains slithered travellers through the forests to Hazelton. The coming of the rail eased travel and gentled Hazelton's hotels. Tourists came. The G.T.P. ran its line close to several of the Indian villages and the tourists looked curiously to see how our Aborigines lived. They did not see real Indian life, the original villages, or the grand old totem poles because, flattered and boastful, the Indians tore down their crude but grandly simple old community houses, built white man's houses—shoddy, cheap frame buildings. They turned the totem poles that had faced the river, welcoming visitors who had come by canoe up Skeena: they turned them to face the railroad by which visiting tourists now came. They loaded garish commercial paint over the mellow sincerely carved old poles till all their meaning and beauty were lost under gaudy, bragging show-off.

The Indians hurriedly made baskets and carvings too—careless, shoddy things to catch the tourist's eye—which brought in a few dollars but lowered the standard of their handicraft.

Everything was changed, cheapened—everything, that is, except the river, the eagles, and the Peace, high above Skeena's roar—the Peace, where the Eagles of Skeena reigned.

The eagles came to Skeena every year when the salmon were madly dashing up-river to their spawning grounds. From near and far, eagles came to feed on the worn-out fish that leaped, struggled, splashed over the shallows among boulders. Pounce! An eagle had a struggling fish gripped in talons and beak.

The railway ousted the sternwheeler and the big passenger canoes, but the fish still came. Eagles followed the fish—Skeena's eagle—watching, mighty king of birds.

Two Women and an
Infant Gull

GREY AND GENTLE, the dusk ran down the Skidigate Inlet, that long narrow waterway between the islands of the Queen Charlotte group. Nobody used this waterway now. The few Indian villages on the Inlet and on the wicked West Coast of the Islands were dead, forsaken. It is a passionate coast—wild, cruel. The chug, chug of our gas engine was the only sound in all the world. Jimmy the Indian snapped the gas off and our boat snuggled her nose between the rocks of a little island.

"Gull Island. Eat now," said the Indian.

Gull Island was small, rocky, and round. It had no trees: was only a rounded heap of loose rocks, sedges, and scrub bushes. Sea-gulls came there to nest. The sheep dog and I were the first to jump ashore. The dog ran forward, nosing; a gull rose from the sedges with an angry squawk.

"Keep back, Billie!"

I discovered that my dog had found a gull's nest. The dog froze, covering but not molesting the one hatched bird and the one pipped egg. The gull chick was scarcely dry from the egg. I stole it and left quickly, so that the mother might return to her pipped egg. A wild creature held in my hand always thrilled every nerve of me.

We ate on the far side of the island. The Indian's wife looked enviously across at the gull.

"I want one too. I want a baby gull," she said petulantly. We searched the island but there were no more nests with young in them. The woman's resentful eyes were on my gull. "I want one. I want one," she kept repeating, and sulked. She loved creatures as I did. All her babies had died. She had only her husband and a white kitten left to love.

"The little gull is cold," she said angrily. "Put him in the bosom of your blouse. He misses his mother's warm."

The clammy webbed feet of the gull scrabbling down my front were not comfortable, but the little gull peeped cosily. The Indian woman's eyes were enviously watching his wiggle in my blouse, her ears enviously listening to the contented peep.

"I wish I had a gull. I wish I had a gull." She turned her back on me.

I remembered that all her children were dead. I remembered that I had a long rough way to go before I would be home. A little creature having to be fed

raw fish every few hours was not going to make travel easy. It would be tough on the gull too, but I was stubbornly greedy about giving him up. I wanted him. I had a passion for acquiring wild creatures to rear, to tame. My people had given up protesting at the things I brought home. Perhaps I *could* manage . . . but was it quite fair to the gull? I crossed to the woman, took the gull from my blouse and handed him across her shoulder.

"You can have him."

The woman snatched him. She poured the white kitten out of her hat onto the stones, filled the hat with grass to make a nest for the gull. Indians take and give; they don't thank. Proportions scale differently with them and with us. This woman's only hat—straw with flowers—meant nothing to her. The cannery store had charged her a big price for it too. Money for a hat represented many hours of packing fish into cans. Part of every female cannery worker's wages went into a hat to be admired by her fellow workers. Envy, pride, bitter jealousy—these things were part of the cannery season. When the girls and women went back to their villages, the hats were discarded: either their splendid black hair went uncovered, or, Indian fashion, it was tied under a far more becoming gay handkerchief. Clara, Jimmy's wife, did not wear her hat at home. She had brought it on this trip because I was a white woman and hatted. As a hat it failed to impress me. It had made a good cradle for the kitten; now it was a nice nest for the gull.

Clara was very happy on the return trip. Sitting in the boat, holding her hat full of seagull, she sang to him.

The Indians went to Alliford Bay. I continued on further to visit other villages.

On my return I went to see Clara and the gull. The kitten and the gull were cuddled together under her cook stove. The bird had thrived.

Clara taught her gull to go back and forth between Alliford Bay, where she worked in the cannery, and Skidigate Village. Her home was in Skidigate; her aged mother lived there. When the old woman saw the bird come it was like a greeting from her daughter.

WILD GEESE

I WAS VISITING in Cariboo. A flock of wild geese in migration descended to feed
in a grain field. Driving with two gun-lovers, I happened to pass that way, and
we came upon the flock feeding. The roadway ran right alongside the field in
which the wild geese were grounded. Such an immense flock was a rare and
unforgettable sight. There were hundreds and hundreds of geese. You could
hear the aggregate snap and shovel of their beaks feeding, nipping the grass,
shovelling grain.

The gun man said to his wife, who also carried a gun, "Drive on. The birds
will not heed the horses. Do not speak as you go. The old ganders will be on
the listen and the lookout."

The man slipped out of the rig while it was still going and crept behind a
line of bushes that hid him, intending to stalk the flock from behind.

The great field was a spread of throb, movement: necks bobbing like black
hooks as the birds' heads worked up and down, up and down, cropping, shovel-
ling, their grey bodies lovely against golden stubble—delicious colour. Look-out
ganders were posted, heads in air, ready at slightest alarm to warn the flock.

I had never experienced a more thoroughly tingly joy than watching that sky
multitude earthed. I had never been close to a flock of wild geese before. In
spring and in autumn they rode high over our West during migration, zigzags of
honkers, black dots, lofty and mysterious. As a child I had wondered and won-
dered about them. Grown-ups immediately said, "Hark, wild geese!" and then
started talking of the changing season. I did not know the meaning of the word
"migration", nor did I till years after associate these high black dots with the
bodies of geese.

Now I was grown up and here was a whole skyful of wild geese emptied at
my feet! I thrilled through and through.

"Why doesn't he shoot? Why doesn't he shoot?" quivered the woman, her
fingers stealing towards the trigger of her twenty-two. "That sentinel is getting
nervous!"

She raised her gun and shot, just as there was a terrific bang from behind the
bushes.

The gander screamed! A single movement and the flock rose, one living
cloud! One goose lay still. He would never go with the flock again.

In a twinkling the geese were incredibly high. A clamour of honks fell down

515

to us. Every bird was exactly spaced behind his fellow. Their formation was perfect: a V inverted with wide-spread sides, its point cutting space. The gunners, grumbling, shoved the goose's warm body into the back of our rig, angry that he was not two.

How, I wondered, had the dead bird's place in their sky flight been filled? No gap showed in the long, evenly spaced lines.

STERN PARENT

IN VICTORIA'S HIGHLAND DISTRICT, where roads were bad and there was little traffic, stood a tiny log cabin used by hunters in the game season. Birds loved this district, the sunny solitudes of its few scattered farms.

In autumn gunmen shot over the district. I rented the cabin for the month of June, when birds were nesting and gunmen were out of season. A grouse hatched her brood beside the cabin door. She brought them to feed in the wild strawberry-patch in front. Father grouse sat on a nearby stump to warn his family of approaching danger. My party—sheep dog, Javanese monkey, and me—he accepted as part of the landscape. Danger might come from us, but we sat still for hours while I sketched, admiring, not molesting, his family. He trusted us. To be honoured by the trust of wild things is to have one's self-esteem hoisted. Condescension from great humans does not pride one as confidence from wild creatures does. When cocked heads and round, curious eyes stare at you direct, when winged timidity stays on human level instead of lifting to bird-freedom, it raises one's faith in humanity and in oneself.

Quail, pheasant, grouse abounded in the Highland district. The whirr of humming-birds' wings was heard in the air. Robins sang and swallows darted; there was every variety of sparrow. There were wrens, chickadees, towhees—black-hooded, long-tailed, rusty-breasted, shy birds. I threw abundant crumbs before my cabin door to indicate that I was friendly. They came warily at first, but soon in numbers. A father towhee came and brought his three newfledged birdlings. Mother Towhee was hatching her second brood back in the woods. The three children sat agape and squawking till Father had filled them up. Then Father, with beak full and crop bulging, flew off into the woods. Soon he was back again, lean, empty, and very hungry. He fed himself. The children watched, too full to squawk. Father Towhee thought it was time to teach his family self-reliance. He took a crumb in his beak and softened it by pinching, then dropped it before his young. The children obstinately refused to bend their necks and

help themselves. Ever since they hatched they had thrown their beaks wide, braced their necks, while a parent poked food down. Father Towhee was weary. Soon it would be all to do over again for the second brood. He disappeared. The children squawked and squalled dismally. Father did not come. I feared some calamity had befallen Mr. Towhee. I could not imagine a parent's heart untorn by such frantic pleadings.

"Sparrows, what *are* we to do? I can't show the little towhees! *You* must."

The sparrows pecked on quite indifferent.

A shadow swooped silently through the cabin door, circled me where I stood, circled me again, swept out into the sunshine . . . Mr. Towhee! Stepping out of the cabin I saw him peeping over the edge of the gutter, worried as I over his stubborn family. But a firm disciplinarian was Father Towhee! For three days he and I watched the obstinate children, hungry almost to starvation.

I had a hammock out in front slung between a tree and the snake fence. Father Towhee would creep along the lower rail of the fence, my bulk hiding him from the crumb patch. He knew that I knew; we pooled knows—watched. Three days' anxiety, then the birdlings, one after another, found the bend in their necks, took bits of food from the ground, twisted them in their beaks, tongued and spit them out—lazy tongues wanting a parent bird to beak food down their throats till it met their gulp. At long last they did learn. Then Father came back and fed with them.

Before I left the cabin Mother Towhee brought her second brood to the feeding grounds and left them to Father. Patiently he began the process all over again, while Mother and the grown brood looked after themselves.

BIRDS OF ENGLAND

EIGHTEEN MONTHS of recuperation in a sanatorium is desperate dulness. The sanatorium was in a part of England crammed with wild-bird life. Only that made things bearable: open fields, hedgerows, little woods, rabbit warrens— places that song-birds love.

The San sat on a little rise. It was a sanatorium primarily for tuberculosis. I was not T.B.; therefore I enjoyed freedom and privileges which lung patients did not. When I was able to roam at all, it was at my own will; the only restriction was, "Don't tire."

T.B. patients had prescribed walks, so many miles to so much time. Men patients took one road, women patients another. I saw them start in dreary

draggles—over-cheery voices contradicted by lagging heels.

At the back of the San lay a little wood; further on was a rabbit warren. I crept into one or the other of these places and lay upon the ground rejoicing in the birds. Theirs was a real joyousness. Those patients' cheeriness was a sham, a brave enduring spread over a pause—life?—death? Meantime suffering, monotony.

Every kind of bird was in my wood—"Cuckoo, Cuckoo!", a robin's trill, a thrush's gush of rapture, liquid running of a blackbird's notes out over the open, the trembling ascension of a lark spilling delight—higher, higher, lovelier for the highness.

The doctor said, "Why do you not walk sometimes with the other patients? If their walks are too far, rest. Let them pick you up on their return. It is morbid to go into woods alone."

Morbid! song-wrung woods morbid! London had broken me. I loathed great cities. Morbidness was in *them*.

Father had always told me of English birds. He had loved them in his English boyhood. In London I crept often to a slummy district called "Seven Dials" where the birdshops were—not the sort of place young ladies were supposed to be. I went into the small, stuffy dark shops of "Seven Dials" to see the English birds which father had told of. I found trapped, frightened creatures, caught with snares or bird-lime. Brutal, coarse men hoped to make a few pennies on each bird. Dispirited little larks crouched in low-roofed cages so that they should not attempt to rise and soar. Thrushes, blackbirds, starlings, some trying to sing even in those miserable quarters! It shamed me. I, who had the whole of London to roam, felt as prisoned and more crushed than they!

Every English boy bragged of his "bird-nesting exploits", exhibiting collections of bird-nest robberies. I heard too of fox-hunting, badger-hunting, of dogs that had lips and cheeks torn off by the badgers who got under rocky ledges and ripped unprotected dog faces. I was told of royal stag hunts: deer hounded up to the royal guns; pheasant shooting, partridge shoots—birds driven by beaters to the guns of men called sportsmen; shoots for the pleasuring of the guests at house parties on great estates of the rich; clean bushes spattered with blood, festooned with scattered feathers of luckless birds, killed not for food but for fun. I raged with disgust, hating it all.

Nine months of London embittered me. Easter came. The Art School was closed for one week. I went to a little village in Kent, Goudhurst, sitting on the top of a low hill. This is where I first properly saw and heard English song birds.

"They don't deserve them! They don't deserve them!" was all I could say as I stood listening, drunk with delight.

Goudhurst had an inn, a chemist, and a butcher. I know, because I stayed at the inn, which, when I arrived, was all bustle, for that very day the butcher's daughter was marrying the chemist's son. The inn folk were nearly distracted with hubbub—rush of visitors from neighbouring villages. The church-bells

nearly dislocated themselves from their hangers, tossing out their clamour. I saw them up in the belfry; I saw the tombstones in the churchyard, gay with roosting gaupers awaiting the bride. I passed among them, came to a stile, climbed, was suddenly in a little wood, new-foliaged for spring, ringing with bird-song. The clang of the bridal bells was out-distanced. I heard only England's birds singing.

Thank you, my English father, for bequeathing to me this happy heritage—joy in birds. Your English birds *are* exquisite: they suit England. I wish Canada too had song birds. But oh, I would not trade Canada's spacy silence—dim, tremendous—for England's warbling woods! When Canada is peopled end to end, then, perhaps . . . not now, not yet.

BULLFINCHES

I WAS THE ONLY MOTHER the nine little bullfinches had ever known. I stole my two bullfinch nests, one having four birdlings, the other five. I stole them while yet the birds were deaf, blind, and only half fledged. When first they heard and saw, they were in a sanatorium and I was poking food down their throats. They found nothing strange about either my voice or looks, apparently; they thought me a comfortable mother.

I wanted to take my bullfinches home to Canada. Then I got ill and was unable to travel. The two nests stood on a tray beside my bed. I fed my nestlings every half-hour from dawn till dusk. The sanatorium nurses and the doctor were most co-operative.

When the little birds discovered that they had wings, their first flight was direct to me: they nestled round my throat as I lay in bed, circling it like a necklace. They never again returned to the nest but were put in a wicker cage in my room. Whenever a sanatorium patient was downhearted or dreary, his nurse came to my door begging, "Lend the little soldiers." Then the nine bullfinches would spend the day in that "down one's" room to cheer him. It was very amusing to lie and watch them sitting in a long bobbing row trying to sing. All the while they tried, they danced and bobbed. The male bullfinches had rosy breasts, the females brown; all had black bonnets.

Only one pair of my bullfinches got out to Canada with me. They were so pugnacious, such bullies, that one by one, for the sake of peace, I had to give this one and that one away, or they would have killed the others. By and by I

had just one pair left, and then at last I came back to Canada. The "Bullies" thrived very well out there for five years. Then one day the cage fell and Mrs. Bully broke her thigh bone.

I took her to a doctor friend of mine. He and his wife often cared for my birds when I was away for a few days.

"She'll live," he said, "but her leg will always stick out hideously. Broken up in the thigh, it cannot be set. Suffer? Yes, I guess she will for a bit."

"Chloroform her for me, please."

The doctor's wife interposed.

"Oh, no! If she dies, Mr. Bully will die too. Bullfinches mate for life. If one of a pair dies, so does its mate."

I stood holding the little bird. She was easy, lying in my hand.

"Think it over," suggested the doctor. "You can bring her to me later."

I held her all day. I could not go to bed holding her in my hand. When I laid her in her cage she called and fretted.

It took only one drop of chloroform on a pinch of cottonwool. Her calm, gentle heart-beat stopped against the palm of my hand. This saved her the worry of being transferred into a strange grasp.

Did the faithful husband fret? He did not. For the first time in his life Mr. Bully was "it", took and gave all the petting which his mate had done him out of, swelling himself in the glory of being "the only".

I kept his cage on a low wide seat so that he could share the doings of the old sheep dog and me. We were his idols. He adored us both, had no fear whatever of the hot-breathed dog; he would lie in the palm of my hand, not one quiver or mad heart-beat, loving the great dog's moist tongue to lick him. If the dog and I went into the next room, Bully would call and fret till I bade the dog "Go, sit by Bully."

The gentle lumbering beast would go into the studio, sigh himself patiently up onto the bench, and hump a shoulder against the bars of Bully's cage. The lonely little bird would trot up the perch to the wire and snuggle against the dog's warmth. Great dog—tiny bird!

I went into the bitter North one mid-winter. I was to be away for only two weeks. I dared not take Mr. Bully with me: he would freeze on the way. I loosed him in the aviary among the canaries. I had before let him fly among them. They were on good terms, but then Bully knew I was always near. Now he called and called—I did not come. At the end of his first week he was dead, just wanting me.

GARDEN GONE WILD

TWO BOYS MOTORING to a near lake to swim invited, "Come along."

"Not to swim, thank you. Drop me on your way at that old forsaken farm in the woods."

I climbed out, their crazy old car wheezed away. I went through a broken gateway and up a grass-infested path. Windows gazed blank, the door creaked on its sagging hinges, its lock gone. Otherwise all was still as death.

This had been a dear little place, somebody's home chipped out of the big forest, a home that had snuggled itself back into the heart of the forest and the forest had hugged it. I wondered why these pioneer farmers had abandoned it. There was the empty chicken house, the dog kennel, the well, the barrel for rain water—empty, all empty. Wind and rain tearing, rotting the little home to bits.

The house was built on a little rounded rise. Just below it in the hollow the settler had made a little garden, unlevel, unfenced. The forest was creeping back, grabbing greedily for its own, binding it with bramble vines, seedling trees springing, choking, choking every planted thing—a few stunted apple trees whose crop the squirrels had commandeered, starved gawky marigolds and marguerites, poppies and a scragged sweet-william. The forest was coming, coming to reclaim its own, to oust them all.

I sat down upon the broken house step; over me was a writhing sprawl of honeysuckle, clinging, swaying round the porch-post. The tips of its scraggy woodiness were hung with clusters of sweetness.

Whirrr! Whizzz! The noises and whir were in my very face; right under my chin was a humming-bird, sipping from the honeysuckle spray I had thrust into my coat. "Mother Hum" was resting on the bush watching her two top-heavy children. A dozen humming-birds, red, green, and darting, were noising their wings, too quick to see.

As soon as the sound of the boys' motor had died in distance the garden had come to life—swallows swaying, circling, wrens, robins, sparrows, quail back in the woods shouting, grouse drumming.

Swallows darted over the garden hollow teaching their young to fly. Even to my eyes it was plain that the young were unsteady and poor at quick turns—wobbly, jerky! It was amazing to see how they improved even in the few hours of my stay in the old garden.

"Sorry we've been so long; water was fine!"

"Were you long? It seems only a minute, boys."

"You were not bored by this awfull stillness?"

"It was not still. When your car snorted away it burst into life! It was noisy!"

Listening, the boys held their united breaths.

"Don't hear a thing!"

"Come on, Goofy! We're famished."

ALICE'S SPARROWS

I LIVE IN PART of Alice's house. My studio window overlooks her garden. Beside my window is Alice's sparrow bush, a great rounded mock-orange shrub, whose myriad stalks and twigs are of just the right gripping size for the feet of sparrows.

Alice is nearly blind. She cannot see the flowers in her garden now; flowers and weeds are all a hazy muddle to her. The apple and the pear-tree are dim and shadowy against the sky. Her feet feel their way down the gravel walk. She fingers the smooth skin of an apple, the smoother skin of a pear, and asks, "Are my trees fruiting well this year?" It is just too bad to be blind.

In the mock-orange bush all day the sparrows sit waiting for Alice to come with handfuls of bread. She has made them lazy. They chortle and wait idly, no thought of searching for their own food.

All the cats in the neighbourhood found Alice's garden a conveniently spread dinner table too—sparrow dinners whenever fancied. Green eyes, yellow eyes peered from under shrubs and plants—sudden darts! agony chirrups! Alice erected a miniature Eiffel Tower, impregnable to cats, on her lawn. She now puts the food on top of the tower. The outwitted cats have slunk back to their rightful homes.

Alice's sparrows comfort her. She hears the flutter of their wings and their chirrups in the air around her head when she carries their food to the tower. She can discern their shadows when they come between the sunlight and herself. She feels less blind because of these shadowy movements.

Suddenly, away fly all the sparrows! They are gone for weeks. Alice is desolate, but she knows it will not be for long. They have gone away to nest and will come back, each pair with a husky brood of dishevelled, half-fledged youngsters, who will sit in squawking rows beneath the Eiffel Tower, mouths open, waiting for parent sparrows to fill them with Alice's bounty.

SITKA'S RAVENS

WHEN IN delicious remembering my mind runs back to Sitka, what does it see? Not the little old town with a long wharf approach straddling over mudflats, its final planks meeting the dirt roadway of Sitka's main street; not the quaint Russian church which is one of Sitka's tourist attractions; not Totem-Pole Walk winding through trees beside a stream named Indian River, named for the pleasing of tourists but really the farthest possible distance from the village of Indian shanties—a walk ornamented at advantageous spots with out-of-setting totem poles, transplanted from their rightful place in front of an Indian chief's house in his home village, poles now loaded with commercial paint to make curiosity for see-it-all tourists, termed by them "grotesque", "monstrous", "heathenish"! Nor do I remember the army barracks—Sitka is a United States military outpost. But I *do* see the barracks flagpole, tall, with a shiny gold ball on its top, and over that ball always, always three or four of Sitka's great black ravens—circling, hovering, trying again and again, each in turn, to maintain a foothold on the slithery gilt ball. Generation after generation of ravens has tried; it is a tribal game, old as the flagpole. No resident of Sitka has ever yet seen one raven succeed. All Sitka's ravens try. It may be the glitter of the gilt which attracts them or it may be just raven fun—no one knows. They balk and hinder each other, clumsily jocular about it.

To the left of Sitka's long wharf, a little way from "White Sitka", lies the Indian village: a straggle along sea-beach of low unpainted shanties; a few weather-worn unpainted totem poles left in their true setting because they were not considered worthy of tourist attention; on the Indians' beach a muddle of canoes, fish-nets, and sea-salvage—and stalking among it, flying over it with guttural croaks and hoarse cries, ravens—Sitka's ravens! Black and shiny as well-kept parlour stoves, their curious half-swallowed, guttural croakings mixing with sound of wave-splash.

Sitka would not be Sitka without ravens—noisy, weighty, powerful, swooping, uttering sepulchral wisdoms, winging, wheeling blackly into the deep woods behind the village, male and female calling over and over his or her own cry—the male and female note differing.

"Ping!" says one—the strident ping of a twanged guitar string. "Qua!" replies the mate—a flat throaty call.

"Ping—Qua! Ping—Qua!" call the ravens of Sitka. Indians have fabulous

tales of Raven; he figures conspicuously on their totem poles.

I asked an Indian, "Could you get me a baby raven from a nest? I would like to take one home."

Grinning, the man shook his head. "Raven lady heap smart. Nobody can't find her nest. Injun tell, s'pose anybody find raven nest that somebody got good luck always, always!"

So I had to be content to carry home with me only raven memories, dear memories of the tricky, persistent, croaking ravens of Sitka.

Tourists came back from their twenty-minute stopover at Sitka and lectured on Indian totem poles and Indian *un*culture, having seen a few old Indian squaws who spread shawls on the end planks of the wharf and sold curios—baskets, panther-claws, bear-teeth, whalebone in the raw, shells that were used in old times as Indian money. There were quaint little rattles too, made of deer-hooves, and carved grease dishes made to hold oolichan oil. The tourist turned over, bartered, carried off the cheapest and poorest articles, exhibited them as specimens of Indian craftsmanship. He hurried to the Russian Church, to the Totem-Pole Walk. Never did he go near the real Indian village. His steamer tooted. He ran down the wharf, returned home—dared lecture on Indians. He had never seen the muddled inside of an Indian house, the motherly cuddle of an Indian woman with a papoose under her shawl, had never smelt salmon steaks smoking over an Indian fire; nor had his eyes smoke-smarted in an Indian hut. Never had he seen an Indian woman's hands fashioning a basket, nor an Indian's acceptance of weather and discomfort, nor an Indian's cool courage in his dug-out canoe among gigantic waves.

Nine-tenths of the tourists probably thought Sitka's ravens only a band of glorified *crows*. These people went back and lectured glibly.

To sense Sitka is to see her composed of a three-strand weave—Indians, peace, ravens. Perhaps the most insistently vital, the most unchanging of the three are the ravens. Soldiers and tourists broke Sitka's peace. Civilization cheapened her Indian. But generation after generation, her ravens will mate, create, go on, on into time . . .

"Ping—Qua! Ping—Qua!"

INDIAN BIRD CARVING

ALL KINDS of nationalities have carved all kinds of birds in all kinds of ways, and from all kinds of material. I think the Indian has used deeper insight, carved with greater sincerity than most. The totemic carvings of his crest emblem, animals and very frequently birds, lived with all their attributes in his work. An Indian believed himself actually related to his totem. This relationship was considered closer even than a blood tie.

Unlike the designers of our heraldry, an Indian might use the creature that was his crest in any pose that suited his fancy; but it must be endowed with the characteristics of the bird or animal represented—never must he waver from the concrete actuality which represented the living creature. From bones to feathers the Indian *knew* his bird—every characteristic, every minutest detail of its true self. He need not arrange its parts in the way nature had sequenced them. For the purpose of decoration, space filling, and symmetry, he might distort, separate, re-colour, but he *must* show the creature as complete in being, though he might conventionalize it. The carver must make it express weight, power, being. Let wings, tail, talons be unconnected: they must be told. Three or four conventionalized feathers on a bird's wing or breast suggested through the carver's art a bird fully feathered.

Eagles and ravens played an important part in Indian totemic heraldry— eagle, fierce and strong; raven, wise and cunning. There was, too, a big bird with a long, long straight beak which often was shown on the poles. I thought it might be a representation of the crane or heron. Indians said not. They called him the "How-how" bird. He was probably mythical.

These great wooden birds were carved with dignity and intensity. Crude, regal, they surmounted tall poles, wings spread or wings folded. In primitive simplicity their calm seemed to pervade the village.

As far as I could judge, Indians seemed to entertain no sentimentality towards creatures. They treated animals and birds with an indifferent brotherliness but, when using them for totemic symbols, the Indian's attitude towards his creature seemed to change. For his clan or personal crest the Indian entertained superstition, fear, reverence, a desire to propitiate the supernatural powers of which the totem creature was possessed.

Some of the eagles and ravens which topped the totem poles were really magnificent. Certain carvers projected the upper part of the great black eye-pupil of

their birds to give the impression that the creature was looking earthward. Bird eyes were humanly shaped and deep-set. They were frequently overhung by a heavy eyebrow painted black. The eyeball was shown in an oblong of white such as the human eye has. These crest birds, endowed with supernatural powers, were supposed to see more, hear more, know more than ordinary birds. Ravens and eagles were provided with huge square ears, one on either side of the top of the head. Birds that had wings wide spread were crudely braced from the back to prevent the wind from tearing the wings away. Cumbersome, heavy as was the build of these wooden birds, you felt the lift and sweep of the carved wings amazingly.

How well I remember one old eagle sitting her pole in Skidigate village. She was uncoloured except where wind and rain had stained and mossed her. The rest of the pole was plain but for the figure of a beaver carved at its base. This eagle had folded wings. Her head was slightly raised, slightly twisted. I called her Old Benevolence. Maternal, brooding, serene, she seemed to dominate Skidigate.

INDIAN AND
OTHER STORIES

In the Shadow of the Eagle

CHIEF MOON looked down upon the wizened brown face of his heir, neatly and securely laced into a coffin-shaped basket cradle. There was grim determination in the small Indian features shut up tight like an aggravated sea anemone. The brows were well defined, the hair long and very black.

Without pause in her basket-weaving, the mother gently shoved the cradle with her naked foot until the shadow of the great carved eagle rested full upon it. The movement did not escape her brother, Chief Moon.

"It is good, Susan Dan, that you put him in the shadow of the big Eagle. That make him come big and stlong."

"He come better now," the mother answered. "Fat come soon."

Moon nodded and lifted his eyes to the noble emblem of his tribe. "Big Eagle take care of your baby, Susan Dan. He got stlong heart—fierce but wise. He not like clooked talk. You teach your boy be very ploud of Eagle."

The woman's soft, thoughtful gaze rested on the great carved bird, standing proud and magnificent above the squatting bear, on the totem pole before Moon's ancient, square-fronted house in this old-time British Columbia village. She loved it as Chief Moon loved it, and as the carver who, loving it, had put himself into every stroke of the tool, seeking to express himself in it. The Eagle was the very essence of his being. The sweep of the wide-spread wings, the tilt of the noble head, cruel curve of beak, powerful talons, keen piercing eye—all were himself. He had given of his life to it, created it.

"I make my boy so Eagle never have shame for him, Moon," said Susan.

The board walk creaked as a massive form waddled towards them. Swiftly Susan took her cradle to her lap, drew her old plaid shawl across it, like the protecting wing of a hen when a hawk is near. But Martha's heavy hand lifted the corner of the shawl. She bent over the child. "Velly small and weak," she said. "Too bad! All your lil babies die, Susan. Too bad! Too bad!"

Martha telescoped onto a log, her chin sinking into her chest, her chest sinking into her stomach, her stomach absorbing her legs, a great groan enveloping all. She removed the handkerchief from her head to wipe her sweat-washed cheeks and brow, and called in a voice half strangled in her fat throat, "Jacob!"

Her oldest, heavy and black, produced her youngest from a dustpile where she had been wallowing. The baby roared at the interruption.

"Hush up! Don't make that noise! Ole Eagle up there get mad. Slap you with his big wing. Pick you eye out. Maybe eat you up."

"Martha, it is not good to tell you childlen clooked talk about the Eagle," said Susan. "Eagle good for his people."

"Ha, ha! Susan, you make me laugh. You ole, ole fashion. I see you bling you poor lil baby, put him down in Eagle shadow, make him come stlong. White woman put her baby in sun make him come stlong. My Steven, my man, got white blood, he tell me. Look, my Paul, he got white man eye, blue-colour."

"You Paul got clooked eye what white man call squint," retorted Susan. "I think blue eye so surplise he not black Injun eye, he never stop looking. No matter for Chief s'pose he not fat if he got stlong heart and talk stlaight."

"Ya! Nobody want skinny chief. Look . . . poor!"

Chief Moon listened with troubled eyes. If Susan's baby died, Martha's coarse child would become chief. It was the tradition of his people, against which he was powerless. But any dread of such an event was veiled by his gentle, kindly voice as he said, "Eagles do not quarrel, do not make squawk like spallow. Eagle see what he want, fly stlaight, take it. Spallow fight and flutter, forget what he want and fly away empty."

Susan's head drooped low over her baby, but Martha waddled off in a huff.

And all that spring, despite Martha's jeers, Susan continued to place her child in the shadow of the Eagle. He grew, but not fast enough to silence Martha, who persisted in her venomous comparison of Susan's frail babies with her strong ones, and her own larger house with Susan's shanty.

For Susan's home, like most in the village, was furnished with the minimum requirements of life. It bore the full brunt of the prevailing wind, and would have collapsed but for long poles of drift-wood wedged under the eaves, which braced it at a tipsy angle. Crevices and knotholes were stuffed with rags and newspaper. Within, the rusty stovepipe twisted hideously on its journey from the cookstove to the roof. There was an iron bedstead, a broken-backed chair, used exclusively for the coal-oil lamp to sit on, a battered sewing machine, a dresser holding a few dishes, a figure of the Virgin, and some paper roses in a jug. Rough, unlovely boxes containing Susan's "things" hobnobbed with beautiful Indian baskets. From a single nail in the wall dangled companionably a cracked mirror, a rosary, and Susan's church dress. These were the worldly goods of Susan Dan.

Dan, Susan's man, occupied a place in the home equivalent to the other things, perhaps not quite as important as the dresser. Sweet-tempered, unambitious, talking little, smoking much, loving Susan and his babies not ardently but comfortably, he was scarcely missed when he went fishing.

This spring, less than ever, Susan dreaded his going. For she had her little Tommy, whose health was too precious to risk life at a cannery. The men would go on the fishing boats, the women pack salmon in tins. But Susan had determined to stay and make baskets for the tourist trade and add to the little store of savings in the box under the loose planks beneath her bed.

So, with little Tommy who had outgrown his cradle and now lay on the plaid shawl beside her, Susan sat before the cabin weaving baskets and watching that activity which approach of the cannery season always brought to the village. Men tinkered with boats, women baked and did up bundles of clothing and bedding which children lugged down to the beach. Dogs watched eager-eyed, anxious.

The breeze played pranks with Susan's cedar roots and dried grasses and fluttered the handkerchief on her neck. Her small brown hands moved swiftly. She ran moistened fingers down the long strands to keep them pliable. A quick, expert twist, followed by a firm rhythmic movement, and strand after strand was finished, pared off with a knife, another started. Sometimes her bare toes wiggled as she sang to her baby.

Martha stopped beside her. "Too bad you can't go to cannely, Susan. Poor lil baby, too weak. Too bad! Too bad!"

"Look," replied Susan, "my baby get big now, Martha."

It did not please Martha to see the child had grown. "I buy buggy at cannely store first thing. My Christine too heavy for Jacob to cally. Mosquito could cally your baby, too small for buggy."

A wave of fury swamped Susan. "I glad you go away, Martha, you scare my baby so he can't glow quick. I don't want buggy. I want him close, close on my bleast under my shawl. I solly for you, Martha. You too fat to cally baby."

"You stupid, Susan! Ole, ole fashion," and Martha waddled off to superintend her family's departure.

Before the boats returned at the end of the season, Tommy had a little sister. Both children thrived. While she made baskets Susan sang Eagle songs to her babies. Time passed swiftly. When the village people drifted back, a boat or two each day, they came to see Susan's new baby and to tell her of Martha, who was working to the last that she might make more purchases.

"She going to buy white-woman clothes," one of the women told Susan. "She no want Injun han'kelchief for head, or Injun shawl. And shoes she want for always, not just go-town shoes. She heap mad that store man just got corset for skinny lady."

Martha had indeed arranged a triumphant return. She stood in the cannery store on the last day of the season searching the shelves with covetous eyes. The storekeeper was weary of her bartering. Her purchases, a silk dress, a purple umbrella, skirts, blouses, sweaters, perfume, powder, a few pots and pans, a stand lamp surmounted by a floral hat, were heaped on the despised shawl. The tip-top moment of her dream was when, dressed in her finery, she would wheel the rest of her new things home in the buggy, tossing Susan a careless nod in passing.

Gathering up the shawl by its corners, she waddled outside to get the buggy and found a little group of people surrounding the howling Jacob. A woman held Christine, quiet and limp. The baby's heavy head hung over the woman's arm. Others were righting two upturned buggies. Christine was dead. Jacob and

another urchin had been racing buggies; Christine had pitched over the bank, striking her head on rusty anchor.

Martha went to her cabin uttering long, blood-curdling, doglike howls. All the village came, even the manager's wife and her widowed mother. "Poor soul!" said the little white woman. "Is there nothing I can do?"

The widow's veil brushed Martha's cheek. Martha's howls ceased abruptly. "You give me that sollow hat for my funeral?"

"Would it help? Of course you shall have it."

"Mother!" gasped the daughter.

"But think what she's lost, Edith. A baby!"

Martha cried no more. The salt spray took all the crisp daintiness out of the sorrow hat, but not the exultation out of Martha's soul. Susan had had three funerals, but never a sorrow hat.

But Susan's eyes were fixed on Christine's little coffin in the wheel-barrow. Never once did she raise them to the sorrow hat which perched precariously on top of Martha's thick hair and rocked in the breeze. Martha caught the flying streamers, tying them under her chin with an exaggerated jerk. But even then Susan did not see. She was crying for Martha.

"Oh, Martha, I so solly. I have pain in my heart for you. I lost lil babies. I know had bad it feel."

Hate burned in Martha's eyes. It was envy she wanted from Susan Dan, not pity.

The little procession straggled its way to the point where lay the cemetery, with its consecrated part for the baptized, presided over by the big white cross, and the heathen portion where Moon had erected a great carved Eagle. In solemn dignity the emblems faced each other. Not even the sorrow hat could sweeten Martha's bitterness when Christine, unbaptized, was placed among the heathen while Susan's three shaggy little graves lay across the line which the tangle of sweet briar and brambles tried to hide.

No more babies came to Martha. But they came and went in Susan's home with amazing rapidity, fluttering in and out, short-lived as butterflies. If it had not been for Tommy and Rosie, Susan could have not borne it. And as the number of little graves grew, Susan realized that only through Tommy could she mother a chief who might uphold the honour of the Eagle.

Martha was always among the first to witness these recurring humiliations of births and deaths. One fine spring morning she waddled as fast as her white woman's shoes and tight skirts would permit to Susan's home. Susan, lying in her bed upon the floor behind the stove, where she loved to have it, felt the floorboards quiver.

Martha's greedy eyes, blinded by the sunlight, searched anxiously until she saw the two tiny papoose cradles tipped up before the stove.

"Girls!" she gasped.

"Yes."

Martha gave a relieved sigh, and pushed among the other women. Susan

winced as Martha fingered the black hair of her babies. "Too bad! Too bad! You always get girls now, Susan. S'pose Tommy die. You got no boy left."

Susan closed her tired eyes. What was it that Moon had said about sparrows and eagles?

Susan's strength came back slowly. Even good-natured Dan grumbled. Twins were not lucky. They belonged to the supernatural world. He felt no great sorrow at their passing.

Martha saw them buried. But some of her bitterness at the number of Susan's consecrated graves was assuaged by the news she rushed to tell Susan. "Steven got a job in his father's sawmill. We go today. We got a house with thlee looms, and a sink and kitchen tap. Jacob and Paul go to school with white children. Too bad you not got white man for husband, Susan. Maybe good house with kitchen sink make you babies come stlonger."

"I like this Eagle place," Susan answered. "Sawmill make too much noise. White boy tease your Jacob and Paul because they stupid."

Martha bounced off the box like a kicked football. "Some day I make sollow for you, Susan Dan," she spluttered, as she bustled ponderously down to Steven's boat.

Susan watched her go. She was glad that Martha would not be present at the arrival of her eighteenth baby. That, too, was her first quick thought when only Johnny Paul came home from the fishing boat on which her Dan and five others had gone to the west coast. The bodies were not recovered. The next day Susan's dead baby was born.

In the years that followed, while Tommy grew into a keen-eyed lad, and Rosie into a sunbeam, a singing soft-eyed thrush, Susan's savings piled high in the secret box. As well as her cannery earnings and basket-making, there were her cherries. The children gathered them from the gnarled old tree before the cabin. In June her customers expected the gentle knock and smile, the "chelly come lipe now" as she held out the glistening fruit.

On Tommy's seventeenth birthday, after just such a trip, Susan and Rosie turned homeward laden with special parcels. "Tommy's eyes stick out like codfish's when he see the white-topped cake," and Rosie rubbed her pink cotton front in anticipation.

"Tommy plitty soon man now. When he come Chief, I make big feast for him."

"Mask dance, tom-toms, and—potlatch?" asked Rosie eagerly.

"Government say no, I say yes, for my Tommy. Long time now I work and save lots of money for my Tommy's potlatch. I got it safe in box under my bed. Lots, lots money."

They turned the last corner and looked for the smoke of Tommy's fire, which was to be ready to cook the birthday feast. Smoke there was but no house. Tommy rushed out from the little group.

"Mother, fire come from nowhere. I not got stove light. Nobody know where he come from."

Susan stumbled to the corner where her savings had been hoarded. She groped and found only ashes.

Chief Moon's kindly voice broke into the wails of women. "Cly no good, Susan. Eagle no cly. You Bludder Moon got big house. Got money for Tommy's potlatch too."

"You good man, Moon. But I like cly just little. Long time I work for make money for my own chief potlatch."

Moon's house was large, dim, peopled by the past. The big roof-beams were supported by massive carved house poles representing squatting bears, surmounted by eagles with outspread wings. The floor was of earth, smoothed and hardened by generations of naked dancing feet. Upon it burned the fire of driftwood, its smoke circling lazily to the hole in the roof. Low sleeping-platforms were built around the walls. A huge painted canoe occupied one corner, and Moon's carved cedar seat, without legs, was before the fire.

It was a happy house. In the autumn, when the people returned from the canneries, there was feasting and dancing. Susan, working again upon her baskets, was content. Even Martha's return to the village could not spoil the peace of that household. Feasting continued long that year, for the weather was mild. Indians travelled from other villages and Moon's house was always filled with guests and mirth.

Then, suddenly, a blast of bitter weather struck the village. Stoves were filled till they roared, clothing stuffed into broken windows. People walked blanket-shrouded and shivering. The cruel wind swept under shacks, darting up between floorboards like sharp knives. It shrieked around frail dwellings, tearing at them, wrenching shakes off the roofs, drifting fine snow under windows and doors. The one tap in the village froze so that the women, looking scarcely human in their wrappings, were forced to carry buckets to the creek and break the ice.

And then influenza, that most dreaded enemy of the Indian, seized its opportunity. Old and young were smitten. Haughty death stalked through the village pointing his finger now here, now there. Wind shrieked like hellish laughter. Snow and sleet churned to mud beneath the feet of the coffin-bearers. The people cowered low—broken, terrified.

Chief Moon was tireless in his efforts to help his people. With a blanket about his shoulders and his head swathed in mufflers, he went from house to house and back and forth to the Indian Agent, getting what help he could. Many he sheltered in his home. Tommy accompanied him everywhere.

Moon saw the anxiety in Susan's eyes. "Be blave. Our young chief must know the way of the Eagle."

Not for anything would Susan have restrained Tommy.

Martha, wearing the sorrow hat, saw her husband, Steven, laid among the heathen, and her greedy eyes sought the cross of the white man. Susan, bare-headed, stood by Rosie's grave, her eyes upon the big eagle, pitiful and imploring. To Moon's house came a dreadful silence. The flickering firelight cast fitful

shadows across the bears and eagles and lighted up the little group of silent watchers gathered about the fire. By Moon's bed was Martha—by Tommy's, Susan crouched.

It was Martha who came to tell Susan that Moon was dead. She peered closer. Tommy's head was cradled upon Susan's breast. Her arms encircled him. Her shawl was drawn across the face of *her* dead chief.

Martha went out quickly to find Jacob.

Spring with its insistent life brought no joy to Susan. Everywhere was warmth and sunshine and pulsing life. The swollen stream, freed from its frozen sleep upon the mountain, roared its way to the sea. Flocks of crows quarrelled on the tide flat. Swallows darted over the water. Buttercups and daisies rushed up to greet the sun. There seemed scarcely room for another blade of grass upon the bank. The village cattle were glutted. Leggy calves followed their mothers. Village dogs produced pups, no two resembling each other, or their mother. New babies cuddled their way into places that had been empty and aching since the influenza.

Spring and winter were all the same to the benumbed Susan, crouching in the low doorway, huddled inside her shawl. She stared out over the sea, scarcely aware of the village happenings. When Tommy died, she had said to the Eagle, "All my young life I tly to make chief for you. What for you not help me?" Her faith in his power was shaken. Her face turned away from him.

Martha made a grand feast for Jacob when he assumed his chieftainship, but angered the people by ignoring many of the old traditions. She selected a showy halfbreed for Jacob's wife. But Jacob, wishing to regain his people's favour, married a full-blood Indian from another village. The bride refused to have Martha live with them. So she lived in her old house above the cemetery, with Paul, whose squint eyes had grown so tired of looking at each other that they had gone blind.

With spring, Martha cast aside her sorrow hat with its dilapidated veil. The detour by which she escaped risking her bulk on the two-plank bridge brought her frequently past Susan's door.

"Hallo, Susan. I got big hully-up. I go get a fine tombstone for my Steven and Christine. My white fliend work on government load," Martha simpered coyly. "Tell me lots toulist come now new load finish. He like see ole time village and cemetely. I want my glaves look smart."

In spite of her "hully-up", she lowered herself onto a box, which proved unequal to the strain and collapsed, throwing Martha back into a dish of fish belonging to Susan's cat. "Oh! Oh!" she wailed. "Fish all in my hair! What for you not got chair for sit, Susan? Not ole lotten box. Too bad! Too bad!"

Susan rolled her over to free her from the box and helped her to her feet. Red and panting, Martha flipped herself with her "white-lady han'kelchief", a scrap of muslin, lace, scent, and dirt. With a fancy comb that held her hair, she combed out the fish, searching for a parting dart to hurl at Susan before she left.

"Now I go get stones," she bragged. "Too bad you got so many glaves, Susan. Nobody could buy stones for all you got. Toulist not see just glass glaves. Too bad! Too bad!"

Like the stinging swish of a whip, Martha's words brought life back into Susan. The limp hands clenched themselves into hard little fighting fists which she shook at the shapeless back of Martha.

"I show Martha who can buy tombstones for glaves. I show that jellyfish Martha. Maybe I show the Eagle too."

From the moment of her awakening Susan's life was one steady push towards a definite goal, with a double objective—the honouring of her children, the humiliating of Martha.

"Oo!" she chuckled as she pierced the tough cedar roots with her deer-bone stiletto. "Martha's house just above my glaves. Martha's eye got to see my eighteen tombstone." Without pause, without hurry, Susan worked steadily on.

A winter's basket-making, a summer at the cannery, a second winter, happy because her triumph was so close. Before Susan left for her second cannery season, she bargained for her stones.

Amos Hearne had moved from the city where rents were high and tombstones a luxury to the vicinity of the Indian reserve, where rents were low and tombstones a necessity. For an Indian will deny himself much in life to make a good showing after death. Since the flu epidemic, business had been excellent. Whistling and chipping, Amos did not hear Susan approach. She touched his arm.

"Hallo, Missus! What can I do for you?"

"How much this kind?" She smoothed the little white cross as if it were flesh and blood.

"Twenty dollars."

"How much for eighteen?"

Amos laid down his chisel and stared. "Say! You ain't a-goin' to start a tomb-shop, are you?"

"I got lots children in glaveyard: sixteen little one, two big one."

"Whew! Some family! Sixteen at twenty 'ud be three hundred and twenty dollars. I'll make it three hundred. One corpse goes deadhead, see?" Amos roared.

Susan supposed he meant dead-in-the-head, or lunatic. "He dead all over," she replied, so gently that Amos was ashamed, and wholeheartedly threw himself into her service.

"When d'you want 'em, Missus?"

"When cannely stop."

Susan struggled with the knots in her handkerchief, and Amos counted her savings—nearly enough to include the tall beauties she had selected for Tommy and Rosie.

Susan went to the cannery with the rest of the people. But she came home a

week earlier and went straight to Amos. High above struggle, sorrow, loss, she stood gazing in ecstasy at the little group of dazzling whiteness that was to commemorate her motherhood.

Amos was to put two words in black letters on each stone free. Licking his pencil, he prepared to make the list. "Can you remember all the names?" he queried.

They slipped from her tongue faster than he could write. Last of all, "Tommy Dan—Rosie Dan. I want gold words for these."

"Cost more."

"No matter."

After they were set in the hummocky grass, Susan lingered, straying from grave to grave, smoothing, patting, whispering the names of the children who had drifted away from her one by one. Now she saw them assembled. She leant against Tommy's stone, her finger tracing his gold words. Lovingly her arms stole about Rosie's stone. She kissed it. The cemetery was bathed in moonlight before she left, and as she opened her cabin door moonbeams glided in, flooding the little room. She left the door open, and the soft breezes whispering across the cemetery point were to her as the voices of her children. With daylight her dreams vanished, replaced by exultation at the chagrin she was about to cause Martha.

The boats came late. Martha squawked and flapped over the ooze like a winged duck, leaving deep footprints in the wet sand.

The people streamed up the bank, all talking at once. Susan could hear Martha's insistent voice, arguing with Jacob. They pointed first to Jacob's pole and then to the cemetery. "Jacob is telling her it is good to have so many fine stones for Eagle. Oh, he-he!" laughed Susan. "Martha heap mad! See her arms go flap-flap like seagull. She so mad an' so fat maybe she bust! Oh, he-he! Maybe I just a little solly for Martha. I wonder who tell it before people come." It was a bigger stir than even she had expected.

As Martha approached, Susan seized an unfinished basket and fell to work to steady herself. But instead of making the detour past Susan's door, Martha strode straight across the flimsy two planks to her own house.

The basket and Susan's jaw dropped. "Oh, what a mad Martha got!" she gasped. Then—"Maybe Martha sick." Snatching her shawl, Susan followed, and, as she climbed the bank, Martha's voice reached her.

"And, Paul, it is five hundred dollars they are giving Jacob for that ole eagle pole. Five hundred dollars for a ole good-for-nothing thing like that! Ha, ha!"

Susan's world went blank. She forgot her stones and her triumph and Martha. Moon's great Eagle, emblem of all that was finest in herself and her people, was to be sold.

"Martha! Martha! What you say? What you say about Moon's big Eagle?"

"He going for culiosity," Martha replied exultingly. "I make my Jacob sell for big money. Silly ole bird make toulist laugh at Injun."

"Cemetely eagle go too?" faltered Susan.

"Na! He too lotten. Nobody want ole bloke thing like that." She glanced

scornfully out of the window in his direction. There was a sizzling noise like hot fat. Her black eyes bulged and grew hard. "Where you get money for all those stone, Susan?"

But Susan was stumbling blindly down the bank to her cabin. She flung herself upon the floor as strangling sobs tore. "When my Tommy die I get big mad for Eagle," she moaned. "Now I shamed, I solly."

After the village lights were out she crept to the pole, laid her forehead on the Eagle's great foot, and, sobbing bitterly, declared anew her faith in his supernatural powers, and her love and allegiance to the noble crest of her forefathers.

Martha's life became unbearable. She heard the village women say, "Susan Dan a good woman and her poles are velly fine." Greed and envy ate into her soul. Every time she threw the water from her dishpan or hung out her washing, she saw Susan's stones, and saw the fingers of the tourists move as they counted them. She cut a new door in the back of her house among the trees and covered the window with sacking. It was no use. The eighteen tombstones haunted her night and day. Martha took blind Paul and went to live in another village.

As predicted, many tourists came. The Indians, resentful at first, found their basket trade good and ceased complaining to the Indian Agent about the intrusion. The Agent endured rather than gloried in his job; as long as the Indians did not bother him he did not bother them. When Susan Dan came into his office, opened a handkerchief bundle, displayed the broken remnants of a china grave-wreath, and said, "White boys make bloke in cemetely." He replied not unkindly, "That's too bad. What shall we do about it?"

"Get padlock and key for cemetely gate," she replied promptly.

"But tourists like to see the cemetery," he objected.

"Me keep key—me show," said Susan.

"Um . . ." Susan's aboriginal quaintness might be an attraction. "Where'd you stay so they could find you quick?"

"Shovel house."

"Go ahead. I'll get the lock and see that you are paid ten dollars a month for showing people around."

Next day Susan moved into the gravedigger's hut. A couple of feet of chain attached the iron gate to the cedar post. The padlock was enormous. The key was Susan's glory.

And so it fell that Horace Wragge, wealthy and somewhat eccentric tourist, faced Susan Dan, West Coast Indian, and asked permission to view the cemetery.

"Me Susan Dan—me show it."

"I have heard of you from others who have been here," he replied. Susan unlocked ceremoniously, opened and shut quickly, and led the way, clutching the big key.

The old part had its tattered wreckage of valued possessions. Clothing, baby buggies, gramophone, sewing-machines, and a few modern stones to the

unbaptized. Horace was much impressed by Moon's big Eagle. "Belong my bludder, Chief Moon." A note of pride rang in Susan's voice and remained there as, indicating the dividing line, she said, "The new fashion. Baptized people."

Horace read the queer mis-spelled wording on the stones and home-painted boards with interest.

Susan saved her corner to the last. With a free, sweeping gesture of the arm and shawl that had circled her babies in life, she indicated their graves. "Mine, all my children."

Horace counted. Eighteen—what a family! "Who put up all the stones?"

"Me."

For some moments Horace remained silent. Susan and this quiet spot and the eagle had cast a spell over him. Then he said, "Susan, I write stories for a big paper. I'd like to tell people about you and your children and the stones and the big eagle. Will you tell me about them? Were any of your sons Chief?"

The old longing to mother a chief swept over Susan Dan, engulfing her as the undergrowth had engulfed the baby graves. Summoning all the dramatic power of the Indian, she made a big, big story for Horace. Tommy as chief was all that she had imagined he would be. She wove every brave deed she had ever heard of or imagined about the lives of her children. Suddenly her eye fell on Moon's Eagle. Her voice faltered—softly, tenderly, she told of the "lil weak babies" who did not stop long even though "I cally evely day and put in the shadow of big Eagle to make them come stlong."

"It's a grand power that eagle has over you people," Horace told her. "I want to take another look at him." But Susan waited by the gate.

Horace wrote far into the night.

And Susan in the shovel house?

When night shut down, Susan's hell closed about her, gripping, tearing, scorching. Her thwarted ambition, repeated losses, even the giving up of Tommy and Rosie, had not equalled this. Those sorrows had numbed and deadened—this quickened, tortured. She had lied, stolen, made crooked talk against the Eagle, which, now that Horace had gone, she was powerless to recall. She had dishonoured her dead, and given Martha cause to laugh. In an agony of remorse she cried out aloud; the wind shrieked back, taunting her, and furiously shaking the ramshackle hut. Then in the cemetery a heavy, dull, horrible thud. Force of habit made Susan rush to the door. Always in trouble or fear she looked to the big Eagle for help. Save for the cross, the skyline was empty.

Morning broke calm and sunny. Horace wanted a basket for his wife and another gulp of atmosphere for his story. He would not have known this wild-eyed, broken Susan.

Pointing to the fallen Eagle, in a torrent of broken English her confession poured out. Then—beseechingly—"Give me the write? Oh, please!"

Reluctantly he handed her his manuscript, and watched it float in a million scraps from her brown hands, while tears of relief coursed down the deep wrin-

kles and fell. Running to her hut, she brought her best basket and laid it at his feet. Rather embarrassed, Horace suggested, "Shall we lift up the eagle?" Susan shook her head. "No can. He ole and bloke."

Then an idea was born in the brain of Horace Wragge which completely changed the life of Susan Dan. "Say, Susan Dan, it was sporting of you to own up. You are a peach of an eagle. Tell you what's going to happen. Right there in the middle of your stones, I'm going to erect a fine motherish one for you. You won't need it for a long time, I hope, but it will be there."

Amazement, joy, and pride rippled in quick succession over the tired old face. Then suddenly—"Will there be words?"

"Sure, what shall they be?"

"Write, 'Susan Dan was the mother of sixteen lil weak babies, one big girl, and one boy nearly come Chief.' . . . And put, 'Susan Dan tol one big lie.'" Susan had atoned. The tourists—even Martha—might laugh. What matter— she was right with the Eagle.

Amos Hearne had one bad debt. The Mayor's wife had ordered a tombstone for her dead husband. Before it was finished, she herself died. Standing there, unclaimed and unpaid for, it had been deeply coveted by his Indian patrons. Horace saw it placed among Susan's stones. Not for worlds would he have deprived Susan of the comfort of her atonement. Beneath her own words he wrote:

Beloved and honoured by Indian and white people
Erected by her friend Horace Wragge

In a far-off village, Martha shook blind Paul from a sound sleep. "Paul! Paul! Susan got the Mayor's tombstone! Injun come tell it. I go see for my own eye."

Susan was not aware of Martha's coming, did not see her creep in by her back door and pull aside the dust-rotted sacking. "Ah! Too bad!" she groaned. "All that gold write and the Mayor's tombstone just for ole Susan Dan!" She would not ask Susan to unlock, but cut a hole in the wire fencing among the trees, crawling through after dark. Thorns and brambles tore her, but she reached the stone, and turning her flashlight, fingered and counted the gold words she could not read. Then stole away.

Creeping stealthily in the shadow of the great Eagle, Martha's foot caught under the brace, and she sprawled at the foot of the great symbol she had dishonoured. Her torch rolled away. In a panic of pain and terror she screamed.

"Ow! Ow! Too bad! Too bad!"

Susan's key grated in the lock.

"Oh, Susan! Eagle make black shadow. I fall down. I all bloke. Too bad! Too bad!"

THE HULLY-UP PAPER

THERE WAS TROUBLE at Bessy's. Jimmy Jacob brought the yellow "hully-up paper" the last lap of its journey by canoe. His lean, brown hand put it into the hand of Jenny Smith, which was plump and old—also Indian.

It was the first wire Jenny had ever seen.

Having delivered the paper, Jimmy Jacob sprawled upon the wide uneven planks in front of Jenny's door, settled his back against the cedar shake wall, and gave himself up to the sun and to his pipe.

Jenny looked at the wire with slow wonder. "What's it say, Jimmy Jacob?" she asked.

"Some trouble come your Bessy. You got to go quick hully-up," he said.

"Who tole you?"

"Letter-house woman say," replied Jimmy.

Jenny bent. They held the wire between them, upside down, scanning the words they could not read. Jimmy had spoken their meaning in English because they were written so. Jenny, having married white, spoke white from habit.

Jenny put her wire back in its envelope and looked a long moment at the splendid typed address: "Mrs. Jenny Smith, Mussel Creek." She was very proud of her name; it was the only thing she knew in print. Her white husband had taught her that.

A white girl may adore her "Smith" husband, but it is safe to say she is not crazy over the name "Smith". Jenny had both loved her husband and gloried in his name. It was infinitely finer to be "Mrs. Jenny Smith" than to have her name hitched to an Indian man's and be "Jenny Joe" or "Jenny Tom".

Her pride changed swiftly to anxiety. There was trouble at Bessy Joe's.

Bessy Joe was Jenny's only child and a bitter disappointment. She had longed to see the blue eyes of John Smith reproduced in her baby, but Bessy was all Indian, dark and strong like her mother.

Jenny had given the child a white name, had insisted that English be spoken in the home, and hoped Bessy would marry white. Bessy had married "Charlie Joe, the Indian", and gone to his people. Her children would be all Indian too. This, and John Smith's death, had swept Jenny's life clean of joy.

But now trouble had come to Bessy, and the love that had congealed during the three years of Bessy's married life poured molten-hot into her mother's heart.

She buttoned the yellow slip under her dress-front, knotted the few bits of food that were in the cupboard into a handkerchief, turned the cat and fowls out to shift for themselves, and took her shawl from the peg. "Get up," she said, prodding Jimmy Jacob in the ribs. "Paper say 'hully up'."

No breath was wasted in words as they tramped over the half-mile of brush trail that led to the spot where Jimmy's canoe was beached.

She joined her weight to Jimmy's. The canoe crunched gravel and met the waves. Kicking off her shoes, Jenny tossed them into the canoe and waded into the icy water holding her full skirts high till she was safely settled in the stern; then she tucked the folds of pink calico about her, brought her arms up above her shawl, and, with a dexterous twist, bound it about her body.

Dip—dip—dip! The paddles cut the water, hers keeping Jimmy's up to time. The breeze fluttered the handkerchief that bound Jenny's head, Jimmy's old felt was jammed down hard. Jenny's every thought was dulled—all but one, the one buttoned up on her bosom.

The canoe shot across the leaping waves; Jenny gave herself to them—they were carrying her to Bessy. Her eyes, soft and motherly, gazed straight ahead as though they would bore through the darkening night into the very heart of her child's trouble.

There was velvety blackness under the wharf when they reached the perpendicular fish-ladder at Hardy Bay. Jenny shook the drops from her paddle, grasped the slimy green rungs, and climbed doggedly towards the dim lantern dangling over the edge. She was not young. The ladder wrenched her rheumatic joints, but she said, "I got to, some trouble has come to my Bessy."

The journey from Jenny's home to the village where Bessy Joe lived was tedious rather than long: a canoe trip—a wait—a drive through virgin forest—a wait—the little gas mail-boat up Quatsino Inlet, passing but not pausing at the village of Koskimo where Bessy lived. There was more waiting than going but Jenny took the waiting as part of the going, and the only way to reach Bessy.

Her broad figure, framed in the doorway of the Hardy Bay store, left little empty space. "That boat for Quatsino—when she come?" she asked. A black silhouette against the coal-oil lamp, with shadow hands weighing things into paper bags, replied, "Tomorrow afternoon."

Jenny skirted the wharf to a straggle of huts squatted above high-water line. She opened a door without ceremony and exchanged a greeting in the Indian tongue. They gave her a corner and a mattress. She ate, drew her shawl about her, and slept—deep, quiet, Indian sleep.

Hurry in the morning was useless. The bus did not go till the steamer came. It only seated six or seven. Many men went through to Port Alice. There was little chance of a seat for Jenny. She negotiated with the Indians to take her in their springless wagon. Perched heavily on a plank across the back and clinging desperately to the seat in front of her, Jenny rumbled through the forest road, her

flesh wobbling with every jolt. Eventually the wagon drew up at the little float where the gas-boat lay moored.

Hour after hour Jenny squatted by the shed, hugging her knees, stolidly waiting. Night had come again before the little mail-boat chugged up the inlet. The water had an oily black smoothness, with treacherous little eddies and whirlpools here and there. Mountain peaks on either side of the inlet stuck up like jagged teeth. When they passed Koskimo, the village was all in darkness.

It was late when they tied up at Quatsino. Jenny took shelter among a pile of oil-barrels, crouching between them and taking what rest she could. She was grateful to the sun when he rose and warmed her cold, stiff body. As soon as whiffs of smoke trembled from the cabin stovepipes, she got up and made her way to a half-breed who owned a canoe. "No good going to Koskimo, old woman," he told her. "The village is empty, everybody gone to the canneries."

Jenny shook her head. "My Bessy stop," she insisted. "She send me hully-up letter, she got trouble."

The man shrugged.

Swiftly, steadily, the canoe doubled back through the inlet to Koskimo. From house to house went Jenny, peeping through blindless windows into disorderly vacancy. "Bessy! My Bessy! she called, but there was no answer. The staring eyes of the big carved eagle on top of the totem pole told nothing. Jenny wrapped the wooden nose of the great squatting bear outside Chief Tom's house impatiently, as if she thought he could tell if he would. The image of D'Sonoqua, the wild woman of the woods, was there too, staring from vast eyeless sockets. Doors were padlocked. Stinging nettles grew high. Jenny had to beat them down before she could look through the windows. The bruised stems gave forth a rank odour. A few cats, lean and shrinking, and a speckled hen were the only living things in the village.

The last cabin in the straggling row had no padlock. There was a blind which was not drawn. Jenny opened the door and entered. All was orderly, the bed neatly made. On the floor were a woman's basket materials and a basket half-woven, lying there as if the worker had just gone. Yet the little pan in which the weaver moistens her strands was empty and rusted. On the stove stood a frypan containing a dried-up fish, and there was a cup stained with tea.

Jenny sat down on the cedar mat beside the unfinished basket, and closed her fingers tenderly over something. It was the knife John Smith had given the little Bessy when she made her first basket; later Charlie Joe had carved her name on the handle. Perhaps Bessy was hiding like she used to long ago. "Bessy!" she called softly. "Me come to help your trouble." But she knew that no human being was there, nor had been for many a day.

Jenny got up. "Who send me that hully-up paper? I dunno. My Bessy know I can't read and I got no one to say it for me." She came out onto the board walk. Turning, she closed the door and waddled down to her canoe.

Two miles further up the inlet was another village. "I dunno—I dunno," her paddle seemed to say as she made her way there.

The second village was almost as empty as Koskimo. There was an old couple there, but they had few wits and scarcely any hearing between them. One on either side of her, Jenny screamed into each of the four ears in turn to try and get a hearing. At last she found that she could dimly penetrate the woman's left ear.

She learned that Bessy had not gone to the cannery with Charlie Joe and the others, but had remained in the village to care for Charlie's infirm old mother. One night a gas-boat passed, going to Koskimo. Soon it returned. Two men came ashore in a small boat. They lifted Charlie Joe's mother from the boat and carried her to the hut of this old couple. They left some money and bade them care for her; said they would come back soon and see about her; said also that Bessy Joe was out in the gas-boat, and that she was going away with them. That was all the old deaf couple knew. They did what they could for the sick mother, but she died two days later, just before the men returned. They took her body away.

Jenny Smith's heart, new-melted with love towards her daughter in trouble, froze harder than ever before. Under the pretext of caring for her mother-in-law, Bessy had let her man go to the cannery alone, and then she had gone off with white men. Bad girls did that. Bessy had disappointed her mother in that she was too Indian; but Jenny had never suspected that Bessy was bad.

Weary and heart-sick, she paddled back to Quatsino, returned the canoe, then took the gas-boat back to Hardy Bay. "I got no more child," she moaned. "I tell Jimmy Jacob, 'Take me home—I want forget Bessy Joe.'"

But Jimmy Jacob was drunk and safely hidden away. So Jenny was forced to wait at Hardy Bay till he sobered. She slumped down on the boardwalk outside the post-office, a faded bundle of dumb misery.

The postmistress came to the door, shaded her eyes with her hand, and looked across the water to see if the southbound steamer was in sight. She saw Jenny. "Did you get your wire?" she asked.

The huddled figure straightened. "Who send me that hully-up paper and fool me?" she asked angrily.

"Don't you know?" replied the woman. "Haven't you been to her?"

"Jimmy Jacob tell the paper say hully-up quick, my Bessy got trouble. I hully, hully. I never stop. That paper fool me. Bessy not there. She quit Charlie Joe. Bessy gone with bad white mans," she added miserably.

"Dear soul!" gasped the woman. "You don't know what happened? I'll tell you. Bessy didn't go to the cannery with Charlie Joe, she stayed behind to care for Charlie Joe's old mother. Then there was an accident at the cannery. Charlie Joe was caught in the machinery and horribly torn. The cannery manager sent at once for Bessy, but Charlie died before she got there. Bessie loved her man. She insisted on seeing his mutilated body. After that she was hurried unconscious to the Alert Bay hospital. Ten days ago her life was despaired of. The hospital wired her mother to come at once. Jimmy Jacob was despatched with the wire from Hardy Bay, but Jimmy got drunk and was discovered days later on

the beach with the wire still in his pocket, was severely reprimanded and sent forward again."

Ten days ago! Jenny sat stupidly staring. From across the water came a gruff "toot". The postmistress stooped and put a gentle hand under the old woman's arm. "Come," she said, "the boat is here. You may be in time yet."

Jenny scrambled up and broke into a loose waddling gait, jostling against the scant population of Hardy Bay, intent on the one thing they all had in common, meeting the boat. The gangplank rattled as she took it on the run, desperately intent on reaching Alert Bay and Bessy.

In a quiet corner between decks the sobbing heave of her haste subsided. She knew now what Bessy's trouble was—knew also that ten days ago Bessy was near death. Perhaps now Bessy's trouble was finished.

Carrying her shoes that she might walk quicker, she covered the mile from wharf to hospital with amazing rapidity. At sight of the building, her haste slackened to a crawl. Sinking on the lowest step, she drew her shawl across her face.

"You wanted something?" asked a nurse coming to the door. The trembling lips could scarcely frame the words, "My Bessy?"

"Bessy Joe? Are you her mother? She's fine now, but how she has cried because you were mad and wouldn't come when we wired!"

Dumb and shamed, Jenny stood beside the little white bed, knowing how she had wronged her child. Bessy's great brown eyes, watching her mother's face, did not read it right.

"Mother, you not be mad any more for me and Charlie Joe. Charlie Joe dead."

The bent head, with its heavy black hair bound by the gay handkerchief, shook vehemently, vibrating the chin and worn flabby cheeks. "My Bessy," whispered the tired old voice. "You got big trouble for Charlie Joe, and I got trouble too for Charlie Joe. Too bad! Too bad!"

Bessy laid a pleading little hand, blanched by weakness, on her mother's brown one. "Mother, you will love Charlie Joe's little Injun baby?" she asked, drawing down the sheet.

The child had Indian hair and was brown and swarthy like his parents. The old thought stabbed at Jenny's heart. If Bessie had married white, her child would have been three parts white.

Keeping her eyes steadfastly on her mother's face, Bessy roused the baby. With a strangling gasp, the new-made grandmother folded her arms tight across her breast, as if something there were too big to hold without support—for Charlie Joe's Injun baby opened eyes blue as those of his grandfather, John Smith.

Jimmy Jacob, sitting beside his canoe on the beach, sad and sober, received a painful jab on the shoulder-blade. "Get up," said Jenny Smith. "My Bessy and me and Charlie Joe Smith want to go home."

"Huh!" grunted Jimmy Jacob. "You always got hully-up, Jenny Smith."

LILIES

IT WAS NOON. Save for an attendant or two, the flowers had the great building to themselves. Exquisite hothouse "exotics" stared at wholesome "garden blooms" and claimed no kinship, but the perfume mingled without snobbery, and the smell of the flowershow was one smell, immense, magnificent.

Tyler's lily exhibit occupied the centre of the great hall. Tyler specialized in lilies. Tyler's Madonna lilies filled the churches at Easter. Potted Madonnas, carefully swathed in transparent wrappings, were exchanged with Easter greetings, or soothed invalids, or decorated graves.

This show, Tyler had outdone himself. In a glorious mass of shining white, the mount of blossoms towered, up, up, into the dazzling light under the great glass dome. So "unearthly lovely" were they that people caught their breath and held it, as if they could not let the delight of their perfume go; while the white purity of the lilies held their tongues silent.

Mr. Tyler's only son Nat was in charge of the exhibit. The hot heavy air sent him dozing. Were those footsteps dream or reality? His own neatly shod feet dropped from the flowerpot. The legs of his chair settled squarely, but he did not open his eyes. Time enough to offer the catalogue when the bombardment of superlatives began.

Silence—then a long-drawn quivering "Oh!"

Nat's eyes opened. A substantial motherly woman was gazing up at the blooms with shining, worshipful eyes. Beside her stood an undersized girl, wide-mouthed, red-haired, freckled, looking, not at the flowers, but at the woman.

"You do love lilies, Ma!"

"Yes, Janie, there ain't nothin' hits me so hard as Madonnas."

Nat stepped forward with his catalogue.

"No, thanks," said the girl. "We can't afford to buy, and Ma likes looking better than print. She's dreadful fond of lilies." Her smile was in her mother's pleasure, not for Nat. She turned to the woman. "Lil's gone to see the peonies, she don't care much about her name-flower. Says they make her head ache. Say, Ma, why'd you call her Lily Madonna?"

"She were my first, Janie, and she were so lovely, seemed like it were the best I could do for her."

"Why didn't you call me Tiger after the speckled kind?"

"You was Pa's namin'. He says, 'She's Jane.' 'For who?' says I. 'Aunt o' mine

and a good woman,' says Pa. So Jane you be."

Before Nat's eyes swam the corner of his father's nursery garden, where a riot of speckled faces, under upcurling crimson petals, sprang up each year, unsown, uncultivated, growing for the sheer joy of life. He did not give the girl a second glance, because Lily Madonna was crossing the hall to join her people. When anyone's eyes fell on Lily Madonna they stayed there. Tall, slim, gold and white, no wonder Ma had named her so. All the superlatives folk showered on "Tyler's Madonnas" shrivelled to commonplace before Ma's Lily Madonna.

"Well, Ma, so you found all the other 'Me's'? Whew! how they smell!" Her quick glance took in Nat's well-set figure, the nice colour of his suit and tie; she did not notice the colour of his eyes, it was only what the eyes told her about herself that interested her. Lily used people as mirrors. Suddenly a pair of small useless hands fluttered out, catching at the end of the stall. "Oh—" she said, and closed her eyes, "oh—the perfume makes me—"

Nat rushed and brought his chair. Faintly smiling, Lily Madonna sank into it.

Jane turned. "Got any water, mister? Or can I tip some out of this vase?"

At the suggestion Lily gasped a little and straightened. "I'm all right now."

"Course you are. Get up and let Ma have the chair. She's tired and will want a long spell with her lilies." She tilted the lovely one out, and planted the seat squarely beneath her mother.

"Huh, old girl," was Nat's mute comment, "you sure should have tagged your other girl 'Tiger'."

Lily had no further return of faintness during the hour that Ma worshipped and Nat's pleasant voice poured the contents of the catalogue, from orchids to parsley, into her dainty roseleaf ear.

When at parting he put the catalogue into her hand, his fingers touched her fingers—his eyes met her eyes. That night, and for many nights, Ma Bunday, and Nat Tyler, dreamt of Madonnas, while Lily Madonna dreamed of the things Nat's eyes had said, and of how she could get another peep into them. Ah!—Ma's birthday was coming soon; she saw a way in which it could be arranged.

Lily was the only member of the Bunday family who ever had any spending money.

The Bundays lived in a mean little row of workingmen's houses, hooked together like a line of more or less dirty-faced children climbing Harry Hill hand in hand. The Bundays' house was a "middle child", and had a clean face. The late Pa Bunday's insurance barely covered the rent. Jane baked and washed and mended for the family of the overdriven Mrs. Swatt, and received inadequate pay at irregular intervals—when Mr. Swatt worked. Lily went every morning to sit beside a wealthy invalid who had servants in plenty but who employed the girl solely for the delight she had in her exquisite beauty. To watch the movement of Lily Madonna's lips as she read, or her rosy fingers playing hide-and-seek in some fine bit of lace she was mending—the shadow of long lashes on her cheek, the glints of gold in the glory of her hair—these were tonic to the invalid. Lily's money was easy-earned. On Saturdays she turned it over to Ma, knowing

well that Ma's right hand would receive it, with a "Good girl, Lily Madonna," and Ma's left hand would slip back a generous coin for the girl's own spending. Moreover, Lily's invalid liked her tonic in attractive wrappings. She delighted in planning and giving her favourite pretty clothes. So Lily tripped up Harry Hill in raiment white and shining as her name-flower, while Jane trudged down to Swatts' in dark print with an apron of stout unbleached under her arm. Ma, standing on the pavement in front of the door, pressed reverent lips to the brow of her lovely daughter, but gathered Jane in motherly arms and slapped a kiss among the freckles. Together they would watch Lily flittering up the hill and Ma would say, "How'd anything so marvellous beautiful come to me, Jane, when Pa and me and you be so ordinary-faced?"

And Jane would reply, "Dunno, Ma. Maybe she broke loose from Heaven, or maybe your naming her after the lilies had something to do with it." Then Ma would say, "You're powerful comfortin', Janie," and little freckle-faced Jane would run down the hill with her wide mouth wider, and Ma would mount the three steps, pass through the parlour, drop another step into the kitchen, and two more into the garden, where her stunted cabbages and onions sat in melancholy rows.

"Hearten, me dears," she would say to them, "it's a grand slop o' suds I'll be givin' ye come washday." But neither dishwater nor wash suds could cheer vegetables and flowers starving in the impoverished soil that generation of cabbages and onions before them had depleted. For tenants do not fertilize other folk's ground, or perhaps, like Mrs. Bunday, were too poor to do so.

The Bundays' house consisted of a parlour and a kitchen, with a steep, black little stair squeezing in between, which led to an attic bedroom. When Ma breasted the stair squarely, her right arm touched one wall, her left arm the other, and the pinched steps squeaked under each footfall. Mrs. Bunday and Lily shared the big bed in the attic room. Jane had a cot in the corner. When, like today, it was hot, the attic was *very* hot.

Jane had done a big washing. She was sprawled on her bed resting. "What's up?" she exclaimed, as she saw Lily slip out of a dainty dress and lay a daintier one on the bed ready for use.

Lily Madonna took out the pins and shook hair like sunshine over her face and shoulders. "Brush it for me, Janie," she coaxed, "and I'll tell you."

When the long strokes were sweeping through the glory of Lily's hair, Jane said, "Well?"

"I'm going up to Tyler's nursery and get some Madonna bulbs for Ma's birthday."

Jane stopped brushing. "Oh, Lil! How splendid! How perfectly splen—" She choked a little because Ma Swatt had not been working. She had no present for Ma.

"I suppose you couldn't—lend? I'll pay back as soon as Mr. Swatt gets his job."

"Sorry, Jane. Bulbs, show, cake will take all there is." Lily put on her shiniest and went out.

Jane wanted to cry: sniffed twice, jumped up, got Lily's catalogue and read: "'Madonnas . . . greedy feeders . . . require rich ground . . . plenty manure.' Poor Ma. Oh poor, poor Ma! It would almost be better if she did not have them."

"Janie! Run up to Dyatts' farm and get the eggs, will ye?" Seemed like the little stair loved to do something for Ma. If it couldn't squeak under her foot it echoed her voice softly.

"I'll go, Ma," was Jane's quick response. As she climbed Harry Hill she said, over and over, "Greedy feeders—rich soil—manure."

Mr. Dyatt was in his lower field, and he was spreading manure.

"Good day, Mr. Dyatt. How is Mrs. Dyatt?"

"Porely, Jane, very porely. Seems she don't hearten none between washdays."

Jane looked out across the rich field. The light in her brown eyes was mellow as the sun on the soil. "Mr. Dyatt, how many washes do you reckon would pay for a load of manure?"

"A load of manure? Nobody hereabouts buys manure. Folks takes and takes and takes the very vitals from the soil, but they don't put nothin' back, they just moves on."

"I'll do Mrs. Dyatt three washings for a load. That will give her a chance to hearten a bit."

Having clinched her bargain, Jane came singing down the hill with the egg-basket on her arm and overtook a radiant Lily. Old Tyler had appreciated Nat's telling of the woman who called her beautiful child for the lilies that were the pride of his heart. That and Lily's face won for her a grand bulb bargain, and Nat had shown her over the greenhouses and the gardens. When she paused for breath in the recital of her doings, Jane said:

"I got a present for Ma too."

"Where'd you get the money? What is it?"

"Didn't get money, traded washings. It's bigger and usefuller and smellier than your present. You'll see when it comes."

Ma's birthday was one grand day. Mrs. Bunday held the little bulbs between her palms. "Oh, Lily Madonna! I never thought as how I'd ever have any of my very own in this world. I thought Madonna lilies was only for the rich. Oh to sum all the power, and growth, and beauty, and smell, tied up in the wee things!" She laid her cheek down against the little white bulbs, realizing them into maturity and blossom. "Oh deary me, oh deary, deary me, if our soil was only a mite richer for the poor dears!"

Jane jumped up. "I'll be back from Dyatts' washtubs at noon, Ma. My present will be coming then. Here's on account," and she gave Ma a kiss for each of her years.

They had hardly finished their noon dinner of pork and the least emaciated of Ma's cabbages when Jane jumped up, exclaiming, "I can hear your present coming, Ma!" Dyatt's wagon rumbled up. Dyatt removed a bar, and Jane's hard-earned gift tumbled over the pavement.

"My liles! My lilies! Oh, what a dear thought, Janie! An' the pore cabbages an'

the onions too! It's beautiful to think of what my garden will be!" Tears stood in Ma's eyes.

"I call it *utterly filthy* and *disgusting*!" cried Lily, behind her handkerchief. "An insult to the street! It shames and disgusts and sickens me!"

"No, no, Lily," said Ma gently. "It be the very wholesomeness of the beauty—it be for nourishin'." Suddenly Ma's jaw dropped. "But—but, Janie— how ever's it to be toted back, when there ain't no through way?"

"All fixed with the fairies, Ma," laughed Jane, her nose mocking Lily's offended one. "You toddle off to the show with Ma, Lil. Your smeller, your eye, and your help aren't needed here."

Alone, Jane wasted no time. Ma's presents had a date in the back yard. There was only one way. Decked out in her worst, with Pa's old whitewash-spattered hat jammed down over her red hair, and armed with two buckets and a shovel, Jane attacked.

"Luck that the back door is smack opposite the front," she commented as she paved the direct route with newspaper.

Soon her young body was swaying to the rhythm. "Four shovels—lift— mount three—pace eight. Drop one—pace six—drop two—*dump*!" Over and over the process repeated itself. The pile sank slowly. The girl's arms ached.

"Does Miss Lily Bunday live here?" Nat addressed Pa's hat, bobbing behind the manure pile.

"One, two, three, four. She does, and she's out. One, two, three, four." The buckets lifted.

Nat held a dainty scarf out, tenderly, as if the precious thing were breakable. "She left this at the nursery."

"She would. Just chuck it inside, will you? I'm pressed." Without pause Jane paced the newspaper path, dumped, returned, set her buckets down with a clank, pushed Pa's hat back, and ran her fingers through her damp red hair. "Whew!" She straightened her tired back. Suddenly her eyes popped. On Ma's work-table lay a dainty florist's parcel, and the smell of lilies wrestled with the smell of manure.

"Oh," she said. "For Ma? Oh, oh, won't she just—!"

"My father sent them," stammered Nat. "Miss Lily said it was your mother's birthday, and I saw at the show how she loved lilies."

"What a birthday—bulbs, and manure, and now these!" Her freckled hands halted in the middle of a clap. "What you doing?"

Nat had taken off his coat and was rolling up his sleeves. He grinned down at her. "Got another shovel, and some more pails?"

"Oh, no, please dress up again, Mr. Tyler, I really couldn't let you—it's my job. My present to Ma."

Nat's determination could not be shifted. So Jane insisted on Pa's overalls, and without further argument they fell to work, wasting no time on chatter. Soon Nat had fallen into the swing of "four shovels—lift—mount three—pace eight—drop one—pace six—drop two—*dump*".

When the rich odoriferous pile was in the back, and Jane was folding the

papers and Nat brooming the pavement, and the bobbing hats of Ma and Lily had just come in sight, Jane smiled up into Nat's face. "I'd never have got through till Christmas, without your help." Flushed and smiling, she looked *almost* pretty. Then Lily came, and was wholly beautiful. "How could Jane let you?" she said, but her eyes added, "I am glad she kept you for me."

Then followed tea and birthday cake, and laughter, and lovemaking. The glowing loveliness of Lily Madonna. Nat's lilies filling the house with delicious sweetness. And Ma, the birthday queen, sitting before them, yet not there at all, but out, out in the lily world, carried there by their purity and shine. Perhaps something in the emptiness of Pa's overalls, hanging on the kitchen wall, made Nat say, "I'm coming to dig the manure in for you—Ma," and blush, and say, "Good night, Mrs. Bunday," and blush again, happily, when strong motherly hands fell on his shoulders, and Ma said, "Thank you, Nat. Good night, my boy."

Old Tyler, sitting up for the boy he both fathered and mothered, saw that in Nat's eyes which made the face of Lily Madonna play hide-and-seek among the blooms in his greenhouses all night.

When the moonbeams back on Harry Hill lay still and white across the eyelids of Lily Madonna, Ma crept down the squeaky stair. In the quiet dark of the room below, the lilies were a vague blur. Ma drew a deep breath, lifted the best vase, and carried the flowers upstairs. "Sleepin' noses don't smell, Janie," she whispered as she passed the cot.

"I'm glad you brought them, Ma. Good night."

The grey head bent close to the red one. "The boy's clean gone on our Lily, Jane. Would any young man shovel manure his half day, just to get a glint of a girl, if he wasn't deep in?"

"No, Ma." Oh, kind moon that did not poke into the corner and show Jane's face.

Nat was budder and grafter for his father. This year the budding was not as successful as usual. Often Mr. Tyler surprised Lily seated on a box close to Nat in the long cool nursery rows.

Old Tyler shook his head. "The girl's too ornamental and the boy's too young," said he, and shipped Nat off to Agricultural College. He called on Mrs. Bunday. "A year apart won't do that young pair no harm, marm. It'll show them where they're at. Ho-hum, tadpoles will turn into frogs. It's lonesome without the boy, and—drat it!—there's the budding. Why can't tadpoles stay tadpoles? Pest 'em!"

Next day a freckled little person stood in Tyler's nursery, and, looking Mr. Tyler straight in eyes that till this moment had been unaware of her existence, said, "Mr. Tyler, do you think that I could learn to bud? Ma says I'm tolerable tidy-fingered."

"Then I believe you could," returned the old man, and he enjoyed teaching Jane, she was so quick and deft. Before long she was employed at the nursery earning a good wage.

"I'd sooner you did not tell Nat," she said to Lily, who wrote every Sunday,

covering the sheet slowly, and looking here and there as if trying to scare up news. Mr. Tyler for reasons of his own did not tell Nat either about his new budder.

The year slipped quietly by. Lily's invalid was growing weaker, more irritable; Lily's money was not easily earned now, and she was required most afternoons now as well as the mornings, to amuse and soothe her employer. Some Sundays she complained of being tired and did not write. Ma saw the look of hungry indignation on Jane's face the first time Nat's letter lay unopened for two days.

Ma's figure folded and unfolded like a huge accordion, as she bent and straightened over her garden. In a little round bed all to themselves, the lilies were blooming. Mr. Tyler had been to see them and pronounced them fine as his own. The cabbages were firm and round, the pumpkins plumping, the third crop of radishes trying to keep their blushes underground and not succeeding. Roots, bulbs, and cuttings found their way to Ma's garden through the kindness of Mr. Tyler.

"Give up, Ma, let the weeds and cutworms have a mite of a rest," called Jane. "Come away, I've made you a cup of tea." Jane had a half-day. Lily was with her invalid. The parlour was quiet and cool. Ma sank into her chair prepared to enjoy her rest and her tea.

Suddenly a whirl of white in the sunshine of the open door. "Oh, Ma! Oh, Jane! I'm married!" Lily burst into the little parlour, and, with a frightened cry, hurled herself into her mother's arms in a passion of wild hysterical weeping.

A swift look of hurt swept across Ma's face, even as her tears fell and her hands patted her lovely one. Her child, who had never been known to distort her face by crying.

Smash went the tray of china, and the tea Jane was setting before her mother. Nat's unopened letter lay on top of the family Bible. Jane longed to snatch it to her bosom. Instead, she seized the broom from the kitchen door and swept the food and the china and herself in a broken jumble down into the kitchen, and shut the door. The coal-scuttle was nearest; she sat down upon the coal and rocked herself to and fro. Lily married! Nat coming tomorrow! Poor, poor, Nat. "Jane, Jane," she cried. "Of course you're sorry for Nat. Nat that loves Lily so. He'll never come here again. He'll never want to see the beastly Bundays again." Then she jumped up from the scuttle, her spine taut. She shook the stinging salt tears from her face. "Maybe it's Nat Lil has married!" she gasped. "Lil said he was coming the end of the week and this is Friday. I must know! I *must!*"

She stuck her head under the tap. The roller screeched as she tugged her towel down and buried her face in the coarse crash. Bursting open the parlour door—"Lily!" she demanded. "Who did you marry?"

Lily did not look married at all, lying there in Ma's lap like a baby. She and Ma were both smiling.

"Janie, Janie! I forgot!" Lily sprang out of Ma's arms and ran to the Bible. From on top, and beneath, and between the leaves, she took Nat's unopened letters. "They're yours, Jane, all yours. Nat sent them that way to help me keep

the secret. I dassn't tell, because of her being so sick, and wanting her folks to think I was safe because I was engaged to Nat. Nat and I never were loves, Jane. It was only my face and those pesky flowers got in the way, just at first. Everything I wrote him was about you, only I did not tell about the budding because you said not to." Lily stopped for breath, and Ma took up the story.

"You see, Lily's invalid ain't got long, Jane, an' nobody dassn't vex her. Them gawpin' relatives was snoopin' round tryin' to fix a match between her son and his cousin. An' all the while he an' our Lily was lovin' these many months. Which his ma let her tell Nat, on the swear of 'em both it wasn't to go no further. Today the sick woman asks for parson, and the relatives, thinkin' the pore soul's dyin', snivels proper. And in comes Lily in her prettiest, and there's Joe an' the ring poppin' out of his pocket, an' it's done." Ma caught her breath, and on a quick gasp, with a beam that signified this was the crux of matrimony, she added, "They love *true*, Janie. An'—an' everybody's free—free for lovin'."

With her letters clutched tight to her breast, like a humming-bird on the wing, Jane swooped and delivered a kiss on Ma's cheek and one on Lily's, then darted up to the attic on a wide golden stair of joy.

"Goodness!" exclaimed Lily Madonna. "Am I me, or a lily, or a crocus, or— or Mrs. Joseph Haldean? And here is Joe, so I must be her." And she began to preen and straighten like a wonderful bird.

Mr. Tyler read the births, deaths, and marriages; folded the paper and groaned between every gulp of coffee. "Poor boy! Poor boy! But better he should know the cream wa'n't solid right through than pine off later on skim. If only he had chose the one with the heart, now, instead of the one with the face! Well, we'll see. Step soft, Dad Tyler; hearts is touch an' go."

The old man's meditations were shattered by a shouting and stamping, and a hilarious Nat burst in. "Hello, Dad! No, don't bother draping your napkin over the paper, I read it on the train. Any coffee left?" He drank it steaming hot, holding the cup high, and crying, "Good luck to the bride!"

"How are the show blooms, Dad? Madonnas shaping well?"

"Right enough. I'm not specializing in Madonnas this year, Nat."

"Not specializing in Madonnas! But—Dad—everyone looks for 'Tyler's Madonnas'."

"Everyone will *stare* at 'Tyler's Tigers' this year instead, Nat. Drat it, I'm sick of them greedy saints, wantin' this and wantin' that. Look what half the fussin's done for Tigers, lad." He led the way to the green-houses.

Nat drew a deep, sharp breath when he saw the riot of joyous speckled faces, their crimson caps jauntily tilted—vigorous—sturdy—rich—sprightly leafed— exultant! He strode down between the gay rows and threw open the door of the Madonna house. After the crude earthy smell of the Tigers, the sickly fragrance of the Madonnas was overpowering. There the Madonnas stood in their pale glistening purity—aloof.

Dad Tyler, watching Nat narrowly, saw his eyes pass from Tigers to Madonnas, from Madonnas to Tigers. "Pretty subtle for a boy of my years," chuckled the old man.

Reverently, Nat closed the door of the Madonna house, and turned to his father. "It was wonderful of you to understand, Dad. I—I was afraid you had sort of built the face of Lily Madonna in here among your show blooms and would despise me for a turncoat. It—it always *was* 'Tiger', Dad, but it took a Madonna to show me. Do you mind if I run up to—to Harry Hill now?"

"Trot along, Nat. On the way, just drop through the budding rows, will you, and tell that jim-dandy budder of mine she can have the day off."

"O.K., Dad."

"He-he," chuckled Dad Tyler, "I done that dainty," and stomped through the lily houses to give orders regarding the cleaning out of a certain little cottage on the far side.

Pausing where Nat had stood, Tyler shook an admonitory finger towards his beloved blossoms. "Listen, you lilies!" he said, "This is a top-notch-year-at-Tyler's, and we're a-goin' to bust the record of all the lilies Tyler ever growed."

W O R S H I P

THE BROCKS had a long pew at the top of the church. The pew had an opulent cushion and footstool upholstered in crimson. On Sunday mornings Mrs. Brock, stiff and demure, sat at the far end of the pew, and Robert Brock, comfortable and paternal, at the other. The much-curled heads of six little Brocks bobbed between—handsome, well dressed children.

Mr. Brock was a business man of integrity. He was also church warden. In the family pew he took the children's hats off and put them on again. He found all their places in the prayerbook and hymnal. If the long sermon got too wearisome he passed a bag of soothing sucker-lollypops down the pew. When the Bishop was nearing his Amen, Robert Brock dived into his pocket and took out a handful of pennies; like the early and late labourer, each child received a penny. Then Mr. Brock left his pew, crossed the chancel, and met his fellow church warden. Side by side they marched down the long centre aisle passing the collection plate. At the church door they parted, one turning right, one left; each took a side aisle. By the time Robert reached his own pew at the top of the church the children's six pennies were lost. Mr. Brock waited, holding the plate, while all the cracks behind the pew cushion were searched, then the floor, even the prayerbooks and hymnals held by covers and shaken, while the big brass collection plate waited and the choir improvised an additional verse to the hymn.

Mr. Brock bought a great field lying some miles beyond the town, a cleared hummocky field that had been pasturage for a farm nearby. There was a two-roomed cabin in the field. Close to the cabin Mr. Brock raised two tents, cosying them with floors and siding. In this camp he planned holidaying his family during the long summer vacations, himself going back and forth to town in a rig with a handsome black horse driven by one of his office men.

Mr. Brock was well pleased with his new property. It was bounded on one side by the sea, having a good bathing beach for the children, on another side by the country road. On the other two sides right up to his fence grew dense pine woods which, after a stretch of forest green on top and purple underneath where the sun could not penetrate, met a high rocky ridge of hills which protected the camp from the prevailing summer winds. Sunshine played across the wide field all day.

Janet Brock was irked by camp life. She hated inconvenience, wasps, and brambles. The ants and mosquitoes bit her. But her children loved camp so much that for their sake she endured with only minor grumblings. She handed the provocations and inconvenience of camp over to Hannah, the cockney maid of all work, folded her pretty hands over her white forearms, and sat the summer through.

"Mother," said Robert, "we should not let the children's religious training drop because we are pleasuring."

"But, Robert, there is not a church within miles of camp."

Robert considered, his eyes roving his field: presently he noted a slight rift in the dark of the woods adjoining his property. He went to it and saw that a great flat moss-covered rock lay in the woods just the other side of his field. The rock was as large as a big room. Robert took axe and saw and cut a hole in his fence. Into the hole he hinged a little gate.

"I have made a church, Mother. Come and see, it is just the other side of our own fence."

"Robert! You know I cannot climb fences!"

"I have made a gate."

The children came from the beach. "Oh, Father! Is this a play-house for us in the woods?"

"No, this is our church. We will keep it just for that."

The Brocks entered the church and looked round. Janet said, "Robert, I could not possibly sit on moss nor pray among ants and beetles!"

"We will carry a chair out for you, Mother."

The trees grew so close together that all their underboughs were rusty for lack of sunshine, nor had they opportunity to grow thick massive boles. Red-purple and a foot thick was the best they could do. They receded back and back till they were lost in mystery, but the standing boles did not absolutely enclose like man-made walls.

There was the pungent sweetness of pines and earth in the air of this woods church. Janet said, "The place smells like a sepulchre!" The quiet of woods shiv-

ered her. She turned back to the bright rock. Its crevices were filled with patches of brilliant green licorice fern. The green yellow of moss on the rock was rich and deep and dotted with pink shepherd's purse and wild blue forget-me-not. Spiraea bushes grew round the edges of the rock, dropping rich creamy bunches of blossoms whose weight bent their slender woody stalks, straining out towards the sunshine which filled the little rock chapel at high noon when the sun was overhead. A bold and brazen tiger lily grew on the edge of the rock. It had five blossoms on each stalk, blossoms with faces furiously splotched, and orange petals rolled back like the lips of angry cats.

The novelty of having an outdoor church pleased the children, so Mrs. Brock made the best of it. A chair was brought out of the cabin and placed on the moss, and Janet felt regal sitting in it, her children grouped around her feet on the moss.

Robert was distinctly nervous the first Sunday when he took his place on a bare portion of the rock and fingered his prayerbook and hymnal. He missed the protection of the church, of the congregation, as well as of the Bishop. There was not anything man-made in this place except the chair upon which Janet sat. Boles and boughs dimmed and dimmed, receding indefinitely. There was deep quiet. Janet bowed her head, the children bowed theirs; still Robert did not begin. He fidgeted with his books. His tongue turned stiff. He wanted to bolt through the little gate back into his own field. The old house-dog lay at his feet. The trustful eyes of the old dog were the first thing to pull Robert together, looking direct and with trust into Robert's face. Janet, shading her face with her hands, was furtively peeping to make sure there was no creeping thing near her. She peeped at Robert, wondering at so long a pause, anxious to get it over, to go away even to the slight shelter of the little cabin. One of the children tittered, watching a battle between two ants down in the moss. Robert thought, "He knows Father is scared. My son shall not think that." Robert's voice rang out strong and firm.

"God is in His holy place; let all the earth keep silence." As he read his voice steadied.

"It was brave of you, Robert," said Janet as he helped her through the gate and carefully tied it. "I could not have done it before the children."

A visiting child once asked, "What is that lovely little place? Could we not go in there to play?" But the Brock children said, "No, that is our church. We do not go there to play."

Two summers spent in the makeshift camp were enough for Janet. Hannah the cockney maid did the camp work, Janet did little but shoo mosquitoes, so she got bored and began to complain. Robert built for her a fine summer cottage far down the other end of the field close to the sea. The cottage had a nice kitchen, a great living-room, and plenty of bedrooms. Tents and cabin were abandoned. Janet's second-best piano was included in the comfortable furnishings brought from town for the new cottage. Janet could almost forgive insects

for being insects now that she did not have to live on such intimate terms with them. She said, "Robert, now that we have the large sitting-room and the piano, it will not be necessary for us to wade across the hummocky field to that absurd rock beyond the gate? We can hold service in the living-room—piano, chairs! I think perhaps we *should* invite those children from the farm, too. The poor things have so few opportunities, and of course there will be Hannah too. An enclosed church with piano and real chairs will remove the familiarity I always felt a danger in that church picnic-style—everyone sitting around equal on the moss lacked class dignity."

"As you wish, Janet." But there was sadness in Robert's heart as he took away the little gate and replaced the boards of the old fence, half envying the birds and snowflakes that could still continue to worship God out on the mossy rock in the woods chapel.

In the cottage living-room the chairs were set in two stiff rows on Sunday morning. Near the door were four other chairs—three for the farm children, one for Hannah.

The farm children plodded ungraciously to service across the fields carrying their Bibles. Their mother made them come. They sat uncomfortably on the edges of their chairs, feet dangling, mouths open.

The Brock children exhibited superiority by pinching, hairpulling, and tying their sisters to the chair-backs by the little girls' sashes, so that when they faced over to pray, chair and all went too.

Janet thanked God that *her* children were not stodgy and heavy like the farm children. Janet played the hymns. Her voice, always a little flat, sounded a little flatter enclosed between walls. Once she had had those long curved white teeth peculiar to Englishwomen. A Canadian dentist had replaced them with shorter Canadian dentures. Her frustrated lips gathered into a pucker. They met like the fluted edges of a cockle-shell. She had nice eyes but they were always grave. The children were proud of their mother, proud of her white idle hands, her straight back, and elegant ways.

The service in the cottage living-room was over. Janet and Hannah rose from opposite ends of the room, rubbing their knees a little. "Polish be 'arder nor moss, mum," remarked Hannah.

The farm children passed out the door. In slow lurching going they were nearly knocked over by a mob of young Brocks heading for the beach.

Hannah shoved the laps of the chairs under the dining-table. "Wuship be huntidity, mum 'ymn books 'iggeldy-piglin' all hover the plice."

Robert and Janet went to sit on the cottage verandah.

Janet's eyes followed the dust-kicking heels of the farm children crossing the fields. "Robert! Oh, Robert, those dreadful children! They are playing toss with their Bibles, the ones I gave them on Christmas! Should we allow our children to be exposed—irreligion!—"

"Only show-off, Mother. Those youngsters are all right. Showing off for nervousness."

Janet sighed. "Our children for a pattern, the fine big room, the piano and the chairs, so different to the woods: I thought religion would—"

The clock in the living-room gave twelve slow raspy strikes. Like the piano, it was only the Brocks' *second*-best. Robert tallied his watch, slipped it back into his pocket, laid a big warm hand on Janet's knee.

"There are as many varieties of worship as there are kinds of time-pieces, Mother. Time himself is all that matters. Time who never hurries or slows. Time, time, time—time Hannah's dinner was ready—come!"

SMALL AND HER CREATURES

W H E N I W A S L I T T L E

MY FATHER never shot at living things. I love that memory of him. He could fire a gun. I only heard him do so once. A burglar was in our house . . . Father aimed at the sky.

Other children bragged, "My father is a sportsman, goes out to shoot deer and birds." I was proud that my father did not. He talked often about the birds of England which he had loved in his English boyhood. Young Canada had very, very few wild song-birds when I was little.

We were picnicking in Medina's Grove. Waving a turnover that dripped jam towards a near bush, I said, "Father, there's a bird's nest in that bush!"

Mother said, "Don't drip jam, child!" Then half to herself she said, "The child inherits her father's passion for bird-life."

I am glad Father gave me that inheritance.

I shall never forget the first full bird's nest I looked into. I was playing "lady" by myself on the old mossy rock in our back field. "Ding-a-ling!" I sang, and pulled at a bush intending to call on myself. It was not a play door that opened to my pretend ring but four yellow real bird mouths right under my hand. First I thought they were tiger-lily petals blown into the crotch of the bush. Then I saw that they belonged to four little birds who thought the rustle of the bush was their mother come. When no mother's beak poked food into their throats, they shut up, disheartened. The nest was under my eye level: I could look right in. I looked and looked. Every day I came back to look again, until the birdlings had fledged and were away.

A yellow warbler built in our lilac. I went closer and closer every day, till the bird trusted and did not fly off her nest at sight or sound of me. By and by she used to come across the lawn to meet me, pecked from the little dish of food I carried for her, flying as she fed. When I set the little dish in the bush, she finished feeding, filled up the children as I stood there, then covered them with herself like a cosy blanket. If I laid a finger on the edge of her nest, she pecked at it. That warbler nested in our lilac-bush for five years.

It was my work and my joy to tend the fowls in our cow-yard. I had a "chum rooster" who was special. I called him Lorum. He came in a coop of chickens

Father bought to fatten. This little fellow was woebegone; everybody pecked him till he was half naked. They would not let him feed. At mealtimes he slunk into a corner, hungry. He had spirit, but he was so much smaller than the two dozen rest.

I was sorry to see his tail and wings and heart all drooped. When I fed the others I took a good shovelful of food over into Lorum's corner and sat with him while he ate. The rooster gave me his whole heart in exchange. He fattened and was soon sleek and dapper. A small-boned bird, black Spanish, with a double rose comb, he was very handsome and, with me behind him, could whip any rooster in the yard.

Lorum waited, waited always by the cow-yard gate listening for me to come. There was such gladness in his neat, fiercely spurred feet as he ran to meet me, wings spread to make his hurry quicker. He flew to my wrist, but his claws gripped too hard, hurting me if he clung tight to balance as I walked; so I sat down on the wood pile and he got into my lap and took first helping from the food dish. He liked just being there better than he liked the food. We were really chums for years, then suddenly Lorum disappeared. I searched and searched. When I discovered that my sister, thinking Lorum would be too tough to eat, had sold him to a Chinaman, I flew into a rage so wicked-tongued that it was an occasion for the riding whip. I just screeched. I did not care how I shamed the family. I did not care a bean about the whip or about the wicked words. I was furious about Lorum—my Lorum.

A DEBT

MRS. LEWIS'S SITTING-ROOM was delightful. Sun streamed across blooming plants in the great bay window. A fire always blazed in the open grate; before it, on the mat, sprawled dogs and cats. Mrs. Lewis's low easy chair was placed on one side of the hearth, the Captain's bigger and more roomy chair on the other. A terribly old clock ticked the minutes into nowhere, sitting between the photos of Mrs. Lewis's father and mother on the mantle. The rest of the room I do not remember, except for the best thing of all: an inside window overlooking a conservatory on a lower level of the cottage.

Flowers loved to bloom for Mrs. Lewis. All in among her plants she had birdcages filled with birds that the Captain had brought her when he came home from strange countries, but mostly she had canaries. The flower scent, the singing of the birds, came through the window and made the sitting-room one great gladness.

In a wide cage just below the sitting-room window a mother canary was nesting. She had four eggs. The next time I went to see Mrs. Lewis, the mother bird was resting on the edge of the nest poking food from her own bill into the mouths of four tiny, naked, wobble-necked birdlings. She did not mind my staring but went right on poking till the little ones were full. Then she sat down on top of them, fluffing her feathers—not to hide them from me, but to keep the birdlings warm. She knew I was glad and proud for her.

Mrs. Lewis never knew how obliged I was to her leg for breaking and laying her up. She sent for me.

"The Captain will lift the cages down, my dear, if you will tend my birds."

If England's Queen had asked me to dust her crown, I could not have been prouder. The leg took six weeks to mend. I tended the birds. The nestful of babies were almost as big as their mother when Mrs. Lewis came into the sitting-room, walking with a stick. We stood by the window looking into the conservatory, right into the cage full of young birds.

"Choose, my dear. You may have whichever one you like best."

"To take home and keep for mine?"

"Yes."

I went crazy-happy. The only live creature I had ever owned before that was a kitten. I had always thought Mrs. Lewis pretty, and she was—but now she looked to me just beautiful. I chose the one with a top-knot and took him home and called him Dick. I loved him.

Dick was tame and had a strong, lovely song. He loved me as much as I loved him. If I was away from home for a few days he fretted and would neither sing nor eat. As soon as I came back he would spring to his perch and sing.

One morning early, early before I waked, the catch on the tray of Dick's cage gave. It was hanging in the conservatory and all the windows were open. Frightened and bewildered at the clatter of the falling tray, Dick fluttered out to unwonted freedom. The world must have seemed wonderful to him in its early freshness. He was strong and flew on and on, irresponsible, and not thinking of direction. Suddenly he tired and found that he had forgotten the way back.

When I found Dick gone I cried myself frightful, couldn't stop. There was not an uglier, more swollen-eyed child in Canada.

Our doctor's wife was Mother's friend. Mother told her about my terrible crying and how she could not stop it or comfort me.

Next morning I was in the garden, my face down in the dirt under a lilac-bush, crying for Dick, when I heard:

"Hi there, little woebegone!"

I looked up and there was Doctor Jim's buggy at our gate.

"Hop in," he said, but I stood at the step hesitating.

"My pinafore is pretty dirty."

"Nothing to your face! Tears and dirt have striped it like a zebra! Scrub it on the corner of your pinafore and hop up."

I climbed in beside Doctor Jim.

"Where are we going?"

"To St. Joseph's Hospital."

I was frightened. I had never been inside a hospital. It was a place where doctors cut people up, took out bad pieces and sewed up others. Was Doctor Jim going to sew up the corners of my eyes so that they could not cry any more? I was very quiet as we drove—scared.

Doctor Jim was very big and clean. I was little and very dirty. We walked down the long corridor of the hospital hand in hand. Sad plaster saints looked down from niches in the wall. A nun met us, led the way into a tiny waiting room. The Virgin Mary and Saint Joseph were there—plaster, of course.

"Bring that bird, Sister!"

The nun was gone only a second. She came back and in her hands was a cage and in the cage was Dick!

Dick flew towards me and beat his breast against the bars of the cage; then he sang.

"Dick! Doctor Jim! Sister! Oh! Oh!"

"Your old men will miss their new toy, Sister. It delighted them that he came to the hospital, to the window of their ward, and asked to be taken in."

My heart tore. Pushing the cage back into the nun's hand, I said, "They can keep him . . . they are old and sick."

Doctor Jim put his arm around me and I hid my face in the rough of his coat sleeve. I did not feel kind, or generous, or brave—only achingly greedy, wanting Dick.

The nun put Dick's cage back into my arms.

"The bird is yours, child. You are the bird's."

Did I imagine it or were the saints really smiling in their niches as we passed under them going down the long corridor?

That was the original little old St. Joseph's Hospital. St. Joseph's has now swelled into an enormous institution; there are labyrinths of corridors. I have been wheeled down them many times. Plaster saints have looked gravely down, but none have ever seemed to smile as gaily as those others long ago, when I have passed going to some quiet room to lie and heal.

A nun stood at my bedside cheering me with chat. I said, "Last time I was here there was a canary hanging in the corridors. He sang beautifully. I loved to listen."

The nun said, "He belonged to an old sick priest. When the priest died the sisters at the convent took his bird."

"I have an aviary at home where I raise birds."

The sister breathed quick. "Oh, do you ever have one to give away? How I would love a bird to sing to the people on my floor!"

When I got better and went home I looked through my aviary. The best young singer I had was marked almost exactly like old Dick. I took him to St. Joseph's and gave him to the nun.

DUCKS AND FATHER
AND MOTHER

SMALL RAISED A BROOD of eight ducklings—she watched them grow from oblong blobs of bobbing yellow to slick-feathered magnificence, watched them pass through every stage of gawky ugliness, drab, rough, ungainly, shovelling in food with voracious developing gluttony, watched their eyes turn from staring beads of black to keen shrewd glitter, set in cheeks which could be tipped, one up, one down, so that they could regard the heavens and the earth simultaneously. Small saw quick peep and flat patter change into quacks and rolling waddles.

There were four ducks and four drakes. The ducks were quiet mottled brown, the drakes gorgeous—dashes of green and blue set among grey and browns that made them seem brighter, short legs and wide-spread feet leaving on the mud imprints like tiny kites. The drakes did not quack, but from their wide-open beaks came long musical chirrups. Their chiefest glory was their heads and necks. Peacock colours, full of sheen and glint. Smooth as satin, rough as plush as the drake's mood changed.

On land the ducks were comical, tipping this way, tipping that—breaking up their food in slovenly hurry, slapping down their clumsy feet—shoving their pothook necks forward, complaining with boisterous, clattering quacks, rushing to the pond and launching with a glide that was grace itself, breasting the water with a joyous push and scarcely a ripple, only an exultant kicking away of the land behind them, drakes leading—eight perfect and unsinkable boats, doubled by eight perfect reflections as bright and smooth as their realities. In a twinkling there were eight headless half-ducks the shape of Frenchmen's well-trimmed beards, kite-like feet and shovel-beaks rippling the water, stirring the mud. Small loved her beautiful ducks.

On a day so splendid that it hated to go to bed, Small came to shut her ducks up for the night, eating a great apple, running, singing—these all together took great breath, but young things breathe easily, young hearts break easily.

Apple fell, song stopped, Small stood rooted. Blood! Blood! She could not scream; as she ran she had heard chop! chop! The axe flashed again, guided by a rough, hairy hand, a hand she had held to, trusted. The hand tossed the bunch of quivering feathers upon the ground, wings spread—there was a flap or two, a lovely green and blue head lay in the dust, separate. Two other heads lay there too—more quivering bodies, spread wings and flopped legs. Burning hate seared Small's heart. She rushed into the house.

Small's mother sat at her machine sewing. Her father read his paper. "Richard, this must not be!" The Mother opened wide her arms to Small. The Father shifted uneasily. "Nonsense!" he said. "Small must learn."

FATHER IS A CANNIBAL

"THE COW has a surprise for you in the back yard, children. Come and see."

The breakfast bell rang as we trooped behind Father. One could not imagine the dear, slow old cow giving or taking a surprise—she was always so calm. But there it was, the loveliest little image of herself, brown and white and very topply on its legs, which were spread out like the legs of a trestle. He was standing under the cow's chin and she was licking his hair all crinkly. His eyes were bluish, and stared as if he were too surprised to see, but he had the friskiest little flipping tail. The cow was delighted with him, and so were we.

Soon the calf was bigger and stronger than any of us. His legs were straight under his body and his eyes saw everything. Bong shut the cow out into the pasture and the calf stayed in his pen. At first the cow bawled furiously and the calf bawled back, but we went to pet and play with him and he was happy, so the old cow nodded her way off to the far corner of the field where the grass grew best. Bong taught the calf to drink out of a bucket. The calf was clumsy and slobbery over learning, and made Bong so mad his pigtail shook loose; he unwound it and rebound the long plaited silk end tight round his head. His clean apron was all spoiled and he said, "Calf velly much bad!"

We loved the calf; he followed us all round the yard. He had toothache in his head where he was cutting horns, and butted us to make us rub the hard knobs. When he was a quarter as big as his mother, he disappeared. We had played with him before our walk—when we came back he was gone. Somebody must have left a gate open. Everyone said they had not. Bigger looked so wise that, if she had not been so dreadfully good, one might have suspected. Middle looked worried and uncertain. Dick was too little to reach the hoop over the top of the gate. We were very unhappy, not only for the calf, but because Father was so fearfully severe about gates, and we dreaded the time when he would come home. The extraordinary thing was that neither Mother, Bong, nor the Elder (who was our grown-up sister) seemed upset about the calf, nor at all disturbed at what somebody was going to get when Father came home. Bong sang his usual song to the cow as he milked. He cleaned out the calf's pen and shut the door. Nothing happened. When Father came, he took his tools and went to the garden as usual.

Three or four days passed; we had half forgotten to wonder, and Doctor Reid was asked to dinner. The Doctor's graces were just as long as his church

prayers, and his *s*'s sizzled just the same. Of course he was helped first—he told so many stories that dinner got on very slowly. If the girls had a great many home lessons they kept a book in their lap and learned out of it when Doctor Reid came to dinner.

In the middle of Doctor Reid's funniest story he stopped. "Delicious veal, Mr. Carr!"

"Home-grown, Doctor. No butcher's skim-fed calves for me."

My knife and fork clattered into my plate. Mother looked up at the noise. "I think I am going to be sick, can I go?"

Out on the chopping block I took my head in my hands.

"Feel better?" asked Middle.

"Worse."

"Well, Small," said Bigger, "you know we have not had permission to go to the cherry tree, they are still very green."

"'Tisn't cherries. It's two disgusting things I've found out."

"Uh-huh," sighed Middle, "sulphur and treacle! It's time, I s'pose; always happens this time of year."

"It isn't sulphur and treacle, it isn't cherries, girls, it's veal is calf, and our father is a cannibal!"

"You wicked, wicked child! Meat is different to people. What did you think meat was?" said Bigger.

"Stuff sold by butchers, like bakers sell loaves. Did you know we were eating our calf, Bigger?"

"I guessed."

"Did you know, Middle?"

"I knew veal *was* calf, but I did not think it was our calf."

Still feeling queer about the knees and middle, I got up.

"Where are you going?"

"To steal Father's best cabbage for the cow. I'll throw it—I couldn't bear to go into her stall, she has such a big sniff. If she smelled her calf on my breath—oh, girls!"

THE CURLY COAT

MOTHER HAD a long coat of black astrakhan. It was too bad that whenever the weather was cold enough for Mother to wear that coat it was too cold for her to be out, because she was ill. So the coat hung in the cupboard, limp and empty.

One winter Bigger and Middle grew so fast and wore their winter coats so hard that when it came time to hand them down they were too dilapidated even for me. My old coat split too, because I was fat. There was too little winter left to buy another coat that year which I would outgrow during the summer. So Mother took the curly coat and cut it down to fit me. She put a pretty new lining in for fear I'd feel bad about having to wear a grown-up's cut-down coat— but I was proud. It was a splendid coat. No other girl in school had such a curly lovely material. I saw them run fingers down it as it hung on the cloakroom peg, caressing it as if it were a puppy, offering to hold it while I got in. I felt like Father, who always had his coat held while he put his arms in the sleeves. I put my arms in slowly so that all the girls should have a chance to see the pretty lining while it was being held.

I finished the winter out proudly. There were ever so many coats like Bigger's and Middle's, but none like mine. There was one peg a little apart from the others and I hung my coat on that. I said to myself, "My coat is so good it will never wear out. I hope it won't finish till I am quite grown up, then I won't have to wear out any more of Bigger's and Middle's."

Spring came and so did spring clothes. Sometimes I would think, "How splendid it will be when winter comes and I can snuggle down into the curls of my winter coat!" But next winter the style changed, all the girls came to school in short jackets. Bigger and Middle had them too. I felt as dowdy as a fox terrier whose tail has not been docked. I hated the curly coat, which came to the bottom of my skirt.

One day I put on the coat, got Mother's shears, stood on a chair in front of the mirror, and chawed the scissors through the curls all round my middle. As I twisted, the shears zigzagged. It looked terrible. The skirt of my coat fell to the floor just as Mother came into the room. I said, "Oh!"—trying to sound ordinary. "Nobody wears tails this year, Mother."

"So this snake-fence effect is the style, is it?"

My face burned and I looked down at all the black curls round my feet. I cried, "What'll I do? Oh, what?"

"Wear it."

"Everybody'd laugh, I couldn't!"

"Sew the tail on again, then."

"Couldn't I wear my summer coat with a jersey underneath?"

"No."

I sewed the tail on; but, though I pressed and pressed, there was a hideous lumpy ridge round my waist and the curls twisted all ways. Going to school, I lagged so everybody would be walking up Fort Street Hill behind me. I carried all sorts of unnecessary books to school in my arms so that my waist would not show. I tried to persuade Bigger and Middle, "Let's have fun and walk China-man-way—one behind the other." (If the front and back were hid the sides did not seem so dreadful.) But Bigger said, "We are not Chinamen but young ladies and must walk as such." I was angry—wouldn't keep step for that, but dropped behind and got late marks on my report. That was more trouble. Wasn't I glad when spring came and Mother told me to hang the curly coat on the back of the store-room door.

I had two summer coats—Bigger's and Middle's of last year. They were tidy, careful children and kept their clothes nice.

All that summer I hadn't one trouble; then came winter and Mother said, "Winter has broken suddenly before I have prepared. Fetch out your curly coat."

It was not there, it was not anywhere. Everyone looked, everyone waited for me to confess; Bigger had ever so many texts to fit. Nobody accused me, but they all made it plain that they were sorry I had not the courage to confess. It made me feel dirty. I really wished the miserable coat would turn up. I'd rather have worn it than the disgrace. Bigger and Middle got new coats, I had an old patched one—too tight. We got through winter.

At spring cleaning the drawers of a chest in the store-room were pulled right out to be brushed behind. Out fell piles and piles of chewed-up black curls and little bits of the pretty lining Mother had put into the curly coat. From the middle of it darted a mother rat and there were four little pink naked rats like sausages in the nest.

Mother called the cat and me at the same time, and mixed our names. Everyone stopped looking disgust at me. I felt as if I had had a bath. Mother bought me an *entirely* new coat, although the winter was half over.

WAXWINGS

THE WAXWING was a migrant, new to Victoria. Different varieties of birds were shyly following man as the country opened up. They shunned our deep dark forests, preferring the new-cleared land, the protection of barns, voices of humans, of cows, horses, and dogs. These sounds reassure birds in strange places. Back in the forests were hawks, owls, eagles. Our native birds (other than edible ones) did not know fear, nor about the guns that men carry.

A man neighbour knocked on our door. Under his arm he carried a gun.

"I ask permission to shoot in your field," he said to my sister. "There is a flock of waxwings just settled in the big cotton-poplar tree. I want a specimen to add to my collection of stuffed birds."

"Say no! Don't let him shoot! Don't let him!" I whispered behind my sister.

"Be quiet!" she bade me, pushing me away from the door, and gave the man permission to shoot.

"Bang!"

Again the man knocked at the door. Delight was in his face. From his hand, each bird dangling by a leg, swung a great bunch of blood-dabbled, feathered death.

"Wonderful luck! Brought down the whole flock. Two only got away—grape shot. Sixteen from which to choose my specimen. Taxidermy is my hobby."

"You beast! You murderer!"

My sister clapped a hand over my mouth before I could say more, pushed me into the pantry and shut the door on me; but not before I had seen the wounded breasts, blood-dripping beaks—blood the same colour as the strange red sealing-wax marking on each loose-flopped wing, the mark that gave waxwing his name.

"Look, look!" I screamed as the pantry door closed. "Look! The brute has not even killed decently!"

One lovely head, eyes fast glazing, raised itself from the lifeless bunch, looked at me.

It was an occasion for the riding whip. I had insulted a neighbour in my sister's house!

I went into the field and cried over the spilled blood and scattered feathers of the waxwings. "Crock" came to me there, all hops, flaps, throaty chortles of

distress at my trouble. The destruction of his fellow birds was beyond the crow's comprehension. He could sense, though, the sorrow of the human he loved: that disturbed him.

WOO'S LIFE

I have not tried to write a book of funny monkey stories, the aimless, helter-skelter ways that appear to be common to monkeys. I have tried to show the apparent reaction of my particular monkey to domestic life and to humans and the reaction of humans and domestic creatures to Woo, my small Javanese who lived under close, loving observation in my home for thirteen of the fifteen years of her life.

BUYING WOO

THE PET SHOP OWNER thought the apex of her troubles was reached in the Customs; now that the shipment was cleared, the crates standing in the centre of the pet shop floor, she realized that this was not so—there were the monkeys! From the pile of boxes and cages on the floor came mews, squawks, grunts—protests of creatures travel-worn and restless. If a crate was quite still, things were bad.

Finches, canaries, love-birds, parrots, Siamese cats, squirrels, and, at the bottom of the pile, monkeys, gibbering, beating their fists upon the sides of crates demanding immediate release.

"You monks must wait," said the weary woman wondering how their bedlam was to be endured. "Your cage is not ready." However, as makeshift she rolled an empty barrel from somewhere, nailed a heavy wire parrot cage over its top and manoeuvred the monkeys from crate to barrel. Two fair-sized monkeys rushed up into the cage, delighted with release from cramping dark, squeaking, thrusting hairy arms through the bars, grabbing hammer, nails, packets of bird seed, the tail of a bantam rooster—anything that could be reached. I, waiting to buy bird-seed, saw a tiny little black face pop from the dark of the barrel to be immediately pushed down by the heavy hind foot of one of the big monkeys. Time and again the little face, a tuft of surprised Kewpie hair peaked on the top of its baby head, tried to get a peep at its new environment, only to be forced back like a jack into its box.

The pathetic little face haunted me. Going to sleep I thought about it and in the night when I woke.

When morning came I went to the phone calling the pet shop.

"Is that tiny monkey boy or girl?"

"Girl."

Suddenly I wanted her—I wanted her *tremendously*. Of course, I wasn't going to buy a monkey, but I asked, "What is her price?" My voice went squeaky with wanting. The woman understood: she had heard that "wanting squeak" before.

"Buy her. She is a *very* nice monkey and the big ones bully her."

"But my family! If I paid so much money for a monkey!"

"Listen, everyone is entitled to some fun. Would you consider even trade for one of your griffon pups?" (She knew my kennel.)

Good luck forever to that understanding woman! The deal was made. She would sell a "griff" quicker than a monk.

Pearl, my kitchen maid, loved animals as I did. I told her first.

"A real monkey, glory be! How soon can I fetch it?" Within an hour Pearl was racing down the street carrying a small parrot's travelling cage and bursting with excitement.

I heard them coming up the stairs just as we sat down to lunch—my sister Lizzie, a man whom we boarded, and I. Pearl's face was absolutely apoplectic. She placed the cage upon the floor.

Dead silence! My sister's eyes popped like a Peke dog's.

"Woo!" announced a plaintive voice from the cage. "Woo, woo, woo!"

"Your new niece, Lizzie!" I said, brave in the knowledge that my home was my own, yet half scared of family criticism.

My sister pushed aside her soup. "Milly! I never, never, never thought a relative of mine would sink to a-a-a baboon!"

The boarder's lips always leaked when he ate soup. In the intensity of his stare he entirely forgot his serviette. Soup splashed from his spoon back into his plate, plop!

"Er, er, er, er!" (Ordinarily he said "Er" only twice to climb to each sentence.)

"Er—er—er—er it's a monkey!"

The monkey decided to investigate us. Sticking one hand and one foot out of each side of the narrow cage she propelled herself across the floor. A walking cage looked so comical that a laugh even squeezed out of Lizzie—she cut it short with, "How much did you pay for the preposterous creature?"

"Even trade for a griffon pup."

"A griffon! The idea!"

You'd have thought that I had traded a diamond necklace for an apple, though Lizzie always *pretended* to despise my little dogs.

"Your house will smell! Everything in it will be smashed! Your friends will drop away—who wants to 'hob-nob' with a monkey!" This awful fate trailed back at me as sister Lizzie rushed down my stair returning to her own chaste house and leaving me to contemplate the wreck I had made of my life.

The boarder, who set great store on the "griffon dogs", groaned, "Er—er, a griffon for a monkey!" and went off to his office.

Pearl and I sat on the floor thrilled by the absorbing strangeness of our new creature.

My sister Alice took the first opportunity to come from her house round the corner to inspect my new queerness.

"Everyone to his own taste", she shrugged. "Monkeys are *not* mine."

So Woo was introduced to my sisters and took her place in our family circle, no more a commercial commodity, but an element pertaining to the family life of three Carr sisters.

Pearl and I spent that afternoon nibbling around the edge of something unknown to us. I had tamed squirrels, crows, coons, even a vulture—these creatures, like myself, were northern bred. This lightning-quick, temperamental,

tropical thing belonged to a different country, different zone, different hemi-sphere. We were ignorant as to what liberties we dare take. If thwarted, Woo opened her mouth, exhibiting magnificent jaws of strong white teeth, jaws so wide-hinged that you could see her wisdoms (if she had any) and right down her throat. The boarder asked nervously, "Er—er—was it King Something or his son that died of monkey bite?"

I put the monkey into a large parrot cage. She snatched ungraciously all that we offered, food or play-things, grimacing back at us. When night fell she began to miss the warmth of the other monkeys, for though they had tormented her by day, they had been willing to pool cuddles at night. "Woo, woo, woo," she cried, and could find no comfort in the hot brick I offered or in Pearl's old sweater or in the boarder's third-best hat.

"Er—er—tell her to curl up in the hat. Er—er—it's a good hat."

He said this as if I were a monkey interpreter. But I had no monkey word to comfort the lonely little beast other than to repeat her own sad wailing, "Woo, woo, woo."

I had intended to call my monkey Jemima, but she named herself Woo that first night and Woo she remained for life.

Near midnight, she rolled herself up in Pearl's sweater and slept. I turned out the light, tiptoed from the room. A jungle stranger had possession of the studio.

Even restricted in a cage she was a foreign, undomestic note in my humdrum house!

There was a small collar on Woo's neck when I bought her. She had never known the pull of a chain. Any restraint, any touch of her collar infuriated her. By keeping a few links of chain always suspended from her neck I soon accustomed her to lead. Then I could take her into the garden.

Woo was teachable. Before I had owned her a week she got away from her chain in the garden.

"Good-bye, Woo!"

I was sad. I thought, of course, she would make for the woods in the Park nearby. No, Woo dashed up my stair, sat waiting on the mat to be let in. She had accepted the studio as her home. That quick response of love and trust entirely won me.

THE HOUSE

I OWNED a small apartment house, living myself in one of the suites. My suite had a large studio with a long stair down to my garden. The small garden in front was for tenants. The big garden behind was mine. Behind it again were yards and my kennel of griffon dogs. Being a landlady was never agreeable to me, but having a kennel of griffons was joy.

When my tenants heard that I had acquired a monkey they looked at one another.

"It will smell," announced Mrs. Smith.

"It will run amuck—destroy," asserted Mrs. Jones.

"Screech and bite!" said Mrs. Robinson. They waited and watched, and none gave notice. In the thirteen years Woo lived in my apartment house, no tenant ever had reason to complain about Woo. An old lady rose from her bed at three one morning, groped her way to the basement because she heard the monkey cry out. I was away once and a man tenant sat on Woo's basement wood-pile daily.

"She was lonesome," he said.

Ladies donated small mirrors from old vanity-cases, cherries, grapes, candies—monkey-loved dainties. Woo found her way to all hearts—merry, unexpected Woo! Her quick actions, her unpredictable quality attracted people. Woo wove herself into the atmosphere of 646 Simcoe Street, accepting attention with regal indifference.

As soon as Woo became used to her chain, I led her down to the dog yard to meet my griffons. The rush of dogs checked when they saw her. Woo scrambled to my shoulder screeching. The dogs stood circled in amazement at this queerness clinging to my collar with almost human hands! Dog noses wiggled at her foreign scent. They resented her cling to me. Woo gripped my collar with a foot, leaving both her hands free to beat at the dogs. They kept their distance—she had to content herself by making grimaces at them. Then she saw the earth and scrambled down in an ecstasy of joy, feeling, smelling, tasting the delight of soil and grass after cage confinement! She turned the stones over and found earwigs and beetles, crunched them with keen relish—dogs were forgotten. I chained her to the fence while I did kennel chores.

When the monkey's appetite for insects was sated, she sat down and looked about her. The dogs, attending to their own affairs, had forgotten her and

tumbled over each other in play. Woo, watching, felt lonely, isolated. She stretched out a tiny black-palmed hand and with careful precision selected a young dog of her own size, caught his stubby tail in both her hands and dragged the surprised pup to her side. A smart twist and she had turned him right about, loosing her grip on his tail to seize his whiskers. Levelling her eyes to his, Woo stared straight into them, mouth open, eyes glaring. The pup did not flinch but gave her stare for stare. The human grip of those hairy little hands made an impression. The pup (Ginger Pop) sat down beside Woo. She let go of his whiskers and began to attend to his coat, parting the hair, combing it through her fingers, searching among it for tiny flakes of skin that have a salty taste. (It is for these that monkeys are always searching, not, as is generally supposed, for fleas.) Ginger Pop loved the feel of her gentle hands. From that day he and Woo were inseparable companions, romping and playing like a couple of puppies. The rest of the dogs Woo ignored and they kept at a respectful distance from her gripping fingers and nipping teeth.

WOO'S APPEARANCE

WOO WAS PROBABLY under two years old when I got her. Trim, alert, dainty, her actions were smart and quick, her coat shone with health—she kept her greeny-brown coat immaculate.

Woo's hazel eyes were set close together and shadowed by bushy brows growing on a prominent ridge of bone—brows which were capable of wide movement, jumping up on her forehead or scowling down over creamy white eyelids which she lowered if humans stared directly at her. Monkeys only give stare for stare when their anger is roused; then a blazing fury burns fiercely at their opponent. The whites of Woo's eyes were dark brown, the irises clear and golden. The palms of hands and feet smooth, soft and black. Her small pointed face was black with a long, flat nose, wide, thin nostrils dilating when she was angry or excited. A fluff of whisker trimmed each cheek. Clean-eyed, clean-nosed, clean-mouthed, Woo washed her face as a cat washes, but, instead of the inner side of a velvet paw, she used the back of a doubled-up fist as a wash rag. She was very neat about her hands, licking them, scolding at any grease or stickiness, using grass, leaves or pinafore to clean them on.

This reminds me of Woo's clothing. Monkeys are liable to T.B. in our climate. I wanted to keep Woo out in the open as long as possible. I decided, therefore, when she began to shiver that I must make Woo some clothes. My first attempt was a dress of soft blue flannel. I fashioned it like a doll's dress. Woo was no

stuffed dummy. The moment my back was turned she ripped the flannel dress to shreds—nothing was left but the collar-band.

"Flannel is apparently unsuitable," I remarked to Pearl.

"You did not allow enough straddle."

Pearl was right. My next attempt was short—wide, as a ballet skirt. Made of stout tweed coating, it had short sleeves. Woo chewed the woollen material into holes, so I made little flaring red duck aprons that she could not rip. These, over her warm tweeds, were cosy. Bobbing around my garden, she looked like a poinsettia bloom. She chewed off all buttons, undid hooks. So I buckled her garments at neck and waist.

Crows and robins visiting my cherry tree found one scare-crow that was no sham. The cherries beyond reach were Woo's. She sat the tree-top—a queen. Amazed crow, baffled robin sat on the fence consulting.

WOO'S CALLS

MY MONKEY'S CALLS were strange and varied. Each had special significance; each seemed to come from a different part of her—high-pitched whoop of pleasure, deep stomachy grunt of anger, coo of contentment, grating croak of alarm, chirrup of inquiry. For me alone she kept an affectionate lip-gibber, interwoven with a kissing sound and always accompanied by a grin. If I caught her in mischief she went through a series of swayings, writhings, and apologetic kissing, throwing down what she had stolen. If anyone else caught her she clung to her theft and showed teeth.

Woo came upstairs for part of every day. She had her own corner in my studio. The wall here was protected, for she loved to dig holes in plaster. Chained to a ring in the wall under an attic stairway she could reach my bedroom door which opened from the studio. She learned to open it by climbing up the post and clinging with her hands, then a large hind foot grasped and turned the door-knob.

The dresser was her delight; hand mirror, hair-pins, powder, combs, perfume, hair wash, pills—nothing eluded her investigation. Each article was scrutinized, then flung onto the floor while Woo sat holding the hand mirror with her feet and her hands felt behind for the *other* monkey and her lips kissed and kissed.

The pet shop lady was going on holiday.

"My assistant is afraid of monkeys," she said. "My poor Mitsey!"

577

"Bring Mitsey to me. Woo will love a companion monkey."

Mitsey came to spend a week with Woo! The two little monkeys sat one on either end of a bench in front of the fire scowling furiously—Mitsey shy, Woo jealous, holding her Ginger Pop away from Mitsey. If he gave so much as a sniff toward Mitsey, Woo smacked him. The space on the bench between the monkeys narrowed and narrowed. At the end of an hour they were hugging, though Woo still held Ginger Pop gripped by one ear.

Woo's cherry tree was flowering. I dressed the two little monkey girls warmly and chained them in it. They played hide and seek among the blossoms. I took them to a beach and they fished in the rocky pools for crabs. They tossed stones, chewed sticks, chased sandhoppers. Yet, strange to say, Woo did not fret when Mitsey went away. The mirror monkey, Ginger Pop, myself satisfied the need for companionship.

Once a lady brought her two pet monkeys to my garden to visit Woo. The three monkeys screamed and sulked; there was anger and bedlam, beating fists, hate, grimaces. The lady pitied poor Woo having no monkey companions. My own belief is that Woo preferred the companionship and admiration of human beings. The friends Lizzie predicted were going to forsake me did not, nor did my house smell of monkey.

Monkey tempers are inflammable—so is mine. I would not have Woo teased! She was a sweet-tempered monkey. She nearly cost me one friend but not quite. The woman despised Woo, and me for keeping her. She said a few hateful things. I ignored them and Woo ignored her.

Soon people accepted Woo as part of an artist's queer equipment. Some of Woo's stupid critics might well have learned, from my monkey, ingenuity, thoroughness. Woo's investigations were never superficial. Every object must be felt, smelt, tasted, pulled to pieces before her curiosity was satisfied. Only when she had completely wrecked a thing did she toss it away as having no more interest.

THREE SISTERS

THREE WOMEN could not be more different in temperament, likes, choice of friends than were the three Carr sisters. Each had her own house, interests, friends. Lizzie was a masseuse, Alice had a school, I was an artist.

When I acquired Woo, Lizzie protested, Alice shrugged, I gloated—Woo accepted both family and domesticity.

When evening came and the hum of our busy lives quieted, one or the other

of the Carr sisters could be seen running across to visit the others. Our three houses were within a stone's throw. If the visiting sister was I, a taggle of dogs, a Persian cat, and the monkey followed.

The creatures loved this between-lights visiting. When first I got the monkey, my sisters sighed when they saw us coming.

"Must they all accompany you, Milly?"

I replied, "*Every one.* The creatures expect it."

Woo soon slipped into place, becoming a part of the habit, and no remark was made when she followed the dogs and me into my sisters' houses.

First we came to Alice's school. It was set in a gravelled play-yard with garden beyond.

As my house abounded in bird and beast, so Alice's abounded in children. Her cottage sat like a wide, squat hen, and the hen in turn was brooded over by a great western maple. At this evening hour there would be a circle of children cheeping round the great open fire in the school room. Cribs full of sleeping cherubs were tucked away under the low-spread wing beyond. My sister "slept" and "ate" as well as taught children.

Alice's kitchen door always stuck, then burst open violently. There were squeals of, "Shut it, shut it!" while the griffons, the cat, the monkey, the wind, and I poured in.

For economy of space a porcelain bathtub was plumbed under Alice's kitchen table, the top hinged up. What with tub, cook stove, sink, wood box, and cooking utensils, there was not an inch of spare room. A stool wedged itself between bathtub and door. On this dogs, cat, monkey, and I all piled, crushing ourselves under an overhanging china cupboard. Alice rubbed down one child before the cook stove and the next one soaked. If the child in the tub was big-gish, she let down the table-top so as to dim herself. There was space between the edge of the tub and the table-top for Woo to squeeze.

"Eek, eek, ow! Woo's drinking my bath!"

"Oooo—she's stolen my soap! She's tearing my washcloth!"

I pulled Woo out. Then my sister's big dog growled because Woo was after his bone. It was difficult to adjust all these troubles without treading on a child, a dog or the monkey's tail. Sweater sleeves and child-pyjamas whacked from the clothes-line strung across the low ceiling. Alice was always calm. Monkey, dogs, children! The greatest of these were children. If *my* creatures amused *her* children Woo was all right. She always had some special treat—a candy or some cherries or grapes—in her cupboard for Woo. Monkeys might not be *her* choice but she was kind to mine. Woo regarded Alice as a goddess of eggs and bananas and loved her next best to me.

Once only I saw Woo angry with Alice: in the crowded kitchen Alice trod on her tail. In a fury the monkey grabbed the strings of Alice's apron, hoping that they were as sensitive as her own tail. Woo tugged and squealed; for the moment the goddess of eggs and bananas was dethroned.

Every Christmas Alice filled a child's sock and hung it with the children's for

Woo. The children screamed with delight watching Woo unpack, appraise her presents. She chewed a hole opposite each object in the sock and pulled out the goody, scrutinizing, smelling, licking, tossing it away with a grunt of scorn if it did not please her.

It was quite dark night when we passed through the gardens which linked my sisters' places and came to Lizzie's house.

"All wipe your feet!" Lizzie shouted.

No house ever shone as Lizzie's did. Every moving object cavorted in the shine of her piano and in the brass coal-scuttle, copper kettle, andirons, and fender. Woo was in her element, kissing the reflected Woos, cooing and jibbering to them.

"Milly, don't let her slobber over everything!"

Lizzie got a spotless duster out of a little bag and erased Woo's kisses.

"Here, Woo, sit on this nice stool."

Woo scorned the wooden stool that the black-bottomed kettle sat on. She rolled over on Lizzie's blue rug, warming her tummy in front of the fire. She knew that Lizzie was a little afraid of her. She was a little afraid of Lizzie too, but flaunted indifference, bravely shaking the edge of Lizzie's snowy apron till the starch rattled, staring Lizzie in the eye and showing every tooth.

"Nasty little beast," scowled Lizzie and bowed as beneath a cross. Woo was one of life's chastisings. Lizzie was pious—chastening thrilled her. It amazed and pained her that one of her family could have chosen a pet so incomprehensible as a monkey. Artists she supposed *were* queer, but owning monkeys out-topped every other queerness.

The walls of Lizzie's room were smothered with neatly framed good-behaviour recipes and with photographs of missionaries dead and living—missionaries bestowing Bibles upon naked heathen, missionaries dashing up raging rivers in war canoes to dispense Epsom salts and hymn books to Indians, missionaries seated under umbrellas taming Hottentots. Of course, one did not have to look at the photographs, but when, as so often happened, a missionary sat in his flesh and blood before Lizzie's sitting-room fire, that was different. Female missionaries drew their skirts up to their necks and shrieked as if Woo were a reptile. Male missionaries usually quoted texts about the devil, as if there was some connection.

If they had been invited to tea they stuck it out; otherwise they hastily left, unless they saw that Woo and I were making a quick get-away, which we usually did to relieve my sister's embarrassment.

What with massage, missionaries, and good works, Lizzie was a busy woman and a good one. She never left you in doubt about your shortcomings, but was always the first to rush to your help in trouble. She did *not* flatter us to our faces; but the dogs and I—and soon too the monkey—knew that she was the Carr family's backbone in time of trouble.

I began to notice that Lizzie was watching the monkey closer and closer, asking

questions about her. I realized that Lizzie was using Woo in her work, hoarding Woo's funniness to amuse some small patient under painful or tedious treatment, using her, too, to win a smile from some weary, bedridden old soul who had nothing but a ceiling to look at and no fun in her mind at all. Lizzie would say, "Milly, take the monkey to visit old Mrs. So-and-So. Woo will while away a weary hour for her."

Yes, in spite of their avowed aversion to monkeys in general, my sisters were *using* mine—one to cheer patients, the other to amuse children. Unsuspecting little Woo had a place to fill in the Carr family, a part to play in the big thing that is called life.

MY GARDEN

FOR THE TENANTS there was the small front garden. The back garden was for me and my creatures. I had created it from a hummocky, wild lot—built my apartment house so that the windows of tenants did not overlook me. Tenants' washlines *did* have to roll, high out over my lawn, but the Smiths, Joneses, and Robinsons did not have to occupy their undies while they flapped over my head.

In my garden were fruit trees and lilac, great eastern poppies, lavender, daffodils, jasmine, hollyhocks, fox-gloves—all the homely old flowers. The lawn was comfortable, with seats and hammock. Beyond the garden were the kennels and yards of my griffon dogs. When I sat in my garden the dogs and monkey rolled and played on the grass about me.

In the centre of the lawn stood a big cherry tree. When Woo came to live with me she took possession of a little shelter box I put in the tree. Woo thought herself queen of the gardens, which she was, and the hub around which life in our garden moved. When visitors came there to see me, they went direct to Woo's tree as people entering a room go straight to an open fire. Even those people who disliked monkeys demonstrated that Woo was the most vital spot in my garden. The human-shaped hands obeying a monkey brain differed from the vague scraping paws of a dog. Ability to cling, to hold, to pick things up, the neatness and precision of those strong slender little fingers, perplexed the dogs, amazed people. Even Woo herself appeared to be surprised at her own hands, holding them up, looking at them intently. Nothing so delighted her as for me to play "This little pig went to market" with her fingers and toes. She held up first one hand and then the other, watching the pigs being told, thrust out one and then the other of her large, flat feet with short, wide spread of

thumb and sat absolutely still and absorbed, listening. When the game was finished she rolled the furry backs of her hands uppermost, looking at them seriously, then at their smooth black palms—well washed, always clean. Her hands were not cold and clammy like most monkeys' but powerful, warm little hands. Often at night I went to her sleeping-box and took one of the soft, warm little fists cuddled under her chin in my hand. She looked at me with sleepy eyes, yawned, murmured, "Woo, woo."

WINTER QUARTERS

WOO'S WINTER QUARTERS were in my furnace room. She had two sunny windows; a narrow lawn lay between them and the street. People walked up Simcoe when they went to the Park, especially to see Woo in her window—not children only. A war cripple whom my sister massaged told Lizzie, "I come down Simcoe Street because of a jolly little monkey in a window there." A cranky old woman who was walked daily by two elderly spinster daughters, coy as Woo, always paused to commiserate with "the poor little captive!" Children begged, "This way, please, Gran, so we can see the monkey." Woo grimaced at them all. She loved admiration, but pretended to respond with *blasé* indifference.

When summer came I moved Woo into a garden shed at the back to sleep. She sat in her cherry tree all day. Her street audience were angry. They said, "Is the monkey dead?"

"No, I have moved her to the back garden for the summer." Muttering something sour, of which I heard "selfish, greedy", they stalked by my house, morosely glowering at Woo's empty window.

Woo was no more than eighteen inches high when she stood upright, not twelve when she sat with her spine hooped monkey-wise. Yet this little bundle of activity wedged herself into the consciousness of the entire neighbourhood. I, twenty times her size, owner of an apartment house, payer of taxes, did not make such an imprint on my locality as my monkey did. In *every* house was a human not unlike me. No other house in the district had a monkey. My house was known as the "monkey-house".

Woo loved summer quarters; her sleeping-box was nailed to the shed wall. She could open and shut the door of her shed at will. She tore shingles off the roof, smashed her drinking cup through the window, undermined the foundations, ripped boards off the floor hunting for earwigs. No dog except her beloved Ginger Pop was allowed to enter her shed, no cat, no fowl whatsoever, no human being but me. My sisters tried it once—this is what happened:

I was ill, tucked in bed down at Lizzie's house. Lizzie loved to fuss over sick people, even cheerfully accepting care of furnace, beasts, and tenants as part of your cure.

She returned from doing my evening chores. "That evil creature has ripped the woollies from her sleeping-box and she will not let me go into her shed to tack them up again! What shall I do?"

"Let her sleep cold."

"No, Milly, no! Woo is tropical," protested my sister. "She will surely take a chill. Oh, dear! If only the beast hadn't such rows and rows of teeth when she is mad!"

"I'll tackle her—Woo likes me," boasted Alice and sailed forth armed with banana, egg, and candy.

Alice did not come back. Dark came. Lizzie was about to make a trip of investigation when Alice came in pink and riled. "Huh! A monkey's prisoner! Never thought I would be that!"

"What happened?"

"Woo grabbed the banana—while she was eating it I went into her house. The creature shut the door on me, held it fast, making evil faces if I tried to open it. I wondered how long it would be before anyone missed me—and my children waiting for their tea, the poor little things!"

"How did you get out?"

"Candy in my pocket. I pushed the door a crack open and flung the candy wide—Woo tore—I bolted. Children hungry because of the senseless whim of a gibberer! Milly, why must you. . . ."

We all laughed. Nobody *could* really hate that merry creature Woo; her pranks warmed our spinster middle-aged lives.

MRS. PINKER'S VISIT

WOO HAD NOT been with me long when Lizzie said, "Mrs. Pinker is coming to town. She wants to stay at your house, but she hates monkeys."

"Too bad for Mrs. Pinker!"

"Are you going to let a monkey ruin your business?"

"Love me, love my monk."

Mrs. Pinker came.

"I hear there is a monkey in the house! I don't like monkeys—disgusting, smelly! Saw enough of them in that hotel in Madeira! Impossible! . . . The loathsome creature owned by Lady Melville, the Duchess of Whitewater's horrible 'ringtail'!"

"How came the management to allow it?"

"Titles and tips, my dear."

Mrs. Pinker liked my house. She enjoyed the big studio's great window, open fire, dogs, cats, parrots.

Sometimes I said, "Why sit in that straight, hard chair, Mrs. Pinker?"

"The little people" (meaning dogs and cats) "have the 'easies'," she replied.

"Nonsense! Creatures readjust themselves easily," and I would tap the beasts onto the hearth rug; Mrs. Pinker thought me cruel.

During Mrs. Pinker's visit I kept Woo below. Her Ginger Pop was in the basement to keep her company.

"Where is this monkey?" asked Mrs. Pinker peevishly.

"In the basement with Ginger Pop."

"I won't have the creature banished because of me! Bring her up."

"Woo is all right down there."

"Bring her up!"

Woo dashed into the studio, took her favourite place by the fire. When she saw a stranger, she made a face and let out a squeal immediately, conscious of Mrs. Pinker's antipathy.

"So!" said the old lady. "You do not like me, eh, Woo?"

Woo spied Mrs. Pinker's ball of knitting wool and made a grab.

"No! No!" protested Mrs. Pinker.

Woo hugged the wool ball and gibbered.

"Drop it, Woo."

The monkey grinned at me and threw the wool down. Mrs. Pinker stooped to pick it up. Woo gave her hand a stinging slap. The old lady rubbed her hand thoughtfully. She began to knit.

I chained Woo in her corner. Ginger Pop went to sit beside her. Soon they were scuffling in play like two kittens. Mrs. Pinker put aside her knitting. Tears of laughter ran down her cheeks as she watched the two fool each other. I had never heard Mrs. Pinker laugh so hard as when Woo, stealing my handkerchief, polished Ginger's nose with it.

Mrs. Pinker requested that Woo be brought up each day.

"But you hate monkeys, Mrs. Pinker."

"Well, I like to laugh."

Next thing I knew, Mrs. Pinker was knitting a diminutive woollen sweater.

"It would be best for you to do the measuring and fitting, my dear," she said. "I wish it were not so sombre a colour . . . very good wool—same that I made a sweater for my son of. It will be cosy for Woo's winter walks."

After the sweater was finished Woo went walking with the dogs and me. Mrs. Pinker was dissatisfied. She went to town and returned with bright scarlet wool.

"Far more becoming," she said, holding it against Woo's green-grey fur. So Woo got two sweaters.

I went sketching in the Park. I took Woo in her scarlet sweater and chained her to a tree while I worked. When I came to loose her a tiny scarlet sweater hung empty on the tree-top. Woo lay flat along a willow bow almost the exact

colour of her own fur. I never told Mrs. Pinker. (I am convinced that, especially in strange environments, monkeys select a background as near to their own colour as possible.)

Mrs. Pinker was ill. The doctor came. As he passed through the studio, he saw Woo.

"Oh, a little monkey! I shall make her acquaintance on my way out."

The monkey jumped to the doctor's knee, interested in the shiny clasp of his bag. He showed her his torch, spent a half-hour trying to teach her how to turn it on. Woo was stupid, would not learn, was furious when he took it away, opening her mouth, staring him in the eye, jerking her head this way and that, slapping at him.

"Woo," said the doctor, "if all patients would open their mouths to that extent, it would put the x-ray out of business."

"What was the doctor doing so long in the Studio?" asked Mrs. Pinker.

"Playing with the monkey."

Mrs. Pinker was peeved. "Ten minutes for the old lady, half an hour for Miss Woo! . . . Huh!" She twitched the bedclothes over her shoulder, turned her face to the wall.

MATERNITY

WOO WAS a natural mother. Sisterhood did not appeal to her. Ordinarily she ignored the griffon ladies but, let one of them have a litter of pups, and Woo was all coax—begging to share.

Cooing to the side of the box, pleading for just one peep—presently her hand would steal over to touch a pup. The mother dog growled, snapped!

When the pups grew and the mother left the box more, Woo, watching her chance, crept in and drew the pups close, cuddling, crooning, gibbering, kissing as she kissed me or kissed herself in the mirror. When the mother dog returned Woo would not give the puppies up. The dog then would come whimpering to me for help. It was the same with the old yard cat's kittens. Woo clutched them to her with ecstatic hugs, ignoring the spitting mother cat.

"It's a shame," I said, and went to Vancouver to talk with the keeper of the monkey house in Stanley Park.

Lizzie looked after my creatures and the furnace in my absence. I returned to meet a furious, purple-in-the-face Lizzie coming out of the basement, picking gobs of sopped bread out of her carefully arranged grey hair. Milk trickled down her cheek.

"Abominable brute!" she exploded. "I stooped to feed the furnace; she crept along the pipe and deliberately emptied her food cup into my hair!"

I offered soothing and appropriate apologies. "Won't your little patients enjoy that," I said.

"Huh! How did you get on in Vancouver?"

"The keeper says monkey-breeding in captivity is very risky; often the mother, the baby or both die."

"Then don't risk it, Milly; don't! Let well enough alone."

So Woo had to cramp her maternal affection into loving other creatures' babies. She handled the pups and kittens so tenderly that the mothers gave up protesting, and Woo philosophically accepted adopting in place of bearing.

WOO AND LIZZIE

LIZZIE WAS DRESSING for work in frantic haste. Her fresh uniform lay upon the bed awaiting the mother-of-pearl links she had removed for its washing. They sparkled on the dressing table and caught Woo's eye.

Lizzie said, "Put those links in my dress, Milly," but before I could reach them they were in Woo's mouth.

"Oh! Oh! She's swallowed my links!" screamed Lizzie. "They are in her stomach. I am late now. How can I go gaping? Oh! Oh!"

"They have not got as far as her stomach yet. I can see the shape of the links through the thin skin of her cheek pouch. Open up, Woo!"

The monkey grinned at me, gibbered. I took her paws in my hand, put my finger under her tongue and fished out the links.

"Ugh!" Lizzie dropped them into the water-jug. "Ugh! Monkeys!"

The links plopped and gurgled. Lizzie rushed them into her uniform. Lizzie and Woo ignited each other, both were quick and peppery.

Lizzie supped with me on Sunday nights. I always brought Woo upstairs. In spite of their spats they amused each other.

I heard, "Spit them out, spit them out, Woo!"

I came running. A little grey packet that had been full of carpet tacks was empty. Woo's mouth was so crammed she couldn't even gibber. I rescued all the tacks I could, but the monkey showed great distress—so did Lizzie.

"Foolish beast!"—then, "Poor Woo, poor, poor Woo! Do they hurt your throat?"

I ran my finger round behind Woo's tongue. No tacks. The monkey took my

finger, pressed it to her gum. I felt a sharp prick—a splinter of bone was wedged between her teeth. I pried it out. Woo was most interested. She held my hand and scrutinized the splinter.

"That monkey is smart, Milly, taking your finger and putting it on the prick. A bad, bad monkey—clever though."

WOO'S ENEMIES

OF COURSE Woo had enemies. The cackling laugh of the parrot, Jane, crazed her. The fact that both were tropical creatures did not link them. It was the human peculiarities of each which annoyed the other. The parrot's words fooled the monkey; Woo's grasping hands enraged the bird—hands that stole food out of the parrot's cage and wrenched feathers from her tail. The hate between parrot and monkey was bitter.

Woo's other enemy was Adolphus, the big grey Persian cat whose dignity enraged Woo. She tore a fistful of silver hair from Dolf every chance she got. Dolf let her feel the barbs under his velvet paw. He spat, hissed, struck. His slaps were less hefty than Woo's but they ripped. Woo teased Dolf by pulling the cushion from under the old cat, drinking up his milk.

When Ginger Pop became adult there were triangle affairs in the kennels. Koko resented young Ginger. Each dog fought hoping to kill. Koko had advantage of weight, Ginger of youth. Anger rattled grimly. Woo championed Ginger Pop. Screaming like a mad thing she rushed into the swirl of battle and held on to Koko's stump of tail with both hands, tugging with all her strength to pull him off Ginger. She beat him, bit his heels. All three combatants screamed. I rescued Ginger who was very small and came off worst. Woo attended to Koko. Sitting square in front of him, taking firm hold of his whiskers, she grimaced in his face, shook, cuffed the old dog giddy, and so abashed him that he shrunk off and hid. Koko never rounded on Woo; he treated her with the same tolerance with which he treated his kennel ladies.

MONKEY LOVE

THAT THE MONKEY loved me I could not doubt. She did not show her love for me in the same way that she showed it for Ginger Pop. He, an animal, was in her own class; I, a human, was something else. Under human gaze Woo assumed false behaviour, became self-conscious. She sensed the superiority, the amusement a human feels towards a monkey, a giggling, stupid human, retreating if Woo looked, stretched a hand towards him. He said, "Horribly human! Disgusting little beast! Perhaps there is a half-brain behind those grasping, holding paws!" rating the monkey as a degenerate branch of the human race instead of an intelligent animal.

If I had been away from Woo even a short while, and she heard my returning footsteps half a block away, she gave high-pitched whoops of delight. Yet, when I came close, she looked the other way or became absorbed in an earwig, not rubbing against me like a pleased cat, nor jumping up like a glad dog, gazing over my head at any object rather than at me. Yet I could feel her quiver of awareness and delight that I was near. For Woo I embodied love, food, warmth, and protection. Frightened, she rushed to me and clung; hurt or sick, she wholly abandoned herself to my care; in strange places she wanted to hold onto one of my fingers; caught red-handed in some mischief, she rocked herself back and forwards, mouthing and grinning apologetically—a dear grin which Woo kept for me exclusively.

THE FOX FUR

WOO'S RAGES spluttered up and went out like struck matches. Open angry jaws, spread nostrils, clutching fingers, jerking head, grunts! Next moment, all forgotten.

Woo was intensely loyal to the few she loved.

I saw this loyalty put to severe test once.

A visitor to the Studio loosed the fox fur she wore and bounced it at Woo. Terrified, the monkey screamed and rushed under the sofa. Ginger dashed to see what was wrong with his chum. The visitor pinched the white fox onto Ginger's stumpy tail. The pinch, the glassy stare of its eyes, the persistent following of the dangling fur crazed the dog; he dashed around the Studio. With a scream of regular jungle rage Woo bounced from her hiding. She forgot her own fear in rushing to rescue Ginger, biting, tearing at the fox, at its stupid false head and dangling feet. Now it was the visitor's turn to yell and rescue her neck-piece.

Many artists from Seattle visited my Studio—professors, art teachers in the University of Washington—often spending week-ends. It amused these staid educators to stay in a house in which there was a live monkey. First thing they asked was, "How is the monkey? Do bring her up to the Studio."

These visitors loved beach picnics and they always wanted to include Woo. They knew Woo was as keen a picnicker as any of us. Sitting on a log with her skirts tucked demurely round her, the monkey accepted her share of the food gently and graciously, drank milk from her own tin cup, suddenly hurling the cup away. A wave of wild beast possessed her. With a crazy screech and a flutter of domestic petticoats, she would skim across sand and drift. Who knows but some old, scarred log, after bobbing across the seas from Java and beaching high and dry in British Columbia, had spoken to Woo, had set some hereditary thrill quivering through this little Javanese. Ginger Pop would trot after Woo. When she had worked off a little steam she sat down and Ginger sat beside her.

"Woo, woo"—the pair returned to our picnic. Woo contentedly played, tossing stones; the little dog watched gravely.

On the grassy slope of Beacon Hill I saw a comical sight: two dignified professors down on their hands and knees stalking grasshoppers to please the appetite of a diminutive scarlet-aproned monkey.

"Here's a beauty! Woo!"

"No, take mine: my hopper is the fattest."

The imperious Woo grabbed a hopper in each hand. Munch! Munch! "Woo," she said. "Woo, woo."

The professors dusted their learned knees, pleased that their offering had been accepted. I snapped Woo's chain to Ginger's collar and, coupled together, dog and monkey raced home, unled, the professors and I demurely following.

CANADIAN CLUB
LECTURE

OUTSIDE, everything dripped; inside all gloomed. The monkey's scarlet apron was the only gay spot this grey day. She sat warming spread toes in front of the Studio fire. Ginger was alert for play, but Woo was pensive.

The telephone whizzed, "May I bring a stranger to your studio?"

"Artist?"

"No, writer."

"Sure, come on!"

The stranger, a woman, asked me to show her some pictures. They interested her.

"Tell me," she said, "why have I not heard of your work? I have been in Victoria for months and I have enquired repeatedly, 'Are there no artists?'"

"Victoria hates my painting. She resents the more modern way of seeing that I learned in Paris. No place is more conservative in art than Victoria."

"Have you given Victorians a fair chance to see it?"

"No. The few who come to my Studio are so depressingly antagonistic— ridicule, loathe it. I don't care whether it pleases them or not. I am not changing back fifty years to please them!"

"Well, Victorians are going to see it now. I am going to rub their noses on canvases whether they like it or not and you are going to give a talk on the newer way of seeing—give it before the Women's Canadian Club!"

"I couldn't! Oh, I couldn't!"

But within a week I found myself booked to give that talk plus an exhibition. Alarming ordeal! No wonder my watch on Woo was slack. While I scribbled notes a stealthy foot stole towards my paint-box, a firm supple tail whipped the large tube of yellow paint towards her foot, her foot gave it into her hand— silent bliss.

I glanced up from writing. "Woo! Woo!" Monkey, rug, and bench were yellow as daffodils; the torn tube lay empty. Woo was obviously beginning to feel very ill.

My talk flew to the four winds. All day I hung over my monkey. I washed inside as far down as I could reach with gasoline rags. I gave emetics and physic. Woo submitted, pocketed the physic in her cheeks and spat it out later. She lay across a hot bottle in my lap.

The veterinary said, "No good my coming out. She would not permit a stranger to handle her. You have done all there is to do. If she lives through the night she'll make it—very, very doubtful!"

The sponsor of my talk rang up.

"How goes the talk?"

"Gone! The monkey's dying."

"You can't let me down! All arrangements made—day after tomorrow. You couldn't!"

"If Woo dies, I shan't talk!"

My sponsor had enlisted the help of a Dutch artist to hang the exhibition.

He phoned, "Dis talk, she is ready? De picture, she ready too? Tomorrow I hang."

"No exhibition—no talk—my monkey is dying!"

"So? What ails leetle monkey?"

"A whole tube of aurioline yellow."

"Dat monkey, she eat?"

"Yes."

"Bad, ver', ver' bad. Yellow most poisonest of all paint. Leetle monkey die for sure—too bad!"

"Good-bye." I slammed the receiver down.

Woo did *not* die. She was violently, yellowly sick; then she sat up, shook herself, and ate grapes.

Early, early in the morning my sponsor's voice quavered through the phone, "Woo?"

"Aurioline came up—going to live—am working on my speech."

"Thanks be. . . ."

The talk went over on the crest of such happy thanksgiving it made a hit. The credit belonged to Woo's tough constitution.

SEWING

I SAT BY THE STUDIO FIRE patching one of Woo's dresses; the dogs and monkey were sprawled round, sleeping. Woo sat up, stretched first one leg and then the other, yawned—every hair on her body stood at attention; she shook a great shake, beginning at her nose and ending at tail-tip. When every vibrating hair had settled into sleek oneness again, she jumped to the arm of my chair and scrutinized the needle going in and out of the cloth. "Woo," she murmured. "Woo, woo."

"Want to sew?" I handed her a pin and a piece of rag. Woo pushed the pin through the cloth; the head stuck each time. Angrily she tossed away pin and rag. I left the room for a moment. Woo was slipping from the table as I re-entered. In her hand was the needle with which I had been sewing and which I had stuck into the pin-cushion on leaving the room. It was the only needle in a cushion full of pins. Woo picked up her rag, began to sew, each time painstak-ingly drawing the needle right through the cloth, sometimes helping it with her teeth, but always bringing it out on the opposite side to the one on which it went in. She would *not tolerate* thread in her needle: it snarled.

For several weeks Woo's favourite occupation was sewing. It absorbed her for an hour at a time. Suddenly she tired, threw away the needle and rag, finished with needle-craft for good. That was Woo's way.

For the sake of variety I sometimes chained Woo to some movable object that she might wander round the garden and hunt insects. The article must be bulky enough that she could not lug it up the Studio stairs—Woo's one desire was always to get into my Studio.

One day I fastened her to a lumbering chair of wood. The chair was heavy and bulky. After proving that the cumbersome thing could not be got up the stair, Woo sat and thought. At the far end of the garden was a loaded apple tree—red, juicy apples. Woo had all the apples she could eat. It was not the fruit she wanted, but the pips at the core. She would destroy dozens of apples simply to get their seeds. She began tugging the chair, intent on reaching that best apple tree. She pulled, she pushed; the chair legs stuck in the grass roots. Then she tried heaving the chair over and over. Had she been able to steer straight, each flop would have brought the chair one length nearer to her goal; but the old chair flopped this direction and that. The tugging, grunting monkey paused every little while to eat an earwig. After a long, long struggle the chair toppled

under the tree. Woo sprang, only to find that her chain would not allow her to climb out to the end of the boughs where the apples clustered.

No gallant serpent being in my garden to hand apples to little Eves, Woo got down, over and over went the chair till at last it was directly under the fruit, the chair on its side. It was still too low for her to reach the apples. She stood the chair upright, climbed the seat, climbed the back, reached for the biggest apple—too big for her hands, it dropped at touch, bumped Woo's head.

"Ooo-ooo-ooo!" She caught the fruit before it rolled beyond reach, gripped it in both wide-spread feet and burrowed for pips.

I saw with amazement my monkey's perseverance again. One sketching trip, I hired a cottage high up a steep bank. I took dogs and monkey to the beach while I worked, fastening Woo's chain to a derelict preserving kettle which I found among the drift. Soon the monkey tired of dabbling in the puddles. Her brain connected my being on the beach with the cottage being empty and the joy of rummaging unchecked.

She began lugging the great kettle over a wide stretch of drift between sand and bank. Mounting each log laboriously she hauled the kettle up on her chain, hand over hand like a sailor. She took it over dozens of separate logs, at last coming to the wooden steps that climbed the bank. Up, up, monkey and kettle toiled, kettle registering each step with a clank. Bushes beside the steps caught the chain—Woo patiently unwound it. She came at last to a small flat landing. From there a steep clay path ascended to the cottage door. Woo made the discovery here that if the kettle were put on its side it could be rolled. After a brief rest she started to roll it up the steep path, but on a hill the old kettle was otherminded. Dragging Woo with it, from top to bottom it rolled down the entire stair, defeating in seconds Woo's hours of toil and landing just where they started, the kettle spun and settled.

"Ooo!" said the monkey. "Ooo-ooo!"

All concentration was jerked out of her. Picking up a foot she extracted a splinter. She then fell to catching sandhoppers—a tired but not disheartened monkey, kettle and climb entirely forgotten.

GINGER POP DIES

GINGER POP took fits and died. A perplexed Woo searched garden, basement, and Studio. Old Koko relaxed now that there was no one for him to vanquish.

Woo was without a dog chum. Both creatures found life flavourless. As the months rolled by they drew a little closer on the hearth rug. By and by Woo's small quick hands were parting, arranging Koko's hair as they had done Ginger's. The old dog liked it. They settled into a comfortable middle-aged companionship.

Woo's cherry tree was dripping dew these autumn mornings. The roof below the Studio got first sun. I chained the monkey there. Old Koko got the habit of climbing the Studio stair, strolling over the roof, flinging himself down in front of Woo as an opulent old aristocrat might throw himself into the barber's chair. Woo, important, efficient, bustled to work.

I now coupled Woo and Koko when we walked. He was the only dog other than her Ginger Pop that Woo ever permitted to lead her. Woo took mean advantage over the old dog too. When out she liked to sit down periodically and look north, south, east, and west. The dogs and I got smaller and smaller; Koko was frantic to catch us up. Woo saw to it that she made her pauses where there was a bush or post around which she could wind her chain and securely tether old Koko until she was ready to move on. It was vain for him to strain and tug at the lead. Woo sat.

When we were out of sight entirely, Woo got panicky—her deft hands undid the chain. With flying petticoats she came tearing. It was all old Koko could do to keep up.

Koko aged faster than Woo. When I saw that to lead her was becoming a burden to him, I did not couple them any more. At the age of thirteen old Koko died and Woo settled down to second widow-hood. She did not look at, nor attempt to fix, the coat of any dog for one whole year; and then one day I dressed a griffon pup up in her dress. Woo watched, interested; she felt him, smelt him, cuffed his ears, pulled his tail. Then she took hold of the loose flesh of his wrinkled cheeks, tried his mettle as she had tried Ginger's, by staring into his eyes, opening her jaws, twisting her head this way and that with alarming ferocity. Griffons are game little dogs: the pup gave her stare for stare. With a gentle cuff or two Woo let him go, having accepted this "pup" as the boy-friend for her declining years. "Tantrum", the deep red, smooth-coated third dog-love of Woo's life, was a sprightly, handsome little griffon.

PICTURES, KEY,
BANTAM ROOSTER

GIVEN AN OLD MAGAZINE, Woo would turn the pages till she found a picture, then make a long staring pause. I wondered whether the monkey recognized objects in the flat. I gave her a book of high-coloured monkey pictures; she was not interested. Just turning the pages seemed to please her. One day she ate half my dictionary, drank a bottle of ink, and chewed up my pen. I was mistrustful of Woo's literary appreciation.

In an old magazine she came across a salad advertisement—coloured, realistic fruit and vegetables. She licked a florid tomato, bit into the pictured fruit, nipped it all over (no nip at all on the background). With a disgusted grunt she turned the page, regarded the holes she had pierced, and threw the book away.

One morning Koko took a juicy bone up onto the roof when he went to be barbered. Woo seized the bone and forgot Koko's coat. Her hands were soon greased. She hated grease. Putting the bone on a ledge beyond Koko's reach, Woo climbed over the roof's edge. Gripping the gutter with her hands she stretched out a long back leg and caught a towel hanging on the clothes-line, tweaked till the clothes-pins flew. Taking the towel to the roof she got the bone and wrapped it up in the towel, wiping her hands free of grease. She then chewed a hole and gnawed her bone, holding it in the towel.

As long as her desire was not jolted in any way Woo had quite a power of concentration; let anything distract her and she forgot her goal.

As she could unfasten every kind of clip I resorted to padlocking her chain to her anchorage. The key fascinated her. I tied it to a big iron handle. Woo stole the handle, chewed the string, and took the key, hiding it in her pouch. Its glitter fascinated her. She would not give it up. I offered a banana in exchange. She wanted the banana and she wanted to go to bed. She knew the key was necessary before I could loose her. Time and again she took it out and looked at it but kept out of my reach. She wanted bed, she wanted the banana. Finally she held out her hands, gibbering, threw the key, seized the banana! Before I could pick up the key she darted, grabbed, carried it to a part of the roof she knew I could not reach!

My bantam rooster and Woo had a fight, the most comical I ever saw. A hen stole a scrap from Woo's food dish. Leaping from her tree Woo tore the tail off the small hen. His hen's squawk, seeing her tail in Woo's hand, enraged the rooster. He rushed upon Woo like a hurricane, wattles scarlet, ruff sticking out

round his face like a halo, leaving the back of his scraggy neck naked. The rooster struck at Woo with beak and spur.

Woo was afraid for her eyes. Each time he attacked she ducked her face into her petticoats so that the bird flew clean over her. When he grounded, the monkey darted, snatched a handful of feathers from him. I tore them apart—both meant killing.

The monkey used her petticoats for defence as naturally as if they grew on her.

ORGY

SPLENDID HEAT roared up my radiators.

"I shall compliment the dealer on this coal," I said.

Before noon stoke-time all the pipes were dead. I went to the basement. The basement had a glass door.

Woo was too absorbed either to see or hear me come. She was walking around carrying in her hands a tin of liquid tar. Every few steps she paused to pour a little tar into any receptacle handy. I saw a black trickle run into my garden hat, which, along with everything else that had been hanging on the basement walls, she had torn down.

The moment my shadow appeared, Woo saw me! Carefully setting the tar can on the floor, she glided into the furnace room. I picked my way among tar puddles. Woo was already seated innocently on her window shelf gazing intently over the tree tops, hands demurely folded in her lap; a loose end of chain dangled from under her chin, another gleam of chain hung down the wall. The ash door of the furnace was flung wide, ashes were raked all over the cement floor. The water-glass egg container yawned on its side, rivers of water-glass ran among the ashes. Egg yolk dripped from the sides of the furnace, from the walls of the room, from door and windows. The coal pile was an omelette. Every bottle in the basement was uncorked, contents had been noted, and either drunk or spilled!

A paper sack containing lime had been emptied into my nail-box, nails stuck out of the lime like little black sticks out of a snow-drift. My geraniums had been transplanted on their heads in eggs and coal. Not a flower-pot was whole.

"Woo! Oh, Woo!"

She neither turned, looked, grinned, nor gibbered. She had had one *good time* and was glad! Stillness brooded over the chaos. Suddenly she caught the broken links of chain, stuffed them in her mouth, gnashed the steel defiantly.

Yet I saw that she trembled. I took a split ring and mended the broken chain. She watched. Never had the whites of her eyes looked so uncannily not-white, never her eyelids seemed so uncannily creamily white! Her eyebrows rested far up on her forehead like those of a tired, tired, old woman. The little pointed face made me think of an old farm-wife I once knew whose drunken husband so terrified her that she used to run and climb into the tree where her turkeys roosted, peering down at the man through the dusk, her crouched form little bigger than that of her tom turkey.

Woo anticipated a spanking. She did not get it; the spank evaporated from my fingertips! What Woo knew about spanking she had not learned from me. I had seen the hefty black hand of a mother monkey beat her little one; I had seen the big monkeys at the pet shop punish Woo.

She had enjoyed one big blissful orgy! The tantalized curiosity about everything in my basement that lay beyond her chain's length was satisfied at last. Humans had taught Woo to connect the words bad and fun or she would have been delighted with her exploits. In the jungle there is no good and bad, no conscience to tweak.

Poor little Woo! Captivity taught you good—bad.

Woo watched me clean the basement intensely interested. When I looked at her she turned away her eyes. I offered some cracked eggs; her passion for eggs was sated for the moment. The basement decent, the furnace pipes warm, Woo jumped to my shoulder, cooed softly in my ear—luxuriously she stretched her body along the hot pipe and warmed her tummy. Maybe conglomerated soap, blueing, disinfectant, linseed oil, turpentine, worm medicine, mange cure were not sitting quite comfortably there.

I am glad I did not spank Woo, glad she had one huge orgy.

TEA PARTY

I GAVE A PARTY in my garden. Every guest greeted me, then went direct to Woo as if she were joint hostess. Woo in her tree was excited and very self-conscious at seeing so many people.

Everyone said, "Hello, Woo!"

She did not look directly at anyone but rather over their heads. As each new guest came through the garden gate she stood upright and gave a throaty croak, intimating, "Stranger!" Her interest in the guests soon slumped; bored, she turned her back upon the people and fell to examining her own hands and her feet.

Two women were watching her. One said, "How horribly human those hands are! Look at the perfect finger nails, the thumbs, even the lines in her palms! Self-conscious little show-off creature; Darwin—oh, pshaw! The humanness of her makes me sick!"

"Aren't you judging the monkey as if she were a tenth-rate human being, not a small, intelligent beast? She has sense enough to be her own amusing self; few of us have that."

The first speaker shrugged.

Tiffed by the monkey's indifference to their presence, some of the guests tried to work Woo into a rage, poking her with sticks or trying to tweak her tail. Eyes ablaze, Woo wrenched the sticks from their hands, chewed them and spat, lashed out at those who tried to pull her tail.

"What a little fury! Jungle tricks! Savage little beast!"

I was more furious than Woo. All she asked was to be let alone, to be allowed quietly to pursue her own investigating of humans, her curiosity regarding objects. I felt Woo had had all the party she could endure, so I produced a mirror. Instantly Woo forgot the people, the party. Leaning the mirror against her tree, turning her back to humans, she fell to cooing, kissing the shadow of her own kind—her monkey self!

WOO SAVES DOLF

WOO'S ENEMY, Adolphus the cat, had been missing for four days. I searched the neighbourhood. Dolf was the colour of dusk. A motor might easily have got him while crossing the road.

Taking Woo on her chain, "I'm not returning till I find Dolf dead or alive," I said.

"Woo hates the cat. Why take her with you?" called Lizzie.

"Woo's curiosity is enormous, her eyes quick. If one hair of Dolf shows she will investigate," I replied.

I went first to the empty house next door and peered through its windows. Could the cat have got shut in? Woo began tugging on her chain. I let her go and followed. She crossed the garden, crouched, peered under a dahlia bush by the division fence, touched something, squealed, thrust her hand in, withdrew it full of silver hair. I pulled Dolf out. He had evidently been crushed under a motor wheel, had crept as near home as he could to die. Like an empty fur he lay across my arm, limp, with glazed eyes and lolling tongue.

I took the cat upstairs; he was chill, not rigid. Having no brandy I put a little cream on his parched tongue, laid his crushed body on a pillow. The cream

revived him. He was home! Sensing that, recognition came into his eyes; he tried to rub his cheek against my hand. His flesh was crushed to jelly. I sent for the veterinary.

"Put Dolf out."

"Not Dolf! If there were broken bones, yes; if he were an ordinary cat, yes, but not Dolf. He will recover."

"I do not want him to suffer."

"You cannot make a suffering cat purr—listen!"

Dolf did recover, thanks to Woo's finding him in time. He lived another three years, dying at the age of eighteen years. He and Woo were enemies to the bitter last.

A S M A C K F O R
H I S M A J E S T Y

WOO AND I went to spend an hour in Beacon Hill Park.

The monkey climbed into a low-hung cedar tree overhanging the lake. She was dressed in a full-skirted woollen dress, covered by a scarlet apron that was buckled round her waist. The autumn days were nippy; the monkey was glad of her clothing.

The boughs of the cedar tree hid the monkey. I sat on a nearby bench to feed the magnificent pair of Royal Swans, presented to the park by the King of England, raised in the King's own swannery.

On the park's other lake were swans too, common swans with whom the royal pair were not allowed to associate. Royalty had a small choice lake; its centre was clear water, round the edges grew water-lilies.

When the majestic swans saw me seat myself and produce a paper bag, they came hurrying down the narrow waterway between massed lily pads expecting a treat.

His majesty approached grandly, high arched neck, proud breast ruffling the waterway. His queen swam gently between the troughs of ripple her lord's hurry had dug on the lake's smooth surface. Unarching his haughtiness his majesty stretched forth an aristocratic bill to take the crust I threw upon the water.

A scarlet flash! A ringing smack! The monkey springing from her bow had landed on a huge flat stone immediately in front of his majesty. The full force of her strong, black little palm hit squarely across the swan's face. The monkey seized the crust out of the kingly bill and, crouching, her eyes staring straight

into his, her mouth angrily open, showed him every one of her perfect teeth. Slapping her hands on the stone in front of him, bending this way, bending that, the creature made herself a grotesque awfulness.

Obviously his majesty had never had his face smacked before! Fury and amazement blazed from his eyes. With infuriated hissings he sought to back, but the way was blocked by her majesty. He bumped into her—she turned with all the haste her gentleness and the narrow way would permit. The birds could not break through the snarl of lily pads. Splashings and furious unroyal squawks! At last they had reversed their going and were paddling madly for the open centre of the lake, hoisting their wings into two angry ridges, one either side of their bodies, bills buried down in their breast feathers in order that the arch of necks might rise higher, foamed waves scurrying before their angry breasts.

With a disdainful grunt the monkey hurled the crust after his majesty, swung herself back into the tree and tucked her cold, wetted hands into her woollen lap to warm.

"Ooo-ooo, ooo-ooo," she cooed, delighted with herself for having smacked the bundle of feathers whose arrogance she despised.

"Ooo-ooo-ooo!"

WOO AND HA'PENNY AND CAMPING

WOO, THE GRIFFS, and I were tucked away in a house-boat up that lovely arm of the sea known as "The Gorge".

At high tide our house-boat floated, at low tide she tipped and one end rested on a mud bank. At low tide there was splendid crabbing along the sides of our scow-float. Woo lay flat on the boards making quick darts as the small crabs crawled out of crannies, tossing them sharply from hand to hand to prevent their nipping her fingers. Each day at five o'clock I relaxed from sketching.

The water lay flat and still. I got the oars, untied the old flat-bottomed, square-nosed boat that rented with the house-boat. The creatures crowded excitedly! Woo was the first to leap in, rushing to the square boat front and flattening her stomach to its boards. She peered into the water, called. "Woo, woo", kissing, coaxing the floating shadow monkey to come.

Koko and Ginger Pop sat themselves one on each side of me on the rower's seat, my body between their enmity. Every stroke of the right oar bumped Koko;

every stroke of the left bumped Ginger—all were too happy to mind bumps or to remember hostilities. Two other griffons, John Bull and Mr. Pumble-Choke, went along steerage, being humble.

Our boat preferred to progress in circles. As neither time nor destination mattered, circles were as good as straight lines.

The silly waves rapturously kissed our craft's ugly sides and Woo tenderly kissed overboard at the shadow monkey. These were the only sounds. I forgot tenants, town, and taxes—they were as drowned as the stones and snags down in the mud, drowned in peace till suddenly across the water. "Cooey! Cooey!"— a table cloth was waving from my house-boat.

I persuaded our boat to circle towards home. The girl I had left in town in charge of tenants and kennels stood on my veranda holding a depressed pup with a dangling broken leg. I went into town. The vet set and splinted the leg. I brought the pup back to the house-boat. Woo was intrigued by the splint. On the third day the swelling of the foot went down. I glanced up from my work to see Woo gently slipping the splint over the pup's foot. I dared not shout for fear she might snatch the splint suddenly and unset the bone. The pup was delighted to be free. Woo slipped a hand through the bandage and fitted the splint to her own arm.

Toiling to the nearest phone, I called, "Doctor, the monkey took the dog's splint off. What shall I do?"

"Ach!" said the veterinary. "Bring 'em both in—chloroform for that monkey, new splint for the pup!"

When my creatures saw stir among household camping derelicts, they went wild with delight, stuck to me with the persistence of ants and house-flies. Early in the morning bedding, food, boxes, chipped crockery, sat on the pavement before my house. Woo was fastened into her travelling box, shrieking delight-edly, rocking the box from side to side. Bearded griffon faces peeped from wire-fronted cages. We looked like an eviction out there on the paved road. Finally the truck came rumbling down the street to pick us up. Tenants watched us from windows, presented us with camping plain wholesome cakes, wishing us well.

I expressed the hope that my understudy would be satisfactory, and climbed up beside the driver. We were off! Every twirl of the wheels left our worries more behind, raised our spirits higher. After the mild bustle and congestion of the town was past, there was nothing but sky, earth, us.

For fifteen years I camped in dilapidated cabins, too out-of-the-way, too out-of-repair for other campers to tolerate. Then I bought a cheap, ugly old caravan trailer. A truck hauled us to wherever I had wintered my van, hitched her on behind, trundled us to a new place. Each year the old van homed us for as long as the apartment house would let me be away.

There were always woods, always water, always sky. The creatures loved it—

so did I. They loved sharing close quarters with their own particular human even more than they loved the freedom.

My bed was across one end of the van—only half an inch to spare for kicking. On one side of the van was a shelf-table with storage spaces beneath; along the other was a low bench on which sat four dog boxes and the monkey box, all wire-fronted so that the creatures could watch my every move. There was a small table by my bedside where I wrote at night. Above the creatures' boxes were pegs for my clothes. The van had windows facing north, south, east, and west. My bed was high; in it I could lie looking out at the stars. There seemed more stars here than in town. Underneath my bed were all my canvases and paint equipment. I had two coal oil lamps, an oil stove for wet days. I cooked outside on a camp fire; we kept our food outdoors under a canvas shelter.

The monkey camped with me for thirteen years. I don't know which of us loved it more—she or I.

In camp once it rained for ten days steady. Being very tired, I went into the van, took the beasts with me and shut the door, just like Mrs. Noah. We slept and slept till the tired went out of us. If the rain stopped for a few moments we all tumbled out of the van to stretch ourselves. No shoes, no stockings—I went like the rest, barefoot. I put on a fisherman's mackinaw. We took pails and fetched water. The soft wet was underfoot, dripping trees overhead.

In the van again, hot water bottles, shakes, rub-downs, and we tumbled into our beds to sleep more. Wet days were almost as black as night—night so dark and thick you could lean against it. Rain rattled on the canvas only a few inches above our heads, rivers gurgled in the road ruts, breakers pounded on the beach. Plop! plop!—leak drops from the van's roof spattered into catch-cans. Snoring creatures, singing kettle, glow of lamps, cups of tea, hot bottles—delicious memories which remain after wet, wasps, ants, and other uncomfortables are forgotten.

Many people, forgetting I was an artist, thought it morbid, queer that I went off to the woods with the dogs and a monkey and no other companion.

The good memory of those times remain for always and Woo runs through it like laughter. I do not think the monkey had greater intelligence than my griffon dogs. She was more curious, more entertaining, more mischievous, less obedient. In spite of her adaptability to domesticity you were always curiously aware of jungle ancestry. The baffling human-acting hands, groping hands, trying, it seemed, to trick and yet to copy.

Before I bought the old van, wishing to work in a thickly wooded part at the foot of Mount Douglas, but unable to locate a shack, I took rooms in an old farm house with an elderly couple. The man worked in nearby tomato greenhouses.

"I must tell you," I said when arranging for my rooms, "that I shall have several little griffon dogs with me."

"Good! We love dogs," said the woman.

"I shall also have a monkey."

"A monkey! Sakes!" she clapped her hands. "I have always loved monkeys."

We had scarcely tumbled out of our truck in front of her house when the woman's husband came home.

"Look, Father, look at the monkey!"

Father gave to each dog, to Woo, to me a separate sour scowl.

"What is to be done with this collection?" he grumbled.

Mother dived into her kitchen.

"I will see that the creatures do not bother anyone; they are never away from my heels."

Two days later Mother tiptoed to my rooms.

"Father is up cherry tree gathering top-best for Woo!"

When Father came from the tomato houses he acquired the habit of passing by Woo's tree and patting his pocket. Woo scrambled down and dived in her hand. There was always a little ripe tomato in the old man's pocket for her. The couple liked, when my work was over for the day, to have us drop into their kitchen for a few minutes' chat. Woo would jump on the arm of the man's chair, put up a finger to feel if his pipe were hot. The man stooped to gather tenderly the little deaf dog, Twinkle, in his arms. Monkey and dog sat in his lap, his hands caressing them, his heart won.

Everyone accepted the griffons, everyone accepted Woo.

We stayed a fortnight at that farm. At the end of the summer, I went out to see the couple. They had been for a trip to Tacoma.

"You should have heard Father telling folks about 'our' monkey," the wife chuckled, "him that was so surly the night you come! One never does know how husbands is going to act."

"Or monkeys either," I replied.

Woo could well have been trusted loose except for her wrecking investigations. Freedom did not attract her. The houses and things of men did. If she were loose, she watched for my mind to be occupied by something other than herself, then rummaged cottage, van, tent, wherever my things were, tearing, smashing, spoiling by her curiosity.

One morning Woo sat unchained by the campfire embers warming her toes. I was setting the camp to rights. I sat down to write a letter before fastening Woo to her stump. The van was in a grassy place under great pine trees, beyond lay a hay field loved by Woo because it was full of grasshoppers.

When I realized Woo really had gone I ran to the woods calling, calling. There was no answering "Woo". Three hours I sought, then I remembered grasshoppers in the field and how she ran after this hopper and that till she got beyond the sound of my call. I walked down the highway which skirted our big field, and came to a house set far back.

"Hi! This your monkey? I seen you yellin' an' lookin'. Lor, the critter scared me proper. Standin' at sink washin' I was, door creaks, opens—no footstep! Then I seen a little hairy hand, then I seen 'er! 'Is it a chip of the devil hisself?' I says, says I."

"Thank you."

I took hold of Woo's chain. "Please lend me a bucket and a broom."

"Lor, them's my ant traps."

Down her verandah ran trickles of syrupy water and drowned ants; empty tomato tins rolled sideways.

Woo, replete with hoppers and 'ants in syrup', was delighted to see me, glad to be led home.

One September we camped on the Gold Stream Flats, a narrow spread of land lying between two high ridges. The sun came into the little valley late and went out early. Night and morning it was chilly. Our van was drawn up under a wide-spreading cedar tree, very old. Its immense bole was hollow. I put Woo's sleeping-box inside the hollow tree bole, dry, draught-proof. I wondered if the old tree could feel the throb of Woo's life inside it. She was just below the van window and could hear my voice. Nights were raw, bitter in the van.

This park was a public camping place. All the campers had gone back to town; we had it to ourselves except for a woman and her three little boys. The woman had the pop stall at the entrance to the park. Up the mountain-side was a farm. The children from the farm came down to play with the pop children. They took a great interest in Woo.

One morning the farm children rushed home with the news, "Mother, the monkey's sick."

"How sick?"

"Castor-oil sick. We saw the van lady pour and Woo spit."

There came a chattering and scattering of stones down the mountain road. Mother pushing a pram, dragging a go-cart, walk-age children hanging on to any part of woman or baby-carriage available. They came straight to my camp. The woman sat down on the log beside me, matronly efficient.

"How does she ail?" she pushed a gentle hand under Woo's covering, stroking the listless body lying across my lap.

"A stomach full of green paint."

"Mercy! It's fatal!"

"She recovered from both blue and yellow," I said.

"Green's worse—emetics and warmth is all I know. If she lives, here's new-laid eggs and milk."

She fished a dozen of one and a quart of the other from the pram.

She said, "Dark's coming," and trundled pram and go-cart up the hill.

Mrs. Pop-lady left her stall in care of her biggest small boy. "Someone may turn in from the highway, Willie. I'm going along to see how Woo is."

Heavily she slumped down on the log beside me, bent, and shook a frizzy bobbed head over Woo. "Looks bad! . . ."

Woo's white eye-lids were half closed, saliva trickled from her mouth; near the fire swathed in shawls she shivered. We were joined by another visitor.

"Willie told me."

She too sat down on the log—a spare woman, gruff voice, mannish hair-cut, thick boots, wide stride, and the softest heart in the world. This woman often spent a week-end in the park, sometimes with her husband, sometimes alone, in an old shack up the mountain. She loved wild things. She bent over Woo.

"Ah, me," she sighed. "I loved that mite from the moment I set eye on her—now she's done for!"

"Not yet! She has recovered from the yellow and from blue."

"But not from green!—deadly! Our cow died after no more'n three licks of our fresh painted boat."

"They told me yellow was the deadliest."

"Nope! Green! Woo's as good as gone!"

Excessive pessimism puts my back up—it did Woo's too.

She rolled feebly over, stretched a leg towards the fire. I offered milk, I offered egg, neither aroused interest. Violently Mrs. Pop bounced off the log, started to run over the hummocky ground in the direction of her stall.

"Willie!" she shouted, "Willie, bring a cone—vanilla!"

"Who for, Ma?"

"Woo, if you ain't too late."

"Ain't Woo goin' a-die, Ma?"

"Maybe not—hurry!"

Breathing heavily, Mrs. Pop sat again upon the log. Willie and cone came; Woo's pale tongue ran out, took a feeble lick. Woo lived.

"Beats all!" murmured a voice on the far side of Woo and me. "Monkeys is robuster'n cows."

E X I T

GINGER POP, Koko, Jane, Adolphus filled out their lives, died, and became memories. Woo was fourteen years when I sold my apartment house and moved into a cottage. The uprooting did not bother her. Wherever I was, there Woo was content. She had been in and out of camp so often that to be packed into her travelling-box and trundled over the road in a truck was no new experience. There were no hot pipes in the cottage for Woo to roast her front on, no basement woodpile for winter play. She had a large cage in the big old-fashioned cottage kitchen and loved having her nose and fingers continually in my pies. There was a plum tree in the garden, lovely as Woo's cherry tree: there was a brand new admiring audience to make faces at.

Woo was heavier now, thicker through the middle. She showed a preference for sitting beside the fire rather than walking. When my heart gave out the

doctor forbade me taking an active part in household tasks. Woo and I looked into the fire and thought. The doctor sent me to the hospital for a long rest. Poor old Woo! (I wonder what the nuns would have said had I arrived at hospital with a monkey!) Monkey and dogs sat forlorn in the cottage kitchen, waiting.

My sister had to go to them as well as come to me in hospital. The weather was bad—something had to be done. The dogs were easy to arrange for. A monkey? Few people want to bother with a monkey, willing to enjoy someone else's monkey, but too lazy or indifferent to earn the real enjoyment of owning. I wrote to the Vancouver monkey house in Stanley Park. Woo would here enjoy companionship and good care. The Park Board accepted Woo, friends shipped her before I came out of hospital. Giving her up hurt. Others nailed her into a box, gave her into strange hands. When I came home she was gone.

Friends in Vancouver went to see Woo nearly every Sunday, took all the dainties she liked best, eggs, cherries, grapes. At first they did it for my sake, these friends, but soon they went for their own pleasure. They loved to see the little hands stretch through the bars for goodies, to hear Woo's whoop of welcome. She had a roomy cage to herself, soon became a favourite with visitors. She was the "belle of the monkey house"! The keeper's daughter was especially fond of her.

Woo lived in the Vancouver monkey house for a year. My friends went one Sunday and found her cage empty.

"Old age—natural causes," said the keeper. "No ail, no mope . . . just died."

"Fine exit, Woo! If that is monkey way, I am glad domesticity did not spoil it."

P A U S E

A S K E T C H B O O K

C O N T E N T S

AUTHOR'S NOTE

THE FAT GIRL AND HER FAILURE

The fat girl came from the far west where the forests are magnificent and solemn but no singing birds are there. The fat girl found birds in the early days of her sojourn in England. She heard a thrush sing. It was a poor prisoner in London, broken tailed and bedabbled, in such a dirty cage, but the pure song coming from its dreary prison touched the fat girl. By and by illness came and the fat girl subsided into a San with a limp and a stutter. Then it was that the plan came to her to rear some thrushes and take home to her glorious silent woods. The fat girl bucked up. Spring came, birds built. The fat girl waddled forth with her stick and watched for many weeks the pretty mothers build and sit and hatch their clean and ugly babes.

The Sanatorium,
Nayland,
Colchester,
Suffolk,
March 1903.

CONDEMNED

THE HARLEY STREET Specialist pretended that he had not noticed me lay his fee in gold upon his desk. He hoisted his well-satisfied self onto the toes of his shiny patent-leathers, and forcefully repeated, "Madam, the voyage to Canada is for the present entirely out of the question. Best of care, rest, rest, good food, above all fresh air . . . you are young. . . ."

"But Doctor—?"

"You have people this side of the world?"

"No one."

"Who looks after you?"

"I look after myself."

"Inadequately. Sunhill Sanatorium, that is the place! Doctor Sally Bottle, Lung Specialist, Harley Street. Arrange with her for a year's stay in the Sanatorium. A year's rest and care will do wonders. Good day."

"But Doctor, I am not T.B. I came to London to study Art. I've just worked too hard, that's all."

"Precisely." He rang for the maid to show me out.

"A year!" I stumbled down the steps of the Specialist, made my way to Doctor Sally Bottle's. Within twenty-four hours I was seated in the train, bound for Sunhill Sanatorium, wildly rebellious at heart.

I was met at the station by James, sole male worker around the Sunhill Sanatorium. From doctors to 'Odd Jobs' the entire staff were women.

"Sun'ill, Miss? 'Osses is be'ind 'ere." He gathered up my luggage.

The seat of the San bus was shaped like a horseshoe, intimating luck to San curings, perhaps. At the back, across the opening of the shoe, were two iron steps. To keep you from falling off the horseshoe cushion, it was circled at about the height of your shoulder blades by a narrow strip of upholstery mounted on an iron rail. The bus was drawn by a pair of meek grey horses. James woke them, boosted me up the two iron steps, tossed a sack of mail at my feet, and from the back called "Gidaap"; by the time he had leisurely walked round to the driver's seat the horses had each put one foot forward.

Low hillocks puckered the face of the land; everything was fast whitening under a turbulent snowstorm. I was soon white and shivery. There was no protection

under the horseshoe seat and none over top. The wind did what it liked with you. It was useless to tuck your skirt round your legs. You were lucky to be able to sit on the top part of your skirt or the thing would have flown away altogether. The greys pulled slowly up the little hills. The weight of the horseshoe bus pushed them down again ready to climb the next. Our wheels made lazy zigzag trails on the white road.

We kept overtaking slow-moving little groups of red-nosed men and women with bare blue hands. "Why don't they hurry a little to keep warm?" I asked of James.

"Dassen't, Miss. Lungs is all in tatters. Doctor'd fix 'em proper if they was to 'urry. Most all 'ere is T.B. Cook now, and Doctor is sound. The rest on us—!" He produced a cough, as intimation.

"That's 'er, Miss." James pointed with the whip, as it returned from a gentle lag over the backs of the greys, just to remind them that they were dragging the big horseshoe bus along the road and not standing in their stalls. "Sun'ill San! there she be."

Sunhill Sanatorium stood on a grassy bump hardly worth the name of hill. It had a chunky body and two long, long wings, spread, drooped slightly forward so that every window could catch its share of sun during the day. It was now covered in a drape of snow, not a sign of life anywhere; it lay in horizontal deadly flatness, having the cower and spread of a white bird pausing, crouching for flight. This cold white place was approached by a long straight drive. I learned afterwards that I had come during the evening Rest Hour, five to six o'clock. Every patient lay upon his bed resting, the House Doctor was making visits from room to room, and nurses were preparing supper trays for their bed-patients.

Matron came out of a tiny office near the door meeting me with a broom and sweeping snow from me. Then she swept James and bade him carry in my luggage. She rang for a nurse who came with a wheel-chair and insisted that I get in and be wheeled down one of the long, long corridors in the wings to my room. I would have preferred to walk.

My room had no front. From the ceiling to a foot above the floor it was open to the turbulent snowstorm. All the patients' rooms were on the south side of the corridors; the north side of each corridor was all open windows, the wind roared down with hurricane velocity. High over our beds was a row of small windows opening into the corridor; patients were forbidden ever to shut windows without permission. A draft swept across the ceiling of patients' rooms continuously. It was colder in the rooms than outdoors. The nurse asked, "Did you bring a hot bottle? There is a stone pig in your bed." She shook a mound of snow off the counterpane and showed a smaller mound underneath not warm enough even to damp the snow. I crawled into bed and stuck my frozen feet against the hard cool thing. Hoping for something better when the nurse came back with my rubber bottle I found she had filled it with only tepid. I wanted to scream, "Boil it, boil it!" but she was gone, clicking off the light. I was in the

cold, the dark. A year of this! I turned into my pillow and cried. It seemed the only logical thing to do.

Suddenly my room was full of light and an abnormally large woman stood by my bedside. I stuck out a snivel-red nose.

"Any temperature?"

"No."

"Cough?"

"No."

"What ails you? Doctor Bottle sent no instructions. She will be down herself tomorrow. Meantime, what's the good of crying?"

"Who could help crying in this most horrible place? My people are all in Canada. The Doctor says I must have a year's rest before I can travel. I've worked too hard." I dived under the bed-clothes again.

Doctor McNair was Scottish by birth. Her tongue clung still to the Scots but her ways were English. She was London trained and wished to acquire English professionalism. She stood by the heaving lump in my bed for a minute or two but I did not come out till she asked the surprising question, "Do you smoke?"

"Why, a little," I admitted, "but I did not expect to be allowed to here."

"I'll be in after supper and have one wi' ye." She was gone.

A maid in scarlet with a frilly white cap and apron hummed in and clattered, hummed out and clattered, swinging her implements. Nurses started pattering up and down the corridor, clanking trays, banging doors. They could not help it with a typhoon raging in the corridor. I humped my knees up to throw off the snow that had drifted in afresh. My supper was wheeled up across the top of the bed.

Doctor came after supper, smoked one of my cigarettes and approved the brand.

"Ye'll reconcile to the place after a wee bittie," she said, and left me in the dark. Snow was still falling. Wind howled. "Please couldn't you make them a little hotter?" I pleaded when the nurse filled the hot bottles for the night.

"That is regulation," she said coolly. I kicked their clammy uncomfortableness onto the floor. They chilled what little warmth there was in me.

I heard a scrabbling sound over by the bureau. Prickly with nerves I darted for the light switch. There, perched on top of the mirror was a tiny brown bird. At the light click she took her head from under her wing and looked at me. After one sleepy blink she put it back.

The little bird in my room made all the difference. I slept fitfully, turning on the light every while to see if she were still there. Her coming unasked was so friendly, so warming. Next morning a robin breakfasted from my tray.

Stupid, stupid Doctor Sally Bottle, praising this and that about your old San, omitting to tell of the chiefest, most joyous thing—Sunhill's birds.

SUNHILL SANATORIUM

THE SUNHILL SANATORIUM belonged to a company. It consisted of Doctor Sally Bottle and a handful of nonentities who gave sums of money to Dr. Bottle to turn over for them.

Doctor Sally Bottle was as omnipotent in the company as she was omnipotent in the San. She rushed down from her Harley Street office late Friday night and took hold, returning to London late Sunday night. Doctor Sally filled not only the San with herself. She filled every corner of the property—a large acreage. Dining room, kitchen, garden, fields, home-farm, even the tiny morgue, where they hid away the dead that we were supposed to know nothing about—Doctor Sally Bottle dominated all.

They gave us very little credit for having sense in Sunhill. We came here to pause our ordinary activities. Even thinking was prohibited. Doctor Bottle's brain worked for all the fifty patients and even for Donkey Jinny who mowed the lawns of Sunhill, her feet laced into two pair of human boots. It was Dr. Bottle's command that Jinny wear boots, an indignity to Jinny's dainty hooves. Jinny invariably gave a derisive bawl when the meek greys plodded up the drive-way with Doctor Sally behind them in the horseshoe bus. Jinny was the only creature who dared voice a come-back at Doctor Bottle.

During her visit the oversize resident Doctor shrivelled. To the naked eye Doctor McNair was a vast woman. Her bulk was only flesh and blood; her voice was thin and meek, her decisions wavery, her eye unobservant. She was pompous and over-masterful to the staff. When she was in charge, she wished it remembered that in Doctor Bottle's absence *she* was official head. Among the patients she showed favouritism. (I happened to be one of her favourites so I do not say this for spite.) It rather amused us to see Dr. Mack sink like sediment beneath the swirling ferment of Doctor Bottle's activity during weekends.

It was scarcely light on Saturday morning when we heard the procession advance upon the sleepers. The procession started from the Doctor's office. Windows along the corridors had stood open all night, and were open now to the early morning chill. Dr. Bottle in a stout stuff dress of plum colour buttoned to the chin bustled ahead clap, clap, clap. She had large feet, the kind that slap the floor with every step, iron-grey hair, coarse and smeared back to an onion at the nape of her neck. The wind took liberties with Doctor Sally's hair,

streaming it three or four inches ahead of her face. She was always blowing or pushing it back with hands or lips. Behind Doctor Sally in the procession came Nurse Pickwick, trundling a heavy iron scale on wheels—the kind of scale butchers use to weigh carcasses. Doctor McNair, meek-voiced, long-legged, clasping the Doom Book in both hands, tailed the lot. The scale halted at each door, stopping with a screech. The door opened, out came a scantily clad patient, stepped onto the scale's iron platform, first kicking the woolly shoes from off her feet. Nurse Pickwick adjusted the weights. Doctor Bottle read the tally. Doctor McNair made entry in the Doom Book. If there was no gain the patient slunk back into her room without comment. If there was loss, the Doctors wagged their heads and the victim knew there would be an increase in the size of her helpings at table, vastly oversize now for any normal appetite.

Nobody lingered over their dressing in these icy rooms. Through winter's coldest, her wettest days, only one half hour of heat was allowed to unchill the registers night and morning against freeze-ups, not to unthaw us. The great dining-room was open to the weather on three sides. I was not permitted to get up for breakfast. All those red noses and purple hands must have looked pitiful. My own meals were moderate enough: I was not T.B., I was not under weight.

Because weighing delayed patients dressing, on Saturday morning they were excused if they were a little late. Immediately after the meal the two Doctors went to the office and hung great stethoscopes like glorified wishbones round their necks. One by one the lung patients submitted to soundings and tappings. From these lung soundings I was exempt, but my heart got them good and plenty later.

Patients were graded as 'Downs', 'Ups', and 'Semis'. 'Downs' kept their beds; 'Semis' spent part of each day lying in a long row of reclining chairs on the Circular Porch, or on the gravelled terrace just below the open fronts of the patients' rooms; 'Ups' had begun to respond to treatment, went to meals in the dining-hall, and took prescribed walks, so many hours (or was it minutes?) to the mile.

The Sanatorium was built in the form of a cross. In the body of the cross were dining-hall, kitchen, offices. To the right and to the left of the body were the long wings two stories high. All the patients' rooms were under these wings or arms. Between them projected a circular brick-paved porch, as it were the head of the cross. Doctor McNair's office had a window opening onto the Circular Porch so that serious patients were always under her eye. From her room she could look down the right and left terrace, see the long rows of reclining chairs.

The 'Ups' assembled on the Circular Porch to await tea and rest-bell. Twelve to one and five to six were San Rest Hours when every patient lay and was still. From her window the Doctor could time the coming back of each patient from his walk, note if he had over-hurried or dawdled, by timing his arrival on the porch. Everything was horrible clockwork, tick tock, tick tock. You felt like a mechanical toy.

Nothing but cheer was permitted in the corridors. If a patient had a huge

misery, knew she must cry, she ran to her room under the San's long brooding wings, ducked behind her scant dressing screen, gave way. It was more indecent to be seen crying in the San than to be seen naked.

New patients soon caught on to the San code: T.B. taboo, symptoms taboo, grumbling taboo, mention of death taboo of taboos. Of course, there were the few who could and would talk of nothing but themselves and their disease, but they soon discovered they were shunned.

Pickwick, Bandley, Brown, Bunker, Maggy, Ada, and a nondescript creature known as 'Odd Jobs'—this was the San's nursing staff, with Specials sent from London when they were required. Old Pickwick was a certified nurse, the rest though apparently in good health were ex-T.B. patients, whose lungs were still owned by Dr. Sally. In return for keep and treatment they nursed under the supervision of Matron Lovat. Nurse Brown was my nurse, a sad prim soul whom I promptly nicknamed Jokey Hokey. At first she protested, because not being trained 'regulars' our nurses were more particular than ordinary about professional etiquette. Soon Nurse Brown warmed to my pet name, permitting me to 'Hokey' her providing I did not do it in public.

I read my own behaviour in Hokey's face. If I was suffering, it was sad; were I provoking or contemptible, Hokey's face set like a junket. When I was simply impossible she went away and left me.

A habit that English nurses had, that of calling their patients 'Dear' from the moment they came on a case, annoyed me tremendously. Hokey deared me just once.

"Don't do that to me," I shouted. "I won't be 'Dear' except to those who mean it and to whom I am dear." Hokey never deared me again; when I was being dear, though, she would give me one of her rare sweet smiles.

Pickwick because of her certificates was bumptious and unpleasant. Bunker had a puffy face, fallen arches and wheezy breath. Maggy was short, snorty, and religious. She devoted herself to the Cranleigh boy who was very ill. Each nurse had one specially serious case. The 'Ups' and the 'Semis' did not require much care. Hokey's bad case was old John Withers.

Last and least of the nurses was Ada the Quakeress, who smashed all my ideas of Quakerism. She burst into the room in a sky-blue dress. All the other nurses wore navy serge, and white caps and aprons. The San was much too cold to wear white starched uniforms. The Quakeress wore this razzle-dazzle blue, was loud of voice, a door banger, a soup slopper. She nipped snacks of food off patients' trays, and screeched if she saw an insect. The rooms being so open, all sorts of creatures naturally found their way in. I loathed Ada the Quakeress.

Beyond all ranking, at the tail of the list came 'nondescript', neither nurse, maid, nor patient. Her neck was a continuation of her lean cheeks; she had no chin, she had sly eyes which skidded. This creature went by the name of 'Odd Jobs'. The nurses called on her inefficiency for bits of help if they were extra busy.

Under a cheerful crust there was something wistful about our nurses; maybe

it was constantly watching the finish of that which tainted their own lives. They could not go in for regular hospital training; most of them knew they were just marking time. When five years later I met an old San patient in Paris and enquired for nurses and patients, one by one, only in an occasional instance would the old San patient say, "He was cured." It was, "Did you not know T.B. got him in the end?" She told me that the treatment had been very much modified since my San days.

The men patients at Sunhill Sanatorium kept to themselves, enjoying a grouch. They made me think of a little band of ducks in a big hen yard. Someone had advised their seeing the Big Lung Specialist, Sally Bottle of Harley Street. Of course Doctor Sally advised Sunhill San at once. "Just a few weeks in the open air in that lovely part of England, there you were! well again!" She kept them in bed for some weeks, according to the severity of their case. Then they were promoted to 'Semis' and put to lie in a lounge chair on the terrace.

It was then that they found out, and their fury boiled! Twenty women to every man, rows of red-faced woolly-clad women, aggressively cheerful. The men scuttled into being 'Ups' with all possible speed, to get away from the women. They grew beards, quit the terrace, herded on the lawn, or walked in an angry group.

The lungs of the 'Ups' underwent a thorough overhaul every week. That was the time patients saved for questioning, because during examination doctor and patient necessarily were close. The patient quavered.

"Doctor Bottle when—?"

"Hold your breath."

"Please, Doctor Bottle—"

"Double over."

"But, couldn't you tell me—?"

"Next!"

The questioner had to wait till Rest Hour to try and get a hearing, but Doctor Bottle held the latch of the door in her hand in spite of the draught that nearly blew the hair off her head. "How are you? How are you?" Blithe and without waiting for an answer she was gone. Lung healings are slow. Probably Doctor Bottle did not know herself, but it was disheartening for patients. By and by they stopped asking.

Everyone loved Matron Lovat. She faced things, had the courage of a cook who plunges a clean blade into the middle of her cake to test, rather than nibble round the edges. She was quiet and understanding, had none of that mock cheer the rest of the staff stuck on. We took our minor troubles to Matron. Doctor Mack was jealous, overbearing. She disliked Matron, resentful that we felt the comfort of going to her. The Doctor pushed Matron back into her place. Matron was a fully trained nurse; Doctor was an intern, not as yet a complete doctor. One day Matron came into my room. I said, "Those open ventilators over my head create a perpetual draught, give me neuralgia. Could I have them

closed?" Matron shut the ventilators. Doctor Mack strode into the room. "Since when has the Matron taken upon herself to close my patients' windows?" She snatched the cords, opened the windows with a bang! Matron quietly left the room—a big little lady.

"I will send you something for your neuralgia," said the big woman, who was small, and hurried down the hall. I heard her overtake Matron, heard Doctor's dictatorial bluster. Matron said never a word.

THE CIRCULAR PORCH

'DOWNS' kept their beds; 'Ups' walked in all weathers and went to the dinner table; 'Semis' lay prone on lounge chairs upon the Circular Porch, the better part of most days.

The Circular Porch was a dreary place. The long row of chairs was circled to fit its surroundings. They had wavy seats to accommodate the reclining forms of emaciated bodies. When the porch was empty of people the chair seats looked like a heaving yellow sea that almost made you feel seasick.

Round about noon the glass swing-doors were shoved back by nurses so piled with books and pillows you might have thought that they were laden moving-vans set on a pair of human shoes. The nurse did not show at all except her back, and to that clung her patient, tottery and stumbling.

When the nurse had arranged all the rugs and pillows, put the smelling bottles, the work bags and books all in place, she helped the patient sit, then wrapped her up like a mummy, and left her to doze, lie dead-still, or cough as she had a mind to. Only the worst cases were put on the Circular Porch. The better ones lay on the long row of chairs on the terrace.

There were few words spoken on the Circular Porch. It took all the strength of the poor beings there to breathe and cough. Click, click, click, the dreadful little blue-glass sputum bottles with silver tops that every bad patient must always have by him, opened and shut.

Nurses came often and looked through the glass doors. Doctor was frequently framed in the window of her office that overlooked the circled bunch of chairs.

When, after they had kept me in bed for three months, I was promoted to a 'Semi' and put for the first time onto the Circular Porch, I pleaded, "Not again, Hokey. Oh, put me *anywhere*, anywhere at all. Please, please let it not be the Circular Porch!" Hokey helped me to the lawn and pushed my chair under a

bush. There was a bird's nest in the bush. Presently Jinny the donkey came dragging the mower back and forth over the lawn, James persuading Jinny's every reluctant step. Boots hurt Jinny's pride.

VISITORS

A NEW PATIENT was put to bed, all his peculiarities noted, entered in the Doom Book. Had he one or two lungs? was he emaciated or naturally lean? cheerful dispositioned or grumpy? possessed of a poor appetite or just pernickety?

When this knowledge had been ascertained and recorded, Doctor McNair cast about for a couple of suitable visitors to cheer the newcomer. For me she selected Scrap.

Scrap opened my door inches—enough to squeeze her emaciated body through. It was that tiresome time after supper. You were too weary to do much and not yet ready for sleep. Scrap said,

"Doctor sent me. Do you mind?"

"I should say not! Won't you sit down?"

My one chair was full of books. "I'll sit up," said Scrap, and scrambled to the top of the high gilt radiator which, except for that brief half-hour night and morning, never radiated. It did serve, however, as an exalted seat for a visitor. There was no danger of him sitting too hot either.

Scrap was dark, thin, hungry-eyed.

"My name is Mrs. Scrapton. Everyone calls me Scrap."

"You don't look like a Mrs."

"I am though and have a baby six months old." At mention of her baby the hunger in her eyes turned ravenous. "I have been here two months, two months without my baby!"

I asked, "Are you ever warm? ever comfortable? ever happy here?"

Scrap's thin shoulders shrugged. "Not so bad once you get used to it, except—oh, I want my baby! Life here is like facing back, being a little girl again, told what to do, everything thought out for you, no responsibility, obey, drift, hope, that is all."

She drew a bit of woolly baby knitting from the pocket of the great-coat she wore. Her cold little blue hands began to work. That was the beginning of a friendship that lasted as long as Scrap lasted.

My other visitor was Miss Angelina Judd. Angelina had sped swiftly from 'Down' to 'Semi', from 'Semi' to 'Up', yet still her case was not fully diagnosed. She had hay fever in a superlative degree. I had thought that her persistent

sneeze was a young rooster crowing about the grounds. Down in the hollows, up on the hills, it came with mechanical precision. How that cockerel does wander! was my thought. Angelina combatted her complaint by valiantly ignoring it. She sneezed right on.

Tap!—the opening of my door—a spasmodic bob. "A-choo! A-choo!" seven times repeated, then, "Doctor McNair sent me, and—" sneeze. "Do you like reading? What type? A-choo! A-choo!" She moved into the centre of the room. A question lurked in every sneeze, the violence of the spasm bumped her head on wall or furniture if she had not space.

Each week a great box of books came down from London addressed to Miss Angelina Judd. There was a book suitable for every patient; Angelina had previously probed every individual's taste. If a patient were unequal to reading, Angelina read to him. The sense was all sneezed out but Angelina kept right on. She had a little mouth and small pointed teeth that gleamed as she read. Her nostrils were as black as coal buckets, burnt with nitrate of silver for her hay fever.

Like a striking clock, or a cow with a bell, Angelina by her sneeze kept us informed of her exact whereabouts.

When a box of new books came, she piled them up and up on her chest till the topmost was wedged under her chin, then she started on her rounds. "A-choo!" The first sneeze almost strangled her because of the library; off flew the top book! That loosened the whole pile. "A-choo, bang! A-choo, bang!" all down the corridor. Angelina no sooner picked one up than she sneezed another off, but like the fine old battle-ship she was Angelina steamed straight ahead.

BIRDS FOR CANADA

MY LUNGS being healthy I was not of much interest to Dr. Bottle. Once in a while I received an apathetic visit. On one of these occasions she said, "There is a possibility I may be going out to Canada; tell me about the climate in the West. Western Canadian yourself aren't you?" I told and Dr. Sally listened, her head a little on one side, calculating the effect of such a climate on lungs. At the end of my tellings I said, "England is a great disappointment to me. I don't like it but in one thing it does beat Canada."

"What is that?"

"Birds. In the West of Canada we have very few birds—almost no songsters."

"Why do they not import some?"

"It has been tried—unsuccessfully. The birds died."

"What was wrong?"

"Adult trapped birds, most of them, died on the voyage; the remainder, dazed and terrified, were loosed immediately and were destroyed by birds of prey."

"Do you think it could be done successfully?"

"Yes, by hand-rearing the birds from the nest in England, shipping them to Canada, keeping them in large semi-free enclosures, till they were acclimatized and had raised young in the new country. Free the young when the band was strong. Loose them in open, settled country from which settlers had routed hawks and owls."

Dr. Bottle's head twisted a little more, her eyes popped.

"Go ahead," she said.

"You mean here? Raise the birds here!"

"Why not? Another month and there will be thrushes' and blackbirds' nests in every hedge, every bush."

That night I wrote to London for bird books. I learnt everything about thrushes and blackbirds; those were the songsters I wanted most. I waited breathlessly for spring.

The foolish birds could not bide for the trees to be leafed before they began their building boom. The hedge rows were so bare that the nests were in plain sight. Boys and cats took their toll. Parent birds screamed for an hour, then rushed to rebuild; nothing could stem the spring-tide of creative activity.

My books said, "Take the nest entire after the young are partly feathered, but before consciousness has come to their eyes; then, the old birds have ceased to brood and are tired of feeding."

Dr. Mack was generously sympathetic to my plan. She let me skip a rest period that I might make my first theft at dusk. I put a cloth over the nest, loosed the hold of the twigs. The thrush family was mine! It was thrilling to hold the throbbing nest full of birdlings.

The nest was put in a little basket that stood on a tray by my bedside. As soon as it was light I began to feed the nestlings and did so at half-hour intervals till it was dark. In all I took six nests of thrushes, two of blackbirds. The birds throve, rushing to maturity. Soon the sightless blue bulges opened, disclosing round black eyes. Nakedness was fully feathered. They stood upon their feet when they saw me, squawking, gaping over the side of the nest, demanding, confident, as sure of me as if I had been a beaked and feathered parent.

Dr. Mack named me Bird Mammy. Every Rest Hour she looked at them. To this drab place the birds brought interest and joy. Patients crowded hungrily around the new interest. Men took empty match-boxes on their walks and came back with pockets literally bulging with worms and beetles. Women took long-handled spoons and robbed ant hills of their eggs. "Great fun! Zips up the walks!" they said. One woman there was who stalked ahead muttering, "Disgusting!" The others enjoyed her fury for she was not a favourite.

Sick hands, thin and white, were always slipping offerings across my windowsill, offerings for the birdlings. Brown hands of gardeners added wormy

contributions. Mrs. Green, the cook, gave huge rhubarb leaves which we spread on the lawn; wetted, they yielded a harvest of little white slugs coming from nowhere and making wonderful meals. The birds were the delight, the talk of the San. Everybody worked for them.

Hokey was splendid. Sometimes at post-time she came in dangling little bags from her finger tips. "Ugh! If I did not love you!" She dropped the sacks upon my table; they contained yellow meal worms from London pet shops.

"Hokey, you are an angel."

Ada the Quakeress was anything but an angel. She found my glass jar of meal worms and beetles behind the washroom boiler. The San rocked with her shrieks. There was cloth tied over the top and meal inside. I always forgot if the worms turned into beetles or the beetles turned into worms.

The birds outgrew their nests, their cages, my room. Then they were moved to a large cage out of doors.

If at any time I was unable to go to my birds, there was always some patient willing—glad to lend a hand. Common boredom, common interests, knit us tight. Shuttles we were, flying across the warp of San rules—empty shuttles to be sure, but maybe the San was weaving more pattern than we guessed.

J E N N Y

"GO CHEER the child in the next room, Mammy. Bad lung case—overwhelmingly homesick—name, Jenny."

I found a straight-haired little girl, a child of twelve—pointed chin, big eyes, flushed cheeks, hollows under their pink, eyes too bright, set deep.

"Hello! I'm your neighbour; Doctor said I could visit you. You are Jenny, aren't you?"

"Yes, are you the Bird Lady?"

"The baby thrushes and blackbirds are mine."

"I have never seen a baby bird. I come from London. Do your little birds keep you from aching for home?"

"Well, I live in Canada. That is a long, long ache, but the birds do help a lot, Jenny."

"I'm glad you've come. Have you been in the San long?"

"Four months."

"Four months! And I only, only two weeks. My little brother and I are orphans. We live with our Aunt in London. She is very rich. She says it is scandalous the price the San charges to keep me here, but she is willing because

she is dreadfully afraid of catching my lungs. She won't let me kiss her, or kiss my brother. It's dreadful living without kisses. Tell me about your birds. Birds are the nicest things in Sunhill, don't you think?"

"The very nicest, Jenny."

"Let's be friends. Enormous friends!"

"All right. I tell you what; our beds are right against each other, just the wall between. We'll invent tap-talk, shall we?"

Jenny frowned, "Shout back and forth? We daren't. Doctor'd hear."

"We wouldn't shout things; we'd say things by tapping on the wall—tap, tap, 'Good morning', tap, tap, tap, 'I'm fine'."

"That will be fun," said Jenny. "What else shall we say?"

"Clean plates are very important. Four taps: 'Have you made a clean plate? Smart tap: 'Yes', dull bang with the palm, 'No!'"

The code worked splendidly.

After supper one night in answer to my four taps a monstrous slap from Jenny's palm.

I went to her. She pulled the sheet over her head to hide red eyes. Before the child was a plate piled with sliced raw carrot.

"Hello! What's that?"

"A beastly new idea of Dr. Bottle's—raw carrot!"

"She has got you mixed with Jinny the donkey!"

Between giggles and "he-haws" the carrots began to go down. We were making fine fun and did not hear Dr. Mack till she was in the room. Over her glasses and under her glasses the Doctor's eyes called me "Fool". In her most awful tone she said, "Hush!"

"Sorry, Doctor. I was trying to help Jenny's carrots down."

"Temperatures, Mammy! Temperatures! Must not excite the child. Neither laughing nor crying to excess is permissible here!"

ORCHID

HOKEY stood at the foot of my bed, holding a single flower up for my inspection, fully conscious that this was some splendid thing she had to offer. It was an uncanny flower with a pouchy body as big as a pigeon's egg. It was yellow, splotched with brown-red. At the top it had a five-point purple crown. Live little veins of red laced its pouchy body. Not only was it unusual, there was mystery in its dull glowing, too, some queerness almost sinister, very, very un-English.

"Hokey! What? Where?"

"Orchid—London—a box of flowers sent to Mrs. Spoffard by an old admirer. Came from a Regent Street swell florist. She divided the flowers among the patients. This was the only orchid. She said the splotches on the body made her think of your thrushes. She wished you to have the orchid."

"How kind! I don't even know her."

"She is always fussing round your bird-cage," said Hokey. "Loves them and through your birds she loves you. Your birds make a lot of friends, don't they?"

"Patients here *are* generous, Hokey, always sharing up what they get."

Hokey nodded.

I wrote a polite note of thanks for Mrs. Spoffard. We put the orchid in a vase by itself. In my room I had other flowers but this one stood aloof like a stranger in a crowd whose language he does not understand. It grew a little larger; its pouch bulged pouchier; it poised its crown a little more erect. When it was mature, entirely complete, it stayed so, not altering, not fading, week after week till six were past. A tremendously dignified, regal bloom. Everyone who looked at it seemed impelled to reverence, as though the orchid was a little more than flower.

In the dark one night the orchid abruptly died. Died completely as it had lived. Died like the finish of a bird's song. In the morning it was shrivelled to a wisp. Hokey took it away. There was a blank, forlorn miss on my bedside table.

Suddenly I imagined that I understood what had been the link between the strange flower and me. Both of us were thoroughly un-English.

THE JOKER

ANGELINA JUDD was not the only patient fired with desire to cheer her fellows. There was Susie Spinner, a sparrow-like creature with a giggle, and nostrils that bored into her face like a pair of keyholes. You saw these black holes before you saw Susie. All the rest of her was colourless—neutral drab hair, grey skin peppered with pale freckles, toneless giggles in bunches. After each bunch of giggles at one of her own jokes, a great sigh burst through the keyholes and Susie's flat forehead churned into wrinkles. Susie was enthusiastic over her own jokes and sprang one after another like waves splashing on a beach. Each joke had a bridesmaid, or rather four bridesmaids, when everything Susieish happened all over again, giggle, sigh, wrinkle, joke!

Susie Spinner was not T.B. She was a friend of Dr. Bottle's and came to the San for week-end jaunts because she loved the place. She ran an office in London, also an aged mother. She was not young herself. These little rests at the

San kept her going; she loved to float on the dead sea of San life, doing as she was told, stretched inert on a lounge chair on the terrace, speculating as to each patient's chances, telling Susie Spinner jokes.

"Hokey, I prefer dismal patients to jokers, if patients there must be."

Hokey said, "Miss Spinner wants to meet you."

"A want not reciprocated."

"Don't be a grump." She set out chairs side by side on the terrace.

Close-up, the gymnastics of Susie's features were more irritating than I had suspected.

"I have heard about your birds for Canada. (Giggle!) Splendid idea. (Giggle, giggle!) I adore birds, don't you? But, of course, or you'd never—." (Giggle, giggle, giggle.)

Rest bell. I got up. The bell's clanking vibrations drowned the end of Susie's giggle. I left her doing all the things that completed the sequence over again.

"Hokey, I hate you."

"Why now specially?"

"Susie Spinner'll brood my birdlings day and night. My life will be addled with Susieisms."

"Miss Spinner is a nice woman, always comes down from London with a headful of jokes to make everyone laugh—everyone but old grumpies like you." She shook her head, gave my pillow the punch I deserved.

"All right, Hoke, long live the giggles! I do thirst for some mourning-doves, some weeping-willows round here; everything is so forcedly gay."

"That's morbid," scolded Hokey.

"It is not morbid. Listen! Once, out in Canada, I stayed with some Indians, lived right in their own home. Primitive it was but wise. When they were hungry, they ate—happy, they sang—sleepy, they slept—when they wanted to cry, they cried torrents, vast oceans of tears that washed their miseries completely away, left their faces clear as morning."

"Very sloppy—very uncontrolled," said Hokey.

" M E "

I WAS NOT always polite, not always biddable. The monotony bored me. I despised the everlasting red tape, the sheep-like stupidity. What one did, all did, and because they always had done such and such it meant that they always must.

Doctor McNair was a pretty good sort, if a bit pompous to her underlings, and a bit servile to her superior. Doctor Sally Bottle, I frankly despised for a toady. She licked the boots of the wealthy and fairly ate the feet off a title. She

was terribly almighty over week-ends in the San.

I don't believe Doctor Sally saw people when she looked in their faces. She saw and calculated the value of the lungs in their chest.

I got on with most of the nurses. I loved Hokey and Matron Lovat.

Serious work had been put out of my life but I used to make caricatures and silly rhymes about the patients and staff, at which they used to laugh immoderately. Because of those laughs they forgave a lot of my shortcomings.

Time ambled by, days alike as peas in a pod—sleeping, eating, resting. They kept me in bed for three months. Then I was a 'Semi' but I never was a complete 'Up'. I only went to table for the noon dinner and walked little.

S O L D I E R S

WHEN A DOWNER was very down, a nurse would come to my door and say, "Lend the soldiers?"

The soldiers were my bullfinches. When the thrushes were out of hand, I stole and reared two nests of black-bonneted, rose-breasted, chesty bullfinches. Always singing, always dancing, they went their round of cheer. Very sick patients would lie and watch them by the hour. Chortling on the perch, squabbling for place and importance, the supreme glory was to be wedged in between two cosy brothers. For this they fought.

Jenny, the Cranleigh Boy, John Withers, all the 'Downs' loved my soldiers.

To John Withers "them pioneers", as he called the thrushes for Canada, were even dearer. As long as his weary body could drag, Hokey put his chair in the sheltered corner by the thrushes' cage and took him there that he might enjoy their daily bath. John laughed till the tears ran down his cheeks, tears and the splashes from the birds' bath. Again and again I filled the big dish. After the bath there was shakings and preenings. It was the delight of John's day. Hokey led him back to his room. There was a hard spell of coughing after the exertion, but John went again next day to watch the birds bathe.

As he lay back on his pillows afterwards, with closed eyes, Hokey would often think John slept, till,

"Hark, Nurse!" John's eyes would open to follow an ascending speck out over the fields, watch till the clouds took the lark. Only the golden pebbles of his song scattered back to earth.

" 'Ear 'im, 'ear 'im, Nurse! Carted 'is music clear to 'evin, 'e 'as." John was a Londoner. He had been with his master through the Boer War, contracted T.B.

His master, an Honourable, brought him home, placed him in the San. He said, "Give my John everything, anything. I can never repay John's faithfulness." His master's visits, the birds of Sunhill were all John wanted, dear, gentle old man. Doctors and nurses loved him.

John's cough went from the east wing. Hokey tried to force cheerfulness, settling me for the night. "Books, singing-soldiers, have I done everything?" she prattled, forcing gaiety.

"Hokey, don't sham! Was it the larks or the nightingales that sang John Withers into Heaven?"

Hokey choked. "Dear old man . . . a lark going up, up, up, was the last thing he noticed." Doctor's step! Hokey pulled her face straight, flew from my room.

F O O D

FORTY AND MORE fickle appetites strolled into the San dining-room, unenthusiastically took their places at table. A big part of the T.B. treatment was eating. Eating was compulsory. If patients refused to eat, the San refused to keep them as patients. Doctor McNair and Matron stood at a side table and served. Were Doctor Bottle present, she dictated the helpings, cruel mountains of meat, vegetables and pudding helpings that would stagger the appetite of healthy men and women, and were positively loathsome to invalids. The maids brought the hateful plates and slapped them down before each patient. You felt "pull-together" and "nausea" struggle in disgust and revolt as each patient surveyed her pile. When all were served Doctor and Matron took their places, one at either end of the long table, and started animated conversation. One by one the patients picked up their knives and forks and began to attack the food. It was bravely done.

There was an oldish school-master who had been attacked by T.B., a man accustomed to exact, not yield obedience. I saw this man scowl at his helping of spinach with a little boy's fury; I saw little boy's tears come into his eyes, tumble down his cheeks, hide their shame in his man's beard. He beckoned a maid and whispered. In turn she whispered in the Doctor's ear.

Clear and stern, Doctor McNair enunciated so that everyone could hear. "If Mr. Dane cannot eat spinach, substitute a double helping of carrot." The oldish man smiled his thanks. "Sorry, Doctor, never could even as a boy."

His neighbour, a florid woman nodded; "I entertain the same attitude towards carrots, Mr. Dane."

Munch, munch, munch. Miss Dobbin, the woman opposite, chewed doggedly, determined to see the treatment through. She scorned the whimperings of the little neurotic on her left, the yawning envelope pinched between the knees of the hypocrite Marmaduke Jepson on her right. Between chews Miss Dobbin could not resist peeping to see if Marmaduke's flip had landed true. His policy was to engage Doctor in an eye-to-eye conversation while he flipped. Great portions of his food flew into the waiting envelope; without so much as a glance his aim was accurate. Doctor was always holding Jepson up as an example to the rest, too, because of the speed with which he made clean his plate.

"Not that it has made much impression on your bones yet, Mr. Jepson. It will tho'. Patience, courage!"

"Thank you, Doctor, thank you, I try to be a credit to the San."

"Credit! Ugh!" grunted Dobbin, as Jepson's baked potato landed in the envelope.

Miss Bret laid down her knife and fork, closed her eyes; just for one second she must shut out the sight of food. She heard Doctor say:

"If this weather holds we shall have strawberries next week." Food, food, always food!

A maid bent close, "Are you going to finish, Miss Bret?"

A silent head-shake. The maid removed the meat plate, substituted a generous cut of roly-poly pudding oozing jam. The struggle began all over again. Miss Bret knew that the plate of meat and vegetables would be taken straight to her room and must be eaten some time before supper. The jam roly-poly would join it there unless—. She severed six jammy little pieces, bolted them one after another like pills, controlling herself heroically against being sick.

"Suppose you can't; suppose you won't?" I once asked a patient.

"At bedtime it will be removed and a huge bowl of Benger's gruel substituted for it."

"Suppose you refuse that too?"

The patient rolled her eyes round in her head like an owl. "You couldn't. Your people would be asked to remove you, not giving the treatment a chance! Or Doctor Bottle's reputation, either!"

"Drat Doctor Bottle and her reputation!"

"Quite so, but your people? They have made sacrifices. You can't let them down, and there is always the chance you might infect someone at home, besides making life uncomfortable for them—open windows, special food!"

Every Saturday Mrs. Cranleigh dined with us. She came from a distance to visit her son and her daughter. Both were patients in the San. The son was bad, the daughter only slightly infected. Mrs. Cranleigh had already lost two children with T.B. She was taking no chances with Kate.

In spite of her children that were dead and her children that were sick Mrs. Cranleigh was hideously buoyant and optimistic. The staff alluded to her as

"that brave soul!" They said she was a "moral uplift" to the San. She paraded her fortitude to such an extent and hoisted her buoyancy to such a pinnacle it made everyone else slump.

Mrs. Cranleigh's favourite food was cabbage. The San garden excelled in great crisp monsters; all of the cabbage tribe were represented. Miss Brown, the gardener, Doctor Bottle who was always present at Saturday's dinner, and Mrs. Cranleigh lapped up the flabby green with relish, discoursing all through the meal on the merits of the different species. Mrs. Cranleigh kept up a running undertone. "Beautiful cabbage! Beautiful cabbage!" The patients nicknamed her, 'Beautiful Cabbage'. Then Doctor Bottle would insist that everyone must have a second helping. She inflated over the San's beautiful cabbage, till she nearly burst. It was a privilege to be able to eat home-grown cabbage such as this! "Beautiful cabbage. Beautiful cabbage!" echoed Mrs. Cranleigh till we hated cabbage of every kind, human or vegetable.

Marmaduke Jepson sat near the dining-room door; he always sprang from his seat to open it for Doctor McNair. When she swept from the head of the table down the long dining-hall, Dr. McNair, what with her great height, the flowing dinner gowns she always effected, and all the dignity she had at her command, looked like a ship in full sail advancing.

Marmaduke sprang as usual, took out a perfumed florid handkerchief with a flourish, fluttered it to undo its folds, pulled out more than the handkerchief. Plop! Right in front of Doctor's feet slapped the pancake Marmaduke should have eaten at table. Doctor had to detour to avoid treading on it. Marmaduke swooped—too late! The Doctor swept by with a pointed, "See you at Rest Hour, Mr. Jepson."

"Good Lord, Dane!" Marmaduke called to the spinach objector, "did you see her face? Quick, let's make a prompt get-away for our walk." They took hats and sticks from the hall-rack and bolted.

"One minute, Dane."

Jepson took his cane and bored a hole in the soil of the garden, widening and deepening the bore to accommodate the pancake and an envelope, very fat. Carefully he covered them with earth.

The lady gardeners could have told of a vast under-crop of envelopes addressed to Marmaduke Jepson, Esq. in the garden. They did not. Marmaduke always had a smile for them, always a compliment.

THE GARDEN

THE GARDEN lay in a shallow valley tucked between the hill on which stood the San and a moundy hillock where sheep grazed. When the wind blew from the west, you smelled the sheep and heard their mock-meek bleats.

The little valley caught and held all the sunshine. Great cabbages, beets and onions absorbed it. There were few flower-beds in the San garden; its purpose was to provide fruit and vegetables for San patients.

In the centre of the garden was a huge evil-smelling tank into which drained the suds and dish-water of the laundry and kitchen; it was used for irrigating the garden. Dr. Bottle's pride was that there should be no waste. Economy, efficiency ruled Sunhill.

A lady gardener, by name Miss Brown, queened it over the garden. Miss Brown was sister to my Hokey, but Miss Brown the gardener and Miss Brown the nurse were not alike. There was also, in the San garden, an understudy, one Miss Lavinia Mole. The two garden ladies were sun and soil-parched, hair, skin, work gloves, shoes, all yellowish clay-colour; this brace of Eves toiled and sweated among the roots and fruits of Sunhill.

Dr. Bottle loved the garden. Every Saturday her squat hatless figure ran down and puffed up the hill, to examine, to dictate, while the not-so-keen Dr. Mack plodded after. Having no voice and little heart for agricultural pursuits, she dragged wherever her chief dictated.

In the garden Dr. Bottle met her match. The high-bridged hooky-nose that pinned hardness down onto Miss Brown's face did not audibly sniff at Dr. Bottle's agricultural ignorance; Miss Brown simply brushed it aside and took her own way. Smiles seldom waded among the leathery wrinkles of her face. She was a good gardener, not flowery-sentimental, but produce-proud. An occasional posy graced the San's public rooms. The dinner-table always groaned under her vegetables.

It was strawberry time. The heavily netted vines were loaded. Scarlet lusciousness peeked between the leaves, making your mouth water.

"Oh, Miss Brown, what a monster! What a perfectly splendid berry; most as big as a pumpkin!" My foot struck against flesh—dead flesh—irresponsive, sickening.

A pile of little bodies, glossy black or mottled brown, having limp spread

wings—lolling heads—music stilled in twisted throats—dead! Thrushes and blackbirds.

"Oh, oh!" I cried. Miss Brown shrugged, laughed through her high-bridged nose. "Thieves netted in my berry patch."

Horrible, horrible garden! Smelly tank, clay women, dead birds, naked fledglings waiting, waiting in the nearby nests, holding up scrawny necks till they could no longer support the gaping mouths, heads flopped. Starved birdlings! Tomorrow morning there would be another pile, every morning more! Miss Brown would fertilize her garden with their beautiful bodies! Earthworms would writhe around throats lately filled with song. I hurried from the garden, left it to the cabbages and the clay women.

THE FRENCH BABY

DR. BOTTLE bustled down from London. Nothing so delighted her as to get some patient a little out of the ordinary.

"Youngest yet!" she purred, leading the way to the largest, most expensive room in the San. A young couple followed carrying a baby, a pitiful little wreck. Both parents cried aloud as they came. This was their firstborn. "Pierre, Pierre, Petit Pierre!" they moaned.

A little white cot had been put in the centre of the big room. The weeping parents drew chairs, one on either side of the cot. The cot was sometimes put on the terrace, then the French couple took their chairs and sat holding hands across the canopy of the baby's cot. No matter where the nurses put Baby Pierre, papa and mama picked up their chairs, followed. They wept and kissed; a hand of each was locked in that of the other.

If Nurse took the baby away to tend it, the couple walked up and down the terrace kissing, comforting. Their foreignness seemed to enclose them in complete privacy. We did not exist, nothing in the universe existed except themselves and their great sorrow. Cold English allowed their tears to congeal, ossify under the skin of their faces. The French said, "Stupid fools. We French cry." They cried hard and watched their child fade.

The baby was too weak to wail any more. The father's and mother's hands froze in each other's grip. Everyone tiptoed past the room where little Pierre was; we knew the baby was dying; it was not kept secret like mature death. The whole San cried for Baby Pierre, boldly, unashamed.

The door of the room stood wide; the little cot was gone. Gone too were the French couple. A tiny white marble cross stood among the more mature tombstones of Sunhill Cemetery.

MRS. VINEY

A GAUNT CREATURE, wobbling between dignity and weakness, made her first appearance on the terrace. She chose the lounge chair that was between one occupied by a woman with transparent ringed hands and another containing an abnormally clerical parson, with a collar like a retaining wall.

When the new patient was tucked, pillowed, hot-water-bottled and smelling-salted, she turned to the clergyman.

"My first time up."

Silence.

"I am free of temperature and cough!"

Still silence.

She tilted the pink tam a little more, sparkled her eyes, smiled at the parson.

He sank down into the protective starched circle of collar. A pair of pale hands raised a drab-bound volume up, up, till his face was gone.

"Nurse! Nurse Maggie! Face me the other way."

On readjustment she enquired of Rings, "Are you normal?" Rings glowered. "Temperature, of course. This wild life is said to be healing. Detestably monotonous, I must say."

Rings bowed coldly.

The newcomer shook out her knitting; her needles clicked angrily.

Up piped a childish treble, "Mrs.—, Mrs. New Lady. Perhaps no one has told you; it's the San way not to mention temperature or coughs. Those things are only Doctor's business here. We are not allowed to talk sickness."

"And who may you be, Miss Pert?"

"I'm Jenny. What is your name, please?"

"Mrs. Viney. Pray, Jenny, what *are* we permitted to talk about in this place where nothing ever happens?"

Jenny looked across the lawn. "Well, there's birds, Mrs. Viney."

"Birds and to spare making bedlam of day and night!"

A bell clanged; silence fell upon the terrace; every soul either there or in his room was sucking a thermometer and quiet. It was the noon Rest Hour.

MRS. DOWNIE

I DON'T KNOW how I got to know Mrs. Downie because she was exclusive. "Come to tea and bring your doings," she invited. For the moment my "doings" were effigies of the two Doctors. The 'Ups' bought wooden dolls for me at the village shop in Stillfield. I adapted and costumed them to mimic characters.

Tea was set in the big bay-window of Mrs. Downie's room. Her fine room at the end of the east wing overlooked not only the terrace but the whole country-side as well.

Mrs. Downie did not walk with 'Ups'. She did not lie on the porch with 'Semis'. She was not a 'Down'. She reclined on a lounge chair in the window of her big room, surrounded by the newest books in clean jackets and the choicest flowers from London shops. Her meals were served to her there.

She lay now watching with amused interest my effigies being stitched into life. I was working on Dr. McNair's undies. Mrs. Downie asked, "What do the Doctors say to their effigies?"

"Just laugh. I had trouble in getting Dr. Mack's legs long enough and the right twist on Dr. Sally's neck; you know her listening kink? I had to borrow Cook's meat-saw, saw through the neck and glue it back twisted. I had to give Dr. Mack's legs an extra joint."

On the terrace below, heavy tea cups clanked, listless hands busied themselves over bits of needlework or knitting; round bright tams bobbed beneath us like toy balloons, floating singly, bunching for gossip. Jenny's merry laugh floated up, other laughs, some infinitesimal joke. "Hush! . . . Doctor." "Probably Dr. Mack is framed in her window!" I told Mrs. Downie.

Miss Brown and Lavinia Mole humping up the garden hill, tired, sweaty, wanting their tea. "A-choo! A-choo!" Angelina Judd somewhere behind the rise. Two men mounting the terrace steps; one limps, the other has a scar across his cheek.

"Out in Africa—," says Limp. "I remember," replies Scar.

The two men take their tea standing on the terrace, sipping slowly. A child's sweater is held up for inspection, "Are those sleeves a pair?"

"True as scales." "Nice colour, how many stitches?"

The bell, bobbing tams, closing doors, silence. Mrs. Downie turned from the window. "They *are* brave. I am a coward. Just seeing them is almost more than I

can bear. Dr. Bottle advised. Tom begged." She shrugged. "I stipulated that I should not eat or mix with them. Tom and I waited seven years to marry. They said I had quite outgrown the tendency. T.B. is hideous the way it lurks and pounces, long after you think you're safe."

Rest bell. Mrs. Downie settled into her lounge chair. I packed the Doctors' effigies into their box, went to my room.

Mrs. Downie stayed in the San a few months, then she went with her husband to Sicily. From there she sent me what must have been glorious flowers. Alas, when I opened the box every flower was dead. She said she was sending me a box of flowers every week. I wrote, "Don't. They come dead." The San people said I was foolish, I should have let Mrs. Downie have the pleasure of thinking she had given me that joy. I felt that would be shamming, dishonest. I appreciated her thought and told her so. In the San they said, "Mrs. Downie has money. She would not miss their price. It is better to tell a minor fib than to disappoint." They accused me of striding rough-shod over people's more delicate feelings.

SONG

A NURSE from London, doing 'Special', was singing. The piano was at the end of the long dining-hall. 'Ups' were grouped around it listening. The nurse's voice was neither good nor bad. The music carried across the court to the patients' rooms under the wings. All sounds were common property at the San.

Men and women patients lay in bed, some critical, others soothed. Nurses paused in corridors, maids stood just inside the dining-room swing doors. A hefty foot swung the door from the kitchen, scattering the maids. The door stayed open. Mrs. Green's plump elbow kept it so. She stood lapping up the music. Soon she was weeping over the mawkish sentiment that sent nurses about their business, patients to their rooms.

I looked in to see Jenny. "Hear the music, Jenny?"

"Uh, huh."

"Enjoy it?"

"Not much. Hark! He does it every night just at this time. I have been so afraid her noise would drown him."

Across the night, across the garden, into Jenny's room swept the serene melody of a nightingale. Again and again it came. Jenny and I held our breath.

It was the nesting season. All night the male sat near, singing to his brooding mate. It is the nightingale way.

In a room down the corridor Mrs. Viney sprang from her bed. "Confound the brute! Just as I was getting off!" Bang! went the smelling-bottle onto the floor, as she reached across the table for cotton wool. She jabbed a wad into each ear and slapped her head down onto the pillow.

Mrs. Viney appealed to the Parson next day. The Parson was reclining on the terrace. Nurse Maggie came staggering under a load of invalid accessories. Everybody knew to whom they belonged, before he saw the peevish face behind.

Mrs. Viney sank into the chair. "Have I everything, Nurse? Book, glasses, smelling-bottle, handkerchief. Oh! the thermometer, hand me the thermometer. I shall take my Rest Hour here." She languished among her pillows with closed eyes, long enough to impress. Then she "unfurled", (she had stated on the terrace that people *should* unfurl their lids like petals, not pop them like ginger-beer corks).

The Parson had just found his place. He plunged into his book the moment Mrs. Viney came. She generally sought his proximity. Today she leaned across, laid an appealing hand on his rug, "Mr. . . . Mr. . . . ?"

"The Rev. Brocklebee, if you please."

"How stupid of me! Brocklebug of course." For sweetness her smile would have shamed honey. "Do you not think, Mr. Brocklebug, the price we pay and all, something should be done? Why should our rest be disturbed by vermin? You, a clergyman, a public speaker, could you not voice our opinion publicly?"

"Do you refer to mice? I have experienced no trouble," said the Parson stiffly. "Our rooms are open; creatures come in naturally; field mice are quite harmless."

Mrs. Viney shouted, "Nightingales, Sir! Who can sleep through their horrible din? Something *must* be done! Invalids waked! I declare. Only poets and fools rave about the nightingale. I *had hoped*, . . . being a public speaker . . ." She gave the Parson a saccharine smile.

Reverend Brocklebee's heavy face lifted from his book. "I take great delight in the nightingale's song, pray excuse!" He lifted his book.

Upright in her chair sprang Jenny, eyes flaming, cheeks scarlet. "How can you say those things? The birds making night hideous! Calling them vermin! Oh, Mrs. Viney!"

"Don't excite yourself, Jenny child. There! I would not wonder if you have put your temperature up. All for nothing! Silly Jenny, very, very silly, little girl."

LEGITIMATE PREY

THE LAWS of Sunhill Sanatorium were primarily made for the T.B.'s. Those patients not T.B. were more or less free-lances. We were therefore pounced upon by T.B. patients as legitimate prey to question for information regarding the "how bad state" of new patients. I never walked with the 'Ups'; otherwise I would have been asked about everybody and myself too. I heard that during the long slow walks of the 'Ups' I was the subject of a good deal of speculation. "No cough, no food restrictions, no temperature." Yet, here I remained in the Sanatorium month after month. Did anyone know what *was* the matter? "Heart perhaps?" "No, I have an Aunt with heart, etc." "Liver?" "In that case she would be sallow. I once had a friend—" "You don't think it can be mental?" "Mental nothing! Her tongue is sharp enough to mow the lawn." The Gossips strolled along. The discussion jogged to the time of their slow feet and got them nowhere. It was young Jenny who used to tell me of these wonderings at my expense. They knew the child was dear to me and I to her, but Jenny was close-lipped. When they put their questions to her direct, she replied, "I don't know. I only know I love her. The San says we are not to talk disease." The child was very loyal to the San and to me.

The favourite walk of the 'Ups' was to Stillfield village. The village shop sold peppermint bull's-eyes, soap, stamps, and cigarettes. The proprietor, Mrs. Stocking, waited on San patients grudgingly; got them out of her shop as soon as possible. "T.B. bug-carriers" the village folk called San patients. They were angry when the Sanatorium was put in the district, although the San brought trade to the village and did not lie close to it. If village folk met patients on the roads they crossed and turned their faces away.

The San bus rattled through the village at train-time, picked up patients and mail and rattled home again, disturbing nothing but the dust. Matron sorted the mail and set the letters climbing the wire rack in her office. The 'Ups' waited, watching, apparently indifferent. They took their letter from the rack casually. In the corridor they hugged the envelope close, hurried to their room, laid it on the bedside table till Dr. McNair's visit was over. (Letters reddened one's nose and eyes most embarrassingly; being sloppy was such bad form.) You'd got to stay here till Dr. Sally Bottle released you. Cry-babying only smashed your morale, made the powers that ruled angry.

A RABBIT WARREN
AND A PIGGERY

"IT'S A BAD, mad, crazily brambled snarly place riddled with rabbit holes; it's a bedlam of bird song. Nobody goes there; I just came upon it by chance. Here! I picked this posy for you there—all wild."

"I *must* see this place, Scrap, is it far?"

"Too far for you."

"Tell me the way."

Scrap drew a plan on my bed-quilt. Just in from her morning walk she had dropped in to tell me about this rabbit warren she had discovered, and to bring me the bunch of wild flowers.

"There's the Rest Hour bell!" Scrap put the flowers into my tooth-mug and went to her own room.

My walks were not set by the Doctors like those of the T.B. patients. I was free to walk where I would, providing it was not too far, and I did not overtire.

Immediately after our noon dinner I slipped out the side door without any-one seeing, past my birds' cage, skirted the San's big field, crossed the highway, found the lane that dwindled into a narrow foot-path and ended in the Warren. It was indeed a wilderness! Tired I flung my body down upon the hot earth and shut my eyes, leaving free my other senses—feeling, smelling, hearing.

Brambles clutched and wove themselves about everything. Under the tangle of gorse and broom bushes gaped the cool mouths of rabbit holes; deep in them rabbits were sleeping, waiting for the cool of evening to release the kick in their long hind legs. Like the rabbits I, too, was soon fast, fast asleep.

Little feet scuttering across my body woke me! Rabbits bobbed everywhere. The sunny buzz of insects had stopped. Shadows were long, scents and bird song evening-sweet.

The five o'clock rest-bell would have gone long ago; deliberately I rolled over. The Doctors had told me it was better I should be late than hurry. I did not want more sleep. I wanted just to take all this in a little longer. I had not known you could find such wildness in England. This place seemed so beautifully mine—mine, and the birds' and rabbits'.

I walked very slowly back to the San. The supper-bell rang as I was going up the drive. I met Doctor McNair in the hall; she looked reproach. "We were beginning to wonder, Mammy."

"Sorry, Doctor, I fell asleep in the Rabbit Warren."

She shook her head. "At least you were resting. I will see you after supper."

She came after the meal, helped herself to a cigarette. "Mammy, how far is this Rabbit Warren?"

Was she going to forbid my going again? I dawdled through my telling of how delicious it was, postponing the evil moment. Instead of forbidding me as I expected, Doctor said, "Take me there, Mammy." If once Doctor saw it she would surely understand. That week we went to the Warren, Doctor and I. It was just as fine a day as before. We crossed the field, the highway, the lane, and were in the little path.

"I don't like this narrow way, the brambles tear me," complained the Doctor.

"We are just at the Warren; look, there is a dove nesting in that tree. The gorse and broom bushes are full of linnet and bullfinch nests, and, oh, Doctor, you should see the rabbits bobbing about when the cool comes! Just now they are down in their burrows sleeping." "A dangerous place, this Warren, Mammy. The ground is riddled; one could easily stumble, break a leg!"

We sat down to rest. Silence fell between us. I could feel the Doctor and the Warren were not in sympathy. The Warren would not do any of the things that it did for me the other day. It went stupid, made me feel a liar. The birds were quiet; no rabbits scuttled; not even a cricket gritted his wings.

"Come, Mammy. We shall be late for Rest Hour." We went through the path and the lane. On the highway Doctor said, "You must not come to this place again. The walk is too far. The place is morbid."

"Morbid!"

"Solitary walking in woods is always morbid. Keep with the rest of the patients, Mammy. Go the shorter walks with them."

"That is morbid if you like!" I cried. "Disease, disease, always disease."

"They are forbidden to talk of their ailments."

"There are those who talk of nothing else, once they are out of the San's earshot."

I was suddenly dreadfully tired. I sat down on the roadside, my feet dangling over the edge of a dry ditch.

"That's right, Mammy, take it easy. I will hurry along."

As I sat on the edge of the ditch I was angry with pieces of me. I talked to my legs. I said, "You silly old legs, why must you tremble?" And to my heart, "You spluttering, silly heart. Why must you act up?" I smacked the leg that did not feel with my stick, then I got up and followed Doctor, Doctor who had gone back happily to her bottles and patients and stethoscope; to the inexorable law, the forced cheer of the San.

From that day Doctor McNair supervised my walks; she did not insist that I go with the others, but I must not walk far. I went into the little wood close behind the San. I discovered, too, an old orchard a short piece down the road. The trees were twisted and moss-grown. The orchard was now used as a piggery. I was hunting bullfinch nests, and followed a lane that ran at the back of the

piggery-orchard. I entered squeezing through a hole. I therefore did not see the notice up in front of the pig-farm: VICIOUS BOAR BEWARE! I heard a terrible roaring. The heavy beast was making straight for me. He had immense white tusks. I did not know any of the pig family could make such speed, could look so terrible! I could not run. I took a backward lucky step. It landed me in a deep hidden dry ditch. The bushes closed over and the boar lost me. He leapt the ditch and tore past roaring. I lay there till the pig's dinner-time, then I crept back to the San late again. I was ill. I told them about my boar fright. They kept me in bed. Doctor McNair stood beside my bed. "Mammy, Mammy, why must you? Bed is the only place to keep you safe. Other patients don't go to these extraordinary places, do these queer things."

"I was only hunting a bullfinch's nest, Doctor McNair." There seemed nothing queer or extraordinary to me about pig-farms and rabbit warrens.

TEA TIME

TWO LITTLE MAIDS in scarlet, and very snowy as to caps and aprons, staggered onto the Circular Porch, one bearing a heavy tray. On it was an enormous "Brown Betty", nests of cuddling cups, plates of thick bread and butter. The other maid was provided with a folding table. Tea was served on the Circular Porch.

'Semis' waited for tea before going back to their rooms. Tea was optional. 'Ups' relished its reviving warmth on returning from their walks. Everybody scorned the bread and butter. They read cups and gossiped.

"Didn't 'Beautiful Cabbage' gobble of her favourite at dinner time? Four helpings no less!"

"Kate sneaked her cabbage over onto her mother's plate while the old girl and Miss Brown were having that deep discussion 'cabbage versus sprouts'. Was the old lady furious? Whew!"

"Saw, did she?"

"Rather! Shot the cabbage back onto Kate's plate with a deadly look, eyebrows tipped clean over the top of her head! A Cranleigh funking! In a tone that would have cracked a bass viol she shouted, 'Play the game, Kate!' "

One gossip handed the other gossip a cup of tea. "One lump or two? Bread and butter?"

"One lump, and don't mention the bread, butter or any form of food. Dinner congealed in cold gravy on my dressing table waiting to be eaten this very minute—supper only two hours off. Oh dear!"

"Same here, potatoes and spinach! Oh, my! Isn't Doctor's face . . . when there is food on your bureau . . . ?"

"It certainly *is*."

A plaid tam bobbed up the path. "Hello! News everybody! New brand of peppermint bull's-eyes in the metropolis of Stillfield. 'That 'ot they blisters,' says Ma Stocking." The speaker was always gay; her lungs were making satisfactory progress, her face brick-red, weather-beaten.

"How you can stuff yourselves with those vulgarities on top of our meals, I can't think!" sneered Mrs. Viney.

"They are for Jinny the donkey, not for us. Great fun, feeding peppermints to Jinny. Crunch, crunch. Jinny hee-haws to high heaven and rushes for the stream."

"Cold water on top of hot peppermint. Wow!"

"Jinny's a sport. Back she comes with her tongue and tail lashing furiously—asks for more."

Clang, clang, clang, the Rest House bell!

"Come on, let's attack our bureau dainties before Doctor brings her face in." The little mob pressing through glass doors, clatter, clatter, down bare corridors, opening doors, shutting doors, silence. Every soul seriously sucking a thermometer and staring at the ceiling. Doctor's heavy tread, her small voice, "How are you? and you? and you?"

Gay answering chirrups, "Fine—fine, Doctor—just fine." The orthodox sanatorium lie!

A GOOD CRY

GRACE WILLET read the letter while lying upon her bed during the noon Rest Hour.

"How awful, you poor darling, incarcerated in that lung place. How can you bear it? but, for the sake of others—of course. *If* (scratched out and *when* substituted) you do come out, you will have to be so frightfully careful, careful for yourself, careful for others."

Grace Willet scrunched the letter, wrung it like wash, flung it under the bed.

"I am going to cry! simply howl. Don't care! I just shall!"

Doctor's step in the corridor. "I'd better wait till she has paid her visit, then cry, cry, cry I shall!" Doctor took the east wing first. The lunch bell had gone by the time she came to the west wing and Grace. Grace was still holding back her tears.

"Can't go to lunch bellowing!" She powdered her sharp little nose, brushed the reddish terrier-like hair back from dry burning eyes, went to table.

Dobbin said, "Where do you walk this afternoon, Grace?"

"Stillfield."

"Good, so do I."

Dobbin was a dull but steady talker. Grace Willet gave vague answers or none. She was saying to herself, "I want to cry, I want to cry!"

"You're walking too fast, Grace!"

"Don't care. Something I must do before supper."

Grace got the clean hankie, the lavender-water, arranged the hiding screen. Everything was to hand, everything except tears.

"They've teased to come all day. They shall come. I'll make them!" She tried and tried. Her eyes remained desert dry.

She even scrambled under the bed and retrieved the letter. Smoothed, read it from "My Darling!" to "Eternally yours". Not one tear.

Doctor came to pay her Rest Hour visit, sat toying with the lavender-water bottle. "Bonny wee bottle." She removed the cork and substituted her nose.

"A-a-a guid! Lavender grew in our old home garden." She returned the cork, continued her rounds.

"Lavender, lavender! Mother cutting the long stiff spikes." For nearly an hour Grace's homesick tears poured.

Supper! A letter torn to bits in the waste-basket—cold water—powder—clean hankie. Grace sailed down the dining-room, sharp little nose red, but very "up". Between munches Dobbin remarked, "You're all perked up again, Grace! You were dull company on our walk."

P I C N I C

IT WAS the San Event. Everything timed back to last year's or forward to next year's Picnic. Unless death actually had his finger poked into you, no one able to stand on his two feet missed the Picnic; otherwise he would be considered a funker.

The Picnic lingered on patients' tongues from one year to the next, a function prefaced by lively activity and anti-climaxed by sniffs and rheumatics.

Lungs are slow healers. Some patients took in many Picnics. They might go home between whiles, might have spells of tolerable wellness. Sooner or later it seemed, though, that they always came back for additional treatment, and perhaps during that come-back took in another Picnic.

Whiffs of preparation had been coming from the kitchen for days. (There were no secret smells in this place of open windows.) Boiled ham and spice-cake odours chased each other up and down the corridors. Mrs. Green, the San cook, had a Picnic formula. She would no more dream of departing from it than a doctor would dream of stethoscoping a patient with the sugar tongs.

The great event was set for tomorrow. "Weather permitting" was a term unknown in the San. All weather permitted. Seasoned San patients passed through spring, summer, autumn and winter without comment. Weather was just weather, that was all there was to it. Patients accepted it like animals. Newcomers might growl; nobody paid any attention to them. The wise patient blew on his fingertips, stamped his feet, and avoided the mirror; enough to see all the blue noses down the long, long dinner-table without looking at his own.

"Where do we picnic, Hokey?"

"Usual place."

"This is my first San Picnic."

"So it is! Well, then, beside the church."

"What, picnic in a graveyard?"

"Not exactly, we eat in a little strip of woods opposite, then cross to the graves."

"Rather . . . rather . . . isn't it, considering the condition of the picnickers?"

"Gloomy? Oh, my—no! The graves are the entertainment. You see, our patients cannot play active games or sing or do ordinary picnic stunts. They love to count the new stones. It is like visiting old patients. The nurses enjoy being among the ones they have nursed too. There is the old church for the *very* sick patients to sit and rest in. San's Picnics have always been beside the graveyard. They would not be the same anywhere else."

"Then, it seems once corpses are in graves they are taboo no longer?"

Hokey frowned, "How you do put things!"

The Picnic morning was wet, rain drizzled. Picnickers took the weather in their stride. Those unable to walk were stowed away along with picnic baskets and Doctor McNair in the horseshoe bus. As cows with tails dangling and trickles of rain running down their sides hunch from stable to pasture, "Ups" ambled across the fields headed for the graveyard.

Dr. Mack was not a Picnic enthusiast but she clenched her teeth and was staunch to the San régime. It was said in the San that no one ever caught cold, owing to the elements. Colds were handed to you by a fellow-human. If a San patient got a cold he was isolated as if he had the plague.

Doctor Mack was stuffed with woollies till she was as shapeless as a bologna sausage. After everyone was set in the horseshoe bus, she staggered out of the San with what appeared to be a whole year's issue of the London *Times*. She rammed the space under the circular seat full of *Times*, murmuring, "Picnic sittings". Her eye caught the little basket I carried.

"Private lunch, Mammy?"

"The baby birds, Doctor."

"Surely, surely, wee birds must not starve because their mammy goes picnicking."

The bus stopped at the break in the old cemetery wall. All eyes ran across the graveyard, marking the white new stones among the old and moss-grown.

Doctor shepherded us into the sparse little wood across the road. "Eating before entertainment," she said.

The bus started back to the San. "One moment! James! Leave us the cushions."

James scratched his head, "Beg pardon, Doctor Mum. Is them new ones to ride from the station on nothin', so to speak?"

"Right, James. For the moment, the Picnic drove new patients out of my head." Doctor started rationing the London *Times*.

I hung the bird basket in a tree and the patients crowded round to see them gobble worms from a small pair of wooden tongs. I put the empty worm box back into my pocket. There was a general rush to help unpack the picnic baskets. Doctor laughed, "For once my patients are eager for a meal!" She mounted an Eiffel Tower of London *Times* and tried to control the chatter of her teeth.

Thick cups of steaming coffee were handed round; our blue hands circled them; everybody wished they could submerge under the hot brown liquid. They grudged having to grasp with a stone-cold hand one of Mrs. Green's hefty sandwiches. Blobs of rain dripped off our tams, sogging the bread and dripping down our collars. The men, who never wore hats, tossed the water from their hair with angry shakes; even so, dripping tangles of hair leaked into their eyes, and ran down their faces like floods of tears. This annoyed the men worse than the wet. Our laps filled with rain in spite of the London *Times* underneath us. It was found best to eat standing—one could drain better. Men shook their hair, women their tams, trees collected blobs specially to hurl down patients' necks. Nobody grumbled. It was the Picnic! Only the honest old stream by whose side we ate whimpered complainingly as it meandered through the wood. (A mean straggle of trees to call a wood. Just a huddling strip of grey boles which lay between the high road and a cow pasture.) The tree-boles half hid the pasture like a scant chemise. You saw the rail fence here and there between the trees; like lingerie ribbon it threaded in and out.

It pelted rain all the while we ate. We hurried the dishes into the baskets and stampeded for the cemetery. The women went into the church. Men drew hatless heads down inside their coat collars and huddled under a great beech tree among the graves.

The church was dark and squat. It smelled earthy and was full of creaks and crackles; pigeons mourned in the belfry, emptiness shouted from pulpit, choir, organ and lectern. Our wet clothes made the varnish of the pews smell. We were silent till Jenny, choking back an unholy laugh, said, "I'm stuck!" and wrenched herself free with a click. We were all stuck! They had recently revarnished the pews. The backs of the seats were hairy from our woollen clothes.

A pale little sunbeam straggled up the aisle. Miss Dobbin tiptoed from the pew to see if it were real. The sunbeam leapt over her like a happy pup. She

beckoned and we filed out of the church just as the little band of men broke and scattered among the graves.

Up and down, up and down, between the tombstones we crept in single file, reading names. The soil of one grave was newly turned; it had no headstone but the wreaths on it were still alive.

"Whose?" someone whispered. Nurses pretended not to hear. Death in that grave was too new to mention. Mentally I fitted the cough I had missed in the east wing for the last few days into that grave.

We all stood round a tiny grave having a wreath of bead immortelles under a glass globe and a white marble cross at the other end. On the cross in gold lettering we read, "Petit Pierre". Near the tiny grave was a long one, "John Withers, aged fifty years, erected by his master and friend." "Why Hokey," I whispered, "I thought John was old, old."

"He suffered," she said, and smoothed her hand over the top of the solid granite.

Sun strengthened; the earth steamed. A storm thrush settled in the top of the great beech tree and, as is his way after storm, shouted hallelujahs! The rain was done; thrushes and blackbirds, larks and warblers, sang as if their throats would burst. "Cuckoo, cuckoo!" The monotonous note was flung from graveyard to woods, back and forth, back and forth, with tombstone monotony. The brook had taken on a happier tone, replenished by new waters. It sang more contentedly as we leaned over the little bridge spanning its waters and waited for the San bus to pick us up.

The San's good-looking boy patient was at my elbow, leaning over the rail. We were both gazing into the meagre little wood.

"Remind you of Canada?"

"No! Oh, no!"

The bus drove up. The picnic baskets were stowed in. Patients mounted the two iron steps to take their seats on the cushion. Flap, flap, our wet skirts smacked against the iron step. Our woollies smelled like wet sheep.

We were hustled to our rooms at once. It was the evening Rest Hour. We climbed into dry clothes and lay upon our beds. Doctor, much more serene and comfortable than she had been during the Picnic, visited from room to room.

"Did you enjoy the Picnic?"

"Oh, immensely."

To the next patient, "Did you have a good time at the San Picnic?"

"Tip-top, Doctor!"

So, up and down the corridors everyone lay upon his bed and lied. Some of us wondered, "Next year will the picnickers be reading my name on a stone? Will the next be me?"

The white owl hunted early. Her brood in the hollow oak tree at the back of the San were voracious. She swooped up and down the terrace, peering into each lighted room, asking with her great rolling eyes and her soft enquiring voice, "Who? who? who?" The question we asked ourselves.

When the owl "who'ed" Mrs. Viney she hurled her shoe at its blinking eye, with lively vehemence, but missed. Nurse Maggie retrieved the shoe from the terrace, grumbling a little at the wet and dark.

NOBODY'S PATIENT

HOKEY had appendicitis; went up to London for operating; left me high and dry as a beach-log cast beyond flood-tide. I was nobody's patient and was again a 'Down' confined to bed.

When Bunker's mumpy face and fallen arches shuffled round my room I feigned sleep.

Ada's violence shattered all sham. Bang, bang, bang, things crashed till Matron came to look into it.

"Got a headache?" she asked me, not appearing to watch Ada.

"Awful. When will Hokey be back, Matron?"

"Soon now." She smoothed my pillow, held my wrist a minute. The mop handle g-r-r—ed down the wall, smacked the floor. "Gently, Ada, gently," Matron said.

But Ada could not be gentle, her make-up was row. A spider ran across my bureau. "A-ow!" she screamed and flung her dust-pan clattering after it. When she saw a harmless insect she yelled as if it were a lion. Doctor met a red-faced Ada rushing down the corridor! I begged, "Couldn't I please have any other nurse? Even an 'Odd Jobs' rather than Ada?"

I was handed over to Nurse Bandly, spontaneous likeable Bandly, who knew how to both laugh and cry, tall Bandly swooping down to gather you into her arms, her starched bonnet strings sawing you head from body. You did not see Bandly's tears, only heard their wetness in her voice when she was sorry. Bandly could not be my nurse for long, because a new man patient came and Bandly settled the men in better than any other nurse.

I fell then to the ministrations of that holy nurse, Maggie. That is, her energetic body rattled around my room occasionally, stirring the dust, but her heart was all for the Cranleigh boy at the end of the corridor. She grudged every moment she had to spend away from him. He was a bad case.

If I wanted to claim Maggie's attention, I said, "D—n!"

Maggie reared like a scorched caterpillar, bolted back to her sick boy, told him about the d—n. He told 'Beautiful Cabbage', his mother; she passed it on to Kate. Kate spread all over the San that I blasphemed and was to be avoided. It

came back to me and I said, "D—n, darn, d—n!!! Let them all go to the devil and sit on their hats! I don't care!"

When next Maggie came into my room, I sang,

> *"I am not very long for this world,*
> *My white wings will soon be unfurled,*
> *Old Peter will say, hoorip and hooray!*
> *For Mammy is coming today, today,*
> *For Mammy is coming today!"*

That finished me with Maggie.

D E A T H

THE TAP on my door was gentle but firm. A strange nurse entered and stood at the foot of my bed.

"I have come to do you up."

"Have you?" I said, a little puzzled. "Aren't you the Special who came from London to look after the very sick boy in the west wing?"

"He does not need me any more."

"Tell me, was it dreadful?"

"No, quite easy, poor laddie."

Nurse Patterson got my fresh day gown, the water, soap and towels. She seemed to know where everything should be without asking. Item by item she laid everything ready. You could tell she had trained well. Our nurses were efficient enough in San nursing, but they had limitations. When anyone was frightfully sick Specials came down from London to nurse them.

Nurse Patterson did not talk as she worked. I liked her silence; it made me ask, "I want to know about that boy's dying. I have seen dead people but I have never seen anyone do it. Is it terrible? Do they mind? I have often wondered how it would feel to face death. Here death is never mentioned though several patients have died since I was in the San."

"In twenty years of nursing I have seen many die, many beautifully, some sadly, a few terribly," said Nurse Patterson. She told me something of each kind. She worked as she told; I listened intently. You felt it earnestly true, not dreadful as I had thought.

"Thank you, Nurse. I have heard a lot in Church and in Sunday School about death, nothing about the practical side of dying; I would not have dared

ask anyone in the San. Death is sort of a disgrace here, something to be hidden, never mentioned. You miss a cough. The room is being got ready for a new one. The old one's name seems to die with him."

Nurse Patterson said, "Don't dwell too much on death, child. Death has a way of preparing for itself. The San people would probably be angry with me for talking to you of these things."

"I shan't tell. My nurse is away sick. I am nobody's patient, just done up by anyone who has time."

"You are going to be mine till your nurse comes back. I am filling in."

"Oh, I am glad. I like my nurse tho', and she will understand more when she comes back, because she has felt being sick."

"I expect she will. Sometimes I am sorry I trained. I have a little sister who wants to be a nurse. I am trying to dissuade her."

"Why? Are you sorry about yourself? Why want to stop her?"

"My little sister is a joyous being. I am afraid she may lose her joy, or that she may grow hard."

"You haven't grown hard. Have you lost joy?"

"I don't know," said Nurse Patterson, "I don't know." Tears came into her eyes. Doctor Bottle tore into my room in her cyclonic way. "Nurse Patterson, you are to special No. 15 in the east wing." I never saw Nurse Patterson again; again I was nobody's patient. Hokey was back but not working. I drew a picture of a girl preparing to commit suicide in a water-jug. One hand was holding up a very small plait of hair so that it should not get wetted. The other hand steadied the jug; under the drawing I printed, DESPERATE.

Hokey came back. "Don't do it again, Hoke."

"Can't. Nature gave us only one appendix."

SCRAP'S CHILD

SCRAP'S BABY was nervy and fretful. She was brought occasionally to the San to visit her mother. Scrap had seen so little of her child, since the babe was old enough to take notice, that the child preferred her nurse. The woman spoiled her. Scrap groaned when the child turned away, but she dared not offend Nurse. The woman cared well for the infant.

Scrap and I had become very good friends. After supper in the evening my door would open—such a very little way, it seemed, when you remembered it was to admit an adult. I tossed a pillow up on to the top of the high gilt radiator that was always stone cold. Scrap climbed, took a bit of wool knitting from her

great-coat pocket, told me the San news and little bits from her home letters. I read her pickings from my Canadian ones.

This night Scrap was full of one subject; she braced her toes against the edge of my bed and began excitedly, "What do you think?"

Scrap had been down-hearted lately. I was glad to see her animated.

"Has Doctor Sally given you permission to go home?"

"Almost as good! She is going to let me have baby here. Nurse will come too, of course, to look after baby. We will have the big room at the end of the west corridor. Baby in a cot close to my own bed. Just think! Aren't you glad for me?"

I was silent. Scrap looked keenly into my face.

"You don't think it good?"

"I do not, Scrap. I don't care what two hundred and fifty Bottles say. Fretting lungs don't heal. Lungs are all Doctor Bottle cares about. She is letting your baby take risks because she wants to add you to her list of cures."

"I want my baby."

"Several other mothers in the San doubtless want their babies too. They'll enjoy having yours to dandle. How Dobbin will kiss her at every opportunity!"

Scrap winced! After a moment's quiet she asked, "Shall I recite?"

"Please do."

Her head was full of memorized odds and ends. We often wheedled half-hours by in this way; odd bits of poetry, little bits of prose drifted our thoughts away from San monotony. We were so surrounded by open air, it was easy to fly away on phrases, words that caught our fancy, travel through dark and space, leaving our bodies, our ailments and disappointments in the San. The bell for Turn-in rang. Scrap got down from the radiator.

"Good-night. I am not bringing baby here."

"Good-night, little Scrap." She had thrown herself across my bed. For a moment things reversed; I, who was older than Scrap by several years, just then was her baby. Years did not count. Scrap needed something human to hug at that moment. Her husband was a cold man. He had never kissed Scrap nor allowed her to kiss him, since he learned she had T.B. He did not want her home, did not want every window in his house open to all the winds of heaven. I doubt if he would have allowed his child to go to the San. (Scrap had not told him yet of Doctor Bottle's plan.) Scrap and I had a tiny cry, a big hug. She went to her room.

Life in the San did queer things to us. Was it our common troubles and discomforts? Or was it the open—birds, trees, space, sharing their world with us—that did it? I don't know.

TWO ENGLISHWOMEN

THEY CAME TO the San together. Now, they were leaving together. During their stay in the San they had stuck close to each other as damp postage stamps.

Miss Bodwill was tweedy—raised mannish—batched with a brother.

Feminine woollies clung softly natural to Nellie Millford. She wore a little jewellery, had a titled aunt, and gloried in pretty feminine things.

Dr. Mack liked these two women. They were welcomed in her sitting-room at all times; she joined them in their walks. The patients rolled jealous eyes and whispered, "A house doctor should not have favourites, should mix with all, or remain solitary."

Could one see Dr. Mack hob-nobbing with the stolid Dobbin, with Mattie Oates, linking arms with dull, foamy Mrs. Viney? I could not.

The three tall women continued to walk together, looking calmly over the tams of the cat-eyed. They went on having their good little times. Summer passed.

By late autumn Nellie Millford was well, Miss Bodwill well-with-tolerable-care! They left the San. Doctor Mack was lonely. She would not have admitted it, but I saw the sag of the solitary about her. The two women came to bid me goodbye.

"I am off to Scotland with my Aunt, Lady Broadley," said Nellie, twiddling an engagement ring. "I am going to be married." Suddenly her arms were round me, hugging! "I'm well and frightfully, outrageously happy!"

Miss Bodwill wagged a cropped head and two tweed arms into my room. "So long! Good luck!"

The London post brought me a delicious box of foolishness from the two women—baby birds that gaped, frogs that leapt, woolly things that made noises—together with two letters containing things Nellie Millford and Miss Bodwill had left unsaid when they came to bid me goodbye.

Nellie wrote, "I am almost ashamed to be as happy as I am. Six months ago I went to the San desperate. Now! Hurray for Dr. Sally B."

"It is grand to be home again," wrote Miss Bodwill, "to be puttering about a house and garden. Brother-men are hopeless housekeepers."

I had not realized that under cropped hair and mannish tweeds Martha Bodwill was all woman.

CHRISTMAS

CHRISTMAS descended upon the San as an enormous ache, a regular carbuncle of homesickness with half a dozen heads.

A super-cheerful staff festooned greenery on Christmas Eve. Overworked stomachs groaned at the enormity of Mrs. Green's preparations.

The post-bag went out from the San stuffed with the gayest of Christmasy letters written by patients practically drowning in tears. Beside each bed was a little pile of cards addressed to various comrades in exile. Nurses would deliver them on breakfast trays, jokey nurses lit with fraudulent gaiety—tainted exiles, nevertheless, homesick as the rest of us.

Hokey, gathering my Christmas cards, caught her breath, dumped the pile hastily from chair to apron pocket, left the room. I tried to remember whose name was on the top of my pile, the name that choked Hokey. For the moment I could not. A horrible noise began out on the terrace. Four men and two boys came reeling past our rooms, singing a carol in six different keys, peering impertinently into the lighted rooms. Everyone switched into darkness, became headless bumps in beds.

While the boys screeched a duet, the four men paraded up and down the terrace, thrusting a tin cup into the rooms at arms' length, rattling a penny to the tuneless jumble of tipsy whimpering. " 'Ave a 'eart for the poor Waits. What for the Waits?" Between each shake of the cup the men whined. Receiving no response the Waits grew angry, insulting. They had been drinking. They stood on the terrace silhouetted against the night, refusing to go till they got money. Nurses took the tin cups and carried them from room to room. Everyone was angry at hearing the dear old carols insulted on drunken tongues. A few pennies clanked into the cups to induce the Waits to go. Religious little Jenny I could hear crying through the wall. Susie Spinner on the other side of me was shouting one of her tiresome jokes to Hokey through the open transom.

Christmas day broke dark and windy with little flurries of snow. The big dinner was set for five, with a light lunch at noon when every patient was permitted to eat as much or as little as he wished. All patients that could sit up were dragged to the festival table. If they could not walk they were taken in wheel-chairs. Complete "Downs" were served decorated trays in bed.

Log fires burned in the grates at either end of the long dining-hall. The corridors smelled of pine boughs, holly prickled in corners, mistletoe was taboo.

(T.B.'s are not supposed to kiss.) Scarlet-dressed maids flittered about like robins. Through the steamy kitchen Mrs. Green's voice boomed like a deep sea liner in a fog.

We wore our usual woolly garments with a sprig of holly stuck on us somewhere. Monster turkeys, juicy and rosy brown, were dismembered at the side-table by Doctor Mack and Matron. The turkey helpings were heaped about with sauces and dressings. The pudding burned with brandy-fire. The sprig of holly on top crackled. At the end of the meals, toasts were drunk in a pink liquid, non-alcoholic. All plates were emptied because they did not have to be and because it was a splendid dinner. Mrs. Green was called for. They pulled her into the dining-room, scarlet with embarrassment, little trickles of sweat meandering down her cheeks. She dare not mop for fear of slopping the pinkish liquid in her glass. She just got redder and redder, bracing herself against the swing door. It took several maids to keep the door taut.

"Mrs. Green! Hurrah!" All solemnly drank.

"Speech, Mrs. Green! Speech! Speech!"

It was not possible for her red to go redder. Her hand shook so violently she had to entrust the pink liquid to a maid. Mrs. Green's kind blue eyes embraced us every one. She burst out with ill-suppressed sobbing.

"Pour souls! Poor souls! God bless youse all!" Then completely overcome she ordered the maids to give way and let her back into her kitchen.

Chairs shuffled; we moved into the sitting end of the dining-hall for entertainment. Gathered around a real fire, comfortable, we were strangers to each other. In the open, taking treatment, at table struggling with food, we were comrades, intimates; sitting cosy, warm, luxurious, we were strangers.

Lung patients turned faint from unusual warmth and were compelled to move to the open windows; sitting quietly there, they watched the falling snow.

A Christmas paper had been preparing for several weeks. Every San patient had contributed something. It was to be read aloud on Christmas night.

The Reverend Brocklebee put on his spectacles, moved up under the light, cleared his throat, spread the paper.

My contribution was called, "Matron's Dream." It was a skit on the names of all patients and staff in the San. In the middle of my very best sentence the Reverend Brocklebee stumbled, peered close, reddened, skipped.

Fool! What a mess he had made of it! Couldn't the man read? Or had some name been purposely omitted? Miss Ecton had not been at the dinner-table. She was up and about yesterday. I remembered Hokey's face as she pocketed my cards. Miss Ecton's name had been on top. Now I remembered. It was the last card to be addressed.

We did not have a Christmas tree but there was a gift-giving of sorts. Skeletons of dressing screens without their drapery were placed at one end of the room. On these hung a multitude of little butcherish brown paper parcels (each might have contained one chop). The parcels were knotted and tied with white butcher-string. Each patient was blindfolded, led to the rack, to choose his own parcel, silly little gifts aimed to provoke a smile. The San meant well.

When we had all taken, each nurse stepped up and took for her bed patients.

"Hokey, you forgot Miss Ecton." I watched her closely. There was sham behind her casual, "So I did," and stepping jauntily she took another parcel. Hokey couldn't act well.

At nine o'clock we went to our rooms. Christmas was done, and nobody was sorry.

Hokey came to tuck me up. "Hokey, I know. You need not lie. Tell me about Evelyn Ecton. I chatted with her last night at five o'clock on the porch."

"She was dead at six—haemorrhage," Hokey choked.

Evelyn Ecton had come to the San about the same time as myself. We both were Hokey's patients.

Yesterday I had appeared on the porch, first time up in two months. Evelyn Ecton coming back from her walk greeted me, "Hello, I've been up, you down. See-saw, see-saw." She laughed. All Christmas Day she had lain in the San morgue awaiting burial. We Christmased within earshot of the little brick morgue but Evelyn Ecton's self was away. Our forced merriment did not disturb her rest.

GOODBYE

PATIENTS drifted into the San, paused, and drifted out again. Some went coffined, some rode triumphant in the horseshoe bus, many to return later for further treatment. Always secrecy regarding goings. Were they coffined or horseshoe bus goings? Sometimes the San left us uncertain. A patient just disappeared; tight-lipped and evasive were the staff over the word "death".

"Gone home," they said vaguely, and left us to wonder. The San walled death about, hid it from us as if it were an indecency.

All my contemporaries were gone from the San, some one way, some the other.

Scrap was back home with her baby. Kate Cranleigh had recovered and was home with 'Beautiful Cabbage', who now that she had her daughter home and no son to visit dined with us no more. The Cranleigh boy's going was one of the mysterious departures, like John Withers, Miss Scrobie, Evelyn Ecton, little Jenny, and the rest. What big fools the Staff took us for!

Miss Dobbin's patient chewing triumphed. Mrs. Viney, who never did accept the San code, had anticipated pleasurably a recital of her symptoms when she got home only to find that then she had no symptoms left to tell.

I had been in the San eighteen months, was back in bed, losing ground. A new treatment was suggested. Dr. Bottle promised to write my people in Canada. Month after month she forgot.

Each week Dr. Mack asked, "Mammy's letter, Dr. Bottle?" and Dr. Bottle would run past my door, too confused to face me. I despised her. Had my check from home not come regularly she would have remembered. Had I been titled or important she would have remembered. I was only a student. Hokey, Matron, Doctor Mack humoured me like a pup which is about to be bucketed. They were gentle, did some spoiling of me.

Lying helpless, I worried about my birds, calling, calling. All the old stand-by patients were gone. They were at the mercy of this one and that. The new outfit were strangers to me and to the birds. At last it was decided to try the special treatment.

"Doctor McNair, may I get up?"

"You are not able, Mammy."

"Something I must do."

"Your nurse is here."

"No one can do this but me."

The birds came to my hand; one by one I put them into a box. Their round trusting eyes pierced me. I took the box to my room.

"Hokey, ask Doctor to come."

She came to me hurrying.

"The birds, Doctor. There in the box. Chloroform them."

"Mammy!"

"Quick, they are waiting."

"Free them, Mammy!"

"They do not know freedom. Villagers would trap them—tiny cages—slow starvation. Suppose they stole a berry from Miss Brown's garden! Broken necks, fertilizer for cabbages! Please, Doctor. I love them too much." The big overruling woman obeyed.

It seemed the San code enveloped even bird-death. No allusion was ever made to my birds' sudden disappearance. If possible, the staff were extra kind to me. I had been in the San more than a year. I, too, had learned San silence. I did not mention birds for Canada again. I could not.

HUNDREDS AND THOUSANDS

THE JOURNALS OF AN ARTIST

CONTENTS

MEETING WITH THE
GROUP OF SEVEN,
1927

Thursday, November 10th

I LEFT HOME Tuesday night, November 8th. Called at the Vancouver Art School
and met Mr. Varley. He was very pleasant, and took me home with him. His
sketches most delightful, appealingly Canadian, a new delineation of a great
country. Mrs. Varley, a dear little woman, gave me warm welcome.

12 o'clock noon. We have passed through a vast mileage of fireswept moun-
tain country—snow, and ground with dark stubs standing and lying till they
form a black and white check pattern across the snow-covered hills, and the
green-grey river at their base. It is mysterious, weird. Now we are in heavier
pine-wooded country and it is snowing hard. The trees are heavy with it. There
is a cold, mysterious wonder amid the trees. They are not so densely packed but
that you can pass in imagination among them, wonder what mysteries lie in
their quiet fastness, what creeping living things, what God-filled spaces totally
untrod, what voices in an unknown tongue.

2:15 P.M. Ten minutes at Blue River. Had a good walk in the snow. Entered
quite a little settlement. The higher mountains are wrapped in snow mists.
Oblivious, though, the sun shines coldly, touching the snow here and there with
patches of pale gold. What a lot of different varieties of pines there are! Why?
How does the seed of different species get here? There are lots of slim straight
cedars too. We have left the green river now and are running beside a brown
one. The patches of snow and half-frozen ice look like water-lilies. Since we left
the ranges with the brown cattle with white faces, we have seen no living crea-
ture. There are many little lonely roofless cabins of rough logs proudly used
when the road was in construction. How desolate they look!

I should like, when I am through with this body and my spirit released, to
float up those wonderful mountain passes and ravines and feed on the silence
and wonder—no fear, no bodily discomfort, just space and silence. A logging
camp, grey shacks hung thick with icicles, and ruddy-faced men pausing with
big hooks in their hands to watch us pass. We're on a down grade. Daylight is
drawing in and it is only 3 o'clock.

Friday, November 11th

8:00 A.M. We have stopped at Edmonton and are on our way again. As we were late we did not stay long. Edmonton was awake; tram cars running and lights everywhere at 6:30. The night was a slow affair. We were going over muskeg beds and the travel was rough and jerky with frequent stops. We were late. We have left the mountains now. It is flat, brown and white; snow and dry grass and low, scrubby, bare trees. Grain elevators everywhere.

11:00 A.M. Wainwright. Had a nice brisk walk for ten minutes and made friends with a big kind dog. Bright sunshine, snow, but not so cold. Large stuffed buffalo in glass case at station to advertise the buffalo preserve at Wainwright.

Saskatoon. Held up here one and a half hours already. I took a half-hour's brisk walk, then we were bustled on to the train, but though the doors were shut we are still here. Saskatoon is a big town. The station was crowded and bustling. It was cold and clear, but not so cold as Edmonton as there was no wind.

Saturday, November 12th

1:30 P.M. Arrived Winnipeg. The fatherly porter set me on the way. Winnipeg cold and sunshiny. Streets glibbed with ice. Had lunch in the station and then set out for a walk, but everyone I asked the way of was foreign. The Westerners are gentler, more refined, than the prairie folk, who look much foreigner and less British. They are all running hither and thither huddled in fur coats. Guess they'd have to or they'd freeze in their tracks. It was 5° below this morning in Winnipeg.

It's snow everywhere. The pine trees are different to ours. They are much smaller and straight from top to bottom, not pyramidal like the Western ones. I saw one little bird flutter up, the only living thing in all these miles.

Sunday, November 13th

7:40 A.M. Arrived in Toronto. Went straight to Mrs. Mather's. When they saw it was me the welcome was warm. I spent the day there till late afternoon. Then we found a hotel, the Tuxedo, 504 Sherbourne Street.

Monday, November 14th

Slept till nearly noon. Went with Miss Buell and Mrs. Housser to tea at Mr. A. Y. Jackson's Studio Building. I loved his things, particularly some snow things of Quebec and three canvases up Skeena River. I felt a little as if beaten at my own game. His Indian pictures have something mine lack—rhythm, poetry. Mine are so downright. But perhaps his haven't quite the love in them of the people and the country that mine have. How could they? He is not a Westerner and I took no liberties. I worked for history and cold fact. Next time I paint Indians I'm going off on a tangent tear. There is something bigger than fact: the underlying spirit, all it stands for, the mood, the vastness, the wildness, the Western breath of go-to-the-devil-if-you-don't-like-it, the eternal big spaceness of it. Oh the West! I'm of it and I love it.

Tuesday, November 15th

Today I am going to Mr. Arthur Lismer's studio and see his things. These men are very interesting and big and inspiring, so different from the foolish little artists filled with conceit that one usually meets. They have arrested the art world. They are not afraid of adverse criticisms. They are big and courageous. I know they are building an art worthy of our great country, and I want to have my share, to put in a little spoke for the West, one woman holding up my end. I feel the group will be dissatisfied when they see my work and I think I could do better now I know they're there. I *must* get back to it and let other things go. If not, my chance is gone. I've not so much time left now. Every year after sixty one is going downhill in vitality. Soon I'll reach that mark. Perhaps it will be easier after this trip and the girls may not feel it quite such a waste of time, a useless quest.

Wednesday, November 16th

I have met the third of the "Group of Seven," Arthur Lismer. I don't feel as if these men are strangers. Somehow they wake an instant response in me. Lismer's two last pictures gave me a feeling of exhilaration and joy. All his works are fine, but he is going on to higher and bigger things, sweep and rhythm of the lines, stronger colours, simpler forms. He was extremely nice. I wonder if these men feel, as I do, that there is a common chord struck between us. No, I don't believe they feel so toward a woman. I'm way behind them in drawing and in composition and rhythm and planes, but I know inside me what they're after and I feel that perhaps, given a chance, I could get it too. Ah, how I have wasted the years! But there are still a few left.

Lismer's studio is apart from his house, warm and light and quiet—ideal. He has only recently quit teaching at the Toronto School of Art. The "other element" made things impossible for him. He is lecturing now, spreading the gladness of the newer way, revealing the big, grand things of our country to its sons and daughters without the fret and carping of his students or the scorn of his adversaries. He is spreading his wings and soaring up, up! He is more poetical than Mr. Jackson, but Mr. Jackson is steady and strong. His feet are planted firmly and he has the grit to push and struggle and square his shoulders and stand by the others and by his convictions. He is still young in years but old. Probably the war did that. Oh, they're very fine! I'm glad, glad I have seen them and their work. Tomorrow I shall meet Lawren Harris, another of them.

Thursday, November 17th

Oh, God, what have I seen? Where have I been? Something has spoken to the very soul of me, wonderful, mighty, not of this world. Chords way down in my being have been touched. Dumb notes have struck chords of wonderful tone. Something has called out of somewhere. Something in me is trying to answer.

It is surging through my whole being, the wonder of it all, like a great river rushing on, dark and turbulent, and rushing and irresistible, carrying me away on its wild swirl like a helpless little bundle of wreckage. Where, where? Oh,

these men, this Group of Seven, what have they created?—a world stripped of earthiness, shorn of fretting details, purged, purified; a naked soul, pure and unashamed; lovely spaces filled with wonderful serenity. What language do they speak, those silent, awe-filled spaces? I do not know. Wait and listen; you shall hear by and by. I long to hear and yet I'm half afraid. I think perhaps I shall find God here, the God I've longed and hunted for and failed to find. Always he's seemed nearer out in the big spaces, sometimes almost within reach but never quite. Perhaps in this newer, wider, space-filled vision I shall find him.

Jackson, Johnson, Varley, Lismer, Harris—up-up-up-up-up! Lismer and Harris stir me most. Lismer is swirling, sweeping on, but Harris is rising into serene, uplifted planes, above the swirl into holy places.

Friday, November 18th

I wrote and read late into the night. Around 3 o'clock I slept heavily and always I was away in that new world of planes and spaces. Never have they been absent a minute from my consciousness. I must talk with Mr. Harris again. He told me to go back. I'm going and I want to go alone. I want to see again "Above Lake Superior" and that stern mountain cradling the cloud. I want to see them all, but those two I *must* see before I go West again. I am tired today. Yesterday I was so deeply stirred, moved beyond what I can express. It has exhausted me.

Miss Buell and I went to MacDonald's studio today. His son, Thoreau, a boy all spirit, almost too fine to stay down on this earth, showed us his father's things, Mr. MacDonald himself being at his school teaching. The boy is clever and will do great things one day (if he lives). They all speak of him as something apart. They say his mother is a lovely woman. In this atmosphere of intimacy with the Group, how could such a sensitive soul fail to rise to wonderful heights?

Mr. MacDonald's canvases were big and fine—lovely design and sometimes good colour. At other times I found them a little hot and heavy and earthy. I enjoyed them greatly but without thrill. They waked few emotions in me. "The Tangled Garden" I liked about the best. Possibly I may see more in Ottawa and understand his things more.

I left my glasses in MacDonald's studio. Tomorrow I shall go for them and, if I can bear it, I will go and see if Lawren Harris is in and ask to see his things again. He meant it when he said, "Come back again." They have been good to me, these men. Harris said to me as he brought out his things, "If you see anything you can suggest, just mention it, will you?"

Me? "I know nothing," I said.

"You are one of us," was his reply.

Oh, how wonderful to think they feel that! Their works call to my very soul. Will they know what's in me by those old Indian pictures, or will they feel disappointment and find me small and weak and fretful? Have the carps and frets and worries that have eaten into my soul, since I returned from Paris full of ambitions and then had to struggle out there alone, made me small and mean, poor and petty—bitter? They too have had to struggle and buffet and battle, but

they've stood together and the fire in them has burned steadily. They're rising above it with sincerity and bigness and courage. They've forged ahead, helping each other, sympathizing, strengthening each other and straightening out the way, working vitally and serenely. Surely a movement that has such men for its foundation must prevail and live and become an honoured glory to our land. If I could pray, if I knew where to find a god to pray to, I would pray, "God bless the Group of Seven."

Saturday, November 19th
Rhythm and space, space and rhythm, how can I learn more about these? Well, old girl, you'll have to get down and *dig*.

Thoreau has returned my glasses to the Arts and Crafts. I'm sorry. Now I have no excuse to visit MacDonald. It doesn't seem fair to disturb those workers again, though I know they are big-hearted enough to help one. I've got to go and shop. How I hate it! And there's a tea this afternoon. I don't care about that.

10:00 P.M. I *did* care. The Houssers were delightful. Mr. Housser feels so strongly with the Group. He's surely one of them in spirit. His wife is painting too. He has two splendid canvases of Harris's, a Lismer, a MacDonald and a Jackson. They live on a hill-top in a beautiful new house. Mr. Housser is a newspaper man.

Monday, November 21st
This morning I left to go to Carol's by the 8:45 train but the train was 7:45. As there was no other train, I hustled off and saw about my ticket and money. Both happened to be in the same building. Then I got price lists from the Artist's Supply, 77 York Street, had lunch, and took the 1:30 train to Ottawa—a long, hard, hot, horrid trip. The train was stifling and smelly. I watched the country. Rather nice—no snow but rain. Jolly farm country with queer gaunt houses set down anyhow. No gardens. Straight up and down with a peak gable and small windows, sitting uncomfortably with no compromise. Dark set in early and the landscape was blotted out. I'm wondering if Carol's disappointed, poor kid, but I really couldn't go back and take a room at the hotel for one night with my things all at the station.

Tuesday, November 22nd
I went up to the museum about 11:30 and asked for Mr. Brown. I entered the upper office and there they all were, Mr. Brown, Mr. Barbeau, Mr. Holgate, Mr. Lismer, Mr. Pepper, Peggy Nicol and Mr. McCurry. They gave me a royal welcome and we went down to the lower floor. There sat the exhibition all round the floor. They were just starting to hang it. There are ripping things of Langdon Kihn, and Mr. Holgate and Mr. Jackson. I felt my work looked dead and dull, but they say I have more of the spirit of the Indian than the others. They were lovely to me about them. Peggy Nicol paints too, Indian things, but they're feeble. Poor kid, she's so enthusiastic, a dear little soul, and perhaps it will carry her on. She's young.

Mr. Brown took us to lunch. There were Lismer, Holgate, Peggy, the Browns and I. We were all happy and gay and the Browns' flat is charming. Afterwards Peggy took me to collect my things. We went to my room and then on to the gallery for the rest of the afternoon. I just longed to buckle to and do some of the hanging. Men talk and squint and haggle so long over hanging. Holgate's things are ripping, so strong. He asked me if any of my watercolours were for sale, and the rugs.

Mr. Barbeau and Mr. Lismer called for me, after I'd dined at Bromley Hall and met some people. The Barbeaus' home is delightful and she is just charming. I saw the two dear little kids in bed. Mr. Pepper and Mr. Holgate came in and we spent a delightful evening talking. Mr. Barbeau beat a great Indian drum and sang some Indian songs that were very touching and real. I did not get home till 12 o'clock. It was a delightful evening with a touch of the foreign; both Mr. and Mrs. Barbeau are French. Supper was wine and dainty sandwiches and French pastries.

Mr. Lismer has gone back to Toronto. He asked me to look him up again when I go back. How nice they are, these big, earnest painters! They make painting so worth while. I almost feel as if I were home. Three of my things were on Barbeau's wall. The gallery was strewn with them, and my rugs and pots. He's not showing the watercolours. They are for some other show that comes later.

Sunday, November 27th

Lots has happened. It has been a full and happy week. They've all been so lovely. Yesterday I had cold clutches of homesickness, but drowned it in hard work at the museum on the Indian designs I was sketching. I had not been in the gallery since Wednesday because I was afraid of intruding. They asked me to design a cover for the catalogue and I made one. I made two ghastly mistakes, first in size and another in print and could have cried with mortification. I had worked till 1:00 P.M. and was tired out anyway and disgusted.

Mrs. Brown gave a tea for me Wednesday. We met in the museum and saw the Old Masters and then went to the Browns'. On Thursday Mr. Brown took me for a drive and Saturday I worked all day in the museum.

Today I went to the Barbeaus' in the morning and met Mr. Jackson there. We had dinner and three charming French Canadians came. The atmosphere of that house is delightful. There is sincerity, cleverness and a joyfulness that catches you up. The children are darlings. I came home at 4 o'clock and was called for and taken to the Cheneys' to tea. Charming young people with a lovely home on the canal. She paints. Peggy Nicol, Mr. Pepper and Mr. and Mrs. Brown were there. The talk was largely art and books.

I feel as if I have met the "worthwhiles" on this trip, people who really count and are shaping a nation. They are all so big and broad, so kind to the younger struggling ones, so proud of the bigness of their country, so anxious to probe its soul and understand it. Lawren Harris's work is still in my mind. Always, something in it speaks to me, something in his big tranquil spaces filled with light

and serenity. I feel as though I could get right into them, the spirit of me not the body. There is a holiness about them, something you can't describe but just feel.

December 5th

The exhibition has opened, and I might almost say opened and closed again. It was horrid. Up to the very night of the affair, Mr. Barbeau was so full of enthusiasm and hope, so gay. He opened a bottle of wine for supper and we drank a health. He purred over the programmes and was pleased with them. "There will be a great jam," he said at supper, "it's the best show we've had, and it is always packed." I saw his wife was anxious. She asked me several times just what Brown had said about it being "quite informal." She hesitated when I asked if we wore gloves and said she'd take them anyway and see.

We got there in a cab. I thought we were the first but there were a few others. Not many came after us. It was a dead, dismal failure. The big rooms with the pictures hanging in the soft, pleasant light were almost empty. The grand old totems with their grave stern faces gazed tensely ahead alongside Kihn's gay-blanketed Indians with their blind eyes. I was glad they were blind. They could not see the humiliation. The Browns were there, a trifle too forced in their gay humour. A great many of the few present were introduced to me. They were all enthusiastic in their praise. Maybe it was honest, maybe not. Mrs. Barbeau's eyes were flashing angrily. Her body was tense. It was as though she could slay the Browns. "Look at my husband," her eyes seemed to say. "They've wounded him and humbled him and hurt him." What could I say? Mr. Barbeau never said a word. His face was set and hard and all the light and enthusiasm had gone from it.

A little past 10 o'clock we went to the Browns' and had coffee and met some dull people. Mr. Brown tried to be gay and asked us facetiously how we liked it and wasn't it splendid? No one answered except one small, hysterical, stupid little woman who raved over everything. We came home tired and quiet. I could have cried for Mr. Barbeau. He had worked so hard to make it a success, old Brown leading him on and making him believe it was a big affair. "Usually there were 2,000 invitations, such a crush you couldn't move, and a great feed of refreshments." No invitations were sent out except to a few artists and those in the building. Others were angry at getting no cards or notices except the eleventh hour general invitation that came too late to be taken. All Mr. Barbeau said was, "Well that's over. Now we'll go on to the next job."

And down in the basement, turned face to the wall, are four beautiful canvases, far better than anything upstairs, rejected, hidden away, scorned—beautiful thoughts of fine men picturing beautiful Canada. Canada and her sons cry out for a hearing but the people are blind and deaf. Their souls are dead. Dominated by dead England and English traditions, they are decorating their tombstones while living things clamour to be fed. For me, half of the things they had me send are in the basement too. For myself I do not mind as much as I do for the others. Mine are not so good in workmanship. Only one point I give to

mine. I loved the country and the people more than the others who have painted her. It was my own country, part of the West and me.

It is humiliating to have nothing to tell them of the opening at home, to admit it was a fizzle. No one will come now. If the people are not caught up in the first swirl, they do not come; enthusiasm is not worked up.

Montreal
Arrived 11:50 and after lunch went straight to the Royal Canadian Academy. It was a good show. The big room (mostly Group of Seven) was very enjoyable. It was the first time I have been able to sit and take my time over the Group of Seven. I studied them separately and together. There was Jackson, Lismer, Harris, MacDonald, Carmichael and Casson represented—all except Varley.

Harris's "Mountain Forms" was beautiful. It occupied the centre of one wall—one great cone filled with snow and serenely rising to a sky filled with wonderful light round it in halo-like circles. Forms purplish in colour lead up to it. He gets a strip of glorious cold green in the foreground and the whole sky is sublimely serene.

I sat and watched it for a long, long time. I wished I could sweep the rest of the wall bare. The other pictures jarred. Two fashionable women came in and called others. They laughed and scoffed. After wondering if the thing was an angel cake, they consulted the catalogue. "It is 'Mountain Forms'." They all laughed. How I longed to slap them! Others came and passed without giving more than a brief, withering glance. A priest came. Surely he would understand. Wouldn't the spirituality of the thing appeal to one whose life was supposed to be given up to these things? He passed right by even though he walked twice through the room—blind, blind!

Jackson's "Autumn in Algoma" did not please. It was thin and unconvincing and unfinished. But his "Barns" was delightful, and his other things. "Barns" had such a swing to the earth and sky—a huddled group of old barns with a flock of sheep trying to shelter from the wind. Lismer had "Happy Isles," red-brown rocks with windswept trees, and sky forms that followed the shapes of the trees too closely I thought. I did not find the canvas restful though there is lots of liveliness in it. MacDonald's "Solemn Land" is very big and powerful and solemn. I wish he wasn't quite so fond of broom. His design is lovely but he has not the true movement or imagination I want. His "Glowing Peaks" I like except for the brown water, but his other rocky things did not please me. An unpleasant cloud form was speared by a mountain peak. I did not like the colour. Carmichael is a *little* pretty and too soft, but pleasant. Casson I don't care about. His work is cold, uncompromising, realistic. His "Dawn" gave me no pleasure.

I wish I could paint as well as any one of these men. In criticizing them I am only trying to see further. Their aim is so big it makes the rest of the stuff seem small and poor and pretty. There are a few others worth while and some fine women.

Had a visit at the hotel from Annie Savage. She was very nice and friendly. Was glad I'd rung her up. As she teaches, she came right after 4 o'clock. I had a furious nosebleed in the morning that delayed me getting out but I spent half an hour at the gallery and went over my favourite pictures again, especially the Group work. Mr. Holgate left a message at the hotel for me and Miss Savage and I went to his studio and saw his things. I like him. He is young and enthusiastic and clever. His work is strong and full of form but a little dull and dead in colour.

Took the 6:45 train to Ottawa. I phoned the Barbeaus and had a nice conversation with both. Mr. B. was much brighter about the exhibition. He says Brown is going to give an evening and wake things up a bit. Toronto, Montreal and Winnipeg want the exhibition afterwards, but I don't know if it will go to all three yet. I was glad to hear him more cheerful.

Sunday, December 11—Toronto
Got up about 9 o'clock and was cross and cold. I wanted something badly in the back of my mind and was nervous and uncertain. Those pictures of Lawren Harris's, how I did long to see them again before I went West, and yet I did not like to ring up and ask. What right had I to take up his time? But in my heart of hearts I was sure he would be willing to help a stranger from the West. I went to the phone and was told he was at dinner and to ring again. My heart sank but after lunch I phoned again. Yes, I could go on Tuesday at 2:30 to his studio. I was delighted. Fifteen minutes later he rang up and asked me to go to supper tonight.

I went to the museum and saw some Pueblo pottery with lovely black and white and red designs. A little before 7 o'clock Mr. Harris came for me in his car. Mrs. Harris welcomed me and I gave a long look to see what she was and how she influenced his work. She was beautiful, quiet, gentle, not very young, a peaceful person. I decided she would be a great help and strength to him. The little daughter, Peggy I think, came in. I loved the little girl. She was about eleven or twelve I should say. A smaller boy was singing to himself upstairs in bed.

I left my things in the hall and we went into the drawing-room. Oh! On the mantle was one of his quiet seas. A heavenly light lay upon one corner, shining peacefully. Three cloud forms, almost straight shafts with light on their tips, pointed to it. Across a blue-green sky, a long, queer cloud lay lower down, almost on the horizon, but you could move in and on and beyond it. A small purplish round island, then four long, simple rock forms, purple-brown, with the blue sea lapping them. Two warmer green earth forms and some quiet grey forms that might be tree trunks in the foreground. Peace. My spirit entered the quiet spaces of the picture.

There were two woodsy and lake paintings, one each side, happy things with gold autumn foliage in the foreground and quiet sunny islands covered with pines. A little group of quiet dull-green pines was on the lower flat and then a

white sky with a mellow golden sort of light. The trees in the foreground were painted in rather solid gold masses. They were very joyous. Down further hung three smaller pictures in a row, all on a more tragic note. Opposite was one of his beautiful old houses in a snow-storm, solid and fine.

In the dining-room was a snow scene at Jasper—pine trees weighted with heavy snow, weighty substance, quiet and cold, and an autumn seashore, all queer tree forms in golden shades reflected in the water. Opposite, a gay autumn thing with bare trees in foreground, reflection and reality scarcely distinguishable. The bark of the trees was painted in rather gay blobs. On one side hung a Tom Thomson and on the other Jackson's "Edge of the Maple Wood."

Mrs. Harris curled up on the sofa and sewed. Mr. H. showed me all kinds of small things, pottery from Damascus and rugs, all interesting and beautiful. It is a lovely house, full of quiet, dignified objects, and it's homey. Then Mr. Harris played a long symphony on his magnificent orthophonic. It was superb, such volume of glorious sounds filling the big quiet room. He had just brought the record from New York. To sit in front of those pictures and hear that music was just about heaven. I have never felt anything like the power of those canvases. They seem to have called to me from some other world, sort of an answer to a great longing. As I came through the mountains I longed so to cast off my earthly body and float away through the great pure spaces between the peaks, up the quiet green ravines into the high, pure, clean air. Mr. Harris has painted those very spaces, and my spirit seems able to leave my body and roam among them. They make me so happy.

Monday, December 12th

Fifty-six years ago tonight there was a big storm out West and deep snow. My dear little Mother wrestled bravely and I was born and the storm has never quite lulled in my life. I've always been tossing and wrestling and buffeting it. How little I've accomplished! And the precious years are flying by and never, never one minute will the clock tick backwards. Tomorrow I am to see the pictures again. That's a wonderful birthday treat.

Tuesday, December 13th

A splendid birthday. Got up late and went to the museum to sketch a little. Miss Buell and Miss Bertram had lunch with me and then I went down to Mr. Harris's studio. It's so big and quiet and grey and very restful. He was painting and I hated to feel I was stopping him, but he wouldn't hear of my going away for a bit. He said he had got to a good place to stop. He was working on a big canvas—rock forms in deep purples with three large rocks in the middle distance. The sky was wonderful—swirly ripples with exciting rhythms running through them. The right corner was in brilliant light and from under the clouds shafts of strong sun pierced down on the rocks in straight wide beams that made a glowing pool of pure light on the water that lay flat and still. Behind, was a deep, rich blue distance. To the right the shafts of light turned it paler green-blue. On the other side a blinding blue played richly with the purple rocks. Under the left

side of the rippling, swirling grey cloud forms the water lay flat in blue-grey wonderfulness. The foreground was unfinished but would be dark roots. There was a wonderful feeling of space.

Mr. Harris showed me the different qualities he put in his paint to give vibration. He often rubs raw linseed oil on to the canvas and paints into that, and he oils out his darks, when they sink in, with retouching varnish. I wonder if he realizes how I appreciate his generosity and what the day meant to me in trying to solve the riddles and mysteries that I've plugged along with alone for so long. Of this I am convinced: that he has come up to where he now is by diligent, intelligent grinding and wrestling and digging things out; that he couldn't do what he is doing now without doing what he has already done; that his religion, whatever it is, and his painting are one and the same. I wonder where he will rise to. In eight years his work has changed entirely. In eight years more what will happen to it?

He showed me a black and white sketch inspired by the coal strike in Halifax. A woman, distraught, gaunt, agonized, carrying a child who was pitiful, drooping, hopeless and dumbly submissive. Half of the face of another child was cut by the bottom of the picture. The background was houses, black and desolate. There was a thunderous, stupendous horror in the air. The woman's eyes were wild and frantic. Someday he will make a canvas of it. It will be terrific.

He showed me "Above Lake Superior" again. It is wonderful, but I believe I love the mountains better than the tree forms. Bleached, wonderful, in purified abandon, they are marvellous. The great mountain with the swirling shaft of cloud leaping from the crater is beautiful, but the cloud is not quite compatible yet.

Over the mantle is a huge canvas of a mighty mountain mass. It is the fifth time he has worked it out and he is still unsatisfied and wants to do another canvas of it. The sky is dark and wild. Blue clouds are tossed behind the peaks. In the centre the lines are not harmonious, and he doesn't like the foreground, considering it too realistic. It has the long, cold greens he gets. It is a superb subject.

He brought out some very old ones. Lovely colour, but oh, so different! At one time I would have loved them, but after the newer ones they seem tame and uninteresting and unconvincing. The new ones make me so intensely happy. The old ones are sadder, more full of worldly trouble and tragedy.

I was there about two hours. He told me that they want two more canvases for their exhibition of my stuff and he asked me a bit about my work, and said he hoped I'd go on. He said that Jackson and Lismer both felt that though my knowledge was poor, I had got the spirit of the country and the people more than the others who had been there—Kihn, Jackson, Holgate. I am very glad. I long to return to it and wrestle something out for myself, to look for things I did not know of before, and to feel and strive and earnestly try to be true and sincere to the country and to myself. Mr. Harris gave me the names of four books he thought would help me in the struggle. I'll get these if it costs my last

penny because I want so terribly to feel and know more, to understand.

Wednesday, December 14th

I left Toronto last night at 9 o'clock. It had been a busy day. I went downtown and hunted for the books. Of the four I was only able to get two, *Art* by Clive Bell and *Tertium Organum* by Peter Ouspensky. I attended to my bank business and then went to the Grange. There is a little picture exhibition on there. All the Group are represented except Carmichael. As I walked through the gallery each member of the Group stood out clearly. I looked round quickly at the others and summed up that there were none of particular interest.

At the end of the second gallery I felt the irresistible call of the Harrises, seven small pictures in silver frames. Whenever I go into a room or a gallery where they hang they draw me irresistibly, and instantly my inner consciousness responds to the call. Everything else in the gallery seems to grow small and insignificant, just paint in fact. Although the rest of the Group pictures charm and delight me, it is not the same spiritual uplifting. These satisfy a hunger and rest the tired in me and make me so happy. Three of them were for sale—$65, $75 and $85. How I'd love to have bought one! What a joy to possess! But I have the memories and no one can take them away, ever. It has been a privilege to see so many.

What a long day it's been! I have read and knitted, read and knitted with monotonous regularity. I have read a lot of P. D. Ouspensky. I get glints here and there but such lots of it I don't understand. That's not strange since I haven't studied along these lines before. It interests me vastly. I shall stick at it and try to see it in time, for I am sure somehow it will help my work. It produces the quality of spaciousness in Mr. Harris's pictures that I lack. One more day and I'll be home to the sisters and dogs and monkey.

Sunday, December 18th

We got to Brûlé at sunrise. It was very wonderful—a superb peak and a grey-blue sky with warmer purplish clouds and spots of brilliant gold, some little bigger than stars. The mountains are glorious, powdery with fresh snow, majestic and quiet and lofty. We have just passed Rainbow Lake from where the Athabaska and the Fraser take their course, the Fraser to the West, the Athabaska to the East. The mountains seem more beautiful since I have seen Mr. Harris's pictures which have helped me to see them in a bigger way. I judge space better now. How I do want to learn more about space!

Sunday, December 25th

Christmas Day and I've been four days home. Now it's all like a dream, my wonderful trip. Christmas, and sick dogs, and sick Teddy, and Christmas parcels, all the oddments of jobs and cleaning up of things indoors and out after my long absence have taken every minute and left me woefully tired. When will I start to work? Lawren Harris's pictures are still in my brain. They have got

there to stay. I don't believe anything will oust them. I hope not because they make my thoughts and life better. The memory of them is a never-failing joy. They are the biggest, strongest part of my whole trip East. It is as if a door had opened, a door into unknown tranquil spaces. I don't tell anyone about them because they would not understand. I spoke about them to Mr. Varley but he does not feel about them as I do. He thinks Harris is going too far, brings religion in too much. For his own part, he says, he likes to stick a bit firmer to good old Earth. Maybe, but somehow to me there is more reality in a Lawren Harris than in any of the others. I seem to know and feel what he has to say. To me it is a clearer language than the others are using. Why, I wonder? I have never studied theosophy and such things, and I don't think I want to. But there's something that gets at me, and if it is theosophy that gives that something I'd like to hear about it. It could be nothing bad that inspired those pictures. Dig! Delve! Study! Think! Keep your thoughts high and clear and pure! I shall never do much myself, I'm afraid, and time is pushing me into the sixties. It's so hard to keep from being choked and swallowed up in the little petty cares and bothers of a home. But I must hold my end up and not let my sisters down for in their unselfish, hard-working lives they're the finest women ever.

S I M C O E S T R E E T
1 9 3 0 - 3 3

Sunday, November 23rd

Yesterday I went to town and bought this book to enter scraps in, not a diary of statistics and dates and decency of spelling and happenings but just to jot me down in, unvarnished me, old me at fifty-eight—old, old, old, in most ways and in others just a baby with so much to learn and not much time left but maybe somewhere else. It seems to me it helps to write things and thoughts down. It makes the unworthy ones look more shamefaced and helps to place the better ones for sure in our minds. It sorts out jumbled up thoughts and helps to clarify them, and I want my thoughts clear and straight for my work.

I used to write diaries when I was young but if I put anything down that was under the skin I was in terror that someone would read it and ridicule me, so I always burnt them up before long. Once my big sister found and read something I wrote at the midnight of a new year. I was sorry about the old year, I had seemed to have failed so, and I had hopes for the new. But when she hurled my written thoughts at me I was angry and humbled and hurt and I burst smarting into the New Year and broke all my resolutions and didn't care. I burnt the diary and buried the thoughts and felt the world was a mean, sneaking place. I wonder why we are always sort of ashamed of our best parts and try to hide them. We don't mind ridicule of our "sillinesses" but of our "sobers," oh! Indians are the same, and even dogs. They'll enjoy a joke with you, but ridicule of their "reals" is torment.

When I returned from the East in 1927, Lawren Harris and I exchanged a few letters about work. They were the first real exchanges of thought in regard to work I had ever experienced. They helped wonderfully. He made many things clear, and the unaccustomed putting down of my own thoughts in black and white helped me to clarify them and to find out my own aims and beliefs. Later, when I went East this Spring, I found he had shown some of my letters to others. That upset me. After that I could not write so freely. Perhaps it was silly, but I could not write my innermost thoughts if *anybody* was to read them, and the innermost thoughts are the only things that count in painting. I asked him not to. He saw my point and said he wouldn't. I trust him and can now gabble freely. Still, even so, I can't write too often, hence this jotting book for odd thoughts and feelings.

I've had a good Sunday in the blessed quiet studio. Pulled out my summer sketches and tried to get busy. It wouldn't come. I got to the typewriter and described Fort Rupert minutely, its looks and feeling and thoughts. Then I got

to some charcoal drawing and commenced to *feel* it but got nothing very definite. At night I heard a sermon where the Children of Israel said their enemies regarded them as "grasshoppers" and they felt they were. How they lacked faith and failed, he said. Everyone needed faith in God and faith in himself. The good of the sermon was all undone by the beastly streetcars. Took me till after ten to get home. I was chilled to the bone waiting on corners in fog and got very ratty and rasped. Went to bed with nerves jangling.

Monday, November 24th

This morning I've tried the thing on canvas. It's poor. I got a letter from Tobey. He is clever but his work has no soul. It's clever and beautiful. He knows a lot and talks well but it lacks something. He knows perhaps more than Lawren, but how different. He told me to pep my work up and get off the monotone, even exaggerate light and shade, to watch rhythmic relations and reversals of detail, to make my canvas two thirds half-tone, one third black and white. Well, it sounds good but it's rather painting to recipe, isn't it? I know I am in a monotone. My forests are too monotonous. I must pep them up with higher contrasts. But what is it all without soul? It's dead. It's the hole you put the thing into, the space that wraps it round, and the God in the thing that counts above everything. Still, he's right too. I must pep up. I wonder if he had seen my stuff in Seattle. I thought perhaps Hatch would write but no word, only a printed invitation to preview some Japanese prints and temporary shows, so I suppose I'm lumped with the "temporary shows." It's a bit of a kick and goes to show I am conceited and thought my show was to be the main item of the galleries in Seattle for the month, but I'm only lumped in "temporary."

Wednesday, November 26th

No word from Seattle. The show opened last night. Well, forget it old girl, I guess your work is only humdrum—ordinary anyhow—just a little sideshow of the galleries for the month.

I have copied a bit from Lawrence's book, *St. Mawr*, about a pine tree. It's clever but it's not my sentiments nor my idea of pines, not our north ones anyhow. I wish I could express what I feel about ours but so far it's only a feel and I have not put it into words. I'll try later because trying to find equivalents for things in words helps me find equivalents in painting. That is the reason for this journal. Everything is all connected up. Different paths lead to the great "it," the thing we try to get at by hook and by crook. Lawrence's book is so sexy. Everything these days is people talking of sex and psychology. I hate both. This would-be-smart psychology makes me sick; it's so impertinent, digging round inside people and saying why they did things, by what law of mind they came to such and such, and making hideous false statements, and yanking up all the sex problems, the dirty side of everything. They claim they are being real and natural, going back to the primitive. Animals are simple and *decent* with their sex. Things happen naturally and just *are*. It's all simple and straight, but we— ugh!—we've fouled it all . . . dirty books. filthy cinemas, muck everywhere.

Friday, December 5th

So, that devil's job, my pottery exhibition, that annual Christmas horror of mine, is over, and badly over. Scarcely anyone came, though there is usually a throng and good selling. This year was just a scattering over two afternoons and two evenings. The work was interesting and made a good show, too. Last show I'll give. How I loathe standing round on one leg, showing off the stuff and having everything picked over! I was so exhausted I spent most of the next day in bed too tired to paint or even think, though I must hurry up with my Baltimore canvas.

Mrs. Spier came from Seattle for seven days. She was there for the opening and said there was a great division over my stuff. People were either decidedly for or against it. Some thought it crazy, said they had never seen Alaska look like that. Well, it wasn't Alaska. Others were thrilled. Since, I have received two letters. Miss Rhids writes with warm congratulations and thinks I've come on a bit in the last few years. Mrs. Spier gave a talk on North West art. She says it is creating a great stir in Seattle art centres. Letter from Hatch. He says no one comes and goes without saying *something*, which is satisfactory. He also says Royal Cortissoz gave me three sentences of slanging in *The New York Times*, which is a boost as he is the conservative leader and considers most contemporary artists beneath contempt altogether. Hey, ho! What does it matter? Get busy, old lady, and grind away. As L. H. says, if we keep right on something is bound to happen. I wish he'd write. His letters always help me when I feel a bit downed. Last night I dreamed of Sophie. She had a motor and was quite a swell in a chiffon dress. I looked at her wondering but somehow I knew she was the same old Sophie underneath and I loved her still.

Wednesday, December 31st

Only half an hour left of 1930. I finished Flora's book, *New Art of Lawrence Atkinson*, and found lots of things to remember and digest. I love his abstracts. I feel there is very much in abstraction but it must be abstraction with a *reason*, that is, there must be an underlying truth—something—the pith or kernel, the inner essence of the thing to be expressed. If that doesn't speak then it's a dead abstraction without cause or reason for existence. This coming year I must work harder, must go deeper.

Sunday, January 11th, 1931

No word from Hatch about the Seattle show. I don't feel it has been a success at all. At least it waked them up. That's something. Hatch did not boost it in any way, that's plain. Still, it did me good to have to rattle around and work and get ready for it. The fact that it fell flat was good for my conceit. If the work had been big enough—hit the bull's-eye—people would *have* to acknowledge it. It missed. But oh, how can we get "it," the great universal language that everyone understands, the thing down deep that we all feel? Oh, the lazy minds and shrinking hearts of us who shirk the digging grind! Our blind old eyes don't see

and our souls lie flat on the earth, too dead to soar up, up into the place that Lawren Harris calls "Where all the universe sings." Oh, that lazy, stodgy, lumpy feeling when you want to work and you're dead! Is it liver, I wonder, or is it old age, or just inertia, or something from which the life has gone forever, that just belongs to youth?

Monday, January 12th

W. Newcombe has been spending the evening. Lord, what a lot he knows! I feel my knowledge superficial when I talk with him. My aims are changing and I feel lost and perplexed. I've been to the woods today. It's there but I can't catch hold.

Thursday, January 15th

Had to clean a second-hand gas stove for Mrs. Howell's flat. Wahah! I phoned Edith Hembroff today but her mother told me she was still away. Poor kid, her two canvases for the Canadian Exhibition were rejected in Vancouver as too French. Mrs. H. said she would like to own a canvas of mine as she was sure some day they'd be unobtainable. What bosh! I got Harry Lawson to fix my will with Lawren Harris as joint trustee with Mr. Newcombe.

Sunday, January 18th

I have done a charcoal sketch today of young pines at the foot of a forest. I may take a canvas out of it. It should lead from joy back to mystery—young pines full of light and joyousness against a background of moving, mysterious forest. Last night I dreamed that I came face to face with a picture I had done and forgotten, a forest done in simple movement, just forms of trees moving in space. That is the third time I have seen pictures in my dreams, a glint of what I am striving to attain. Perhaps some day I shall get things clearer. Every day I long for the woods more, to get away and commune with things. Oh, Spring! I want to go out and feel you and get inspiration. My old things seem dead. I want fresh contacts, more vital searching.

Tuesday, January 20th

I have been to the woods at Esquimalt. Day was splendid—sunshine and blue, blue sky, and two arbutus with tender satin bark, smooth and lovely as naked maidens, silhouetted against the rough pine woods. Very joyous and uplifting, but surface representation does not satisfy me now. I want not "the accidentals of individual surface" but "the universals of basic form, the factor that governs the relationship of part to part, of part to whole and of the whole object to the universal environment of which it forms part."

Wednesday, January 28th

For the first time in two months the pendulum has begun to swing. I was working on a big totem with heavy woods behind. How badly I want that nameless thing! First there must be an idea, a feeling, or whatever you want to call it, the something that interested or inspired you sufficiently to make you desire to

express it. Maybe it was an abstract idea that you've got to find a symbol for, or maybe it was a concrete form that you have to simplify or distort to meet your ends, but that starting point must pervade the whole. Then you must discover the pervading direction, the pervading rhythm, the dominant, recurring forms, the dominant colour, but always the *thing* must be top in your thoughts. Everything must lead up to it, clothe it, feed it, balance it, tenderly fold it, till it reveals itself in all the beauty of its idea.

Lawren Harris got the $500 award from the Baltimore show for that lovely stump thing. I am so glad he got the recognition. He so richly deserves it and doesn't get half enough. He is always so modest.

A picture does not want to be a design no matter how lovely. A picture is an expressed thought for the soul. A design is a pleasing arrangement of form and colour for the eye.

Sunday, February 1st
I worked all afternoon, first on "Koskemo Village," x. 1., and then on x. 2., "Strangled by Growth," which is also Koskemo (the cat village). It is D'Sonoqua on the housepost up in the burnt part, strangled round by undergrowth. I want the pole vague and the tangle of growth strenuous. I want the ferocious, strangled lonesomeness of that place, creepy, nervy, forsaken, dank, dirty, dilapidated, the rank smell of nettles and rotting wood, the lush greens of the rank sea grass and the overgrown bushes, and the great dense forest behind full of unseen things and great silence, and on the sea the sun beating down, and on the sand, everywhere, circling me, that army of cats, purring and rubbing, following my every footstep. That was some place! There was a power behind it all, and stark reality.

Wednesday, February 4th
Lizzie, Alice and I went to hear the Seattle Symphony. First time in years we have been out together. It was delightful as we sat there unanimously enjoying it. I couldn't help wondering why it was that we could all meet and be lifted up in the music while had it been a picture exhibit we'd have had no shared sympathy at all. Has music something art lacks? The new art does lift one but so few understand. They refuse to be lifted. They will not go beyond the outer shell. They want the surface representation; the soul behind it they do not want and cannot feel. Surely we artists must fail somewhere. Why can't we lift the veil and reveal the soul if the musician can? Is the eye more earthy than the ear?

Yesterday Mrs. Spier came to speak before the Canadian Club on the Indians of the West Coast, and spoke well. She touched on their religion, secret societies and folk lore. She had supper with me and we talked much. I told her I felt my Seattle exhibition had been a failure. She said it had meant more than I knew and had "stirred and caused discussion." It was what they needed. I said I felt my work had moved into a different phase and was of no more interest to the anthropologist. Her reply was that it meant more to them than I thought. They felt I was getting at the spirit of the people more. "I think perhaps you don't

realize yourself," she said, "how steeped in the Indian you are, how saturated with the feel of him." I am glad she said that.

I have started a new canvas, x. 3. I have hankered after a go at it for long. Funny, subjects I have really felt give me no peace till I get down and search into them. They call to me and will not let me rest till I have brought them out and wrestled with them, dug into my memory and lived them over again. Some that were only felt superficially don't worry me at all. I'm through with them.

I have started to write "The Nineteenth Tombstone" again. Shall I succeed in getting it over this time, in making it human and real and in realizing the Indian element?

Thursday, February 5th

Put in a good day's painting below the skin. Got the Cumshewa big bird well disposed on canvas. The great bird is on a post in tangled growth, a distant mountain below and a lowering, heavy sky and one pine tree. I want to bring great loneliness to this canvas and a haunting broodiness, quiet and powerful. "Strangled by Growth" is giving much trouble.

Sunday, February 22nd

Yesterday we went to a dance and potlatch at the Esquimalt Reserve. Stayed from 8 to 11:30 p.m. It was *grand*—the great community house and smoke holes both pouring sparks into the sky, and the rhythmic victory of tom-toms, the inky darkness outside, then the sea of faces—Indians seated on benches in tiers to the roof, many of them with painted faces, two enormous fires which were fed fast and furiously by the young men with huge pieces of cord wood. The different reserves were all allotted places.

March 19th

The earth is soaked and soggy with rain. Everything is drinking its fill and the surplus gluts the drains. The sky is full of it and lies low over the earth, heavy and dense. Even the sea is wetter than usual!

I want to paint some skies so that they look roomy and moving and mysterious and to make them overhang the earth, to have a different quality in their distant horizon and their overhanging nearness. I'm still on Indian stuff as it's too wet for the woods, but, of joy, spring is coming, growing time for the earth and all that is therein. The papers are full of horrible horrors and the earth is so lovely. Money and power, how little either counts!

Mrs. Pinkerton wrote of "In the Shadow of the Eagle." It must be rewritten. She says it is so very bad in parts and so very good in others. My brain is very lazy. I have much trouble with it.

April 17th

Last night I went up on Beacon Hill and rose into the clouds. Everywhere was beautiful, full of colour and life. There were bulging clouds and little fussing ones, light and shadow clouds and blue, blue sky between. The broom was a

wonderful green. The sea, too, was mysterious and a little hazy. There were two bright spots of gold peering through a black cloud and sending beams of light down. I thought they might have been God's eyes. Tonight it was all different, so bitterly cold, and hard, angry-looking bunches of cloud, and everything beaten-about and sallow-looking and mad. One didn't want to linger but get back to the fire.

Goldstream, June
I walked in the woods tonight among the cedars and the rain and it was heavenly sweet. There were just a few birds, my dogs and I. The rain dripping softly, the trees hanging low with the weight of the wet. Birds for the same reason flew low and heavily. The smells kept down too and were earthy and very sweet. The rain had beaten the bushes across the path and the stream was noisy and swollen.

My work today was not good. Perhaps the weight of the damp atmosphere was upon me too.

June 17th
I am always asking myself the question, What is it you are struggling for? What is that vital thing the woods contain, possess, that you want? Why do you go back and back to the woods unsatisfied, longing to express something that is there and not able to find it? This I know, I shall not find it until it comes out of my inner self, until the God quality in me is in tune with the God in it. Only by right living and a right attitude towards my fellow man, only by intense striving to get in touch, in tune with, the Infinite, shall I find that deep thing hidden there, and that will not be until my vision is clear enough to see, until I have learned and fully realize my relationship to the Infinite.

June 30th
Find the forms you desire to express your purpose. When you have succeeded in getting them as near as you can to express your idea, never leave them but push further on and on strengthening and emphasizing those forms to enclose that green idea or ideal.

September 28th
Got a new pup. He is half griffon. The other half is mistake.

November 3rd, 1932
So, the time moves on, I with it. This evening I aired the dogs and took tea on the beach. It had rained all the earlier day and the wood was too soaked to make a fire, but I sat on the rocks and ate and drank hot tea and watched the sun set, with the waves washing nearly to my feet. The dogs, Koko, Maybbe and Tantrum, were beloved, cuddly close, and all the world was sweet, peaceful, lovely. Why don't I have a try at painting the rocks and cliffs and sea? Wouldn't it be good to rest the woods? Am I one-idea'd, small, narrow? God is in them all.

Now I know that is all that matters. The only thing worth striving for is to express God. Every living thing is God made manifest. All real art is the eternal seeking to express God, the one substance out of which all things are made. Search for the reality of each object, that is, its real and only beauty; recognize our relationship with all life; say to every animate and inanimate thing "brother"; be at one with all things, finding the divine in all; when one can do all this, maybe then one can paint. In the meantime one must go steadily on with open mind, courageously alert, waiting always for a lead, constantly watching, constantly praying, meditating much and not worrying. Walt Whitman says:

> Say on, sayers! sing on, singers!
> Delve! mould! pile the words of the earth!
> Work on, age after age, nothing is to be lost.
> It may have to wait long, but it will certainly come in use,
> When the materials are all prepared and ready, the architects shall
> appear.
>
> I swear to you the architects shall appear without fail,
> I swear to you they will understand you and justify you,
> The greatest thing among them shall be he who best knows you, and
> encloses all and is faithful to all,
> He and the rest shall not forget you, they shall perceive that you are not
> an iota less than they.
> You shall be fully glorified in them.
>
> <div align="right">(Song of the Rolling Earth)</div>

So—no matter if we are not to make the goal ourselves. All our work helps us to accumulate material for the great final structure. Our business is to do our own small part with absolutely no thought of personal aggrandizement or glory.

November 12th
Go out there into the glory of the woods. See God in every particle of them expressing glory and strength and power, tenderness and protection. Know that they are God expressing God made manifest. Feel their protecting spread, their uplifting rise, their solid immovable strength. Regard the warm red earth beneath them nurtured by their myriads of fallen needles, softly fallen, slowly disintegrating through long processes, always living, changing, expanding round and round. It is a continuous process of life, eternally changing yet eternally the same. See God in it all, enter into the life of the trees. Know your relationship and understand their language, unspoken, unwritten talk. Answer back to them with their own dumb magnificence, soul words, earth words, the God in you responding to the God in them. Let the spoken words remain unspoken, but the secret internal yearnings, wonderings, seekings, findings—in them is the communion of the myriad voices of God shouting in one great voice, "I am one

God. In all the universe there is no other but *me*. I fill all space. I am all time. I am heaven. I am earth. I am all in all."

Listen, this perhaps is the way to find that thing I long for: go into the woods alone and look at the earth crowded with growth, new and old bursting from their strong roots hidden in the silent, live ground, each seed according to its own kind expanding, bursting, pushing its way upward towards the light and air, each one knowing what to do, each one demanding its own rights on the earth. Feel this growth, the surging upward, this expansion, the pulsing life, all working with the same idea, the same urge to express the God in themselves— life, life, life, which *is* God, for without Him there is no life. So, artist, you too from the deeps of your soul, down among dark and silence, let your roots creep forth, gaining strength. Drive them in deep, take firm hold of the beloved Earth Mother. Push, push towards the light. Draw deeply from the good nourishment of the earth but rise into the glory of the light and air and sunshine. Rejoice in your own soil, the place that nurtured you when a helpless seed. Fill it with glory—be glad.

November 16th

A wire from Brown asking three watercolours for the Royal Scottish Water-colour Society. I am glad because maybe it shows that Brown feels kindlier towards me and also sees he cannot get me through Vancouver. My watercolours are not so good. I have none spot fresh and somehow I cannot feel things done two years ago are yourself today. It is quite possible as you pass through growth that they might get better. You have your ups and downs of inspiration but your work of now, today, should have something that your work of yesterday did not, if you are thinking, if you are growing.

Just come from the Seattle Symphony concert. It was fine and I enjoyed it thoroughly but how I did want to be more spiritually alert to its uplifting! I listened like a dumb beast, as I've seen a cow stop chewing the cud and throw back her ears and listen to music. She knew it pleased and satisfied her, that is all. She slowly swished her rope of a tail and her four feet remained firmly planted on the solid earth. So I, with pleased senses, sat in the hot, crowded gods and my soul rose no higher than those filthy painted cherubs daubed on the ceiling, wallowing in cobwebs and grime.

"Inspiration is intention obeyed."

December 2nd

To attain in art is to rise above the external and temporary to the real of the eternal reality, to express the "I am," or God, in all life, in all growth, for there is nothing but God.

> Artist, Poet, Singer, where are you going today?
> Searching, struggling, striving to find the way.
> Artist, Poet, Singer, tell me what is your goal?
> By listing, learning, expressing, to find the soul.

Artist, Poet, Singer, what are you after today—
Blindly, dimly, dumbly trying to say?

Aye, Artist, Poet, Singer, that is your job,
Learning the soul's language, trying to express your God.

(M. E. Carr)

Half of painting is listening for the "eloquent dumb great Mother" (nature) to speak. The other half is having clear enough consciousness to see God in all.

Do not try to do extraordinary things but do ordinary things with intensity. Push your idea to the limit, distorting if necessary to drive the point home and intensify it, but stick to the one central idea, getting it across at all costs. Have a central idea in any picture and let all else in the picture lead up to that one thought or idea. Find the leading rhythm and the dominant style or predominating form. Watch negative and positive colour.

January 25th, 1933
I've been figuring out with myself how it is I hate write-ups. Someone always sticks them under my nose. I figure thus: people here don't like my work, it says nothing to them, but they like what is *said* about it in the East. In other words, they like the "kick up" not *it*. That's the hurt.

What do I want out there in that open space of sea, bounded above by sky and below by earth, light, space? All space is filled with God, light, love, and peace.

January 26th
What is beauty?—God. What is that vital thing, in ugly as well as lovely things and places, the thing that takes us out of ourselves, that draws and attracts us, the unnameable thing claiming kinship with us?—God, the divine in us calling to the divine in all else, the one essence and substance.

January 27th
The sunset was grand after a wet day. The dogs and I walked on the shore. Your eye ran across level green expanse of water fretted and foaming on the beach and rocks. Serene. Far out it ended mistily in pale space line, then rose to a sky full of low soft clouds with the domed blue above.

The People's Gallery scheme is over for the present. It was a good idea and I am convinced put for some purpose into my mind. I went ahead as far as I could; then it came to a *cul de sac*: no money, no help, no nothing but to let her lie by and sleep and some day she may revive. I don't know now. My energies are centred on the cliffs and sea. Have made six paper sketches. Looked them over today—too stodgy, just paint, not inspiration. I must go out and feel more.

In working out canvas from sketches, the sketches should convey the essence of the idea though they lack the detail. The thing that decided you to attempt

that particular subject should be shown, more or less. Take that small sketch home and play with it on paper with cheap material so that you may not feel hampered but dabble away gaily. Extravagantly play with your idea, keep it fluid, toss it hither and thither, but always let the *idea* be there at the core. When certainty has been arrived at in your mind, leave the sketch alone. Forget it and put your whole thought to developing the idea.

Empty yourself, come to the day's work free, open, with no pre-conceived ideas, no set rule of action, open and willing to be led, receptive and obedient, calm and still, unhurried and unworried over the outcome, only sincere and alert for promptings. Cast out the personal, strive for the spiritual in your painting. Think only of the objective. Desire only that the consciousness of the presence of God may show and speak, not as accomplished by you, not as your work, not as having anything to do with you, but being only a reminder and an explainer of the manifested Father, the Christ. You yourself are nothing, only a channel for the pouring through of that which *is* something, which is all. Your job is to keep that channel clear and clean and pure so that which passes through may be unobstructed, unsullied, undiluted and thus show forth its clear purity and intention. Strive for this thing, for the stillness that should make it possible. Do not let it be a worried obsession causing your life to become a struggle and turmoil but let go that the spirit may work in calm and peace. Learn by listening attentively, be aware of your aliveness, alert to promptings.

June 7th—Pemberton, B.C.
I left home on May 15th and went to Brackendale first. I was accompanied by Koko, who simply could not live without me, Tantrum, who must learn the job of "Mom-minding" while I am sketching, and Susie, the rat, whom no one would look after during my absence so must of necessity come along. I had the usual paraphernalia of sketching, made as light as possible but still heavy as one's heart in great affliction, the dogs, each in a cosy box, and Susie (after an obstreperous scene in which she romped out of two containers) finally settled in a rolled-oat carton cut down, this tucked in my hand bag. And so we got to Vancouver, got to Squamish, got to Brackendale, along with vast quantities of prospectors going to the mines with their packs on their backs. I rejoiced that their packs were even worse to behold than mine.

Lil met me and we travelled to her farm. How the kids had grown! Jolly bunch. What a tumble-up the farm was! Young chickens, rabbits, bees, children, washing, cooking, picture puzzles, picture painting, post-hole diggers, wire netting, shovels, brooms, school books and bags, lunch pails, clomping up and down stairs of hobnail boots, groan of kitchen pump, dash of churn, hum of cream separator, and other sights and sounds and smells. And Lil's voice roaring above all the hubbub, first at this one, then at that. And trips in the truck, and walks in the rain, and splashing through puddles, and watching for the clouds to pass, and dashing out to sketch. And finding to my great joy that Sophie was in Brackendale, and Lil asking her and Frank to lunch, and her sister and the child

coming too, and the happy, comfortable time we all had, and Sophie so much to me and I so much to Sophie, and the enjoyment of the good food Lil provided. And Larson coming in and talking to Frank about his boat that he had made by himself and come to Squamish in, which ended in Larson buying the same the next day, to the joy of all parties. And how we all trooped down to the river to see and try the boat, and the little boys so pleased, and David and Donnie each taking her out alone, and my naming her the *Waterlily* after Lillian.

Then the goodbyes and the sore, sore heart in me because Koko had failed so for the last week, and how I prayed that he might die, being so full of years and feebleness, and the last night how he struggled for breath but in the morning was stronger and better. Then Larson running back for the mail and getting five letters, one from Bess and one from Lawren, always welcome, besides the home ones.

The settling down in the train with the creatures comfortably arranged for and my eye all agog to absorb scenery. Mountains towering—snow mountains, blue mountains, green mountains, brown mountains, tree-covered, barren rock, cruel mountains with awful waterfalls and chasms and avalanches, tender mountains all shining, spiritual peaks way up among the clouds.

Seton and Anderson lakes, shut in by crushing mountains. A feeling of stifle, of being trapped, of oppression and depression, of foreboding and awe. The train slowly crawling along the lake side on the trestled ledge.

Then Lillooet at 8 P.M. The dull hotel where I must wait for my room till the proprietress had had her greasy hair curled and fixed. A tiny, drab, inconvenient room, and my beloved Koko very feeble. All night I tried to soothe him but he was restless and unhappy. I knew in my heart, and shuddered at, what I must do in the morning for I loved the blessed old pup, and now was the testing time of that love. I left Tantrum in my room and, with Koko in my arms, hunted Lillooet for a vet. There was none, nor a chemist, only a foolish boy doctor who was not oversympathetic. It was 10 o'clock before he was in his office. He said it was pneumonia and heart but he knew nothing of dogs or dog diseases, had no chloroform, and was afraid of strychnine. He agreed that it was cruel to let him go on suffering and suggested a bullet; there was a constable at the police office. Oh, the awful misery of that walk of a few blocks to ask for a bullet for my blessed pup to whom guns and all pertaining to them were horror! Koko's eyes were hardly off my face. He would throw back his head as he lay in my arms, and his beautiful, loving, trusting eyes would look straight into mine with absolute faith. How could I fail him? I did not. It was nothing to a dog who had travelled so much to be put in his cosy box, carried in the constable's car across the river. Just a little second. He had no fear or anticipation. A prisoner whom the constable had with him dug Koko's grave beside the roaring river. I went up to my room and cried bitterly.

Fourteen years of devoted love. Ah, little Koko, you are not dead. You have given up that little quaint brown body, but the essence of you, all your love and sweetness and loyalty are not dead, only gone on somewhere to grow some

more. Will that which was you and that which is me come together sometime, somewhere? I am very thankful, little dog, for the years of joy we shared. I do not grudge you your rest for you were very tired. Young Tantrum seems so immature and foolish but he will grow. I must have patience with him.

So I plunged into work. Oh, these mountains, great bundles of contradiction, hard, cold, austere, disdainful, remote yet gentle, spiritual, appealing! Oh, you mountains, I am at your feet—humble, pleading! Speak to me in your wordless words! I claim my brotherhood to you. We are of the same substance for there is only one substance. God is all there is. There is one life, God life, that flows through all. He that formed me formed you. Oh, Father of all, raise my consciousness to that sense of oneness with the universal. Help me to express Thee. Do Thou use me as a channel, help me to keep myself clear, open, receptive to Thy will. Open my understanding and make my eye to see and my ear to hear. Let me not fuss and fret at my incompetence but be still and know that Thou art God.

I stayed five days at Lillooet and then came on down to Seton. Seton and Anderson lakes used to be one till a mountain sat down in its midst and divided it squarely amidships, leaving each lake eighteen miles long. The Durban's stopping place was full of prospectors coming and going in a steady stream, men seeking for gold, strong men, glad to get away from city fuss into the great open, to shoulder their packs, make themselves into beasts of burden, struggle up the stony, steep mountainsides, enduring hardship, cold, hunger, tiredness, always with that gold god ahead, planning their lives when they would find the gold, and building airy castles for themselves, and wives, children, aged parents, and who-not, generous in their imagined affluence. Then, when they do not strike it lucky, collapsing like burst bubbles. Some, not having the courage to face those at home who they bragged to, end it with a bullet. Others will come again next year and the next. Others will stake unworthy claims and bamboozle some poor fool to buy them.

The Durban House at Seton looked like an erupted volcano. Specimens of rock everywhere, on tables, shelves, seats, verandahs. Men pounded them in mortars, making horrid noises, and washed them in pans, making sloppy the porch. They did up bundles and parted them. They carried little canvas sacks full. Indians brought ponies with pack saddles to the front and outfits with frypans, blankets, grub, and always the axe, pick and shovel; loaded the beasts till only their ears and tails were visible. The Indian superintended, then the laden beasts, tied in a string one behind the other, started up the trails. You met them a few days later wearily returning, empty of their packs, the Indian cheerful—he had his money safe in his pouch, no digging for gold for him!

One boy had brought an old friend down in a coffin, returning him to his wife in Vancouver. Disheartened, so a bullet in his brain. The boy had had it all to see to, broke the shack door open just as the gun went off. He had had to make the poor body decent, to help make a coffin, to get others to help him carry him one and a half miles down the rough trail, to make arrangements. For he had known this middle-aged man since he himself was a boy of sixteen—he

had been to him like a father—and the poor suicide had left a message that he was to take his body down to Vancouver to his wife. There were circles round the boy's eyes. He talked incessantly at dinner (there were only the two of us that night) and he played the piano and was restless.

The boy told me of the inside of the big Pioneer mine and I wondered how they had the grit to go down into the blackness, to sink down, down that awful shaft on a lift—only a platform, no cage, no sides. If anything went wrong with the lift there were ladders perpendicular up the sides of the shaft—their only way of coming up—a ladder of certain length, then a plank to rest on, another ladder and a plank, and so on and so on, and that awful, awful black hole if one slipped or got dizzy. The telling sickened me. If a man's light went out he must stand perfectly still and shout. He said the blackness was different from any other, a smothering density you could feel. This boy's job was to set and fire the blasts. It must be done with exact precision and remembering acutely which was which, then the lighting and the mad rush to get away, far, far as possible. The succession of concussions that split your ears and knocked you down. Oh, is there any gold in all the world worth all that?

Everyone got up early at the Durban. The walls were so thin you heard the sighs and yawns from 5 A.M. The men washed in the open hall, I in my room, so it was befitting I should be the last to go down the hall to breakfast. I usually did that at 7 or 7:30. There were seldom the same men for two days. I, being the one woman, wielded the maternal teapot. Everyone loved Tantrum and had a smile for or at him.

Today I moved on to Pemberton and it is pouring rain.

June 10th—Pemberton

Here we are. Three days at Pemberton have passed already. It is beautiful and exhausting. First day they told me of a walk. Said it was four miles. It proved to be six and I got home exhausted and mad, also late. Today I went up Harvey Mountain, supposed to have one of the grand views. They said it covered all the peaks. I expected a glorious panorama and to walk five miles. I crossed three railway bridges, beastly things, scuttling over them lugging Tantrum and all my gear, counting my steps and reckoning each one aloud to Tantrum. I met two patrollers and stood on edges of track to let them pass. The mountains glorious, tossing splendour and glory from peak to peak. Yesterday there was fresh snow. They are half white and half navy blue and the beastly, treacherous Lillooet River snakes through the willows and meadows. I don't like these rivers. They are oily smooth and swift but swirling, with mean currents and whirlpools. You feel as if they asked you sneakily and stealthily to fall in and be swallowed, swept away swiftly to nothingness. There is meanness in their muddy green-grey water and shelvy sand banks. I never go to the rivers about here or want to look at them or hear them.

Well, after miles and miles along the tracks, I climbed the waggon road to Harvey Mountain. At the summit I sat to rest and made a sketch. The view was certainly fine in a middling way but not all the wonder they raved over, so I

supposed this was only the beginning and the trail went up from there. A boy came along on a bike with a bear skin, still newly wet, in a sack. He told me he had just shot the bear. It had been fighting and was in a mean temper. It turned on him so he had shot even though it was off season. I asked about the trail and he showed me where it started up a few rods away, and off I started, on and on and on. It got worse and worse, perpendicular, stony, ghastly. Still I struggled on. From the amount of bear spoor there must have been millions about. It was fresh. Would I meet one? Would it be ugly and attack? Surely, I thought, this is a queer trail to set a woman of sixty off on alone.

There seemed to be no top. I plunged into valley after valley, spooky, silent, grey places. Tantrum heeled splendidly, but he looked into the forest and growled. The mosquitoes were the only life except one startled hawk. I felt as if bear eyes were peeping in all directions and as if my back hair might be clawed and the hot snorting breath of a beast might suddenly touch my ear. But I hated to be a slacker and turn back so I toiled on. Evidently no one had been there recently for trees were across the way. It was very stony, mostly a sort of stony ditch and steep gully. I reached a place where the trail stopped, was lost in undergrowth, and dipped into another valley. I tied my handkerchief to a tree and scouted round for a trail. There was no light showing, as if I was near the top. I'd had enough. Slowly I retraced my steps, counting myself a slacker, but to be lost on that mountain in a regular bear "rancherie" did not seem good enough to risk.

Some way back I had noted a bare bluff, so I tore paper and marked bushes and, leaving a trail, I climbed up. The view was good but the place creepy in the extreme. I ate and took out my sketch things. I was too tired and too creepy to work or to rest. The dog stared into the forest and growled and barked. "I'm getting out," I said and, consigning my informants at the hotel to hot places, I started the descent and kept going without pause. Somehow I missed the trail. When I got to the road again it was in totally different country; however the track was there, so I knew I could make Pemberton by walking along it far enough. I could have kissed the beastly bridge, it was so good to be sure where I was.

When I limped into the hotel kitchen they were appalled. "My goodness," said the daughter, "you'd got to the top that we meant, when you 'started' on the trail. You must have got on the old McCulloch trail up to an old mine. Why, I wouldn't dream of going up there without a man." Counting that awful climb, I must have gone nine or ten miles. I ache dreadfully.

THE ELEPHANT

1933

July 16th

Once I heard it stated and now I believe it to be true that there is no true art without religion. The artist himself may not think he is religious but if he is sincere his sincerity in itself is religion. If something other than the material did not speak to him, and if he did not have faith in that something and also in himself, he would not try to express it. Every artist I meet these days seems to me to leak out the fact that somewhere inside him he is groping religiously for something, some in one way, some in another, tip-toeing, stretching up, longing for something beyond what he sees or can reach.

I wonder will death be much lonelier than life. Life's an awfully lonesome affair. You can live close against other people yet your lives never touch. You come into the world alone and you go out of the world alone yet it seems to me you are more alone while living than even going and coming. Your mother loves you like the deuce while you are coming. Wrapped up there under her heart is perhaps the cosiest time in existence. Then she and you are one, companions. At death again hearts loosen and realities peep out, but all the intervening years of living something shuts you up in a "yourself shell." You can't break through and get out; nobody can break through and get in. If there was an instrument strong enough to break the "self shells" and let out the spirit it would be grand.

I ought to descend to the basement and do out a tub of washing but I am so woefully tired I shan't. It's been very hot for two days; now the wind is up doling out bangs and smacks with a lavish hand. The roses are protesting—only the young strong ones can stand it, the old tired ones flop to the earth in soft, tired twinklings.

A nice elderly couple called on me today to show me their griffon and to see mine. Theirs was o.k. but my four somehow were finer. They obeyed and there was a wise sweetness to them the other fellow lacked. During tea in the garden with the beasts the old lady said, "Are you a sister of Emily Carr, the artist?" "I am her." They said they *loved* pictures and would like to go up to the studio. Their tastes were conservative. I knew that because they told me of a lovely painting of flowers by *me* in the Vancouver Gallery. It was not mine. I knew whose it was and so what they liked. So we clambered up the stairs. They edged in past the litter and fell to talking of the studio to gain time. They spoke of their lovely old watercolours and beautiful photographs. Then I produced some canvases. They were a sweet, honest old pair and they said what they could with

cautious sincerity. They are coming to fetch me to see theirs. So be it. *I* shall be in the same box wondering what to say.

July 17th

Bess and Lawren think over-highly of my work. Of course I'm glad they think there is something in it other than smearing on of paint, but I feel a little hypo-critish too because sometimes one lets the mundane sweep across their work, the earthy predominate, and the spiritual sleep. Bess's letter was fine. I don't follow all the theosophy formula but the substance is the same as my less complicated beliefs: God in all. Always looking for the face of God, always listening for the voice of God in Nature. Nature is God revealing himself, expressing his wonders and his love, Nature clothed in God's beauty of holiness.

July 20th

Tomorrow there is to be a fool fuss presenting my picture "Kispiax" to the government. I'm not going to the affair in the buildings but have to appear at a pink tea at the Empress. Why can't those who collected and got the thing say, "Here!" and the Government say, "Thanks!" and the janitor hang it on the wall? And why must one drink tea at the Empress on the occasion? But then poor lit-tle Edythe has had a job collecting for the thing and I guess she will enjoy being tea-ed. I wonder why being confronted with my work in the face of the public always embarrasses and reproaches me so terribly. Is it because there is dishon-esty or lack of sincerity in the work, something that doesn't ring true, a lack of integrity in my presentation of the subject, or is it a sort of reaction arising from the perpetual snubbing of my work in my younger days, the days after I went away and had broken loose from the old photographic, pretty-picture work? Gee whiz, how those snubs and titters hurt in those days! I don't care half so much now, and yet those old scars are still tender after all these years.

July 22nd

They did it and the Government took it and it all went off quite well, they say. I went to the tea party and felt a fool when I was congratulated by some fifteen or twenty tabbies. Edythe was so sweet and pretty and cool. I loved her. And Pro-fessor Fred did his part nobly. Edythe and Fred came to supper with me later, a splendacious curry in the studio. I received $166 for my "Kispiax Village" and felt very wealthy. So that's that.

July 23rd

Dreams do come true sometimes. Caravans ran round inside of my head from the time I was no-high and read children's stories in which gypsies figured. Peri-odically I had caravan fever, drew plans like covered express carts drawn by a fat white horse. After horses went out and motors came in I quit caravan dreaming, engines in no way appealing to me and my purse too slim to consider one any-how. So I contented myself with shanties for sketching outings, cabins, tents, log huts, houseboats, tool sheds, lighthouses—many strange quarters. Then one day,

plop! into my very mouth, like a great sugar-plum for sweetness, dropped the caravan.

There it sat, grey and lumbering like an elephant, by the roadside—"For sale." I looked her over, made an offer, and she is mine. Greater even than the surprise of finding her was the fact that *nobody* opposed the idea but rather backed it up. We towed her home in the dark and I sneaked out of bed at 5 o'clock the next morning to make sure she was really true and not just a grey dream. Sure enough, there she sat, her square ugliness bathed in the summer sunshine, and I sang in my heart.

Now she's just about fixed up. She has no innards, that is works, so I'll have to be hauled. I've chosen the spot. Goldstream Flats, a lovely place. I'm aching to be off but not yet as nobody wants to go with me. I've asked one or two. I thought it would be nice to have someone to enthuse to, just for the first trip. With one accord they all made excuses except Henry. Poor Henry, who has lived twenty years and only developed nine when sleeping-sickness overwhelmed him and arrested his progress, like a clock whose hands have stuck though it goes on ticking—Henry *wants* to go along.

I wonder who went with me in the dream caravan. I do not remember but I was not alone. Maybe it was Drummie. No, Drummie was before that. We were only pals when I was a wee girl and I do not remember that he ever was anywhere except in our big garden. He was a dream pal and I used to ride all round the garden with him on a dream horse. There was one overgrown corner. Rocket ran riot there, all shades of it from mauve to purple, and white butterflies hovered amongst it in thousands and the perfume and the sunshine made things woosey. Drummie seemed to come most to that corner. I used to trot like a pony up and down the gravel walk; the rocket was as high as my head. The dream horse and the dream boy and I all talked and had a splendid time that nobody ever knew about except ourselves. I do not remember ever seeing Drummie's face. That was an unimportant detail. Where the name "Drummie" came from I have no idea. Sometimes since, I have wondered if it was some small boy's spirit that really did come to play with me in the old garden. It was a wonderful enough old garden to produce anything, with its flowers and fruit trees and berry bushes and the round tadpole pond where you dipped them into the old iron dipper that the chicken food was measured with. There was a stone paved walk to it with hurdles across to prevent the cows getting mixed when they went to drink. You stood on the hurdles and saw the upside-downness of the daffodils and primroses, the trees, our faces and our white pinafores, and the ducks swam serenely over their double, perhaps finding them as companionable as I did my Drummie dream boy.

July 25th

I have been to a wedding—my sister's little maid—such a pure, high, sweet little soul, an adopted daughter of a chimney sweep. The sweep and his lady shone by soap suds. His skin was so clean and so red it looked as if it had been burned. His lady was in blue with an immense sweet pea bouquet, pink, upon

her ample bosom. The little church was filled. A man, middle-aged and "middle" in every other way, muddled in an inharmonious way over the harmonium. Another middling person sang a solo, bellowing the words, "love" and "dear," with suitable volume.

Nearly everyone in the audience had a child. The small ones howled and the big giggled. The parson was a stick as he squeezed from behind two small panels serving as a vestry followed by two shy boys, the groom and his man. Then the old boy at the harmonium fell upon the stops, pranced his big hands over the keys, out squeaked the wedding march and in came the bedecked little flower girls and the bride, white and pure and lovely. How such a lily could have grown to womanhood in that sooty family is a marvel. So all-good, standing there, taking her marriage vows before God, high in her ideals of womanhood and matrimony, giving the whole of her sweet self to the man she really loved, prepared to face life with him on $30.00 per month and love. Bless the child. He is a lucky boy to have won that pearl.

I was looking at a picture, a weak watercolour, a present from a friend to a friend, and trying to sum up why the thing, which was a fairly good surface reproduction of the scene, was so unconvincing and awful. The painter just had not experienced the thing he represented. The objects, water, sky, rocks, were there but he hadn't felt that they were big or strong or high or wet.

I want my things to rock and sway with the breath and fluids of life, but there they sit, weak and still, just paint without vitality, without reality, showing that I myself have not swayed and rocked with experiencing when I confronted them. It was but their outer shell; I did not bore into them, reach for their vitals, commune with their God in them. Eye and ear were dull and unreceptive to anything beneath the skin. This great mountain might be a cardboard stage set, not an honest dirt-and-rock solidity of immovableness. What were those infinitesimal trees and grass and shrubs? Pouf, the wind sways them, the fire burns them and they are gone! But the mountain bulk! Ages it has stood thrusting its great peak into the sky, its top in a different world, changed in that high air to a mystic wonder. It is praying to God. God throws a white mantle over it and it is more unearthly than ever in its remote purity, yet its foundation sprawls with solid magnificence on the earth.

July 27th

Oh, these mountains! They won't bulk up. They are thin and papery. They won't brood like great sitting hens, squatting immovable, unperturbed, staring, guarding their precious secrets till something happens. At 'em again, old girl, they're worth the big struggle.

July 28th

A long spiel in the paper tonight, my name figuring in the headline—quite unnecessary. I am mentioned in connection with two watercolour exhibits now travelling abroad. Why then do I go to bed heavy and heartachy? Write-ups depress me horribly. I feel as if somebody was making a mistake, especially after

a day of wrestling with that mountain. The dismal failure I have made of it makes my spirit sick and bedraggled. I must get that lifting strength, but how?

The women's clubs are sending "Vanquished" to Amsterdam for the Convention of the Confederation of Women Something-or-Other. Three women selected it today. Goodness, when I brought it out I felt maybe I'd gone back since I painted that three or four years ago. I believe it *is* stronger, and my heart is sick. Perhaps I'm approaching my dotage and my best is done. Oh, I must look up and pray!

I have wiped out the village at the foot of the mountain. Now I shall paint the little cowed hollow that the village sits in and maybe toss the huts in last of all. It is the mountain I *must* express, all else subservient to that great dominating strength and spirit brooding there.

July 29th
Oh, my mountain! I am like a tiny rowboat trying to tow it into port and the sea is rough.

July 30th
I have contraried my usual custom and ignored my painting this whole Sabbath. The day was perfect and the garden delicious; so the dogs, monk and I sat there and *lived*. Lizzie came to supper, and Henry who was alone tonight. I read Fred Housser's *Whitman to America*. It's wonderful, a splendid book to nourish the soul. Fred knows his Whitman and Whitman knew life from the soul's standpoint. What glorious excursions he made into the unknown! He wrote, "Darest thou now, O soul, Walk out with me toward the Unknown Region, Where neither ground is for the feet, nor any path to follow"; and he *dared*. We, Henry and I, went to the beach after and lit a fire and watched the moon rise across the water. There was absolute peace down there.

Oh, today I am akin to the worm, the caterpillar and the grub! Where are the high places? I can't reach anything, even the low middle.

The sketch should make the mouth water, but the finished picture should fill and satisfy with a sense of completeness. My sketches move people, not my pictures. I'm a *frost*!

August 7th
Two visitors today, one male, inflated and bloated with conceit like a drowned pup, one female, a writer, rather interesting, the mother of a fifteen-year-old boy yet ogling the "bloated pup" as if his sex made him *wonderful*. I toted out canvases and took the opportunity to scan them closely for any sign of falling below par. They do; they are indefinite and weak. I have wrestled again with my mountain. It is much like a great corsetless woman or a sitting pillow. I wish I could sit before it again and realize it fiercely, vitally.

I am happy. At last I have found a use for those fool newspaper write-ups I detest so. I found it in the Lunatic Asylum. I went out to Wilkinson Road

Mental Home to see Harold. He was unusually clear-headed and happy. He gets the keepers and patients to cut out any notes about my painting and hoards them and rejoices over them. "I just danced round the ward for joy when I read they'd sent your picture to Amsterdam," he said. "Oh, I was so glad." Poor lad, he begged me to do him a sketch of Kispiax Village where he lived with the missionaries. It is amongst his poor bits of treasures. He has ceased fighting against the bars now and is happy and contented. They let him come with me into the grounds today, first time he'd been outside in months. We sat on a bench in the shade and I unpacked my bag—such things as one would take to a child, and he near forty, apples and lavender from my garden; chocolate and a cake of sweet soap and a pencil for his child's side, cigarettes because he is bodily an adult. We fed the bear chocolate. It was very hot, with a lovely little breeze. No wonder the man-boy was so happy outside the bars for a brief spell, his poor clouded mind fluttering back and forth over memories of when he was free. It is worth a whole lot to see his face light when the keeper brings him in and he ambles forward on his misshapen feet with both hands outstretched to me in welcome.

August 12th

Fred Housser's *Whitman to America* is absorbingly interesting and wonderful to me. It clarifies so many things. Integrity has a new meaning for me, living the creative life seems more grandly desirous (opening up marvellous vistas) when one is searching for higher, more uplifting inspiration, when one is listening intently for what a thing is saying and for the urge of life pouring through all things. I find that raising my eyes slightly above what I am regarding so that the thing is a little out of focus seems to bring the spiritual into clearer vision, as though there were something lifting the material up to the spiritual, bathing it in the above glory.

Avoid outrageousness and monstrosity. Be vital, intense, sincere. Distort if it is necessary to carry your point but not for the sake of being outlandish. Seek ever to lift the painting above paint.

I thought my mountain was coming this morning. It began to move, it was near the speaking, when suddenly it shifted, sulked, returned to obscurity, to smallness. It has eluded me again and sits there, mean, puny, dull. Why? Did I lower my ideal? Did I carelessly bungle, pandering to the material instead of the spiritual? Did I lose sight of God, too filled with petty household cares, sailing low to the ground, ploughing fleshily along?

August 19th

My van elephant is now a reality. While she sat there in the lot she was only a dream shaping itself. She was bought so suddenly after long years of waiting. It is two months from the morning that I got out of bed at 5 A.M. to peep out of the studio window and see if she was really there in the lot beneath. Then came all the fixings, meat safe, dog boxes and monkey-proof corner. And when she was ready, equipped in full, the hauler came and said that it was impossible to

get her out of the lot because she was too low, and he was horrid and I was mad. "Well," I said, "if the man brought her 3,370 miles across the Rockies, surely she can be taken twelve miles to Goldstream Flats." And she was, but not by that old fool. The third who inspected ventured. The family sat on the creature crates and watched the tugging, heaving and wrenching. Sweat and cussings poured! Poor rat Susie was aboard and must have got severely jerked. The lid was off her box when we got there but Susie sweetly asleep within.

Henry and I and the animals drove in the truck. Whew, it was hot at the wood yard! The jacking-up blocks weren't ready. Then we stopped for the tires to be winded. We lumbered right through Government Street. Mercy, it was hot! And the delays were so numerous I patted my wallet and wondered if she was fat enough but they only charged the original $3.50 agreed upon. I was so thrilled that I "coned" and "ginger-popped" the man liberally when we got to the pop shop on the Flats.

It wasn't the spot I had picked, but the Elephant found it to her liking. The Elephant is a grand sitter but a heavy traveller.

Henry went all to pieces when we got there, not a steady nerve in his body. He hopped and wiggled and shook and stuttered. I ran hither and thither getting blocks and bricks and stones to aid the man in hoisting the Elephant off her tires. It was almost 5 P.M. when he left. The Elephant had chosen a favourite cow spot and much raking was necessary. This was accomplished with the aid of a row of rake teeth absolutely devoid of a handle. Everyone on the Flats collected to see us unpack, the monkey, of course, being the centre of attraction. The tent fly tormented me but I got it stuck up at last unaided. I made up the beds and prepared supper. Black fell down among the great cedars before I was nearly out of the mess.

Neither of us slept. I could hear Henry groaning and tossing under the tent. The creatures were all in the van with me and very good. The monkey is housed in a hollow cedar tree, cuddled into its very heart. Surely I have at last found her a habitation she *cannot* wreck. She'd have made matchwood of the Elephant. I ship-shaped up next morning and we are spick and span, very comfortable and very happy. Henry's nerves torment and wrack him a little less. There's a great peace under these magnificent cedars and the endless water sings its endless sound not a stone's throw off. I've made a range to rival any "Monarch" or "Canada's Pride" ever invented. The ingredients are a piece of automobile frame, the leg of a stove, a pile of rocks, scraps of iron, tin and wire, and parts of a gridiron. It's a peach!

Last night we slept like babies. Each creature has dropped into its own niche. The spirit of freemasonry and intimacy among us all is superb. It's wonderful to watch the joy of the pups playing tag among the cedars. There is a delicious little breeze humming among the leaves without bluster or vulgarity. Today I love life, so do the four dogs, the monkey and the rat. And poor Henry; this must make up to him a little for all that he hasn't got in life.

Last night when the pop shop was shut and everyone was in bed I slipped into a nondescript garment and tumbled into the river. It was wonderful. I lay

down on the stones and let the water ripple over me, clear, soft water that made the skin of you feel like something namelessly exquisite, even my sixty-year-old skin. When I had rubbed down and was between the sheets in the Elephant's innards, I felt like a million dollars, only much cleaner and sweeter and nicer. The precious pups were asleep all round, and rat Susie, Woo just outside the window in her hollow cedar, Henry in the tent lean-to. The cedars and pines and river all whispered soothingly, and there was life, life, life in the soft blackness of the night.

Today is wonderful again. Henry has found companionship with the pop lady's small boys. They are playing ball, all laughing, which is good, for at breakfast he was troublesome and morose. Woo has bathed in the river and is exploring the underneath of a big tree root. I am preparing a stew on the "Monarch" range.

Sunday, August 20th

Oh, today is awful! They started early this morning—the Public. The beautiful cedars are dim with dust, the air is riled up with motor snorts, dog barks and children's screechings. The Elephant is beside the public road. For every two feet that pass, kicking up the dust, one nose, two eyes and one gaping mouth are thrust into the caravan. Every party has one or more dogs, every dog has many yaps. One picnic party with a dog contemplated settling on top of my camp. I suggested that it was rather close and there was the whole park. The woman was peeved and said, "But that's the spot I like." Finally she moved very grudgingly by. Woo is very smart. She has betaken her little grey body among the roots in the bank where she does not show, so no one notices her and I am not bombarded. The dogs are shut in the van and are weary of the public. I've had visitors myself for two days.

Henry is better today, looking quite smart and happy. His sister came out and I got a letter from Fred. He talks about his Whitman book. I do want it printed so I can have a copy for my own eye, to line and score and study and make my very own. Just reading a thing over two or three times doesn't do that. One has to go back and back to bits and points. I'm slow as snails at absorbing.

The sun has left the Flats. It is not even visible on the mountain for the smoke of forest fire is all about. Night will be here soon. Even now the folk are piling into motors; snorts and dust clouds are increasing. Two Boston terriers that have been tied up all day are worn out with squealing and only give piercing wailing, yelping whines at intervals. Mrs. "Pop Shop" has subsided into her wicker chair on the platform behind the pop booth. She is very fat and billows all over it. I can see the tired sag of her fat from here. I haven't heard one person, no child or anyone, laugh today. They rush and tear to get, but don't stop to enjoy the getting. I'm longing to paint. Why don't I? I must go into my closet and shut the door, shut out Henry and camp cooking and visitors and food and drink and let the calm of the woods where the spirit of God dwells fill me, and these ropes that bind my hands and the films before my eyes fade away, and

become conscious of the oneness of all life, God and me and the trees and creatures. Oh, to breathe it into one's system deeply and vitally, to wake from sleep and to live.

August 31st

A wet day in camp. The rain pattered on the top of the Elephant all night. Mrs. "Pop Shop" and I went for our nightly dip in the river. It was cold and took courage and much squealing and knee-shaking. Neither of us has the pluck to exhibit the bulges of our fat before the youngsters, so we "mermaid" after dark. I dare not *run* back; the footing among the cedars is ribbed with big roots. One's feet must pick and one's eyes must peer through the dim obscurity of the great cedars and maples. Once inside the Elephant, scrubbed down with a hard brush and cuddled up to a hot bottle, I thought I loved the whole world, I felt so good. But last night as I stood in my nightie and cap, a male voice made a howl and a male head thrust into the van. Well, all the love and charity fled from my soul. I was red hot and demanded his wants. By this time the dogs were in an uproar and I couldn't hear his answer. Finally I caught, "Can I get any bread?" "No," I replied tartly, "The shop is shut out there." He disappeared in the night and then I felt a beast and ran to the door to offer him what I had in camp but he had vanished, swallowed up in the black night. I might have been more tolerant, but I hate my privacy being torn up by the roots. I thought of that one word "bread" every time I awoke.

At 6 A.M. we got up and climbed the mountain to a nursery garden. The little woman was a wonder—five babies under five years and yet she was smart and active. By 7:30 her house was all in order, baby washed and being fed. She is the kind who ought to have a family; they don't annoy or worry her. The whole place spoke of thrift and contentment. I did admire that woman and family.

September 5th

It started to rain last night and has rained all day. I packed Henry off home because his shelter was too slim. Anyhow he has had two good weeks. I had spent all day rearranging the camp for rain and snugging it up. I moved the "Monarch" range up close in front of the awning. The great cedar hangs over it and sheds off the rain. Woo in its innards is dry and cosy. She loves her cedar home. The woods are delightful in the rain, heavily veiled in mystery. They are delicious to *all* the senses but most to the smell. An owl came and sat on my cedar beside the fire. How I love it when the wild creatures pal up that way! The van is cosy, come rain, come shine, and all is well. Now Henry is gone I hope to try and work. Perhaps it wasn't Henry; maybe it was me. I care much too much for creature comforts and keeping the camp cosy and tidy. It seems necessary, especially with all the creatures. Mrs. Giles, the nursery woman, said that when her small boys went home and reported that there was a lady in the Flats in a house on wheels, with four dogs, a monkey and a rat, and a hopping boy, she thought it must be a section of a circus or travelling show. They also reported

that when they came into my camp I chased them all off with a broom. I believe I was considerably tormented that first morning. How different you sound when described to what you feel!

September 7th

This is my first real day in the van. I mean by that the first day I have risen a tiny bit above the mundane. At 6:30 A.M. I looked from my berth in the Elephant and saw the sun faint but hopeful on the tipmost top trees of the mountain. Mount Finlayson is on one side of us and a nameless sheer rocky cliff on the other. The Goldstream Flats are a narrow lowness where Goldstream babbles its way out to the Saanich inlet on Finlayson Arm. The sun gets no look-in for several hours after rising and winks a goodbye to us long before he has finished his daily round.

The four dogs burst like fireworks out of the van door at 6:30. At seven I followed and we took our dewy walk in the woods. Then some washing, dried on the camp fire which made my undies look and smell like smoked fish. I got to work, with my things for the first time all comfortably placed about, everything to hand. I made a small sketch and then worked a larger paper sketch from it. The woods were in a quiet mood, dreamy and sweet. No great contrasts of light and dark but full of quiet flowing light and fresh from the recent rain, and the growth full, steady and ascending. Whitman's "Still Midnight"—"This is thine hour, O soul, thy free flight into the wordless"—sang in my heart. I've a notion, imagination perhaps, that if you are slightly off focus, you vision the spiritual a little clearer. Perhaps it is that one is striving for something a bit beyond one's reach, an illusive something that can scarcely bear human handling, that the "material we" scarcely dare touch. It is too bright and vague to look straight at; the brutality of a direct look drives it away half imagined, half seen. It is something that lies, as Whitman says, in that far off inaccessible region, where neither ground is for the feet nor path to follow.

I do not say to myself, I will do thus or so. I leave myself open to leads, doing just what I see to do at the moment, neither planning nor knowing but quietly waiting for God and my soul.

September 8th

Oh, what a joy morning! Sun blazing, whole woods laughing, dogs hilarious. Camp all in order, calm radiance everywhere. What a lucky devil to have an Elephant and browse among such surroundings! The monk in her warm dress is sitting in the sun, replete with satisfaction. Susie the rat's pink nose keeps popping out from the front of my jacket. Her whiskers do tickle! Susie's heaven is right under my chin. There, I believe, she finds life complete, except maybe she hankers for a mate. Maybe I ought to provide one but they are so populous.

I had thought this place somehow incongruous, the immensity of the old trees here and there not holding with the rest but belonging to a different era, to the forest primeval. There is no second growth, no in-between. It is too great a jump

from immensity to the littleness of scrub brush. Today I see that I am what Whitman would call "making pictures with reference to parts" not with reference to "ensemble." The individual mighty trees stagger me. I become engaged with the figures and not the sum and so I get no further with my reckoning up of the total. Nothing stands alone; each is only a part. A picture must be a portrayal of relationships.

Later

Such a terrible loneliness and depression is on me tonight! My heart has gone heavier and heavier all day. I don't know any reason for it so I've mixed a large dose of Epsom Salts, put my sulky fire, which simply would not be cheerful, out, smacked the dogs all round for yapping and shut myself in the Elephant, although by clocks I should not be thinking of bed for three hours yet. This is the dampest spot I was ever in my life. The bed, my clothes, the food, everything gets clammy. I burst two hot bottles two nights running. I took a brick to bed the next night; too hot, set fire to the cover. Tonight I invented a regular safety furnace. I put the hot brick into an empty granite saucepan with a lid on. It is safe and airing the bed out magnificently. (One thing that *did* go right.)

I made two poor sketches today. Every single condition was good for work, but there you are—cussedness! What a lot I'd give tonight for a real companionable pal, male or female, a soul pal one wasn't afraid to speak to or to listen to. I've never had one like that. I expect it is my own fault. If I was nice right through I'd attract that kind to me. I do not give confidences. Now look at Mother "Pop Shop." There she is in her tiny shop doling out gingerpop, cones, confidences and smiles to all comers. Let any old time-waster hitch up to her counter and she will entertain him and listen to him as long as his wind lasts. Tonight one was there a full hour and a half. She has nothing to sit on at the counter. She's awfully fat and heavy but she lolls with this bit of fat on a candy box and that bit on a pop bottle and another bit on the cream jars and the counter supports her tummy while she waggles her permanent wave and manifold chins and glib tongue till the sun sinks behind the hill and her son whimpers for supper and the man has paid his last nickel and compliment. Then she rolls over to the cook stove complaining at the shortness of the day. Does she get more out of life by that sort of stuff than I do with my sort of stuff? I wouldn't change—but who is the wiser woman? Who lives fullest and collects the biggest bag full of life? I dunno. . . .

September 9th

All is fine today, unbeatable weather, no campers, no rubbernecks, no headache, nothing but peace. I worked well this morning and again before dark and felt things (first ideas) then drowned them nearly dead in paint. I don't know the song of this place. It doesn't quite know its own tune. It starts with a deep full note on the mighty cedars, primeval, immense, full, grand, noble from roots to tips, and ends up in a pitiful little squeak of nut bushes. Under the cedars you

sense the Indian and brave, fine spiritual things. Among the nut bushes are picnickers with shrieking children bashing and destroying, and flappers in pyjama suits. And there are wood waggons and gravel waggons blatantly snorting in and out cutting up the rude natural roads, smelling and snorting like evil monsters among the cedars. The Indian used the cedars, shaped beautiful things from them: canoes, ropes, baskets, mats, totem poles. It was his tree of trees. The picnickers mutilate them with their hideous initials, light fires against them, throw tin cans and rubbish into their hollow boles, size up how many cords, etc.

Sunday, and I've straddled over it somehow. At home I can't get enough of its peace. Here I get too much of its pests. Mrs. "Pop Shop" has gone and Mrs. Hooper has come. Curls and undulating curves of fat give place to mannish crop and straight up-and-downishness. The little pop shop has starched right up—positive. The negative slop of the other personality has melted away. She has brought two guns and a dog. "You holler," she said when I told her of two undesirable youths who came to my camp and ordered supper, "and I'll pepper a load of shot about their feet."

After all the motors had departed and it was black among the cedars, a car drove in past my van to a delightful opening among the cedars. They picnicked, a young middle-aged man and wife, a boy and two liver-and-white spaniels. I watched them a long time. They were so happy. They spread rugs and supper in the light of the "car" and ate and chattered. What a nice memory for the boy when he grows up! They were all intimately close, the man, woman, boy, dogs, trees. As they drove out they stopped by the stream. Of course, as is the way of all young things, the boy would want a drink just to prolong the goodness a bit. Can't I remember myself, when all protests were useless to postpone bedtime, asking for a drink?

Woo has been very ill today. Somehow or other she contrived to help herself liberally to green paint off my palette. It's two years since her orgy of ultramarine. I've washed her outside and inside, made her a new dress and pinafore because she was sick all over the other. Her trust in her "ole Mom" is wonderful. She lay in my lap while I poured Epsom Salts down her and washed out her cheek pockets. She was dreadfully ratty with the dogs who probably jeered at her tummy-ache. She was still meek and woebegone when I tucked her up in her hollow cedar but I think the worst is over. Her stomach is a marvel.

No work today. How could one address oneself to upstairs thoughts with sick monkeys and motorists scattered every old place? The dogs also have been devilish.

Do not forget life, artist. A picture is not a collection of portrayed objects nor is it a certain effect of light and shade nor is it a souvenir of a place nor a sentimental reminder, nor is it a show of colour nor a magnificence of form, nor yet is it anything seeable or sayable. It is a glimpse of God interpreted by the soul. It is life to some degree expressed.

September 12th
Homesick—that's me tonight. The cold clammy dark of this place is on me.

Tomorrow I shall go out searching for winter quarters for the Elephant. I went up the mountain to see Mrs. Giles and her babies today. It seemed so light and high and clear up there. I sank down into our valley at about six o'clock. It was dusk. Mrs. Hooper thought I was lost and said that the dogs had howled. It was pot-black night long before they were fed and seen to. Such a blackness! It is like being blindfolded with a black rag, and when you light your lamp and fire it seems to make things worse and spotlights you to all the hobos, wild beasts, villains and spooks. I made myself cook some supper and retired to my van and ate it. It's time I was home. It's a dark, desolate winter place. The Elephant stands alone. Mrs. Hooper's little stand is a block of stumps and roots and hollows away and her living quarters are in behind at the back. Her light doesn't show. I suppose I'm a coward. I am not afraid exactly but it's creepy.

September 14th
I have found winter grazing for the Elephant after much tramping. It has settled in to pour. Mrs. Hooper supped in my camp and by the fire we sat long, talking. There is a straight-from-the-shoulderness about her I like. She does what comes to her hand to help people—reared a worse than parentless girl, looked after and helped old poor sick women. Through her conversation (not boastfully) ran a thread of kindness and real usefulness. I feel wormy when I see what others do for people and I doing so little. I try to work honestly at my job of painting but I don't see that it does anyone any good. If I could only feel that my painting lifted someone or gave them joy, but I don't feel that. I enjoy my striving to express. Another drinks because he enjoys drinking or eats because he enjoys eating. It's all selfish.

The rain is thundering on the van top. The creatures are all folded down in sleep, the park blackly wrapped about in that dense dark. There is a solidity about the black night in this little valley, as if you could cut slices out of it and pile them up. Not a light anywhere. The stream gargles as if it had a perpetual sore throat. A car passes up on the Malahat highway with a swift flash of light on this and that up above us and is gone like an unreality.

September 16th
After living for a whole month, or thereabouts, in a caravan and then to return to a two-storey house with six rooms all to oneself makes one feel as if one had straddled the whole world. The Elephant is bedded down opposite the Four Mile House in a quiet pasture. It is hard to settle down. The house feels stuffy and oppressive but the garden is joyful. The trees are heavy with near-ripe apples and the autumn flowers plead for yet a little sunshine so that they can mature their late crop. The rain is drooping them heavily. Woo is still in her summer residence, defying the World, the Flesh and the Devil with hideous faces. The dogs who were so delighted to go away are now tickled stiff to come back. And Susie? To her the studio is splendid and to roam free among its litter is the tip top of life.

I have uncovered "The Mountain." It makes me sick. I am heavy in spirit

over my painting. It is so lacking. What's the use? Sometimes I could quit paint and take to charring. It must be fine to clean perfectly, to shine and polish and *know* that it could not be done better. In painting that never occurs.

Oh, I am frightened when I look at my painting! I have had some back today from exhibitions and set it afresh. There is nothing to it, just paint, dead and forlorn, getting nowhere. It lacks and lacks. The paint chokes me and I ache. Better eat paint like the monkey and make my body sick than dabble my soul in it and make that sick. A dose of salts fixed her body. What can I take to fix my soul? It is sick and aching and heavy. Be still. *Be still.* Fretting and forcing don't get one anywhere. I've gardened and washed blankets today and done them well. That is apparently my level. The work I did at Goldstream Flats is a fizzle, not one uplifting statement, only muddled nothings. And yet at times I thought something would come through and there are some thoughts in it to work out.

"Missing you a long time. I now write to invite you to my exhibition of art." So wrote little Lee Nan. He is a Chinese artist. When I had the exhibition trying to start the People's Gallery, he was much disappointed that the gallery did not go through. His exhibition was in an old brick store in Chinatown, 556 Cormorant Street. It must have taken some courage. His cold, moist little hand, as I shook it, said it did. (He once tried to join the Arts and Crafts Society and was refused because of his nationality.) His work is good and he knows it and loves it.

He had a room full of his paintings. The big double door was open and the shop window was hung with green cotton curtains, truly Chinese. He had covered the brick wall with a thin wash of white but it was still a brick wall, no delusion. There was an organ in the room and a box in a corner draped with a black and white oilcloth. There was a gay bunch of flowers on it and a little new exercise book in which the guests wrote their names, the Orientals on one side of the page and the whites on the other. There were not many signatures.

Lee Nan met each guest and said a few words. His English is very difficult but his face beamed with nervous smiles. I love his work. It is simple and sincere and very Oriental. He bookkeeps in a Chinese store and has not a great deal of time to paint. His subjects are mostly birds and flowers with a few landscapes. They are mostly watercolours. The birds live and are put into their space just right. There is a dainty tenderness about them and one is not conscious of paint but of spirit. As I stood by little Lee Nan something in me went out to him, sort of the mother part of me. I wanted to shield him from the brutal buffets of the "whites" and their patronizing. ("Quite good for a Chinaman, aren't they?" they say.) "Did you send many invitations?" I asked. "Oh, yes," he said and stopped to count. "I sent seven." I could imagine the labour those seven neat little half-sheets had cost. I have telephoned a lot of people, including two newspaper women. I hope they give him some write-ups. It would please him greatly. I and my work feel brutally material beside Lee Nan and his. I asked the price of a sketch. "Oh, I don't know. Who would want it?" he replied.

I went again to Lee Nan's exhibition. Not one of the old sticks I told about it, who thanked me so smugly and said they would surely go, has been. A great old fuss there'd be if it was someone in *society*. Lee Nan was smilingly cheerful. He expects so little. He has sold three sketches and thinks that the people will come by and by. He would like me to teach him. I feel more that I would like him to teach me. He has what I lack, an airy, living daintiness, more of the "exquisite" of life. There is a purity and sweetness about his things, much life and little paint. How different the Oriental viewpoint is! I should think we hurt them horribly with our clumsy heaviness.

It's frightfully difficult being a "good" landlady. You've simply *got* to keep the place decent, and so many tenants are indecent and if you say anything at all, you are a "beastly, cranky old landlady." It should be perfect balance of both parties, but it is not. Some of them have no self-respect at all. Dirty milk bottles in front windows or doors, underwear on front porches to sun, unmade beds in the afternoon in front of open doors, minor indecencies of all sorts, regular cut worms that nibble all your joy sprouts. I suppose I should be thankful that they are quiet ones at present, but they are such a really drab lot. No one laughs or sings or whistles or enjoys the garden. They are mouse-quiet so that you don't know if they are in or out. That's all right, but it's like a morgue full of corpses. They're not alive. Every one of them said how *good* it was to hear the dogs home again and me youlping at them. They're a lot of inanimate, mincing ninnies. I have had the other sort too, deafening rowers with squalling babies and radios and pianos, door slammers and heavy foots. I wish, oh I do wish, someone *really* nice and companionable would come, a friend person. Thank the Lord for dogs, white rats and monkeys. They, at least, are stable. Their love springs don't dry up but bubble on and on right to the grave and after.

I am painting a flat landscape, low-lying hills with an expanding sky. What am I after—crush and exaltation? It is not a landscape and not sky but something outside and beyond the enclosed forms. I grasp for a thing and a place one cannot see with these eyes, only very, very faintly and with one's higher eyes.

I begin to see that everything is perfectly balanced so that what one borrows one must pay back in some form or another, that everything has its own place but is interdependent on the rest, that a picture, like life, must also have perfect balance. Every part of it also is dependent on the whole and the whole is dependent on every part. It is a swinging rhythm of thought, swaying back and forth, leading up to, suggesting, waiting, urging the unworded statement to come forth and proclaim itself, voicing the notes from its very soul to be caught up and echoed by other souls, filling space and at the same time leaving space, shouting but silent. Oh, to be still enough to hear and see and know the glory of the sky and earth and sea!

September 26th
Little book, I have toiled all day and caught nothing. It's the mountain again.

There's nothing to it, just a fritter of nothing like a foam sauce and no pudding to go with it. I say to myself, "Lie down, old girl. Be quiet. Relax. It will never come if you fuss. Leave it. It is not your affair. It may never come but it may be a stepping stone to some other thing better."

I have been mounting paper sketches for the Edmonton Exhibition. I am not quite sure if it is a good thing to exhibit sketches—thoughts. Then I think that maybe it won't do *me* any good but maybe it will give some other person an idea that will be way ahead and go much further than mine, and that *would* be good. It's the *thing* that matters not who does it. To glorify and express the supreme being, that is *all*.

September 30th
Little book, I'm tired, bodily and mentally. I've had a visitor for three days and to one who lives much alone a visitor disturbs and exhausts. Superficially we had quite a lot in common, interiorly little. Does one ever have interior friends? I doubt it. When my work was surface smattering she liked it extravagantly. Now when I am trying to dig deeper she shies at it. She is pleased at any recognition I receive but it is for the sake of the "I told you so" of the old work when she liked it and folk ran it down, not for the sake of any growth there is in it. That is what hurts. People don't care about any development or growth, most of them anyway. I don't care a whoop for myself (it means nothing) but that I am not making them see further into the thing I am after hurts.

They have asked for two exhibits for Edmonton. When the man came to see me in summer I was all "hedgehogged" up in bristles and prepared with No. But he was so nice. He told me of the many Alberta people stuck out there on farms. Their ideal was to finish life out at the coast after they had grubbed out a fortune on their prairie farms, toiling through heat, cold, blights and blizzards, with the thought of the mild coast climate, the sea, the trees and gardens always before them. Now, with the long-continued badness of things out there, and snowed under in debts, they have settled in dumb despair to finish out there. He said they were knife keen on seeing and hearing anything to break the dull monotony. The Carnegie Extension were doing a lot in spreading round exhibitions, borrowing here and there. He said the exhibition would be crowded, people driving miles, and great appreciation shown. When he said all this my bristles all fell and I felt glad, proud to contribute a wee bit. I promised him two exhibits, one oils— he wanted them for the university—and one my paper sketches for the people. I have them all mounted now and can honestly say they are quite an exciting exhibition, rough and unfinished but expressing, a little.

October
I have just had a surprise and a great joy. My sister Alice came to see the sketches and they really moved her. She went over and over them for a full hour, changing them about on the easels, sorting and going back again to particulars. And she repeated several times, "They're beautiful. No that's not quite it. They're wonderful." And she kissed me. I felt stuffy in the throat and foolish but that

meant more to me than three columns of newspaper rot.

Two artist photographers came to the studio today. They were very enthusiastic over my work. Said it was individual and I was getting something. Am I? I've worked happily for a week grinding at some of my long commenced canvases. I think some of them are waking and beginning to move a little. It's vastly interesting. I'm a lucky devil to be as free as I am: home of my own, studio, no money but as long as I can keep clear of debt I don't need much except paints. If it wasn't for the infernal repairs always bobbing up!

I have written hard all day reconstructing my story "The Heart of a Peacock." It was the first of my animal stories and very weak and sentimental. I changed the angle somewhat. I think it sounds better now. I got so excited!

Little Lee Nan also came to see the Edmonton sketches. He sat Chinawise on his heels, spread the sketches on the floor and studied them seriously. I felt more sympathy and understanding from him than from all the other "locals" put together. His Chinese hands were expressive, pointing, indicating and swaying over the sketches. His English is broken and obscure.

Max Maynard and his wife came in later. Max picked on footling unessentials, harping on the misplacement of one small hut. He ignored the forty-five other sketches while he rasped and ranted over that one little hut. He says that women *can't* paint; that faculty is the property of men only. (He is kind enough to make me an exception.) He tells me he only comes for what he can get out of me but he goes away disgruntled as if I'd stolen something from him. Sometimes I think I won't ask him to come over any more but if he can take anything out of my stuff (and he does use my ideas) maybe it's my job to give out those ideas for him and for others to take and improve on and carry further. Don't I hold that it is the work that matters not who does it? If we give out what we get, more will be given to us. If we hoard, that which we have will stagnate instead of growing. Didn't I see *my* way through Lawren? Didn't I know the first night I saw his stuff in his studio that through it I could see further? I did not want to copy his work but I wanted to look out of the same window on to life and nature, to get beyond the surface as he did. I think I can learn also through Lee Nan and Lee Nan thinks he can learn through me, light and life stretching out and intermingling, not bottled up and fermented.

October 5th

Oh, that mountain! I'm dead beat tonight with struggling. I repainted almost the whole show. It's still a bad, horrid, awful, mean little tussock. No strength, nobility, solidarity. I've been looking at A. Y. Jackson's mountains in the C.N.R. Jasper Park folder. Four good colour prints but they do not impress me. No *I* could not do one tenth as well but somehow I don't *want* to do mountains like that. Shut up, me! Are you jealous and ungenerous? I don't think it is that.

October 6th

My mountain is dead. As soon as she has dried, I'll bury her under a decent

layer of white paint and top her off with another picture. But I haven't done with the old lady; far from it. She's sprawling over a new clean canvas, her germ lives and is sprouting vigorously. My inner self said, "Start again and profit by your experience." Oh, if I could only make her throb into life, a living, moving mass of splendid power and volume!

TRIP TO CHICAGO
1933

October 9th

A letter from Lawren telling me of his visit to the Chicago World's Fair, setting up within me the awfullest ache of longing to go and see for myself the picture exhibition. It must be comprehensive and wonderful. To be on the same continent and not to go to see it seems a shame. I wouldn't care about the rest if I could see the pictures. What an education! Well, if it was necessary for my soul's fulfilment I would see them. Maybe I've got to plough along alone and find my own way, going straight to God for knowledge and instruction. I'm not going to grunt anyhow.

Direction, that's what I'm after, everything moving together, relative movement, sympathetic movement, connected movement, flowing, liquid, universal movement, all directions summing up in one grand direction, leading the eye forward, and satisfying. So to control direction of movement that the whole structure sways, vibrates and rocks together, not wobbling like a bowl of jelly.

October 14th

Things have to be in Toronto for the first group of twenty-eight by the 25th. Only three days more to pull them together. Yet knowing that, perhaps because I knew that, I chucked all to the winds and went to Beecher Bay with Phil. It was splendid. We built a fire, ate tea on the beach. Four little tiny beaches made by jutting rocky points with round, flattened trees and wind pouring up the ravines. Groups of small trees scuttling together in hollows, and frail wind-broken shacks—such glorious shades of weathered boards. Pine trees and grey sea and sea gulls and glowing russet-red bracken. All lovely, forsaken, free and wild. Got home to my ravenous dogs at seven o'clock. I took a long straight look at my canvases.

I think we miss our goal very often because we only regard parts, overlooking the ensemble, painting the trees and forgetting the forest. Not one part can be forgotten. A main movement must run through the picture. The transitions must be easy, not jerky. None must be out of step in the march. On, on, deeper and deeper, with the soul of the thing burrowing into its depths and intensity till that thing is a reality to us and speaks one grand inaudible word—God. The movement and direction of lines and planes shall express some attribute of

God—power, peace, strength, serenity, joy. The movement shall be so great the picture will rock and sway together, carrying the artist and after him the looker with it, catching up with the soul of the thing and marching on together.

Don't cultivate parsons out of their pulpits. They are very disappointing. Let them step up in the pulpit and stay stepped up. It is best for them and you and ideals. I asked one to supper tonight and to see my pictures after. He enjoyed his supper enormously and the pictures not at all. I had hoped he would see a little in them. Down came my hopes, bang! smash! The further back to my old canvases I got the better he liked them, just skin-deep pictures, full of pettiness and detail. "There's such lots in them," he would say, "so much detail." That pleased him while the struggle for bigness, simplicity, spirit, passed clean over his head, only meaning bareness, lack of interest to him. "I don't want to see any more," he said at last (I had only brought out about one dozen) and, pointing to my totem mother, "I'd hate to dream of her." Oh, those that gab about beauty and can't see it! Another can be ungodly and all that is bad, and yet beauty can just hoist him up easy as a steam winch. We are queer. "To know the universe itself as a road, as many roads, as roads for travelling souls."* If the terminus of all roads is God, what matter which road we take? But hail your fellow travellers from a distance. Don't try to catch up and keep step. Yell cheerio across the fields, but stick to your own particular path, be it paved or grassed, or just plain old dirt. It's your path and suits your make of boots.

October 17th
The mountain is finished, and the Brackendale landscape and the tree with moving background will be coffined tomorrow and away. They ought not to go out as pictures, finished. I feel them incomplete studies, just learners not show-ers. Will I ever paint a show-er, forgetting the paint and remembering the glory? I will not berate them. I have wrestled with them honestly, now I put them from me and push on to the next, carrying with me some bit of knowledge and growth acquired through them—on, up! Oh, the glory of growth, silent, mighty, persistent, inevitable! To awaken, to open up like a flower to the light of a fuller consciousness! I want to see and feel and expand, little book, you holder of my secrets.

October 18th
I gave a birthday dinner party. Of the four guests one was a vegetarian, one a diabetic, one treating for biliousness, and the remaining one a straightforward eater. I cooked all afternoon to pacify the vagaries of each and it was a good supper but I hated food-stuffs as I dished up the messes. We three old sisters make much of our birthdays, meeting at one or the other of our houses, exchanging visits and gifts and sitting round fires to talk. Alice starts in October, Lizzie follows in November and I end up in December. Only three of us

* Walt Whitman.

left. We are particularly free of outer relatives, cousins and things. Alice usually carts along a mob of other people's offsprings, her boarders, and Woo and the dogs and Susie join the circle if the party is at my house. They have inaudibly accepted Susie now. That is, they don't hysteric when she cavorts round under their chairs.

I'm going to Chicago to see the art exhibition first and foremost and the Fair incidentally. Both Lawren and Bess have written of it and say it's grand and I'm wriggling with thrills. The art of all ages collected together, the old thoughts and the new thoughts hobnobbing on the walls, saying to each other, "We are all akin and not so different either." I wonder what they will do to me. I hope they'll speak plain, the old ones and the clever ones and the holy ones. As always, I go alone. Funny, it seems it must always be so. I'd love an *understanding* companion. Otherwise I'd sooner be alone. It teaches one things. The girls are quite keen and enthusiastic over my going and the railway fares are ridiculously low, so low it would be trampling on Providence not to take advantage. I'm dreadfully busy making clothes and safe dog pens, cleaning stove-pipes and generally arranging. I used to think the world couldn't wag if I wasn't right here running my house. That's silly, fancying oneself so important and growing into a congealed stagnator instead of living and moving and seeing.

Such sewings, carpentering, basement cleanings, shoppings! I got my ticket and moneys, silly little bank notes smaller by half than ours, and had my coat cleaned and boots soled and bought a hat warranted to be uncrushable, unspottable, uncomfortable and entirely travel proof. I've made a beautiful dress, a passable petticoat and two impossible bloomers, and had my shoes poked out in bay-windows over my worst corns, and made a comfortable pen in the basement for the dogs during my absence. Nobody wants Susie to care for, poor lamb, and she's so easy and loving and sweet. I don't think I'd better take her along, though I'd like to. The ticket man has written things all over my envelopes of tickets and things in a hand so small it will take three telescopes and a microscope to read it all. I always get a giddy head when they shoot rates, fares, prices, time tables, and directions at me. I earnestly pray the sea will be calm because I cross to Seattle on the little *Iroquois* boat.

S. S. Iroquois, October 30th
It's one grand and perfect day for a starter. I left at 9 A.M. for Port Angelus. Won't get to Seattle till 4 P.M. We (me and the gulls) have the deck to ourselves. Gulls don't wear trousers; their naked legs stick right out of their waistcoats. They are mostly young, with spotty pinafores and smudged faces showing their grown-upness is on the way. The old ones look so smooth and white and adult, the unwinking clear grey of their eyes fearlessly splendid. The whole round of the upper back deck is a solid row of sitting gulls, hitch-hikers, and no two of them have the same expression. The rail is too rounded for the comfort of their heel-less webbed feet and they keep slithering and changing places in the row

and squawking about it. As soon as they are settled a steward flaps something and then it's all to do over again.

I don't know if I feel more like a princess or a convict, I'm being taken such care of. Archie, the ticket-agent, has encircled me with care-keepers and looker-out-fors; must have thought I looked a bit old and unstarched for travelling. He saw me off himself, wrapping me in the Purser's care.

It's awful to see the ticket man flip the yards of tickets that cost so much into his pocket and give you a mere scrap of paper in return, though it is nice to be relieved of its responsibility. I simplified my rather intricate system of keep-safes to one central pocket attached round my waist with a corset lace, pinned to my petticoat with a stout safety and covered decorously by my skirt. I hope I shan't lose things. I have everything tied on and the untieables poked down my front till I look like a pouter pigeon. But I am so lost a person things just wilfully hide.

Later

It is raining at Paradise, Montana, and the clock has jumped nearly an hour. It's pretty—rolling hills and farms. There is a funny kind of pine tree that changes to a gold colour—so astonishing. I like Montana. It would be lovely to ride and ride and ride on a dear companionable pony, on and on and on. The hills look like soft shaded velvet.

Wonderful skies towards dusk—deep, billowing clouds walloping across the sky. There is snow on some of the mountains, newly falled. The little towns look so old and battered, and forlorn and forsaken. Very little life is visible and many houses are broken-windowed or boarded up. Oh, it is a vast, lonesome country, lean and unprofitable, with bitter cold and torturing heat, a place to teach me courage and endurance. I wonder if I have ever experienced it in a past incarnation or shall I yet in another? Night has shut down just before we come to the grandest part and dark will be on the Bad Lands that I wanted to see.

October 31st

Here's yesterday's tomorrow and we are rushing on and on and on, eating up space, passing through what are queernesses to my Western eyes. Occasionally, a minute of keen, pure air that cuts like a knife as one clings close to the car step for fear of getting left. Mercy! What would one do? I guess *our* West is just grand. What these people have to put up with, being fried and frozen, parched, blown to chaff! Even the telephone poles are blown bent. The little water is brackish and there are ugly scars of burnt along the grass. Just one thing I love— its space. The sky sweeps round in noble curves and deigns to come down, down even below the earth. At first I thought it was the sea in the distance, but no, it's just the sky swooped down below the brown, rolling hummocks, making you feel the earth is floating in the air, wrapped about in it. If you could be under the earth it would be there too.

Last night the train bumped scandalously as though we were being hooked on and off the engine every few blocks. At every bump some monster shouted,

"Wake," and I waked and stared straight at the sky with its high bright moon and clouds rolling and stretching out sublimely, and here and there a patch of blue with a star winking in it. The quiet brown earth, solid and sullen, seemed as if the liveness of the sky was trying to wake it up and couldn't, as if it was disheartened and sad. Poor earth, what does it want? For it can't stop growth. But the blizzards and the hail strike it, its crops are tortured by thirst, the farmer throws down his implements and leaves it to itself. Surely something will wake it all some day. After aeons of time it will come into its own and the empty, forlorn houses will have curtains and smoking chimneys, and its yawning weariness will be all cheered up and sing. I watch and watch till I fall asleep. It's all so new and interesting. I like being alone; things talk plainer so.

There is a cackling woman opposite *en route* to bury Mamma in Wisconsin. She doesn't seem depressed though she wonders if she will feel just like taking in the Chicago Fair the day after. Her heart is gummed shut around her superlative husband and her super-superlative daughter whom she left behind, but she sure brought along a waggling tongue. I don't wonder she has stomach trouble; her tongue *must* neglect her organs—it's so busy elsewhere.

There are no hummocks now. The earth is flat, not a bump except for an occasional pile of chaff, the thresher's leavings. I wish I could express that sky and space.

Oh, it gets worse and worse! It has gone so flat and thin looking. It's new ploughed mostly, and black or dead brown. Out there in the miles of flatness is a cemetery. I did not know the earth could look so thin and poor and hard. Our engine smoke rolls low over it, crushed down. I think I'll read Whitman to cheer up on.

November 1st
Chicago tomorrow and the pictures! What will they teach me? Oh, I pray I may be receptive to what there is for me. I have just read Fred Housser's letter thanking me for the sketch I sent. It came as I left home. I read it once and put it away quickly for fear of growing vain and smug. I'd so hate to be that. I have so much to learn and fall so short. I do hope the Chicago pictures give me a boost. It's so long since I've seen other people's thoughts, and my own seem wearily me-ish.

This morning it is clear and glorious—flat country, with prosperous looking farms and satisfied cattle, pigs and chickens, and vast fields of cornstalks and windmills and decent fencing, and old-fashioned houses with one-peak gables and fat barns. I suppose it's Wisconsin. There is sun and haze and a nip of frost.

Chicago, November 2nd
I'm here, and oh, the awfulest blow, the pictures aren't! They closed on the 30th! Oh my, oh me, I did so badly want to see them! I feel like going straight home and bawling. I'm going to wash and then go up and beat my head on the stone doors of the Art Institute.

Later

It's true—there's nothing to be done about it. It closed only last night. I left an order for a catalogue. They had none but will send one on when more are printed. I feel as if someone had hit me and I want to cry horribly. Now I suppose I must see the Fair, though I haven't much heart for it. It doesn't seem to matter.

Night

Spent about six hours of weary tramping from building to building and did not get one kick. The workers looked so utterly jaded and weary of the sham, for it is a sham right through, tawdry make-believes. The real things, the flowers, bushes, trees and shrubs, can't stand it. They are dried up and dead and knocking their bare, crackling limbs on the hollow plaster walls. Nobody laughs. They try to force souvenirs on you and turn peevish when you don't buy. I came home wet and cold to the Y.W. and sat in my room and snivelled dismally in self-pity.

Why, why, why must I always stand alone in my work, away from other artists, away from seeing other worthwhile work? Now I'll take my brine-pickled eyes to sleep. Maybe tomorrow they'll be clear enough to see something else besides that gallery door slammed on my nose.

November 3rd

I received a letter from Lawren. Knowing I was *en route* and the show over, he'd telegraphed, but too late. He told me to go see the director but it was no use. I did but he was hedged in by a hedge of old secretaries, regular cacti, their spikes spearing every move. I footed it to the Field Museum. The Natural History is grand, so beautifully mounted, intensely interesting. The museum is gigantic. If only one was provided with legion eyes and could toss one in every hall to do its work, collecting them as you came out, how grand it would be!

Hall of Science overwhelming; very excellent and noble but disgusting. All diseases exposed, microbes and medicine. I sat down to rest and found a movie of the first operation under anaesthetics. When the victim began to writhe I fled. Next I got mixed up in the bladder diseases, then tuberculosis. Pigs' lungs, cows' lungs, rats' lungs hanging in a row made me sick. Then came the microbe family and the toxins. Finally I arrived at human embryology. Should I or shouldn't I? I went in and it was beautiful. The little unborn babies in bottles were beautiful—such character and pathos and reality; no two alike. They looked so wise and unearthly! Yes, I loved the babies.

November 4th

It doesn't matter about the pictures really, not a bit. What I am looking for I must work out for myself. It is between God and me. Laziness made me desire to look at the pictures of others, to try and pick up short-cut recipes that others have used to get what they desired to express instead of going straight to the thing itself, to stand before it meek and silent, feeling deeper and deeper and more intensely till its life throbs and vibrates through you, till the inaudible

words of the earth, God's words, speak to you and tell you what to do, how to express.

Chicago is as windy as Victoria. Went to Marshall Field's. Huge place, floor after floor. When you roll up your eyes from the shop's middle the landings go clean to Heaven and then some. I did a little shopping. They tried my corsets on right in the eye of all Chicago (over my clothes of course) and I was embarrassed. The shop women are very courteous and helpful, the young girls so bright and attractive and anxious to help, and "please" and "thank you" when they hand the parcel and wish you goodbye and hope you'll enjoy your purchase. I hope, indeed, I shall enjoy the corset but am doubtful.

Now for more fairing. I'll tidy up that job before I do up Chicago.

Later

I've finished the Fair, that is I think I've got all I want. The nights are so bitter and cold, it's time it closed. First I went to the Aquarium and that was enchanting. It is not in the Fair grounds and is real—solid, alive, beautiful. The fish are magnificently staged and their colour and shape and markings and grace are subtle and superb. They have dignity and intelligence and marvellous beauty. It is real joy to watch their movements. The place is all dim and mysterious, long corridors with tanks sunk in the walls, beautifully lighted from above. No two fish, even of the same species, have the same expression. It's wonderful to contemplate that infinite variety of creation.

Out into the bitter blast again and into the Fair. I went here and there. Every nose was redder than the next, except the ones that were purple. The little sham lake puddles were all aboil like angry little oceans, and the fountains slopped over and blew against the disgusted passers. Flag ropers flagged, sign post directors creaked and groaned, and the dead trees rattled their bones and shivered, but not so badly as the poor souls in the Morocco Village. They looked the acme of all misery, done up in blankets and coarse overshirts, clinging feebly to life and tightly to their prices, and how folks haggled! The Chinese place was the same, and the Belgian. In the *Christian Science Monitor* hall they were snug and warm. In the Hall of Religion I heard a first-rate talk by a Mormon on their beliefs. He was so convincing and sincere I nearly turned Mormon. Then I saw Firestone tires created from start to finish, and the outside of Byrd's ship and his Husky dogs in kennels, and medieval monsters in caves with horrid smoke and abominable bellowings, heads and tails that moved and eyes that glittered electrically. I did not think much of that lurid show.

Then I came to the Streets of Paris and paid 10c. and went in. It was pretty and well got up and realistic but the undercurrent was dirty and I was glad to go out. I was sorry for the half-naked, shivering girls and hated the vulgar, coarse men who exhibited them. The wind must have tortured their nakedness. They were blue and wretched under the paint. Then, at last, I crossed over, paid 25c. and saw the babies in the incubators. They looked cute and cosy, the only warm life in all that three miles or whatever-it-is of bitter blasts, kings and queens in their own right, completely indifferent to the passing show. I could

almost willingly have shrunk myself into an incubator and started life all over again.

My one extravagance is a taxi home. When you are not sure of the way and your feet are aching blobs, it's glorious to wave a yellow cab like Cinderella and her pumpkin and be whirled off to the spread wing of the old Y.W.C.A.

Sunday, November 5th

Too late for breakfast so had it round the corner, better and cheaper. Bitter wind still persists and the sky heavy. Inside you suffocate; outside you freeze. What is one to do? Stand in the doorways and be batted by both? It is not hard getting round; the traffic is not dense and the police kind and courteous. I have not boarded a streetcar yet. Somehow I shrink when they come near and go on footing it. I must be very animal and earthy because I love the earth; it's so dependable. I can't trust machines. All machinery to me is terrifying, with an inexorable determination about it, cruel and bloodless. Yet I've heard men who love engines talk about them as if they were human. "Why," said Bert Fish, who ran the lighthouse at Friendly Cove, patting his well-kept engine lovingly, "She's like a baby. She tells me at once when anything is wrong. There's a different sound that tells you at once." I wish I could feel that way. I wonder how many incarnations it will take to grow strong and wise and get away from one's cabbage state.

I went to the Unity Centre which is no bigger than ours at home though not quite so simple. Miss Edith Reynolds gave a fine talk and a lot of it fitted in with my big disappointment of this week. I know that it is all right—working out fine. All resentment has gone. On the way home I dropped into the Institute to see the Blake engravings again. Blake knew how!

Chicago streets look Sundayish. Mr. Ford's motor wasn't turning bottom up but sat demurely in the window. The doll in the candy shop wasn't dancing. Only the United Airways nose or tail (I don't know which it is) waggled round and round, a newer invention and therefore further removed from godly ways, I suppose. Finally I got up the courage to enter a bus, after many enquiries as to which. It was one of those skyscrapers with a tin stairway that makes you feel as one must have felt when perched on one of the first one-wheel, high bikes of the dark ages. The lake looked furious, with high, dirty-brown waves as if the bottom was on top, a shake-the-bottle effect. Lincoln Park is spacious and the zoo very fine. I wanted to hug the lions and tigers and comfort them. Such glorious strength and vitality to be crowded in by bars while the great wild spirits of them walloped out, bursting through space, out, out to their jungles and their freedom!

The monkey's don't mind; they see the funny side of life and enjoy investigating anything strange and new. As long as they can play and show off and tease each other and get what they like to eat, all the rest is made up for. They *enjoy* humans, life's a jolly game of investigation. The big chimpanzees and orangoutangs, gorillas, were very human, so despairing, bored with life and mostly alone. Two red orangoutangs sat in adjoining pens leaning either side of the same door. They wanted each other's society awfully and kept up a series of rap-

ping to each other with their hairy, human hands—doubtless in code. The gorilla reclined on his elbow with crossed eyes, like a lazy old man on the park grass, and regarded the people indifferently. I wonder what he thought of us— very little I imagine.

Monday, November 6th

I have been to the ticket officer and I may be able to change my ticket to return home via Toronto and the c.p.r. I do hope so. I'm nearly full of Chicago. I went into two picture shops and stood and looked into awfulness. They seemed piti- ful. I saw the poor starved soul trying to express something, just the surface, try- ing, wanting, but unable to see or feel or express. But isn't it something that he wanted to do something, a beginning? So those who are further along than I am must feel about mine. We can't paint till we can see and feel into our subject, experiencing it. There are no short cuts. The matter rests between God and your own soul. Another's thoughts are not ours and to copy them gives us no growth. Our own expression is as subtle as the difference of expression on the face of each fish in the aquarium. Some will say a fish is a fish. No, a fish is an entity and is its own self.

It is dark today, brooding and oppressed. The lake looks cruel, bottomless and hard. The wind has dropped and Chicago is still and sullen. No letters from Toronto or elsewhere. I did expect to hear today. My first letter to them was posted Thursday. Drat the mails! Or don't they love me up there any more and are indifferent alike to my woes and to my coming? Bess has reason to know me for a spit-cat and Lawren will be up to his top hair in the exhibition and too busy to think of old me at all. Emily, don't you know by now that you're an oddment and a natural-born "solitaire"? There is no cluster or sunburst about you. You're just a paste solitaire in a steel claw setting. You don't have to be kept in a safety box or even removed when the hands are washed.

Tuesday, November 7th

The Lord be praised! I leave Chicago tomorrow at 9:15 A.M. I have felt bouncy ever since I made up my mind at 3:30 to migrate. I do look forward to seeing those dear folk in Toronto and their pictures, and to some inner talks about all the best things. I expect I shall only be able to sit like a bell without a tongue and just make a note if someone kicks me. I don't get much chance to talk to people out home about the real things, so I have no words. I want to hear Bess, Fred and Lawren talk. What a selfish brute I am! I want to get and I have so lit- tle to give. I'm afraid to give out the little I have got, afraid of mixing things up and putting them wrong and being laughed at.

Wednesday, November 8th

No letter from Toronto but I am off and it's good to leave Chicago. The ground is white and frosted. Oh, I do look forward to seeing the Toronto folk. I do wish I had heard, but I think Bess wants me. Goodbye, great station and apart- ment blocks and the university. Goodbye, blunt-towered churches who do not

use your index finger but point to Heaven with your thumbs. Soon it will be country fields and space.

I like to travel alone, to sweep along over space and let my thoughts sweep out with it. They seem to be able to go so far over the open, flat spaces that run out and meet the sweep of the sky and the horizon like body and soul meeting, the great sky illuminating the earth, the solid earth upholding the sky. Snow falls intermittently and the earth is like a woman who has fixed her face badly. There are mud icicles hanging under the motors. The railroad and the motor road lie parallel and close.

November 10th
Noon. I'm there! Bess and Fred met me and were so gloriously kind.

Bess gave a lovely party, mostly artists but all were doers of things and thinkers. The room was not only full of them but what they did was there too. I knew a lot of them before and those I didn't I do now. They were all so awfully nice to me. I loved every one. It's a rare thing to be in a company of doers instead of blown-out air cushions. At home I want to sneak off and yawn but this party lived.

November 17th
One week and two days have passed. Every minute has been splendid, too full of living to be written down. I have had a long talk with Fred and Bess, wanderings in those far-off regions where neither ground is for the feet nor path to follow. I have had long talks with Lawren in his studio, unashamed talks from the naked soul, a searching for realities and meanings, the beautiful pictures gleaming all round, calm, inscrutable notes and glimpses of the between places where the soul penetrates and the body does not, where sex, colour, creed, race do not enter.

Lawren's studio is wonderful, all quiet and grey, nothing unnecessary. There is equipment for painting, equipment for writing, a roomy davenport and peace; that's all. It is a place to invite the soul to come and gather the riches of thought, and ponder over them and try to express them, an orderly place of an orderly mind. I'm glad, glad, glad that I have these rare privileges and that I am able to talk straight and unafraid. One can't do that with many. Just with Fred and Bess and Lawren can I let go like that, throw away the shell, escape for a brief spell to a higher place of thoughts and ideals. Three times I had this experience. Now I am going home happy, contented, equipped for further struggle.

There was a rounded-out completeness about this visit—nine days of refreshing content spent with those toddling along the same path, headed in the same direction. And I was one of them. They accepted me. My own two pictures (they did not hang the third) were very unconvincing hanging there. To a few people they spoke, saying nothing but hinting at a struggle for something. My frames were shocking. Bess complained bitterly of that. But no frame, however rich, could have helped. An empty cup is an empty cup, though it may have a fine gold rim. Yet strangely I am not cast down. I can rise above the humility of

my failure with an intense desire to search deeper and a blind faith that some day my sight may pierce through the veils that hide. I know God's face is there if I keep my gaze steady enough. Everybody must work. Not only wrestling but tuning in.

Yesterday we went to tea with a little Russian lady artist. Quite a number of other artists were there—Mrs. Adaskin, a pianist and wife of the violinist, Mrs. Harris, Betty Hahn, the sculptress, and many others. One night we went to dinner with Isabel McLaughlin. She has a beautiful flat, modern and severely beautiful. It was in a high building and you looked out over the lighted city. The furniture was modern and very attractive. She's a painter. After that we went to hear Kreisler. At first I did not enter in. I remained solidly on my seat regarding the elderly man with the sad face. He had a shock of iron-grey hair and legs not perfectly straight, and he wore a heavy gold chain. Through the middle of the programme I became more clearly conscious of enjoyment but he did not lift me from the earth. I suspect I am not deeply musical. Shall I wake to it in this life or wait for some other? Bess was awake to its beauty and thought it grand.

Bess gave a great tea for me on Saturday. I knew many of the people from my last visit and there were a few new ones. Oh, they were so kind and so good to me! They made me feel one of them and not a stranger from the far off West.

All that morning I had felt awful. The day before I had talked long with Lawren. We discussed theosophy. They are all theosophists. I know there is something in this teaching for me, something in their attitude towards God, something that opens up a way for the artist to find himself an approach. We discussed prayer and Christ and God. I didn't sleep well and woke at 5 o'clock the next morning with a black awfulness upon me. It seemed as if they had torn at the roots of my being, as if they were trying to rob me of everything—no God, no Christ, no prayer. How can I ever bear it? I ached with the awfulness of everything and cried out bitterly. I had thought I might get some light but I was stiff with horror. I was soul-sick. Bess and Fred saw and were merciful.

Bess left me at the Gallery where Arthur Lismer had classes. I tried to throw myself into the work. When the guests arrived for the party I made an awful effort, and succeeded, but it was there in my heart below. We spent the evening alone talking and reading and discussing the party till midnight and as I said goodnight Fred asked, "What's ailing you, Mom?" He looked so kind and honest and I knew Bess was sympathetic so I told them about things. Fred talked on till 1 o'clock. He's a splendid explainer. He cleared up lots of things I'd got all wrong and I went to bed happier and slept.

At the party Lawren asked me to come to his studio and have another talk on Monday. Between the two of them I saw clearer and the black passed over. Yes, there is something there for me and my work. They do not banish God but make him bigger. They do not seek him as an outsider but within their very selves. Prayer is communion with that divinity. They escape into a bigger realm and lose themselves in the divine whole. To make God personal is to make him little, finite not infinite. I want the big God.

November 18th

On and on and on gliding through space, going through fine and bad, cold and mild weather. The pigs are rooting happily in the soft earth and a breath or two later the boys are skating on the Mississippi River. The trees are powdered with fresh snow. Farmers haul late grain over muddy roads. A woman comes out of her cottage with a great pail. We, as we pass, are nothing to her; the pump in the yard is her goal. This great flat country is all backyard. There are no hollows to hide the unsightly things. Rubbish is heaped in full sight. Back doors are exposed in all their "back-doorness." No friendly, protecting fence surrounds the house. Posts and wire are about the fields. The land lies naked to the eye. Only that which is enclosed by the houses' four walls remains to themselves. Other than that is public property, open to the eye of the world and to storms. Only when black night comes is there hiding or secrecy. Yet there is a baffling, open mystery, greater perhaps than our own forests where the mystery comes so close you can almost touch it. Here you go to meet it. There it comes to you and envelops you. This open land reeks of the sweat of man's toil. That forest knows nothing of toil and sweat; it is unsubdued. If they cut the forests they grow again, covering the scars quickly with new growth which again hides and shrouds its mysteries. Man can't keep up with its growth. Does he stop his blasting and sawing even a few months, it is hushed back into hidden mystery. But this land, year after year, lies open and ready for man's planting. It is servile to man. The West is servant to no one but growth only.

Last Sunday evening Lawren Harris lectured in the Theosophy Hall on war. It was a splendid lecture but terrible, one of those dreadful things that we want to shirk, not face. He spoke fearlessly about the churches and their smugness, and of mothers offering their sons as sacrifices, and the hideous propaganda of politics and commerce exploiting war with greed and money for their gods while we stupidly, indolently, sit blindfolded, swallowing the dope ladled out to us instead of thinking for ourselves. His lecture was mainly based on two recent books, *No Time Like the Present* by Storm Jameson and another I forget the title of. The preparations for war are fearful beyond relief. It took some courage to get up and tell the people all that awfulness.

The weak sunshine is throwing long, long shadows. I wish I was like a doll that can sit either way. I used to love to make mine sit with their back hair facing their laps and their hind-beforeness ridiculous. I loved to make my dolls look fools to get even with them for their coldness, particularly the wax or china ones. I loved the wood and rag much best. The wooden ones rolled their joints with such a glorious, live creak and the rag ones were warm and cuddly. But none of them could come up to a live kitten or puppy.

Valley City! How can it be called that? It takes hills to make a valley. Oh, I see it is unflat before and behind, though not so much but that the tombstones can peep over. Poor deads, I wonder if that is the highest they ever get. One last burst of sunshine is over the fields, gilding them. Our smoke is rolling behind in golden billows. There's a golden farm and a windmill and a golden cow and horse, but the richest of all in goldness and shameless shamming are the stacks

of straw and chaff. The turkeys have gone to bed on top of the barn roof, up above the icicles. How uncosy! It's getting so near Christmas that perhaps they've lost heart and think any old roost will do, poor dears! I'd rather barn roof and icicles than roasting pan and gravy myself. Life is very full of opposite contraries.

November 19th

8:00 A.M. Montana, and the grandest kind of morning. The night was also grand. I was awake a lot. I think every star in the universe was out and was newly polished. The sky was high and blue and cold and unreachable. I'm glad I know now that that is not where we have to climb to find Heaven.

I like Montana, the going and coming of it and its up-and-downness. Lovely feelings sweep up and down the rolling hills getting tenser as they rise, and terminate in definite rather defiant ridges against the sky. The sky itself does wonderful things, pretending to be the sea, or to be under the earth, and to be unreachably high. It loves to wear blue and to do itself up in little white pinafores and flowing scarves of many colours, and to tickle the tops of the mountains so that they forget about being rigid and defiant and seem to slide down the far side as meek as Moses. There's lots of cattle, heavy, slow-moving, bestial, black or red, with white faces and shaggy coats. The foolish square calves pretend to be frightened of our train. Bluffers! Haven't they seen it every day since they were born? It's just an excuse to shake the joy out of their heels.

Livingston, and my feet have touched Montana. I've smelt and tasted it, keen, invigorating. Things here are much propped up and reinforced. There are myriads of clothes-pins on all the lines. I suspect the nippy wind of this morning is not unusual. We have gone through the Bad Lands in the dark again.

Logan, Montana. I should not like to live here. The hills are clay-coloured rock with scrubby, undernourished trees. Lightning balls are on any houses of size.

The mountains are higher now, barren and a little cruel. I feel in my bones there will be beastly black tunnels soon. Nearly every house has a dog—no kind, just a leg at each corner. It's Sunday and children and elders are doing things, playing, riding, driving, looking over cattle. There are a few out in automobiles, and one complete family is setting out for church with their books under their arms, and conscious of their best. There are magpies and pheasants and rabbits, occasionally flocks of turkeys and beehives. Tomorrow we will reach the far West. Gee, my back aches!

I was in the diner when we came to those great plains before you get to Butte. We had been climbing for some time and we were high up on queer mountains of odd-shaped boulders thrown together in masses. The train wound in and out among them groaning horribly as it took the curves. Down below was a vast, tawny plain with long winding roads and a few horses and cattle. Your eye went on and on and slowly climbed the low distant brown hills. I never saw anything like it before. It was not a space of peace but rather of awe. It seemed a great way before we saw queer built-up places and great mounds of

slag, and scarred mountains with their bowels torn out and reservoirs and towns, and queer mining erections and cars of ore, all the ruin and wrack of man's greed for the wealth of the earth. We circled the great plain and went on through sage-brush. There would be a wonderful wealth of material for a certain type of painter here. Stunted little black trees and black cattle are scattered among the hills, and you can't tell which is one and which the other.

It has happened in the last half hour while I was asleep. I do not know it by the map but in my own self that the East is past and the West has come. As we came down from the hills the trees thickened. Heavy fog has shut down and all we can see is the dim ground and tree roots—everything else washed out.

I have been reading "Song of Myself" by Walt Whitman. I am very tired. I think we of the West are heavier and duller than the Easterners. The air is denser and moister, the growth more dense and lush, the skies heavy and lowering. (My hair is all curly on the edges with damp.) Might not all this affect us too?

We will arrive in Seattle at 8:30 A.M. tomorrow. I should be home by 1:30 if I connect. Beloved West, don't crush me! Keep me high and strong for the struggle.

November 20th

All night the demon monster has been rushing us into the West in a series of rough jerks and bumps, as if we lagged and it bullied. It is all West now, no trace of East left—low sky, dense growth, bursting, cruel rivers, power and intensity everywhere. I think it is a little crushing and then I note the fine trees, how straight they grow, not one kink or swerve in a million of them, plumb straight.

Now I am on the boat. Here's a corner of the lounge where I can perhaps sleep away the time or part of it. Funny thing, there was not a moment to be lost on the train. I looked intently always. But the boat is different, just water and more water, and sky galore, and snatches of land here and there, but vague and not intimate. How queenly this ship is after the snorting bumpity train! But the sea is restless. It has not the calm pushing growth of the earth.

Victoria (night)

Everything at home fine. Hot welcome from tenants, sisters and beasts. Jobs piled hat high from front gate to kennels. I'm glad I went; it was a joyful affair.

MOVING FORWARD
1933 – 34

November 28th, 1933

Yesterday three of the Hart House quartette came to see me. (They gave a splendid concert in the Empress on Thursday night.) Mr. Blackstone and Mr. Hambourg came in the morning with Miss Bicknell, but Harry Adaskin came at 2 P.M. for a real visit and talk. We plucked the easy chairs off the ceiling and got to it right away. We discussed theosophy and our work and justice and God and prayer. He told me about his new violin. It means everything to him. It is lovely to see how much. We went through my canvases and sketches. He said he liked my things in the show in Toronto and that they were always fresh and inspiring, and a different note from the Eastern material and he thought I was expressing the West and that all made me very happy. He stayed to supper. Lizzie came, found out he was a Jew by birth, filled him to the hat with British Israel and they got on fine. He is a dear boy, sincere and sweet right through. When he left he took both my hands and said he had had such a happy afternoon and he stooped and kissed first one of my hands and then the other. I loved the sweet way he did it and felt another friend added to my beloveds in the East.

Oh weary old me. Did the household round of little nothings inside and out in the sodden garden and noon was upon me before I was aware the day was fully started. Then painted till 4 P.M. and dark—one of the Goldstream Flat studies—working steadily and sanely—not very tip-toey. Then took a long walk along the shore and back through the little wood in the dusk with the four dogs. The dear old park is plucked and foolish now. The straggle of trees have lost their mystery, and the dense places where we hunted lady-slippers and felt we were right in the forest as kids. Now you cannot hide from an electric light blinking like the eye of man. The grass is muddy and turned up by football games. Just the sky is unchanged. Thank God they can't mutilate and modern-improve that. It was low tonight, bulging with wet, dropping to the horizon and then some, so that it smudged over the cold grey sea, and the gulls hurried east. The dogs were uproarious. They think about that walk all day, but they are patient. At 4 o'clock their moist noses and red tongues are a-waggle for supper but that is second to the walk. Yet, were they loose they would not go a step without me. The walk and I are *one* joy.

What hind-before topsy-turvy beings we are! Always trying to unwind the ball from the wrong end and getting in horrible snarls, starting to write from the tail end back and to paint the outside of our pictures before constructing the skeleton inside. Have you ever rubbed your cheek against a man's rough tweed sleeve and, from its very stout, warm texture against your soft young cheek, felt the strength and manliness of all it contained? Afterwards you discovered it was only the masculine of him calling to the feminine of you—no particular strength or fineness—and you ached a little at the disillusion and said to yourself, "Sleeves are sleeves, cheeks are cheeks, and hearts are blood pumps."

December 1st
A heaviness descended upon me this afternoon, a great, black foreboding cloud. Why? I cannot shake it. Are those I love worried or in trouble? I cried far into the night. Why? How should I know? Just a great wanting, a longing to know and understand which way.

I have looked at the catalogue of the pictures in Chicago that I did not see. What is the test of a picture? Not form or colour or design or technique. It is intensity of experience and feeling, the existence of the thing *spiritually*. If the spirit does not speak, nothing has been said even though the surface forms clamour and clank. If the small, still voice of reality cannot be heard above the hubbub of objective seeing, the picture is a blank nothing. Oh to realize that intensity! It is of the soul. Oh God, give it to me! It is mine already deep within, but asleep. How can I wake it? Oh, how?

Work has gone well today. I entered into the spirit of it and am tired but happy. Fred offered to look over some of my stories. I got out a great bunch last night and must tackle some of them and try and shape them. I believe it is in me to be able to, but they don't come, and the construction, grammar and spelling! Just like the paintings—thoughts but no orderliness of mind. Pull up, old girl, and remember the "pact"—I *can*, I *shall*, I *will*.

December 7th
You need not expect Lawren Harris to do your thinking for you. He suggests—leaves you to ask questions if you are interested—answers them patiently and fully—then gives you, as it were, a gentle push-off and leaves you to think things out for yourself. That's *real* teaching.

December 8th
Remember, the picture is to be one concerted movement in a definite direction for a definite purpose, viz. the expression of a definite *thought*. All its building is for that thought, the bringing into expression and the clothing of it. Therefore if you have no thought that picture is going to be an empty void, or worse still, a confusion of cross purposes without a goal. So, old girl, be still and let your soul herself find the thought and work upon it. She alone understands and can communicate with her sister out in nature. Let her do the work and, restless workers,

running hither and thither with your smelling, looking, feeling, tasting, hearing, sit still till your Queen directs but do not fall asleep while you wait—watch.

I have just come off a three days' starve and feel fine. We eat too much. It is my cure for neuralgia and such-like pains. Orange and grapefruit juice only for three days. How clean and easy one feels after, gay as pyjamas on the line on windy wash days. Yet the weakness of me puts it off, making every excuse before starting in. When started I generally stick.

December 12th
Emily Carr, born Dec. 13, 1871 at Victoria, B.C., 4 A.M. in a deep snow storm, tomorrow will be sixty-two. It is not all bad, this getting old, ripening. After the fruit has got its growth it should juice up and mellow. God forbid I should live long enough to ferment and rot and fall to the ground in a squash. I have been having supper with Mrs. Stevenson. It is her birthday today—eighty-six. She is wonderfully able but complains a good deal of rheumatics and loneliness. I think then I should want time alone to rest, meditate and prepare for the change. I am twelve years older than my mother was at her death. I do not think we shall meet those others as we left them. I do not think we shall know each other in the flesh, only in the spirit. It will be those who have been akin in spirit here, more than akin in the flesh that will meet and rejoice together.

Visitors to the studio. Some from Montreal and others, English, from Cobble Hill. The Easterners take art more seriously (effect of Group of Seven influence). The English rile me—hard, dictatorial, self-satisfied. Nice enough people but my heart goes not out to meet them. All the doors of my inner self are shut. I entertain them in the front hall and put the clock on a little to hasten their departing. I don't want to go into their best parlours and sit down any more than I want them in mine. I let the rat out hoping they'd be scared and quit quick but they loved her and stayed longer to play with her.

Went last night to "New Thought." Dr. Ryley from the States expounded on the spiritual mystery of Christmas or birth of Christ in the soul. Oh goodness gracious! What is one to *believe*? Everyone thinks he is right and runs down the other fellow's religion and extols his own. God, God, God. That's what we all want, to get a nearer and better understanding of God. Today I wrote Lawren and told him I couldn't swallow some of the theosophy ideas. I had to be honest. Couldn't let him think I was wholeheartedly in tune with it, when I am not. I do see the big grandness of much of it. It's their attitude toward the Bible I can't endorse. It's awful to have your holy of holiest dusted with a floor rag and a stable broom.

December 19th
Been out to the asylum to see Harold. The place was in an upheaval for their

Christmas concert. Harold and I sat on two straight wooden chairs just inside one of the ward doors—eleven plain little iron beds, flat and immaculate, with little square pillows. No other thing in the room but those eleven beds a foot apart with a two-foot aisle down the centre, between each row, bare, clean floors.

You go through three padlocked iron grated doors. The windows are barred. The stairs are all iron cage work. A helper paces the corridor or sits in the room always. They like me and always seem glad when I come and there is a happy feel in knowing you have brought a wee glim of sunniness into that grim place. I jolly Harold and he is quite merry. We talk of all the Indian villages we both know and of animals which we both love and I take an interest in his work, polishing the brass spittoons. And he is fearfully interested in my painting. He hoards up every notice that ever appears in the paper about it. His pockets are stuffed with my letters and press notices. The worst bore is when he reads my *own* letters aloud to me. How I wish then I had not made them so long-winded!

Now all the jobs are about done up. Parcels for the nieces are bought or made and packed and posted. The candy-making orgy is over for the year. Cards are posted, cemetery holly wreaths made. Maybe tomorrow or next day I can paint a little. There was a piece in the paper about my picture that the women's clubs sent to Amsterdam. The critics had dubbed it the only one in the collection showing spirituality. Oh, if it really *were* a "spiritual interpretation." Will my work ever really be that? For it to be that I must myself live in the spirit. Unless we *know* the things of the spirit we cannot express them.

Christmas Day, 1933
That's over. We've turkeyed and mince-pied and exchanged gifts and feasted each other and kissed all round and written and received mail sacks of letters. They have charity-ed and Sunday-School-treated and heard services radioed from Bethlehem and admired church decorations while I cleaned and stuffed turkey, made ginger-beer and candy and pie and cemetery wreaths and done the menial family jobs, and now it *can't* happen again for twelve whole months and I'm mighty glad. I painted a little this afternoon. I walked along the cliff yesterday with the dogs. The heavy rains have washed down whole banks. They've slithered and sat low and left bare clay scars, slimy, unbeautiful. I must get out there and study and absorb; realize space and eternity out there.

December 28th
Oh you half-thoughts that come tantalizing and eluding! Why do you tease so? Why not come and *stay*? This Hide-and-seek business tires one. Do you say, "If we showed ourselves too plainly the game would be over; you would cease to seek"? Perhaps. It's the same always—people, places, pictures, reading. The same thing. I suppose Lawren would call it "Law." When you are dimmest and not really looking you see clearest. You can't put the "dimmer" on yourself. It is just there at times. When it's there your memory works in a different way. For instance in reading you won't remember a single *word* but inside you remember

the meaning or a glimpse of it. You couldn't put it into words or explain it to someone else. In painting you don't see the woods or whatever you are looking at but something else bigger and more vital. In people, you do not see nor can you afterwards recall their features; their faces do not exist. What you know and love is way in back, in their souls. I know that Bess is beautiful and serene. I know Fred's smile. I know nothing about Lawren's face, can't remember one feature—yet I know him best and love him best. I do not remember Harry Adaskin's face.

The spirit and its vehicle, or manifested body, must work together, through each other, for perfect realization. What would be the good of a carriage with no *go*? What would be the good of the *go* with no carriage to sit in? The body must not be ignored and the soul must not be ignored—a third thing must be born of the two. I cannot name the thing and all the books can't and I do not think it needs a name. A name would spoil it, would be too crude for such an elusive—spirit? being? thing? Even a thought is too hard and material to press upon it, though sometimes it travels in thought. When you go to pick it out of the thought, separate it, clothe it in definitions, it has gone—lifting up beyond, just out of your reach—and left you empty.

Do you know the exquisite, self-respecting, firm feel of a mended garter and taut stockings that have slopped down your calves from a broken one? Well, that's the same feel you get from a good *honest* day's painting after a period of impossibility.

December 31st
Express, express, express, lead up and on through the picture. God is trying to get through, trying to speak. Swing the thought through the whole, no abrupt disharmonies, transitions. A bird flies straight with ever-flapping wings till it has reached its goal. Then it is finished and rests till the next idea of action comes to it and away again to a fresh goal, forgetting its last flight. Only its wings are kept strong and ready by every flight.

11:30 P.M.
A few minutes more and the New Year will come. The present moment, that's all we have. This looking forward and looking back is unprofitable. I have done? I will do? No. I AM DOING.

I have been to my two sisters'. Oh, how little our real lives touch! We love each other dearly. I can't imagine life without them; it would be one awful blank. They are so good and so unselfish. Yes, we are jig-saw puzzles with the pieces mixed. We don't make one picture. Was it accident we all came in one family? Nothing is accident; we needed each other. Will we be together in the next incarnation? We are each so utterly different—lives, aims, outlook. Bless them, bless them! God bless us all and make us all more understanding in 1934.

January 5th, 1934
I worked well today, painting with vitality and intention. In consequence, am tired and glad.

January 16th
Here I am, little book, having neglected you for some time. I have written to Lawren twice, so that does you out of your little spiel for I work it off on him instead of on you. It's all the same as long as you can get it off your chest, only it's easier when there is flesh and blood at the other end and, more than that, an answering spirit.

I heard from Gerhardt Ziegler yesterday and was so happy, for the last time he wrote he was very near death, but he is better now after much suffering. Poor boy, he has a beautiful mind. If all Germans were like him—he has altered my whole attitude towards Germans. Oh, we are all bad and all good. If we could only all meet on our *good* planes! Gerhardt says there's a little bit of me over there in South Germany in his garden, the little bit he took back in his heart of me. I'm glad; I like a little bit of me to be over there in that land of strangers. I too have that little sprig of German niceness in my heart's garden here in B.C. which he brought and left with me. We were both looking perplexed, and poor Klaus too, that day up the Malahat, where we drove in their travelling van, and picnicked and talked of all these things and read Walt Whitman aloud. Little Koko was there too. Now Klaus and Koko have gone on to other places to grow but we have more here to learn first.

My six pictures came home from Ottawa yesterday, returned without thanks, no praise, no blame. Wish Brown had said something even if it had been bad that would have put my back up. Nothing hurts like nothingness. A flat, blunt weapon gives the deepest, most incurable wound. I look at the pictures and wonder are they better than my present-day ones—this year's? I don't know but I do not *think* they are. I think they have better colour and perhaps more strength but any shapely or fine-coloured object can be pleasing. (Not that Mr. Brown did find my pictures pleasing; apparently the reverse.) But as I look at my big forest I find a lack of life—the essence. If manufactured materials were heaped together in a good light and pleasing folds wouldn't they do just as well? That is not what I want—the thing I search for. They lack that vital understanding thing, which must grow and develop and unfold in you yourself before it can come out. That something must be realized and experienced in your own soul before it can possibly be expressed by you. So I heap the pictures back in their room, not ashamed, regarding them as the under-crop that is to prepare the soil for a finer one—dig them in for manure. Don't sit weeping over your poor little manure pile, but spread it and sow a new crop on top and the next one will surely be richer for it.

I went to hear Raja Singh's lecture on Gandhi. Singh is a Christian Hindu, educated and vital, big, broad and spiritual. Gandhi is *not* a professing Christian but he lives it. There was no mean, petty narrowness so often visible in Christ-

ian missionaries and preachers. The man was big. When he got through you loved him and Gandhi both.

Jack Shadbolt and John MacDonald wrote from New York. They want me to have some pictures of my pictures taken and send them over there in the hopes they can persuade one of the galleries over there to stage an Emily Carr exhibition. I refused. It is not practical and I do not want that thing, publicity. I want work. I do not think for an instant they would want my stuff anyhow and oh, the worry and trouble! No thanks.

January 18th
I asked Raja Singh to supper and Willie Newcombe and Flora Burns to meet him. Somehow I wanted to ask him into a Canadian home that wasn't a parson's. He is a most charming man, vital, intense. He phoned at 5:30 to say he was just in from a meeting and would be along shortly after six. I gave him minute directions and got my dinner all cooked. The others came and I sent Willie out to hunt the Raja. A perfect deluge of rain came suddenly. Willie found the Raja wallowing through it in the black, completely lost. When he accosted him he thought Willie was a holdup man. Well, you never saw such drowned rats! The Raja was hatless and had no umbrella. His black hair hung down in dripping ringlets like a wet spaniel's. We got his coat off and shook it. His pants were soaking from the knees down, and his shoes. I suggested he take off his shoes, but his pants! I offered to go below and borrow a pair but he wouldn't hear of it, so I got him a towel and he dried his hair and we had supper and were very merry over it all. He brought some interesting photos. He will come and visit me some afternoon he says and I hope so, for I like him—so in earnest and no prig, but splendid, big and doing something. He works with Eurasians, notwanted children of low caste Indians and white men, often Oxford and Cambridge men. They have to fight to get the children; the women want them to sell for prostitutes. They move them right away to a colony by themselves. When they are grown, they are given free choice, not coerced religiously or any other way, but left to be individuals, with the ideal before them of making a fine contribution to India and of being looked up to, not down on. He says their brains are splendid. They will make a fine, new race. That is real missionary work.

January 25th
I have heard two more lectures by Raja Singh, and today he has been in my studio from 10:30 to 1:45. He is fearless, earnest and grand. We talked of many things. Everything in him centres on Christ—being consecrated to Christ, opening oneself to become a channel to be used by Christ. He has a child-like, simple faith—no sect, no creed, no bonds but just God and Christ.

January 29th
I have said goodbye to the Raja. He's splendid. I heard him eight times and I

am so glad he came here—I can't tell you how glad. My whole outlook has all changed. Things seem silly that used to seem smart. I have decided to take my stand on Christ's side, to let go of philosophers and substitute Christ. I wrote to "Uncle Raja" (that's what his Eurasian children call him) and he gave me a beautiful "May God bless you" as I took his hand and said goodbye tonight after the lecture on Mahatma Gandhi. Oh, I do want the kind of religion that he offers—it is verily of Christ. As he lectures you lose him; it is God speaking. His great clear voice, rich and carrying well, rolls out uttering fearless truths, sincerity, conviction. The man is surely inspired; the vitality he puts into it is not human. From his fingernails to his toe tips and right up through his Indian black hair, it is life exultant. He is radiant. When it is over, great beads of sweat are on his forehead. He wipes his face and his human body sinks into his seat and he covers his face with his hand and I know he prays then. His invitation to pray is so simple, just "Shall we bow our heads in silent prayer?" And after a few full, live moments he begins, deep and quiet, "Our loving, holy, Heavenly Father" and the few simple sentences take you right in front of God. Oh, this is live, vital religion. The theosophy God and philosophy are beautiful but cold and remote and mysterious. You circle round and round and rise up a little way so that your feet are loose but there is beyond and beyond and beyond that you never could reach. God is absolute law and justice. But here a live Christ leads you to God, and the majestic awfulness is less awful. Tonight he interpreted the life of Mahatma Gandhi, brought out all his nobility and greatness, and spoke so lovingly and understandingly of his weakness as if he was speaking of his own father that he loved.

I loved to be blessed by good ones. Now there is one more added to the remembrance garden deep in my heart—Uncle Raja. Down in my garden is neither creed, nor sex, nor nationality, nor age—no language even—there is just love. Only those who have touched my inner life, my soul, do I plant down there. No matter how intimate I have been with them they cannot get into that place unless that mysterious something has happened between our souls.

I have written to Lawren and told him about things. I think he will be very disappointed in me and feel I have retrograded way back, fallen to earth level, dormant, stodgy as a sitting hen. I think he will hardly understand my attitude for I have been trying these three years to see a way through theosophy. Now I turn my back on it all and go back sixty years to where I started, but it is good to feel a real God, not the distant, mechanical, theosophical one. I am wonderfully happy and peaceful.

Last night I learned that dreadful, horrible thing about poor Lizzie. I am glad she has told us and asked us to help. She is such a good soul! I just can't bear it. Those are the places Christ helps. He did last night.

God, God, God! Oh, to realize so completely that you could utterly let go and passionately throw your soul upon the canvas.

February 7th
Fred's crit is fine, and kind too. He was honest with me and, oh goodness, how

few people are! It's a compliment when people don't think you want "eye wash," as Fred calls it. He says there's too much *me*, too much *originality* (I suppose he means *striving for effect*, I did not know I had done that). I'll at them again and try and unify and concentrate and build to a pyramid and unhitch my horse and put him before the cart and cast out *me* and seek to find expression for the wordless subtlety of the beasts. He says I must live and experience my stuff. Heavens! I thought I did. They swamp me at times but I haven't got connection between the thing and its equivalent in words.

The snapping of this theosophy bond will make a difference to my beloved friends in the East. They all do so believe in its teachings. I wonder if it will cut me completely adrift from them. But I am glad to be back again and have peace in my heart. Alice is much interested in the Raja's message also. That and this dread thing hanging over Lizzie is bringing us closer together.

February 12th, 6 A.M.
I woke with this idea. Try using positive and negative colours in juxtaposition. Complementary are negative to positive. Try working in complementaries; run some reds into your greens, some yellow into your purples. Red-green, blue-orange, yellow-purple.

I have decided to do what I can to give practical enjoyment with my painting, when anyone who can't afford to buy but *really* enjoys one, to give it freely. I have given one to the Houssers, to Harry Adaskin, to Harold in the asylum and also one to his friend, to make Harold happy, and one to Lee Nan as a New Year's gift and one to Gerhardt Ziegler in Germany and am sending two off to Mr. Hatch. He wrote he never thought women's work (painting or writing) serious or strong but he excepts me and a few others. Edythe, Jack, John and Fred all say my work is better than the American work in New York. I do not agree. I don't want to be mean and snippy but I don't think they know. I must get a hustle on and make time. Not a brush stroke today—painted stairs, cut down a pear tree, went to town to see Lee Nan for his New Year, fixed my sketch-keeper under the table—a million little chores. But I am *hedging*, not facing the problem before me—how to express the forest—pretending I must do this and that first, and indeed things must be done some time, somehow, but the other should come *first*; it's my job. It's much easier to dig the garden, clean the basement, paint stairs, than paint to express subtle interior things. I let myself follow the path of least resistance and shirk delving down to the bottom of my soul. I wish someone would spank me and set me down hard so I'd cry and be good after. The woods begin to tease me these fine early spring days but I can't go yet and the winds are bitter cold.

Dr. Wells of Edmonton came and was apparently interested. He stayed an hour and a half. He said, among other things, that Eric Brown does like my work and considers me one of Canada's serious workers. That being so, why does he sniff so at what I send over? He treats me very queerly, ignores my stuff, looks the

other way and doesn't hang it. It's funny that my work doesn't speak out of its own dirty old studio. Dr. W. declared the things I sent to Edmonton were not the same he saw here. They *were* those very same. Lawren said his always looked so much better in his studio. Seems to me his look pretty fine out too but my own out among others make me *sick*. They look awful. It's pretty rotten painting like that for you can't send your studio forth with the pictures, to background them. Good work should tell out anywhere.

I worked well today, carrying out what came to me the day before as I woke, about painting in primaries, using positive colours with a few negatives for rests between. I felt my canvas pretty stirring. It did not seem like "guidance" because it seemed too giddy and violent a method to come from God. All the same I did not dare to refuse and went ahead. Something is needed to wake me; I've got pretty stodgy and negative in colour.

I wonder if I should open the studio to the public for two days. There are many who are kind to the work. I think somehow perhaps I should. It *might* help someone. I don't like it but it's my job, perhaps. Gee! I want those woods to go whiz-bang and live and whoop it up with a vim. *Not* vulgar, blatant see-me-do-it, but joyous, irrepressible, holy, glorying uplift to God.

February 16th

I have had a long, fine letter from Lawren. How could I ever have doubted his friendship and thought that when I told him about having gone back to Christianity our ways would more or less part? He is glad I have found inner light and blesses me harder than ever. I am so glad! I want to struggle ahead like thunder now and, after all, the struggle is being still—not slack, but *still* and *alert* for any leads that may come through, and, like poor Mary, ponder them in my heart. I like the Virgin Mary; she was not a blabber.

February 18th

Went to early communion at the Cathedral this morning (8 A.M.). I couldn't help noting how melancholy all the people looked. They clasped their hands and looked straight down their noses as if something awful had happened instead of being grateful and glad in their hearts. I can't think that holiness means unhappiness. Seems to me real holiness should mean lasting happiness. That's the kind I want to get hold of. That's the kind of holiness I want to come into my painting too—praise, every bit of nature praising God. In *The Sadhu*, lent me by Raja Singh, he is describing Heaven as seen by him in an ecstasy. He says, "Everything, even inanimate things, are so made that they continually give praise and all quite spontaneously." That is a wonderful thought, and here in a minor way they may be doing the same thing if we were sufficiently spiritual to see it. That seems to me to be the real meaning of art. If we could see and express that one thing only. But that could only be attained by living a pure spiritual life and by constant prayer and communion with God as one works. This is difficult. So many evil, selfish or vain thoughts come into the mind even in the midst of painting—grouches and grudges. One can not always sing in his

heart while he works but a singing heart, I am convinced, and the mixing of joy and praise with the very paints, as well as the ideals and inspirations one receives, and the forgetting of oneself is the only way. Those old religious painters lived in their religion, not themselves. Our B.C. Indians lived in their totems and not in themselves, becoming the creature that was their ideal and guiding spirit. They loved it and were in awe of it and they experienced something. We must have awe and reverence but above all *love* of God, if we want to express his creation.

I have been reading the life of Vincent Van Gogh—poor chap, so strong and so weak!

Just came from a lecture on the history of art. Went sound asleep in the middle. Met the lecturer at dinner first. Conscientious stuff but not thrilling and too long-winded. Slides were good. What those men got into their work was astounding—knowledge of power and the something underneath. Makes us poor, puny present-dayers look pretty small, and cheap as tooth-picks. Look at their thoughts and their draughtsmanship!

My canvases came from Toronto yesterday. Took $7.40 to pay express, which leaves me $1.40 to live on for one week and buy dog meat as well. What's the good of sending to exhibitions? First I sent to get the crits of the men in the East, which were helpful. Now they don't give me any. Why? I got *nothing* this time. Two people, neither of them artists, caught the meaning. One of the mountain and one of the tree. Just two people. Is that all I gave? It's rather disheartening, this painting. Is it useless and selfish? Or is it my job, with a hidden meaning for myself and others? I don't know. The pictures look so much better in their own studio! Now, at home, they seem to mean a little; in Toronto they looked poor, mean and awful. I am digging into housecleaning and gardening. Spring is bursting but the wind cuts like ice.

February 28th

I have finished the "Cow Yard." I think it's better than the rest. I've put all I know into it, lived the whole thing over, been a kid again in the old cow yard, fished for tadpoles in the pond, felt the cow's slobber on my hand, roasted potatoes in the bonfire, scuttled past the "killing tree." I get so worked up over my funny creature stories, then once they're finished, I'm done with them completely, don't make any use of them nor have the courage to *try* a market. I've never tried one yet. I'm sure no one would take them. Still it's feeble not to try. I like the "Cow Yard." It's honest and every incident is true.

March 2nd

I read the "Cow Yard" to my two sisters. What a much worse ordeal it is to read or show your own work and your own self to your own people than to the rest of the world! Why, I wonder. They smiled a few anaemic smiles as old episodes brought memories of the old cow yard and both said, "Very good" in

a wishy-washy way when I had finished, then went on with their work and did not allude to the story again. *Could* that mean interest? They simply did not see anything in it. Lizzie said, "I wonder if you couldn't get it into a child's magazine." Alice said, "I'd like to see it in print." Neither of them understand the sweat and thought and heartaches that go into painting a picture or writing a story. They want just some surface, sentimental representation. I did sweat over the "Cow Yard," trying to show the cow yard's internals and the big lessons of life to be learned there but I guess I failed entirely. It was never intended for a children's story. I was trying to show life. Well, chuck she goes into the failure drawer, done with. What a houseful of failures I have, to be sure! That's that! What next?

Life, life, life, why are you such a huge, big Why? Why can't we all talk one language and understand each other? I really *do* feel a deep interest in both my sisters' work and what goes on in their lives, as far as they let me. Mine does not seem to interest them in the least. The dogs are much more interested in my doings, even Susie is. Now, this is despairing and it won't do and it is busting the "contract." I've got to keep my courage up and remember the Sadhu's prayer. "Graciously accept me and, wheresoever and whensoever Thou wilt, *use me* for Thy service." That's all that matters.

I don't want that fluffy stuff. Better that they should be indifferent than that. I suppose it's sympathetic understanding one craves. When I read the "Cow Yard" to Flora she discussed every bit and chuckled away over the incidents and I felt like ginger ale just opened. Now, after reading it to Lizzie and Alice, I feel like the dregs left in the glasses next morning.

March 3rd
I've been thinking. The girls did not care for the "Cow Yard" because they never really cared about the real cow yard. It didn't mean anything to them in itself. It was just a place where creatures were kept. They weren't cow-yard children. How could they get the feeling of it? All the same, *I* was the one that failed; I did not make the meaning plain.

March 5th
Lizzie came in. "I've brought you a book so you can get the address to send the 'Cow Yard' to. It's *Short Stories by Ella Wheeler Wilcox*." It was by Mary E. Wilkins and published twenty-two years ago in Edinburgh. She said, "I wish you'd change the name. 'The Barn Yard' or something else would be better I think." "But," I said, "the whole point would be gone. It's the *cow* yard. The cow is the centre of the whole story; it's built round her." "Well," she insisted, " 'The Barn Yard' would do as well and sounds better." Oh, didn't I make my story clear even on that one point?

March 6th
It's a help to sing to your picture while you work. Sing that canticle, "O, all ye works of the Lord, bless ye the Lord. Praise Him and magnify Him forever." I

am trying to get that joyous worshipping into the woods and mountains, the work of the Lord. I'm glad I have a lonesome studio with no one to hear but the dogs and Susie—and God.

I have begun the crow story. It is to be done mostly by conversation—people discussing his merits and demerits—little direct description.

March 7th

There now! It doesn't pay to try to be nice. Mortimer Lamb asked to come to the studio and I said, "I will try and be decent and amiable and helpful to him." So I tried and I rattled out millions of canvases and sketches, which is hard, tiring work. Result—"I *have* enjoyed myself so much. May I look in *again* before I leave," says Mortimer. He's all keen on having an exhibition of my stuff in London. (They'd never accept it.) "It's a shame to think of you stuck out here in this corner of the world unnoticed and unknown," says he. "It's exactly where I want to be," says I. And it is, too. This is my country. What I want to express is *here* and I love it. Amen!

Oh, I'm a lazy woman. To *paint* one must make the *supreme* effort. I mean the effort of emptying oneself, the effort of abandonment. But one goes out and dreams and *drifts* instead of absorbing. Heavens! What a lot of stuff these people pour into my ears! It doesn't harm me any, for the simple reason that I don't think they *know*. If I did think they did I might get chesty. Nobody knows any other body's struggles. Oh, that great, big, huge, enormous something supreme that my stuff lacks so entirely, that oneness and unity, the thing that lifts one above paint, above rot, that completeness! I think if one could find that they would stand face to face with God. How could one ever hope to be holy enough to paint that way?

March 8th

Out on the cliffs sketching for the first time this year. It was unbelievably good, sunny and warm. Protected by the bank from the north wind, I put my "whole" into it—sky and sea. Came home and built a big paper sketch from the small, got quite a sweep and swirl to the thing and lost it again. Will whack again tomorrow. Very happy all day.

March 9th

Dear Mother Earth! I think I have always specially belonged to you. I have loved from babyhood to roll upon you, to lie with my face pressed right down on to you in my sorrows. I love the look of you and the smell of you and the feel of you. When I die I should like to be in you uncoffined, unshrouded, the petals of flowers against my flesh and you covering me up. As a baby it seems I loved to roll and grovel on you. My mother told a story. A small boy and she were comparing babies. My mother seemed to be coming out on top; her baby was a girl, his a boy; hers was fat, his lean; hers sweet-tempered and healthy, his lean and fretful. Then he found wherein his beat Mother's baby all hollow. "Anyhow, Mrs. Carr," he said, "my baby's the *cleanest*." I, toddling and

tumbling in the garden, was earth-coated, his baby was spotless in his pram.

Another time I remember my brother-in-law trying to pay me a compliment on my return, grown-up, from the Art School. "Quite a young lady," he said. "Not such a smell and flavour of Mother Earth about you." Oh, Mother Earth, may I never outgrow the wholesomeness of your dear smell and flavour!

I have been entertaining a woman who has been giving a course of lectures on the history of art. Oh, what a dull woman! It was like trying to make merry with a stone crusher. She is not an artist, only a book-learnt lecturer on art. She drones on nearly two hours. As soon as the lights go out for the slides you hear a gulp of relief go round and the chairs creak gently as relaxed bodies settle to sleep. I don't know one soul there who doesn't sleep through the latter half, and such a blinking when the lights come on! Well, she got even with me by the corpse gaze she gave my pictures. I have never showed to a dumber. It was awful! If she'd only said, "Damn! They're awful!" I'd have been so thankful. She evidently hated them. Wonder what she'd have said to today's and yesterday's sea sketches. They're pretty wild and I hope lived a little before I loaded on paint and strangled the life out. Will I ever learn the art of developing the vision without killing it? Oh, the things waiting down there to be expressed and brought forth in gloriousness!

March 18th

Ah, little book, I owe you an apology. I've got to like you despite how silly you seemed to me when Lawren suggested I start you. You help me to sort and formulate thoughts and you amuse me, which is more than housecleaning does, and that is what I have been doing for the week. Well, it's all in the day's march, but the housecleaning march is bad, uphill going, stony, grim, and grimy, and nothing so unflinchingly and brutally tells you your exact age.

Three women from the Business and Professional Women's Club came out to select the picture I told them they could have to hang in their clubroom. Two stiff-backs came, just. I could feel them bristle as they entered the studio. I asked what space they had and what sort they wanted. One of them said, "I like your Indian" (an old, old man). Well, I brought out some. Nothing suited. They sniffed and stared and stared and sniffed while I felt helpless, irritated. A third dame of selection was to come later. Well, I fumbled round the canvases trying to see things with their eyes, and couldn't. My stature simply isn't business profession. However, No. 3 came duly and pretty quickly sorted out her likes and the others' dislikes. They took the despised "Mountain" which the Easterners saw nothing in. Gee! I wrestled with that mountain and I'm not through with "it" (the subject) yet.

Yesterday Phil took me on a van location hunt. We found one I like greatly, the Esquimalt Lagoon. Wide sweeps of sea and sky, drift galore, and hillside and trees, and great veteran pines. It will be some time yet before I can go. We looked in *en route* to see the Elephant and jacked her up higher. The dear beast

looked O.K. It was the lovely time of day and the Lagoon and woods were at their best—mysterious, the material dormant, the spiritual awake. I *think* I could paint there.

March 20th

I sailed up the church aisle Sunday late, so as to avoid the obnoxious soloist, and got there just in time for her solo. Then we had a hymn and as I looked down at my book I discovered great splotches of whitewash on the sleeves of my coat. Then I further discovered I had gone to church in my *very worst* yard coat—whitewash and paint all over and two holes in the back as big as oranges and the lining hanging out. I laughed right out—I couldn't help it—and caught Mr. W's eye. He was holding forth and I suppose he thought I was laughing at him. Nothing for it but to sit it out. I got out during the last hymn, fuming. It's too bad to wear even to the beach. A big worsted loop keeps it shut at the neck. I'm fed up with that church somehow since they amalgamated—too much repetition, too much music (or noise rather). The pianist BANGS and the soloists shriek, too many flowers stuck all over the platform in all sorts of vases on footstools, jazzy lace curtains with horrible zigzag patterns, and Mr. W. so tickled and smug—at getting the job and a salary, I suppose. He tells the same old stories by the yard. His voice is like the gramophone needle scraping blank. I guess it's time I moved on. But where? I'd "sit under" the Dean but I can't hear one word in the Cathedral. Most of the parsons just chew words. *If* there is any juice to their performance they swallow it. It's me that's wrong, I guess. I want Christ's teaching and living, not church dogma and doctrine. I wonder why Raja Singh did not answer my letter. Somehow I'm afraid he's in trouble or sickness because he's very polite and it needed answering.

They came and got the "Mountain" today. I was ungracious and did not ask them in, said I was housecleaning and hauled the Mountain to the door. Goodbye, old Mountain. How will you like the "Business and Professional" eye? Will they be kinder to you than the "Grange" eye, or even worse?

March 26th

Heavy today. Such a weight upon me. Weather grand—several hours' good rain, and the earth, flowers, birds whooping it up and rejoicing in mellow deliciousness. I did a fair sketch this morning, too. Am working intensively this week. I make a sketch one quarter size, loose-knit and superficial but *observed*, bring it home and make a full-sheet one (oil on paper). I try to take it further than the small one and express all I know of that particular theme and the purpose of the sketch to wake and enter the place of it. What I am struggling most for is movement and expanse—liveness. By George, it's *living* out there on the Beacon Hill cliffs. I'm a lucky devil to live near that wideness because it gets increasingly difficult to urge myself to the effort of setting forth on longer journeys for material. Weariness and rheumatic joints try to down me and I have to flog my spirit to rise and fly over them.

March 27th

I got a letter today that pleased me greatly. It was from Smith's Falls, about a picture exhibit, that one of mine was in. She says, "We have had a glimpse of British Columbia through your eyes and want to thank you. We know the B.C. woods and it made us homesick. Undoubtedly many did not understand your picture, not knowing the almost tropical growth of B.C. We, my husband and I, have lived in it, climbed in it, camped in it and found it just right. Accept our sincere gratitude." That's worth a lot of struggles, the kind of praise that thrills and makes you tingle to go on, to think you'd made someone feel. How different to those beastly empty write-ups, varnishing the "you" and ignoring (or worse) the thing you're struggling for.

March 31st

Did Good Friday penance—went to see Harold at the insane asylum. He is writing an autobiography and spent the hour and a half of my visit reading it to me. It is wonderful, quite good in spots and wild romance in others—things he has got from stories he's read or heard but that never happened to him. Still, it keeps him busy. He kneels and writes at a chair. The other patients laugh at him and steal his papers away. However, the attendants seem quite interested and keep his book for him. I took him a fresh supply of scribblers and pencils. He is intensely occupied with his story, just as thrilled as I was with the "Cow Yard." "The trouble is, I don't get enough time," he says. "You see there is my work [the polishing of the brass spittoons] in the morning, and I help set the tables." Then he kneels to the chair, with his white face and damaged forehead bending low over the seat and his misshapen feet thrust out behind and his poor dull brain rummaging among his confusing memories of happenings and readings. "You see," he told me half a dozen times, "I want to do this thing thoroughly and put down the whole truth—only the truth." When he read, his whole being went into the thing. When he described the cattle round-up in the Nicola he made the calls of the cattlemen with terrific gusto. New paragraphs were frequently started, "I Harold Cook, author of this book." It is all written in a fine, neat hand. Sometimes it takes him very long to find his words and spelling in his dictionary. Sometimes the patients help him.

He wouldn't let me go, asking me about its publication, clinging on to my hand, the keepers waiting. "Look here," I said, "I'll get shut in and you'll miss your supper," and finally got out. He has been writing it for several months now. Well, at least it means that the poor, muddled brain fretting over captivity has been released for spells into the freedom of memory and imagining. No bars of asylums or jails or poverty and sickness or any devilishness whatever can arrest the flight of our imaginings nor hide from us what is stored in our memories. This bit of rummaging in my own memory, probing and clothing the ideas that come to me about the creatures I have had and known and loved—what a joy and unfolding of many things it has brought to me! What matter if they are never printed or heard of or seen? Maybe they've helped to develop some unexplainable thing. Anything worth while is bound to burst out, but we don't know

how or when or where. Hidden away in a drawer they may have done something, even if it's only developing me so that I may help others by *understanding* them better. I certainly can enter Harold's joy in his biography far deeper than if I had never tried writing myself. Funny world.

April 1st—Easter Sunday
I went to Early Celebration at the Cathedral. It was full—men and women all "remembering." It was cold and wet and early and the flowers through the park were trying to bear their burdens of rain and hold themselves up from the mud. The church was full of lilies and daffodils. I took communion in the side chapel. The little Chinese curate passed the cup. I liked being served from his hands. There is something specially spiritual about the Orientals. Their slender hands touch beautiful things so reverently. Our British hands are large, practical, useful appendages, but they are ugly, clumsy, uncouth. They are not reverent and tender of the touch of loveliness.

One feels aged in the Cathedral. It is impossible to hear and hard to see. I don't try to any more. I just sit and "feel" God, just try to get close and let the words go. The Cathedral is very new and, because it is, it tries to pretend age. The decrepit, old, and lame attend, decent and uninteresting spinsters, and "h"-less. Old Country families that stick like limpets to the rock of the "Church." And, oh the headgear!—postscripts tagging on to the tail of Queen Mary.

April 4th
I woke this morning with "unity of movement" in a picture strong in my mind. I believe Van Gogh had that idea. I did not realize he had striven for that till quite recently so I did not come by the idea through him. It seems to me that clears up a lot. I see it very strongly out on the beach and cliffs. I felt it in the woods but did not quite realize what I was feeling. Now it seems to me the first thing to seize on in your layout is the direction of your main movement, the sweep of the whole thing as a unit. One must be very careful about the transition of one curve of direction into the next, vary the length of the wave of space but *keep it going*, a pathway for the eye and the mind to travel through and into the thought. For long I have been trying to get these movements of the parts. Now I see there is only *one* movement. It sways and ripples. It may be slow or fast but it is only one movement sweeping out into space but always keeping going—rocks, sea, sky, one continuous movement.

April 5th
Lawren asked if he could see the "Cow Yard" so I posted it today. He will pass it on to Fred.

I am trying chalks. Hang! Why don't they invent a good sketching material? My oil and paper are fine but the oil paints are such a nuisance to carry. But it's a dandy method for five finger exercises in the studio. I've learned heaps in the paper oils—freedom and *direction*. You are so unafraid to slash away because

material scarcely counts. You use just can paint and there's no loss with failures. I try to do one almost every day. I make a sketch in the evening and a large paper sketch the following morning—or vice versa.

April 6th

Just come from the last lecture on art. This afternoon there was a tea for the lecturer—old women like me, very dull—refreshments drab and uninteresting. After the lecture tonight there was a reception at the Business and Professional Women's Club—mixed ages, vivacious old and stodgy young—peppy sandwiches and snappy cakes—lots of chatter. What's it all about, this art? We've had the *reason* for the way each man worked. We've had the viewpoint of each man. We've had the thoughts of each man. We've had the man turned inside out and the work turned outside in, and how much of it is true? Who of us *knows* just *why* we do what we do, much less another's *whys*, or *what* we're after? Art is not like that; cut and dried and hit-at like a bull's eye and done for a reason and explained away by this or that motive. It's a climbing and a striving for something always beyond, not a bundle of "rules" or a bundle of feels nor a taking of this man's ideas and tacking them on to that man's ideas and making a mongrel idea and calling it "my own." It's a seeing dimly beyond and with eyes straight ahead in a beeline, marching right up to the dim thing. You'll never quite catch up. There will *always* be a beyond. It would be terrible to catch up—the end of everything. Oh God, let me never catch up till I die. Let me be always feeling up and out, beyond and beyond into eternity.

A friend drove me out to the Lagoon to look, really to tread on and to measure up the camp ground for the van. I think it will do quite well, in an unfenced property near a stream, near the beach, near the road, near the woods. My friend and two boys and my sister and I went. One boy was bilious and miserable, the other boy greedy and dull. My friend and my sister and I chattered surfacely.

It was not a pretty day—fine, but hard and cold. Everything was dressed in its glorious new spring green but seemed to say, "I'm in my new spring finery. Keep at a distance. Don't soil me." The sky was hard and the mountains peaked and clear-cut and the sea steely blue and cold. It was an "English" day, high-brow and haughty. The Lagoon needs the mellow light of sunset to make it human—no—make it God-like. The old longing *will* come. Oh, if there was only a really kindred spirit to *share* it with, that we might keep each other warm in spirit, keep step and tramp uphill together. I'm a bit ashamed of being a little depressed again. Perhaps it is reading the autobiography of Alice B. Toklas—all the artists there in Paris, like all the artists in the East, jogging along, discussing, condemning, adoring, fighting, struggling, enthusing, *seeking* together, jostling each other, instead of solitude, no shelter, exposed to all the "winds" like a lone old tree with no others round to strengthen it against the buffets with no waving branches to help keep time. B-a-a-a, old sheep, bleating for fellows. Don't you know better by now? It must be my fault somewhere, this repelling of mankind and at the same time rebelling at having no one to shake hands with but myself

and the right hand weary of shaking the left. Stop this yowl and go to your story and enter the joy of the birds. Wake the old sail up, hoist it up in the skies on lark songs. Lay the foundations strong and flat and coarse on the croaks of the crows and the jays and the rooks. Fill it with thrush songs and blackbirds, and when the day is petering out wrap the great white owl's silent wings round it and let the nightingale sing it to sleep.

Sunday

I feel I have "sat under" Mr. W. for the last time. I have done with the loud music, or rather noise (about ten or twelve hymns and a horrible solo by a wretched little man with no voice and a bucketful of affectation and a woollen sweater under his jacket which showed all down the front), and Mr. W's monotonous voice, and that queer, hard stare from under his eyebrows out of eyes with no lashes, and the same endless anecdotes I have heard for two years, and the smother of flowers in the junk vases standing on assorted stools, and the pianist in violent blue beating out violent noises, and the long stupid explanation about the silver bowl at the entrance for the collection. The whole thing disgusted me and seemed hard-set and unspiritual. I must not go again. It is not good to feel that way. I feel that Mr. W. has grown pompous and smug and that it isn't what I want and it doesn't get me any nearer to God. Why do all these parsons lay things so dogmatically before the people? They're all alike, all *sure* that theirs is the only way. The road is the same but some tread it in shoes, some in sandals, some in slippers, some in gumboots and some barefoot. Some run and some walk and some sit a lot to rest. God, God, God, we all want to get to the journey's end in time. Fit us with boots to suit our own feet and make us tolerant of the footgear of the rest. I've read "The Snack" over again. It's perfectly *awful*—meaning not clarified, sentences clippy and rough, sense twisted. I'll never, never, never be able to express them. I looked at my six beach sketches, just heavy with paint and expressionless. It is wilting to find yourself out now and again. Your short-comings all jump out at one and b-a-a-a. Maybe if it's true about reincarnation everyone goes through this stage just to prepare for the next, sort of a priming for next time's fruit, and the fellows who are ahead this trip are the ones who get deep priming last.

A man came today and he wanted to know all about modern art—every single thing in one sitting and I am sorry I couldn't explain better. I'm no good at it. I want to give out the little bit I know but I can't find words. I hauled out quantities of canvases and he went away shaking his head. He said he was too old to learn and too busy and he went back to the old, old ones and said he liked those best because he understood them but he wanted to understand the others and he couldn't, and his wife sat and tried to squeeze out feelings over the canvases like you squeeze out icing ornaments on a cake and messed herself and left ungainly blobs and I felt so helpless that I couldn't help them to understand better. Somehow we couldn't catch on to each other's understanding and we were unhappy over it and it was all hopeless, like a wrong key turning round and round in a lock and having nothing happen.

April 12th

Sewing—a necessary evil—and a sketch on the cliffs in the evening. They are very beautiful. It is when the sun has dropped behind the Sooke hills and blobbed yellow and red over everything just before he did it. People generally rave over the red and yellow but I'm in a hurry always for it to get over. Then "it" comes, tender, melting mystery. I love the woods at that hour—no blaring lights and darks to perplex and make you restless with their shifting and sparkle, but that lovely mellow peace so much deeper and richer than sun glare. I shall love the lagoon in the evenings. The woods will darken quickly because of the hill but the grand expanse of beach and sea will hold the after-glow for long. I showed the crow story to a girl last night, read it to her. She did not think it entirely satisfactory. Some bits of description of the crow she liked very much. It did seem rough and jerky as I read it aloud. It needs a lot of cutting up and smoothing, as the thing I'm chasing in it is abstract and very difficult. I'm a bit of a fool to try that indefinite material before I can do definite stuff but those subjects interest me and I *must* try to get it over even if I fail. The trying is well worth while, only it seems so selfish to just go on trying unless one's tries amount to something. Lawren has the "Cow Yard" today. Wonder if he feels it or if it is only oddities like me, the "cow-yard child," who can wallow with delight in cow yards. Even I did not realize all the joy and sorrow of its deeps till I *wrote* the "Cow Yard." Maybe I've used too many *people* in the crow story. I must think into it deeper.

Be careful that you do not write or paint anything that is not your own, that you don't know in your own soul. You will have to experiment and try things out for yourself, and you will not be sure of what you are doing. That's all right; you are feeling your way into the thing. But don't take what someone else has made sure of and pretend it's you yourself that have made sure of it till it's yours absolutely by conviction. It's stealing to take it and hypocrisy and you'll fall in a hole. Art is an aspect of God and there is only one God, but different people see Him in different ways. Though He is always the same He doesn't always look the same—as the woods are the same, the trees standing in their places, the rocks and the earth, but they are always different too as lights and shadows and seasons and moods pass through them. Even the expression of our human face changes. So does God's wonderful infinite face, which is beyond all human picturing or even imagining, which hasn't any human thoughts big enough to think it even, but is beyond and beyond and beyond.

If you're going to lick the icing off somebody else's cake you won't be nourished and it won't do you any good, or you might find the cake had caraway seeds and you hate them, but if you make your own cake and know the recipe and stir the thing with your own hand it's *your* cake. You can ice it or not as you like. Such a lot of folk are licking the icing off the other fellow's cake.

April 15th

Am eating today after a fast of seven days and it feels very good inside. I wish I

had been brought up to think nothing of food, instead of encouraged to have a palate sensitive to and demanding good eats. I believe those who are reared on short-comings are best off spiritually and bodily. I was reared an earthy child. I remember the spirit in me used to try and look up but the fat earth body sat on it. Now it fights to lift but sixty years of being sat on has flattened it. I have painted today a paper sketch. I tried to say something, to work out last evening's thought in my sketch on the beach. It spoke a little so I quit for fear of strangling its mite of speech. There's wonderful things out there on the cliffs and over the sea.

Tonight there was the tiniest, delicate new-born moon, needle-sharp at its points and whooped upwards, and the most delicate blue-green-grey sky with warm brownish clouds coming right over the top of you, and cold blue-grey, flat clouds, and the mountain, and the sea, quiet and low grey. How can a human hand dare to feel into that light and space? Only the soul can feel out into its formless realities, too subtle for forms and mediums. Only the soul can cope with it. Only she can feel her way into its fineness.

April 16th

I woke to this dream: I was in a wood with lush grass underfoot and I was searching for primroses and a little boy came. I did not see him, only his bare feet and legs among the grass and I saw my own feet there among the grass also. "What are you looking for?" said the boy. "Primroses." "There are no primroses here," said the boy, "but there are daisies. Gather them." Perhaps what I want most is not for me. I am to take "daisies" instead of primroses.

I washed a wall. While it dried I went to the beach and made a sketch. Came home and kalsomined. While that dried I did my big sketch from the small one and went back and did my second coat of kalsomining. My sketch was half good, a certain amount of light, freedom and space, but not sensitive enough. I need much refining away of clumsiness. Christ said, "I am come that ye might have life and have it more abundantly." Having Christ in one's life should waken one to a far bigger sense of life, far bigger than the sense of life that comes through theosophy, that static, frozen awfulness, sort of a cold storage for beautiful thoughts, no connect-up with God by Christ. At one time I was very keenly interested, thought perhaps it was the way. Now it numbs and chills me. It's so bloodless, so tied up with "states" and laws and dogma, and by what authority?

The beach was sublime this morning—low, low tide that showed things that are most times hidden, great boulders, and little round stones the size of heads, covered with a kind of dried sea moss and looking like the tops of human heads. The sea urchins squirted at you as you walked and crabs scuttled, and the air and the sea and the earth were on good terms, and made little caressing sounds. The sea kissed the pebbles and the little breeze petted everything and wasn't cold or annoying. As for the earth, she is beside herself with sprouts and so happy. The air and the earth and the sea seemed to be holding some splendid wonderful secret, folding it up between them and saying to you, "Peep and

guess. If you guess right you can have it." And you're almost scared to guess for fear of being wrong and not getting it.

I think perhaps it's this way in art. The spirit of the thing calls to your soul. First it hails it in passing and your soul pauses and shouts back, "Coming." But the soul dwells in your innermost being and it has a lot of courts and rooms and things to pass through, doors and furniture and clutter to go round and through, and she has to pass through and round all this impedimenta before she can get out in the open and catch up and sometimes she can't go on at all but is all snarled up in obstructions. But sometimes she does go direct and clear and catches up and goes along. Sometimes they can only go a little bit of way together and sometimes quite far, but after a certain distance she always has to drop back. But, oh, if you could only go far enough to see the beauty of the whole complete thought that has called out to you!

April 22, 1934
Life is so cram-full of disappointments and some are little things that one should not mind at all and often those little brutes seem to cut deepest. I got a letter from Lawren. I did want a good honest opinion on the "Cow Yard." All he said in a three-page letter was one-half sentence: "The Cow Yard is fine. Have only read it once. Will read it again later. Have no criticism to offer." Now what help is that? I know it's fine because I put all my best into it, but I wanted some help-ful hints, comments, suggestions, opinions. Shucks! "Not one can acquire for another, not one can grow for another, not one," says Whitman. Plow, harrow, seed your own land with your own hand. Fred gives you a cracking hard crit, lances clean to the bone, hurts and helps. I wonder what aeons of time will elapse before I hear from Fred. What an impotent devil I am. If one could see things *clearer*. After all, we all stand so *utterly alone* and our only real critic and judge is our own soul. I suppose if we were absolutely straight and honest with our own selves . . . but, there you are, everything's a muddle.

April 24th
A dull tea with a dull woman at the dull Empress. The pups, Tantrum and Pout, the only gay things about it and the conservatory a joy of airy, fairy, gay colour, too exquisite and upstairsy to describe in words, like colour stairways of joyous-ness leading out beyond earth things. My companion a veritable twist of nerves, jerking, jumping, blinking, mouthing, worriting and religious, clinging to life with every atom of her and telling you all the while how ready she is to "pass on." Oh dear, and me so deaf and straining to hear her muttering and gibber-ings and not catching things and answering wrong and bringing her home to supper and her swearing she can't eat a thing but a dry crust and tucking in to a good "square" and smacking her lips. And shovelling her home at last, and glad to get to bed, and thanking God fervently that I don't have to live with her. Oh better a million lonelinesses than an uncongenial companion! "Can I see your pictures?" she said and regarded three finished sketches. "Oh, not finished," she

said and made no further remark. I told her about the "Cow Yard." She was not the least interested. Nobody is interested in anything these days except themselves and their own doings and thoughts. It's queer; folk *used* to be interested. Now it seems there is too much of *everything* in the world. We're all "overproduced." Everybody *does* everything and there is a surfeit of all things and everyone wants to flap out from the flag pole at the tip top and nobody wants to climb the stairs and, step by step, get used to the higher air. The garden has never been so lovely. The lilacs are a dream, their perfume penetrating every corner.

Two easels stand in the studio and on each is a paper oil sketch of the beach. Unlike my canvases, they have no dust sheets, and I watch people's reaction. No one gives them more than a passing glance—some not that. There can be nothing in them. They make no appeal. Yet I am keenly interested and I do feel I put more of myself into them, a great deal more, than a year or so back when I was thinking design and pattern and painted more or less from memory of things I had seen. I am painting on my own vision now, thinking of no one else's approach, trying to express my own reactions.

Beach fine today. Wide, wide expanse shimmering off further than one could think. Five middle-aged nuns picnicking—enormous quantities of food and books, black draperies flapping, (Oh, how awful to be swathed and wrapped up in that trailing stuffiness!) silver crosses dangling and glinting in the sunshine. The nuns had a good time. They were very pernickety in their selection of a rock to picnic on. Tried three, flapping from one to the other like dishevelled crows. One sat down and dabbled her feet in the sea. She spread out all her black layers like a sitting hen, so that only the mussels and limpets, who apparently have no eyes, could see her bare skin. She did things with a newspaper. Perhaps she wrapped her feet in it when she immersed them so the he-fish should not see. Anyhow she took her time and the others read a whole library of religious books they'd taken along. They then had an enormous feed and everyone had a bottle of queer pop and tipped the bottles up and drank out of them. The pop bottles looked deliciously irreligious, sticking out of their nun's bonnets.

Two youths sawed logs, stripped to their waists. They oiled the saw a great deal. I guess they enjoyed oiling more than sawing for it was very hot. I brought my thought sketch home and thrilled acutely, putting it on a large sheet. Oh, I hope the brute won't die tomorrow when I load on more paint and struggle. It seems as if those shimmering seas can scarcely bear a hand's touch. That which moves across the water is scarcely a happening, hardly even as solid a thing as a thought, for you can follow a thought. It's more like a breath, involuntary and alive, coming, going, always there but impossible to hang on to. Oh! I want to get that thing. It can't be done with hands of flesh and pigments. Only spirit can touch this.

What's the good of trying to write? It's all the unwordable things one wants to write about, just as it's all the unformable things one wants to paint—essence. It's nearly dawn and I have been awake for a couple of hours. All the

birds have started up such a racket. Now they haven't got any words and don't want or need any. All they are impelled to do is to toss praise into space where it mixes up with all the other essences of joy that all the rest of creation is pouring forth, bubbling up and spilling over and amalgamating with other spills-over, and becoming a concrete invisible something of great power. It becomes the something that feeds longing souls food, the something that has burst through its mortal wrappings and is pouring back to its source—God—in praise, a concentrated essence, very strong and very subtle in its strength. Everything is in it: light, perfume, colour, strength, peace, joy, and it has no needs, no special name. A name would weigh it and keep it down. It could not have a name of this world because it is of another. One day we will go out and meet it in another world and then we will know its name because we will understand that language. It is a thing that must not be pried and wrenched open but left to unfold. You cannot pry open the dawn. It comes. Day is here now and the birds have come back to the material and are hunting breakfast.

Another week gone and no word from Fred Housser re "Cow Yard." Shucks, Emily, you old fool, when will you learn to be, as Whitman puts it, "self-balanced for contingencies to confront night-storms, hunger, ridicule, accidents and rebuffs like the trees and animals do" and not diddle round as to what this and that one thinks. Make your own soul your judge. Nobody else cares, so why bother them? Search in your own soul and see if the thing is honest and fits your meaning square as you have the ability to make it plain, then quit and don't worry. What does this or that little "do" of yours matter anyhow? It's all for growth. If the soul has gained something by writing or painting it, it is surely worth while. *If* it says something to someone else's soul, that's grand, but our own soul has got to learn the language before it can talk.

A vague artist woman came tonight. She is well-equipped technically and keeps her soul well clamped under and caters to the surface wants of the public, starving her soul that the bodies of herself and family may thrive. She thinks we are here as sort of stop gaps to keep the universe going and sometimes she doubts if there is any afterwards, she says. She asked what set me working this way. I don't know, any more than a dandelion knows why it's yellow. It's just growth, I guess. Lawren's work influenced me. Not that I ever aspired to paint *like* him but I felt that he was after something that I wanted too. Once I used to think, "How would Lawren express this or that?" Now I don't think that any more. I say, "Emily, what do *you* make of this or that?" I don't try to sieve it through his eye, but through mine. She saw many shortcomings but said my sketches stirred her and carried her out. She thought if I *did* find what I was after it would be big. I wonder. I want the big thing but even if it never comes satisfactorily in paint, the trying for it is worth while. There are places that are out-and-out bad in my pictures too.

May 3rd
I have been to Vancouver to be on the judging committee of the Art School

Graduates Association for their show, and I have also seen Sophie and I am home again and have kalsomined a large flat, and this all in two days. I thought the work appallingly bad, no meaning to it, no drawing, no nothing except badness. The other judges entertained me at the Georgia with a very poor lunch. However Sophie's visit was satisfactory and happy. She was watching at her window, the curtain drawn back, and her one eye and her toothless gums expressed everything they were capable of. I love Sophie's smile of welcome. It is just as dear, perhaps dearer, now that her countenance is abbreviated by losses.

Movement is the essence of being. When a thing stands still and says, "Finished," then it dies. There isn't such a thing as completion in this world, for that would mean Stop! Painting is a striving to express life. If there is no movement in the painting, then it is dead paint.

NOAH'S ARK

1934

Esquimalt Lagoon, May 12th

And so we're here. Kalsomining, paint washing, preparing the flat to rent, pack-ing and getting here is all accomplished and past. But weariness is also accom-plished and present. A mental, physical and spiritual inertia swamps me. I am ashamed, very tired and ashamed of being so tired right through.

May 14th

Spring is crisping up a little. I had a good night and my two-day visitor has gone; a nice little person who loves nature ardently but a little strenuous to be teamed with my old bones. I am more like me now and less like an agitated Mrs. Noah. The creatures are all in their own niches, so good and so happy. One is so obviously their God that it ought to make one careful. If one got to Heaven and found God snappy and cross how awful it would be! This living right close to their adored is Heaven to the beasts. It is very Heavenly, this daisy patch. The old Elephant is sitting in millions and millions of these daisies. They are thick under the van, and growing harder so as to peep out from beneath and are even more lovely, gleaming there palely. The fellows out in the open are straddled out, exultantly staring up at the sun. The others are striving harder, aspiring, working out of the gloom. The dew is still on them though it is noon and it looks like great tears sparkling on their faces. Woo rolls among the daisies with her four hands in the air, playing with her tail. There are immense bushes of sweet briar roses that will be in bloom soon scattered all over my pasture. The sheep come to the far corner under the trees with their lambs. The dogs keep them from coming too close. A beautiful bird with a lemon yellow breast with a jet black brooch in the middle is under one of the rose bushes feeding a young-ster that flaps and squawks. The air is full of bird song and the frogs were croak-ing right in the awning lean-to of the van, which is hemmed in by a nettle patch. From the van window beside my bed I can see the sea and the stars at night as thick as the daisies by day.

The camp is very comfortable now it's all fixed. The first day was a little awful. We sat out on the pavement outside home waiting for the truck at 7:30 A.M. It did not come until 8:30. The man next door evidently thought I'd been evicted. He kept looking out at the beasts and me sitting round on the deplorable old chairs and at the kettles and the rusty stove pipes and old carpets.

We got here around 9 o'clock and I turned out the last year's stuff and cobwebs. The walls looked bad so Miss Impatient had to get busy and paint them. As soon as the inside of the van was all painted up and messy, down came the rain, so everything had to be rushed into shelter. Gee, how I admired Mrs. Noah as I marshalled all the creatures into the van—Woo and the rat and the four dogs! She had ever so many more varieties and the rain battering on the roof for forty days instead of twenty-four hours. But I bet she did not have wet-paint walls to contend with. God gave them warning to get their chores done up before the rain came. So we all turned into bed and semi-slept. The rain came through but did not fall and I was glad of that. It let me get up and have a couple of hours straightening in the lean-to next morning and then it did it again, but I turned round and round in the van straightening as I turned so that when it stopped we were quite straight inside. And just as all was in order, my sister and four others came to tea. I was delighted that all was straight and everyone thought it was lovely. They brought me letters and cigarettes and sweet cake, more than I know what to do with, so that I hope some more come to eat it. A man came Sunday morning and offered me green leaf lettuce which I hate and a woman gave me skim milk.

Now let's see if I am kidding myself about being too tired to work or if it's just laziness about assembling my stuff and setting out. How life does tear us this way and that—what you ought to do and what you want to do; when you ought to force and when you ought to *sit*! There's danger in forcing but there is also danger in sitting. Now hens know just when they ought to sit. Hens are very wise.

May 15th

The wind kicked up all the horrible ructions it knew how last night. I thought the van would up and fly away on its flaps. The buckets and pans rolled round. Everything inside blew out and outside things blew in till in and out were all mixed up. I sketched on the beach—results indifferent. We tucked into the van but at midnight the gusts were very fierce and I got into boots and came out and unhooked the flaps and lashed things together a bit and it was better. Rain threatens.

It's fine here. Nobody pesters you. The great wide beach is yours for the taking, its lapping waves and its piles of drift all yours. The roses on the bank, bursting in a riot of cool pink from the piles of deep green leaves, toss out the most heavenly perfume. I love to pass the corner where the spring gurgles up out of the black earth. The roses are so busy there drowning the old skunk cabbages' smells and the birds are applauding us with wing-flappings and such shoutings. A lovely little couple were down pecking in the black earth. I watched them. He, rusty red about the head, a regular Scotchman. She, quiet grey and very ladylike. They were obviously very attached, keeping close and chatting, not polite he-and-she-manners talk like some married couples, but companionable babble.

There are times out here when one just looks and times when one just listens,

and others when one just feels or smells, and there are times when one does all of them at once and others when one is just vacant and nothing works. I believe these times are good too, not to be worried over as savouring of laziness but regarded as times of preparation for development, like a field lying open and fallow and bare.

Oh, the birds! They are as birdy and as busy as they can be in May. Before it is light they are at their singing. Then there's breakfast and the all-day-long job of feeding and teaching the young. Maybe that is why they do get up so early, to have a little quiet to themselves and have time for their devotions. I do not think of birds as saying anything but only as tossing off the overflow of their joy in being in the few notes that are peculiarly their own. The bird doesn't need many notes because he doesn't know many emotions. When his feelings are bad he does not express them but hides them away somewhere off in the silence. He's noisy and ecstatic over living. Over dying he is silent and secretive. I know now why birds, those perpetual campers, sing after rain.

3 P.M.

The rain pours. I have put us in and pulled us out until I feel like a worn concertina. If it does it again, I shall ignore it and drown. This is our lazy old April's postscript in May. Fool, fool, fool, that is what I called myself to leave a comfortable home to be drowned and frozen, to cope with wet wood and primitive stove and the bucksaw and water lugged from the spring, this pattering through puddles in a cotton nightgown and rainboots and pleading with the wet wood while hunger and hot-drink longings gnaw your vitals. But, at last, the fire began to burn the sticks, the kettle began to boil, the sun began to shine and I began a new chapter.

May

The only dry thing in the whole camp is the water bucket. It's wonderful how one learns to manage to combat and yet work with the elements. I think of Mrs. Noah a great deal: "And Noah went into the Ark and shut the door." When I cosy the creatures into their boxes and take the hot water bottle and shut the door of the Elephant, I feel very safe and able to sauce the elements sitting up in the bunk looking over the sullen grey sea and the old wrecked automobile sitting on the beach among the drift and the drowned daisies who never opened all day yesterday, hiding their golden eyes with cold red fingers, the briar roses sullen and not thinking any more about putting on their lovely pink dresses, and the blackthorn bushes not white round bundles of blossoms but sodden drab lumps. But it's cosy in the van, the rain hitting hard just a few inches above your head and you able to say "Fooled!" as you hear its thwarted trickle down the van sides, and four comfortable snores coming out of the four dog boxes, and Woo's puff, puff and the soft little tearing of paper, Susie's old maidish preparations for the nests she's always building and never filling. Yes, the van is cosy when it rains.

Sunday

The Morleys spent all day and it was very nice. We ate and talked and I read them "Cow Yard" and "Balance" and "No Man's Land," and they liked them, and out it came, the longing that everyone has to write to express that seething inside that so wants to find an outlet. It is not pride or notoriety or fame people are really after; it's the great longing to grow and to find out what is in oneself and *do* something to bring it into expression.

Camp life is one steady wrestle—with the elements, with inadequate means. One says, "When I have leisure in camp I will do this and that," but the leisure never comes. Indians, those superb campers, had leisure in abundance because they understood; they did not combat. If the wind wanted to come in, they let it and shifted themselves out of its way. If the tide served, they went, if not, they waited. No fussy, hurrying clock to watch, only the steady old sun. If the sun said, "Too hot to work," the Indian did not work. Time was no object and waiting enjoyable. There was no friction so there was peace and they went with nature and nature is quite comfortable if you don't thwart her. My stinging nettle patch is perfectly sweet-tempered if I don't annoy her. I go and come through it with never a bite. I'm not afraid of her.

Oh, this inertia! I don't *want* to work. It blows and blusters and is much nicer sitting in the van than anywhere. I've reconstructed the shelf-table, made a nice little pulpit table with part of the shelf and evened and strengthened the shelf that's left. I love things firm and steady. Now they are. I wish I was firm and steady. All I've done today is make a good camp stew and learn a piece of poetry, *viz.*

> When He appoints thee, go thou forth—
> It matters not
> If south or north,
>> Bleak waste or sunny plot.
> Nor think, if haply He thou seek'st be late,
>> He does thee wrong.
> To stile or gate
>> Lean thou thy head, and long!
> It may be that to spy thee He is mounting
>> Upon a tower,
> Or in thy counting
>> Thou hast mista'en the hour.
> But, if He comes not, neither do thou go
>> Till Vesper chime,
> Belike thou then shall know
>> He hath been with thee all the time.

> (*Specula* by Thomas Edward Brown)

May 22nd

Oh mercy, how it blows! This place is all superlatives. It blows extremely hard or rains extremely hard or suns until you're melted or all at once until you're giddy. The slop about one's feet is awful. It lies round the van splashing up as you walk—disgusting slop, cold and penetrating. Under the fire is a well of water; the fire sits on a tin tray on top. Sometimes I think I must move on, and dread the expense and bother.

Somehow theosophy makes me shudder now. It was reading H. Blavatsky that did it, her intolerance and particularly her attitude to Christianity. Theosophists say that one of their objects is study of comparative religions and on top of that claim theosophy is the *only* way. It's that pedantic know-it-allness that irritates me. I'm a beast.

Instead of trying to force our personality on to our subject, we should be quite quiet and unassertive and let the subject swallow us and absorb us into it, and not be so darn smart of our importance. The woods are marvellous after the sun has dipped and quit tickling them. Then they get down to sober realities, the cake without the icing. They are themselves, then, like people alone and thinking instead of persons in a throng trying to sparkle and taking on reflection from others. Dear trees, we don't stop half enough to love and admire them.

It is as I said: go with nature and she's easy and delicious. The swamp round the van was awful and my feet in torment, rebelling at rubber or wet stockings. So off they came and barefoot I paddled through big and little puddles. It's the most wonderful feel. The grass is so soft. The daisies tickle and leave pink and white petals on your naked feet. They never cling to your boots. The earth, even the squelching black mud, kisses your feet as you pass through and the sun is far warmer than shoes. Legs are not so happy. They don't touch the reality, only the air, but they'll get to love the air too. To think how I've fussed over wet feet for two weeks, bucking instead of accompanying!

May 24th

Oh, the misery of living in this slop! The water lies all round the van. I can't stand it. My feet are hideously sensitive to cold, to wet, to unevenness, more sensitive than my hands. Even with thick shoes I feel *everything*. When I had a toe amputated I suffered tortures. The doctor remarked on the extreme liveness of my feet nerves. Underfoot things can do things to my whole being—exquisite pain and exquisite pleasure. There you are. Much easier to have old cowhocks and squelch round in the mire when life is so full of mire. Tomorrow I go into town and command the hauler to drag me up the hill on to the Metchosen Road, high above all the slop. I've seen a lovely place. There won't be beach and open expanse but there will be shelter and the holiness beneath trees, and *dry* grass. So, I moved the stove in under the tent and am warmed with thoughts of dryness. My frog is croaking right in my left ear and a pheasant and a robin are calling. Woo is cuddled in the sweet briar bush. How do those soft little hands of hers avoid the thorns? I believe we must have been intended to go naked.

Rain-soaked clothes don't connect with a common-sense creator and a perfect universe. Drat Eve's modesty complex.

May 27th
Here we are, all settled in Mr. Strathdee's field, dry and happy. The move was awful. I'd have given the van away, with a kiss thrown in, to anyone who'd have dragged her out of the hole. Friday morning I waited, all packed, in great discomfort from 9:30 (the appointed hour) until 11:30. Then the haulers came and drove round and round the briar bushes, mud and slosh splashing to heaven, but they couldn't get near the van and nothing would work in the bog. Then I ran hither and thither hunting a man to help but there weren't any, so the hauler hauled me and the beasts and junk up and sat us in the field and went to town for help. We sat and sat until 4 P.M. from 12 noon. As I sat there in my wicker easy chair with the two beds, three chairs, stove, buckets, pots, food boxes and all the animals round me, a funny little body grinned along the fence. Every step she grinned harder. Somehow the grin ran along the top fence rail seeming to go along and continue because after she was long past her head was turned behind so that the grin ran back again and met you from the other way. It was such a kindly, enveloping grin! She was a neat little person with glasses on, and carrying many bags, and not any more young. She went past and into the back gate of Mr. Strathdee's place and went through his house and came down the path to my corner. She hadn't heard about me coming to his place and she said, "Are ye having a wee bit picnic, dear?" and she smiled some more in a kind, welcoming way. It did tickle me to think of one solitary soul taking all that clutter along for "a wee bit picnic" all alone. She works in a hotel and comes out Saturdays to tidy up "Brother." She washed and scrubbed; smoke poured out the chimney and mats shook out the doors. Then she trotted off through the woods to see "Sister" who lives in the other direction, stopping at my camp to give me quite a good helping of their family history and to admire the "nice wee doggies" and the "nice wee monkey." Saturday is her one day off so she sets out at 9 A.M. and gets the 11:30 P.M. bus home. Tidies "Brother" and tidies "Sister" by way of rest!

When the old Elephant came lumbering up the hill, I was glad after all that she was mine, but I was very tired and a fair price would have bought her and quit me of camping for ever. But I fell to. Then when I was tucked in bed my spirits hoisted a bit and this morning was so shady and sweet and calm, all the troubles were gone and I wouldn't sell the van for a mint.

May 29th
I am circled by trees. They are full of chatter, the wind and the birds helping them. Through the sighing of the wind they tell their sorrows. Through the chortle of the birds they tell their joy. The birds are not so intimate here as down in the swamp. There they flew low and sought earth things and dug for worms. Here their concerns are in the high trees. My spirit has gone up with the birds. On the Flats it was too concerned with the mud. I hate to leave camp in the

mornings, it is so delicious under the gracious great pines. In the afternoon, when the sun has dodged down and blares forth and gets glaring, red hot and bold, I like to get off into the calm woods. When he has gone, leaving just a trail of glory across the sky which the pines stand black against, it gets wonderful again and presently an enormous motherly moon comes out of the East and washes everything and all the sweet cool smells come out of things, not the sunshine smells of day that are like the perfumes and cosmetic smells of fine ladies but the after-bath smells, cleanliness, fine soap and powder of sweet, well-kept babies. And when you put the van lamp out and lie in the cool airy quiet, you want to think of lovely things. Only sleep is in such a hurry. She has fallen already on the dogs and the monkey and even the rat, and the moonbeams and sleep whisper together, and there you are, helpless as when you lie on an operating table and the doctor is putting you under. You've got to give in; it's no use kicking, so you wonder where you are going and what you're going to see. You wake up once or twice to peep but it only spoils things and looses the thread, so that when morning bustles in your "wake" and "sleep" are all mixed up and vague.

There's the big, hard, cryable disappointments and then there's the horrid little jolts not worth defacing your eyes and nose about, but accumulative, making in the aggregate a tougher, harder, bigger thing to swallow than the big individual troubles that made you cry.

The folk round here kept singing the praises of a certain widow. They just about wept as they told you about all the knocks life had dealt out to her. Her husband had died on her tragically, her son ditto, and now her son's dog. She was, they said, so brave and heroic in her affliction. I began to admire this woman and to want to know her and when it came to the dog's death, and she seventy years old and so emptied of all she loved, I looked over my outfit and decided the lonely widow should have Maybbe who is such an affectionate, companionable creature. I pictured the widow woman and Maybbe all of a-cuddle in the winter evening and the woman saying, "What a comfort this creature is in my loneliness," and the dog creeping further and further into the woman's heart, wriggling into that empty ache till their love was all tangled up together. So I set out to call on the widow and feel the way to offer my gift graciously. I did not take Maybbe with me because her pups are nearly here and she looks awful, but I took Tantrum and Pout. I would say, "She's the mother of these two and she's having more this week but as soon as they're weaned you shall have her. She's such a companionable creature and I shall be so glad to know she has a lovely home."

From my camp I had seen the widow's big straw hat bobbing round her flower garden. Her pinks smelt delicious as I went up her long, straight path. I introduced myself and asked, by way of excuse, if she had any eggs for sale. No, she had not. Livestock were such a nuisance, dragging one out in all weathers. My heart went down a little. Dogs and cats were not so bad; you could call them. My heart went up a little. She showed me the pinks and the peaches, and there was the empty kennel.

"You have a dog?"

"No, he was killed the other day but, oh well, they are a nuisance anyhow with so many sheep round."

"My griffons don't look at sheep," I said.

"You never know. Another dog may set them off."

We looked at the Canterbury bells and the snapdragons and roses. The garden was shadeless and very hot. Evidently her feet ached like mine for we both shifted on to the other foot often. The cottage looked cool, dark and inviting. I wished she'd ask me in to rest and cool. We went from flower to flower.

"I must be going," I said finally, adjusting my sketch sack on my shoulder.

"Yes," she acquiesced. "I can't ask you in because of those dogs. I never allow a dog in my house."

While I was eating my lunch, a great wind gust blew a canvas chair across the table and smashed the mouth of the milk jug. From then on, the wind got more and more vulgar and violent. I selected the wood behind the hill and I did two sketches but about all they had to say was, "I'm paint" and "I'm canvas," and I went home. At the gate I met all my saucepan lids, the saw and the coffee pot. The chairs all lay flat and the fly hung by one hook. Everything you did not want exposed was and there were whippings, bangings, and topplings going on everywhere. I dared not light a fire but about seven o'clock I did and sat by it with a bucket of water. The grass caught once. I got a pot of tea and a hot bottle, for it was very cold, and I put the fire out with water and cosied the creatures down into their boxes, took food in the van and tucked into bed. No moon-baths tonight. Noisy blackness and quivery shakes as if the Elephant had ague, and tappings and rattlings as if she was haunted. How completely alone each one of us is and yet we are so helplessly atoms of the whole!

May 30th

The elements obviously say, "Hibernate," so I wrap myself round in the van and do so. The wind is keen and raw, it rains when the wind will let it come down. The trees take the wind so differently. Some snatch at it as if glad of the opportunity to be noisy. Some squeak and groan, and some bow meekly with low murmurs. And there are tall, obstinate ones who scarcely give even a sulky budge. The differences make the kick-up even more turbulent than if they all went together. The last two days have been one perpetual catering to the elements. It's cold enough for snow tonight and the wind nips and rain spits. I have written all day on the crow story. Lots of clarifying needed still.

June 1st

Maybbe's puppies have come. All day she was so restless. No nest suited her. I gave her two to choose from, one blanket, one paper. She tore the paper up and was sick over the blanket. She tried all the dog boxes and decided on Tantrum's, which she was barely able to squeeze into. She tried my suitcase and my paint box and finally had her puppies on the shelf, so I had to rush with a plank to keep them from rolling off, but when she settled to business she was O.K. and

has four loud-voiced squealers. And there we are. Something new seems to have happened inside the old Elephant. Maternity is very wonderful. Those four tiny new lives have meaning.

It's a clear, keen morning.

June 3rd

Everything in this part of the world is doing just right today and the earth is beautiful—enough wind, enough sun, enough heat, enough cool. The puppies lie in a sleek, rich-coloured row against their mother, deaf and blind to all about but conscious of the warm maternal closeness of the old dog. Impatience was born in them. They tug furiously at the mother who patiently yields to them her whole being, all she has to give, feeding, warming, cleaning, guarding them. She enjoys their exhausting worry. They are hers and possession is sweet. She lies very content, gathering back the strength she has spent on them so that she may have more to lavish on them. The wonderful instinct of the earth to reproduce and keep things, their own kind, going on. The pups are settling down to the strange feels of the outer world, feels entirely embodied in their mother as yet.

The days fly and the nights too. There is so much to feel and see and hear out in the open. It keeps your whole being alert, drinking in wonders till you are drugged by them, and drift off carried by this smell and that feel and this sound, that colour—out, out, to that which stands behind all these things, God, comprehending all substance, filling all space.

June 4th

Last night I went to hear Raja Singh. At 5:30 I picked up the paper my sister had brought out Saturday. There I saw that he was speaking three times Sunday. I did not know how I was going to get into town but I automatically got ready, shut the creatures up, and had tea and went out on to the highway. I hailed and a nice couple stopped and took me to the very door of the Centennial Church on Gorge Road. The subject was Christ in India. It was an earnest and lovely address as he always gives. He looked frail and rather far away. One feels those people are much nearer spiritual things than the Western civilization. We have not their mysticism. We are so heavily cluttered with our bodily wants and necessities, our possessions, that we lose sight of the forest in the trees. I felt my life was small and greedy, grasping for the little and overlooking the big. What can we do? I suppose the answer is fill our own niches as full and comprehensively as we know how, fill our own place. When it's full to bursting maybe our limits will be pushed back further and we will have more space to fill. I taxied home and was very glad I went.

King's birthday. All the mosquitoes drank the King's health, literally, in my blood.

June 5th

Sketched in the big old wood. Trees old-fashioned, broad-spreading and nobly moulded, beyond cutting age. There is no undergrowth in that wood, only old

fallen branches and wild grass, but mostly moss, very deep and silent, sponging down many old secrets. The other wood, just across the way, is different in type. It has been liberally logged and few giants are left, but there are lots of little frivolous pines, very bright and green as to tips. The wind passes over them gaily, ruffling their merry, fluffy tops and sticking-out petticoats. The little pines are very feminine and they are always on the swirl and dance in May and June. They snuggle in among the big young matrons, sassing their dignity, for they are very straight and self-respecting, but the youngsters always tip and peep this way or that. It is good to work among the venerables and then cross the road and frivol among the infants.

A hot night is following a hot day. Everything that opens in the van is open. I've had a cold bath out in the open with the velvety dark shrouding my nakedness. I wish it was always like that. It's a pure, lovely feel, the real you touched direct by the real earth and grass, and trees and air, all vibrating and live, not dead and senseless like garments. I sketched in the frivolous wood tonight and did a big slice of the crow story in the afternoon.

4 A.M.

The solemn wood is all lit beyond, where the sky glimpses through and sparkles like jewels. That is the sunrise sky beyond. Though light of day has not quite come, the world has on her mystery complexion. Night and day are saying goodbye for twenty-four hours. Night is in a hurry to be gone but day hangs on to him a little. The birds say, "Hurry, hurry." They want breakfast. The flowers want the light so they can unfold and grow. Everything is as ready to wake as it was to go to sleep. Nature is always ready to get along. We are the only yowlers, never quite ready to wake, never quite ready to go to bed, never quite ready to die, never quite anything, always on the road, never quite caught up, always wishing something was a little different. Well, if we didn't we'd be beastly smug. It's wanting keeps us going. The flowers and the creatures are content with routine. We want more. We want progress.

June 11th

Time slips by, quick and smooth. It is morning—it is noon—it is night—it is nearly midsummer. The puppies have more than doubled their size. Their unseeing blue eyes opened yesterday. How hard they are on the mother and yet how she loves them and patiently endures them.

I've worked well the last week, painting and writing. I shall get some surprises by and by for I run the sketches straight into their receptacle in the van. There is no place to exhibit them to myself. When I see them again, I shall have forgotten I ever did many of them and maybe it will be good to see them fresh like that. The first thoughts may speak stronger.

There is a great deal going on here but it is all the still noise of silent growth. There are few man noises, only the rip and snort of the tearing motors, inhuman machine noises, seldom flesh and blood noises. One doesn't connect the bird notes with flesh and blood but rather with abstract things, joy pouring out

unplanned, natural overflow, and the wind is always on the sing. The field is full of dandelions, energetic people always doing something, turning their clear yellow faces this way and that as the sun moves, wagging their heads in the wind, growing fearfully fast and hauling their green caps over their faces at night.

June 16th

The first time for days that there is not a cyclone raging at this time of day. I have done quite a lot of painting, quite different to work before. Better? Worse? I can't say but I *think* it goes further. I don't know what the Easterners would say and I don't think I care so much now. Their criticisms don't seem to mean anything now like they used to. The last two years they have not been worth having. Mostly they say nothing. I'd much prefer a slating. Probably they find my work gone downhill but I can't honestly say *I* think it has, for I see and strive for something further and am not so concerned with only design. I want depth and movement and find my older work empty. I am anxious now to put this newer stuff up against it and see if it holds. I have no chance here to give it a second look when I bring it in but I have felt that I am getting a little further away from paint. These are only sketches but I am trying to feel out to bigger things. How I shall manage my canvases I don't know. Lawren's sketches are finished, every corner, every detail. They take you to their destination and leave you. Mine don't take you to any destination but I want them to give the desire to get there, to go on and not sit down anywhere *en route*. I want to express growing, not stopping, being still on the move. These subjects are stumps and pines and space. They are difficult to express, but my feeling is if one can see the thing clearly enough the expression will follow. The thing is to be able to apprehend things, to know what we are trying to get at, to know what we see. So many of us open our flesh eyes but shut the eyes of the soul.

There's a torn and splintered ridge across the stumps I call the "screamers." These are the unsawn last bits, the cry of the tree's heart, wrenching and tearing apart just before she gives that sway and the dreadful groan of falling, that dreadful pause while her executioners step back with their saws and axes resting and watch. It's a horrible sight to see a tree felled, even now, though the stumps are grey and rotting. As you pass among them you see their screamers sticking up out of their own tombstones, as it were. They are their own tombstones and their own mourners.

There is no right and wrong way to paint except honestly or dishonestly. Honestly is trying for the bigger thing. Dishonestly is bluffing and getting through a smattering of surface representation with no meaning, made into a design to please the eye. Well, that is all right for those who just want eye work. It seems to satisfy most people, both doers and lookers. It's the same with most things— the puppies, for instance. People go into screams of delight over them—their innocent quiet look, their fluff and cuddle, but when the needs of the little creatures are taken into consideration they are "filthy little beasts" and a nuisance.

The love and attraction goes no deeper than the skin. You've got to love things right through.

When first I got the van I called her the Elephant. She entailed a certain responsibility, seemed a bit unwieldly and cumbersome. You didn't just know how to fit her in. You were, in fact, a little scared of her. Now she's a bully old girl; the scare of her is gone. She's not like an elephant now but like a motherly old hen. Towed out, she meekly squats, fluffs out her flaps on all sides and encloses us. There's always room for another beast and we never seem crowded. Each one has his own particular feather to shelter under. Maybbe's four pups are just right up there in the corner. Woo appropriates her niche, always delighted to cuddle in, screeching for it when she's cold or tired, looking neither to the right nor the left, just diving into her box with a contented chuckle. Tantrum and Pout and Wopper know and love their own places. I guess my bed is the van's very heart. When I am tucked up there I am very content, books on the shelf above my head and the good old coal-oil lamp. My sketches are under the bed, that other pile of thoughts, some good, some poor. When I lie cosy and the wind is howling round outside (for this place abounds in wind) I can peep out the little window beside the bed and feel for all the world like a chick peeping out of the feathers of an old Plymouth Rock. And there's all the lifey smells coming in and out through the flaps—hay and pine boughs and camp fire and puppies and cake and coal-oil and turps and paint and toilet soap and wash soap and powder and disinfectant and the rubber of the hot water bottle and mosquito oil. They come in and out over the groceries and water buckets standing under the flaps, but the camp fire and the hay and the pine trees are the strongest and compound them all into one sweetness. And the sounds of the trees and the birds that seem so much a part that you can't quite make out if they are in your own head or in the world. And the puffing and snoring of sleep and Susie's gentle tear, tear of paper to make nests. And then some small foot kicks the tin side of the van and the wind tweaks the flap, and sometimes it gets so rough that we let the flaps down and the red hen tightens up, resisting the cold until the sun shines out and shames the wind's rudeness and our flaps are all loosed up again and we poke our heads out. She's a nice old van.

Quite a downpour but what care we, snugged up all cosy under the old tin hen. The rain comes in insignificant little titters on the canvas top with an occasional heavy ha-ha as the big accumulated drops roll off the pine boughs. Susie cavorts round in glee and all the rest snore cosily. I am a lucky woman, I have a brick in a biscuit tin at my feet, and a lovely afternoon's writing before me, and the mystery of the solemn wood to look into. It's a very nice wood but wickedly full of mosquitoes. Perhaps they belong to the mystery. Doubtless they, with their poisonous little pricks, have their place and undoubtedly they enjoy us. Three baby fir trees sit on the edge of the solemn wood and look as out of place as children at a grown-ups' party. Ghost flowers grow in the woods—beauties. I shall take a big clump home. They are mystery flowers.

The wind's been dreadful for two days and two nights. The tent blew down. I was flitting round all night. My smallest pup was very sick. I think the cold wind caught him. He cried and cried. I got in and out of bed, first to locate which pup was wailing and then to wrap him in a woolly and take him into bed. But he wailed in pain. I put bacon fat on his chest, and eucalyptus. Then a great gust came and the tent nearly dragged the van over, so I went out and wrestled with it. In bed and out of bed, in the van and out, what I had on blowing scandalously, what I had off heaped round, and all in the way. The monkey let out unearthly screeches and Susie tore paper. The dogs in their cosy boxes saw no cause for complaint and snored. That was reassuring.

June 20th

More maddening wind and another sick puppy that wailed all night to the accompaniment of the wind. I just loathe to see it suffering yet at times it looks quite fine. I've done everything I know, which is not much when it comes to such youngsters. I hate to leave it and go out and I hate to sit and hear it wail and I hate to destroy it unless it has to be. These tearing ice blasts sweep across the earth piercing everything. In the lulls it's quite warm. The sun dodges back and forth peeping through rain clouds. The whole universe is aggravating.

I wonder what I have learnt on this trip? I guess it's a matter of infinitesimal daily gain (as long as we are honest over it). We should not expect to drink immense swallows of knowledge but just go out with our eyes and soul open. Clamber, clamber. One does not always plant one's feet daintily when one is covering rough ground.

I am not glad and not sorry to move on. The summer parch is on the earth.

No word from the East. What's the matter with those people? It's over a month since I asked for the return of the manuscript. I guess they had it about three. I try not to think of them but I do because they've become part of my life and it's hard sorting them out and standing square on my own old running shoes irrespective of their opinion and criticisms, and it's good for me. Their crits don't help any more. They're drifting in art and not pushing on. Just because Lawren is not working others think they can't. The group's collapsed and the new group hasn't taken hold. Maybe it's up to us Westerns to wriggle up a bit. No mistake, the times *are* depressing. People simply can't afford the price of transportation to shows. I can't and I work with no idea of exhibit but just to squeak ahead a little.

H O P E S A N D D O L D R U M S
1 9 3 4 - 3 5

June 23rd, 1934
The roof seems low and heavy and the walls squeezing us. Yet the house is enormous after the van. But the van was so much nearer the big outside, just a canvas and a rib or two and then the world. And the earth was more yours than this little taxed scrap which is under your name. I left two little pups out in the solemn wood. It's nice to see my own family again. Yes, it's good to be home.

Mr. Hatch wrote acknowledging the two paper sketches I sent him. He found their vigour and profoundness appealing. Said few people *understand* them. Now I can't see *what* there is to be understood. They are just woodsy statements, no secrets or obscurities beyond the fact that all life is a mystery. Perhaps folk would like a numbered bit on the back: 1. a tree, 2. a root, 3. a grass, 4. a fool looking. Oh, life, life, how queer you are!

My new sketches thrill me a bit, sort of exhilarate me when I look at them, and a joy to work on. The job is to keep them up, up, up, to keep the praise in them bursting, rising, passing through the material and going beyond and carrying you with it.

The days are glorious and splendid, and just beyond are all the horrors peeping and jibbering. What can one do? Live in the present day by moment but ready to face squarely what shall come when it does, meantime making the best of the flying moments, using them. I went to hear Mr. Springett from Toronto yesterday. He did as they all do, ran round and round and did not find a finish. That's all any of them can do, Church, Christian Science, Oxford Group, all the million and one different kinds, various as the flowers of the earth, bearing their different seeds and fruits and scattering them, all with something right in them and some wrong too, pushing and growing to get up above the dirt.

Went to hear Mr. Springett again. He certainly is fine and quite alive. When he starts to speak people sit up. His great hulk heaves itself out of his chair and sort of hurls itself into an open spot on the platform, not behind the reading desk like the other speakers—that would cramp him. Besides he has a bay in front and needs room for his physical as well as his spiritual parson's collar (celluloid

I think) round his massive neck, but his chins and things are inside, not hanging over. It's more like a fence than a collar, a tight thing fitted to the throat. This circlet is big enough for a waist belt, big to let all the thoughts that roll up from his heart pour through. He is never still a moment and evidently knows all near objects are in danger for he moves the water jug and the glass and the vase of flowers at his feet and the chair to safe distances, and all the time he is talking hard and unbuttoning his coat and taking his watch out of his pocket and putting it safe and far over on the reading desk. His legs take on a wide straddle and then his arms begin working. They fly up, up unintentionally and big cuffs shoot out from his sleeves and catch on his coat sleeves. This little restriction pulls him up and he wrestles furiously and smashes them back up his sleeves and buttons up his coat again as if he feared they'd burst out that way and all the time his words are pouring out and you can, in a way, feel them striking on people's hearts like water hissing on hot metal. And after an immense outpouring he stops short and says, "And there it is," and leaves it with folk to digest. Then he forgets his cuffs and unbuttons his coat, but before long it all happens over again. People are all het up at the finish and say to each other, "Isn't he fine? Wasn't it wonderful?" And then they go home and eat and sleep and the next day and all the days after it gets weaker and weaker. We're such desperate hypocrites. If we actually believed in our hearts' cores it was *all true*, we'd burst because of its immensity, and everything else would be nothing. We're not really honest or else we're too little to compass it. And everybody says everyone else's way is all wrong and one longs to know. Are all ways wrong or all ways right?

My sketches have zip to them but they don't strike bottom yet. They move some but I want them to swell and roll back and forth into space, pausing here and there to fill out the song, catch the rhythm, to go down into the deep places and pause there and to rise up into the high ones, exulting. Let the movement be slow and savour of solidity at the base and rise quivering to the tree tops and to the sky, always rising to meet it joyously and tremulously. The objects before one are not enough, nor colour, nor form, nor design, nor composition. If spirit does not breathe through, it is lifeless, dead, voiceless. And the spirit must be felt so intensely that it has power to call others in passing, for it must pass, not stop in the pictures but be perpetually moving through, carrying on and inducing a thirst for more and a desire to rise.

July 5th
For years I have been "pillared" and "pillowed" on the criticisms and ideals of the East. Now they are torn away and I stand *alone* on my own perfectly good feet. Now I take my own soul as my critic. I ask no man but push with my own power, look with my own eyes, feeling into and praying always. My only shame is indolence or slovenly smattering over surface appearance instead of quietly and soberly digging and boring beneath.

July 9th
Little book, I started to take a summer school course in short story writing so

perhaps I can improve in my treatment of you. I'd like to make little daily incidents ring clean cut and clear as a bell, dress 'em up in gowns simple and yet exquisite like Paris gowns. I have not much confidence in the instructess but anyhow she knows heaps more than I and it's fun to work along with others. It's so long since I worked other than like the proverbial pelican in the wilderness, not since art school days.

July 11th

I am enjoying the short story course at summer school. It's nice to be among the young things and sharpen myself up against their keen brains. I'm the veteran antique among twenty-two. The desks are built for young things. My big front can hardly squeeze in. I touch back and front. I sit up in the front row because of being deaf. It was horrid when our first things were read out loud. I came first. Mrs. Shaw asked if I'd read my own or prefer her to. I grabbed at her offer. It was so funny to sit and listen to my thoughts coming out of another's mouth, the first time I'd ever done so. We had to write something that had happened, an incident, between the first and second morning of our course. I struck a humorous note and the young things clapped and grinned at times and it helped to start them off with more courage. Some of them were very good but most were frightfully serious. They haven't grown high enough yet to see over the top of life's fence and note the funny things on the other side. One of them asked if I was the painter and grabbed my hand and shook it and asked why I was wasting my time there when I could do the other. Lots of them are school teachers; they sit stiff, their mouths shut tight. There are time-killers and some middle-aged, bravely trying to keep up, and the teacher's son, brought by Mother and a little afraid to let go and expose his depths to the maternal eye.

The wide corridors bustle with youth and fifteen little nuns glide in and out, catching the convent school up to date. There isn't much giddy giggling like old days. There's rather a hard times' sober pushing to acquire more knowledge as bait to hook a job.

July 26th

That's that. A garden party for the short story class (summer school)—between twenty-five and thirty. Every man jack came. The tea was good but *very* simple, only hot biscuits and sponge cake layer with whipped cream and tea. Afterwards I passed round a basket of apples from the tree. The day was obligingly warm and windless so that the cool under the apple tree was welcome. The pups were in good form and the monkey, and the pale green apples bobbed up and down over the tea table. I had blue linen cloths and lots of benches and chairs. Then we ambled upstairs to the studio and there was an awful half-hour when they all stood at the end of the room like a lot of cornered rats, pop-eyed and shocked at the sketches. Nobody knew what to say so there was that awful silence in which one tosses sketch after sketch on the easel hooks with nervous haste and wants to sink through the floor. Then someone breaks the silence with a horrid, "What's that *supposed* to be?" and somebody else says, "Do explain them to us,"

and someone else gasps, "Just *where* is that?" and you want to slap all their faces, burn up *all* your stuff and then dig a deep hole, tumble into it and claw the earth over yourself. The world's queer.

Horrid things are in the paper today. Austria up to ructions. Somebody assassinated. Europe trembling and everyone saying, "What's coming?" God alone knows. Gee whiz, I'm tired, mentally and physically.

August 3rd

It's a long week since I told you anything, little book. Here's a secret first. Others might say it was silly. For the second time a soul has kissed my hand because of a picture of mine—once a man, once a woman. It makes one feel queer, half ashamed and very happy, that some thought you have expressed in paint has touched somebody. Today I sold a sketch and gave another, though of my very most recent. They always pick the newest and leave the old frowses. One's glad, in a way, that the recentest should be approved above the older. It looks like progress. One would rather like to keep one's latest, but there's always the hope that there'll be better ones than the latest by and by, so scoot them off before they grow too drab. I'm thirsting to be at it again but the story course has me tied by the arms and legs for another week yet. I've written an Indian story, "The Hully-up Paper." The class liked it.

Miss Richardson of London has been lecturing on teaching children to make pictures. It is interesting. Slum children's work was what she showed. They were lovely, done from the centre of the children's being, and belonging to themselves. It's a big thing and very worth while, hoisting them up above convention and tough outsides and giving them the courage to look inside and try to express in paint what they see, the same thing that I am trying to do in my own work. The children are nearer that God-thing and handle it naturally. I come to it in fear and trembling, with a clumsy, self-conscious hand, saying too much, hanging on to the thing too hard for very fear of it fluttering away. It is so easily bruised and crushed. It wants to hover above, free, not strained, not caged like a captive bird, mad and moping, but free, coming and going between God and you.

August 8th

My story has been selected by class vote as the one to be read at the closing assembly exercises of summer school. I was stricken with horror when I found I had to read it *myself*, and wished they'd chosen someone else's, but now I don't care any more because I want to do honour to the Indians. It's an Indian story— just a simple, tender, old Indian mother. I want to make them love her and feel her Indianness like I want people to see and feel the "Cow Yard" in spite of no plot. Mrs. Shaw doesn't like "Cow Yard" much. Says it's plotless and "maybe she could help me fix it up." I don't want Mrs. S. to fix it. I don't want it to have a darn magazine story plot and set people worrying to unravel it. I just want it to be the "Cow Yard" and make people feel and smell and see and *love* it like I did as I wrote it—blessed old heaven of refuge for a troubled child and a place of bursting joy for a happy one.

August 10th

I did it. It wasn't very awful except that the hall is terrible to speak in. It does horrible things with your voice so that it is a big effort. I had just two wants as I stood there reading: to make my voice carry and to make them see "Jenny" and "Bessy" and "Charlie Jo's little Injun baby." They gave me a lovely bunch of flowers and clapped when I went on and off. This evening we went to the house of one of the students. It was a simple, honest, happy affair. They're a nice set of young things and we olders aren't so bad and all get on together. We sang and played games and had supper with *very good* coffee and I drank two cups and can't sleep. We're going to meet at my studio on October 1st and everyone is supposed to bring a manuscript that they've written between now and then.

August 12th

I haven't one friend of my own age and generation. I wish I had. I don't know if it's my own fault. I haven't a *single thing* in common with them. They're all snarled up in grandchildren or W.A. or church teas or bridge or society. None of them like painting and they particularly dislike my kind of painting. It's awkward, this oil and water mixing. I have lots more in common with the young generation, but there you are. Twenty can't be expected to tolerate sixty in all things, and sixty gets bored stiff with twenty's eternal love affairs. Oh God, why did you make me a pelican and sit me down in a wilderness? These old maids of fifty to sixty, how dull they are, so self-centred, and the married women are absorbed in their husbands and families. Oh Lord, I thank Thee for the dogs and the monkey and the rat. I loafed all day. Next week I must step on the gas.

August 22nd

We three went on an excursion round Salt Spring Island. A perfect day. All were amiable and enjoyed every bit. Moon across the water on return was superb. It has been in my thoughts all day, silvery ringing space filled with every colour and glorious light, and such peace, the kind of "God" that passes all understanding.

August 23rd

Edythe and Fred came and chose three sketches to send to Gertrude Stein, Paris. Tommy rot I call it! Dear children, they are good to this old woman but I'm sure Gertrude won't bother and she'd think my sketches mediocre.

August 24th

Mr. Sught came and photographed some of my pictures. They looked punk old things as I pulled them out, hey ho! I must do some better canvases. Mr. Checkley came and saw about some sketches for the Willows fair. I guess that's where my things belong—among the sheep and pigs at the agricultural fair. Anyhow I'd rather show among livestock than among the Arts and Crafts Society. Two American women phoned and did not *ask* if they might come to the studio, just said they were coming. Cheek, I call it, not to say, "By your leave."

Well that's that, three things off my chest in one day, all a bit nasty. I do wish I could feel *satisfied* just once over my work. It's so faulty and poor. I'm wanting to get out in the woods again.

Sunday, August 26th

The girls came to dinner. We had it on the balcony outside the studio. It was lovely, just we three girls, overlooking the garden. The gladioli and Hadley roses were gay in the round bed. We went down and looked round the garden and saw the roses and the pups. The girls weren't in the hurry they usually are and there was slow restfulness. I like that. The perpetual scurrying to get away to the next thing wears one. Yesterday I sold a picture to Flora. She likes my work and thinks over-highly of it but I love her to have my things. I gave her another so she will have one woods and one calm sea. Flora is very fine in spirit and her life is not easy.

The pups, Caravana and Metchosen, are so cute and so different and so alike and so wise and so foolish all at once. Metchosen takes life with a joyous ease. Caravana has a more suspicious nature and takes life much harder. M. is all "he." C. is all "she."

The last week has been warm with superb nights and whispers of coming fall. I have been on the beach around 7 o'clock in the morning. It's pearly across the sea, not many mountains showing. The cliff's parched, colourless. I said to myself this morning, "What is it I want to meet out there?" It is light and space and inside them, well enveloped in the peace and glory of it, God. "I am pure being in whom all things be." And yet we're always hedging, scared to face squarely, scared to acknowledge the author of our being and go to meet Him and listen to what He has to say. I say to myself, "But I must hurry because the years crowd by so quickly I have little working time left." Fool. Time is God's. You will have just as long as He intends you to have, all the time and all the opportunity He wills. You and your work are not so important as you think. The only thing that *is* important is God, and the trying to see something of Him in everything.

August 27th

Such a day! 7:30 A.M. on the beach cliff, painting—just a light empty sky, a strip of dark blue sea, a wave of mountains and wisp of dry grass. Brought the sketches home and started on a big one of it, not entirely satisfactory but in the right direction. After noon Mayo Tong, a Chinese cook boy, came to see pictures. He was delightful, so keenly interested and such an understanding person. His remarks and quaint criticisms were most illuminating. He studied each canvas and each sketch deeply. He knew at once the ones he liked. He fell at once for a Goldstream Flats tree thing. "*Why* do you like it?" I asked. "Because it is beautiful," he said, "very, very beautiful and I can go long, far, into it." I put up some of my old ones. "No!" he said. "It is nice but it is still and it is like it is.

This one goes like wind coming through it." One wood canvas he liked very much. He said, "I like tree places. That was a lonesome place." He was very courteous and appreciative that I took time to show him things. A nice boy with lots of feeling, the fine sensitive feeling of the East for art. Then Delisle Parker and Mrs. Parker and Miss Dallas from Vancouver. Delisle, just back from Paris, was more than enthusiastic, dubbed some of the canvases and sketches "magnificent." All can see the promise of something in this year's work, something that lifted them and took them out. I am so happy about it. I pray for more wisdom and knowledge and humility and I thank God that my work should stir others and induce enthusiasm in them to make them run off intending to *work*. Then Flora came to tea, and people about dogs, and people about flats, and I'm tired but happy to think that artists from Paris who have been looking out into bigger worlds see something in mine in this small corner.

August 30th
Mr. Parker, direct from Paris, opines that Emily Carr can hold her own with the painters *anywhere* and went from my studio all puffed up with the desire to work himself. Mrs. Parker told me, and she said herself that my new work brought tears to her eyes like solemn music does. That is all very extraordinary. Yet, as I was mounting sketches today I felt so many shortcomings and I believe more and more that one's only real critic, the one that counts, is one's own soul. The true part of one's self knows how far you have fallen short. Oh Christ, keep my ideals *high* and help me to look up above praise or flattery.

I'm having a smash of people in the studio. Why? It's sort of my job. People are kind to me and if my stuff gives them pleasure and helps them to see things a little I am happy.

Oh! Oh! OH! I'm tired. Had a big party, some twenty-five souls, mostly artists, visitors, two Paris, three Seattle, one New Haven, three New York, one missionary, and the rest locals, but with all so recently from the other cities it was quite interesting. I showed millions of mounted sketches and many canvases, and gave them good eats, and got so tired over the last few sticker-ons that I was almost crying. I showed pictures steadily for about two hours. They liked them and said all sorts of things, some silly, some true. It's funny how little I care what they do say. All that "goo" trickles over me and runs down the other side and makes not one indentation. I do not think it is empty flattery. I think most of them *felt* something but it kind of nauseates me. I liked the little China-boy's remarks much better, badly expressed but from his heart. Oh gee! I want to get away to the van, away from everybody, out with the thing itself, and just the restful beasts. Tonight when they were all cackling around, my soul just wanted to gather up my heels and away. I ought to be ashamed and so very glad that the sketches spoke to people. I have mounted fourteen new ones.

Oh, I'm sure I wasn't nice, not a bit nice to people tonight. They liked my evening and me in spite of me not because of me. I'm a cat.

September 2nd

People keep saying nice things about my party but the best of all was when Lizzie said *she* enjoyed it and *saw* something in my work for the first time. I was very tickled. Alice liked it too, but she had liked it once before, when I was getting it off for Edmonton. And now I'm off again to the van and keen as pepper to be at it again. I've had a big few days preparing beasts and paint, materials and food and clothes, and typewriter and stories to work on. And I shall forget all about the house and the tenants and bothers and settle down in the van and work. I am very blessed in having it. I have talked to a Jewess today. It was interesting—a different viewpoint. She is sure that Christ is coming very soon to earth. Surely this thing is stirring all peoples and religions.

September 5th. At camp at Mr. Strathdee's, Metchosin Road

It is beautiful, very calm. The forest fires fill the gaps and valleys with blue. The sky is high. The grass is parched and leaves continually fall down. Time is only bounded by light and dark and hunger. People have welcomed us back kindly. I had four accidents yesterday as a starter—just put a peach in my pocket and sat on it, left the fish I'd prepared at home, knocked the pickle bottle across my glasses and broke them, and broke the van window. The beasts are so happy and I've forgotten all about the grunting tenant. What a grand list she will collect against my return though it doesn't seem to me there are many headings left. She's had moths, heat, floors, plumbing, garbage, rent, dates, door bell, window cleaning, blinds, walls, furniture, neighbours, garden, hot water and noises already—and some I've forgotten.

It falls dark early. Rain has threatened all day and is longed for by those who are fighting forest fires. Mr. S. has been out all day scraping moss off rocks to keep the fire from spreading. He is a most uncheerful anticipator of evil: knows the fires are going to sweep straight for his premises, knows his apple trees won't bear, knows there is a dead sheep smelling and it will get worse and worse, knows my pups will fall into his cistern and be drowned one day and run over the next, and that all the hens have tuberculosis and that the ants will eat his house clean to sawdust!

I have made a sketch—fair. Oh goodness, it's splendid off in the rough land behind here. The wild rose hips are scarlet and the bracken is turning brown russet. The grass is parched silvery, hardened and wired into ripples where the prevailing wind has run over it so perpetually it has stiffened and given up trying to straighten up. The grasshoppers click and tick across the grass, low and heavy, and there are wasps everywhere, and myriads of little sober-coloured birds eating thistledown.

September 6th

I have sat over the fire. It has been dark some time, a wonderful, mysterious not-black dark. The trees are so inexplicably beautiful! I've been thinking about

them, how in a way they are better than we humans. They are more obedient to God and recognize him clearer. They go straight ahead doing what God tells them; they never pause or question; they grow, always moving in growth, always unfolding, never in a hurry, never behind, doing things in their season. God did not give them the right to choose good and evil like he did us so they don't make as big a mess of things. That grand thing, that final choice, is our prerogative, the thing that makes us God's sons and daughters and not just his creation. His spirit is among all the other things because it is everywhere. The woods are very full of it tonight. I think our mistake is trying to humanize the woods to make them conform to us, instead of going out to them in a spirit of recognition of the God spirit among them. Only when we realize our kinship in spirit will we get understanding.

September 8th
Only 7 o'clock when I shut myself in tonight and yet it was dark—practically no sun today. Did a morning sketch and finished yesterday afternoon's. The morning one promised well and fulfilled ill. Little "Wee Bit Picnic" lunched with me, queer little dodger, all fixed up fancy when she comes down the road, till she gets to work on "Brother's" house-keeping deficiencies. Off come her stockings and everything that will take off and she puts on an apron made of three legs of men's overalls—one goes cross ways over her middle and the other pair dangle. When I invite her she refuses and excuses and finally succumbs and comes as she always intended to. She adores Woo who makes faces at her and then turns her back. She has two subjects of conversation, "Brother" and the inadvisability of marrying an "out of work" or anyone who can't keep you as well as you can keep yourself. She was full of the beautiful things an old man left her whose room she attended to at the Empress for three years—seventeen dress shirts, my dear! But he was a very thin old man and "Brother" is so wide the shirts refuse to enclose him. I wondered if the three jean legs that formed the apron were part of the legacy.

It blew terribly last night. Writing won't come these days. I seem too tired at night to apply myself, am reading quite a lot and the days fly. I think the most splendid thing would be to paint so simply that the common ordinary people would understand and see something of God in your expressing. The educated look for technique and pattern, colour quality, composition. Spirit touches them little and it's the only thing that counts.

September 9th
All the elements have had a hand in today—rain, shine, wind. You have to jump all ways at once to accommodate them. Oh my! Oh me! Life in a caravan in pouring rain with two dogs, two puppies, one monkey and one white rat along! No good imagining a fire for breakfast. I did it on canned heat on a bean tin. The peak of things was when I discovered I'd left my mackinaw out in the rain all night.

September 12th

Only 7:00 P.M. and I'm already tucked in bed. The night is rough and bitter. Everything is closed down and the creatures, like myself, all have an extra blanket. I've typed nearly all day—"The Praying Chair." I think it rather quaint but I don't know; to others it may be silly. It's my own awful longing to possess a dog and of course it's very real to me. How that longing has been fulfilled and what a lot my dogs have meant to me! Sometimes I think I'm not half grateful enough to the creatures. I wonder if my book with little sidelights on their lives will make animals any dearer or any clearer to anybody. I couldn't imagine a world without the love and the interest of them. They put up with you when nobody else will. In your very most hateful moods they still love you.

September 15th

It is glorious weather again with a moon at nights. Sketching full blast. Worked half the day, taking my lunch into the woods. High and blue sky, straggle of distant pines and stumps and dry grass in the foreground, and all soused in light and vibrating with glow. Product not marvellous but I have learned quite a bit and saw somewhat. The whole place is full of subjects. By that I mean that things speak all over the place. You have to go and look here and there as you go. It's no good putting down a stroke till something speaks; then get busy. Form is fine, and colour and design and subject matter but that which does not speak to the heart is worthless. It is the intensity of feeling you have about a thing that counts.

When I tried to see things theosophically I was looking through the glasses of cold, hard, inevitable fate, serene perhaps but cold, unjoyous and unmoving. Seeing things the Christ way, things are dipped in love. It warms and humanizes them. "I am come that ye might have life and have it more abundantly." God as cold, inexorable law is terrible. God as love is joyous.

September 16th

Time is racing swiftly. Before one knows it the van will be folded down and winter here. So? There are good things for the winter too—canvases to work out of the sketches, illustrations for the animal stories. My animal stories come slowly and I am truly disheartened with them; they are so crude and lame and badly put.

Dear old van! There's something very cosy about her and very peaceful about the environment. The black-faced, fool sheep and the pups and I have it all to ourselves, and a few little birds. The skies are grand and high, and the pines poke their noses up among the clouds without a quiver.

Heat and cold chase one another like pups playing—yesterday ovenish, today cold storage. This morning a sketch of "nothing in particular," one of the most difficult to perform. Afternoon a beautiful subject, the overshadowing of one monstrous tree. I worked honestly both whiles, not using my own determinings; led to both subjects and giving myself over to them. Yesterday a dreadful douse of visitors which was far more exhausting and upsetting than the most violent work. They are beginning to want me home I can see.

Oh, perfect in the pauses when the wind forgets and the sun remembers! Summer is past but the full ripeness and maturity holds still as if it were pausing in fullness before disintegration sets in. The fruits of the earth are garnered. The season's development holds.

There was a fierce storm a few nights back. Twigs and boughs snapped off my old pine and struck the van in passing with reports like pistols. The canvas did not break but it sounded like a drum and I did not know which minute a great bough, dead and hanging from the tree, would come through the frail top and—perhaps, who knows? I popped out the lamps, for if a tree fell it would be worse to have fire added to it, and slept in my blanket chemise so if I was pinned and had to yowl for help I'd be found decent and having made full preparation. Nothing happened but it was some fierce storm everyone says.

Goodbye, dear place! Tomorrow we leave the dear gracious trees and face grouchy tenants. It's been a lovely free month. Twenty-one sketches, lots of thinking, and six stories pulled into shape. It rains a little tonight. Tomorrow I shall eat at an ordinary table in a roofed house. I wonder if the pines will miss me. I have loved them.

September 29th

To sit on a perfectly decent chair with four steady legs on a wooden floor, to eat at a solid table with four even legs, to have a plaster ceiling instead of a sky quivering with movement and light, to turn the tap and apply a match instead of adjusting the stove-pipe to meet the wind and collecting sticks from the woods and axing and bucksawing a bit and blinking the smoke out of one's eyes and blacking one's hands (but oh, the lovely smoky smell and taste), to spread out in a wide bed and look over dim house roofs and chimneys (I remember the moon through the pine trees), to have a whole room to oneself instead of sharing a little van with monkey, dogs and rat! Ah well, there you are—some like one, some the other, but God's a little closer out there and the earth and sky and trees are very sweet. The house shuts these things out a little.

October 1st

Things can be altogether abominable and they are today. The short story class were all to meet at my house on October 1st. Only ten came and it was a hopelessly stupid evening. Two sloppy love stories were read. The words flowed easily but there wasn't any stuff in them. It was an utterly profitless evening and ended in Woo biting Mrs. Shaw's leg. I scarcely blame the monkey; the woman was stupid and all the people teased Woo till she was almost crazy, and me too. My Indian story was returned from *Maclean's Magazine* without thanks. I longed for the van and Mr. Strathdee's peaceful field and the wise, tender old pines and the all-over peace of outdoors.

October 5th

Tired into a smash. Two old girls did it, ages eighty-four and eighty-seven. Spent the day, lunch and tea and dinner. Poor old wearisomes, comparing their

cataracts and rheumatisms, their loneliness and children, bragging about their servants and past English gardens, bewailing the immorality of the world and comparing their churches. I gave them nice soft victuals with nothing seedy to get under their plates and we had lunch in the glorious sun in the garden. One of them slipped off to sleep with her head thrown back over her chair like a towel hanging to dry, and her mouth open. One had bobbed hair with pink scalp very visible and her face a network of wrinkles—such ugly ones, pockets and bags and ditches. The other had iron grey hair drawn back into an onion and a wonderfully smooth face with pink cheeks. Goodness, I don't feel twenty years younger than they are. I feel old, old, old and stiff and tired, except when I paint; then I'm no age. At night, folded close in the blackness among the trees it was not lonesome by the roadside in the old van. In town it is different, in the great, still house. Empty rooms are around, except those filled with impossibles—souls that never touch mine, greater strangers than the strange; no common interests or doings or thoughts; thin partitions dividing our bodies, immense adamant walls separating our souls.

The world is so messy at present everyone is depressed. I don't fit anywhere, so I'm out of everything and I ache and ache. I don't fit in the family and I don't fit in the church and I don't fit in my own house as a landlady. It's dreadful—like a game of Musical Chairs. I'm always out, never get a seat in time; the music always stops first.

I've written reams of horrid letters to picture galleries that *won't* return my exhibits. National Gallery had three for *three years*, Toronto Watercolour had three for *two years*. Why should one have to beg and beg to get their own belongings? I wrote Brown straight from the shoulder. He'll ignore it like always, as if I did not exist, weren't worth a glance even from his eye.

Abominations are thick as bee stings in a hive—the horrid tenant below, the miserable woman who lost my dog, the creature I met in the street the other night who took me by the shoulders and *shook* me because I was trying to fend her dog off mine, the insurance company who have swindled me out of cash by misrepresentation of their men—all these and more heaped in a pile and me straddled atop trying to forget them all, but they will stick out teeth and claws and gnaw and pinch and scratch and it's hard to sit steady on the pile, so tight they smother and shrivel and die! Every time you bounce up with a new burst of mad they take a fresh breath and draw strength and attack again. Out with you into the rain and wind and get blown on, old girl; you're mired.

October 20th
The wind is down on all fours pounding. The poor withered leaves do not know which way to turn; they are balked in every direction. They had no idea they would see so much of the world before they found a grave in some crevice and retired back to their elements, giving back to earth exactly what they had drawn from her. That's the plan, I guess, always giving back exactly what we have absorbed so that nothing is lost. But every time things turn over they accumu-

late interest. From my bedroom window I see the sea waves too. They are per-plexed at being driven in four adverse ways at once and stand on end surging up in rebellious white foam with the wind tied up in its fabric, hanging on to it, imprisoning it in salt wet prisons. When the storm is over it will release it, mild and chastened.

October 21st
Mrs. Lawson is dead.

Death, serene, beautiful, compelling awe and veneration. The fragile outer petals of a little old lady, all the troublesome old problems of weariness, stiffness and aches dissolved away. A kiss of peace pressed on the loose broken petals ready to drop and to fade away like other flowers that surround her little worn old hands, hands that raised the large family through which she spread her own self and caught herself back again in the joy and pride of her grandchildren. Goodbye, little lady! I do not think you mind being gone. You only dreaded the going a little as we all must—that first footstep out "where neither ground is for the feet, nor path to follow."

October 22nd
There was a tea party today at the Arts and Crafts Society exhibition. I was invited among some ten artists and club members. The whole affair ached with horridness. The show had just opened and a straggle of the type that always go on opening days were there, faded people who have time to kill, people with no particular job and of no particular age, belonging to no particular "set." They simpered over their catalogues and smeared an asinine glance over the pictures, spent much longer looking for its name in the catalogue than examin-ing the work of art when found. If anybody spotted an artist near his or her own picture they darted across and went into mild hysterics and spat out adjectives.

Tea was spread on three or four rickety card tables strung together so close to a row of chairs along the wall that your person was horridly squeezed. Deep breathers throbbed the tables with each respiration. There was a grand deal of talk about seating (no two women together, nor two men) and every time a late comer came, and most of them were late, everyone had to seize their cup and plate because people had to be re-sorted and everything got knocked over. There wasn't *one* of us young or vital, no spirit, no poetry, no youth, just prosey flesh picking with tired hands from meagre plates of sparsely buttered bread and dice of uninteresting cake. Oh, the pity! We represented (more or less) Victoria's art! Oh, that is not art! I do not think there can be any such thing as *societies* for art. Those are "snarling" societies (I myself no better than the rest). The fellow-ship of art is out among the angels in wide space and high skies, things one can-not word and can only feel dimly.

The rain has come wholeheartedly. It is invigorating to hear it pelting against the shingles a few inches above your head in the attic bedroom. Except the near houses everything is smudged out. Half of Victoria has been re-roofed this fall. I

guess all that half is purring. Only one corner of mine was done and I purr even over that. These days make one feel domestic and inclined to clean out wood-boxes and cupboards and straighten things and cosy up. The house sort of wraps you round. It would be nice to hibernate, to hug yourself and dream and rest your brain and your stomach and your whole being. That's the worst of us. We streak along full stretch, top speed. Trees and beasts and every other thing rests. In old days the farmers and farm women used to enjoy recreation and ease, more or less, in winter, Oh, why have we all gone so against nature I do wonder?

October 25th

The garden is all righted up for winter. Mr. Lanceley helped me fix it and we had a lovely day. He forked up the earth which after the rain was easy and mellow. The bulbs are very busy underneath. When you turned them up you felt almost ashamed as if you had disturbed their privacy and should say, "Excuse me!" You can feel the force of life breaking through their brown jackets and starting up white shoots and you think of all that's got to happen before spring is ready for them. There they are kicking their heels like impatient children. Some day the sun will tantalize them, soaking through the purple brown earth, but as they push and push trying to pierce it, down will come bitter, biting frost and drive them back disappointed. It looks loved and tidy now all the apples are stored away and the fern bed is well leafed over and the garden chairs stowed in the shed. In another week the real winter months start.

November 1st

A letter from Lawren. He and Bess have divorced and married each other. None of my business but I feel somehow as if my connection in the East were over.

On request (mine) my pictures are tumbling home to me after two to three years of exhibiting. I don't know where; we are not kept informed and I had to hunt for them and write many letters. I shall not send again. Express is prohibitive, returns so uncertain, and—does it matter? Is one painting for the world? If one were very big indeed perhaps one would. Or is one just trying to get nearer to God and express that of him which is in all things and fills all space? Is the latter way selfish or does every soul just have to do that individually—work out their own salvation?

The world stands still like a patient child while the rain pours, drenches, washes, soaks rotten things back into earth to start all over again from the process of decay up. Miracles and miracles! But if God would only speak plainer or give us another hearing!

November 7th

After a real struggle I finished the story of the crow. Is there anything in the stories? I feel them deeply as I write. I wonder if Flora is right that my painting is waiting on my writing. How interesting it is to work on the two! They are alike and different. I want to write and write longer spells than I want to paint. Writing is more human than painting.

November 9th

I went to an Authors' Association meeting yesterday. It was very stupid. They talked about everything but writing. Mostly old women there like me, and a sprinkling of the ugliest men I ever saw, and afterwards we went to the conservatories and saw the chrysanthemums, which were far more inspiring—yellow, pink, white, red like dark blood. But even the chrysanthemums were spoilt by forcing and weren't nearly so "luscious with a tang" as the garden ones. Forced and fed on scientific fertilizers, they had never known a pure outdoor breeze or the real earth with the pull of the whole world behind it and water straight from Heaven and sun unfettered by protecting glass, so they got swollen and swollen till they were unreal and forced outsize, with their perfume and sweet freshness absorbed in their bulk. They had no imperfections that individualized them. All their faces said the same thing like a row of suet puddings made to recipe and well risen.

I am rewriting "D'Sonoqua's Cats," living it bit by bit—the big wooden image, the woods, the deserted villages, the wet, the sea and smells and growth, the lonesomeness and mystery, and the spirit of D'Sonoqua over it all and what she did to me.

November 14th

I am looking through my book and see several places where the blank pages are stuck together. Isn't that like life? Those blank days that stuck together and recorded nothing! In our carelessness we stupidly let them stick and remain blank. Instead of prying them open and rejoicing at the things that were in those days, we let them stay empty.

Flora spent the night and we worked, tidying up my stories and deciding where to send them. Gee, it's good to have a friend like Flora, good and wonderful. She knows so much and she loves the creatures. She's enormously unselfish and generous, always doing kind somethings and cheering one when they are flagging and flat. She's an inspiration. We worked until 1:30 A.M. and I read and slept and saw the sun rise glorious in the studio east window at 7:30.

November 17th

Well, I had the chimney swept today and Caley, the sweeper, and I had a long conversation over politics and religion. Fancy a few years back talking to a sweep about Jesus Christ and the state of Russia and communism and soul-stirring things! He knew lots more than me and said some fine things, broad and big, that made one think. He spoke about nothing being ours. "Now you," he said, "have a great gift, but it is not yours; it belongs to us all. It has been lent to you from God and the millionaires' gold and silver is not theirs but has been lent to them for service—empty service." He was just fine, that sweep and his views. Everywhere one goes it's the same. People are thinking and talking and one is not ashamed any more. You used to feel it wasn't quite decent to discuss God, and the name, Jesus Christ, always made you feel queer and priggish somehow; and your voice went different. But now it doesn't matter and it's

wonderful. Oh, is it the beginning of the coming of the kingdom "on earth as it is in Heaven"?

November 18th

A happy day. Harry Adaskin of the Hart House Quartet came to lunch and we talked more than we ate. The Quartet was playing modern music tonight at Mrs. Hinton's and Mr. A. invited me and a friend, so Flora went. Oh, it stirred deep. Lovely music—rebellion, ferocity, tenderness, resignation—superbly played. Our hostess did not like it, which was an amaze to me. Are people afraid to dip down and find out about life, I wonder? The man who wrote it and the men who interpret it have to dig and drink dregs to produce it. It means some tearing of themselves, exhausting, searching, striving for ideals.

November 26th

It is a week since the Quartet was here. The classical concert on the Monday was the best they had ever given, everyone said, and even the Quartet themselves said it was a good concert. Everybody and everything about it seemed to swing right and swing together. After, I went behind to say goodbye. They were tired but happy. Harry Adaskin sat on the step of the stage lovingly polishing his beloved fiddle for the night before laying it in its case. Geza de Krész took my hand and held it tight while he excused himself, with his eyes anywhere but on me. They were anxiously on his fiddle that was lying in its case loosely, and the awful fear was upon his face that I or some other would brush past the chair and overset it. I realized then how much their instruments mean to these men, the mechanics of expressing the glories they know are within them. It is splendidly wonderful, the things that lie beyond, that we try to capture with instruments or paint or words, the same things that we are all trying to build, to create, the thing that our bodies are trying to give a spirit to and our spirits are trying to provide with a bodily expression. Mr. Adaskin came to see me again Monday, and Boris Hambourg also. He is very gentle in spirit. I suppose he has to be because his wife is a tornado, but I like her; she always sends me loving messages. They're nice and their music is a whisper from elsewhere and gives one fresh courage. They found my latest work youthful and inspiring in spirit. It refreshed them. I work on at these canvases and long for more depth and intensity.

December 2nd

What a spooky place an empty theatre is when there are no lights! Clem Davies uses the Empire Theatre for his services. I did not know he had changed and went this morning. I was a little late. No one was around the door, but the theatre was open. I swung the door, crossed the vestibule and went through the inner door. The lobby was dimly lighted from the outer door. No usher and no pile of notice papers. I must be *very* late, I thought, and crept up to my usual seat in the balcony. I got no further than the gallery entrance. Ill-ventilated black met me, a dense smothering black as if all the actors and the audience had

left something there, something intangible in that black hole of a place. The deathly silence was full of crying. It made you want to get out quickly, as if you were looking at something you should not see. I came out quickly into the dull street, Government Street in Chinatown, with all the dirty curtained windows and the shut shops. Two little Chinese girls were licking suckers, red ones that rouged their tongues, and were comparing tongues in the mirror on the door outside.

I walked to the Empress Hotel, straight into the Conservatory, passing through the empty lounge and corridors. I suppose most of the guests were still in bed. Boys with dust pans looked here and there for possible dirt. The Conservatory was empty of humans—just the flowers, and they were at worship and let me join them. Cyclamen, pink, red, purple-red, rose; prunella; little pink begonia; pots of green; calla lilies (Bess' flower); and poinsettia, looking Christmasy, already hung up on straggly stems and ending abruptly in scarlet blobs. Fatherly palms and soft, motherly tree ferns stood in huge tubs, their leaves drooping low. The little fountain gurgled and splashed. Every now and then it gushed out in a bigger spray and gurgle as if it had some sudden extra sorrow and must cry harder. The sun came dancing through the glass and the light flowed over the blooms, trickled among the leaves, and showed up tiny transparent diamond drips from the pouts of the lily leaves where before only drops of water had been. A few flies buzzed. And all the while I sat quite quiet.

It was very holy in there. They were worshipping as hard as they knew how, fulfilling the job God gave them to do. The stream of life, God's life, was passing through them. You could feel their growth and their praise rising up to God and singing, not as we humans sing, but glorifying in their own way, their faces pure and lovely, growing, fulfilling, every moment. I saw an arum lily sway gently to and fro once or twice. Then it stopped, and a little variegated leafy trailer suddenly outgrew some little catch; a spray slipped loose, every life quivering. There was a great peace. I was glad the theatre had been empty so that I had been led to worship with the flowers.

December 3rd

The woman's crits in the short story class are perfectly futile. I was down about my writing anyhow, down in the depths. She jumbled through my story in the reading, giving it no sense, mixing words, hurrying frantically. The comments afterwards were neither helpful nor constructive. The class hunted hectically for "complaints" and laid fingers on good, bad or indifferent, irrespective. If only there was someone who really *knew*.

December 6th

Today in the early part I walked in the park with the dogs. We were by the lake. A large band of ducks was standing on the bank. When they saw the dogs they rose all together, sixty wings, with the quick flap, flap of duck flight, all their necks stretched straight out, all their legs folded back exactly the same. Thirty squawks were one. Thirty moving creatures that combined in one movement in

the sky. I suppose one would scarcely have noticed one lone duck rise but the accumulated repeat strengthened it mightily. Perhaps prayer is like that. The concerted repeat makes it stronger. Maybe that is the good of church, if the worshippers are really meaning the words and not thinking how hard the floor is, or how ugly the bobbed hair of the elderly is when their hats are bowed and their necks show, or what a scraggy neck someone has or what humped shoulders, instead of realizing the whole mob as a praying unit before God. If you could only leave your body in the porch and enter in your naked souls, it would be grand. How wonderful a church for the blind must be if everybody, you included, were blind! No, I think perhaps all this is wrong. All these delicious sights and beauties should hoist me up nearer to the source of it. One should busy their thoughts with nothing but their relation to God. We are awfully frail-minded.

December 10th
Back they come, the "Hully-up Paper" from *Saturday Evening Post*, "Cow Yard" and "Peacock" from *Atlantic Monthly*, returned without thanks, not wanted, found unsuitable. I feel my stuff will not interest this day's public. They want blood and thunder, sex and crime, crooks, divorce, edgy things that keep them on the *qui vive* wondering which way the cat is going to jump and hoping it's the *risqué* way. I can't write that stuff. I don't want to learn. I won't. So I guess my little homely tales of creatures and things will sit in my box forever. I want the money dreadfully but I don't want dirt money.

December 11th
Have been struggling with "D'Sonoqua." Big, strong simplicity is needed for these carvings and forests. I am appalled at the petty drivel I get down. It feels strong when I'm doing it; afterwards it's crude. Ugh! How does one bridge "feels" with "words"? If only I were better educated, but how I *hated* school! It takes a genius to write without education. I utter the senseless squawks of a feathered fowl. Often I wonder at the desire in me being so strong and drivelling out in such feeble words and badly constructed sentences.

December 13th
My sixty-third birthday and everyone's been lovely over it. Bless them all! The rain is on the shingles overhead in the attic. All the mountains are washed out in mist and the telephone wires are solid rows of diamond drops. I've got to rattle out and vote for mayor and then come home and make pounds of Christmas candy for the Christmas boxes of the nieces. I'd far rather write and write and write—about D'Sonoqua and the West coast, about the looks and smells and feels, and the joy and the despair and the bigness and depth and sweetness and awfulness.

Alice got a letter from a boy in hospital. He saw an article in the *Province* about me and my work. What the boy said was worth more to me by far than all the newspaper slop. He doesn't know art at all but he knows the B.C. coast and

the "bite" of lonesome places, and had a notion of what I was trying to get at and my stuff spoke to him and that makes me happy. A man I met the other day said much the same to me. In those he saw at the Fair he felt the power and strength of the Forest. Those are the crits that count and make one cocky. A third man who has two of my sketches told me he never came into the room where they hang without them touching him deeply. Those things are very sweet to hear.

Night 13th

We had a lovely birthday party down at Alice's, just we three old girls—tea with goodies and a cake with three dilapidated candles. We had jokes and giggled a lot. In the evening we all worked at Christmas stuff. They sewed and knitted. I pitted four pounds of dates for the candies, and then read a fine article aloud about the Prince of Wales. Now I've launched into year sixty-four.

Christmas is on the wing. In five more days she'll settle. The candies are all made and posted. The holly is gathered but it is too pouring wet to snip boughs surreptitiously off the boulevard cedars for the cemetery wreaths. Alice's school breaks up tomorrow. Lizzie's hamper-packing and church-decorating. Oh, Holy Babe in your manger, how we have spoiled your birthday and made it a greedy, toilsome time. We know it, but everybody else does the same, so we go on doing it.

December 21st

I am very ashamed because Christmas has chafed and wearied and irritated me so this year—stuffing turkeys, making holly wreaths, postings and writings, hampers, donations. A week of dragged-out tommy rot. The most joyous thing about the whole show was the smell of the pine and the cedar—delicious! So much of the rest is silliness and sentimentality instead of holiness.

December 24th

It's raw and shining, bitter and shrivelling. The post has just come and brought me a stack of cards, some I did expect, some I didn't. *The Countryman* has turned down my stories but as he could not use them he has sent them on to someone else. Not just their type, he said. In the same post came a letter from a man in Edmonton re my exhibit up there. He said, "As you are no doubt aware, your work is not popular. To the few who like it and could see what you were striving for, it was a treat." If I loved humanity *en masse* more would I suit them better? I don't like the stuff the painters and writers cater to. Ought I to like it? It seems to me so garish and cheap, so full of crime and the suggestion of indecency and dirt.

Christmas Day

It was still night when I set out for the cathedral's early celebration and it was

raining hard and everywhere was dark and wet and mysterious. Only one or two kitchen lights, and all the street lights. Even the children had not opened the one eye that could shut out Santa and rest the tiredness of Christmas Eve shopping. The puddles gleamed under the street lamps and the shadow of my umbrella accompanied me all the way. There is something very holy about Communion before it is light, something dark and warm and mystic in the dim corners of the Cathedral—the pine smell of the decorations, the scarlet of the berries and the poinsettia blooms. When we came out dawn was coming, grey and wet. The street lamps were out so the umbrellas had to march alone without a companionable jogging shadow. The houses were still asleep, stuffy people with windows tight closed; robust, uncomfortable souls with blinds and windows wide so that you could picture their red noses and foggy breath emerging from the blankets. Just ordinaries were lighting their kitchen stoves and dragging in milk bottles. I woke the pups and we breakfasted over the fire.

We gifted last night.

December 30th

Went to church, that is to service held in the Empire Theatre by Dr. Clem Davies. The Kitsilano boys' band was playing, and the house was full. So I wandered back through Chinatown and saw Lee Nan seated at his organ among all his pictures. He was playing so vigorously he did not hear before many knockings, and gave me a fine welcome. I asked him to play and he did, putting aside his bashfulness and throwing himself into his Chinese music. I liked it. It was very like their pictures, very akin. Then I asked him to sing and he did that too. There is something sweet and sincere in Lee Nan, a striving for higher and lovely things. Something affecting about the neat surroundings, all decent and in order, his Chinese books and pictures, a flower or two and a bowl of goldfish, the photo of a Chinese girl, her hair in a modern fluff over one eye, in a red plush frame. On top of the organ his Chinese calendar and various Chinese photos, his Chinese arithmetic log. Oh, when will all nations be one and understand each other's ways and thoughts! Even people of one nation are enemies to each other; how much more so people of other traditions! Perplexity, perplexity. I can't understand my own family, nor they me—born of the same parents. Every soul is so completely, totally *alone*. We don't understand our very closest, and half our trouble comes from thinking we do and reading them through our own particular coloured glasses.

The rain is pelting on the unceilinged roof twelve inches above my head, quick, jagged patters reeling off millions of little noises that make one interminable, monotonous noise. If I slept in an ordinary plastered room I should miss all those sweet sounds, the wind sighing through the cracks and sometimes a rat scrabbling and gnawing in the edges of the attic beyond my ship-lap walls. If things don't perk, I'll have to give up my house. That would hurt.

January 1st, 1935

So, over at last and back again to plain roast beef and milk pudding. We dined

at Lizzie's. A happy dinner in the old home again and games and sittings round the fire, three old women and a couple of youngsters.

Edythe and Fred Brand brought a university couple round in the afternoon. They appeared to like my pictures and said lots of things in low voices that my deaf ear did not catch. Deafness is a nuisance, but perhaps it is better that one does not hear all that is said because there is so little genius in criticism. People say things they do not know and things they do not mean and maybe it is best to think things out for yourself and not be swayed by what others say. Oh to be thoroughly human, to love humanity more! I so wonder if that poor love I deliberately set-out to kill after it had overpowered me for fifteen years (and *did* kill) can ever sprout again. I think it was a bad, dreadful thing to do. I did it in self-defence because it was killing me, sapping the life from me. But love is too beautiful, too lovely a thing to murder and it musses one up. The spatter of love's blood is upon one's hands, red blood that congeals and turns black and will not wash off the cruel hands. It does not hurt the killed; it hurts the killer. Maybe if I had not killed love I would have had more intensity for the love side in my painting. Maybe I would have grown further and accumulated more in this life, or maybe it was one of the lessons I had to learn—how to manage my love. It's no good pondering the maybes; too deep. Rather, better to open up all one can, grow, and know that the lesson was for my learning.

I hope 1935 will bring me more zest for work, more inspiration. Maybe I'll have to be stripped of everything, even my house, before I come down to brass tacks. God, humanity, my work—if I could only burst forth with live, spontaneous, bursting love like the throbbing love I had for the birds when I was a child and stood tiptoe to peep into a nest. The secrecy and mystery, the ecstasy of wonder and love that thrilled me to the very core! If one could only feel that all again, and the love you had for Mother when you'd been bad and she'd been patient, a sort of shy and adoring love, so thoroughly comfortable.

My house is up for sale or exchange. If it goes, the parting from the studio and the garden will be an awful wrench. The renting part would be a joy to be rid of.

Tenants come and tenants go. When unsuited and unsuitable ones come and go some jarring sensation is in the air. You feel it in the basement and the garden, in their coal bin at the back. It runs up and down their front steps even when they are out. It sits brooding in the emptiness. It steals upstairs at night and slaps me in the face. These new ones now, I like them both but I feel in my heart that the flat does not suit them. They want one of those torrid-heat apartments. Everything has gone wrong with their gear as it never did before. First the stove fell down and then the clothesline with all her wash on it. And there was the awful north wind snap and their pipes wouldn't work. They are nice over everything but disappointed, I see, and it makes me feel bad when the house falls short of expectations. Agents came and looked it over today and told me what I already knew, that it needed painting and doing up, and they were more enamoured over my dogs than my house.

I'm so dreadfully sore with writing. I verily believe my stuff gets poorer and

poorer. The writing class gets duller and duller, and I *will* fall to yawning and that makes her mad and she's so dull and dense and so am I. She's bored stiff with her class and we are all bored stiff with her. I'm off painting and writing. If only the ground wasn't frost-bitten I would go and dig. Maybe I'll whitewash.

January 15th

Snow! The white ground is soiled by traffic. Very white roofs, black and white trees. Leaden sky, heavy with more snow. The chimney smoke shows light against it. The children's voices sound different, resounding back from the snow instead of from the earth. Crows look doubly black and the chimneys redder against the snow. There is a hush over everything, in sharp contrast to the roaring, lashing wind of the last two days. It is as though God had whipped the earth, then hushed her to sleep under clean blankets. There is a loveliness about new snow that wakes in one an awed wondering. The horizon and the sky are down and in. Everything is closer and more intimate. Visitors get a warmer welcome, are pulled in quickly and the door shut. Handshakes are heartier; even cold houses are warmer against the contact of outdoors. Alone inside the house it is very quiet. Outer noises become muffled.

It is very, *very* cold. Relentless frost, bitter, boring, determined, will not be satisfied till it has penetrated to the centre of every single thing and made it cold and hard like itself, aided and abetted by a cruel north wind. A cuddle-stove day. The garbage waggons are collecting ashes, cans, and soiled waste of all kinds. It looks horrid against the purity of the white world. Mother Earth will hide it away in her ample brown folds and purify it and absorb its good, bringing it back to usefulness. Or maybe fire will do it quicker and with fierce licking. We only know that nothing is to be lost—just slips from one state to another, always at work, everything in exact order.

I am trying to exchange my house for a small practical one. When the wind brawls round and the frost pinches and the whole plumbing system sits on one's chest, and the tenants, grunting and unreasonable, blame the landowner for the element's shortcomings, then one wants dreadfully to be *rid* of the thing. It's easy enough to stand up to one's own discomforts but not so easy to shoulder others' unavoidables.

There's ice in the park. The ducks look forlorn standing on one leg each, cuddling their noses, beaks tailwards, wondering why the water won't meet them and float them, and the dogs rush down the bank and out on the frozen lake and are equally astounded as to why they don't fall in, and look back to see if I notice how smart they are. One feels kind of sorry for the sky. Suffering has turned it sullen. One must have looked like that sometimes when they wanted to cry fearfully till the wanting hurt—but they couldn't cry. The few bits of green in the garden are darkly transparent and pinched. Nothing joyous or sparkling there.

Oh, winter! one never, never loses the surprise and wonder of new fallen snow, that inexplicable something that touches the core of your innermost being as you stand in your nightie shivering and amazed at the pure glory of the

transformation. In youth your young quick blood danced the cold aside. Now, winter meets winter. Stiff knees and rheumatic hip descend the stair stiffly, build the fire, and find one excuse after another to stay there hugging it. The joke has gone out of the cruel north wind, which shrieks derisively, "Whew-oo-oo-te-oo." Jam and apples freeze in the cooler so I stand them in the big studio which is shut up because of its northness. Susie gets busy, like Mother Diggle-bones, and samples all the pots and takes a toothful out of every apple and then she goes back to her snug rag bag and sleeps off the cold snap. When the new coal comes Woo rushes to her sleep box and draws the blankets over her. The wind rolls in the open window, but she can't resist satisfying her curiosity. As every sack thunders its contents into the bin, she draws aside her covers and peeps.

January 17th
There's a glint of moderation in the weather tonight. That which froze remains frozen, but the piercing cruelty has abated. I'm gladder for Lizzie and Alice even than for me. They look their years. Neither house has a furnace and things are difficult, Alice keeping kids warm, Lizzie waiting on sick tenants. People are morose, disheartened or mad at the weather according to the state of their accommodation and finance. It will be *choice* to open up the house to fresh air and not dread the trip to the basement, dressing for it as if one were going to the Arctic. The robins and sparrows are loose dumpy balls without pep enough to fix up their undies but let them flop on their spindle legs as close to their toes as possible. One would think that hanging loose that way the draughts would hit their skin. I expect lots creep off and die. Such spots of life to battle with a universe full of cold, taking it all in a dumb, brave, philosophical way, without question, singing for sun, hunching for cold, and taking what comes!

It's a sweet sound, the gurgle of new-thawed taps, as though some icy fear had melted away inside you as well. It is warm enough to snow today, slow, difficult snow, reluctant little flakes with no hurry.

The church was cold. Dr. Clem Davies preached in his overcoat with his hands deep in its pockets, and stamped his feet (reverent little stamps) while he read. The woman facing my spine had a loud cold. She alternated between raucous booms and squeaks, and sneezed between verses. I envied the nicety with which she controlled the intervals, bringing the sneezes off in exact time. The congregation was sparse and everyone smiled at everyone else. We emerged like creeping cats from the cold interior of the Empire Theatre into the colder blizzard of flying snow. But the blizzard is one hundred per cent better than those icy north winds and what they do to your plumbing. The house is so cosy.

It's a straight-on-end deluge. The rain doesn't come in drops but in long streaks like macaroni. Basements are flooded (not mine). Garage roofs collapsed in Vancouver under the snow. Ships are grounded on the dry land, which I suppose was so be-puddled that they mistook it for sea. Bad weather conditions of all sorts abound, scooting from one variety into another with violent transi-

tions. People are bruised and bumped and broken by falls and slithers and tumbles. There's a big incendiary mill fire, and sudden deaths, and crueler slow deaths, and humanity sitting and saying, "What next?" The bulbs are bravely sprouting, facing their fresh green babyhood unconcerned and orderly. The robins have demolished all the haws during the snap and have shuffled off elsewhere since the thaw.

I had a visitor from Germany yesterday. She says the tendency in German art today is to give minute surface detail. She had seen, she said, no work just like mine.

Last night I did not sleep for wondering foolishly what I would do about a studio if I exchanged my house, and I got moiled up and bewildered. Surely art is bigger than four walls and a top light. It's a little person who can't paint big in a small place, and there's always outdoors in summer.

The Provincial Library Building is heavy, ornate—horrible. I can't imagine it heavier or more horrible than when the Art Historical Society are sitting uncomfortably humped in its middle. The ceiling of the library is heavily beamed and lumped with hideous blobbed plaster ornaments in oblong squares like an upside-down graveyard under snow, and there is a white marble coping round the dead fireplace. Never-read, dry-bones of books are locked under the glass coffin-like cases along the walls, and wherever there aren't books there are horrible light-brown wooden floral wreaths and sprays. They look like brown paper. Every manner of flower, fruit, seed pod, vegetable and grain is represented, as though there was to be another flood and a pair of each specimen had to be preserved.

In the front of the room was a square table. The President man and the Secretary woman sat at it. There was a tray with a glass jug of water and a tumbler which the President banged to call the meeting to order. The members were stolid. I felt dreadfully sorry for the janitor. He was a tired-looking man leaning on his broom just outside the open door waiting to sweep out. I wanted to yell, "Sweep, sweep them out. Choke them in their own dust. Turn the ceiling upside-down and bury them under the white plaster oblongs." On they droned about preserving the old buildings and emulating England whose power and glory was in preserving her past. Hang them all! Why can't they die and move on? The needs of today are pressing. The past is past.

Sunday, January 24th
Dr. Clem Davies preached on Moses seeing but not entering the promised land. Moses knew God *face to face*. I had a little speech on the ideals of Indian art in my pocket all typed and threw it into the collection dish instead of my offering in its envelope. What on earth would Clem think at such an offering? And I am afraid it had my name on it.

An artist came yesterday and brought a thing for me to criticize, and he did not like it when I did. It had some nice things in it and some foolishness. He had tried to distort for the sake of queerness. Distortion is all right for empha-

sis—to get your point over. There is something dramatic (blood and thunder threatening) about sky and houses looking dour. But there was nothing spiritual, nothing that hoisted the soul a little. Oh, it is difficult, but should not be difficult if we lived nearer to God and got our inspiration direct. If one could only rise and strike out from the heights, but I suppose first we must climb to the rise above the trivial snippiness, quit bickering and open our eyes wider and get stiller—quit fussing. Perhaps the promises given to our children and children's children work out in old maids through the channels of art. Supposing one could go up into a mountain and see the expressions of future generations, showing the unripe strivings in our own lives brought to fruit in them. We'd know the grind and perplexities we went through were part of the foundation.

I wish I knew if I really am as *completely* beastly a person as Lizzie makes me out. She doesn't allow me one good thought or feeling or trait. I come back from visiting her so discouraged with myself. She has the faculty for hauling all one's worst to the surface. At the age of four, and she was eight, she took me to a child's party at the Langleys'. I remember her wrathful indignation over my behaviour there, and telling Mother she'd never take me to a party again, as I was a disgrace. I jammed my hands at tea, lost my little white cotton gloves, cried for a prize at "Aunt Sally." I remember Mother kissed her fat disgraceful baby and did not pay much attention to all the wickedness.

February 8, 1935
I feel very, *very* old, round a hundred I should say, maybe more—just a tired, nothing-left feel; writing a humbug, painting a bore. I could sleep, sleep. I tell myself "shame," put forth a big effort and wash all the outside steps or make soap, or wash and get tireder. My manuscripts are all back from everywhere. Why do *all* one's friends seem to go back on you altogether? They might take turns. Funny about friends, you want them frightfully, but you can't find any to fit. Nothing in you and them that answers each other, only commonplaces—weather conditions, ailments or food—beyond that, blank. They slam the door of their innards and you slam the door of yours.

When I contemplate the possibility of selling this place and moving I am in a panic. When I think of not selling and not being able to rent and not paying my taxes and the city gobbling my home into its maw, I'm in a quadruple panic, and where's your faith? If one could only put their finger definitely on God! Yet what more does one want when miracles are popping up every single second? *Everything's* a miracle. Every time we lift a finger or do a thing, it's a miracle that we could no wise perform alone.

Well, today has been like a day of lead. Why are there days when yeast, gunpowder and champagne are lifeless and you are brown and sagging as a rotten apple, days when one *longs* for somebody with their whole soul? Somebody that they never met or knew or saw. Somebody with no body or appearance but with an enormous love and sympathy who would not only give to you but call out

from you oceans of sweetness and the lovely feel of giving it out with a lavish hand to someone who *wanted* it, giving it generously and unashamed.

Life's hideous just now, everyone anxious and pinched and unnatural and sore about something. Some wicked fairy has turned all the blood and flesh hearts into affairs of fire and lead and stone, with all the warm soft gone out, just a hard, dry ache and a hungry want. Where have you gone to, Joy? You are ached out of existence.

I am painting a sky. A big tree butts up into it on one side, and there is a slope in the corner with pines. These are only to give distance. The subject is sky, starting lavender beneath the trees and rising into smoother hollow air space, greenish in tone, merging into laced clouds and then into deep, bottomless blue, not flat and smooth like the centre part of the sky, but loose, coming forward. There is to be *one* sweeping movement through the whole air, an ascending movement, high and fathomless. The movement must connect with each part, taking great care with the articulation. A movement floating up. It is a study in movement, designed movement—very subtle.

A newspaper criticism on the art exhibit, in which I was especially mentioned— my work "Blunden Harbour," and the little spindly pine tree peeking up into the sky. Art criticism was flowery, from a professor of English at the University. The fact that the canvas was a sky study entirely missed them. Below was a low, beaten stretch of earth; they called it "the thicket." It was only an incidental. The sky was the subject. What rubbish these critics are, or is it one's own stupidity in blundering to the point? The professor dipped out feathery fluff, but— well—there you are.

My Indian story, "Hully-up Paper" back from International Correspondence Criticism Service. The literary critic squashed my story flat—not marketable, no plot, only a bit of narrative. Might pass in a Canadian magazine, but not in an American since "it lacks the elements that American magazines require." "Not good enough to make the grade with commercial markets," was his criticism. One *does* get disheartened, no good denying. Is it pure conceit that makes one feel so squashed? The truth of it is I don't *want to* write that popular mechanical twaddle that is called for. I know my stuff is poor in wording and expression, construction. But what joy is there in blowing oneself up with high flavoured impossibilities of plots lacking reality when one longs to just express simply the everyday lovely realities that happen in front of your nose? I suppose if I had the education I would express these realities so they were readable. What is this rebellion inside me? Rebellion against orthodox mechanics. Is it egotistical conceit? Or life's ardor dimming? Or outworn sentimentality? I want dreadfully to express something, but why? I think, old girl, you'd better quit writing.

If you don't write things down where do they go? Into the lazy bog of neglected

opportunities. Thoughts we might have developed, actions we might have accomplished. Inertia and deadness. Look what is happening in the garden this very minute. All the little winter thoughts of it are bursting forth. The earth has softened down, opened up, paid attention, and developed her thoughts. Now there is a roaring hubbub, a torrent of growth gushing forth that won't be stopped because the dear old earth has nursed and treasured her thoughts deep down in the winter quiet. Now they are paying her back gloriously. If only we did our part as faithfully.

A woman came to my studio. She is an artist with two children and an invalid husband to support. I esteemed her very much. She said, "I cannot paint. It takes all my strength to support my children and bring them up to think of beautiful things, to be with them and share with them in their impressionable years. I feel if I try to teach a good *honest* commercial art that is of service to my pupils, I am doing more good than dabbling around in paint myself, doing weary and unconsciously weak work."

She was really interested in my work. She said that it appealed to her like religion. Art and religion you can't separate, for real art is religion, a search for the beauty of God deep in all things.

I had visitors, an artist that also showed at the Vancouver show and his sister-in-law. Why can't I take all the nice things they say like a dainty dish one is offered by a hostess? Help oneself and be thankful and eat it with gusto! I just can't. I *cannot* feel that the things they say are merited. Oh, I wish I could! It would be so comfortable to smack my lips and say, "That's me. I *deserve* their praise. My work is good. All they say is true, likening me to Van Gogh, saying my work will live, and all the slop about its profundity and depth and meaning." But there is the consciousness of how I've *wanted* to sink right into it and absorb and how my mind has wandered from point, on and on, and I've dragged it back and *forced* it instead of opening myself up and letting it fill me and then gush out at my finger tips, powerless to hold it back. When I read of artists who worked and worked, patiently expanding through the years, and all their thoroughness in mastering technique, and then look at my own spatter, I realize that it has no construction. It is raw, clumsy, unfinished. Then I feel a lazy shirker and I am sure that those who applaud my efforts don't realize or recognize good work or they'd see the failings of mine.

March
Everyone is waiting and waiting and waiting these days and nobody knows for what. There is a lonely blue brooding over everything. Everything is so difficult. People's bodies and hearts are aching. It is not all because people's purses are empty. It's some other dreary, lonesome thing. We're off the boil, no cheerful sing, no quivering lid, just a sullen lukewarmness, sooted on the bottom and furred within. Oh for a jolly old fire to set life's kettle singing and bubbling and steaming!

Housecleaning is not so bad when you throw your heart into it. I've kalsomined four rooms, with their ceilings and walls (and floors too, but that I had to scrub away after). They began to smell nice. All the clean sparkling dishes and pans look so glad and yell out, "Put me here," as if the scrubbed shelf was their heaven they longed to be boosted into. Perhaps it's the last time I'll have the privilege of cleaning dear old 646. It's so thrilling to go down the morning after to see if the evil old stains are really obliterated now the kalsomine is dry. Only one does have much too many things. I hoard trash. There's all sorts of things, and repairs to other things, to be done with oddments. I'm a specialist in utilizing refuse.

There's something *honest* about getting into bed with every muscle aching from real straight domestics, honestly acquired. Sort of a brick in your character building.

Cleaning one's domicile is terribly saddening. Out of every out-of-the-way corner that one delves into, after the dust accumulation that is not disturbed more than annually, something comes to light that reminds one of an incident or a person and sets up an ache inside you, a photo, or a letter or a little gift. Letters are the worst to make you ache. Somebody you'd nearly forgotten and you don't know if they are dead or still alive, and you wonder how the intimate friendliness could have died; how after being so close you are so far. The dead ones are nearer and not half so saddening as the "uncertains." And there are congratulation letters on little successes and sympathetic letters about disappointments, and giggly letters and indignant ones, and the pages of life that have been glued up all these years suddenly seem to loosen up so you can read them again, and just as you are in the middle of reading, suddenly they stick together again and stay silent till next year's big clean.

Such nerve-pinching decisions about what one shall keep and what throw out! Your hand poises there over the garbage pail, weighing the article in decision. "Wretched old trash, I've housed it long enough. Still—I don't know if I should; maybe it would come in handy; after all, it doesn't take much room. But why clutter up with such stuff? Come to think of it, though, probably this year I will need it." The yawning garbage can *doesn't* get it, and it starts on another twelve month round of rust and cobweb accumulation.

I cried over one letter today. It was from a pretty young married woman, and she loved me then and had great faith in my work, and I said to myself, "Was her faith justified?" Had I made good? I felt a blighter and cried a little. You always feel when you look it straight in the eye that you could have put *more* into it, could have let yourself go and dug harder.

SPRING AND SUMMER
1935

April 2nd

The house is as clean as a new-laid egg. And now, oh horrors, an exhibition! I hate the publicity, but deep down I have felt for a long time that it was my job to do this particular thing. I am so selfish and no good and there's all the people who love painting and haven't any chance and here am I greedily hoarding up thoughts and things that are not mine—only lent to me. If the others get anything out of them then it is up to me to hand it on. Perhaps none of them will come. That will be dull and flat and worse. I don't particularly want the idle rich, the people who are always catered to in art establishments, here. I want the people who think and feel, not the ones who flatter and lie and spoon out the correct things to say. A college teacher said, "Well . . . I don't know . . . of course the idea is nice . . . but I doubt the students would want to come if the working class were specially invited." Let them stay away, then, and read their art books and go to the Arts and Crafts shows. They don't care for the real of art, only for the fashion and the correct jargon.

April 3rd

Today was the second day of the public exhibition in my downstairs flat. I showed a group of old Indian pictures, thirty in number. A lot of people came yesterday and were appreciative and interested. Today the thing drags. Quite a few have been but they were smart-alecky and priggish. A prim young photographer came. He shot out a camera and without a by-your-leave signified his intention of photographing *me*. "I prefer not," I said very firmly. Then his wife or sister or female relation of some sort said, "Have you done it?" "No, she won't have it." He smirked and I glowered and I saw his finger straying to his camera. I think he had come intending to photograph *ad lib* and I sure wasn't going to have it, not without a by-your-leave anyhow.

Stacks more people have been, some very appreciative, some very stupid. I am tired, tired. There has been a surprising lot of people but the interest has centred more on the historical than on the art side. I feel very old. I wish the work was a million times better. I wish, I wish, I wish. People were very genuinely interested, I think. So many said they were glad they had come, it was very worth while. So I think it was.

April 5th

Now the third exhibition is hung, my modern landscapes and modern Indian things, which look somehow lacking and dark. Maybe I am tired and that's the reason. How completely alone I've had to face the world, no boosters, no artist's backing, no relatives interested, no bother taken by papers to advertise, just me and an empty flat and the pictures. Two men helped me to hang the first and last show. I did the other. It is surprising to me as many came. There were several withered little old men and women trying to paint a little, now that the hustle of their family life has eased off for them. They'll never do anything much in this life to show, but who knows but the start of thinking about these things here will help them in another world. I do not perhaps mean really to paint there but to see God's beauty, if we paint it maybe with different pigments. I don't suppose painting or singing or playing are really what matters but the expressing of the realization of God in all and everywhere.

I read Flora "D'Sonoqua's Cats." She found a *great* many faults in it. Most of them I agreed with but some I did not. The thing I had struggled hardest for she did not see, made no comment on, so I suppose I had not made it the least bit plain. In hanging the show too, the man looked disapprovingly at "D'Sonoqua and the Cats." "What's the meaning?" he asked. I just gave a sort of a laugh. "Oh, there's a story," I said, but I did not tell it. He would not have understood. And after, I brought out another canvas and took her away. I think the story and the picture were special things experienced by me and I must put them away. I don't know anybody I could talk it out with. Perhaps I could have once with Lawren, but I am not sure he would have understood, and now that intimacy of our life work is all gone too, door shut, windows barred, ways parted. So be it! One *must* learn that one's own two feet are made to stand on and that one cannot use others as props and crutches. How extraordinarily alone everyone is! Each one walking along his own path to the one gate through which every one goes alone. Art and religion are alike. It doesn't matter what our sect or what our method, the one thing that matters is our sincerity.

Saturday, April 6th

Today's show was horrible and has left me tired out and exceedingly depressed. Have been diving down to see why. Quite a few came, some who had been to the other two exhibitions. There were the usual "babblers," little people who felt that they must say stuff, and fluttered away and left nothing said. There was not an artist among them. The artists have ignored the show except little Lee Nan. He understood more than all the rest and I felt nearer to that little Chinaman in understanding than to all those others.

April 7th

The sixth day of the exhibition is over, the whole thing done with. It has been far beyond my expectations in success. I imagine some two hundred people came, and on the whole were keenly appreciative and interested in the work, as

was evinced in many of them coming two and three times. Today there were mostly the college students, boys and girls, a keen lot. The young folk like the modern stuff. The old folk shy and back, poor dears. It is a gulp to swallow after what they are used to. They can't think of power or movement or bulk or light. They want little complete objects in paint put concisely before them telling a little story completely worked out and leaving no labour for their imagination. It made you feel so old when one and another would say, "What a lot of work." Of course it is. Practically your whole life's work was summed up and laid out on a platter before you, like a drowning man's, and now it was up to you to kick the bucket, instead of feeling as I do that I want to begin all over fresh and hit out harder. You do not feel much interest in what you have done. It's what you want to do that peps you up. I do think we all live so much in the past instead of pushing further. The greatness of the Old Masters seems to me to be their sincerity in realizing their present, rounding it out and filling it in. I'm not a proper artist at all. To be that one should be in it body and soul, giving all your time and absorption, living above paint, above colour, above design, even above form, searching the spirit, centring the eyes just above the horizon, going out into pure being to *be* along with it. How can one explain that to people? It's one of the wordless things and your spirit runs ahead of your hands and eyes that toil fleshily after, slow and clumsy. Poor soul, wrestling, striving to learn its lessons out of the old book of flesh, tossing the book impatiently aside—stupid dull print—and picking it up again to reread the words and get the sense clearer.

April 8th
How tired one can get and not die! When the exhibition closed yesterday I longed to get to painting. First, however, the flat the exhibition was in had to be got ready for a tenant. The kitchen was peeling. I bolted out of bed this morning right on to the stepladder with a knife and those walls had to be scraped inch by inch. I did not give myself time to think. I said, "Put your whole zest into that, old girl. It's necessary, so make it worth while. When it is all clean maybe you can paint." Life is such a continual struggle inside.

Everything in life seems to contradict something else. If I was a real artist I'd let everything else go, but I can't and don't and so I'm not. Even today as I went to buy kalsomine, I met two people. So sorry I was out. Wanted to come to the studio. I said, "It has been open to the public two weeks. Now the exhibition is closed." And that's to be it, too. I'm not having my meagre paint time pottered into by this one and that and have to haul out stuff. The man was forty-two years old and had just started to think about painting. The woman said he was a *genius* and should be encouraged tremendously. She begged him to show me the wonderful production he had done. He drew a dirty bit of lined writing paper out of his hip pocket, a mess in blue and red, and then fell into raptures about *her* work and what a genius *she* was. All this took place on the city street. I did not ask them over. I'm horrid. I ought to help beginners, but they do make such a mock-modest fuss about themselves.

April 9th

Such sunshine is pouring over everything! Get anything between you and it, though, and it is very cold. While the kalsomine prepares I am bathing in the sunshine of the big east window. The trees are still open to let the sunshine pour through, just little blobs of transparent yellow-green. All the grand loveliness of the beach is waiting. The spring sky is high and full of movement. Steady, on with the job, old girl, so you can be free to go to it.

Since the exhibition I have been thinking a lot. People said, "Explain the pictures." How could anyone do that? Perhaps I do not know any more than they. Why? It is not a definite set goal—sort of a groping, changing day by day and yet imperceptibly. If one wanted colour or design or form or representation perhaps one could explain a little what one was trying for, but how can one explain spirit? How can one find it or know how to look? The biggest part of painting perhaps is faith, and waiting receptively, content to go any way, not planning or forcing. The fear, though, is laziness. It is so easy to drift and finally be tossed up on the beach, derelict.

April 11th

Lunch on beach with Alice and a squad of youngsters. How that woman ever has the patience—day in, day out, year in, year out—and always amiable! We sat on logs and ate mutton sandwiches and bananas. The high clear heat of morning hazed over a bit at noon. After a big washing was glad to sit and sun in afternoon. Too tired to paint.

Letter from Lawren. Good to hear of his work again. It will be interesting but I can't quite find the spirit in abstract. Maybe I am too earthy, but I want to seek out, to follow the spirit.

April 14th

Spring sunshine and frosts are dickering over the garden growth. The flowers are tattered by the pushing and pulling back. The Empress conservatory is unruffled by extremes. The great ferns are sending out long, majestically curved new fronds and the cineraria, spiraea, schizanthus, begonias, callas and other things I don't know are rioting gloriously. It is splendid to sit amongst them for a bit, and yet folk pass through with scarcely a glance.

I must pull myself together and start painting. I keep saying will I get this or that done up first and put off the more intense struggle of the higher work till things are more settled and the clutter of daily jobs is eased off a bit so my mind is clearer. I don't know if that is best or worst for development. Is it because I am too orderly naturally to work in hugger-mugger or is it that my soul is more lazy than my body?

April 20th—Easter Eve

I wonder will we ever consciously look back and see the plan of things, the reason for this and that and the good of it? This house—what a mixture of love and hate! What a dear house and studio and garden—as a renting proposition

how beastly! Was this very thing needed for the good of my soul? Tenants, how I've *hated* the whole business of them—like a galling collar round my neck. Of all that have passed through my flats in twenty years how very, very few I have said goodbye to with regret. Some of the partings have been very ugly indeed, some bitter.

April 21st—Easter Day
Spring is very cold and treacherous, almost crueller than winter. Things are prepared for bitterness when nature has wrapped them up safe, but in spring the young things are all peeping out, little creatures, little flowers, in a mad rush to burst from their dark prison. They are tantalized by bits of sunshine and stretch forth into it, only to be nipped and buffeted and bruised. I suppose it tends to strengthen them, but often it leaves scars and blackens their blossoms so that they do not mature and then have to wait a whole year before they can try again. It's hard to feel sweet when icy winds are blithering through you. What you accumulate on the one fine day in ten is all blown away on the other nine.

April 22nd—Easter Monday
The world looks round and small and complete from the top of Beacon Hill, like a toy world with no beyond. The sky fits over the top with beautiful patterned clouds. Sometimes they lid down very low. All around on every side are purple hills or snow-capped mountains on the other side of the Straits. You forget all about Asia and Europe and Africa and the rest, and the wars and famines and earthquakes. Beacon Hill is important when you are up there with the dogs. The wild flowers and the broom and the nesting birds all seem so much more important than horrible things in the newspaper. Is it selfish to feel so?

To compose a picture you have first to get an idea. Something has to hit your fancy, hit it and settle into it like a bird does into her half-built nest. She knows what she wants and why she wants it. She keeps bringing more material and more twigs and fixing one thing into another till it's firm and shaped so it will hold something. Then she gets into it and twists and wiggles and kicks and irons till it is smooth and fits her. She does not put the precious eggs in till it fits. So with the big idea; we must be sure we know what it is, what we want to express. Then to weave and weave its nest. No good just laying the ideas there in a heap so the first puff blows them away. It is easy to grab the impression, to suggest, leaving half to the imagination of the other fellow. Tighten the idea into a definite plan, take it through the sketch, find the threads, loose them again perhaps and pick them up again and again til you don't see the threads but the tightly woven fabric that forms a complete nest. I am afraid that we artists have a tendency to reduce loveliness to paint instead of making paint express loveliness. To have complete command of material and technique so your thoughts can float through it unconsciously would be great.

April 28th
Another Sunday and another good sermon from Clem Davies. Another coming

out of the dingy, tawdry theatre, whose dinginess and tawdriness you never noticed at all because everything was enveloped in quiet peace and people's thoughts lifted. You came out into the glorious spring sunshine, feeling earnest and kindly and you walked through ugly Chinatown headed for the Empress Hotel conservatory with your head high and feet light, in spite of the rheumatics in them. The wallflowers sent volumes of smell out to greet you. The joy of it climbed down your nose and throat. You were full of their smell and their richness, and the glory of colour filled your brain, climbing in through the eyes. Then you stooped and felt their cool velvety life and praised God in your heart for inventing and creating such glorious things. In the greenhouse the flowers were more languishing, pampered and a bit peevish, bending over, the big forced blossoms too heavy and their stems lacking the sturdy robustness of the direct wind and sunshine upon them; tropical beauties a little homesick. A woman hobbled through without a look to right or left. Her face said, "Corns."

April 29th
An Irishman came to the studio tonight. He appeared profoundly touched. He said he felt B.C. breathing through my pictures and canvases. He did not *know* much but he felt quite a bit, allowing for good selvages of blarney. I fancy his goods were genuine. "I go away hungry to see more," he said. I was hungry for food and tired when he went.

May 1st
Yesterday I got this letter.

> Dear Madame Emily Carr:
> Just a few words to express my great admiration for your
> beautiful picture, "Peace." To me this picture represents
> Divinity and I have often been sitting in front of it this last
> week.
> Compliments,
> *Hanna Lund*

When I read it I cried hard. I don't know who Hanna is, but somehow my soul spoke to hers, or rather, God spoke to her through me. Then he spoke back to me through her thought of writing me. I am humbly grateful that my effort to express God got through to one person. That is between God and her and me, not a thing to be shown around or talked about but to be pondered on in the heart, a cause for thanksgiving but not conceit.

These days are filled with menial jobs. Surely they are filled with opportunity to lift the menial into the realm of the spiritual, bringing the shine of wholesome sweetness out beyond the wear and tear of the material grime. And the garden—what a joy! A sick woman slept in it yesterday. Today the wind is punishing the blossoms, tossing them this way and that, but the good old roots are not disheartened at all. They just stick on a sturdier resistance for next year's blossoms. They don't stop growing to snivel and despair.

May 9th

I must say great inconsistency is exhibited over this that we call death. A woman said today, "Poor Miss H. paid me a long, long visit yesterday. We were not interrupted and she told me all that was in her heart. Poor, poor soul, she will never, never cease to mourn her sister (who died a year ago), not as long as she lives." "But," I said, "her sister was a great sufferer. Isn't it a bit selfish of them, and she a Christian?" I don't know, but it seems to me this perpetual mourning seems a bit selfish. Aren't they mourning most for their own lonesomeness? Immensity seems to me more than anything the immensity of the universe. To be lost in *Space* would be a terrifying thought. Like an endless falling. But how can we realize these things while we are in the physical? Whatever comes will be what Whitman calls "Equal equipped at last prepared for them." If God prepared us for this world, he can prepare us for the next and equip us. I don't suppose we'll even be surprised. We are not surprised when we come to realize we are alive in this one.

Chimney sweeps are the most arrogant of all men. Such airs, so independent. After letting you *prepare* for the beastly performance they are just as like as not to come three days late and with high head and turning heel suggest you get someone else if you are not perfectly satisfied with them, and threaten to leave you sitting in the upheaval and waiting for another fortnight till another of the same profession feels like attending to you. Well *I'd* be extremely unpleasant if I had to follow that sooty profession.

May 28th

I have been in among the broom on Beacon Hill sketching. It is difficult sometimes to separate its yellow glory from the yolks of countless eggs. The smell gets right inside of you. It and the blackbirds' song permeate your whole you. If one could only approach a subject like that, by drinking it up to the sky! I think it is such a glory.

May 31st

Sometimes the soul gets so lonely it tries to break through its silence. The tongue and ear want to handle it, to help it grow, fertilize it. Everything is for the soul's growth. She calls to all the physical and material to help her. This physical body is so short-lived and its only use is to contribute to the growth of the soul. And yet we act as if its sole use was for itself, for its comfort and ease.

When souls touch and commune, either silently or by speech, it is the keenest joy there is, I suppose. Perhaps in later lives we shall be sorted out not in physical families but in soul families. And we'll use soul talk, soul attributes, and put on soul growth. These human contacts and relationships are very difficult—so much misunderstanding, so much binding. Perhaps we should not heed the human relationships too strongly but look about among those we meet and contact and perchance recognize some soul relatives, people who have the same common ingredients as us.

The whole of life appears to have great longing and reaching out. The trees and the plants are just the product of the longings of the root down there in the quiet earth, longing to get above ground into the freedom of the light and air. The creatures want to be close to humans, to do what the humans, who are their Gods, do, to go with them, live with them. And we, we want to push on too, to know more and do more things and peer into the unknown, and get a glimpse of the mystery beyond. I suppose the desire is growth.

June 12th. In the caravan at Albert Head
Many things need clearing up in my mind so I'd better try to write them out. I figure that a picture equals a movement in space. Pictures have swerved too much towards design and decoration. These have their place, too, in a picture but there must be more. The idea must run through the whole, the story that arrested you and urged the desire to express it, the story that God told you through that combination of growth. The picture side of the thing is the relationship of the objects to each other in one concerted movement, so that the whole gets up and goes, lifting the looker with it, sky, sea, trees affecting each other. Lines at right angles hold the eye fixed. Great care should be taken in the articulation of one movement into another so that the eye swings through the whole canvas with a continuous movement and does not find jerky stops, though it may be bucked occasionally with quick little turns to accelerate the motion of certain places. One must ascertain first whether your subject is a slow lolling one, or smooth flowing and serene, or quick and jerky, or heavy and ponderous.

Today everything is sullen and black. The wind slams things, and the trees are provoked at having their petticoats turned over their heads. The under sides have a pale, wilted look like a faded garment that has been turned and remodelled and turned back again. Every moment it seems as if the sullen sky were going to leak its waters, as it has already leaked its gloom on the earth. I have waited all morning for it to happen; now I shall defy it.

This is a strange set-apart life. How I wish I were a clear thinker. This is a grand opportunity, when there is nothing to distract, to think things right through to the finish, but there you are taking one pace forward and two back every time, whirling around as if an egg beater were mixing your thoughts. If a plum of a thought would only stick in the wheels and arrest its whirling for a few moments! What is coming? Why worry? The three dogs lie on the bed, their heads touching, a little spiral of snores ascending from the middle, just living, their little lives grown placid, contented, undisturbed about the future, with a great blind faith somewhere inside them that everything will be O.K., trusting me to attend to their wants, living for the moment. Oh, God, how their faith shames ours.

June 15th
The pliability of growth is marvellous. The limbs that have life in them bend and toss and sway but they do not break. Just the dead ones snap. Life springs

back joyously. It's one continuous battle with the elements here, rain, wind or heat. Moderation is at a premium.

This is a place of high skies, blue and deep and seldom cloudless. I have been trying to express them and made a poor fist of it. Everything is eternally on the quiver with wind. It runs on the short dry grass and sluices it as if the earth were a jelly. The trees in shelter stand looking at the wobbly ones in the wind's path, like a strange pup watches two chum pups playing, a little enviously. I think trees love to toss and sway; they make such happy noises.

The camp is comfortable. It took a little manoeuvring and adapting of the tent and windbreak canvas, and the stove pipe adjusted to the wind, and the elements accepted as part of the game. Life is lovely. The Simcoe Street house and all its troubles and perplexities are in another place in my mind. They have gone to sleep and will, I hope, wake up the better for their nap. I ran in to town yesterday. The garden was a glory of huge poppies and the roses are coming on. Gardens grow so dear to one but I think perhaps we are apt to let them chain us, as we do all our earthly possessions, and encumber us instead of rejoicing us. We do let so much joy slip over our heads and beneath our feet, and let our lives be so full of care. We waste lots of time worrying about our old age that we may never arrive at. We are really awful fools, taking us all round.

A just-right camp morning! There is no rain, no wind, no scorching heat but a joyous moderation of all things, and great peace. Yesterday's visitors saw my sketches and thought them above last year's. I hope so, but there is still very much to be desired. There is a need to go deeper, to let myself go completely, to enter into the surroundings in the real fellowship of oneness, to lift above the outer shell, out into the depth and wideness where God is the recognized centre and everything is in time with everything, and the key-note is God.

One slumps fearfully as one grows old. It is difficult to understand what one should give in to as belonging to one's years and what one should combat as lazy indulgence. It is so easy to drift. There should come a time for quiet meditation and pondering over things spiritual, but great care should be taken not to sit vacant.

There's a row of pine trees that won't leave me alone. They are straight across the field from the van. Second growth, pointed, fluffy and thick. A field of fine dried-out grain bounded by a cedar-post-and-wire fence edges the field, then the public road, and close to the roadside comes the row of little pine trees. They are very green, and sky, high and blue, is behind them. On days like today the relationship between the trees and the sky is very close. That, I think, is what makes a picture, a thought so expressed that the relationship of all the objects is shown to be in their right place. I used to paint a picture and stick in an interesting sky with clouds etc. that would decoratively balance my composition. It wasn't part of the conception of the whole. Now I know that the sky is just as important as the earth and the sea in working out the thought.

June 30th

The wind is roaring and it is cold. I revolted against wrestling with the campfire and shivering over breakfast in the open field, so I breakfast in the van. It is a day to cuddle down. Even the monkey pleaded to come back to her sleeping box, tuck her shawls about her and watch me.

We worked in the woods yesterday, big dense woods, very green. A panther had been snooping around after the sheep in this neighbourhood. (They go up the trail cropping the grass.) Suddenly there was a great hullabaloo, jangling of sheep bells, and a ewe and her two lambs tore lickety split down the trail, flew over my dog and me, and rushed out of the wood. I wonder if the panther was near?

I did two sketches, large interiors, trying to unify the thought of the whole wood in the bit I was depicting. I did not make a good fist of it but I felt connections more than ever before. Only three more whole days of this absolute freedom and then I have to pack up and get back to the old routine, though it will be nice to get back to those two dear sisters who plod on, year in and year out, with never a break or pause in their monotonous lives. But it would not give *them* a spacious joy to sit at a little homemade table writing, with three sleeping pups on the bunk beside me, a monk at my shoulder and the zip and roar of the wind lifting the canvas and shivering the van so that you feel you are part and parcel of the storming yourself. That's living! You'd never get that feel in a solid house shut away securely from the living elements by a barricade!

July 1st

I feel that there is great danger in so valuing and looking for pattern and design as to overlook the bigger significance, Spirit, the gist of the whole thing. We pick out one pleasing note and tinkle it regardless of the whole tune. In the forest think of the forest, not of this tree and that but the singing movement of the whole. I suppose that is what the abstractionists are trying to do, boil the thing down to a symbol, but that seems to me rather like cutting a flower out of cardboard. The form may be correct but where's the smell and the cool tenderness of the petal?

July 2nd

Something's happened, I don't know what. A cloud and a heaviness is on this place. It doesn't speak any more. The wind is rude and rough, the skies have lost their lofty blue graciousness. I don't want to work. My heart is like a weight inside me. I am tired of it all but I dread going home to shoulder the house burdens. It's time I broke camp. Everything needs washing and water is short and dragging it up the steep hill from the well makes one precious with it.

July 4th

It's fun to go away from home and great fun to come back. The last week at camp was very bad—such storms that I'd gladly have come home any day. I find

Albert Head sketches rather disappointing. They ought to be better. Subject not enough digested. Spirit not enough awake.

July 18th
My house is up, advertised and listed with agents. I am trying to keep neutral, desiring neither way but knowing that God has ways we know not of and that I shall be provided for.

August 3rd
Exhibition in the lower east flat by request of the Summer School. Open to the general public today, Sunday. Very well attended. Could one sift the entire sayings and conversation that passed in that flat today during those three hours, putting sincerity in one pile and insincerity in the other, which pile would mount higher? It is hard to be absolutely sincere. I believe people were absolutely sincere in their appreciation of the exhibition being open to the public free of charge. They like to get something for nothing and to satisfy their curiosity. A few were sincere in their liking of the work, but the insincere pile mounted high when it came to the work. One feels very strange, very callous.

The thing that makes one sickest is to be asked to explain. You can't *explain*. You can't any more than you can see God—physically, I mean. When people give me slush to my face and it comes to me after they have jeered behind my back, I can't respect them any more, or their honesty. I am not a bit nice to people. I try to be polite but I don't care a hang. I don't want to win them. I don't want to educate them. I don't want to coerce their favours to my own way of seeing. Then there are the horrid commercial types whose joint question is, "Do you sell much?"

Suddenly, in the middle of all the people and all the confusion of tumbling, unmeaning words, someone says, "Where's that?" And you lift your eyes to the painted husk and pass through it, out, out, ever so far, to the story that beckoned and urged you to try to express it. Then someone comes up and says, "What did you mean?" They want lettered words that can be rolled on the tongue. They can't understand you could not word those happy yearnings, those outgoings when the Supreme Spirit touches its child.

The days roll on and you laugh and cry, pout, wonder, rage, sing, and wait for what comes next. It takes all sorts of material to make a pudding. You go on stirring in spice and flour and rising and shortening and salt. Everyone is throwing all those things in, one after another, and life is mixing them up. By and by you forget about the ingredients and just wait for the cooking to be finished. And then will come the realization of the whole good pudding. The flour and the spice and rising and shortening won't exist as themselves but the pudding will exist whole and complete—delicious.

August 6th
Great and extreme weariness today after general public exhibition Sunday and

Summer School exhibition Monday. A great many came and were appreciative. One stands like a bullock waiting to be killed. Then suddenly someone will, as it were, stick a pin in you by some remark, and you jump to life with a quiver because someone has laid a prick in a sensitive spot, and suddenly you are back there where the thing spoke to you and you tried to record it, and if the eye-looker does not get the idea at all you are shamed. A great crop of impatience springs up and you try to hurry away out of anywhere, away from people, back to the silent words that nature uses.

How glorious it will be when we don't have to use words at all, just a knowing in our hearts and a seeing in our souls! But first we will have to graduate in knowing and seeing. The whole world the classroom!—just to think of it makes one feel like a nestling must peeping over the edge of the nest.

It's perfect *agony* for me to work with anyone watching behind my back. Seems as if their eyes are a million needles piercing through your marrow deep. I have made a little tent affair to cover over my canvas and I squat like an Indian and work in under the wind flaps and the sun streaks. I don't mind them; it's eyes that agonize. Some artists don't mind a bit. I envy them and wish I did not. I hate every human being when I am at work. No wonder I am no painter, since love is the connect-up that unifies all things. How can one express anything with meaning without love at heart?

From observation I note married life is not all bliss. They say cruel things to each other, then they are sorry. When away from the other they are very loyal and tender; when together they twang each other's nerves to breaking. Familiarity breeds contempt, all right. Probably royalty, amid conditions where there has to be more formality, get on more comfortably, practising more reserve and not tumbling into disappointment so often. There's servants to open and shut doors, so no excuse for banging them.

A man told me he was dining at a hotel and at an adjacent table he heard a man say to another, "Well, I've had a splendid morning, most enjoyable. I spent it with Emily Carr in her studio and she gave me the best criticism ever I had in my life. She's outspoken but she's to the point and I felt it most helpful." It pleased me much. I so often feel I am not much use to my fellow men either by working or being alive. Perhaps it comes of the quiet ignoring of my work by my own folk, that I have been reared up to feel my profession rather a useless, selfish one. So when anyone says, meaning it, that they have got any help or inspiration from my work I feel terribly glad. Life seems to have been one long tussle between my duty to art and to my people—which shows I am no *real* artist or I could not let any single thing divide honours with my work.

A TABERNACLE

IN THE WOOD,

1935

September, 1935

Blessed camp life again! Sunshine pouring joyously through the fringe of trees between the van and the sea. I got up very early today. The earth dripped with dew. These September days are fiercely hot in their middles and moistly cold at the beginning and end. In spite of its fierce heat the sun could not disperse the fog across the water all day yesterday. It hid the mountains. All night and most of the day the fog-horn blared dismally, each toot ending in a despairing groan.

There is a young moon early on in the evening, but she goes off to wherever she does go and leaves the rest of the night in thick velvety blackness, shades darker than closed eyes and so thick you can take it in your hands and your teeth can bite into it. When that is down upon the land one thinks a lot about Italy and Ethiopia and wonders how things will settle. One hangs on for dear life to the thought there is only one God and He fills the universe, "comprehends all substance, fills all space" and is "pure being by whom all things be."

Life looks completely different after a good night's sleep. The hips on the rose bushes never looked so brilliant nor the light through the trees so sparkly. Breakfast cooked on the oil stove in the van and eaten tucked up in my bed with the window and the world on my right and the row of dogs in their boxes, still sleeping, on the left. Sheep and roosters crying, "Good morning, God, and thank you," and the fog-horn booing the fog out of existence, making it sneak off in thin, shamefaced white streaks.

There will be sunshine in the woods today, and mosquitoes and those sneaky "no-see-ums," that have not the honest buzz of the mosquito that invites you to kill him. You neither see nor hear nor feel "no-see-ums" till you go to bed that night, then all the venom the beast has pricked into your flesh starts burning and itching and nearly drives you mad.

Sketching in the big woods is wonderful. You go, find a space wide enough to sit in and clear enough so that the undergrowth is not drowning you. Then, being elderly, you spread your camp stool and sit and look round. "Don't see much here." "Wait." Out comes a cigarette. The mosquitoes back away from the smoke. Everything is green. Everything is waiting and still. Slowly things begin to move, to slip into their places. Groups and masses and lines tie themselves together. Colours you had not noticed come out, timidly or boldly. In

and out, in and out your eye passes. Nothing is crowded; there is living space for all. Air moves between each leaf. Sunlight plays and dances. Nothing is still now. Life is sweeping through the spaces. Everything is alive. The air is alive. The silence is full of sound. The green is full of colour. Light and dark chase each other. Here is a picture, a complete thought, and there another and there. . . .

There are themes everywhere, something sublime, something ridiculous, or joyous, or calm, or mysterious. Tender youthfulness laughing at gnarled oldness. Moss and ferns, and leaves and twigs, light and air, depth and colour chattering, dancing a mad joy-dance, but only apparently tied up in stillness and silence. You must be still in order to hear and see.

September 13th

How it has rained! With the canvas top of the van so close to my crown I have full opportunity to note all the different sounds: the big, bulgy drops that splash as they strike, the little pattery ones, the determined battalions of hurried ones coming with a rattling pelt, the soft gentle ones blessing everything, the cleansing and the slopping and the irritated fussy ones. It is amazing that no two of them sound alike when you listen. The moss and grass and earth are gulping it in. Every pot and pail in camp is overflowing. After the water short-age it seems so reckless to throw any away. Mists rush up from the earth to meet the rain coming down so that between them both the fog-horn is in a constant blither.

All the busy bustle has gone out of the wasps' wings. They drift in drearily seeking a warm corner to give up in. It is the third day of rain; everything is soggy and heavy now. Patches of bright green show in the faded, drab fields, and patches of pale gold are in the green of the maples. Colours are changing their places as in Musical Chairs to the tune of the rain. The fog-horn has a fat sound in the heavy air.

A dreary procession of turkeys is mincing down the road. The rain drips one end from their drooping tails and the other from their meek heads. There is no gobble left in the cock and even the pathetic peep of the hens is mute. If ever any beast had the right to be depressed it is the turkey, born for us to make merry over his carcass. The peep of the chicks and the hens is downcast, their walk funereal, their heavy flight bewildered. The cock tries to put a good face on it occasionally and denounces his fate with purple indignation, but you have only to "shoo!" and he collapses.

September 15th

From the window of the van, tucked up cosily with a hot bottle across my feet, I can sit and watch the angry elements. It has poured for five days, wholehearted, teeming rain. Today loud, boisterous wind is added. The sea is boiling over the black rocks; branches of foaming white smother them. Where there are no rocks to punish, it boils in wicked waves, row upon row that never catch up. The sheep and turkeys across the fields crop restlessly. They scatter and do not lie down. The waves and trees shout back at each other, a continuous roar and hub-

bub. Only in the van is there a spot of quiet. The dogs, monkey and I are all in our beds in a row like links in a chain of peace. We are cuddled down listening with just a shell of canvas shutting out the turmoil.

It is very wonderful dumped here in its middle and yet not of it. Time was when I would have wanted to go out and be buffeted, join in, hit back. Years change that wish—rheumatics, sore joints, fat here and there, old-age fears and distrust of one's capabilities. I am sorry about the work but I haven't one doubt that it's all a part of the discipline and training.

September 19th

The early morns are nippy, dewy, penetrating cold that won't be denied admittance either to the van or to your person. It ignores canvas and flesh and blood. It is after rheumatic joints and dull livers. Last night I wasn't much removed from a mollusc because I'd been behind myself pushing all day—real liverish. It was not till 4 P.M. I got up steam and a real enthusiasm over a bit of near woods. It seems an impossibility to squeeze energy to walk the big wood distance. A domineering liver is a fearsome thing.

When the horn, normal at first and developing into a despairing grunt, informs the early world that fog is on land and sea, van cosiness reaches its high water mark. One effort and you have clambered out of bunk. A match across the shelf checks the horn back. Soon the sweet kettle song rises. Toast-and-teaish odours skedaddle the fog. And there you are, washed, ready, pillowed, hot-bottled, breakfasted, and full of content.

I rose early and made tea and spent a delicious hour in bed, luxuriating. The sun is penetrating through the woods now. The green grey is coldly lit with a cool sparkle. How solemn the pines look, more grey than green, a quiet spiritual grey, blatant gaudiness of colours swallowed, only the beautiful carrying power of grey, lifting into mystery. Colour holds, binds, "enearths" you. When light shimmers on colours, folds them round and round, colour is swallowed by glory and becomes unspeakable. Paint cannot touch it, but until we have absorbed and understood and become related to the glory about us how can we be prepared for higher? If we did not have longings there would be nothing to satisfy.

Yesterday I went into a great forest, I mean a portion of growth undisturbed for years and years. Way back, some great, grand trees had been felled, leaving their stumps with the ragged row of "screamers" in the centre, the last chords to break, chords in the tree's very heart. Growth had repaired all the damage and hidden the scars. There were second-growth trees, lusty and fine, tall-standing bracken and sword ferns, sallal, rose and blackberry vines, useless trees that nobody cuts, trees ill-shaped and twisty that stood at the foot of those mighty arrow-straight monarchs long since chewed by steel teeth in the mighty mills, chewed into utility, nailed into houses, churches, telephone poles, all the "woodsyness" extracted, nothing remaining but wood.

And so it must be. Everything has to teach something else growth and development. Even the hideous wars are part of the growth and development. Who knows? It may be that the great and strong are killed to give the shrivelled

weaklings their chance. We just don't know anything. We can only trust and grow as straight as we can like the trees.

The world would laugh at these "pencil thinkings," but they help one to think, reach conclusions. Our minds are a mess of "begun" thoughts, little abortive starts. Another twitch and we are off on another thought leaving them all high and dry along the beaches because the waves of our thoughts have not swept high enough to pick them up again. Perhaps a full tide with big waves will come later and refloat them and carry them to another beach and on and on till they stick somewhere and their elements turn into something else. Nothing ever, ever stands still and we never, never catch up. One daren't think about it too much for it makes one giddy.

When the early morning nip is blueing your nose, and "Little Smelly" is tuning up the tea kettle, and the van windows have modesty blinds of steam, and the air is too full of vapour for the wasp wings to have any buzz and you hope their stings also are waterlogged, then it is good to pin a yesterday's sketch up and look it squarely in the face. Um! It did not look so bad in last night's light. It is done in swirly rings. Why? Not for affectation any more than the cubists squared for affectation. Like them I was trying to get planes but used disks instead of cubes. It gives a swirling, lively movement, but until mitigated is too blatant. Things are swirling by themselves. The thing to do now is to swirl them together into one great movement. That is going to be a thrilling canvas to work out in the studio later, refining, co-ordinating, if there is money enough to buy paints. Why worry? Here the job is to absorb. What, eat the woods? Yes, as one eats the sacrament. Munching of the bread is not eating the sacrament; it is feeding on it in our hearts by faith with thanksgiving. It is good for remembrance.

We are still among material things. The material is holding the spiritual, wrapping it up till such time as we can bear its unfolding. Then we shall find what was closed up in material is the same as is closed up in our flesh, imperishable—life, God. Meantime bless the material, reverence the container as you reverence a church, not because of the person or the pulpit or the pews, not because of the light coming through the stained glass or the music rolling through the air, but because of those who go there to meet God, compelling their material bodies to sit in the wooden seats and allowing their souls to go out to meet "wholeness," the stream of life, God. "God is a Spirit: and they that worship Him must worship Him in spirit." How we do try to make God into an image! No conceivable image could permeate through all time, space, movement as spirit, that which *is* though it is not formed or made. We cannot elude matter. It has got to be faced, not run away from. We have got to contact it with our five senses, to *grow* our way through it. We are not boring down into darkness but through into light.

Bads and goods have hurled themselves with velocity through this day. The lamp went on the blink. The kettle broke. Woo got the salt bottle when I was out, threw the top down the bank and filled the bottle with bugs. In a moment

of emphasis I waved the iodine bottle to bring home a point and deluged Mrs. McMuir, arms, dress, floor, and it won't wash off. Then I clambered up a ladder to paint the lid of the old lady and waterproof her for winter; the little devils of dogs, seeing me well set, took the lid off the meat pot and devoured today's and tomorrow's dinner. And I got a cheque for $15 for a sketch I never expected to materialize. Burned my melba in the McMuirs' oven. Came home and found the Yates girls had left a lamp wick and some good prune plums on the van step. All in one day. Such is life.

Splendid days, cold and hot; gold, grey; soft, crisp. Any hour any condition may prevail. The woods are tender one minute and austere the next, sometimes riotously rich, coldly pale in colour. I did two studies yesterday in thick, wild undergrowth. At the beginning of each I dropped into a merry swing-off and ended in a messy conglomeration, but there are thoughts in them to follow up. They swing a little but not in one sublime swinging "go." Something keeps peeping out; look at it and it's gone.

Most men are very stupid. You ask a perfectly clear, straight question, "Can I go through your gate up into the woods to sketch?" He looks at you, closes the gate, looks over the top, grins foolishly, weighs himself first on one foot and then on the other, and says, "I don't know. It would not be any good to you."

"Why?"

"Well, you see. . . . What do you want?"

"To pass through the gate and get up the bank on to those rocks."

Again he went through all his silly manoeuvres. "It wouldn't be any good," he said again. "There's a high barbed fence. You could not get through."

Stupid ass, why didn't he say so right off!

The schoolhouse is at the top of the hill. A rough playground is scooped out of the trees and brush. It looks dull. Not a sound comes out of the open windows. The door is fast shut, and there are jam bottles holding a few scrubby flowers on the high window-ledges. There are two swings, two rings and two privies. I'd hate to be educated there. At the corner, the hill takes a nasty curve. The gravel is rough and twists ankles. The man's barbed wire fence has turned and runs up through the jungle. Now one can turn in among the sallal bushes. The sheep have made walks there. Their hooves have cut the rotten fallen logs where they cross. The earth is damp and reddish brown. Mostly it is thickly spread with coarse herbage and fallen trees rich with moss, tough sallal with fat black berries walking single file up their stalks like Chinamen, strong naked roots veining the red earth like old knotted hands. There are a few birds but all the woods are mostly hushed and mysterious. When a squirrel coughs and when wrens hop among the twigs, it makes one jump. The big sword ferns point up in imitation of the high-pointed pines.

A hundred yards farther on the road is lost. The forest has closed about you. You will see neither beast nor man unless you keep to the little sheep trail. It is all above your head, the tangle, and there is no place for your feet for the rotted tree boles that lie waist high, hidden in scrub so that you cannot perceive them.

There is the next generation of pines, cedars, hemlocks; uprooted tree-roots as high as a house, the earth clinging to them still, young trees and bushes growing among them and the hole the tree left filled now with vigorous green. You need not penetrate far into this massed tangle. Here is a little stream's dried-up bed. Across it the tangle rises, the sheep path goes up. You can sit on the path and look down on the snarl of green. It is lovely. Suddenly, its life envelops you, living, moving, surging with being, palpitating with overpowering, terrific life, life, life.

September 29th
The end of sitting in the quiet has come. Tomorrow I pack up to quit camp and square my shoulders to receive the burden of the apartment house. Goodbye to these intimate friends, the trees, and this slice of deep sky over my field that is fuller with stars than any sky I've ever seen. Goodbye to the shimmer that lies between the boles of the trees on the bank near the cliff, neither sky nor sea but between the two, which shows first when I draw the van curtains. Goodbye to the jungle wood with its rich red-brown earth pungent with autumn, and flares of the late maples and calm green-grey pines.

The light goes early these afternoons leaving the forest to the grip of a penetrating chill. Tantrum complains bitterly and will not sit on the earth but jumps into my lap so that I must work across him, struggling with those swaying directions of movement, space rolling into space, this into that, blending, meeting, pursuing, catching up till the thing is one, all things settled into one grand movement which holds and looks back at you and speaks. The hammock comes down, the camp fire goes out and the little van will sit lonesome at the base of the high, high pine.

The last sketch of my van season is a study of underbrush and not successful. There is a sea of sallal and bracken, waving, surging, rolling towards you. Green jungle, thick yet loose-packed, solid, yet the very solidity full of air spaces. Perfectly ordered disorder designed with a helter-skelter magnificence. How can one express all this? To achieve it you must perch on a desperately uncomfortable log and dip among the roots for your material. Yet in spite of all the awkwardness there is a worthwhileness far exceeding a pretty sketch done at ease. There is a robust grandeur, loud-voiced, springing richly from earth untilled, unpampered, bursting forth rude, natural, without apology; an awful force greater in its stillness than the crashing, pounding sea, more akin to our own elements than water, defying man, offering to combat with him, pitting strength for strength, not racing like the sea to engulf, to drown you but inviting you to meet it, waiting for your advance, holding out gently swaying arms of invitation. And people curse this great force, curse it for a useless litter because it yields no income. Run fire through this green sea, burn it, break it, make it black and frightful, tear out its roots! Leave it unguarded, forsaken, and from the bowels of the earth rushes again the great green ocean of growth. The air calls to it. The light calls to it. The moisture. It hears them. It is there waiting. Up it bursts; it will not be kept back. It is life itself, strong, bursting life.

There are no words, no paints to express all this, only a beautiful dumbness in the soul, life speaking to life. Down under the top greenery there is a mysterious space. From the eye-level of a camp stool you can peep in under. Once I went to some very beautiful children's exercises in a great open space. There was no grandstand. The ground was very level and it was most difficult to see. I took a camp stool and when my feet gave out I sat down. It was very queer down among the legs of the dense crowd—trouser legs, silk stockings, knicker-bockers, bare legs, fat legs, lean ones—a forest of legs with no tops, restless feet, tired feet, small, big, lovely and ugly. It was more fun imagining the people that owned the legs than watching the show. Occasionally a child's face came level with yours down among the milling legs. Well, that is the way it feels looking through bracken stalks and sallal bushes. Their tops have rushed up agog to see the sun and the patient roots only get what they can suck down through those tough stems. Seems as if there is something most wonderful of all about a forest, especially one with deep, lush undergrowth.

October 11th, Victoria
The first dismal rain of winter. Summer hanging between life and death. Everything shivering and dripping like the time between death and the funeral. War news dismal, fires sulky. If one were a bear, now, how jolly it would be to take your fat-prepared body into a hollow tree already selected, ball yourself up with your paws over your face, and sink into a peaceful stupor, absorbing your own fat for sustenance without even the pest of selection, chewing or dish-washing.

I can't find a mode of expression for jungle undergrowth. It just sticks at paint as if the coming and going of mystery were abhorrent to paint. I say to myself, "Why want to paint? When the thing itself is before one why not look at it and be content?" But there you are. You want something more. It is the growth in our souls, asking us to feed it with experience filtered through us. We are very lazy experiencers, content with the surface instead of digging down.

This from Psalm 132:

> I will not give sleep to mine eyes, or slumber to mine eyelids, until I find out a place for the Lord, an habitation for the mighty God of Jacob. Lo, . . . we found it in the fields of the wood. We will go into his tabernacles: we will worship at his footstool. Arise, O Lord, into Thy rest.

Surely the woods are God's tabernacle. We can see Him there. He will be in His place. It is God in His woods' tabernacle I long to express. Others prepare a tabernacle for Him here and there, in a church, a flower or vegetable garden, a home, a family. Everyone has his own special tabernacle set aside for God in the place where He seems nearest.

October 19th
I have known for some days that I was to have an exhibition in Toronto at the "Women's Art." I felt a little thrilled about it—a chance to see if my work

means anything to the outside world. The West is an absolute blank when it comes to ranking one's work. It had been on the tip of my tongue to tell my sisters, then somehow my shoulders shrugged of their own accord and I remained silent. Alice is too absorbed in her little ones to care, or too busy, poor dear, even to waste hearing time. I said to Lizzie, "I'm having a fifty-sketch exhibition in Toronto." She replied, "Oh." And immediately, "Miss Heming's brother has just got a big commission, six pictures at $1,000 apiece. Just think, $1,000 apiece!! I hope he will give some to his sister." Our art conversation was ended; she turned off to other matters.

What was it that hurt all over? Not jealousy of Heming's luck. I can't do the "big money" stuff and I don't want to. The reproductions of his work I have seen made no appeal to my desire to do likewise. Blatant, selling things, done for money, with money in view from their first conception. I *do not* envy him his success. True, I'd be dreadfully glad to sell to help out but I would not give up the moments of pure joy I get out in the woods, searching, for his artificially gaudy "pleasers." The hurt came from her complete indifference. She did not want to know when or where or why. No money in my shows and, in my people's mind, that is the only reckoning of art of any worth. It was as if someone had kicked my favourite dog. How curious that one should care so.

For the last week I have been struggling to construct a speech. Today I delivered it to the Normal School students and staff. It was on "The Something Plus in a Work of Art." I don't think I was nervous; they gave me a very hearty response of appreciation, all the young things. (It hit them harder than the three professors, all rather set stiffs.) "Something quite different from what we usually get," they said. The most pompous person said after a gasp of thanks—"I myself have seen that same yellow that you get in that sketch, green that looked yellow. Yes, what you said about the inside of the woods was true, quite true—I've seen it myself." Pomposity No. 2, very tidy and rather fat, introduced himself with a bloated complacency, "I am so and so"—a long pause while he regarded me from his full manly height. "I have seen your work before but never met you." After this extremely appreciative remark, he added, "Most interesting." Whether he meant the fact we had not met before or my talk was left up in the air. The third Educational Manageress was female. She said, "Thank you. It was something quite different from the talks we usually get. I am sure I do not need to tell you how they enjoyed it—you could see that for yourself by their enthusiastic, warm reception." They did respond very heartily. One boy and one girl rose and said something which sounded genuine, though it could not penetrate my deaf ear. I could only grin in acknowledgement and hope it was not something I ought to have looked solemn or ashamed over. I was interested in my subject and not scared, only intent on getting my voice clearly to the back of the room and putting my point over. Afterwards I wished I had faced those young things more steadfastly. I wished I had looked at them more and tried to understand them better. If ever I speak again I'm going to try and face up to my audience squarer, to take courage to let my eyes go right over them to the very corners of

the room, and feel the space my voice has to fill and then to meet all those bright young eyes. There they are, two to each, some boring through you—waiting. Of course I had to read my talk and that makes all the fuss of spectacles on for that and off for seeing the audience. It must be very wonderful to be a real speaker and to feel one's audience as a unit, to feel them sitting there, to feel them responding, at first quizzically then interested, finally opening up, giving whole attention to what you yourself have dug up, what you have riddled out of nature and what nature has riddled into you. Suppose you got up with a mouthful of shams to give them and you met all those eyes. How you would wither up in shame! What a sneak and an imposter if you did not believe sincerely in what you were saying and were not trying yourself to live up to that standard!

November 1st
Within the last few months three men have been to the studio who were all bitterly opposed to me and to the newer creative art. All three are artists (of sorts), and all were ardent in appreciation. I wonder if it was quite genuine? Apparently they seemed to find something there that moved them. Oh, Emily, Emily, be very careful. Strive earnestly towards the real. Let nothing these or any say satisfy or puff you. It is a trust. Seek earnestly, reverently. Stick tight and do not get dismayed. Those men do little, inefficient, footling things and seem vastly satisfied, and *yet* they seem to find something beyond money value in my work. They start out by talking money-value and "are-you-selling-these-days?" stuff, and brag a little if they have made a sale. Oh, if money and art never needed to be connected, how much purer art would be! It is like money and religion. Money spoils it all.

 Worked on some sketches that needed strengthening in expression. I must work on some canvases. If only one could combine spontaneity with more careful depth got through study.

November 3rd
Clem Davies reads the Psalms beautifully. I never realized the prophecy and the affirmation of God's wonderfulness were told there to such an extent. Clem stops and talks about verses. He reads and prays beautifully. You feel he is talking to God and you feel God is talking through the Bible via Clem Davies when he reads it. I'd just as soon be read the Bible as preached to. On the way home I go to see the Empress conservatory. For three weeks the chrysanthemums have slowly been bursting—raggedy ones, curly ones, spindle blossoms and great heavy-headed blooms on sturdy stems. At the base is a border of primulas. The house is quite cool and the smell of the primulas and that clean, pungent odour from the mums is delicious. Perhaps at this stage they please the nose even more than the eye.

November 4th
Life, the house is filled with it; from the attic bedroom come little inarticulate

squeals. Vana has four of her new-born pups up there. More little squeals issue from the sitting-room where the overflow are in an old felt hat supported by a hot bottle and an Indian basket. Day and night Vana and I supply warm milk. We swap bunches every few hours as Vana has to undertake all the bathing operations. So we bunch the four males and the four females and alternate so that all get equal nursing. Vana has implicit faith in my arrangements and never disputes my judgement. There is a grand feeling in being trusted unreservedly. Goodness, if we would only trust our God like the animals do theirs.

Nine men and women came to the studio last night. I handed out sketches and canvases for an hour and a half. It was harder work than feeding nine puppies by hand for one week.

November 16th
Sometimes my whole soul cries out in revolt at this *beastly* house, at the slaving and pinching to keep up for the one mean tenant paying so little, exacting so much, hinting at the limitations of my establishment, insinuating its age and incompleteness and how much better other places are, and magnanimously allowing that all old houses are like that, that things will wear out and following the statement by the wonderful flat Mrs. So-and-so has. She does not mention the fact Mrs. So-and-so pays double as much and has some disadvantages like tiny rooms, mere cupboards of kitchens, dark out-looks, no garden, no beloved park at the door. Oh dear, oh dear, all the wickedness in me rebels at the beastly, rotting house. I know it is crumbling up, I know it needs repairs, I know it is not modern, I know I am not a real downright good landlady, willing to grovel before my tenants, to lick their dirt and grab their cheques. It crushes the life out of me, this weight of horrid things waiting to be done because my back hurts so I *can't* do them myself and have no money to pay someone to do them. And then maybe I go into the beautiful studio and see some sketches about and feel my skin bursting with things I want to say, with things the place said to me that I want to express and dive into, to live—and there's that filthy furnace to clean out and wood to chop and sweeping and dusting and scrubbing and gardening, just to keep up a respectable appearance for the damn tenants so as to squeeze out a pittance of rent to exist on. And all the time know you are shrivelling up, growing sordid because time and strength which you need for enrichment to allow you to search and absorb and grow cost money and time and strength—and your bile boils over and you are full of bitterness and hate yourself for being bitter when loads of folks these days have worse. God seems so deaf—your prayers dwindle away half formed or, if by effort you force yourself to form the words, they hit back at you like empty echoes.

There is not one living soul one can say things to, empty your heart out before. It is better to bottle up than to pour into a cold, unsympathetic ear and be told, "Well, you know, Millie . . . etc., etc. . . ." in a righteous endeavour to show you it is all entirely your *own* fault, your wrong thinking and wrong acting. Then maybe the friend starts out with, "It is simply a shame you have to do all these other things. You should have time, money, etc. to develop." Then a

great burst of contrariness makes you leap the other way, defend the jobs, retort that it "makes you paint better to have to struggle first," and then your heart says, "Do you mean that, or are you lying for fancy-work?" And you don't know what you mean and jog on sullenly and resentfully. Now go out, old girl, and split bark and empty ashes and rake and mend the fence. Yet—should I? Or should I climb higher, shut my eyes to these things and paint? Rise above the material? No—I think you've got to climb *through* these things to the other.

November 26th
Recorded no thoughts today either in paint or words. Worried at a jungle of undergrowth. I think there must be such days and they are not lost.

There is a side of friendship that develops better and stronger by correspondence than contact, especially with some people who can get their thoughts clearer when they see them written. Another thing—that beastliness, self-consciousness, is left out, shyness, shamedness in exposing one's inner self there face to face before another, getting rattled and mislaying words. The absence of the flesh in writing perhaps brings souls nearer. It is possible to form some warm friendships with people one has never seen, only written to and heard from. Some people can become beloved friends, calling back through ages to you through written words, and you can sort of talk back too. Friendships are very delicate—apt to snap when strained—shouldn't, but do. Perhaps everybody has to have a *secret* place deep in the middle of themselves where they are not supposed to admit others, only God, a spot you've got to keep sacred. It seems so natural and "meant to be" to stand guard in front of that inmost place as though we were meant to be solitary like raindrops falling. And then when we hit Heaven (or Heaven hits us) we won't be drops any longer but one ocean; there won't need to be a secret place inside any more, because we will have nothing ugly to hide.

November 28th
Working on jungle. How I want to get that thing! Have not succeeded so far but it fascinates. What most attracts me in those wild, lawless, deep, solitary places? First, nobody goes there. Why? Few have anything to go *for*. The loneliness repels them, the density, the unsafe hidden footing, the dank smells, the great quiet, the mystery, the general mix-up (tangle, growth, what may be hidden there), the insect life. They are repelled by the awful solemnity of the age-old trees, with the wisdom of all their years of growth looking down upon you, making you feel perfectly infinitesimal—their overpowering weight, their groanings and creekings, mutterings and sighings—the rot and decay of the old ones—the toadstools and slugs among the upturned, rotting roots of those that have fallen, reminding one of the perishableness of even those slow-maturing, much-enduring growths. No, to the average woman and to the average man, (unless he goes there to kill, to hunt or to destroy the forest for utility) the forest jungle is a closed book. In the abstract people may say they love it but they do

not prove it by entering it and breathing its life. They stay outside and talk about its beauty. This is bad for them but it is good for the few who do enter because the holiness and quiet is unbroken.

Sheep and other creatures have made a few trails. It will be best to stick to these. The sallal is tough and stubborn, rose and blackberry thorny. There are the fallen logs and mossy stumps, the thousand varieties of growth and shapes and obstacles, the dips and hollows, hillocks and mounds, riverbeds, forests of young pines and spruce piercing up through the tangle to get to the quiet light diluted through the overhanging branches of great overtopping trees. Should you sit down, the great, dry, green sea would sweep over and engulf you. If you called out, a thousand echoes would mock back. If you wrestle with the growth it will strike back. If you listen it will talk, if you jabber it will shut up tight, stay inside itself. If you *let* yourself get "creepy," creepy you can be. If you face it calmly, claiming relationship, standing honestly before the trees, recognizing one Creator of you and them, one life pulsing through all, one mystery engulfing all, then you can say with the Psalmist who looked for a place to build a tabernacle to the Lord, I "found it in the hills and in the fields of the wood."

December 1st
The year's last month. Everything broods today, the sky low and heavy. Was there ever a sun? Where has he gone? Nor ray, nor warmth has he left behind him. There is a heavy, waiting feel (like you get in a dentist's ante-room waiting your turn).

December 3rd
A dumpish day—cold spreading from the feet up, the sodden earth piercing up through your boot soles, jeering at your stockings, and aching your feet to the ankle.

People have been to see the puppies. They are four weeks old, like a box full of precious gems, sparkling and perfect. I hate to sell, to take filthy money for life and love. Isn't it horrid to mate creatures so that lives may be produced that we may sell those lives and use the money to feed ourselves and keep our lives going? Life is all wheels within wheels!

December 11th
Life, life, how difficult! The horrible doubts that come, that brood over you and eat into the very marrow, turning the whole world into an ache! This morning's mail brought an envelope full of theosophical literature. Once it interested me, now it sends me into a rage of revolt. I burnt the whole thing. I thought they had something, Lawren, Bess, Fred, something I wanted. I tried to see things in their light, to see my painting through theosophy. All the time, in the back of my soul, I was sore at their attitude to Christ, their jeering at some parts of the Bible. Raja Singh came; I hurled H. P. Blavatsky across the room. Who was she to set herself up? Who was she to be a know-it-all of life and death? I wrote to those in the East, told them I'd gone back to the beliefs of childhood. The

exchanged letters cut all the real bonds between us. Now there is a great yawn—unbridgeable—their way and my way; the gap is filled with silence.

Real success must be this—to feel down in your own soul that the thing you have striven for has been accomplished. To this must be added the appreciation of the thing done by those you love and whose appreciation you value. The person who counts is the person who has nothing to gain, who lets himself go out to meet the thing you have been striving to create, the nameless something that carries beyond, what your finger cannot point to.

December 12th

I am sixty-three tomorrow and have not yet known real success. When someone comes to my door I hide my canvas, as if it was something shameful, before I open to a stranger. If people ask to see my pictures I show reluctantly. It is *torture* to exhibit to some. I say to myself, "Why? Is this some type of ingrowing conceit?" But I can't say. I do not know the answer. If anybody whose judgment meant anything real to me came, I would be very glad. But I do not know of any such person—an absolutely honest soul. There is something down deep in our own selves that is our critic and our judge. Everybody carries his own judge and jury round inside him and tries to dodge them too, or to argue them down and sass them back.

A friend brought me today a piece from *Saturday Night*. A man who had been to my studio wrote it.

WORLD OF ART *

by G. Campbell McInnes

I have made the acquaintance recently of one of the most sincere, forceful and genuinely artistic personalities it has been my pleasure to meet. She is Miss Emily Carr, of Victoria, B.C., who is having a showing at the Women's Art Association at 23 Prince Arthur Avenue. She calls her pictures "Impressions of British Columbia"; she does herself less than justice. Impressions they may be, but so striking, so vivid, so full of the real *furor poeticus*, that they are unforgettable.

She paints quickly and with a fierceness and passion that are completely convincing. Her technique is astonishing. Viewed closely, the sheer audacity of her rapid brush strokes compels admiration, while each picture, regarded as a whole, has in it the concentrated essence of the impact of a deeply sensitive and fervent nature on a scene for which she feels with an intensity that only prolonged study and profound conviction can bring.

Saturday Night, Vol. 51, No. 5, Dec. 7, 1935. By permission

Painting to her is almost a religious experience, but there is
no suggestion of a sentimental mysticism. Rather there is, in her
work, despite its strength and dynamic movement, a joyous quality
reminiscent of the early work of Vlaminck. But Vlaminck has since
become what the cruel French call a *faiseur*; Miss Carr is a great artist
and will never do that. I should not like to think that anyone would
miss this exhibition. They will meet an artist who is, in her own way,
as *possessed* with the creative urge as that powerful and tragic figure of
the last century whose name was Vincent Van Gogh.

I felt dreadfully embarrassed and blushed up when she read it out.

December 14th

Today writing Christmas letters, saying the usual easy, tossed-off "Merrys," the
same "Happy New Years." This 1936, what will it bring to the world? Will the
nations rush at each other's throats and spill each other's blood? One can only
wait day by day with one's hand on the little day-by-day jobs. I wonder if I shall
crawl from under the weight of my house this year. I have ceased dreading the
change; the wait has become irksome, unbearable. The house is like a jail about
me. I feel curiously hard now, tired of it all. Honour has come to me here; some
of the flattering things said in my studio have rung true. I feel to the house like a
bird must to her last year's nest. What happens to the old birds that are beyond
nesting? That has always been a wonderment to me.

Not so cranky today. I guess the liver is the seat of the Devil anyhow. Mercy,
but Alice is patient with all those people's rasping brats and, worse than them,
the mammas, papas and grands.

People have been looking my house over. I would not care so much if they
confined their looks to the house. They prod the walls, smell up the chimneys,
poke into cupboards, investigate leaks, examine the furnace's inside with lighted
newspaper. One expects all that. But they don't stop at that; they examine *me*,
and I resent it. I suppose your home is full of yourself, your own little notions
and mannerisms and hobbies and idiosyncracies, the use you've put things to,
the stamp of yourself on your own things. These things they smile at and remark
on. That is not their business. You are not trying to sell these things any more
than you are trying to sell yourself. I resent being a show for strangers, exposing
the me-ness of my home, and I shiver when they peer and discuss the personal-
ity in my studio, my mode of painting and living. "And she keeps a monkey!"
"And she has a van and takes all the creatures!" "And. . . ." "And. . . ." "And. . . ."
And I pull them back severely to the money value, income-bearing properties, to
the garden, the chimney, the big windows, the high ceilings. Then there is a bel-
low, "Look at the chairs hanging from the ceiling!" What business of theirs
where I keep my chairs? I'd strap them round my waist so that they'd naturally
sit me whenever I bent, if I *wanted* to. I want to hit out, but also I want to sell,
so I bottle down. But I sizzle sometimes like a tap without a new washer.

These nights the mists lie low across the lake and among the pines. They

drench the earth, more penetrating than rain. Five pines, thin, gawky ones, point up over the top of the mist like long fingers with the palm they belong to down in the mist. When you look straight up you see above the mist and the sky is a deep blue-black peppered with stars. Stars frighten me and that awful space between you and them, terrifying, unknown, filled with lights and colours and sounds that we don't know yet. Even I can remember when the park was full of woods and wild flowers, and owls hooted and there were lady-slippers and wild lilies and the lakes were swampy pools with thick straggly growth round and in them. In winter we slid on the ponds. In summer they covered up with green slime and frogs hatched there and croaked madly. The flowers that grow in the park now would turn up their noses, if they had them, at the flowers that grew then. I, walking there, am as different to what I was than as all the rest is different to what it was.

Christmas Eve, 1935
We have just had our present-giving at Alice's, just we three old girls. Alice's house was full of the smell of new bread. The loaves were piled on the kitchen table; the dining-room table was piled with parcels, things changing hands. This is our system and works well: we agree on a stated amount—it is small because our big giving is birthdays. Each of us buys something for ourselves to our own liking, goods amounting to the stated sums. We bring them along and Christmas Eve, with kissings and thankings, accept them from each other— homely, practical little wants, torch batteries, hearth brooms, coffee strainers, iron handles, etc. It's lots of fun. We lit four red candles in the window and drank ginger ale and ate Christmas cake and new bread and joked and discussed today and tomorrow and yesterday and compared tiredness and rheumatics and rejoiced that Christmas came only once per year. We love each other, we three; with all our differences we are very close.

Christmas Day, 1935
Praise be! It's over! Why do we do it? It is not Christian. Oh, I'd have *loved* to sneak off to the woods and be hidden, the week before and the week behind Christmas, and remember the real meaning of it and give thanks in my heart. I love my friends for their kind thoughts of me, but it's all wrong; it's cheap and commercial and fluffy. You can point to all the full churches and special music and decorations, but what does it all *mean* to them? The girls would say shame and shame again on me. I get more rebellious every year.

The girls are in Vancouver. How strange to pass Lizzie's house and see her rooms dark and then Alice's house and see that dark too, to know I can't dongle their telephone bells or run in. My spirit is still black and smarting. I can't think why it riled up against Christmas so this year. It kicked with its boots on. It did not want to do, or see, or be; it wanted to hide away from the fuss and weariness. Liver, I suspect.

Two would-be art critics came to the studio. They were "pose-y," waved their

paws describing sweeps and motions in my pictures, screwed their eyes, made monocles of their fists, discoursed on aesthetics, asked prices, and expounded on technique. One paints a little and teaches a lot, the other "aesthetics" with I do not quite know what aim. Both think women and their works beneath contempt but ask to come to the studio on every occasion. Why?

December 31st
Nineteen thirty-five has two hours more to run. Then 1936 and what? What will the poor old world get up to?

BECKLEY STREET

1936

January 1st

1936 has sniveled in. The darkness held hard as though the first day did not want to start. It did not blow or bluster; it just wept down-heartedly as if it did not know quite what was the matter. I wonder will it find out before the year ends. The man next door let his guests out of the house at 5:55 A.M. They were not noisy. In fact they seemed depressed, though one man kept wishing Harry "Merry Christmas." Old "Two-Bitty," the aged Chinaman, came half an hour late to do the chores. When I expostulated with him he groaned, "No care. Me too welly tired." Fellow feeling made my wrath dry up. He *is* very old. His breath is gaspy and he collects heaps of boxes to mount his basket to his shoulder because he can't swing it up. He loves his dinner. I try to make it tasty for the poor soul—his head is so bald.

I painted one of the thick jungle sketches. Perhaps I am getting "junglier." They won't be popular. Few people *know* the jungle or care about it or want to understand it. An organized turmoil of growth, that's what those thick undergrowth woods are, and yet there is room for all. Every seed has sprung up, poked itself up through the rich soil and felt its way into the openest space within its reach, no crowding, taking its share, part of the "scheme." All its generations before it did the same. Mercy, they are vital! There is nothing to compare with the push of life.

Max came in and thought many of my new sketches lovely. People often connect my work with Van Gogh—compare it. Van Gogh was crazy, poor chap, but he felt the "go" and movement of life; his things "shimmered." Mine wriggle and move a little but they don't get up and go like his.

"The eye is not satisfied with seeing, nor the ear filled with hearing. . . . In much wisdom is much grief." [Eccl. 1-8, 18.] Certainly this applies to artists, both painters and musicians. We look and look, listen and listen, but we are never full. No matter how much we absorb we want more, more, more—to know more, to see further, to hear higher. The whole study is teed up with longing. If it were not for ideals and our longing after them, what would life be?

Some days I feel *very* old, my body stiff with pains and soreness, brain tired and somnolent as though I wanted to be down and sleep and sleep. It is not good to

feel like this; it is shocking. I am ashamed because I am not so old really, in years. I see the girls, who are both my seniors, shouldering their heavy burdens and pushing on valiantly. Have they more grit and endurance? They don't go up and they don't go down like me. When you walk a dog on leash he runs by your side demurely. When he is free he helter-skelters far and wide, takes many more steps, noses into everything, learns lots, takes more risks, may get run over, may get lost, gets mud-spattered and weary. The girls heel better than I.

January 17th

Over and over one must ask oneself the question, "What do I want to express? What is the thought behind the saying? What is my ideal, what my objective? What? Why? Why? What?" The subject means little. The arrangement, the design, colour, shape, depth, light, space, mood, movement, balance, not one or all of these fills the bill. There is something additional, a breath that draws your breath into its breathing, a heartbeat that pounds on yours, a recognition of the oneness of all things. When you look at your own hand you are not conscious of feeling it (unless it hurts), yet it is all intimately connected up with us. Our life is passing through it. When you really think about your hand you begin to realize its connection, to sense the hum of your own being passing through it. When we look at a piece of the universe we should feel the same. Perhaps it is a gradual process of becoming conscious of the life of nature, the hum of life in us both, tuning-in together. If the air is jam-full of sounds which we can tune in with, why should it not also be full of feels and smells and things seen through the spirit, drawing particles from us to them and them to us like magnets? Creative expression, then, must be the mating of these common particles in them and in us. First there is a wooing on both sides, a mutual joyous understanding, a quiet growing, waiting, and then. . . . Oh, I wonder if I will ever feel that burst of birth-joy, that knowing that the indescribable, joyous thing that has wooed and won me has passed through my life and produced one atom of the great reality.

January 18th

Today I looked at a home near Five Points. Rentable, saleable, but, for me, not liveable. The worst of me is that I picture myself in a place immediately. I can see myself doing thus and so, here and there, the dogs, the monkeys, the studio. In this house I could only see a most miserable me. I couldn't see the easels, I couldn't see the pups or Woo. It was too clean and spandy in every corner for paints and pictures, though the easy heating and the nice basement charmed me. The woman had slaved making it liveable and fancy. Mind you, I could make any house *do* me but some places don't belong to your type—squares in rounds and rounds in squares. I want a place I can be free in, where I can splash and sling, hammer and sing, without plaster tumbling. I think I want a warm barn. I want space and independence with people not too near and not too far. There must be a place *somewhere* for me. Where is it? That woman was awfully proud of her house. She'd slaved away, side by side with her husband, fixing it. Her face

was worn and furrowed. Some of its lines had been made by the cement basement floor. She had worked at it down on her knees, troweling the wet cement flat. She was proud of the sunporch. It housed a canary and an aspidistra and was full. If I took the house and wanted to sun myself in the sunporch, I couldn't keep a canary and an aspidistra. It *would* make a nice pup pen.

Some things that we do or earnestly desire to do surprise me very much. Why should I want to express "Mrs. Drake"? I began the story, a description of a visit to Mrs. Drake's, when I was in camp seven months ago. It tickles away at my brain. There is something in it I want badly to get out, to express. It won't leave me alone. It was a horrid visit, made when our Mother was very ill. I hated Mrs. Drake and admired her too in a way, because she stood for—what? Now, there it is. What did she stand for in my child eyes? Maybe a certain dignified elegance—breeding—not humanness. My mother stood for human motherliness; she was like a beautiful open, sheltering alpaca umbrella. Mrs. Drake was like an elegant silk one neatly furled and banded, shut so tight and long that the wear showed in the cutting of the delicate folds not in the umbrella's honest use, a splendid, elegant mother to possess but not a sheltering one in storms.

January 20th

Our good King George is dead. People said it in hushed voices, then passed on. You knew they were thinking, as you were, "What next?" Everyone is sorry; he was a good king. The new King is good too and well prepared to take on the job. What a terrible, overwhelming responsibility! One feels as if they had lost something, as though something had gone wrong with the Empire and there was a hole where King George was.

The Hart House Quartet are here, such dear, beloved men! Mr. Adaskin and Mr. Hambourg called on me this morning. They did look so gentle; they looked like their music. The concert was grand tonight. A great, overwhelming audience. It was very hot. They played magnificently. I do not know one composer from another but I suppose most of the big audience did because they have radios and become familiar with good music. Some of them sat very still and some turned this way and that posing absorption.

January 28th

I am returning from a week in Vancouver with Edythe and Fred. They were very kind and hospitable and their little home is very cosy and tasteful. At the end of a perfect trip from Victoria to Vancouver Edythe met me with a warm welcome and a cold in her head. One hour before I left Victoria I gave my word to sell my house, or to exchange it rather, for a cottage—with glad and bad. But it seemed everything had sort of slidden into place as if it was to be. I will miss the studio and garden bitterly. I will miss the tenants and furnace agonies and upkeep delightedly. Mrs. Finlay who takes it is a nicer woman than I, amiable and kindly. They will like her above me. All the trip I thought about it. The house is not pretty, it is not new, it is not the locality I want to live in. It has no

place I can paint but it is in good repair and is a nice little place, more saleable and more rentable than my big one. I shall try to rent it and find a hovel to live in with the dogs and monkey, and near the girls. I can see that Lizzy dreads me going away far. We do need each other in emergencies. They don't come to me often but I can go to them, and it is comforting to know that we could go quickly if things were wrong.

Vancouver is quite different from Victoria. The character of the houses, the mountains, the woods, even of the vacant lots is different. The houses are an ugly hodge-podge of every kind of architecture. A house will be all jumbled up like an omelet—stone, brick, wood, shingle, cement. The University has extensive lands but the buildings are crude, squat and temporary, with only a few portions permanent. The floor of the big hall leading to the Art Library is badly kept. There is far too much licence allowed in handling and borrowing of books and pictures. They belong to the country and should be better protected from, and by, the students and young college professors, who borrow and handle them in an irresponsible manner. It annoyed me. The young folk of today are very haphazard. They get things and privileges so easily.

The view from Edythe's windows was across the North Vancouver mountains. Mist ran in and out among them. All day long they changed: pinks, mauves, all blues, purple. It is grand to live where one can see them always. They are more intimate than our mountains. Out by the University is a new part. Houses crowd close in some spots and leave great gaps of second-growth bush in others.

There was a smear of black and purple drapery over the front of the station for King George's funeral tomorrow. Everyone speaks of tomorrow as a "holiday." It is given to honour the memory of a good dead man who did his best for his empire. Kings are just *men* from whom strenuous self-sacrifice and much diplomacy is demanded.

The boat is hot, the sea smooth. Boats are terribly alive; all the bits of them pulse together as a unit. When you go in them you belong and are part, going with it, jiggling with it, feeling its heat and cold and its movement, utterly dependant on it. You've got to put up with the boat's joggle if you want to get home. And I have not got a home any more. For twenty-two years my growth has clambered over that place; now I've got to dig it up, prune, chop, reset it again in new soil. Not so easy as planting a slip; the roots are bruised and torn with being ripped up.

This morning an old decrepit Chinaman came and we hurled antiquities out of the attic, mostly my early art efforts. I wished there had been someone to giggle with at some of the funny old things. That's the penalty of being an old maid. There is no one to hand on to, no one interested in your past, no one to carry on the old family traditions and peculiarities. So you just burn and burn all the old sweet things, the sad and the merry, turn over the new leaf, so near the end of the book, a little wearily. It's good to destroy the old botched and bungled things. Every one brought back some memory of models or students or friends. I was surprised to see how much life work I had done. It was all pretty poor, and

yet there was a certain something. I could see a feeling of the person behind the paint. It is funny how I went back on the humans afterwards and swung out into the open, how I sought my companionship out in woods and trees rather than in persons. It was as if they had hit and hurt me and made me mad, and cut me off, so that I went howling back like a smacked child to Mother Nature.

I am glad no one will ever have to groan over my accumulations. It is a decent thing to clear out before you die. The thought of a new home has many attractions. I feel as if all I wanted was peace and a quiet place to study and paint and die in. Am I getting pessimistic, or lazy, or indifferent, or perhaps a little disgusted or is it that I feel I have not fulfilled the promises of youth?

The old Chinaman looked at a pile of old sketches I was about to heap on the bonfire, and carted them into the basement. "Maybe good put there. You look more. Some burn, some maybe keep." But I think all will burn. They are not good or big enough to whip up any imagination in others.

January 29th
Cleaning out progresses slowly. I took a bag of old letters, childish poems I wrote mainly when in love, dear, kind letters from lovely people when I was ill in England. They touched a magic finger to spots I thought were dead. Such tender, loving sympathy, dear fatherly letters from our beloved old guardian, letters from fellow patients at the San and from old school pals, a letter from my mother to her children and grandchildren! What does it all mean, this giving and receiving of love? Love like a merry ball bouncing back and forth from one to another—new fellows joining in the game, old ones dropping out, but the ball always bobbing, gaining something from every hand that touches it. When is its final bob? What is love? It has so many aspects, so many kinds, is good, bad, merry, sad, absorbing, selfish, heroic, fierce, gentle, tender, cruel, God-like, devilish. It goes on right through our life, from cradle to grave, never leaving us quite alone. It is a God-like thing—God is love. Love is a grand, grand thing, the most magnificent there is. That old green bag, the one I used to carry my dance slippers in, was chock full of love, love coming to me in letters, love burst from me in the poor, silly little rhymes that eased me in writing. For writing is a strong easement for perplexity. My whole life is spread out like a map with all the rivers and hills showing.

January 31st
Oh, I want to cry but I have no tears. Two drawers full of memories, words, letters, photos, tumbling out of old creased envelopes, faded faces, my own and others looking out from old photos. I did not know people were so dear, so kind. I have not been half grateful and now they are gone! What sweet, tender, kind little things are in those old yellow letters, things that my conceit took as my due, lightly, without thought. The two deep drawers of the writing table were stuffed with memories—dog registrations and photographs, exhibition catalogues, insurance policies, mortgage papers, Dede's will, Father's will, my will.

Oh, oh, oh! Every one of those things had a hand in the making of me. Oh, life and love! What are you all about? I wonder and wonder.

February 2nd

Does anything make one feel more paltry and inexcusable than to see one's things, the things of one's cupboards, laid out in the blare of daylight? The basement and the attic have yielded up their hoards, trivial, dust-wrapt, tied together with memory strings—no use, no ornament—why kept? Yet it takes resolution and hardening to throw them out. Is it good or bad to be dragged back by the scruff over rough ground? To another the oddments would mean nothing. When one laid them away they were very live. They went deader and deader as the years passed. The good old dust tried to hide them away. Then suddenly you raid the attic and blow the dust and the sparks of memory ignite. Memory is not dead, she just needs a jog. Biff! off she blazes. It is good to hoard, good to walk back over the years. No good whining because they are gone—others are coming and others after them. It is good to rejoice over the finished years, to be glad over the glad things and glad over the sad things, lessons all of them.

The top attic and the studio are the places filled with tender things. I wonder what the house will feel like to the new people, if any flavour of *me* will be in it after my things are out, if my spirit will immediately abdicate. When the chairs I keep hung from the ceiling to economize space in the studio are down, when all the daubs of paint are covered up with clean kalsomine, when the floors the pups and I have worn and scratched and spattered as we painted, when the wood box I've cursed as I filled, and the woodwork that Woo has chewed and the nails I loved to drive in everywhere to hang things on have been extracted and the holes puttied up and the walls and ceilings have ceased to resound to dog barks, typewriter clicks, singing and talking to the pup and monkey, when the door latches are all mended and hinges oiled, the taps have stopped dripping and the mended gutters don't require that you dash under to avoid the splash— when all these things are fixed and decent for the new occupiers, then all the me will be gone and the personality of the new folk planted. The tenants will like my new people; they will do better by them, be more even and steady. Temperamentals should not "run" places to house other people. I was not cut out for a landlady; I'm not a nice one. But I guess I had to learn things through that particular way and the tenants had to learn painfully through me. I was honest enough with them, but peppery. They were just a necessary evil. Oh, I'm glad my apartment days are nearly over. Always wondering what was going wrong next for complaints, if rents were coming, if No. 1 was disturbing No. 2, how long No. 3 would be empty, if the pipes were going to freeze, if the sinks were going to stop up, what made the chimney smoke, if the next-door man was going to get drunk or his dog was going to bite his butcher, which my tenants would complain to *me* about. All these things will be grand to miss. But it's going to be *awful lonesome*. I wonder how the others feel about it—glad or sorry?

February 9th
Days race! The work of destruction goes on, tearing down what has taken years to build, tearing up a home, my real, permanent, mature womanhood home. I am glad I have had a real experience in home-making, in fitting up an atom of the universe to fit myself, imposing my taste and queerness and individuality and me-ness on a place. It has doubtless taught me a lot, some bitter lessons through tenants, some happy experiences through studio, garden and creatures. The weather has done its beastliest, so that the agony of waterpipe anxiety, fuel bills, etc., have been grand weaning. Both shoulders must go to the wheel the next two weeks. Most of the tender things are finished up, the old letters and sketches with their hoards of memories. The thing that has amazed me is the love that has been given to me from odd folk here and there, friends I had about forgotten, those who knew me when I was ill for so long in England, those who knew me when a student in San Francisco and London and Paris, Indians, dog breeders whom I have corresponded with, our introductions exchanged solely by dog business, each rubbing against the other solely through our "doggie" sides. (One calls me, "my dear unseen friend"; we corresponded for years and knew each other intimately from that side.) Lovers' letters I destroyed years back; no other eye should see those. But there was a note, written forty years and more after the man had been my sweetheart and he loved me still. He married as he told me he should. He demanded more than I could have given; he demanded *worship*. He thought I made a great mistake in not marrying him. He ought to be glad I did not; he'd have found me a bitter mouthful and very indigestible, and he would have bored me till my spirit died.

There were such lots of dog photos, dear, faithful bobtails and griffons, twenty-two years' rotation of dog adoration looking back from the pictured eyes, forgiving all the meanness, irritability, selfishness I ever had; just loving and worshipping me as their god. I have not touched pictures yet. This week I attack material things—chairs, tables, pots and pans and shall be *very* practical—no memories.

The junk has gone. The auction discards have gone. One big bonfire has blazed a thousand memories into oblivion and another waits for the match. Whenever I come into the great light studio, spacious and half dismantled, a pang darts through my innards. When the agent of my new house said, "May I ask why you gave up such a splendid studio?" I wanted to bite. Irony—you give up the *working place* because there is not time or strength enough to paint in it and you go to a poor place to gain time and strength and lack the *working place*. Which is going to prove the greater, work or environment? Willie Newcombe's help and courage help enormously. My spirit periodically flits down and flaps round my new abode, fixing. I think it's willing. It's like a bird that has selected the crotch to build in and flies round and round, getting used to the environment.

February 16th
Well, the studio looks like a junk shop rampant. But the bantams are laying
fine, twenty-seven eggs, and all through this bitter weather. I love giving away
new-laid eggs for people's teas. Weather continues bitter, keeping householders
in spasms of apprehension about north wall pipes.

Things are getting down to their bare bones. The essentials of life only are left
intact, all the etceteras are packed.

When I look over things I see that I have been careless over my receipts. I have
had lots of recognition. Way over West it has come to me and I have not prop-
erly appreciated it. Why? It did not seem to mean much to me. I was wasteful of
it, did not follow it up. I might have, and perhaps would have, become well off
and financially successful. Things were suggested but I let them slip, was saucy
over them. Now bad times have come; I cannot reach the public and the public
soon forget. Some tire and look for a new person of interest. I would not kow-
tow. I did not push. Praise embarrassed me so that I wanted to hide. You've got
to meet success half-way. I wanted it to come all the way, so we never shook
hands. Life's queer.

You can be too tired to say so, too tired for the exertion of going to bed. There is
a gnawing in your innards that resembles hunger, but is exhaustion. When you
sit you have to stand again because you are too tired to sit and in bed you're too
tired to sleep and your darn brain goes whizzing on, thinking of how tired you
are. The only comfort is that your tiredness is legitimate, because you really have
put enormous exertion into great activity. If life was not so overcomplicated and
cluttered up you'd not need to sort out your possessions, you'd own a coat and a
cup, you'd sleep anywhere like the beasts, and when you fell sick you'd die with-
out physic or operation.

February 23rd
The world is wide and white today, with sky low and frowning blackly over it.
Live things are humped up. The big studio is all of a mess with packages and
cases everywhere. The reflection of the snow through the uncurtained windows
gives off a cold white light. The trees have shaken off their snow and stand out-
side in naked black. The cottage will have to wait for me till the snow has
cleared. Often I find myself down in it, going from room to room experiencing
it. It is always full of sunshine when I am there. The rooms are all fixed and I am
happy there. There is just one room I don't *know* yet, which my spirit is not at
home in, and that is the studio. It is not a studio yet. I have written, sewed,
cooked, slept, eaten, gardened, but so far my spirit has not *painted* there, nor
have my pictures hung on the walls, nor have I seen myself at an easel painting.
Nobody has ever painted in that room nor thought about painting in it. It was
probably the eating place of the household. Rooms take on habits. I will have to
teach that environment. It may repulse me and I shall have to woo it. I wonder

how the old studio will react on the Finlays, whether a little of me will stay behind. I would like to leave a picture behind to hang there always. The pictures in the Finlay house are awful. They are waterfalls, mostly of a blackish-brown cromotype, and dry, unlit water. One dreadful one was a row of three waterfall panels in one frame. Mrs. Finlay likes paper flowers. I just can't see the old studio decorated with waterfalls and paper roses, and I expect my pictures are equally repugnant to her. And I wonder how the studio will stand up under two men. It's a woman's room, was built by a woman for a woman. The bedroom too, with the frogs and big spread eagles gallivanting over the low ceiling above my bed. I expect they will kalsomine them down. And the garden where the trees and shrubs knew me! I feel rather like a deserter. The animals will be just as happy or better; just the flowers I have fussed with may miss me as I them. But that is silly—growth is just growth; it takes what is necessary from whatever source it can reach.

White, hard, defiant winter holds my cottage. It has burst the pipes and broken the porch and hidden the burning rubbish in the yard so that we can't clean up, so there's nothing to do but smile and sit back in the dismantled studio with all the inanimates laughing at you. Glorious to be a bear or chipmunk and hibernate over winter. Plumbers earn every cent, freezing there under houses, coaxing toilets and ungreasing sinks.

Nothing is left in my flat but a bed and a pup and me.
The studio clock has gone. Twenty times I have looked up where its face used to be. There is a clean spot in the kalsomine where she hung and a horrible stillness which bursts at any knock or sound. This sleeping in the emptiness is like sitting up all night with a corpse.

The King, Edward VIII, spoke for the first time to his empire as sovereign this morning. I went to a flat below to listen; it was very impressive, very, very solemn. Big Ben struck and they sang "God Save the King" magnificently. I pooh-poohed Lizzie at dinner when she said all in their house sniffed and wiped eyes surreptitiously, but it was only the presence of strangers that prevented me.

March 2nd
I have moved! I have slipped out of the chemise of worry that 646 Simcoe dressed me in. I have dropped the chemise and the Finlays have put it on. The cottage is shaping nicely and beginning to live. I liked its sun-shininess from the beginning but it was cold and empty then. I brought the central stove and put it up, and gradually warmth spread from the centre of the house. Presently the studio clock was throbbing on the wall beside the stove, its tick-tock penetrating every room, and then the creatures came pattering in and out of all the rooms, delighting in investigation, and the place became a living thing, warm, responding. The workmen have been abominable, undependable, impertinent, lazy. Ugh, I loathe them, all but the truckers who were kind and obliging. But the engineer who set the whole works going was Willie. Those kind, keen eyes

penetrate into every corner, sum up needs, set things to rights. In the avalanche of dirt and cold stone I'd have been snowed under but for his help a million times. Willie's a wonderful individual. I do not know what his beliefs are but the motivation of his whole life seems to help, always doing something for somebody, giving generously of time and strength and knowledge.

March 5th

Things are getting straightened out. Each corner suggests objects. Sometimes the objects object, but mostly, if the corner calls, the object responds. Furniture is very alive. It knows who it wants to hobnob with. Sunshine has poured into the cottage all day and has gladdened everything. I am beginning to love the cottage. It's homey. Woo is very rambunctious, screeching and barging. She has torn every wire clip and snib off her cage and wrecked the wire front already. She has removed every cork out of every bottle in the kitchen, overturned, scattered, tasted, and finally hid in the oven which fortunately was not too hot. If this weather continues she can go outdoors soon. That will calm her burstings-out.

At last a letter from Yvonne about my paper sketches in the East. She was very enthusiastic. She said that many people were *thrilled*. Said they *made her want to work*. She said that they were alive and stimulating, that they talked and meant more to her the more she saw of them, and that she was glad to see so many of mine together. She got the conviction that the artist was used to open space and distances, and not only to closed, dense woods such as they had always associated me with. Well, that's that. I believe Yvonne to be genuine. I'm glad, not conceited glad, but earnestly glad.

The bantams have sampled the surrounding yards but come back to me. Breast to breast, with a board fence between, my rooster has defied the neighbour's rooster. The dogs love the new place—it is sunny and I most always in their sight. I too like it. It is "homing" up, all but the studio, that has not caught on. How can it? It does not know what is required of it, nobody having thought art there.

The cottage is dominated by the cook stove and the cook stove has the sulks. The wood is wet; and the wetness disheartens the coal. The air is keen today too. Seems there are too many rooms. Not for my possessions—they are all over-full—but too many for my spirit. It has not formed its "rest spot." Big community Indian houses must have been very jolly, each family with its own fire—public privacy. One apple on a tree is lonesome, a crop is jolly; they must encourage each other no end.

Sunday, March 8th

Living solo in a place built for a whole chorus is . . . nice and not nice. There is a strong sense of isolation. The new little studio is as unfamiliar with me as I with it. There is a cosy, popping fire with a rug full of dogs and monkey. There is the rack Willie made me, so handy and right for its piled shelves of sketches.

The lighting problem has been satisfactorily solved, but the little room is big with lonesomeness. Similarly time, unpunctuated with "janitarian" jobs, is long. There is something about both time and place that feels selfish. The newspaper is very disquieting with its wars and rumours of war.

What am I going to do with this life of mine now that I am free? "No man liveth to himself and no man dieth to himself." I wish I could make my paintings help the world. Somehow all this stuff hoarded up is a great encumbrance. I do give away some when I find an odd person to whom they mean anything, but those persons are few and far between. My heart tells me that there is something in my work that appeals to some people, I mean that explains in a wordless way something that they know. Yvonne said they "spoke" to many in the East. But you cannot go round handing out pictures like free samples of breakfast food. Also one has to live. Why buy a picture if you can get it for nothing? It is hard to think straight, and to nail thoughts into words or paint is like crucifying them.

Someone has asked me if I will write a splurge to go into the catalogue of a post-mortem show of her mother's paintings. Oh, yes, I will. It's tommy-rot, but I will. But I won't lie. If the bouquets are garden flowers and homely they shall be sweet, wholesome posies from my own garden.

March 21st
B.B.'s body was brought home today. Lizzie wanted to go over for the funeral but we advised her not. She's a strong one on funerals. She enjoys the flowers and the hymns punctuated with sniffs, and the coffin on its perambulator trundling up the aisle, and counting the followers and noting their places in the procession, and driving to the cemetery after the hearse, and hearing the earth thud, thud on the coffin and coming home again and telling all about it and repeating tid-bits of the death-bed sayings. She does not say "dead" or "died" but "passed away" or "gone." It's all a very melancholy, lugubrious affair but, on the whole, satisfactory to attend and to discuss after and to say "dreadful" over. Sometimes, when I have heard her describing death scenes and sayings quoted mostly from her parson I have felt I'd like to die quite alone. I saw Father die. Just as he was doing it the Bishop came and he prayed. Father did not like the Bishop. Alice and I were kneeling at the horse-hair sofa with our faces hidden.

March 27th
"Millie, will you come to tea—6:30 and spend the evening tomorrow? I made a nice pudding."

"Thursday? Sure. Thank you."

(Tomorrow) 5:30—furious ring at telephone.

"Millie, what time are you coming to tea?"

"You said 6:30."

"No, I did not! Well, that's all right but be sure to come on time."

6:15: Millie arrives, tea nowhere near ready.

"Hello!"

"Hello!"

"Millie, hang your things in the hall; *don't* come in here with them; don't hang them too near the telephone; don't hang them too near the stove, and, Millie, put your rubbers *out*side."

"I want a drink of water."

"Well, go into the Owens' flat, but don't be long. Tea will be ready soon, so don't stay."

Table set prettily—chop cooked to a turn—pudding in centre of table.

"Sit here, Millie. No, don't sit there. . . ." Shafts of long frowning at dog on sofa. "Don't let the dog muss the pillows."

Follows a long grace in a sanctimonious, guttural mutter. I like grace, believe in grace but I can't stick *her* grace. I look round at her bent white head and eyes screwed to lean dashes, at the chop on my plate and the flowers, taking plenty of time and some to spare before her slow, apologetic "Amen." She'd have liked longer grace.

"Why don't you eat all the chop?"

"I have—all but the bone."

"Why don't you give the dog the bone? . . . on the *verandah*; don't give it in here."

Then comes the particularly messy, uninteresting sweet.

"Have some more?"

"No, thanks."

"Oh, why don't you have some more? Won't you have some more?"

"No, thanks."

"Why?"

"I don't want it."

"Well, have some more of the fruit part."

"No!"

"Well, you need not be so rude and horrid. If you asked me in your house to have more pudding. . . ."

"Well, I would not pester you. I'd think you meant No when you said No."

"Well, you are horribly rude."

"You do pester so!"

"Well, why don't you want more?"

"Oh, darn the pudding! I do *not want* more."

"Well, you're rude and horrid."

Meal concluded—the pudding remnant is served on to a dish.

"Millie, take this pudding up to Alice if you are going."

Alice: "What's that mess?"

"Leavings of Lizzie's pudding."

Alice: "I hate left-over puddings."

"So do I. I hate that particular pudding, anyhow."

"Give it to your dog."

"Not good for him. Give it to yours."

"Won't eat it."

"Let's pitch it out."

Plop! It's in the garbage. Ssss! the dish is under the tap.

March 30th

I have decided that I want a radio so that I can hear the news, keep up with the times, get to know music. Physically my whole nature revolts. When I go to houses where they are turned on full blast I feel as if I'd go mad. Inexplicable torment all over. I thought I ought to get used to them and one was put in my house on trial this morning. I feel as if bees had swarmed in my nervous system. Nerves all jangling. Such a feeling of angry resentment at that horrid metallic voice. After a second I have to clap it off. Can't stand it. Maybe it's my imperfect hearing? It's one of the wonders of the age, simply marvellous. I know that but I *hate* it. All the time I am wondering how anything could be so wonderful. I remember how I marvelled over the telephone when that came out. But somehow that is the real voice of your friend. The other is a beastly, mechanized strident thing, all the life whipped out and the cruel hardness of the machine and the new, hard, modern people whipped in. A terrifying unreality, as if man had ceased to be human, all his flesh and blood and feelings gone. Not a human mouth and throat, not a human heart and feelings at the back of them; just mechanical noises like steam whistles tearing, cutting through the air, and the sounds of lovely instruments harshened to cracking point. I spent the evening at a house last week where they had a beautiful, tip-top radio. It was turned on most of the evening in the next room; unconsciously everyone's voices were pitted against it. Oh, if I could have thrown it out the door! By 8 o'clock I was so nervously exhausted I could have cried. I am sorry about this feeling of mine and ashamed to own the agony it is for me to live with a radio. It is not affectation. It's a strange nervous loathing, as if the power of the thing was using me to pass through, like drawing a nutmeg grater across a piece of satin, ruckling it up and catching the threads.

The young man placed the machine on the table. I was in the other room when it began to sputter, and the silence of the cottage ripped. I wanted to shout, "Take the brute away! The quiet of this cottage is mine. How dare the whole world mob it! Go away! Go away! I can't bear it." There she sits like a black baby coffin full of tinned voices, of horrid sounds and pip, pip, squeal, squeal, and the awful roarings, unearthly, cruel.

April 1st

The radio and I are getting reconciled, that is in some measure. The newscasts are fine, Clem Davies fine, organ concerts fine. Choruses, jazz and opera turn me sick—loud, quick noise and the sputter of static wrack me. The man came today and I paid for the radio ($11.95) and now it is mine and I am linked up with the world. The world comes into my room, kicks the silence about, smashes it into smithereens, builds little cobweb bridges so your thoughts can cross to Germany and Russia, to France.

April 4th
Humphrey came last night with an armful of breeches, sweaters, bathing suits, etc., which he invited me to trade for some of my old sketches, cast-offs he spied the other night. So we swapped derelict clothes for derelict pictures. His pants and coats will be converted into useful rag mats. I hope he will get something from my old tattered thoughts.

April 7th
Yesterday a boy child sang a solo. He was small and sensitive, perfectly natural and so sweet. The little song was,

> Light the lights, lamplighter,
> Light the candles, grandmother,
> Light the stars, Gabriel.

Why did one suddenly splash over big tears down on your gloves and feel like a fool? There was a big orchestra of young people from Vancouver. They were so lovely, so young and fresh. I liked looking at them better than their music. They had won lots of championships. Clem gave them his sermon time, and half the collection.

April 8th
Been working on two canvases, one of dense undergrowth, the other of sky. I am keen as pepper. It is good to feel keen and not like a boiled onion. Why can't one always? The sky study should be exultant, leading up with vibrating light, and full of movement.

Good Friday
The trouble with our painting lies largely with our trying to impose our ideas and our technique on the picture instead of allowing our subject to *impose itself on us*, asserting ourselves instead of making ourselves a blank and letting the subject express on that blank that which it will. When you are out in nature she works for you. In the studio your imagination steps in, your sense of design, what *you* want. That is why the first sketch done on the spot smacks of something bigger and more vital than the fixed-up product of the studio. In the one we dominate, in the other nature does. If the spirit has climbed up honestly from solid fact to solid fact, good. If she has floated idly without experiencing, bad.

April 15th
A dense undergrowthy thing—two great moss-grown stumps. It must be *organized chaos* with the elimination of unnecessaries, massing of individuals into group movements, space swinging into space, movement meeting movement, balance, borrowing and paying back, a density and immensity that is so obvious in our Western woods. I want my work to be typically Western.

Nobody mentions the war clouds hanging so low and heavy over everything. They listen to radio, read newspapers and make no comment. They switch off the radio and cast aside the papers and are quiet for a little, perhaps staring into the fire. Then they shut the ugly thing out of their minds and plunge into something that will turn their thoughts. *What* are people thinking about these days, I wonder. Perhaps we do not know ourselves, we are just drowning under perplexities.

April 20th
It is many days now since I last wrote because I have had no thoughts in particular. I have seen and heard and done things but nothing has said anything in particular, nothing made me skip other jobs and write it off my chest. A teacher of English is going to swap some crits of my poor writings for a sketch. The mechanics of my construction and wording are very bad, commonplace and small. Will she help? Can anyone help anyone else? We all stand so totally alone like standard rose trees blossoming at the top. The suckers that come up round our base spring from our wild, ungrafted roots. That which is grafted into our juice produces the good bloom. The other is only wild growth. I admire cows enormously. They are so patient, chewing, chewing, chewing instead of gobbling up the new spring grass, grabbing, grabbing furiously, always after more. I'd like to be a cowish artist, gather (in sketches) and chew (in studio). I do not produce good, rich milk, only lick and crop more and more. Cud-chewing rasps me.

April 23rd
It is time to stir among this lethargic mass of brain debris before it corrodes. The neighbourhood is pleasing to me. I pine for the old 646 Simcoe Street not at all. These folk live more. The men dig, the women wash, clothes-line pulleys screech their freight in and out, wheelbarrows groan up and down Beckley Street with their beach-drift loads. There are good-natured mongrel dogs and well-favoured cats. How gloriously the children play, fluttering and squalling like sea-gulls over the rough, open ground in front! Hopscotch is very much in vogue. Every house and cottage has a garden of some sort, mostly utility. There are daffodils and wallflowers, but the brown earth is better acquainted with onions and potatoes and beets. There are no lawns to speak of. At this month rows of sticks with seed-packets crucified on them head and tail the garden beds.

Phyllis next door is a joy. She and her brother have built a house in their apple tree opposite my kitchen window. Our hands are always a-flutter waving to each other. She tells me I am the nicest lady she has ever known (as though her six years were aeons of ages), and that I am not so fat as some of the ladies in the funny papers. She's an enormous waggletongue, chattering all day long, happy chatter. She's rushing pell-mell in and out of the kitchen door, down the steps and up the ladder into the playhouse she and her brother have made in the old apple tree. It has an oil-cloth roof, sack sides, and its floor is a table perched

in the prong of the apple tree high up. The "smoke" Persian rushes out of the kitchen, down the other steps, up the apple tree just the way the child does, just a swoop of grey movement, down and up again in a lovely curve. Then I call from my kitchen, "Hello, Mrs. Bird," and she calls back, "Where's the monkey?" and I say, "How's the measles?" and she says, "They are all gone now." She has a horse, too. It's an old trestle with a hearth brush tacked on for a tail, but no head—that appendage is unnecessary; Phyllis is its brain. There is a saddle and a bridle—a rope with two loops and wooden strips for stirrups. Phyllis is attired as a cowboy with a rope lariat and, of course, a whip which the stick legs get plenty of. The horse is carefully brushed down, its own tail being used for the purpose, and tethered to a wallflower bush. Other days Phyllis is a Highlander. She has a Scotch cap and khaki jacket and a huge red lard pail for a drum. Again, she is a lady with a fur cap, a black satin skirt trimmed with red crepe paper frills, and shawls and feminine gewgaws, mink, drapery, and two hideous rag dolls, a boy and a girl, who claim to be twins and have very scant clothing as though the mother had only expected one. Next day, Phyllis is just a little girl catching bumble bees in a bottle. She bursts out of the kitchen with a jam jar, unscrews the lid, climbs the plum tree, shakes the glorious foamy-white blossoms, and then the triumphant screech, "I got a bee!"

April 26th
This neighbourhood is all peaceful little streets with peaceful little gardens, well tilled, and homely men and women, and happy, unspoiled children playing their games. Every garden has wallflowers and sweet alyssum and just a few sweet old flowers—the rest is vegetable. Every yard has wash and a cat and an apple tree. The wild bit of Armadale is bursting out in tender leafage and the birds do a great deal of discussing there. Wild lilies of the valley are shooting up umbrella-like leaves to hide the blossoms they are going to get. The salmonberry bushes are dotted with deep pink blooms. Skies are fine these days. White clouds dance over the blue dome. Oh, that dome! The blue is so much more than blue, the illusive depth boring into Heaven's floor. Nothing stands still these days. It is growing and moving double-quick. Trying to keep up takes one's breath. Every-thing is absorbed in reproducing its kind, always with the hope of producing something bigger and better than itself and yet picturing itself in the new thing it's making. As soon as every single thing becomes adult its desire is always the same, to keep the thing going. Unmated things are never quite complete. They lack experience.

May 4th
Spring has gone ahead by leaps and bounds. Everything has burst out; old used-up bud skins are cast everywhere. I am hurrying to finish up mounting, framing, and shipping to Ottawa for the Jury of Selection to sit on my canvases, among others, for a Southern Dominions Exhibition. Rain is softly blessing the earth, caressing her new sprouts. World events are pushing on like spring growth, only they are terrible instead of lovely. Ethiopia is crushed. All sorts of countries are

doing all sorts of horrid, spitty things in each other's faces. It seems as if war was inevitable.

May 9th
Three pictures are ready for Ottawa. Am a little disappointed in this year's trio. I feel them a bit studied over—feel their groans.

May 10th
Tonight was perfect through the little bush trail. The mountains beyond were high and very, very blue, clear and ringing colour. The sky and sea were greys. As the evening latened the mountains crouched down and the sky went high. The wind threw just the right degree of coolness against one's face. Dogs had all had a bath and looked red and fluffed up. Pout and Vana are mated and very content. Health and satisfaction are the order of the day. On the beach I was wondering about things, all the new marvels for our ears and eyes, noses and senses.

I think it must be rather illuminating to be a garbage man—the dregs of human discards pouring out of the big, dirty cans: dust and mildew, mold, decay, roots and parings, papers full of old news that has flared in the world and gone out, offal of the cherry fires that have finished warming and gone to their gritty ash, cans that shone gaily on pantry shelves when in tight-full splendour—empties now, with all their respect gone, dismally blushing rust. The giant grey cans themselves, labelled "Property of City of Victoria," always relegated to the meanest spot on the property, a utensil to be hidden. But, let him wear out and leave his proprietor without his useful presence, what a howl goes up! The noses of sanitary inspectors come snorting out of nowhere demanding that a new can immediately replace the old.

We are in full spring. Winter bareness, full firing, heavy clothes lie behind us for five or six moons. There is a little treachery under spring's loveliness. Youth, so tender itself, is often hard and a wee bit spiteful. What different faces the world can put on, such hideous ones and such splendid! A gentle rain is misting down. Sweet smells are running up and down the earth kissing every nose. Some noses don't heed, some do. Flower heads hang heavy, drunk with pure water. The race to maturity is full on. When the goal is reached there will be a long pause, fullness, content, balance, the scales full and steady, before autumn starts tipping down the one that is up now.

This morning an artist of Budapest visited me. He looked at sketches as a nature lover looks at a live wood, seeing the trees and the space between. He looked two and a half hours. He began by looking over Indian old ones, enthusiastic over the barbaric totems. That was what he had come to see, really. Then I rambled out the modern woods and his spirit answered to something in them more strongly than to the others. He left off being historic and decorative and

floated out. The man who had brought him here reminded him that he had a boat to catch shortly. "There will be another tomorrow," he said. "Had I left Victoria this morning I would have got nothing. I do not like Victoria, but now I have got something from these. I have got something. I cannot find words easily."

He thinks music comes nearer than any other medium to expressing the spirit because it is less material. We discussed many things, the difficulty of finding a medium to express in. I felt that more difficult than finding our way through the medium was finding out just exactly *what* we had to say, getting it perfectly clear in our minds. If that was crystal clear then I think the medium would wrap it round. Perhaps too much medium is like a fine wrapper with no goods to wrap. He found my work more like a man's than a woman's. He thinks women find it harder to separate things from themselves, to forget themselves in their work, to concentrate. He had none of his own work here. I would like to have seen it. It is wonderfully heartening to speak with another artist. I have missed the contact with Lawren bitterly. To both of us religion and art are one. He opened his door a crack and I peeked in. I went just a little way in and found it was a fair garden, serene and beautiful but *cold*. When I touched the lovely flowers they were wax. They had not the exquisite feel of live petals and no smell. I was frightened and ran out of his garden and the door shut and I grabbed the homely, sunwarmed weeds and simple wild flowers that grew outside the gate and held them tight.

I feel a fraud and rather mean. I claim to despise women's clubs and here I've just come from the Business and Professional Women's Club annual dinner (invited by Margaret Clay) and enjoyed every minute—good dinner, good talk by Irma Sutter. Met new good people and old good ones I had not seen for years. Everyone was so nice to me and I was the *worst* dressed person in the room too. I was driven there and back. There was a large percentage of elderlies and middle aged and such a display of shoulder blades and vertebrae I never saw before. Afterwards some of us sat outside the ballroom. The May Queen Dance was going on and hussies three-quarters naked buzzed in and out. I never saw such dresses—tighter and more suggestive than their own skins, so tight across the seat and thighs, draggling long and nakedly low at back. I did not see one pretty bare back. They all looked as if they were prepared for the chiropractor. Hideous vertebrae and shoulder blades, ugh!

June 1st
Theresa took me to see my camp spot. It's covered with ant hills. There's the great yawning gravel pits, the vast flat sea, and there's the pines, and bleached and blackened stumps, and sheep, a water tap, a kindly care-keeper who had selected the exact spot where I was to sit. I felt like a child: spanked and set. It's rather far from habitation—the vast pit, sky, sea and me. And how it pours and pours! I'm glad I am not there *yet*.

June 4th

I'm here but the van is not. The clock, mounted on a stump, says 11 o'clock. It is three hours since we locked the door of 316 Beckley and got underway. It rained, a fine drizzle. Now it's quit, but sulkily. The sky is low and dull, sea flat and misty. Everything has that waiting look. Pines all have their new dresses. There are immense ant colonies all round. I can't see eye to eye with Solomon about ants. It is a good opportunity to see if I can cultivate a placid admiration of the brutes. One cannot see into the gravel pits from here. There is greeny-grey grass with a ripple as the breeze passes, and then sea and sky with no division line. If you saw it for the first time you might think it was all sea or all sky. And the air on the land is full of wet too. It's a watery day—air, sea and sky. A robin is trying to whisper to his mate but jerky notes like his talk cannot whisper. There are two immense brown upturned roots behind me, with all their underground secrets exposed. The lying logs are bleached or fire-blackened or chewed to rusty meal by the ants and ready to mix right with the soil and go back to their beginnings.

June 5th

It is perfect weather. I woke with the glorious sky looking into the van window and I lay thinking it was a painting. Just enough breeze to stir and keep things from grilling. The camp is splendid, complete; everything fits comfortably. I know *how* to camp and this one is extra excellent. Despite the vow I would never make another one—my camp days were over—I shall go on till ninety. The grass is dry, soft and green. I ran barefoot all morning—such a lovely, lovely feel.

I painted this evening. Not greatly successful, but a beginning, and the palette set. It was a mellow, high-keyed night with no clouds, only a few white streaks sideways. A slash of blue sea and an impossibly glowing, grey-green stretch of grass with two stumps and a bush. The predominating characteristic here, perhaps, is space, the great scoops out of the gravel pits, the wide scoop of sea (trees are not close), wide patches of that indescribable, lit-up, very live grass, thin, fine stuff that quivers over the earth, not luscious, luxuriant growth. It's like baby hair compared to adult, but it is not young-looking like the other kind in spring. It's adult pigmy grass with seeds on it and three hot days would turn it to standing hay. The ants are very active. Immense colonies everywhere. Solomon can say what he likes; I am sure their housekeeping is frenzied chaos. The sea must be very still. Each Victoria light has a trickle of glow below it. The lights themselves wink furiously. Here I lie in bed miles away and see the lights clearer than when I'm living on top of them.

June 6th

Casually, you would think the world very still this morn, but really, when you consciously use your ears, there's quite a bustle and stir. One is so lazy about life, about using our senses. It is easier to jump into the luxurious vehicle called

Drift and go nowhere particular, then wonder why we don't get anywhere. There's smells—they have to fairly knock us over before we heed them. They are such a delicate joy, and we miss three-quarters of it because we don't tune our noses in. Fussy enough about taste because our stomachs are so demanding, we take sight for granted and only half use it, skimming along the surface. Nor do we listen in to the silence and note all the little, wee noises like the breezes and insects. Good heavens, the row there'd be if you could hear the footfall of all the ants! And then there's feel. We don't get one one-hundredth what we should out of feels. What do we bother about the feel, the textures of things alive, and things made, and things soft, and hard, cold and hot, smooth and rough, brittle and tough, the tickle of insects, the touch of flesh, the exquisite texture of flower petals, the wind's touch, the feel of water, sleep pressing our eyelids shut? We accept all these things, that could so immeasurably add to our life, as a matter of course, without a thought, like animals do. In fact animals seem to get more out of their senses than many people, yet we are supposed to have minds and they not.

June 8th

It is 6 A.M. Change has come. The sky warned of it last night. A little wind is creeping over the grass, that thin wiry grass heavy with seed. Each separate little gust runs alone. Back from the woods it seems to come running like a fire in wavy creeps, passing over the grass, bending and shaking it till the edge of the cliff is reached. Then it jumps from the grass over into the big gravel pit. Presently another little gust comes, and another, in quick procession but never overtaking each other. They neither begin nor end, but just succeed with an almost imperceptible pause between each.

Suddenly, the little runs trembled and stopped. Then the rain came, gently, then hard patter, patter. Big heavy tears chase each other down the window. Distant Victoria and the sea and the pits are all smothered out with fine white wet. Even the burnt stumps are vague, and there's more water than substance to the bowed grass. Yet this 12 x 5½ is dry and cosy, a tin and canvas haven saying with authority, "Keep out." It must be lovely to be a creature and go with the elements, not repelling and fearing them, but growing along through them.

The best part of a week gone already. It's been very wet for work. Did one sketch. Fairly happy over it. Have read "D'Sonoqua's Cats" through. There's some good thoughts in it if I can simplify and sort them out.

June 9th

The sun is right there but it seems as though every time he peeps a great black cloud slaps his face and struts in front. Then it is patter, patter on the van top again. An old sheep was just below the van window when I woke. This old girl winked her right eye and waggled her right ear furiously. She was round Woo's stump trying to figure out the smell, her seeing and hearing all tangled up. She lipped a piece of orange peel into her foolish mouth and began a silly side-to-side chew. She liked its hot nip and went off flipping her tail. A lamb's tail that

has not been cut is the most inane appendage, just dangling there expressing nothing.

Now for my bath, or rather, dabbing three pores at a time in a small receptacle. After the whole surface has been dabbed you take a vigorous scrub with a harsh scrub brush. How much more sensible it would be to roll naked in this soft, sopping grass, a direct-from-heaven tub. Maybe in a former state I was a Doukhobor. The *liveness* in me just loves to feel the *liveness* in growing things, in grass and rain and leaves and flowers and sun and feathers and fur and earth and sand and moss. The touch of those is wonderful.

June 10th

Still pouring, only worse. Poor world, she looks so desolate and depressed, as if she did not know what to do with all the wet. The earth won't hold any more. The sea is full and the low clouds are too heavy to hold up. The sky leaks, earth oozes, so the wetness sits in the air between and grumbles into your breath and bones and rheumatic aches. The sweetest thing in the universe is a hot bottle. The sheep go right on eating, fine or wet, poor darlings, contentedly making mutton.

June 12th

Everything that makes for exquisite weather is contributing today and the earth, her young tenderness ripened almost to maturity, is exultant. I read, rested and sketched in fits. Have not got any notion how to tackle them so far, those big emptinesses. They must work together with the sky—that I know. They must express emptiness but not vacancy. They must be deep. I run back into the woods with their serene perplexities, their fathomless deeps and singing fresh green tips. These days when the sun is bright they just chuckle with glory and joy.

Sunday and pouring rain again. Hibernated till 8:30. Now I will work on "D'Sonoqua."

Yet another day's weeping Heaven. Two days I have slaved on "D'Sonoqua" but she remains choppy and inadequate. Why do I go pounding on when results are so poor? What is the tease within me that won't give writing up?

June 17th

Shan't mention weather again till it improves. It's just awful. Suffice it to say rain continues to pour. The Spencers are "straight nice," Father, Mother and boy. Mrs. likes to talk and Mr. to joke and all three like the dogs. I keep remarkably busy tending beasts, cooking for them, fixing the good old van—everything has to sit *so* or we couldn't move. Then there's writing and a *very* occasional sketch in a five-minute period of "fine," and letter writing and reading and singing to the dogs to keep their hearts up and playing "this pig went to market" on Woo's toes and fingers to make her life less drab in the wet. Two

families come to my tap in the woods to get water. I notice they come no more. All they have to do these days is hold a cup up to the sky and hang clothes on a line and iron. Poor strawberry growers! Their crops sopped to mush!

There is a deal of satisfaction in singing rubbish to the beasts. They take it for what it is worth. Today is radiant though now and again the sky puckers up. I have sketched this morning near the van. This afternoon will attack the gravel pits. The stuff about is big. Its beauty consists of its wide sweeps and is difficult, for space is more difficult than objects. Objects are all well enough for studies, but what this place has to say is out in the open. It is like a vast sound that must be produced with very few notes and they must be *very true* or else it will be nothing but noise. There are no interruptions to complain of for beyond the baker not a single soul has been to the camp. I can go to the Spencers' when I want to. Three black bears were down in the next bay two nights back. They killed one and wounded one.

June 19th
There is great heat. The earth has forgotten about the sousing it recently received. This poor fine little grass is drying into hay that will never be cut. The sheep pant and crop just the tidbits. For the first time in days one of the people who use my tap in the woods has come. I suppose their cloud water is finished.

It is not good for man to be *too much* alone unless he is really very big, with stores of knowledge to draw from and a clear brain to think with. That's the whole problem: a clear brain that can take thoughts and work them out, can filter—clean out—muddy, confused thoughts, can read meanings into things, draw meanings out of things and come to conclusions, a brain that converses with life and can, above all, enable a man to forget himself. The tendency in being alone and not having anyone to exchange thoughts with is to be always on the fence between yourself and yourself.

June 20th
It's one of those days that blare. Sky high and blue, sun dictatorial, wind uncertain, puffing here, huffing there. The grass is ripe. It is turning pinkish and leaning. The seeds are heavy on the sere stalks. The sea has no depth. It is all shimmering like a glass-topped table. You could slither things over its surface and they'd go on and on as far as the momentum of your throw. Nothing would sink, just slide over the top. It looks like ice except that it *looks* hot, not cold. The pines are solid colour now, no contrast between the new tops and adult needles. Lambs are blithering for their m-a-a-as. How *do* the lambs know the silly face of their own m-a-a-a from all the other silly faced m-a-a-a-s or each sheep know its own waggletail, woolly child. All their b-a-a-a-s are in exactly the same key.

June 22
Up at six—van gets hot. All the camp chores now done. Powerfully hot but a

nice breeze. Last night I called on Mr. Strathdee, my camp host of two years ago. We conversed, me holding three dogs, he leaning on the fence. I heard all the little neighbour gossip and told about my move and the monk and dogs. He was pleased I went; his life must be very humdrum. What a help radio is to those isolated souls too shy to exchange much with humans! The unbodied voice comes to them; there is no one there to make them self-conscious by scrutinizing their reactions. They can talk back if they want to, they are utterly free, they have neither to agree nor disagree. Thoughts and news and music tumble into their minds to be sorted by them at leisure—very wonderful and humanizing. I got home just at dark. The Spencers were going to bed as I passed. My pines were black. There was no moon or rather such a baby he was hardly born. I meandered through the black stumps keeping to the road for fear of treading on an ant hill but I was not scared even when I thought of the three bears in the neighbourhood. I ate doughnuts and strawberries in bed and read myself to sleep amid snores and puffings of the beasts. "D'Sonoqua" is laid by again for more blemishes to rise and be skimmed off at a future date. It disappoints me.

This morning is a morning superb. The camp jobs are jobbed, pups and monkey bathed, all our beds aired and made up. Woo is tethered to a five-gallon shiny coal-oil can. She can boost it round camp and I can keep tab by the clank, and she cannot get it through the van door on a wrecking bout. Now for a few moments of quiet and then the woods. Did a good sketch yesterday—woods, light, movement, and wrestled with the gravel pit last night of which I made a botch and learned something. I suppose the whole hitch is I am not sufficiently interested in the pits. They are spacy but there is the crudity of men about them, and they smell commercial. The merry rattling stones and the glistening gravel are now roads and buildings, married to other ingredients, dead and uninteresting, and nature has not had time to heal the scars and holes yet. Fluffy little trees are bobbing out of the gullies. The pines are wrapped about in warm, sunny greens and standing still. Yesterday those silly single spikes on top of the young growth bobbed and bowed to each other like gawky, immature youths. Today they are trying to straighten and brag who can reach the sky first.

Humphrey came out to camp this morn. Nice of the boy to bicycle ten miles in the heat to see an old woman. (There is such yards of clean, fresh *him*.) I made buckets of fresh lemonade for him. I can't help wishing I had been in town this week. There were lots of ones I knew came for a medical conference, many from a long way away. But from the paper it seems that most of the time was spent in garden parties. I'd think that after the expense and all they'd want to hear and hear and talk, talk, compare, consult and chin over all the new stunts, not gad and garden-party. Gee, if we only had artists' conventions and all met, how luscious it would be!

June 23rd
I don't know anything as cold and deep a blue as the sea today with the sky high

and blue above it. There sits Mount Baker, very unreal, nosing up in the sky, and there Victoria, rather dull and aggressive today, between sea and Heaven. I got lost in the woods. Did not note the direction I took going in. I was very hungry and very cross and went round and round and came out where I least expected. It must be awful to be really lost. I knew the woods I was in were not vast and that I'd get somewhere some time. When I came into camp the monkey had eaten my dinner—I was mad!

June 27th
Indians must have felt the same way as I did when I ran into town for one hour yesterday. The town felt and smelt stale. It was hot, airless and noisy. Folk looked feverish and sweaty and ugly. My sisters' gardens looked lovely, one mass of flowers, but when I got out of the motor, such a rush of heavy perfume from all sorts of blooms burst out at the gate it was almost nauseating. Country smells are sweeter and wilder, more subtle and mysterious and evasive.

What a place this is to dream and drift and let the world go by, to go on and on and never catch up with your thoughts, to chew and stare like cows and sheep! The sky is low and full over a grey sea, and the breeze is moist and sticky.

The sun shouts, "Right about face," and every little dandelion looks him plumb in the eye. The grass is full of them, bright and pale yellow among the now warm pinky ochre of the drying-up grass. It is cloudless. Heaven has put on her blue dress and climbed to the top beyond all reach.

July 3rd
It's not raining but very cold and miserable. The grass and trees, even the birds' wings, are all heavy with wet, and the sheep look waterlogged. If there is going to be another deluge like June's I'm glad to go home though I've done good work these last few days and am in the swing of it. Yesterday it was the open spaces; burnt stumps and sea and sky trimmed up the edges, but it was the hole that I was trying for.

July 4th
Therese and Dr. Gunther brought us in. House dirty and much housecleaning necessary. Great tiredness. Welcome from Phyllis and Mary and the other kids in the neighbourhood did the heart good. Sisters looking bleached with weariness. I feel bad about it and can't do anything. They are impossible to help. Weeds in garden knee-high, weeds in yard neck-high, a wilderness. Nan Cheney came Saturday. We had a long talk. Willie, Sunday. Edythe, today.

GOODBYE TO LIZZIE

1936

July 8th

I'm just whizzy! Sold four pictures, one from Vancouver Gallery, "Shoreline,"
one paper sketch, one French cottage, one Victoria.

What a help to finances! Mrs. de Pencier of Toronto bought the first and her
daughter the other three. Edythe and Fred came to supper and we had a lovely
evening. I read them my "D'Sonoqua's Cats." Some of the descriptions they
thought beautiful. I felt there was something did not satisfy Fred though appar-
ently he could not quite put his finger on it. He suggested condensing it more
and he took it home to read again. How sweet a place the world and all its
inhabitants are at times!

Everything seemed shining today, from the freshly cleaned house and the
sleek new pups to the sunny little "Mrs. Bird" and my visitors, one of whom
was the daughter of an old pupil of mine and brought such happy memories of
her mother and me in the old studio in Vancouver. The world of today was
clear, bubbly, and just straight nice.

July 13th

Yesterday the Cathedral bells were consecrated. I did not go to the service but
went to my radio. Suddenly joy burst right into the room. The whole air
seemed alive. It was as if the tongues of those great cold, hard metal things had
become flesh and joy. They burst into being screaming with delight and the city
vibrated. Some wordless thing they said touched something so deep inside you
that they made tears come. Some of them were given in memory of dead peo-
ple. That's a splendid living memorial, live voices speaking for the dead. If
someone were to die and you were permitted either to see *or* hear them, I think
it would be best to hear their voice. What a person says comes out of his heart;
you have to use your own imagination to interpret his looks. People reacted far
more to the bells than they would have to a picture.

July 22nd

Received $120 for picture "Shoreline." Gallery took $30 commission from
$150 sale price to Mrs. de Pencier. Also got $75 for three sketches from Miss de
Pencier.

Glorious weather. Bright sun. Spanking breeze. I went with Alice to Gorge

Park. How good she is, dragging those million kids to pleasures! The gardens were so lovely, with the flowers, birds and fish, and the Japanese waiters all smiles. Children bobbed everywhere and sunshine trembled on to the walks under the trees in little pools. The trees were so tall and green and protective. There was a hum of chatter as people unpacked baskets and the Japanese ran here and there with teapots and ice cream, the children revelling in revels and licking lick-sticks.

July 31st

Lizzie has been in the hospital four days now, suffering patiently. Oh, why? Alice is wonderfully competent and untiring. I feel such a flab. All the prayer people poke in to pray beside Lizzie. Why can't they do it at home? I think they like to be *seen* doing it. Seems like I can't pray much these days. Seems like I just want to lean up against God and say nothing. I take myself to task for not praying more but I guess He understands. Why is it when one goes to a hospital they want to burst out blubbering first thing? I feel blunted all over and very old. Tonight is very lonesome. Lizzie lies in St. Joseph's Hospital very ill. Alice lies in her little house, with the children's soft breathings all about her and the great powerful dog Chum standing guard on them all. And I down in my cottage with just the dogs.

August 1st

Lizzie's room swarms with posies and reeks with their smells, heavy, cloying smells. They are very lovely and stand for many, many kindly souls and kindly thoughts, but oh, if I were there I'd rather have Indian flowers, a sprig of cedar, of mignonette, of lemon verbena or lavender, to hold and feel. The great branches of sweet peas are so flabbily determined to last out every other flower. The gladioli are glorious but if they collide against one another they sulk and shrivel. The carnations look like paper. Cut flowers are so cut off from life. Outside or on their roots they are so joyful.

 Lizzie lies among the flowers facing death. I wonder how she feels about it. I wonder how I should feel if it was me. I can't believe that Lizzie is dying. She seems so usual. Any minute she might go or she may linger on and on. Anything would be better than that slow eating of disease. That is horrible.

August 3rd

Lizzie died at 5:45 this morning. I can't use the words "passed away" or "gone" or "fell asleep." They seem to me an affectation. I just have to say "dead." A little past six Alice and I went to the hospital. The sisters were lovely. Lizzie died quickly and quietly. It was merciful and blessed. The day has been interminable. Alice is so brave and I snivel easily. The nieces are here, at Alice's house. I came home to the pups and slept at night. It is nice to be alone. We are glad, everyone is glad, she was spared a long agonizing end. I don't think of her as at the undertaker's but as somewhere free and surprised and glad, somewhere over beyond. Dear Lizzie!

August 4th

Old ladies have been to see us all day, such decrepit ones, not quite contemporaries but older. We all quietly rejoice in Lizzie's quick, peaceful end. The old ones are half-envious. Alice and I went to see her. We took flowers from her own garden, beautiful gay marguerites and verbenas and asters, yellow snapdragons, geraniums, godetia, mignonette and honeysuckle. She was not ready. Another service was being held in the chapel. A hard-voiced, rouge-lipped, noisy woman was in the office where we sat waiting. She took the nightdress and stockings in a cold, callous way and said, "You can sit in the office and wait." Then a man came in and they laughed and joked noisily. People whistled and banged doors. There was a spittoon next my feet filled with stale cigar stubs. "Come on," I said to Alice, "into the parlour. It will be quieter." Alice followed grudgingly for she hates my nervy "uppiness." The other room was little better except that there were no people. There were pictures of cemetery plots and diplomas for undertaking and embalming. The sun blazed in and showed lots of dust and grime. In the hall were pots of aspidistra and some deadish gladioli. People in black went through to the other funeral. Two girls in grey, who could not make up their minds to go into the chapel and face the coffin, peeped in the door and went away again quickly when the organ spoke. The hymn was quavery. It stopped. There was sniffled shuffling, and the sound of car doors shutting. Then a coarse, horrible person in black came to us. "She's not ready," he said. "Come back later." "We were told to come an hour back," I said. "Wait then," he said and left us.

Then at last the noisy woman clanked over the tiles and said, "Come to the chapel." She threw open the door and clicked on the lights, and slammed the door, and we were with Lizzie. The touch of Alice's quiet hand through my arm turned a tap behind my eyes. All that was left of the old Carrs stood looking down into the quiet grey coffin. All the fret and worry was ironed out of Lizzie's face. Every bit of earthiness was washed out and Heaven flooded in. I did not know she was so beautiful, so dignified and so sweet. It is good to look on the faces of the dead. They look like crumpled old lace that has been beautifully laundered and renovated. We laid the flowers from her own old garden in the coffin.

August 5th, 1936

The three long, long days of marking time, muffled voices and shuffling feet, whispering voices and dripping tears are over. Today the scrap of ground that Father bought and coped with granite yawns open for the fifth time. Alice and I, the pitiful remnant of Father's nine children, must put her away among the others, hear the hollow rattle of the sod against the box way down below, and mound the brown earth and pile it high with the flowers that loved her and she loved so well. Then the shorn family must creep back to finish up the family chores.

It's 7:30 and time to face the day. I wish the funeral was from the church instead of from those loathsome parlours. It would be comforting, I think. Carr

funerals always have been, but Lizzie said it was desecration, "to take dead bodies to the house of God." So we are carrying out her wishes. Perhaps she was really denying herself as she always did.

Later
The funeral chapel was crowded to the doors—all kinds of people. I'll bet everyone had had some kindness from Lizzie Carr. At the back was a little room for family so that we could cry in peace—Una, Alice, Gardner, Emmie and me. The place was banked with glorious flowers and Lizzie lay among them perfectly serene and gloriously happy, with all that crust of fret chipped off. The graveside service was not sad. The dear brown earth was covered with a spread of mock grass, bright green. A man pushed a button and the grey coffin sank noiselessly and took its place between Father and Mother, earth to earth, dust to dust, ashes to ashes. The man who ran things threw three handfuls of sod.

Then we left her. Several people came and shook our hands. They cried but they smiled too. I think they were the ones who had looked into the coffin and had seen how happy she was and realized how splendid God had been to take her so easily and spare her so much. We had tea at Alice's and then she and I went down to feed the pups. In the evening Una took us to the cemetery. The plot was massed with lovely flowers but already the wind had hurt them.

People say, "I want to remember Lizzie as last I saw her in life." But I love to remember her as last I saw her in death. Life had always seemed so full of frets and worries for her. Quick, troubled movement. So often she prefaced her sentences with, "I'm afraid," or "I'm worried over." It was like being introduced to a new Lizzie, this radiant person in the coffin. It was as though the spirit, stepping out of the clay, had illuminated it in passing and showed up the serene, queenly presence within. People are afraid to look at the dead. Sometimes they say they want to remember them going about their ordinary tasks. I want always to remember Lizzie's coffin face. It was so completely satisfied.

August 8th
There is a dishonest feeling almost like indecency or eavesdropping in being thought dead when you are alive. Someone told me today that a girl next her in the funeral chapel was crying bitterly. Then she got up and looked in the coffin. "Oh, I've made a mistake," she cried. "It is not Miss Carr, the artist." Someone cried because they thought I was dead. That was nice of them. They did not know Lizzie. There has been much confusion because the name Emily belongs to both of us.

August 14th
How hard it is to fill up a hole that somebody has gone out of! The empty feel, the hollow quietness, that ache that you can't place as if one were sickening for something you don't quite know what. Every day we go over to Lizzie's house for a few hours. Her flowers, her bantams, the big clematis vines over the verandah,

the still, empty rooms that echo to the bell pull. The upstairs flat so clean and polished, left ready for a new tenant to jump into, the downstairs half empty of furniture, odd bits sitting round like orphans staring at the empty spots where the other furniture had been, and now the shabby places were bare and exposed. It was dreadfully heartachy today. We were sorting the little, last things she used, the table-napkin in its ring, the table cloth and knives and forks and cup and plate she always used. We just choked up and cried over and over. The last entry in her diary—surely by it she knew she was to go soon.

We divided the silver and the knives and the linen. We agreed that if either wanted anything in particular to speak. Now and again we could joke over some poor old family thing or some little oddity Lizzie had harboured. The joke was only a cloak to cover the awful heartache. When we came to some frightful vase or teacosy, "Yours," Alice would say, "No yours," I would reply, and we would push the article back and forth.

We were crying over the things in the table drawer when suddenly Alice ducked under the table and pointed towards the window. I saw a black and white female passing it with a stooped, melancholy back. I ducked too, even forgot my sciatica. There was a mournful rapping on the front door. The emptiness rapped back. Then a horrible thought—the blind was up a little. Alice oozed further under the table. I pulled my tell-tale legs further behind the sofa. We did not breathe till the gravel had stopped crunching. We were stiffer getting out than going under. The work has to be done. We had to stop the day before to mop a visitor's eyes, and got nothing done.

The bedroom is the hardest; the empty clothes, moulded and trained to Lizzie's body, the dip of hat brims, shoes like stopped clocks, woolly jackets with little grey hair nets, her purse and her handkerchiefs, shawls, lavender water, the drawers full of well-worn things. Alice shut them quickly. "I can't. There's no immediate hurry. Let's do the household linen first." The table cloths and sheets were more impersonal.

So we divided Lizzie's linen. Dainty, well laundered, so beautifully kept. She took such pride in these little ways, like a real woman. She scolded me so often—"Don't muss that cloth." "Millie don't fold the cloth like that." I remember how she used to make one take the end of the big table cloth and fold it, running her fingers down the fresh creases while I hung on to the other end, and how we used to fold for the old mangle, holding the sheets and shaking and shaking and her so vigorous shakes wrenching it out of your hands—the white sheets soiled—the heat of her wrath—the quick nervous jerk. What a trial I was to her! She taught me to make beds. How she pressed and smoothed, smacked pillows and set up the shams! And how bored I was! She called me a "filthy child" because I did not dust the top of the doors, and she left me the rungs of the chairs and the fat table legs to do. And I persistently started to dust the stairs from the bottom just to annoy her. What a peppery pair we were! She said I was a disgrace to the name of Carr, with slovenly ways. I was always a thorn in her side. She loved Alice way and ahead more. That's why I want Alice to have

all her *nicest* things. She'd have loved her having them. But Alice wants us to have everything equal. I don't think Alice could ever quite understand what happened when Lizzie and I collided. Lizzie and Alice could wear each other's clothes. They went to the same church, and "served" people, and their properties joined. Lizzie did not have to go on a public street. She ran to Alice's carrying the same thought that started in her own home and caused her to go there, but when she came to me she met other people on the way and distractions, so the thought she started with got mixed up *en route* and when she got there, there was me and out shot both our horns.

The glove drawer—that was the worst of all. Black, white, brown folded neatly in pairs. We pulled the drawer open. There were two half sobs and a great deal of blinking before we saw clear enough to begin sorting. We worked steadily from 11 to 4 o'clock. "Yours," "Mine," "Rubbish," "Yours," "Mine," "Rubbish." Five drawers in the mahogany chest, four in the white chest. Why do we hoard? But the oddments are handy. I have a bothersome way of finding a use for everything. I know I am thrifty. I hate to waste. An article would dangle with our four eyes appraising it. Alice would shake her head, "No room in my house." My knot would nod; it would come in for so and so. Seemed like everything could be used some way, and it would be rammed into my trunk. I can't think what will happen when I bring them home. "This?"—Alice held up a layette outfit (paper patters). "One of us might have a baby," I said, and we went off into a "sixty-year cackle." It was those silly cackles that kept us up. Cackle or cry? Alice looked very white. My sciatic limp was bad coming home.

Lizzie had millions of tracts; prayer circle literature, missionary societies, little framed recipes for pious behaviour, pious poems, daily reminders, church almanacks, church of the air, British Israel, Christian Endeavour, Y.M.C.A., Sunday school, church gazettes, and enough bibles to supply the whole British and Foreign Bible Society. I can't think how she could read them all in three life times. She was that way from her cradle up—*pious* and *good*.

I do not think it is any healthier to have drawers, shelves, tables, cupboards stuffed with tracts and holy books, recipes for when, where, and how to pray, daily reminders, etc. etc., than it is to have every room of the house stuffed with edibles. Dear soul, how she worried over how to get there. She *got* there—the radiant glow in her face told *that*—but she travelled by a different route. All the routes are hard anyhow, I guess. Maybe those who take the hardest enjoy most the joy of arriving. It seemed rather horrible burning up all those hundreds of pamphlets. Lots of the recipes for prayers were good and well tested, but rather elaborate. (Mrs. Cridge used to make the most *delicious* little dropcakes. Once a week we went over to the Cridges' and read one of Dickens' books aloud. About ten minutes before we were due Mrs. Cridge seized a mix bowl, ran to the cupboard, dipped out flour, raisins, sugar, spice—pinches of things—beat them together with her own fingers. The batter dropped off the end, bumpy with raisins, and set in little blobs higgledy-piggledy over a black square pan. Oven door banged, fire crackled and lovely smells ran to the front door. When we

rang there was flour on Mrs. Cridge's nose, even when she kissed us. Those cakes were just grand—no recipe at all, just Mrs. Cridge's common sense and good will and nice material.)

My backyard is wild. It is bounded by a board fence and a tangle of blackberry and loganberry vines, and the chicken house and shed, two plum trees and one apple, all heavy with fruit. Woo sits in one plum tree very content. The bantam cock and hen have a little bower under some seeding parsnip tops. A great pile of wood is sunning itself, storing up glow for the winter grates. The big griffons are sprawled dead with sleep. The baby griffs are cutting teeth on each other's ears; life is jokey with them. My pupil is scrubbing away, making a blue sky, two sunny houses, and a bit of plum tree. She is happy. I am trying to get behind her eyes and poke them out into space. The backyard is full of peace. No one overlooks me. Clean wash hangs high in neighbours' yards. Sometimes a reel-line squeaks, a chicken clucks about an egg, or a man chops wood. No children play in the backyards. The vegetables grow there; the children play in the streets. There is quiet shady space under the fruit trees. Space is more real than objects.

August 22nd
I am proud of our ancestry and our family. Today we have been through Father's and Mother's desks. Alice's eyes hurt, so I read. There was Grandfather's and Grandmother's letters to our father when he was a young man, and there was his sisters' and brothers' and cousins' and nephews' letters to him. Every one of theirs expressed great love for the young man out on his own, seeing the world, great anxiety for his welfare, and concern over the dangers of the wild life and place he was exposed to. But every one of them had some expression of gratitude for some kind thought or remembrance or help he had given to them. They seemed mostly to be poor, and he was always sending them money, and newspapers to the old men, and letters when he could. Apparently they had to know someone going who could take a packet and the vessels were most uncertain and trips perilous. But you felt they loved him, and he was good to them, and that he was high-principled and honourable, and that they were sure of him. Then there were all the letters about Dick's death down in Santa Barbara, away from all his people, fighting tuberculosis. What long letters they write about him! One man, his closest friend writes, "He was the most honourable young man I have ever known—a beautiful character, loved very greatly by all he contacted." They mentioned innumerable good things of his, done so quietly they would never be known. There were letters written to Dede and Lizzie mentioning their extreme kindness and hospitality in the old home and garden, particularly to strangers and missionaries. There were letters telling of the helpful through-and-through sweetness of Tallie, and her patience in her sufferings, and always cheer and kindness for others. And there are all the letters we have just answered about Lizzie, her unselfishness to humanity and Christ's work. The last two days has been steeped in reading of these dear

souls, and long letters of Mother's and Father's, and of little Lizzie to her mother and father, a shy sensitive lovely soul, reverently offering a little note with a card or drawing done by her little young hands, thanking them for her lessons. Such a conscientious little person! I never knew she was so sweet a little girl.

We were rather surprised to find our forefathers so earnestly religious. Perhaps people know others really better after death than before because the shyness and self-consciousness is absent. When Father died, he was worth about $50,000, hard and honourably earned. He stood on his own feet and owed no man. I wonder what soured him, drove him into his shell and hardened him over? He had much physical suffering—perhaps it was that. Mother was a dear affectionate wife. I always thought him hard and selfish to her, an autocrat, but it seems he was loving too, and quite religious, and very honourable.

August 30th
Visitors have been to my studio. Do people mean those things they say? Does the work warrant it? One man said no work had moved him so much except Van Gogh's. Another said that the vitality of it was astounding. A woman said that they went away feeling uplifted as if they'd been in a different world. I don't know. Sometimes I feel *almost* as if it was good and sometimes not. One man called me long distance from Vancouver on passing through from Japan to New York. "I wanted to hear your voice," he said. "You know, I believe in you." When people say that it makes you taller. You've simply got to put your best foot forward. I want the woods and sky and sea, the whole outdoors. The cottage is too comfortable, too shut in. Rheumatic joints plead for inactivity, only my soul strains on its leash.

August 31st
Flora took Lizzie's big begonia to live with her today. Now all the life is gone from her sitting-room. It was a great plant with handsome leaves. It spread itself in front of the window and made a screen. Lizzie loved it, fed and watered it, admired it and upheld it when I used to growl that it kept out too much light. When she was gone it gloomed the room, shedding loneliness. The other plants Alice and I took to our homes but the big begonia was too big for our houses. Alice watered it and there it sat for one month all alone. Flora was glad to have it and we were glad to see it go. The sitting-room is dead now. None of the things that breathe are there. Everything in it has stopped. The windows are shut and no air moves round. The door bell on its old curly wire spring sits quite steady. The walls give no echoes. Taps don't drip. No clocks tick. No fires crackle. "Finished" seems to be written on everything, on our babyhood and girlhood and womanhood, on our disappointments and happinesses, tendernesses and bitternesses, joys and sorrows. Dreams have been born there and have flown out of the windows again, dreams that only the dreamers knew, some that grew up and became fact, some that were still-born. I wish the dear old house could fold up and fly away. It is so tired. Lizzie cared for it very tenderly and kept it so very decent and in order. It is such a lady of an old house, rather prim.

The tops of the windows are curved like surprised eyebrows and the door wide and hospitable. I never have been up in the attic. A wide ladder went up through the broom closet. The top ended in blackness and terror. I was so scared of the dark! It took awful heart beatings and resolution to go down cellar. There was an electric light, but you had to go down into the black and grope to find it. How enormous the upstairs seemed before there was any electric light, and we went to bed with candles—a weanty little glow a few inches round! The nippy cold smell of upstairs on winter nights. If by any chance I was left *alone* in the house, I always opened all the doors and windows, or went out in the garden among the trees and shrubs, so much more companionable than sofas and tables and chairs full of nobody. Dear old house, if we could only give a great puff, Alice and I, now we have finished with you, and blow you into nothing—not sit and watch you rot. The house was something special to Lizzie. We took from it. Lizzie coaxed and petted it, denying herself things so it could be kept decent—painting a floor and stingeing on a hat, upholding its tax honour, wreathing it about with flowers, upholding the dignity of the front gate, and keeping the lawn well barbered.

September 6th—In camp
How easy it is to rip three months off the face of the calendar and what a lot of things they represent! Lizzie has gone, even her things are tidied away, and her grave smoothed and seeded down. The old house is empty and the agents working to sell it. Summer has come and gone. Alice's school has reopened and the new-born pups I took in from camp, three inches and a squeal, are now half dogs. I was ready to leave on Saturday, but a friend was ill and I wanted to know how things were with her, so I came Sunday. There were five dogs to bring, and Woo. I bustled for two hours and then a grand calm the rest of the day—sleep, write, read, look. The sheep grass is silver-yellow and lies flat on the earth. If you part it the new green is underneath. At 5 o'clock this morning the van was filled with chill murk. I used the torch to see the clock. Outside, the moon and dawn were at grips. The moon was very high and superior, but dawn was pushing with a soft intensity. The rawness was aching my bones. I lighted the stove and got a hot bottle. I cosied down, waking at eight with the sun roaring over my bed, and the dogs wanting out.

September 8th
It is 3 o'clock in the morning and *bitterly* cold. The creatures were so restless I got up and put the oil stove on to take the chill from the air. The lamp smells to Heaven. There is a magnificent moon and the sky peppered with stars, and a holy hush. The monkey has been restless all night. "Oo-oo-oo" punctuates the clock at irregular intervals.

Did good work this morning. Did poor work this afternoon. I am looking for something indescribable, so light it can be crushed by a heavy thought, so tender even our enthusiasm can wilt it, as mysterious as tears.

Wind has come up; rain clouds are skulking round. Have worked hard—two sketches in woods, with a bite in between. The woods are brim full of thoughts. You just sit and roll your eye and everywhere is a subject thought, something saying something. Trick is to adjust one's ear trumpet. Don't try to word it. Don't force it to come to you—your way—but try and adapt yourself *its* way. Let it lead you. Don't put a leash on it and drag it.

The pines are wonderful, a regular straight-from-the-shoulder tree. From root to sky no twist, no deviation. They know no crookedness, from trunk to branch-top hurled straight out, with needles straight as sewing needles. Other trees ramble and twist, changing colour, clothed or naked, smooth or knobbly, but the pine tree is perpetually decent. In spring she dances a bit more. How her lines do twirl and whirl in tender green tips! She loves you to touch her, answering in intoxicating perfume stronger than any words. I'd rather live in a pine land than anywhere else. There is a delicious, honourable straightness to them.

September 11th

It pours in a ladylike, drizzlish manner. Everything looks drab. I don't mind usual rain but this is beastly revolting stuff. I am going home tomorrow morning.

September 23rd

I painted *well* today, working on the summer sketches, reliving them—loving them. I think I have gone further this year, have lifted a little. I see things a little more as a whole, a little more complete. I am always watching for fear of getting feeble and *passé* in my work. I don't want to trickle out. I want to pour till the pail is empty, the last bit going out in a gush, not in drops. I must get the sketches cleaned and clarified. Some I do not need to touch. I have said what I thought and moiling over them would bungle the point, where there is one. But others I can see the thought sticking half through and it needs a little push and pull and squeeze. It's muddlesome, a bit. I wonder will I ever attain the "serene throb," that superlative something coming from perfect mechanics with a pure and complete thought behind it, where the thing breathes and you hold your breath as if you had spent it all, had poured it into the creation. Sometimes when you are working, part of you seems chained like a bird I saw in England once, tied by a thread on its leg to a bush. It fluttered terribly, and I went to see what was wrong. The string cut through the leg as I came and the bird fluttered harder. The leg was left on the bush with the string, and the bird was free. Has one always to lose something, a very part of them, to gain freedom? Perhaps death is like that, the soul tearing itself free from the body.

September 25th

A man told me recently that my painting was like music to him. A woman said yesterday my writing was more like poetry than stories. Now this is silly. Why shouldn't pictures be pictures and stories be stories? Ruth Humphrey liked my stories "Mrs. Drake" and "D'Sonoqua's Cats" very much. "Unnamed" she found

wanting. I feel myself that it is wrong and yet I feel that there is something more subtle way back in it, where the wild crow contacts the humans, than perhaps there is in the other two stories which are straight experiences. "Mrs. Drake" more or less satisfies me. It was the easiest. "D'Sonoqua" brings in the supernatural element and the forest, but "Unnamed" touches something too delicate to define and I have overpowered it by the brutality of the man. I will lay it by but there is something there I must dig out. This morning I began "White Currants." I want it to be so dainty, so ephemeral that it just melts as you look at it like a snow-flake.

Alice sat opposite the lawyer and I at the side. The baize covered table was spread with papers. Some of them had seals on. Some were peculiar paper with the look of money and divided up by little perforated fences. The lawyer said, "I have divided the bonds as evenly as possible." He gave us each a statement to read and went and stood at the window while we read. He asked if it was satisfactory and gave us his fountain pen and we signed. Then he put part of the queer money-like paper by Alice and part by me and told us to go to our two banks and each get a box and put them in. So Lizzie's estate was divided. I wanted to cry dreadfully. My throat hurt and I expect Alice's did too. It was like Lizzie's strength and blood lying there on the table. It was her life's work. Oh no! Not that. That is all saved up in people's muscles and bones, in crippled children, and old folk's aches that she eased. That money was only the earthy side of the thing. Alice had to go home to those pestiferous kids. I bought an armful of lovely flowers and went to the cemetery and cried. I had the flowers all fixed and the car was coming, but I went back and cried some more and took the next car. Life will be some easier for Alice and me because of what Lizzie left us, but an ache goes with it.

I finished "White Currants." It appeals to me rather because I suppose it is true of that corner of the garden. I can see it so clearly and the boy "Drummie" who came sometimes—just a felt presence, not a seen one. I so often have wondered who and why he was. I don't remember anything he did or said—only the jog trot of my own fat legs which was the jog of the two white horses. The whole thing was "white currant clear." I never told a soul. I would never have dreamt of telling even Alice. She would not have understood then any more than she did tonight when I read "Mrs. Drake" to her. Once or twice she laughed when she remembered one of the incidents, a superior unhearty laugh that somehow hurt. I could never read "White Currants" to her or to anybody, I think. Why do I *want to* write this foolishness? Just to hide it away? It hurts getting it out and then it hurts when it is out and people see it. The whole show is silly! Life's silly. I'm silly and it's silly to mind being silly.

October 22nd
I fought against starting a canvas for weeks. I wanted to but I was afraid; did not know where to begin. First I'd say, "No, you can't begin a canvas till you've cleaned up and mounted the summer sketches." So I finished them. Then it

was this and then that, sewing, gardening and seeing people, and all the time the new canvas lay on my chest as clean as the day it was stretched. Today I said, "It shall be," and still I hovered round dallying. Even when everything was ready I had to eat a pear and smoke a cigarette and do things I did not have to do. Finally I did get out the sketches and sat before them and thought. The canvas was an upright and the subject a horizontal. There were three clamps fixing it to the easel. Back and forth through the picture room I went measuring other canvases, and then . . . I spiritually kicked myself, got up and unclamped the three clamps, turned the canvas, and suddenly seized the charcoal and swung in. Most of the day was gone by then, but no sooner did I put touch to canvas than the joy of it came back and I spent one happy hour. I do not understand this great obstinacy, wanting and won't all in the same moment. Seems as though I am chained up and have to wait to be loosed, as though I got stage fright, scared of my own self, of my blindness and ignorance. If there were only someone to kick me or someone to be an example (I'd probably hate them), but it is so dull kicking and prodding your own self. When I'd broken the ice and made a start I was excited at once.

There's words enough, paint and brushes enough, and thoughts enough. The whole difficulty seems to be getting the thoughts clear enough, making them stand still long enough to be fitted with words and paint. They are so elusive, like wild birds singing above your head, twittering close beside you, chortling in front of you, but gone the moment you put out a hand. If you ever do catch hold of a piece of a thought it breaks away leaving the piece in your hand just to aggravate you. If one could only encompass the whole, corral it, enclose it safe, but then maybe it would die and dwindle away because it could not go on growing. I don't think thoughts *could* stand still. The fringes of them would always be tangling into something just a little further on and that would draw it out and out. I guess that is just why it is so difficult to catch a complete idea. It's because everything is always on the move, always expanding.

November 1st
Wills are pesky. To sit down in healthy cold blood and portion out your stuff, to appoint an executrix (a word you don't even know how to spell), to talk about your stuff as if it was not yours any more and you were very much to blame for encumbering your nearest and leaving things behind that they did not know what on earth to do with, all this makes you feel small and mean. Of course, any goods—money, bonds, or ordinary useful articles—are another matter. Nobody minds those, the more the merrier, but it's that load of pictures that nobody wants. The relatives sigh and say, "Oh, lor!" The lawyer obviously thought so very little of them or of the chances of their ever selling, he said I should empower their keeper to *give* them away if he could not sell them. He seemed so sorry and sympathetic for those they were left to. I came home feeling like a mean soul. I almost wished the cottage would burn and the pictures with it, to relieve everyone of bother. And then Alice told me something that hoisted me

wonderfully. She said Muriel told her the picture she has of mine helped her when she felt bad. It sort of gave her peace. Whew! I was pleased. I always thought the nieces despised my work. One is very greedy. Why should they expect every picture to speak? They ought to be so darn grateful if just a few say just a little.

Ruth Humphrey is helping a lot. Writing is coming easier and I see more. She said "White Currants" was beautiful and she likes "D'Sonoqua" and "Mrs. Drake." She helped me a lot in criticizing the "Cow Yard."

I have not written in my book for a long time. I have been writing stories and that, I expect, eased me, pouring out that way. It seems as if one must express some way, but why? What good do your sayings or doings do? The pictures go into the picture room, the stories into the drawer.

November 6th
It is Lizzie's first birthday away. Her affairs were just settled up, so Alice and I took a plant for Mrs. Owen and the cheques for the church and for Mr. Owen that Lizzie left for them. We went first to the cemetery and then to the Owens'. The little parson talked like an eggbeater. Mrs. Owen was quiet but pleased at us going. Now we have done up everything as far as we know that Lizzie wished. I suggested most of the things. The ideas just seemed to come to me. Alice always acquiesced. Lizzie was much fonder of Alice than of me. She never talked to me of her affairs or wishes or health or friends; she talked to Alice. Perhaps she could do it more easily after she died. Possibly she was able in death to say things to me she could not in life. I do like to remember her face as it was in her coffin, so perfectly happy and radiant and only just beyond reach, at one with the aloof loveliness of her flowers.

I had an evening showing in the cottage with about twenty-five guests. In one room were modern oils, in one Indian mixed periods, and in the studio woods things. My sketches were shown in the kitchen. The people were seated at the end of the room, the lighted easel and I at the other. One man sat on the stove which was not lighted. I showed about twenty-five 1936 sketches. The people sat pretty stodgily. Willie was among them at the back and said the mutters were appreciative. My deaf ear was towards them. It is a trying job. Fifty eyes done up in pairs scrutinizing your soul—bewildered, trying not to give offence, yet wanting themselves to seem wise and deep. The old ones are the most dull and annoying, particularly would-be art teachers and critics. "How long does it take you to make a sketch?" "What time of day was the sketch taken?" "Was that north or south of so-and-so?" Others want to know the exact materials you use, or the exact size of brush. I am glad today has left yesterday behind. Today I have no patience.

November 25th
The horrible Christmas turmoil draws near. How I hate it. It is not Christian; it

is barbarous. Am I mean or is it consequent on seeing people give so lavishly when *unable* to do so that has set up revolt inside me? I do not know. I am always making up my mind to give my paintings away freely, and then I don't much. So often doubt of people really wanting them stops me. I can see the people so bored, wondering where to hang the thing, or groaning over getting a frame for it, or sitting it down behind some furniture to hang someday and never doing so. I shall give away six for Christmas.

December 1st

I have been requested to send some pictures to Toronto on approval, all expenses paid! I wonder if they will buy one or just return them with thanks. Every night I go to bed, put the light out, and remember something I'd like to have written. In the morning it is gone—where? Sleep overtakes one's intentions so vigorously and suddenly. I think that to try to express each day some incident in plain wording would help one to build up one's writing, painting, observing, concentrating and all the other things. I have painted vigorously the last two weeks, running a race with the daylight.

The big fat man asked if I was Emily Carr. He had a big envelope in his hand. His fine automobile was at the gate. Perhaps it was a summons for something. My knees got shaky while I rapidly surveyed my past life. (When one had the apartment house one never knew what might go on in any of the flats and you be held responsible.) "The letter will explain," he said between chews on his gum. It was only about the pictures. Everything was o.k. The man said, "My daughter has a turn for art. She can copy magazine covers in pencil fine. I guess she ought to be cultivated." (As if she was a turnip.) He represented the Gutta Percha Rubber Company, tires, etc. It seemed as if he was chewing on a tire, he did it with such strength and length.

Willie brought a Dr. Something (anthropology). The youth had brown eyes— and a cold. Willie unearthed *everything*. We had tea off the kitchen oil cloth. The house was fairly tidy. People roam round it without embarrassment. If I kept it any cleaner I really would get no time to paint at all.

Oh, I do want that thing, that oneness of movement that will catch the thing up into one movement and sing—harmony of life.

Why when people are *extra* kind to you do you want to run and hide, or to cry? Why does praise make one humble? The whole world is a question mark this morning, and outside the gloom is livened by raindrops hanging like diamonds from everything. Three yellow old apples are still on the bare tree outside the kitchen window, shrivelled and lonely like three old, old maids. I am troubled in the head, or rather in the heart today. Things, thought things, are congested, stuck. I can't go ahead; have to detour over a bad road and ruts and woods. Those woods with their densely packed undergrowth!—a solidity full of

air and space—moving, joyous, alive, quivering with light, springing, singing paeans of praise, throbbingly awake. Oh, to be so at one with the whole that it is *you* springing and *you* singing.

I went to two parties today. I was sent for and treated with such kind consideration. All the others were young—not very, but not old. The supper was delicate and the conversation bright. No one touched on the big matters that the air is full of, our beloved King and the perplexity of the nation, and his obstinancy about Mrs. Simpson, and the Queen Mary's tears. The nation is trembling with apprehension but nobody spoke of that although it must have been at the back of all our thoughts.

Then we went through the dripping rain to the second party. The hostess had a nice flat and apologized for everything. She showed us into a clean, empty room and gave us an illustrated lantern lecture on modern art. She did not know the subject and apologized for the painting and the pictures and herself. It was too long and too heterogeneous. Everyone tried to sparkle but when it went on and on they flattened. She bit round the edges of her subject for two solid hours. I wished she would not keep asking me things as if I knew everything just because I painted. When I said, "I don't know," she thought me mean, but I meant I did not know. She is the one who thinks that everything is done by a rule of technique and that you should be able to sift out all the influences that contributed to an artist's mode of expressing himself, what he got from this person and what from that. I think that one's art is a growth inside one. I do not think one can explain growth. It is silent and subtle. One does not keep digging up a plant to see how it grew. Who could explain its blossom? It can only explain itself in smell and colour and form. It touches you with these and the thing is said. These critics with their rules and words and theories and influences make me very tired. It is listening; it is hunting with the heart. How can one explain these things?

December 9th
The sky is flat and the sea cross. Irritated waves reared up but the wind came all ways. The waves hissed and spluttered but did not hit. These white splutters tormented the deep green-grey. The horizon was a dark line overhanging space, thick, smothering space. There were just two things ahead, sea and space.

The King and Mrs. Simpson, that is all you hear these days. It is the national scandal. People do not know what to say. We love our King but feel it lowering to have a double divorcee for the first lady of the land. Which will conquer, the people's love of a kind tender-hearted King or virtue and the Church? The nation cannot decide; neither can the individual. Will God point? Is it one of His mysterious ways to right things—national things?

December 10th
All for the love of a woman Britain's King has abdicated.

December 11th

The thought of the King bursts, oozes from people according to their natures. Many are already finding the Duke of York more suitable for the throne. How swiftly people change! They are sore because the King let his job down. They are personally slighted at his not wanting to remain their King, at his preferring a divorcee to them. Some say it is preordained. The young King is going to be dreadfully homesick for British soil. Fancy owning half the earth and the hearts of the people and homage to be nearly worshipped by them, and then suddenly to be a banished nobody. Is England's crown no greater than a shuttlecock that he prefers her to an empire?

December 17th, 2:30

We have just said goodbye to Edward VIII, our beloved King. Who is to condemn him, who to praise him? I do not think any public national event has ever moved me so deeply. I am glad no one was here at my radio. I cried right from the deep of me.

December 19th

It is rather wonderful to get a Christmas letter from a man who loved you forty years ago. And he tells you he thinks of you very often, and in the folder he has put pressed flowers. He ends the greeting with, "I send you my very dear love," remembering the girl in her twenties who is now in her sixties. All that love spilt over me and I let it spill, standing in the middle of the puddle of it, angry at being drenched and totally unable to accept or return it.

Three old women lived together separately, that is, they each had a house. Each house was on a different street, but altogether none of them was a block away from the others. They were sisters tied close in affection to one another and miles apart in temperament, in habits and likes. By and by one moved further off and one died. Then the remaining two, though they were further apart, were tied closer together than ever.

December 24th

Alice and I took wreaths of holly and of cedar to the cemetery. The grass has covered the scarred earth. It is smoothed down and green over Lizzie. It was raining and dark. We placed our wreaths and came quickly away. I went straight home and lighted the fires. Alice shopped and followed. There were parcels at my door. I switched on the light and the tiny Christmas tree in a pot in the front window burst into twinkles of red, green, and blue. The shiver of gloom fled and that holy hush that shimmers about a lighted tree filled the little parlour. Down the hall the kindling cedar crackled and popped, and presently the smell of turkey roasting swept up the hall. Alice looked so tired when she came. After our meal we felt better. Willie came and brought a great barrow full of dry logs for me. We sat round the fire chatting. When he left we opened our parcels and letters and cards and got chokey when there were messages about Lizzie. I walked almost home with Alice. We took the turkey carcass.

December 25th

This morning we met in her church, dined at her house. We wanted it just quiet. There were more letters and more chokes. Then we went our ways till supper at my house. There was a stack of mail again—dear kind letters. Oh, very, very lovely letters from all over. When 9 o'clock came, we took the streetcar into town to see the beautiful lights. When we met the return car we got off and boarded it and came home, parting where the car turns. She would not let me go on home with her. I worry when she is out at night, she is so blind. But I phoned later. The wind is crying out long bitter wailing sobs. Christmas 1936 is past.

To be in a position to criticize one must have one or both of the aspects to work on. He must understand the medium or he must know the subject matter. So-called critics who get a smatter of "book art" and do not enter into the field of nature are absolutely incompetent to criticize pictures.

Old 1936 is bundled up ready to depart. He is at the very door. Just a second or so and the door will slam behind him and he will never come back, never, never, and poor little 1937 stands naked and shivering, waiting to come in. Now he has come; that strange nothing has taken place that ticks off another year and leaves a clean new sheet. If we could stop its coming, make it stand still always at '36 we would not do it. It's the going on that is really worth while and exciting.

H O S P I T A L

1 9 3 7

January 1st, 1937

At twenty to seven the cab came for us. We were dressed in the best we had. Alice looked sweet in her dark prune with the ruche. I had on my black and Dede's cameo brooch.

They are great friends of my sister's. We have known them since we were all girls. We are Alice and Millie; they are Millie and Alice. Their Alice, our Millie are the bossy, disagreeable ones. All of us were grey haired and our hands knotted and bony. I had not been in their house for years. We sort of stepped on each other's tails. It's all over now; they've had sorrow and we've had sorrow and I guess we've forgotten all about our tails now. Dinner was good and there was lots of talking.

It was delicious to get home again, warm and peaceful in the cottage. I love this cottage more and more. It's humble, quiet, suits my needs. I went into the studio and turned the light on two sketches I worked on today. I seem to be after something without a name. It's to do with movement, a transcendental thing but not quite clear. People don't know what I'm after now. How would they when it's so misty to myself? I'll just go straight on. Maybe it will clarify. Maybe someone else will pick up the thread where I leave off. One can't tell what they don't know. I wonder will Lawren understand—I doubt it.

January 2nd

Two men asked if they might come to the studio to see what I had been doing. I had to go out and post some sketches to Lawren and Hatch and so only had one hour to spare. I told Jack and John that but they came half an hour late. I brought out several canvases and sketches. They sat staring, but neither said one word. It became very embarrassing. After showing about six with no comment whatever I clapped them back to the wall and showed no more canvases. A few sketches received the same reception so I sat down and quit. It's rude of them. Even if they had condemned it would have been easier. They are unmannerly cubs anyhow and their comments not worth registering but these things do affect an artist. Perhaps there is nothing in my present work. I had hoped there was joy and movement. Joy and movement would not appeal to Jack. His outlook is very morbid. He likes blood and thunder. His big idea is design. He does not know and feel woods. That bunch over there in Vancouver don't. They want

design and technique and colour. The spirit passes their senses without touching. Or am I a doddering old fool weakly toddling round my grave's brink, nearly through with "seeing"?

January 5th
It is one of our bitterest days. Everything is fighting everything else. The wind is roaring and the ground adamant. The few plants that have not dropped every leaf and gone to sleep are drooped low begging the hard, cold earth to shelter them. It says, "Nothing doing," and relentlessly shuts down harder than ever. Everything cruel is loose, biting and battering. My cottage is moderately warm, but what of those without fuel, and the cutting winds piercing in through the cracks?

January 9th
Yesterday the pain that has come and gone intermittently for many years came and stayed, protesting at the bitter cold snap. Finally I sent for Dr. MacPherson. He diagnosed it "heart" immediately. I am not to lift or stoop or walk, not even to Alice's. I have to rest, rest, rest and crawl "crock's pace" to the tomb. It's a bit of a blow but today I feel somewhat better and am trying to count up the things I can do and forget the ones I can't. It will take some reconstruction, like learning to think in a different language. I hope my patience hangs out. I have been a roustabout from a babe, going pell-mell after what I wanted. How can I learn to shove not lift, kneel not stoop, to walk no more in the glorious woods with my sketch sack on my back? Ah, but while my heart sits pumping furious rebellion, my soul can glide out of itself and be among the trees and the sea of growth. It can smell the damp earth. Oh the joy of a travelling soul that has learned its way about the woods! Suppose I lived always in a city and my soul only knew houses and streets! I do thank God for all the freedom I have had and the power to relive it. I will not moan in self-pity. It is going to be hard enough for Alice, with me so stodgy who had planned on being so useful to her failing sight.

January 10th
Had attacks of pain one on top of another. The whole world seemed full of pain with an extra share of it stuffed into my house and just me to cope with it. Should I send for the doctor? No, certainly not on a Sunday night! So I left undone all the things I should have done and tumbled into bed. Then I fell asleep only to wake to a fresh pile of pain. When I saw it was only 10:20 my mind was made up. The doctor's young son answered the phone.

The doctor gave me a hypo and expected me to sleep till morning. Not me. After two hours of exquisite, rosy quiet I burst into another attack. Then came three hours' sleep and from five o'clock on for twelve hours life was good and mean. Now as long as I am still I'm fairly happy. The doctor's orders are "bed entirely." Such a comic household, with me in bed, Alice and Elinor and Mrs. Hudson coming and going, Willie trotting in and out, Woo in the kitchen

bombarding everyone, and the dogs evading them to sneak in on to my bed. It's all right till they start to fight on my prone body. Then it is more than I can stand and the silly little pain grows bigger and bigger, tweaking every organ in my body.

January 15th—In hospital

Myriads of nurses fluttering about like white butterflies, sisters as dignified as pine trees, the gracious round-aboutness of them spreading and ample. One could never reach their hearts. If you crushed up close to a prime young pine it would give forth a glorious spicy sweetness, its boughs would sweep round and fold you, but always they would hold you a little aloof; so far, no further; its big branches would hold you back from its heart, though it would bathe you with fragrant sweetness. I do not know my Sister's name but she's beautiful and radiant. She is young and straight and serene standing there near the door. Unless you need something she will not touch you and you would never dare to put out your hand to touch her.

Outside I look into a quiet enclosure that sinks down several stories and is floored by a flat roof. It has a quiet north light such as I love and such as cats, too, like when they are sick and crave shadow. There are four stories above us on the other side of the court. The only window that shows life is a semi-private. Nurses are always passing back and forth, and there is a pink cyclamen and a primula looking out across to me. In one corner of the court over the semi-private is a square of sky, the only living, moving, free thing not held in by bricks and mortar. At first I thought the court was just dead windows and tar roof but today, first, a pale woebegone sunbeam sneaked in half-heartedly and the next time I looked snow-flakes were jiggering crazily every way. It was much more entertaining than my book. Three gulls swept over very high just as the sunbeam was going.

Out in the sunroom at the end of the hall is a canary. Throb, throb, throb purrs the note in his throat till the whole ecstasy bubbles up and over and splashes down the corridor. All night the flowers sit outside the doors and watch. One night when I came here to see someone flowers were massed outside some rooms, big groups. Gladioli and gay summer fellows seemed to see who could look most giddy and bright. Outside one door was a tiny bunch of common marigolds. I wanted to stoop and kiss the homely little bunch from someone's own garden, their faces were so honest. When I told Alice about the marigolds she said she would be insulted if any one sent *her* marigolds. I have a bunch of precious January daffodils and some chrysanthemums. I was crying when they came, the dreadful depression that follows hypos, but when I put my head down into the box something extraordinary happened to the blues. They put them on my bed table and I kept jigging the bed so that they would nod their heads at me. I crushed up a leaf and it poured out that delicious pungent chrysanthemum smell that is as strong in the leaves as in the flowers. Just above them opposite my bed is a wooden cross with a silver Christ. No matter what

light is in the room it always gleams on Christ's body, across His heart and on His feet.

January 21st

It is a drizzle of a day. I had four visitors besides Alice, and a pudding. Down flat you are a horrible prey to their kisses. Take notice, me, don't kiss the sick.

A new doctor came to see me. He told me too much and was mad with himself. I told him I knew it before he told me and that I would not tell my own doctor that he had let it out. He patted my head like a good pup. I drowsed all day neither awake nor asleep. Now I have written letters about the dogs and the monkey. It's like scraping on your raw heart with a dry pen. The babies in the maternity ward have not cried today and the old man across the corridor has not groaned. My nurse has quit and she who substitutes has neither years nor intelligence. I feel as helpless as a nutshell boat with no little boy with a long stick to guide it.

January 22nd

More lovely flowers came today. There were daffodils, high fellows, from a sunny young boy and violets from Mrs. Hudson, sweet-scented, modest, afraid of intruding. There were white chrysanthemums that I buried my face in a long while, from a sweet, thoughtful woman. The parson came (not my parson), and offered a little prayer for Alice and me. Alice comes every day at the same time. The door comes gently open and she steals in like moonbeams. We tell each other the happenings. It is difficult to believe that there is cold and snow and bitter slop outside. In here it's spring, with daffodils and tulips and violets. I lie selfishly in the peace forgetting the horrible tumult of the angry nations, the floods and freezings and murders and kidnappings. The top of the chapel is just outside my window, which is always open. The sisters' prayers pass right up past it. If I send mine out maybe they will catch up with and join the bunch.

January 23rd

My little square of sky is blue and a wash of pale sunshine illuminates the court, the grey-washed bricks and the big wasps' nest opposite. The bird sings very gaily this morning. Someone screamed terribly early and the sisters' singing in the chapel came up dimly. Now the Cathedral chimes have burst out. The patter of the little white people and the chatter of the bells and buzzer is incessant.

January 25th

Sister, our Sister, has gone into retreat. I wish I knew what "retreat" meant. I know they retire, speak to no one, and take no part in the work, but why? Who tells them it's for the good of their souls? Do they tell themselves? Does the stress of seeing people suffer and die become too much so that they must pause to collect their garment of peace? Is it because their faith is shaken and they have to seal up the cracks afresh? Or perhaps they've kicked over the traces and

dipped into worldly thoughts, and have to sit down and untangle themselves. Perhaps it is not self-discipline but a law of the order to sit meditating only on holy things. How can they? Everything is God-filled. Just to sit and contemplate the fact in one's soul is surely prayer. To say prayers over and over is to churn words and tire God. Is it voluntary or enforced? That's what I want to know. I miss her beautiful face. I seem to feel a serene light under the sombre trappings. I wish I knew about it. I wish I knew that it was not selfish to quit and pray and pray. The new Sister is playful and bright and radiant but not so serene.

The evenings are long and silent but the visitors of the day have left themselves, some in books, some in flowers, some in the kind things they said. Ruth read "The Little Street" aloud to me. She went away a little thoughtful and took it with her. It is amazing how kind everyone is. I did not guess that people would be so tender and loving to me. I seem so little to deserve it. Alice is the peach of them all. My room is full of kind, gentle things and thoughts.

When a boy thumped on my door and bounced a telegram at me I went to pieces. Of course at first I was quite sure that Alice was dead or at least broken, though afterwards Reason said, "Why wire?" Well, it was from a man at the Vancouver Art Gallery asking for an appointment next Friday for an art critic from the *Manchester Guardian* who had been told by the Canadian National Gallery to inspect my pictures. I began to write, "No," and then asked the telegram boy what he thought I had better say. I lost my breath and saw fifteen telegraph boys at once. Fortunately a friend was there and saw what a mess my brain was in and phoned to Willie to answer the telegram. I blithered and dithered and recovered after a bit till they came back from the telegraph office to say that Vancouver was waiting for an answer. Then I broke up again and this time Alice and Harry came in and sorted me out. The rest of the day I was like a beached cod. The doctor says that I have kept going all keyed up and now I have cracked and will have to relax. I guess I need the prop of St. Joseph's a bit longer. Again I have rolled the load over to Willie but I believe he'll like showing the pictures. I believe he almost feels as if he'd done them himself. He does not know that one day they will be half his, half Alice's. Oh, I wish they were ever so much better, that I could have been pure-souled enough to see deeper and express what I saw in paint or words or something. Maybe next time I shall see and understand more.

January 29th
Mr. Eric Newton, art critic for the *Manchester Guardian*, came to see me in hospital. He is medium-sized, lean and earnest. I should like to have heard his lecture. Willie and Ruth and Alice had him down at my cottage but he said that he had only seen a little. He and Ruth came to the hospital to see me during hours. He stayed half an hour and my heart bore up well. He was quiet. He said what he had seen had impressed him very greatly, more than anything he had seen anywhere else, even in London, because it was honest and deep. He said that he'd driven through such country all day coming from Duncan and in my studio he had seen it expressed. "Get better," he said, "and go on. Those hands

must not lie idle there when you can do things like that with them." He liked the woods best and I am so glad. I was just afraid that the queerness of the totems might have led him off the track, but I believe he was very sincere. Dear Willie, he had everything all tabulated, dated, dusted and in order. Ruth took Mr. Newton for a bite to eat and then they went back to my house to see the pictures. He said, "I have till midnight to revel and glory in them. I'm looking out for a good time after seeing a few. I knew that I'd have to see *you* and then come back." It is a big honour he did me. It is those honours that make one feel very lowly and get down and beg God to let you see clearer and interpret more wisely.

Willie came in earlier in the day. I went through a lot of things with him and rocketed about and collapsed hauling out papers about exhibitions and dates. He left, scared, and told my nurse and she came in and brought brandy. They were for not allowing me to see the man, but Dr. MacPherson *knew* it would bother me less to see him and said go ahead. I kept a good hold on my wits and came through fine, but I wish I'd been healthy to talk to a big man like that and get his ideas on things. He evidently has the big outlook and spirit counts with him.

January 30th

I have suffered from great weariness all day and a severe headache. Have not seen Willie or Ruth since Mr. Newton made his selection. Willie sent me a list. Rather a poor choice, I thought, from my different periods. Drat periods! They don't seem to me to matter. Today I seem to have lost all interest in the pictures and the choice, and would rather think of the great outdoors and what it is trying to say through me. I want to hear more distinctly. Why must everything one does be measured up, tabulated and exhibited? It ought to be just joy, not information.

Willie and Alice both have been here. Willie brought some pictures I had to sign and a bottle of gas and a brush like a kalsomine brush. They've wired again from Ottawa to send on Mr. Newton's choices. What a time they did have there by themselves last night! It's comic. It must have been almost as if I was dead. I don't want to be dead; I want to search and understand deeper. This I know, whether here or there it will be the right place for me to be growing.

February 1st

I don't seem to get much stronger. I'm not fussing to return. It would be hard on everyone, and I have not a cat's strength at present. Alice looks tired and a little down. Living in perpetual twilight is enough to make one so. I'm not thinking about things. For me it's O.K. somehow. For Alice it's blur and blind and alone. I could almost wish her to be gone first. She is very alone, but for me. Sister is back, gliding into my room like a seagull with the sun on it and all the calm of the sea behind. I was so glad my hand flew out and touched hers. She gave no response except a smile. "I enjoyed my retreat," she said, "but it's nice to be back on the floor. The nurses need a sister. They've been so busy." Bless them; they have indeed.

February 2nd

Rain is falling in sheets. Nothing in the air of my court is ever done; it is always doing. The snow-flakes are fluttering and rain pouring, but you never see them arrive, only on the way, because for me the court has no bottom. I haven't seen dear Mother Earth for three weeks. Even the gulls never come into the court. They fly over the top. Just their shadows flicker down, if there is a sun.

February 3rd

I progress slowly. These queer blobs beneath me are not my own feet yet. Being sick is a horrid way to spend your money. Alice brought me all her cherished Chinese lilies and her Christmas cactus. I just revelled in their perfume all night. Smells lift you, and the heart knows their words well. If in the next life we have no noses or ears or organs we will surely have some medium of contact with these lovely things, a beautiful drawing of these essences into ourselves; ourselves being drawn into still bigger ones.

February 9th

The doctor told me I could begin to make arrangements for going home in a day or two. When he'd gone out of the room I cried. I felt so unequal to coping with life on my own and with the "person" who has yet to be found. I suppose I might give her the chance to be a nice one, but I am all prickles out when I feel her in the air. It is intolerable to think of her bossing me and my house, and I don't feel fit to boss a caterpillar. I want to be home, but I'm so flabby that I shall miss the care. But after the first kick-off I'll begin to get stronger and throw out new shoots. I think perhaps it's the beginning of leading an invalid's life that I hate so, but I must not let Alice see.

The last few days have been *bad*—overpowering headaches, hot salty tears running down into my pillow. Because I got exhausted trying to walk a few steps, blub. Because my bell broke, blub. Because the door banged all day and night, blub. Because the next-door radio boomed, blub. Because two would-be ladies-in-waiting came to interview, blub. (Not to their faces but as soon as they were gone, from the effort of talking and explaining.) Because I got a cheque for $200 for a picture I lay awake all night, dry and exhausted.

Funny about that girl. We both liked her so. She seemed so suitable and she liked us and we definitely engaged. Elinor took her down to the cottage, lit fires, etc., then she came back and said, "I can't stay. I can't accept the post. I'm sorry, but I can't." She went up and told Alice she did not know why, but she could not live there and she couldn't explain why. She just could not. It was as if she'd seen a ghost. Very baffling. Possibly she was afraid of my dying, being alone there with me. It seemed as if she had a hunch or something. So it's all to do over again. The first question all ask is, "How much time do I have out?" And then money. Few want to sleep in. Mother used to say, "There's as good fish in the sea as ever came out of it." They are over-full and short staffed at the hospital. Home would be good if I only had a little more strength to cope with it.

February 14th

Tomorrow, joyful tomorrow, home! There are two pots of tulips and one of hyacinths on my table, and the air is like spring and my eyes have dried up. A lovely letter from Lawren, one from Mr. Band and one from Mr. Brown. All say they can't see me any way but on the bustle and in the woods. They don't see a meek me by the fire with my hands folded so I must buck up patiently and paint again. Lawren and Bess like their sketch, feel it, feel the joy of the growth, and live happily with it. Blessed, blessed woods! I want to be out in them. It's a long time yet to summer. Maybe by then I can kick the moon. If the "person" is satisfactory to me and I to her I shall get on famously. There are stories to be worked up, things to be rooted out of the storage of young womanhood—Indian forests and deep waters. What words are there for these things, solemn big things with joy wrapped deep in their middles? Episode after episode comes back, not photographically, not the surface. I was consciously striving to reproduce; I was unconsciously absorbing. We are always hearing things we don't recognize at the moment. Alice has packed me and I'm terribly excited for tomorrow.

February 16th

Said goodbye to hospital yesterday. Mr. and Mrs. Hudson came for me, one boosting each side with Elinor behind. I mounted the four or five steps and was hustled straight to bed. Everything looked lovely. I was not allowed to wait to inspect. I feel one hundred per cent better already. The "person" I dreaded is nice and the dogs are all back, but not Pout yet. It's delicious to feel their warm bodies cuddling into mine. Home is heavenly!

February 24th

I progress slowly, lying in bed to do it. Getting up is not so good—sudden spells of extreme weariness. The nurse says that I'm a good patient, taking my treatment well and not fussing. She told the doctor and I swelled proudly because I'm considered a crank.

February 27th

Every day is the same and yet every day is different a little. At seven in the morning Mrs. H. comes in, toothless and tousle-headed and her elbows sticking out of a hole in her sweater. She does not want to be spoken to. I used to say, "Good morning," but now I don't, as it's not advisable. After my breakfast tray, when Eliza and Matilda are out and the chickens' hot mash is given, she always comes in quite bright. It's the beasts that do it I think. She chats to the pups. She really likes them I think. Me she tolerates and does her duty by, also the house, keeps us clean, overlooks our shortcomings as much as she can. We are just a woman and a house and we don't touch her heart at all. Her job touches her sense of duty and self-respect. She says I'm a good patient, and I think she is an excellent nurse, and there we stop. We don't want to know any

more about each other and probably never will. She has absolute control over everything and does what she wants to, but I am there and so are my things. They do not unbend or kowtow. The pictures shut themselves up and have no meaning.

March 9th

I have been home over three weeks. I can do more now, I can see, looking back, but it is slow work. I get up for a few hours and dress and listen to Dr. Clem and do some typing. I have two stories, "Eight From Nine" and "Time," roughly typed and corrected, and a beginning to "Indian." I am getting restless as the days get spring-like. I don't want to paint yet. I get too tired just sitting. Mrs. H. goes when her month is up. She has kept things and me beautifully. I dread a new person. It won't be a nurse now; it will be a housekeeper. I'll take care of myself.

March 10th

Mr. Band has bought "Nirvana" for $200, Mr. Southam "Haida Village" for $150, and Lawren Harris another for $200. A number of others are over in the East being sat on and considered. It is funny, but I can't enthuse over my sales. Sort of ashamed that the pictures are not worthier. Praise always makes me feel humble. I do rejoice in the sales in that I am able to pay my bills. I am truly grateful to the pictures for that.

March 14th

An old pupil of some thirty years back in Vancouver came to Victoria and looked me up. She is a charming woman. She came in with arms out to me and a smile on her face. Not one bit changed. She exclaimed and laughed at the griffons asleep on my bed, one under each arm. She looked through my sketches and went off with one really pleased. She told me that she had always been glad she had taken lessons from me because it had put something into her life that made her outlook bigger and her seeing of nature different. We had good times in the old Vancouver studio. Belle, who used to help me there, writes letters full of memories. There were seventy-five pupils, little children and young people, and we made a joy of it. There was always fun flying round, and dogs, parrots, white rats, bullfinches, parents, exhibitions, sweethearts, Indians, artists. I cried little in those days. There were some lonely spots and some bad health, but there was joy, independence, and lots of laughing. Life's that way, but one remembers the ups more than the downs, afterwards. The best endowment we've got is humour.

March 16th

Dead alone for the first time in nine weeks. I am very helpless, not a soul to call upon. Alice could not come anyway because she could not see. Dear soul, how patient she is! I'd rail, I know I would. How it must hurt to be tied like that!

March 23rd
Soon I'll have tried all the women in the world. It embarrasses me to think people will blame me for a crank, but only one has left nastily. The others seem like bad luck.

Alice has been to see about her eyes. The verdict is not clear yet. It does not seem too good, but the doctor has not said it is definitely hopeless. If only she had gone sooner, but she is so hopelessly stubborn and put off longer the more we wanted her to go. Poor darling, if only she does not have to go into the dark for good. I am afraid it will break her heart to depend on others, and me so useless. I shall take all the care possible and do what they say so as to stand by her. I wish she had friends, loads of good ones, but she has ceased to cultivate them for so long; she has drowned herself in school and now that is failing. They've sucked her dry, taken everything, and now they forget how good she was to their children and how patient with all their tomfoolery.

March 24th
How selfish *everyone* is, and me too, I suppose. These women who come to tend one don't give a hoot. They want to get as much as possible and give as little as they can. They like to make one feel it is very good of them to look after anything so lazy as you are and to indicate that they are rather martyrs and that you are taking rather more care than necessary and are quite capable. Poor old women, we are not nice as we begin to decay, to slow up and grow stupid. We hang on to youthful ideas and the youngsters laugh at us. We love our liberty and ability whereas we have no strength and ought to be in homes and cared for like the too-young-to-be-sensible are. We are no more fit than they to cope with heavy problems but we have known the freedom of independence and they have not.

Today I sat in the back yard with the chickens and dogs, seeing a million things that needed doing, little things but beyond me. I said to myself, "Quit it. Remember that you've done these things in your day and now you must sit and watch others do some things for themselves, not for you. You're finished. You now take on a different phase of life. What is the good of struggling to keep up? That's going back. Your job now is different. If you would go forward you must adapt and press on into something new befitting the development you have attained, less bodily activity and more spiritual activity, accepting the change happily."

March 28th—Easter Sunday
It is a glorious day with a bitter wind. I am restless and empty. Want to stir and live again, to refill and relive. I do not want to write. I am dried up. Funny, sometimes you are juicy and ripe and sometimes you are like an empty cocoon. Mount Tolmie is quiet. Even the wind that buffeted it all day is dead. Under the brown of everything the sap is running. The green is bursting, shouting, hollering a song of growth.

April 3rd
Ottawa has bought two canvases, a paper sketch, "Blunden Harbour," a Haida village and "Sky" for $750. Madame Stokowski, wife of the composer and conductor, bought a small canvas for $75. Mr. Southam bought a small Skidigate sketch in oils for $150 and Mrs. Douglas a French cottage for $15. An old Vancouver pupil took a Pemberton sketch, also for $15. How lucky I am, or rather, how well taken care of!

<div align="center">

15
15
150
75
750
———
$1005 Goodness!

</div>

April 6th
How comfortable Willie is! We had a long talk. If there was war and he had to go I'd die I think. It's so awful about Alice's eyes. If you sympathize with her she says, "Don't moan, I hate it." It seems so heartless just to say nothing, and all the time you ache for her. Barriers, why must they be between all humans, even the ones we love best, things our self-consciousness will not let us voice, so scared of showing ourselves. Sometimes I feel as if it would be easier to see Alice die than go blind. It's going to hurt her independence so. She just can't stand being led or pitied or helped. I think I like a little to be babied and wheedled and coaxed (by some people). Alice repels petting or softness. She gives grandly and takes poorly.

April 10th
Alice goes into hospital Wednesday to have one eye done. She is brighter, talks freely, so it's much easier.

April 14th
Alice did not go to hospital. They could not operate for another week. I'd have been all edgy. She is calm and resigned.

I have been painting a Nass pole in a sea of green and finished "Cauve," an Indian story. I sent four pictures off to the Vancouver exhibition, "Massett Bears," "Metchosen," "Alive," and "Woods Without Man" (invitation B.C. Artists show). I got a nice little maid, a farm girl from near Edmonton, called Louise. She mothers me.

April 16th
I heard yesterday about my one-man show in Toronto. There were about twenty canvases collected from Toronto and Ottawa. I got two good write-ups

from different papers and two letters, also a cheque for $50 from a Miss Lyle for a canvas.

I have been thinking that I am a shirker. I have dodged publicity, hated write-ups and all that splutter. Well, that's all selfish conceit that embarrassed me. I have been forgetting Canada and forgetting women painters. It's them I ought to be upholding, nothing to do with puny me at all. Perhaps what brought it home was the last two lines of a crit in a Toronto paper: "Miss Carr is essentially Canadian, not by reason of her subject matter alone, but by her approach to it." I am glad of that. I am also glad that I am showing these men that women can hold up their end. The men resent a woman getting any honour in what they consider is essentially their field. Men painters mostly despise women painters. So I have decided to stop squirming, to throw any honour in with Canada and women. It is wonderful to feel the grandness of Canada in the raw, not because she is Canada but because she's something sublime that you were born into, some great rugged power that you are part of.

April 17th
Today another cheque came, for $225. It's almost unbelievable. Mr. McLean of Toronto bought one little old canvas and one brand new. Everyone is tickled. One thing I must guard against, I must never think of sales while I am painting. Sure as I do, my painting will roll downhill. Mr. Band writes, "I am considering 'Grey.' Do you like it? I do." Yes and no. I did like it and many people have liked it, but since painting it my seeing has perhaps become more fluid. I was more static then, and was thinking more of effect than spirit. It is like the difference between a play and real life. No matter how splendid the acting is you can sit there with your heart right in your mouth but way down inside you know that it is different to the same thing in life itself.

April 19th
It seems to me that a large part of painting is longing, a fluid movement ahead, a pouring forward towards the unknown, not a prying into things beyond but a steady pressing towards the barriers, an effort to be on hand when the barriers lift. A picture is just an on-the-way thing, not something caught and static, something frozen in its tracks, but a joyous going, towards what? We don't know. Music is full of longing and movement. Painting should be the same.

April 20th
Alice went into hospital to have her eye operated on tomorrow.

I have been painting all day, with four canvases on the go—Nass pole in undergrowth, Koskimo, Massett bear, and an exultant wood. My interest is keen and the work of fair quality. I have been sent more ridiculous press notices. People are frequently comparing my work with Van Gogh. Poor Van Gogh! Well, I suppose they have to say something. Some say I am great and some that I am not modern. I don't think these young journalists know what or where or

how I am. I am glad that they all seem to agree that I am pre-eminently Canadian. I do hope I do not get bloated and self-satisfied. When proud feelings come I step up over them to the realm of work, to the thing I want, the liveness of the thing itself.

It's splendid to have the money just when Alice and I need it. I don't feel as if it was money paid for my work joy. It doesn't seem to have any connection. It is as if the money had tumbled out of the clouds, not as if I had bartered my thoughts for it. I feel that it came fairly and honestly and welcome. Alice is pleased about it, and very glad for me but the pictures or press notices or work don't enter her head. When I mentioned that I had been sent more press notices in letters she said, "That's nice," but she never asked to hear them or were they good or bad. She just rejoices in my luck as a bit of sheer luck; that's all it is to her.

April 24th

Alice's eye was operated on this morning. I went to hospital where she lies patiently, bandaged up, shut into the blackness. It sickens one. Is it the beginning of the dark for her? I find myself shutting my eyes and imagining it night all through the day. We took sweet smelling flowers to her.

April 25th

She'd had a good night and does not feel too bad this morning. I am back in bed. Felt weepy and not up to shucks. Guess the nervous tension was higher than I realized the last few days. If one could only *do* something for her. There's going to be heaps of heartaches.

April 26th

Victoria University Women's Club are making me an honorary member. "In appreciation of your contribution to the world of creative art," the letter said. It is very lovely of them and very embarrassing to me. Why should one be honoured for doing what one loves to do? If I have "contributed" it was because it was my job and I couldn't help it.

April 30th

I had a letter from Toronto this morning. Toronto Art Gallery has purchased "Western Forest," "Movement in the Woods" and "Kispiax Village" for $1,075. I was stunned when I opened the letter. It is wonderful. I should feel hilarious. I am truly grateful but so heavily sunk in pain (liver or gall) that I am dull as a log and rather cranky. I'd rather have twenty-five sick hearts than one sick liver. The doctor came today. Says heart fairly improved but liver ructious. Ruth came to say goodbye. She is a staunch and true friend.

May 3rd

I am afraid. Vancouver Art Gallery is considering buying some pictures. Suppose this sudden desire to obtain "Emily Carrs" were to knock me into conceit. Suppose I got smug and saw the dollar sign as I worked. That would be worse than

dying a "nobody," a thousand times worse. When they sat picking possibilities to be sent forward a great revolt filled me. I do not mind parting with the old pictures. I was glad of the money and a little glad that those who had always jeered at my work should see it bear fruit, but there was not the deep satisfying gladness of letters from someone who has felt something in my work that thrilled or lifted them.

May 12th

King George VI and Queen Elizabeth were crowned today. I went to bed feeling punk and determined not to get up at 1:30 A.M. to listen to the broadcast but I woke promptly on time. I woke the maid, who was sleeping like a log. She is young and it seemed right that she should hear it to remember. She came in like one drugged. We sat till 4:30 listening. I was disgusted not to hear a peep out of the Queen. On and on it spun, one giddy succession of gaudiness and magnificence. Your mind saw them, up and down on their knees, sitting in this state chair and that and saying, "I will" and "I do," putting on crowns and taking them off. I just thought that if the King and Queen could be off in a wood and vow their vows straight to God away from the crowd, how much happier they would be, but perhaps they would not.

Night

King George VI spoke to the people all over the world. I honour him tremendously. He spoke with extremely slow deliberateness. It must have been an ordeal for a nervous man with an impediment that has only recently been overcome holding that enormous position and facing the world. What he said always included his Queen and was solemnly grand too. Long live our King! I am glad the popular hail-fellow-well-met with all his lovableness has given place to this more sober, home-loving man, dignified and kingly.

May 14th

The day is too glorious for words. Things are growing like wildfire. I am in a blither of embarrassment over a great coffin full of lovely flowers that came from the University Women's Club to welcome me as a member. It's wonderful. I feel like old Koko at the Empress Hotel when they brought him a huge silver salver of cream that was upset. He was far too embarrassed to lap it. But I have sniffed and gloried in the flowers. Only it seems as if it was all a mistake, just old Millie Carr being a member of that group and being so honoured, and here I am such a liverish wreck, too nauseated and depressed to put a brush to work. I want to cry, but I haven't any tears. I want to work. There are such lots of things to do and maybe only a little time to do them in. I don't know, sometimes I feel finished and in tatters and then I think I am good for aeons of ages. Ruth has gone. I did not know how blue I'd be without her. She has meant an awful lot these last months. Must hurry and get to another Indian village. It is marvellous how they help to keep one in place. There is something about the great calm of them.

May 22nd
Ruth has seen Dr. Sedgewick who likes my stories and will be glad to write an introduction if Macmillan's will publish them. He is also willing to edit them.

June 10th
I have been too busy writing Indian stories to enter my diary. I have been very absorbed. Some days it seems hopeless trying to say what I want. I just flounder in mediocre thoughts and words and paint. Well, those days one should plod away at technical difficulties and not worry or be depressed because that which is greater than oneself seems to have forsaken you and that which is greater than the objects to which it belongs seems to be asleep.

I am very tired. I corrected and typed the Skidigate story, "My Friends," and worked on the gravel pit picture. Jack Grant came.

June 14th
Dr. Sedgewick came to visit. It was the first time I had met him. He is a funny, merry person.

June 24th
I posted twenty stories to Dr. Sedgewick for his reading and criticism. I had worked on them very hard and felt that there was good stuff in them but bad workmanship. I was very disgusted and tired and felt one minute that I never wanted to see the things again and the next was ardently anxious to know what Dr. Sedgewick would find in them. The stories were "Ucluelet," "Kitwancool," "Sailing to Yan," "Tanoo," "Skedans," "Cumshewa," "Friends," "Cha-atl," "Greenville," "Sophie," "Juice," "Wash Mary," "Martha's Joey," "Two Bits and a Wheelbarrow," "Sleep," "The Blouse," "The Stare," "Balance," "Throat and a Monkey's Hands," and "The Heart of a Peacock." The last three are not Indian stories. Probably when people do not know the places or people they will be flat but they are true and I would rather they were flat than false. I tried to be plain, straight, simple and Indian. I wanted to be true to the places as well as to the people. I put my whole soul into them and tried to avoid sentimentality. I went down deep into myself and dug up.

August 1st
It is a long time since I wrote here. The stories have taken all my energy and satisfied for the time being my desire to express myself in words. It is a week since I finished them. For some days I was too tired to think about writing or painting. For the last three days I've painted. I turned out a box of small paper sketches and found some thrill in them. I did not know that some of them were so good. I can see what I was after more plainly than at the time I did them. Some seem stronger than the things I am doing now. Now I understand the things I did then better than when I did them. I was, as it were, working ahead of myself.

August 3rd

Little Beckley Street got a shock today! The vice-regal chariot rolled into its one-block length of dinginess. Just before Lady Tweedsmuir was due the most disreputable vegetable cart drew up at my gate and John went up and down pounding at doors and coming back to his cart for dibs of vegetables in baskets. The old horse hung between the shafts and the tatters of oilcloth flaps drooped over the vegetables. Thank the Lord, John moved his rusty waggon and musty roots just in time for the resplendent vice-regal motor. As I went out on to the porch to meet her Vice-Highness, I could not help an anxious look across the street and, thank Heaven, "the Nudist" had his shirt on.

Lady Tweedsmuir looked like a racing yacht as she headed for my door. Her lady-in-waiting and equerry trailed behind. I said, "It is very kind of you to come to see me, Lady Tweedsmuir." She replied, "Not at all. I am much interested in your work. I have one of your canvases in Government House in Ottawa." I hauled out much stuff—Indian and woodsy. She liked the woods best. The good-natured equerry helped me, also the English lady-in-waiting. Lady Tweedsmuir wanted to see some rugs and so I took her into my funny little sitting-room. They stayed three-quarters of an hour, bought a sketch and trooped out.

August 4th

The equerry brought the sketch back to be signed today. Had four good days' painting. I worked on a mountain and the inside of a woods, up a hill. So far it is mediocre; it all depends on the sweep and swirl and I have not got it yet.

My blue budgerigar is like a lovely flower. I keep him close to me and he is taming fast. He gives me great pleasure. His colouring and marking are so exquisite. Had a letter from Ruth from Norway.

In the afternoon a professor from Edmonton, a Mr. Kerr and wife, came to buy. He was charming. They bought a paper sketch for $30. Then I painted.

September 6th

I started a new canvas today, a skyscape with roots and gravel pits. I am striving for a wide, open sky with lots of movement, which is taken down into dried greens in the foreground and connected by roots and stumps to sky. My desire is to have it free and jubilant, not crucified into one spot, static. The colour of the brilliantly lighted sky will contrast with the black, white and tawny earth.

September 9th

I have started a woods canvas. I am aiming at a trembling upward movement full of light and joy. I blocked in movement first thing with a very large brush and was thrilled. Mr. Band came from Toronto. It was a real treat to see him. We had one and a half hours of hard talking on work and news. He has ordered three canvases to be sent to Toronto, where he thinks he can sell them. They are "Lillooet Indian Village," "Trees in Goldstream Park" and "Sunshiny Woods."

Willie is going to crate them tomorrow. I sent Vancouver the pictures for the show today.

September 14th
It is intensely hot. I have been painting up to all hours and am very tired. I am working on two woods canvases. One shows a small pine in undulating growth and the other is a tall shivery canvas. I began them with huge brush strokes, first going for the movement and direction such as I got in my sketches, and with great freedom. The danger in canvases is that of binding and crucifying the emotion, of pinning it there to die flattened on the surface. Instead, one must let it move over the surface as the spirit of God moved over the face of the waters.

October 12th
Alice and I are clearing up the old home at 207 Government Street, preparatory to letting it go to the city. We plodded up and down, up and down, lugging trash out of the cellar. It was mostly broken and empty bottles. We had the stuff put on the back verandah and sorted—hoarded inanities of Dede's, religious books of Lizzie's. The house that was once the pride of Father's heart is a dreadful place, dingy, broken and battered. Apart from Lizzie's personal things, there is no sentiment.

October 18th
Alice's birthday. I went to dinner and provided a chicken. Louise iced her a cake and I put a big tallow candle in the middle and "Happy Returns" round it. Took a bunch of gay autumn flowers.

October 25th
Yesterday we finished the sorting and clearing. The stoves are gone, Lizzie's massage books and electrical things. Florence has taken some of the old suite of Lizzie's furniture. Everything else is trash. Great bonfires have roared on the gravel walk. Tomorrow we are going to attack the garden. We will transplant some of Lizzie's favourites to Alice's garden and mine.

November 17th
I have had such a treat this week. Nan Cheney has been here every day. She is over from Vancouver to paint a portrait of me so we have chatted for long hours while she worked. She has made me look a jolly old codger and did not force me to sit like the dome of the Parliament Buildings. I could wiggle comfortably with Pout in my lap.

I finished "The House of All Sorts" two days ago. I *think* the sketches are a little more concise and to the point. They are in a series of what Dr. Sedgewick calls "pen sketches" on the various tenants who lived in my 646 Simcoe Street house. Nan likes them very much, so does Flora. They are the only two who have heard them. There is room yet to have them more smooth, but I am pretty

old to start in to write and am thankful if they even improve some. I don't believe they will ever be up to an editor's standard. Already things are teasing in the back of my brain for a fresh spasm. A new picture is fermenting to get on canvas, too, a big woods picture.

November 28th
We are nearly at November's tail and are hurrying towards December and Christmas, hurrying on through our span and soon out of life. I think about death a lot, always wondering what the surprises of death will be like, the things that eye hath not seen nor ear heard, nor that have entered into the heart of man. When the shudder of the plunge is over and our spirit steps out of this shell we have treasured, and all its aches and pains, I don't suppose we will ever turn back to look at it. A butterfly bursts its cocoon and leaves it hanging there dried up without a thought of it again. I can't see people hovering round their old treasures or desires after they have gone on. Youngsters don't hang round the doors of the classroom after they have passed out. They are too proud of having passed on.

Three new pictures are on the way, an immense wood, a wood edge and a woods movement. These woods movements should be stupendous, the inner burstings of growth showing through the skin of things, throbbing and throbbing to burst their way out. Perhaps if one had felt the pangs of motherhood in one's own body one could understand better. Until people have been fathers or mothers they can hardly understand the fullness of life.

When you want depth in a woods picture avoid sharp edges and contrasts. Mould for depth, letting the spaces sink and sink back and back, warm alternating with cool colour. Build and build forward and back.

December 13th
Sixty-six years ago tonight I was hardly me. I was just a pink bundle snuggled in a blanket close to Mother. The north wind was bellowing round, tearing at everything. The snow was all drifted up on the little balcony outside Mother's window. The night before had been a disturbed one for everybody. Everything was quietened down tonight. The two-year Alice was deposed from her baby throne. The bigger girls were sprouting motherisms, all-over delighted with the new toy. Mother hardly realized yet that I was me and had set up an entity of my own. I wonder what Father felt. I can't imagine him being half as interested as Mother. More to Father's taste was a nice juicy steak served piping on the great pewter hotwater dish. That made his eyes twinkle. I wonder if he ever cosseted Mother up with a tender word or two after she'd been through a birth or whether he was as rigid as ever, waiting for her to buck up and wait on him. He ignored new babies until they were old enough to admire him, old enough to have wills to break.

December 21st
I have got my stories back from Dr. Sedgewick. He says, "I have no criticism of

the sketches. The pieces need no revision but what can be supplied by a publisher's office. They are very sharply etched as they are now, in the main, and should not be tampered with. Matter and manner seem to me very well fused indeed. . . . They certainly should be published for the benefit of those who have eyes and ears. They aren't likely to have a large audience. The select few will be appreciative."

December 22nd
Somewhere there is a beautiful place. I went there again last night in my dreams. I have been there many, many times. It is extremely Canadian—typically Vancouver Island. It ought to be in a particular coastal spot not far out from Victoria but it is not there. I know all that coast. It is a wide snubby point. On the east it is bounded by a deep bay with a beach along the edge. I had never seen it from that side till last night. The beach is sandy and covered with drift-wood, and all the steep bank above is covered with arbutus trees, monstrous ones with orange-scarlet boles twisting grandly in a regular, beautiful direction that sings, slow powerful twists all turning together, shifting angle and turning again. It is a long, long row and superb. Other nights I have been to other sides of this place so I know what is up beyond the arbutus trees. That is where the buildings are. I have only seen the tops of the roofs. It is not public property. You approach the other side from a high earth road, unpaved, and you look down on the tops of the pine trees. Something seems to keep you out, I don't know what, a certain private feel, not law but delicacy. I wonder where this place is, what it belongs to, why I go there and love it and am content, for the present anyway, to keep out.

Christmas Day
There is deep snow but it is not bitter. I heard King George VI at 7 o'clock this morning speaking to his empire. It was wonderful. Maybe one day it will come so that the empire can shout back to the King. There is great peace in the cottage this morning. Louise is very busy "lining up" so that she can get away early for all day. Alice and I Christmased yesterday. We had a tiny tree in a flowerpot on the table and the presents round it. In the other window burned three red candles in my old red Swedish candlestick. Louise cooked good turkey and plum pudding and brandy sauce. There was a dandy fire. The lovebirds, chipmunks, and dogs and we ate, enjoyed, and were thankful. Then we undid the tree. Willie came. Edythe and Frederick came in the afternoon. I got millions of presents. People were good and we were happy.

December 31st
In one and a half hours it will be 1938, and a new year will have begun. What has 1937 contributed to life? Invalidism. Teaching me what? Alice says I've been sweet-tempered over it. Perhaps I've been too busy to cuss for I've written a lot, painted a lot, and have had lots of visitors. Illness has not meant idleness. It's drawn Alice and me closer. It's seen the last of our old 44 Carr Street-207 Gov-

ernment Street home. It's seen Alice and me setting out in our little, frail old boats on the last lap. The year has aged us both. Both of us have had a lot to give up, loosening of the ties. I have thought about Death a great deal this year. Sometimes he seems quite close and then again as if there'd have to be a long hard kick before it finished. And the world? Oh, the world that is said to be going to be finished in this era is breathing hard but going on just the same, on and on and on forever.

I am very settled in the cottage. It has grown round me. If I were pulled up now there'd be a tearing of roots. I have made it to fit myself. All my bumps are accounted for and my peculiarities taken care of nicely since the old house stuff came into it. It is very homey. Everyone says how cosy the cottage is and how attractive.

The little Christmas tree burned for its last time tonight. Such a silent, still glow the lights of a Christmas tree have. Up the street there is a wink-light tree—on and off, on and off. It has lost all the still radiance of Christmasy holiness and become a jazz show tree.

11 P.M.
I rang the bell and yelled, "Happy New Year" to Louise and it was only eleven, not twelve, that struck. There is one hour more of 1937 to live.

12 P.M.
It is 1938. Without one second's pause between old and new, 1938 is here.

THE SHADOW OF WAR
1938 − 39

January 8th, 1938

I am writing "Birds,"* a sketch of the sanatorium in England where I stayed for eighteen months. How dreadfully real the places and people are as they come back to me! The experiences must have been *burnt* as in pyrography. The story is a bit grim so far but I want to weave it round the birds, give it the light, pert twist of the birds. Birds are not tragic.

January 9th

Last night I was on the way to "the place" again. How strange that I am so often conscious of that place. It is very familiar but where is it? I am never quite there. I look up at it and down on it and on the way there I know the country all about it but actually I never enter the estate. I wonder if I ever shall.

I have burnt and destroyed stories, papers, letters. If you knew *when* you were going out you'd destroy all. There is no one to be interested or care after. Alice has destroyed everything, she says, and yet I like a few old letters, a few old notes of the past. You forget how much some of the friends out of the past loved you till you read again some loving letters. Some men and lots of women loved me fiercely when I was young. I wonder when I read the old letters from friends not given to talk and flattery, was I as generous with love to them? My love had those three deadly blows. Did it ever fully recover from those three dreadful hurts? Perhaps it sprouts from earth again, but those first vigorous shoots of the young plant were the best, the most vital. I have loved three souls passionately. I have known friendship, jealousy and dreadful hurt.

February 25th

I have been slaving away at the sanatorium sketch. In a way I think it is the best thing I have written but don't know. I know so very little about writing and not too much about life. I think this is deeper than "The House of All Sorts" but I don't know and who is there to tell me, or who to care if it is better or worse? Every one of us matters so little, and yet all of us must have a reason for being.

*Later *Pause*

March 20th
I gave the sanatorium sketch its third typing and read it to Flora. She was enthusiastic, read it to Margaret.

June
I have been working in Macdonald Park. Very delicious. May has just abdicated to June. The birds are settled into their nests and calling and singing to their sitting mates swaying quite violently in the June greenery because there is a lot of wind. The grass is long. People are chewing off tag ends of wild grass. The wild roses are particularly intoxicating this year. Banks of them are rolling round the base of the old trees of Macdonald Field—a big flat "splank" for each blossom, deep in its middle fading to its rim. The voice of their smell is beyond everything convincing, rushing at you, "I'm here! I'm here!" pulling you closer, closer with their ardent perfume, compelling you to come and look into their vital round faces, and lay your cheek against their coolness and draw deeply of the rich spiciness at their hearts.

The bracken is not yet adult. Each tip is an exquisite brown coil, very tight and very bashful, and the lower leaves that have opened are hothouse-tender and yellow-juiced rather than green. Little white butterflies quiver among the roses and ferns and over the heady grass powdery with pollen. Every minute the leaves draw closer, denser, about the birds' nests in the trees. Mrs. Bird's family will be quite shrouded in green seclusion by the time they are old enough to attract attention by their movements; by the time the tightening down of the mother's feathers conveys to them the sense of "hush" when danger is near.

June 25th
The secrets are out. The bracken tips have unfurled and baby birds are squawking and flapping among the dense foliage. The trees are fully dressed, brilliant and "spandy" in their new clothing put on with an imperceptible and silent push. There is nothing so strong as growing. Nothing can drown that force that splits rocks and pavements and spreads over the fields. To meet and check it one must fight and sweat, but it is never conquered. Man can pattern it and change its variety and shape, but leave it for even a short time and off it goes back to its own, swamping and swallowing man's puny intentions. No killing nor stamping down can destroy it. Life is in the soil. Touch it with air and light and it bursts forth like a struck match. Nothing is dead, not even a corpse. It moves into the elements when the spirit has left it, but even to the spirit's leaving there is life, boundless life, resistless and marvellous, fresh and clean, God.

November 3rd
I am tired of praise. The "goo" nauseates me. It has pleased me *very* much, the warm reception of my work. It is satisfactory to feel that people have got something from your interpretation, that you have been able in a small degree to let life speak *through* you, using your mind and fingers. I hear that there was one

adverse criticism, one who jeered. I should like to have seen that. I was the only one mentioned in particular in the London *Times* write-up by Eric Newton. What he wrote I think was more what he saw in my studio when he was out here than what was over there in the Tate Gallery. I have been doing portrait sketches, turning from my beloved woods for fear that all this honeyed stuff, this praise, should send me to them smug.

Life carries some exquisite pleasures! Outside my window grows a fuchsia bush. Three years ago I planted it and this year it crept up to peep in the window. It is scarlet and purple, a tiny, dainty swaying bell silently ringing with the slightest breeze. The organs on each side of your head don't register the sound but the soul does. The crimson-pointed tops catch the sunlight. They throb with colour as one would imagine the blood of a pure heart would glow, glistening with health. The purple of the bell is royal. The small insignificant leaves of the plant are eclipsed by the scarlet and purple of the bells. The bloodstream of the plant flows scarlet up the twigs and branches.

My fuchsia tree is loved by others than me. As I lie in my bed close to the open window there is a constant humming, a soft fine whirr quite different to mechanical, metal sounds. It is a velvety sound of flesh and blood. The air dandles it like a loved baby. Hummingbirds are sipping the nectar from the life of my fuchsia, jamming the bells by their hum and thrusting long beaks into the centre, into the inexplicable core and essence of the fuchsia's being. The hummingbirds whizz and whizz and whisk away with the flashing dart of a spontaneous giggle. It is as though you had been able to stick out a finger and stroke the joy of life. The fuchsia bells hang like scarlet drops; their secrets are still inside them folded tight, gummed up in silence and sweetness that even the hummingbirds cannot penetrate.

September 3rd, 1939

It is war, after days in which the whole earth has hung in an unnatural, horrible suspense, while the radio has hummed first with hope and then with despair, when it has seemed impossible to do anything to settle one's thoughts or actions, when rumours flew and thoughts sat heavily and one just waited, and went to bed afraid to wake, afraid to turn the radio knob in the morning. It was recommended by Clem Davis that we read the 91st Psalm for our comfort. I read it when I went to bed and went on reading psalm after psalm. What most struck me was the repeated "Praise the Lord," "Bless the Lord," "Praise, Praise, Praise." At 8 o'clock I turned on the radio and I knew it was war. It was almost a relief to hear it settled one way or another. All day we have listened, not able to keep away from the radio. You felt your job, the job of every soul, was to go on as reasonably and unselfishly as possible. I remember so well twenty-five years ago. I had just built my apartment house and war had been hovering. I went over the field to Dede's and heard there that war was declared. After the word had been spread by newspaper, telephone and extras yelled in the street by boys,

we all just looked blankly at one another. No one had any idea what the next move was going to be. Everyone wondered. This time, we who went through the last war have an idea, though we can't tell very much. Things have changed so, with the air and the radio. We know more things that are, perhaps, even more cruel. The *Athenia*, a great merchant ship carrying passengers and refugees, has been torpedoed and sunk off the Irish coast with 1,400 passengers.

The radio announcers seem sometimes as if they can scarcely get their tongues to word things, to throw such beastliness on the air. The blackened cities at night must be fearful. How can Hitler hold up, knowing what he has done to the world, under the black weight of nations cursing him.

September 4th

There is a singular emptiness in the air. The world is crying out. Nations glower at one another spitting hatred and condemnation, looking each other hatefully in the eye with their feathers loosened and flaring like creatures of the chicken-yard measuring each other. Their hot blood is still inside their own skins. They have not yet clashed and spilled it. Perhaps some day radio will be so powerful that battlefield screams and the suck of sinking ships with their despairing chorus of the drowning will reach our ears. That frightfulness would surely end war. We could not bear it. My maids know that they have only to dissolve into tears for me to soften to a pulp, no matter how they have angered me. If the air were filled with sobbing nations one could not bear it.

Today is Labour Day, a holiday. The street is quiet. The children reflect the mood of their grown-ups and everyone is wondering. A tremendous war has started and millions of human beings are holding their breath, asking one another, "What next?" All love their own harder than they did before. When I told my maid that there was a war she laughed. It made me very angry. It was so with the two maids before this one. War conveyed no meaning to them. It was a big ugly word tumbled into their world. Their main feeling seemed to be one of careless curiosity. Here was some new half-joke to explore and they sniffed around it, pleasurably excited at any change in the monotony of life that would make for variety. When it comes to the curtailment of any liberty or pleasure for them it will look very different. They don't particularly love their country. Oh, of course, it's "all right" but what's the use, things have always gone on and they always will. Why fuss about them so long as one can do what one wants for the moment? Let the other fellow look out for himself. Why should Canada fight for Britain?

We went to the Japanese Garden and took our lunch. It was very calm and beautiful there. A few people strolled through the garden. Nobody was smiling. Everyone was spending Labour Day guiltily.

On the other side of the world they are fighting, bombing and torpedoing. Vessels here and there are sinking to the bottom. Buildings and people are being hurled into the sky from the cities and coming down in scraps and tatters. Here we are in melancholy peace.

September 5th

The news seems vague and far off, not as if it were really happening. It sits on us like an ache. We are trying to ignore it lest the pain become unbearable.

September 6th

German planes have been hovering over London and Paris but have been driven off. There is fighting on the fronts but there is little news that is definite.

September 7th

The Montreal show that was to be held has been assembled, named and priced. Tomorrow it will be dusted and then sit waiting to hear if it is to go forward or not. War halts everything, suspends all ordinary activities. Fear and anxiety top everything. It seems that the only thing to do is to shove ahead day by day and make oneself keep busy.

September 14th

I am camping in Mrs. Shadforth's little one-room shack on Craigflower Road. It is very cosy, set upon a ridge among unspoiled trees, tall firs, little pines, scrub, arbutus bushes and maples. It is filled with great peace. One forgets that beyond the bushes, beyond beyond and beyond, across the world, there is war. Nations are hating and hissing, striking and wrecking and maiming. People are being hurt, maimed. The sea is swallowing them up in submarine explosions. Earth is drinking their blood. The sky hurtles their planes out of itself and their bodies crash and break in falling, and all because that hideous monster, war, is loosed and is dashing around the world. The earth is hideous with his roar. Any moment he may rush anywhere and devour. He is too strong for his keepers to have the courage to chain him up again. No gate is strong enough to pen him. His teeth are cruel and his talons rip.

Here in this spot is peace. There are just the dogs, the bird, Florence and I in this cabin in the woods. It wants to rain and a few drops squeeze down and hang around on the leaves, forgetting to tumble, or roll sullenly off the roof. Everything is quite still. There are no shakes or quivers. No birds twitter. Nature seems motionless, but all the while she is slowly, slowly swelling to the moisture, earth loosening, moss rising, leaves taking on a shine, not the dancing, shifting shine of sunlight but the calm slow glow of wet. From every point of the maple leaves outside the cabin window hangs a diamond. The green of the thin flat leaves is clear. Some of them have already turned golden, and the old rusted "locks and keys" jangle in a whisper above the maple. Far up in the sky is the blue green-grey of the tall pines.

The rain drops hit the roof with smacking little clicks, uneven and stabbing. Through the open windows the sound of the rain on the leaves is not like that. It is more like a continuous sigh, a breath always spending with no fresh intake. The roof rain rattles over our room's hollowness, strikes and is finished. Outside the water drips from leaf to leaf and comes to the sipping lips of the earth. She

drinks joyously. The colours are brightening, rich and deep under the wet. The arbutus leaves are new and tender, not finished and done like the others. It has thrown off the old bark of its limbs in crinkly little rolls and under them the new bark is satin-smooth, orange and red and green-gold. The wasps are drunk. They crawl and fly with no buzzing, tired, drowsy, unvital, like old folk nearly finished with a life that is fun no more, only achy.

Young Florence sits reading, only half interested. She is "wondering" behind the words. Her wonders nearly smother the sense of the print. She is thinking of odds and ends mostly, lipstick, hair curlers, her sore finger, her firewood that is getting wet under the rain, and what about dinner? One dog is on my feet, her side hugged to my hot bottle. The other in his box emits short, uneven snores. Blue Joseph is breakfasting. Between seeds, as he pares the husks with his tongue and beak, his head twists this way and that and his eye rolls up at the sky, indifferent to a joy he has never tasted.

In a grey woollen gown under the scarlet blankets, with pillows at my back and hot bottle at my feet, I find the earth lovely. Autumn does not dismay me any more than does the early winter of my body. Some can be active to a great age but enjoy little. I have lived.

September 16th

It is a foggy morning. A clammy cold clings to everything. It douses the pale sunbeams off the floor and greys the tree tops. It keeps the wasps down to the earth. The fog-horn comes thickly, shouting a stomachy blare like a discontented cow. Our cabin is cosy. The air-tight heater draws fiercely enough to permit our two windows and door to be wide open without discomfort. Outside, cobwebs staked at corners sag with dewdrops. As I sat on the doorstep brushing my teeth, I saw hundreds of them in the grass. Florence is sweeping the floor, erasing the dirt down a large knothole. Her one sorrow in this camp is that I brought no dustpan. She keeps the camp nice and orderly. The two beds covered with red blankets are neatly tucked. The frying pans hang side by side, velvety black at the bottom. There is a bench for the water pails, a meat safe, a table and a cupboard. The table is very stout. We built it.

We each have our own shelf by our bed for our particulars. Florence's has her curlers and her powder boxes, lipstick, fancy purse and mirror. All her things are young. On my shelf are books, hair brush, work basket, knitting, a jar of black jam, physic, and a dictionary. We each have a lamp on our shelf and read in our beds to which we retire at seven. My painting things are under and behind my bed, hanging in canvas sacks. Finished work is under my bed, flat. I should like to have one or two on the wall to study. I would if I were alone. But the old hiding of my work from a sniffing public has become a fast habit amounting to actual physical pain when they are under critical, unsympathetic eyes. It is foolish how even a little servant girl's eyes upon my crude, half-born thoughts hurts. When they are home and I have looked at them critically and clarified my thoughts about them a little I don't mind so much, but for people to criticize a

half-made sketch breaks something and then it is done for.

Noises come across the Gorge waters from the highway but they don't have any connection with our life here. They and an occasional speedboat fluttering down the Gorge are outside. Dogs bark and roosters crow but they, too, are over the water like the boat and mill whistles. They have nothing to do with us, nor has the howl of war on the other side of the earth. Only when one opens the newspaper does it throw a streak of hurt across the world.

It is queer how totally I forget my own home when I go to camp. It belongs to another world. I suppose it is comfortable to have it in the background but I am glad it has the good taste to sit in the back pew and not push up to the woods' altar when I am there.

September 17th

A long stagnant Sunday. No newspaper, no visitor, no work. I took the doctor's insisted weekly rest. Suspended stillness, suspended sunshine, suspended work, suspended news, everything hanging mid-air in heavy tolerance of being.

September 18th

Had breakfast at 7:30 in crisp, sparkling sunshine, still and cold. The wasps have no buzz and little appetite. They crawl sadly over the jam and are petulant. The dogs balk at being put out and Joseph noses his beak into his beard plumage and grouchily chews the upper mandible on the lower. Today I shall paint. A little brown bird hops into my cabin and runs over the floor looking for crumbs. He thinks Florence keeps the cabin over-clean and hops out again. Why is a hop more cheerful than a run?

September 24th

We quit camp tomorrow. I have worked hard. It is rather interesting stuff I think, but it is scuttled under the bed as soon as it is done. I can tell its worth better when it is home and I look at it in cold blood. The woods are trembling under the glow of autumn. There is a still, vibrating quiver, moist and lumi-nous, over everything, as incongruous as a "slow-hurry." Summer is lingering, winter pushing, and autumn standing contemplative, impatient to get to winter, yet reluctant to leave summer—just as I feel about camp this minute. I want to stay and to go. It is dark and cold soon after six o'clock. We have had supper in the hut for two nights. The chilly night air brings on heart pain.

September 25th

Florence is all stir and bustle at 7:00 A.M. I restrained her from rising at 6 o'clock to pack our few oddments. We do not leave till 2:00 P.M. She pounds round the cabin so that it wobbles and quivers like a jelly house, and the tin equipment clanks. The maple tree leaning towards the uncurtained window has given me great joy. The grey twisty stems swoop down and curl up again. The big flat leaves are brown, yellow and green. Through them you look up to the grey-

green pine towering in dignified silence up in the sky which is an amalgamation of greys and blues. And so I leave another camp and return to that ordinary part of the city known as Beckley Street. So be it. It houses me and my work. Back to war rumours, sad wonderings, censored news, and long faces, doubtful faces, angry faces.

Home

We brought the woods with us, a bundle of pine boughs for the aviary, huge sacks of moss for the chipmunks, also a bag of rosehips for them and a pailful of sword ferns for the corner of the garden. As one drives through town a change takes place in one's being. Not quite so bad as when I would come to London again after holidays in English country, and the train glided through those endless drab brick workingmen's houses, all alike in monotonous streets in districts where big chimneys belched smoke and smell. I will never forget that feeling of heaviness and dark in me as if someone had turned your illumination off from the switch and you were a solid-right-through lump of black. Victoria was not as bad as that, only the town looked tired and Beckley Street hopelessly sordid, with scraps of paper and peel, dirty-faced youngsters, yapping dogs and scuttling cats. The garden still has flowers but all the past-and-done brown shrivels are blown into the corners of the porch and steps. My flowers *wanted* me and so did my birds. All had been fed and watered, even too lavishly. Plants stood in puddles but they missed the wholesome picking off of dead blossoms and leaves. They looked desolate in the closed, airless house.

The aviaries are bursting with life. I have never heard such a whirring of wings. I have to run out every hour or so to sit among them, with the whole flock whirring round me. The bird house is over-full. There are nearly fifty budgies of all colours, beautiful, smooth young birds, still fluffily innocent-eyed and babyish. I love this winged life. It is like no other. It is so irresponsible and unearthy. There is such chortling, such bowing to each other and kissing. Bashful babies crowd upon each other in the corners of the nests when you peep into their boxes. To throw a pile of greens upon the floor and see the flock settle to feed is perhaps the loveliest thing of all. Their heads bob and the greens, blues, mauves, and yellows weave in and out in perpetual motion like a kaleidoscope. Each is intent on the business of keeping noisily alive and of reproducing himself as prolifically as possible, singing about it all the while. I have no desire to fly. I love the earth and am afraid of the infinity of the sky. It is over-vast for my comprehension.

September 27th

We broke camp just in time. The wind is blowing and the Balm of Gilead trees in Macdonald Park are rattling their leaves in a fury of clacking racket. My neighbour's late apples are falling too soon. The light that dips through the windows is a gloomy glower with no sparkle. One of my new sketches is up opposite my bed on a little shelf I have behind the door, hidden from every eye but

mine. The foreground is delicate with washes of autumn colour. The trees behind are wave upon wave of quiet greys. A blue sky recedes wave upon wave behind that. It is outdoorsy and I think I like it.

September 28th

I have been through my twenty-three new camp sketches. Autumn is in them and a certain lighthearted joy strangely out of keeping with war. I can remember the French painting teacher in San Francisco badgering me into rages so as to get my best work out of me. I think perhaps war in its heaviness pressed this gaiety from me. It escaped through my finger-tips and autumn borrowed it and together they hoisted a few little blobs of cheer-up into the dreary world. Or is it just that I was born contrary? Or is it the smaller the cage a bird is put into the better he sings?

October 3rd

The fog-horn is blaring. Fog squeezes into the house and lurks in the corners of the rooms, dimming and stupefying, but Joseph sings beside my bed and the young canary practises his trills in the studio. The hall stove is lighted for the first time. It is a sulky old brute. Lying awake a couple of hours last night I got to thinking about my manuscripts. Flora is correcting them and it galls me. She has command of English and I have not. I am glad of the help; I want it; but when she and Ruth have finished with the manuscripts I hate them. I feel that the writer (me) is a pedantic prig. If they'd only punctuate and let me be me and leave them at the best I can do! Heaven knows I sweat over them hard enough! Flora wants too much sentiment and Ruth strips and leaves them cold and inhuman. A hint of anything religious is crushed out in the modern kill-God way. I am disheartened. I know I am raw. Ruth and Flora have helped me, but their way of expressing is not my way. When I put in their words and changes, even though they are better, I can feel myself shrug and quit. Now is this conceit? When Ruth wants to cast out one of my words and is looking for her own substitutes I note that she has great difficulty. The words don't come to her. Flora wants my English to be perfect, but in the biography I'm talking as myself, of very average education, my words learned of decent parents rather than from a stabilized school education.

I think this is the last time I shall hand my manuscript over to others. What does it matter anyway? They won't be published. They just give me easement in writing. Were they any good, as Mr. Brown thought, in encouraging young students of Canada, then they'd do their job better, I feel, in my own words than in A-1 language that does not belong to me.

NEW GROWTH
1940–41

January 17th, 1940

The owner of my house wants to sell it. I have to move from this comfortable cottage that has housed me and my pictures and my beasts for four years. It is a great upheaval. I have been happy here. At first I was dismayed at the news, but now I know it's just one of those giving-up things that come to old age and must be calmly faced. It has a purpose in my life. Jogs are better than ruts. The balm of the whole show is that Alice anyway half wants me and it is luck that I have her empty flat to go to. Houses are hard to get and I shall be near her yet independent in my own flat. She has given me leave to alter the flat to suit my needs, which makes me more anxious not in any way to go against what she wants. The big room is all wrong as to light for work (it faces south) but somehow I shall manage, I know, and will make it cosy too. It will be nice for old age to be so close to each other. There will be many advantages and *some* disadvantages. I have made the owner an offer of $500 for this house. Should she accept I will repaint and resell it at a small profit to help finance the fixing of the other. If she won't, well I'll be quit of the worry and must do the best I can without it. Worries have a way of solving themselves. There's the dogs; they will be right on the street unprotected, but I shall contrive something for them I'm sure.

February 1st

We are awaiting a building permit and tomfoolery. It takes a quorum of three to decide whether or not you may have your toilet twisted back to front or your bath put into a legitimate bathroom instead of under the kitchen table. One of the three is sick, one is away, and the third could not possibly decide so momentous a question, and so the world waits for one to return or one to recover.

I wanted to paint the house. I have money enough. The painter roughly estimated that it would cost $65-$70. Alice was furious when I said I wanted to do it. I tried to put it all the nice ways I could, so as not to let her feel that *I* was doing it and that I was getting too much hold on the house, which seems to be what she fears so terribly. Then I said, "Alice, I won't have it painted, but I want to give you a cheque for $70 with no tabs on it, a free gift. Paint it any colour that suits you. It would improve and preserve it."

She flew into a towering rage. "The house is not mine any more," she said.

"It was good enough for me. It is good enough for anybody."

I said, "Alice, the old man who did your part just left patches of white, grey, or any old colour. My new boards will have to be done. Why not let me do the whole while the man has all the stuff here for the inside work?"

"Do what you like," she flung back. "The place is mine no longer!! Be quiet, I won't talk about it any longer."

"Then I shall paint it," I said and I cried a little. "I only want to do the house good."

But she sat in a dumb rage so I got our book and read steadily for two hours. Then she went home without a goodbye, without a word. I had a bad night. I am trying to face up to it and do what is fair and right. I shall pay my rent and let the house fall down if it wants to. Today I am sending her a letter saying, "I am *not* painting your house. I shall always remember, I hope, that the house is yours and I am a tenant."

Alice's house is her obsession. She resents having a thing done to it by anyone else. There was a like scene when I got some extra money last spring and tried to help her with the taxes. Does she feel that I am a smarty-prig because I keep my own place up as tidily as I can and because people love my studios with clean animals about and my paintings, and say complimentary things? I seldom mention what they do say just because she acts so queer and jealous. Perhaps she felt bad yesterday. Perhaps she felt sad because she was sorting up her school things, battered desks and tables and books, to make room for me. She *acted* as though she wanted me to go there to live. I so want to live happily beside her and yet I can't bear disorder. I'm like Father. Things about must be straight and nice, except for art litter which is unavoidable.

February 2nd

I have just had such a warm greeting and appreciation from a woman unknown to me. She did not even give her name. She wanted to know if she could get my books. She had heard my broadcast and loved "Sunday." She said it made her own childhood so clear. She did not know when she had ever enjoyed anything so much. I have had several calls of appreciation. One woman said, "What a fine man your father was to bring you up like that." I was glad that I had shown them Father's straightness.

Last night I did a lot of cleaning out of oddments, things necessary and things unnecessary to one's life. We clutter ourselves with a great deal of stuff, and yet when we turn that accumulation out we feel that there must have been a purpose in hoarding it. It shows us we were not quite through with it. Some of us assimilate so slowly that we have to go over and over a thing before we have got what was in it for ourselves. The half-thoughts that I wrote down bring back some memory of an experience. Maybe we have outgrown it now, but it helped establish our underpinnings. And all the odd people we meet in our lives, they too are grains of sand piling up to be mixed into life's foundation. The patchwork of our lives is made up of very small stitches keeping the patches in place.

Has a root or bulb the power to look up through itself and see its own blos-

som? Or must it live always in its own dark domain, busily, patiently sucking its life from the earth and pushing it up to the flower? How terrific the forces of nature are! To see roots split stone appals one. I think that has impressed me more than anything else about the power of growth. An upheaval is good, this digging about and loosening of the earth about one's roots. I think I shall start new growth, not the furious forcing of young growth but a more leisurely expansion, fed from maturity, like topmost boughs reflecting the blue of the sky.

February 7th

I have been having a kind of general regurgitation of my work preparatory to moving. Everything has had to be cleaned and sorted in a general review of thoughts that had shaped themselves into sketches and sketches that had shaped themselves into canvases. I've done an immense amount of work. In looking back I can see the puckerings of preparation for ideas that burst later and bore fruit, little brown acorns that cracked their shells and made little scrub thickets full of twists, and a few that made some fairly good oaks. Tired though I am, I want to start working again. The afterlooks at some things have made me anxious to wriggle out of that particular rut and try another. After four months lying dormant owing to moving and flu, I itch to hold a brush and catch up with myself. I have written a lot in bed, even during the upheaval of moving preparations, for I can only put in from noon to six o'clock at manual work. But in the early morning I can write, sometimes as a sedative. I write when I can't sleep for planning. Usually I dare not write at night or my mind is too stirred for sleep, but in this stress writing seems to calm it. I can lose myself in my story.

February 8th

The last two Mondays I have been "on the air" and listened to my own thoughts coming back to me like echoes out of space. Dr. Sedgewick reads them beautifully. The first he read was "Sunday." The public chuckled, at least Victorians who have mentioned it did. It amused them and many tell me that it brings their own childhood back to them very clearly, and others say the pictures are very vivid to them. The second time Dr. Sedgewick read three short Indian sketches that were from my account of Ucluelet. The first gave the church and the old man who came without pants and the second was a description of the village itself. The third was "Century Time." I think I liked these better than "Sunday." They were not so amusing but went deeper, and were more adult in perception. Perhaps I shall never do anything beyond my Indian stuff because it struck into my vitals when I was freshly maturing into young womanhood and my senses were keenly alert. The ever-growing universe called to the fast-developing me. The wild places and primitive people claimed me.

Last Saturday the picture half of me moved. Next Saturday the rest of me moves. Today is Thursday. The little cottage looks mournful. Partial emptiness leaks out of the rooms. The "derelicts" waiting in one room to be taken to the

auction room look dilapidated and forsaken. That which moves with me waits, huddling together like a lot of sheep waiting to be herded into a new pasture. Houses don't like being empty. The corners cry out when you speak.

The creatures are suspicious of all the stir. The canaries sing harder as if they wanted to drown the lonesome echoes. The garden has grown bald spots. The old Chinaman dug the flowering shrubs gently and wrapped cloths about their roots, tipping a gentle shovel of earth into each bundle like giving to each sad child a lollipop to soothe it. Then a waggon came and I drove off with my shrubs, sitting among their roots, their leaves tickling my ears as we drove. We lowered the plants into the new-dug holes as soon as possible. I can fancy the little roots feeling their way into the new environment slowly, exploring the soft, strange earth. The leaves were a little drooped and the good new earth silently called to them, anxious to give them life when they were in heart again to tackle it.

It is a sober business this uprooting, this abandoning of a piece of space that has enclosed your own peculiarities for a while. Up and down the street each house and lot is full of individual queernesses seamed together by fences, a complete patchwork-quilt affair, with a street running down the centre. Alice's street will be different, more select, with no bawling youngsters, no workmen's dinner pails, no up-and-downers to the corner shop, to return with loaves and milk. The street cleaner goes down St. Andrew's Street but Beckley Street knew him not.

Alice is hurt so easily and I am rather clumsy, I fear. If I enthuse over the new flat, she withers up like a fern you have drawn through a hot hand, or shrugs and says, "It suited *me* before all these changes." If I don't enthuse, she thinks me unappreciative and hard to please. It must be dreadful groping round in perpetual twilight with blindness peeking and mowing at you from all the corners. It must be my special care to watch my clumsy steps, to leave her as much alone as she wants and yet to watch how I can help without seeming officious, never, never trespassing beyond my rights as a tenant. That house is her obsession and she craves admiration for it. I shall have the better part of it. My workmen have done a good job. The old derelict who fixed her part did a rotten job but she would not heed either Joan's telling or mine, and only got furious with us for trying to warn her. There is no one in the world more obstinate than Alice.

February 23rd
Goodbye to Beckley Street. There is one load left. All else is packed. I am very tired. A new page of life is about to turn and my finger is licked to flip the corner. It is four years to the day since I took possession and cried for the awful ache of the moving forlornness. I came in alone because Lizzie was too sick and Alice was busy with her kids. Good old Willie found me crying on a stool behind the front door. How little my sisters have entered into the important shake-ups of my life! Alice, nearly blind and so bent and decrepit, has done all she could this move, working more than she ought to have done, and Willie is again to the fore, good, dependable, fussy old Willie. Fourteen-year-old Florence has done well; she stuck at it like a Trojan.

The canaries and Joseph are already in place in the new house. I do not regret leaving any of my neighbours. They are all right. I have found them good enough neighbours but we meet so surfacely. Our interests and outlook are entirely different. I resent the unswept, dirty street littered with chocolate bar papers. Now I am going home to end my life a few yards from where I started it. How shall I paint and how write in the new environment, or are my work days done? Goodbye, little cottage.

Everyone says, "Ah, that is much better! It will be so nice for you to go back to the old place." The insinuations are a little dig in the ribs to Beckley Street, as if to say, "That was a pretty poor part." Well, it was not. I have had four of the calmest and best working years of my life there. I have had more distinguished visitors, sold more work, had more recognition and been more independently myself than ever before. Lizzie criticized my living. She was always watching for things that were not up to her conservative estimate of what Carr actions should be. Alice was equally indifferent to whether I was 646 Simcoe or 316 Beckley, though she did rub in the superiority of St. Andrew's Street.

February 25th—218 St. Andrew's Street
At ten A.M. we moved. I said goodbye to Mrs. Newal and Mrs. Leckie, to Grannie and Mrs. Hobbs, and to the children who swarmed to see the last things being put into the van. The new house was ready, in a way, with good Willie waiting to help. Florence was a little aghast at the smallness of the kitchen and the immensity of the packing cases. The dogs were patiently excited in their boxes. Their little yard was all ready for them. The birds were fretting at the small cages and rejoiced ecstatically when they were liberated into the verandah cage. The chipmunks, all newly mossed down, nervously sniffed the change. And me all mussed and pretending not to be fussed.

The verandah was one awful mess of recent rain on oily paint, indescribably mussy and dirty. The dreadful floors are still unpainted. The garbage pail was flaunting its beastliness at the front door, being as ugly as it could in its short spell of aristocratic location. The pictures were hiding their faces to the walls. The old clock was willing to tick, given an upright position, even though it was bereft of its appendages. Alice's bush was full of sparrows, cheeping their hearts out and watching the affluent canaries and doves with their full seed hoppers. Neighbours' eyes followed neighbours' noses as near to the fence as their dignity permitted. Their curtains fluttered between curious fingers and peeking noses. The wind knifed in draughts round the blindless and curtainless windows. The calmest things in the house were the geraniums sitting on my bedroom window-ledge, green and scarlet and serene, chewing sunlight and air as contentedly in St. Andrew's as in Beckley Street, growing every moment and taking their lowly sips of life from a tiny flowerpot full of earth.

Florence and I went to the forlorn and forsaken Beckley Street and cleaned up the empty house, ravished garden and voiceless bird house. We burned the last of the bird house's cedar boughs and they crackled up to Heaven with parched, independent roars and a sweet smell. Then we doused water on the

live ashes. We locked both doors and got into a waiting taxi with the cage of grumbling lovebirds. I ran back again to gather a goodbye handful of wallflowers from the bush by the step. I had to take a great many heart pills yesterday, more than any day; weariness and fear of a final stroke agitated my heart.

We came back to 218 St. Andrew's to find the great glutton of a fireplace cleared out and my little old stove giving the whole place a fine heat. It was a great relief for I was anxious about the cold of the flat and how I was going to make do. The birds tried in every way to break their bonds and I have had to swathe their cages in muslin. Lovers had got parted in the three separate cage groups and there are bitter quarrels. Willie is working on the aviary but until it is finished there will be civil war in birddom.

The wild riot of furniture begins to sort itself a little. Tables are tables again and chairs prepare to accommodate people instead of a miscellany of objects. The pictures are still dumb. The geraniums alone are exultantly cheery. They like life and human society better than the colder aloofness of a cottage front room, though I used to visit them often. The big begonia sulks and has flung his leaves to the ground. His gnarled, woody stalks were pruned back and tied together to avoid breaking in transit, and he is mad.

Night

As I cannot sleep, I may as well write. The house begins to be a home. The unfamiliar places are beginning to fold the familiar objects into their keeping and to cosy them down. Objects that swore at each other when the movers heaved them into the new rooms have subsided into corners and sit to lick their feet and wash their faces like cats accepting a new home. The garden is undeniably mine already, with its neat fence and the griffon dogs. The great brooding maple is thinking of spring and with half-waked stir is drawing the juice from my little patch of earth. The big fuchsia and the young japonica, blushing with its first year's blooming, are set orderly against the newly painted walls, with thongs of moose hide from the North softly restraining their young branches. Spring won't be long now. We two old winter birds will welcome her. Alice says pitifully, "What is there?" as she stoops and feels some tender young thing springing from the earth. It must be terrible knowing that she cannot expect to see them with those eyes any more, and having to rely on other people telling her. It is like learning a new world, comprehending by touch, smell and sound. Thwarted sight cries out to sort things for itself in the accustomed way.

My bedroom is large and has a great deal in it, not only furniture but millions of memories, memories of when it was the school dining-room and I took noon dinner at my sister's. Alice carved at one end of the big table and Lizzie slapped vegetables on plates at the other, making cheerful or fretful conversation. Many, many children have sat in this room, nice ones and nasty. Suddenly they all come trooping hungrily in again from the schoolroom, clambering into high chairs or mounting upon the big dictionary or a cushion to allow their fat elbows and round faces to appear above the table edge, nice, funny little tykes or rude, home-spoiled horrors. Alice patiently pecks at them, "Other hand, Billie.

Don't chew out loud, Sally. No talking. Eat a little of the fat too." Then there is
the scraping of chairs after being excused and a row of children standing by the
kitchen sink to have the maid untie their bibs and sponge their lips and fingers.
Lizzie would streak like a stone from a catapult back to her own house, to her
dusting and her charities, and I would have a little chat with Alice as she drib-
bled water on the flowers in the glass alcove of the schoolroom, one eye and ear
on the children playing in the yard, running to the door every five minutes to
say, "Stop yelling! I won't have it, children!" Then I would go around the corner
to my own house and the job of landlady, which I detested, or would scurry off
to paint in some woods, which I loved. Time dragged on, pulling us with it
regardless of everything, drawing us through the successive seasons indifferent
to our grunts or grins. Life's interesting. There is so much to see, so much to
bite off and store and chew on—chew, chew—like cows converting our crop-
pings into the milk and meat of life.

February 29th

I am unutterably weary but happy in the satisfaction that we are on the high
road to being established permanently. It is nicer and cosier all the time. I had
visitors today and the carpenters came to finish up odds and ends. I feel very
content with it all. I think Alice is too but she would not admit for worlds that
it was improved. The builders tell me that the house was practically tumbling
down and was waterlogged and rotted at the corners from broken gutters.
Every door was out of whack. Blinds, oh! Floors, oh! Paintwork, oh! Now it is
beginning to look loved and cared for. The poor old lilac tree has had the trash
cleaned from between its branches and the suckers pruned out. The brambles
and trash outside my windows are gone. The bird houses are neat and will be
attractive when painted. Alice mourns over these innovations. It seems as if she
wanted these things to age and grow dilapidated to keep pace with our own
ageing.

March 2nd

Big things bump into you, bruising. Little things chafe and nag and have no
finality. The thousands of little chores pertaining to cleaning up and to the
decencies of living squeak, "Me, me, me!" all clamouring to be done first. Big
things have taken all my energy and bounce; the squeaking of the little ones
irritates me now.

The sun is determined to show up every blemish in the window fixings. I
promise myself a day of recovery in bed but I cannot hoist myself high enough
above minor details to rest. The birds are liberated into the new aviary and the
chipmunks are there too. All are delighted after a week in small, crowded cages.
The budgies stretch and preen. Reunited lovers kiss and beak each other's
whiskers. The chipmunks creep with little jerky darts, scampering in and out of
their cage which serves as a mossy run so that they can go in and hide when
they feel exclusive. The birds do not notice their comings and goings. The
aviary is a weave of beautiful colour and swift movement. It is delightful. I

called to Alice, "Come and see." She came crossly. "I can't see them, so what's the good of my coming?" She began grumbling about the cage's location, able to see the scattered lumber and missing the lovely bird part. Good old Willie has tried so hard to please us and has done everything so kindly and well that I feel ashamed of her nastiness to him. "Give us time," I said, "and we will get everything cleared up soon." But she slammed off with a growl.

March 5th

The world is horrid right straight through and so am I. I lay awake for three hours in the night and today as a result I am tired and ratty even though the sun is as nice as can be. I want to whack everyone on earth. I've a cough and a temper and every bit of me is tired. I'm old and ugly, stupid and ungracious. I don't even want to be nice. I want to grouch and sulk and rip and snort. I am a pail of milk that has gone sour. Now, perhaps, having written it all down, the hatefulness will melt off to where the mist goes when the sun gets up. Perhaps the nastiness in me has scooted down my right arm and through my fingers into the pencil and lies spilled openly on the paper to shame me. Writing is a splendid sorter of your good and bad feelings, better even than paint. The whole thing of life is trying to crack the nut and get at the bitter-sweetness of the kernel.

Some copper wire, a spot or so of electricity and a curly-headed youth have hitched me to the round world and, marvel of marvels, voices, travelling unaccompanied by their vocal cords and all the other fleshly impedimenta, are visiting in my studio. Silly gigglers, ghastly crooners, politicians, parsons, advertisers of every known commodity, holy music, horrid music, noise with no music, the impartial air carries them all, distributing to any who have a mind to tune in. The ghastly breath of war roars and bellows. Someone has collected the dregs of terror, stirred them into a fearful potion, and poured them on to the air.

The wind is tearing and roaring. The heavy cedars on the boulevard of St. Andrew's Street writhe their heavy, drooping boughs. Shivery and flexible, they never break; they only toss in agonized swirls. It has been a brutally bullying day.

March 6th

Today I received a compliment which pleased me. I was just through with giving a grocery order when the grocer's rather gruff voice said, "Say, are you the Miss Carr whose stories were on the radio recently?" "Yes." "Well, I want to tell you how much my wife and I enjoyed them. We were sorry there were not more. Say, won't there be more? We liked them. They were humorous, they was." And Una wrote how thoroughly she's enjoyed them. That was most *warming*, from one of the family.

The house is now curtained. Curtains are foolish. Why leave "see-outs" in walls and then blind the vision with cataracts of curtaining? I have only done what is necessary to quell the fierceness of the sun for painting, to comply with the law about the world seeing one's raw flesh, and to satisfy Alice that her house looks decent. All are on quickly pushed-back rings so that except when absolute modesty or painting necessitates I can face the outside. I can see the beautiful

cedars on the boulevard and the decorous well-blinded windows of St. Andrew's Street on which, unlike Beckley Street, every soul is respectable, every garden trim, and down which the street sweeper and boulevard attendants make periodic visits. I like decency. Wild places are totally decent but tame places that are slovenly and neglected are disgusting beyond words.

We have supper at Alice's and then bed. The dog boxes are one each side of me, two boxes of calm snore to my bed full of toss. Alice kisses me goodnight and says it is nice to be under the same roof.

Morning brings cold and wet. The house is very cold this morning and it caused great indignation when I said so. I must go carefully. Alice cannot bear one criticism of her house. Her answer is always, "It suited *me*."

Later

We had tea round the studio fire—on top of it, grilling like steaks. It is comfortable enough but the great maple tree over the house is the real heat sucker and benefiter by the studio fire. When we pile logs into the huge cavern the old tree yowls, "That's my relative," and claims the heat, permitting us to have the ash. The chimney is big enough to have the boy sweeps of old go up with a hand broom. Necessary and unnecessary articles are heaped one on top of the other in the studio. The great blank windows stare. In bed with two hot bottles is the only comfort I've found yet. In time I'll get used to it. The layout is nice if only there was heat in my bedroom cupboard. The water has soaked down the walls for epochs of time; it is sodden. What a freeze-up would be like I cannot imagine. This winter is mild, though yesterday there was sleet and penetrating cold that chilled one to the heart, and the doors and windows leak draughts. I feel like an alligator who has swapped places with a polar bear. Life is harsh, as though it had turned its deaf ear towards you.

I used to wonder what it would be like to be sixty-eight. I have seen four sisters reach sixty-eight and pass, but only by a few years. My father set three score years and ten as his limit, reached it and died. I, too, said that after the age of seventy a painter probably becomes poor and had better quit, but I wanted to work till I was seventy. At sixty-four my heart gave out but I was able to paint still and I learned to write. At sixty-eight I had a stroke. Three months later I am thinking that I may work on perhaps to seventy after all. I do not feel dead, and already I am writing again a little.

I used to wonder how it would feel to be old. As a child I was very devoted to old ladies. They seemed to me to have faded like flowers. I am not half as patient with old women now that I am one. I am impatient of their stupidity and their selfishness. They want still to occupy the centre of the picture. They have had their day but they won't give place. They grudge giving up. They won't face up to old age and accept its slowing down of energy and strength. Some people call this sporty and think it wonderful for Grannie to be as bobbish as a girl. There are plenty of girls to act the part. Why can't the old lady pass grandly and not grudgingly on, an example, not a rival? Old age without

religion must be ghastly, looking forward to only dust and extinction. I do not call myself religious. I do not picture after-life in detail. I am content with "Eye hath not seen, nor ear heard." Perhaps it is faith, perhaps indolence, but I cannot imagine anything more hideous than feeling life decay, hurrying into a dark shut-off.

The days fill out. They are happy, contented days. I am nearer sixty-nine than sixty-eight now, and a long way recovered from my stroke. There is a lot of life in me yet. Maybe I shall go out into the woods sketching again, who knows? I have got the sketches out that I did on the trip just before my stroke. They are very full of spring joy, high in key, with lots of light and tenderness of spring. How did I do these joyous things when I was so torn up over the war? They were done in Dunkirk days when we were holding our breath wondering if those trapped men were going to get out. We did not know the full awareness of it then; we were guessing. Yet when I went into the woods I could rise and skip with the spring and forget my bad heart. Doesn't it show that the good and beautiful and lovely and inspiring will of nature is stronger than evil and cruelty? Life is bigger than war and the tremendousness of spring can wash out the dirt of war. The terrific thing that is working over the nations is quite beyond the human. It is no good being dismayed. It is as inevitable as night. Tomorrow can't come till the night has finished today. Nature finishes off one season's growth and begins all over again. Her worn-out cast-offs contentedly flutter down to the honourable joy of fertilizing the soil so that the new growth may better thrive from their richness. It is not dismayed when it turns yellow and sere, when it shrivels and falls.

October 23rd
Lawren and Bess Harris came to Victoria from Mexico and paid me a three-and-a-half-hour visit, rooting well through my picture racks and expressing pleasure in them. I said to Lawren. "You have not told me of the bad ones," and he said, "There are none." But I expect he found them tame after abstraction. He said that I was after the same thing as he was but had not gone so far. He thought my work had gone on. He seemed, I thought, to hanker back somewhat to the more advanced Indian material. He spoke little. I felt that they were both taken aback to see me aged and feeble. For days on end I have had a steady headache and feel very, very tired and old.

December 13th
I am sixty-nine years old today. It has been a nice birthday—cold, bright and frosty. Such lots of people remembered my date. Lollie Wilson and Hattie Newbery came to tea; Ruth Humphrey and Margaret Clay looked in, one with cigarettes and one with flowers. Alice asked Flora Burns to supper and we had a nice evening round the fire chattering. A *very* satisfactory birthday. Only one more year of man's allotted time to go.

I do not mourn at old age. Life has been good and I have got a lot out of it, lots to remember and relive. I have liked life, perhaps the end more than the

beginning. I was a happy-natured little girl but with a tragic streak, very vulnerable to hurt. I developed very late. Looking back is interesting. I can remember the exact spot and the exact time that so many things dawned on me. Particularly is this so in regard to my work. I know just when and where and how I first saw or comprehended certain steps in my painting development. Of late years my writing has shown me very many reasons for things. I do not resent old age and the slowing-down process. As a child I used to say to myself, "I shall go everywhere I can and see and do all I can so that I will have plenty to think about when I am old." I kept all the chinks between acts filled up by being interested in lots of odd things. I've had handy, active fingers and have made them work. I suppose the main force behind all this was my painting. That was the principal reason why I went to places, the reason why I drove ahead through the more interesting parts of life, to get time and money to push further into art, not the art of making pictures and becoming a great artist, but art to use as a means of expressing myself, putting into visibility what gripped me in nature.

December 20th

A week of my new year has gone already, apparently quite uneventfully. But who knows? A seed of something may have been sown and be turning over, preparing to root. I don't suppose we know from moment to moment what trivial happening is going to develop into something big or is just going to snuff right out. Maybe it is a sentence in a book or a statement by someone on the radio, or a true start, like a flight or a flower or a bird, the alive in us being caught up by the alive in the universe.

I am not writing but I have three new canvases on the way. I am being objectively busy making garments for refugees and letting my brain lie lazy after writing "Prim Pyramids," which Ruth says is not successful in its human side. The cedars are good. I know that. I ought to stick to nature because I love trees better than people. I don't know humans as deeply. I see their faults above their virtues and they are so hideously self-conscious.

December 22nd

I have spent a long Sunday in bed. I like staying in bed on Sundays now, first because after the week of pottering busily to top-notch of power I'm tired and tottery and need it. Sunday begins at 8 A.M. when it is still very dark, with the newspaper rattling and the kindling crackling, and the kitchen door opening, and the studio door shutting, and the slip-slop of Alice's retreating footsteps. Then comes the effort of turning the radio dial and clutching the glass of lemon juice. Both are on the bedside table. "This is London calling on the overseas service of the B.B.C." and with businesslike velocity the news is vomited into the room, a mess of war. After fifteen minutes one is quite awake, completely of the earth again and not earth at its best. A tray of beastly melba toast and tea sits beside you and you feel like a stall-fed cow with her eye on the dewy pasture while munching the dry, dusty hay. Then comes a church service to which I lend an ear while I sew for refugees. Then, in my gown, I do the birds with

Alice, followed by a bath and dinner, nap, tea, letters and reading aloud. The dogs never move off the bed the day I am in it. At last Alice goes off and I read a little and think a lot and Sunday has gone.

December 24th
Lawren and Bess came in today. Lawren pulled out a lot of canvases but his crits were not illuminating, although they were full of admiration and appreciation. He seemed to pick on some small, unimportant detail and never to discuss the subject from its basic angle. Trivialities. I observed that he turned back to former canvases often with epithets like "swell," "grand," "beautiful," and the later canvases he was perhaps more silent over. I wonder if the work is weakening and petering out. Perhaps so. I feel myself that the angle is slightly different. Perhaps the former was more vigorous, more disciplined, but I think the later is more thoughtful. I know it is less static. Perhaps the static was more in line with his present abstract viewpoint. He was enthusiastic enough and complementary— but not enlightening. Praise half as warm many years ago would have made me take off into the sky with delight. Now I distrust criticism. It seems to be of so little worth. People that know little talk much and folk that know halt, wondering, self-conscious about their words. Perhaps the best thing I got out of this visit of the Harrises was a calm looking with impartial eyes at what Lawren pulled out of my racks, things I had almost forgotten that stirred my newer and older thoughts together in my mind and made me try to amalgamate them.

December 26th
Christmas over. That anticipatory feeling lies quiet, dead level now, mixed with relief. It was a nice Christmas. Paul Newel, Alice and I dined in the studio. Alice was rather flat over it but fairly cheerful. It was to have been in her sitting room but she put her tree on the table. She'd have liked it in her kitchen with all the news and suffocation of turkey sizzling and plum pudding steaming and the low, flat roof crowding the smells down on to us, and someone falling over a cooking utensil at every move. I simply could not face it, after my stroke under similar conditions in the same place a few months back.

Paul did all the extra carrying and running. Alice cooked the meal calmly, without fuss and crowding. We ate a very nice dinner and Christmas mail came just at the end. Then we sat round the picture end of the studio enjoying cigarettes and animals, and Marjorie, Henry and Willie Newcombe looked in. Then we went into the bedroom and listened to the King's speech. We had a simple supper and cleared up. Then the calm of being alone and sewing refugee garments an hour before bed. Paul may have felt it a wee bit flat his first Christmas from home in a big family, with only two old crows for company, but he did not show it.

December 28th
Why do inexplicable sadnesses suddenly swell up inside one, aching sadness over nothing in particular? There is generally some self-condemnation at the bottom

of the feeling, disappointment with yourself by yourself, or else a disappointment with someone else who makes you mad. (But in that case it is more mad than ache that ails you.) I am disappointed in everyone just now. I don't feel as if there was one solitary soul that I could open up to. Sometimes you forget and find yourself opening up. Then, like a stab, the other person suddenly shows that they don't understand, don't agree, have a different viewpoint, and you bump back on yourself with a thud that nearly stuns you. Morals and religion are the chief subjects for disagreement. Am I intolerant? I don't know. Lying, sham, belief in God, there are only two sides to questions like that—right and wrong. I don't mean the *way* of regarding those things, I mean those actual things. To church-goers I am an outsider, but I *am* religious and I always have been. But I am not a church-goer and my attitude towards the Bishop, whose narrow church views I could not accept, made my family's disgust of me thunder upon my being and pronounce me irreligious and wicked. I could not sit under a man whose views I despised. It would have been hypocrisy. Alone, I crept into many strange churches of different denominations, in San Francisco, in London, in Indian villages way up north, and was comforted by the solemnity. But at home, bribed occasionally into the Reformed Episcopal, I sat fuming at the mournful, "We beseech Thee to hear us, Good Lord," and "God be merciful to us miserable sinners." They said them in quavery, hypocritical voices, very self-conscious, and I hated it. I wanted to stand up and screech and fling the footstool and slap the prayer books. Why must they have one voice for God and one for us? Why be so conscious of their eyes on the prayer book and their glower on you? Why feel disapproval oozing from them and trickling over you? Why feel yourself get smaller and smaller, wilting like spinach in the process of being boiled? I longed to get out of church and crisp up in the open air. God got so stuffy squeezed into a church. Only out in the open was there room for Him. He was like a great breathing among the trees. In church he was static, a bearded image in petticoats. In the open He had no form; He just *was*, and filled all the universe.

December 31st

We have come to the end of 1940, and goodbye to it. Nineteen forty-one is coming in with a stir and a burst like a baby that is giving its mother an awful time, screaming and shrieking. Will the child thrive or shrivel? It *can* die. That would break the continuity but God alone knows if it will go from one convulsion into another till we wish it would be out of its agony. I fear that we are a long way from the worst yet. Mercifully we can't see ahead. Moment by moment is enough. You can always bear the present moment; why anticipate the next hour?

I hate painting portraits. I am embarrassed at what seems to me to be impertinence and presumption, pulling into visibility what every soul has as much right to keep private as his liver and kidneys and lungs and things which are coated over with flesh and hide. (He'd hate *them* hanging outside his skin. He'd be as disgusted as the public at the sight of his innards exposed.) The better a

portrait, the more indecent and naked the sitter must feel. An artist who portrays flesh and clothes but nothing else, no matter how magnificently he does it, is quite harmless. A caricaturist who jests at his victim's expense does so to show off his (the artist's) own powers, not to portray the subject. To paint a self-portrait should teach one something about oneself. I shall try.

January 1st, 1941

At a quarter to twelve I put my 1940 light out. Alice and I had drunk some port wine and eaten some shortbread, and later we kissed and wished and separated. I had read from the hymn book this verse:

> God the all wise by the fire of Thy chastening,
> Earth shall to freedom and truth be restored;
> Through the thick darkness Thy kingdom is hastening,
> Thou wilt give peace in Thy time, Oh Lord.

Repeating it, I slipped into sleep and did not wake till the half-light of 1941 had dawned.

The radio has bawled and buzzed its string of war events. I feel sixty-nine and wonder how I would feel about war were I six or nine instead of sixty-nine. I am glad I had a childhood without war.

February 21st, 1941

I finished "Wild Flowers" and gave it to my sentimental critic. She rang me with volumes of assurance that the manuscript had arrived safely—silence—"Did you read it?"—long hesitation—"Yes"—then ha's and hem's. Of course I knew it had not registered. She began picking on the construction. It had no plot. (Of course it had no plot but it had something else; it had life.) Flower character it had but that had passed right over her. I have not the least doubt it is rough, unlettered, unpolished, but I *know* my flowers live. I *know* there is keen knowledge and observation in it. I don't know how much one should be influenced by critics. I do know my mechanics are poor. I realize that when I read good literature, but I know lots of excellently written stuff says nothing. Is it better to say *nothing* politely or to say *something* poorly? I suppose only if one says something ultra-honest, ultra-true, some deep realizing of life, can it make the grade, ride over the top, having surmounted mechanics.

I was so disheartened by my critic I felt like giving up. For a week I have lain flat but today I perked slightly and decided what my other two critics have to say will interest me. If all three agree as to the badness of "Wild Flowers" I'll either quit or hide; I won't show anything to anybody again. But I think I shall work on still. I still feel there is something in "Wild Flowers." I've never read anything quite like it.

The inevitable is coming; it is surging over all. Stupendous things are happening moment by moment, terrific forces are at work. The old world is being smashed and ground and powdered. I don't think we should mourn it so much.

All those marvellous cathedrals and churches were built by men who believed and worshipped. They built them to worship God in. They are now primarily for show. The holiness clinging to them was the holiness of past generations. The young have rooted God from their lives, explained him away with science. Life is nothing without God.

It is the ugliness of old age I hate. Being old is not bad if you keep away from mirrors, but broken-down feet, bent knees, peering eyes, rheumatic knuckles, withered skin, these are *ugly*, hard to tolerate with patience. I wish we could commune with our contemporaries about spiritual stuff. With death getting nearer it seems to get harder. We think of it often, but rarely mention it, then only in stiff, unnatural words.

March 7th
Today Miss Austie took me for a drive round the park and to the Chinese cemetery. The sun was powerful, the Olympics strong, delicate blue, Mount Baker white. The cat bush is already green and the weeping willows round the lake droop with the weight of flowering life, but there are no leaves yet. Everything was splendid. The lend-lease bill has gone through in the States. The war is staggering. When you think of it you come to a stone wall. All private plans stop. The world has stopped; man has stopped. Everything holds its breath except spring. She bursts through as strong as ever. I gave the birds their mates and nests today. They are bursting their throats. Instinct bids them carry on. They fulfil their moment; carry on, carry on, carry on.

Aug. 29/06 Donated